COMFORTABLY *Wild*

FALCON®

An imprint of The Rowman & Littlefield Publishing Group, Inc.
4501 Forbes Blvd., Ste. 200
Lanham, MD 20706
www.rowman.com

Falcon and FalconGuides are registered trademarks and Make Adventure Your Story is a trademark of The Rowman & Littlefield Publishing Group, Inc.

Distributed by NATIONAL BOOK NETWORK

Cover design by Amanda Wilson
Front cover photos: top (Fronterra Farm) by Mat Coker, bottom left (Playa Viva) by Kevin Steele, bottom middle (Trek Guatemala) by Matthew Humke, bottom right (Luna Mystica) by Amanda Powell
Back cover photo (Asheville Glamping) by Stephen Walasavage

British Library Cataloguing-in-Publication Information available

Library of Congress Cataloging in Publication Data available
ISBN 978-1-4930-3779-7 (paperback)
ISBN 978-1-4930-3780-3 (e-book)

∞™ The paper used in this publication meets the minimum requirements of American National Standard for Information Sciences—Permanence of Paper for Printed Library Materials, ANSI/NISO Z39.48-1992.

The authors and The Rowman & Littlefield Publishing Group, Inc., assume no liability for accidents happening to, or injuries sustained by, readers who engage in the activities described in this book.

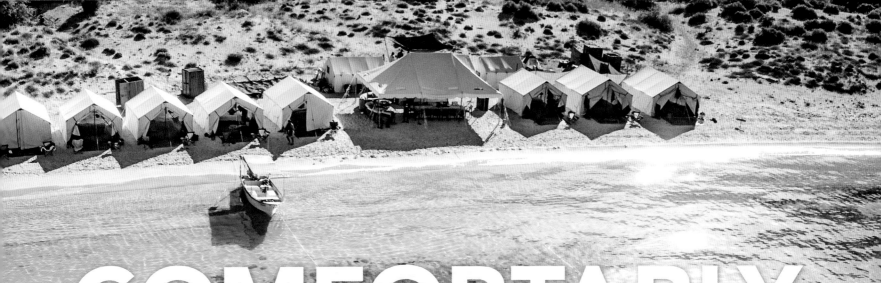

THE BEST **GLAMPING DESTINATIONS** IN NORTH AMERICA

COMFORTABLY
Wild

Mike & Anne Howard
HoneyTrek.com

FALCON®

Guilford, Connecticut

Contents

Introduction 1

Glamping: Past, Present & Future 5
 What Is Glamping? 5
 The History of Glamping 8
 Why Glamping? 12
 Scientific Benefits 16
 The Future of Glamping 18
 Find Your Experience 19

Structure Styles 22
How to Use This Book 24
Property Map 25

1. CULTIVATE 26
More than farm-to-table cuisine, these are farms that invite guests to pick vegetables, feed the animals, and cook meals from the earth.

2. SAFARI 48
Visit regions rich with wildlife and properties that seek respectful and educational encounters.

3. REJUVENATE 70
From guided retreats to low-key getaways, these destinations offer yoga, spa treatments, art workshops, and wellness options that encourage us to slow down and appreciate the simple things.

4. LIVING HISTORY 92
These properties are keeping traditions alive, whether it's restoring a train-stop town or celebrating African heritage through art and music.

5. IN MOTION 114
From hut-to-hut hiking to river-rafting camps, this chapter features outfitters where the journey is the experience and adventurous spirits are handsomely rewarded.

6. URBAN OASIS 136

For those who want the best of both worlds, these venues allow you to be in nature and near the dynamic offerings of a lively town.

7. WILD WEST 158

These ranches offer creative accommodations, from prospector tents to entire ghost towns, and opportunities for city slickers to live out their cowboy fantasies.

8. FANTASTICAL 180

Ice hotels, tree mansions, medieval encampments . . . these places play up the fantasy of glamping with out-of-the-box architecture and over-the-top experiences.

9. CONSERVATION 202

Beyond sustainable, these inspiring properties are improving the land, empowering local communities, and inspiring guests to be stewards of the environment.

Vacation Matchmaker 224

Get Glamping 227
 Prepare 227
 Packing 228
 Gear Essentials 228
 Diversions 230
 Cooking 231
 Responsible Travel 232
 Types of Glamping Properties 233
 Planning & Booking Sites 234

Random Awesomeness 236
North America Glamping Directory 238
Conclusion: Away We Go 242
Acknowledgments 244
Photo Credits 245
Sources 246
Index 247
About the Authors 250

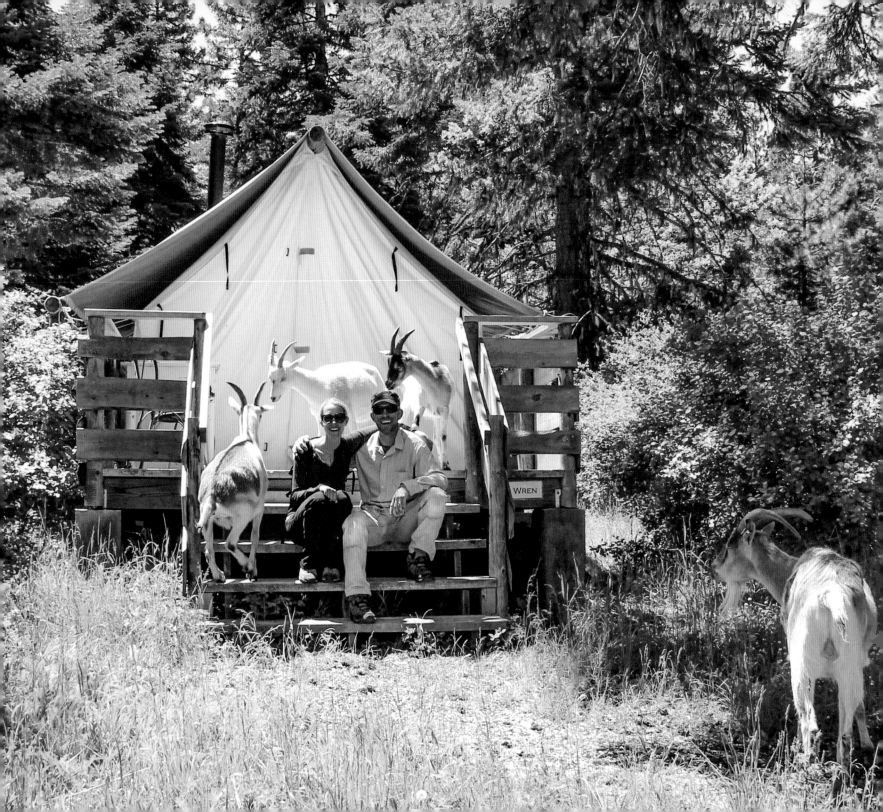

Introduction

BEFORE MIKE AND I STARTED DATING in 2006, he tried to woo me with a camping trip. While I grew up in the Santa Monica Mountains and hiking was one of my favorite pastimes, I was no camper. In colorful detail, Mike described how fun it would be to go river rafting, cook over a fire, and sleep under the stars. That sounded intriguing, so I accepted the invite—on what would become our first date.

With a dozen friends decked out in mismatched life vests, we embarked on a 10-mile odyssey down the Delaware. Seven miles in, there was a huge flash of lightning and crack of thunder that rippled the water. The wind picked up, and it wasn't blowing downstream. As a boat full of city kids, we didn't necessarily think we were going to die, but it crossed our minds. Mike, ever the Boy Scout, spotted an old tarp on the banks—and without warning dove overboard to retrieve it. "Hold up your oars! We can use it as a roof!" We made it to camp feeling victorious until we realized we still needed to set up our tents in the downpour. Taking that same tarp and whatever camp spirit we had left, we mustered up a shelter. When we finally tucked into our sleeping bags, Mike looked at me with my tangled wet hair and raccoon-esque eye makeup, and we burst into a fit of laughter. He leaned in for a kiss, and I smirked, "Next year, let's get a cabin."

Since that fateful camping trip, we've explored 58 countries across all 7 continents on what is considered to be the "world's longest honeymoon." In January 2012 we ditched our desk jobs, rented out our apartment, and sold our possessions to celebrate our marriage with a trip around the world (aka our HoneyTrek). A bucket list of adventures propelled our journey to the Maasai Mara, Great Barrier Reef, Machu Picchu, Antarctica, and beyond. Though somewhere between having our bus break down in a random village and taking a wrong turn on a hiking trail, we realized the best places barely make the map. Seeing the sunrise over Angkor Wat with 700 tourists didn't move us like waking up in Laguna Colorada, surrounded by thousands of flamingos. The wildlife, rugged landscapes, and people we encountered along the way to the world's most renowned sights are what left the deepest impression.

With five years of international travel under our belt, we decided to approach our journey across North America a little differently. Europe is dense with historic cities and highly connected by trains, while Asia had enough buses and affordable tour operators to get us everywhere we needed. In North America the beauty is in our wide-open spaces and all the places public transportation can't reach. We couldn't be tethered to transit hubs and truly explore the Rocky Mountains, Sonoran Desert, Great Bear Rainforest, and Everglades. To find the best glamping in North America, we were going to need an RV.

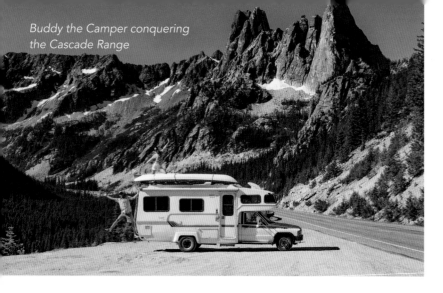

Buddy the Camper conquering the Cascade Range

Meet Buddy the Camper. Born in 1985 to Toyota parents, this "Sunrader" is a vintage charmer and mighty four-cylinder steed. Despite his age and lack of horsepower, he has taken us 56,000 miles around the United States and Canada. And where Buddy couldn't go, we used our airline points to venture to the Dominican Republic, Costa Rica, Honduras, Nicaragua, Guatemala, Belize, and Mexico. Many people think of North America as the northern half of the map, but it extends from the Arctic Circle down to Panama, and also includes the Caribbean. To do right by this dazzling continent, we embraced the full definition of North America and covered as much ground as we possibly could in 2 years' time.

If you Google "best glamping destinations," there are over 14,000 results. Our quest was partly motivated by our frustration with these listicles. Not only did they mostly feature far-flung archipelagos and the African bush, but the same properties were being regurgitated with photos commissioned by the marketing department. We weren't convinced the authors had been to many of the destinations. How do they know these places are the best if they haven't experienced them or tried hundreds of others for comparison? Call it bold, but having scouted hotels around the world for Honeymoons.com, blogged for Glamping.com, and written National Geographic's first book on couples adventure travel, we felt we could take on this project with a certain level of authority and learn a heck of a lot along the way.

We, of course, took these top 10 lists into account and added many of the properties to our route. Some were as fabulous as described; some didn't make the cut. We'll probably catch some flak for not including a few of the most famous glamping destinations, and we know many of them deserve their fame for five-star service and luxurious facilities—but that's not what this book is about.

This book is about the dreamers and the doers. It's about the individuals who had a crazy idea to create unconventional retreats in the most unlikely places. People who took incredible risks and poured their hearts into a property so they could share it with glampers like us. Some of the most inspiring folks we've *ever* met are the proprietors in this book. Going on a four-day trip with Teton Wagon Train & Horse Adventure, founded by the descendants of the first guide to bring pioneers over the Teton Pass in 1889, we were in awe of the Warburton family. From 22-year-old Jordan, who composes brilliant songs about the spirit of the West, to their dad, Jeff, who is an animal science expert and wagon master, this family is the real deal. More than just a few lasso tricks, they taught us what it means to be a cowboy.

In addition to interviewing these passionate owners in person, we had them write down their key details and stories—some as long as 36 pages. We cried when we read the Good Knights questionnaire. Co-owner Linda Smith is an archer, seamstress, pewter caster, and survivor

of polio and spina bifida. Her mobility issues have never held back her ambitions. Her husband, Sir Daniel (he's actually been knighted), wrote about how they had always loved camping, but "My lady deserved better than sleeping on the ground." So he handmade her a four-poster wooden rope bed and bought a spacious bell tent so they could camp at the Renaissance Faire in style. That tent is what started their now glamping retreat, Good Knights medieval encampment (p. 196), where they both can teach you to shoot a longbow bull's-eye.

There was a moment when we considered organizing this book by type of structure (after all, that's mainly how the glamping websites do it). But is it really about the act of sleeping in a wall tent versus a dome? While there is an inherent sense of adventure waking up in a treehouse or a 1950s Airstream, a great glamping destination offers so much more than that. We want to zipline to that treetop suite and make breakfast in the vintage camper using the fruit we picked in the organic orchard. We seek new opportunities and unforgettable experiences.

Navigating Lake Nicaragua

Want to horseback ride to a secret saloon (p. 173)? Unearth dinosaur fossils in the badlands (p. 223)? Fat-bike over the frozen Arctic Ocean (p. 52)? It's all possible.

What do *you* want from a glamping vacation? To help you brainstorm and discover fresh ways to travel, we've organized this book by type of experience. Looking to de-stress? Try the hot springs and art workshops in the "Rejuvenate" chapter. Want your kids to understand where food comes from? Have them harvest veggies for a farm-to-table dinner at the farmstays in "Cultivate." Are you fascinated by historic places and other cultures? "Living History" has your answers from British Columbia to Lake Nicaragua. In addition to the four main properties in each chapter, we share three more that elaborate on the topic. For example, at the end of the "Safari" chapter, we feature nonprofits where your glamping stay helps with wildlife conservation. In the middle of each chapter, there is a two-page photo spread; this is usually a behind-the-scenes moment and a bonus adventure.

In the upcoming chapter you will read about the who, what, when, where, and why of glamping. We want people to understand that this style of travel, once called a fad, actually has a rich history and staying power. In our fast-paced, work-driven, tech-heavy society, we need glamping now more than ever. Most of us have become detached from nature in our everyday lives and forget what it feels like to be surrounded by something bigger than ourselves. We need the time and space, without our phones buzzing, to look each other in the eye and laugh about our own adventures, not what we saw online. As authors and explorers, we've worked our tails off to compile the best glamping destinations in North America—now all you have to do is pack your bags.

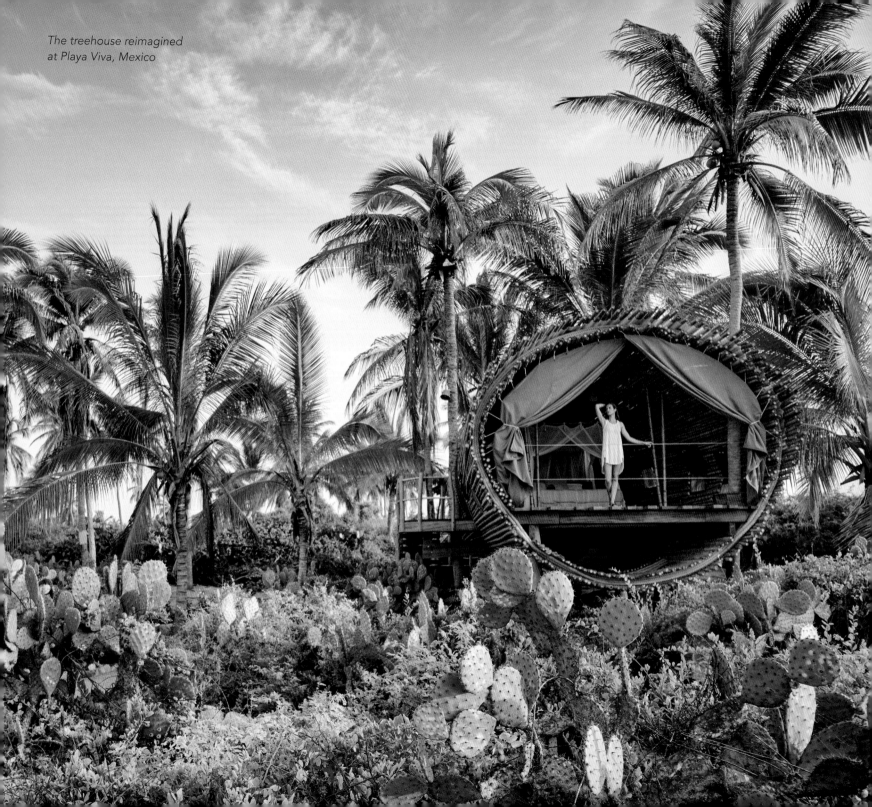

The treehouse reimagined
at Playa Viva, Mexico

Glamping: Past, Present & Future

NO MATTER WHAT YOU BELIEVE glamping to be, there is a worldwide craving to get back to nature, stay in unique places, revel in little indulgences, connect with family and friends, and have experiences that inspire us. To understand glamping, we need to break down this funny word—its history, structures, creators, participants, and what's in it for you.

WHAT IS GLAMPING?

Only added to the *Oxford English Dictionary* in 2016, "glamping" (a portmanteau of "glamorous" and "camping") has been defined as "a form of camping involving accommodation and facilities more luxurious than those associated with traditional camping." But we're not going to take the word of a linguist in a cubicle as gospel. To get to the bottom of this, we interviewed leaders and proprietors across the glamping industry, dug through countless studies on travel and camping trends, and heard from the glampers themselves. We went on a 2-year quest, glamping in over 60 places across 9 countries, to find its meaning—not so much in words, but what it means to us as 21st-century humans. To discover why we need this particular style of travel—for our health, community, planet, and for the fun of it all!

These are the hallmarks of an ideal glamping destination:

- Access to nature
- Comfortable accommodations
- Creative structures
- Sustainable practices
- Engaging experiences

Access to Nature

Purists might say glamping is not "camping" and that having someone else build your haven in the wilderness defeats the point. And while we definitely respect the woodsmen who hike with their gear and fish for their dinner, they've had the great outdoors to themselves for far too long. For someone who's grown up in the city, even getting to the woods is an achievement—much less wrangling a tent. "I'm just so happy to see that glamping has gotten more people outdoors," says MaryJane Butters, glamp camp owner since 2004 and author of the DIY guide *Glamping with MaryJane*. "Camping was always a man's domain. And I thought, 'Why can't we *all* find a way to enjoy the outdoors?'" Everyone benefits from access to nature, and the ease of glamping is blazing a new trail.

Glamping has opened up millions of acres that were largely untapped. "Everyone has a fantasy as they drive through wilderness areas," says Butters. "They think, 'How do I get out there?' I wanted to make it more accessible." Intrepid glamping property owners have been harnessing wild forests, mountains, lakes, beaches, and even patches of nature in the city. While glamping destinations are most commonly built around breathtaking

landscapes, they don't need to be in Patagonia or the Serengeti to have an impact. Glamping is giving people a chance to rediscover nature and love it too.

Comfortable Accommodations

Some people refer to glamping as "comfort camping," and they have the right idea. Most of us don't go for the chance to feel "glamorous" in the woods; we just want to feel at ease. We want to find the beauty of nature without all the gear shopping, schlepping, and setup. We don't want to exhaust ourselves building out a camp, only to sleep on the cold hard ground. Glamping owners totally get that and have upgraded the camping experience with spacious tents, fluffy beds, and outdoor lounges. Teresa Raffo, co-owner of the gorgeous Mendocino Grove (p. 142), says, "We were not aiming for luxury but just enough comfort to let your guard down and nature in." People who previously ruled

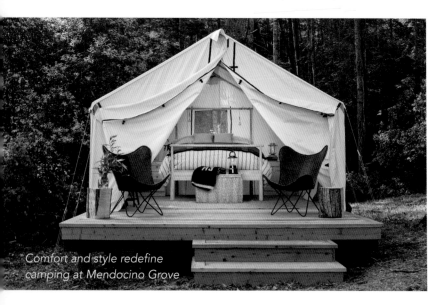

Comfort and style redefine camping at Mendocino Grove

out camping vacations no longer have to worry about roughing it. They are being welcomed in with beautiful spaces and a friendly host for any needs that arise.

Creative Structures

Glamping isn't just an alternative for campers, it's a fresh choice for anyone who feels like chain hotels around the world—be they in Boston or Beijing—are all the same. Business travel has made staying in a hotel feel like a boring extension of work and something people want to get far, far away from. No matter how nice a room might be, when there are 50 identical suites on your floor, it just doesn't feel that special.

Glamping thrives on creative design. Treehouses, geodesic domes, teepees, wall tents, yurts, vintage trailers, shipping containers . . . there are no limits to what a glamping structure can be, as long as it offers comfort in nature. GlampingHub.com, a leading online booking platform for unique outdoor accommodations, prides itself on offering more than 25 types of structures and 35,000 listings. When we asked cofounder Ruben Martinez how he makes sense of this diverse influx, he said, "When we see a new and exciting property, we include them, rather than say they don't fit because they're different. That's not what glamping is. Glamping *is* different."

Sustainable Practices

Creative design should never be at the expense of the environment. The good news is that glamping structures are inherently light on the land. Teepees, yurts, tents, and trailers are nomadic dwellings, self-contained and nimble enough to work with the existing landscape. The highly acclaimed Treebones eco-resort (p. 76) was proud

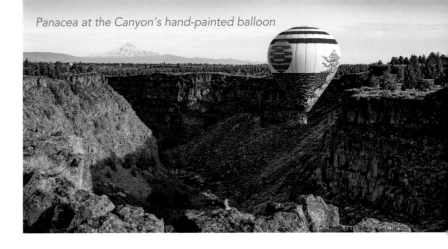
Panacea at the Canyon's hand-painted balloon

to say that even their most luxurious tent (500 square feet with a fireplace, claw-foot tub, and looks akin to the Sydney Opera House) could vanish tomorrow and leave only four postholes in the ground.

Many of the luxe glamping properties are off-grid—harnessing solar and wind power, capturing their greywater, and growing their own produce. Pacuare Lodge (p. 214) is a five-star National Geographic Unique Lodge of the World, and their suites don't even have electricity! Why? Because it's far more romantic when someone lights dozens of candles around your room each night. Under Canvas, the largest glamping organization in the States, says their tented camps use 87% less water than a similar-sized hotel, thanks to low-flow toilets, smart faucets, and other conservation techniques. Part of Under Canvas's drive to keep opening more glamping retreats is "the power to affect hospitality as a whole," says cofounder Sarah Dusek, "to show different ways to experience these beautiful places and how it can be done sustainably."

Engaging Experiences
Though perhaps the number-one criterion for glamping is the reason most of us travel at all: unforgettable experiences. Whether it's the novelty of sleeping in a treehouse or the act of river rafting to reach it, unique adventures are what the 21st-century traveler desires. Skift, travel's largest industry intelligence platform and media outlet, put out a report in 2014 on "The Rise of Experiential Travel." Their synopsis:

> Intense global demand for travel experiences that resonate on a deeper emotional level is driving travel brands to develop a product that is more adventurous, more personalized, and more attuned to local culture, inspiring consumers toward a path of self-discovery.

They deemed this the hot new travel trend, but it didn't fade away like the pet rock or the cronut. As of 2019 they say, "Now, we understand 'experience' as being an integral and desired part of *all* leisure travel." Today it's the parent category that great new trends live under. It's no longer about just eating a nice meal; it's about harvesting the ingredients and preparing them alongside a five-diamond chef (p. 189). It's not just about going on a hot-air balloon ride but that your glamping host is the balloonist and artist that hand-painted your flying canvas (p. 85). Glamping offers activities we all love—hiking, yoga, paddling, cooking, swimming—but there's usually an interesting twist and an inspiring person making it happen.

You'll find guest quotes throughout this book, because sometimes you just want to hear from your peers. After a stay at a 115-year-old salmon cannery with original manager cabins (p. 94), a guest was moved to write: "Memories are not made in the chain hotels. Memories are made when you take an adventure from the norm."

THE HISTORY OF GLAMPING

The roots of modern-day glamping structures are largely found in the ancient dwellings of nomadic people, who found these portable and easy-to-assemble structures conducive to their lives on the move. Military expeditions also played a big role in glamping's evolution. Traveling armies needed a place to sleep, and officers were not going to bunk with the lower ranks. As empires expanded and royal lifestyles became more sophisticated, camps evolved into lavish tented cities. Surrounded by beautiful decor and exquisite surroundings, the royals recognized the benefits of outdoor accommodations. Glamping began to take hold as a form of recreation, and a variety of styles played out over the millennia.

Below is a very rough timeline of when certain glamping-esque structures and related pastimes came to be. It should be noted that other styles of dwellings have also inspired glamping, but these are some of the most formative.

15,000 BCE: Huts & Earth Shelters

Made from organic material, like branches, grasses, and leaves, huts are hard to trace to an exact time frame, but we know they originated well before this date and were an early advancement after cave dwelling. However, around 15,000 BCE, migratory hunters in Europe began covering their huts with turf and soil as an insulator[1], akin to the new age Earthship or Hobbit home.

7000 BCE: Native American Teepees

Evidence of these conical tents, shown by the presence of circular stone enclosures and the imprints of lodgepoles, has been found east of the Rockies.[2] While other Native American tribes used similar structures for hunting, the Plains Indians are credited with this iconic dwelling.[3]

1000 BCE: Mongolian Ger (aka Yurt)

This circular structure, made of wooden lattice and covered in felt, originated from the Mongolian nomads. It was ideal for housing larger groups (up to 15) and withstanding the steppe's harsh climate.[4] Sturdy, spacious, and quick to assemble, yurts became popular across Central Asia.

100 BCE: Roman Tent

Makeshift tents, propping up hides with sticks for shelter, had been well under way, but the savvy Romans laid the foundation for the modern-day wall tent. To expand the empire and house thousands of soldiers along the way, the Roman Army created lightweight and easy-to-assemble tents made of hide panels. Secured by stakes, guy ropes, and poles, soldier tents could sleep eight people, and a general would enjoy 144 square feet with 9-foot-high walls.[5]

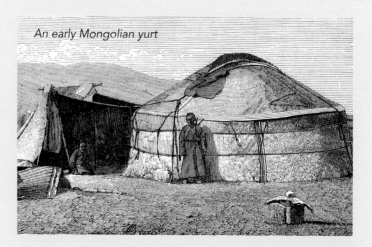

An early Mongolian yurt

100 CE: The Treehouse

In its simplest form as an elevated refuge, the tree dwelling has ancient roots in the tropical forests of the South Pacific. However, as a place of diversion and luxury, one of the earliest known examples goes back to Roman Emperor Caligula. There is a written account of his 15-person banquet in a tree, complete with servants and acrobats for entertainment.[6] Europeans continued to build in the boughs, from the Franciscan monks' meditation rooms to the Medici family's extravagant dining rooms.

1200 CE: Persian Royal Tents

Persians also had a nomadic lifestyle, following warmer weather and greener pastures for their livestock. Tents were not just for sheepherders, however; some sultans spent a third of the year in the countryside as a getaway from the dirty cities and royal responsibilities. By the 1400s these tented accommodations had become as lavish as palaces and were often preferred to their stationary counterparts in the city.[7]

1300 CE: Ottoman Tent Cities & Palaces

Turkish tribes had long been living in domed tents, and this adaptability as nomads aided the expansion of the Ottoman Empire. During military campaigns, they set up tented cities with simple abodes for commoners to palace-like complexes. For the upper class, columned tents with conical roofs had a double-shell construction, embellished with a satin inner layer and intricate appliqué decoration to resemble tilework or floral patterns.[8] Filled with ornate furnishings and plush rugs, these lavish living and entertaining spaces were the gold standard for centuries to come.

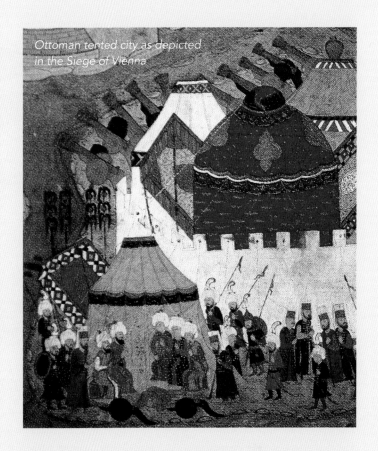

Ottoman tented city as depicted in the Siege of Vienna

1500 CE: Renaissance Royal Gatherings

When European royals traveled or received visiting nobility, they were known to set up castle-like tents with extravagant provisions. A prime example is the 1520 summit between King Henry VIII of England and King Francis I of France. The tournament field hosted thousands of tents (plus a wine fountain) and was coined "The Field of the Cloth of Gold" for the volume of fabric woven with silk and gold. Each trying to out-luxe the other, Henry's pop-up palace spanned 108,000 square feet.[9]

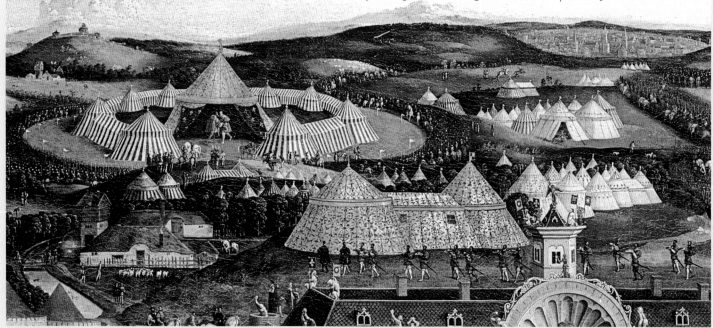

The Field of Cloth of Gold painting documenting the lavish European royal summit of 1520

1800 CE (mid-century): African Safari

With explorers, missionaries, and resident generals sending tales of Africa's unbelievable wildlife back to Europe, the allure of safari took hold in the mid-1800s. By the turn of the century, entrepreneurial "white hunters" living in Africa started organizing trips for Europeans and Americans. Bringing volumes of staff and gear in tow, they hunted for big game by day and stayed in decked-out bush camps by night.[10]

1800 CE (late century): Victorian Camping

With the Industrial Revolution mechanizing Victorians' lives and polluting their cities, they felt a need to get back to nature—but weren't quite ready to rough it. Used to living with luxury, they brought their servants and hired guides to set up tents, cook over the open fire, and navigate their adventures.[11] This more-comfortable brush with the wilderness allowed them to learn about nature and themselves.

1900 CE: Travel Trailer

It didn't take long after the invention of the car for people to use it as a means of comfortable camping, with early adopters even bolting on tent platforms. In 1910, Pierce-Arrow's "Touring Landau" was the first RV, with a fold-out bed, sink, and chamber pot. Later that year, Los Angeles Trailer Works and Auto-Kamp Trailers began rolling off the assembly line.[12] By the 1930s there were around 400 travel trailer companies, but their popularity declined with the Great Depression and didn't spike again until after World War II.[13] When those GIs came home, they were ready for a road trip! RVs and

travel trailers were the most efficient and affordable way to explore the country in comfort and style. Mid-century campers like Airstream, DeVille, and Spartan are timeless designs that inspire many of today's glamping destinations.

2000 CE: Modern-day Glamping

The turn of the 21st century's tech boom and financial bust brought a yearning for the simple pleasures of camping. The UK's Glamping Association credits its beginnings in the late 1990s to a one-two punch of a down economy and a new law that required a special license to tow a travel trailer. To find an affordable and comfortable alternative, they needed to get creative. Even without a name to call themselves, glamping destinations were quietly emerging to fill this void. By 2005 the British newspaper *The Guardian* had put the pieces together, saying, "These days, it's more glamping than camping," and the term hit the mainstream. Met with a mix of intrigue and mockery, the trend prevailed, with more and more luxury tented camps, treehouses, and wildly imaginative structures. In 2016 the word was officially added to the *Oxford English Dictionary*. By 2019 tens of thousands of glamping destinations and multiple associations had been created to support the longevity of glamping.

The Rise & Almost Fall of Glamping

For all the reasons listed above, glamping boomed—almost to the point of its demise. The trend got so hot, with tented camps popping up everywhere and people misappropriating the word in all sorts of jokes, that there was a backlash. In a 2014 Today.com poll of least-favorite

Camp Arden circa 1880—a rustic getaway for high-society New Yorkers

made-up travel words, "glamping" came in second, just behind "babymoon." Bloomberg.com went so far as to say it had become a "four-letter word" in the mid-2010s and that the accommodations were confused and "ultimately felt neither glamorous nor like camping."

The novelty of putting a four-poster bed in the woods was no longer enough. Glamping property owners began to set themselves apart, and creative minds joined the mission to make this noble style of lodging stick. They had to tune out the haters and steadily grow to greatness. Better properties were hitting the scene, and more people were giving glamping a go.

GlampingHub.com has been growing 75% year over year, and 90% of their accommodations are rated four or five stars. In 2017 a San Francisco investment firm bought a minority stake in Under Canvas for $17 million. This was not a fad. With proof of concept, major hotel chains like Marriott and Rosewood started opening up properties. Glamping had gone from trendy to a new standard in experiential travel.

WHY GLAMPING?

Glamping is appealing to people across demographics and for a variety of reasons. Kids can run wild, parents get a little pampering, couples have a romantic space, dogs are welcome, city folks can come as they are, and—if you didn't hear—even celebs like Oprah and Prince William love glamping. It is great for just about everyone—here's why people dig it:

Real Relaxation

Unlike a cruise ship or amusement park, glamping is not about constant stimulation—we get enough of that on our smartphones. "To pare down and shed complexity . . . this, in essence, is the origin of 'camping,'" says Jens Bergen of Fronterra Farm Camp and Brewery. "It's why we chose the noble tent and simple garden as our tools for change." Once we strip away the distractions, we finally notice the puffy clouds and singing birds. In a 161-page study on the US glamping market's industry outlook and forecast for 2019–2024, research firm Arizton Advisory & Intelligence had many interesting findings on this little-researched topic. They found relaxation to be a main driver, with 37% of people seeing it as a way to de-stress.

Nostalgia

Whether out of necessity or pleasure, mankind has been camping since the dawn of time. We get nostalgic when we think of a crackling fire, the taste of s'mores, and late-night storytelling. Though when the moment comes to get all our gear out of storage, we suddenly remember that our tent leaks and our significant other loathes

sleeping on the ground. "Glamping offers everything you love about camping without everything you hate," says Martinez of Glamping Hub. When we know all that hassle is out of the way, we can hang on to our good memories and head out to make new ones.

This is particularly true of parents and grandparents who want to share their own childhood pastimes of hiking, fishing, and playing in the woods with their tech-laden kids. "There is definitely a nostalgia," says Rainer Jenss, founder of the Family Travel Association (FTA). "Stories and memories come out around a campfire, and those magical moments form bonds."

Family Friendly

In the FTA's 2018 US Family Travel Survey, these were among the top 10 motivations to travel: (1) Discover new places and have new experiences; (2) bond and grow closer; (3) relax and unwind; (6) experience nature;

(7) disconnect from tech and everyday pressures; (9) be pampered and experience luxury. This study wasn't about glamping, but it sure sounds like what the thousands of respondents were looking for. The founder actually used to work for Glamping.com and says he started the FTA because he "wanted families to know that there are alternatives to Disney." He says glamping is fantastic because "it gets kids in nature, creates opportunities to bond as a family, and saves money as compared to traditional resort options." The good news is that parents are catching on, and when it came to choosing preferred vacation types in the survey, they ranked both camping trips and adventure vacations above cruises.

The Instagram Effect

Whether playing to our nostalgia or bending our minds with an unconventional design, glamping just looks cool. A canvas tent at the edge of a sea cliff, a treehouse balancing in an old-growth cypress, a vintage camper serving martinis out the window; these are images you've seen on Instagram, and whether you realized it was glamping or not, you wanted to be there. And with all these dreamy moments coming at us on social media, FOMO (fear of missing out) has run rampant. It has made us rethink the big-box hotel and inspired us to do something worth posting about. (When you do, include @HoneyTrek #ComfortablyWild and we'll cheer you on.)

A Story to Tell

Ever had a helicopter fuselage for a living room (p. 186)? Been bobsledding on an Olympic track (p. 210)? Taken a stagecoach to a Dutch oven cookout (p. 164)? We hadn't either until we tried them out for this book—and we can't wait to share them with you! As Sarah Riley, founder of InspiredCamping.com, says, "People want places with a story, something they can tell their friends about and share with their family year after year."

Staycation

With the high cost of airfare for a family, the fearmongering about international travel, and the challenge of taking many vacation days at once, the staycation starts to make sense. In their 2019 North American Camping Report, KOA found that 54% of campers stay within 100 miles of their home. Glamping can be found in nearly every state in the US, and it's all over Canada (we could

Father and son sharing a hike in Yosemite, California

do a book *just* on glamping in Quebec). Arizton backs that up by saying that "consumers are riding the staycation wave, as it provides a means for experiential vacations that constitute unique and unusual options." Try any of the 70-plus places featured in this book or the 80 in our Glamping Directory, and if you're still looking for something closer to home, just plug in the name of your state and the word "glamping" into Google.

Low Barrier to Entry

While the nightly price of glamping may be more than a plot of grass at a state park, the upstart costs of camping can add up. Tent, sleeping bag, mattress pad, stove, cookware—the shopping list gets real long, real fast. In the Coleman Company Outdoor Foundation's 2017 American Camper Report, they found that campers spent an average of $181.61 per person on gear for their first trip. And, of course, that price doesn't include the campsite, comfy bed, complimentary breakfast, or a place to store all that stuff. If you're going to try camping for the first time or you only plan on going once a year, it makes sense to have someone else provide the latest gear and expertise.

Sustainability Is Smart & Sexy

The environmental pressures on our planet and social impact on the communities we visit are starting to weigh on travelers too. While there are plenty of people still taking mega cruises, the 2018 Luxe Report by Virtuoso, the leading luxury and experiential travel network, showed that sustainability is a *significant* factor in their clients' destination and activity choices. The study showed that while all generations saw an increase in environmental awareness, millennials are three times more likely than Generation X to use travel companies that are committed to sustainable tourism. A glamping structure's light footprint and a camp's emphasis on preserving the surrounding environment are a natural fit for these groups. With younger generations leading the charge, green travel is here to stay.

Everybody's Welcome

You don't need to have outdoor experience, be physically fit, or even set foot in REI to qualify as a glamper. "For those who might have otherwise felt intimidated by all the gear, setup, or just getting dirty," says Jenss of the FTA, "glamping opens up the world of camping and the great outdoors." Trending images across social media have also made it feel more accessible. Even city kids who don't know a redwood from a telephone

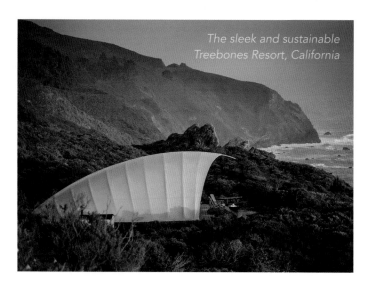

The sleek and sustainable Treebones Resort, California

pole suddenly have a point of reference and an appetite for the wilderness. They see pictures of millennials like them in a fedora and Chuck Taylors going camping and think, "Wait, I can do that." The LGBTQ+ community, who once might have thought camping was only for the good ole boys, now see the inviting spaces and creative people behind them and suddenly feel welcome. In fact, KOA's report found new campers to be even more diverse than the overall US population! No matter your background, you're not going to be out of place in this neck of the woods.

Vacation Compromise

When trying to plan a trip with an angler, a spa gal, and a teenager who won't disconnect from Wi-Fi, it may seem that you have to go separate ways, but glamping can cater to each of you. Adventure and luxury can easily be married, without the price tag of a five-star resort. Nicer amenities offer a cushy landing into a wilderness getaway, and glamping's cool factor gets the kid to look up from his or her phone. Speaking of Wi-Fi, as much as glamping is about a tech detox, owners often realize that an internet connection can actually help us ease into vacation and stay a little longer. When it came to the most valued amenities, the Outdoor Foundation reported that Wi-Fi ranked even higher than toilet and shower facilities. It's not that guests want to be on the internet all day, but knowing they have a way to check in with work and family makes it easier to be gone for multiple days.

Bonding

Unlike the average hotel, where the primary function is to offer a bed and a shower, glamping brings people together. Glamping Hub was actually inspired by the concept of "to-gather." As Martinez says, "Creating experiences that bring people together—that is our focus." Being built around one-of-a-kind accommodations and activities out of the norm, glamping offers a lot of firsts for families and friends. It gives them something to talk about—and a reason to chat in the first place. "How many families even eat dinner together anymore?" asks Linda Clark of Glamping.com. "When you're on a hike or around the fire, it gets the conversation going. It's when the real stories come out." Without all the distractions of everyday life and with new adventures to share, glamping lets us be present with one another.

SCIENTIFIC BENEFITS

While the opportunities to bond, get exercise, and try something new are all good things, science points to a physical and psychological need for this kind of vacation.

Nature's Medicine

Science has proven that immersing yourself in nature has a myriad of health benefits. While the Japanese practice of "forest bathing" may sound like a fad spa treatment, its results are very real. A study by Dr. Qing Li published in the US National Library of Medicine showed that walking through the forest and breathing phytoncides (an organic compound emitted by plants) significantly increases our energy levels and decreases anxiety, depression, and anger. It also suggests that habitual forest bathing can help lower the risk of psychosocial stress-related diseases.[14] Glamping is like one big forest bath. Whether you are hiking or sleeping, you're surrounded by the trees and giving them extra time to work their magic.

Similarly, being at the beach and taking in the sea air, rhythmic sounds, and blue hues activate our parasympathetic nervous system, which triggers a sense of calm and relaxation. It's also believed that the negative ions in the ocean air calm our brain and increase levels of serotonin.[15] Scientists and crystal readers aside, I think we all know being at the beach and in the forest just feels good.

Power of Human Connection

In a recent study on social health and relationships, the American Association for the Advancement of Science

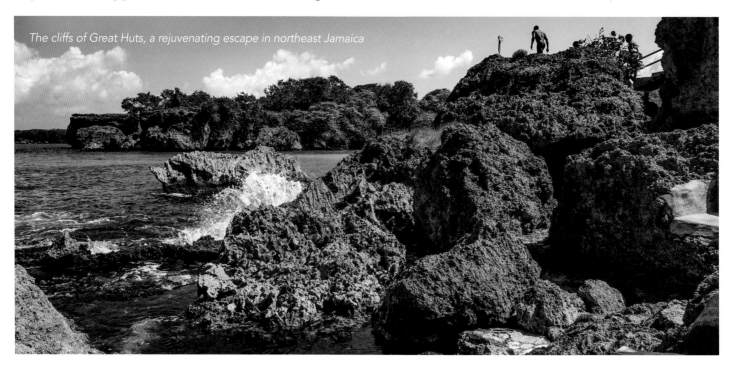
The cliffs of Great Huts, a rejuvenating escape in northeast Jamaica

(AAAS) reports that a lack of human connection can be even worse for your health than smoking, obesity, and high blood pressure! This study, published in *Science* magazine, says that when we connect, it not only makes us feel better on an emotional level but also boosts the immune system and reduces stress hormones, inflammation, anxiety, and depression. It's time to walk away from the Wi-Fi and take a hike with a friend.

Tech Detox

According to the data collected by Apple, we interact with our smartphones around 80 times a day. With that volume of buzzing, pinging, and dinging, how can we even think straight? The human addiction to phones has been likened to Pavlov's dogs, where we associate that buzz with the pleasurable thought of a funny message or beautiful image. "Every time you look at your phone, you don't know what you're going to find—how relevant or desirable a message is going to be," says psychologist David Greenfield. "So you keep checking it over and over again, because every once in a while, there's something good there."[16]

The thought of going without Wi-Fi or cell service can give some of us separation anxiety. Chris Hougie, co-owner of Mendocino Grove, witnesses this each check-in day. He finds that many of their weekend warriors spend Friday evening lingering by the hot spot, though after a night in the forest and breakfast by the campfire, they rarely see them near the router again. We're not telling you to put your phone away; nature will hopefully make that happen on its own.

"Magic is waiting for you," says Butters; "it just can't find its way in when there is so much clutter in the brain."

It's as though we are afraid to be bored and won't give ourselves a moment of quiet for fear of missing out. Though, as she says, "When you're a little bored, that's when you look up at the clouds and discover yourself."

The average American child spends less than 7 minutes a day in unstructured play outdoors and more than 400 minutes a day in front of a screen.[17, 18] While we could go on about the negative social, psychological, and physical effects this has on kids, we'll focus on the benefits of spending time in nature. As the Child Mind Institute says, spending time in nature builds confidence, promotes creativity, teaches responsibility, sharpens their senses, offers exercise, and creates a sense of wonder.

The power of a tech detox, on both a familial and a personal level, is profound. This was most eloquently expressed by a glamping guest after a weekend on the remote coast of Big Sur, California:

"While sitting by the fire in the lodge, playing old-school board games, perched upon a cliff, ocean views for miles, no phone, no laptop . . . I was reminded, if just for a moment, how beautiful life really is."

THE FUTURE OF GLAMPING

Glamping's growth shows no signs of slowing down. According to the *North American Camping Report*, the number of households that camp at least once a year has increased by 22% since 2014, and 45% of all campers surveyed said they would like to experience glamping in the coming year—a rate that has more than doubled since 2018. With more information and inspiration on outdoor accommodations, people are empowered to get out there. Plus, with the rise in glamping options, a lot of their fears about camping being difficult, uncomfortable, or scary have been assuaged. As Clark of Glamping.com says, "If you can get people out of their element, they'll be hooked."

Popularity is great for the industry, as long as that growth doesn't sacrifice quality. Part of what's going to ensure that is the addition of the American Glamping Association and the World of Glamping. These two organizations are showing new properties the way and offering a rating and accreditation system to help consumers sort the wannabes from the winners.

"The fact that there is so much competition is what makes glamping so interesting," says glamping business coach Sarah Riley. "Properties have to be very clever and offer amazing experiences to succeed." Novelty is what brought glamping to fame, and fresh ideas will help it thrive. "We'll still be talking about glamping in 20 years . . . and while the definition might be slightly different, the experiential element will never go away," says Clark. "There are so many creative people out there, and when we use our imagination, the potential is limitless."

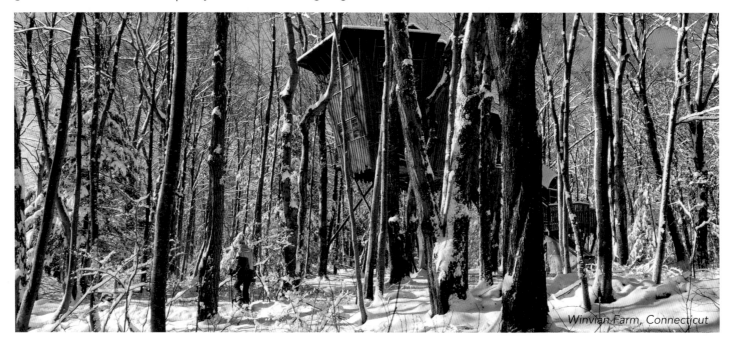
Winvian Farm, Connecticut

FIND YOUR EXPERIENCE

Before we get into tips for picking your ideal destination, know that these chapters are the culmination of years of hands-on research. We've personally tested the majority of the properties and have come to know the owners like friends. You can't go wrong. While each chapter focuses on a different type of experience (farmstays, wellness retreats, wildlife encounters, etc.) and each property is unique, there are a few delightfully common threads. With only 5 to 25 units, glamping hosts can offer personal attention, and you can easily meet your fellow glampers over happy hour or horseshoes. Being situated in a gorgeous natural area, properties are designed for both kicking back with a view and setting out for a hike. Run by charming families or creative individuals, these places are built with heart and made for memorable experiences. They all excel when it comes to creating opportunities for adventure, relaxation, and connecting with the people we love.

We hope you visit as many of these awe-inspiring destinations as possible. To help pinpoint the best venue for your next trip, these are the things to ask yourself and keep in mind.

GUEST LIST: Who's coming on the trip plays a big role in finding a glamping property that suits everyone's varying needs and interests. Is this a solo, couples, family, multigenerational, or friends trip? If going solo, you'll find great options like yoga retreats and art workshops in our "Rejuvenate" chapter. If you're bringing little kids or someone with mobility issues, take note of each property's symbols for accessibility and age requirement (don't worry, you're never too old).

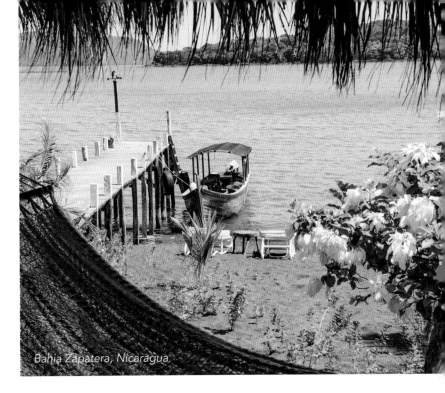

Bahia Zapatera, Nicaragua

TRIP GOALS: What do you want in a vacation? Are you looking for relaxation, adventure, romance, farm-to-table cuisine, or a wildly new experience? All these destinations offer a great mix of activities, though some specialize in certain areas. Ask yourself what you're craving right now and how you want to feel when you return.

REGION: Depending on where you call home, you'll hopefully find plenty of places within road-trip distance or an easy flight away. Wait, you want to get far-flung? Good, we've got archipelagos, rainforests, and hike-in destinations you're going to love. Another interesting thing about glamping venues is that they are rarely in household-name destinations. The goal is to get away from the crowds and celebrate the wild spaces. So don't let a place you've never heard of scare you away. Read on; it's probably a hidden gem.

Ranch at Rock Creek, Montana

VACATION LENGTH: How long do you have for a holiday? On property, we'd say three to five days is ideal, though depending on how remote and dynamic the region, you might want to build in more time. See each property's "Getting There" section to gauge how long you'll need for travel—particularly if it's in an area that begs for a road trip. For those who want a longer vacation, change of scenery, lots of adventure, and as little planning as possible, flip to the "In Motion" chapter (p. 114). These multi-destination trips range from two to nine days and are planned to perfection so you can let the fun unfold.

WHEN TO GO: Are you looking to embrace the cold or escape it? If it's August, how hot is *too* hot for you? We've included a "When to Go" section within each property because, while we factor in the optimal weather, ideal timing isn't always about the temperature. We try to pinpoint when that places shines from within, be it for the gray whale migration or an ice canoeing festival. We know you can't change the date of your kid's spring break, but if you have a little flexibility, try to catch the must-see events and off-season deals.

ACTIVITIES: Think about what experiences you miss doing and what you've always wanted to try. If you haven't kayaked in years or wondered what it's like to rappel down a waterfall, now's your chance. Glamping is built on unique experiences, and this book highlights our absolute favorites. For each property, we also list four "Adventures" and try to recommend two on-site and two nearby. No matter how fabulous an all-inclusive resort is, it's always good to explore the surrounding area for local culture and discover what makes the region so special.

MEALS: Do you like cooking? For traditional campers and many glampers, grilling up a feast over an extended happy hour is half the fun. And for families who have picky eaters or kids who can't sit still in a restaurant, cooking for yourself can be the best way to go. If the idea of touching a spatula sounds more like work than vacation, fear not; we have incredible culinary destinations across chapters (even a number of award-winning restaurants). Notice each property's symbols for cooking and dining facilities to see if it whets your appetite.

LEVEL OF LUXURY: Do you want more glamour or more camping? We have five-star wilderness resorts where you don't need to lift a finger and others that give you the chance to flex your mountain-man muscles. We'd recommend trying both at some point, but it's up to you to decide what's best for your specific trip. At the very minimum, every place in this book provides a lovely shelter and comfy mattress. For the vast majority, you could show up with little more than sneakers and a toothbrush and be ready to glamp. However, there are rare exceptions where the experience is so cool, we let a sleeping bag slide. Why? Because it means you get to raft one of the top 10 rivers in the world and are rewarded

with delicious Dutch-oven feasts with free-flowing wine. You'll never rough it in this book, and if the property isn't exactly luxurious, you'll be richer for the experience.

BUDGET: How much to do you have to spend on this vacation? There are incredible places in this book for as little as $35 per night (and that includes breakfast!). We also have a few Relais & Châteaux and National Geographic Unique Lodges of the World that are renowned for their five-star service and one-of-a-kind experiences. The price you are paying for these exceptional offerings may seem high, but often includes gourmet meals, fine wine, trained guides, activities, even skiing with lift tickets and gear. Try not to judge a place by its price tag alone; these are once-in-a-lifetime experiences worth a closer look.

HAPPY GLAMPING

We all need a vacation, but in this fast-paced world we live in, we could really use some glamping right about now. It's good for our health, relationships, and the earth, plus it's a blast! You deserve better than run-of-the-mill hotels and packaged tours. Turn these pages—and let's get *Comfortably Wild*!

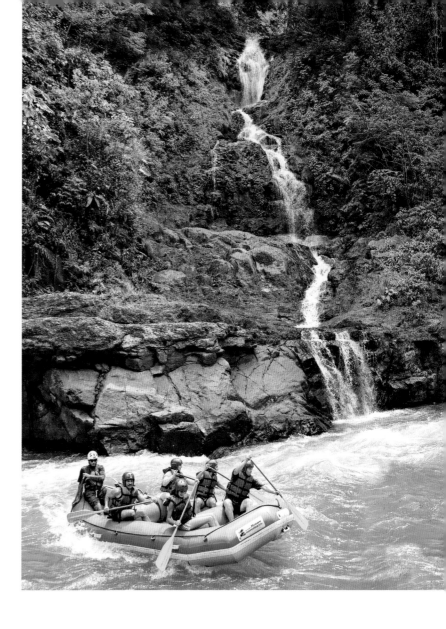

1

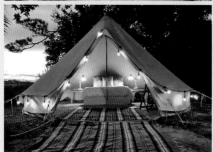

2

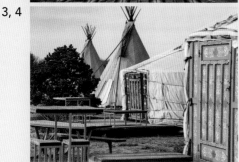

3, 4

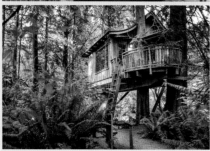

5

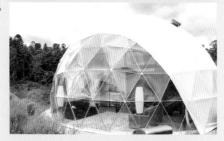

6

STRUCTURE STYLES

There are countless styles of glamping structures to choose from, and many are so creative they defy categorization, although understanding the classics will help you navigate the options. Please note that the descriptions below are far from the rule, but they will give you a good sense of the construction, layout, and benefits.

TENTS: Not the nylon camping-store variety, glamping tents come in a range of shapes and sizes, but they always offer enough room to walk around and fit a proper bed or two.

1) *Wall Tents:* Also called a safari tent or prospector tent, this is the most common glamping accommodation. Made of heavy canvas or tough synthetic material, it has straight walls and a pitched roof similar to a house but reminiscent of *Out of Africa*. These are usually built on a raised platform that acts as a deck and occasionally have multiple rooms. Zip-down windows are on two or three sides, and cloth doors roll back for extra breeze.

2) *Bell Tents:* With their short walls and long sloping roof, this circular design looks like a hybrid between a teepee and a wall tent. Held up by a central pole and supported by guy lines, it's easy to set up and offers ample headroom, even in its smallest versions. The "Lotus Belle" tent is a rounded variation on this design with a dramatic peak.

3) *Teepees:* The iconic Native American teepee is a tall conical tent, typically with beautiful painted motifs, held up by a wooden-pole framework and tied together at the top. The fabric walls let in natural light, and the door doubles as a window.

4) **YURTS:** Invented by ancient nomads of Central Asia, these portable wood-and-fabric dwellings are spacious and sturdy. Lattice walls expand 10 to 30 feet in diameter to create a circular living space. Dozens of rafters angle up toward the point of the roof, which is left open for a chimney or, most commonly, a clear dome for light and stargazing.

5) **TREEHOUSES:** Built in the boughs of a hearty tree, this elevated dwelling can range from a simple cabin to a veritable mansion in the canopy. It is often accessed by suspension bridges or ladders that can extend to multiple levels. Stilts are sometimes added as support or as the foundation of a treehouse-like structure.

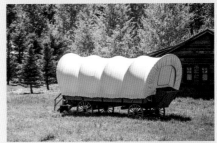

6) **DOMES:** Walls gradually round into the roof for a smooth half-sphere. An intersecting steel-strut framework gives the interior a graphic diamond pattern. Covered with a mix of opaque and clear materials, these spacious structures are fabulous for panoramic views.

WAGONS & TRAILERS: While travel trailers (à la the Airstream) dominate this category, their wooden, horse-powered predecessor is worth a mention.

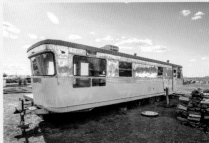

7) *Wooden Wagons:* Variations on the 19th-century mobile home have rolled onto the glamping scene. A covered wagon like that of the Western pioneers has metal arches that give the roof its rounded shape and framework for the taut canvas. Sheepherder wagons are more like a wooden cabin on wheels, while gypsy wagons take a similar construction but tend to be more ornate and playful.

8) *Vintage Trailers:* A space-efficient house on wheels, these retro campers pack in bedrooms, living rooms, kitchens, and often bathrooms. Some glamping properties completely renovate their trailers with a modern look; others take pride in preserving their mid-century design. There are also rental companies that will let you take one on a road trip.

9) **CABINS & CABANAS:** These free-standing, house-like structures use materials suited to their surroundings. Mountains call for hearty wood cabins, while the tropics inspire cabanas with bamboo walls and thatched roofs. Durability, privacy, and rustic charm with indoor plumbing are the overarching appeal.

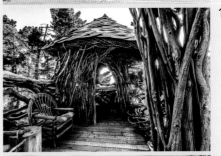

10) **HUTS:** Inspired by their primitive roots, these dwellings are made from organic materials like branches, snow, stone, or clay. Modern options are still rustic, but their traditional building methods and historical connection make for a memorable experience.

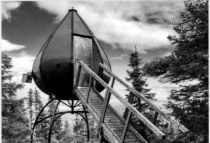

11) **UNIQUE & UNUSUAL:** A glamping structure could be repurposed, like train cars or shipping containers. It could go deep into the earth like a Hobbit hole or mountain cave. Or it might spring from an architect's imagination, like a teardrop suspended in the air.

From timeless igloos to modern ice hotels, glamping will continue to evolve. As long as it's comfortable, stylish, and in nature—anything goes!

How to Use This Book

IF YOU ARE CONSIDERING any of these glamping destinations, call to confirm the details that matter most to you and your trip. Offerings are subject to change as their businesses evolve.

Property Overview

On the first page of each destination feature, a sidebar provides key details and trip logistics. Here's what to know about each section:

LODGING: The types of glamping structures on-site. You'll find more specifics under "Glamping Experience," which also includes information on the property's dining options and activities.

WHEN TO GO: While many are open year-round, some properties and units are seasonal. We note the date range in months, since exact days can vary.

GETTING THERE: The nearest city is listed as a reference point for driving times or distances, as well as the nearest airport with its three-letter IATA code. *GPS:* Coordinates refer to the property location. *Note:* Remote camps may have alternate meeting points and transportation options.

PRICING: This US dollar amount is based on the starting price in low season, including any fees (not taxes). Most places are priced by the room per night; however, for all-inclusive properties that also provide meals, drinks, activities, and other services, prices are listed as per person per night (PPPN). Unless otherwise noted, all rates are based on double occupancy; singles should call for pricing.

CONTACT: Main phone number and website.

NICE TOUCH: A particularly thoughtful gesture by the property to improve the guest experience.

Symbols

Symbols represent the services and amenities a property offers. If a symbol is grayed out, that service is not available.

 On-site restaurant, serving at least breakfast.

 Cooking facilities available for guest use, be it a private kitchenette, communal kitchen, or grill.

 At minimum, Wi-Fi is available in the main building.

 Pet-friendly units available.

 Handicap accessibility in common areas and one or more units.

 Number denotes minimum age for guests. 0+ means all ages welcome.

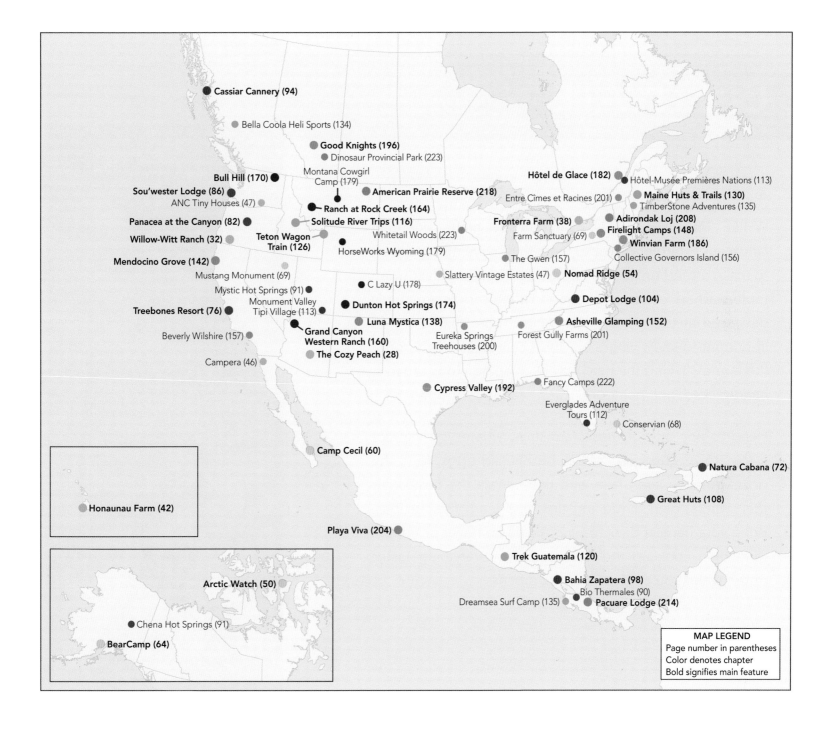

Cassiar Cannery (94)

Bella Coola Heli Sports (134)

Good Knights (196)

Dinosaur Provincial Park (223)

Montana Cowgirl Camp (179)

Bull Hill (170)

American Prairie Reserve (218)

Hôtel de Glace (182)

Hôtel-Musée Premières Nations (113)

Sou'wester Lodge (86)

Entre Cîmes et Racines (201)

Maine Huts & Trails (130)

ANC Tiny Houses (47)

Ranch at Rock Creek (164)

TimberStone Adventures (135)

Panacea at the Canyon (82)

Solitude River Trips (116)

Fronterra Farm (38)

Adirondak Loj (208)

Willow-Witt Ranch (32)

Whitetail Woods (223)

Firelight Camps (148)

Teton Wagon Train (126)

Farm Sanctuary (69)

Winvian Farm (186)

HorseWorks Wyoming (179)

Collective Governors Island (156)

Mendocino Grove (142)

The Gwen (157)

Mustang Monument (69)

Slattery Vintage Estates (47)

Nomad Ridge (54)

Mystic Hot Springs (91)

C Lazy U (178)

Depot Lodge (104)

Monument Valley Tipi Village (113)

Treebones Resort (76)

Dunton Hot Springs (174)

Asheville Glamping (152)

Luna Mystica (138)

Forest Gully Farms (201)

Beverly Wilshire (157)

Grand Canyon Western Ranch (160)

Eureka Springs Treehouses (200)

Campera (46)

The Cozy Peach (28)

Cypress Valley (192)

Fancy Camps (222)

Everglades Adventure Tours (112)

Conservian (68)

Camp Cecil (60)

Natura Cabana (72)

Honaunau Farm (42)

Great Huts (108)

Playa Viva (204)

Trek Guatemala (120)

Arctic Watch (50)

Bahia Zapatera (98)

Bio Thermales (90)

Dreamsea Surf Camp (135)

Pacuare Lodge (214)

Chena Hot Springs (91)

BearCamp (64)

MAP LEGEND
Page number in parentheses
Color denotes chapter
Bold signifies main feature

CULTIVATE

WHILE MOTHER NATURE effortlessly crafts bountiful landscapes, farmers have to work their coveralled tails off to make a seed grow. Sometimes we forget that fact when triple-washed lettuce and rounded baby carrots are neatly displayed at the grocery store. Now more than ever, it's important to know where our food comes from—to honor the farmers taking the hard way by keeping crops organic, hand-picked, and heirloom.

Head to any one of these farmstays, where you can eat a tomato off the vine, gather freshly laid eggs, feed the goats—maybe even hike with them. Walk the fields with the owners, gain gardening tips, and learn new recipes. Bring your harvest back to your Airstream trailer or bubble tent; then cook up the freshest feast. Everything tastes better when you are a part of the process.

Biking from our tiny house on Destiny Ridge Vineyard, Washington

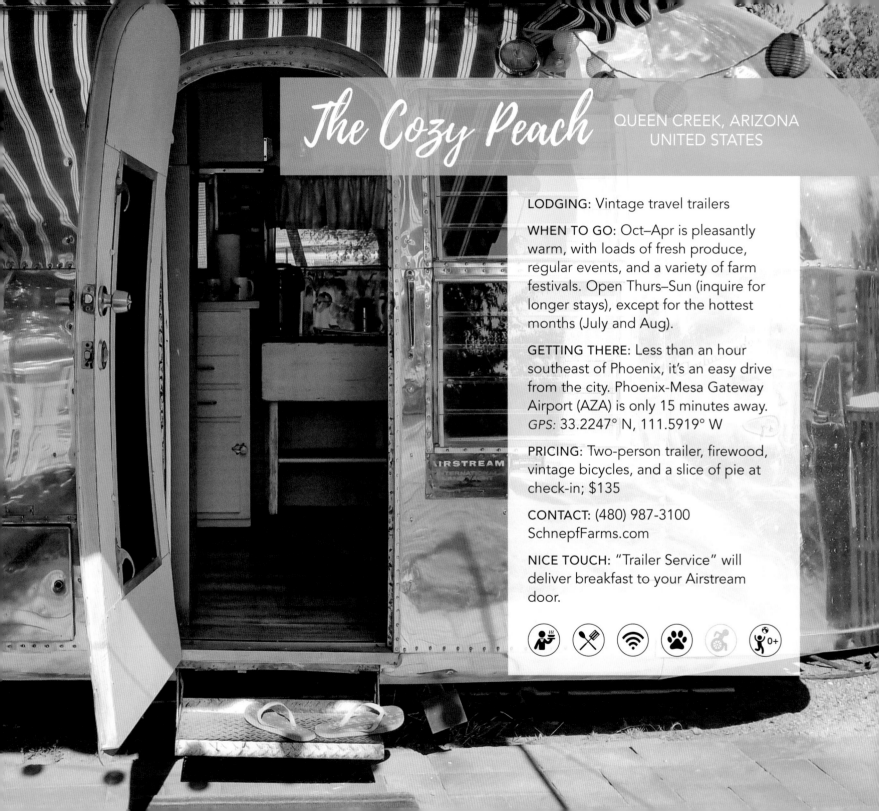

The Cozy Peach

QUEEN CREEK, ARIZONA
UNITED STATES

LODGING: Vintage travel trailers

WHEN TO GO: Oct–Apr is pleasantly warm, with loads of fresh produce, regular events, and a variety of farm festivals. Open Thurs–Sun (inquire for longer stays), except for the hottest months (July and Aug).

GETTING THERE: Less than an hour southeast of Phoenix, it's an easy drive from the city. Phoenix-Mesa Gateway Airport (AZA) is only 15 minutes away. *GPS:* 33.2247° N, 111.5919° W

PRICING: Two-person trailer, firewood, vintage bicycles, and a slice of pie at check-in; $135

CONTACT: (480) 987-3100
SchnepfFarms.com

NICE TOUCH: "Trailer Service" will deliver breakfast to your Airstream door.

REMEMBER THAT FARM you visited as a kid to pick fruit, feed the goats, and take a hayride? Those bucolic pastimes are alive and well at Schnepf Farms—and made even dreamier. Planting seeds since 1941, the Schnepfs are excellent farmers nationally renowned for their peaches, but their ambitions were always bigger than stone fruit.

In the late 1980s, Mark Schnepf saw the Phoenix countryside breaking up into housing subdivisions and the Maricopa County heritage of farming (dating back to 300 CE) at risk. Mark became the first mayor of Queen Creek and helped incorporate the town, now Arizona's premier agritourism destination. Alongside neighbors growing ancient grains and harvesting olives for their small-scale press, the Schnepfs don't grow their produce for chain grocery stores. Their 25-plus varieties of fruits and vegetables are for the enjoyment of those who visit the farm. Wanting guests to stay longer to enjoy the surrounding San Tan Mountains and their 300 acres of orchards, forest, and fields, they created The Cozy Peach: a glamping getaway with 10 travel trailers, from a 1948 Spartan Manor to a 1972 Airstream Land Yacht. Not only is Mrs. Schnepf their head farm-to-table chef, she can also wield a hammer and decorate to *House Beautiful* perfection. Just the right blend of nostalgic and contemporary, each trailer has been polished like a gem.

Take one of the complimentary vintage Schwinn or John Deere bicycles for a ride among 5,000 peach trees, and join the farm happenings—including gardening, a cooking class, or one of their multiday festivals with live music, vintage amusement rides, and crafts.

RELIC RESCUE

A curious assortment of old buildings line the dirt road in the center of the farm. When the Schnepfs see a local historic structure at risk of demolition, they try to rescue and restore it—starting with the 1910 train station master's cottage, which they rolled here on telephone poles. Now the Schnepf Family Museum, it houses exhibits on the early days of Queen Creek, the farm, and the family's own colorful history. Browse the retro photographs and a century of mementos, and you'll soon realize why the governor designated Schnepf Farms an "Arizona Treasure."

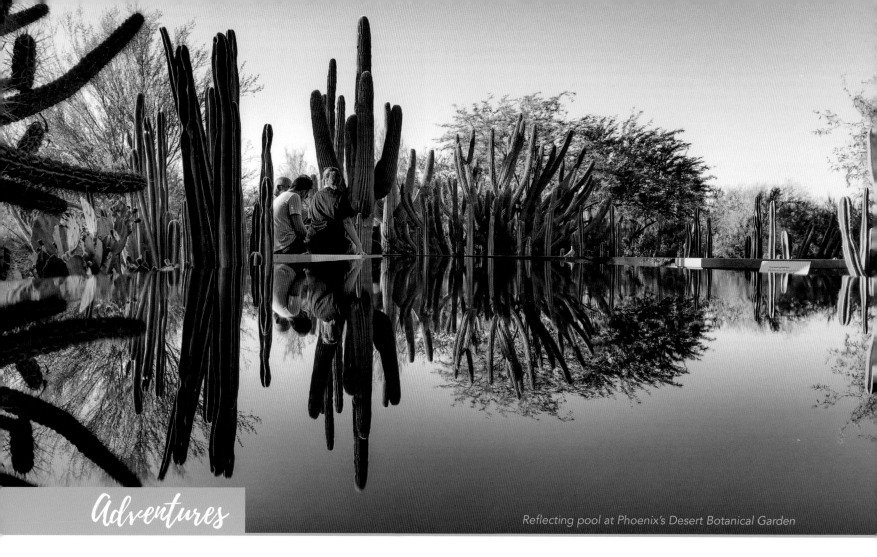

Reflecting pool at Phoenix's Desert Botanical Garden

GARDEN COOKING CLASSES

Grab a harvest basket and meet the chef in the garden. Learn about the menu's ingredients as you pick them off the vine. In the outdoor kitchen, you'll learn to make a new recipe—be it Carrie Schnepf's radish-top soup or the perfect collard greens. Enjoy your spoils with a delightful lunch al fresco.

JOSHUA TREE HUGGERS

With 4,482 species and 50,000-plus plant displays, Phoenix's Desert Botanical Garden is in a league of its own. Take the Plants and People of the Sonoran Desert Loop Trail to understand the region's complex cultural relationship with cacti. Check the events calendar for tours, concerts, storytelling, and their psychedelic Electric Desert light-and-sound night exhibit.

Glamping Experience

ACCOMMODATIONS: Unique vintage trailers, retaining around 90% of their original materials, are freshened up with cheery paint colors, chic throw pillows, crystal chandeliers, and updated en-suite bathrooms. Sleep in cloud-like beds with 1,000-thread-count sheets, and ease into the day wearing a terry-cloth robe and sipping coffee in your private yard—complete with a pink flamingo. (*Pssst . . . treehouses are in the works.*)

DINING: The country store and restaurant are open for breakfast and lunch, with dinner delivery available—either from the menu or chef-prepped ingredients for a campfire feast. Fix a bite in your trailer kitchen, grill on the barbecue, or roast a meal over your firepit. Be sure to join the owners for their weekend farm-to-table dinners.

ACTIVITIES: Gardening, cooking and baking classes, hayrides, cycling, train rides, petting zoo, orchard yoga, massage, and winter ice skating

HONEYTREK TIP: Harvest vegetables before the "you-pick" organic garden opens, then bike to the secret library in the pine forest and swing in the hammock with a book of desert poetry until you fade into a midmorning nap.

ARTISANAL MILL TOURS

Meet the neighbors! The Rea family has planted 7,000 olive trees for their boutique mill. Join their Olive Oil 101 Tour for a guided orchard walk, press demo, and tasting. Down the road, you can shadow the bold father-daughter team at Hayden Flour Mills who are bringing back ancient grains and stone-grinding them in the fashion of our ancestors.

CATCH A FESTIVAL

The Schnepfs know how to hoedown. Upwards of 100 days a year, the farm is in festival mode, with celebrations like the Pumpkin & Chili Party and the Peach Festival. Come enjoy the classic roller coasters, hand-painted carousel, giant jumping pillows, minigolf, ziplining, pedal cars, live music, farm games, and fresh food that draw a quarter million people each year.

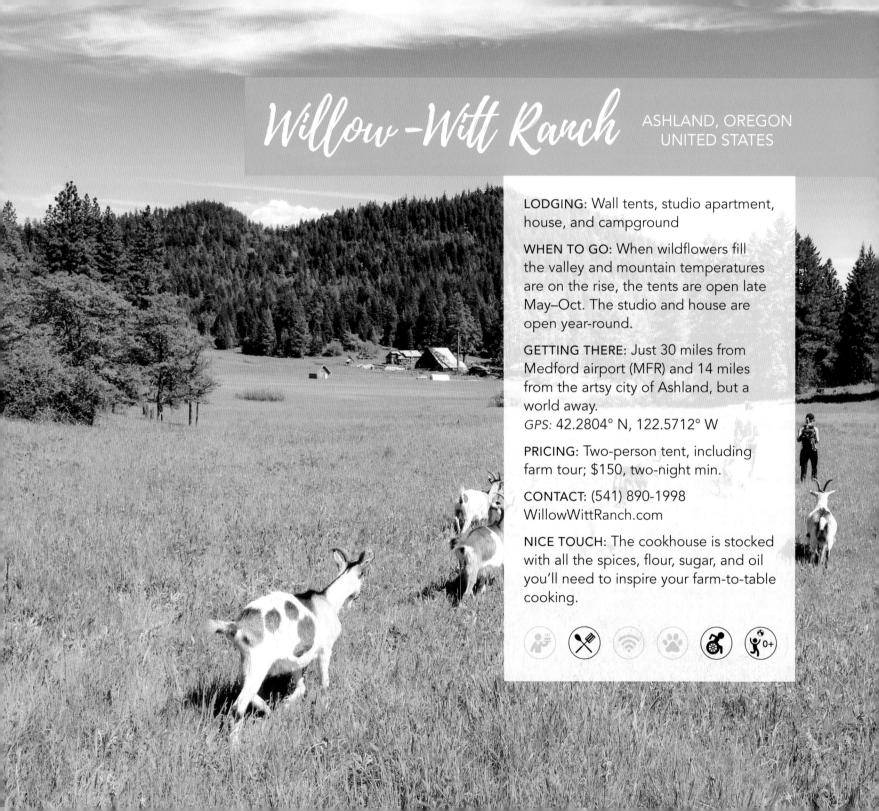

Willow-Witt Ranch

ASHLAND, OREGON
UNITED STATES

LODGING: Wall tents, studio apartment, house, and campground

WHEN TO GO: When wildflowers fill the valley and mountain temperatures are on the rise, the tents are open late May–Oct. The studio and house are open year-round.

GETTING THERE: Just 30 miles from Medford airport (MFR) and 14 miles from the artsy city of Ashland, but a world away.
GPS: 42.2804° N, 122.5712° W

PRICING: Two-person tent, including farm tour; $150, two-night min.

CONTACT: (541) 890-1998
WillowWittRanch.com

NICE TOUCH: The cookhouse is stocked with all the spices, flour, sugar, and oil you'll need to inspire your farm-to-table cooking.

BEFORE BUYING A 445-ACRE RANCH (around 400 acres more than they were aiming for), Suzanne Willow and Lanita Witt cross-country skied into the hidden valley of the Cascade-Siskiyou National Monument for one last look at the farmhouse, buried under 4 feet of snow. "We weren't farmers—heck, we were barely even skiers," said Suzanne, "but we had fallen in love with the land and could feel magic was afoot." Native Americans used the valley as their summering grounds for thousands of years, generations of European-Americans had farmed the land since the 1800s, and now two Californians with medical degrees were going to carry on the legacy? Yes, and better yet, improve it! Since 1985 this inspiring couple has worked to return the overharvested forest to a healthy balance, restore the eroded wetlands, protect threatened plants, increase wildlife, and educate future generations about this unique ecosystem with their nonprofit, certified organic farm, and cozy inn.

Guests aren't expected to help on the farm, but when you see the sun crest over the Cascades, Suzanne harvesting spinach, and Lanita milking the goats, it just might inspire your participation. Their hard work reminds you where food comes from and that a nurturing hand makes everything taste better. Go ahead, feed the baby pigs, gather duck eggs, or pick veggies for cooking in the outdoor kitchen. Retire to your private porch overlooking the wildflower meadow and watch the stars grow brighter with a bottle of Rogue Valley wine. When the air at 5,000 feet turns brisk, cozy up by your own wood-burning fire for sweet dreams.

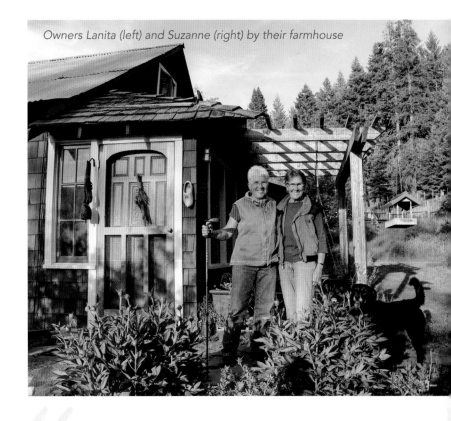

Owners Lanita (left) and Suzanne (right) by their farmhouse

"What a perfect family vacation . . . relaxing, educational, outdoors, unplugged. Our kids loved collecting eggs, feeding the goats, meeting the newborn pigs, letting the ducks out each morning, looking at the stars at night . . . the list goes on!

—Nancy, Oregon

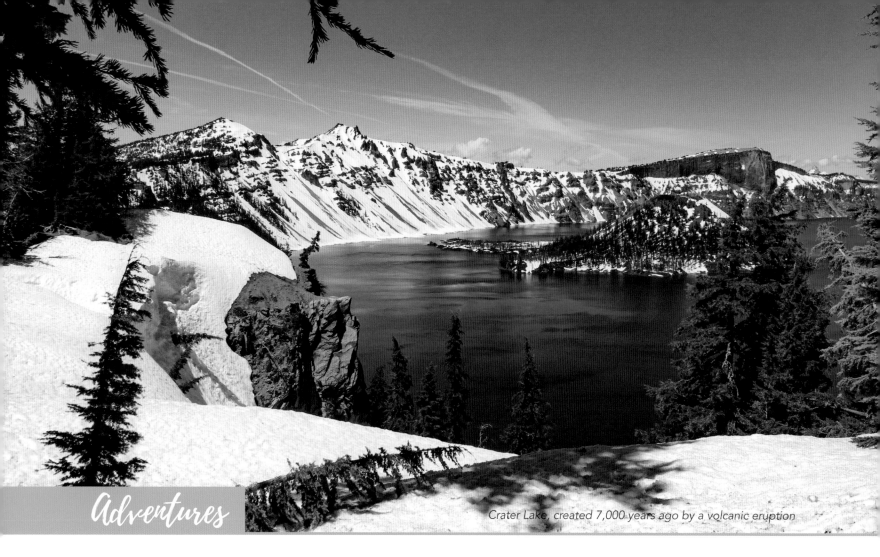

Crater Lake, created 7,000 years ago by a volcanic eruption

ROAD TRIP TO CRATER LAKE

Hop on the Volcanic Legacy Scenic Byway, with a special pit stop at the Rogue River Gorge and Beckie's Cafe for pie. Enter Crater Lake National Park and cruise along the 33-mile Rim Drive, breaking for photo ops of the deepest lake in the US (1,949 feet). The full loop is open midsummer to early fall, while the rest of the year you can snowshoe and have cocktails at the historic lodge.

MORNING HARVEST & MILKING

Play farmer for a day. Join the morning's vegetable harvest, collect eggs from the chicken hoop house, feed the pigs, and ask Lanita and Suzanne how you can be of help—every day is different and there is always something to be done on the ranch. If nothing else, grab a coffee and watch the team at work or hang out with the animals—you're bound to learn something new.

Glamping Experience

ACCOMMODATIONS: Nestled in the forest with views to the meadow and mountains, four furnished wall tents sleep two to four guests. A comfy mattress, sumptuous linens for both bed and bath, and a seating area make it homey. Wood-burning stoves serve for ambience, warmth, and light. A micro-hydro system and solar panels power the ranch, while lanterns are at the ready for reading or walking at night. Wash up at the contemporary bathhouse or opt for an outdoor shower with valley views. For those looking to come in winter or as a larger party, book the cozy Farmhouse Studio (sleeps 6) or Meadow House (sleeps 10).

DINING: Their impressive outdoor cookhouse is fully equipped with stoves, an oven, and prep sinks, plus cookware and dining essentials. Their farm store sells organic meats, milk, eggs, and all the veggies you can pick!

Outdoor shower overlooking the meadow

ACTIVITIES: Farm tours, yoga, hiking trails, harvesting vegetables, feeding the animals, trekking with goats, summer camps, and wood-heated hot tub

HONEYTREK TIP: Don't sleep in. Waking up with the sun, birds, and pigs is to see the farm when it's most alive. (Plus, you don't want to miss the hysterical baby goat feeding frenzy!)

TREKKING WITH GOATS

Pack animals by trade but Labradors at heart, Willow-Witt's French-Alpine goats will stay by your side for an entertaining hike to the old dairy barn. Reach the ruins for a glimpse into early 20th-century farm life, rest among the wildflowers, and revel in the majestic views of Mount Shasta. Head a little higher for a peek at Mount McLoughlin, a 9,493-foot stratovolcano.

SOUTHERN OREGON WINE TRAIL

One of the most diverse wine regions, southern Oregon's patchwork of mesoclimates nurture 70 different grape varieties. Within an hour of the ranch, you'll find more than a dozen wineries. Start at Dana Campbell Vineyards for a tasting and round of bocce with spectacular views. Two miles farther you'll reach Grizzly Peak Winery; enjoy gold-medal wines and Friday night concerts.

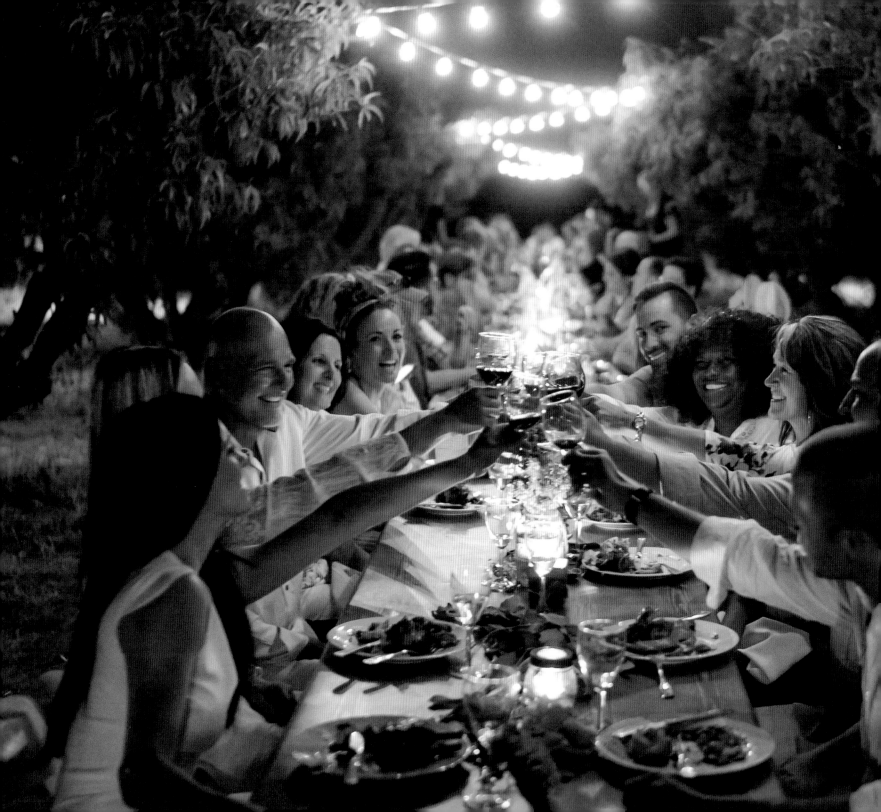

DINNER DOWN THE ORCHARD

WE WALKED THROUGH THE ORCHARD of 5,000 peach trees, following the twinkling lights strung between the branches. We reached our dining table, set for 110, and the white linen seemed to go on for acres. Foodies flock to Schnepf Farms from every corner of greater Phoenix to dine at one the most anticipated meals of the year. Inspired by the stone fruit growing around us, each course—be it heirloom faro with bourbon peach and basil chutney or country-style peach cobbler with vanilla bean ice cream and salted caramel sauce—tasted better with the earth under our feet, fruit trees overhead, and farmers sharing from the heart.

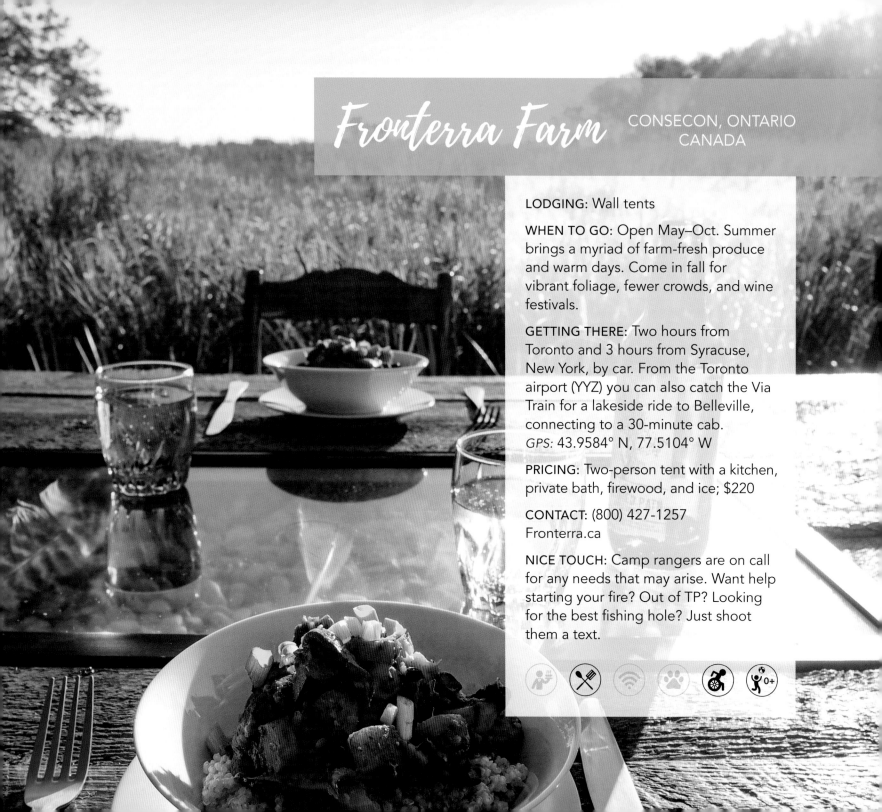

Fronterra Farm

CONSECON, ONTARIO
CANADA

LODGING: Wall tents

WHEN TO GO: Open May–Oct. Summer brings a myriad of farm-fresh produce and warm days. Come in fall for vibrant foliage, fewer crowds, and wine festivals.

GETTING THERE: Two hours from Toronto and 3 hours from Syracuse, New York, by car. From the Toronto airport (YYZ) you can also catch the Via Train for a lakeside ride to Belleville, connecting to a 30-minute cab. *GPS:* 43.9584° N, 77.5104° W

PRICING: Two-person tent with a kitchen, private bath, firewood, and ice; $220

CONTACT: (800) 427-1257 Fronterra.ca

NICE TOUCH: Camp rangers are on call for any needs that may arise. Want help starting your fire? Out of TP? Looking for the best fishing hole? Just shoot them a text.

FIND YOUR ROOTS. Follow your heart. Don't quit.

Passionate and visionary, Jens Burgen and Inge Alberts are on a mission to revive the farming and brewing tradition that brought Prince Edward County to fame during the booming Barley Days. In 1900 the owner of this 58-acre farm on the shores of Lake Ontario won the World Agricultural Fair for the best malting barley. Despite its success, this heirloom grain and tradition of handcrafted brewing virtually vanished in the region—until Jens and Inge rolled up their sleeves. They knew that reviving ancient strains would be no easy feat, but being born into a lineage of German brewmasters that dates back to the Middle Ages and concocting beer recipes since the *under*-age of 15, there was no one better for the job. "We set out in a flurry of doing—renovating the farmhouse, converting the fields, building a hop yard, and crafting the camp," said Jens. "It was an epic amount of work and risk." Years later, the aromatic hops tower 20 feet high, and hearty fields of barley surround their very own craft brewery.

Join them on this journey from plow to pint with a beer-making workshop. Pick up homegrown goodies from the Farm Boutique and enjoy cooking at your well-equipped tent, each designed to tell a piece of the county's rich history. Further access the region's bounty with a bike ride along dozens of award-winning vineyards or a leisurely canoe trip to one of the largest freshwater sand dune systems in the world. Go farther afield on the Loyalist Parkway to find a fascinating chapter in US and Canadian history, not to mention farmers markets, charming shops, and posh restaurants. At Fronterra, your cup will runneth over.

Owner Jens tending to his hopyard

"To the camping purists who are anti-luxury, I want you to know that being comfortable in nature in an ecological manner in no way detracts from the magic of it. The tents at Fronterra are so thoughtfully constructed, down to the smallest level of detail—this made us feel very well cared for. Their holistic lifestyle is a true inspiration that everyone can follow.

—Ivon, Ontario

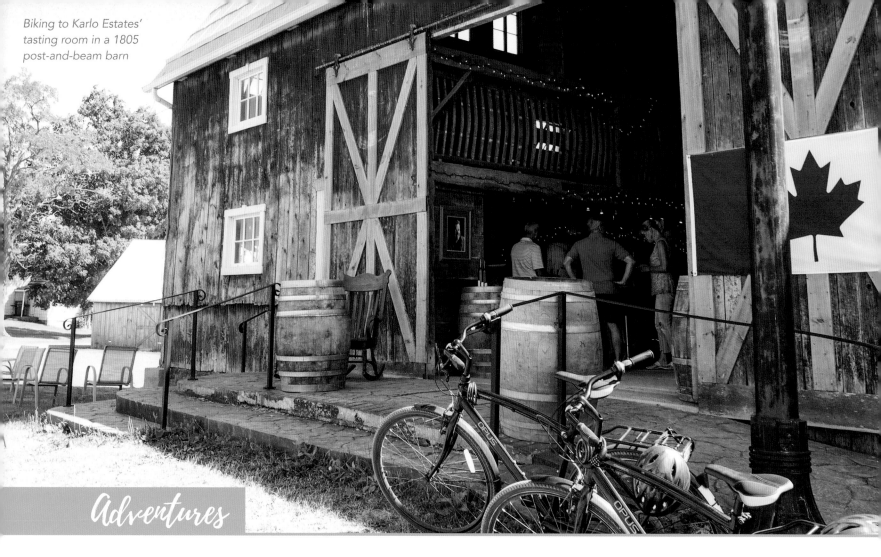

Biking to Karlo Estates' tasting room in a 1805 post-and-beam barn

Adventures

PICNIC ON A PRIVATE SAND DUNE

Fill your Fronterra canoe with barbecue fixings and paddle across to North Beach Provincial Park. The parking lot closes at sunset, but arriving by boat, you'll have one of the world's largest freshwater dune systems to yourself. Stroll to the Lake Ontario side and go for a swim as the charcoal heats up. Feast away, and keep the grill stoked for s'mores and stargazing.

BIKE THE WINERIES

With 40 wineries in Ontario's latest appellation, wonderfully organized tours abound. For self-guided exploration bike to Fronterra's neighboring vineyards. Within a 4-mile ride through gentle countryside, you can visit the solar-powered Harwood Estate, sample the Canadian hybrid Vidal wine at Hillier Creek, and try a chocolate and wine pairing at Traynor Family Vineyard.

Glamping Experience

ACCOMMODATIONS: Whether tucked in the woods or with views over North Bay, each off-grid tent is designed in harmony with the region's terroir and history—from the rustic stone and log of the early prospectors to the brass and glass of the rumrunners. Your outdoor shower might spring from a tree trunk, and 19th-century stone walls could support your kitchen counter. King-size beds with premium mattresses and linens offer a deep sleep; outdoor dining rooms encourage long evenings under the stars.

DINING: Picking fresh produce, gathering eggs, fishing the bay, and cooking in your outdoor kitchen are central to this farmstay bliss. Cookware, a dual-burner stove, and service for four make proper meals a reality in the wilderness. Extra provisions are available in their Farm Boutique, and gourmet restaurants are just a 15-minute drive.

ACTIVITIES: Biking, canoeing, garden yoga, sand-dune meditation, fishing, swimming, veggie harvesting, farm workshops, and beer camp

HONEYTREK TIP: As a family-run property and working farm, the availability of most classes and workshops depends on demand. To help drum up interest, let Fronterra know your activity wish list before your arrival, bring friends, or chat up your neighbors.

CATCH & CURE SALMON

Stretch those arms, you're going to be reeling in 20-pound salmon on a Lake Ontario fishing charter. Bring your spoils back for a European-style fish-curing workshop. Gather herbs in the garden while learning about their family recipe. Rub salt, anise, and dill on the salmon before burying it. By morning, your delicacy will be ready to prep for breakfast or as a lovely souvenir.

BREWING WORKSHOP

Join Jens in the barley fields, where the road to beer begins. Take in the textures on the vine then move into the craft brewery. Learn about the wet-hopping technique of adding unkilned and unprocessed hops to the kettle for maximum freshness, all the while grinding, stirring, and pouring your way to beer-vana. Can't make a workshop? Guided tours are on tap most Saturdays.

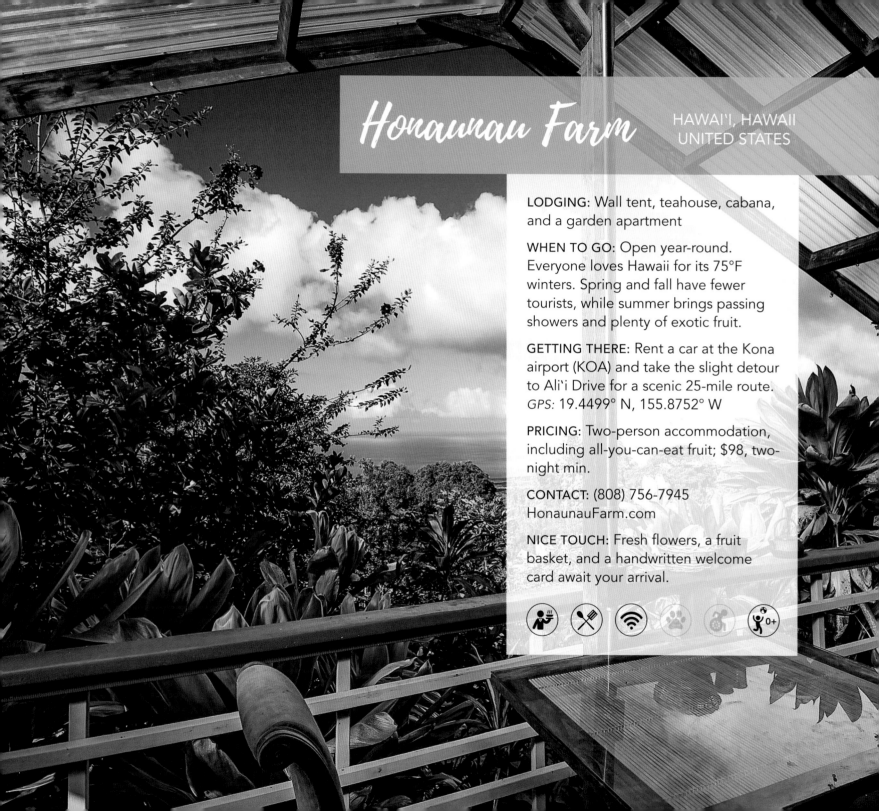

Honaunau Farm

HAWAI'I, HAWAII
UNITED STATES

LODGING: Wall tent, teahouse, cabana, and a garden apartment

WHEN TO GO: Open year-round. Everyone loves Hawaii for its 75°F winters. Spring and fall have fewer tourists, while summer brings passing showers and plenty of exotic fruit.

GETTING THERE: Rent a car at the Kona airport (KOA) and take the slight detour to Ali'i Drive for a scenic 25-mile route. *GPS:* 19.4499° N, 155.8752° W

PRICING: Two-person accommodation, including all-you-can-eat fruit; $98, two-night min.

CONTACT: (808) 756-7945
HonaunauFarm.com

NICE TOUCH: Fresh flowers, a fruit basket, and a handwritten welcome card await your arrival.

YOU'RE WALKING THROUGH a tropical fruit farm, picking passion fruit, cracking macadamia nuts, and snacking on lychees as you stroll. You return to your lofted teahouse to put your harvest in the kitchenette before hopping in the outdoor shower. Staring at the sunset sky as you lather up, you lose track of time. The farm owners are preparing an organic dinner on the lanai, and you wouldn't want to be late for such gracious hosts.

The founders of Honaunau, Steve Sakala and Melinda Goossen, met in college while studying environmental engineering and sustainable systems. They lost touch while he was in the Peace Corps in West Africa and she was launching a wellness retreat along the Columbia River Gorge. Reconnecting in 2009, a light bulb went off to unite their passion for healthy living into one blissful Hawaiian farm.

With the opportunity to watch the lava flow at Volcanoes National Park, stargaze from the tallest mountain in the Pacific, and stroll green sand beaches, anyone would want to stay on the island of Hawai'i—but you're the savvy traveler who knows a big-box hotel isn't the way to experience its natural beauty. Perch yourself over Kealakekua Bay, and you'll have pristine forest all the way from your balcony to Mauna Loa Volcano. From the farm you can easily access the tourist attractions while having the locals' insights and hands-on access to Hawai'i's bounty. See the landscape from the eyes of a permaculturist, learn the latest in medicinal hemp, take a class on regenerative farming, and eat all the fruit you can carry. Honaunau brings the Big Island back to its purest form.

"A life-changing opportunity to reset and recharge the soul. It was a stay in paradise, to say the least. They're great people who received me with the most loving hearts. The food at the farm is deliciously organic, the animals extremely docile, and the experience of learning about sustainable farming are some of the highlights of this retreat! I had no idea my mind, body, and spirit would be this nourished.

—Fernanda, New Mexico

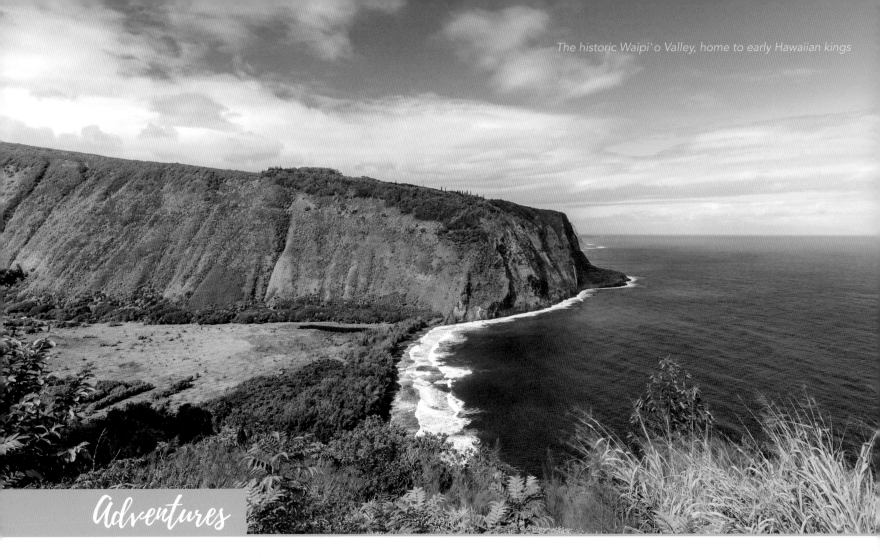

The historic Waipi'o Valley, home to early Hawaiian kings

Adventures

TASTING PICNIC TOUR

Ever tried a tree tomato, soursop, lilikoi, or loquat? Fruits you'd be hard pressed to find growing anywhere else in the US are here for the picking. Walk with the farmer through the groves and learn about Honaunau's regenerative agriculture and permaculture practices. Harvest as you go for the freshest picnic, complete with Kona coffee and thoughtful conversation.

WAIPI'O: THE VALLEY OF THE KINGS

Once the capital and royal residence, the valley is a naturally majestic fortress with 2,000-foot cliffs, waterfalls, snaking rivers, and black sand beaches. While you can hike down, a horseback riding tour covers your trip there and back, plus gives unique access to the terrain and culture. Be sure to ask about the centuries-old agriculture systems.

Glamping Experience

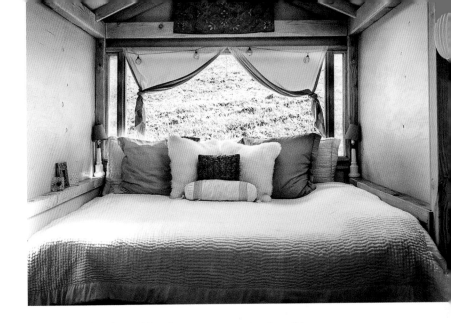

ACCOMMODATIONS: Each space has a unique design, with a common thread of king beds, kitchenettes, covered decks, and ocean views. The Zen-inspired Teahouse Cottage boasts lofted ceilings and a 10-foot-wide window. The elevated Tent Cottage has canvas walls, hardwood floors, and an inviting outdoor kitchen. The 1940s Coffee Shack is original to the property and retains its old-growth-redwood construction, including a built-in bed nook. These three structures have shared bathroom facilities with outdoor showers and an infrared sauna. Below the two-bed-and-bath apartment in the Ohana House is a community kitchen and lounge.

DINING: With abundant organic produce at your doorstep, now is the time to try that raw food diet you've been contemplating. With a stocked kitchenette you can whip up a meal, or arrange a farm-fresh dining experience cooked by your hosts.

ACTIVITIES: Farm classes, guided walks, yoga, qigong, massage, bodyboards, sauna, wellness consultations, and communing with farm animals

HONEYTREK TIP: Visiting Hawai'i Volcanoes National Park is a must, but with an active volcano, the best timing is up to Mother Nature. Check the park service website (NPS.gov/havo) for any alerts.

HEMP 101

Medical marijuana has been legal in Hawaii since 2000, and Steve has played a key role in policy, research, and development, even growing the first hemp seed varieties for Hawaii's department of agriculture. In a 90-minute farm class by the guru himself, learn about this cutting-edge crop, including how it's grown, processed, and used for a variety of health reasons.

KAYAK & SNORKEL SAFARI

Kealakekua Bay is home to a pod of spinner dolphins and a vibrant reef ecosystem. Early one morning (when the dolphins are most active) rent a kayak and snorkeling gear to explore the route of Captain Cook—Hawaii's first significant contact with the West. Snorkel in calm waters and see tropical fish, manta rays, and a window into history.

Off the Vine

If your idea of enjoying the great outdoors is hiking through grapevines to a tasting room, you're in luck. Vineyard glamping is taking seed around the continent (not just in California), from classic wall tents to surreal bubble bedrooms. When the winery closes, you'll get after-hours privileges to roam the manicured hills at sunset and open a reserve bottle by a bonfire.

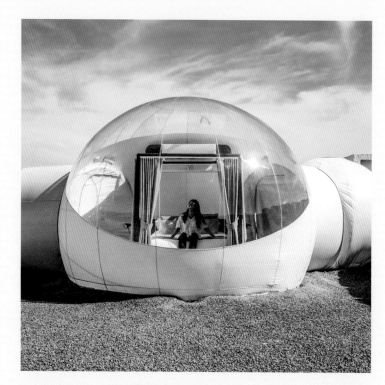

Snake River Valley, Idaho

BOTTLES & BUBBLES

One of the only bubble hotels in North America, Campera Hotel Burbuja's clear spherical tents line up like a string of pearls against the Docepiedras vineyard. A well-crafted French design pressurizes the bubble so that only a thin clear wall separates you from the vines and the Milky Way. Draw back the privacy curtains on your canopy bed and catch a shooting star without leaving your silky sheets. Wake up to a sea of vines and a day of vineyard hopping at Valle de Guadalupe's 80 wineries, or just open your mini-bar to sample the wines grown from grapes outside your see-through door.
CamperaHotel.com

MIDWESTERN TERROIR

Don't underestimate the Nebraska wine scene, especially when the Slattery family is behind the tasting room bar. At Slattery Vintage Estates they're serving 50 different Nebraska wines (who knew?!) ranging from sweet to dry, plus charcuterie boards to enjoy by the courtyard fountain. Go ahead, have a second tasting, or buy a bottle of their Carriage House Red—you're staying the night. Spacious wall tents, adorned with antique furniture, are elevated on wooden platforms, with decks overlooking the vineyard. Sit in your Adirondack chairs by the firepit roasting s'mores, then warm up or cool down with your fan/heater; the sites are electrified and worth a toast. SVEVineyards.com

TINY HOUSE LIVING

Ever dreamt of living in a tiny house? What if we told you it was designed by HGTV, on a vineyard overlooking the Columbia River, and with a free-flowing wine tap? Alexandria Nicole Cellars won the bid for the television series *Tiny House, Big Living*, and HGTV spared no expense, with details like glass garage doors that roll open to the deck and accent walls made of wine barrel staves. Ranging from 218 to 392 square feet, each of the four houses is tucked in the vines of the Horse Heaven Hills appellation. The check-in process begins with a tasting and is typically followed with a game of bocce. Explore the hundreds of acres by bike, and stop for a chat with the vintner about his latest creation. ANCTinyHouses.com

SAFARI

2

YOU KNOW THAT EXCITEMENT when you're hiking and a magnificent animal crosses your path? It's the first thing you tell your friends about and one of the most memorable parts of that vacation. What if you could increase your odds of wildlife sightings and re-create that thrill each day of your trip? You can on safari.

Ever seen two hulking muskoxen spar for dominance? An Alaskan coastal brown bear giving her two cubs a piggyback ride? Or a 30,000-pound fish wave its tail in front of your snorkeling mask? Africa isn't the only place with awe-inspiring wildlife. And animals are just the beginning of what makes the following glamping destinations so spectacular.

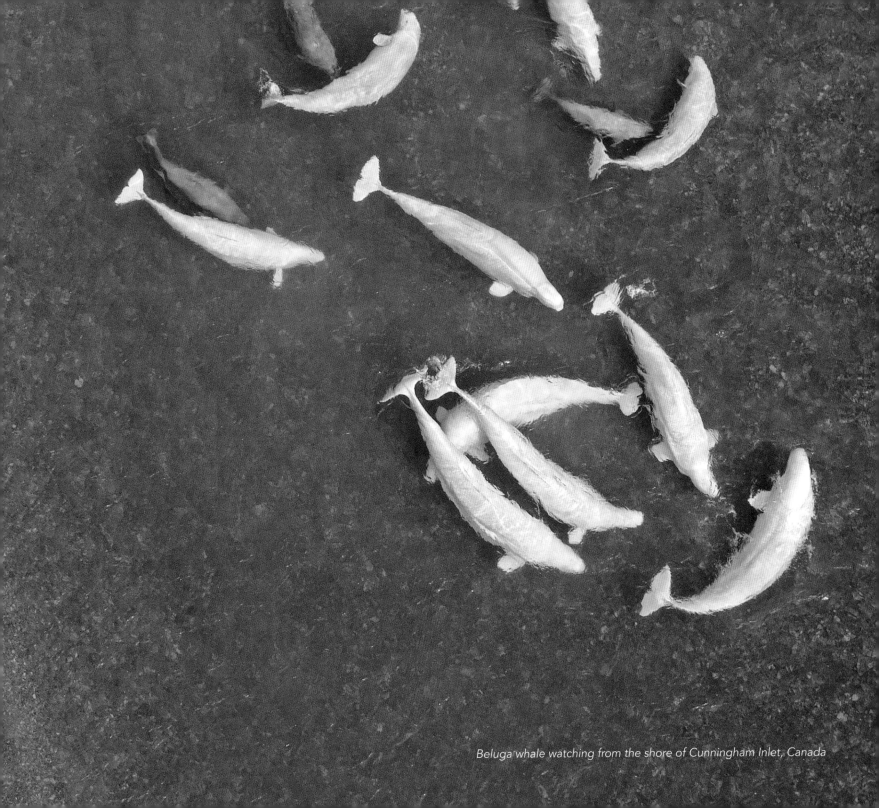

Beluga whale watching from the shore of Cunningham Inlet, Canada

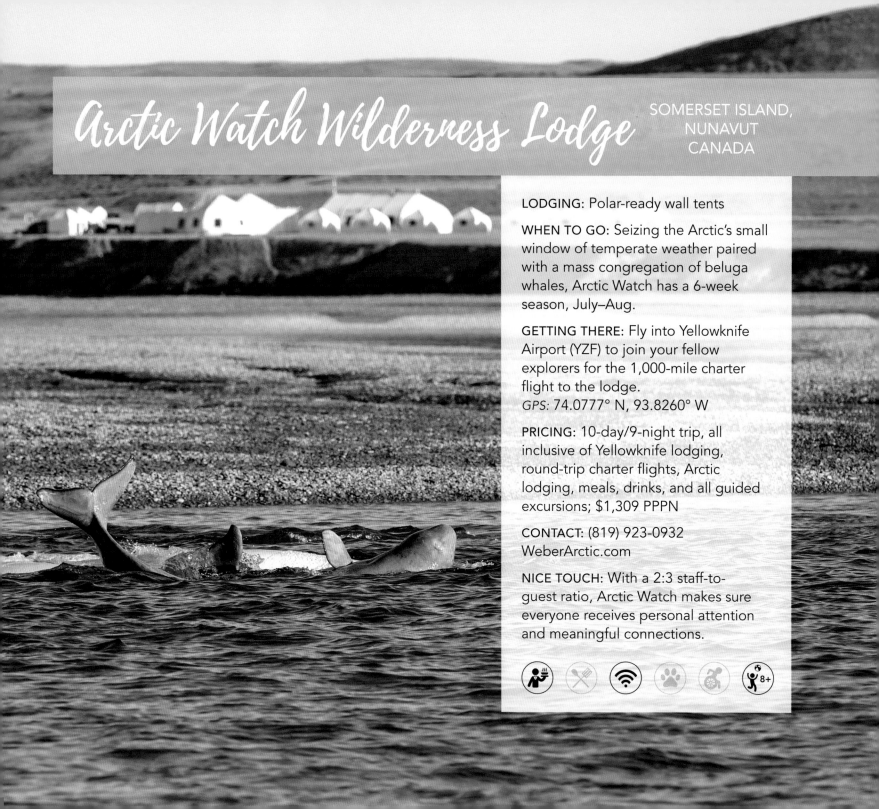

Arctic Watch Wilderness Lodge

SOMERSET ISLAND,
NUNAVUT
CANADA

LODGING: Polar-ready wall tents

WHEN TO GO: Seizing the Arctic's small window of temperate weather paired with a mass congregation of beluga whales, Arctic Watch has a 6-week season, July–Aug.

GETTING THERE: Fly into Yellowknife Airport (YZF) to join your fellow explorers for the 1,000-mile charter flight to the lodge.
GPS: 74.0777° N, 93.8260° W

PRICING: 10-day/9-night trip, all inclusive of Yellowknife lodging, round-trip charter flights, Arctic lodging, meals, drinks, and all guided excursions; $1,309 PPPN

CONTACT: (819) 923-0932
WeberArctic.com

NICE TOUCH: With a 2:3 staff-to-guest ratio, Arctic Watch makes sure everyone receives personal attention and meaningful connections.

FEW WOULD DREAM OF BUILDING a lodge 500 miles deep into the Arctic Circle, but few understand the Arctic like the Weber family. Cofounder Richard is one of the world's preeminent polar explorers, with more than 60 successful Arctic and North and South Pole expeditions. His wife, Josee, has pioneered women-only expeditions to both poles. Their son's first foray into the Arctic was at 6 weeks old, and together, brothers Nansen and Tessum have gone on to start the world's northernmost heli-skiing operation. If anyone could create sustainable, adventurous, and luxurious trips to the historic Northwest Passage, it would be this family of explorers.

The most northerly fly-in lodge in the world is strategically placed at the Cunningham Inlet, one of the largest and last beluga nurseries. When the ice thaws, thousands of whales swim up the river, playing in the shallows. As the season goes on, the prehistoric muskoxen steal the show with battles of the rut, while arctic foxes and polar bears are never far.

Tackle the terrain with the Webers and their expert team as you fatbike over the frozen ocean, kayak alongside a pod of whales, and hike tundra where few have ever set foot. Adventures can happen anytime—especially when the sun never sets and darkness is defined in shades of pink. Savor moments of stillness with an espresso in the polar library and dinners of locally caught arctic char and French-Canadian cheeses from their southerly Québécois neighbors. Raise a glass; you're a polar explorer now.

Thank you for an incredibly eye-opening, life-expanding experience! We've seen things we couldn't have imagined before—the canyons, the deep blue water and ice, belugas, and more. We were amazed by the delicious food, incredible planning, and vision for this place. We know this trip will inspire many more adventures.

—The Bassett Family

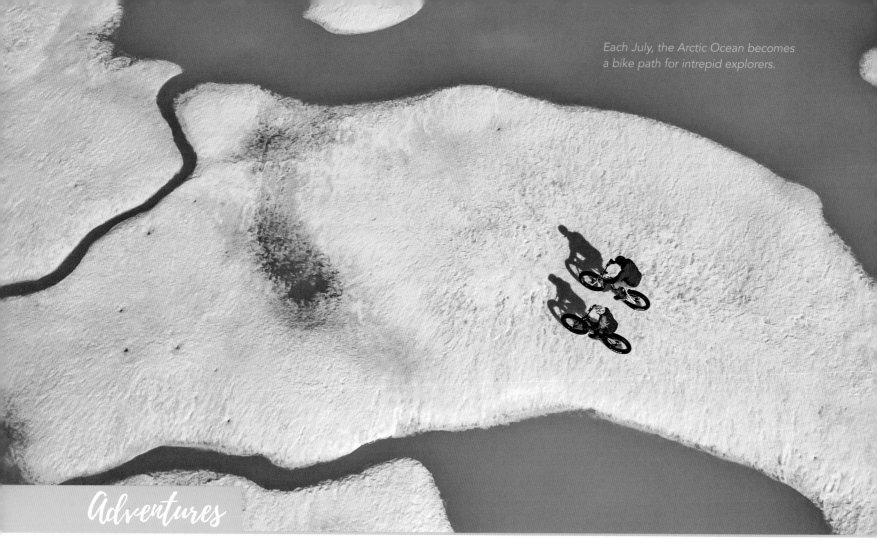

Each July, the Arctic Ocean becomes a bike path for intrepid explorers.

Adventures

FATBIKING THE ARCTIC OCEAN

There aren't too many places you can ride a bike on a frozen ocean. With nubby 4.5-inch-wide tires and seasoned guides, you're ready to take on the tundra and the sea ice. Mind over matter, you'll cross turquoise fissures and puddles that seem to plummet into the abyss. Arctic biking is quite the sight; even the ringed seals come out to watch.

BELUGA WATCHING

In the evening, join a guide for a short hike to the Cunningham River and watch pods of 3,000-pound whales as they rub up against the rocks, gurgle, and play in the freshwater. The river is constantly changing the terrain, with high tide often bringing the whales just a few yards from shore.

Glamping Experience

ACCOMMODATIONS: Not your typical canvas wall tent, these structures are made of multiple layers of high-tech fabric stretched tight over an aluminum frame. The polar-inspired interiors are made cozier with heavy duvets, flannel sheets, electric heaters, and nightly hot-water bottle delivery. Each tent is equipped with a marine toilet and sink, with showers in the main complex to mind the region's sensitive environment.

DINING: Defying the remote island's lack of culinary resources, talented chefs make bread, yogurts, ice cream, and more from scratch. They celebrate Canadian cuisine with locally sourced Baffin Bay turbot, Alberta organic beef, and Okanagan wines for the most impressive dining experience you can find in the Arctic.

ACTIVITIES: ATVing, fatbiking, standup paddleboarding, sea kayaking, hiking, Unimog off-roading, fishing, archaeological center, and wildlife watching

HONEYTREK TIP: Expect unpredictable weather. Give yourself a buffer with an extra night in Yellowknife at the end of your trip. Keep it interesting with a houseboat B&B on Great Slave Lake and dinner at the Wildcat Cafe.

BATTLES OF THE RUT

ATV through the tundra and across the river delta to the Muskox Ridges. Here you'll observe the shaggy muskoxen, a native species that's been virtually unchanged for a quarter-million years. The summer rut brings horn-on-horn combat between 800-pound males and mating by the victors. Take the River Trail home, with an eye peeled for snowy owls, jaegers, and rough-legged hawks.

BOB AROUND HOUSEBOAT BAY

Flying in and out of Yellowknife, you'll have time to explore the capital of the Northwest Territories' quirky neighborhoods. Take a boat tour or kayak around Houseboat Bay, a community of colorful floating cottages and hearty people who, depending on the season, paddle to town or take the ice road at their front door.

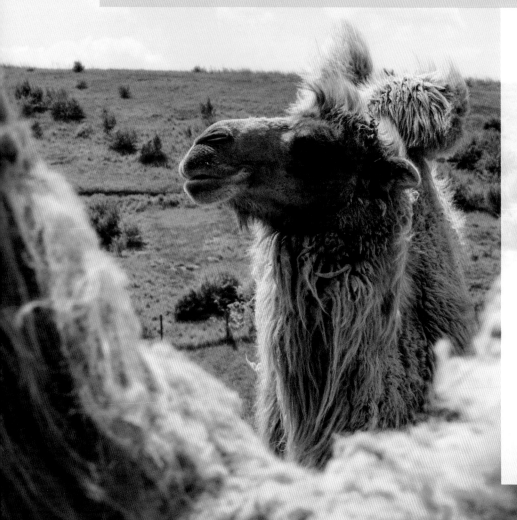

Nomad Ridge at The Wilds

CUMBERLAND, OHIO
UNITED STATES

LODGING: Yurts and cabins

WHEN TO GO: The Wilds conservation center and select cabins are open year-round; May–Oct is the time to experience the yurts and all programs in full swing.

GETTING THERE: An easy 75-mile drive east from downtown Columbus or its airport (CMH)
GPS: 39.8295° N, 81.7331° W

PRICING: Yurt, breakfast, dinner, and open-air safari tour; $113 PPPN

CONTACT: (740) 638-5030
TheWilds.org

NICE TOUCH: The cabins at Straker Lake are perfect for families; the yurts at Nomad Ridge are adults-only to maximize the serenity of nature and the romance of safari.

THERE ARE MANY "WILDLIFE PARKS" around North America, some that even have glamping, but they are *not* created equal. The Wilds is a conservation center for endangered species and one of the largest and most respected on the continent. Upwards of 10,000 acres of prairie, forest, and lakes are reserved for animals whose populations are diminishing around the world due to loss of habit and poaching. Here, the southern white rhino population is in its fifth generation (the only facility outside Africa to achieve this under human care) and the scimitar-horned oryx have a chance to survive, despite their extinction in the wild. And unlike a zoo, The Wilds has programs to release and sustainably reintroduce select animals into their natural habitat. They've worked with the Smithsonian Conservation Biology Institute and foreign national governments to bring populations like the Sichuan takin back to its native China and oryx home to Chad.

Starting as a nonprofit in 1984, The Wilds has taken decades to diligently restore this former coal mining area to a healthy habitat. With conservation as their primary focus, accommodations began as education camps and slowly expanded to the luxurious Nomad Ridge. Tucked on a forested hillside overlooking Stillman Lake (one of 150 on the property), the 12 yurts are a window to a world of wildlife. From your porch you can see herds of American buffalo move across the prairie, Kenyan zebras grazing, and Persian onagers drinking from the local watering hole. Explore The Wilds by open-air jeep, zipline, or horseback, and go on one of the best game drives this side of Africa.

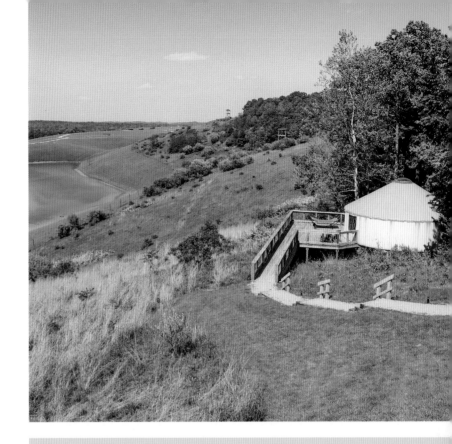

OUT OF AFRICA

Back in 2012, we traveled overland for 100 days across East Africa to reach the border of Kenya and Ethiopia—the last of the terrain for the endangered Grevy's zebra. As we were exploring The Wilds by open-air jeep, we gasped when we saw the same hypnotically striped mammal. "Are we really in Ohio right now?" In one way, it seemed weird to spot a Grevy's in the Midwestern prairie, but it was comforting to know that this zebra, along with a dozen in the breeding program, was making the species stronger from afar.

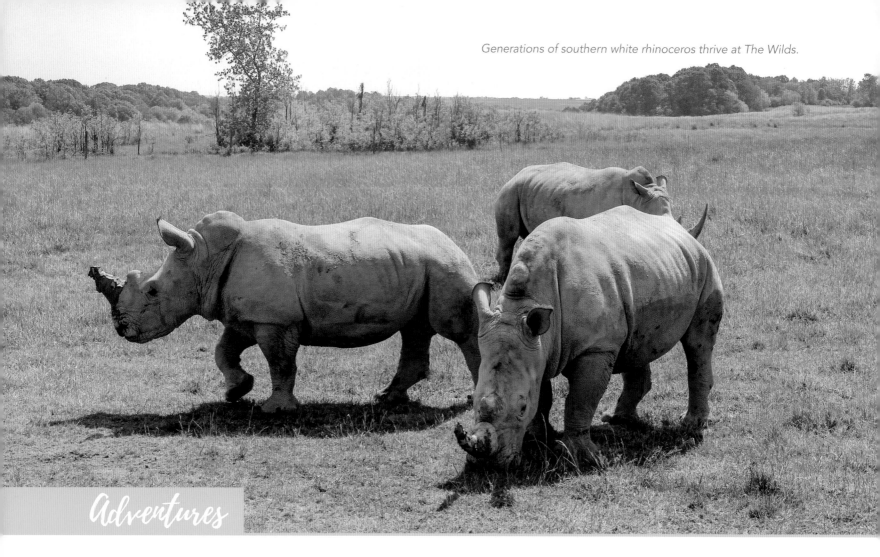

Generations of southern white rhinoceros thrive at The Wilds.

THE WILDSIDE TOUR

The Wilds has 500-plus animals and 28 species; see how many you can find. Go off-roading in an eight-person safari vehicle to see rhinos, eland, sables, and more in the open range; then visit the carnivore conservation center, where you'll find cheetahs and African painted dogs. Every tour is different; you may catch a vet-tech conducting a medical procedure or an ostrich doing a mating dance.

ZIPLINE ZOOLOGY

Put on your harness and helmet to explore the wildlife areas by zipline. Fly through the trees and over the animal-dotted pastures on a 2.5-hour, 10-line tour then descend by stomach-dropping rappel. Strategically placed platforms double as observation decks over some the liveliest watering holes and grazing hangouts.

Glamping Experience

ACCOMMODATIONS: Tiered on the hillside with expansive decks, the 12 yurts overlook the lakes and rolling pastures. A classic nomadic design, the canvas walls wrap around a circular lattice framework and the roof rises to a stargazing skylight. A colorful accent wall separates two-person bedrooms from the luxe bathroom. Each yurt has AC/heat, refrigerator, coffeemaker, and Wi-Fi. For groups and families, there are brand-new three-bedroom cabins at Straker Lake and a six-bedroom lakeside "Lodge," all with kitchens.

DINING: The Overlook Cafe is where Nomad Ridge guests enjoy their complimentary breakfast and multicourse dinner, like pecan-encrusted tilapia with blackberry sauce, followed by lava cake. Two more cafes are tucked throughout the park for lunch and snacks.

ACTIVITIES: Horseback riding, catch-and-release fishing, ziplining, mountain biking and hiking trails, education programs, summer camps, and guided safaris

HONEYTREK TIP: Consider getting an annual membership for as little as $55. It supports the nonprofit *and* gets you a slew of benefits during your stay, like discounts on lodging, tours, food, and souvenirs. Plus, it offers free and discounted entrance to AZA-accredited zoological facilities across the United States.

BIRDS & BUTTERFLIES

The Wilds's recovery from a strip-mined wasteland to a thriving habit for both exotic animals and local fauna is truly remarkable. To see their restoration ecology at work, stroll the 10-acre wetlands and woodlands at the Butterfly Habitat. Perch yourself at the Jeffery Point birding station and see why the Audubon Society recognizes The Wilds as an "Ohio Important Bird Area."

A WILD COCKTAIL HOUR

Make the most of sunset, when the animals are more active and basked in photo-perfect light, with an "Evening at the Outpost." This exclusive tour and cocktail hour brings you to the giraffe and rhino pastures. Enjoy drinks and light bites as you observe the wildlife at close range. Since these animals are permanent residents, you can help feed them for an even deeper connection.

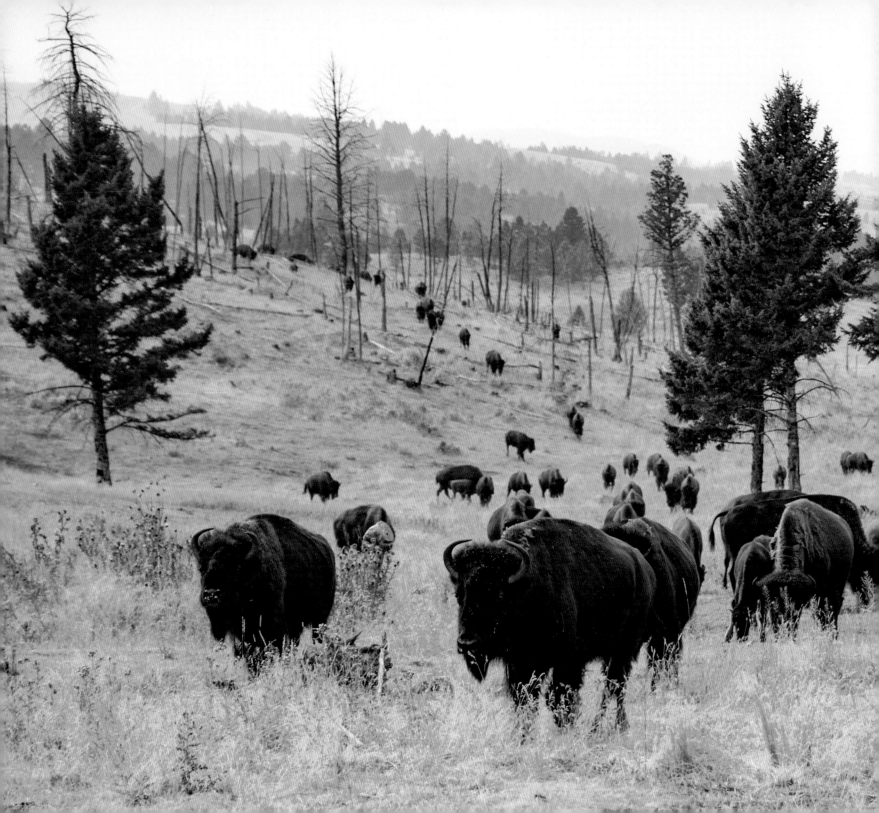

LET THE BUFFALO ROAM

AS A WILDLIFE BIOLOGIST AND HEAD of buffalo management for the Fort Belknap Reservation, Craig Knowles's heart broke to see this herd of bison penned in tight quarters. Without thinking through all the details, he offered to buy them from their negligent owner. Not many wives would be game to adopt a dozen bison, but Pam Knowles is also a wildlife biologist. They bought 480 acres in central Montana for their herd—and eventually for Bison Quest glamping guests to learn about North America's largest and most iconic land mammal. "People have to know about wilderness to love it," says Craig. "And if they love it, they will fight to preserve it."

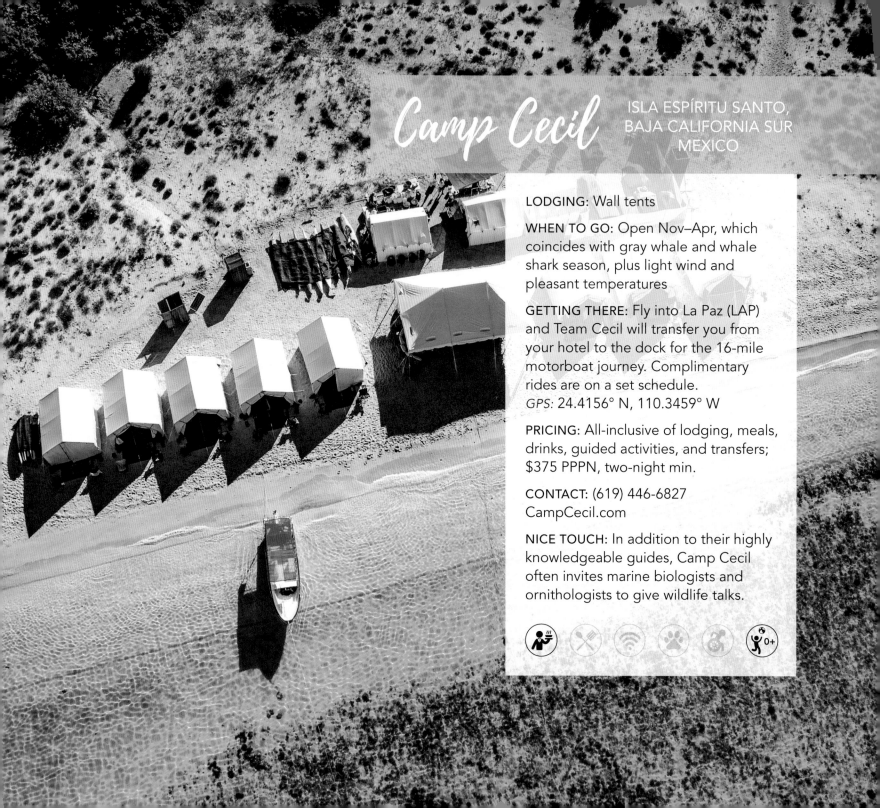

Camp Cecil

ISLA ESPÍRITU SANTO,
BAJA CALIFORNIA SUR
MEXICO

LODGING: Wall tents

WHEN TO GO: Open Nov–Apr, which coincides with gray whale and whale shark season, plus light wind and pleasant temperatures

GETTING THERE: Fly into La Paz (LAP) and Team Cecil will transfer you from your hotel to the dock for the 16-mile motorboat journey. Complimentary rides are on a set schedule.
GPS: 24.4156° N, 110.3459° W

PRICING: All-inclusive of lodging, meals, drinks, guided activities, and transfers; $375 PPPN, two-night min.

CONTACT: (619) 446-6827
CampCecil.com

NICE TOUCH: In addition to their highly knowledgeable guides, Camp Cecil often invites marine biologists and ornithologists to give wildlife talks.

"THE AQUARIUM OF THE WORLD"—that's how legendary ocean explorer Jacques Cousteau summed up Mexico's Sea of Cortez. It's home to 39% of the world's total number of marine mammal species, 891 fish species, and more vascular plant species than any other site on the UNESCO World Heritage List. Of course this 244-island protected area, which includes Espíritu Santo, has flurries of tropical fish, but it's also where the world's largest fish—the whale shark—comes to feed all winter. In this archipelago, rare blue-footed boobies and sea lion colonies get their own islands and humans are a rare breed.

Hotels would love to build along the white sand beaches, volcanic cliffs, and turquoise sea of Isla Espíritu Santo, but no permanent structures are allowed; eco-friendly glamping is the only approved lodging. Camp Cecil is run on solar power and disappears without a trace every April. Even with Mother Nature taking precedence here, there is still plenty of luxury to enjoy. Oceanfront tents are outfitted like five-star suites. Margaritas and ceviche arrive on cue with the sunset, and their on-sand restaurant is said to be one of the finest in greater La Paz.

The concept of safari is a pursuit for wildlife encounters, but in this world-renowned reserve, you won't have to work very hard. Sea turtles come to feed in their beach cove, bird rookeries are the nearest neighbors, and whale watching is just what happens on any given boat trip. Whether exploring on a standup paddleboard or snorkeling among the profusion of marine life, Camp Cecil will help you find your inner Cousteau.

IT STARTED WITH A LOVE STORY

In 2000, Camp Cecil's cofounder, Bryan Jáuregui, and her sisters decided to do a kayaking trip in Baja. After debating the various outfitters, they opted for one promising cold beer and Mexican guides. "Both of which are key elements to our story," said Bryan. The first night on Espíritu Santo, sister Blair drank a good bit of that cold beer and set about talking up Bryan to the local guide, Sergio. She assured him that Bryan, who could barely boil water, was a great cook and had many other desirable qualities. "Well, he took the bait, hook, line, and sinker," relayed Bryan, "and the wedding followed two years later." Camp Cecil is a product of their love for each other, Espíritu Santo, and food (cooked by someone else).

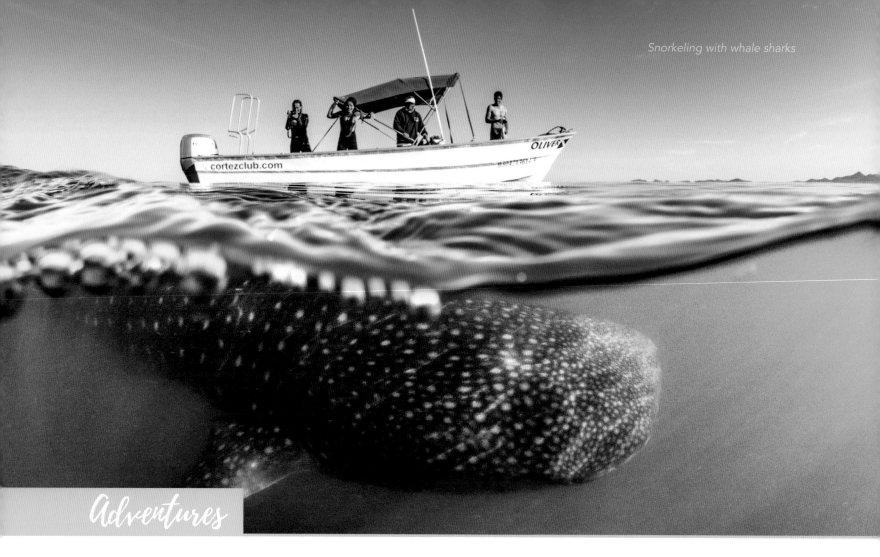

Snorkeling with whale sharks

Adventures

CAPITAL CULTURE

As the capital of Baja California Sur, La Paz is your best chance to experience authentic Mexican culture in the Land of Cabo. Stroll the colonial streets around Plaza de la Constitución, visit the impressive Museo de la Ballena (whale and turtle museum), eat lots of street tacos, and enjoy a nightcap at the chic La Miserable *mezcaleria*.

WHALE SHARK EXPEDITION

The Bay of La Paz is not only home to one of North America's largest whale shark populations, but also one of the most environmentally friendly places to swim with them (absolutely no feeding and no crowding!). When your captain spots these massive fish (up to 30 feet long), you'll hop in to swim alongside and observe their graceful movements and curious style of filter feeding.

Glamping Experience

ACCOMMODATIONS: All eight tents are on the sandy beaches of the Sea of Cortez. Sisal rugs, chandeliers, upholstered lounge chairs, and vanities make a desert isle feel surprisingly sumptuous. Choose from king-size or twin beds (cots available for families). Shared solar showers and compostable toilets help minimize environmental impact. Relax in the evenings on your private porch or central sofa lounge.

DINING: Start your gourmet day with not one breakfast but two (cold for early risers then hot for all). The cuisine is a mix of Mexican and Mediterranean, with fresh fish sourced from neighboring fishermen (a pair of brothers in their 90s!). Meals are served in a large dining tent, and nightly cocktail hour brings everyone to the water's edge for sunset.

ACTIVITIES: Standup paddleboarding, kayaking, snorkeling, hiking, birding, and naturalist talks

HONEYTREK TIP: Consider extending your Baja trip with one of the incredible excursions—from cooking to culture—with Todos Santos Eco Adventures (TOSEA.net), Camp Cecil's parent company and leading outfitter since 2002.

KAYAK SAFARI

With your knowledgeable naturalist guide, kayak along the towering cliffs and beach coves that fringe the island. In the air you'll spot reddish egrets, great blue herons, and oystercatchers, while magnificent frigate birds are certain to be at their rookery in the mangroves. Through the clear waters, you'll spot marine life from the comforts of your craft.

SNORKEL WITH SEA LIONS

Hop in a panga boat and keep your eyes peeled for dolphins, manta rays, and sea turtles. In under 30 minutes, you'll hear a cacophony of California sea lions. Up to 400 blubbery adults waddle, bark, and cuddle on the rocks, while curious pups come out to play. Dive in and try to follow their acrobatic moves as they swim around you and bat their big eyes.

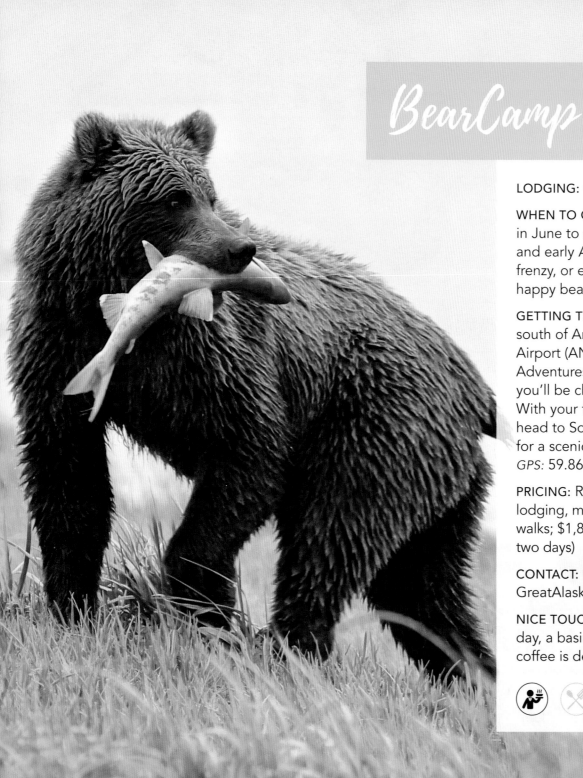

BearCamp

CHINITNA BAY, ALASKA
UNITED STATES

LODGING: Quonset-style huts

WHEN TO GO: Open June–Aug. Come in June to see the spring cubs, late July and early Aug for the salmon feeding frenzy, or end of season for fat and happy bears.

GETTING THERE: Two and a half hours south of Anchorage International Airport (ANC), Great Alaska Adventures' Kenai River Lodge is where you'll be checking in for BearCamp. With your fellow safari-goers, you'll head to Soldotna and hop a bush plane for a scenic 50-minute flight to camp. *GPS:* 59.8633° N, 153.1295° W

PRICING: Round-trip flight to BearCamp, lodging, meals, wine, and guided safari walks; $1,895 per person (one night, two days)

CONTACT: (866) 411-2327 GreatAlaska.com

NICE TOUCH: To help jump-start your day, a basin of hot water and fresh coffee is delivered to your hut.

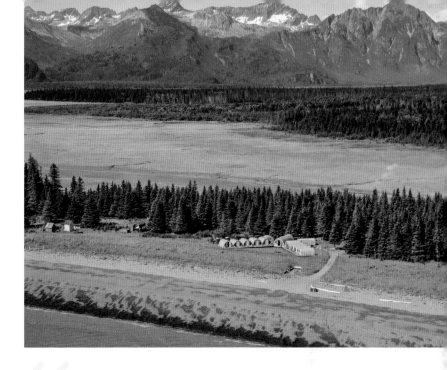

FLYING IN A BUSH PLANE, you hum past active volcanoes and blue glaciers of the Aleutian and Alaska Ranges. Where the mountains ripple down to the shoreline of Cook Inlet and Lake Clark National Park, that's your landing strip. The pilot skims along the sandy beach and stops directly in front of BearCamp.

If you feel like a pioneer, you're not too far off. This was the homestead of Wayne Byers, a true Alaskan and bear whisperer. With salmon-rich rivers and beaches laden with clams, he could see why coastal brown bears called this glacial spit home. So Wayne moved in alongside them for 47 years. On one of his biannual trips to the mainland, he connected with the cofounders of Great Alaska Adventures (a father-son team, plus a lady homesteader), and their intrepid spirits sparked. Getting on in years, Wayne invited them to set up BearCamp on his property.

Unlike adventure outfitters that chase down bears in trucks and choppers, Great Alaska has been grandfathered into a place where humans and wildlife have been living harmoniously since the 1960s (not to mention the indigenous people before them). All you have to do for prime bear viewing is roll out of your queen bed. Quonset-style huts are situated in front of the beach, where bears love digging for clams. After seeing cubs play and alpha males spar, you won't want the day to end. Good thing the Alaskan summer sun doesn't fully set. Wildlife viewing continues until your last fireside nightcap and picks right up again with morning coffee on your porch.

This is Alaska. And rugged Alaska. Glamping is in the eye of the beholder—you get great food with great tents and the most important part: BEARS! The bears are beyond the beyond. You get close and safe and overwhelmed all at the same time. It was an experience of a lifetime. Don't do yourself a disservice and come for just one night. We did four and can't wait for next summer!

—Cybill, California

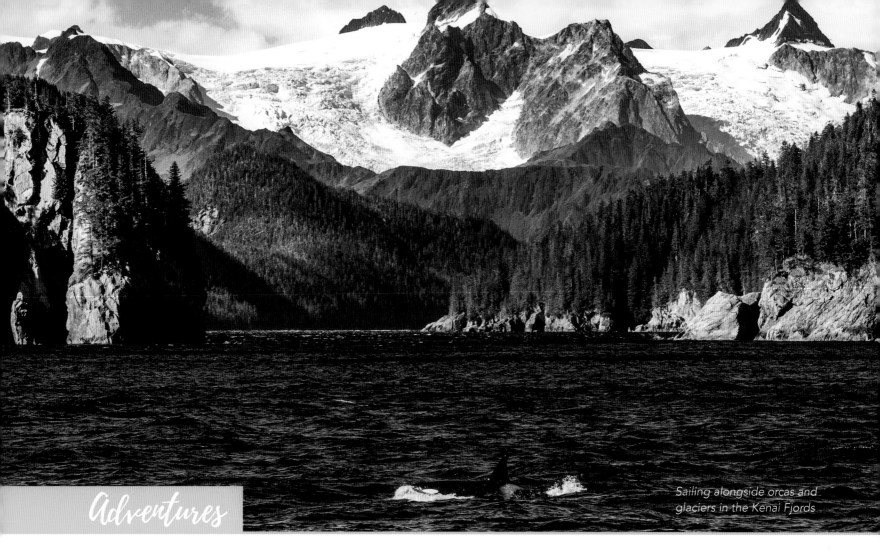

Sailing alongside orcas and glaciers in the Kenai Fjords

Adventures

BE AN AVERAGE BEAR

Get in tune with the rhythm of the Alaskan coastal brown bear. They tend to follow the tide for feasting opportunities—from clam digging in the exposed shoreline to salmon fishing in the creek. Climb the viewing platform to scan the beach for activity, then continue on a walking safari, listening for the roars of an alpha male or claws scratching on a spruce.

CRUISE THE KENAI FJORDS

Watch majestic marine life against a backdrop of glaciers in Kenai Fjords National Park. A 6- to 8-hour catamaran journey takes you deep into fjords where 200-foot-tall glaciers drop icebergs into the sea like cannonballs. Alongside your boat, humpback whales and super pods of orca breach and dive, while seabirds soar in the Pacific Ocean updraft.

Glamping Experience

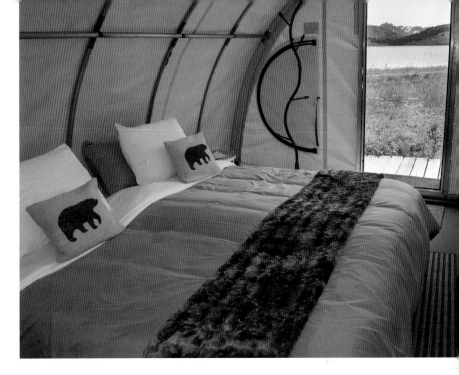

ACCOMMODATIONS: Being mindful of nosy neighbors and the safety of guests, BearCamp has an electrified fence around the living and dining quarters. Two-person huts aren't the breezy canvas variety; they're WeatherPort Shelter Systems that have been tested for the harshest environments. Queen beds with down bedding and bear-print throw pillows soften the wilderness, and a propane heater makes the accommodations fit for Goldilocks. Hot showers and composting toilets are in the nearby and sparkly clean bathhouse.

DINING: Seasonal produce, seafood, and meats are flown in throughout the week for the freshest backcountry cuisine. Wine and appetizers are the prelude to a multicourse dinner of refined American fare. A hearty breakfast, lunch, and snacks will keep you fueled throughout the day.

ACTIVITIES: Bear viewing, walking safaris, beach yoga, bonfires, board games, and photography workshops

HONEYTREK TIP: When everyone else is asleep, join a guide for perimeter patrol to watch the bears greet the day. Use this time to ask questions, gather tips, and feel like a ranger.

HOMESTEADER DIARIES

Enter the time capsule that is Wayne Byers's home. See how this homesteader lived off the land, and in concert with it, as a fisherman, trapper, gardener, and one resourceful human being until 2014. Hear wild stories of his encounters with wolves, journeys by snowshoe, and the ways he'd entertain himself without connection to the outside world.

FISH FOR THE WORLD'S LARGEST SALMON

Thriving with four of the five species of salmon, the Kenai River is famous for having the world's largest king salmon. The turquoise water flowing over pea-size gravel makes it a spawning paradise and angler's dream. Ply the Kenai with Great Alaska's pros and cast for the big bites. Not into fishing? Take their float trip and watch the bald eagles do it for you.

To the Rescue

When we see a beautiful wildlife encounter—animals playing, hunting, or caring for their young—it stops us in our tracks. But in a rapidly developing world, sometimes we need to step in. These noble nonprofits have taken great strides to protect threatened animal populations, and they invite you to join their mission with immersive experiences. Stroll Caribbean beaches for nesting birds, gallop in stride with wild horses, and feed adorable orphaned lambs—making a difference should always be this fun.

Protecting least terns

IT'S FOR THE BIRDS

Be a citizen scientist and a conservation pirate! After a decade of studying migratory birds in the US Gulf Coast, the Conservian nonprofit team realized that the birds' wintering habitat in the Bahamas was in trouble. Join this conservation crew on a 75-foot sailboat and tropical island hop for a weeklong volunteer vacation. As you stroll the sandy beaches, learn how to identify nesting birds, track breeding pairs, and spot baby chicks. Posting signs and collecting data helps protect Wilson's plovers, least terns, American oystercatchers, and more at-risk species. Good deeds are rewarded with sunset cocktails, snorkeling sessions, plenty of hammock time, and comfy schooner cabins.
CoastalBird.org

WILD HEARTS CAN'T BE BROKEN

In 2008, when the US Bureau of Land Management was considering euthanasia and overseas slaughterhouses for their 30,000 unwanted wild horses, activist and philanthropist Madeleine Pickens decided to create a 576,000-acre horse reserve. Set in Nevada's Ruby Mountains with full rivers and green pastures, Mustang Monument is idyllic for wild horses and guests alike. Stay in a luxury cabin or hand-painted teepee, with lavish decor inspired by the region's Old West and Native American heritage. Wake up at sunrise to help feed the horses, enjoy a five-star breakfast, then hop on your steed to see the landscape through their eyes. Proceeds from your all-inclusive stay benefit Saving America's Mustangs.

MustangMonument.com

HOLD THE BACON

Rescuing thousands of animals from factory farms and negligence, Farm Sanctuary is a place where sheep, pigs, cows, goats, and chickens are treated like friends. While you can visit their Southern California sanctuary for the day, the Finger Lakes, New York, location accepts overnight guests in their classic cabins and ultra-stylish tiny homes. With names like Marjorie Goat and Turpentine Turkey, accommodations share that creature's story and carry a cute animal theme throughout the decor. Take a heartwarming tour of the 275-acre farm, meeting and feeding a few of their 800 rescues. Watch them frolic the grassy hills from your porch and the visitor's barn, where a complimentary vegan breakfast is served.

FarmSanctuary.org

REJUVENATE 3

MORE THAN RELAXING on a beach chair, rejuvenation clears our mind, inspires our creativity, and invigorates the body and soul. It's not passive, it's a pursuit. Sure, this chapter has plenty of spa treatments where all you need to do is lie on a massage table or soak in a hot spring to feel fabulous, but those delights are just icing on the cake. These destinations offer tools for inner-exploration, like wellness workshops (from Ayurvedic cooking to radical self-love) and art classes (from batik dying to ecstatic dance). And while you could do some of these things in a studio in New York City, their natural setting is what makes each lesson resonate. Practice yoga overlooking the Caribbean Sea, explore a meditation labyrinth on a high-desert cliff, and hone your creative writing in an old-growth forest. Reaching these destinations is where your journey begins.

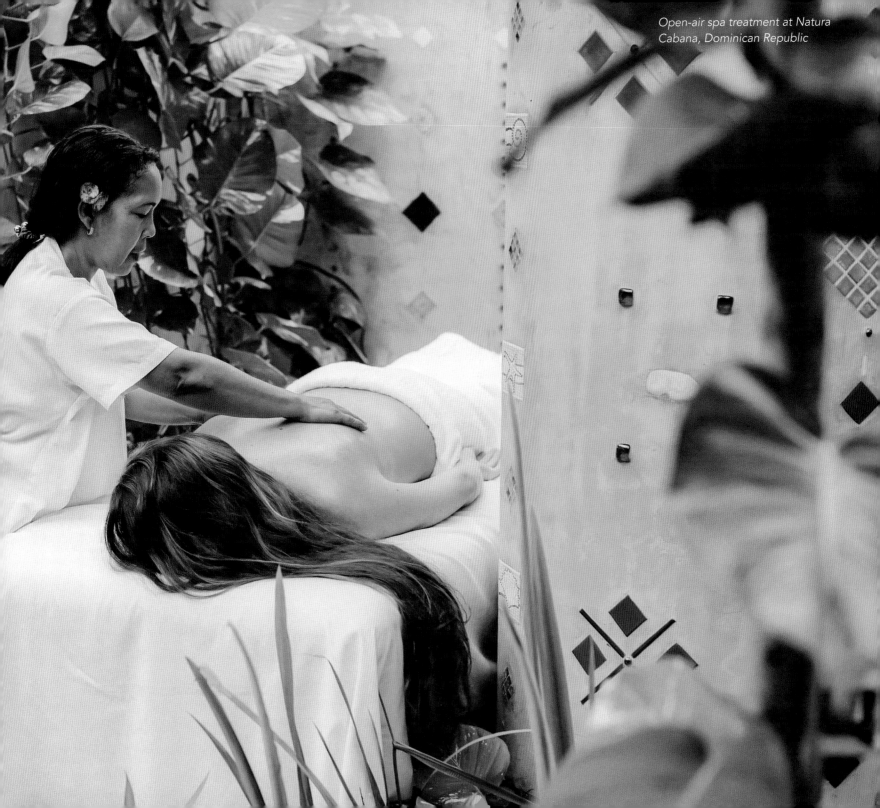

Natura Cabana

**CABARETE, PUERTO PLATA
DOMINICAN REPUBLIC**

LODGING: Cabanas

WHEN TO GO: Open year-round, with consistently warm weather. Jan–May offers clear skies and just the right amount of heat.

GETTING THERE: Fly into Puerto Plata's international airport (POP); in less than 30 minutes, a *taxista* can have your toes in the sand.
GPS: 19.7830° N, 70.4629° W

PRICING: Cabana and breakfast for two; $180

CONTACT: (809) 571-1507
NaturaCabana.com

NICE TOUCH: In their organic fruit and veggie garden, they've laid the "Buddha Path," a trail with meditative art and benches to encourage guests to slow down and watch the butterflies flutter and flowers grow.

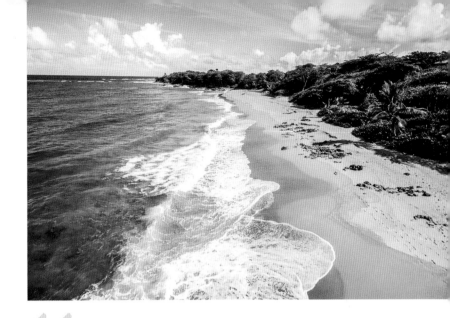

EVER FALLEN SO IN LOVE with a vacation destination that you thought about moving there? Well, the Sumar family pulled the trigger and bought their slice of paradise on the Dominican Republic's northwest coast. It started as a vacation home from their native Chile, but by 1996 the allure of Cabarete had drawn the couple and their four daughters to move there full time. They built a guesthouse for family and friends, and as these happy campers returned for extended holidays, the Sumars decided to build a few more. "I would cook the meals, serve fresh juice, and offer yoga classes. I wasn't even a certified instructor!" laughs Lole Sumar about the early days. "We just wanted to share the magic of this place." Flash forward two decades, and it's an award-winning hotel with 12 stunning bungalows, two gourmet restaurants, and an extensive wellness program.

Having started as a family home and expanding with friends in mind, Natura Cabana is made with heart. Each room is unique and inspired by a favorite treasure from the Sumars' travels or time on the island, like a Rajasthani wall hanging or the Caribbean seashells they've collected. Working with a feng shui expert and an artful eye, they've designed spaces that put you at ease. Natura Cabana has extensive wellness offerings at their studio and spa, though they didn't start them because they were the trendy thing to do. Lole has studied natural medicine for decades, and her youngest daughter is a certified health coach. They grow their own produce for the restaurant because they know organic is what's best for everyone. Pure and simple, Natura Cabana is good for the mind, body, and soul.

> "My mom and I just wanted a break from city life, and this place gave us what we needed! The spa was a wonderful experience; both the Swedish and Intense massages were amazing. I have practiced yoga many times, and their instructor Gigi has become my favorite! She had such a relaxing voice and could modify positions for everyone's level. My mother continues to rave about her classes.
>
> —Lidia, New York

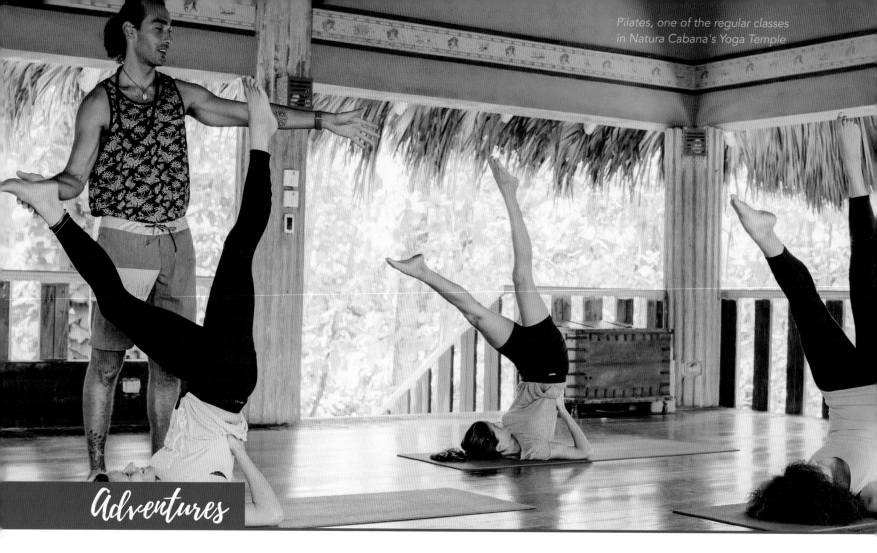

Adventures

SCRUB, RUB, SWOON

Not your typical spa menu, the offerings take inspiration from the indigenous Taino people, the surrounding jungle, Caribbean Sea, and Mother Earth herself. Slip into a robe and sip exotic fruit juice as your therapist prepares your seaside massage table or treatment room for a moisturizing Dominican mud wrap or honey exfoliation. With over 30 treatments, stress doesn't stand a chance.

LEGENDARY KITESURFING

Acclaimed as one of the world's top kitesurfing destinations, Cabarete is the perfect place to try this extreme sport. Head to Kite Beach to scope out the classes or just catch happy hour with views of kiters busting tricks. Beginners, opt for a school that practices at the quieter Bozo Beach; advanced kiters should find "The G-Spot," a locals' break between Kite and Encuentro Beaches.

Glamping Experience

ACCOMMODATIONS: Each bohemian-chic cabana is unique, with a name hinting at its inspiration, like Piedra's river stone construction, Coral's seashell walls, and Tanzania's African textiles. Thatched roofs shade hammock-clad patios, and ample windows bring in the ocean breeze. Bamboo accent walls, shell borders, and flagstone floors complete the organic look. Choose from one- to three-bedroom bungalows with private bathrooms, many with kitchenettes.

DINING: Dietary restrictions? Pescatarians, vegans, juicers, gluten-free, and paleo people, you're in the right place. Enjoy their two restaurants—the more casual Kayraya for breakfast and lunch, then the elegant Natura by night. If you'd prefer a meal at your beach chair, the charming and attentive staff will be happy to serve you.

ACTIVITIES: Spa, pool, yoga, Pilates, dance, wellness workshops, cooking lessons, garden tours, surfing, and treehouse playground

HONEYTREK TIP: Natura Cabana runs great deals and creative vacation packages, particularly in low season. Check the "Offers" section of their website; you may even get your third night free.

SPELUNK THE 27 CHARCOS

The serpentine Damajagua River has carved out 27 cascading pools and a spelunker's paradise. Head upstream with the pros at Iguana Mama, starting with an hour hike through a tropical jungle and the river itself with the help of ladders, ropes, and buff guides. Each waterfall presents a new font of adventure—cliff jumps, natural waterslides, shimmering grottoes, and double dares.

DANCE IT OUT

Merengue and bachata music grew from the Dominican countryside and swept the international dance scene. Get into the rhythm with a Biodanza free-form dance session at Natura Cabana, then refine your Latin moves at Alma Libre Dance School. If nothing else, head out for a night at the Cabarete beach bars for a cultural experience with bongos and hip shakes.

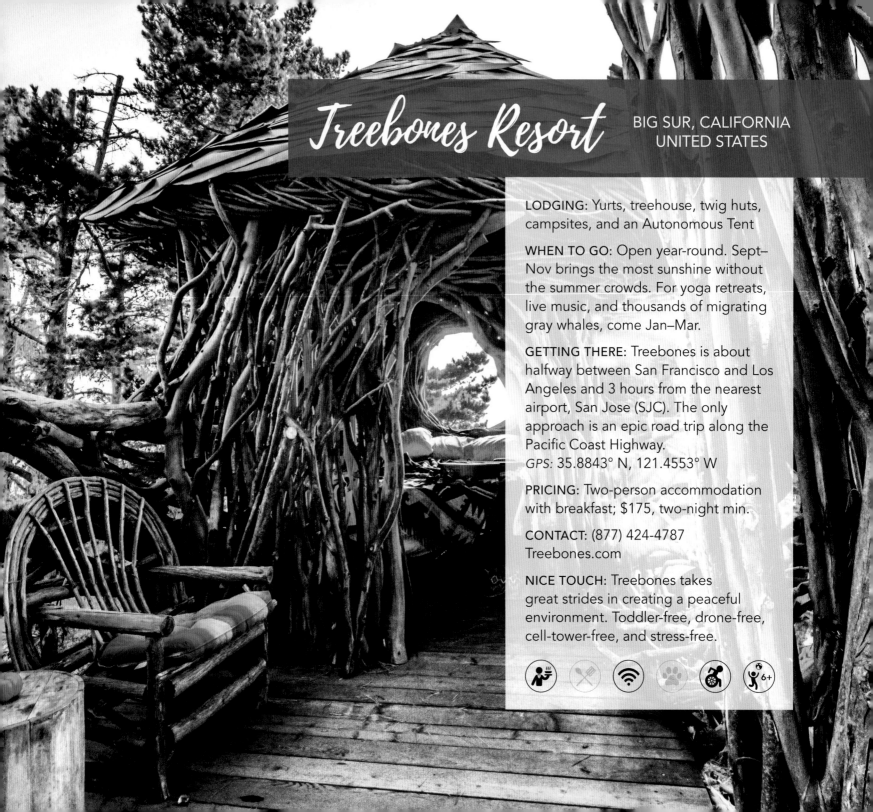

Treebones Resort

BIG SUR, CALIFORNIA
UNITED STATES

LODGING: Yurts, treehouse, twig huts, campsites, and an Autonomous Tent

WHEN TO GO: Open year-round. Sept–Nov brings the most sunshine without the summer crowds. For yoga retreats, live music, and thousands of migrating gray whales, come Jan–Mar.

GETTING THERE: Treebones is about halfway between San Francisco and Los Angeles and 3 hours from the nearest airport, San Jose (SJC). The only approach is an epic road trip along the Pacific Coast Highway.
GPS: 35.8843° N, 121.4553° W

PRICING: Two-person accommodation with breakfast; $175, two-night min.

CONTACT: (877) 424-4787
Treebones.com

NICE TOUCH: Treebones takes great strides in creating a peaceful environment. Toddler-free, drone-free, cell-tower-free, and stress-free.

DRIVING DOWN THE PACIFIC COAST HIGHWAY, hugging the curves of the Santa Lucia Mountains, crossing bridges of architectural wonder, and passing beach coves framed by redwoods, you reach the heart of Big Sur. Chain restaurants, big box stores, cell service—these things are behind you now. It's time to get back to nature. Scientific studies have proven the mental and physical health benefits of time spent by the sea and the forest, and now you're surrounded by both.

As former Angelenos, Corinne and John Handy know about the rat race and the need for rejuvenation. After dozens of weekend getaways to Big Sur, they bought this 11-acre plot of land in 1987. They didn't have any real plans for a house or hotel but knew they deeply needed this place. Long before "glamping" was a word, they began dreaming of an eco-friendly destination with creative structures, yoga classes, massage treatments, and a redwood bar overlooking the Pacific Ocean. It took nearly two decades and an immeasurable volume of work, but they made Treebones a reality in 2004.

Giving a nod to the ancient nomadic structures in the round, they started with luxury yurts but have since pushed to the forefront of glamping design. Their Autonomous Tent could be described as a cocoon meets the Sydney Opera House. Their treehouse is designed by none other than Pete Nelson of Discovery's *Treehouse Masters*. Whether sleeping in an artist-made "nest," taking a yoga workshop, or forest bathing in the redwoods, the magic of this place will cast its spell on you too.

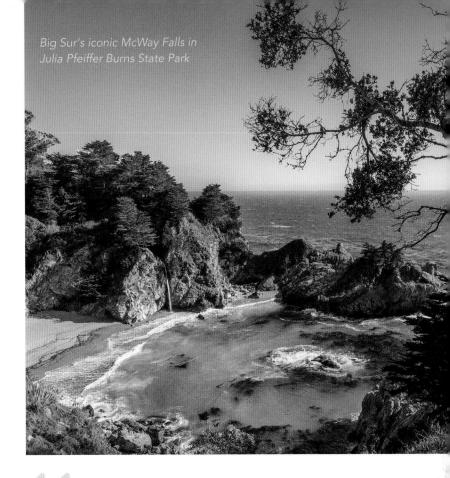

Big Sur's iconic McWay Falls in Julia Pfeiffer Burns State Park

" While sitting by the fire in the lodge, playing old-school board games, perched upon a cliff, ocean views for miles, no phone, no laptop ... I was reminded, if just for a moment, how beautiful life really is.
—Casey, Washington

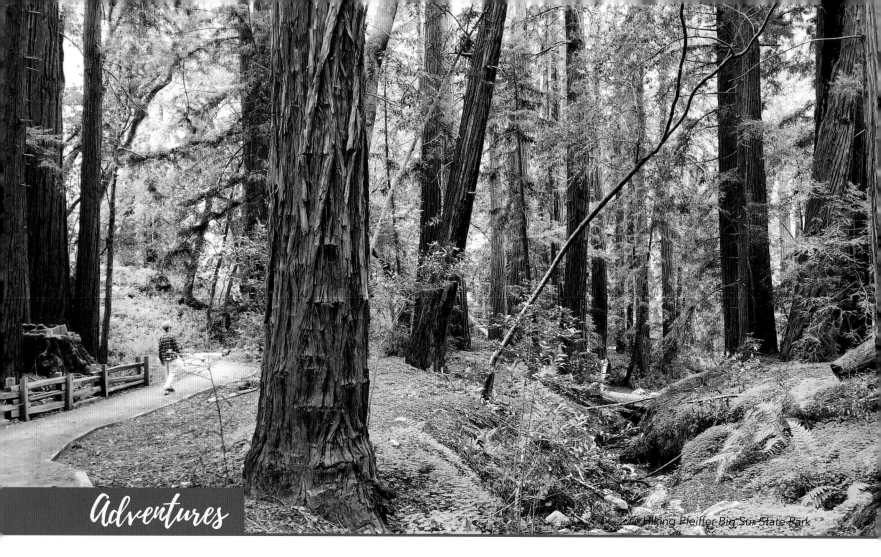

Hiking Pfeiffer Big Sur State Park

HIKE AMONG THE REDWOODS

To experience the world's tallest tree species (some more than 300 feet tall and 2,000 years old!), try these old-growth forest trails: Pfeiffer Falls & Valley View Trail (2.4 miles) in Pfeiffer Big Sur State Park (*tip:* the biggest tree is by the softball field), Ewoldsen Trail (5.0 miles) in Julia Pfeiffer Burns State Park, and Vicente Flat Trail (10.8 miles) in Los Padres National Forest.

SEA CLIFF HOT SPRINGS

The Esalen Institute is legendary for its programs in wellness, spirituality, and humanistic psychology—plus, cliffside hot springs! Consider enrolling in one of their 600 multiday workshops; otherwise, you can access the clothing-optional springs when you book a massage. Arrive early for a soak over the crashing waves, then melt into a puddle with a whole-body rubdown.

Glamping Experience

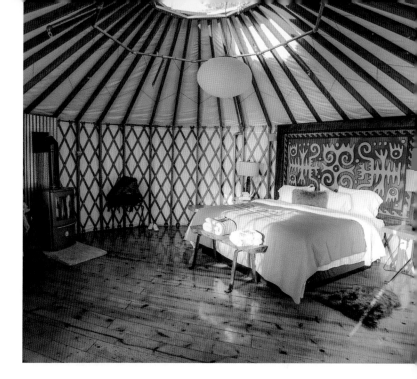

ACCOMMODATIONS: At the core of this sustainable retreat with ocean views are 16 fully furnished yurts with running water and redwood decks. All lodging shares bathroom facilities with radiant-heated tile floors, save for the Autonomous Tent. With 500 square feet of living space, en-suite bath, and two fireplaces, this is the most luxurious option. For adventurous types, the Human Nest and Twig Hut are walk-in sites and works of art. While these fantastical wood-woven structures do have a mattress, they're admittedly rustic (BYO bedding and rain plan). Fan of *Treehouse Masters*? Book Pete Nelson's suspension-bridge hideaway.

DINING: The Wild Coast Restaurant and Sushi Bar boast California-fusion cuisine, sourced from local farmers and their own organic garden. Enjoy all three meals in their contemporary dining room with heated wraparound deck. Their innovative Sushi Bar crafts a nine-course Omakase dinner Wed–Sun, Mar–Nov.

ACTIVITIES: Swimming pool, hot tub, yoga classes and retreats, massage treatments, and concert series

HONEYTREK TIP: Take the Big Sur Pledge! Share the road, leave no trace, respect the community, be fire safe, and act as a steward for this fragile environment. BigSurPledge.org

COMMUNE WITH ELEPHANT SEALS

Just south of Hearst Castle (also a must-see), San Simeon is the gateway to the Monterey Bay National Marine Sanctuary. Visit one of the world's only elephant seal rookeries that you can easily access—year-round and for free. From the Piedras Blancas's observation deck, watch thousands of adorable seals cuddling up, kicking sand, and scooting around the shoreline.

JADE TREASURE HUNT

At low tide, take the 1.5-mile loop trail to Jade Cove for one of the best chances to find this precious gemstone. Before you go hauling the beach to the bank, follow local regulations and decipher between jade and the green serpentine rocks by scratching your best finds with your keys (jade is too hard to scuff). Double your luck with a beachcombing session at nearby Willow Creek Beach.

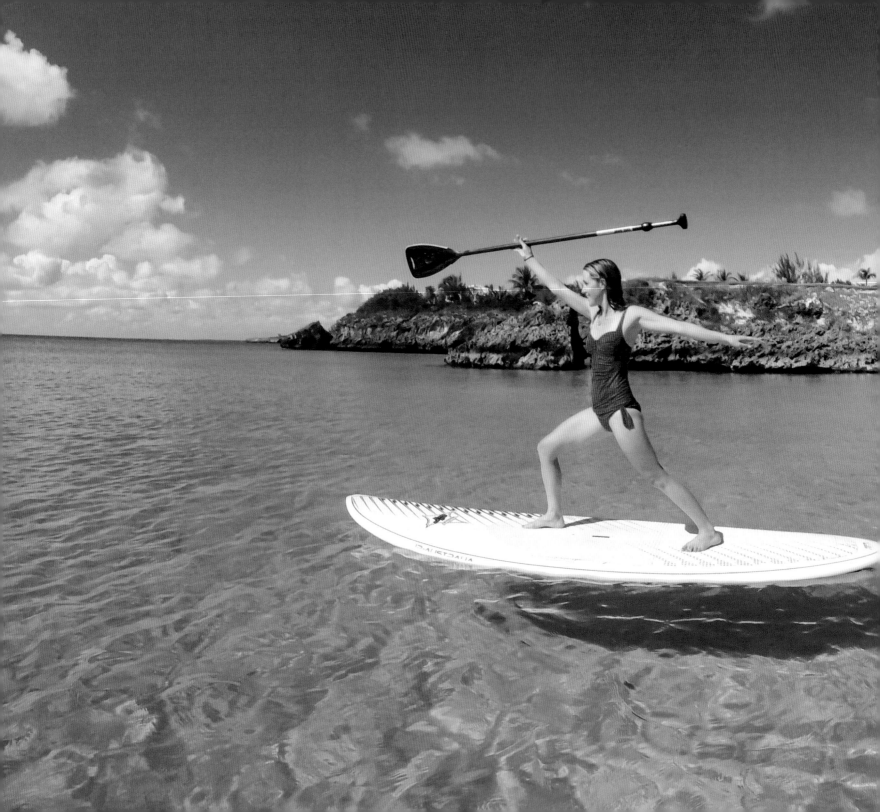

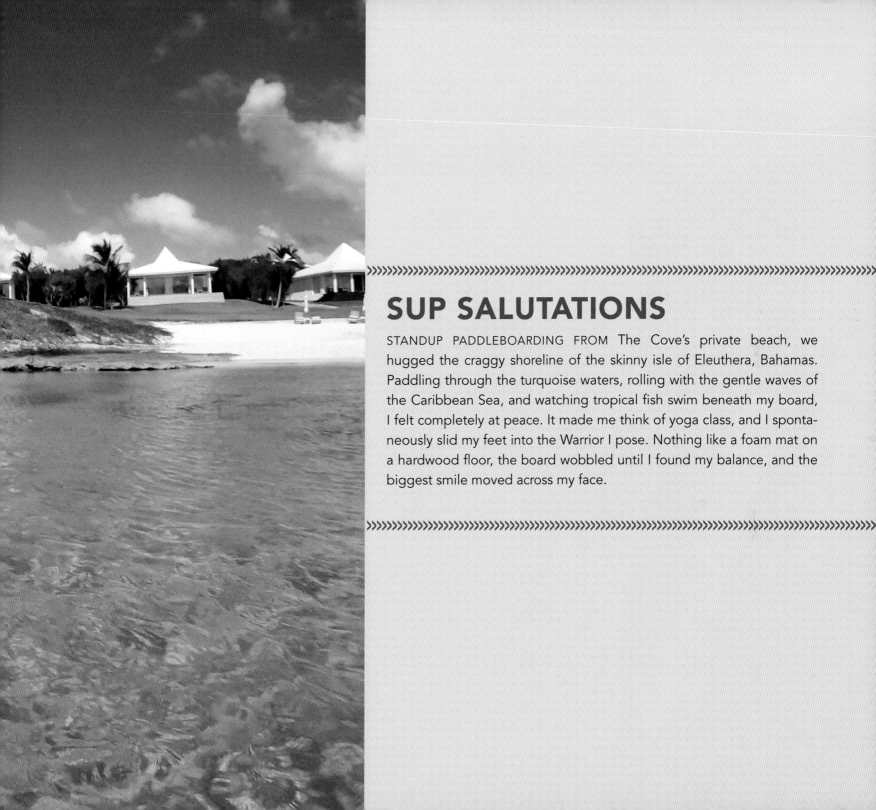

SUP SALUTATIONS

STANDUP PADDLEBOARDING FROM The Cove's private beach, we hugged the craggy shoreline of the skinny isle of Eleuthera, Bahamas. Paddling through the turquoise waters, rolling with the gentle waves of the Caribbean Sea, and watching tropical fish swim beneath my board, I felt completely at peace. It made me think of yoga class, and I spontaneously slid my feet into the Warrior I pose. Nothing like a foam mat on a hardwood floor, the board wobbled until I found my balance, and the biggest smile moved across my face.

Panacea at the Canyon

CULVER, OREGON
UNITED STATES

LODGING: Stargazer wall tents

WHEN TO GO: A boutique immersive retreat, Panacea is designed for long weekends (Thurs–Sun), May–Oct.

GETTING THERE: Twenty minutes north of Redmond Municipal Airport (RDM) and a scenic 3-hour drive from Portland
GPS: 44.4050° N, 121.2249° W

PRICING: Lodging, meals, cocktail hours, yoga, creative exercises, excursions, and wellness or romance program; $425 PPPN, three-night min.

CONTACT: (541) 604-6158
PanaceaResort.com

NICE TOUCH: At the end of each day, Panacea facilitates a meditative "earthing" walk followed by a foot bath with a salt scrub made from their own lavender and sage.

PAN·A·CEA |pa-nə-'sē-ə (NOUN): A solution or remedy for all difficulties or illnesses; something that would make all of one's problems or troubles disappear.

That definition is what guided Shawn Armstrong and Darren Kling in their journey to create a boutique wellness retreat in central Oregon's high desert. With Shawn's background as a yoga instructor and Reiki master and Darren's as a mixed-media painter and professional balloonist, the husband-wife team was made for this project—but that didn't make it easy. It was a six-year challenge to make this slice of paradise available to guests, although perseverance is just one of the many attributes to glean from Darren and Shawn.

Using this time to their advantage, Darren said, "We took years to let the land show us where to put each site, meditation labyrinth, pool, spa, yoga deck—everything." The 40 acres of sage and wild grasses, framed by red volcanic cliffs and the Crooked River Gorge, were carefully developed to maximize beauty with minimal impact. The entire property runs on solar energy, and every choice, down to the organic linens, has the environment and your well-being in mind.

Panacea at the Canyon is designed as a three-day wellness retreat, be it deepening your connection as a couple or with one's self. "It is so important to take the time to slow down, put away the electronics, and reconnect with yourself, the natural world, and those around you," says Shawn. "It informs us of what we need to thrive."

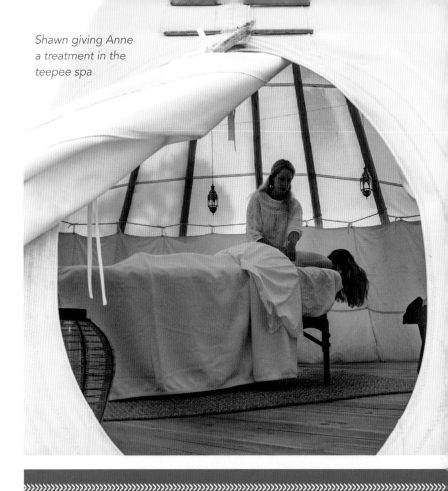

Shawn giving Anne a treatment in the teepee spa

NEW ENERGY

I walked toward the spa teepee for my chakra balancing and Reiki treatment. To be honest, I had no idea what that entailed, but it sounded interesting. The room smelled of lavender, and sunlight filtered through the canvas walls, giving the circular space a halo-like glow. Shawn, with her long curly blonde hair and white linen shirt, had a similar radiance. She asked about my stresses, then set out to relieve them by massaging from my feet to the crown of my head with essential oils. Her hand never left my body, always keeping a point of contact, and it lingered wherever she felt an energy block. When the treatment ended, it was as if I had awoken from a dream.

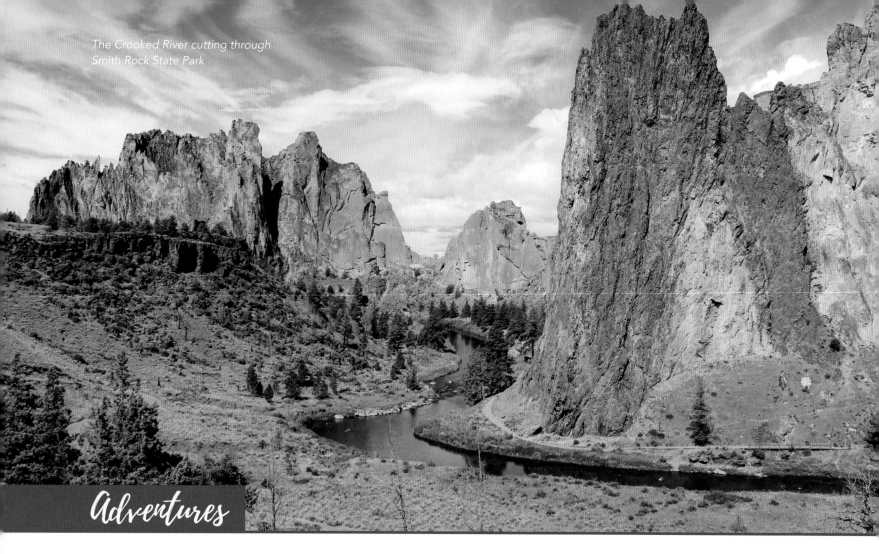

The Crooked River cutting through Smith Rock State Park

Adventures

COUPLES CONNECTION

Deepen your bond as partners with Panacea's "Romantic Reconnection" program. Choose the exercise that speaks to your relationship, and set your intention for the day. Hike the grounds, paint the landscape, journal your thoughts, and enjoy a couples massage before regrouping with a certified counselor to share what you appreciate about each other.

ONE OF SEVEN WONDERS OF OREGON

Rock climb a few of the 1,000-plus bolted routes of Smith Rock State Park, or simply watch the world-class climbers that flock to "the birthplace of American sport climbing." If you prefer to keep your feet on the ground, take the 3.8-mile Misery Ridge Loop Trail for a challenging hike with immensely rewarding views of the red cliffs, Crooked River, and Cascade Range.

Glamping Experience

ACCOMMODATIONS: Seven canvas-wall tents are generously spaced for the feeling of a private retreat. Choose from queen or king size (both are plenty spacious), with a seating area by the fireplace and a large deck with Adirondack chairs. An artist-made juniper headboard and a stargazing window make the bed particularly inviting. The bathroom could be straight out of a five-star hotel, except it's in the open air. Enjoy a hot shower while bird watching.

DINING: Served in the outdoor dining pavilion, breakfast, lunch, and dinner focus on local and organic fare. Saturday nights, Darren man's the wood-fired pizza oven while their neighbors from Maragas Winery do an organic wine pairing. For those interested in a full-body cleanse, a three-day menu plan can be arranged with a top-notch juicery.

ACTIVITIES: Daily yoga, massage, chakra balancing, aromatherapy, lake trips, wading pool, hot-air ballooning, writing and painting workshops

HONEYTREK TIP: Bend, one of Oregon's liveliest cities, is just 30 miles away. Check the VisitBend.com event calendar to see what art, music, workshops, and fun is happening around your stay. If nothing else, stop by Humm Kombucha Taproom for a healthy pint.

SUNRISE BALLOON FLIGHT

As you sip your coffee, watch Darren prepare his personally hand-painted balloon for a sunrise flight. Hop in the wicker basket; the ground will soon fade away and the mountains, volcanic buttes, and river gorge come into focus. Learn about the area's geology and local lore as you dip into the 500-foot-deep canyon and below its historic steel-arch bridges.

ENERGY HEALING SAMPLER

Center yourself with a combination of Reiki (a Japanese relaxation technique), chakra clearing (ancient Indian method of opening your energy centers), an elements assessment (identifying whether fire, water, air, or earth drive you and tips to stay in balance), and aromatherapy. Complete the experience with a labyrinth meditation overlooking the canyon.

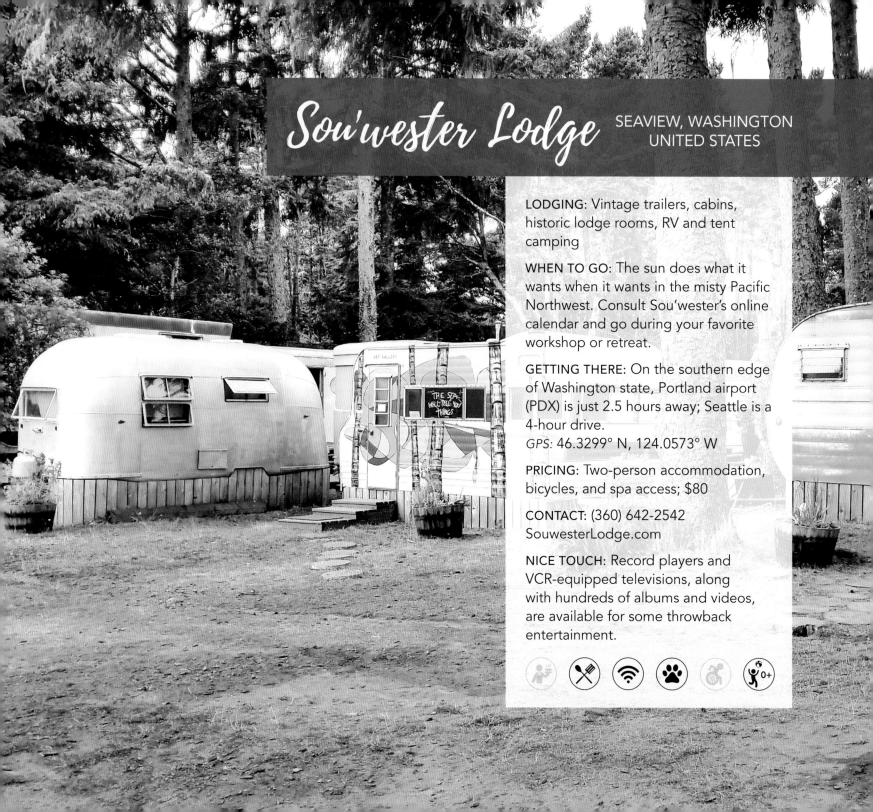

Sou'wester Lodge

SEAVIEW, WASHINGTON
UNITED STATES

LODGING: Vintage trailers, cabins, historic lodge rooms, RV and tent camping

WHEN TO GO: The sun does what it wants when it wants in the misty Pacific Northwest. Consult Sou'wester's online calendar and go during your favorite workshop or retreat.

GETTING THERE: On the southern edge of Washington state, Portland airport (PDX) is just 2.5 hours away; Seattle is a 4-hour drive.
GPS: 46.3299° N, 124.0573° W

PRICING: Two-person accommodation, bicycles, and spa access; $80

CONTACT: (360) 642-2542
SouwesterLodge.com

NICE TOUCH: Record players and VCR-equipped televisions, along with hundreds of albums and videos, are available for some throwback entertainment.

WHAT'S YOUR CREATIVE OUTLET? Is it dance, writing, painting, cooking, sewing beverage koozies—or maybe you're not sure but are looking for a craft that gets your juices flowing. Sou'wester Historic Lodge and Vintage Travel Trailer Resort is a 501c3 nonprofit that seeks to create community with art, music, and wellness. As founder Thandi Rosenbaum says, "It's a space for folks to create, connect, restore, and renew, in order to experience transformation within themselves and their work."

When she stumbled upon the curious pairing of a 19th-century seaside mansion and a vintage trailer park, she was intrigued. The hotel was run by an older couple who had the concept of bringing guests together with intellectual gatherings. "Though if you tried to make a reservation and let 'dude' slip into a sentence," Thandi laughed, "they might not have a room for you." She also liked the idea of workshops, but as a former set designer and waitress, she believes in art for all. That everyone is an artist at heart—they just need the space to be creative. That's why Sou'wester has designed a pavilion for workshops and performances and converted different trailers into a recording studio, a rotating art gallery, and a crafter's thrift shop.

Every year they host more than 50 creative and wellness workshops across an incredible range of topics from macramé weaving to channeling creativity through tarot. And for those just looking to clear their minds, the Finnish spa, meditation trailer, and bike path along the Pacific are at your doorstep. The Long Beach Peninsula is an area rich in history, from its tradition of family-run oyster farming to Lewis and Clark's final stop on the Corps of Discovery expedition.

MAY THE SPA BE WITH YOU

Confession: I had never seen the original *Star Wars* until we borrowed it from Sou'wester's VHS collection. This had been a point of contention in our marriage, so to convince a non-sci-fi fan to watch this cult classic, bribery was needed. Mike ordered the Sou'wester wellness kit to our 1952 Westcraft trailer, drew me an Epsom-salt foot bath, massaged my face with a sea clay mask, and cooked dinner as I watched the Rebel Alliance take on the Dark Side. If all *Star Wars* screenings could be this way, I just might finish the series.

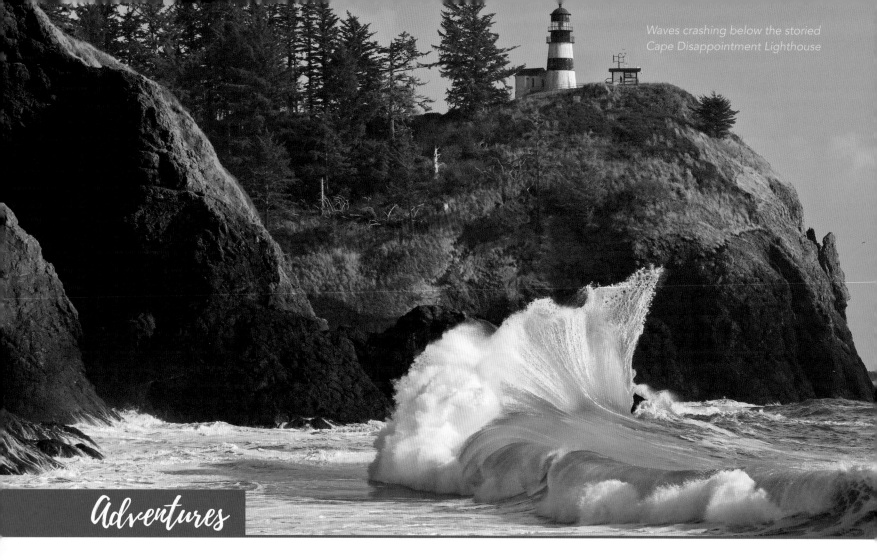

Waves crashing below the storied Cape Disappointment Lighthouse

Adventures

LEARN A NEW CRAFT

Upwards of 100 unique art workshops are available throughout the year, like the Art of Wandering, Dance Therapy, Doodling for Creativity, Printmaking without the Press, Ayurvedic Cook & Learn Dinner Party, Leatherwork for Mason-jar Koozies—there is no limit to the creativity at Sou'wester! Check the schedule to find a class that lights your fire.

BIKE THE DISCOVERY TRAIL

Take a beach cruiser along the tall grasses, saltwater marshes, and rugged coastline until the Pacific Ocean meets the Columbia River. This region is where the Corps of Discovery ended its 18-month expedition in 1805. Within Cape Disappointment State Park, the Lewis & Clark Interpretive Center and historic lighthouse round out a fascinating afternoon.

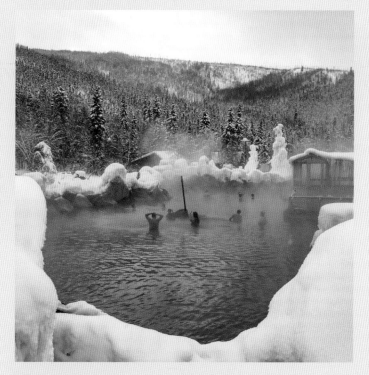

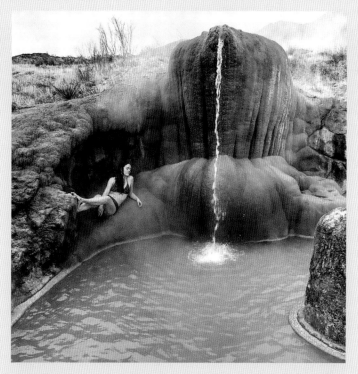

LIQUID GOLD

Alaskan miners and Native Americans have been flocking to Chena Hot Springs for centuries. Even under a blanket of snow, the hot waters rise from 3,000 feet deep in the earth. The resort's rock lake is so expansive, it inspires you to move around and get the circulation going. Once your hair has frozen into a hysterical up-do, it's time to try the geothermal indoor pool and hot tubs. As you soak, dream about your next move in this winter wonderland—dogsledding, ice fishing, snowmobiling, or aurora chasing. (You have to go to their ice museum; it's been frozen for more than 15 years.) While they have lodge rooms and simple yurts, we'd recommend their charming cabins.

ChenaHotSprings.com

PEACE, LOVE, SOAK

Ever watched a concert while soaking in a hot spring? Mystic Hot Springs has been a place of music and merriment for more than a century. Keeping Utah tradition alive, the owner has salvaged 15 historic cabins to create his Pioneer Village, and he's also transformed six vintage school buses into suites fit for the Grateful Dead. This place is a trip, even before you see the surreal red rock pools. Stand under the waterfall for a gravity-powered massage, then soak in a vintage cast-iron tub on the hillside. When the sun sets, the live music sparks up, and considering 1,100 acts have played here (including Rusted Root and Tim Reynolds), you never know what fun is on tap.

MysticHotSprings.com

LIVING HISTORY 4

WE LOVE WHEN A PLACE is a glamping destination and they didn't even know it. The Plains Native Americans started sleeping in teepees millennia ago, and the people of Lake Nicaragua always found shelter under a thatched-roof cabana—not because it was trendy, but because it's what worked best. These are beautiful structures, though sometimes it takes an outsider to see the charm in what you've got. (A train conductor probably wouldn't turn a caboose into a cottage, but the creative Mulheren family would.)

Whether it's someone preserving his or her cultural heritage or honoring a forgotten past, each innkeeper in this chapter is giving history new life, and your presence helps keep it alive. Trace Jamaica's African roots from the dance floor, sample penny candy at a century-old general store, and hunt for petroglyphs on a sacred island. Discover glamping before it was a word.

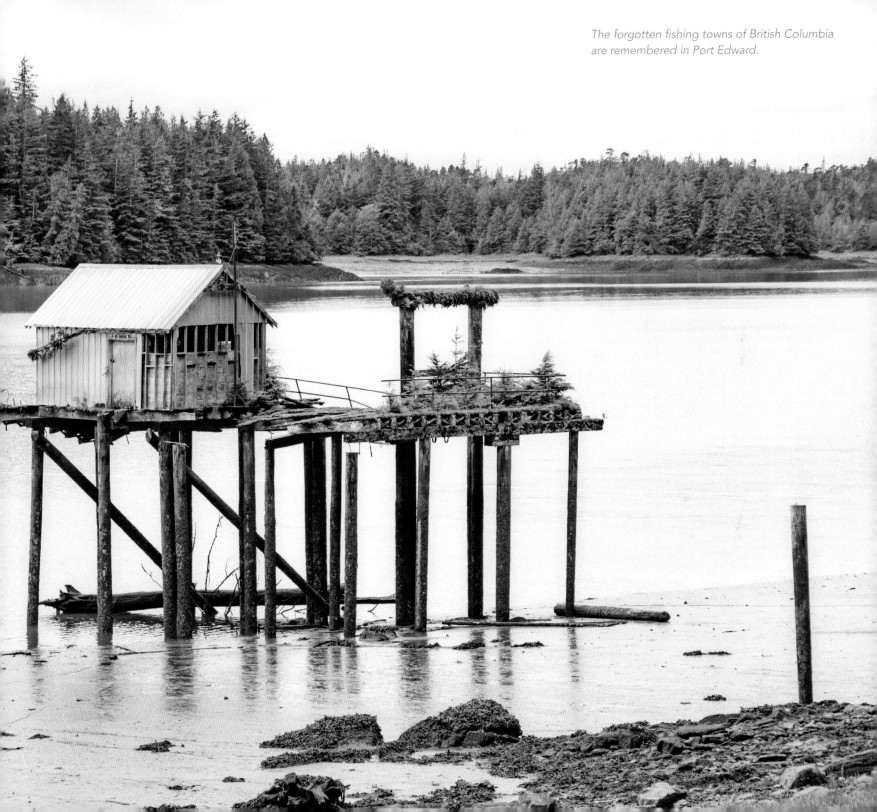

Cassiar Cannery

PORT EDWARD, BRITISH COLUMBIA CANADA

LODGING: Cannery manager cottages

WHEN TO GO: Open Mar–Nov. Wildlife watchers will be in heaven all summer between the sea lions, whales, and grizzlies. Check the calendar for experiential programs.

GETTING THERE: A 30-minute drive from Prince Rupert Airport (YPR) or the BC ferry terminal, which plies the stunning Inside Passage. By Via Rail, you can request the secret Cassiar Cannery train stop for drop-off at their door.
GPS: 54.1777° N, 130.1765° W

PRICING: Two-person waterfront cottages with kitchen; $115

CONTACT: (250) 628-9260
CassiarCannery.com

NICE TOUCH: If you don't want to lose time grocery shopping, the owners will stock the fridge to your liking for a nominal fee. And whenever they head to town, you're welcome to catch a ride.

Glamping Experience

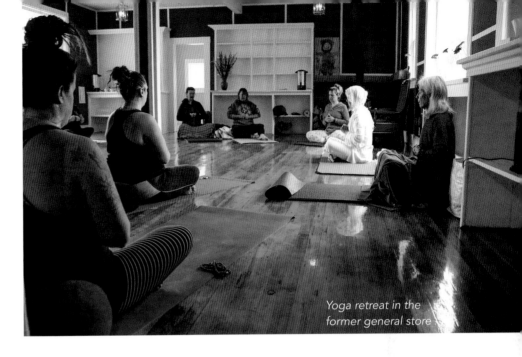

Yoga retreat in the former general store

ACCOMMODATIONS: Ranging from one to three bedrooms, self-contained cottages embrace the view of the river and mountains with reclaimed cedar decks. The decor celebrates Cassiar's history with maritime maps, First Nations art, and beds handcrafted from driftwood. Thoughtful touches like binoculars will inspire wildlife watching, tide charts will guide your day's exploration, and games and movies will keep you entertained at night.

DINING: Each cottage has a well-equipped kitchen and outdoor grill. Don't want to cook each night? Gourmet prepared meals are available with advance notice. Come during one of the experiential programs, and a chef will handle breakfast, lunch, and dinner.

ACTIVITIES: Property tour, beachcombing, jet boating, fishing, hiking, massage, and a variety of themed retreats

HONEYTREK TIP: Bring rubber boots to romp around like a local. Kids will have a field day exploring the cannery relics, but because of the historic property's rugged nature, they should adventure with supervision, and everyone should follow the safety rules.

WOMEN'S REJUVENATION RETREATS

Ladies, you need some "me time." Throughout the year, Cassiar hosts three- to six-night retreats with yoga, spa treatments, gourmet food, canoe trips, wildlife-watching excursions, and female bonding. Come solo or make it a girls' trip; either way, you'll be among a dozen friends. From the door-to-door train service and all-inclusive programs, all you need is a packed suitcase.

SONGS OF THE SKEENA

Take the scenic drive to Terrace and board a jet boat with local musicians and storytellers. They'll enliven the river's history as you ride past the sheer mountains, islands, and cannery relics and enjoy various stops. After your full-day pleasure cruise, a delicious dinner and charming lodging awaits. If you can't make these special events, book one of Cassiar's knowledgeable boat guides.

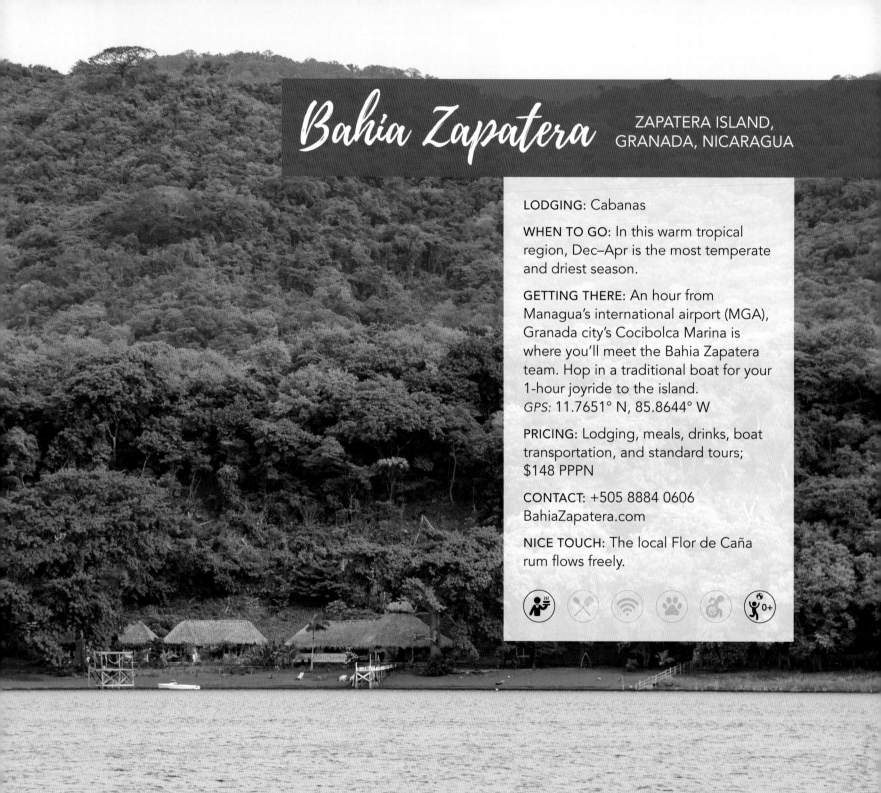

Bahia Zapatera

ZAPATERA ISLAND,
GRANADA, NICARAGUA

LODGING: Cabanas

WHEN TO GO: In this warm tropical region, Dec–Apr is the most temperate and driest season.

GETTING THERE: An hour from Managua's international airport (MGA), Granada city's Cocibolca Marina is where you'll meet the Bahia Zapatera team. Hop in a traditional boat for your 1-hour joyride to the island.
GPS: 11.7651° N, 85.8644° W

PRICING: Lodging, meals, drinks, boat transportation, and standard tours; $148 PPPN

CONTACT: +505 8884 0606
BahiaZapatera.com

NICE TOUCH: The local Flor de Caña rum flows freely.

Rafael guiding us through the Isla el Muerto petroglyphs

THE SECOND-BIGGEST ISLAND on Lake Nicaragua, with soft sand, spa-like lagoons, a billowing volcano, and one of Central America's densest concentrations of pre-Columbian petroglyphs, Zapatera National Park has the makings of a booming tourist destination. But instead it's Nicaragua's best-kept secret. A spiritual home and ceremonial center of the Chorotega Indians from 800 to 1350 CE, then a private island for the Chamorro-Córdova political dynasty from 1850 to 1983, the Zapatera archipelago was hidden from the public eye for more than a thousand years. But it's slowly opening to travelers, with the help of Rafael Córdova Álvarez, great-great-grandson of the island's deeded owner. Ever since he was a child, he knew this place was special, so rather than following in the footsteps of the six Nicaraguan presidents and dozens of political leaders in his family, he's carrying on the legacy of Zapatera.

Your Bahia Zapatera adventure begins in colonial Granada, where you meet their wooden boat for a ride on Central America's largest lake. Weaving through hundreds of lush islets, you feel the pull of Zapatera Island. It's an extinct volcano, weathered down to a 2,000-foot peak, rolling hills, and a sandy shoreline. As you approach the dock, the exotic gardens, smiling faces, and tropical drinks invite you in. The open-air lobby is lined with generations of family photographs and Chorotega Indian artifacts. You spot the handwritten deed from 1850 on the wall and notice the mysteriously round boulder in the center of the room. You feel the power of this place. "*Bienvenidos,*" says Rafael, your guide through the archipelago and a millennium of history.

FOREVER YOUNG

When Rafael was a child, petroglyphs were like coloring books for him and his siblings. In the days before Zapatera was a national park, they would trace the 1,000-year-old lines with chalk and bring the pictures to life. Today, it's a playground for intrepid archaeologists in the know. In the early 2000s the International Council of Monuments and Sites reported that Zapatera archipelago's "El Muerto has probably the densest concentration of Lower Central American petroglyphs . . . [yet] they are almost undocumented." National Geographic funded an extensive study in 2013, and the University of California Berkeley is in the process of unveiling more mysteries, but for now they are for Rafael's guests to discover.

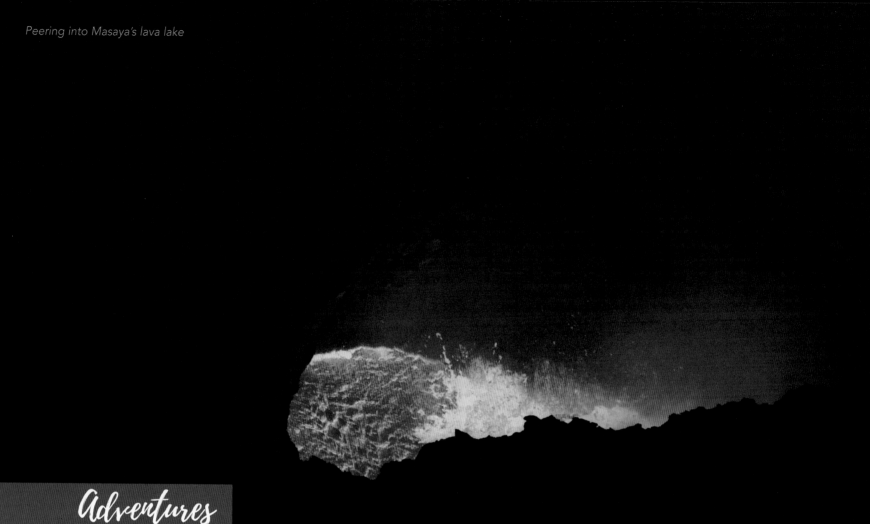

Adventures

ISLA EL MUERTO PETROGLYPHS

A quick boat ride leads to one of Nicaragua's most import-ant archaeological sites. No tickets required, just wave to the caretakers by the Plazoleta: a 260-foot rock slab with petroglyphs from 800 CE. The 125 motifs are clues to the Chorotega history—how they tracked the stars, made sacrifices, and documented significant events (note the Spaniard on a horse and the volcanic eruption).

LAVA POOL OF MASAYA VOLCANO

Nicaragua is home to one of the world's only active lava lakes. Helicopters or fire-retardant suits won't be nec-essary; you can drive right up to this caldera filled with fiery molten rock. This national park, situated between Granada and Managua, stays open at night so that visi-tors can see the golden glow, churning lava, and burst-ing bubbles at their most radiant.

Glamping Experience

ACCOMMODATIONS: Four bungalows, made with local wood and thatched roofs, face the lake and volcano. Glass doors, large windows, and screens maximize views, as do the hammock-clad patios. Simple interiors with a queen bed, bunk bed, and private bathroom make it perfect for both families and any lake lover. Between the breezy central living area and sun chaises along the beach, common spaces are a delight. With 27 acres and a 16-guest maximum, you'll have plenty of space to stretch out.

DINING: It's a family affair, where a mother-daughter-son team of chefs and fisherman prepare delicious Nicaraguan dishes like grilled rainbow bass, stewed yuca with *chicharrones* (crispy pork belly), *tostones* (fried green plantains), and *gallo pinto* (spiced rice and beans). The house specialty is "Sopa de Amor," a soup to be enjoyed with the one you love.

ACTIVITIES: Hiking, traditional fishing, swimming, archaeological tours, island hopping, massage, camping trips, yoga, and billiards

HONEYTREK TIP: If you have children, request the "El Muerto Treasure Hunt," where clues are hidden around the jungle-covered archaeological site. Rafael can make any kid feel like Indiana Jones.

HIKE TO A VOLCANIC MUD BATH

A 1-mile hike brings you to a vista point of Zapatera Bay and the rim of the crater lake. Legend has it that when the Spaniards arrived, the Chorotega Indians hid their gold in the muddy bottom. The Chamorro family never found the jackpot, but they did notice how the silty waters softened their skin. Lather on the mineral-rich mud, let it dry in the sun, and enjoy nature's spa treatment.

ART HISTORY IN GRANADA

The charming colonial city of Granada with its cobblestone streets and 16th-century architecture is worth a day or two, especially to see the Chorotega sculptures at the San Francisco Convent. Zapatera's impressive black basalt statues are exhibited in museums around the world, although Granada has one of the grandest displays, with two dozen hand-hewn figures standing tall.

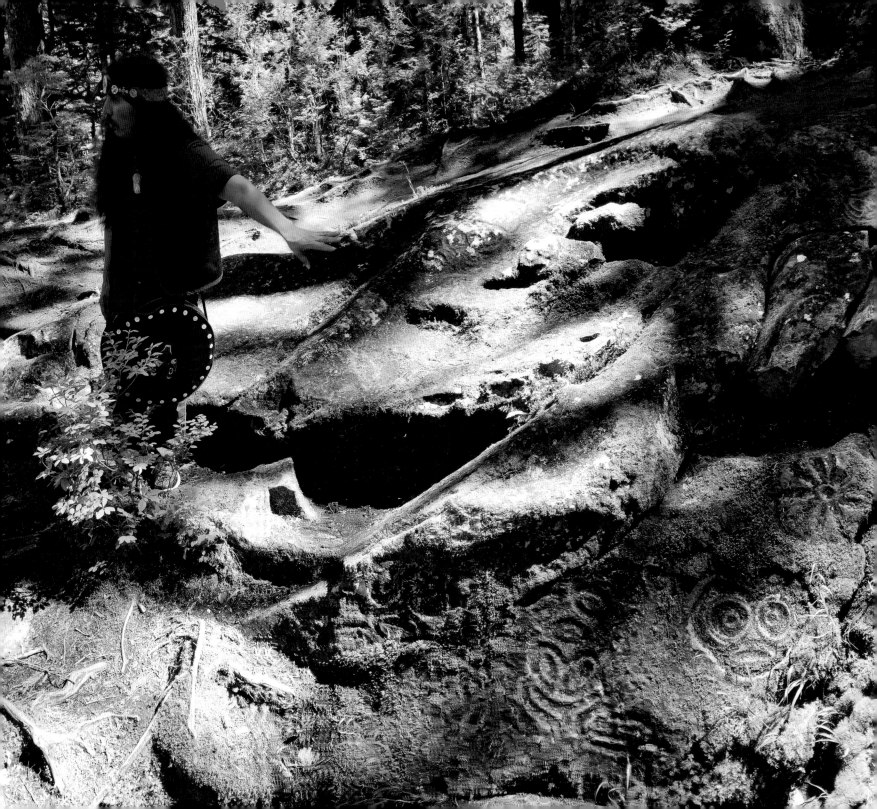

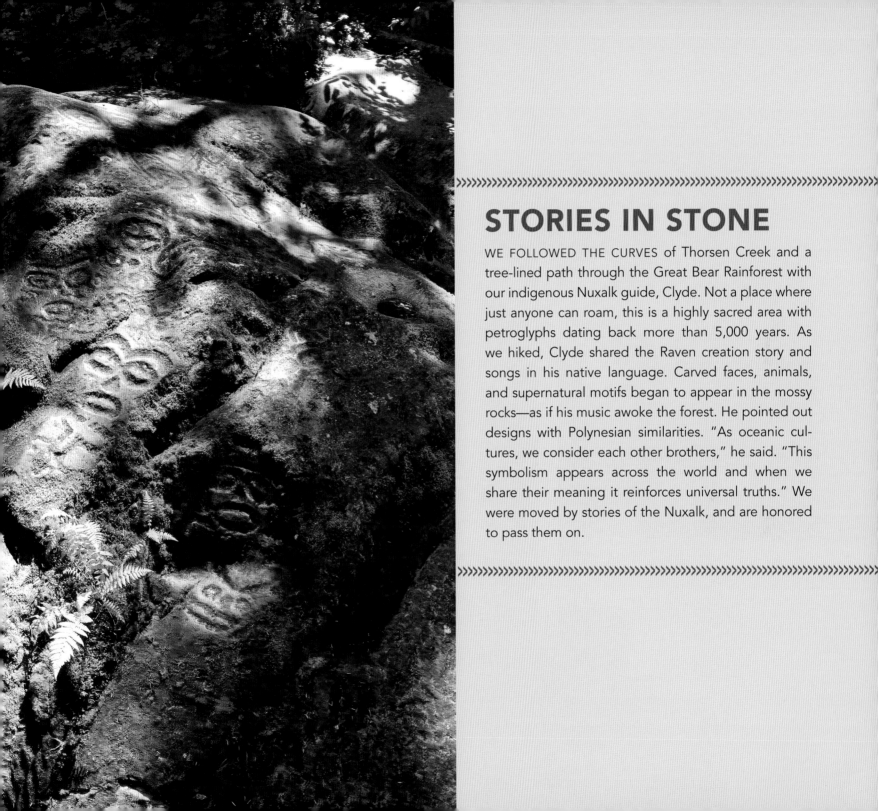

STORIES IN STONE

WE FOLLOWED THE CURVES of Thorsen Creek and a tree-lined path through the Great Bear Rainforest with our indigenous Nuxalk guide, Clyde. Not a place where just anyone can roam, this is a highly sacred area with petroglyphs dating back more than 5,000 years. As we hiked, Clyde shared the Raven creation story and songs in his native language. Carved faces, animals, and supernatural motifs began to appear in the mossy rocks—as if his music awoke the forest. He pointed out designs with Polynesian similarities. "As oceanic cultures, we consider each other brothers," he said. "This symbolism appears across the world and when we share their meaning it reinforces universal truths." We were moved by stories of the Nuxalk, and are honored to pass them on.

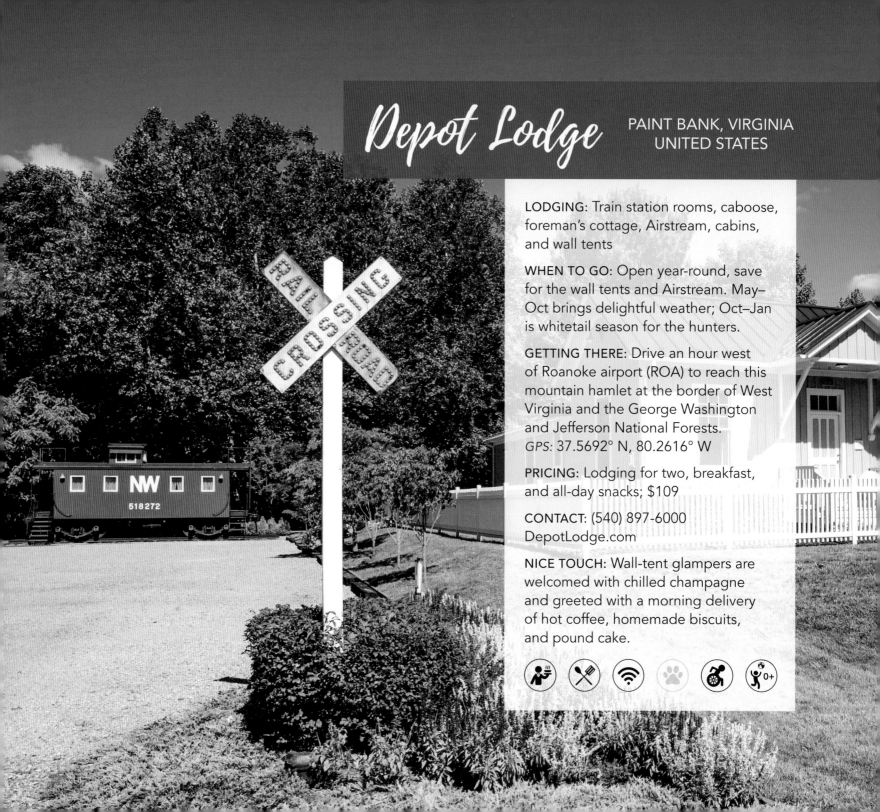

Depot Lodge

PAINT BANK, VIRGINIA
UNITED STATES

LODGING: Train station rooms, caboose, foreman's cottage, Airstream, cabins, and wall tents

WHEN TO GO: Open year-round, save for the wall tents and Airstream. May–Oct brings delightful weather; Oct–Jan is whitetail season for the hunters.

GETTING THERE: Drive an hour west of Roanoke airport (ROA) to reach this mountain hamlet at the border of West Virginia and the George Washington and Jefferson National Forests. *GPS:* 37.5692° N, 80.2616° W

PRICING: Lodging for two, breakfast, and all-day snacks; $109

CONTACT: (540) 897-6000
DepotLodge.com

NICE TOUCH: Wall-tent glampers are welcomed with chilled champagne and greeted with a morning delivery of hot coffee, homemade biscuits, and pound cake.

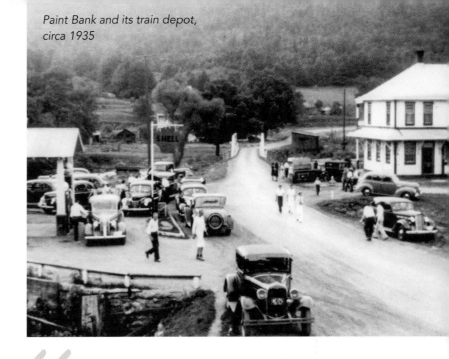

THE TOWN OF PAINT BANK was virtually forgotten. In the early 1900s, with the discovery of iron ore and the extension of the Norfolk & Western Railway, this town boomed. European workers flocked here to make their riches, hotels and saloons emerged from the sticks, and the train came twice a day—connecting this remote valley to the world. When the last locomotive left the station in 1932, the town drifted back to sleep in the shadows of 4,000-foot mountains.

In the 1980s the Mulheren family stumbled upon Paint Bank, only to find the train station being used for grain storage and the general store with bare shelves. It needed their help. With their love of Virginia (Roanoke College is their alma mater) and passion for history, they poured all they had into restoring the town. By 2002 they had reopened the train depot to the modern traveler. The old boardinghouse now offers well-appointed accommodations, as does the neighboring Section Foreman's Cottage and the little red caboose. The century-old general store has been brought back to its original glory and expanded with the Swinging Bridge restaurant, which receives more than 50,000 visitors a year—from motorcycle rallies to bands on tour (Zac Brown likes his "chicken fried").

Paint Bank may never return to its boomtown days, but its surrounding national forests, raging rivers, extensive cave systems, hot springs, and abundant wildlife are happier that way. Nature lovers and history buffs will find plenty to do; just make sure to sit still on the depot porch and listen to the wind—you may just hear the whistle blow.

> "First, I almost don't want to give a review and keep this our little secret. Second, my husband, who is not one to go gaga over places, was blown away by the attention to detail—down to the monogrammed bathrobe hooks! With no Wi-Fi to bother us, we sat by the creek with the breeze and quiet conversation. If you like to reconnect, disappear for a bit, and just relax . . . there's no better place.
>
> —Danielle, Virginia

Adventures

BIKE THE RAIL TRAIL

Retrace 5 miles of the Potts Valley train line, passing century-old trestles, stone culverts, and wooden bridges—one soaring 100 feet over the creek. Stop at interpretive signs and benches to contemplate the history and engineering feat of building within this sheer mountain glen. Make it a loop ride by connecting Rays Siding and Waiteville Roads.

LOST WORLD

Voted "America's Coolest Small Town" by *Budget Travel* magazine, Lewisburg, West Virginia, is worth a walk around—and down. The area has thousands of caves, including the impressive Lost World Caverns. Follow the craggy tunnels 120 feet underground to a cathedral of stalactites and stalagmites. Walk the dazzling half-mile loop, or go deep with a 4-hour spelunking tour.

Glamping Experience

ACCOMMODATIONS: No matter your needs or interests, there's a lodging style to match. Groups up to six will delight in the historic Company House or brand-new Ponderosa Cabin along the creek. Couples will love the romantic glamping tents (the most lavish we've seen for the price) and the charming Norfolk & Western Caboose. To be in the heart of town, stay in the 120-year-old Station Foreman's Cottage or cozy boardinghouse above the train station lobby. All accommodations are decorated with thoughtful details—framed train tickets, 1930s hat boxes, Appalachian quilts, and modern luxuries at every turn.

DINING: Continental breakfast is served in the lobby (with refreshments all day), while glamping tents receive theirs as a morning delivery. The campy Swinging Bridge restaurant serves Southern comfort food, from barbecue ribs prepared in their locomotive-shaped smoker to bison and veggies from their own farm. Come on a Bluegrass Thursday for the music of the mountains.

ACTIVITIES: Hiking, fishing, hunting, historical exhibits, biking trails, bison farm, and games

HONEYTREK TIP: Sit a spell with Mikell, the manager and spitfire running the Depot day to day. She's a wealth of historical information, a true Appalachian woman, and a hoot!

BOWHUNTING TO FLY FISHING

From the Cherokee Indians to homesteaders, hunting has always been vital in these remote mountains. With ground blinds, ladder stands, heated guide shack, and processing facility, Potts Creek Outfitters' semi-guided trips make a novice's or pro's experience go smoothly. Bow-hunt for whitetail deer, catch an eastern gobbler, or fly fish for rainbow trout on a float trip.

COLD WAR BUNKER TOUR

Did you know a Cold War bunker was hiding in a West Virginia resort? Carved below the five-star Greenbrier was a fully operational, 112,544-square-foot government relocation facility, ready to house Congress and run the country in a flash. This was a top-secret world for 30 years, but now it's open for tours. Finish with afternoon tea in the iconic Dorothy Draper lobby.

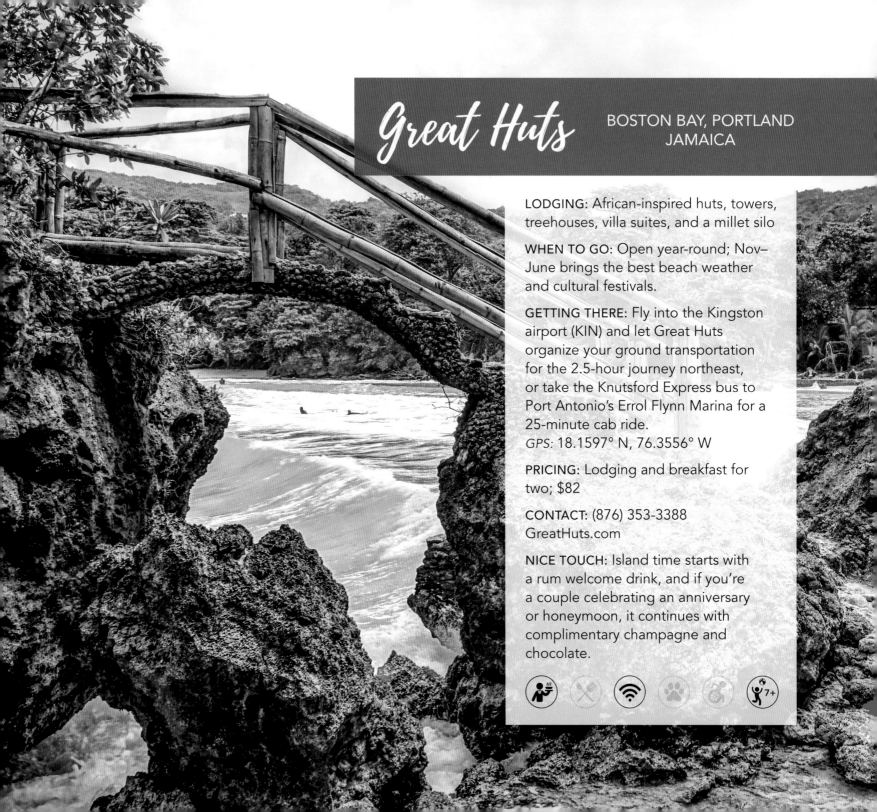

Great Huts

BOSTON BAY, PORTLAND
JAMAICA

LODGING: African-inspired huts, towers, treehouses, villa suites, and a millet silo

WHEN TO GO: Open year-round; Nov–June brings the best beach weather and cultural festivals.

GETTING THERE: Fly into the Kingston airport (KIN) and let Great Huts organize your ground transportation for the 2.5-hour journey northeast, or take the Knutsford Express bus to Port Antonio's Errol Flynn Marina for a 25-minute cab ride.
GPS: 18.1597° N, 76.3556° W

PRICING: Lodging and breakfast for two; $82

CONTACT: (876) 353-3388
GreatHuts.com

NICE TOUCH: Island time starts with a rum welcome drink, and if you're a couple celebrating an anniversary or honeymoon, it continues with complimentary champagne and chocolate.

NINETY-FIVE PERCENT OF JAMAICANS descend from West Africa, yet you'd never know it by the architecture and decor of most hotels on the island. Working as a physician and traveling around the country for decades, Dr. Paul Rhodes was always perplexed by this lack of deference for Afrocentricity. On his way to a jerk chicken stand in Boston Bay in the late 1990s, he saw a "For Sale" sign on a plot of virgin rainforest along the sea cliffs of the island's best surfing beach. It sparked a vision of a resort that would celebrate West African culture and the means for his humanitarian work in Jamaica.

Collaborating with local architects and artists, Great Huts has built African-inspired structures with motifs from the Akan, Igbo, Ibibio, Mandingo, and Yoruba tribes (from which most Jamaicans descend). Bamboo huts, almond treehouses, stone towers, millet silos, and royal-themed rooms showcase African art and antiques alongside local works. More than 250 pieces of art adorn the property, and various cultural events, including four-day art and film festivals, happen throughout the year. A portion of each guest's stay and all proceeds from the festivals support eastern Jamaica's only homeless rehabilitation center, cofounded by Dr. Paul (as he's fondly called around the island).

If you're looking for even more good vibes at Great Huts, just practice yoga overlooking the Caribbean Sea, soak in the cliffside pool, or dance the night away to live reggae. Jamaican hospitality is sure to charm you—from the staff to the grandpas running the jerk pits in town. While most tourists default to a package vacation in Montego Bay, this is where you will find the heart of Jamaica.

"This was my third stay at Great Huts. I find the setting beautiful inside and out. It helps me connect with Jamaica. The location is brilliant, with so much to explore away from the usual touristy parts of the country. Plus, the staff is always incredibly friendly and remembers you when you return.

—Tracey, Texas

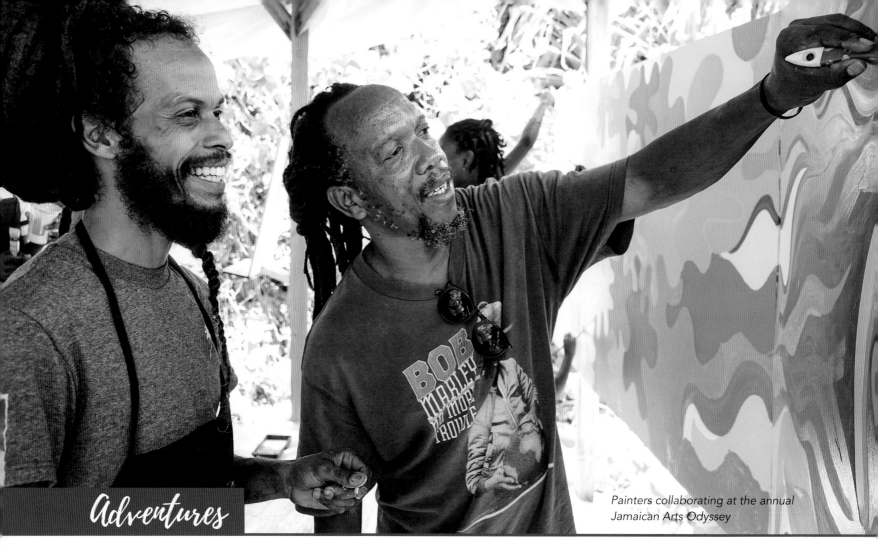

Painters collaborating at the annual Jamaican Arts Odyssey

<h3>RETURN TO THE BLUE LAGOON</h3>

There are many legends, even a Brooke Shields movie, about this deep lagoon that turns every shade of blue against the green jungle. Discover it for yourself with a ride on a traditional bamboo raft and a refreshing swim in waters blended by cool springs and the warm Caribbean Sea. Continue to the lush Monkey Island and enjoy its secluded beach and tree swing.

<h3>CATCH A CULTURAL FESTIVAL</h3>

Join one of Great Huts' annual celebrations of local artists and African roots. The Jamaican Arts Odyssey offers spectacular exhibits, demonstrations, workshops, and an African masquerade ball. The Cinema Paradise Portie Film Festival brings Jamaican shorts, Hollywood classics, Afro-themed documentaries, and lively discussion. Proceeds benefit the homeless shelter.

Adventures

110 *Comfortably Wild*

Glamping Experience

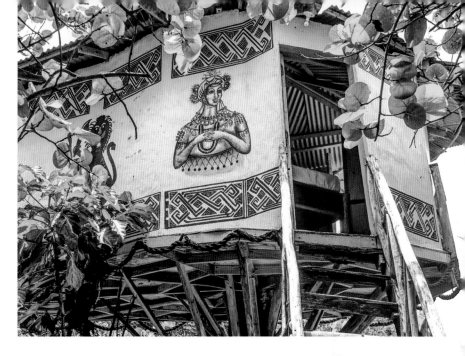

ACCOMMODATIONS: Ranging from rustic-chic bamboo huts to an incredible multi-suite villa, there are 20 African-inspired accommodations to cover all price points and tastes. The one-person millet silo with hand-painted walls might be the least expensive ($38), but it's just as intriguing as the three-story Queen of Sheba ($229). Each space has a unique story to tell, with vibrant textiles, art, and antiques. Select rooms have panoramic ocean views, air-conditioning, private bathrooms, and kitchenettes.

DINING: Three open-air dining areas are spread throughout the property, serving international and Jamaican dishes. The vibrant Safari Deck Restaurant (and its 15-foot-tall giraffe) offers all meals, the chill Royal Lounge is great for lunch, and the cliffside Sankofa makes for extra romantic dinners.

ACTIVITIES: Swimming pools, cliff diving, nature trails, yoga, meditation, massage, surfing, cooking classes, art gallery, and an extensive library

HONEYTREK TIP: Connect with the charitable work of Great Huts with a visit to the Portland Rehab Management Homeless Shelter. Attend their weekly "Healing with Art" jewelry-making workshop, or join the residents for a board game, light gardening, or interesting chat.

GET TO KNOW THE JERK

The mountains of Boston Bay is where "jerk," the iconic spice rub of Scotch Bonnet peppers, thyme, garlic, cinnamon, allspice, and a touch of magic, all began. Get your cultural and culinary fix with lunch at the Boston Jerk Centre. Go stall to stall, taking in the savory scent of slow-cooking meat and the banter of the pit masters. Order it to go for a beach picnic and surf spectacular.

ROOTS, ROCK, REGGAE

Forget the Bob Marley cover band, the Manchioneal Cultural Group is the real deal. Playing together for 30 years and at Great Huts every Saturday for a decade, these local legends will take you on a musical journey from African drumming to traditional folk dances to rocksteady, dancehall, and modern-day reggae. Not a staid dinner show, everyone gets up to shake a tail feather.

Dream Catchers

Teepees, yurts, igloos, and indigenous-inspired structures are popping up everywhere, from resorts to music festivals. When you put this "trend" in the context of the cultures that created them, these designs are as timeless as it gets. Meet the people behind these traditional dwellings, and enjoy their authentic overnight adventures.

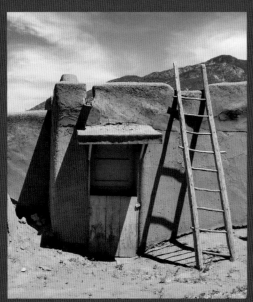

Taos Pueblo, New Mexico

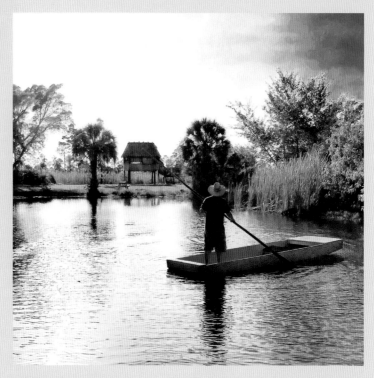

ABOVE WATER

Living in the Florida Everglades, a 1.5-million-acre "river of grass," Seminole and Miccosukee tribes had to find a way to stay high and dry. Crafted of bald cypress frames and woven palmetto roofs, "chickee" huts resisted the water and buoyed a fishing society. Early American Gladesmen looked to the ingenuity of the Native Americans, and five generations later, the Shealy family is sharing the wetlands' traditional way of life through Everglades Adventure Tours. By pole boat, the founder will propel you through the Big Cypress National Preserve. Away from the noisy fan boats, you'll glide past alligators, herons, and turtles and learn about the swamp's inner workings. After a day on the water, relax in your stilted hut, built by Miccosukee craftsman. EvergladesAdventureTours.net

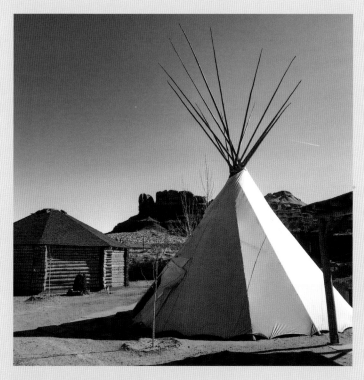

NAVAJO NIGHTS

When in the Navajo Nation and Utah's awe-inspiring Monument Valley, a hogan is the true way to stay. The Navajo people's traditional dwelling, an octagonal log cabin with an east-facing door to welcome the sun, is honored alongside the iconic Plains Indians tents at Monument Valley Tipi Village. Take your pick of Native American structures, both styles decorated with indigenous art and decor, for a meaningful stay in the 30,000-acre tribal park. Perfectly positioned between Tear Drop Arch and "Where the Jagged Rock Ends," the Navajo-owned retreat is prime for hikes in canyon country. Take one of their 4×4 tours through the buttes and spires, learning about the Navajo stories, iconography, music, and spirit.
MonumentValley-TipiVillage.com

LONGHOUSE STORIES

Balancing contemporary tastes with indigenous traditions, Hôtel-Musée Premières Nations is one of Quebec's most alluring destinations. Within the city limits and the Huron-Wendat reserve, the hotel features indigenous design, cuisine, art, and music with 21st-century amenities. It's as luxurious as it is culturally rich—especially when you spend the night in their traditional longhouse. Enter the fortress of towering birch logs, then proceed to the 65-foot-long community dwelling. A Huron-Wendat firekeeper dressed in traditional garb will share the story of Aataentsic, the mother of mankind. Another fire is lit outside to make bannock bread and tea before climbing up to your bed of pelts.
HotelPremieresNations.ca

IN MOTION

5

WE LOVE THE IDEA OF TREKKING into the mountains and finding a backcountry camping spot, far away from the crowds. It all sounds so dreamy—except for that detail about schlepping our gear and cooking over a propane canister. Fortunately, with the help of a few savvy outfitters, backcountry glamping is on the rise. More than guides setting up camp, they're bringing gourmet food, hot showers, and comfy mattresses to some of the continent's most remote and pristine wilderness areas.

Not a big hiker? River raft, horseback ride, or cross-country ski to get there. With these featured outfitters, it's all about the journey. We'll admit these aren't the fanciest accommodations in the book, but considering that they were hand-delivered and crafted daily with your enjoyment in mind makes them five-star.

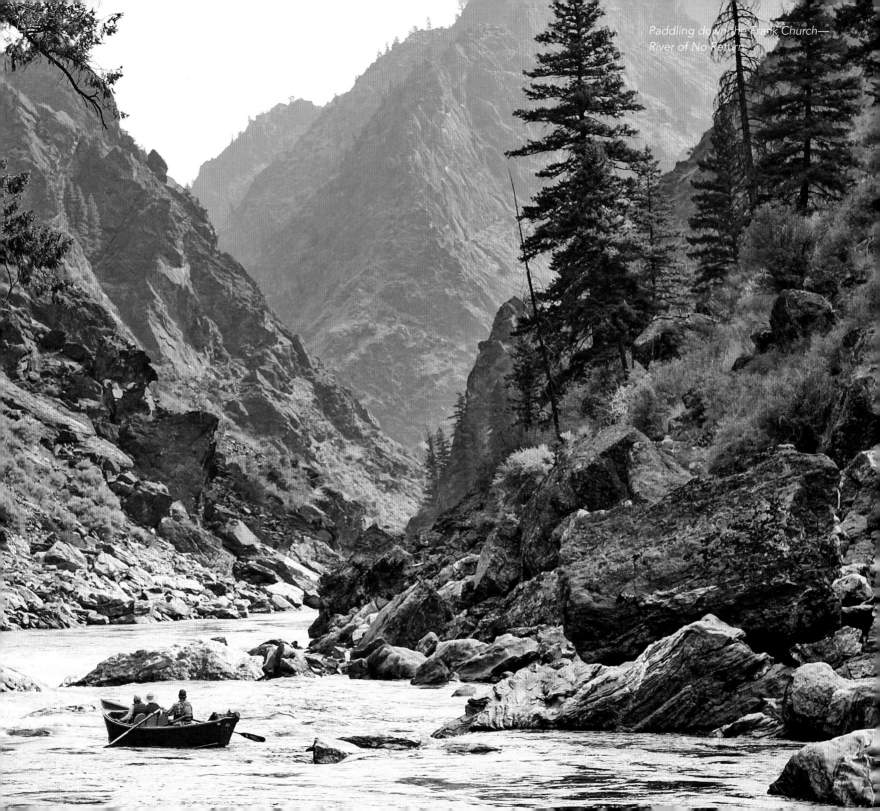

Paddling down the Frank Church—
River of No Return

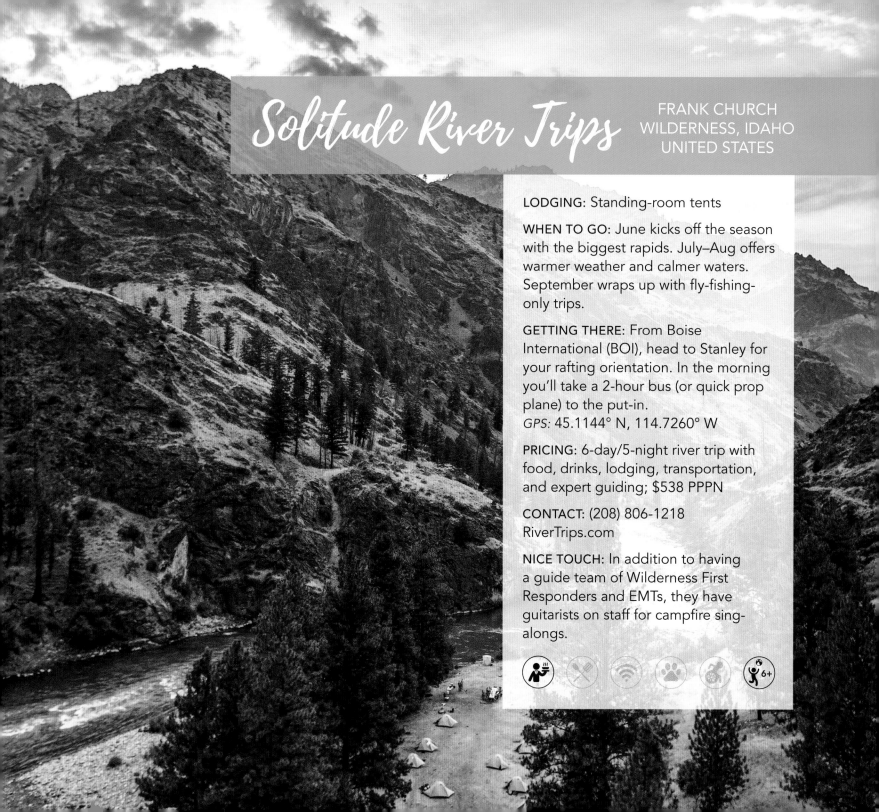

Solitude River Trips

FRANK CHURCH
WILDERNESS, IDAHO
UNITED STATES

LODGING: Standing-room tents

WHEN TO GO: June kicks off the season with the biggest rapids. July–Aug offers warmer weather and calmer waters. September wraps up with fly-fishing-only trips.

GETTING THERE: From Boise International (BOI), head to Stanley for your rafting orientation. In the morning you'll take a 2-hour bus (or quick prop plane) to the put-in.
GPS: 45.1144° N, 114.7260° W

PRICING: 6-day/5-night river trip with food, drinks, lodging, transportation, and expert guiding; $538 PPPN

CONTACT: (208) 806-1218
RiverTrips.com

NICE TOUCH: In addition to having a guide team of Wilderness First Responders and EMTs, they have guitarists on staff for campfire sing-alongs.

Glamping Experience

ACCOMMODATIONS: Every evening brings a gorgeous new riverside campsite. By the time you pull ashore, the support team has already set up your spacious tent (four-person tents are their standard double). Leave the cold hard ground to the Boy Scouts—Solitude provides cots, air mattresses, ultra-warm sleeping bags, and pillows. Guides pride themselves on creating a pleasant backcountry bathroom (with proper toilet seat) in a secluded area with a fantastic view. Hot showers are available every day but the first.

DINING: Guides double as masterful chefs on the grill and Dutch oven, whipping up pork chops, stuffed peppers, omelets, coffee cake, and an array of dishes. Even pit-stop lunches are impressive buffets. To ensure extra-fresh ingredients and bottomless beverages, they coordinate a bush-plane delivery halfway through the trip.

ACTIVITIES: Rafting, kayaking, fishing, hiking, campfire sing-alongs, backcountry library, cliff jumping, swimming, and hot springs

HONEYTREK TIP: Even if you're not super into fishing, get a license at the Lower Stanley Country Store for a chance to learn from the pros. It's sold as a date-specific pass; reserve it for day three or four of the trip.

DECIPHER PICTOGRAPHS

Discover the Middle Fork's earliest human history, painted on the canyon walls by the Sheepeater band of the Shoshone tribe. Note the hunting scenes with big-horn bows and ground blinds, the importance of dogs in their society, and the arrival of the gunmen on horse-back. If you're lucky you'll meet Shoshone anthropologist Diana Yupe for her insights and a travel blessing.

TAKE A BITE OUT OF THE SAWTOOTHS

At the foot of the Sawtooth Mountains with their 40 jagged peaks, Redfish Lake is where everyone comes to marvel at the range from a kayak, beach chair, or hiking trail. Kick back or step it up with a challenging 11-mile round-trip hike from Redfish to Alpine Lake. The trailhead is accessed by a scenic boat shuttle, and the trail offers gorgeous meadows, rock gardens, and mountain views.

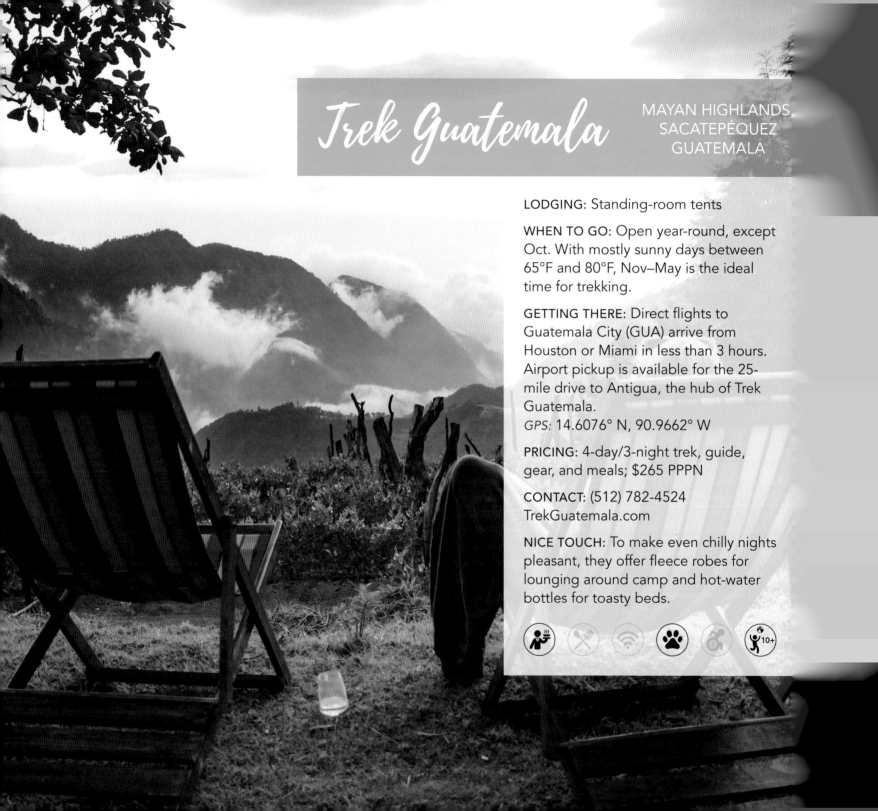

Trek Guatemala

MAYAN HIGHLANDS,
SACATEPÉQUEZ
GUATEMALA

LODGING: Standing-room tents

WHEN TO GO: Open year-round, except Oct. With mostly sunny days between 65°F and 80°F, Nov–May is the ideal time for trekking.

GETTING THERE: Direct flights to Guatemala City (GUA) arrive from Houston or Miami in less than 3 hours. Airport pickup is available for the 25-mile drive to Antigua, the hub of Trek Guatemala.
GPS: 14.6076° N, 90.9662° W

PRICING: 4-day/3-night trek, guide, gear, and meals; $265 PPPN

CONTACT: (512) 782-4524
TrekGuatemala.com

NICE TOUCH: To make even chilly nights pleasant, they offer fleece robes for lounging around camp and hot-water bottles for toasty beds.

Glamping Experience

ACCOMMODATIONS: While you're hiking with your light daypack, the "trek truck" is hauling all the essentials to build a luxury camp. Find the 10 × 14-foot tent with your name on it (handwritten on a framed chalkboard), drop your things in the antique chest, and lie down on your deluxe Sound Asleep air mattress with down comforter and hand-woven throw pillows. Their custom-made truck has a flushing toilet, sink vanity, and hot-water shower. Groups are typically 6 people and never more than 12, so you'll have plenty of privacy.

DINING: Days begin with a hearty English breakfast, Guatemalan-style *desayuno* (eggs, beans, plantains, and tortillas), or a continental spread. Trail snacks will keep you energized until the picnic lunch or happy hour at the finish line. Traditional dinners, like *pepián* stew or ginger-stuffed chicken, are served in the dining tent.

ACTIVITIES: Trekking, farm tours, cooking lessons, swimming, games, and campfire circles

HONEYTREK TIP: If you're feeling fit, add a volcano hike to your Trek Guatemala itinerary. Overnight to Acatenango, where you can see Volcán de Fuego's eruptions and glowing lava flow; or make a day trip to Pacaya, where you get so close, you can roast marshmallows over the lava.

THE LIFE OF A COFFEE BEAN

Day four of the trek is a veritable food tour, passing through farms of avocados, oranges, and snap peas. When coffee trees are as far as the eye can see, you are near plantation Café Azahar. See how this family operation harvests, washes, dries, selects, shucks, and roasts the beans. Try your hand at de-shelling with their traditional equipment to earn a cup of artisanal joe.

LAKE TOWN HOP

Everyone from 18th-century explorers to 20th-century authors have called Lake Atitlán "the most beautiful lake in the world," not only for its dramatic blue hue and surrounding volcanoes but also for the vibrant Mayan communities. Hop a water taxi to experience San Juan La Laguna's artisan cooperatives, San Marcos's wellness offerings, and Santa Catarina Palopó's modern murals.

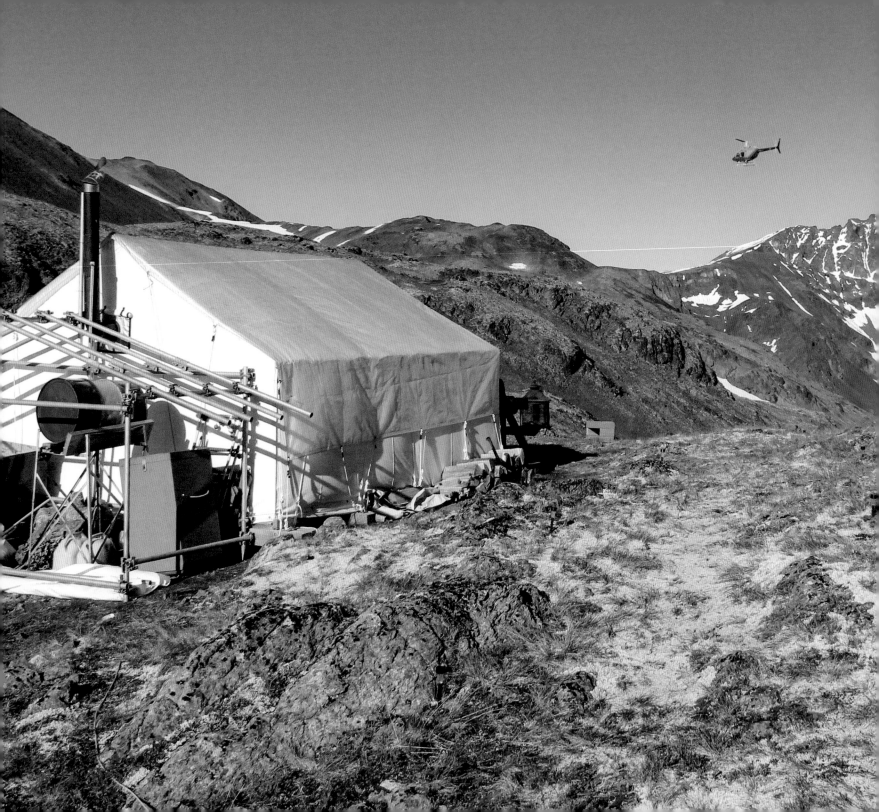

HELI-GLAMPING

OUR HELICOPTER FLEW INTO THE MIST of the twin waterfalls cascading out of Hudson Bay Mountain. We crinked our neck to gaze at the stunning falls until the last possible second. Just when we thought this aerial tour of northern British Columbia couldn't get any better, we turned around and saw our Bulkley Adventures camp. A wall tent at the top of Opal Ridge with outdoor sofas around a firepit—was that just for us? The pilot landed in front of what was indeed our very own private glamping camp at 5,893 feet. While our guide fired up the grill for a feast, we explored the summit, spotting lakes, glaciers, and countless peaks of the Telkwa Range. We followed the mesquite smoke back to camp, feeling like the king of the hill.

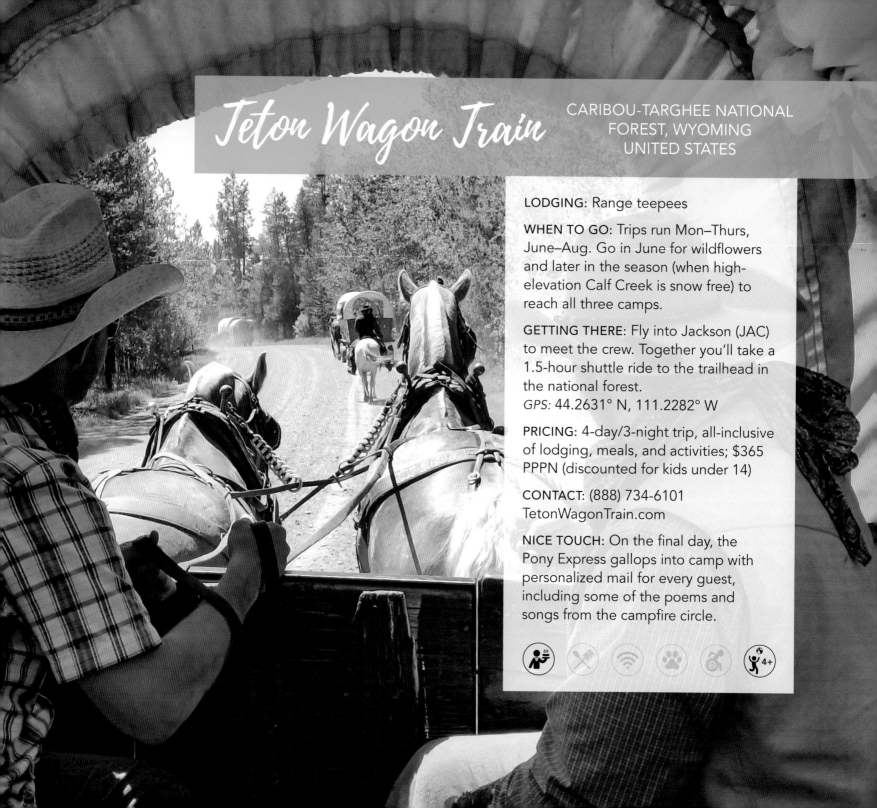

Teton Wagon Train

CARIBOU-TARGHEE NATIONAL FOREST, WYOMING
UNITED STATES

LODGING: Range teepees

WHEN TO GO: Trips run Mon–Thurs, June–Aug. Go in June for wildflowers and later in the season (when high-elevation Calf Creek is snow free) to reach all three camps.

GETTING THERE: Fly into Jackson (JAC) to meet the crew. Together you'll take a 1.5-hour shuttle ride to the trailhead in the national forest.
GPS: 44.2631° N, 111.2282° W

PRICING: 4-day/3-night trip, all-inclusive of lodging, meals, and activities; $365 PPPN (discounted for kids under 14)

CONTACT: (888) 734-6101
TetonWagonTrain.com

NICE TOUCH: On the final day, the Pony Express gallops into camp with personalized mail for every guest, including some of the poems and songs from the campfire circle.

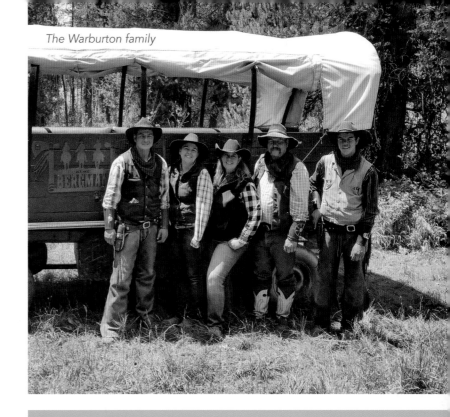

The Warburton family

REMEMBER THE OREGON TRAIL? Whether it's the pioneers' covered-wagon journey across the West in the late 1800s or the 1980s video game that comes to mind, this four-day trip through the Tetons invokes both nostalgia and awe.

Started by the great-grandson of Elijah Nicholas Wilson, the man who guided the first families in covered wagons over the Teton Pass in 1889, Teton Wagon Train & Horse Adventure has been offering authentic Western journeys for nearly 50 years. Today it's run by the Warburton family, a couple who met while working these very wagons and raised five kids with reins in their hands and spurs on their boots.

Saddle up in the Caribou-Targhee National Forest, a pristine wilderness nestled between Grand Teton and Yellowstone National Parks. Each leg of this leisurely 16-mile journey is a choose-your-own-adventure—be it learning to drive a covered wagon, riding a horse, kayaking across the lake, or hiking through wildflower fields. Each night at one of the three lake- or creekside campsites, the sun sets and the fire sparks up for Dutch-oven cooking, acoustic guitar, cowboy poetry, and pioneer tales.

This trip is for any guest with a fascination for the Wild West—no matter your fitness level or age (4- to 93-year-olds have enjoyed this trip, and one guest was so enamored she went 37 times!). It's a journey to learn new skills, unplug from the 21st century, and revel in the past. Join the Warburtons for a few days in the saddle and find your real McCoy.

COWBOYS CRY

On our final day, the Teton Wagon Train team lined up in their best cowboy attire—leather chaps, engraved belt buckles, and felted hats—to send us back into the modern world. Face to face, they each shared something nice from our time riding the trail—learning to lasso, singing by the fire, or laughing ourselves silly. By the fourth hug, I was welling up. By the time I got to Jordan, the middle Warburton son and lead wrangler, we both had tears rolling down our cheeks. What had come over us? I'd been on hundreds of multiday adventure tours and he'd sent off thousands of guests before, but no matter how seasoned we were, we didn't want this unforgettable week to end. They say, "Nothing makes a cowboy cry but a broken heart." Good thing the Warburtons have a lot of heart to spare.

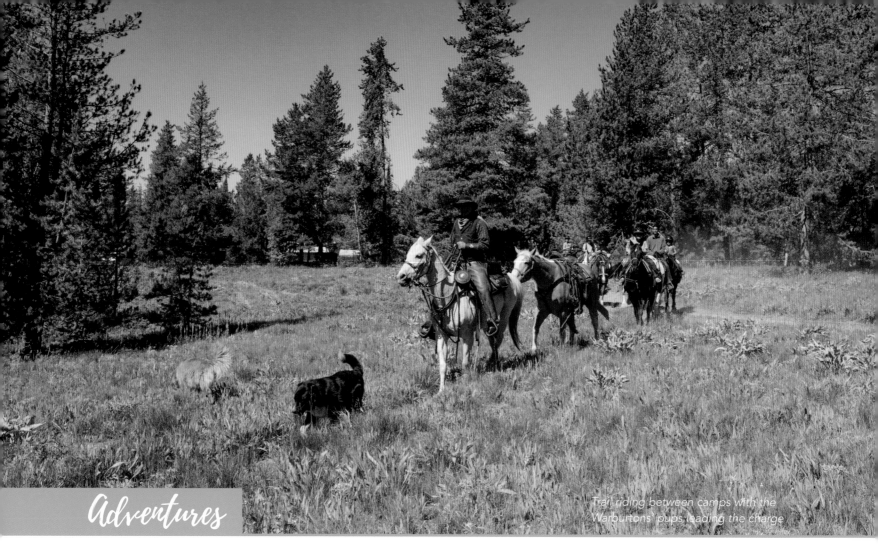

Trail riding between camps with the Warburtons' pups leading the charge

DRIVE A WAGON TRAIN

Drive Belgian draft horses along former trails of the Shoshone Indians, mountain men, and stagecoaches of yesteryear. Feel the power of these 2,000-pound animals in your hands. Listen to the *clickety-clack* of hooves, the jingle of chains, and the instruction of the wagon master. With a hearty *"Heeyaw!"* you're in control of the covered wagon and keeping a Western tradition alive.

CANOE LOON LAKE

After a day's ride through the aspen forests and fields of lupines, you'll reach the second camp: Loon Lake. Named for the rare birds that nest here, it's the best place to hop in a canoe. Paddle through a veritable sea of lily pads, explore small creek channels, and watch the reflection of the mountains ripple in the sunset light before the dinner bell rings.

Glamping Experience

ACCOMMODATIONS: Range teepees have been the shelter of choice since the dawn of the American cowboy—why mess with tradition? Inspired by the original 19th-century design, the Warburtons brought back these simple yet spacious canvas tents. Better than Buffalo Bill had it, guests get a comfy foam mattress and subzero sleeping bags, sheets, and pillows. Outhouses are provided courtesy of the US Forest Service and improved by the hardworking Teton Wagon Train team with regular scrub-downs and air fresheners.

DINING: The most important wagon in the train is undoubtedly the chuckwagon, dishing out three yummy meals a day—plus unlimited snacks! All the stick-to-your-ribs meals (roast beef, biscuits and gravy, peach cobbler, and more) are cooked in Dutch ovens over a campfire.

ACTIVITIES: Horseback riding, canoeing, hiking, driving wagons, knife and tomahawk throwing, roping, horseshoes, sing-alongs, and skits. And if you feel like lending a hand and learning new skills, you can care for the horses, learn backcountry cooking, and do as the cowboys do.

HONEYTREK TIP: Campfires are like an intimate talent show, with staff and guests offering up a Western song, poetry, or story. Before you leave home, print out your favorite poem to share. Need a little inspiration? Look up "Baxter Black."

ALL-IN-ONE TRIP

Between the lively city of Jackson, two national parks, and major wilderness areas, you should really extend your vacation. To plan a robust trip in a single phone call, add the Warburton's local adventure package. It includes lodging, a downtown stagecoach ride, a van tour of Yellowstone National Park, Snake River rafting, and a covered wagon cookout at their family ranch.

STAGECOACH BAR IN WILSON

While all the tourists are going to the Million Dollar Cowboy Bar in Jackson, the locals are country line dancing at the Stagecoach in Wilson. This town is named for Teton Wagon Train's very own Elijah Nicholas Wilson. Go to "Sunday Church" and dance to the world-famous Stagecoach Band (they've played more than 2,500 shows here). Raise a glass to Uncle Nick and a great wagon trip!

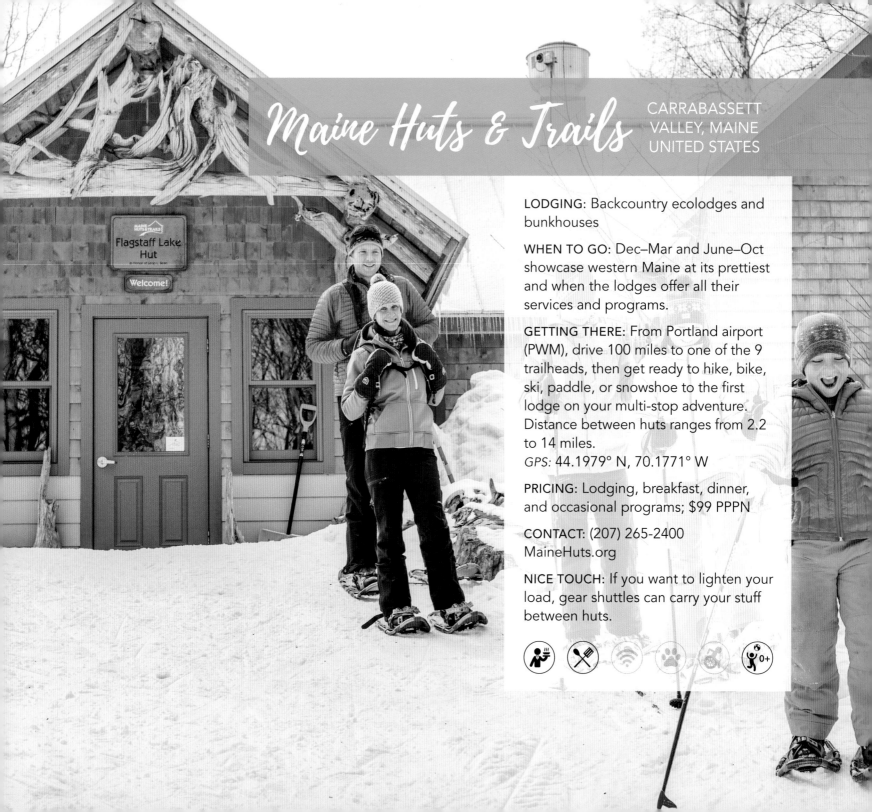

Maine Huts & Trails

CARRABASSETT VALLEY, MAINE
UNITED STATES

LODGING: Backcountry ecolodges and bunkhouses

WHEN TO GO: Dec–Mar and June–Oct showcase western Maine at its prettiest and when the lodges offer all their services and programs.

GETTING THERE: From Portland airport (PWM), drive 100 miles to one of the 9 trailheads, then get ready to hike, bike, ski, paddle, or snowshoe to the first lodge on your multi-stop adventure. Distance between huts ranges from 2.2 to 14 miles.
GPS: 44.1979° N, 70.1771° W

PRICING: Lodging, breakfast, dinner, and occasional programs; $99 PPPN

CONTACT: (207) 265-2400
MaineHuts.org

NICE TOUCH: If you want to lighten your load, gear shuttles can carry your stuff between huts.

AFTER A DAY OF CROSS-COUNTRY SKIING through an alpine meadow, a chalet appears under a blanket of snow. The innkeeper opens the door and welcomes you for a homemade meal, comfy bed, and hot shower. After a night laughing with new friends by the fire, you awake well rested and ready for the journey to your next cozy hut.

Sounds like a ski vacation in the Swiss Alps, right? Try the Rangely Mountains of Maine. This European style hut-to-hut trail system is thanks to the big dreams of one local, Larry Warren, and his nonprofit, Maine Huts & Trails (MH&T). He wanted to make the Maine Lakes and Mountains region (home to 10 of the state's highest peaks and hundreds of glacial lakes) more accessible to the public, as well as preserve them for generations to come. With the support of community volunteers, students, donors, and MH&T members, they have developed 80 miles of nonmotorized trails and built four state-of-the-art ecolodges, all less than a day's hike, bike, canoe, or snowshoe apart. To call them environmentally friendly is an understatement, considering their solar power and hydropower, organic veggie garden, high-efficiency wood stoves, composting toilets, and Leave No Trace ethos. (After your multicourse dinner, take their Energy Systems Tour; it will blow your mind.)

Come when the season suits your style. Hike beneath fiery autumn leaves, cross-country ski the freshly groomed trails, mountain bike through wildflowers, or canoe into a summer sunset—no matter when you visit, an inviting lodge will be there to reward your efforts.

FALLING FOR AUTUMN

We followed the trail of autumn leaves up the switchbacks to Stratton Brook Hut. The state-of-the-art lodge and resident chef welcomed us and two other guests. Chatting over local beers, the middle-aged Californian couple could barely contain their excitement for the fall foliage. They'd never seen this New England spectacular before, and that day's mountain-bike ride under the red canopy had been a missing check on their bucket list.

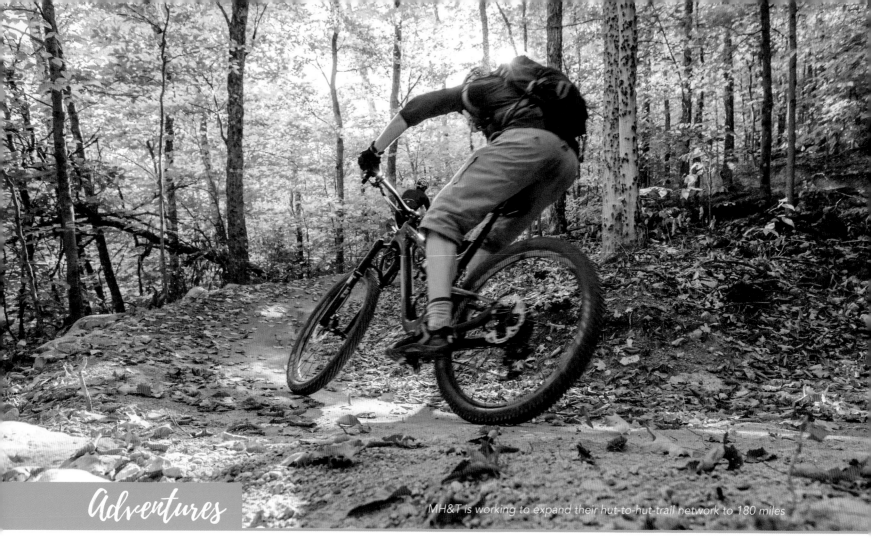

MH&T is working to expand their hut-to-hut-trail network to 180 miles

PADDLE TO BED

Enjoy a 6-mile canoe trip through easy flatwater and gorgeous mountain scenery until you reach the trailhead to Grand Falls Hut. Stow your boat and continue 2 miles by foot through the forest and around the 40-foot horseshoe waterfall. You've arrived at an impressive backcountry lodge with spectacular views and a bottle of wine to toast your full-day adventure.

BROOKE BIKING

Stratton Brook Hut is perched at the top of the legendary Oak Knoll Trail, with some of the best singletrack in Maine. Take in the majestic views of the Bigelow Range and Sugarloaf Mountain, then grind, ratchet, and shred up to 30 miles of groomed trail through the valley. Looking for a winter getaway? MH&T keeps their snowy trails fatbike ready.

Glamping Experience

ACCOMMODATIONS: Be it lakeside or mountaintop, each of the four lovely ecolodges is unique in design and setting. High-ceiling dining rooms, inviting libraries, radiant-heated floors, and pristine shared bathrooms are a common thread. In backcountry fashion, sleeping quarters are simple bunkhouses (your choice: private or shared) with a mattress and pillow (BYO bedding) and offer more than enough for a good night's sleep. Challenge yourself to experience at least two of these gorgeous wilderness lodges!

DINING: Locally sourced, organic, and community-grown ingredients are the foundation of every meal. Hot beverages, wine, and craft beer are available, including their very own MH&T lager (you've earned it!). After a hot breakfast, wholesome goodies are laid out to build your own sack lunch. In low-season, the industrial-grade kitchen is yours to cook up whatever fuels you on the trail.

ACTIVITIES: Canoeing, standup paddleboarding, birding, fishing, board games, and an extensive groomed trail network for hiking, mountain biking, cross-country skiing, and snowshoeing, plus guided multiday trips. *Note:* Rentals are available at Sugarloaf Outdoor Center.

HONEYTREK TIP: The gorgeous L.L. Bean-inspired Flagstaff Hut is perfect for families and backcountry newbies, offering a variety of outdoor activities, lake access, and the shortest approach.

DOWNHILL THE LOAF

A skier can't leave Carrabassett Valley without a day at one of the East Coast's best resorts: Sugarloaf! Bookend your MH&T trip with skiing or snowboarding this 4,237-foot-high mountain. Ride their high-speed lifts then swoosh down 1,240 skiable acres across 162 trails. Sugarloaf is also open in summer and fall, with a slew of activities from disc golf to ziplining.

WALK & FISH

You're probably too active to just sit on a dock with a fishing pole. But walk and fish? Now we're talkin'! Hike along the mountain stream beyond Stratton Brook Hut with their registered local guides, and the rare native brook trout will chase down your line. Carrying on to Grand Falls Hut? The pool below the falls is a hot spot for salmon and rainbow trout.

Suite Sports

Rather than gaze at the sea, you look at the ocean and think, "I wanna ride that wave." That snowy peak? "Let's carve those lines." You're not a lie-by-the-pool kind of person; you see your vacation as an opportunity to learn something new, sharpen a skill, and earn your cerveza at the end of the day. Here's where to play hard.

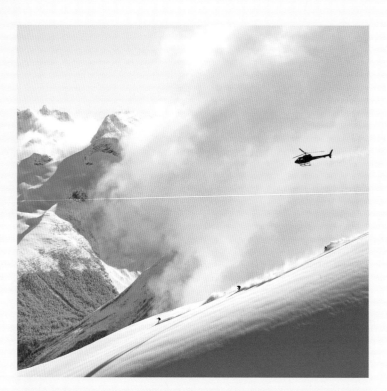

Tweedsmuir Park Lodge, British Columbia

HELI-SKIING HIDEOUT

Voted World's Best Heli-Ski Operator (twice!) by the World Ski Awards, Bella Coola Heli Sports is your ticket to ride. The founders started as British Columbia ski filmmakers and guides but decided to share their secret lines with adventurous glampers like us. To live out your Warren Miller fantasy, use their handy "Experience Finder" to match your skill level (beginner to expert) and level of luxury (from single-occupancy rooms at a cattle ranch to private cabins at Tweedsmuir Park, an esteemed Magnificent 7 Wilderness Lodge). Drop into their 2.64 million acres (that's 499 times the size of Vail), then ski the legendary powder and back bowls of British Columbia's Coast Range.
BellaCoolaHeliSkiing.com

TEES & TREES

Everyone thought this 56-acre swath of cliffs, rock slabs, and thick forest in Stoneham, Maine, was unbuildable—unless you're designing a treehouse and disc golf resort. When Josh Ring asked his parents if they wanted to cofound TimberStone Adventures, they said, "What's disc golf?" After explaining that the sport is like golf but with a Frisbee, they were intrigued, but what sold them was his treehouse designs (since they were already living in one). The Rings crafted four treehouses ranging from the 1,200-square-foot Grand Oak to the little Birdie tucked in the dynamic 18-hole course. Drive your disc from towering rock ledges into the birch forest, and be sure to stop at the Castle Tower for lake-studded views.

TimberStoneAdventures.com

SURF & SUN SALUTATIONS

Tamarindo, Costa Rica, is known as one of the world's best beaches to learn surfing. Dive in with a seven-night stay at Dreamsea's surf-camp-meets-yoga-retreat. Settle into your bell tent, complete with private deck to enjoy the jungle's tropical birds and acrobatic howler monkeys, and meet your professional instructors and new surf buddies. Try the breaks at any of their four neighboring beaches, then stretch it out each evening with some downward dog. Promoting a healthy lifestyle, the chefs embrace Costa Rica's tropical bounty and spice it up with global recipes. Stay for a one- or two-week session, or make it a true *Endless Summer* by applying to be a volunteer in exchange for accommodation.

DreamseaCostaRica.com

URBAN OASIS

IS A GORGEOUS WILDERNESS DESTINATION that's also near art galleries, gourmet restaurants, and a Broadway-style playhouse too much ask? Of course not! There are plenty of idyllic retreats just a quick Uber or Lyft from downtown. While even Chicago, New York, and Los Angeles have glamping these days (p. 156), this chapter focuses on little cities with natural beauty and creative properties that capitalize on having the best of both worlds.

Ithaca may be "gorges," but it's also foodie heaven. Asheville has one of the densest concentrations of working artists in the South, plus it's the birthplace of US forestry. These destinations' dramatic contrasts and striking landscapes are often what inspired the musicians, painters, and chefs to move here in the first place. Glamping has given visitors the option to enjoy these beautiful cities without the noise of downtown.

Sunset over the Blue Ridge Mountains rivals the Asheville city lights

Luna Mystica

TAOS, NEW MEXICO
UNITED STATES

LODGING: Vintage trailers

WHEN TO GO: Open year-round. June–Oct is when this artsy mountain town turns it up with cultural happenings and the weather is prime for outdoor adventure. Dec–Feb dumps powder at nearby Taos Ski Valley.

GETTING THERE: Seventy miles north of Santa Fe, 145 miles from the Albuquerque airport (ABQ), and surrounded by Southwestern scenery across state lines, Luna Mystica should inspire a road trip.
GPS: 36.4648° N, 105.6598° W

PRICING: Two-person trailer; $85

CONTACT: (505) 350-6574
HotelLunaMystica.com

NICE TOUCH: Their sister brewery offers "Hoppy Hour," weekdays 3–6 p.m., with great deals like $2 barbecue pork sliders and $3 Kachina Peak pale ales.

Glamping Experience

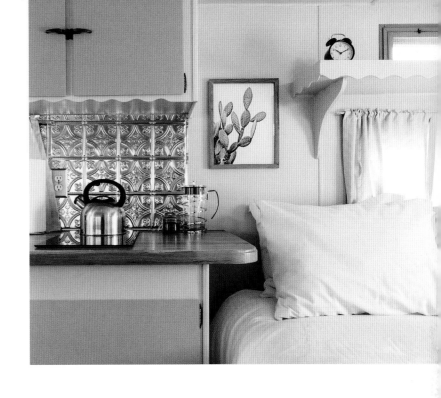

ACCOMMODATIONS: Two dozen trailers from across the mid-century decades and manufacturers—Spartan, Vagabond, Scout, Airstream, and more—make up their growing fleet. While most original details have been preserved, style and comfort always come first, with modern appliances, updated bathrooms, and swank furnishings. Cozy up in your living room or take in the mountain view from your private patio and fire ring. An eight-bed trailer hostel (or party mobile for groups), tent sites, and primitive RV spaces with access to outdoor showers are also available.

DINING: Kitchens with stoves, minifridges, and the necessary cookware (including the all-important French press and coffee) make it easy to whip up meals, plus each room has a snack bar. Taos Mesa Brewery has the freshest beers on tap and serves casual lunch and dinner. See your in-room dining guide for dozens of Taos restaurant recommendations.

ACTIVITIES: Live music, dancing, open mic, trivia, horseshoes, table tennis, and weekly yoga

HONEYTREK TIP: Check out TaosArtCalendar.com for the latest gallery openings, creative workshops, and cultural events.

GALLERY HOP

School yourself in classic and modern New Mexican art with a visit to Harwood, the second-oldest museum in the state. Work your way toward iconic Taos Plaza, where galleries radiate in every direction (particularly down Kit Carson Road), and stop for a bite at the charming Taos Inn, where the Taos Society of Artists was founded. Try to time your visit with the city's First Friday fun.

RIO GRANDE HOT SPRINGS

With a 15-minute drive and 20-minute hike, you'll reach Manby Hot Springs—natural pools at the ruins of an old stagecoach stop. Take in the canyon views while soaking in 100°F water. Have time for another natural spa treatment? The equally beautiful Black Rock Hot Springs is 3.5 miles up the road, and clothing optional.

Mendocino Grove

MENDOCINO, CALIFORNIA UNITED STATES

LODGING: Wall tents

WHEN TO GO: Open May–Oct. Weather is consistently in the 60s, with summer and fall festivals turning up the heat.

GETTING THERE: If you take the inland route, it's a 3.5-hour drive from San Francisco and 2.5 hours from Sonoma County Airport (STS). Take the ultra-scenic Pacific Coast Highway, and you'll have a fabulous trip before you even check in.
GPS: 39.2959° N, 123.7955° W

PRICING: Two-person tent, breakfast, all-day hot beverage station, and weekend nature walks; $149

CONTACT: (707) 880-7710
MendocinoGrove.com

NICE TOUCH: When you arrive on a Friday evening, a hot meal, wine, homemade dessert, and new friends will be waiting around the farmhouse table.

BAY AREA DWELLERS, like many of us in the modern age, love the idea of a nature getaway but might like it better if we knew good restaurants, art galleries, and Pilates studios were nearby (you know, in case of emergency). The founders of Mendocino Grove, longtime North Bay residents, understand these complex fears and desires. When Teresa Raffo and Chris Hougie found a property on the wooded bluffs of the Pacific, just a quarter mile from downtown Mendocino, they thought, "This is the yin and yang we all need."

This Victorian seaside village grew its initial wealth from the logging days when the Big River floated redwoods down to the seaport. Grand 19th-century houses were made for the mill barons, but today they are home to bookstores, coffee shops, organic markets, and top-notch restaurants. Trees once cut for industry are now protected by seven state parks within a 10-mile radius. And that juxtaposition of delicate architecture and rugged nature is what makes it such an alluring art colony.

From Mendocino Grove, you can access hikes into the grand fir forest, vegan white-tablecloth meals, and award-winning theater without even getting into a car. Though with a camp this seductive, you might never make it to town. Breakfast is served in the meadow followed by weekend yoga, your tent has ocean views, and a s'mores kit can be delivered right to your fire ring. As Teresa says, "We were not aiming for luxury—just enough comfort to let your guard down and nature in."

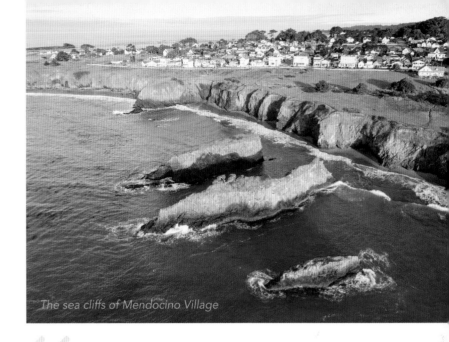

The sea cliffs of Mendocino Village

"Location, location, location. A few minutes from Mendocino, right by kayak/bike rentals on Big River (which has a 7-mile long estuary that is sooo much fun to paddle), and next door to Van Damme State Park. And the grounds are lovely on their own with ocean views and mature trees. We had a fantastic time, and we saw lots of other happy campers too.

—Carolyn, California

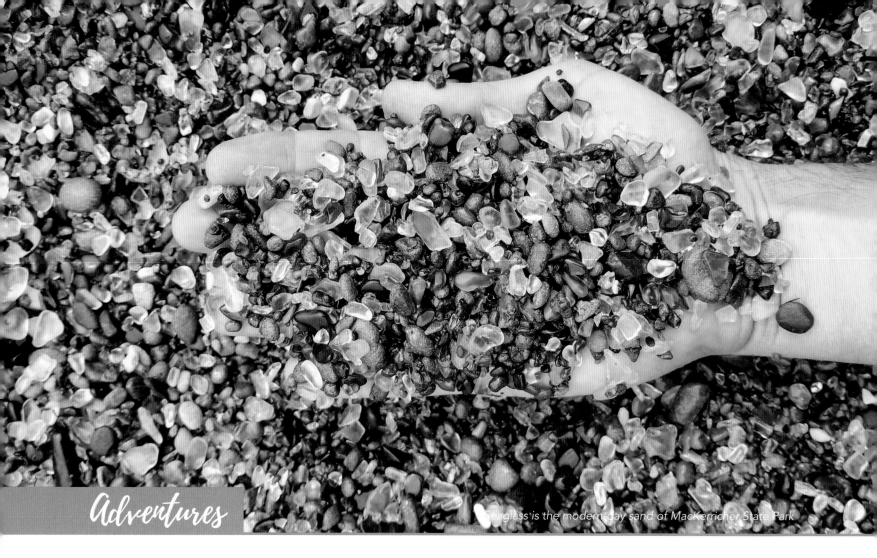

Seaglass is the modern-day sand of MacKerricher State Park

BREATHE IN THE TREES

Meet Mendocino Grove's resident botanist for a complimentary guided hike along their loop trail. John will teach you about the canyon of ferns, redwoods, and birds he spots with his eagle eye, and still have you back in time for yoga class. Having warmed up the body and the mind, you'll experience deeper stretches and relaxation in your forest studio.

TRASH TO TREASURE

From 1906 to 1967 northerly Fort Bragg had its city dump at the beach. Environmental organizations cleaned up the mess on land, while the ocean smoothed the remaining glass and ceramics into a shimmering shoreline. Explore MacKerricher State Park's world-famous Glass Beach and comb for classic Coca-Cola bottles and mid-century pottery; just remember to take only photographs.

Glamping Experience

ACCOMMODATIONS: Wall tents are scattered across 37 acres, with secluded ocean-view sites and a family-friendly meadow with lawn games. Every option is big on style and comfort, with deluxe beds topped with vibrant pillows and throw blankets, not to mention heated mattress pads. Wicker is too pedestrian for these sophisticates; leather butterfly chairs adorn your redwood deck. Communal bathhouses (including outdoor showers) took a cue from five-star hotels, with marble countertops, sumptuous towels, organic toiletries, and fresh flowers. Vintage trailers are coming in 2020!

DINING: A complimentary breakfast of fresh fruits, yogurt, and granola is served by the fire each morning, and an impressive hot beverage bar offers a pick-me-up any time of the day. Shared grills are peppered throughout, and there are firepits at each site. Cooking supplies, s'mores kits, and ice chests are available for rent so you can feel like a Scout, even if you came unprepared.

ACTIVITIES: Hiking trails, naturalist walks, yoga classes, badminton, volleyball, horseshoes, corn hole, and bocce

HONEYTREK TIP: Make it a long weekend and get 50% off your third night and your fourth night free!

PAINTINGS & PLAYS

Since 1959, the Mendocino Arts Center has been cultivating local talent and showcasing the work of painters, sculptors, actors, and more at their campus on the bluff. Those who are artistically inclined can sign up for one of the 150 annual workshops or open studios, and anyone can wander around their permanent galleries and enjoy a performance at the Mendocino Theatre Company.

OUTRIGGER SAFARI

Within Mendocino Headlands State Park, ply the Big River Estuary in a hand-carved redwood outrigger from Catch a Canoe. Not only works of art, these Polynesian designs are also speedy and stable (they can even handle your excited canine copilot). Paddle upstream, and keep an eye out for river otters, seals, sandpipers, herons, and relics from Mendocino's logging days.

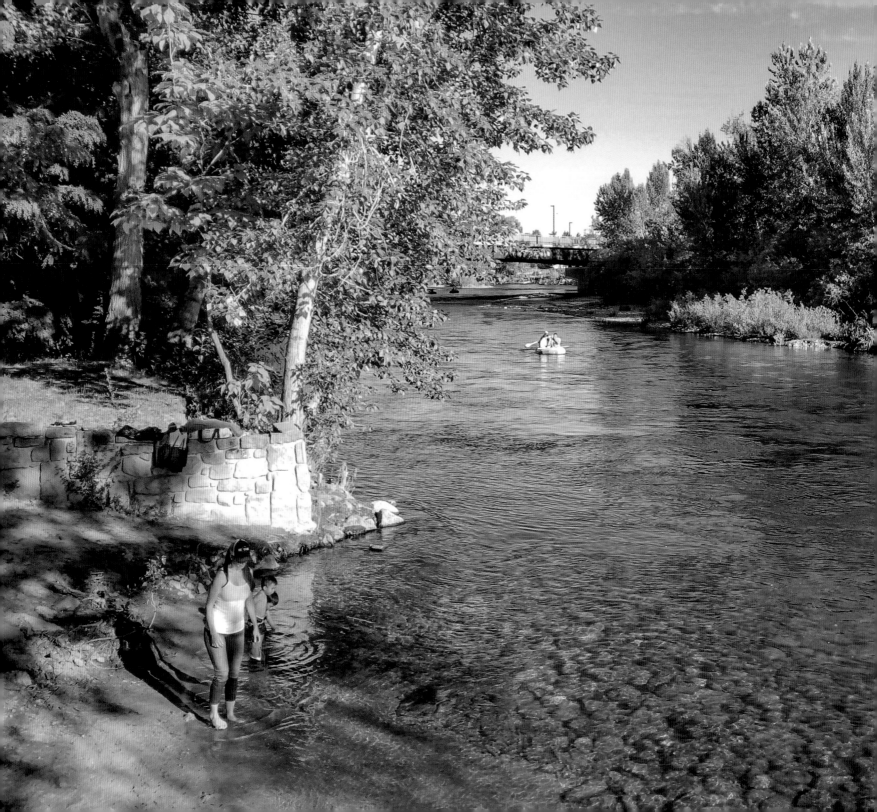

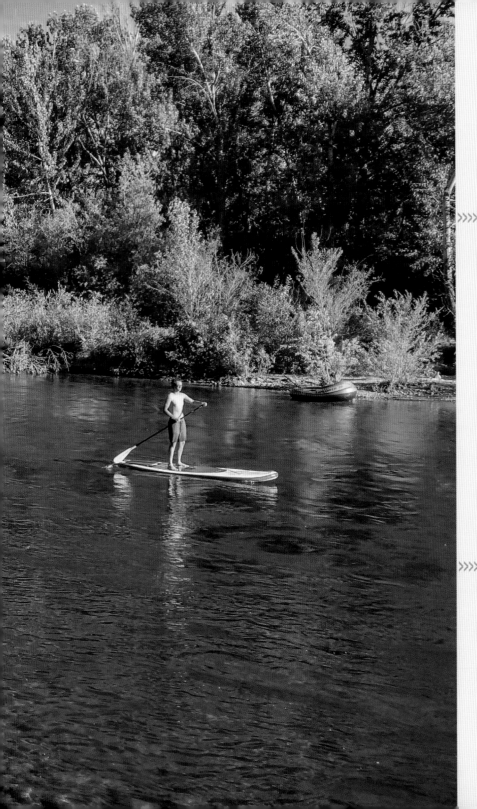

PARK & RIDE

TRAVELING BETWEEN SOLITUDE RIVER TRIPS and Bull Hill Guest Ranch, we stopped in Boise, Idaho. It's the capital of the state, with a big university, booming brewery scene, and vibrant historic center. It's one of the fastest-growing cities in the country, and we think the Boise River Greenbelt has a lot to do with it. Twenty-five miles of bike path connect the metropolis through the woods, spurring out to pocket parks, beaches, and outdoor cafes. It makes residents' commute a walk in the park and their weekends at home feel like a getaway. We went for a bike ride on a Saturday, and it seemed the whole town was floating on a raft, tube, or paddleboard. Surrounded by nature, a city never looked happier.

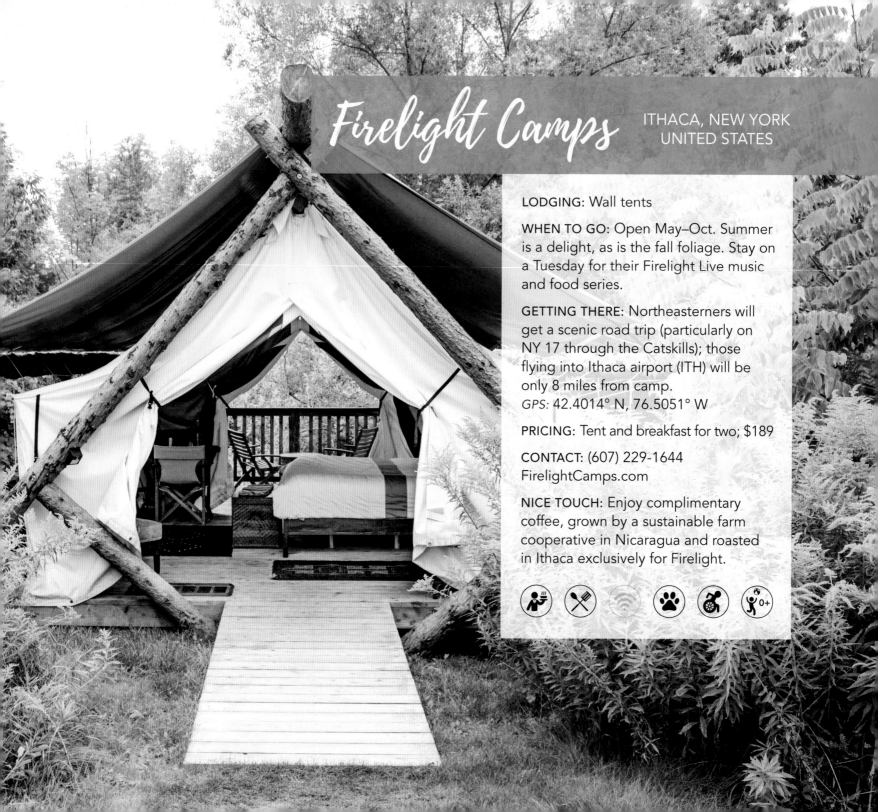

Firelight Camps

ITHACA, NEW YORK
UNITED STATES

LODGING: Wall tents

WHEN TO GO: Open May–Oct. Summer is a delight, as is the fall foliage. Stay on a Tuesday for their Firelight Live music and food series.

GETTING THERE: Northeasterners will get a scenic road trip (particularly on NY 17 through the Catskills); those flying into Ithaca airport (ITH) will be only 8 miles from camp.
GPS: 42.4014° N, 76.5051° W

PRICING: Tent and breakfast for two; $189

CONTACT: (607) 229-1644
FirelightCamps.com

NICE TOUCH: Enjoy complimentary coffee, grown by a sustainable farm cooperative in Nicaragua and roasted in Ithaca exclusively for Firelight.

SO MAYBE YOU LIKE THE IDEA of glamping but would feel better knowing you have an escape plan. Like a hotel where you get a Swedish spa treatment and filet mignon, in case there isn't enough glamour to justify the camping. Firelight completely understands. While owners Bobby and Emma Frisch are plenty adventurous, having opened their first B&B in Nicaragua, they also know the finer things in life as a Cornell Business School graduate and a Food Network star.

Their camp is strategically located 5 minutes from the vibrant city of Ithaca, abutting Buttermilk Falls State Park, and on the 70 acres owned by the lovely La Tourelle Hotel and Spa. Guests are welcome to use the amenities of the hotel, but Firelight is so chic and comfortable, you won't need a thing.

Tucked in the forest of hemlock and ash trees, 19 safari tents are decorated with campaign furniture and textiles inspired by the Frisches' travels. The lobby tent is where everyone likes to gather at 5 p.m., when the campfire is lit and bartenders are crafting artisanal cocktails muddled with wild fruits or pouring Pinot Noir from the surrounding Finger Lakes wine region. Local and bespoke are Firelight's middle names, showcasing the bounty and talent of upstate New York, from its farmers to its bakers, brewers, and musicians. And if it's not sourced from a local vendor, Emma probably made it herself—after all, she's the author of a hot new cookbook.

So, do you want to spoil yourself rotten at the spa or challenge yourself to hike through gorges and waterfalls? Both? Good, you're in the right place.

When we met Emma, it was the week before our first travel guide, *Ultimate Journeys for Two*, was hitting the shelves and her cookbook, *Feast by Firelight*, was due to the publisher. We instantly understood each other and respected her all the more for carving out the hang time. Her book is now ready for your next glamping trip. Try any of the 70 recipes, perfected from decades of campfire cookouts, to elevate your great outdoor dining experience.

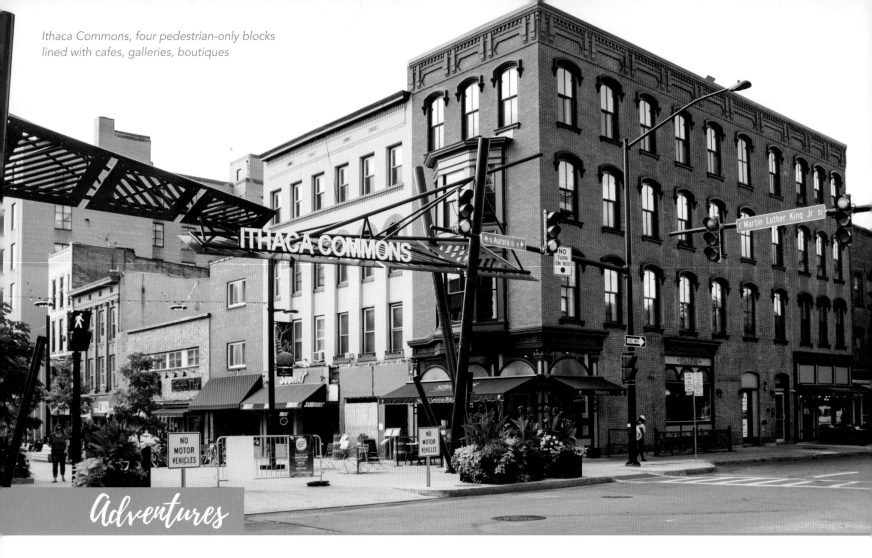

Ithaca Commons, four pedestrian-only blocks lined with cafes, galleries, boutiques

Adventures

FORAGING IN THE URBAN FOREST

Did you know that dandelions are high in potassium? That a cattail offers similar skin remedies to aloe? See everyday plants in a new light on a 90-minute walk with forager extraordinaire Sarah Kelsen. Starting from camp, this hands-on adventure teaches you how to identify and use a variety of Northeastern species. Hungry for more? Nibble your way to Lower Buttermilk Falls.

GO IVY LEAGUE

Put on a button-down and a ball cap to play college kid. Walk the Cornell campus, with its 19th-century architecture and botanic gardens. Study up at the A. D. White Library, a bibliophile fantasy akin to Hogwarts. Climb the bell tower to see the daily chimes concert and panoramic view. Belly up to a picnic-table bar at Collegetown Bagels—you don't have class tomorrow.

Glamping Experience

ACCOMMODATIONS: Hardwood platforms support canvas wall tents with queen or king beds, writing desks, copper side tables, and rocking chairs on the porch, made all the more exotic with Indian kantha quilts and tribal-motif rugs. Electricity is available in some tents, while all have smart lanterns to charge your phone and give a romantic glow. The shared, spa-like bathhouse has steamy showers, fluffy towels, eco-friendly toiletries, and even hair dryers along the vanity bar.

DINING: Complimentary continental breakfast has never been so gourmet, with Emma's very own granola, local baked goods, hard-boiled eggs, fresh fruit, and high-octane coffee. The camp store sells plenty of snacks, including homemade s'mores kits, while the bar pours some of the best craft cocktails this side of New York City. For lunch and dinner, you can grill at camp, walk up the hill to La Tourelle's two restaurants, or take a quick ride to downtown Ithaca.

ACTIVITIES: Daily yoga, hiking trails, wild foraging classes, spa treatments, swimming hole, bocce court, and nightly bonfires

HONEYTREK TIP: Go to the lively Ithaca Farmers Market (as cultural as it is agricultural) to listen to music, shop the artisan goods, and pick up fresh ingredients for a picnic or grilling back at camp.

FALLS TO LAKES

Ithaca has more than 150 waterfalls in just 10 square miles, but if we had to pick one, we'd vote for Taughannock Falls. Framed by an amphitheater of 450-foot-high cliffs, it is the tallest single-drop waterfall east of the Rockies. Reach the base with a three-quarter-mile hike by following the creekside trail and roar of the falls. Carry on to adjacent Cayuga Lake for a relaxing beach day.

S'MORE MUSIC

Guests and locals alike don't want to miss Firelight Live. Every Tuesday a band plays under the stars, bringing people onto the dance floor or lingering a little longer by the fire. The camp store always has gourmet snacks, and the occasional food truck dishes out anything from Korean tacos to artisanal omelets for what feels like a night on the town, without leaving the forest.

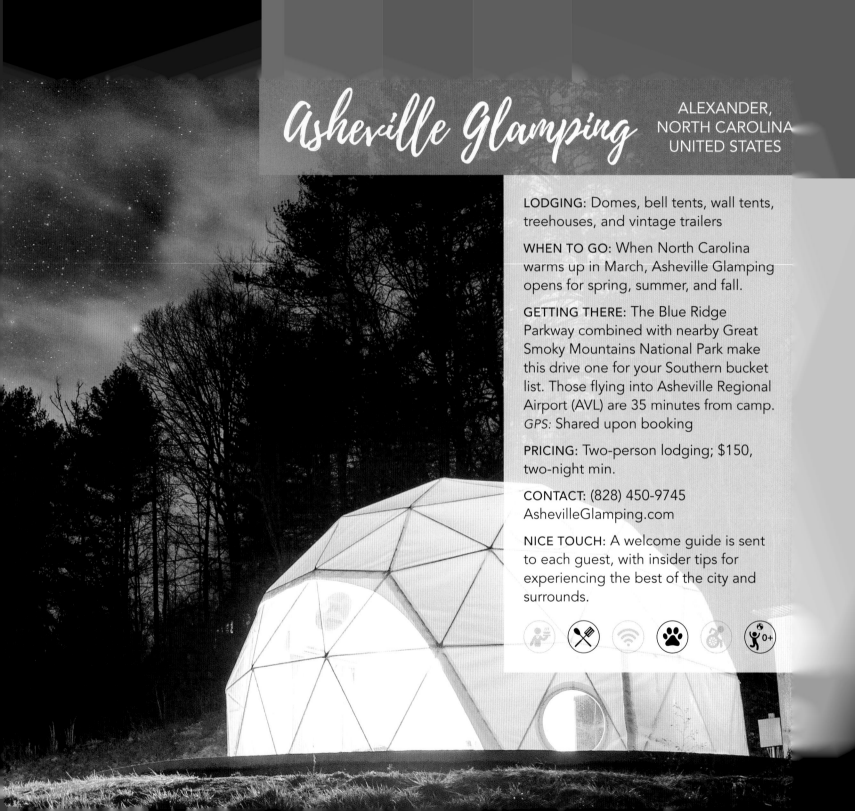

Asheville Glamping

ALEXANDER, NORTH CAROLINA UNITED STATES

LODGING: Domes, bell tents, wall tents, treehouses, and vintage trailers

WHEN TO GO: When North Carolina warms up in March, Asheville Glamping opens for spring, summer, and fall.

GETTING THERE: The Blue Ridge Parkway combined with nearby Great Smoky Mountains National Park make this drive one for your Southern bucket list. Those flying into Asheville Regional Airport (AVL) are 35 minutes from camp. *GPS:* Shared upon booking

PRICING: Two-person lodging; $150, two-night min.

CONTACT: (828) 450-9745
AshevilleGlamping.com

NICE TOUCH: A welcome guide is sent to each guest, with insider tips for experiencing the best of the city and surrounds.

JOANNA CAHILL DOESN'T JUST own Asheville Glamping; she lives it. While dreaming up the concept for this ultra-hip glamp camp, Joanna lived in a yurt she built herself. When she was able to buy the rolling hills just 10 miles north of downtown, she moved into a vintage trailer to save up for geodesic domes. Today the 18-acre property is a glamper's candy shop, with 5 completely different styles of structures—from bell tents to treehouses. Having started her glamping business in her 20s, she knows what millennials want—a two-story dome with a corkscrew slide to get down to the living room. They want the opportunity to chill around a firepit with views to the Blue Ridge Mountains *and* hop in an Uber when there's a good indie band in town.

The city of Asheville's charm has always been its convergence of rustic and chic. In 1888 its stunning mountains, rivers, and fresh air inspired George Vanderbilt to build his 250-room French Renaissance chateau here. The project to build the largest house in America attracted the world's best architects, designers, artisans, and high society to work and play in the area—a combination that sparked a gilded age of development in Asheville. The city is renowned for its pristine Art Deco, Beaux Arts, and Art Nouveau design, despite the mid-century urban "renewal" that bulldozed such architecture in many other American cities. The arts still thrive in Asheville, with one of the densest concentrations of working artists in the South and a craft brewery explosion that's dubbed Asheville "Beer City USA." So whether you're a Vanderbilt, a hipster, or a hiker coming to North Carolina, you know where to stay.

" I squealed with delight when we saw our dome lit up on the hill. We opened the door and were in awe of our mountain view with the fall colors. We loved the simplicity of the space. All I wanted to do was to lie back in our comfy bed and look at the stars through our clear ceiling. Despite our crazy busy lives, this gave us a space to unwind, talk, and laugh with each other.

—Ashleigh, North Carolina

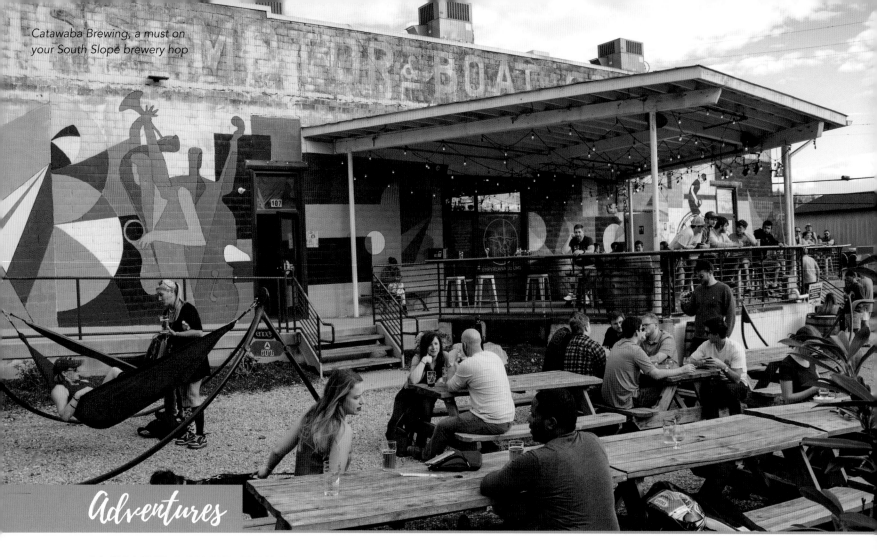

Adventures

PLAY LIKE A VANDERBILT

Of course you have to explore inside the 19th-century masterpiece that is the Biltmore House, just don't forget about its 127,000-acre backyard. Biking, hiking, carriage rides, horseback riding, falconry, sporting clays, Segway, and electric three-wheeler tours are all available to explore the grounds designed by Frederick Law Olmsted, the father of American landscape architecture.

CRAFT BREWERY HOP

With more than 30 breweries, Asheville has plenty of ways to drink up. If you like a fun-loving crowd, join Asheville Brews Cruise—the original brewery-hopping bus tour. If you want to get heady about it, BREW-ed offers the city's only tours led by a Certified Cicerone (think sommelier of beer). Prefer a self-guided crawl? Head to the South Slope for the city's densest concentration of craft breweries.

Glamping Experience

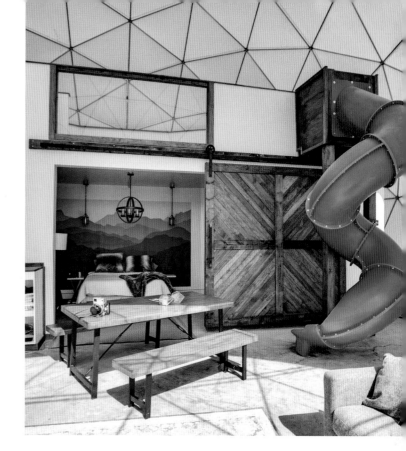

ACCOMMODATIONS: Choose from more than a dozen unique sites, including domes, deluxe bell tents, a safari tent, vintage trailers, and two brand-new treehouses. No matter if you're staying in the retro 1955 Silver Bettie trailer or a mod dome with 30-foot-high ceilings, you'll find fabulously decorated and comfy spaces in nature. All sites have electricity and air-conditioning; some have running water—even hot tubs! Find the one that suits your needs and personality.

DINING: Vintage trailers and treehouses have kitchenettes for whipping up meals, and propane grills are in abundance for cookouts. The camp store is open on weekends for coffee and provisions. Enjoy one night cooking under the stars and the next among the city lights—Asheville's foodie scene warrants a couple of meals out.

ACTIVITIES: Hiking, stargazing, campfire circles, and photo shoots

HONEYTREK TIP: Asheville Glamping is closer to a vacation rental than a hotel, so be ready to do your own thing. It offers the serenity of nature and the city at your doorstep; if you need more entertainment, pack lawn games, a journal, or whatever helps you have fun and unplug.

THE URBAN TRAIL

Navigate Asheville's wealth of Art Nouveau, Beaux Arts, and Art Deco architecture with the Urban Trail. Pick up the detailed walking map at the visitor center in Pack Square Park to start a 1.7-mile loop of the city's most architecturally and culturally significant sights. If you're with kids, download the scavenger hunt version and stop for a banana split at the Woolworth Walk soda fountain.

PADDLE THE RIVER ARTS

Head to French Broad Outfitters for a 6-mile standup paddleboard or kayak trip through lush woodland to the city's edgy arts district. After a leisurely 2 hours down this section of the French Broad, one of the oldest rivers in the world, you'll dock just north of the River Arts District. Towel off and head to Wedge Studios and explore 30-plus working-artist studios, plus a brewery.

Ultra Urban

City folks are out of excuses—glamping has made it to the metropolis! New York, Los Angeles, and Chicago have found a slice of the great outdoors for their chic accommodations. Despite the lack of forests, beaches, and deserts that most glamping destinations boast, their urban ingenuity and eye for style can turn a high-rise terrace into a wild escape.

Central Park, New York City

THE BUCOLIC BIG APPLE

Catch a Broadway matinee, shop Fifth Avenue, dine at the world's hottest new restaurants, then sail to Manhattan's sister isle, Governors Island. Closed to the public for centuries, this historic military fortification and national monument is now attracting discerning travelers with the help of Collective Retreats. From the comfort of your luxury wall tent or shipping container with a glass-walled bedroom, you can take in the New York City skyline. No need to hop the ferry for cosmopolitan delights—museums, cultural festivals, and concerts are readily available on this car-free island. Come sunset, when the tourists are heading home, you'll be enjoying a gourmet dinner and slumber party with Lady Liberty.

CollectiveRetreats.com

HOLLYWOOD GLAMOUR CAMPING

When a penthouse suite has a 2,140-square-foot terrace overlooking Beverly Hills and warm weather year-round, why stay inside? The Four Seasons' thoughts exactly. Their iconic Beverly Wilshire Hotel has pitched a bell tent with a queen bed, crystal chandelier, and antiques for your outdoor oasis. To pair five-star service with the spirit of camping, a personal chef can prepare an eight-course meal in a wood-fired oven and charcoal grill. No Hershey's here, your s'mores are made with Valrhona chocolate, Tahitian vanilla bean marshmallow, and shortbread cookies—topped with 24k gold leaf. Feel like this is all too decadent to keep to yourself? There's a dinner table for eight and a spare bedroom!

FourSeasons.com/beverlywilshire

CHICAGO STYLE

As one of Chicago's hottest new hotels, The Gwen knows glamping is where it's at. Soon after opening, they gave their presidential suite an adjoining outdoor accommodation for guests to get in touch with the urban jungle. Rising from the earth, skyscrapers by some of America's greatest architects surround your 16th-floor terrace. Take in the neo-Gothic and 21st-century designs of Michigan Avenue from your open-air living room and Lotus Belle tent. The contrasts continue under the canvas with Bohemian decor, like braided Indian jute rugs, macramé seat cushions, and live plants in bold ceramics. Get ready for sweet dreams with your s'mores turndown service.

TheGwenChicago.com

WILD WEST

7

RIDING A HORSE INTO THE SUNSET, cooking over an open fire, singing to the strum of a guitar, and sleeping under the stars—the cowboy way evokes undeniable nostalgia. When the 19th-century pioneers blazed a trail across the West, anything was possible—claiming land, striking gold, or finding solitude in the vast wilderness. But in reality, it wasn't easy being a homesteader or a cowboy. It took resourcefulness, heartiness, and bravery—a fact that's easy to forget when you're at a luxury ranch, hopping off your horse to head for a massage, but that's okay. Let these incredible destinations smooth the rough edges of the Wild West while paying homage to the pioneers by enjoying their trades—horsemanship, roping, cattle driving, shooting, and storytelling.

With hundreds of ranches to choose from, it can be difficult to separate the canned acts from those truly preserving tradition. Here you'll find fifth-generation cattle ranches, revitalized ghost towns, outlaw hideaways, and 19th-century homesteads just waiting for the sound of your spurs.

OWNER JIM MANLEY DIDN'T grow up a cowpoke, but his childhood fascination with the West inspired him to create the ranch of all our dreams. In the rugged Rocky Mountains, with a river running through it, the 6,600-acre homestead is a place where horses run free, trout leap out of the stream, and sapphire riches are underfoot. Here you feel empowered to ride a stallion, shoot a rifle, catch a fish, and rope a calf (without enduring the saddle sores and canned-bean dinners). They indulge your adventurous spirit and reward you for it. Sure, lemon ricotta pancakes are available in the lodge, but wouldn't breakfast taste better if you reached it by covered wagon? Wouldn't hot chocolate be a little sweeter if you were cross-country skiing and it appeared in the middle of the forest?

Their incredible attention to detail and above-and-beyond service have earned them the triple crown of hospitality: National Geographic Unique Lodge of the World, Relais & Châteaux, and Forbes Travel Guide Five-Star Hotel. All that praise might go to one's head, but being down to earth earns them that extra star. Their staff is made of real cowboys, fly fishermen, and farm-to-table chefs doing what they do best. They offer 43 different guided activities, and if you don't see a ranch adventure on offer, they'll do their best to make it happen. Want to barrel race in a rodeo with the pros? Show 'em what you got. Looking for some country music with your barbecue? LeAnn Rimes regularly plays their fall festival. There is no dream too lofty in Ranch at Rock Creek's corner of Big Sky Country.

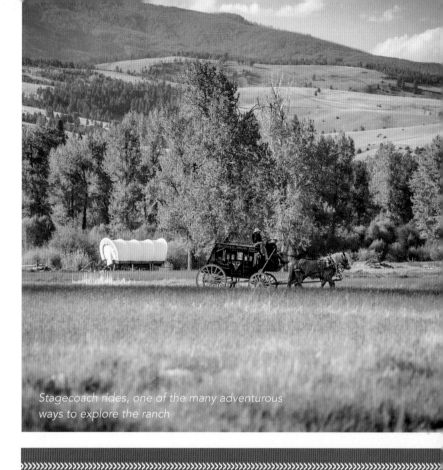
Stagecoach rides, one of the many adventurous ways to explore the ranch

COWBOY CAMARADERIE

As we were walking out of the Rod & Gun Club, I heard a familiar voice in a stunned tone, "Anne?!" It was one of my best friends from high school. We immediately embraced in a bear hug. Far from Los Angeles, and hardly one I'd peg as a fly fisherwoman, Anna was here for a birthday celebration. Her mother-in-law chose the ranch as the perfect place for the family to share new experiences, incredible food, and lodging (under one roof, or *just* far enough apart). We went to the on-site rodeo together, chatting all the way through the barbecue and team-roping, and closed the night on the saddle stools at the Silver Dollar Saloon. There is something about hanging out in cowboy hats that brings people together again.

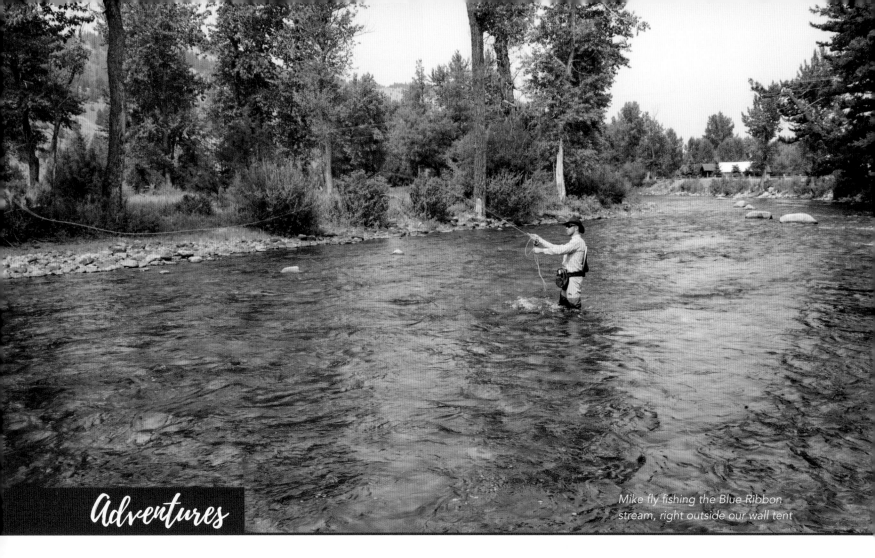

Mike fly fishing the Blue Ribbon stream, right outside our wall tent

BLUE RIBBON FLY FISHING

Fly fish their 4 miles of Blue Ribbon trout stream (read: pristine waters, thousands of fish per square mile, and some of the best angling in the States). Take a lesson and gear up like a pro for incredible odds of catching one of the creek's seven species, like bull trout or Rocky Mountain whitefish. Take a guided float trip, or wade in right from your glamping tent.

GRANITE GHOST TOWN

Explore this state park and former boomtown. In the 1870s the mining company was sent a telegraph calling for its closure, but during the time the message was delayed, miners struck a $40 million silver bonanza. Peek into the Miner's Union Hall and saloon, dynamite-blasted tunnels, and crooked cabins. On your way back, stop by the lively Western town of Philipsburg.

Glamping Experience

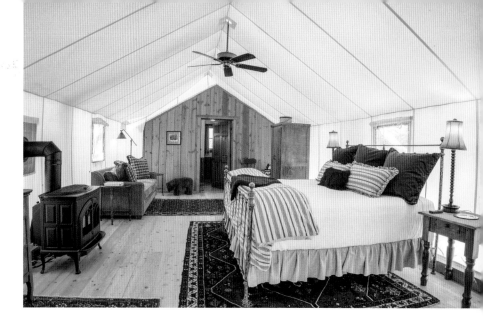

ACCOMMODATIONS: Stay in the beautifully converted 19th-century barn with leather furniture and thoughtful antiques, while the kids sleep in the stables. (Don't worry, Frette sheets are the new saddle blankets.) The refined creekside wall tents have thick log frames, screened-in porches, and radiant-heated floors. Luxury homes are fab for groups, and lodge suites put pairs in the heart of the action.

DINING: The finest ingredients are sourced from 75 local purveyors to support Montana's farmers, brewers, and coffee roasters, then crafted with care—be it a quick bite at the Blue Canteen or fine dining at the Granite Lodge. Mealtime is often an adventure, like horseback riding to a Dutch oven cookout or snowshoeing to happy hour at the ice-skating pond.

ACTIVITIES: Stagecoach rides, horseback riding, arena lessons, fly fishing, shooting range, yoga, ropes course, mountain biking, photo workshops, fitness center, pool, hot tub, bowling, movie theater, and spa

HONEYTREK TIP: Wintertime is the most affordable, least crowded, and barrels of fun. In addition to their 27 year-round activities, there are 9 snowy exclusives (sleigh rides, UTV tours, cross-country, etc.), not to mention complimentary downhill ski passes and gear, plus your fourth night's lodging is free!

PAN FOR SAPPHIRES

Rock Creek has the biggest deposit of sapphires in all of Montana. Put on your miner's duds and try your luck at Philipsburg's Gem Mountain. The mine has produced more than 180 million carats of sapphires. Around $30 gets you a full bucket, a wash screen, and a chance to strike it rich. Sapphires come in a beautiful array of colors, so you can find a full spectrum of gems and fun.

ROUGH STOCK RODEO

A weekly rodeo with pro riders, announcers, and a grandstand—at a boutique property? Oh yeah and yee-haw! Kicking off with a cowboy happy hour, the festivities continue with bucking broncos, team roping, and bull riding. Prove your skills to the wranglers and they'll let you enter in the barrel races (or at least the boot toss). Here on a weekend? Get local at the Drummond Rodeo.

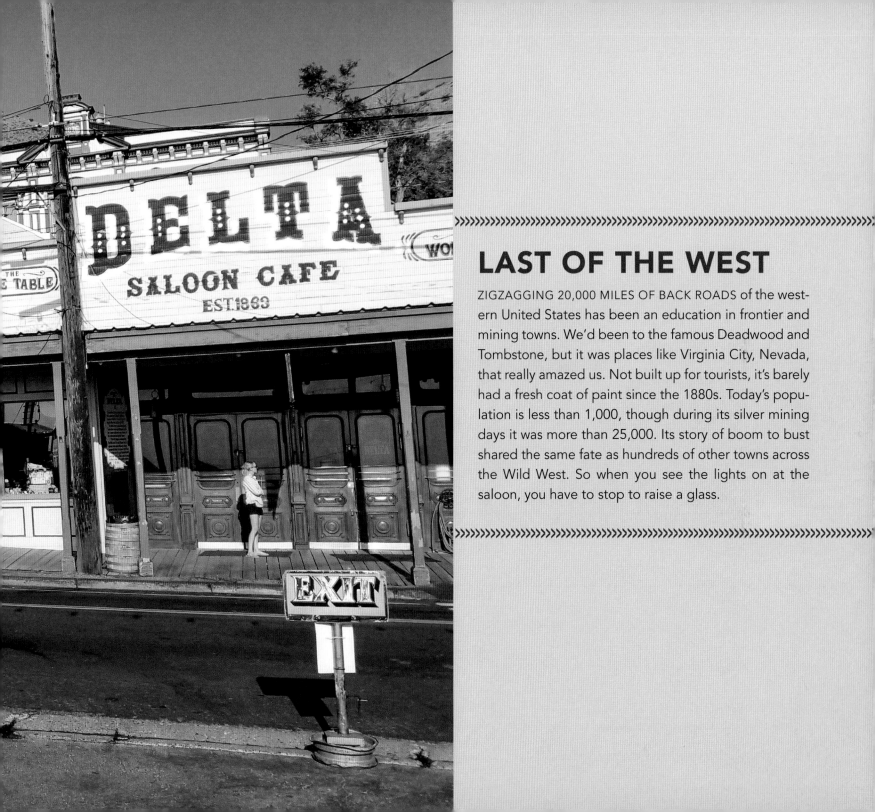

LAST OF THE WEST

ZIGZAGGING 20,000 MILES OF BACK ROADS of the western United States has been an education in frontier and mining towns. We'd been to the famous Deadwood and Tombstone, but it was places like Virginia City, Nevada, that really amazed us. Not built up for tourists, it's barely had a fresh coat of paint since the 1880s. Today's population is less than 1,000, though during its silver mining days it was more than 25,000. Its story of boom to bust shared the same fate as hundreds of other towns across the Wild West. So when you see the lights on at the saloon, you have to stop to raise a glass.

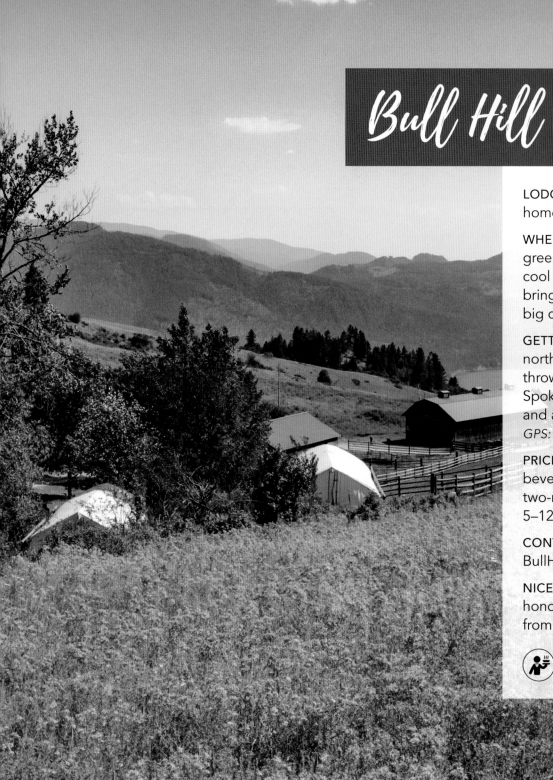

Bull Hill

**KETTLE FALLS, WASHINGTON
UNITED STATES**

LODGING: Wall tents, cabins, and luxury homes

WHEN TO GO: Open May–Oct. For the greenest landscapes, wildflowers, and cool weather, try May. Late Sept–Oct brings incredible fall foliage and the big cattle roundup.

GETTING THERE: This secluded northeast Washington ranch is a stone's throw from Canada, a 2-hour drive from Spokane International Airport (GEG), and a 320-mile road trip from Seattle. *GPS:* 48.8868° N, 117.9221° W

PRICING: All-inclusive of lodging, meals, beverages, and activities; $225 PPPN, two-night min. (discounted for ages 5–12, free under 5)

CONTACT: (509) 732-1171
BullHill.com

NICE TOUCH: No cash register, no honor store; help yourself to a cookie from the jar and a beer from the fridge.

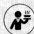 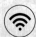

"THERE'S NO BETTER MOTIVATOR than a century of ancestors breathing down your neck," jokes Tucker and Hunter Guglielmino, brothers and descendants of the ranch's founder. When their great-great-grandpa Peter Ansaldo arrived from Italy via Ellis Island, he picked up odd mining jobs as he moved west, until he arrived in the northeast corner of Washington state in 1903 and found a place that felt like home. Peter started a cattle ranch, and today the Guglielmino family (siblings, uncles, nieces, cousins—the whole fam damily) continues his legacy with 50,000 acres, 1,000 head of cattle, and countless happy guests from around the world. "We try not to have more guests than horses," said Tucker, and in cowboy terms, that speaks to the quality of this all-inclusive ranch. They want guests to go on as many trail rides as they please, help themselves to the fridge, and stay up late dancing in the cookhouse—right alongside them. When we first walked into the bar at around 9 p.m., everyone was having so much fun cutting a rug, we thought we'd crashed a wedding. Turns out, everyone at Bull Hill just becomes fast friends.

Join the Guglielmino crew as they drive cattle through the Colville National Forest and toward the Canadian border, or take a leisurely ride down to the Columbia River for a picnic, dip, and visit to an organic winery. Advanced riders will be in horse heaven with the wild mountainous terrain; so will sunseekers looking to while away the day on a paddleboard. Whatever you do, there's no pressure, no judgment—you're family here.

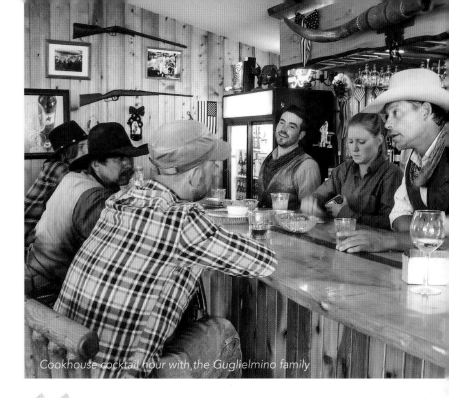
Cookhouse cocktail hour with the Guglielmino family

"For the overwhelming hospitality and letting us share a little piece of paradise, thank you. This is the kind of vacation that reminds our family what we value—simple living, a beautiful view, and meeting new friends. We hope to see you soon.

—The Olsens

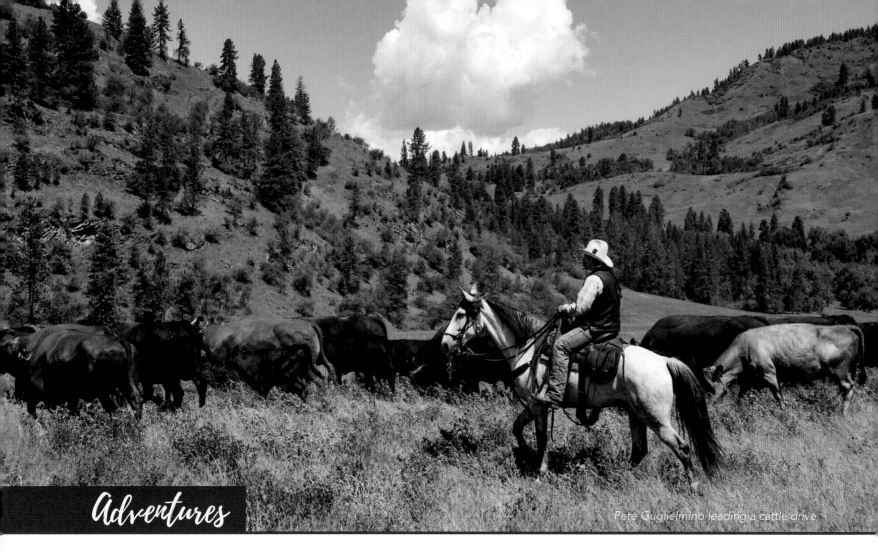

Adventures

DRIVE CATTLE

Some guest ranches offer cattle drives for show—not Bull Hill. They're moving the herd so the 1,000 head are ready for market. There is no set schedule; it's determined by the needs and locations of the cows that day. Let Hunter or Uncle Joe know you're interested, and you'll soon be roundin' up them doggies over the mountains and through the woods.

MARVEL AT THE COLUMBIA

As the largest river in the Pacific Northwest, with a drainage basin roughly the size of France, the Columbia deserves respect. Pay homage, whether it's trail riding from Bull Hill to their favorite riverside picnic spot, fly fishing for redband trout with the pro anglers at The Evening Hatch, or swimming the beautiful pools at Black Sands Beach.

Glamping Experience

ACCOMMODATIONS: Choose from canvas wall tents, ranch cabins, or luxury vacation homes—a hot tub is never far. The two tents are at the edge of the meadow and offer the best views over the ranch and mountains. Enjoy your covered porch, two queen beds, heat, and fans. Your private bathroom is just down the stairs. Ranch cabins are tucked into the cedars and aspens, with cozy living areas, large bathrooms, double beds, and a loft with twins. Lonestar and Bullagio are luxurious three-bedroom, two-bath homes with kitchenettes, picture windows, and contemporary Western decor.

DINING: The Cookhouse, with its panoramic patio, old-time bar, comfy couches, and help-yourself food and drink policy, is the heart of camp. Each meal is a grand buffet with options like Traeger-smoked rib roast dinners, salad bar lunches, and griddle breakfasts. Chef Chris (after 20 years of service, she's family too) always leaves out fresh baked goods and fruit for snacking.

ACTIVITIES: Unlimited horseback riding, cattle drives, skeet shooting, water sports, riding arena, horseshoes, hiking/biking trails, and fishing

HONEYTREK TIP: Don't fall off a horse (the penalty is a shot from a bull's horn), and hang onto your hat (that's a half shot).

STONEROSE FOSSIL HUNT

Take the Sherman Pass Scenic Byway to the Old West town of Republic. In the late 1800s everyone was mining for gold; today they're digging for fossils. Head to the Stonerose Interpretive Center to learn about this Eocene-era site, and pick up your hammer and chisel. Chip away at the ancient lakebed's layers of shale and you'll find insect, leaf, or fish fossils from 49 million years ago!

CROWN CREEK SALOON

Imagine you're horseback riding under the hot summer sun; then, like a mirage, a watering hole appears. You tie up at the hitching post, push open the swinging doors, and a bartender says, "What'll ya have pardner." It's a saloon out of a John Wayne movie—and it's only open for Bull Hill riders. Stay for a firewater, a game of pool, and a chat with the craftsman behind this cowboy heaven.

Dunton Hot Springs

LODGING: Historic cabins and wall tents

WHEN TO GO: The San Juan Mountains are a poster child for summer, winter, spring, and fall; pick your favorite. Cabins are available year-round; the tented Dunton River Camp is open June–Oct.

GETTING THERE: Fly into the closest airport, Cortez Municipal (CEZ), or the larger Durango (DRO) for a 2-hour ride to Dunton. Airport pickup is available. *GPS:* 37.7728° N, 108.0940° W

PRICING: Lodging, meals, beverages, hot springs, mountain bikes, and laundry service; $348 PPPN, two-night min.

CONTACT: (877) 288-9922
DuntonHotSprings.com

NICE TOUCH: All guests receive a metal water bottle to help reduce plastic consumption and enjoy as a souvenir.

 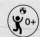

THERE ARE HUNDREDS OF MINING TOWNS scattered across the West that vanished with the gold dust. A lucky few have survived as tourist attractions or protected ruins; then there is Dunton. This 1880s town was built on the dreams of the pioneers, and with each guest that visits, their legacy lives on.

Travel deep into the San Juan Mountains, through red rock desert and national forest, and you'll wonder how people ever found this place. It was the whispers of ore that lured the miners, but for us it's the chance to set foot into a forgotten world. Pull up to the 19th-century saloon, where you'll meet the concierge over a libation and chat about your Western adventure ahead—soaking in the town bathhouse, fly fishing in the West Fork of the Dolores River, yoga in the Pony Express office, hiking with llamas—the possibilities are endless. Now to find your room. Did you reserve the general store or the old well house with the on-demand hot spring? Each accommodation had its role in town and a story to tell—like the inviting Bjoerkman Cabin, named for the Scandinavian miner who built it by hand.

The Henkel family bought the town of Dunton in 1994 as their vacation property and put their heart and soul into restoring it. As much as they enjoyed their family hideaway, they always felt a bit guilty about letting their revitalized ghost town go vacant most of the year. In 2001 they opened this one-of-a-kind resort, so now we can all feel like we've struck it rich.

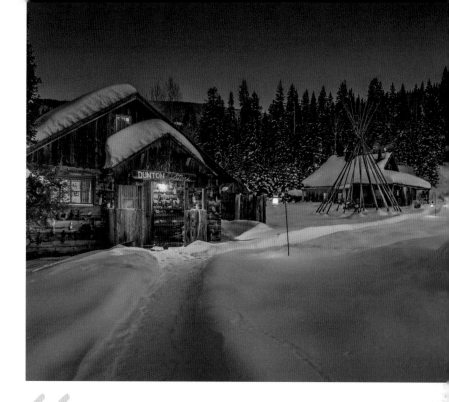

"Dunton is likely the most romantic, exquisite, and wild getaway I've ever experienced. My wife and I thoroughly enjoyed its remote and rustic atmosphere coupled with sensational food, drink, and service. Just enough outdoor access to keep even the most adventurous couples happy between luxurious soaks under a star-clustered sky.

—Matteo, Italy

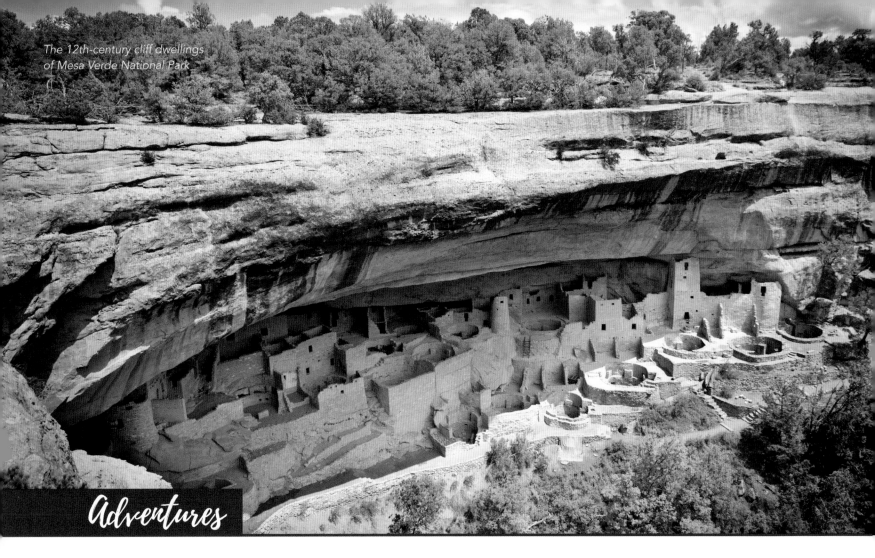

The 12th-century cliff dwellings of Mesa Verde National Park

Adventures

HIKE TO COLORADO'S ONLY GEYSER

Hidden in the San Juan National Forest, yet a stone's throw from Dunton, lies a trail to the state's mini Old Faithful. In the spring it's an exhilarating snowshoe along frozen waterfalls, and come summer it's a stroll among the wildflowers. After 1.5 miles, the bright blue pool will appear like a gem. Take a seat on J. Luther's rock (signed and dated 1901) and watch the waters bubble up.

NATIONAL PARK & UNESCO SITE

Carved into the Mesa Verde Plateau is an ancient civilization with 4,000-plus archaeological sites. Learn about the Ancestral Puebloan people and their architectural evolution from pit houses to cliff palaces boasting 150 rooms. Join an adventurous ranger-guided hike to the Balcony House, involving a series of ladders and tunnels to access the well-preserved rooms, plazas, and kivas.

Glamping Experience

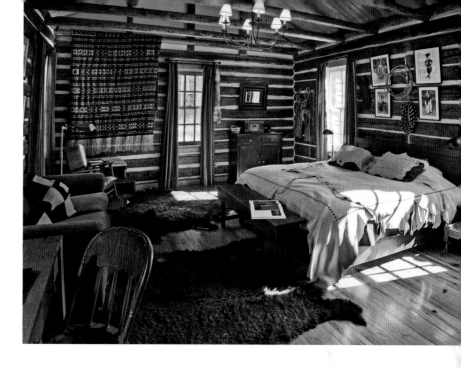

ACCOMMODATIONS: The homes and businesses from 19th-century Dunton, along with buildings saved from other Colorado ghost towns, have been revitalized as stylish guest cabins. Period antiques, Western memorabilia, and contemporary decor blend for rooms that are both nostalgic and sophisticated. Cabins range from one to five bedrooms, some with kitchens and private hot springs. Want to stay in a prospector tent? Dunton Hot Springs has one, and its sister property, "River Camp," has eight of these luxe canvas beauties just a few miles downstream.

DINING: Like any good Western town, the heart of Dunton is the saloon, where everyone gathers round for free-flowing drinks and hearty meals. (Find Butch Cassidy's signature on the bar.) The menu changes daily to reflect what's in season locally or growing in their garden, and can be adapted to virtually any dietary restriction or craving.

ACTIVITIES: Hot springs, yoga, spa, mountain biking, fishing, snowshoeing, skiing (cross-country, backcountry, and heli), ice climbing, snowmobiling, photography tours, and hiking

HONEYTREK TIP: If you're ever in southwestern Colorado even for a short stint, snag a Dunton day-pass to soak in the springs, enjoy a gourmet lunch or dinner, and belly up to the saloon. It's a silver-dollar steal!

CROSS-COUNTRY SKI LIKE AN OLYMPIAN

Climb into Dunton's very own snowcat and ascend to 10,000 feet. Strap on skis or snowshoes and follow a 3-mile trail designed by former Olympic Nordic skier Wendy Wagner. Swooshing through the pristine high meadows offers a boost of both adrenaline and serotonin. This can be done on most any snowy day, though there are complimentary group trips three times a week.

DESERT TO VINEYARD RIDE

Horseback ride through the Canyon of the Ancients National Monument, taking in red rock formations and Puebloan ruins. Three hours later, like an oenophile's mirage, a sea of Syrah and Cabernet Franc appears out of the desert, with a sommelier ushering you in for lunch. Taste the terroir you've traveled upon with 90-plus-point wines from Sutcliffe's elevation-defying vineyard.

Equestrian Escapes

If you love horses and want to level up your cowboy skills, these three ranches will put another notch in your belt. More than extra trail rides, this is your chance to connect with horses from the birth of a foal to training with a Thoroughbred. It's your shot to feel like a rodeo star, whether taking a barrel racing clinic or looking the part with a cowgirl fashion workshop. Giddy up!

HorseWorks Wyoming

READY TO RODEO

C Lazy U is a mainstay on the list of top luxury ranches, but few hold a candle to their equestrian program. With more than 180 horses to choose from, this century-old Colorado ranch will match you with your perfect steed. Adult and youth riding clinics will get the whole family involved. Learn the basics of horsemanship and hone your skills in the arena (outdoors or a 12,000-square-foot, heated indoor ring). Rest up in your plush cabin to get ready to ride in the "Shodeo," a final performance for guests to show off their barrel racing skills, roping tricks, and wrangler moves. Celebrate your accomplishments with gourmet food, brews, and square dancing.
CLazyU.com

COWGIRL CAMP

Sorry, cowboys. This is the girls' time to shine. Founder Jeana Noel didn't grow up in the West but felt at home and empowered on Montana's ranches. She wanted to share that feeling with other women and give them a place to explore their inner cowgirl. With beautifully decorated bell tents as your home on the range, the seven days are spent trail riding through the foothills of the Little Belt Mountains, eating fine food, and gathering with like-minded ladies. Jeana leads daily programs, from Western fashion workshops to motivational talks about living the cowgirl way. While no equipment or skills are required, equestrians are welcome to bring their own horse. MontanaCowgirl.camp

HORSE HOMESTEAD

Founded by a Wyoming Cowboy Hall of Famer and hosting riders since 1941, HorseWorks is as much an equine internship as it is a vacation. While this ranch does rent cute glamping cabins for those who just want that Western ambience while they explore central Wyoming's hot springs and Big Horn River, its specialty is one- to four-week immersive stays. Be there when a foal is born, do groundwork with colts, round up cows, and team pen. Join your new buddies for daily trail rides or an overnight adventure at the Cow Camp homestead. The longer you stay, the lower the price per night—so stick around! HorseWorksWyoming.com

FANTASTICAL 8

AS A CONCEPT, glamping is already pretty fantastical—houses built in the trees, clear domes for stargazing from bed, and Airstreams that take you back in time. Then there are the places that shatter the mold; those that dream up a design that defies categories and an experience that leaves you speechless.

When we first heard about a medieval encampment in Alberta, we didn't even know what that meant—but we are so glad we found out. A hotel made entirely of snow and ice? Oh, we slept there, and it wasn't in Sweden. At the following destinations, you could be ziplining between treehouses, wielding swords with a knight, or having cocktails in a helicopter cockpit. Trust us, anything is possible.

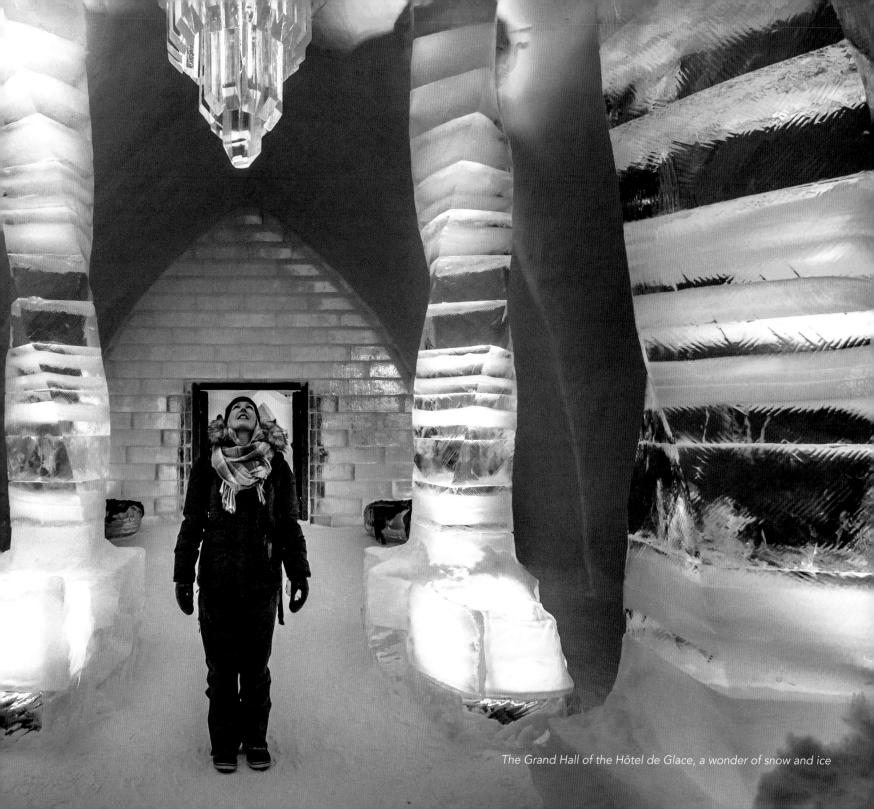

The Grand Hall of the Hôtel de Glace, a wonder of snow and ice

Hôtel de Glace

SAINT-GABRIEL-DE-VALCARTIER, QUEBEC CANADA

LODGING: Snow-and-ice-carved suites

WHEN TO GO: Open Jan–Mar, with exact dates determined by Mother Nature. Try to time your visit with the festive Carnaval de Québec.

GETTING THERE: Thirty minutes from Quebec City and its international airport (YQB), Hôtel de Glace is easily accessible by cab. Road tripping? It's 4 hours north of Burlington, Vermont, and 3 hours east of Montreal. *GPS:* 46.9427° N, 71.4747° W

PRICING: A two-person room in Hôtel de Glace, plus a king suite in the four-star Valcartier hotel to help you prepare and reacclimatize; $260

CONTACT: (888) 384-5524 HotelDeGlace-Canada.com

NICE TOUCH: Guests are welcomed with a cocktail in a glass made of ice, followed by an ice-sculpting workshop to craft your own vessel or work of art.

A SOLID WEEK OF below-freezing temperatures is not something many look forward to—unless you're the founder of Hôtel de Glace. This is when Jacques Desbois's team can create bricks of ice, blow the perfect snow, and lay the foundation for the only ice hotel in North America. When Jacques, a former igloo designer for festivals and museums, saw Sweden's Icehotel in 1996, he flew there to meet the architect. By 2001 he had opened his own Hôtel de Glace (French for "ice hotel") and has rebuilt it every winter since.

Using 500 tons of ice and 30,000 tons of snow, the hotel is erected with cathedral ceilings, walls carved into 3-D murals, and a maze of suites. Each year the 18 sculptors are inspired by a different theme, like myths and legends, global gardens, or fire and ice. We visited during the "Circus" and saw acrobats flying down the hall, jugglers tossing hundreds of snowballs, and a bear and ringmaster waltzing around a deluxe suite.

Adding to the fantasy, Hôtel de Glace is alongside the continent's biggest winter playground: Valcartier. Though when the tubing slopes, ice-skating rink, sugar shack, and architecture tours have closed for the day, Hôtel de Glace becomes exclusive to its 100 guests. Join your fellow insiders for a drink at the ice bar, sipping creative cocktails like the Ski-Doo Accident and Sex on the Snow. Snuggle up on a fur-topped banquette, whiz down the ice slide, and poke around all the uniquely crafted suites. After a hot tub session at the starlit spa, tuck into your bed fit for a polar explorer.

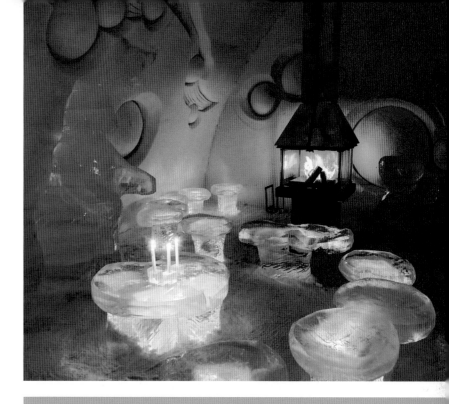

HEART & HARDY

Set on the bluffs of the Saint Lawrence River and surrounded by the Laurentian Mountains, Quebec City is beautiful in summer, but winter is when the spirit of the provincial capital shines bright. Under a blanket of snow, the city grooms its bike trails for cross-country skiing and adds free ice-skating rinks to its 16th-century plazas. We saw little kids ice fishing in the harbor and grandmas taking Sunday strolls, even if it required a wheelchair on skis. You've gotta love that while most people in the North are counting the days until the spring thaw, Quebec is coming up with more and more reasons to fall in love with the cold.

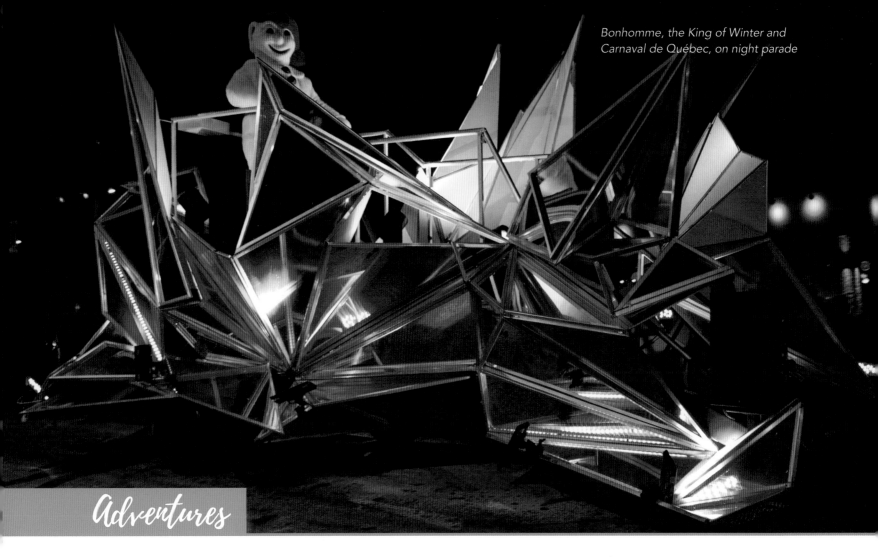

Bonhomme, the King of Winter and Carnaval de Québec, on night parade

Adventures

SNOW TUBING FOR BIG KIDS

Set up like a ski mountain, with lifts and terrain of varying difficulty, Valcartier's tubing park is anything but kiddie. There are 11 slides and a snow fort to keep the children happy, but there are also two dozen advanced runs for the crazy teenager inside us all. Shred the DemiLune half-pipe, speed to 50 miles per hour on Himalaya, and brave the 110-foot drop of Everest.

CARNAVAL DE QUÉBEC

A tradition dating back to 1894, Quebec's winter carnival has grown to be the world's largest, running for 10 days, with more than 200 activities and 500,000 partygoers. The fun spreads across the city streets with over-the-top parades, musical acts, art exhibitions, ice canoe races, and traditional to cheeky Canadian games (mechanical moose riding, anyone?).

Glamping Experience

ACCOMMODATIONS: Forty-two rooms, ranging from minimalist to artist-carved spectaculars with fireplaces and private saunas, are sheltered between the 8-foot-thick walls. All furnishings are made of ice, even your bed. Though believe us when we say you won't be cold cuddled up on their high-tech mattresses in subzero sleeping bags. If you do get cold feet, you can always go inside to your king suite at Hôtel Valcartier. This is also where you store your luggage, shower, and hang out, pre- and post-night in your ice castle.

DINING: Choose from seven different restaurants for healthy dishes, gourmet lunch boxes, bistro menus, and multicourse meals. In addition to the Bar de Glace, a sugar shack is also located on snow. (Get the maple taffy!)

ACTIVITIES: Spa, swimming pool, tropical water park, snow tubing, forest ice skating, game room, architecture tours, and ice sculpting

HONEYTREK TIP: Themed suites are one-of-kind works of art and worth every penny; though don't worry if the basic room is what fits your budget. You'll get to explore all the fabulous designs before check-in, and waking hours are spent socializing in the common spaces.

GO BEHIND THE SCENES

How do you build a 40,000-square-foot hotel out of snow? Learn the secrets behind the construction and maintenance of a meltable structure, with a behind-the-scenes tour of the ice workshop and hotel. See how they make the arch molds, temper the bricks, and chisel a chandelier. Put your new knowledge to work by drilling your own ice glass for a complimentary cocktail.

FRENCH COLONIAL ESSENCE

Take the funicular to Basse-Ville to see the heart of the 17th-century city. Stroll the narrow Rue du Petit-Champlain (a street lauded as the prettiest in Canada) for shops, cafes, and homes out of a French fairy tale. Round the corner to Place Royale and marvel at North America's oldest stone church and the colossal trompe l'œil mural illustrating the city's 400-year history.

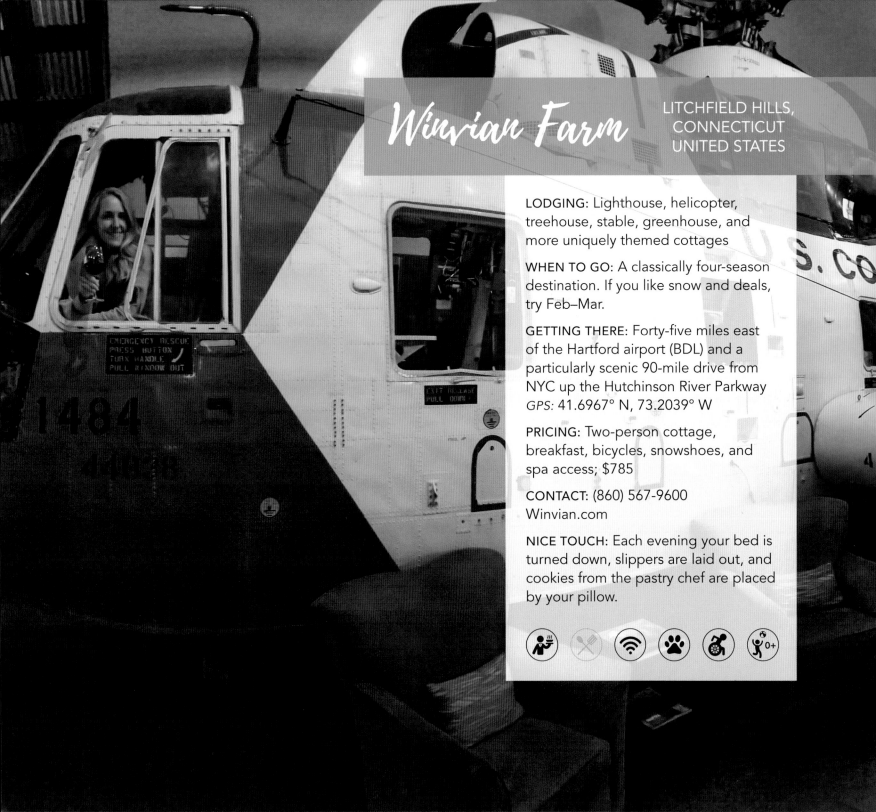

Winvian Farm

LITCHFIELD HILLS, CONNECTICUT UNITED STATES

LODGING: Lighthouse, helicopter, treehouse, stable, greenhouse, and more uniquely themed cottages

WHEN TO GO: A classically four-season destination. If you like snow and deals, try Feb–Mar.

GETTING THERE: Forty-five miles east of the Hartford airport (BDL) and a particularly scenic 90-mile drive from NYC up the Hutchinson River Parkway *GPS:* 41.6967° N, 73.2039° W

PRICING: Two-person cottage, breakfast, bicycles, snowshoes, and spa access; $785

CONTACT: (860) 567-9600 Winvian.com

NICE TOUCH: Each evening your bed is turned down, slippers are laid out, and cookies from the pastry chef are placed by your pillow.

WHAT'S YOUR DREAM . . . to be a musician, a helicopter pilot, an artist, or a member of a secret society? It can come true at Winvian. Pick any of the 18 cottages, designed by different high-profile architects and executed with unique wit and whimsy. The golfer can putt on his plush carpet green, and the pilot can sip a martini in the fuselage of her 1960s Coast Guard helicopter.

"One of my favorite descriptions of Winvian Farm," says Maggie Smith, proprietor of the family-owned and -operated resort, "is where Norman Rockwell meets *Alice in Wonderland*." Imagination ran wild with each design, but the property's rich history helps it keep one foot on the ground. At the heart of Winvian is the 18th-century home, originally owned by an eccentric physician and purchased by the Smith family in the 1940s. (Winvian stems from the combination of Winthrop and Vivian Smith's first names.) The clapboard house has been expanded with reclaimed barn wood and embellished with antiques that speak to its days as a colonial estate. Staying true to its farm roots, the organic garden and greenhouses provide up to 80% of the produce for their AAA Five Diamond restaurant. Executive Chef Chris Eddy is a leader in the seed-to-table movement, crafting meals around the ingredients harvested that day.

Take a cooking class in the historic kitchen, or take flight in a hot-air balloon right from the backyard. Wield a sword in a fencing bout before retiring to your King Arthur–inspired suite, or hike from your treehouse into Connecticut's largest nature sanctuary. As they say at Winvian, each day is "a flight of fancy, a leap of faith, pie in the sky."

DOWN TO EARTH & OPEN ROAD

Rolling into a Relais & Châteaux property in our 1985 RV, we imagined the classical music in the lobby scratching to a halt. We walked in ready to apologize for Buddy the Camper, but before we could, Maggie, the owner, broke into a nostalgic story about her own Winnebago road trip. "We took a month to go cross-country with the kids, even picked up my mother and a new dog along the way," she said, with a twinkle in her eye to match her jewelry. "I'd do it again in a heartbeat." Anne and I let out a sigh of relief and a laugh. We chatted by the fire for nearly an hour, and she closed by saying, "Thank you for adding Winvian to your route."

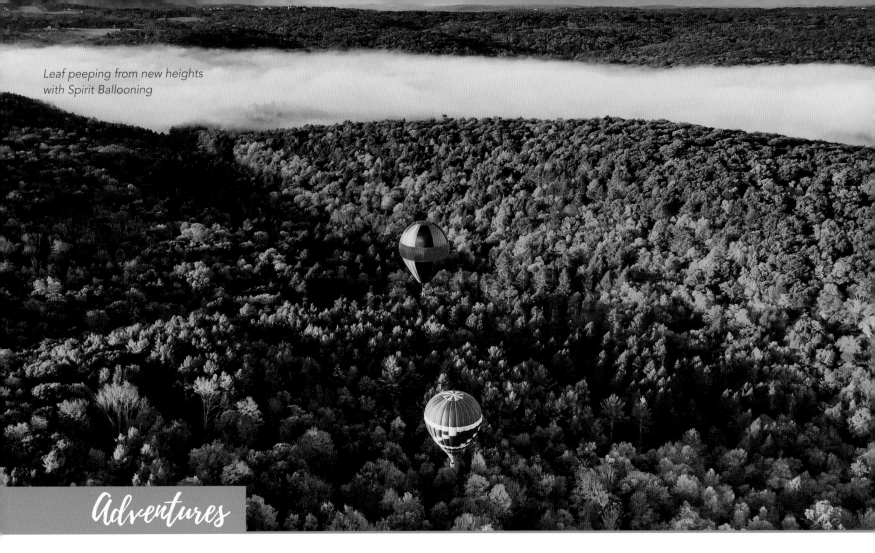

Leaf peeping from new heights with Spirit Ballooning

Adventures

PAINT & SIP

Bring your favorite bottle of wine to the colorful HUE Studios for a lesson by modern artist Jennifer Sabella. Select your palette and loosely follow her technique of layering, removing, scraping, and blending. Snacking on complimentary appetizers, chatting about art and life, and letting creativity flow, the evening ends with new friends and fresh wall decor.

BALLOONING THE LITCHFIELD HILLS

Directly from Winvian's meadow, take flight in one of its purest forms. Your hot air balloon will soar over the southern swath of the Berkshires, Connecticut's largest natural lake, rolling farms, and colonial hamlets. Enjoy a picnic in the sky and raise a champagne flute to your 1.5-hour aerial journey. New England's spectacular fall foliage elevates this to bucket-list status.

Glamping Experience

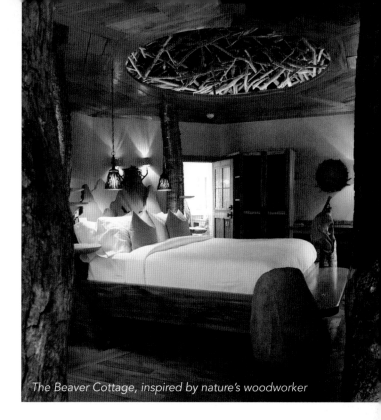

The Beaver Cottage, inspired by nature's woodworker

ACCOMMODATIONS: Ranging from 950 to 1,250 square feet, each cottage feels like a dream house. While all 18 are unique, there is an overarching theme of "bringing the outdoors in," with features like 20-foot-tall tree trunks soaring to the ceiling, bathroom waterfalls, woodland murals, and river-stone walls. Cottages include a porch, fireplace, steam shower, jetted tub, Bose surround system, and minifridge. To be at the heart of the hotel, stay in the historic Hadley Suite. For whimsy to the max, we'd recommend the following cottages: Helicopter, Stable, Woodlands, Maritime, Camping, Beaver, or Stone.

DINING: Complimentary breakfast is far from continental. Homemade pastries are merely an appetizer for your artful egg dish. Lunch is available on weekends and every day in summer. Dinner is a multicourse love affair with award-winning farm-to-table cuisine.

ACTIVITIES: Spa, fencing, cooking and mixology classes, yoga, guided hikes, snowshoeing, kayaking, lawn games, swimming pool, game room, bicycles, volleyball, badminton, horseback riding, and maple tapping

HONEYTREK TIP: Upon arrival, ask the front desk what rooms are still available and if they have a moment to give a quick tour. Each one is dazzling from the outside, but you won't believe the interiors.

COOK WITH A CULINARY MASTER

Trained at the French Culinary Institute and a former sous chef to Michelin-starred Alain Ducasse, Chris Eddy can teach you to cook like a pro. Join him in the organic garden to pick ingredients for your class in savory soup or pasta making. Learn to fold the perfect farfalle bow tie and roll the illusive pici noodle, then enjoy your creations over lunch.

WALK ON WATER

Get to the heart of the 4,000-acre White Memorial Conservation Center with this 3-mile hike. Start by exploring the impressive interactive museum, then ask a ranger for the "outdoor scavenger" hunt to spice up your walk to Little Pond Boardwalk. This elevated walkway (made of 57,000 boards) hovers over precious wetland and brings you eye to eye with nature rarely seen on foot.

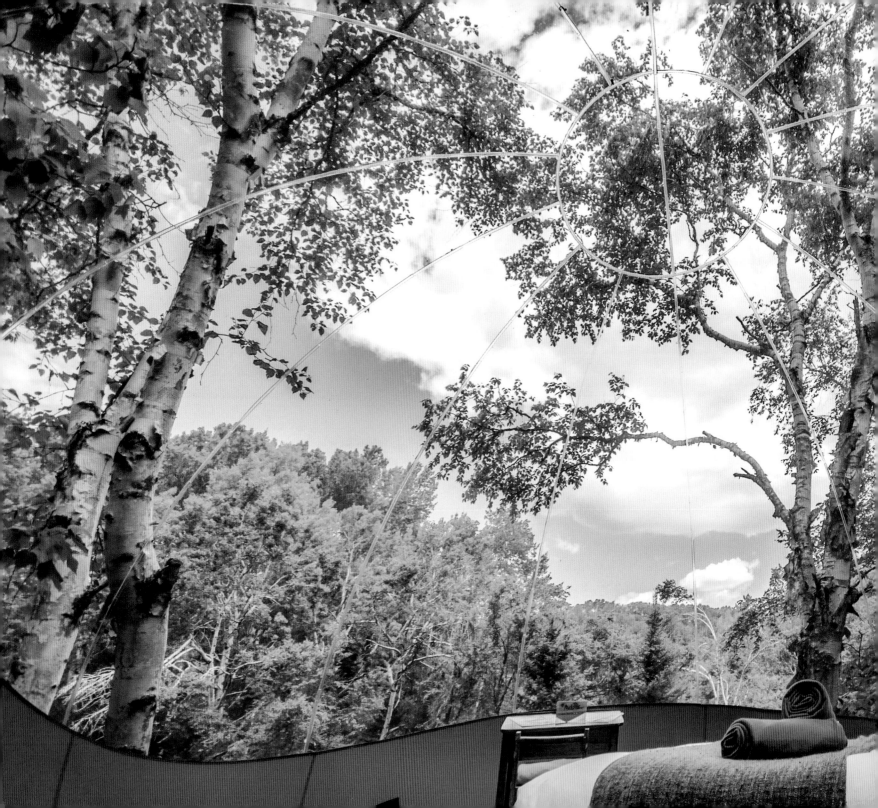

THOUGHT BUBBLE

WE CLIMBED 18 FEET UP to our Canopée Lit treehouse, though it didn't have a ceiling or even walls. Only a thin clear layer separated us from the boreal forest and views to Fjord-du-Saguenay—a Canadian national park and the only fjord in southern Quebec. We threw ourselves on the fluffy bed with a squeal of glee then a sigh of utter relaxation. From our linen viewing platform, we watched the birds fly overhead, squirrels chase each other from branch to branch, and eventually, the stars take over the sky. That thin barrier seemed to vanish and, in that moment, we felt a part of the galaxy.

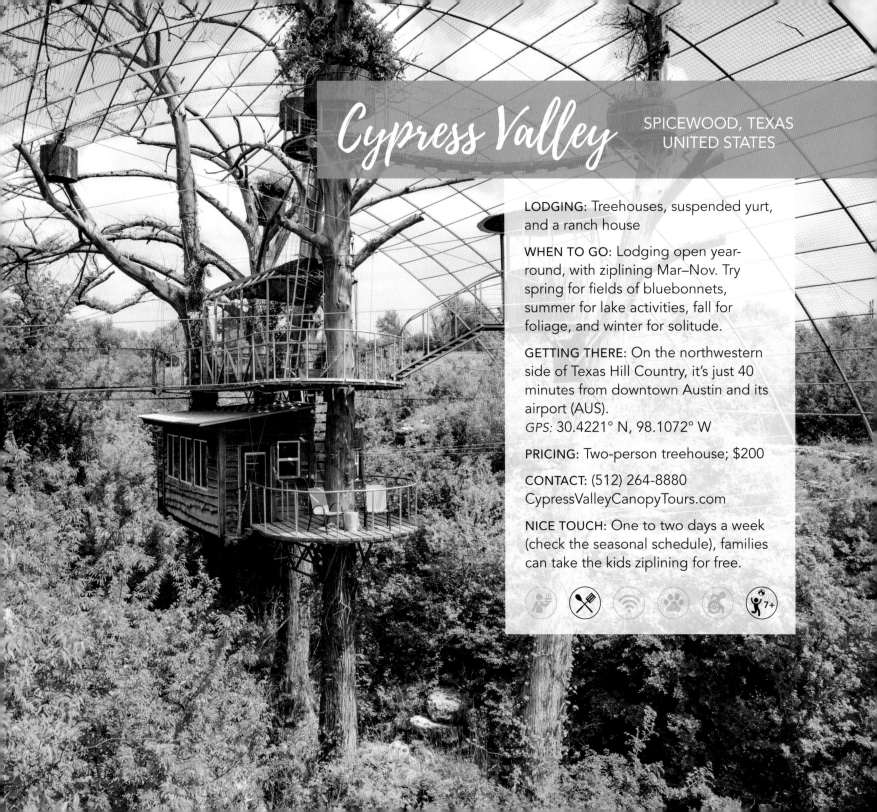

Cypress Valley

SPICEWOOD, TEXAS
UNITED STATES

LODGING: Treehouses, suspended yurt, and a ranch house

WHEN TO GO: Lodging open year-round, with ziplining Mar–Nov. Try spring for fields of bluebonnets, summer for lake activities, fall for foliage, and winter for solitude.

GETTING THERE: On the northwestern side of Texas Hill Country, it's just 40 minutes from downtown Austin and its airport (AUS).
GPS: 30.4221° N, 98.1072° W

PRICING: Two-person treehouse; $200

CONTACT: (512) 264-8880
CypressValleyCanopyTours.com

NICE TOUCH: One to two days a week (check the seasonal schedule), families can take the kids ziplining for free.

EVER DREAMT ABOUT LEAVING the rat race and starting again on a remote plot of land? What about growing your own food, harnessing electricity, purifying rainwater, and raising a family of five in a Mongolian yurt? That's where the dream might wear off for some, but not the hearty Beilharz family. It was a bold leap to leave the cushy Austin life and buy 88 acres of raw ranchland, and equally brave to start one of the first zipline companies in the United States back in 2005. They saw how much the kids and their friends enjoyed playing in the rocky ravine, meandering creek, and old-growth cypress trees. "They had the space and time to explore and frolic—something so few children experience these days," said Amy Beilharz. "Their creativity soared and their ability to solve problems increased, as well as their overall emotional resilience. With the zipline course, we found a way to offer that to more people." By this time, David Beilharz and his son Will were done building the family ranch house, but Will's passion for designing with nature was just beginning. He used his backyard as a lab to create the first treehouses for Artistree, a firm that has even caught the eye of *Architectural Digest*.

Connecting the zipline course to a series of treehouses made perfect sense in their creative minds. Now guests can continue the magic of flying through the forest by spending the night up in the boughs. And not just any structure wedged in the branches—it could be a 35-foot-high yurt with a suspension bridge or their latest creation—Yoki, a veritable mansion spanning three trees. Come take the leap.

A creative guest-book entry

MAGIC—PASS IT ON

Hopping into bed in the Willow treehouse, we noticed a leather journal on the side table. Each page had different handwriting, with a poem, musing, drawing, or confession. They were the stories of those who'd slept in these branches before us. "Be certain there is a special kind of magic in this treehouse," one wrote in a flowing cursive. "I came here with the weight of a heavy heart and leave here with new clarity. I wish the same for whoever chooses to share their energy with this beautiful place." These guest books weren't written for the owners, they were written for us.

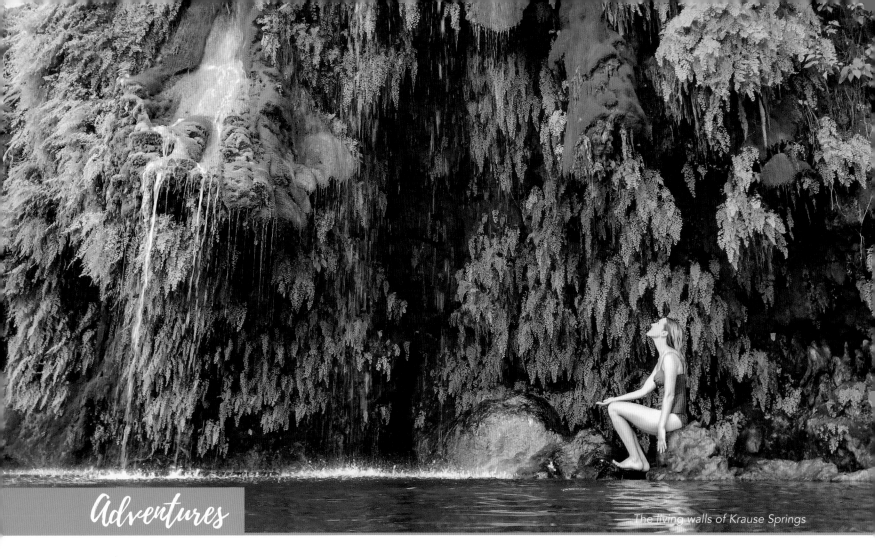

Adventures

ZIPLINE BY DAY OR NIGHT

Fly through the canopy of old-growth cypress trees. Steel cables, some 350 feet long, send you whizzing between the scenic platforms, bridges, rappelling deck, and an optional high dive for a lake dismount. Time your trip with a full-moon night tour, when they decorate the tree-lined creek with twinkle lights and glow sticks. At high speed, the neon forest makes for a psychedelic ride.

FERNTASTIC SPRINGS

Cool down at the Krause family property, a lush 115 acres featuring 32 bubbling springs. A pool cascades down a fern-covered cliff to the swimming hole. The minerals in the water help create a lush living wall that glistens with moss and exotic plants. Swim in the whimsical cove behind the falls, take a leap off the rope swing, or float down the creek toward the fishing hole.

Glamping Experience

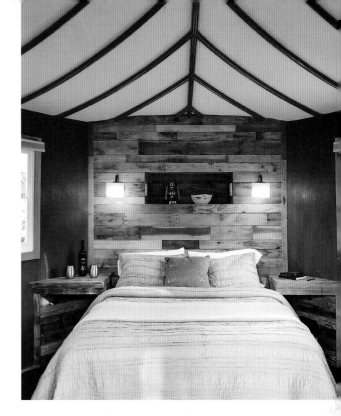

ACCOMMODATIONS: Each treehouse is built to highlight the magnificence of the tree and its location in the ravine. The Nest sleeps six in a series of high-style pods across the branches of a massive cypress; ladders to crow's nests and bridges between suites make this a particularly playful design. The honeymoon-worthy Lofthaven yurt hovers in a steep gully to appreciate the limestone cliffs; its suspension bridge leads to a waterfall-filled bathtub and dining area. The brand-new Yoki is even more luxurious, with extra living space, two-story deck, and soaking tub across the bridge. Juniper and Willow treehouses have leaf-shaped roofs with gold-vein ceilings over their queen beds; bathrooms are a short walk away. The ground-level Ranch House is perfect for parties up to 16.

DINING: The Nest boasts a full kitchen; Lofthaven and Yoki have a kitchenette; Juniper and Willow enjoy a lakeside grill. Fabulous restaurants are nearby, from fine dining to legendary Texas barbecue.

ACTIVITIES: Ziplining, swimming pool, basketball hoop, sand volleyball court, and a pond for swimming, rowing, and rope swinging

HONEYTREK TIP: Yoki stretching your budget? The more economical Juniper and Willow have their own perks, with a virtually private lake and swimming pool.

WINE & DINE

Elevate your canopy experience with the "Romantic Package." Enjoy a wine tasting at the lakeside Stonehouse Vineyards (buy a Cuvee Cuddles for later). Then head to a candlelit dinner at Apis, rated one of the top restaurants in greater Austin. Return to your treehouse, sit on the wraparound porch hovering over the ravine, open that bottle of bubbly, and toast to the high life.

ENCHANTED ROCK

Not just distinct for Texas, this natural granite dome is the second largest in the country. Arrive an hour before sunset and climb its gradual slope and smooth surface, appreciating the cracks that sprout with cacti. It's just a half mile to the top, so you'll have plenty of time to bounce around the moonlike landscape and appreciate the sunset colors over Hill Country.

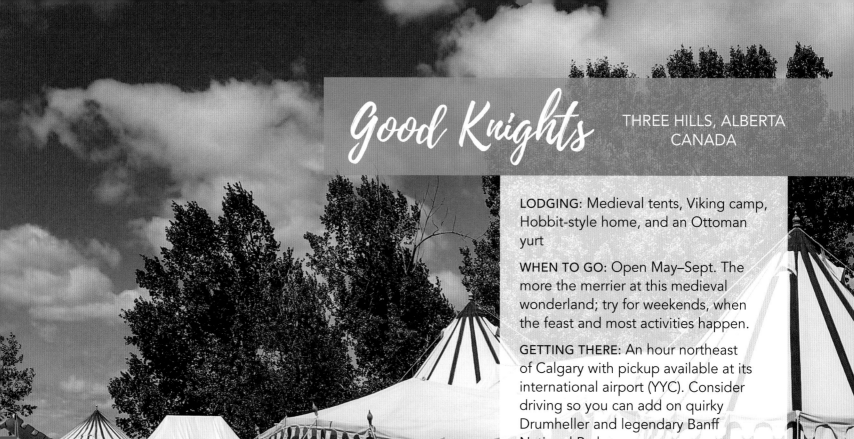

Good Knights

THREE HILLS, ALBERTA CANADA

LODGING: Medieval tents, Viking camp, Hobbit-style home, and an Ottoman yurt

WHEN TO GO: Open May–Sept. The more the merrier at this medieval wonderland; try for weekends, when the feast and most activities happen.

GETTING THERE: An hour northeast of Calgary with pickup available at its international airport (YYC). Consider driving so you can add on quirky Drumheller and legendary Banff National Park.
GPS: 51.6170° N, 113.2262° W

PRICING: Tent for two with breakfast, games, sports, and craft workshops; $75

CONTACT: (403) 443-3660
GoodKnights.ca

NICE TOUCH: Guests are invited to wear any of their 300-plus medieval costumes and warm woolen cloaks.

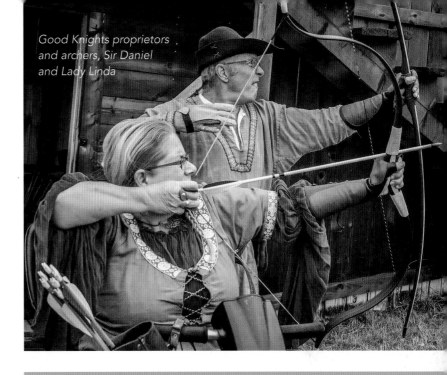

Good Knights proprietors and archers, Sir Daniel and Lady Linda

DRIVING THROUGH THE ALBERTA countryside, you'll see colorful flags flying over the formidable wooden gates. This isn't your typical 21st-century glamping retreat; it's a medieval encampment. Inspired by the fanciful architecture, decor, and pursuits of the French and English nobility during the Hundred Years' War, it's a village of lavish tents where you can play princess, knight, or Elven. No matter which persona you choose from their costume closet, you'll live like a king for the weekend.

Founders Daniel and Linda Smith connected on a high school field trip to the United Kingdom and a fateful feast in a Welsh castle. This sparked a lifelong love of each other and all things medieval. More than attending the occasional Renaissance Faire, they've schooled themselves in the arts of sword fighting, leatherwork, pewter casting, and knighthood. For 10 years they hosted a medieval festival and reenactment on their 18-acre property; their friends enjoyed it so much, they decided to keep the fantasy going all summer long. With the help of their creative community, they converted the barn into a feast hall, built a longbow archery range, sourced antiques, sewed costumes, and built rope beds, all in 14th-century fashion. In 2017 they opened their wooden gates and were an instant hit with the fantasy crowd. But the real test of their success? Skeptics like us. We initially came for the novelty of Good Knights, but after seeing everyone dressed up, learning new skills, and frolicking in merriment (ourselves included), we couldn't resist the magic of this place.

HANDI-CAPABLE

How many people with polio also teach longbow archery? Linda has had mobility issues most of her life, and they've never slowed her down. When the doctor gave her a cane, the intrepid couple took it as a sign to plan a trip around the world. When she could no longer walk well, they took up competitive wheelchair dancing. When it came time to retire from the 9-to-5, they opened up a multi-sport medieval encampment. Today she inspires princesses to become knights—and everyone to be a hero.

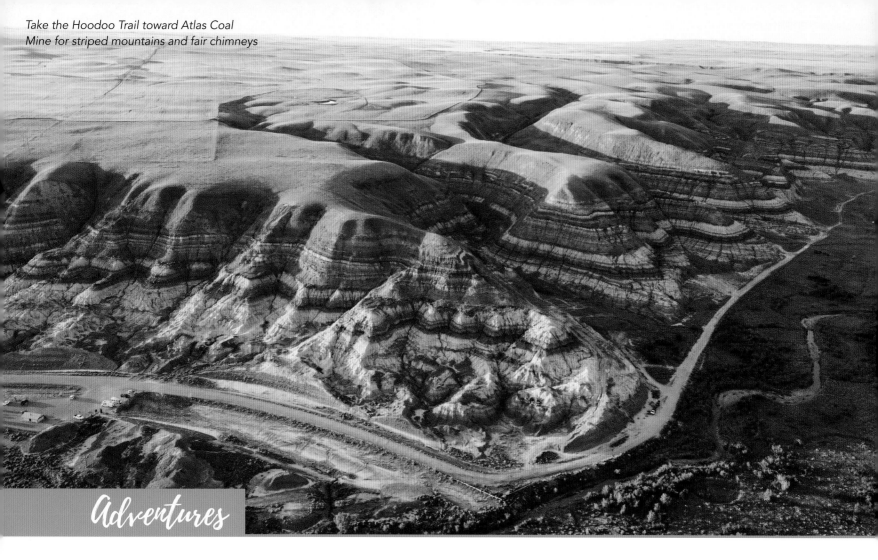

Take the Hoodoo Trail toward Atlas Coal
Mine for striped mountains and fair chimneys

Adventures

SWORD SCHOOL

Put on your chain mail and metal gloves for broadsword training by a true knight (no joke, Sir Daniel has been knighted). Learn the basics of weaponry, armor, and combat with their complimentary hands-on workshop. Schedule your visit when the advanced Knights School is in session to get your sword sparking, or attend a mini-tournament to watch the pros in unscripted combat.

DINOSAURS & BADLANDS

Step further back in time at the Royal Tyrrell Museum of Paleontology. After exploring the world-renowned exhibits and research center featuring 130,000 artifacts dating back 112 million years, join the Dinosite Expedition. Learn about the geology of the Canadian badlands, Alberta, during the Cretaceous period, and how to differentiate fossils from rock.

Glamping Experience

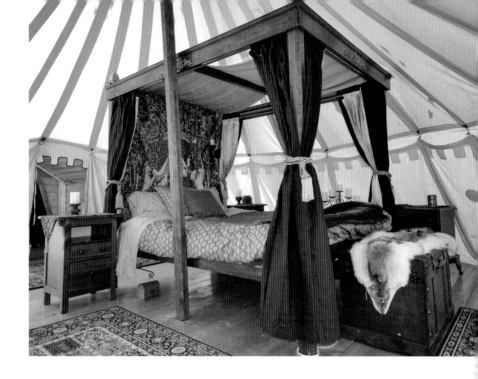

ACCOMMODATIONS: Embellished with ribbons and scalloped awnings, canvas tents of all varieties (French bell, wall, marquee, and pavilion) dot the field. Keeping in medieval style, tapestries adorn the walls, four-poster beds are draped with fur throws, and fireplaces roar. Each tent has its own private bathroom, and all share the delightful indoor and outdoor showers. The Nomad Yurt and four-tent Viking Camp with kitchen are great for large families and groups, while *Lord of the Rings* fans will geek out for the "Burrows," carved into the hillside and decorated to Hobbit standards.

DINING: A bountiful continental breakfast is served in the outdoor pavilion, and the fully equipped kitchen is available anytime. Saturday stays include a five-course feast with live entertainment, dancing between courses, and mead that flows from the hall to the bonfire. Romantic in-tent dinners are available upon request.

ACTIVITIES: Archery, sword fighting, breadmaking, crafting, trebuchet, historic lawn games, and observatory

HONEYTREK TIP: Get into it! Rock the costume closet, learn a new craft, play with swords, and dance like a court jester. There's no judgment here.

DRUMHELLER DIVERSIONS

At the base of an 86-foot-tall *Tyrannosaurus rex*, you can find the city visitor center and climb into Rex's jaws for a pic. Follow the Dino Walk, digging into the area's incredible prehistoric heritage. Pop over to the Atlas Coal Mine to climb Canada's last remaining wooden tipple. Stay after dark for the Drumheller Guided Ghost Walk, led by Lothar the Magnificent.

MEDIEVAL ART CLASS

Good Knights craft classes are available throughout the week, so depending on your interest and timing, you could learn to cast pewter, dip candles, emboss leather, handweave with a lucet, or bake bread in a clay oven. Workshops are around 40 minutes and leave you with a handmade souvenir and newfound skill. Advanced crafters can sign up for multi-hour classes with tutoring throughout the weekend.

Hobbit Homes

Built into the hillside or underground, earth shelters have been around for millennia. However, when *The Lord of the Rings* graced the silver screen, suddenly everyone wanted to stay in a "Hobbit Hole." As a glamping option, these structures are especially whimsical, with circular doors, wonky woodwork, and living roofs. Plus, the soil's insulation is energy efficient! Whether you're an environmentalist or a *LOTR* fan, everyone will remember a night in Middle Earth.

"Le Hobbit," Entre Cîmes et Racines

HIGH AND LOW

Arkansas's Eureka Springs, a Victorian town on the National Register of Historic Places and dubbed "The Magic City," is a fitting place for fantastical glamping. Eureka Springs Treehouses, Caves, Castles & Hobbits began with lodging in the boughs, then decided the high life could also be found underground. They burrowed into their grassy knolls and created a variety of earthen caves. Rocky walls open up to light-filled spaces that look to the forest. Bathrooms have Jacuzzi tubs, and canopies of ivy give the feel of an enchanted forest. While any kid would love this fantasyland (especially the castle-treehouses), it's an adults-only resort and your chance to play make-believe.
ESTreehouses.com

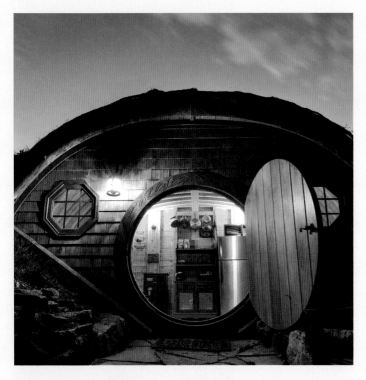

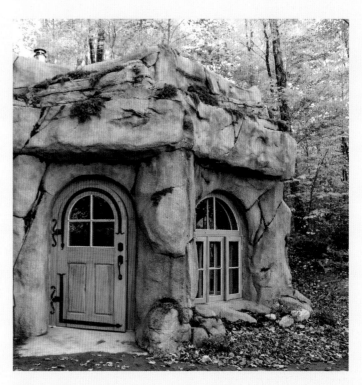

FANTASY FARM

Hobbits know how to live off the land—we should too! Get back to the roots of our food systems with a stay at Forest Gully Farms. The Giffin family has opened up their fanciful 29-acre homestead in Maury County, Tennessee, to share the wonders of food forestry and permaculture. To make the experience extra serene and personal, the two underground cabins, kitchen hut, and bathhouse are only rented to one group at a time (up to eight people, plus little kids). So round up your family and friends for a slumber party in this cozy riverside hideaway. Harvest organic produce and gather fresh eggs for a homemade feast by the fire.

ForestGullyFarms.com

FOREST FIRST

Setting the trend, the founders of Entre Cîmes et Racines were the first in Quebec to build Hobbit-inspired lodging. With a background in sustainable development, the Berger family wanted an organic design to blend with their 175-acre landscape. Of their 12 creative cabins, 3 are built into the grassy hills and tucked in the boulders for a true Shire vibe. Rounded windows, wrought-iron chandeliers, and wood-burning stoves will have you curling up with a sci-fi novel. True to rusticity and sustainability, they have candlelight, composting toilets, and linens for rent (or BYO). Explore their labyrinth, hunt for mushrooms, and lose yourself in their 9 miles of trails.

EntreCimesEtRacines.com

CONSERVATION 9

WE HOPE THERE COMES A DAY when "eco-friendly" is no longer something of note, but the standard. A day when renewable energy is the go-to power source, greywater flushes toilets, reusable jugs are the only plastic water bottles, and veggie scraps find a second life in the garden. We're proud to say that the majority of the properties in this book were designed to tread lightly on the earth. Then there are destinations, like those in this chapter, that go the extra mile to make the world better than they found it. Places like Playa Viva, which looked to biologists, anthropologists, and village leaders before they broke ground, or American Prairie Reserve, which has acquired over 405,000 acres, not just for their guests' enjoyment but also for the rehabilitation of northeastern Montana's fragile ecosystem. Come discover a deeper shade of green.

A 200-ACRE STRETCH OF PACIFIC COASTLINE, backed by estuaries, mangroves, lakes, and mango trees, came up for sale in 2006. This undeveloped beach north of Acapulco was prime for a resort, but to develop such a wild ecosystem required kid gloves. David Leventhal and Sandra Kahn, a couple that grew up in Mexico and worked in the social impact field, bought the land but didn't want to build just another eco-resort. They wanted to restore the area to the paradise it once had been—and a place the locals dreamt it to be. They sent out experts, including biologists and anthropologists, and interviewed the Juluchuca community members. Then they distilled the data into seven core principles to guide the property's restorative development.

"When we first envisioned Playa Viva, we were so excited about the possibilities," said Sandra. "We talked of driving our veggie biodiesel van to pick up guests and making our own soap from the glycerin byproduct." Over a decade later, they successfully use 100% solar power, greywater and blackwater treatment, and organic and local products; they have even achieved that seemingly impossible soap. As green as a property can be, "locals are what create the path to change," said David. Empowering the community through education, health care, economic development, and a pride for their region's natural beauty, Playa Viva and the village are in this together, and they hope you can join in. Pack supplies for the elementary school, help release baby turtles at the sanctuary, and dine on fare from their local network of organic farmers. You never know, giving back could feel as good as Playa Viva's yoga classes and spa treatments.

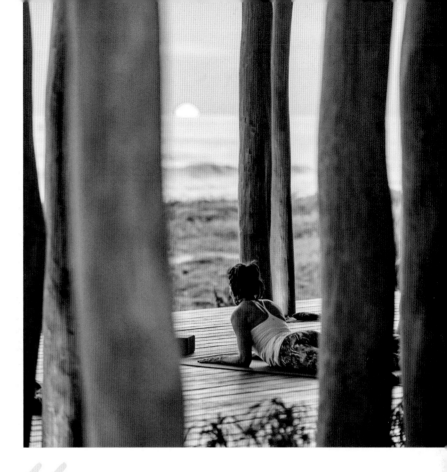

"First, thank you for such a lovely place to sit, breathe, and grow. Second, I wanted to share that I went over to the local school to play some music for the kids. It was the highlight of my time here. If there is ever a way I can continue to help, please let me know.

—Molly, Tennessee

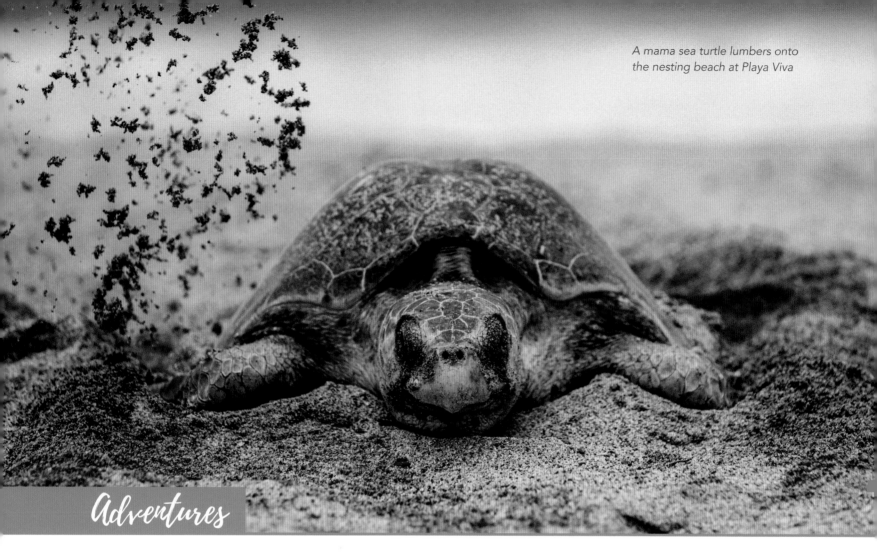

A mama sea turtle lumbers onto the nesting beach at Playa Viva

Adventures

HELP A TURTLE

Join the turtle sanctuary team in gathering freshly laid leatherback and green turtle eggs (Oct–Dec) for their incubation, or help release the adorable newborns into the sea (Nov–Jan). There is some turtle activity throughout the year, so no matter when you arrive, you should take the sanctuary tour and learn about Playa Viva's fantastic conservation efforts.

FARM FUN

Ride an ATV into the mountains to visit a traditional family farm. After a 1.5-hour off-roading adventure, you'll reach the Gutiérrez's home for a field-to-food tour of coffee, cacao, bananas, sugar cane, and more. Admire their incredible self-sufficiency as they prepare a meal, fresh from the garden. Gather around the table for this unique chance to break bread.

Glamping Experience

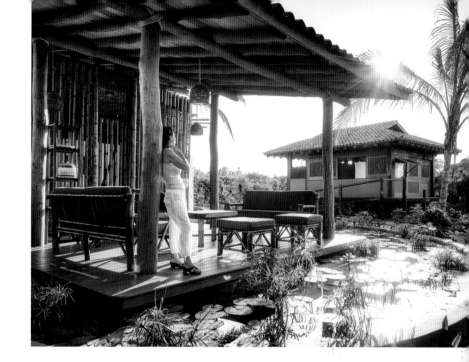

ACCOMMODATIONS: The 12 eco-luxe units with private bathrooms are raised off the ground and enjoy sea views. The freestanding EcoCasitas have sliding walls, while the private casita, deluxe suites, and studios boast a breezy palapa-style construction. Choose from secluded rooms or adjoining accommodations sleeping up to 12 people. For the ultimate Instagrammable pad, snag the tubular treehouse nestled in the palms, made of hundreds of bamboo poles and featuring an in-floor hammock.

DINING: Mexican cuisine with an international and health-conscious twist is made with farm-fresh ingredients four times a day (of course you need breakfast before and after yoga). Meals are served family style; for more privacy, just request a table in the beach observatory. Get to know the kitchen crew; they'll be happy to give you a snack or an impromptu cooking class.

ACTIVITIES: Yoga, spa, horseback riding, archaeology museum, ATVing, fishing, scuba, snorkeling, surfing, farm tours, and volunteering opportunities

HONEYTREK TIP: Save a little space in your luggage so you can "Pack for a Purpose." See Playa Viva's latest supply list for the local school, health clinic, and community yoga program.

WELLNESS WORKSHOPS

Deepen your yoga practice with a multiday workshop. Choose from more than 20 retreats throughout the year, combining yoga with everything from massage to Ayurveda, aerial arts, meditation, Qigong, and living with gratitude. Open-air classes are interspersed with walks on the beach, relaxation, and healthy meals. Check PlayaViva.com/retreats for the timing and teaching that speaks to you.

SHARE A SKILL

Are you a singer, chiropractor, teacher, soccer player, or lover of community? Then coordinate with Playa Viva's social and environmental impact manager to share your talent with the Juluchuca village. If nothing else, see the incredible work the long-term volunteers are doing at the clinic, school, salt cooperative, and organic farms—it will likely inspire you to lend a helping hand.

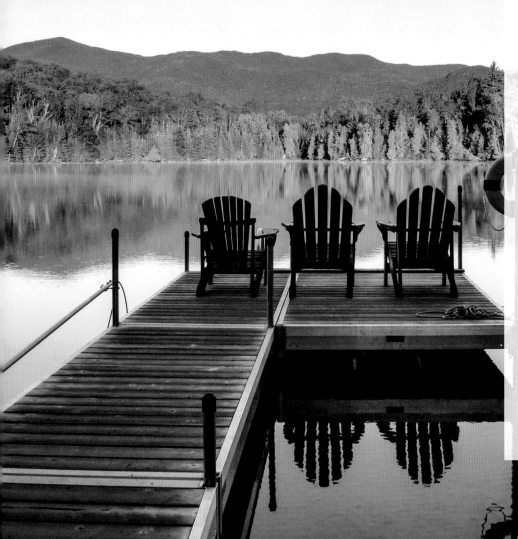

Adirondak Loj

LODGING: Historic lodge, cabins, yurts, wall tents, and lean-tos

WHEN TO GO: A four-season destination. The lodge and cabins are ready for even the snowiest months, while the glampground is open May–Oct.

GETTING THERE: Two and a half hours north of Albany and 45 minutes from Adirondack Regional Airport (SLK). Train and bus service runs to Lake Placid, and the Loj is just a 15-minute cab ride from town.
GPS: 44.1826° N, 73.9663° W

PRICING: Lodging for two; $50

CONTACT: (518) 523-3441
ADK.org

NICE TOUCH: The Loj offers complimentary naturalist-led hikes, lectures, even campfire storytelling with s'mores.

DESPITE HAVING MORE THAN 200 STATE PARKS, New York does not have a single national park. It's always been up to New Yorkers to protect their wilderness, and the founders of the Adirondak Loj at Heart Lake have been doing just that since 1878. Henry Van Hoevenberg, a trekking guide, inventor, and telegraph operator, had the novel idea to build a lodge where people could enjoy nature in luxury. In the center of the Adirondacks' 6-million-acre preserve, the lodge was built in memory of his true love, Josephine (whom he met while leading a hike on the adjacent mountain, now named Mount Jo). Not only a pioneer in glamping, he was also among the first to build in an intentionally rustic style, leaving bark on the logs and designing with nature's wild beauty in mind. The largest log structure of its time, it included a 70-foot observation tower. In 1903 a forest fire destroyed the lodge and over 600,000 acres, but the devastation awakened the senses of outdoor enthusiasts. In 1922 the Adirondack Mountain Club (ADK) was founded with 208 charter members. Today the statewide organization has more than 30,000 members, and ADK even has an environmental advocacy wing in Albany. Though when it comes to enjoying the wilderness and educating the public on forest preservation, its heart remains at the Loj.

Start your Adirondack journey at the High Peaks Information Center to learn about their extensive offering of guided hikes, backcountry workshops, wilderness trips, and a variety of accommodations. Stay in a wall tent, a tricked-out cabin, or the full-service lodge; get even closer to nature in a classic lean-to surrounded by the Adirondacks' 46 peaks.

WILDERNESS SURVIVAL 101

To be an instructor of a wilderness workshop at ADK, you should have a few credentials—like having thru-hiked the entire 2,653-mile Pacific Crest Trail or walked the length of New Zealand. The highly qualified Tyler and Seth led our two-day "Winter Survival 101" course, teaching us everything from the Leave No Trace principles to treating frostbite. But mountain men can't be confined to the classroom; they had us snowshoeing up icy mountain faces, navigating the dense woods with a compass, and building quinzhee snow shelters. We left feeling like we could take on Everest—but with the smarts to know we should start with Mount Jo.

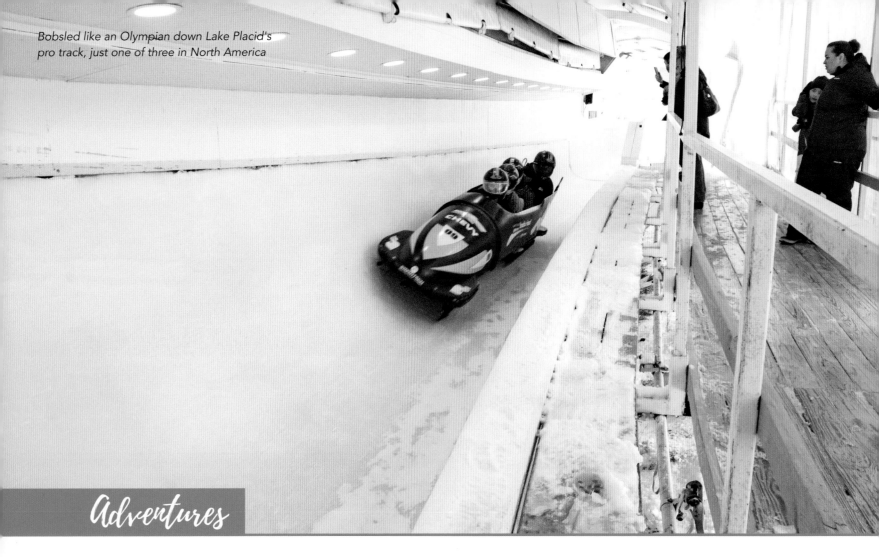

Bobsled like an Olympian down Lake Placid's pro track, just one of three in North America

Adventures

BAG A 46ER

The trailhead to both of New York's two tallest mountains leaves from the High Peaks Information Center. Opt for the shorter but equally challenging and impressive Algonquin hike (8.5 miles round-trip). When you reach the halfway mark at a gorgeous waterfall, take a break—it's about to get steep. Rock scramble your way up the cone to enjoy panoramic views at 5,115 feet.

WALK LIKE AN OLYMPIAN

Explore the 1980 Winter Olympics facilities and premier training grounds for future champions. Maximize your time with the Olympic Sites Passport, which includes tours of the 26-story ski jump tower and ice luge track, Whiteface Mountain gondola, Olympic Museum tickets, ice skating on the oval ring, plus a discounted ride down the top-speed bobsled track.

Glamping Experience

The cozy lobby of the 1920s lodge

ACCOMMODATIONS: At the center of the expansive grounds is the 1920s lodge with its inviting stone fireplace, stained-glass windows, and sofas with pillows embroidered by its members. In the lodge you can choose from a quaint private room or shared space; all have communal bathrooms. Three cabins, sleeping four to 16 people each, have comfortable bedrooms, full kitchens, and bathrooms. The Wilderness Campground has classic tent sites, plus seven canvas wall tents and 16 log lean-tos (BYO bedding).

DINING: Family-style meals are served three times daily at the Adirondak Loj (breakfast included for lodge guests). No dehydrated chili and gorp here; everything is home-cooked and can accommodate dietary restrictions. May–Oct, the Hungry Hiker snack bar can fuel you up before or after the trail.

ACTIVITIES: Guided hikes, backcountry skiing, snowshoeing, canoeing, swimming, standup paddleboarding, educational programs, naturalist walks, lecture/entertainment series, kid and teen programs, multiday trips, and outdoor skills workshops

HONEYTREK TIP: Come midweek for fewer crowds and amazing deals on full room and board in the lodge.

GET WILD

Natural history museums should all be this interactive. At the Wild Center you can climb four-story treehouses, make clouds, blow snow, paddle canoes, and commune with 50 animal species in a 115-acre forest, all while learning about the Adirondacks' unique ecosystem. Check their calendar for an impressive selection of events, from forest bathing to Native American storytelling.

MAP & COMPASS FUNDAMENTALS

Learn the basics of field navigation—a vital skill in backcountry preparedness (something few of us have once our cell phone dies). In this full-day course, ADK's expert guides will teach you map interpretation, compass use, backcountry travel, and how to follow bearings to confidently traverse a landscape. (Backpacking and survival courses also touch on basic navigation.)

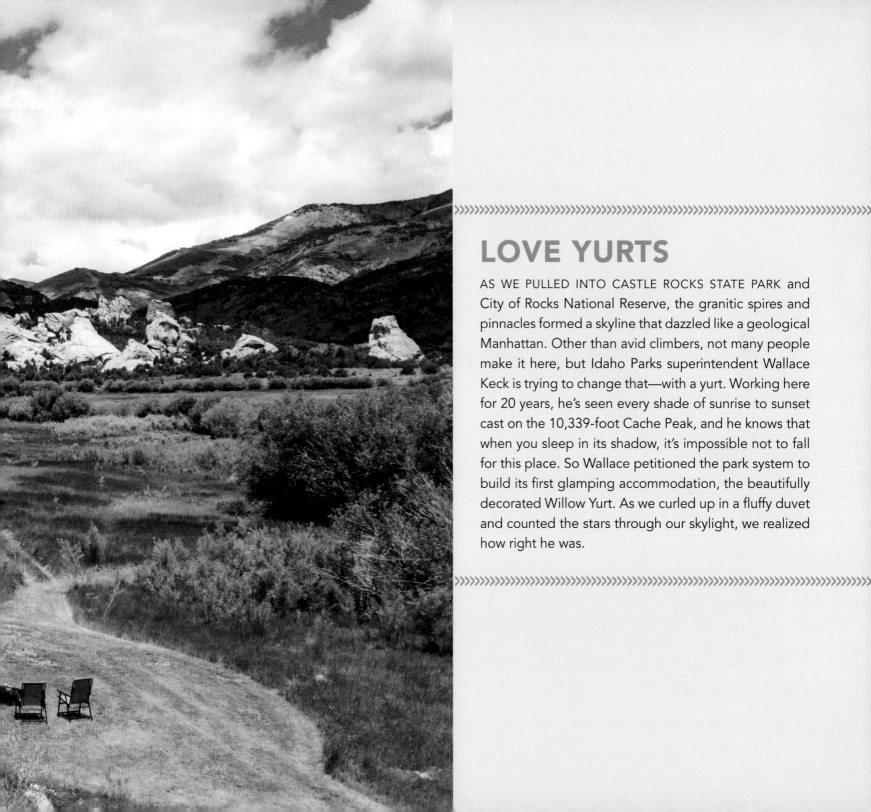

LOVE YURTS

AS WE PULLED INTO CASTLE ROCKS STATE PARK and City of Rocks National Reserve, the granitic spires and pinnacles formed a skyline that dazzled like a geological Manhattan. Other than avid climbers, not many people make it here, but Idaho Parks superintendent Wallace Keck is trying to change that—with a yurt. Working here for 20 years, he's seen every shade of sunrise to sunset cast on the 10,339-foot Cache Peak, and he knows that when you sleep in its shadow, it's impossible not to fall for this place. So Wallace petitioned the park system to build its first glamping accommodation, the beautifully decorated Willow Yurt. As we curled up in a fluffy duvet and counted the stars through our skylight, we realized how right he was.

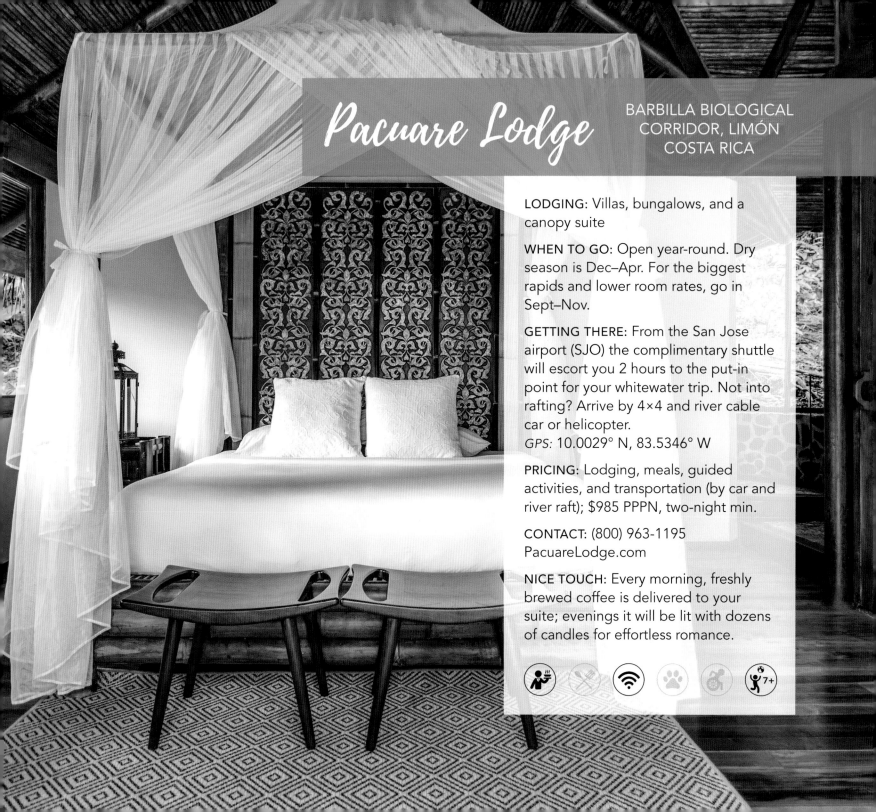

Pacuare Lodge

BARBILLA BIOLOGICAL CORRIDOR, LIMÓN COSTA RICA

LODGING: Villas, bungalows, and a canopy suite

WHEN TO GO: Open year-round. Dry season is Dec–Apr. For the biggest rapids and lower room rates, go in Sept–Nov.

GETTING THERE: From the San Jose airport (SJO) the complimentary shuttle will escort you 2 hours to the put-in point for your whitewater trip. Not into rafting? Arrive by 4×4 and river cable car or helicopter.
GPS: 10.0029° N, 83.5346° W

PRICING: Lodging, meals, guided activities, and transportation (by car and river raft); $985 PPPN, two-night min.

CONTACT: (800) 963-1195
PacuareLodge.com

NICE TOUCH: Every morning, freshly brewed coffee is delivered to your suite; evenings it will be lit with dozens of candles for effortless romance.

THERE IS NO ROAD TO PACUARE LODGE—a swift river is your highway and an oar your engine. Whitewater raft through the Barbilla Biological Corridor, one of the largest networks of protected wilderness in Central America, passing countless waterfalls and lush green cliffs until this National Geographic Unique Lodge of the World peeks through the rainforest. Roberto Fernández, the founder and a native Costa Rican, grew up running rivers with a pool floaty and an airline life vest. He took his first job as a river guide and began dreaming of his own sustainable adventure company and lodge. In the 1980s tourism in the country was developing quickly without much foresight. "It was as if the river was constantly reminding me to relieve the environmental problems we were causing," said Roberto. He seized an opportunity to buy 5 acres in the Pacuare River Valley and today owns 2,075—protecting the rainforest, the indigenous Cabécar footpaths, and the endangered jaguar habitat (a conservation initiative in partnership with the University of Costa Rica).

Check into your beautifully appointed bungalow, villa, or canopy suite and you'll see that Roberto is building as much for his guests as for Mother Earth. Mesh-screen walls are made for panoramic views and to amplify the jungle's symphony. Hydro and solar power the lodge, while in-room light is cast by a romantic abundance of candles. Why is it good to understand how green Pacuare's initiatives are? Because otherwise, in a place this luxurious, you'd never know.

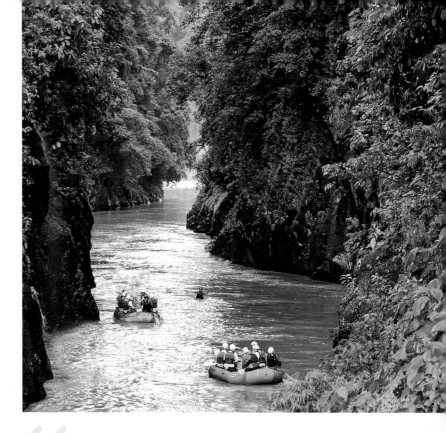

"This is truly one of the most spectacular places on Earth, not only because of the richness of the landscape and biodiversity, but also the people. The humor, knowledge, and wonderful outlook on life of the lodge staff has made this visit one that has been filled with wonder, laughter, and true appreciation for the pura vida.

—Erin, Colorado

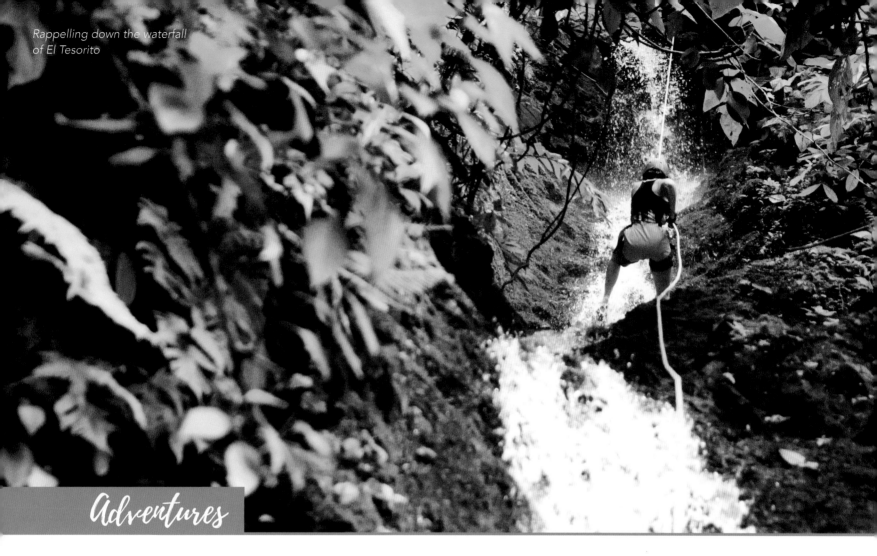

Rappelling down the waterfall of El Tesorito

Adventures

CANYONEERING EL TESORITO

Flowing through the rainforest into a narrow gorge, El Tesorito Creek is your source for a multifaceted adventure. Head to the canyoneering base camp, where you'll gear up and learn the basics for maximum safety and fun. Then you're off like Tarzan, rock climbing down waterfalls, sliding along cables, swinging through the jungle, and rappelling down a 90-foot rock face.

SUSTAINABILITY TOUR

It's not easy being green. Learn about Pacuare's sustainability program, including renewable energy, water treatment, community programs, and more with their fascinating behind-the-scenes tour. Visit their micro-hydro turbine, recycling center, and Jaguar Hall to learn about their extensive conservation efforts and national monitoring program for this endangered feline.

Glamping Experience

ACCOMMODATIONS: Melding with the natural surroundings, free-standing suites with hand-woven palm roofs are strategically positioned by the river or nestled in the rainforest. High ceilings, teak floors, and screened-in walls bring the natural environment closer, while outdoor showers, private terraces, spring-fed plunge pools, lounge chairs, and hammocks make spending time outdoors a joy. Each of the plush villas is more than 2,500 square feet, with The Jaguar being the grandest. However, the smallest accommodation may be the most sought after, with its private suspension bridge to the Canopy Suite. All villas have Beautyrest mattresses and Egyptian cotton linens.

DINING: Pacuare takes great pride in growing the majority of its food and working with neighboring communities to develop sustainable organic farming practices. Costa Rican fusion cuisine is served three times a day in their open-air dining room.

ACTIVITIES: Canyoneering, ziplining, river rafting, kayaking, hiking, birding, and spa treatments

HONEYTREK TIP: When you go ziplining, be sure to request lunch in the ceiba tree. You'll soar into your private dining room and enjoy a multicourse meal 60 feet up in the canopy.

INDIGENOUS WATERFALL TRAIL

Begin with a steep climb through the rainforest to the Cabécar Indians' ancestral route. Switchbacks lead you to the "path of the puma" (keep an eye out for big cats) and an impressive waterfall. Enjoy a dip and picnic lunch before hiking down to an indigenous village to experience the Cabécar way of life. Follow a new trail home to complete a full day of culture and adventure.

COLONIAL CARTAGO

En route to Pacuare, and just 16 miles east of San Jose, sits the country's original capital from 1574 to 1824. Unlike most Costa Rican cities, Cartago has the old-world vibe you dream about in Central America. Wander the basilica, Santiago Apóstol Parish Ruins, municipal museum, and the central market (especially lively on Thursday and Saturday), all to the backdrop of Irazú Volcano.

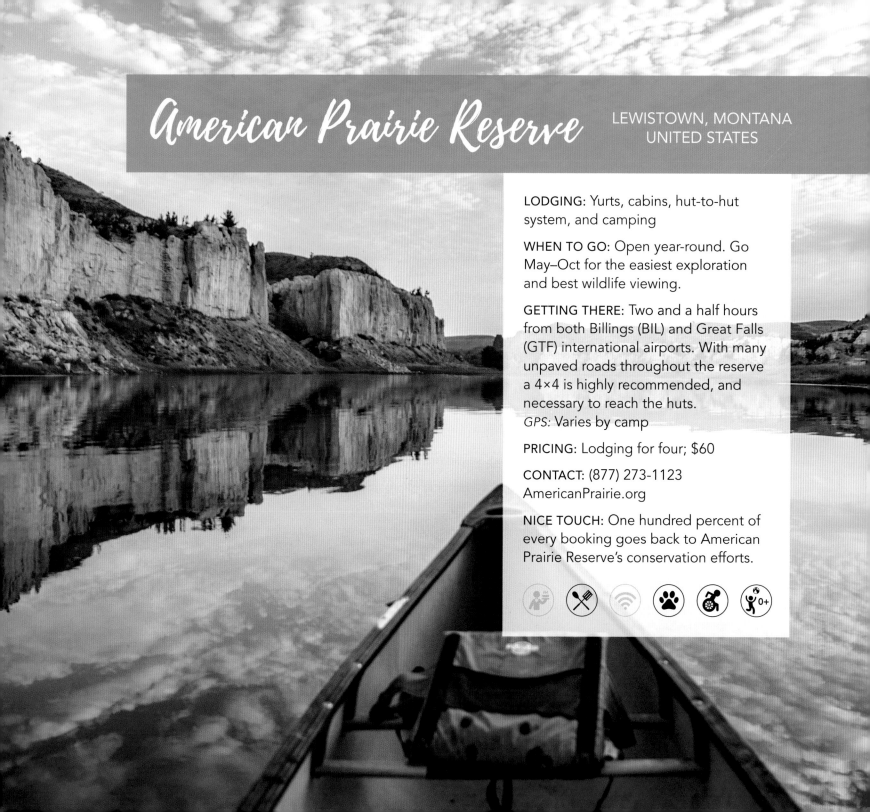

American Prairie Reserve

LEWISTOWN, MONTANA
UNITED STATES

LODGING: Yurts, cabins, hut-to-hut system, and camping

WHEN TO GO: Open year-round. Go May–Oct for the easiest exploration and best wildlife viewing.

GETTING THERE: Two and a half hours from both Billings (BIL) and Great Falls (GTF) international airports. With many unpaved roads throughout the reserve a 4×4 is highly recommended, and necessary to reach the huts.
GPS: Varies by camp

PRICING: Lodging for four; $60

CONTACT: (877) 273-1123
AmericanPrairie.org

NICE TOUCH: One hundred percent of every booking goes back to American Prairie Reserve's conservation efforts.

BE A PART OF SOMETHING BIG—like 405,169 acres big—and one of the most ambitious conservation projects of the 21st century. In a developed world where many habitats have changed to the point of no return, The Nature Conservancy saw hope in Montana's Northern Great Plains. Identified as just one of four places in the world where the landscape and wildlife could be conserved on an ecosystem scale, the area became a top priority in 1999. The land surrounding the existing national wildlife refuge and national monument was virtually pristine but disjointed by cattle ranches, keeping wildlife and outdoor enthusiasts from roaming freely. In 2001 Montana native Sean Gerrity and conservation biologist Curt Freese hatched the monumental plan of linking 3 million acres of public and private land into one nonprofit: American Prairie Reserve (APR). "Imagine Yellowstone National Park in 1880," said Mike Kautz, APR's director of recreation. "That's how wild this is." And the goal is to get wilder. Since bison were reintroduced to the area in 2005, the small herd has grown to more than 800. Prairie dog towns outnumber the human variety, and elk come out in force each mating season.

Lewis and Clark blazed their trail across this very land, and when it comes to ecotourism, you'll be blazing one too. With APR's brand-new cabins and hut-to-hut trail system, you'll be among the first to stay in this vast wilderness, and you need to be a self-sufficient explorer. If a full-service experience is in the budget, fabulous outfitters are available, and APR's luxurious Kestrel Camp comes with a private chef and PhD biologist. Choose your level of comfort and find your spirit of adventure.

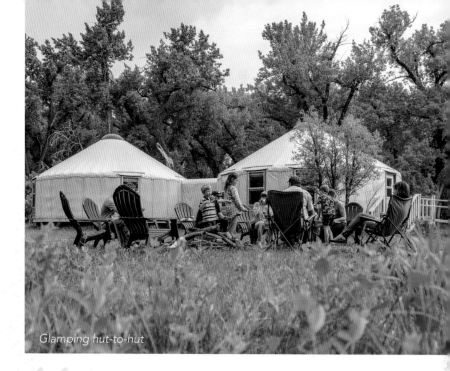

Glamping hut-to-hut

" I actually woke up to a bison napping by my tent. The animals are far more relaxed here than national parks because there aren't loud crowds and they have enough space to live naturally, as they did before. The skies are an ever-changing watercolor, and the stars are incredible. I can't say enough about this peaceful, rich reserve and the friendly people who make it happen.

—Skip, Washington

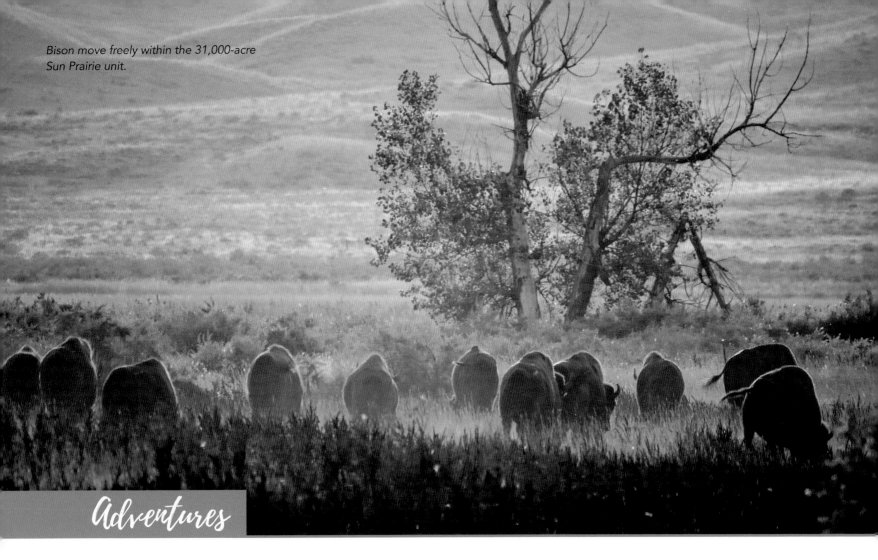

Bison move freely within the 31,000-acre Sun Prairie unit.

Adventures

SAFARI THE AMERICAN SERENGETI

Wildlife can be found all over the reserve. To increase your sightings, head out in the early morning or late afternoon to the Sun Prairie Unit to find roaming bison (with calves in spring and battling bulls in late summer) and the Burnt Lodge region for bighorn sheep and bobcats. Pack your binoculars and field guide, and see how many of the 150 bird species you can spot.

CANOE LIKE LEWIS & CLARK

Explore the Upper Missouri River Breaks National Monument with the full-service outfitters at Lewis & Clark Trail Adventures. They run incredible multiday trips packed with dramatic scenery and historic sites, including a route that hikes from APR's Founders Hut to Craighead Hut, continues by canoe down the Judith River to the Dog Creek Hut, and finishes paddling among the sweeping badlands scenery of Stafford Ferry.

Glamping Experience

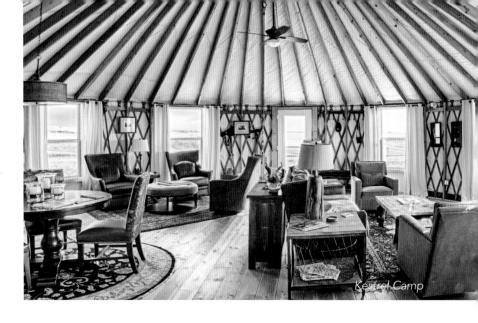
Kestrel Camp

ACCOMMODATIONS: From classic campgrounds to one of North America's most exclusive safari camps, APR caters to a range of adventurers. Huts are made of three connecting yurts, with four bedrooms, bathroom, living quarters, and kitchen. Embark on an independent hut-to-hut journey, or enlist Lewis & Clark Trail Adventures for gear, meals, and guides. The Antelope Creek Campground at Mars Vista opened in 2019 with four cabins (BYO bedding), powered RV sites, tent platforms, and a bathhouse. Kestrel Camp offers five yurt suites, a posh lounge area, and a dining room for private groups of 8 to 10. Staffed by acclaimed chefs, PhD safari guides, and housekeeping, this ultra-luxe experience doubles as a generous donation to the nonprofit.

DINING: Hut kitchens are fully equipped with fridge, stove, oven, and cookware; just remember to bring water. Antelope Creek Campground offers grills and potable water to get your cookout going. At Kestrel Camp, let them know your dietary restrictions and they'll prepare the finest cuisine.

ACTIVITIES: Hiking and biking trails, canoeing, horseback riding, wildlife viewing, and education center

HONEYTREK TIP: To properly prepare yourself for a journey into this remote wilderness, visit AmericanPrairie.org/your-safety.

THE BIRTHPLACE OF MONTANA

The terminus of three wagon trails and the innermost steamboat port, Fort Benton played a key role in Western exploration. A National Historic Landmark, it's often voted one of prettiest towns in the United States. Visit the Fort Benton Museums & Heritage Complex, stroll the state's oldest steel bridge, and grab a whiskey on the 19th-century's "bloodiest block in the West."

MOUNTAIN BIKE HEAVEN

Load up the bikes, APR's trails abound! Explore the 50,000-acre PN Ranch, the site of an 1860s homestead, Montana's first military outpost, and one of the earliest discovery sites in North America. From the Sun Prairie Unit, take in striking scenery and stop by the Enrico Science and Education Center to learn about the reserve's latest developments.

Posh Parks

While many national and state parks are content with the camping status quo, a number of savvy park systems are shaking it up with style. They know that more creative and luxurious accommodations will attract a wider subset of campers and connect these visitors with the environments they are trying to protect. If it takes a comfy bed to engage people with conservation, these rangers say— bring on the duvet!

Castle Rocks State Park, Idaho

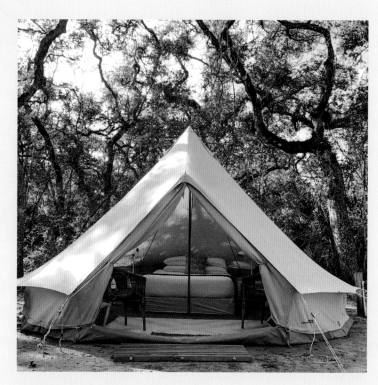

FANCY CAMPS

Florida's Panhandle has white sand and turquoise beaches that rival the Caribbean, though instead of letting mega resorts build up the coastline, the state has protected the finest sections. People love to camp along the dunes of Topsail Hill Preserve and Grayton Beach State Parks, but savvy vacationers book through Fancy Camps. Using the existing campsites along miles of protected beach, they set up bell tents with pillow-top mattresses, sisal rugs, heating/cooling units, and twinkly lights for proper glamping. Have a special request or occasion? They're happy to adorn tents with birthday balloons or romantic bouquets; as they say, "No request is too big or too small!"
FancyCamps.com

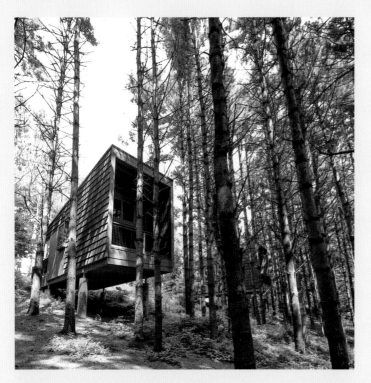

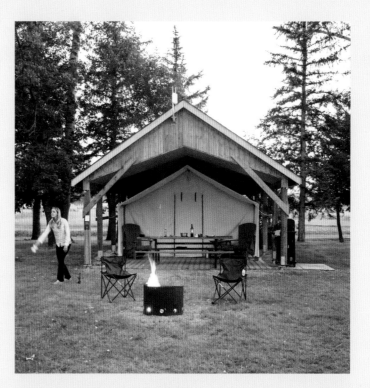

TINY PARK, BIG DREAMS

New parks don't get added every day, so when Minnesota's Dakota County got the go-ahead for their first in 30 years, they pulled out all the stops. Working with Minneapolis's HGA Architects, Whitetail Woods Park elevated the standard cabin concept into three mod treehouses. Perched atop 14-foot stilts, with floor-to-ceiling windows and a spacious porch, they offer the best views of the forest. Their striking exterior, paired with a warm cedar interior, have indeed made a splash—they even received an award from the American Institute of Architects. So if you've never considered the Farmington wilderness for vacation, now you have the perfect reason.
www.Co.Dakota.MN.us/parks/parkstrails/whitetail woods

DINOSAURS & DUVETS

Ever dreamt of digging for dinosaur fossils and discovering the land before time (only to realize you needed a doctorate and a remote desert base camp)? Well, Alberta's Dinosaur Provincial Park lets you satisfy those ambitions in an overnight stay. This UNESCO World Heritage Site, an unrivaled destination for its volume and quality of Cretaceous fossils, now offers glamping tents in the Canadian Badlands. No master's degree or sacrifices necessary, you'll have a stylish bedroom, spacious porch with barbecue, and a cafe if you don't feel like grilling. After a great night's sleep, go on a fossil safari or an all-day excavation with a paleontologist!
AlbertaParks.ca/parks/south/dinosaur-pp

Vacation Matchmaker

PAIR YOUR TRIP STYLE WITH THE FEATURED DESTINATIONS THAT EXCEL IN YOUR AREAS OF INTEREST.

FEATURED PROPERTIES	ROMANTIC	FAMILY FRIENDLY	ADVENTURE	SPA-TASTIC	CULINARY	ACTIVITY PACKED	WINTER GETAWAY	SUPER DEAL
Adirondak Loj (p. 208)		●	●			●	●	●
American Prairie Reserve (p. 218)		●	●					●
Arctic Watch Wilderness Lodge (p. 50)			●		●	●		
Asheville Glamping (p. 152)	●	●						
Bahia Zapatera (p. 98)	●	●	●			●	●	●
BearCamp (p. 64)			●			●		
Bull Hill (p. 170)		●	●			●		●
Camp Cecil (p. 60)	●		●		●	●	●	
Cassiar Cannery (p. 94)		●						●
The Cozy Peach (p. 28)		●			●			
Cypress Valley (p. 192)	●	●	●					
Depot Lodge (p. 104)		●						●
Dunton Hot Springs (p. 174)	●		●	●	●		●	
Firelight Camps (p. 148)	●			●	●			
Fronterra Farm (p. 38)	●	●			●			
Good Knights (p. 196)		●				●		
Grand Canyon Western Ranch (p. 160)		●	●			●	●	

FEATURED PROPERTIES	ROMANTIC	FAMILY FRIENDLY	ADVENTURE	SPA-TASTIC	CULINARY	ACTIVITY PACKED	WINTER GETAWAY	SUPER DEAL
Great Huts (p. 108)	•	•	•	•	•		•	•
Honaunau Farm (p. 42)	•	•		•	•		•	•
Hôtel de Glace (p. 182)		•	•	•		•	•	
Luna Mystica (p. 138)	•							•
Maine Huts & Trails (p. 130)		•	•				•	•
Mendocino Grove (p. 142)	•	•						•
Natura Cabana (p. 72)	•	•		•	•		•	
Nomad Ridge at The Wilds (p. 54)	•		•			•		•
Pacuare Lodge (p. 214)	•	•	•	•	•	•	•	
Panacea at the Canyon (p. 82)	•			•	•	•		
Playa Viva (p. 204)	•	•	•	•	•		•	•
Ranch at Rock Creek (p. 164)	•	•	•	•	•	•	•	
Solitude River Trips (p. 116)		•	•		•	•		
Sou'wester Lodge (p. 86)		•		•	•		•	•
Teton Wagon Train (p. 126)		•	•			•		
Treebones Resort (p. 76)	•			•	•		•	
Trek Guatemala (p. 120)			•		•	•	•	
Willow-Witt Ranch (p. 32)	•	•			•			
Winvian Farm (p. 186)	•	•		•	•		•	

Get Glamping

NOW THAT YOU KNOW WHERE you'd like to go glamping, let's make it happen! One of the best things about this style of travel is that you don't need a lot of prep to have a smooth trip, but there are a few things to know when it comes to planning—from packing to best practices. Plus, we want you to feel empowered to go beyond the destinations in this book for a lifetime of *Comfortably Wild* adventures.

PREPARE

How to prepare for a glamping vacation largely depends on the property's amenities, region, and time of year. We tried to cover the nuts and bolts within each feature, though it's always good to dig deeper into your prospective accommodation's website and give them a call for any specific questions. These are the topics to keep in mind.

WEATHER: This plays a big role in any vacation, particularly one spent in the outdoors. To help you decide when to go and to be more informed about your chosen season, check the monthly historical averages for temperature. Note the nighttime lows, since glamping structures tend to be light on insulation. Even if it looks like nominal rainfall, it's good to have a fun contingency plan.

DINING: Does your chosen glamping spot have a restaurant, cooking facilities, or nearby dining options? They might have all three, but to what degree? If they have a restaurant, what meals do they serve? If they offer a kitchen, what kind of supplies do they have to get you started? See if they have a camp store, and find out how close they are to supermarkets and good restaurants, in case you need anything or feel like dining out.

POWER: Campfires, candlelight, and lanterns all add to the romance of glamping, but you might want a bit of electricity too. If your site doesn't have power, what do they offer for lights and charging? They'll have more than enough lighting to keep you from tripping on the bed, but their responses to your queries could inform your packing choices.

CONNECTIVITY: Disconnecting from tech is a big part of the experience, though it's still good to know the property's Wi-Fi and cell tower situation. In case Mother Nature starts your tech detox early on those back roads, jot down the property's phone number and screenshot or print *their* directions to camp (Google Maps isn't all-knowing) before you leave civilization.

INSIDER INTEL: After you do a little digging on the property's website, give them a call to get the best information for your interests and needs. Their team knows which sites have the best views, least noise, and most privacy. Or maybe you want to be near the social areas and the closest bathroom. Looking to stay awhile or make it a road trip? Properties often have custom guides they can e-mail you or give a few tips to build out your itinerary.

PACKING

This isn't traditional camping—no need to pack the car to the gills or pay the airline for oversized luggage. The property is doing all the heavy lifting, so you can get back to the simple pleasures—spending time with family, friends, and the trees.

LUGGAGE: Keep that wheelie suitcase in the closet—you are leaving the land of sidewalks and wall-to-wall carpet. A duffel bag or backpack will let you navigate dirt roads, tree roots, and river stones without hitting any bumps. In addition to your primary luggage, everyone needs a good daypack for excursions. Lightweight, easy-access pockets, back support, and a water-bottle holder are essential features. Throw in a couple thin, sturdy tote bags for beach days, picnics, shower runs, and overflow.

CLOTHING: Versatility and comfort matter most. Layering is the age-old strategy to prepare for temperature swings and nature's curveballs. If you feel like playing up the glamour, throw in a fedora, sundress, or your most stylish plaid accessory. It never hurts to have one nice outfit when you feel like dressing up for dinner or having a night on the town. And for properties with a restaurant on-site or a more social component, you might want a couple of cuter outfits to mix it up.

At the top of the packing list is clothing that protects you from the elements and gives you opportunities for adventure: raincoat, sunhat, beanie, gloves, hiking boots, flip-flops (for beaches or communal showers), exercise clothes, and bathing suit (you don't want to miss that hot tub or waterfall jump).

Find more packing tips and lists at HoneyTrek.com/ComfortablyWild.

GEAR ESSENTIALS

While these properties have more than your basic needs covered, you don't want to be tethered to camp. You want to be ready to explore the trails, paddle across the lake, and take a day trip without looking back. If you're staying at an all-inclusive, most of this gear would be overkill, but good for any glamper to know!

WATER BOTTLES: We love our sturdy glow-in-the-dark Nalgene and our collapsible 2-liter Platypus that packs down thinner than a pancake. An insulated bottle is also great for coffee to go or for slow-sipping a hot toddy around the fire.

WATER PURIFIER: When spending time in the wilderness or traveling abroad, we always have our SteriPEN. Fill your bottle from any tap or stream, then dip in this ultraviolet light, swirl it around for 48 seconds, and kill 99.9% of protozoa, bacteria, and viruses.

LIGHT: No matter where you stay, the small but mighty headlamp is great to have on hand for sunrise and evening hikes, late night bathhouse trips, or rummaging through your bag. For easy ambience, try the Luci inflatable solar lantern and a three-wick scented candle.

POWERBANK: To charge your phone (aka camera) while you're out adventuring, throw in a portable USB powerbank. If you're traveling as a family, having one more diesel charger (at least 20,000mAh of juice) with multiple ports will be handy in the tent.

BASIC FIRST AID KIT: Pick up a travel-size kit, or build your own with Band-Aids, disinfectant, Neosporin, anti-itch cream, aloe vera gel, and ibuprofen (for the wine that's in your future).

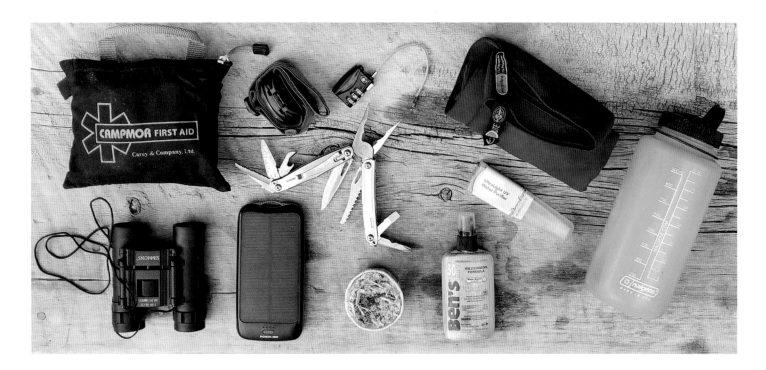

QUICK DRY TOWEL: Even if your glamping retreat provides fluffy white linens, these lightweight microfiber towels are a no-brainer. They pack down small and are antimicrobial, so they're perfect for toweling off at the hike-in swimming hole or laying down at a picnic spot.

BUG REPELLENT: Prevent pesky skeeters with your favorite repellent. (We start with a natural bug spray but keep DEET on hand.) A great option for hanging around camp and keeping the film off your skin is a Thermacell portable bug repeller, a butane device that creates a 15 × 15-foot protection zone. In areas with Lyme disease, spray your shoes and pants with permethrin; it lowers the chance of tick bites by over 70%.

MULTI-TOOL: A Swiss Army knife or Leatherman can pack over a dozen handy tools into a pocket-size device. Knife, scissors, pliers, bottle opener, file, screwdriver, mini saw, and more will help you get in touch with your inner outdoorsman, and if nothing else, open your beer.

LUGGAGE LOCK: Considering most glamping tents don't have locks, it's good to bring your own for peace of mind. We like Pacsafe's three-dial cable lock. Slide it through the door zippers, or just put one on your most valuable bag of stuff.

FIRESTARTER: To look like an Eagle Scout (even if you haven't made a campfire in years), buy a few Lightning Nuggets. Place this nontoxic ball of compressed pine and paraffin wax on your wood stack to give it time to thoroughly catch for a badge-worthy fire.

BINOCULARS: A pair of 10×42mm binoculars will significantly increase the quality of your wildlife sightings, not only for their magnification but also your stealthiness as you observe animals from a distance. *Bonus:* It doubles as a basic telescope.

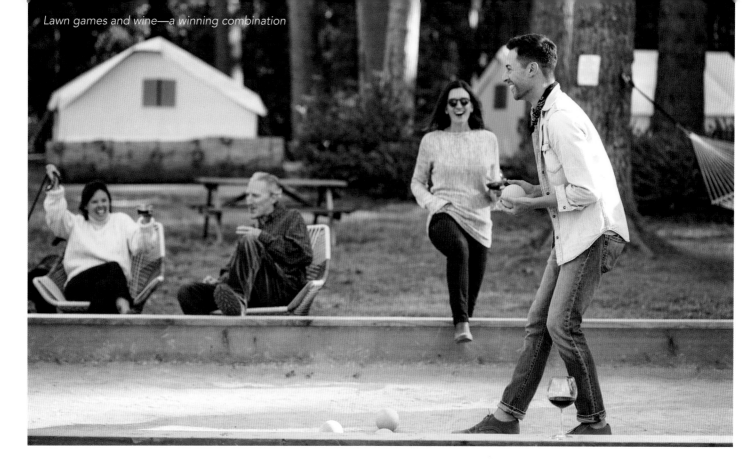

Lawn games and wine—a winning combination

DIVERSIONS

When you're at your desk and daydreaming of vacation, what do you see yourself doing—are you in a hammock reading a book, strumming a guitar by the campfire, or biking under a canopy of trees? As you pack, think about what will make your trip more fun and relaxing, and bring along your simplest tools for happiness.

Find out what the property offers before you schlep your own kayak, bicycle, and cornhole set. Many properties have sporting equipment and board games. We always bring our bocce set—this Italian bowling game can be played on virtually *any* terrain by all ages and barely takes up any space in the car.

Since we know we can't keep you off your smartphone entirely, we might as well equip it with a few entertaining and helpful apps! AllTrails offers 60,000-plus offline maps and guides to help you choose hikes and not get lost. Geocaching points you via GPS to millions of little treasures hidden in nature, inspiring new hikes with a scavenger-hunt feel. Point the SkyView app at the heavens and instantly identify stars, constellations, and satellites for informed stargazing.

For those used to constant stimulation, nighttime in the woods can feel unusually low key; though in time, you'll be amazed what the stars and a campfire can do for conversation and relaxation.

COOKING

No need to pack the old camp stove or Dutch oven, these glamping destinations will satisfy your appetite, from fully stocked kitchens to gourmet restaurants. For properties with kitchens, just pack as if you were going to a normal vacation rental, adding a few more energy-packed trail snacks and s'mores supplies. For the handful of places in this book that just provide a grill or firepit, revel in the act of cooking like our ancestors and the rich flavors of wood-fired food. Simple menus like artisanal sausages, grilled asparagus, and potatoes can be done without even a cutting board. For true outdoor cooking know-how and inspired yet simple recipes, we defer to our friend Emma Frisch, author of *Feast by Firelight*. Her cookbook is an invaluable guide for camping purists with refined tastes.

Bring a cooler to transport your food and hold your favorite happy hour delights. It's also good to have shelf-stable, easy meals like instant oatmeal and PB & Honey. (*Tip:* Honey is also great for your tea and oatmeal.) If your glamping property doesn't have a restaurant or extensive cooking facilities (mostly those in the "Urban Oasis" chapter), that usually means there are multiple restaurant options nearby.

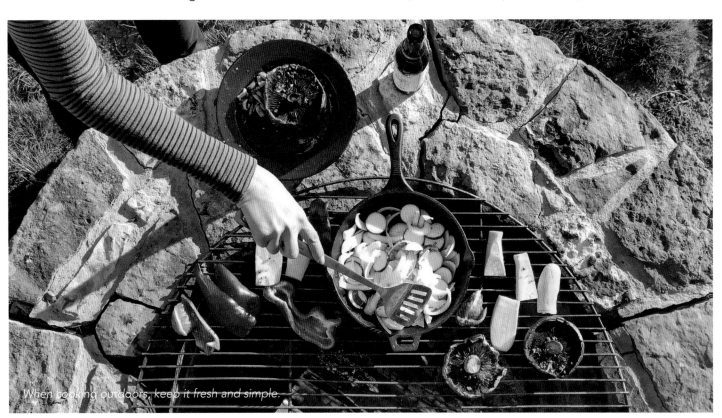

When cooking outdoors, keep it fresh and simple.

RESPONSIBLE TRAVEL

You've likely chosen a vacation in nature because you think it's beautiful, calming, and reenergizing—let's keep it that way! Would camping be as enjoyable if there were heaps of litter, music blasting, or wildlife begging for food? You're probably familiar with Leave No Trace Center for Outdoor Ethics' seven principles. (If not, definitely check out LNT.org.) Taking their guidelines into consideration, these are the ways you can be a responsible glamper.

TRASH GENERATION & DISPOSAL: Avoid heavily packaged and single-use plastic goods. These nonrecyclables quickly generate trash for the property owners and the planet to deal with. Bring reusable items, and pack out everything when you go adventuring.

LEAVE WHAT YOU FIND: As tempting as it is to bring home souvenirs from the wild, leave natural objects (rocks, plants, seashells) and cultural sites as you found them.

Remember you're Mother Nature's guest; respect her house.

MINIMIZE CAMPFIRE IMPACTS: Even in a fire ring, flames need minding. Clear the surrounding area of flammable and meltable items, and don't try for a big blaze. To put it out, drown the flames with water (add dirt if you're short on H_2O) and use a stick to stir the embers until the steam has subsided.

RESPECT WILDLIFE: Observe wildlife from a distance; don't follow or approach them. Never feed animals, and be mindful of your food storage so you don't attract them. If you bring your dog, make sure it's under control and not causing local fauna any distress.

LOVE THY NEIGHBOR: While it's nice to play a little music during happy hour or belly laugh until midnight, your neighbors' walls are thin. Give your fellow glampers and yourself the chance to listen to nature's soundtrack. That said, don't be a stranger. Introduce yourself, lend a hand, and swap a tale or two.

KNOW YOUR SKILLS: Properties make it easier to build a campfire, catch a fish, explore the backcountry, and forget that the wilderness is in fact a wild place. While we definitely encourage you to be adventurous and try new things, don't be a hero. Doing a 10-mile solo paddle as your second kayak trip may not be the smartest move. Also, since you'll be in some remote areas and partaking in a variety of new adventures, consider getting travel insurance. While it might not seem necessary for a vacation to a neighboring state or province, travel insurance offers a lot of benefits and peace of mind for not much money. If you take more than a couple of trips a year, we recommend getting an annual policy (we use Allianz Travel) so you can be more spontaneous and covered for medical emergencies and vacation mishaps.

TYPES OF GLAMPING PROPERTIES

While we are sharing our 70 awe-inspiring properties in this book, they aren't the only style of glamping. This new wave of lodging is hitting every outdoor scenario, from pop-up Marriott suites at Coachella to Tentrrs in big backyards. To help figure out who's behind all this glamping and find more venue styles that might suit you, here are the main categories.

BOUTIQUE: Like most of the properties in this book, these small businesses are designed specifically for luxury camping in the great outdoors or as an extension of a ranch, farm, or even a cave system. With around 5–25 sites, they offer personal attention, unique activities, wellness offerings, gourmet dining or cooking facilities, and ample amenities in nature.

CAMPGROUNDS: Everyone from KOAs to state parks is converting existing sites into upscale camping options. These will typically be in a designated area but often share facilities like a swimming pool with a larger campground. Properties like Sandy Pines (Maine) and Arapaho Valley Ranch (Colorado) are merging these two worlds with grace and style.

MULTISITE: Taking a cue from successful hotel brands that balance uniqueness with a level of consistency, a handful of glamping companies have emerged with similar camps in multiple destinations. Under Canvas and Collective Retreats are excellent examples of hotel-quality accommodations and service in wild settings.

SINGLE UNIT: Similar to Airbnb, droves of property owners are offering their secondary structures (guest cabin, treehouse, greenhouse, etc.) for vacation rental. While some hosts offer meals and activities, this option is typically self-catering. GlampingHub.com is your go-to resource for this.

LOCATION INDEPENDENT: Rental companies offering luxury tents, teepees, vintage trailers, and all the necessary furnishings can set up virtually anywhere within a couple hundred miles of their hub. Try the charming Tinker Tin (western US), East Coast Glamping (Nova Scotia), and Camp'd Out (California).

ROAD TRIP: Not just sitting pretty, some vintage trailers and retro van companies have vehicles ready for the open road. Pick up your favorite, then tow or drive it on a trip. Roll with Peace Vans (Washington), Vintage Surfari Wagons (California), or Route Fifty Campers (Ohio).

EVENT BASED: Multiday festivals and events have found that pop-up luxury camps are a fabulous solution for those who like the amenities of a hotel but don't want to leave the action or sleep on the ground. Bonnaroo, the Indy 500, and Firefly Music Festival are just a few places you can rock out and glamp.

PLANNING & BOOKING SITES

There are numerous websites around the globe for discovering and booking glamping accommodations. Their online tools let you search for properties by region, structure type, experience, and price. While there are plenty of fantastic European resources, these are our favorites with a North American focus.

GLAMPING.COM: A curated collection of more than 800 properties worldwide, Glamping.com focuses on the best hotel-style wilderness accommodations, with multiple units, robust activities, luxury amenities, and excellent service. Glamping.com lists their properties by name and offers a good backstory, which makes it easy to understand a destination's offerings and cross-reference websites for your own research.

GLAMPINGHUB.COM: One of the largest and most diverse platforms around, Glamping Hub features more than 35,000 unique accommodations. They break out each listing by individual structures, whether it's the only cabin on the property or part of a larger resort. They are filled with independently owned gems and do a great job of giving local recommendations for activities, since many are self-catering. Their customer reviews (more than 60,000!) offer extra helpful insights.

NUMUNDO.ORG: As much a movement for positive impact travel as it is a booking website, NuMundo is a network of sustainable communities offering immersive experiences. You'll discover wellness retreats, volunteer projects, green-living workshops, and opportunities for cultural exchange around the world.

HIPCAMP.COM: Campsites are the heart of this ever-growing site (300,000-plus listings), though they also have plenty of glamping options like yurts, tents, treehouses, and cabooses around the US. Hipcamp is great for last-minute planners and glampers on the go, with technology that helps find sites near you, even secure same-day bookings.

TENTRR.COM: Tentrr works with US landowners to create private campsites with uniformly upscale wall

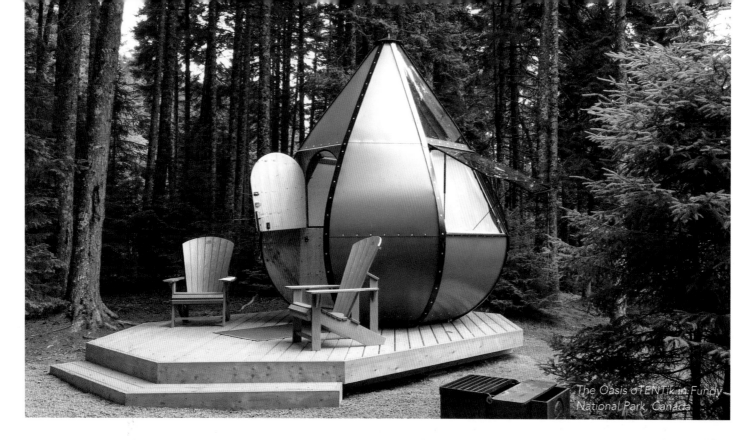
The Oasis oTENTik in Fundy National Park, Canada

tent accommodations. Their team has built platforms, pitched tents, and stocked them with comfy camping amenities around the US. Largely focused on the East Coast but quickly expanding across the country, there are more than 500 properties within 1 to 2 hours of major cities. Tentrr lets you know what you're getting while offering the delight of unique private settings.

FARMSTAYUS.COM: Farmers on ranches, vineyards, orchards, and more are opening up their land and accommodations to those looking for bucolic getaways. While not specifically focused on glamping, you can narrow down your search by accommodation type (yurt, cabin, tent, farmhouse, etc.) to find farmstay experiences like those in our "Cultivate" chapter.

OUTDOORSY.COM: The largest RV rental marketplace has lots of vintage trailers to add glamour to your next road trip. Tapping into the fact that more than 17 million RVs in North America sit unused 350 days a year, they created a handy place for peer-to-peer rentals. Search by your starting location and add the keyword "vintage" to find Airstreams, Boleros, Scouts, Sunraders, Westfalias, and one-of-a-kind mobiles, plus stylish new options.

PARKS CANADA (PC.GC.ca): The provincial and national park system caught on to the demand for glamping and created "oTENTiks." Creative lodging options like A-frame cabin tents, micro-cubes, elevated teardrops, converted lighthouses, and more make a total of 410 comfortable camping sites across 30 parks.

Random Awesomeness

IN OUR YEARS RESEARCHING GLAMPING, we've come across some wacky and wonderful places. Here's a handful so cool, we couldn't keep them to ourselves.

BETTER THAN THE BAT CAVE: If you thought caves were dark and dank, you've never seen Beckham Creek Cave. Nestled in a natural cavern in the Ozark Mountains, this 6,000-square-foot private retreat makes the Bat Cave look pedestrian. Sleek modern furniture goes beautifully with the craggy walls and waterfall that cascades through the living room.
BeckhamCave.com

FANCY A FRANK LLOYD WRIGHT?: Many homes by America's most iconic architects have turned into museums or gone to the hands of millionaires—not the Seth Peterson Cottage. This stunning one-bedroom abode is one of the few Wright buildings available for overnight rental and it's in the lush woods of Wisconsin's Mirror Lake State Park.
SethPeterson.org

BIG BIRDHOUSES: Inspired by the majestic birdlife of Quebec's coast, the Pointe-aux-Outardes nature park decided to make five mansion-like birdhouses for their human guests. Bed frames are interwoven twigs, chandeliers dangle with giant eggshells, and wall art honors their namesake species like Osprey, Bluebird, and Lapone Owl. A hoot for kids and adults alike.
ParcNature.com

FRENCH LAUNDRY COOKING: Before Thomas Keller, there were the Schmitts. The original owners and chefs behind one of the world's most coveted restaurants have gone on to fulfill foodie fantasies with their cook-and-stays on the Philo Apple Farm. Book one of their orchard cottages for their hands-on cooking classes, incredible feasts, and farmlife at its most gourmet.
PhiloAppleFarm.com

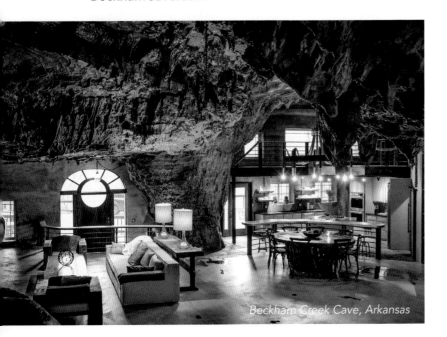
Beckham Creek Cave, Arkansas

GLAMPING FOR HEROES: A stay in a luxury teepee, bubble tent, or Conestoga cabin among the peaks of the Colorado Rockies—that also benefits war veterans and first responders suffering from PTSD? Count us in! Proceeds from your stay in Bison Peak Lodge's creative accommodations provide a vacation for those who need it most. BisonPeakGlamping.com

EQUINOX POP-UP CAMP: A luxury tented camp appears in the middle of an ancient Chacoan civilization and UNESCO site just twice a year, when the sun crosses the celestial equator. Built in 830 CE with astronomy in mind, New Mexico's Chaco Canyon has many solstice and equinox markers—which become evident after waking up in your plush tent and seeing sunrays stream through the doors of the most sacred kiva. HeritageInspirations.com

UNDERSEA SUITE: At 21 feet deep in the ocean, Jules' Undersea Lodge can be reached only by scuba diving. Not certified? They are adjacent to Florida's John Pennekamp Coral Reef State Park—one of North America's best places to dive—and they offer classes. Celebrate your new diver status in a retro underwater suite. You can even have pizza delivered to your Poseidon-themed party. Jul.com

DREAM BIG, STAY SMALL: Blame HGTV, but we're all curious about tiny houses. Check into a couple hundred square feet of adorable living space at WeeCasa—the world's biggest tiny house resort, located in Lyons, Colorado. Each has its own flair, from modern to Craftsman to Hobbit style, and enough amenities for living large. WeeCasa.com

A Snow Bear Chalet

SKI IN, SLEEP UP: Forget those 1980s condos, a tree castle is your ski-in-ski-out lodging at Whitefish Mountain. With turrets and swooping roofs, Snow Bear Chalets' three wooden treehouses feel more like a page in a Swiss fairy tale than a Montana ski resort. Soak in the hot tub, relax by the fire, and sleep in if you'd like; the slopes are just outside your door. SnowBearChalets.com

PRIVATE ISLAND GLAMPING: Take a boat alongside pods of dolphins from Jekyll Island, Georgia, to your very own Atlantic cay. This reef island is rich with history, from the Timucua and Guale natives to European explorers. After a cultural and marine biology tour, find your luxury tent decorated to *Southern Living* perfection. Cook under the stars or have a romantic dinner catered by their chef. LittleRaccoonKey.com

North America Glamping Directory

MORE DYNAMIC DESTINATIONS TO EXPLORE ACROSS THE CONTINENT

EASTERN CANADA

Au Diable Vert (Sutton, Quebec)
AuDiableVert.com

Cabot Shores (Englishtown, Nova Scotia)
CabotShores.com

Canopée Lit (Sacre-Coeur, Quebec)
Canopee-Lit.com

Les Toits du Monde (Nominingue, Quebec)
LesToitsDuMonde.ca

Longpoint Eco Adventures (Turkey Point, Ontario)
LPFun.ca

Outpost (Obabika Lake, Ontario)
OutpostCo.com

Ridgeback Lodge (Kingston, New Brunswick)
RidgebackLodge.com

WESTERN CANADA

Clayoquot Wilderness Resort (Clayoquot Sound, British Columbia)
WildRetreat.com

Flora Bora (Emma Lake, Saskatchewan)
FloraBora.ca

Free Spirit Spheres (Qualicum Beach, British Columbia)
FreeSpiritSpheres.com

Nimmo Bay (Great Bear Rainforest, British Columbia)
NimmoBay.com

REO Rafting (Boston Bar, British Columbia)
REORafting.com

Rockwater Secret Cove (Halfmoon Bay, British Columbia)
RockwaterSecretCoveResort.com

Skoki Lodge (Lake Louise, Alberta)
Skoki.com

Sundance Lodges (Kananaskis, Alberta)
SundanceLodges.com

Tweedsmuir Park Lodge (Bella Coola, British Columbia)
TweedsmuirParkLodge.com

CARIBBEAN

Anegada Beach Club (Anegada, British Virgin Islands)
AnegadaBeachClub.com

Dominican Tree House Village (Samaná, Dominican Republic)
DominicanTreeHouseVillage.com

Le Domaine des Bulles (Le Vauclin, Martinique)
LeDomaineDesBulles.com

Pitahaya (Cabo Rojo, Puerto Rico)
JFKey.vip

Wild Lotus (Valley Church Beach, Antigua)
WildLotusCamp.com

CENTRAL AMERICA

Casa Cayuco (Bocas del Toro, Panama)
CasaCayuco.com

Isla Chiquita (Puntarenas, Costa Rica)
IslaChiquitaCostaRica.com

TreeCasa Resort (El Papayal, Nicaragua)
TreeCasaResort.com

MEXICO

Cabanas Cuatro Cuatros (Ensenada, Baja California)
CabanasCuatroCuatros.com.mx

Cangrejo y Toro (La Majahua, Guerrero)
MexLux.com

Harmony Glamping Tulum (Tulum, Quintana Roo)
HarmonyGlampingTulum.com

Verana (Yelapa, Jalisco)
Verana.com

EASTERN UNITED STATES

Camp LeConte (Gatlinburg, Tennessee)
CampLeConte.com

Camp Orenda (Johnsburg, New York)
CampOrenda.com

Elatse'Yi (Ellijay, Georgia)
NorthGeorgiaGlamping.com

Historic Banning Mills (Whitesburg, Georgia)
HistoricBanningMills.com

Huttopia (North Conway, New Hampshire)
Huttopia.com

Moose Meadow Lodge & Treehouse (Duxbury, Vermont)
MooseMeadowLodge.net

Outlier Inn (Woodridge, New York)
OutlierInn.com

Posh Primitive (Chestertown, New York)
PoshPrimitive.com

Sandy Pines Camping (Kennebunkport, Maine)
SandyPinesCamping.com

Seguin (Georgetown, Maine)
SeguinMaine.com

Shawnee Inn Island (Shawnee on Delaware, Pennsylvania)
ShawneeInn.com

Terra Glamping (East Hampton, New York))
TerraGlamping.com

The Bike Farm (Pisgah Forest, North Carolina)
TheBikeFarm.com

The Mohicans (Glenmont, Ohio)
TheMohicans.net

CENTRAL UNITED STATES

Allen Ranch (Hot Springs, South Dakota)
AllenRanchCampground.com

Arapaho Valley Ranch (Granby, Colorado)
ArapahoValleyRanch.com

El Cosmico (Marfa, Texas)
ElCosmico.com

Glamping St. Louis (St. Charles, Missouri)
GlampingSTL.com

Green Acres (Utley, Texas)
GreenAcresaTX.com

High Lonesome Ranch (De Beque, Colorado)
TheHighLonesomeRanch.com

Kinnikinnick Farm (Caledonia, Illinois)
KinnikinnickFarm.com

Lone Mountain Ranch (Big Sky, Montana)
LoneMountainRanch.com

Rocky Top Farms (Ellsworth, Michigan)
RockyTopFarms.com

Royal Gorge Cabins & Rafting (Cañon City, Colorado)
RoyalGorgeCabins.com

Snow Bear Chalets (Whitefish, Montana)
SnowBearChalets.com

Tennessee Pass (Leadville, Colorado)
TennesseePass.com

The Resort at Paws Up (Greenough, Montana)
PawsUp.com

Timber Ridge Outpost (Herod, Illinois)
TimberRidgeOutpost.com

Treehouse Utopia (Utopia, Texas)
TreehouseUtopia.com

Turpin Meadow (Jackson Hole, Wyoming)
TurpinMeadowRanch.com

WESTERN UNITED STATES

Alpenglow (Glacier View, Alaska)
AlpenglowLuxuryCamping.com

Caravan Outpost (Ojai, California)
CaravanOutpostOjai.com

Capitol Reef Resort (Torrey, Utah)
CapitolReefResort.com

El Capitan Canyon (Santa Barbara, California)
ElCapitanCanyon.com

Escalante Yurts (Escalante, Utah)
EscalanteYurts.com

Hart's Camp (Pacific City, Oregon)
HartsCamp.com

Kate's Lazy Meadow (Landers, California)
LazyMeadow.com

Leanto (Orcas Island, Washington)
StayLeanto.com

Linn Canyon Ranch (Victor, Idaho)
LinnCanyonRanch.com

MaryJanesFarm Bed & Breakfast (Moscow, Idaho)
MaryJanesFarm.org/bb

Orca Island Cabins (Seward, Alaska)
OrcaIslandCabins.com

Safari West (Santa Rosa, California)
SafariWest.com

Sequoia High Sierra Camp (Giant Sequoia National Monument, California)
SequoiaHighSierraCamp.com

Shash Dine' Eco-Retreat (Page, Arizona)
ShashDine.com

The Shady Dell (Bisbee, Arizona)
TheShadyDell.com

Trailer Pond (Paso Robles, California)
TheTrailerPond.com

Ultima Thule Lodge (Wrangell-St Elias National Park, Alaska)
UltimaThuleLodge.com

Ventana (Big Sur, California)
VentanaBigSur.com

Wanderlust Pop Up Glamping (Las Vegas, Nevada)
WanderlustPopUpGlamping.com

MULTI-DESTINATION

Appalachian Mountain Club
Outdoors.org

AutoCamp
AutoCamp.com

Collective Retreats
CollectiveRetreats.com

Tentrr
Tentrr.com

Under Canvas
UnderCanvas.com

Conclusion: Away We Go

WHERE WILL THIS BOOK TAKE YOU? You know life is too short for generic hotels and stock experiences—that getting off the beaten track is where the magic happens, and that love and nature cure just about everything. Glamping is a way to connect with our environment, each other, and ourselves. It's a means to explore, renew, and have fun. It's one of the best ways to travel.

We hope these destinations stirred your wanderlust and that you already have a vacation or two in mind. When you need a burst of travel inspiration, *Comfortably Wild* will be at the ready. Plus, we're here for you! We've had our lives forever changed by travel and want nothing more than to help people get out there. Reach out to us at @HoneyTrek on social media for more tips and to see where we're glamping next. For behind-the-scenes content, extra resources, glamping deals, and custom-signed books, check out HoneyTrek.com/ComfortablyWild.

Wherever you go, treat each trip as an opportunity to try something new, reconnect with the people you love, and discover more of this beautiful world.

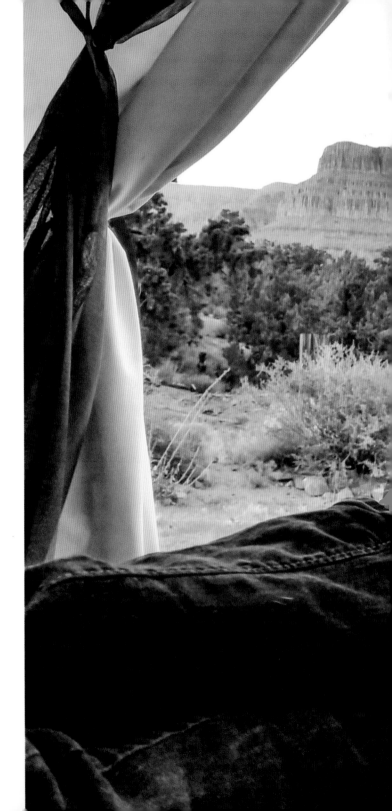

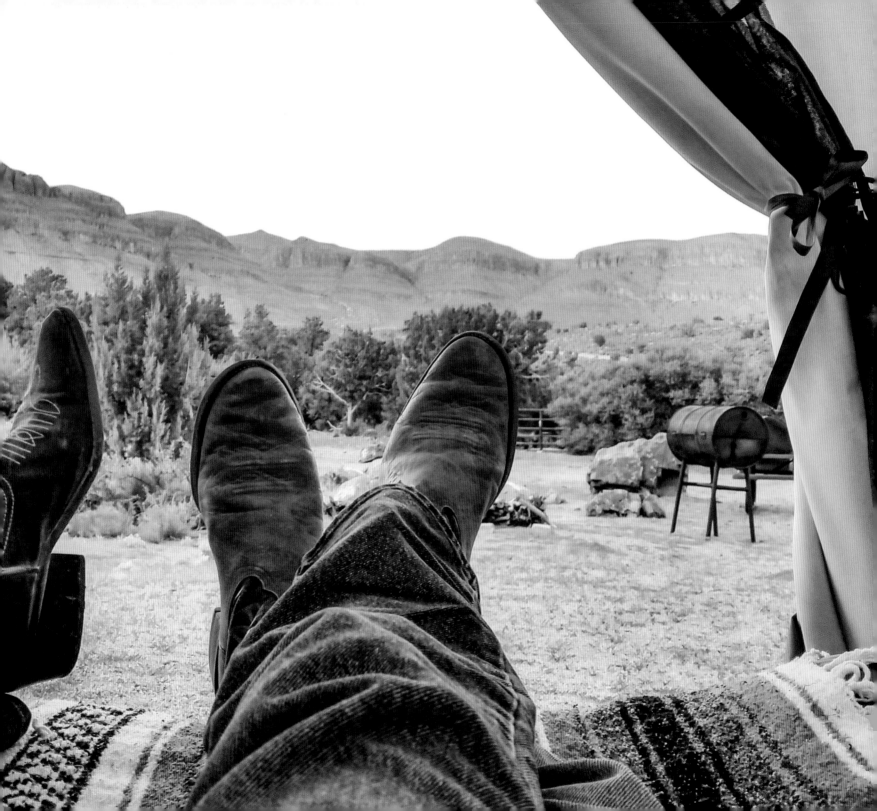

Acknowledgments

IT TOOK A GLAMPING VILLAGE to complete this book. To understand what makes each destination so special, we needed each property owner's and their team members' help. Your hard work—from building inspiring retreats to answering our million questions—is what makes these pages shine. Thank you for welcoming us onto your properties and into your hearts.

We couldn't have made the journey without Buddy the Camper and all the roadside angels along the way. When we blew a head gasket in the boonies of British Columbia, we thought we'd never get rolling again. While waiting on the Heiltsuk Nation for a ferry to the nearest mechanic (9 hours away), the Wilsons took us in. When we reached the Prince Rupert port, the MacCarthy GM team came to the rescue with five days of repairs and Champagne to wish us bon voyage. Complete strangers, like Montana Mike, who patched our flat tire, and Texas Jim, who extinguished an engine fire, were the ultimate roadside assistance.

We thought we could write this book from a camper, but no. With the help of the housesitting community, we found a beach bungalow in Honduras (crazy story— see HoneyTrek.com/Roatan) and a cottage in upstate New York. Thanks to Fynn and Smoochie for being our emotional support animals and Ashley, Denise, and the Roatán crew for looking out for us. Those who let us crash for extended stopovers, like Kate, Will, Ryan, Chelsea, Doc, Vallie, Steve, Sherry, and the Schmids,

you helped us make a dent in this 256-pager. To our parents, Patricia, Robin, Pat, and Valerie, thank you for always checking in on our whereabouts, progress, and sanity. We love you and truly appreciate your support.

To the industry leaders, Ruben Martinez, Sarah Dusek, Rainer Jenss, Sarah Riley, and MaryJane Butters, thank you for sussing out the meaning of glamping with us. Your visionary thinking and dedication to this groundbreaking travel style have made it thrive. And thanks to Mey and Linda of Glamping.com. If we didn't write a column for you, FalconGuides might have never found us!

We wouldn't have dreamt of taking on this project without the support of the Falcon team. David Legere, thank you for believing in us, being so patient, and letting us chase our *Comfortably Wild* dreams. Jim Childs, chatting with you in 2016 empowered us to think differently and do the unexpected. Paulette Baker, thanks for being so smart and sensitive. Amanda Wilson and Melissa Evarts, your design skills have made this book absolutely beautiful! Meredith Dias, thanks for wrangling all the pieces and keeping this caravan moving. Ryan Meyer, love your enthusiasm and appreciate your hard work! Ethan Savel, your research unearthed some of our favorite places! And Will and Blair, thanks for taking your Beer Camp duties so seriously.

To our 288,387 HoneyTrek fans, you have kept us motivated with every "Like" and comment of encouragement. We can't wait to hear about your own glamping journey!

Photo Credits

ALL PHOTOGRAPHS BY MIKE AND ANNE HOWARD OF HONEYTREK.COM EXCEPT THE FOLLOWING:

Photo on pp. iii, 60–63 Colin Ruggiero, ColinRuggiero.com ; pp. iv–v © Getty Images/iStock/Onur Dogus Lalegul; pp. 4, 205, 207 Kevin Steele, KevSteele.com; pp. 6, 145, 230 Mimi Giboin; p. 7 BigSkyBalloonCo.com; p. 8 © Getty Images/DigitalVision Vectors/Nastasic; p. 10 (cropped) courtesy Royal Collection Trust; p. 11 courtesy Arden Creek; p. 13 © Getty Images/iStock/noblige; p. 14 Kodiak Greenwood; p. 15 © Getty Images/E+/wundervisuals; pp. 16, 108–11 Alain Hottat; p. 17 © Getty Images/E+/Lisa5201; pp. 20, 23 (#7), 165, 167 Michael Chilcoat; p. 21 Fernando Acuña; p. 22 (#2) Danielle Heller; p. 22 (#5) Adam Crowley courtesy Nelson Treehouse; p. 22 (#6) Joanna Cahill; pp. 23 (#8), 138, 141 Amanda Powell; pp. 23 (#10), 76 Corey Gwin; p. 23 (#11) Biome Canada; p. 25 (map) © FreeVectorMaps.com; pp. 36–37 Julie Foskett; pp. 38–40 Blair Kay; p. 41 Kevin Wagar; pp. 42, 43, 45 Hannah C. Photography; p. 44 © Getty Images/iStock/Png-Studio; p. 46 Luis Meza, BIEN Media; p. 47 (left) The Leekers' Photography; pp. 48–53 Nansen Weber; p. 64 Ole Kristian Roenningen; pp. 65, 67 Cathy Hart; p. 66 © Getty Images/iStock/troutnut; p. 68 (left) Jim Gray; p. 68 (right) Maureen Lilla; p. 69 (left) Michael Partenio; p. 69 (right) Farm Sanctuary; pp. 70–72, 74, 75 ErinAndGabri.com; p. 73 LopezSpratt.com; p. 77 © Getty Images/iStock/bluejayphoto; p. 79 Ben Ricard; p. 88 © Getty Images/iStock/David_Johnson; p. 90 (right) Kathleen Dyhr; p. 91 (left) Chena Hot Springs; p. 91 (right) Aubrey Ixchel; p. 94, 97 Justine Crawford; p. 95 courtesy Snidal Collection; pp. 104, 107 Alex Herring; p. 112 (right) Maria Shealy; p. 113 (left) Samantha D. Schwab; pp. 114–19 Kat Cannell; p. 121 Matthew Humke; p. 123 Daniel Lopez Perez; pp. 130–32 JamieWalter.com; p. 134 (left) Paul Morrison; p. 134 (right) Eric Berger, p. 135 (right) Shane Lepley; pp. 136–37 © Getty Images/iStock/Sean Pavone; p. 143 Getty Images/iStock/Velvetfish; p. 149 Kaylyn Leighton; p. 152 Stephen Walasavage; p. 153 Chelsea Cronkite; p. 154 RomanticAsheville.com; p. 155 Taylor McDonald; p. 156 (left) © Getty Images/iStock/Andrew Bertuleit; p. 156 (right) courtesy Collective Retreats; p. 157 (left) Abran Rubiner; p. 157 (right) E3 Photography; p. 164 Ranch at Rock Creek; p. 172 Bull Hill; pp. 175, 177 Jack Richmond, p. 176 © Getty Images/iStock/YinYang; p. 178 (left) Janet Reinbold; p. 178 (right) C Lazy U Ranch; p. 179 (left) Loni Mae Carr/Whiskey Ginger; p. 179 (right) Aly van der Meulen; pp. 180–81 Dany Vachon; p. 182 Luc Rousseau; pp. 183, 185 Renaud Philippe; p. 187 Kindra Clineff; p. 188 Hillary Henrici; pp. 190–91 Greg Mallet; p. 197 Grant Zelych; p. 199 Daniel Smith; p. 200 (left) Marc Lajoie; p. 200 (right) Ironside Photography; p. 201 (left) Jon Griffin, p. 201 (right) Entre Cîmes et Racines; pp. 202–3 Visit California/Myles McGuinness; p. 204 Leonardo Palafox; p. 206 Dave Krugman; pp. 208, 211 Seth Jones; p. 214 Rebeca Saborio; pp. 215–16 Pacuare Lodge; p. 218 Jacob Moon; p. 219 Reid Morth; pp. 220–21 Gib Myers; p. 222 (right) Josh Langan; p. 223 (left) Brian Basham; p. 233 Pat Jensen; p. 235 Parks Canada/Jessica Seguin; p. 236 Mallory Jane Photography; p. 237 Trevon Baker Photography

Sources

1. Lloyd Kahn, *Shelter* (California: Shelter Publications Inc, 2000), 6.

2. Kevin Black, "Tipi," *Colorado Encyclopedia*, last modified August 31, 2017, https://coloradoencyclopedia.org/article/tipi-0.

3. "Teepee," *Encyclopedia Britannica*. Accessed March 15, 2019, https://www.britannica.com/technology/tepee.

4. "Yurt," National Geographic Resource Library. Accessed March 10, 2019, https://www.nationalgeographic.org/encyclopedia/yurt.

5. Gary Brueggeman, "The Pre-Marius Camp," *The Roman Army*, September 2013, https://romanarmy.info/camp1/camp1.html.

6. Candida Collins, *Treehouse Book* (New York: Skyhorse Publishing, 2009), 9.

7. Bernard O'Kane. 1993. "From Tents to Pavilions: Royal Mobility and Persian Palace Design," *Ars Orientalis* (23): 249–268. https://www.jstor.org/stable/4629452.

8. Nurhan Atasoy, *Otağ-ı Hümayun: The Ottoman Imperial Tent Complex* (Istanbul: Koç Yayınları, 2000).

9. "Field of Cloth of Gold," *Encyclopedia Britannica*. Accessed March 15, 2019, https://www.britannica.com/place/field-of-cloth-of-gold.

10. Brian Herne, *White Hunters: The Golden Age of African Safaris* (New York: Holt Paperbacks, 2001), 5.

11. Livia Gershon, "How the Victorians Went Camping," *JSTOR Daily*. Accessed June 27, 2017. https://daily.jstor.org/how-the-victorians-went-camping.

12. Jim Morrison, "Commemorating 100 Years of the RV," *Smithsonian*. Accessed August 24, 2010. www.smithsonianmag.com/history/commemorating-100-years-of-the-rv-56915006.

13. "H Is for the History of Travel Trailers," *Airstream*. Last modified September 19, 2014, http://www.airstream.com/blog/h-history-travel-trailers.

14. Dr. Qing Li, 2010. "Effect of Forest Bathing Trips on Human Immune Function," *Environmental Health and Preventive Medicine* 15 (1): 9–17. https://doi.org/10.1007/s12199-008-0068-3.

15. Mark R. Elkins, et al. 2006. "A Controlled Trial of Long-Term Inhaled Hypertonic Saline in Patients with Cystic Fibrosis," *New England Journal of Medicine* 354: 229–240. https://www.nejm.org/doi/full/10.1056/NEJMoa043900.

16. Michaeleen Doucleff and Allison Aubrey. "Smartphone Detox: How to Power Down in a Wired World," *NPR Online*. Last modified February 12, 2018, https://www.npr.org/sections/health-shots/2018/02/12/584389201/smartphone-detox-how-to-power-down-in-a-wired-world.

17. Victor C. Strasburger, Amy B. Jordan, and Ed Donnerstein. 2010. "Health Effects of Media on Children and Adolescents," *Pediatrics* 125: 4. https://pediatrics.aappublications.org/content/125/4/756.

18. Amanda Cooke, "Whole Child: Developing Mind, Body and Spirit through Outdoor Play," *National Wildlife Federation*. Last modified August 5, 2010, https://www.nwf.org/educational-resources/reports/2010/08-05-2010-whole-child.

Additional Sources

Dr. Lynn Minnaert, "US Family Travel Survey 2018," October 2018. Available from Family Travel Association.

Arizton Advisory & Intelligence, "Glamping Market in the US—Industry Outlook and Forecast 2019–2024," February 7, 2019.

Coleman Company and Outdoor Foundation, "2017 American Camper Report," December 1, 2017.

Kampgrounds of America, "2019 North American Camping Report," April 24 2019.

Index

Alaska
 BearCamp, 64–67
 Chena Hot Springs, 91
 Kenai Fjords National Park catamaran
 cruises, 66
 Kenai River float trips, 67
Alberta
 Atlas Coal Mine, 199
 Dinosaur Provincial Park, 223
 Drumheller, 199
 Good Knights, 196–99
 Royal Tyrrell Museum of Paleontology
 Dinosite Expedition, 198
Arizona
 Cozy Peach, The, 28–31
 Desert Botanical Garden, 30
 Grand Canyon West and Hualapai
 Nation, 163
 Grand Canyon Western Ranch, 160–63
 Hayden Flour Mills tours, 31
 Hoover Dam biking, 162
 Queen Creek Olive Mill tour, 31
Arkansas
 Beckham Creek Cave, 236
 Eureka Springs Treehouses, Caves, Castles
 & Hobbits, 200
Arts and crafts, 88, 101, 141, 155, 188, 199
ATVing, 53, 206

Bahamas
 Coastal Bird Conservation, 68
 Eleuthera Island paddleboarding, 80–81
Ballooning, hot air, 85, 188
Bears, 51, 64–67, 96
Bell Tents, 22, 135, 152, 157, 179, 222
Biking, 52, 88, 106, 132, 147, 162, 221
Bird watching, 57, 63, 68, 128, 133, 144, 217,
 220, 236
Bison, 55, 59, 107, 220, 237
Botanical tours, 30, 144
Breweries, 41, 140, 154

British Columbia
 Bella Coola Heli Sports, 134
 Bulkley Adventures, 124–25
 Cassiar Cannery, 94–97
 Khutzeymateen Provincial Park, 96
 North Pacific Cannery tours, 96
Bubble tents, 46, 190–91, 237

Cabins, 23, 54, 69, 86, 91, 104, 134, 160, 170,
 174, 178, 208, 218, 223, 237
California
 Catch a Canoe outrigger canoeing, 145
 Esalen Institute, 78
 Four Seasons/Beverly Wilshire Hotel, 157
 Glass Beach, 144
 Jade Cove/Willow Creek Beach
 rockhunting, 79
 Mendocino Arts Center, 145
 Mendocino Grove, 142–45
 Pfeiffer Big Sur State Park redwood
 hiking, 78
 Philo Apple Farm, 236
 Piedras Blancas Elephant Seal Rookery, 79
 Treebones Resort, 76–79
Canada, see specific provinces
Canoeing, 40, 128, 132, 145, 220
Canyoneering, 216
Cattle drives, 159, 172
Caves and caverns, 8, 106, 200, 236
City glamping, 136, 156–57
Cold War bunker tours, 107
Colorado
 Bison Peak Glamping, 237
 Canyon of the Ancients National
 Monument, 177
 C Lazy U Ranch, 178
 Dunton Hot Springs, 174–77
 Mesa Verde National Park, 176
 Sutcliffe Vineyards, 177
 San Juan National Forest geyser, 176
 WeeCasa Tiny Houses, 237

Connecticut
 HUE Studios paint and sip, 188
 White Memorial Conservation Center
 hike, 189
 Winvian Farm, 186–89
Cooking classes, 30, 122, 189
Costa Rica
 Bio Thermales Hot Springs, 90
 Cabécar Indians ancestral trail, 217
 Cartago city tour, 217
 Dreamsea surf camp, 135
 Pacuare Lodge, 214–17

Dancing, 75, 88, 111, 129, 140
Dinosaurs, 198, 199, 223
Disc golf, 133, 135
Domes, 23, 46, 152, 153, 155, 237
Dominican Republic
 Alma Libre Dance School, 75
 Iguana Mama spelunking, 75
 Kite Beach kitesurfing, 74
 Natura Cabana, 71–75

Equestrian glamping, 69, 177–79

Fantasy-themed glamping, 196–201
Farms, 26–45, 69, 186–89, 201, 236
Festivals, 31, 110, 140, 184, 233
Fishing, 41, 67, 107, 118, 133, 166
Florida
 Everglades Adventure Tours, 112
 Fancy Camps, 222
 Topsail Hill Preserve and Grayton Beach
 State Parks, 222
 Jules' Undersea Lodge, 237
Food tours, 21, 31, 44, 122, 123
Foraging tours, 150
Fossil digs, 173, 223

Gemstone hunting, 79, 167
Georgia: Little Raccoon Key, 237

Geysers, 176
Ghost tours, 199
Ghost towns, 166, 175
Glamping, overview
 benefits of, 16–17
 cooking, 231
 fundamentals of, 5–7
 directory, 238–41
 future of, 18
 history of, 8–11
 packing tips, 228–30
 planning and preparation, 19–21,
 224–25, 227
 property types, 233
 reasons for, 12–17
 reservations and resources, 234–35
 structure styles, 22–23
 travel guidelines, 232
 unique and unusual, 236–37
Goat treks, 35
Guatemala
 Antigua walking tour, 122
 Café Azahar coffee farm, 123
 Lake Atitlán tour, 123
 Tortilla-making classes, 122
 Trek Guatemala, 120–23

Hawaii
 Honaunau Farm, 42–47
 Kealakekua Bay kayaking and
 snorkeling, 45
 Waipi'o Valley horseback riding, 44
Helicopters
 as lodging, 186
 heli-glamping, 124–25
 heli-skiing, 134, 177
 tours with, 152
Hemp cultivation, 45
Hiking, 44, 75, 78, 101, 119, 121, 132, 133,
 189, 210, 217
Historical sites, 122, 140, 154, 155, 163, 176,
 185, 237
Hobbit homes, 196, 199, 200–201, 237
Horses, 69, 158–73, 177–79
Hot springs, 78, 90–91, 141, 174
Hunting, 107
Huts, 8, 23, 108–12, 218, 221

Ice hotels, 181–85

Idaho
 Boise, 146–47
 Castle Rocks State Park, 213
 Middle Fork rafting and fly fishing, 117–18
 Sawtooth Mountains hiking, 119
 Sheepeater pictographs, 119
 Solitude River Trips, 116–19
Illinois: Gwen, The, 157

Jamaica
 Blue Lagoon and Monkey Island boat
 trip, 110
 Boston Jerk Centre, 111
 Cinema Paradise Portie Film Festival, 110
 Great Huts, 108–11
 Jamaican Arts Odyssey, 110

Kayaking, 45, 63, 119, 155
Kitesurfing, 74

Lava lakes, 100
Longhouses, 113

Maine
 Maine Huts & Trails, 130–33
 Sugarloaf Mountain, 133
 TimberStone Adventures, 135
Map and compass classes, 211
Medieval glamping, 9, 196–99
Mexico
 Bay of La Paz whale-shark snorkeling, 62
 Campera Hotel Burbuja, 46
 Camp Cecil, 60–63
 La Paz tour, 62
 Playa Viva, 204–7
Minnesota: Whitetail Woods Park, 223
Montana
 American Prairie Reserve, 218–11
 Bison Quest, 59
 Drummond Rodeo, 167
 Fort Benton Museums & Heritage
 Complex, 221
 Gem Mountain sapphire mining, 167
 Granite ghost town, 166
 Lewis & Clark Trail Adventures, 220
 Montana Cowgirl Camp, 179
 PN Ranch mountain biking, 221
 Ranch at Rock Creek, 164–67
 Snow Bear Chalets, 237

Upper Missouri River Breaks National
 Monument canoeing, 220
Mud baths, 101
Museums, 29, 62, 91, 101, 141, 189, 198, 210,
 211, 217, 221
Music, 89, 91, 97, 111, 140, 151

Native dwellings, 112–13, 163
Nebraska: Slattery Vintage Estates, 47
Nevada
 Mustang Monument, 69
 Virginia City, 169
New Mexico
 Black Rock Hot Springs, 141
 Earthship Biotecture, 140
 Harwood Museum of Art, 141
 Heritage Inspirations, 237
 Luna Mystica, 138–41
 Manby Hot Springs, 141
 Ranchos de Taos mission church, 140
 Sovereign Nation of Taos Pueblo, 140
 Taos Inn, 141
 Taos Mesa Brewery, 140
 Taos Plaza, 141
New York
 Adirondak Loj, 208–11
 Collective Governors Island, 156
 Cornell University and White Library, 150
 Farm Sanctuary, 69
 Firelight Camps, 148–51
 High Peaks Information Center and
 Algonquin hiking, 210
 Lake Placid Olympics facility tours, 210
 Taughannock Falls, 151
 Wild Center Natural History Museum of the
 Adirondacks, 211
Nicaragua
 Bahia Zapatera, 98–101
 Granada, 101
 Isla el Muerto petroglyphs, 99, 100, 102–3
 Masaya Volcano lava lakes, 100
 San Francisco Convent, 101
 Zapatera Island mud bath hikes, 101
North Carolina
 Asheville Brews Cruise, 154
 Asheville architectural tours, 155
 Asheville Glamping, 152–55
 Biltmore House tours, 154
 BREW-ed tours, 154

French Broad Outfitters water
 sports, 155
Northwest Territories
 Houseboat Bay, 53
 Wildcat Cafe, 53
Nunavut
 Arctic Watch Wilderness Lodge, 49–53
 Cunningham River whale watching, 52
 Muskox Ridges, 53

Ohio: Nomad Ridge at The Wilds, 54–57
Olive orchard tours, 31
Olympics facility tours, 210
Ontario
 Fronterra Farm, 38–41
 Harwood Estate Vineyards tours, 40
 Hillier Creek Estates Winery tours, 40
 Lake Ontario salmon fishing and curing, 41
 North Beach Provincial Park canoeing and
 picnics, 40
 Traynor Family Vineyard tours, 40
Oregon
 Crater Lake National Park, 34
 goat treks, 35
 Panacea at the Canyon, 82–85
 Smith Rock State Park, 84
 Willow-Witt Ranch, 32–37
Oyster farm tours, 89

Paddleboarding, 53, 63, 80–81, 133, 155
Petroglyphs, 99, 100, 102–3
Pictographs, 119
Public land glamping, 222–23

Quebec
 Basse-Ville visit, 185
 Canopée Lit, 190–91
 Entre Cîmes et Racines, 201
 Parc Nature de Pointe-aux-Outardes, 236
 Hôtel de Glace, 181–85
 Hôtel-Musée Premières Nations, 113

Rafting, 110, 117, 118
Ranches, 32–35, 159–73, 178–79
Redwoods, 78, 144, 202–3
Rockclimbing, 84, 213
Rodeos, 167, 178

Safari glamping, 50–67
Salmon fishing, 41, 67, 133
Scuba diving, 207, 237
Skiing, 133, 177, 237
Snorkeling, 45, 63, 68, 207
Spas, 74, 78, 83, 89, 91, 97, 149, 167, 177, 183,
 189, 207, 217
Sport-centric glamping, 134–35
Surfing, 75, 111, 135, 207
Sustainability, 6–7, 14, 216, 202–23, 232

Teepees, 6, 8, 22, 69, 113, 126, 129, 237
Tennessee: Forest Gully Farms, 201
Tents, 8, 9–10, 22, 116–23
Texas
 Apis Restaurant, 195
 Cypress Valley Canopy Tours, 192–95
 Enchanted Rock, 195
 Krause Springs, 194
 Stonehouse Vineyards, 195
Tiny houses, 47, 69, 237
Train depot rooms, 104–7
Treehouses, 9, 22, 186, 190–91, 192–95, 200,
 204, 207, 223
Turtle sanctuaries, 206

United States, see specific states
Utah
 Monument Valley Tipi Village, 113
 Mystic Hot Springs, 91
 Wall Tents, 32, 38, 47, 50, 60, 82, 104, 142,
 148, 152, 160, 164, 170, 196, 208, 223

Vineyards, 35, 40, 46–47, 177, 195
Vintage trailers, 10–11, 23, 28, 38–31, 86–89,
 138–41, 152–55, 233, 235

Virginia
 Depot Lodge, 104–7
 Potts Creek Outfitters guided tours, 107
 Potts Valley Rail Trail, 106

Wagons, 23, 126–29, 161, 165
Washington
 Alexandria Nicole Cellars Tiny Houses, 47
 Bull Hill Guest Ranch, 170–73
 Cape Disappointment State Park, 88
 Columbia River, 47, 172
 Evening Hatch, The, 172
 Sou'wester Lodge, 86–89
 Stonerose Interpretive Center fossil
 digs, 172
 Willapa Bay Interpretive Center oyster farm
 tours, 89
Wellness treatments and workshops, 45, 74, 76,
 82, 89, 97, 111, 207
West Virginia
 Greenbrier, The 107
 Lewisburg, 106
 Lost World Caverns, 106
Whale watching, 52, 66
Wildlife conservation, 54, 68–69, 206, 211,
 215–16, 218
Wildlife tours, 52, 56, 62, 63, 66, 69, 96, 220
Wildlife nonprofits, 68–69
Wisconsin: Seth Peterson Cottage, 236
Women's retreats, 97
Wright, Frank Lloyd, 236
Wyoming
 HorseWorks, 179
 Loon Lake canoeing, 128
 Stagecoach Bar country line dancing, 129
 Teton Wagon Train, 126–29
 Yellowstone National Park tours, 129

Yurts, 6, 8, 22, 54, 192, 196, 212–13, 218, 221

Ziplines, 56, 133, 194, 217

About the Authors

MIKE & ANNE HOWARD left on their honeymoon in January 2012 and never came home. They created HoneyTrek.com to chronicle their journey across all seven continents and to help people mobilize their travel dreams. Their story as the "World's Longest Honeymooners," savvy tips, and blog have been acclaimed by the AP, Lonely Planet, *USA Today*, *Condé Nast Traveler*, CBS, and more. Having blogged for Glamping.com, scouted hotels around the world for Honeymoons.com, and authored National Geographic's best-selling book on couples adventure travel (*Ultimate Journeys for Two*), the Howards were poised to write the first-ever book on glamping in North America. Through their writing, photography, public speaking, trip coaching, travel advising, and social media, the Howards hope to inspire more people to explore outside their comfort zone.

Follow their adventures @HoneyTrek.

11TH EDITION

STRATEGIC MANAGEMENT

THEORY

11TH EDITION

STRATEGIC MANAGEMENT

THEORY

CHARLES W. L. HILL

University of Washington – Foster School of Business

GARETH R. JONES

MELISSA A. SCHILLING

New York University – Stern School of Business

CENGAGE
Learning

Australia • Brazil • Japan • Korea • Mexico • Singapore • Spain • United Kingdom • United States

Strategic Management: Theory, 11e

Charles W. L. Hill
Gareth R. Jones
Melissa A. Schilling

Product Director: Joe Sabatino

Sr. Product Manager: Scott Person

Sr. Content Developer: Mike Guendelsberger

Product Assistant: Tamara Grega

Sr. Content Project Manager: Cliff Kallemeyn

Media Developer: Courtney J. Bavaro

Sr. Media Developer: Sally Nieman

Sr. Art Director: Stacy Jenkins Shirley

Manufacturing Planner: Ron Montgomery

Sr. Rights Acquisitions Specialist: Amber Hosea

Production Service: MPS Limited

Internal/ Cover Designer: Mike Stratton

Cover Image: © iStockphoto.com/saintho

For product information and technology assistance, contact us at
Cengage Learning Customer & Sales Support, 1-800-354-9706

For permission to use material from this text or product, submit all requests online at **www.cengage.com/permissions.** Further permissions questions can be emailed to **permissionrequest@cengage.com.**

Library of Congress Control Number: 2013941272

Student Edition:

ISBN-13: 978-1-285-18449-4

ISBN-10: 1-285-18449-1

Cengage Learning
200 First Stamford Place, 4th Floor
Stamford, CT
USA 06902

Cengage Learning is a leading provider of customized learning solutions with office locations around the globe, including Singapore, the United Kingdom, Australia, Mexico, Brazil, and Japan. Locate your local office at: **www.cengage.com/global**

Cengage Learning products are represented in Canada by Nelson Education, Ltd.

To learn more about Cengage Learning Solutions, visit **www.cengage.com**

Purchase any of our products at your local college store or at our preferred online store **www.cengagebrain.com**

Printed in Canada
1 2 3 4 5 6 7 17 16 15 14 13

Brief Contents

PART ONE INTRODUCTION TO STRATEGIC MANAGEMENT

1	Strategic Leadership: Managing the Strategy-Making Process for Competitive Advantage	1
2	External Analysis: The Identification of Opportunities and Threats	43

PART TWO THE NATURE OF COMPETITIVE ADVANTAGE

3	Internal Analysis: Distinctive Competencies, Competitive Advantage, and Profitability	80
4	Building Competitive Advantage Through Functional-Level Strategies	116

PART THREE STRATEGIES

5	Business-Level Strategy	153
6	Business-Level Strategy and the Industry Environment	178
7	Strategy and Technology	210
8	Strategy in the Global Environment	246
9	Corporate-Level Strategy: Horizontal Integration, Vertical Integration, and Strategic Outsourcing	286
10	Corporate-Level Strategy: Related and Unrelated Diversification	318

PART FOUR IMPLEMENTING STRATEGY

11	Corporate Performance, Governance, and Business Ethics	359
12	Implementing Strategy in Companies That Compete in a Single Industry	395
13	Implementing Strategy in Companies That Compete Across Industries and Countries	439

Glossary	G-1
Index	I-1

Contents

Preface xix

Acknowledgements xxiii

Dedication xxvii

PART ONE INTRODUCTION TO STRATEGIC MANAGEMENT

Chapter 1 Strategic Leadership: Managing the Strategy-Making
 Process for Competitive Advantage 1

Opening Case 1

Overview 3

Strategic Leadership, Competitive Advantage, and Superior
Performance 4
 Superior Performance 5
 Competitive Advantage and a Company's Business Model 6
 Industry Differences in Performance 7
 Performance in Nonprofit Enterprises 8
Strategic Managers 9
 Corporate-Level Managers 10
 Business-Level Managers 10
 Functional-Level Managers 11
The Strategy-Making Process 11
 A Model of the Strategic Planning Process 11
 Mission Statement 12
Major Goals 16
 External Analysis 17
 Internal Analysis 17
 SWOT Analysis and the Business Model 17

Strategy in Action 1.1: Strategic Analysis at Time Inc. 18
 Strategy Implementation 19
 The Feedback Loop 20
Strategy as an Emergent Process 20
 Strategy Making in an Unpredictable World 20
 *Autonomous Action: Strategy Making by Lower-Level
 Managers 21*

Strategy in Action 1.2: Starbucks' Music Business 21
 Serendipity and Strategy 22
 Intended and Emergent Strategies 22

Strategy in Action 1.3: A Strategic Shift at Charles Schwab 23

Strategic Planning in Practice 25
 Scenario Planning 25
 Decentralized Planning 26
Strategic Decision Making 27
 Cognitive Biases and Strategic Decision Making 27
 Techniques for Improving Decision Making 29
Strategic Leadership 29
 Vision, Eloquence, and Consistency 30
 Articulation of the Business Model 30
 Commitment 30
 Being Well Informed 31
 Willingness to Delegate and Empower 31
 The Astute Use of Power 32
 Emotional Intelligence 32

Chapter 2 External Analysis: The Identification of Opportunities and Threats 43

Opening Case 43

Overview 44
Defining an Industry 45
 Industry and Sector 46
 Industry and Market Segments 47
 Changing Industry Boundaries 47
Competitive Forces Model 47
 Risk of Entry by Potential Competitors 48
 Rivalry Among Established Companies 50

Strategy in Action 2.1: Circumventing Entry Barriers into the Soft Drink Industry 51

Strategy in Action 2.2: Price Wars in the Breakfast Cereal Industry 53

 The Bargaining Power of Buyers 55
 The Bargaining Power of Suppliers 56
 Substitute Products 58
 Complementors 58
 Summary: Why Industry Analysis Matters 59
Strategic Groups Within Industries 60
 Implications of Strategic Groups 61
 The Role of Mobility Barriers 62
Industry Life-Cycle Analysis 63
 Embryonic Industries 63
 Growth Industries 64
 Industry Shakeout 64
 Mature Industries 65
 Declining Industries 66
 Summary 66

Limitations of Models for Industry Analysis 67
 Life-Cycle Issues 67
 Innovation and Change 67
 Company Differences 69
The Macroenvironment 69
 Macroeconomic Forces 69
 Global Forces 71
 Technological Forces 71
 Demographic Forces 72
 Social Forces 72
 Political and Legal Forces 72

PART TWO **THE NATURE OF COMPETITIVE ADVANTAGE**

Chapter 3 Internal Analysis: Distinctive Competencies, Competitive Advantage, and Profitability **80**

Opening Case 80

Overview 82
The Roots of Competitive Advantage 82
 Distinctive Competencies 83
 Competitive Advantage, Value Creation, and Profitability 85
The Value Chain 89
 Primary Activities 89

Strategy in Action 3.1: Value Creation at Burberry 91
 Support Activities 91

Strategy in Action 3.2: Competitive Advantage at Zara 92

The Building Blocks of Competitive Advantage 93
 Efficiency 93
 Quality as Excellence and Reliability 94
 Innovation 96
 Customer Responsiveness 96
Business Models, the Value Chain, and Generic Distinctive Competencies 97
Analyzing Competitive Advantage and Profitability 98
The Durability of Competitive Advantage 103
 Barriers to Imitation 103
 Capability of Competitors 105
 Industry Dynamism 106
 Summary 106
Avoiding Failure and Sustaining Competitive Advantage 106
 Why Companies Fail 106
 Steps to Avoid Failure 108

Strategy in Action 3.3: The Road to Ruin at DEC 109

Chapter 4 Building Competitive Advantage Through
 Functional-Level Strategies 116

 Opening Case 116
 Overview 117
 Achieving Superior Efficiency 119
 Efficiency and Economies of Scale 119
 Efficiency and Learning Effects 120

 Strategy in Action 4.1: Learning Effects in Cardiac Surgery 122
 Efficiency and the Experience Curve 122
 *Efficiency, Flexible Production Systems, and Mass
 Customization 124*
 Marketing and Efficiency 125

 Strategy in Action 4.2: Pandora: Mass Customizing
 Internet Radio 126

 Materials Management, Just-in-Time Systems,
 and Efficiency 128
 R&D Strategy and Efficiency 129
 Human Resource Strategy and Efficiency 129
 Information Systems and Efficiency 132
 Infrastructure and Efficiency 132
 Summary 133
 Achieving Superior Quality 134
 Attaining Superior Reliability 134

 Strategy in Action 4.3: General Electric's Six Sigma Quality
 Improvement Process 135
 Implementing Reliability Improvement Methodologies 136
 Improving Quality as Excellence 138
 Achieving Superior Innovation 139
 The High Failure Rate of Innovation 140
 Reducing Innovation Failures 141

 Strategy in Action 4.4: Corning—learning from Innovation
 Failures 142

 Achieving Superior Responsiveness to Customers 144
 Focusing on the Customer 144
 Satisfying Customer Needs 145

PART THREE STRATEGIES

Chapter 5 Business-Level Strategy 153

 Opening Case 153
 Overview 154
 Low Cost and Differentiation 155
 Lowering Costs 155

Strategy in Action 5.1: Low Costs at Southwest Airlines 156
Who are Our Customers? Market Segmentation 161
Business-Level Strategy Choices 164
Business-Level Strategy, Industry and Competitive Advantage 166

Strategy in Action 5.2: Microsoft Office versus Google Apps 167
Implementing Business-Level Strategy 168
Competing Differently: Searching for a Blue Ocean 171

Chapter 6 Business-Level Strategy and the Industry
Environment 178

Opening Case 178
Overview 179
Strategy in a Fragmented Industry 180
 Reasons for Fragmentation 180
 Consolidating a Fragmented Industry Through Value
 Innovation 181
 Chaining and Franchising 182
 Horizontal Mergers 183
Strategies in Embryonic and Growth Industries 184
 The Changing Nature of Market Demand 185
 Strategic Implications: Crossing the Chasm 188

Strategy in Action 6.1: Crossing the Chasm in the
Smartphone Market 189
 Strategic Implications of Differences in Market
 Growth Rates 190
Strategy in Mature Industries 191
 Strategies to Deter Entry 192
 Strategies to Manage Rivalry 194

Strategy in Action 6.2: Toyota Uses Market Development
to Become the Global Leader 198

Strategy in Action 6.3: Non-Price Competition at Nike 199
Strategies in Declining Industries 201
 The Severity of Decline 201
 Choosing a Strategy 202

Chapter 7 Strategy and Technology 210

Opening Case 210
Overview 211
Technical Standards and Format Wars 213

Strategy in Action 7.1: "Segment Zero"—A Serious Threat
to Microsoft? 213
 Examples of Standards 216
 Benefits of Standards 217

Establishment of Standards 218
Network Effects, Positive Feedback, and Lockout 219
Strategies for Winning a Format War 222
 Ensure a Supply of Complements 222
 Leverage Killer Applications 222
 Aggressive Pricing and Marketing 223
 Cooperate with Competitors 223
 License the Format 224
Costs in High-Technology Industries 224
 Comparative Cost Economics 225
 Strategic Significance 226

Strategy in Action 7.2: Lowering the Cost of Ultrasound
Equipment Through Digitalization 227

Capturing First-Mover Advantages 227
 First-Mover Advantages 229
 First-Mover Disadvantages 229
 Strategies for Exploiting First-Mover Advantages 230
Technological Paradigm Shifts 233
 *Paradigm Shifts and the Decline of Established
 Companies 234*

Strategy in Action 7.3: Disruptive Technology in Mechanical
Excavators 238

 Strategic Implications for Established Companies 238
 Strategic Implications for New Entrants 240

Chapter 8 Strategy in the Global Environment 246

Opening Case 246

Overview 247
The Global and National Environments 248
 The Globalization of Production and Markets 248
 National Competitive Advantage 250
Increasing Profitability and Profit Growth Through Global
Expansion 253
 Expanding the Market: Leveraging Products 253
 Realizing Cost Economies from Global Volume 255
 Realizing Location Economies 256
 Leveraging the Skills of Global Subsidiaries 257
Cost Pressures and Pressures for Local Responsiveness 258
 Pressures for Cost Reductions 259
 Pressures for Local Responsiveness 259

Strategy in Action 8.1: Local Responsiveness at MTV
Networks 260

Choosing a Global Strategy 261
 Global Standardization Strategy 262
 Localization Strategy 263
 Transnational Strategy 264

International Strategy 265
Changes in Strategy over Time 265

Strategy in Action 8.2: The Evolving Strategy of Coca-Cola 267

The Choice of Entry Mode 268
Exporting 268
Licensing 269
Franchising 270
Joint Ventures 271
Wholly Owned Subsidiaries 272
Choosing an Entry Strategy 273
Global Strategic Alliances 275
Advantages of Strategic Alliances 275
Disadvantages of Strategic Alliances 276
Making Strategic Alliances Work 276

Chapter 9 Corporate-Level Strategy: Horizontal Integration,
Vertical Integration and Strategic Outsourcing 286

Opening Case 286

Overview 287
Corporate-Level Strategy and the Multibusiness Model 288
Horizontal Integration: Single-Industry Corporate Strategy 289
Benefits of Horizontal Integration 290

Strategy in Action 9.1: Larry Ellison Wants Oracle to Become
the Biggest and the Best 293

Problems with Horizontal Integration 294
Vertical Integration: Entering New Industries to Strengthen
the "Core" Business Model 295
Increasing Profitability Through Vertical Integration 297

Strategy in Action 9.2: Specialized Assets and Vertical
Integration in the Aluminum Industry 299

Problems with Vertical Integration 301
Alternatives to Vertical Integration: Cooperative Relationships 302
Short-Term Contracts and Competitive Bidding 303
Strategic Alliances and Long-Term Contracting 303

Strategy in Action 9.3: Apple, Samsung, and Nokia Battle
in the Smartphone Market 304

Building Long-Term Cooperative Relationships 305

Strategy in Action 9.4: Ebay's Changing Commitment to
Its Sellers 306

Strategic Outsourcing 307

Strategy in Action 9.5: Apple Tries to Protect Its New Products
and the Workers Who Make Them 308

Benefits of Outsourcing 310
Risks of Outsourcing 311

Chapter 10 Corporate-Level Strategy: Related and Unrelated
Diversification 318

Opening Case 318
Overview 322
Increasing Profitability Through Diversification 322
 Transferring Competencies Across Businesses 323
 Leveraging Competencies to Create a New Business 324
 Sharing Resources and Capabilities 325
 Using Product Bundling 326
 Utilizing General Organizational Competencies 327

Strategy in Action 10.1: United Technologies Has an "ACE" in
Its Pocket 329

Two Types of Diversification 331
 Related Diversification 331
 Unrelated Diversification 331
The Limits and Disadvantages of Diversification 333
 Changes in the Industry or Company 333
 Diversification for the Wrong Reasons 334
 The Bureaucratic Costs of Diversification 335

Strategy in Action 10.2: How Bureaucratic Costs Rose
Then Fell at Pfizer 337

Choosing a Strategy 338
 Related Versus Unrelated Diversification 338
 The Web of Corporate-Level Strategy 338

Strategy in Action 10.3: Sony's "Gaijin" CEO Is Changing
the Company's Strategies 340

Entering New Industries: Internal New Ventures 341
 The Attractions of Internal New Venturing 341
 Pitfalls of New Ventures 342
 Guidelines for Successful Internal New Venturing 344
Entering New Industries: Acquisitions 345
 The Attraction of Acquisitions 345
 Acquisition Pitfalls 346
 Guidelines for Successful Acquisition 348
Entering New Industries: Joint Ventures 349
 Restructuring 350
 Why Restructure? 350

PART FOUR IMPLEMENTING STRATEGY

Chapter 11 Corporate Performance, Governance,
and Business Ethics 359

Opening Case 359
Overview 361

Stakeholders and Corporate Performance 362
 Stakeholder Impact Analysis *363*
 The Unique Role of Stockholders *363*
 Profitability, Profit Growth, and Stakeholder Claims *364*

Strategy in Action 11.1: Price Fixing at Sotheby's and Christie's 366

Agency Theory 367
 Principal–Agent Relationships *367*
 The Agency Problem *367*

Strategy in Action 11.2: Self-Dealing at Hollinger
International Inc. 371

Governance Mechanisms 372
 The Board of Directors *372*
 Stock-Based Compensation *373*
 Financial Statements and Auditors *374*
 The Takeover Constraint *375*
 Governance Mechanisms Inside a Company *376*
Ethics and Strategy 378

Strategy in Action 11.3: Nike–the Sweatshop Debate 379
 Ethical Issues in Strategy *380*
 The Roots of Unethical Behavior *383*
 Behaving Ethically *384*

Chapter 12 Implementing Strategy in Companies That
Compete in a Single Industry 395

Opening Case 395

Overview 396
Implementing Strategy Through Organizational Design 397
Building Blocks of Organizational Structure 398
 Grouping Tasks, Functions, and Divisions *399*
 Allocating Authority and Responsibility *399*

Strategy in Action 12.1: Bob Iger Flattens Walt Disney 402
 Integration and Integrating Mechanisms *403*

Strategy in Action 12.2: Centralization and Decentralization
at Union Pacific and Yahoo! 404

Strategic Control Systems 405
 Levels of Strategic Control *407*
 Types of Strategic Control Systems *407*
 Strategic Reward Systems *410*
Organizational Culture 410
 Culture and Strategic Leadership *411*
 Traits of Strong and Adaptive Corporate Cultures *413*
Building Distinctive Competencies at the Functional Level 414
 Functional Structure: Grouping by Function *414*
 The Role of Strategic Control *415*

Developing Culture at the Functional Level 416
Functional Structure and Bureaucratic Costs 418
The Outsourcing Option 419
Implementing Strategy in a Single Industry 419
Implementing Cost Leadership 421
Implementing Differentiation 421
Product Structure: Implementing a Wide Product Line 422
Market Structure: Increasing Responsiveness to Customer Groups 424
Geographic Structure: Expanding by Location 424

Strategy in Action 12.3: The HISD Moves from a Geographic to a Market Structure 426

Matrix and Product-Team Structures: Competing in High-Tech Environments 426
Focusing on a Narrow Product Line 429
Restructuring and Reengineering 430

Chapter 13 Implementing Strategy in Companies That Compete Across Industries and Countries 439

Opening Case 439
Overview 440
Corporate Strategy and the Multidivisional Structure 441
Advantages of a Multidivisional Structure 443
Problems in Implementing a Multidivisional Structure 444

Strategy in Action 13.1: Organizational Change at Avon 446

Structure, Control, Culture, and Corporate-Level Strategy 447
Implementing Strategy Across Countries 451
The International Division 451
Worldwide Area Structure 452
Worldwide Product Divisional Structure 454
Global Matrix Structure 455

Strategy in Action 13.2: Dow Chemical's Matrix Structure 457

Entry Mode and Implementation 458
Internal New Venturing 458
Joint Ventures 459
Mergers and Acquisitions 460

PART FIVE ANALYZING A CASE STUDY AND WRITING A CASE STUDY ANALYSIS

What is Case Study Analysis C-2
Analyzing a Case Study C-3
Writing A Case Study Analysis C-8

The Role of Financial Analysis in Case Study Analysis C-9
Profit Ratios C-10
Liquidity Ratios C-11
Activity Ratios C-11
Leverage Ratios C-12
Shareholder-Return Ratios C-12
Cash Flow C-13
Conclusion C-14

Glossary G-1
Index I-1

ment. For example, the scenario in Chapter 11 asks students to identify the stakeholders of their educational institution and evaluate how stakeholders' claims are being and should be met.

- The **Strategy Sign-On** section presents an opportunity for students to explore the latest data through digital research activities.

 - First, the Article File requires students to search business articles to identify a company that is facing a particular strategic management problem. For instance, students are asked to locate and research a company pursuing a low-cost or a differentiation strategy, and to describe this company's strategy, its advantages and disadvantages, and the core competencies required to pursue it. Students' presentations of their findings lead to lively class discussions.

 - Then, the **Strategic Management Project: Developing Your Portfolio** asks students to choose a company to study through the duration of the semester. At the end of every chapter, students analyze the company using the series of questions provided at the end of each chapter. For example, students might select Ford Motor Co. and, using the series of chapter questions, collect information on Ford's top managers, mission, ethical position, domestic and global strategy and structure, and so on. Students write a case study of their company and present it to the class at the end of the semester. In the past, we also had students present one or more of the cases in the book early in the semester, but now in our classes, we treat the students' own projects as the major class assignment and their case presentations as the climax of the semester's learning experience.

- **Closing Case.** A short closing case provides an opportunity for a short class discussion of a chapter-related theme.

In creating these exercises, it is not our intention to suggest that they should *all* be used for *every* chapter. For example, over a semester, an instructor might combine a group of Strategic Management Projects with 5 to 6 Article File assignments while incorporating 8 to 10 Small-Group Exercises in class.

We have found that our interactive approach to teaching strategic management appeals to students. It also greatly improves the quality of their learning experience. Our approach is more fully discussed in the *Instructor's Resource Manual*.

Teaching and Learning Aids

Taken together, the teaching and learning features of *Strategic Management* provide a package that is unsurpassed in its coverage and that supports the integrated approach that we have taken throughout the book.

For the Instructor

- The **Instructor's Resource Manual: Theory.** For each chapter, we provide a clearly focused synopsis, a list of teaching objectives, a comprehensive lecture outline, teaching notes for the Ethical Dilemma feature, suggested answers to discussion questions, and comments on the end-of-chapter activities. Each Opening Case, Strategy in Action boxed feature, and Closing Case has a synopsis and a corresponding teaching note to help guide class discussion.

The Role of Financial Analysis in Case Study Analysis C-9
 Profit Ratios C-10
 Liquidity Ratios C-11
 Activity Ratios C-11
 Leverage Ratios C-12
 Shareholder-Return Ratios C-12
 Cash Flow C-13
Conclusion C-14

Glossary G-1
Index I-1

Preface

Consistent with our mission to provide students with the most current and up-to-date account of the changes taking place in the world of strategy and management, there have been some significant changes in the 11th edition of *Strategic Management: Theory*.

First, we have a new co-author, Melissa Shilling. Melissa is a Professor of Management and Organization at the Leonard Stern School of Business at New York University, where she teaches courses on strategic management, corporate strategy, and technology and innovation management. She has published extensively in top-tier academic journals and is recognized as one of the leading experts on innovation and strategy in high-technology industries. We are very pleased to have Melissa on the book team. Melissa made substantial contributions to this edition, including revising several chapters and writing seven high-caliber case studies. We believe her input has significantly strengthened the book.

Second, several chapters have been extensively revised. Chapter 5: Business-Level Strategy has been rewritten from scratch. In addition to the standard material on Porter's generic strategies, this chapter now includes discussion of *value innovation* and *blue ocean strategy* following the work of W. C. Kim and R. Mauborgne. Chapter 6: Business-Level Strategy and the Industry Environment has also been extensively rewritten and updated to clarify concepts and bring it into the 21st century. Despite the addition of new materials, both chapters are shorter than in prior editions. Substantial changes have been made to many other chapters, and extraneous material has been cut. For example, in Chapter 13 the section on implementing strategy across countries has been entirely rewritten and updated. This chapter has also been substantially shortened.

Third, the examples and cases contained in each chapter have been revised. We have a new *Running Case* for this edition, Wal-Mart. Every chapter has a new *Opening Case* and a new *Closing Case*. There are also many new *Strategy in Action* features. In addition, there has been significant change in the examples used in the text to illustrate content. In making these changes, our goal has been to make the book relevant for students reading it in the second decade of the 21st century.

Practicing Strategic Management: An Interactive Approach

We have received a lot of positive feedback about the usefulness of the end-of-chapter exercises and assignments in the Practicing Strategic Management sections of our book. They offer a wide range of hands-on and digital learning experiences for students. Following the Chapter Summary and Discussion Questions, each chapter contains the following exercises and assignments:

- **Ethical Dilemma**. This feature has been developed to highlight the importance of ethical decision making in today's business environment. With today's current examples of questionable decision making (as seen in companies like Countrywide Financial during the 2007–2009 global financial crisis), we hope to equip students with the tools they need to be strong ethical leaders.
- **Small-Group Exercise.** This short (20-minute) experiential exercise asks students to divide into groups and discuss a scenario concerning some aspect of strategic manage-

ment. For example, the scenario in Chapter 11 asks students to identify the stakeholders of their educational institution and evaluate how stakeholders' claims are being and should be met.

- The **Strategy Sign-On** section presents an opportunity for students to explore the latest data through digital research activities.

 - First, the Article File requires students to search business articles to identify a company that is facing a particular strategic management problem. For instance, students are asked to locate and research a company pursuing a low-cost or a differentiation strategy, and to describe this company's strategy, its advantages and disadvantages, and the core competencies required to pursue it. Students' presentations of their findings lead to lively class discussions.

 - Then, the **Strategic Management Project: Developing Your Portfolio** asks students to choose a company to study through the duration of the semester. At the end of every chapter, students analyze the company using the series of questions provided at the end of each chapter. For example, students might select Ford Motor Co. and, using the series of chapter questions, collect information on Ford's top managers, mission, ethical position, domestic and global strategy and structure, and so on. Students write a case study of their company and present it to the class at the end of the semester. In the past, we also had students present one or more of the cases in the book early in the semester, but now in our classes, we treat the students' own projects as the major class assignment and their case presentations as the climax of the semester's learning experience.

- **Closing Case.** A short closing case provides an opportunity for a short class discussion of a chapter-related theme.

In creating these exercises, it is not our intention to suggest that they should *all* be used for *every* chapter. For example, over a semester, an instructor might combine a group of Strategic Management Projects with 5 to 6 Article File assignments while incorporating 8 to 10 Small-Group Exercises in class.

We have found that our interactive approach to teaching strategic management appeals to students. It also greatly improves the quality of their learning experience. Our approach is more fully discussed in the *Instructor's Resource Manual*.

Teaching and Learning Aids

Taken together, the teaching and learning features of *Strategic Management* provide a package that is unsurpassed in its coverage and that supports the integrated approach that we have taken throughout the book.

For the Instructor

- The **Instructor's Resource Manual: Theory.** For each chapter, we provide a clearly focused synopsis, a list of teaching objectives, a comprehensive lecture outline, teaching notes for the Ethical Dilemma feature, suggested answers to discussion questions, and comments on the end-of-chapter activities. Each Opening Case, Strategy in Action boxed feature, and Closing Case has a synopsis and a corresponding teaching note to help guide class discussion.

- **Case Teaching Notes** include a complete list of case discussion questions as well as a comprehensive teaching notes for each case, which gives a complete analysis of case issues.
- **Cognero Test Bank:** A completely online test bank allows the instructor the ability to create comprehensive, true/false, multiple-choice and essay questions for each chapter in the book. The mix of questions has been adjusted to provide fewer fact-based or simple memorization items and to provide more items that rely on synthesis or application.
- **PowerPoint Presentation Slides:** Each chapter comes complete with a robust Power-Point presentation to aid with class lectures. These slides can be downloaded from the text website.
- **CengageNow.** This robust online course management system gives you more control in less time and delivers better student outcomes—NOW. CengageNow™ includes teaching and learning resources organized around lecturing, creating assignments, casework, quizzing, and gradework to track student progress and performance. Multiple types of quizzes, including video quizzes are assignable and gradable. Flexible assignments, automatic grading, and a gradebook option provide more control while saving you valuable time. CengageNow empowers students to master concepts, prepare for exams, and become more involved in class.
- **Cengage Learning Write Experience 2.0.** This new technology is the first in higher education to offer students the opportunity to improve their writing and analytical skills without adding to your workload. Offered through an exclusive agreement with Vantage Learning, creator of the software used for GMAT essay grading, Write Experience evaluates students' answers to a select set of writing assignments for voice, style, format, and originality.

For the Student

- **CengageNow** includes learning resources organized around assignments, casework, and quizzing, and allows you to track your progress and performance. A Personalized Study diagnostic tool empowers students to master concepts, prepare for exams, and become more involved in class.

Acknowledgments

This book is the product of far more than two authors. We are grateful to our Senior Product Managers, Michele Rhoades and Scott Person; our Senior Content Developer, Mike Guendelsberger; our Content Project Manager, Cliff Kallemeyn; and our Marketing Manager, Emily Horowitz, for their help in developing and promoting the book and for providing us with timely feedback and information from professors and reviewers, which allowed us to shape the book to meet the needs of its intended market. We are also grateful to the case authors for allowing us to use their materials. We also want to thank the departments of management at the University of Washington and New York University for providing the setting and atmosphere in which the book could be written, and the students of these universities who react to and provide input for many of our ideas. In addition, the following reviewers of this and earlier editions gave us valuable suggestions for improving the manuscript from its original version to its current form:

Andac Arikan, *Florida Atlantic University*

Ken Armstrong, *Anderson University*

Richard Babcock, *University of San Francisco*

Kunal Banerji, *West Virginia University*

Kevin Banning, *Auburn University- Montgomery*

Glenn Bassett, *University of Bridgeport*

Thomas H. Berliner, *The University of Texas at Dallas*

Bonnie Bollinger, *Ivy Technical Community College*

Richard G. Brandenburg, *University of Vermont*

Steven Braund, *University of Hull*

Philip Bromiley, *University of Minnesota*

Geoffrey Brooks, *Western Oregon State College*

Jill Brown, *Lehigh University*

Amanda Budde, *University of Hawaii*

Lowell Busenitz, *University of Houston*

Sam Cappel, *Southeastern Louisiana University*

Charles J. Capps III, *Sam Houston State University*

Don Caruth, *Texas A&M Commerce*

Gene R. Conaster, *Golden State University*

Steven W. Congden, *University of Hartford*

Catherine M. Daily, *Ohio State University*

Robert DeFillippi, *Suffolk University Sawyer School of Management*

Helen Deresky, *SUNY—Plattsburgh*

Fred J. Dorn, *University of Mississippi*

Gerald E. Evans, *The University of Montana*

John Fahy, *Trinity College, Dublin*

Patricia Feltes, *Southwest Missouri State University*

Bruce Fern, *New York University*

Mark Fiegener, *Oregon State University*

Chuck Foley, *Columbus State Community College*

Isaac Fox, *Washington State University*

Craig Galbraith, *University of North Carolina at Wilmington*

Scott R. Gallagher, *Rutgers University*

Eliezer Geisler, *Northeastern Illinois University*

Gretchen Gemeinhardt, *University of Houston*

Lynn Godkin, *Lamar University*

Sanjay Goel, *University of Minnesota—Duluth*

Robert L. Goldberg, *Northeastern University*

James Grinnell, *Merrimack College*

Russ Hagberg, *Northern Illinois University*

Allen Harmon, *University of Minnesota—Duluth*

Ramon Henson, *Rutgers University*

David Hoopes, *California State University—Dominguez Hills*

Todd Hostager, *University of Wisconsin—Eau Claire*

David Hover, *San Jose State University*

Graham L. Hubbard, *University of Minnesota*

Tammy G. Hunt, *University of North Carolina at Wilmington*

James Gaius Ibe, *Morris College*

W. Grahm Irwin, *Miami University*

Homer Johnson, *Loyola University—Chicago*

Jonathan L. Johnson, *University of Arkansas Walton College of Business Administration*

Marios Katsioloudes, *St. Joseph's University*

Robert Keating, *University of North Carolina at Wilmington*

Geoffrey King, *California State University—Fullerton*

Rico Lam, *University of Oregon*

Robert J. Litschert, *Virginia Polytechnic Institute and State University*

Franz T. Lohrke, *Louisiana State University*

Paul Mallette, *Colorado State University*

Daniel Marrone, *SUNY Farmingdale*

Lance A. Masters, *California State University—San Bernardino*

Robert N. McGrath, *Embry-Riddle Aeronautical University*

Charles Mercer, *Drury College*

Van Miller, *University of Dayton*

Tom Morris, *University of San Diego*

Joanna Mulholland, *West Chester University of Pennsylvania*

James Muraski, *Marquette University*

John Nebeck, *Viterbo University*

Jeryl L. Nelson, *Wayne State College*

Louise Nemanich, *Arizona State University*

Francine Newth, *Providence College*

Don Okhomina, *Fayetteville State University*

Phaedon P. Papadopoulos, *Houston Baptist University*

John Pappalardo, *Keen State College*

Paul R. Reed, *Sam Houston State University*

Rhonda K. Reger, *Arizona State University*

Malika Richards, *Indiana University*

Simon Rodan, *San Jose State*

Stuart Rosenberg, *Dowling College*

Douglas Ross, *Towson University*

Ronald Sanchez, *University of Illinois*

Joseph A. Schenk, *University of Dayton*

Brian Shaffer, *University of Kentucky*

Leonard Sholtis, *Eastern Michigan University*

Pradip K. Shukla, *Chapman University*

Mel Sillmon, *University of Michigan—Dearborn*

Dennis L. Smart, *University of Nebraska at Omaha*

Barbara Spencer, *Clemson University*

Lawrence Steenberg, *University of Evansville*

Kim A. Stewart, *University of Denver*

Ted Takamura, *Warner Pacific College*

Scott Taylor, *Florida Metropolitan University*

Thuhang Tran, *Middle Tennessee University*

Bobby Vaught, *Southwest Missouri State*

Robert P. Vichas, *Florida Atlantic University*

John Vitton, *University of North Dakota*

Edward Ward, *St. Cloud State University*

Kenneth Wendeln, *Indiana University*

Daniel L. White, *Drexel University*

Edgar L. Williams, Jr., *Norfolk State University*

Jun Zhao, *Governors State University*

Charles W. L. Hill
Gareth R. Jones
Melissa A. Schilling

Dedication

To my children, Elizabeth, Charlotte, and Michelle

– Charles W. L. Hill

For Nicholas and Julia and Morgan and Nia

– Gareth R. Jones

For my children, Julia and Conor

– Melissa A. Schilling

Strategic Leadership: Managing the Strategy-Making Process for Competitive Advantage

OPENING CASE

© iStockPhoto.com/shaunl

Wal-Mart's Competitive Advantage

Wal-Mart is one of the most extraordinary success stories in business history. Started in 1962 by Sam Walton, Wal-Mart has grown to become the world's largest corporation. In 2012, the discount retailer—whose mantra is "everyday low prices"—had sales of $440 billion, close to 10,000 stores in 27 countries, and 2.2 million employees. Some 8% of all retail sales in the United States are

made at a Wal-Mart store. Wal-Mart is not only large; it is also very profitable. Between 2003 and 2012 the company's average return on invested capital was 12.96%, better than its well-managed rivals Costco and Target, which earned 10.74% and 9.6%, respectively (see Figure 1.1).

Wal-Mart's persistently superior profitability reflects a competitive advantage that is based upon a number of strategies. Back in 1962, Wal-Mart was one of the first companies to apply the self-service supermarket business model developed by grocery chains to general merchandise. Unlike its rivals such as K-Mart and Target that focused on urban and suburban locations, Sam Walton's Wal-Mart concentrated on small southern towns that were ignored by its rivals. Wal-Mart grew quickly by pricing its products lower than those of local retailers, often putting them out of business. By the time its rivals realized that small towns could support a large discount general merchandise store, Wal-Mart had already pre-empted them. These

LEARNING OBJECTIVES

After reading this chapter you should be able to:

1-1 Explain what is meant by "competitive advantage"

1-2 Discuss the strategic role of managers at different levels within an organization

1-3 Identify the primary steps in a strategic planning process

1-4 Discuss the common pitfalls of planning, and how those pitfalls can be avoided

1-5 Outline the cognitive biases that might lead to poor strategic decisions, and explain how these biases can be overcome

1-6 Discuss the role strategic leaders play in the strategy-making process

towns, which were large enough to support one discount retailer but not two, provided a secure profit base for Wal-Mart.

The company was also an innovator in information systems, logistics, and human resource practices. These strategies resulted in higher productivity and lower costs as compared to rivals, which enabled the company to earn a high profit while charging low prices. Wal-Mart led the way among U.S. retailers in developing and implementing sophisticated product tracking systems using bar-code technology and checkout scanners. This information technology enabled Wal-Mart to track what was selling and adjust its inventory accordingly so that the products found in each store matched local demand. By avoiding overstocking, Wal-Mart did not have to hold periodic sales to shift unsold inventory. Over time, Wal-Mart linked this information system to a nationwide network of distribution centers in which inventory was stored and then shipped to stores within a 400-mile radius on a daily basis. The combination of distribution centers and information centers

enabled Wal-Mart to reduce the amount of inventory it held in stores, thereby devoting more of that valuable space to selling and reducing the amount of capital it had tied up in inventory.

With regard to human resources, Sam Walton set the tone. He held a strong belief that employees should be respected and rewarded for helping to improve the profitability of the company. Underpinning this belief, Walton referred to employees as "associates." He established a profit-sharing scheme for all employees, and after the company went public in 1970, a program that allowed employees to purchase Wal-Mart stock at a discount to its market value. Wal-Mart was rewarded for this approach by high employee productivity, which translated into lower operating costs and higher profitability.

As Wal-Mart grew larger, the sheer size and purchasing power of the company enabled it to drive down the prices that it paid suppliers, passing on those saving to customers in the form of lower prices, which enabled Wal-Mart to gain more market share and hence lower prices even further. To take the

| Figure 1.1 | Profitability of Wal-Mart and Competitors, 2003–2012 |

Source: Calculated by the author from Morningstar data.

sting out of the persistent demands for lower prices, Wal-Mart shared its sales information with suppliers on a daily basis, enabling them to gain efficiencies by configuring their own production schedules for sales at Wal-Mart.

By the time the 1990s came along, Wal-Mart was already the largest seller of general merchandise in the United States. To keep its growth going, Wal-Mart started to diversify into the grocery business, opening 200,000-square-foot supercenter stores that sold groceries and general merchandise under the same roof. Wal-Mart also diversified into the warehouse club business with the establishment of Sam's Club. The company began expanding internationally in 1991 with its entry into Mexico.

For all its success, however, Wal-Mart is now encountering very real limits to profitable growth. The U.S. market is saturated, and growth overseas has proved more difficult than the company hoped. The company was forced to exit Germany and South Korea after losing money there, and it has faced difficulties in several other developed nations. Moreover, rivals Target and Costco have continued to improve their performance, and Costco in particular is now snapping at Wal-Mart's heals.

Sources: "How Big Can It Grow?" *The Economist* (April 17, 2004): 74–78; "Trial by Checkout," *The Economist* (June 26, 2004): 74–76; Wal-Mart 10-K, 200, information at Wal-Mart's website, www.walmartstores.com; Robert Slater, *The Wal-Mart Triumph* (New York: Portfolio Trade Books, 2004); and "The Bulldozer from Bentonville Slows; Wal-Mart," *The Economist* (February 17, 2007): 70.

OVERVIEW

Why do some companies succeed, whereas others fail? Why has Wal-Mart been able to persistently outperform its well-managed rivals? In the airline industry, how has Southwest Airlines managed to keep increasing its revenues and profits through both good times and bad, whereas rivals such as United Airlines have had to seek bankruptcy protection? What explains the persistent growth and profitability of Nucor Steel, now the largest steelmaker in the United States, during a period when many of its once-larger rivals disappeared into bankruptcy?

In this book, we argue that the strategies that a company's managers pursue have a major impact on the company's performance relative to that of its competitors. **A strategy** is a set of related actions that managers take to increase their company's performance. For most, if not all, companies, achieving superior performance relative to rivals is the ultimate challenge. If a company's strategies result in superior performance, it is said to have a competitive advantage. Wal-Mart's strategies produced superior performance from 2003 to 2012; as a result, Wal-Mart has enjoyed competitive advantage over its rivals. How did Wal-Mart achieve this competitive advantage? As explained in the opening case, it was due to the successful pursuit of a number of strategies by Wal-Mart's managers, including, most notably, the company's founder, Sam Walton. These strategies enabled the company to lower its cost structure, charge low prices, gain market share, and become more profitable than its rivals. (We will return to the example of Wal-Mart several times throughout this book in the *Running Case* feature that examines various aspects of Wal-Mart's strategy and performance.)

This book identifies and describes the strategies that managers can pursue to achieve superior performance and provide their companies with a competitive advantage. One of its

strategy
A set of related actions that managers take to increase their company's performance.

central aims is to give you a thorough understanding of the analytical techniques and skills necessary to identify and implement strategies successfully. The first step toward achieving this objective is to describe in more detail what superior performance and competitive advantage mean and to explain the pivotal role that managers play in leading the strategy-making process.

strategic leadership

Creating competitive advantage through effective management of the strategy-making process.

strategy formulation

Selecting strategies based on analysis of an organization's external and internal environment.

strategy implementation

Putting strategies into action.

Strategic leadership is about how to most effectively manage a company's strategy-making process to create competitive advantage. The strategy-making process is the process by which managers select and then implement a set of strategies that aim to achieve a competitive advantage. **Strategy formulation** is the task of selecting strategies, whereas **strategy implementation** is the task of putting strategies into action, which includes designing, delivering, and supporting products; improving the efficiency and effectiveness of operations; and designing a company's organizational structure, control systems, and culture.

By the end of this chapter, you will understand how strategic leaders can manage the strategy-making process by formulating and implementing strategies that enable a company to achieve a competitive advantage and superior performance. Moreover, you will learn how the strategy-making process can go wrong, and what managers can do to make this process more effective.

STRATEGIC LEADERSHIP, COMPETITIVE ADVANTAGE, AND SUPERIOR PERFORMANCE

Strategic leadership is concerned with managing the strategy-making process to increase the performance of a company, thereby increasing the value of the enterprise to its owners, its shareholders. As shown in Figure 1.2, to increase shareholder value, managers must pursue strategies that increase the profitability of the company and ensure that profits grow (for more details, see the Appendix to this chapter). To do this, a company must be able to outperform its rivals; it must have a competitive advantage.

Figure 1.2	Determinants of Shareholder Value

© Cengage Learning

Superior Performance

Maximizing shareholder value is the ultimate goal of profit-making companies, for two reasons. First, shareholders provide a company with the risk capital that enables managers to buy the resources needed to produce and sell goods and services. Risk capital is capital that cannot be recovered if a company fails and goes bankrupt. In the case of Wal-Mart, for example, shareholders provided Sam Walton's company with the capital it used to build stores and distribution centers, invest in information systems, purchase inventory to sell to customers, and so on. Had Wal-Mart failed, its shareholders would have lost their money— their shares would have been worthless Thus, shareholders will not provide risk capital unless they believe that managers are committed to pursuing strategies that provide a good return on their capital investment. Second, shareholders are the legal owners of a corporation, and their shares therefore represent a claim on the profits generated by a company. Thus, managers have an obligation to invest those profits in ways that maximize shareholder value. Of course, as explained later in this book, managers must behave in a legal, ethical, and socially responsible manner while working to maximize shareholder value.

By shareholder value, we mean the returns that shareholders earn from purchasing shares in a company. These returns come from two sources: (a) capital appreciation in the value of a company's shares and (b) dividend payments.

For example, between January 2 and December 31, 2012, the value of one share in Wal-Mart increased from $60.33 to $68.90, which represents a capital appreciation of $8.57. In addition, Wal-Mart paid out a dividend of $1.59 per share during 2012. Thus, if an investor had bought one share of Wal-Mart on January 2 and held on to it for the entire year, the return would have been $10.16 ($8.57 + $1.59), a solid 16.8% return on the investment. One reason Wal-Mart's shareholders did well during 2012 was that investors believed that managers were pursuing strategies that would both increase the long-term profitability of the company and significantly grow its profits in the future.

One way of measuring the profitability of a company is by the return that it makes on the capital invested in the enterprise.[1] The return on invested capital (ROIC) that a company earns is defined as its net profit over the capital invested in the firm (profit/capital invested). By net profit, we mean net income after tax. By capital, we mean the sum of money invested in the company: that is, stockholders' equity plus debt owed to creditors. So defined, *profitability is the result of how efficiently and effectively managers use the capital at their disposal to produce goods and services that satisfy customer needs.* A company that uses its capital efficiently and effectively makes a positive return on invested capital.

The profit growth of a company can be measured by the increase in net profit over time. A company can grow its profits if it sells products in markets that are growing rapidly, gains market share from rivals, increases the amount it sells to existing customers, expands overseas, or diversifies profitably into new lines of business. For example, between 1994 and 2012, Wal-Mart increased its net profit from $2.68 billion to $15.7 billion. It was able to do this because the company (a) took market share from rivals, (b) established stores in 27 foreign nations that collectively generated $125 billion in sales by 2012, and (c) entered the grocery business. Due to the increase in net profit, Wal-Mart's earnings per share increased from $0.59 to $4.52, making each share more valuable, and leading in turn to appreciation in the value of Wal-Mart's shares.

Together, profitability and profit growth are the principal drivers of shareholder value (see the Appendix to this chapter for details). *To both boost profitability and grow profits over time, managers must formulate and implement strategies that give their company a competitive advantage over rivals.* Wal-Mart's strategies have enabled the company to maintain a high level

risk capital
Equity capital for which there is no guarantee that stockholders will ever recoup their investment or earn a decent return.

shareholder value
Returns that shareholders earn from purchasing shares in a company.

profitability
The return a company makes on the capital invested in the enterprise.

profit growth
The increase in net profit over time.

of profitability, and to simultaneously grow its profits over time. As a result, investors who purchased Wal-Mart's stock in January 1994, when the shares were trading at $11, would have made a return of more than 620% if they had held onto them through until December 2012. By pursuing strategies that lead to high and sustained profitability, and profit growth, Wal-Mart's managers have thus rewarded shareholders for their decisions to invest in the company.

One of the key challenges managers face is how best to simultaneously generate high profitability and increase the profits of the company. Companies that have high profitability but profits that are not growing will not be as highly valued by shareholders as companies that have both high profitability and rapid profit growth (see the Appendix for details). This was the situation that Dell faced in the later part of the 2000s. At the same time, managers need to be aware that if they grow profits but profitability declines, that too will not be as highly valued by shareholders. What shareholders want to see, and what managers must try to deliver through strategic leadership, is *profitable growth*: that is, high profitability and sustainable profit growth. This is not easy, but some of the most successful enterprises of our era have achieved it—companies such as Apple, Google, and Wal-Mart.

Competitive Advantage and a Company's Business Model

Managers do not make strategic decisions in a competitive vacuum. Their company is competing against other companies for customers. Competition is a rough-and-tumble process in which only the most efficient and effective companies win out. It is a race without end. To maximize shareholder value, managers must formulate and implement strategies that enable their company to outperform rivals—that give it a competitive advantage. A company is said to have a **competitive advantage** over its rivals when its profitability is greater than the average profitability and profit growth of other companies competing for the same set of customers. The higher its profitability relative to rivals, the greater its competitive advantage will be. A company has a **sustained competitive advantage** when its strategies enable it to maintain above-average profitability for a number of years. As discussed in the opening case, Wal-Mart had a significant and sustained competitive advantage over rivals such as Target, Costco, and K-Mart for most of the last two decades.

The key to understanding competitive advantage is appreciating how the different strategies managers pursue over time can create activities that fit together to make a company unique or different from its rivals and able to consistently outperform them. A **business model** is managers' conception of how the set of strategies their company pursues should work together as a congruent whole, enabling the company to gain a competitive advantage and achieve superior profitability and profit growth. In essence, a business model is a kind of mental model, or gestalt, of how the various strategies and capital investments a company makes should fit together to generate above-average profitability and profit growth. A business model encompasses the totality of how a company will:

- Select its customers.
- Define and differentiate its product offerings.
- Create value for its customers.
- Acquire and keep customers.
- Produce goods or services.
- Lower costs.
- Deliver goods and services to the market.
- Organize activities within the company.

competitive advantage
The achieved advantage over rivals when a company's profitability is greater than the average profitability of firms in its industry.

sustained competitive advantage
A company's strategies enable it to maintain above-average profitability for a number of years.

business model
The conception of how strategies should work together as a whole to enable the company to achieve competitive advantage.

STRATEGIC MANAGERS

Managers are the linchpin in the strategy-making process. It is individual managers who must take responsibility for formulating strategies to attain a competitive advantage and for putting those strategies into effect. They must lead the strategy-making process. The strategies that made Wal-Mart so successful were not chosen by some abstract entity known as "the company"; they were chosen by the company's founder, Sam Walton, and the managers he hired. Wal-Mart's success was largely based on how well the company's managers performed their strategic roles. In this section, we look at the strategic roles of different managers. Later in the chapter, we discuss strategic leadership, which is how managers can effectively lead the strategy-making process.

In most companies, there are two primary types of managers: **general managers**, who bear responsibility for the overall performance of the company or for one of its major self-contained subunits or divisions, and **functional managers**, who are responsible for supervising a particular function, that is, a task, activity, or operation, such as accounting, marketing, research and development (R&D), information technology, or logistics. Put differently, general managers have profit-and-loss responsibility for a product, a business, or the company as a whole.

A company is a collection of functions or departments that work together to bring a particular good or service to the market. If a company provides several different kinds of goods or services, it often duplicates these functions and creates a series of self-contained divisions (each of which contains its own set of functions) to manage each different good or service. The general managers of these divisions then become responsible for their particular product line. The overriding concern of general managers is the success of the whole company or the divisions under their direction; they are responsible for deciding how to create a competitive advantage and achieve high profitability with the resources and capital they have at their disposal. Figure 1.4 shows the organization of a **multidivisional company**,

general managers
Managers who bear responsibility for the overall performance of the company or for one of its major self-contained subunits or divisions.

functional managers
Managers responsible for supervising a particular function, that is, a task, activity, or operation, such as accounting, marketing, research and development (R&D), information technology, or logistics.

multidivisional company
A company that competes in several different businesses and has created a separate self-contained division to manage each.

Figure 1.4 Levels of Strategic Management

Corporate Level CEO, Board of Directors, Corporate staff — Head Office

Business Level Divisional managers and staff — Division A, Division B, Division C

Functional Level Functional managers — Business functions, Business functions, Business functions

Market A, Market B, Market C

© Cengage Learning

that is, a company that competes in several different businesses and has created a separate self-contained division to manage each. As you can see, there are three main levels of management: corporate, business, and functional. General managers are found at the first two of these levels, but their strategic roles differ depending on their sphere of responsibility.

Corporate-Level Managers

The corporate level of management consists of the chief executive officer (CEO), other senior executives, and corporate staff. These individuals occupy the apex of decision making within the organization. The CEO is the principal general manager. In consultation with other senior executives, the role of corporate-level managers is to oversee the development of strategies for the whole organization. This role includes defining the goals of the organization, determining what businesses it should be in, allocating resources among the different businesses, formulating and implementing strategies that span individual businesses, and providing leadership for the entire organization.

Consider General Electric (GE) as an example. GE is active in a wide range of businesses, including lighting equipment, major appliances, motor and transportation equipment, turbine generators, construction and engineering services, industrial electronics, medical systems, aerospace, aircraft engines, and financial services. The main strategic responsibilities of its CEO, Jeffrey Immelt, are setting overall strategic goals, allocating resources among the different business areas, deciding whether the firm should divest itself of any of its businesses, and determining whether it should acquire any new ones. In other words, it is up to Immelt to develop strategies that span individual businesses; his concern is with building and managing the corporate portfolio of businesses to maximize corporate profitability.

It is the CEO's specific responsibility (in this example, Immelt) to develop strategies for competing in the individual business areas, such as financial services. The development of such strategies is the responsibility of the general managers in these different businesses, or business-level managers. However, it is Immelt's responsibility to probe the strategic thinking of business-level managers to make sure that they are pursuing robust business models and strategies that will contribute to the maximization of GE's long-run profitability, to coach and motivate those managers, to reward them for attaining or exceeding goals, and to hold them accountable for poor performance.

Corporate-level managers also provide a link between the people who oversee the strategic development of a firm and those who own it (the shareholders). Corporate-level managers, and particularly the CEO, can be viewed as the agents of shareholders.[3] It is their responsibility to ensure that the corporate and business strategies that the company pursues are consistent with maximizing profitability and profit growth. If they are not, then the CEO is likely to be called to account by the shareholders.

Business-Level Managers

business unit

A self-contained division that provides a product or service for a particular market.

A **business unit** is a self-contained division (with its own functions—for example, finance, purchasing, production, and marketing departments) that provides a product or service for a particular market. The principal general manager at the business level, or the business-level manager, is the head of the division. The strategic role of these managers is to translate the general statements of direction and intent that come from the corporate level into concrete strategies for individual businesses. Whereas corporate-level general managers are concerned with strategies that span individual businesses, business-level general managers are concerned with strategies that are specific to a particular business. At GE, a major corporate goal is to be first or second in every business in which the corporation competes.

Then, the general managers in each division work out for their business the details of a business model that is consistent with this objective.

Functional-Level Managers

Functional-level managers are responsible for the specific business functions or operations (human resources, purchasing, product development, customer service, etc.) that constitute a company or one of its divisions. Thus, a functional manager's sphere of responsibility is generally confined to one organizational activity, whereas general managers oversee the operation of an entire company or division. Although they are not responsible for the overall performance of the organization, functional managers nevertheless have a major strategic role: to develop functional strategies in their areas that help fulfill the strategic objectives set by business- and corporate-level general managers.

In GE's aerospace business, for instance, manufacturing managers are responsible for developing manufacturing strategies consistent with corporate objectives. Moreover, functional managers provide most of the information that makes it possible for business- and corporate-level general managers to formulate realistic and attainable strategies. Indeed, because they are closer to the customer than is the typical general manager, functional managers themselves may generate important ideas that subsequently become major strategies for the company. Thus, it is important for general managers to listen closely to the ideas of their functional managers. An equally great responsibility for managers at the operational level is strategy implementation: the execution of corporate- and business-level plans.

THE STRATEGY-MAKING PROCESS

We can now turn our attention to the process by which managers formulate and implement strategies. Many writers have emphasized that strategy is the outcome of a formal planning process and that top management plays the most important role in this process.[4] Although this view has some basis in reality, it is not the whole story. As we shall see later in the chapter, valuable strategies often emerge from deep within the organization without prior planning. Nevertheless, a consideration of formal, rational planning is a useful starting point for our journey into the world of strategy. Accordingly, we consider what might be described as a typical formal strategic planning model for making strategy.

A Model of the Strategic Planning Process

The formal strategic planning process has five main steps:

1. Select the corporate mission and major corporate goals.
2. Analyze the organization's external competitive environment to identify opportunities and threats.
3. Analyze the organization's internal operating environment to identify the organization's strengths and weaknesses.
4. Select strategies that build on the organization's strengths and correct its weaknesses in order to take advantage of external opportunities and counter external threats. These strategies should be consistent with the mission and major goals of the organization. They should be congruent and constitute a viable business model.
5. Implement the strategies.

The task of analyzing the organization's external and internal environments and then selecting appropriate strategies constitutes strategy formulation. In contrast, as noted earlier, strategy implementation involves putting the strategies (or plan) into action. This includes taking actions consistent with the selected strategies of the company at the corporate, business, and functional levels; allocating roles and responsibilities among managers (typically through the design of organization structure); allocating resources (including capital and money); setting short-term objectives; and designing the organization's control and reward systems. These steps are illustrated in Figure 1.5 (which can also be viewed as a plan for the rest of this book).

Each step in Figure 1.5 constitutes a sequential step in the strategic planning process. At step 1, each round, or cycle, of the planning process begins with a statement of the corporate mission and major corporate goals. The mission statement, then, is followed by the foundation of strategic thinking: external analysis, internal analysis, and strategic choice. The strategy-making process ends with the design of the organizational structure and the culture and control systems necessary to implement the organization's chosen strategy. This chapter discusses how to select a corporate mission and choose major goals. Other parts of strategic planning are reserved for later chapters, as indicated in Figure 1.5.

Some organizations go through a new cycle of the strategic planning process every year. This does not necessarily mean that managers choose a new strategy each year. In many instances, the result is simply to modify and reaffirm a strategy and structure already in place. The strategic plans generated by the planning process generally project over a period of 1 to 5 years, and the plan is updated, or rolled forward, every year. In most organizations, the results of the annual strategic planning process are used as input into the budgetary process for the coming year so that strategic planning is used to shape resource allocation within the organization.

Mission Statement

The first component of the strategic management process is crafting the organization's mission statement, which provides the framework—or context—within which strategies are formulated. A mission statement has four main components: a statement of the raison d'être of a company or organization—its reason for existence—which is normally referred to as the mission; a statement of some desired future state, usually referred to as the vision; a statement of the key values that the organization is committed to; and a statement of major goals.

mission

The purpose of the company, or a statement of what the company strives to do.

The Mission A company's **mission** describes what the company does. For example, the mission of Google is *to organize the world's information and make it universally accessible and useful.*[5] Google's search engine is the method that is employed to "organize the world's information and make it accessible and useful." In the view of Google's founders, Larry Page and Sergey Brin, information includes not just text on websites, but also images, video, maps, products, news, books, blogs, and much more. You can search through all of these information sources using Google's search engine.

According to the late Peter Drucker, an important first step in the process of formulating a mission is to come up with a definition of the organization's business. Essentially, the definition answers these questions: "What is our business? What will it be? What should it be?"[6] The responses to these questions guide the formulation of the mission. To answer the question, "What is our business?" a company should define its business in terms of three dimensions: who is being satisfied (what customer groups), what is being satisfied

Figure 1.5

Main Components of the Strategic Planning Process

© Cengage Learning

(what customer needs), and how customers' needs are being satisfied (by what skills, knowledge, or distinctive competencies).[7] Figure 1.6 illustrates these dimensions.

This approach stresses the need for a *customer-oriented* rather than a *product-oriented* business definition. A product-oriented business definition focuses on the characteristics of the products sold and the markets served, not on which kinds of customer needs the products are satisfying. Such an approach obscures the company's true mission because a product is only the physical manifestation of applying a particular skill to satisfy a particular need for a particular customer group. In practice, that need may be served in many different ways, and a broad customer-oriented business definition that identifies these ways can safeguard companies from being caught unaware by major shifts in demand.

Google's mission statement is customer oriented. Google's product is search. Its production technology involves the development of complex search algorithms and vast databases that archive information. But Google does not define its self as a search engine company. Rather, it sees itself as organizing information to make it accessible and useful *to customers*.

The need to take a customer-oriented view of a company's business has often been ignored. History is peppered with the ghosts of once-great corporations that did not define their businesses, or defined them incorrectly, so ultimately they declined. In the 1950s and 1960s, many office equipment companies, such as Smith Corona and Underwood, defined their businesses as being the production of typewriters. This product-oriented definition ignored the fact that they were really in the business of satisfying customers' information-processing needs. Unfortunately for those companies, when a new form of technology appeared that better served customer needs for information processing (computers), demand for typewriters plummeted. The last great typewriter company, Smith Corona, went bankrupt in 1996, a victim of the success of computer-based word-processing technology.

| Figure 1.6 | Defining the Business |

In contrast, IBM correctly foresaw what its business would be. In the 1950s, IBM was a leader in the manufacture of typewriters and mechanical tabulating equipment using punch-card technology. However, unlike many of its competitors, IBM defined its business as providing a means for *information processing and storage*, rather than only supplying mechanical tabulating equipment and typewriters.[8] Given this definition, the company's subsequent moves into computers, software systems, office systems, and printers seem logical.

Vision The **vision** of a company defines a desired future state; it articulates, often in bold terms, what the company like to achieve. In its early days, Microsoft operated with a very powerful vision of a computer on every desk and in every home. To turn this vision into a reality, Microsoft focused on producing computer software that was cheap and useful to business and consumers. In turn, the availability of powerful and inexpensive software such as Windows and Office helped to drive the penetration of personal computers into homes and offices.

vision
The articulation of a company's desired achievements or future state.

Values The **values** of a company state how managers and employees should conduct themselves, how they should do business, and what kind of organization they should build to help a company achieve its mission. Insofar as they help drive and shape behavior within a company, values are commonly seen as the bedrock of a company's organizational culture: the set of values, norms, and standards that control how employees work to achieve an organization's mission and goals. An organization's culture is commonly seen as an important source of its competitive advantage.[9] (We discuss the issue of organization culture in depth in Chapter 12.) For example, Nucor Steel is one of the most productive and profitable steel firms in the world. Its competitive advantage is based, in part, on the extremely high productivity of its workforce, which the company maintains is a direct result of its cultural values, which in turn determine how it treats its employees. These values are as follows:

values
A statement of how employees should conduct themselves and their business to help achieve the company mission.

- "Management is obligated to manage Nucor in such a way that employees will have the opportunity to earn according to their productivity."
- "Employees should be able to feel confident that if they do their jobs properly, they will have a job tomorrow."
- "Employees have the right to be treated fairly and must believe that they will be."
- "Employees must have an avenue of appeal when they believe they are being treated unfairly."[10]

At Nucor, values emphasizing pay for performance, job security, and fair treatment for employees help to create an atmosphere within the company that leads to high employee productivity. In turn, this has helped to give Nucor one of the lowest cost structures in its industry, and helps to explain the company's profitability in a very price-competitive business.

In one study of organizational values, researchers identified a set of values associated with high-performing organizations that help companies achieve superior financial performance through their impact on employee behavior.[11] These values included respect for the interests of key organizational stakeholders: individuals or groups that have an interest, claim, or stake in the company, in what it does, and in how well it performs.[12] They include stockholders, bondholders, employees, customers, the communities in which the company does business, and the general public. The study found that deep respect for the interests of customers, employees, suppliers, and shareholders was associated with high performance. The study also noted that the encouragement of leadership and entrepreneurial behavior by mid- and lower-level managers and a willingness to support change efforts within the organization contributed to high performance. Companies that emphasize such values consistently throughout

their organizations include Hewlett-Packard, Wal-Mart, and PepsiCo. The same study identified the values of poorly performing companies—values that, as might be expected, are not articulated in company mission statements: (1) arrogance, particularly to ideas from outside the company; (2) a lack of respect for key stakeholders; and (3) a history of resisting change efforts and "punishing" mid- and lower-level managers who showed "too much leadership." General Motors was held up as an example of one such organization.

MAJOR GOALS

Having stated the mission, vision, and key values, strategic managers can take the next step in the formulation of a mission statement: establishing major goals. A goal is a precise and measurable desired future state that a company attempts to realize. In this context, the purpose of goals is to specify with precision what must be done if the company is to attain its mission or vision.

Well-constructed goals have four main characteristics[13]:

- They are precise and measurable. Measurable goals give managers a yardstick or standard against which they can judge their performance.
- They address crucial issues. To maintain focus, managers should select a limited number of major goals to assess the performance of the company. The goals that are selected should be crucial or important ones.
- They are challenging but realistic. They give all employees an incentive to look for ways of improving the operations of an organization. If a goal is unrealistic in the challenges it poses, employees may give up; a goal that is too easy may fail to motivate managers and other employees.[14]
- They specify a time period in which the goals should be achieved, when that is appropriate. Time constraints tell employees that success requires a goal to be attained by a given date, not after that date. Deadlines can inject a sense of urgency into goal attainment and act as a motivator. However, not all goals require time constraints.

Well-constructed goals also provide a means by which the performance of managers can be evaluated.

As noted earlier, although most companies operate with a variety of goals, the primary goal of most corporations is to maximize shareholder returns, and doing this requires both high profitability and sustained profit growth. Thus, most companies operate with goals for profitability and profit growth. However, it is important that top managers do not make the mistake of overemphasizing current profitability to the detriment of long-term profitability and profit growth.[15] The overzealous pursuit of current profitability to maximize short-term ROIC can encourage such misguided managerial actions as cutting expenditures judged to be nonessential in the short run—for instance, expenditures for research and development, marketing, and new capital investments. Although cutting current expenditures increases current profitability, the resulting underinvestment, lack of innovation, and diminished marketing can jeopardize long-run profitability and profit growth.

To guard against short-run decision making, managers need to ensure that they adopt goals whose attainment will increase the long-run performance and competitiveness of their enterprise. Long-term goals are related to such issues as product development, customer satisfaction, and efficiency, and they emphasize specific objectives or targets concerning such details as employee and capital productivity, product quality, innovation, customer satisfaction, and customer service.

External Analysis

The second component of the strategic management process is an analysis of the organization's external operating environment. The essential purpose of the external analysis is to identify strategic opportunities and threats within the organization's operating environment that will affect how it pursues its mission. Strategy in Action 1.1 describes how an analysis of opportunities and threats in the external environment led to a strategic shift at Time Inc.

Three interrelated environments should be examined when undertaking an external analysis: the industry environment in which the company operates, the country or national environment, and the wider socioeconomic or macroenvironment. Analyzing the industry environment requires an assessment of the competitive structure of the company's industry, including the competitive position of the company and its major rivals. It also requires analysis of the nature, stage, dynamics, and history of the industry. Because many markets are now global markets, analyzing the industry environment also means assessing the impact of globalization on competition within an industry. Such an analysis may reveal that a company should move some production facilities to another nation, that it should aggressively expand in emerging markets such as China, or that it should beware of new competition from emerging nations. Analyzing the macroenvironment consists of examining macroeconomic, social, governmental, legal, international, and technological factors that may affect the company and its industry. We look at external analysis in Chapter 2.

Internal Analysis

Internal analysis, the third component of the strategic planning process, focuses on reviewing the resources, capabilities, and competencies of a company. The goal is to identify the strengths and weaknesses of the company. For example, as described in Strategy in Action 1.1, an internal analysis at Time Inc. revealed that although the company had strong well-known brands such as *Fortune*, *Money*, *Sports Illustrated*, and *People* (a strength), and strong reporting capabilities (another strength), it suffered from a lack of editorial commitment to online publishing (a weakness). We consider internal analysis in Chapter 3.

SWOT Analysis and the Business Model

The next component of strategic thinking requires the generation of a series of strategic alternatives, or choices of future strategies to pursue, given the company's internal strengths and weaknesses and its external opportunities and threats. The comparison of strengths, weaknesses, opportunities, and threats is normally referred to as a **SWOT analysis**.[16] The central purpose is to identify the strategies to exploit external opportunities, counter threats, build on and protect company strengths, and eradicate weaknesses.

At Time Inc., managers saw the move of readership to the Web as both an *opportunity* that they must exploit and a *threat* to Time's established print magazines. Managers recognized that Time's well-known brands and strong reporting capabilities were *strengths* that would serve it well online, but that an editorial culture that marginalized online publishing was a *weakness* that had to be fixed. The *strategies* that managers at Time Inc. came up with included merging the print and online newsrooms to remove distinctions between them; investing significant financial resources in online sites; and entering into a partnership with CNN, which already had a strong online presence.

SWOT analysis
The comparison of strengths, weaknesses, opportunities, and threats.

1.1 STRATEGY IN ACTION

Strategic Analysis at Time Inc.

© iStockPhoto.com/Tom Nulens

Time Inc., the magazine publishing division of media conglomerate Time Warner, has a venerable history. Its magazine titles include *Time, Fortune, Sports Illustrated,* and *People,* all long-time leaders in their respective categories. By the mid-2000s, however, Time Inc. was confronted with declining subscription rates.

An external analysis revealed what was happening. The readership of Time's magazines was aging. Increasingly, younger readers were getting what they wanted from the Web. This was both a *threat* for Time Inc., as its Web offerings were not strong, and an *opportunity,* because with the right offerings, Time Inc. could capture this audience. Time also realized that advertising dollars were migrating rapidly to the Web, and if the company was going to maintain its share, its Web offerings had to be every bit as good as its print offerings.

An internal analysis revealed why, despite multiple attempts, Time had failed to capitalize on the opportunities offered by the emergence of the Web. Although Time had tremendous *strengths,* including powerful brands and strong reporting, development of its Web offerings had been hindered by a serious *weakness*— an editorial culture that regarded Web publishing as a backwater. At *People,* for example, the online operation used to be "like a distant moon," according to managing editor Martha Nelson. Managers at Time Inc. had also been worried that Web offerings would cannibalize print offerings and help to accelerate the decline in the circulation of magazines, with dire financial consequences for the company. As a result of this culture, efforts to move publications onto the Web were underfunded or were stymied entirely by a lack of management attention and commitment.

It was Martha Nelson at *People* who first showed the way forward for the company. Her *strategy* for overcoming the *weakness* at Time Inc., and better exploiting *opportunities* on the Web, started in 2003 with merging the print and online newsrooms at *People,* removing the distinction between them. Then, she relaunched the magazine's online site, made major editorial commitments

to Web publishing, stated that original content should appear on the Web, and emphasized the importance of driving traffic to the site and earning advertising revenues. Over the next 2 years, page views at People. com increased fivefold.

Ann Moore, then the CEO at Time Inc., formalized this strategy in 2005, mandating that all print offerings should follow the lead of People.com, integrating print and online newsrooms and investing significantly more resources in Web publishing. To drive this home, Time hired several well-known bloggers to write for its online publications. The goal of Moore's strategy was to neutralize the cultural *weakness* that had hindered online efforts in the past at Time Inc., and to redirect resources to Web publishing.

In 2006, Time made another strategic move designed to exploit the opportunities associated with the Web when it started a partnership with the 24-hour news channel CNN, putting all of its financial magazines onto a site that is jointly owned, CNNMoney .com. The site, which offers free access to *Fortune, Money,* and *Business 2.0,* quickly took the third spot in online financial websites, behind Yahoo! finance and MSN. This was followed with a redesigned website for *Sports Illustrated* that has rolled out video downloads for iPods and mobile phones.

To drive home the shift to Web-centric publishing, in 2007 Time announced another change in strategy—it would sell off 18 magazine titles that, although good performers, did not appear to have much traction on the Web.

In 2007, Ann Moore stated that going forward, Time would be focusing its energy, resources, and investments on the company's largest and most profitable brands: brands that have demonstrated an ability to draw large audiences in digital form. Since then, the big push at Time has been to develop magazine apps for tablet computers, most notably Apple's iPad and tablets that use the Android operating system. By early 2012, Time had its entire magazine catalog on every major tablet platform.

Sources: A. Van Duyn, "Time Inc. Revamp to Include Sale of 18 Titles," *Financial Times* (September 13, 2006): 24; M. Karnitsching, "Time Inc. Makes New Bid to Be Big Web Player," *Wall Street Journal* (March 29, 2006): B1; M. Flamm, "Time Tries the Web Again," *Crain's New York Business* (January 16, 2006): 3; and Tim Carmody, "Time Warner Bringing Digital Magazines, HBO to More Platforms," *Wired* (July 3, 2011).

More generally, the goal of a SWOT analysis is to create, affirm, or fine-tune a company-specific business model that will best align, fit, or match a company's resources and capabilities to the demands of the environment in which it operates. Managers compare and contrast the various alternative possible strategies against each other and then identify the set of strategies that will create and sustain a competitive advantage. These strategies can be divided into four main categories:

- *Functional-level strategies*, directed at improving the effectiveness of operations within a company, such as manufacturing, marketing, materials management, product development, and customer service. We review functional-level strategies in Chapter 4.
- *Business-level strategies*, which encompass the business's overall competitive theme, the way it positions itself in the marketplace to gain a competitive advantage, and the different positioning strategies that can be used in different industry settings—for example, cost leadership, differentiation, focusing on a particular niche or segment of the industry, or some combination of these. We review business-level strategies in Chapters 5, 6, and 7.
- *Global strategies*, which address how to expand operations outside the home country to grow and prosper in a world where competitive advantage is determined at a global level. We review global strategies in Chapter 8.
- *Corporate-level strategies*, which answer the primary questions: What business or businesses should we be in to maximize the long-run profitability and profit growth of the organization, and how should we enter and increase our presence in these businesses to gain a competitive advantage? We review corporate-level strategies in Chapters 9 and 10.

The strategies identified through a SWOT analysis should be congruent with each other. Thus, functional-level strategies should be consistent with, or support, the company's business-level strategies and global strategies. Moreover, as we explain later in this book, corporate-level strategies should support business-level strategies. When combined, the various strategies pursued by a company should constitute a complete, viable business model. In essence, a SWOT analysis is a methodology for choosing between competing business models, and for fine-tuning the business model that managers choose. For example, when Microsoft entered the videogame market with its Xbox offering, it had to settle on the best business model for competing in this market. Microsoft used a SWOT type of analysis to compare alternatives and settled on a business model referred to as "razor and razor blades," in which the Xbox console is priced at cost to build sales (the "razor"), while profits are made from royalties on the sale of games for the Xbox (the "blades").

Strategy Implementation

Once managers have chosen a set of congruent strategies to achieve a competitive advantage and increase performance, managers must put those strategies into action: strategy has to be implemented. Strategy implementation involves taking actions at the functional, business, and corporate levels to execute a strategic plan. Implementation can include, for example, putting quality improvement programs into place, changing the way a product is designed, positioning the product differently in the marketplace, segmenting the marketing and offering different versions of the product to different consumer groups, implementing price increases or decreases, expanding through mergers and acquisitions, or downsizing the company by closing down or selling off parts of the company. These and other topics are discussed in detail in Chapters 4 through 10.

Strategy implementation also entails designing the best organization structure and the best culture and control systems to put a chosen strategy into action. In addition, senior managers need to put a governance system in place to make sure that all within the organization act in a manner that is not only consistent with maximizing profitability and profit growth, but also legal and ethical. In this book, we look at the topic of governance and ethics in Chapter 11; we discuss the organization structure, culture, and controls required to implement business-level strategies in Chapter 12; and we discuss the structure, culture, and controls required to implement corporate-level strategies in Chapter 13.

The Feedback Loop

The feedback loop in Figure 1.5 indicates that strategic planning is ongoing: it never ends. Once a strategy has been implemented, its execution must be monitored to determine the extent to which strategic goals and objectives are actually being achieved, and to what degree competitive advantage is being created and sustained. This information and knowledge is returned to the corporate level through feedback loops, and becomes the input for the next round of strategy formulation and implementation. Top managers can then decide whether to reaffirm the existing business model and the existing strategies and goals, or suggest changes for the future. For example, if a strategic goal proves too optimistic, the next time, a more conservative goal is set. Or, feedback may reveal that the business model is not working, so managers may seek ways to change it. In essence, this is what happened at Time Inc. (see Strategy in Action 1.1).

STRATEGY AS AN EMERGENT PROCESS

The planning model suggests that a company's strategies are the result of a plan, that the strategic planning process is rational and highly structured, and that top management orchestrates the process. Several scholars have criticized the formal planning model for three main reasons: the unpredictability of the real world, the role that lower-level managers can play in the strategic management process, and the fact that many successful strategies are often the result of serendipity, not rational strategizing. These scholars have advocated an alternative view of strategy making.[44, 17]

Strategy Making in an Unpredictable World

Critics of formal planning systems argue that we live in a world in which uncertainty, complexity, and ambiguity dominate, and in which small chance events can have a large and unpredictable impact on outcomes.[18] In such circumstances, they claim, even the most carefully thought-out strategic plans are prone to being rendered useless by rapid and unforeseen change. In an unpredictable world, being able to respond quickly to changing circumstances, and to alter the strategies of the organization accordingly, is paramount. The dramatic rise of Google, for example, with its business model based on revenues earned from advertising links associated with search results (the so-called "pay-per-click" business model), disrupted the business models of companies that made money from online advertising. Nobody could foresee this development or plan for it, but companies had to respond to it, and rapidly. Companies with a strong online advertising presence, including Yahoo.com and Microsoft's MSN network, rapidly changed their strategies to adapt to the threat Google posed. Specifically, both companies developed

their own search engines and copied Google's pay-per-click business model. According to critics of formal systems, such a flexible approach to strategy making is not possible within the framework of a traditional strategic planning process, with its implicit assumption that an organization's strategies only need to be reviewed during the annual strategic planning exercise.

Autonomous Action: Strategy Making by Lower-Level Managers

Another criticism leveled at the rational planning model of strategy is that too much importance is attached to the role of top management, particularly the CEO.[19] An alternative view is that individual managers deep within an organization can—and often do—exert a profound influence over the strategic direction of the firm.[20] Writing with Robert Burgelman of Stanford University, Andy Grove, the former CEO of Intel, noted that many important strategic decisions at Intel were initiated not by top managers but by the autonomous action of lower-level managers deep within Intel who, on their own initiative, formulated new strategies and worked to persuade top-level managers to alter the strategic priorities of the firm.[21] These strategic decisions included the decision to exit an important market (the DRAM memory chip market) and to develop a certain class of microprocessors (RISC-based microprocessors) in direct contrast to the stated strategy of Intel's top managers. Another example of autonomous action, this one at Starbucks, is given in Strategy in Action 1.2.

1.2 STRATEGY IN ACTION

Starbucks' Music Business

© iStockPhoto.com/Tom Nulens

Anyone who has walked into a Starbucks cannot help but notice that in addition to various coffee beverages and food, the company also sells music CDs. Most Starbucks stores now have racks displaying anywhere between 5 and 20 CDs right by the cash register. You can also purchase Starbucks music CDs on the company's website, and music published by the company's Hear Music label is available for download via iTunes. The interesting thing about Starbucks' entry into music retailing and publishing is that it was not the result of a formal planning process. The company's journey into music started in the late 1980s when Tim Jones, then the manager of a Starbucks in Seattle's University Village, started to bring his own tapes of music compilations into the store to play. Soon Jones was getting requests for copies from customers. Jones told this to Starbucks' CEO, Howard Schultz, and suggested that Starbucks start to sell music compilations. At first, Schultz was skeptical, but after repeated lobbying efforts by Jones, he eventually took up the suggestion. In the late 1990s, Starbucks purchased Hear Music, a small publishing company, so that it could sell and distribute its own music compilations. Today Starbucks' music business represents a small but healthy part of its overall product portfolio. For some artists, sales through Starbucks can represent an important revenue stream. Although it shifts titles regularly, sales of a CD over, say, 6 weeks, typically accounts for 5 to 10% of the album's overall sales.

Sources: S. Gray and E. Smith, "Coffee and Music Create a Potent Mix at Starbucks," *Wall Street Journal* (July 19, 2005): A1; and J. Leeds, "Starbucks Stumbles into Music," *New York Times* (March 17, 2008).

Autonomous action may be particularly important in helping established companies deal with the uncertainty created by the arrival of a radical new technology that changes the dominant paradigm in an industry.[22] Top managers usually rise to preeminence by successfully executing the established strategy of the firm. Therefore, they may have an emotional commitment to the status quo and are often unable to see things from a different perspective. In this sense, they can be a conservative force that promotes inertia. Lower-level managers, however, are less likely to have the same commitment to the status quo and have more to gain from promoting new technologies and strategies. They may be the first ones to recognize new strategic opportunities and lobby for strategic change. As described in Strategy in Action 1.3, this seems to have been the case at discount stockbroker Charles Schwab, which had to adjust to the arrival of the Web in the 1990s.

Serendipity and Strategy

Business history is replete with examples of accidental events that help to push companies in new and profitable directions. What these examples suggest is that many successful strategies are not the result of well-thought-out plans, but of serendipity—stumbling across good things unexpectedly. One such example occurred at 3M during the 1960s. At that time, 3M was producing fluorocarbons for sale as coolant liquid in air-conditioning equipment. One day, a researcher working with fluorocarbons in a 3M lab spilled some of the liquid on her shoes. Later that day when she spilled coffee over her shoes, she watched with interest as the coffee formed into little beads of liquid and then ran off her shoes without leaving a stain. Reflecting on this phenomenon, she realized that a fluorocarbon-based liquid might turn out to be useful for protecting fabrics from liquid stains, and so the idea for Scotchgard was born. Subsequently, Scotchgard became one of 3M's most profitable products, and took the company into the fabric protection business, an area within which it had never planned to participate.[23]

Serendipitous discoveries and events can open all sorts of profitable avenues for a company. But some companies have missed profitable opportunities because serendipitous discoveries or events were inconsistent with their prior (planned) conception of what their strategy should be. In one of the classic examples of such myopia, a century ago, the telegraph company Western Union turned down an opportunity to purchase the rights to an invention made by Alexander Graham Bell. The invention was the telephone, a technology that subsequently made the telegraph obsolete.

Intended and Emergent Strategies

Henry Mintzberg's model of strategy development provides a more encompassing view of what strategy actually is. According to this model, illustrated in Figure 1.7, a company's realized strategy is the product of whatever planned strategies are actually put into action (the company's deliberate strategies) and any unplanned, or emergent, strategies. In Mintzberg's view, many planned strategies are not implemented because of unpredicted changes in the environment (they are unrealized). Emergent strategies are the unplanned responses to unforeseen circumstances. They arise from autonomous action by individual managers deep within the organization, from serendipitous discoveries or events, or from an unplanned strategic shift by top-level managers in response to changed circumstances. They are not the product of formal top-down planning mechanisms.

Mintzberg maintains that emergent strategies are often successful and may be more appropriate than intended strategies. In the classic description of this process, Richard Pascale described how this was the case for the entry of Honda Motor Co. into the U.S. motorcycle

1.3 STRATEGY IN ACTION

A Strategic Shift at Charles Schwab

© iStockPhoto.com/Tom Nulens

In the mid-1990s, Charles Schwab was the most successful discount stockbroker in the world. Over 20 years, it had gained share from full-service brokers like Merrill Lynch by offering deep discounts on the commissions charged for stock trades. Although Schwab had a nationwide network of branches, most customers executed their trades through a telephone system called TeleBroker. Others used online proprietary software, Street Smart, which had to be purchased from Schwab. It was a business model that worked well—then along came E*Trade.

Bill Porter, a physicist and inventor, started the discount brokerage firm E*Trade in 1994 to take advantage of the opportunity created by the rapid emergence of the World Wide Web. E*Trade launched the first dedicated website for online trading: E*Trade had no branches, no brokers, and no telephone system for taking orders, and thus it had a very-low-cost structure. Customers traded stocks over the company's website. Due to its low-cost structure, E*Trade was able to announce a flat $14.95 commission on stock trades, a figure significantly below Schwab's average commission, which at the time was $65. It was clear from the outset that E*Trade and other online brokers, such as Ameritrade, which soon followed, offered a direct threat to Schwab. Not only were their cost structures and commission rates considerably lower than Schwab's, but the ease, speed, and flexibility of trading stocks over the Web suddenly made Schwab's Street Smart trading software seem limited and its telephone system antiquated.

Deep within Schwab, William Pearson, a young software specialist who had worked on the development

of Street Smart, immediately saw the transformational power of the Web. Pearson believed that Schwab needed to develop its own Web-based software, and quickly. Try as he might, though, Pearson could not get the attention of his supervisor. He tried a number of other executives but found little support. Eventually he approached Anne Hennegar, a former Schwab manager who now worked as a consultant to the company. Hennegar suggested that Pearson meet with Tom Seip, an executive vice president at Schwab who was known for his ability to think outside the box. Hennegar approached Seip on Pearson's behalf, and Seip responded positively, asking her to set up a meeting. Hennegar and Pearson arrived, expecting to meet only Seip, but to their surprise, in walked Charles Schwab, his chief operating officer, David Pottruck, and the vice presidents in charge of strategic planning and electronic brokerage.

As the group watched Pearson's demo, which detailed how a Web-based system would look and work, they became increasingly excited. It was clear to those in the room that a Web-based system using real-time information, personalization, customization, and interactivity all advanced Schwab's commitment to empowering customers. By the end of the meeting, Pearson had received a green light to start work on the project. A year later, Schwab launched its own Web-based offering, eSchwab, which enabled Schwab clients to execute stock trades for a low flat-rate commission. eSchwab went on to become the core of the company's offering, enabling it to stave off competition from deep discount brokers like E*Trade.

Sources: John Kador, *Charles Schwab: How One Company Beat Wall Street and Reinvented the Brokerage Industry* (New York: John Wiley & Sons, 2002); and Erick Schonfeld, "Schwab Puts It All Online," *Fortune* (December 7, 1998): 94–99.

market.[24] When a number of Honda executives arrived in Los Angeles from Japan in 1959 to establish a U.S. operation, their original aim (intended strategy) was to focus on selling 250-cc and 350-cc machines to confirmed motorcycle enthusiasts rather than 50-cc Honda Cubs, which were a big hit in Japan. Their instinct told them that the Honda 50s were not suitable for the U.S. market, where everything was bigger and more luxurious than in Japan.

However, sales of the 250-cc and 350-cc bikes were sluggish, and the bikes themselves were plagued by mechanical failure. It looked as if Honda's strategy was going to fail. At the same time, the Japanese executives who were using the Honda 50s to run errands

Figure 1.7 Emergent and Deliberate Strategies

Source: Adapted from H. Mintzberg and A. McGugh, *Administrative Science Quarterly* 30:2 (June 1985).

around Los Angeles were attracting a lot of attention. One day, they got a call from a Sears, Roebuck and Co. buyer who wanted to sell the 50-cc bikes to a broad market of Americans who were not necessarily motorcycle enthusiasts. The Honda executives were hesitant to sell the small bikes for fear of alienating serious bikers, who might then associate Honda with "wimpy" machines. In the end, however, they were pushed into doing so by the failure of the 250-cc and 350-cc models.

Honda had stumbled onto a previously untouched market segment that would prove huge: the average American who had never owned a motorbike. Honda had also found an untried channel of distribution: general retailers rather than specialty motorbike stores. By 1964, nearly one out of every two motorcycles sold in the United States was a Honda.

The conventional explanation for Honda's success is that the company redefined the U.S. motorcycle industry with a brilliantly conceived intended strategy. The fact was that Honda's intended strategy was a near-disaster. The strategy that emerged did so not through planning but through unplanned action in response to unforeseen circumstances. Nevertheless, credit should be given to the Japanese management for recognizing the strength of the emergent strategy and for pursuing it with vigor.

The critical point demonstrated by the Honda example is that successful strategies can often emerge within an organization without prior planning, and in response to unforeseen circumstances. As Mintzberg has noted, strategies can take root wherever people have the capacity to learn and the resources to support that capacity.

In practice, the strategies of most organizations are likely a combination of the intended and the emergent. The message for management is that it needs to recognize the process of emergence and to intervene when appropriate, relinquishing bad emergent strategies and nurturing potentially good ones.[25] To make such decisions, managers must be able to judge the worth of emergent strategies. They must be able to think strategically.

Although emergent strategies arise from within the organization without prior planning—that is, without completing the steps illustrated in Figure 1.5 in a sequential fashion—top management must still evaluate emergent strategies. Such evaluation involves comparing each emergent strategy with the organization's goals, external environmental opportunities and threats, and internal strengths and weaknesses. The objective is to assess whether the emergent strategy fits the company's needs and capabilities. In addition, Mintzberg stresses that an organization's capability to produce emergent strategies is a function of the kind of corporate culture that the organization's structure and control systems foster. In other words, the different components of the strategic management process are just as important from the perspective of emergent strategies as they are from the perspective of intended strategies.

STRATEGIC PLANNING IN PRACTICE

Despite criticisms, research suggests that formal planning systems do help managers make better strategic decisions. A study that analyzed the results of 26 previously published studies came to the conclusion that, on average, strategic planning has a positive impact on company performance.[26] Another study of strategic planning in 656 firms found that formal planning methodologies and emergent strategies both form part of a good strategy-formulation process, particularly in an unstable environment.[27] For strategic planning to work, it is important that top-level managers plan not only within the context of the current competitive environment but also within the context of the future competitive environment. To try to forecast what that future will look like, managers can use scenario-planning techniques to project different possible futures. They can also involve operating managers in the planning process and seek to shape the future competitive environment by emphasizing strategic intent.

Scenario Planning

One reason that strategic planning may fail over longer time periods is that strategic managers, in their initial enthusiasm for planning techniques, may forget that the future is entirely unpredictable. Even the best-laid plans can fall apart if unforeseen contingencies occur, and that happens all the time. The recognition that uncertainty makes it difficult to forecast the future accurately led planners at Royal Dutch Shell to pioneer the scenario approach to planning.[28] **Scenario planning** involves formulating plans that are based upon "what-if" scenarios about the future. In the typical scenario-planning exercise, some scenarios are optimistic and some are pessimistic. Teams of managers are asked to develop specific strategies to cope with each scenario. A set of indicators is chosen as signposts to track trends and identify the probability that any particular scenario is coming to pass. The idea is to allow managers to understand the dynamic and complex nature of their environment, to think through problems in a strategic fashion, and to generate a range of strategic options that might be pursued under different circumstances.[29] The scenario approach to planning has spread rapidly among large companies. One survey found that over 50% of the *Fortune* 500 companies use some form of scenario-planning methods.[30]

scenario planning
Formulating plans that are based upon "what-if" scenarios about the future.

The oil company Royal Dutch Shell has, perhaps, done more than most to pioneer the concept of scenario planning, and its experience demonstrates the power of the approach.[31] Shell has been using scenario planning since the 1980s. Today, it uses two primary scenarios to anticipate future demand for oil and refine its strategic planning. The first scenario, called "Dynamics as Usual," sees a gradual shift from carbon fuels (such as oil)

to natural gas, and, eventually, to renewable energy. The second scenario, "The Spirit of the Coming Age," looks at the possibility that a technological revolution will lead to a rapid shift to new energy sources.[32] Shell is making investments that will ensure profitability for the company, regardless of which scenario comes to pass, and it is carefully tracking technological and market trends for signs of which scenario is becoming more likely over time.

The great virtue of the scenario approach to planning is that it can push managers to think outside the box, to anticipate what they might need to do in different situations. It can remind managers that the world is complex and unpredictable, and to place a premium on flexibility, rather than on inflexible plans based on assumptions about the future (which may or may not be correct). As a result of scenario planning, organizations might pursue one dominant strategy related to the scenario that is judged to be most likely, but they make some investments that will pay off if other scenarios come to the fore (see Figure 1.8). Thus, the current strategy of Shell is based on the assumption that the world will only gradually shift away from carbon-based fuels (its "Dynamics as Usual" scenario), but the company is also hedging its bets by investing in new energy technologies and mapping out a strategy to pursue should the second scenario come to pass.

Decentralized Planning

A mistake that some companies have made in constructing their strategic planning process has been to treat planning exclusively as a top-management responsibility. This "ivory tower" approach can result in strategic plans formulated in a vacuum by top managers who have little understanding or appreciation of current operating realities. Consequently, top managers may formulate strategies that do more harm than good. For example, when demographic data indicated that houses and families were shrinking, planners at GE's appliance group concluded that smaller appliances were the wave of the future. Because

Figure 1.8 Scenario Planning

© Cengage Learning

they had little contact with homebuilders and retailers, they did not realize that kitchens and bathrooms were the two rooms that were not shrinking. Nor did they appreciate that families with couples who both worked wanted big refrigerators to cut down on trips to the supermarket. GE ended up wasting a lot of time designing small appliances, for which there was limited demand.

The ivory tower concept of planning can also lead to tensions between corporate-, business-, and functional-level managers. The experience of GE's appliance group is again illuminating. Many of the corporate managers in the planning group were recruited from consulting firms or top-flight business schools. Many of the functional managers took this pattern of recruitment to mean that corporate managers did not believe they were smart enough to think through strategic problems for themselves. They felt shut out of the decision-making process, which they believed to be unfairly constituted. Out of this perceived lack of procedural justice grew an us-versus-them mindset that quickly escalated into hostility. As a result, even when the planners were correct, operating managers would not listen to them. For example, the planners correctly recognized the importance of the globalization of the appliance market and the emerging Japanese threat. However, operating managers, who then saw Sears, Roebuck and Co. as the competition, paid them little heed. Finally, ivory tower planning ignores the important strategic role of autonomous action by lower-level managers and the role of serendipity.

Correcting the ivory tower approach to planning requires recognizing that successful strategic planning encompasses managers at all levels of the corporation. Much of the best planning can and should be done by business and functional managers who are closest to the facts; in other words, planning should be decentralized. Corporate-level planners should take on roles as facilitators who help business and functional managers do the planning by setting the broad strategic goals of the organization and providing the resources necessary to identify the strategies that might be required to attain those goals.

STRATEGIC DECISION MAKING

Even the best-designed strategic planning systems will fail to produce the desired results if managers do not effectively use the information at their disposal. Consequently, it is important that strategic managers learn to make better use of the information they have, and understand why they sometimes make poor decisions. One important way in which managers can make better use of their knowledge and information is to understand how common cognitive biases can result in poor decision making.[33]

Cognitive Biases and Strategic Decision Making

The rationality of decision making is bound by one's cognitive capabilities.[34] Humans are not supercomputers, and it is difficult for us to absorb and process large amounts of information effectively. As a result, when we make decisions, we tend to fall back on certain rules of thumb, or heuristics, that help us to make sense out of a complex and uncertain world. However, sometimes these rules lead to severe and systematic errors in the decision-making process.[35] Systematic errors are those that appear time and time again. They seem to arise from a series of **cognitive biases** in the way that humans process information and reach decisions. Because of cognitive biases, many managers may make poor strategic decisions.

cognitive biases
Systematic errors in human decision making that arise from the way people process information.

prior hypothesis bias
A cognitive bias that occurs when decision makers who have strong prior beliefs tend to make decisions on the basis of these beliefs, even when presented with evidence that their beliefs are wrong.

escalating commitment
A cognitive bias that occurs when decision makers, having already committed significant resources to a project, commit even more resources after receiving feedback that the project is failing.

reasoning by analogy
Use of simple analogies to make sense out of complex problems.

representativeness
A bias rooted in the tendency to generalize from a small sample or even a single vivid anecdote.

illusion of control
A cognitive bias rooted in the tendency to overestimate one's ability to control events.

availability error
A bias that arises from our predisposition to estimate the probability of an outcome based on how easy the outcome is to imagine.

Numerous cognitive biases have been verified repeatedly in laboratory settings, so we can be reasonably sure that these biases exist and that all people are prone to them.[36] The **prior hypothesis bias** refers to the fact that decision makers who have strong prior beliefs about the relationship between two variables tend to make decisions on the basis of these beliefs, even when presented with evidence that their beliefs are incorrect. Moreover, they tend to seek and use information that is consistent with their prior beliefs while ignoring information that contradicts these beliefs. To place this bias in a strategic context, it suggests that a CEO who has a strong prior belief that a certain strategy makes sense might continue to pursue that strategy despite evidence that it is inappropriate or failing.

Another well-known cognitive bias, **escalating commitment**, occurs when decision makers, having already committed significant resources to a project, commit even more resources even if they receive feedback that the project is failing.[37] This may be an irrational response; a more logical response would be to abandon the project and move on (that is, to cut your losses and exit), rather than escalate commitment. Feelings of personal responsibility for a project seemingly induce decision makers to stick with a project despite evidence that it is failing.

A third bias, **reasoning by analogy**, involves the use of simple analogies to make sense out of complex problems. The problem with this heuristic is that the analogy may not be valid. A fourth bias, **representativeness**, is rooted in the tendency to generalize from a small sample or even a single vivid anecdote. This bias violates the statistical law of large numbers, which says that it is inappropriate to generalize from a small sample, let alone from a single case. In many respects, the dot-com boom of the late 1990s was based on reasoning by analogy and representativeness. Prospective entrepreneurs saw some of the early dot-com companies such as Amazon and Yahoo! achieve rapid success, at least as judged by some metrics. Reasoning by analogy from a very small sample, they assumed that any dot-com could achieve similar success. Many investors reached similar conclusions. The result was a massive wave of start-ups that jumped into the Internet space in an attempt to capitalize on the perceived opportunities. The vast majority of these companies subsequently went bankrupt, proving that the analogy was wrong and that the success of the small sample of early entrants was no guarantee that all dot-coms would succeed.

A fifth cognitive bias is referred to as **the illusion of control**, or the tendency to overestimate one's ability to control events. General or top managers seem to be particularly prone to this bias: having risen to the top of an organization, they tend to be overconfident about their ability to succeed. According to Richard Roll, such overconfidence leads to what he has termed the *hubris hypothesis of takeovers*.[38] Roll argues that top managers are typically overconfident about their ability to create value by acquiring another company. Hence, they end up making poor acquisition decisions, often paying far too much for the companies they acquire. Subsequently, servicing the debt taken on to finance such an acquisition makes it all but impossible to make money from the acquisition.

The **availability error** is yet another common bias. The availability error arises from our predisposition to estimate the probability of an outcome based on how easy the outcome is to imagine. For example, more people seem to fear a plane crash than a car accident, and yet statistically one is far more likely to be killed in a car on the way to the airport than in a plane crash. People overweigh the probability of a plane crash because the outcome is easier to imagine, and because plane crashes are more vivid events than car crashes,

which affect only small numbers of people at one time. As a result of the availability error, managers might allocate resources to a project with an outcome that is easier to imagine, rather than to one that might have the highest return.

Techniques for Improving Decision Making

The existence of cognitive biases raises a question: How can critical information affect the decision-making mechanism so that a company's strategic decisions are realistic and based on thorough evaluation? Two techniques known to enhance strategic thinking and counteract cognitive biases are devil's advocacy and dialectic inquiry.[39]

Devil's advocacy requires the generation of a plan, and a critical analysis of that plan. One member of the decision-making group acts as the devil's advocate, emphasizing all the reasons that might make the proposal unacceptable. In this way, decision makers can become aware of the possible perils of recommended courses of action.

Dialectic inquiry is more complex because it requires the generation of a plan (a thesis) and a counter-plan (an antithesis) that reflect plausible but conflicting courses of action.[40] Strategic managers listen to a debate between advocates of the plan and counter-plan and then decide which plan will lead to higher performance. The purpose of the debate is to reveal the problems with the definitions, recommended courses of action, and assumptions of both plans. As a result of this exercise, strategic managers are able to form a new and more encompassing conceptualization of the problem, which then becomes the final plan (a synthesis). Dialectic inquiry can promote strategic thinking.

Another technique for countering cognitive biases is the outside view, which has been championed by Nobel Prize winner Daniel Kahneman and his associates.[41] The **outside view** requires planners to identify a reference class of analogous past strategic initiatives, determine whether those initiatives succeeded or failed, and evaluate the project at hand against those prior initiatives. According to Kahneman, this technique is particularly useful for countering biases such as the illusion of control (hubris), reasoning by analogy, and representativeness. For example, when considering a potential acquisition, planners should look at the track record of acquisitions made by other enterprises (the reference class), determine if they succeeded or failed, and objectively evaluate the potential acquisition against that reference class. Kahneman argues that such a reality check against a large sample of prior events tends to constrain the inherent optimism of planners and produce more realistic assessments and plans.

devil's advocacy
A technique in which one member of a decisionmaking team identifies all the considerations that might make a proposal unacceptable.

dialectic inquiry
The generation of a plan (a thesis) and a counterplan (an antithesis) that reflect plausible but conflicting courses of action.

outside view
Identification of past successful or failed strategic initiatives to determine whether those initiatives will work for project at hand.

STRATEGIC LEADERSHIP

One of the key strategic roles of both general and functional managers is to use all their knowledge, energy, and enthusiasm to provide strategic leadership for their subordinates and develop a high-performing organization. Several authors have identified a few key characteristics of good strategic leaders that do lead to high performance: (1) vision, eloquence, and consistency; (2) articulation of a business model; (3) commitment; (4) being well informed; (5) willingness to delegate and empower; (6) astute use of power; and (7) emotional intelligence.[42]

Vision, Eloquence, and Consistency

One of the key tasks of leadership is to give an organization a sense of direction. Strong leaders seem to have a clear and compelling vision of where the organization should go, are eloquent enough to communicate this vision to others within the organization in terms that energize people, and consistently articulate their vision until it becomes part of the organization's culture.[43]

In the political arena, John F. Kennedy, Winston Churchill, Martin Luther King, Jr., and Margaret Thatcher have all been regarded as examples of visionary leaders. Think of the impact of Kennedy's sentence, "Ask not what your country can do for you, ask what you can do for your country," of King's "I have a dream" speech, and of Churchill's "we will never surrender." Kennedy and Thatcher were able to use their political office to push for governmental actions that were consistent with their visions. Churchill's speech galvanized a nation to defend itself against an aggressor, and King was able to pressure the government from outside to make changes within society.

Examples of strong business leaders include Microsoft's Bill Gates; Jack Welch, the former CEO of General Electric; and Sam Walton, Wal-Mart's founder. For years, Bill Gates's vision of a world in which there would be a Windows-based personal computer on every desk was a driving force at Microsoft. More recently, that vision has evolved into one of a world in which Windows-based software can be found on any computing device, from PCs and servers to videogame consoles (Xbox), cell phones, and handheld computers. At GE, Jack Welch was responsible for articulating the simple but powerful vision that GE should be first or second in every business in which it competed, or it should exit from that business. Similarly, it was Wal-Mart founder Sam Walton who established and articulated the vision that has been central to Wal-Mart's success: passing on cost savings from suppliers and operating efficiencies to customers in the form of everyday low prices.

Articulation of the Business Model

Another key characteristic of good strategic leaders is their ability to identify and articulate the business model the company will use to attain its vision. A business model is managers' conception of how the various strategies that the company pursues fit together into a congruent whole. At Dell, for example, it was Michael Dell who identified and articulated the basic business model of the company: the direct sales business model. The various strategies that Dell has pursued over the years have refined this basic model, creating one that is very robust in terms of its efficiency and effectiveness. Although individual strategies can take root in many different places in an organization, and although their identification is not the exclusive preserve of top management, only strategic leaders have the perspective required to make sure that the various strategies fit together into a congruent whole and form a valid and compelling business model. If strategic leaders lack a clear conception of the company's business model (or what it should be), it is likely that the strategies the firm pursues will not fit together, and the result will be lack of focus and poor performance.

Commitment

Strong leaders demonstrate their commitment to their visions and business models by actions and words, and they often lead by example. Consider Nucor's former CEO,

Ken Iverson. Nucor is a very efficient steelmaker with perhaps the lowest cost structure in the steel industry. It has achieved 30 years of profitable performance in an industry where most other companies have lost money due to a relentless focus on cost minimization. In his tenure as CEO, Iverson set the example: he answered his own phone, employed only one secretary, drove an old car, flew coach class, and was proud of the fact that his base salary was the lowest of the *Fortune* 500 CEOs (Iverson made most of his money from performance-based pay bonuses). This commitment was a powerful signal to employees that Iverson was serious about doing everything possible to minimize costs. It earned him the respect of Nucor employees and made them more willing to work hard. Although Iverson has retired, his legacy lives on in the cost-conscious organizational culture that has been built at Nucor, and like all other great leaders, his impact will last beyond his tenure.

Being Well Informed

Effective strategic leaders develop a network of formal and informal sources who keep them well informed about what is going on within the company. At Starbucks, for example, the first thing that former CEO Jim Donald did every morning was call 5 to 10 stores, talk to the managers and other employees there, and get a sense for how their stores were performing. Donald also stopped at a local Starbucks every morning on the way to work to buy his morning coffee. This allowed him to get to know individual employees there very well. Donald found these informal contacts to be a very useful source of information about how the company was performing.[44]

Similarly, Herb Kelleher, the founder of Southwest Airlines, was able to gauge the health of his company by dropping in unannounced on aircraft maintenance facilities and helping workers perform their tasks. Herb Kelleher would also often help airline attendants on Southwest flights, distributing refreshments and talking to customers. One frequent flyer on Southwest Airlines reported sitting next to Kelleher three times in 10 years. Each time, Kelleher asked him (and others sitting nearby) how Southwest Airlines was doing in a number of areas, in order to spot trends and inconsistencies.[45]

Using informal and unconventional ways to gather information is wise because formal channels can be captured by special interests within the organization or by gatekeepers—managers who may misrepresent the true state of affairs to the leader. People like Donald and Kelleher who constantly interact with employees at all levels are better able to build informal information networks than leaders who closet themselves and never interact with lower-level employees.

Willingness to Delegate and Empower

High-performance leaders are skilled at delegation. They recognize that unless they learn how to delegate effectively, they can quickly become overloaded with responsibilities. They also recognize that empowering subordinates to make decisions is a good motivational tool and often results in decisions being made by those who must implement them. At the same time, astute leaders recognize that they need to maintain control over certain key decisions. Thus, although they will delegate many important decisions to lower-level employees, they will not delegate those that they judge to be of critical importance to the future success of the organization, such as articulating the company's vision and business model.

The Astute Use of Power

In a now-classic article on leadership, Edward Wrapp noted that effective leaders tend to be very astute in their use of power.[46] He argued that strategic leaders must often play the power game with skill and attempt to build consensus for their ideas rather than use their authority to force ideas through; they must act as members of a coalition or its democratic leaders rather than as dictators. Jeffery Pfeffer has articulated a similar vision of the politically astute manager who gets things done in organizations through the intelligent use of power.[47] In Pfeffer's view, power comes from control over resources that are important to the organization: budgets, capital, positions, information, and knowledge. Politically astute managers use these resources to acquire another critical resource: critically placed allies who can help them attain their strategic objectives. Pfeffer stresses that one does not need to be a CEO to assemble power in an organization. Sometimes junior functional managers can build a surprisingly effective power base and use it to influence organizational outcomes.

Emotional Intelligence

Emotional intelligence is a term that Daniel Goleman coined to describe a bundle of psychological attributes that many strong and effective leaders exhibit[48]:

- Self-awareness—the ability to understand one's own moods, emotions, and drives, as well as their effect on others.
- Self-regulation—the ability to control or redirect disruptive impulses or moods, that is, to think before acting.
- Motivation—a passion for work that goes beyond money or status and a propensity to pursue goals with energy and persistence.
- Empathy—the ability to understand the feelings and viewpoints of subordinates and to take those into account when making decisions.
- Social skills—friendliness with a purpose.

According to Goleman, leaders who possess these attributes—who exhibit a high degree of emotional intelligence—tend to be more effective than those who lack these attributes. Their self-awareness and self-regulation help to elicit the trust and confidence of subordinates. In Goleman's view, people respect leaders who, because they are self-aware, recognize their own limitations and, because they are self-regulating, consider decisions carefully. Goleman also argues that self-aware and self-regulating individuals tend to be more self-confident and therefore better able to cope with ambiguity and more open to change. A strong motivation exhibited in a passion for work can also be infectious, helping to persuade others to join together in pursuit of a common goal or organizational mission. Finally, strong empathy and social skills can help leaders earn the loyalty of subordinates. Empathetic and socially adept individuals tend to be skilled at remedying disputes between managers, better able to find common ground and purpose among diverse constituencies, and better able to move people in a desired direction compared to leaders who lack these skills. In short, Goleman argues that the psychological makeup of a leader matters.

SUMMARY OF CHAPTER

1. A strategy is a set of related actions that managers take to increase their company's performance goals.

2. The major goal of companies is to maximize the returns that shareholders receive from holding shares in the company. To maximize shareholder value, managers must pursue strategies that result in high and sustained profitability and also in profit growth.

3. The profitability of a company can be measured by the return that it makes on the capital invested in the enterprise. The profit growth of a company can be measured by the growth in earnings per share. Profitability and profit growth are determined by the strategies managers adopt.

4. A company has a competitive advantage over its rivals when it is more profitable than the average for all firms in its industry. It has a sustained competitive advantage when it is able to maintain above-average profitability over a number of years. In general, a company with a competitive advantage will grow its profits more rapidly than its rivals.

5. General managers are responsible for the overall performance of the organization, or for one of its major self-contained divisions. Their overriding strategic concern is for the health of the total organization under their direction.

6. Functional managers are responsible for a particular business function or operation. Although they lack general management responsibilities, they play a very important strategic role.

7. Formal strategic planning models stress that an organization's strategy is the outcome of a rational planning process.

8. The major components of the strategic management process are defining the mission, vision, and major goals of the organization; analyzing the external and internal environments of the organization; choosing a business model and strategies that align an organization's strengths and weaknesses with external environmental opportunities and threats; and adopting organizational structures and control systems to implement the organization's chosen strategies.

9. Strategy can emerge from deep within an organization in the absence of formal plans as lower-level managers respond to unpredicted situations.

10. Strategic planning often fails because executives do not plan for uncertainty and because ivory tower planners lose touch with operating realities.

11. In spite of systematic planning, companies may adopt poor strategies if cognitive biases are allowed to intrude into the decision-making process.

12. Devil's advocacy, dialectic inquiry, and the outside view are techniques for enhancing the effectiveness of strategic decision making.

13. Good leaders of the strategy-making process have a number of key attributes: vision, eloquence, and consistency; ability to craft a business model; commitment; being well informed; a willingness to delegate and empower; political astuteness; and emotional intelligence.

DISCUSSION QUESTIONS

1. What do we mean by strategy? How is a business model different from a strategy?

2. What do you think are the sources of sustained superior profitability?

3. What are the strengths of formal strategic planning? What are its weaknesses?

4. To what extent do you think that cognitive biases may have contributed to the global financial crisis that gripped financial markets in 2008–2009? Explain your answer.

5. Discuss the accuracy of the following statement: Formal strategic planning systems are irrelevant for firms competing in high-technology industries where the pace of change is so rapid that plans are routinely made obsolete by unforeseen events.

6. Pick the current or a past president of the United States and evaluate his performance against the leadership characteristics discussed in the text. On the basis of this comparison, do you think that the president was/is a good strategic leader? Why or why not?

PRACTICING STRATEGIC MANAGEMENT

© iStockPhoto.com/Urilux

Small-Group Exercise: Designing a Planning System

Break up into groups of three to five students and discuss the following scenario. Appoint one group member as a spokesperson who will communicate the group's findings to the class when called on to do so by the instructor.

You are a group of senior managers working for a fast-growing computer software company. Your product allows users to play interactive role-playing games over the Internet. In the past 3 years, your company has gone from being a start-up enterprise with 10 employees and no revenues to a company with 250 employees and revenues of $60 million. It has been growing so rapidly that you have not had time to create a strategic plan, but now members of the board of directors are telling you that they want to see a plan, and they want the plan to drive decision making and resource allocation at the company. They want you to design a planning process that will have the following attributes:

1. It will be democratic, involving as many key employees as possible in the process.
2. It will help to build a sense of shared vision within the company about how to continue to grow rapidly.
3. It will lead to the generation of three to five key strategies for the company.
4. It will drive the formulation of detailed action plans, and these plans will be subsequently linked to the company's annual operating budget.

Design a planning process to present to your board of directors. Think carefully about who should be included in this process. Be sure to outline the strengths and weaknesses of the approach you choose, and be prepared to justify why your approach might be superior to alternative approaches.

STRATEGY SIGN ON

© iStockPhoto.com/Ninoslav Dotlic

Article File 1

At the end of every chapter in this book is an article file task. The task requires you to search newspapers or magazines in the library for an example of a real company that satisfies the task's question or issue.

Your first article file task is to find an example of a company that has recently changed its strategy. Identify whether this change was the outcome of a formal planning process or whether it was an emergent response to unforeseen events occurring in the company's environment.

(continues)

STRATEGY SIGN ON

(continued)

© iStockPhoto.com/Ninoslav Dotlic

Strategic Management Project Module 1

To give you practical insight into the strategic management process, we provide a series of strategic modules; one is at the end of every chapter in this book. Each module asks you to collect and analyze information relating to the material discussed in that chapter. By completing these strategic modules, you will gain a clearer idea of the overall strategic management process.

The first step in this project is to pick a company to study. We recommend that you focus on the same company throughout the book. Remember also that we will be asking you for information about the corporate and international strategies of your company as well as its structure. We strongly recommend that you pick a company for which such information is likely to be available.

There are two approaches that can be used to select a company to study, and your instructor will tell you which one to follow. The first approach is to pick a well-known company that has a lot of information written about it. For example, large publicly held companies such as IBM, Microsoft, and Southwest Airlines are routinely covered in the business and financial press. By going to the library at your university, you should be able to track down a great deal of information on such companies. Many libraries now have comprehensive Web-based electronic data search facilities such as ABI/Inform, the Wall Street Journal Index, Predicasts F&S Index, and the LexisNexis databases. These enable you to identify any article that has been written in the business press on the company of your choice within the past few years. A number of non-electronic data sources are also available and useful. For example, Predicasts F&S publishes an annual list of articles relating to major companies that appeared in the national and international business press. S&P Industry Surveys is also a great source for basic industry data, and Value Line Ratings and Reports contain good summaries of a firm's financial position and future prospects. Collect full financial information on the company that you pick. This information can be accessed from Web-based electronic databases such as the EDGAR database, which archives all forms that publicly quoted companies have to file with the Securities and Exchange Commission (SEC); for example, 10-K filings can be accessed from the SEC's EDGAR database. Most SEC forms for public companies can now be accessed from Internet-based financial sites, such as Yahoo!'s finance site (www.finance.yahoo.com).

A second approach is to choose a smaller company in your city or town to study. Although small companies are not routinely covered in the national business press, they may be covered in the local press. More important, this approach can work well if the management of the company will agree to talk to you at length about the strategy and structure of the company. If you happen to know somebody in such a company or if you have worked there at some point, this approach can be very worthwhile. However, we do not recommend this approach unless you can get a substantial amount of guaranteed access to the company of your choice. If in doubt, ask your instructor before making a decision. The primary goal is to make sure that you have access to enough interesting information to complete a detailed and comprehensive analysis.

Your assignment for Module 1 is to choose a company to study and to obtain enough information about it to carry out the following instructions and answer the questions:

1. Give a short account of the history of the company, and trace the evolution of its strategy. Try to determine whether the strategic evolution of your company is the product of intended strategies, emergent strategies, or some combination of the two.
2. Identify the mission and major goals of the company.
3. Do a preliminary analysis of the internal strengths and weaknesses of the company and the opportunities and threats that it faces in its environment. On the basis of this analysis, identify the strategies that you think the company should pursue. (You will need to perform a much more detailed analysis later in the book.)
4. Who is the CEO of the company? Evaluate the CEO's leadership capabilities.

ETHICAL DILEMMA

© iStockPhoto.com/P_Wei

You are the general manager of a home-mortgage-lending business within a large diversified financial services firm. In the firm's mission statement, there is a value that emphasizes the importance of acting with integrity at all times. When you asked the CEO what this means, she told you that you should "do the right thing, and not try to do all things right." This same CEO has also set your challenging profitability and growth goals for the coming year. The CEO has told you that the goals are "non-negotiable." If you satisfy those goals, you will earn a large bonus and may get promoted. If you fail to meet the goals, it may negatively affect your career at the company. You know, however, that satisfying the goals will require you to lower lending standards, and it is possible that your unit will lend money to some people whose ability to meet their mortgage payments is questionable. If people do default on their loans, however, your company will be able to seize their homes and resell them, which mitigates the risk. What should you do?

CLOSING CASE

General Electric's Ecomagination Strategy

Back in 2004, GE's top-management team was going through its annual strategic planning review when the management team came to a sudden realization: six of the company's core businesses were deeply involved in environmental and energy-related projects. The appliance business was exploring energy conservation. The plastics business was working on the replacement of PCBs, once widely used in industrial compounds, which had been found to have negative consequences for human health and the environment. The energy business was looking into alternatives to fossil fuels, including wind, solar, and nuclear power. Other businesses were looking at ways to reduce emissions and use energy more efficiently. What was particularly striking was that GE had initiated almost all of these projects in response to requests from its customers.

When these common issues surfaced across different lines of business, the group members realized that something deeper was going on that they needed to understand. They initiated a data-gathering effort. They made an effort to educate themselves on the science behind energy and environmental issues, including greenhouse gas emissions. As CEO Jeff Immelt later explained, "We went through a process of really understanding and coming to our own points of view on the science." Immelt himself became convinced that climate change was a technical fact. GE executives engaged in "dreaming sessions" with customers in energy and heavy-industry companies to try to understand their concerns and desires. What emerged was a wish list from customers that included cleaner ways to burn coal, more efficient wastewater treatment plants, better hydrogen fuel cells, and so on. At the same time, GE talked to government officials and regulators to try and get a sense for where public policy might be going.

This external review led to the conclusion that energy prices would likely increase going forward, driven by rising energy consumption in developing nations and creating demand for energy-efficient products. The team also saw tighter environmental controls, including caps on greenhouse gas emissions, as all but inevitable. At the same time, team members looked inside GE. Although the company had already been working on numerous energy-efficiency and environmental projects, the team realized there were

and Economics (London: Institute for Economic Affairs, 1994). See also H. Courtney, J. Kirkland, and P. Viguerie, "Strategy Under Uncertainty," *Harvard Business Review* 75 (November–December 1997): 66–79.

[19]Hart, "Integrative Framework"; and Hamel, "Strategy as Revolution."

[20]See Burgelman, "Intraorganizational Ecology"; and Mintzberg, "Patterns in Strategy Formulation."

[21]R. A. Burgelman and A. S. Grove, "Strategic Dissonance," *California Management Review* (Winter 1996): 8–28.

[22]C. W. L. Hill and F. T. Rothaermel, "The Performance of Incumbent Firms in the Face of Radical Technological Innovation," *Academy of Management Review* 28 (2003): 257–274.

[23]This story was related to the author by George Rathmann, who at one time was head of 3M's research activities.

[24]Richard T. Pascale, "Perspectives on Strategy: The Real Story Behind Honda's Success," *California Management Review* 26 (1984): 47–72.

[25]This viewpoint is strongly emphasized by Burgelman and Grove, "Strategic Dissonance."

[26]C. C. Miller and L. B. Cardinal, "Strategic Planning and Firm Performance: A Synthesis of More Than Two Decades of Research," *Academy of Management Journal* 37 (1994): 1649–1665. Also see P. R. Rogers, A. Miller, and W. Q. Judge, "Using Information Processing Theory to Understand Planning/Performance Relationships in the Context of Strategy," *Strategic Management* 20 (1999): 567–577.

[27]P. J. Brews and M. R. Hunt, "Learning to Plan and Planning to Learn," *Strategic Management Journal* 20 (1999): 889–913.

[28]P. Cornelius, A. Van de Putte, and M. Romani, "Three Decades of Scenario Planning at Shell," *California Management Review* 48 (2005): 92–110.

[29]H. Courtney, J. Kirkland, and P. Viguerie, "Strategy Under Uncertainty," *Harvard Business Review*, 75, (November–December 1997): 66–79.

[30]P. J. H. Schoemaker, "Multiple Scenario Development: Its Conceptual and Behavioral Foundation," *Strategic Management Journal* 14 (1993): 193–213.

[31]P. Schoemaker, P. J. H. van der Heijden, and A. J. M. Cornelius, "Integrating Scenarios into Strategic Planning at Royal Dutch Shell," *Planning Review* 20:3 (1992): 41–47; and I. Wylie, "There Is No Alternative to … " *Fast Company* (July 2002): 106–111.

[32]"The Next Big Surprise: Scenario Planning," *The Economist* (October 13, 2001): 71.

[33]See C. R. Schwenk, "Cognitive Simplification Processes in Strategic Decision Making," *Strategic Management* 5 (1984): 111–128; and K. M. Eisenhardt and M. Zbaracki, "Strategic Decision Making," *Strategic Management* 13 (Special Issue, 1992): 17–37.

[34]H. Simon, *Administrative Behavior* (New York: McGraw-Hill, 1957).

[35]The original statement of this phenomenon was made by A. Tversky and D. Kahneman, "Judgment Under Uncertainty: Heuristics and Biases," *Science* 185 (1974): 1124–1131. See also D. Lovallo and D. Kahneman, "Delusions of Success: How Optimism Undermines Executives' Decisions," *Harvard Business Review* 81 (July 2003): 56–67; and J. S. Hammond, R. L. Keeny, and H. Raiffa, "The Hidden Traps in Decision Making," *Harvard Business Review* 76 (September–October 1998): 25–34.

[36]Schwenk, "Cognitive Simplification Processes," pp. 111–128.

[37]B. M. Staw, "The Escalation of Commitment to a Course of Action," *Academy of Management Review* 6 (1981): 577–587.

[38]R. Roll, "The Hubris Hypotheses of Corporate Takeovers," *Journal of Business* 59 (1986): 197–216.

[39]See R. O. Mason, "A Dialectic Approach to Strategic Planning," *Management Science* 13 (1969): 403–414; R. A. Cosier and J. C. Aplin, "A Critical View of Dialectic Inquiry in Strategic Planning," *Strategic Management* 1 (1980): 343–356; and I. I. Mintroff and R. O. Mason, "Structuring III—Structured Policy Issues: Further Explorations in a Methodology for Messy Problems," *Strategic Management* 1 (1980): 331–342.

[40]Mason, "A Dialectic Approach," pp. 403–414.

[41]Lovallo and Kahneman, "Delusions of Success."

[42]For a summary of research on strategic leadership, see D. C. Hambrick, "Putting Top Managers Back into the Picture," *Strategic Management* 10 (Special Issue, 1989): 5–15. See also D. Goldman, "What Makes a Leader?" *Harvard Business Review* (November–December 1998): 92–105; H. Mintzberg, "Covert Leadership," *Harvard Business Review* (November–December 1998): 140–148; and R. S. Tedlow, "What Titans Can Teach Us," *Harvard Business Review* (December 2001): 70–79.

[43]N. M. Tichy and D. O. Ulrich, "The Leadership Challenge: A Call for the Transformational Leader," *Sloan Management Review* (Fall 1984): 59–68; and F. Westley and







#

External Analysis: The Identification of Opportunities and Threats

© IStockPhoto.com/Chepko Danil

OPENING CASE

© mirounga/ShutterStock.com

The Market for Large Commercial Jet Aircraft

Just two companies, Boeing and Airbus, have long dominated the market for large commercial jet aircraft. In early 2012, Boeing planes accounted for 50% of the world's fleet of commercial jet aircraft, and Airbus planes accounted for 31%. The reminder of the global market was split between several smaller players, including Embraer of Brazil and Bombardier of Canada, both of which had a 7% share. Embraer and Bombardier, however, have to date focused primarily on the regional jet market, building planes of less than 100 seats. The market for aircraft with more than 100 seats has been totally dominated by Boeing and Airbus.

The overall market is large and growing. In 2011, Boeing delivered 477 aircraft valued at $33 billion, and Airbus delivered 534 aircraft valued at $32 billion. Demand for new aircraft is driven primarily by demand for air travel, which has grown at 5% per annum compounded since 1980. Looking forward, Boeing predicts that between 2011 and 2031 the world economy will grow at 3.2% per annum, and airline traffic will continue to grow at 5% per annum as more and more people from the world's emerging economies take to the air for business and pleasure trips. Given the anticipated growth in demand, Boeing believes the world's airlines will need 34,000 new aircraft

LEARNING OBJECTIVES

After reading this chapter you should be able to:

2-1 Review the primary technique used to analyze competition in an industry environment: the Five Forces model

2-2 Explore the concept of strategic groups and illustrate the implications for industry analysis

2-3 Discuss how industries evolve over time, with reference to the industry life-cycle model

2-4 Show how trends in the macroenvironment can shape the nature of competition in an industry

43

between 2012 and 2031 with a market value of $4.5 trillion dollars in today's prices.

Clearly, the scale of future demand creates an enormous profit opportunity for the two main incumbents, Boeing and Airbus. Given this, many observers wonder if the industry will see new entries. Historically, it has been assumed that the high development cost associated with bringing new commercial jet aircraft to market, and the need to realize substantial economies of scale to cover those costs, has worked as a very effective deterrent to new entries. For example, estimates suggest that it cost Boeing some $18 to $20 billion to develop its latest aircraft, the Boeing 787, and that the company will have to sell 1,100 787s to break even, which will take 10 years. Given the costs, risks, and long time horizon here, it has been argued that only Boeing and Airbus can afford to develop new large commercial jet aircraft.

However, in the last few years, three new entrants have appeared. All three are building narrow-bodied jets with a seat capacity between 100 and 190. Boeing's 737 and the Airbus A320 currently dominate the narrow-bodied segment. The Commercial Aircraft Corporation of China (Comac) is building a 170- to 190-seat narrow-bodied jet, scheduled for introduction in 2016. To date, Comac has 380 firm orders for the aircraft, mostly from Chinese domestic airlines. Bombardier is developing a 100- to 150-seat plane that will bring it into direct competition with Boeing and Airbus for the first time. Scheduled for introduction in late 2014, Bombardier has 352 orders and commitments for these aircraft. Embraer too, is developing a 108- to 125-seat plane to compete in the narrow-bodied segment. The new entry is occurring because all three producers believe that the market for narrow-bodied aircraft is now large enough to support more than Boeing and Airbus. Bombardier and Embraer can leverage the knowhow they developed manufacturing regional jets to help them move upmarket. For its part, Comac can count on orders from Chinese airlines and the tacit support of the Chinese government to help it get off the ground.

In response to these competitive threats, Boeing and Airbus are developing new, more fuel-efficient versions of their own narrow-bodied planes, the 737 and A320. Although they hope their new offerings will keep entrants in check, one thing seems clear: with five producers rather than two in the market, it seems likely that competition will become more intense in the narrow-bodied segment of the industry, which could well drive prices and profits down for the big two incumbent producers.

Sources: R. Marowits, "Bombardier's CSeries Drought Ends," *The Montreal Gazette*, December 20, 2012; D. Gates, "Boeing Projects Break-Even on 787 Manufacturing in 10 Years," *Seattle Times*, October 26, 2011; and Boeing Corporation, "Current Market Outlook 2012–2031," www.boeing.com/commercial/cmo/.

OVERVIEW

opportunities

Elements and conditions in a company's environment that allow it to formulate and implement strategies that enable it to become more profitable.

Strategy formulation begins with an analysis of the forces that shape competition within the industry in which a company is based. The goal is to understand the opportunities and threats confronting the firm, and to use this understanding to identify strategies that will enable the company to outperform its rivals. **Opportunities** arise when a company can take advantage of conditions in its industry environment to formulate and implement strategies that enable it to become more profitable. For example, as discussed in the Opening Case, the growth of demand for airline travel is creating an enormous profit opportunity for Boeing and Airbus. In particular, both companies have developed new wide-bodied aircraft,

the Boeing 787 and the Airbus A350, to satisfy growing demand for long-haul aircraft in the 250- to 350-seat range. **Threats** arise when conditions in the external environment endanger the integrity and profitability of the company's business. The biggest threat confronting Boeing and Airbus right now is new entry into the narrow-bodied segment of the large commercial jet aircraft business from Comac, a Chinese company, and two successful manufacturers of regional jets, Bombardier and Embraer. In response to this threat, both Boeing and Airbus are developing next generation versions of their narrow-bodied offerings, the Boeing 737 and the Airbus A320 (see the Opening Case). Their hope is that these next generation aircraft, which make extensive use of composites and new more fuel-efficient jet engines, will keep the new entrants in check. In other words, the product development strategy of Boeing and Airbus is being driven by their assessment of opportunities and threats in the external industry environment.

threats
Elements in the external environment that could endanger the integrity and profitability of the company's business.

This chapter begins with an analysis of the external industry environment. First, it examines concepts and tools for analyzing the competitive structure of an industry and identifying industry opportunities and threats. Second, it analyzes the competitive implications that arise when groups of companies within an industry pursue similar or different kinds of competitive strategies. Third, it explores the way an industry evolves over time, and the changes present in competitive conditions. Fourth, it looks at the way in which forces in the macroenvironment affect industry structure and influence opportunities and threats. By the end of the chapter, you will understand that a company must either fit its strategy to the external environment in which it operates or be able to reshape the environment to its advantage through its chosen strategy in order to succeed.

DEFINING AN INDUSTRY

An **industry** can be defined as a group of companies offering products or services that are close substitutes for each other—that is, products or services that satisfy the same basic customer needs. A company's closest competitors—its rivals—are those that serve the same basic customer needs. For example, carbonated drinks, fruit punches, and bottled water can be viewed as close substitutes for each other because they serve the same basic customer needs for refreshing, cold, nonalcoholic beverages. Thus, we can talk about the soft drink industry, whose major players are Coca-Cola, PepsiCo, and Cadbury Schweppes. Similarly, desktop computers and notebook computers satisfy the same basic need that customers have for computer hardware on which to run personal productivity software, browse the Internet, send e-mail, play games, and store, display, or manipulate digital images. Thus, we can talk about the personal computer industry, whose major players are Dell, Hewlett-Packard, Lenovo (the Chinese company that purchased IBM's personal computer business), and Apple.

industry
A group of companies offering products or services that are close substitutes for each other.

External analysis begins by identifying the industry within which a company competes. To do this, managers must start by looking at the basic customer needs their company is serving—that is, they must take a customer-oriented view of their business rather than a product-oriented view (see Chapter 1). An industry is the supply side of a market, and companies within the industry are the suppliers. Customers are the demand side of a market, and are the buyers of the industry's products. The basic customer needs that are served by a market define an industry's boundaries. It is very important for managers to realize this, for if they define industry boundaries incorrectly, they may be caught off-guard by the rise of competitors that serve the same basic customer needs but with different product offerings. For example, Coca-Cola long saw itself as part of the soda industry—meaning carbonated soft

drinks—whereas it actually was part of the soft drink industry, which includes noncarbonated soft drinks. In the mid-1990s, the rise of customer demand for bottled water and fruit drinks began to cut into the demand for sodas, which caught Coca-Cola by surprise. Coca-Cola moved quickly to respond to these threats, introducing its own brand of water, Dasani, and acquiring several other beverage companies, including Minute Maid and Glaceau (the owner of the Vitamin Water brand). By defining its industry boundaries too narrowly, Coke almost missed the rapid rise of noncarbonated soft drinks within the soft drinks market.

Industry and Sector

sector

A group of closely related industries.

A distinction can be made between an industry and a sector. A **sector** is a group of closely related industries. For example, as illustrated in Figure 2.1, the computer sector comprises several related industries: the computer component industries (for example, the disk drive industry, the semiconductor industry, and the computer display industry), the computer hardware industries (for example, the personal computer [PC] industry; the handheld computer industry, which includes smartphones such as the Apple iPhone and slates such as Apple's iPad; and the mainframe computer industry), and the computer software industry. Industries within a sector may be involved with one another in many different ways. Companies in the computer component industries are the suppliers of firms in the computer hardware industries. Companies in the computer software industry provide important complements to computer hardware: the software programs that customers purchase to run on their hardware. Companies in the personal, handheld, and mainframe industries indirectly compete with each other because all provide products that are, to one degree or another, substitutes for each other. Thus, in 2012, sales of PCs declined primarily because of booming demand for tablet computers, a substitute product.

Figure 2.1	The Computer Sector: Industries and Segments

© Cengage Learning

Industry and Market Segments

It is also important to recognize the difference between an industry and the market segments within that industry. Market segments are distinct groups of customers within a market that can be differentiated from each other on the basis of their individual attributes and specific demands. In the beer industry, for example, there are three primary segments: consumers who drink long-established mass-market brands (e.g., Budweiser); weight-conscious consumers who drink less-filling, low-calorie, mass-market brands (e.g., Coors Light); and consumers who prefer premium-priced "craft beer" offered by microbreweries and many importers. Similarly, in the PC industry, there are different market segments in which customers desire desktop machines, lightweight portable machines, or servers that sit at the center of a network of personal computers (see Figure 2.1). Personal computer makers recognize the existence of these different segments by producing a range of product offerings that appeal to customers in the different segments. Customers in all of these market segments, however, share a common need for devices on which to run personal software applications.

Changing Industry Boundaries

Industry boundaries may change over time as customer needs evolve, or as emerging new technologies enable companies in unrelated industries to satisfy established customer needs in new ways. We have noted that during the 1990s, as consumers of soft drinks began to develop a taste for bottled water and noncarbonated fruit-based drinks, Coca-Cola found itself in direct competition with the manufacturers of bottled water and fruit-based soft drinks: all were in the same industry.

For an example of how technological change can alter industry boundaries, consider the convergence that is currently taking place between the computer and telecommunications industries. Historically, the telecommunications equipment industry has been considered an entity distinct from the computer hardware industry. However, as telecommunications equipment has moved from analog technology to digital technology, this equipment increasingly resembles computers. The result is that the boundaries between these different industries are now blurring. A digital wireless smartphone such as Apple's iPhone, for example, is nothing more than a small handheld computer with a wireless connection and telephone capabilities. Thus, Samsung and Nokia, which manufacture wireless phones, are now finding themselves competing directly with traditional computer companies such as Apple.

Industry competitive analysis begins by focusing upon the overall industry in which a firm competes before market segments or sector-level issues are considered. Tools that managers can use to perform industry analysis are discussed in the following sections: the competitive forces model, strategic group analysis, and industry life-cycle analysis.

COMPETITIVE FORCES MODEL

Once the boundaries of an industry have been identified, managers face the task of analyzing competitive forces within the industry environment in order to identify opportunities and threats. Michael E. Porter's well-known framework, the Five Forces model, helps managers with this analysis.[1] An extension of his model, shown in Figure 2.2, focuses on *six* forces that shape competition within an industry: (1) the risk of entry by potential competitors, (2) the intensity of rivalry among established companies within an industry, (3) the bargaining power of buyers, (4) the bargaining power of suppliers, (5) the closeness

Figure 2.2

Competitive Forces

Source: Based on How Competitive Forces Shape Strategy, by Michael E. Porter, Harvard Business Review, March/April 1979.

of substitutes to an industry's products, and (6) the power of complement providers (Porter did not recognize this sixth force).

As each of these forces grows stronger, it limits the ability of established companies to raise prices and earn greater profits. Within this framework, a strong competitive force can be regarded as a threat because it depresses profits. A weak competitive force can be viewed as an opportunity because it allows a company to earn greater profits. The strength of the six forces may change over time as industry conditions change. Managers face the task of recognizing how changes in the five forces give rise to new opportunities and threats, and formulating appropriate strategic responses. In addition, it is possible for a company, through its choice of strategy, to alter the strength of one or more of the five forces to its advantage. This is discussed in the following chapters.

Risk of Entry by Potential Competitors

potential competitors
Companies that are currently not competing in the industry but have the potential to do so.

Potential competitors are companies that are not currently competing in an industry, but have the capability to do so if they choose. For example, in the last decade, cable television companies have recently emerged as potential competitors to traditional phone companies. New digital technologies have allowed cable companies to offer telephone and Internet service over the same cables that transmit television shows.

Established companies already operating in an industry often attempt to discourage potential competitors from entering the industry because as more companies enter, it becomes more difficult for established companies to protect their share of the market and generate profits. A high risk of entry by potential competitors represents a threat to the

profitability of established companies. As discussed in the Opening Case, there is now a high risk of new entry into the market for large commercial jet aircraft. If this entry occurs, it seems probable that one result will be to drive down prices and profits in the industry. If the risk of new entry is low, established companies can take advantage of this opportunity, raise prices, and earn greater returns.

The risk of entry by potential competitors is a function of the height of the barriers to entry, that is, factors that make it costly for companies to enter an industry. The greater the costs potential competitors must bear to enter an industry, the greater the barriers to entry, and the weaker this competitive force. High entry barriers may keep potential competitors out of an industry even when industry profits are high. Important barriers to entry include economies of scale, brand loyalty, absolute cost advantages, customer switching costs, and government regulation.[2] An important strategy is building barriers to entry (in the case of incumbent firms) or finding ways to circumvent those barriers (in the case of new entrants). We shall discuss this topic in more detail in subsequent chapters.

Economies of Scale **Economies of scale** arise when unit costs fall as a firm expands its output. Sources of scale economies include: (1) cost reductions gained through mass-producing a standardized output; (2) discounts on bulk purchases of raw material inputs and component parts; (3) the advantages gained by spreading fixed production costs over a large production volume; and (4) the cost savings associated with distributing, marketing, and advertising costs over a large volume of output. If the cost advantages from economies of scale are significant, a new company that enters the industry and produces on a small scale suffers a significant cost disadvantage relative to established companies. If the new company decides to enter on a large scale in an attempt to obtain these economies of scale, it must raise the capital required to build large-scale production facilities and bear the high risks associated with such an investment. In addition, an increased supply of products will depress prices and result in vigorous retaliation by established companies, which constitutes a further risk of large-scale entry. For these reasons, the threat of entry is reduced when established companies have economies of scale.

economies of scale
Reductions in unit costs attributed to a larger output.

Brand Loyalty **Brand loyalty** exists when consumers have a preference for the products of established companies. A company can create brand loyalty by continuously advertising its brand-name products and company name, patent protection of its products, product innovation achieved through company research and development (R&D) programs, an emphasis on high-quality products, and exceptional after-sales service. Significant brand loyalty makes it difficult for new entrants to take market share away from established companies. Thus, it reduces the threat of entry by potential competitors; they may see the task of breaking down well-established customer preferences as too costly. In the smartphone business, for example, Apple has generated such strong brand loyalty with its iPhone offering and related products that Microsoft is finding it very difficult to attract customers away from Apple and build demand for its new Windows 8 phone, introduced in late 2011. Despite its financial might, a year after launching the Windows 8 phone, Microsoft's U.S. market share remained mired at around 2.7%, whereas Apple led the market with a 53% share.[3]

brand loyalty
Preference of consumers for the products of established companies.

Absolute Cost Advantages Sometimes established companies have an **absolute cost advantage** relative to potential entrants, meaning that entrants cannot expect to match the established companies' lower cost structure. Absolute cost advantages arise from three main sources: (1) superior production operations and processes due to accumulated experience, patents, or trade secrets; (2) control of particular inputs required for production, such as labor, materials, equipment, or management skills, that are limited in their supply; and

absolute cost advantage
A cost advantage that is enjoyed by incumbents in an industry and that new entrants cannot expect to match.

(3) access to cheaper funds because existing companies represent lower risks than new entrants. If established companies have an absolute cost advantage, the threat of entry as a competitive force is weaker.

switching costs

Costs that consumers must bear to switch from the products offered by one established company to the products offered by a new entrant.

Customer Switching Costs Switching costs arise when a customer invests time, energy, and money switching from the products offered by one established company to the products offered by a new entrant. When switching costs are high, customers can be locked in to the product offerings of established companies, even if new entrants offer better products.[4] A familiar example of switching costs concerns the costs associated with switching from one computer operating system to another. If a person currently uses Microsoft's Windows operating system and has a library of related software applications and document files, it is expensive for that person to switch to another computer operating system. To effect the change, this person would need to purchase a new set of software applications and convert all existing document files to the new system's format. Faced with such an expense of money and time, most people are unwilling to make the switch unless the competing operating system offers a substantial leap forward in performance. Thus, the higher the switching costs, the higher the barrier to entry for a company attempting to promote a new computer operating system.

Government Regulations Historically, government regulation has constituted a major entry barrier for many industries. For example, until the mid-1990s, U.S. government regulation prohibited providers of long-distance telephone service from competing for local telephone service, and vice versa. Other potential providers of telephone service, including cable television service companies such as Time Warner and Comcast (which could have used their cables to carry telephone traffic as well as TV signals), were prohibited from entering the market altogether. These regulatory barriers to entry significantly reduced the level of competition in both the local and long-distance telephone markets, enabling telephone companies to earn higher profits than they might have otherwise. All this changed in 1996 when the government significantly deregulated the industry. In the months that followed this repeal of policy, local, long-distance, and cable TV companies all announced their intention to enter each other's markets, and a host of new players entered the market. The competitive forces model predicts that falling entry barriers due to government deregulation will result in significant new entry, an increase in the intensity of industry competition, and lower industry profit rates, and that is what occurred here.

In summary, if established companies have built brand loyalty for their products, have an absolute cost advantage over potential competitors, have significant scale economies, are the beneficiaries of high switching costs, or enjoy regulatory protection, the risk of entry by potential competitors is greatly diminished; it is a weak competitive force. Consequently, established companies can charge higher prices, and industry profits are therefore higher. Evidence from academic research suggests that the height of barriers to entry is one of the most important determinants of profit rates within an industry.[5] Clearly, it is in the interest of established companies to pursue strategies consistent with raising entry barriers to secure these profits. Additionally, potential new entrants must find strategies that allow them to circumvent barriers to entry.

Rivalry Among Established Companies

The second competitive force is the intensity of rivalry among established companies within an industry. Rivalry refers to the competitive struggle between companies within

2.1 STRATEGY IN ACTION

Circumventing Entry Barriers into the Soft Drink Industry

© iStockPhoto.com/Tom Nulens

Two companies have long dominated the carbonated soft drink industry: Coca-Cola and PepsiCo. By spending large sums of money on advertising and promotion, these two giants have created significant brand loyalty and made it very difficult for new competitors to enter the industry and take market share away. When new competitors have tried to enter, both companies have responded by cutting prices, forcing the new entrants to curtail expansion plans.

However, in the early 1990s, the Cott Corporation, then a small Canadian bottling company, worked out a strategy for entering the carbonated soft drink market. Cott's strategy was deceptively simple. The company initially focused on the cola segment of the market. Cott entered a deal with Royal Crown Cola for exclusive global rights to its cola concentrate. RC Cola was a small player in the U.S. cola market. Its products were recognized as high quality, but RC Cola had never been able to effectively challenge Coke or Pepsi. Next, Cott entered an agreement with a Canadian grocery retailer, Loblaw, to provide the retailer with its own private-label brand of cola. The Loblaw private-label brand, known as "President's Choice," was priced low, became very successful, and took shares from both Coke and Pepsi.

Emboldened by this success, Cott decided to try to convince other retailers to carry private-label cola. To retailers, the value proposition was simple because, unlike its major rivals, Cott spent almost nothing on advertising and promotion. This constituted a major source of cost savings, which Cott passed on to retailers in the form of lower prices. Retailers found that they could significantly undercut the price of Coke and Pepsi colas and still make better profit margins on private-label brands than on branded colas.

Despite this compelling value proposition, few retailers were willing to sell private-label colas for fear of alienating Coca-Cola and Pepsi, whose products were a major draw for grocery store traffic. Cott's breakthrough came in the 1990s when it signed a deal with Wal-Mart to supply the retailing giant with a private-label cola called "Sam's Choice" (named after Wal-Mart founder Sam Walton). Wal-Mart proved to be the perfect distribution channel for Cott. The retailer was just beginning to appear in the grocery business, and consumers went to Wal-Mart not to buy branded merchandise, but to get low prices. As Wal-Mart's grocery business grew, so did Cott's sales. Cott soon added other flavors to its offering, such as lemon-lime soda, which would compete with 7-Up and Sprite. Moreover, by the late 1990s, other U.S. grocers pressured by Wal-Mart had also started to introduce private-label sodas, and often turned to Cott to supply their needs.

By 2011, Cott's private-label customers included Wal-Mart, Kroger, Costco, and Safeway.

Cott had revenues of $2.33 billion and accounted for 60% of all private-label sales of carbonated beverages in the United States, and 6 to 7% of overall sales of carbonated beverages in grocery stores, its core channel. Although Coca-Cola and PepsiCo remain dominant, they have lost incremental market share to Cott and other companies that have followed Cott's strategy.

Sources: A. Kaplan, "Cott Corporation," *Beverage World*, June 15, 2004, p. 32; J. Popp, "2004 Soft Drink Report," *Beverage Industry*, March 2004, pp. 13–18; L. Sparks, "From Coca-Colonization to Copy Catting: The Cott Corporation and Retailers Brand Soft Drinks in the UK and US," *Agribusiness* 13:2 (March 1997): 153–167; E. Cherney, "After Flat Sales, Cott Challenges Pepsi, Coca-Cola," *Wall Street Journal*, January 8, 2003, pp. B1, B8; "Cott Corporation: Company Profile," *Just Drinks*, August 2006, pp. 19–22; and Cott Corp. 2011 Annual Report, www.cott.com.

an industry to gain market share from each other. The competitive struggle can be fought using price, product design, advertising and promotional spending, direct-selling efforts, and after-sales service and support. Intense rivalry implies lower prices or more spending on non-price-competitive strategies, or both. Because intense rivalry lowers prices and raises costs, it squeezes profits out of an industry. Thus, intense rivalry among established companies constitutes a strong threat to profitability. Alternatively, if rivalry is less intense,

companies may have the opportunity to raise prices or reduce spending on non-price-competitive strategies, leading to a higher level of industry profits. Four factors have a major impact on the intensity of rivalry among established companies within an industry: (1) industry competitive structure, (2) demand conditions, (3) cost conditions, and (4) the height of exit barriers in the industry.

Industry Competitive Structure The competitive structure of an industry refers to the number and size distribution of companies in it, something that strategic managers determine at the beginning of an industry analysis. Industry structures vary, and different structures have different implications for the intensity of rivalry. A fragmented industry consists of a large number of small or medium-sized companies, none of which is in a position to determine industry price. A consolidated industry is dominated by a small number of large companies (an oligopoly) or, in extreme cases, by just one company (a monopoly), and companies often are in a position to determine industry prices. Examples of fragmented industries are agriculture, dry cleaning, health clubs, real estate brokerage, and sun-tanning parlors. Consolidated industries include the aerospace, soft drink, wireless service, and small package express delivery industries. In the small package express delivery industry, for example, two firms, UPS and FedEx, account for over 80% of industry revenues in the United States.

Low-entry barriers and commodity-type products that are difficult to differentiate characterize many fragmented industries. This combination tends to result in boom-and-bust cycles as industry profits rapidly rise and fall. Low-entry barriers imply that new entrants will flood the market, hoping to profit from the boom that occurs when demand is strong and profits are high. The explosive number of video stores, health clubs, and sun-tanning parlors that arrived on the market during the 1980s and 1990s exemplifies this situation.

Often the flood of new entrants into a booming, fragmented industry creates excess capacity, and companies start to cut prices in order to use their spare capacity. The difficulty companies face when trying to differentiate their products from those of competitors can exacerbate this tendency. The result is a price war, which depresses industry profits, forces some companies out of business, and deters potential new entrants. For example, after a decade of expansion and booming profits, many health clubs are now finding that they have to offer large discounts in order to maintain their memberships. In general, the more commodity-like an industry's product, the more vicious the price war will be. The bust part of this cycle continues until overall industry capacity is brought into line with demand (through bankruptcies), at which point prices may stabilize again.

A fragmented industry structure, then, constitutes a threat rather than an opportunity. Economic boom times in fragmented industries are often relatively short-lived because the ease of new entry can soon result in excess capacity, which in turn leads to intense price competition and the failure of less efficient enterprises. Because it is often difficult to differentiate products in these industries, trying to minimize costs is the best strategy for a company so it will be profitable in a boom and survive any subsequent bust. Alternatively, companies might try to adopt strategies that change the underlying structure of fragmented industries and lead to a consolidated industry structure in which the level of industry profitability is increased. (Exactly how companies can do this is something we shall consider in later chapters.)

In consolidated industries, companies are interdependent because one company's competitive actions (changes in price, quality, etc.) directly affect the market share of its rivals, and thus their profitability. When one company makes a move, this generally "forces" a response from its rivals, and the consequence of such competitive interdependence can be a dangerous

2.2 STRATEGY IN ACTION

Price Wars in the Breakfast Cereal Industry

© iStockPhoto.com/Tom Nulens

For decades, the breakfast cereal industry was one of the most profitable in the United States. The industry has a consolidated structure dominated by Kellogg's, General Mills, and Kraft Foods with its Post brand. Strong brand loyalty, coupled with control over the allocation of supermarket shelf space, helped to limit the potential for new entry. Meanwhile, steady demand growth of about 3% per annum kept industry revenues expanding. Kellogg's, which accounted for over 40% of the market share, acted as the price leader in the industry. Every year Kellogg's increased cereal prices, its rivals followed, and industry profits remained high.

This favorable industry structure began to change in the 1990s when growth in demand slowed—and then stagnated—as a latte and bagel or muffin replaced cereal as the American morning fare. Then came the rise of powerful discounters such as Wal-Mart (which entered the grocery industry in 1994) that began to aggressively promote their own cereal brands, and priced their products significantly below the brand-name cereals. As the decade progressed, other grocery chains such as Kroger's started to follow suit, and brand loyalty in the industry began to decline as customers realized that a $2.50 bag of wheat flakes from Wal-Mart tasted about the same as a $3.50 box of Cornflakes from Kellogg's. As sales of cheaper store-brand cereals began to take off, supermarkets, no longer as dependent on brand names to bring traffic into their stores, began to demand lower prices from the branded cereal manufacturers.

For several years, manufacturers of brand-name cereals tried to hold out against these adverse trends, but in the mid-1990s, the dam broke. In 1996, Kraft (then owned by Philip Morris) aggressively cut prices by 20% for its Post brand in an attempt to gain market share. Kellogg's soon followed with a 19% price cut on two-thirds of its brands, and General Mills quickly did the same. The decades of tacit price collusion were officially over.

If breakfast cereal companies were hoping that price cuts would stimulate demand, they were wrong.

Instead, demand remained flat while revenues and margins followed price decreases, and operating margins at Kellogg's dropped from 18% in 1995 to 10.2% in 1996, a trend also experienced by the other brand-name cereal manufacturers.

By 2000, conditions had only worsened. Private-label sales continued to make inroads, gaining over 10% of the market. Moreover, sales of breakfast cereals started to contract at 1% per annum. To cap it off, an aggressive General Mills continued to launch expensive price-and-promotion campaigns in an attempt to take share away from the market leader. Kellogg's saw its market share slip to just over 30% in 2001, behind the 31% now held by General Mills. For the first time since 1906, Kellogg's no longer led the market. Moreover, profits at all three major producers remained weak in the face of continued price discounting.

In mid-2001, General Mills finally blinked and raised prices a modest 2% in response to its own rising costs. Competitors followed, signaling—perhaps—that after a decade of costly price warfare, pricing discipline might once more emerge in the industry. Both Kellogg's and General Mills tried to move further away from price competition by focusing on brand extensions, such as Special K containing berries and new varieties of Cheerios. Efforts with Special K helped Kellogg's recapture market leadership from General Mills, and, more important, the renewed emphasis on non-price competition halted years of damaging price warfare.

However, after a decade of relative peace, price wars broke out in 2010 once more in this industry. The trigger, yet again, appears to have been falling demand for breakfast cereals due to the consumption of substitutes, such as a quick trip to the local coffee shop. In the third quarter of 2010, prices fell by 3.6%, and unit volumes by 3.4%, leading to falling profit rates at Kellogg's. Both General Mills and Kellogg's announced plans to introduce new products in 2011 in an attempt to boost demand and raise prices.

Sources: G. Morgenson, "Denial in Battle Creek," *Forbes*, October 7, 1996, p. 44; J. Muller, "Thinking out of the Cereal Box," *Business Week*, January 15, 2001, p. 54; A. Merrill, "General Mills Increases Prices," *Star Tribune*, June 5, 2001, p. 1D; S. Reyes, "Big G, Kellogg's Attempt to Berry Each Other," *Brandweek*, October 7, 2002, p. 8; and M. Andrejczak, "Kellogg's Profit Hurt by Cereal Price War," *Market Watch*, November 2, 2010.

competitive spiral. Rivalry increases as companies attempt to undercut each other's prices, or offer customers more value in their products, pushing industry profits down in the process.

Companies in consolidated industries sometimes seek to reduce this threat by following the prices set by the dominant company in the industry.[6] However, companies must be careful, for explicit face-to-face price-fixing agreements are illegal. (Tacit, indirect agreements, arrived at without direct or intentional communication, are legal.) Instead, companies set prices by watching, interpreting, anticipating, and responding to one another's strategies. However, tacit price-leadership agreements often break down under adverse economic conditions, as has occurred in the breakfast cereal industry, profiled in Strategy in Action 2.2.

Industry Demand The level of industry demand is another determinant of the intensity of rivalry among established companies. Growing demand from new customers or additional purchases by existing customers tend to moderate competition by providing greater scope for companies to compete for customers. Growing demand tends to reduce rivalry because all companies can sell more without taking market share away from other companies. High industry profits are often the result. Conversely, declining demand results in increased rivalry as companies fight to maintain market share and revenues (as in the breakfast cereal industry example). Demand declines when customers exit the marketplace, or when each customer purchases less. When this is the case, a company can only grow by taking market share away from other companies. Thus, declining demand constitutes a major threat, for it increases the extent of rivalry between established companies.

Cost Conditions The cost structure of firms in an industry is a third determinant of rivalry. In industries where fixed costs are high, profitability tends to be highly leveraged to sales volume, and the desire to grow volume can spark intense rivalry. Fixed costs are the costs that must be paid before the firm makes a single sale. For example, before they can offer service, cable TV companies must lay cable in the ground; the cost of doing so is a fixed cost. Similarly, to offer express courier service, a company such as FedEx must first invest in planes, package-sorting facilities, and delivery trucks—all fixed costs that require significant capital investments. In industries where the fixed costs of production are high, firms cannot cover their fixed costs and will not be profitable if sales volume is low. Thus they have an incentive to cut their prices and/or increase promotional spending to drive up sales volume in order to cover fixed costs. In situations where demand is not growing fast enough and too many companies are simultaneously engaged in the same actions, the result can be intense rivalry and lower profits. Research suggests that the weakest firms in an industry often initiate such actions, precisely because they are struggling to cover their fixed costs.[7]

Exit Barriers Exit barriers are economic, strategic, and emotional factors that prevent companies from leaving an industry.[8] If exit barriers are high, companies become locked into an unprofitable industry where overall demand is static or declining. The result is often excess productive capacity, leading to even more intense rivalry and price competition as companies cut prices, attempting to obtain the customer orders needed to use their idle capacity and cover their fixed costs.[9] Common exit barriers include the following:

- Investments in assets such as specific machines, equipment, or operating facilities that are of little or no value in alternative uses, or cannot be later sold. If the company wishes to leave the industry, it must write off the book value of these assets.
- High fixed costs of exit, such as severance pay, health benefits, or pensions that must be paid to workers who are being made laid off when a company ceases to operate.

- Emotional attachments to an industry, such as when a company's owners or employees are unwilling to exit from an industry for sentimental reasons or because of pride.
- Economic dependence on the industry because a company relies on a single industry for its entire revenue and all profits.
- The need to maintain an expensive collection of assets at or above a minimum level in order to participate effectively in the industry.
- Bankruptcy regulations, particularly in the United States, where Chapter 11 bankruptcy provisions allow insolvent enterprises to continue operating and to reorganize under this protection. These regulations can keep unprofitable assets in the industry, result in persistent excess capacity, and lengthen the time required to bring industry supply in line with demand.

As an example of exit barriers and effects in practice, consider the small package express mail and parcel delivery industry. Key players in this industry, such as FedEx and UPS, rely entirely upon the delivery business for their revenues and profits. They must be able to guarantee their customers that they will deliver packages to all major localities in the United States, and much of their investment is specific to this purpose. To meet this guarantee, they need a nationwide network of air routes and ground routes, an asset that is required in order to participate in the industry. If excess capacity develops in this industry, as it does from time to time, FedEx cannot incrementally reduce or minimize its excess capacity by deciding not to fly to and deliver packages in Miami, for example, because that portion of its network is underused. If it did, it would no longer be able to guarantee to its customers that packages could be delivered to all major locations in the United States, and its customers would switch to another carrier. Thus, the need to maintain a nationwide network is an exit barrier that can result in persistent excess capacity in the air express industry during periods of weak demand.

The Bargaining Power of Buyers

The third competitive force is the bargaining power of buyers. An industry's buyers may be the individual customers who consume its products (end-users) or the companies that distribute an industry's products to end-users, such as retailers and wholesalers. For example, although soap powder made by Procter & Gamble (P&G) and Unilever is consumed by end-users, the principal buyers of soap powder are supermarket chains and discount stores, which resell the product to end-users. The bargaining power of buyers refers to the ability of buyers to bargain down prices charged by companies in the industry, or to raise the costs of companies in the industry by demanding better product quality and service. By lowering prices and raising costs, powerful buyers can squeeze profits out of an industry. Powerful buyers, therefore, should be viewed as a threat. Alternatively, when buyers are in a weak bargaining position, companies in an industry can raise prices and perhaps reduce their costs by lowering product quality and service, thus increasing the level of industry profits. Buyers are most powerful in the following circumstances:

- When the buyers have choice of who to buy from. If the industry is a monopoly, buyers obviously lack choice. If there are two or more companies in the industry, the buyers clearly have choice.
- When the buyers purchase in large quantities. In such circumstances, buyers can use their purchasing power as leverage to bargain for price reductions.
- When the supply industry depends upon buyers for a large percentage of its total orders.
- When switching costs are low and buyers can pit the supplying companies against each other to force down prices.

- When it is economically feasible for buyers to purchase an input from several companies at once so that buyers can pit one company in the industry against another.
- When buyers can threaten to enter the industry and independently produce the product, thus supplying their own needs, also a tactic for forcing down industry prices.

The automobile component supply industry, whose buyers are large manufacturers such as GM, Ford, and Toyota, is a good example of an industry in which buyers have strong bargaining power, and thus a strong competitive threat. Why? The suppliers of auto components are numerous and typically smaller in scale; their buyers, the auto manufacturers, are large in size and few in number. Additionally, to keep component prices down, historically both Ford and GM have used the threat of manufacturing a component themselves rather than buying it from auto component suppliers. The automakers use their powerful position to pit suppliers against one another, forcing down the prices for component parts and demanding better quality. If a component supplier objects, the automaker can use the threat of switching to another supplier as a bargaining tool.

The Bargaining Power of Suppliers

The fourth competitive force is the bargaining power of suppliers—the organizations that provide inputs into the industry, such as materials, services, and labor (which may be individuals, organizations such as labor unions, or companies that supply contract labor). The bargaining power of suppliers refers to the ability of suppliers to raise input prices, or to raise the costs of the industry in other ways—for example, by providing poor-quality inputs or poor service. Powerful suppliers squeeze profits out of an industry by raising the costs of companies in the industry. Thus, powerful suppliers are a threat. Conversely, if suppliers are weak, companies in the industry have the opportunity to force down input prices and demand higher-quality inputs (such as more productive labor). As with buyers, the ability of suppliers to make demands on a company depends on their power relative to that of the company. Suppliers are most powerful in these situations:

- The product that suppliers sell has few substitutes and is vital to the companies in an industry.
- The profitability of suppliers is not significantly affected by the purchases of companies in a particular industry, in other words, when the industry is not an important customer to the suppliers.
- Companies in an industry would experience significant switching costs if they moved to the product of a different supplier because a particular supplier's products are unique or different. In such cases, the company depends upon a particular supplier and cannot pit suppliers against each other to reduce prices.
- Suppliers can threaten to enter their customers' industry and use their inputs to produce products that would compete directly with those of companies already in the industry.
- Companies in the industry cannot threaten to enter their suppliers' industry and make their own inputs as a tactic for lowering the price of inputs.

An example of an industry in which companies are dependent upon a powerful supplier is the PC industry. Personal computer firms are heavily dependent on Intel, the world's largest supplier of microprocessors for PCs. Intel's microprocessor chips are the industry standard for personal computers. Intel's competitors, such as Advanced Micro Devices (AMD), must develop and supply chips that are compatible with Intel's standard. Although AMD has developed competing chips, Intel still supplies approximately 85% of the chips used in PCs primarily because only Intel has the manufacturing capacity required to serve a large share of the market. It is beyond the financial resources of Intel's competitors, such as AMD, to

match the scale and efficiency of Intel's manufacturing systems. This means that although PC manufacturers can purchase some microprocessors from Intel's rivals, most notably AMD, they still must turn to Intel for the bulk of their supply. Because Intel is in a powerful bargaining position, it can charge higher prices for its microprocessors than if its competitors were stronger and more numerous (that is, if the microprocessor industry were fragmented).

FOCUS ON: Wal-Mart

Wal-Mart'S Bargaining Power Over Suppliers

© iStockPhoto.com/caracterdesign

When Wal-Mart and other discount retailers began in the 1960s, they were small operations with little purchasing power. To generate store traffic, they depended in large part on stocking nationally branded merchandise from well-known companies such as P&G and Rubbermaid. Because the discounters did not have high sales volume, the nationally branded companies set the price. This meant that the discounters had to look for other ways to cut costs, which they typically did by emphasizing self-service in stripped-down stores located in the suburbs where land was cheaper (in the 1960s, the main competitors for discounters were full-service department stores such as Sears that were often located in downtown shopping areas).

Discounters such as K-Mart purchased their merchandise through wholesalers, which in turned bought from manufacturers. The wholesaler would come into a store and write an order, and when the merchandise arrived, the wholesaler would come in and stock the shelves, saving the retailer labor costs. However, Wal-Mart was located in Arkansas and placed its stores in small towns. Wholesalers were not particularly interested in serving a company that built its stores in such out-of-the-way places. They would do it only if Wal-Mart paid higher prices.

Wal-Mart's Sam Walton refused to pay higher prices. Instead he took his fledgling company public and used the capital raised to build a distribution center to stock merchandise. The distribution center would serve all stores within a 300-mile radius, with trucks leaving the distribution center daily to restock the stores. Because the distribution center was serving a collection of stores and thus buying in larger volumes, Walton found that he was able to cut the wholesalers out of the equation and order directly from manufacturers. The cost savings generated by not having to pay profits to wholesalers were then passed on to consumers in the form of lower prices, which helped Wal-Mart continue growing. This growth increased its buying power and thus its ability to demand deeper discounts from manufacturers.

Today, Wal-Mart has turned its buying process into an art form. Because 8% of all retail sales in the United States are made in a Wal-Mart store, the company has enormous bargaining power over its suppliers. Suppliers of nationally branded products, such as P&G, are no longer in a position to demand high prices. Instead, Wal-Mart is now so important to P&G that it is able to demand deep discounts from P&G. Moreover, Wal-Mart has itself become a brand that is more powerful than the brands of manufacturers. People don't go to Wal-Mart to buy branded goods; they go to Wal-Mart for the low prices. This simple fact has enabled Wal-Mart to bargain down the prices it pays, always passing on cost savings to consumers in the form of lower prices.

Since the early 1990s, Wal-Mart has provided suppliers with real-time information on store sales through the use of individual stock-keeping units (SKUs). These have allowed suppliers to optimize their own production processes, matching output to Wal-Mart's demands and avoiding under- or overproduction and the need to store inventory. The efficiencies that manufacturers gain from such information are passed on to Wal-Mart in the form of lower prices, which then passes on those cost savings to consumers.

Sources: "How Big Can It Grow?—Wal-Mart," *Economist*, April 17, 2004, pp. 74–76; H. Gilman, "The Most Underrated CEO Ever," *Fortune*, April 5, 2004, pp. 242–247; and K. Schaffner, "Psst! Want to Sell to Wal-Mart?," *Apparel Industry Magazine*, August 1996, pp. 18–20.

Substitute Products

The final force in Porter's model is the threat of substitute products: the products of different businesses or industries that can satisfy similar customer needs. For example, companies in the coffee industry compete indirectly with those in the tea and soft drink industries because all three serve customer needs for nonalcoholic drinks. The existence of close substitutes is a strong competitive threat because this limits the price that companies in one industry can charge for their product, which also limits industry profitability. If the price of coffee rises too much relative to that of tea or soft drinks, coffee drinkers may switch to those substitutes.

If an industry's products have few close substitutes (making substitutes a weak competitive force), then companies in the industry have the opportunity to raise prices and earn additional profits. There is no close substitute for microprocessors, which thus gives companies like Intel and AMD the ability to charge higher prices than if there were available substitutes.

Complementors

Andrew Grove, the former CEO of Intel, has argued that Porter's original formulation of competitive forces ignored a sixth force: the power, vigor, and competence of complementors.[10] Complementors are companies that sell products that add value to (complement) the products of companies in an industry because, when used together, the use of the combined products better satisfies customer demands. For example, the complementors to the PC industry are the companies that make software applications to run on the computers. The greater the supply of high-quality software applications running on these machines, the greater the value of PCs to customers, the greater the demand for PCs, and the greater the profitability of the PC industry.

Grove's argument has a strong foundation in economic theory, which has long argued that both substitutes and complements influence demand in an industry.[11] Research has emphasized the importance of complementary products in determining demand and profitability in many high-technology industries, such as the computer industry in which Grove made his mark.[12] When complements are an important determinant of demand for an industry's products, industry profits critically depend upon an adequate supply of complementary products. When the number of complementors is increasing and producing attractive complementary products, demand increases and profits in the industry can broaden opportunities for creating value. Conversely, if complementors are weak, and are not producing attractive complementary products, they can become a threat, slowing industry growth and limiting profitability.

It's also possible for complementors to gain so much power that they are able to extract profit out of the industry they are providing complements to. Complementors this strong can be a competitive threat. For example, in the videogame industry, the companies that produce the consoles—Nintendo, Microsoft (with Xbox), and Sony (with the PlayStation)—have historically made most of the money in the industry. They have done this by charging game-development companies (the complement providers) a royalty fee for every game sold that runs on their consoles. For example, Nintendo used to charge third-party game developers a 20% royalty fee for every game they sold that was written to run on a Nintendo console. However, two things have changed over the last decade. First, game developers have choices. They can, for example, decide to write for

Microsoft Xbox first, and Sony PlayStation a year later. Second, some game franchises are now so popular that consumers will purchase whichever platform runs the most recent version of the game. For example, Madden NFL, which is produced by Electronic Arts, has an estimated 5 to 7 million dedicated fans who will purchase each new release. The game is in such demand that Electronic Arts can bargain for lower royalty rates from Microsoft and Sony in return for writing it to run on their gaming platforms. Put differently, Electronic Arts has gained bargaining power over the console producers, and it uses this to extract profit from the console industry in the form of lower royalty rates paid to console manufacturers. The console manufacturers have responded by trying to develop their own powerful franchises that are exclusive to their platforms. Nintendo has been successful here with its long-running Super Mario series, and Microsoft has had a major franchise hit with its Halo series, which is now in its fourth version.

Summary: Why Industry Analysis Matters

The analysis of forces in the industry environment using the competitive forces framework is a powerful tool that helps managers to think strategically. It is important to recognize that one competitive force often affects others, and all forces need to be considered when performing industry analysis. For example, if new entry occurs due to low entry barriers, this will increase competition in the industry and drive down prices and profit rates, other things being equal. If buyers are powerful, they may take advantage of the increased choice resulting from new entry to further bargain down prices, increasing the intensity of competition and making it more difficult to make a decent profit in the industry. Thus, it is important to understand how one force might impact upon another.

Industry analysis inevitably leads managers to think systematically about strategic choices. For example, if entry barriers are low, managers might ask themselves, "how can we raise entry barriers into this industry, thereby reducing the threat of new competition?" The answer often involves trying to achieve economies of scale, build brand loyalty, create switching costs, and so on, so that new entrants are at a disadvantage and find it difficult to gain traction in the industry. Or they could ask, "How can we modify the intensity of competition in our industry?". They might do this by emphasizing brand loyalty in an attempt to differentiate their products, or by creating switching costs that reduce buyer power in the industry. Wireless service providers, for example, require their customers to sign a new 2-year contract with early termination fees that may run into hundreds of dollars whenever they upgrade their phone equipment. This action effectively increases the costs of switching to a different wireless provider, thus making it more difficult for new entrants to gain traction in the industry. The increase in switching costs also moderates the intensity of rivalry in the industry by making it less likely that consumers will switch from one provider to another in an attempt to lower the price they pay for their service.

When Coca-Cola looked at its industry environment in the early 2000s, it noticed a disturbing trend—per capita consumption of carbonated beverages had started to decline as people switched to noncarbonated soft drinks. In other words, substitute products were becoming a threat. This realization led to a change in the strategy at Coca-Cola. The company started to develop and offer its own noncarbonated beverages, effectively turning the threat into a strategic opportunity. Similarly, in the 2000s, demand for traditional newspapers began to decline as people increasingly started to consume news content on the Web. In other words, the threat from a substitute product was increasing. Several traditional newspapers responded by rapidly developing their own Web-based content.

In all of these examples, an analysis of industry opportunities and threats led directly to a change in strategy by companies within the industry. This, of course, is the crucial point—analyzing the industry environment in order to identify opportunities and threats leads logically to a discussion of what strategies should be adopted to exploit opportunities and counter threats. We will return to this issue again in Chapters 5, 6, and 7 when we look at the different business-level strategies firms can pursue, and how they can match strategy to the conditions prevailing in their industry environment.

STRATEGIC GROUPS WITHIN INDUSTRIES

Companies in an industry often differ significantly from one another with regard to the way they strategically position their products in the market. Factors such as the distribution channels they use, the market segments they serve, the quality of their products, technological leadership, customer service, pricing policy, advertising policy, and promotions affect product position. As a result of these differences, within most industries, it is possible to observe groups of companies in which each company follows a strategy that is similar to that pursued by other companies in the group, but different from the strategy pursued by companies in other groups. These different groups of companies are known as strategic groups.[13]

For example, as noted in the Opening Case, in the commercial aerospace industry there has traditionally been two main strategic groups: the manufacturers of regional jets and the manufacturers of large commercial jets (see Figure 2.3). Bombardier and Embraer are the standouts in the regional jet industry, whereas Boeing and Airbus have lone dominated

| Figure 2.3 | Strategic Groups in the Commercial Aerospace Industry |

© Cengage Learning

the market for large commercial jets. Regional jets have less than 100 seats and limited range. Large jets have anywhere from 100 to 550 seats, and some models are able to fly across the Pacific Ocean. Large jets are sold to major airlines, and regional jets to small regional carriers. Historically, the companies in the regional jet group have competed against each other, but not against Boeing and Airbus (the converse is also true).

Normally, the basic differences between the strategies that companies in different strategic groups use can be captured by a relatively small number of factors. In the case of commercial aerospace, the differences are primarily in terms of product attributes (seat capacity and range), and customer set (large airlines versus smaller regional airlines). For another example, consider the pharmaceutical industry. Here two primary strategic groups stand out.[14] One group, which includes such companies as Merck, Eli Lilly, and Pfizer, is characterized by a business model based on heavy R&D spending and a focus on developing new, proprietary, blockbuster drugs. The companies in this proprietary strategic group are pursuing a high-risk, high-return strategy because basic drug research is difficult and expensive. Bringing a new drug to market can cost up to $800 million in R&D money and a decade of research and clinical trials. The risks are high because the failure rate in new drug development is very high: only one out of every five drugs entering clinical trials is eventually approved by the U.S. Food and Drug Administration. However, this strategy has potential for a high return because a single successful drug can be patented, giving the innovator a monopoly on the production and sale of the drug for the life of the patent (patents are issued for 20 years). This allows proprietary companies to charge a high price for the drug, earning them millions, if not billions, of dollars over the lifetime of the patent.

The second strategic group might be characterized as the generic-drug strategic group. This group of companies, which includes Forest Labs, Mylan, and Watson Pharmaceuticals, focuses on the manufacture of generic drugs: low-cost copies of drugs that were developed by companies in the proprietary group, which now have expired patents. Low R&D spending, production efficiency, and an emphasis on low prices characterize the business models of companies in this strategic group. They are pursuing a low-risk, low-return strategy. It is low risk because these companies are not investing millions of dollars in R&D, and low return because they cannot charge high prices for their products.

Implications of Strategic Groups

The concept of strategic groups has a number of implications for the identification of opportunities and threats within an industry. First, because all companies in a strategic group are pursuing a similar strategy, customers tend to view the products of such enterprises as direct substitutes for each other. Thus, a company's closest competitors are those in its strategic group, not those in other strategic groups in the industry. The most immediate threat to a company's profitability comes from rivals within its own strategic group. For example, in the retail industry, there is a group of companies that might be characterized as discounters. Included in this group are Wal-Mart, K-mart, Target, and Fred Meyer. These companies compete vigorously with each other, rather than with other retailers in different groups, such as Nordstrom or The Gap. K-Mart, for example, was driven into bankruptcy in the early 2000s, not because Nordstrom or The Gap took its business, but because Wal-Mart and Target gained share in the discounting group by virtue of their superior strategic execution of the discounting business model.

A second competitive implication is that different strategic groups can have different relationships to each of the competitive forces; thus, each strategic group may face a different set of opportunities and threats. Each of the following can be a relatively strong or weak competitive force depending on the competitive positioning approach adopted by each strategic group in the industry: the risk of new entry by potential competitors; the degree of rivalry among companies within a group; the bargaining power of buyers; the bargaining power of suppliers; and the competitive force of substitute and complementary products. For example, in the pharmaceutical industry, companies in the proprietary group historically have been in a very powerful position in relation to buyers because their products are patented and there are no substitutes. Also, rivalry based on price competition within this group has been low because competition in the industry depends upon which company is first to patent a new drug ("patent races"), not on drug prices. Thus, companies in this group have been able to charge high prices and earn high profits. In contrast, companies in the generic group have been in a much weaker position because many companies are able to produce different versions of the same generic drug after patents expire. Thus, in this strategic group, products are close substitutes, rivalry has been high, and price competition has led to lower profits than for the companies in the proprietary group.

The Role of Mobility Barriers

It follows from these two issues that some strategic groups are more desirable than others because competitive forces open up greater opportunities and present fewer threats for those groups. Managers, after analyzing their industry, might identify a strategic group where competitive forces are weaker and higher profits can be made. Sensing an opportunity, they might contemplate changing their strategy and move to compete in that strategic group. However, taking advantage of this opportunity may be difficult because of mobility barriers between strategic groups.

Mobility barriers are within-industry factors that inhibit the movement of companies between strategic groups. They include the barriers to entry into a group and the barriers to exit from a company's existing group. For example, attracted by the promise of higher returns, Forest Labs might want to enter the proprietary strategic group in the pharmaceutical industry, but it might find doing so difficult because it lacks the requisite R&D skills, and building these skills would be an expensive proposition. Over time, companies in different groups develop different cost structures, skills, and competencies that allow them different pricing options and choices. A company contemplating entry into another strategic group must evaluate whether it has the ability to imitate, and outperform, its potential competitors in that strategic group. Managers must determine if it is cost-effective to overcome mobility barriers before deciding whether the move is worthwhile.

At the same time, managers should be aware that companies based in another strategic group within their industry might ultimately become their direct competitors if they can overcome mobility barriers. This now seems to be occurring in the commercial aerospace industry, where two of the regional jet manufacturers, Bombardier and Embraer, have started to move into the large commercial jet business with the development of narrow-bodied aircraft in the 100- to 150-seat range (see the Opening Case). This implies that Boeing and Airbus will be seeing more competition in the years ahead, and their managers need to prepare for this.

INDUSTRY LIFE-CYCLE ANALYSIS

Changes that take place in an industry over time are an important determinant of the strength of the competitive forces in the industry (and of the nature of opportunities and threats). The similarities and differences between companies in an industry often become more pronounced over time, and its strategic group structure frequently changes. The strength and nature of each of the competitive forces also change as an industry evolves, particularly the two forces of risk of entry by potential competitors and rivalry among existing firms.[15]

A useful tool for analyzing the effects that industry evolution has on competitive forces is the industry life-cycle model. This model identifies five sequential stages in the evolution of an industry that lead to five distinct kinds of industry environment: embryonic, growth, shakeout, mature, and decline (see Figure 2.4). The task managers face is to anticipate how the strength of competitive forces will change as the industry environment evolves, and to formulate strategies that take advantage of opportunities as they arise and that counter emerging threats.

Embryonic Industries

An embryonic industry refers to an industry just beginning to develop (for example, personal computers and biotechnology in the 1970s, wireless communications in the 1980s, Internet retailing in the 1990s, and nanotechnology today). Growth at this stage is slow because of factors such as buyers' unfamiliarity with the industry's product, high prices due to the inability of companies to reap any significant scale economies, and poorly developed distribution channels. Barriers to entry tend to be based on access to

Figure 2.4 Stages in the Industry Life Cycle

key technological knowhow rather than cost economies or brand loyalty. If the core know how required to compete in the industry is complex and difficult to grasp, barriers to entry can be quite high, and established companies will be protected from potential competitors. Rivalry in embryonic industries is based not so much on price as on educating customers, opening up distribution channels, and perfecting the design of the product. Such rivalry can be intense, and the company that is the first to solve design problems often has the opportunity to develop a significant market position. An embryonic industry may also be the creation of one company's innovative efforts, as happened with microprocessors (Intel), vacuum cleaners (Hoover), photocopiers (Xerox), small package express delivery (FedEx), and Internet search engines (Google). In such circumstances, the developing company has a major opportunity to capitalize on the lack of rivalry and build a strong hold on the market.

Growth Industries

Once demand for the industry's product begins to increase, the industry develops the characteristics of a growth industry. In a growth industry, first-time demand is expanding rapidly as many new customers enter the market. Typically, an industry grows when customers become familiar with the product, prices fall because scale economies have been attained, and distribution channels develop. The U.S. wireless telephone industry remained in the growth stage for most of the 1990s. In 1990, there were only 5 million cellular subscribers in the nation. In 1997, there were 50 million. By 2012, this figure had increased to about 320 million, or roughly one account per person, implying that the market is now saturated and the industry is mature.

Normally, the importance of control over technological knowledge as a barrier to entry has diminished by the time an industry enters its growth stage. Because few companies have yet to achieve significant scale economies or built brand loyalty, other entry barriers tend to be relatively low early in the growth stage. Thus, the threat from potential competitors is typically highest at this point. Paradoxically, however, high growth usually means that new entrants can be absorbed into an industry without a marked increase in the intensity of rivalry. Thus, rivalry tends to be relatively low. Rapid growth in demand enables companies to expand their revenues and profits without taking market share away from competitors. A strategically aware company takes advantage of the relatively benign environment of the growth stage to prepare itself for the intense competition of the coming industry shakeout.

Industry Shakeout

Explosive growth cannot be maintained indefinitely. Sooner or later, the rate of growth slows, and the industry enters the shakeout stage. In the shakeout stage, demand approaches saturation levels: more and more of the demand is limited to replacement because fewer potential first-time buyers remain.

As an industry enters the shakeout stage, rivalry between companies can become intense. Typically, companies that have become accustomed to rapid growth continue to add capacity at rates consistent with past growth. However, demand is no longer growing at historic rates, and the consequence is the emergence of excess productive capacity. This condition is illustrated in Figure 2.5, where the solid curve indicates the growth in demand over time and the broken curve indicates the growth in productive capacity over time.

| Figure 2.5 | Growth in Demand and Capacity |

As you can see, past time t_1, demand growth becomes slower as the industry becomes mature. However, capacity continues to grow until time t_2. The gap between the solid and broken lines signifies excess capacity. In an attempt to use this capacity, companies often cut prices. The result can be a price war, which drives the more inefficient companies into bankruptcy and deters new entry.

Mature Industries

The shakeout stage ends when the industry enters its mature stage: the market is totally saturated, demand is limited to replacement demand, and growth is low or zero. Typically, the growth that remains comes from population expansion, bringing new customers into the market, or increasing replacement demand.

As an industry enters maturity, barriers to entry increase, and the threat of entry from potential competitors decreases. As growth slows during the shakeout, companies can no longer maintain historic growth rates merely by holding on to their market share. Competition for market share develops, driving down prices and often producing a price war, as has happened in the airline and PC industries. To survive the shakeout, companies begin to focus on minimizing costs and building brand loyalty. The airlines, for example, tried to cut operating costs by hiring nonunion labor, and build brand loyalty by introducing frequent-flyer programs. Personal computer companies have sought to build brand loyalty by providing excellent after-sales service and working to lower their cost structures. By the time an industry matures, the surviving companies are those that have brand loyalty and efficient low-cost operations. Because both these factors constitute a significant barrier to entry, the threat of entry by potential competitors is often greatly diminished. High entry

barriers in mature industries can give companies the opportunity to increase prices and profits—although this does not always occur.

As a result of the shakeout, most industries in the maturity stage have consolidated and become oligopolies. Examples include the beer industry, breakfast cereal industry, and wireless service industry. In mature industries, companies tend to recognize their interdependence and try to avoid price wars. Stable demand gives them the opportunity to enter into tacit price-leadership agreements. The net effect is to reduce the threat of intense rivalry among established companies, thereby allowing greater profitability. Nevertheless, the stability of a mature industry is always threatened by further price wars. A general slump in economic activity can depress industry demand. As companies fight to maintain their revenues in the face of declining demand, price-leadership agreements break down, rivalry increases, and prices and profits fall. The periodic price wars that occur in the airline industry, for example, appear to follow this pattern.

Declining Industries

Eventually, most industries enter a stage of decline: growth becomes negative for a variety of reasons, including technological substitution (for example, air travel instead of rail travel), social changes (greater health consciousness impacting tobacco sales), demographics (the declining birthrate damaging the market for baby and child products), and international competition (low-cost foreign competition helped pushed the U.S. steel industry into decline). Within a declining industry, the degree of rivalry among established companies usually increases. Depending on the speed of the decline and the height of exit barriers, competitive pressures can become as fierce as in the shakeout stage.[16] The largest problem in a declining industry is that falling demand leads to the emergence of excess capacity. In trying to use this capacity, companies begin to cut prices, thus sparking a price war. The U.S. steel industry experienced these problems during the 1980s and 1990s because steel companies tried to use their excess capacity despite falling demand. The same problem occurred in the airline industry in the 1990–1992 period, in 2001–2005, and again in 2008–2009 as companies cut prices to ensure that they would not be flying with half-empty planes (that is, they would not be operating with substantial excess capacity). Exit barriers play a part in adjusting excess capacity. The greater the exit barriers, the harder it is for companies to reduce capacity, and the greater the threat of severe price competition.

Summary

In summary, a third task of industry analysis is to identify the opportunities and threats that are characteristic of different kinds of industry environments in order to develop effective strategies. Managers have to tailor their strategies to changing industry conditions. They must also learn to recognize the crucial points in an industry's development, so they can forecast when the shakeout stage of an industry might begin, or when an industry might be moving into decline. This is also true at the level of strategic groups, for new embryonic groups may emerge because of shifts in customer needs and tastes, or because some groups may grow rapidly due to changes in technology, whereas others will decline as their customers defect.

LIMITATIONS OF MODELS FOR INDUSTRY ANALYSIS

The competitive forces, strategic groups, and life-cycle models provide useful ways of thinking about and analyzing the nature of competition within an industry to identify opportunities and threats. However, each has its limitations, and managers must be aware of their shortcomings.

Life-Cycle Issues

It is important to remember that the industry life-cycle model is a generalization. In practice, industry life-cycles do not always follow the pattern illustrated in Figure 2.4. In some cases, growth is so rapid that the embryonic stage is skipped altogether. In others, industries fail to get past the embryonic stage. Industry growth can be revitalized after long periods of decline through innovation or social change. For example, the health boom brought the bicycle industry back to life after a long period of decline. The revenues of wireless service providers are also now growing at a healthy clip despite a nominally mature market due to the introduction of enhanced products—smartphones—that has resulted in a rapid increase in revenues from data services. Between 2007 and 2012, wireless data revenues in the U.S. increased from $19 billion to $68 billion, which represented essentially all of the growth in industry revenues over this time period (i.e., there was zero growth in revenues from simple wireless voice service).[17]

The time span of these stages can also vary significantly from industry to industry. Some industries can stay in maturity almost indefinitely if their products are viewed as basic necessities, as is the case for the car industry. Other industries skip the mature stage and go straight into decline, as in the case of the vacuum tube industry. Transistors replaced vacuum tubes as a major component in electronic products despite that the vacuum tube industry was still in its growth stage. Still other industries may go through several shakeouts before they enter full maturity, as appears to currently be happening in the telecommunications industry.

Innovation and Change

Over any reasonable length of time, in many industries competition can be viewed as a process driven by innovation.[18] Innovation is frequently the major factor in industry evolution and causes a company's movement through the industry life cycle. Innovation is attractive because companies that pioneer new products, processes, or strategies can often earn enormous profits. Consider the explosive growth of Toys"R"Us, Dell, and Wal-Mart. In a variety of different ways, all of these companies were innovators. Toys"R"Us pioneered a new way of selling toys (through large discount warehouse-type stores), Dell pioneered an entirely new way of selling personal computers (directly via telephone and then the Web), and Wal-Mart pioneered the low-price discount superstore concept.

Successful innovation can transform the nature of industry competition. In recent decades, one frequent consequence of innovation has been to lower the fixed costs of production, thereby reducing barriers to entry and allowing new, and smaller, enterprises to compete with large established organizations. For example, two decades ago, large integrated steel companies such as U.S. Steel, LTV, and Bethlehem Steel dominated the steel

industry. The industry was a typical oligopoly, dominated by a small number of large producers, in which tacit price collusion was practiced. Then along came a series of efficient mini-mill producers such as Nucor and Chaparral Steel, which used a new technology: electric arc furnaces. Over the past 20 years, they have revolutionized the structure of the industry. What was once a consolidated industry is now much more fragmented and price competitive. U.S. Steel now has only a 12% market share, down from 55% in the mid-1960s. In contrast, the mini-mills as a group now hold over 40% of the market, up from 5% 20 years ago.[19] Thus, the mini-mill innovation has reshaped the nature of competition in the steel industry.[20] A competitive forces model applied to the industry in 1970 would look very different from a competitive forces model applied in 2012.

Michael Porter talks of innovations as "unfreezing" and "reshaping" industry structure. He argues that after a period of turbulence triggered by innovation, the structure of an industry once more settles down into a fairly stable pattern, and the five forces and strategic group concepts can once more be applied.[21] This view of the evolution of industry structure is often referred to as "punctuated equilibrium."[22] The punctuated equilibrium view holds that long periods of equilibrium (refreezing), when an industry's structure is stable, are punctuated by periods of rapid change (unfreezing), when industry structure is revolutionized by innovation.

Figure 2.6 shows what punctuated equilibrium might look like for one key dimension of industry structure: competitive structure. From time t_0 to t_1, the competitive structure of the industry is a stable oligopoly, and few companies share the market. At time t_1, a major new innovation is pioneered either by an existing company or a new entrant. The result is a period of turbulence between t_1 and t_2. Afterward, the industry settles into a new state of equilibrium, but now the competitive structure is far more fragmented. Note that the opposite could have happened: the industry could have become more consolidated, although this seems to be less common. In general, innovations seem to lower barriers to entry, allow more companies into the industry, and as a result lead to fragmentation rather than consolidation.

During a period of rapid change when industry structure is being revolutionized by innovation, value typically migrates to business models based on new positioning strategies.[23] In the stockbrokerage industry, value migrated from the full-service broker model

Figure 2.6 Punctuated Equilibrium and Competitive Structure

© Cengage Learning

to the online trading model. In the steel industry, the introduction of electric arc technology led to a migration of value away from large, integrated enterprises and toward small mini-mills. In the book-selling industry, value has migrated first away from small boutique "bricks-and-mortar" booksellers toward large bookstore chains like Barnes & Noble, and more recently toward online bookstores such as Amazon.com. Because the competitive forces and strategic group models are static, they cannot adequately capture what occurs during periods of rapid change in the industry environment when value is migrating.

Company Differences

Another criticism of industry models is that they overemphasize the importance of industry structure as a determinant of company performance, and underemphasize the importance of variations or differences among companies within an industry or a strategic group.[24] As we discuss in the next chapter, there can be enormous variance in the profit rates of individual companies within an industry. Research by Richard Rumelt and his associates, for example, suggests that industry structure explains only about 10% of the variance in profit rates across companies.[25] This implies that individual company differences explain much of the remainder. Other studies have estimated the explained variance at about 20%, which is still not a large figure.[26] Similarly, growing numbers of studies have found only weak evidence linking strategic group membership and company profit rates, despite that the strategic group model predicts a strong link.[27] Collectively, these studies suggest that a company's individual resources and capabilities may be more important determinants of its profitability than the industry or strategic group of which the company is a member. In other words, there are strong companies in tough industries where average profitability is low (e.g., Nucor in the steel industry), and weak companies in industries where average profitability is high.

Although these findings do not invalidate the competitive forces and strategic group models, they do imply that the models are imperfect predictors of enterprise profitability. A company will not be profitable just because it is based in an attractive industry or strategic group. As we will discuss in subsequent chapters, much more is required.

THE MACROENVIRONMENT

Just as the decisions and actions of strategic managers can often change an industry's competitive structure, so too can changing conditions or forces in the wider macroenvironment, that is, the broader economic, global, technological, demographic, social, and political context in which companies and industries are embedded (see Figure 2.7). Changes in the forces within the macroenvironment can have a direct impact on any or all of the forces in Porter's model, thereby altering the relative strength of these forces as well as the attractiveness of an industry.

Macroeconomic Forces

Macroeconomic forces affect the general health and well-being of a nation or the regional economy of an organization, which in turn affect companies' and industries' ability to earn an adequate rate of return. The four most important macroeconomic forces are the growth rate of the economy, interest rates, currency exchange rates, and inflation (or deflation) rates. Economic growth, because it leads to an expansion in customer expenditures, tends to ease competitive pressures within an industry. This gives companies the opportunity to

Figure 2.7 The Role of the Macroenvironment

expand their operations and earn higher profits. Because economic decline (a recession) leads to a reduction in customer expenditures, it increases competitive pressures. Economic decline frequently causes price wars in mature industries.

Interest rates can determine the demand for a company's products. Interest rates are important whenever customers routinely borrow money to finance their purchase of these products. The most obvious example is the housing market, where mortgage rates directly affect demand. Interest rates also have an impact on the sale of autos, appliances, and capital equipment, to give just a few examples. For companies in such industries, rising interest rates are a threat, and falling rates an opportunity. Interest rates are also important because they influence a company's cost of capital, and therefore its ability to raise funds and invest in new assets. The lower that interest rates are, the lower the cost of capital for companies, and the more investment there can be.

Currency exchange rates define the comparative value of different national currencies. Movement in currency exchange rates has a direct impact on the competitiveness of a company's products in the global marketplace. For example, when the value of the dollar is low compared to the value of other currencies, products made in the United States are relatively inexpensive and products made overseas are relatively expensive. A low or declining dollar reduces the threat from foreign competitors while creating opportunities for increased

sales overseas. The fall in the value of the dollar against several major currencies during 2004–2008 helped to make the U.S. steel industry more competitive.

Price inflation can destabilize the economy, producing slower economic growth, higher interest rates, and volatile currency movements. If inflation continues to increase, investment planning will become hazardous. The key characteristic of inflation is that it makes the future less predictable. In an inflationary environment, it may be impossible to predict with any accuracy the real value of returns that can be earned from a project 5 years later. Such uncertainty makes companies less willing to invest, which in turn depresses economic activity and ultimately pushes the economy into a recession. Thus, high inflation is a threat to companies.

Price deflation also has a destabilizing effect on economic activity. If prices fall, the real price of fixed payments goes up. This is damaging for companies and individuals with a high level of debt who must make regular fixed payments on that debt. In a deflationary environment, the increase in the real value of debt consumes more household and corporate cash flows, leaving less for other purchases and depressing the overall level of economic activity. Although significant deflation has not been seen since the 1930s, in the 1990s it started to take hold in Japan, and in 2008–2009 there were concerns that it might re-emerge in the United States as the country plunged into a deep recession.

Global Forces

Over the last half-century there have been enormous changes in the world's economic system. We review these changes in some detail in Chapter 8 when we discuss global strategy. For now, the important points to note are that barriers to international trade and investment have tumbled, and more and more countries have enjoyed sustained economic growth. Economic growth in places like Brazil, China, and India has created large new markets for companies' goods and services and is giving companies an opportunity to grow their profits faster by entering these nations. Falling barriers to international trade and investment have made it much easier to enter foreign nations. For example, 20 years ago, it was almost impossible for a Western company to set up operations in China. Today, Western and Japanese companies are investing around $100 billion a year in China. By the same token, however, falling barriers to international trade and investment have made it easier for foreign enterprises to enter the domestic markets of many companies (by lowering barriers to entry), thereby increasing the intensity of competition and lowering profitability. Because of these changes, many formerly isolated domestic markets have now become part of a much larger, more competitive global marketplace, creating both threats and opportunities for companies.

Technological Forces

Over the last few decades the pace of technological change has accelerated.[28] This has unleashed a process that has been called a "perennial gale of creative destruction."[29] Technological change can make established products obsolete overnight and simultaneously create a host of new product possibilities. Thus, technological change is both creative and destructive—both an opportunity and a threat.

Most important, the impacts of technological change can affect the height of barriers to entry and therefore radically reshape industry structure. For example, the Internet lowered barriers to entry into the news industry. Providers of financial news must now compete for advertising dollars and customer attention with new Internet-based media organizations that developed during the 1990s and 2000s, such as TheStreet.com, The Motley Fool, Yahoo!'s financial section, and most recently, Google news. Advertisers now have more

choices due to the resulting increase in rivalry, enabling them to bargain down the prices that they must pay to media companies.

Demographic Forces

Demographic forces are outcomes of changes in the characteristics of a population, such as age, gender, ethnic origin, race, sexual orientation, and social class. Like the other forces in the general environment, demographic forces present managers with opportunities and threats and can have major implications for organizations. Changes in the age distribution of a population are an example of a demographic force that affects managers and organizations. Currently, most industrialized nations are experiencing the aging of their populations as a consequence of falling birth and death rates and the aging of the baby-boom generation. As the population ages, opportunities for organizations that cater to older people are increasing; the home-health-care and recreation industries, for example, are seeing an upswing in demand for their services. As the baby-boom generation from the late 1950s to the early 1960s has aged, it has created a host of opportunities and threats. During the 1980s, many baby boomers were getting married and creating an upsurge in demand for the customer appliances normally purchased by couples marrying for the first time. Companies such as Whirlpool Corporation and GE capitalized on the resulting upsurge in demand for washing machines, dishwashers, dryers, and the like. In the 1990s, many of these same baby boomers were beginning to save for retirement, creating an inflow of money into mutual funds, and creating a boom in the mutual fund industry. In the next 20 years, many of these same baby boomers will retire, creating a boom in retirement communities.

Social Forces

Social forces refer to the way in which changing social mores and values affect an industry. Like the other macroenvironmental forces discussed here, social change creates opportunities and threats. One of the major social movements of recent decades has been the trend toward greater health consciousness. Its impact has been immense, and companies that recognized the opportunities early have often reaped significant gains. Philip Morris, for example, capitalized on the growing health consciousness trend when it acquired Miller Brewing Company, and then redefined competition in the beer industry with its introduction of low-calorie beer (Miller Lite). Similarly, PepsiCo was able to gain market share from its rival, Coca-Cola, by being the first to introduce diet colas and fruit-based soft drinks. At the same time, the health trend has created a threat for many industries. The tobacco industry, for example, is in decline as a direct result of greater customer awareness of the health implications of smoking.

Political and Legal Forces

Political and legal forces are outcomes of changes in laws and regulations, and significantly affect managers and companies. Political processes shape a society's laws, which constrain the operations of organizations and managers and thus create both opportunities and threats.[30] For example, throughout much of the industrialized world, there has been a strong trend toward deregulation of industries previously controlled by the state, and privatization of organizations once owned by the state. In the United States, deregulation of the airline industry in 1979 allowed 29 new airline companies to enter the industry between 1979 and 1993.

The increase in passenger-carrying capacity after deregulation led to excess capacity on many routes, intense competition, and fare wars. To respond to this more competitive task environment, airlines needed to look for ways to reduce operating costs. The development of hub-and-spoke systems, the rise of nonunion airlines, and the introduction of no-frills discount service are all responses to increased competition in the airlines' task environment. Despite these innovations, the airline industry still experiences intense fare wars, which have lowered profits and caused numerous airline-company bankruptcies. The global telecommunications service industry is now experiencing the same kind of turmoil following the deregulation of that industry in the United States and elsewhere.

SUMMARY OF CHAPTER

1. An industry can be defined as a group of companies offering products or services that are close substitutes for each other. Close substitutes are products or services that satisfy the same basic customer needs.

2. The main technique used to analyze competition in the industry environment is the competitive forces model. The six forces are: (1) the risk of new entry by potential competitors, (2) the extent of rivalry among established firms, (3) the bargaining power of buyers, (4) the bargaining power of suppliers, (5) the threat of substitute products, and (6) the power of complement providers. The stronger each force is, the more competitive the industry and the lower the rate of return that can be earned.

3. The risk of entry by potential competitors is a function of the height of barriers to entry. The higher the barriers to entry are, the lower is the risk of entry and the greater are the profits that can be earned in the industry.

4. The extent of rivalry among established companies is a function of an industry's competitive structure, demand conditions, cost conditions, and barriers to exit. Strong demand conditions moderate the competition among established companies and create opportunities for expansion. When demand is weak, intensive competition can develop, particularly in consolidated industries with high exit barriers.

5. Buyers are most powerful when a company depends on them for business, but they are not dependent on the company. In such circumstances, buyers are a threat.

6. Suppliers are most powerful when a company depends on them for business but they are not dependent on the company. In such circumstances, suppliers are a threat.

7. Substitute products are the products of companies serving customer needs similar to the needs served by the industry being analyzed. When substitute products are very similar to one another, companies can charge a lower price without losing customers to the substitutes.

8. The power, vigor, and competence of complementors represents a sixth competitive force. Powerful and vigorous complementors may have a strong positive impact on demand in an industry.

9. Most industries are composed of strategic groups: groups of companies pursuing the same or a similar strategy. Companies in different strategic groups pursue different strategies.

10. The members of a company's strategic group constitute its immediate competitors. Because different strategic groups are characterized by different opportunities and threats, a company may improve its performance by switching strategic groups. The feasibility of doing so is a function of the height of mobility barriers.

11. Industries go through a well-defined life cycle: from an embryonic stage, through growth, shakeout, and maturity, and eventually decline. Each stage has different implications for the competitive

structure of the industry, and each gives rise to its own set of opportunities and threats.

12. The competitive forces, strategic group, and industry life-cycles models all have limitations. The competitive forces and strategic group models present a static picture of competition that deemphasizes the role of innovation. Yet innovation can revolutionize industry structure and completely change the strength of different competitive forces. The competitive forces and strategic group models have been criticized for deemphasizing the importance of individual company differences. A company will not be profitable just because it is part of an attractive industry or strategic group; much more is required. The industry life-cycle model is a generalization that is not always followed, particularly when innovations revolutionize an industry.

13. The macroenvironment affects the intensity of rivalry within an industry. Included in the macroenvironment are the macroeconomic environment, the global environment, the technological environment, the demographic and social environment, and the political and legal environment.

DISCUSSION QUESTIONS

1. Under what environmental conditions are price wars most likely to occur in an industry? What are the implications of price wars for a company? How should a company try to deal with the threat of a price war?

2. Discuss the competitive forces model with reference to what you know about the global market for commercial jet aircraft (see the Opening Case). What does the model tell you about the level of competition in this industry?

3. Identify a growth industry, a mature industry, and a declining industry. For each industry, identify the following: (a) the number and size distribution of companies, (b) the nature of barriers to entry, (c) the height of barriers to entry, and (d) the extent of product differentiation. What do these factors tell you about the nature of competition in each industry? What are the implications for the company in terms of opportunities and threats?

4. Assess the impact of macroenvironmental factors on the likely level of enrollment at your university over the next decade. What are the implications of these factors for the job security and salary level of your professors?

PRACTICING STRATEGIC MANAGEMENT

© iStockPhoto.com/Urilux

Small-Group Exercise: Competing with Microsoft

Break into groups of three to five people, and discuss the following scenario. Appoint one group member as a spokesperson who will communicate your findings to the class.

You are a group of managers and software engineers at a small start-up. You have developed a revolutionary new operating system for personal computers that offers distinct advantages over Microsoft's Windows operating system: it takes up less memory space on the hard drive of a personal computer; it takes full advantage of the power of the personal computer's microprocessor, and in theory can run software applications much faster than Windows; it is much easier to install and use than Windows; and it responds to voice instructions with an accuracy of 99.9%, in addition to input from a keyboard or mouse. The operating system is the only product offering that your company has produced.

(continues)

PRACTICING STRATEGIC MANAGEMENT

© iStockPhoto.com/Urilux

(continued)

Complete the following exercises:

1. Analyze the competitive structure of the market for personal computer operating systems. On the basis of this analysis, identify what factors might inhibit adoption of your operating system by customers.
2. Can you think of a strategy that your company might pursue, either alone or in conjunction with other enterprises, in order to "beat Microsoft"? What will it take to execute that strategy successfully?

STRATEGY SIGN ON

© iStockPhoto.com/Ninoslav Dotlic

Article File 2

Find an example of an industry that has become more competitive in recent years. Identify the reasons for the increase in competitive pressure.

Strategic Management Project: Module 2

This module requires you to analyze the industry environment in which your company is based using the information you have already gathered:

1. Apply the competitive forces model to the industry in which your company is based. What does this model tell you about the nature of competition in the industry?
2. Are any changes taking place in the macroenvironment that might have an impact, positive or negative, on the industry in which your company is based? If so, what are these changes, and how might they affect the industry?
3. Identify any strategic groups that might exist in the industry. How does the intensity of competition differ across these strategic groups?
4. How dynamic is the industry in which your company is based? Is there any evidence that innovation is reshaping competition or has done so in the recent past?
5. In what stage of its life cycle is the industry in which your company is based? What are the implications of this for the intensity of competition now? In the future?
6. Is your company part of an industry that is becoming more global? If so, what are the implications of this change for competitive intensity?
7. Analyze the impact of the national context as it pertains to the industry in which your company is based. Does the national context help or hinder your company in achieving a competitive advantage in the global marketplace?

ETHICAL DILEMMA

© iStockPhoto.com/P_Wei

You are a strategic analyst at a successful hotel enterprise that has been generating substantial excess cash flow. Your CEO instructed you to analyze the competitive structure of closely related industries to find one that the company could enter, using its cash reserve to build up a sustainable position. Your analysis, using the competitive forces model, suggests that the highest profit opportunities are to be found in the gambling industry. You realize that it might be possible to add casinos to several of your existing hotels, lowering entry costs into this industry. However, you personally have strong moral objections to gambling. Should your own personal beliefs influence your recommendations to the CEO?

CLOSING CASE

The U.S. Airline Industry

The U.S. airline industry has long struggled to make a profit. In the 1990s, investor Warren Buffet famously quipped that investors in the airline industry would have been more fortunate if the Wright Brothers had crashed at Kitty Hawk. Buffet's point was that the airline industry had cumulatively lost more money than it had made—it has always been an economically losing proposition. Buffet once made the mistake of investing in the industry when he took a stake in US Airways. A few years later, he was forced to write off 75% of the value of that investment. He told his shareholders that if he ever invested in another airline, they should shoot him.

The 2000s have not been kinder to the industry. The airline industry lost $35 billion between 2001 and 2006. It managed to earn meager profits in 2006 and 2007, but lost $24 billion in 2008 as oil and jet fuel prices surged throughout the year. In 2009, the industry lost $4.7 billion as a sharp drop in business travelers—a consequence of the deep recession that followed the global financial crisis—more than offset the beneficial effects of falling oil prices. The industry returned to profitability in 2010–2012, and in 2012 actually managed to make $13 billion in net profit on revenues of $140.5 billion.

Analysts point to a number of factors that have made the industry a difficult place in which to do business. Over the years, larger carriers such as United, Delta, and American have been hurt by low-cost budget carriers entering the industry, including Southwest Airlines, Jet Blue, AirTran Airways, and Virgin America. These new entrants have used nonunion labor, often fly just one type of aircraft (which reduces maintenance costs), have focused on the most lucrative routes, typically fly point-to-point (unlike the incumbents, which have historically routed passengers through hubs), and compete by offering very low fares. New entrants have helped to create a situation of excess capacity in the industry, and have taken share from the incumbent airlines, which often have a much higher cost structure (primarily due to higher labor costs).

The incumbents have had little choice but to respond to fare cuts, and the result has been a protracted industry price war. To complicate matters, the rise of Internet travel sites such as Expedia, Travelocity, and Orbitz has made it much easier for consumers to comparison shop, and has helped to keep fares low.

Beginning in 2001, higher oil prices also complicated matters. Fuel costs accounted for 32% of total revenues in 2011 (labor costs accounted for 26%;

together they are the two biggest variable expense items). From 1985 to 2001, oil prices traded in a range between $15 and $25 a barrel. Then, prices began to rise due to strong demand from developing nations such as China and India, hitting a high of $147 a barrel in mid-2008. The price for jet fuel, which stood at $0.57 a gallon in December 2001, hit a high of $3.70 a gallon in July 2008, plunging the industry deep into the red. Although oil prices and fuel prices subsequently fell, they remain far above historic levels. In late 2012, jet fuel was hovering around $3.00 a gallon.

Many airlines went bankrupt in the 2000s, including Delta, Northwest, United, and US Airways. The larger airlines continued to fly, however, as they reorganized under Chapter 11 bankruptcy laws, and excess capacity persisted in the industry. These companies thereafter came out of bankruptcy protection with lower labor costs, but generating revenue still remained challenging for them.

The late 2000s and early 2010s were characterized by a wave of mergers in the industry. In 2008, Delta and Northwest merged. In 2010, United and Continental merged, and Southwest Airlines announced plans to acquire AirTran. In late 2012, American Airlines put itself under Chapter 11 bankruptcy protection. US Airways subsequently pushed for a merger agreement with American Airlines, which was under negotiation in early 2013. The driving forces behind these mergers include the desire to reduce excess capacity and lower costs by eliminating duplication. To the extent that they are successful, they could lead to a more stable pricing environment in the industry, and higher profit rates. That, however, remains to be seen.

Sources: J. Corridore, "Standard & Poors Industry Surveys: Airlines," June 28, 2012; B. Kowitt, "High Anxiety," *Fortune*, April 27, 2009, p. 14; and "Shredding Money," *The Economist*, September 20, 2008.

CASE DISCUSSION QUESTIONS

1. Conduct a competitive forces analysis of the U.S. airline industry. What does this analysis tell you about the causes of low profitability in this industry?
2. Do you think there are any strategic groups in the U.S. airline industry? If so, what might they be? How might the nature of competition vary from group to group?
3. The economic performance of the airline industry seems to be very cyclical. Why do you think this is the case?
4. Given your analysis, what strategies do you think an airline should adopt in order to improve its chances of being persistently profitable?

KEY TERMS

Opportunities 44	Sector 46	Brand loyalty 49	Switching costs 50
Threats 45	Potential competitors 48	Absolute cost	
Industry 45	Economies of scale 49	advantage 49	

NOTES

[1] M. E. Porter, *Competitive Strategy* (New York: Free Press, 1980).

[2] J. E. Bain, *Barriers to New Competition* (Cambridge, Mass.: Harvard University Press, 1956). For a review of the modern literature on barriers to entry, see R. J. Gilbert, "Mobility Barriers and the Value of Incumbency," in R. Schmalensee and R. D. Willig (eds.), *Handbook of Industrial Organization,* vol. 1 (Amsterdam: North-Holland, 1989). See also R. P. McAfee, H. M. Mialon, and M. A. Williams, "What Is a Barrier to Entry?" *American Economic Review* 94 (May 2004): 461–468.

[3] J. Koetsier, "Old Phones and New Users Are Key Reasons Apple Topped 53% of U.S. Smart Phone Market Share," *Venture Beat*, January 4, 2013.

[4] A detailed discussion of switching costs can be found in C. Shapiro and H. R. Varian, *Information Rules: A Strategic Guide to the Network Economy* (Boston: Harvard Business School Press, 1999).

[5] Most of this information on barriers to entry can be found in the industrial organization economics literature. See especially the following works: Bain, *Barriers to New Competition;* M. Mann, "Seller Concentration, Barriers to Entry and Rates of Return in 30 Industries," *Review of Economics and Statistics* 48 (1966): 296–307; W. S. Comanor and T. A. Wilson, "Advertising, Market Structure and Performance," *Review of Economics and Statistics* 49 (1967): 423–440; Gilbert, "Mobility Barriers"; and K. Cool, L.-H. Roller, and B. Leleux, "The Relative Impact of Actual and Potential Rivalry on Firm Profitability in the Pharmaceutical Industry," *Strategic Management Journal* 20 (1999): 1–14.

[6] For a discussion of tacit agreements, see T. C. Schelling, *The Strategy of Conflict* (Cambridge, Mass.: Harvard University Press, 1960).

[7] M. Busse, "Firm Financial Condition and Airline Price Wars," *Rand Journal of Economics* 33 (2002): 298–318.

[8] For a review, see F. Karakaya, "Market Exit and Barriers to Exit: Theory and Practice," *Psychology and Marketing* 17 (2000): 651–668.

[9] P. Ghemawat, *Commitment: The Dynamics of Strategy* (Boston: Harvard Business School Press, 1991).

[10] A. S. Grove, *Only the Paranoid Survive* (New York: Doubleday, 1996).

[11] In standard microeconomic theory, the concept used for assessing the strength of substitutes and complements is the cross elasticity of demand.

[12] For details and further references, see Charles W. L. Hill, "Establishing a Standard: Competitive Strategy and Technology Standards in Winner Take All Industries," *Academy of Management Executive* 11 (1997): 7–25; and Shapiro and Varian, *Information Rules.*

[13] The development of strategic group theory has been a strong theme in the strategy literature. Important contributions include the following: R. E. Caves and Michael E. Porter, "From Entry Barriers to Mobility Barriers," *Quarterly Journal of Economics* (May 1977): 241–262; K. R. Harrigan, "An Application of Clustering for Strategic Group Analysis," *Strategic Management Journal* 6 (1985): 55–73; K. J. Hatten and D. E. Schendel, "Heterogeneity Within an Industry: Firm Conduct in the U.S. Brewing Industry, 1952–71," *Journal of Industrial Economics* 26 (1977): 97–113; Michael E. Porter, "The Structure Within Industries and Companies' Performance," *Review of Economics and Statistics* 61 (1979): 214–227. See also K. Cool and D. Schendel, "Performance Differences Among Strategic Group Members," *Strategic Management Journal* 9 (1988): 207–233; A. Nair and S. Kotha, "Does Group Membership Matter? Evidence from the Japanese Steel Industry," *Strategic Management Journal* 20 (2001): 221–235; and G. McNamara, D. L. Deephouse, and R. A. Luce, "Competitive Positioning Within and Across a Strategic Group Structure," *Strategic Management Journal* 24 (2003): 161–180.

[14] For details on the strategic group structure in the pharmaceutical industry, see K. Cool and I. Dierickx, "Rivalry, Strategic Groups, and Firm Profitability," *Strategic Management Journal* 14 (1993): 47–59.

[15] Charles W. Hofer argued that life-cycle considerations may be the most important contingency when formulating business strategy. See Hofer, "Towards a Contingency Theory of Business Strategy," *Academy of Management Journal* 18 (1975): 784–810. There is empirical evidence to support this view. See C. R. Anderson and C. P. Zeithaml, "Stages of the Product Life Cycle, Business Strategy, and Business Performance," *Academy of Management Journal* 27 (1984): 5–24; and D. C. Hambrick and D. Lei, "Towards an Empirical Prioritization

of Contingency Variables for Business Strategy," *Academy of Management Journal* 28 (1985): 763–788. See also G. Miles, C. C. Snow, and M. P. Sharfman, "Industry Variety and Performance," *Strategic Management Journal* 14 (1993): 163–177; G. K. Deans, F. Kroeger, and S. Zeisel, "The Consolidation Curve," *Harvard Business Review* 80 (December 2002): 2–3.

[16]The characteristics of declining industries have been summarized by K. R. Harrigan, "Strategy Formulation in Declining Industries," *Academy of Management Review* 5 (1980): 599–604. See also J. Anand and H. Singh, "Asset Redeployment, Acquisitions and Corporate Strategy in Declining Industries," *Strategic Management Journal* 18 (1997): 99–118.

[17]Data from CTIA, a wireless industry association, www.ctia.org/ advocacy/research/index.cfm/aid/10323.

[18]This perspective is associated with the Austrian school of economics, which goes back to Schumpeter. For a summary of this school and its implications for strategy, see R. Jacobson, "The Austrian School of Strategy," *Academy of Management Review* 17 (1992): 782–807; and C. W. L. Hill and D. Deeds, "The Importance of Industry Structure for the Determination of Industry Profitability: A Neo-Austrian Approach," *Journal of Management Studies* 33 (1996): 429–451.

[19]"A Tricky Business," *Economist,* June 30, 2001, pp. 55–56.

[20]D. F. Barnett and R. W. Crandall, *Up from the Ashes* (Washington, D.C.: Brookings Institution, 1986).

[21]M. E. Porter, *The Competitive Advantage of Nations* (New York: Free Press, 1990).

[22]The term *punctuated equilibrium* is borrowed from evolutionary biology. For a detailed explanation of the concept, see M. L. Tushman, W. H. Newman, and E. Romanelli, "Convergence and Upheaval: Managing the Unsteady Pace of Organizational Evolution," *California Management Review* 29:1 (1985): 29–44; C. J. G. Gersick, "Revolutionary Change Theories: A Multilevel Exploration of the Punctuated Equilibrium Paradigm," *Academy of Management Review* 16 (1991): 10–36; and R. Adner and D. A. Levinthal, "The Emergence of Emerging Technologies," *California Management Review* 45 (Fall 2002): 50–65.

[23]A. J. Slywotzky, *Value Migration: How to Think Several Moves Ahead of the Competition* (Boston: Harvard Business School Press, 1996).

[24]Hill and Deeds, "Importance of Industry Structure."

[25]R. P. Rumelt, "How Much Does Industry Matter?" *Strategic Management Journal* 12 (1991): 167–185. See also A. J. Mauri and M. P. Michaels, "Firm and Industry Effects Within Strategic Management: An Empirical Examination," *Strategic Management Journal* 19 (1998): 211–219.

[26]See R. Schmalensee, "Inter-Industry Studies of Structure and Performance," in Schmalensee and Willig (eds.), *Handbook of Industrial Organization.* Similar results were found by A. N. McGahan and M. E. Porter, "How Much Does Industry Matter, Really?" *Strategic Management Journal* 18 (1997): 15–30.

[27]For example, see K. Cool and D. Schendel, "Strategic Group Formation and Performance: The Case of the U.S. Pharmaceutical Industry, 1932–1992," *Management Science* (September 1987): 1102–1124.

[28]See M. Gort and J. Klepper, "Time Paths in the Diffusion of Product Innovations," *Economic Journal* (September 1982): 630–653. Looking at the history of 46 products, Gort and Klepper found that the length of time before other companies entered the markets created by a few inventive companies declined from an average of 14.4 years for products introduced before 1930 to 4.9 years for those introduced after 1949.

[29]The phrase was originally coined by J. Schumpeter, *Capitalism, Socialism and Democracy* (London: Macmillan, 1950), p. 68.

[30]For a detailed discussion of the importance of the structure of law as a factor explaining economic change and growth, see D. C. North, *Institutions, Institutional Change, and Economic Performance* (Cambridge: Cambridge University Press, 1990).

3

Internal Analysis: Distinctive Competencies, Competitive Advantage, and Profitability

After reading this chapter you should be able to:

3-1 Discuss the source of competitive advantage

3-2 Identify and explore the role of efficiency, quality, innovation, and customer responsiveness in building and maintaining a competitive advantage

3-3 Explain the concept of the value chain

3-4 Understand the link between competitive advantage and profitability

3-5 Explain what impacts the durability of a company's competitive advantage

Verizon Wireless

Spencer Platt/Getty Images

Established in 2000 as a joint venture between Verizon Communications and Britain's Vodafone, over the last 12 years Verizon Wireless has emerged as the largest and consistently most profitable enterprise in the fiercely competitive U.S. wireless service market. Today the company has almost 100 million subscribers and a 35% market share.

One of the most significant facts about Verizon is that it has the lowest churn rate in the industry. Customer churn refers to the number of subscribers who leave a service within a given time period. Churn is important because it costs between $400 and $600 to acquire a customer (with phone subsidies accounting for a large chunk of that). It can take months just to recoup the fixed costs of a customer acquisition. If churn rates are high, profitability is eaten up by the costs of acquiring customers who do not stay long enough to provide a profit to the service provider.

The risk of churn increased significantly in the United States after November 2003, when the Federal Communications Commission (FCC) allowed wireless subscribers to take their numbers with them when they switched to a new service provider. Over the next few years Verizon Wireless emerged as a clear winner

80

in the battle to limit customer defections. By mid-2006, Verizon's churn rate was 0.87% a month, implying that 10.4% of the company's customers were leaving the service each year. This was lower than the churn rate at its competitors. Verizon retained its churn advantage through 2012. In that year, its monthly churn rate was 0.84%, compared to a 0.97% churn rate for AT&T, 1.69% for Sprint, and 2.10% for T-Mobile. Verizon's low churn rate has enabled the company to grow its subscriber base faster than rivals, which allows the company to better achieve economies of scale by spreading the fixed costs of building a wireless network over a larger customer base.

The low customer churn at Verizon is due to a number of factors. First, it has the most extensive network in the United States, blanketing 95% of the nation. This means fewer dropped calls and dead zones as compared to its rivals. For years Verizon communicated its coverage and quality advantage to customers with its "Test Man" advertisements. In these ads, a Verizon Test Man wearing horn-rimmed glasses and a Verizon uniform wanders around remote spots in the nation asking on his Verizon cell phone, "Can you hear me now?" Verizon says that the Test Man was actually the personification of a crew of 50 Verizon employees who each drive some 100,000 miles annually in specially outfitted vehicles to test the reliability of Verizon's network.

Second, the company has invested aggressively in high-speed wireless networks, including 3G and now 4G LTE, enabling fast download rates on smartphones. Complementing this, Verizon has a high-speed fiber-optic backbone for transporting data between cell towers. In total, Verizon has invested some $70 billion in its wireless and fiber optic network since 2000. For customers, this means a high-quality user experience when accessing data, such as streaming video, on their smartphones. To drive this advantage home, in 2011 Verizon started offering Apple's market-leading iPhone in addition to the full range of Android smartphones it was already offering (the iPhone was originally exclusive to AT&T).

To further reduce customer churn, Verizon has invested heavily in its customer care function. Verizon's automated software programs analyze the call habits of individual customers. Using that information, Verizon representatives will contact customers and suggest alternative plans that might better suit their needs. For example, Verizon might contact a customer and say, "We see that because of your heavy use of data, an alternative plan might make more sense for you and help reduce your monthly bills." The goal is to anticipate customer needs and proactively satisfy them, rather than have the customer take the initiative and possibly switch to another service provider.

Surveys by J.D. Power have repeatedly confirmed Verizon's advantages. An August 2012 J.D. Power study ranked Verizon best in the industry in terms of overall network performance. The ranking was based on a number of factors which included dropped calls, late text message notifications, Web connection errors, and slow download rates. Another J.D. Power study looked at customer care in three customer contact channels—telephone, walk-in (retail store), and online. Again, Verizon had the best score in the industry, reflecting faster service and greater satisfaction with the efficiency with which costumer service reps resolved problems.

Sources: R. Blackden, "Telecom's Giant Verizon Is Conquering America," *The Telegraph*, January 6, 2013; S. Woolley, "Do You Fear Me Now?", *Forbes*, November 10, 2003, pp. 78–80; A. Z. Cuneo, "Call Verizon Victorious," *Advertising Age*, March 24, 2004, pp. 3–5; M. Alleven, "Wheels of Churn," *Wireless Week*, September 1, 2006; J.D. Power, "2012 U.S. Wireless Customer Care Full-Service Performance Study," July 7, 2012; and J.D. Power, "2012 U.S. Wireless Network Quality Performance Study," August 23, 2012.

OVERVIEW

Why, within a particular industry or market, do some companies outperform others? What is the basis of their (sustained) competitive advantage? The Opening Case provides some clues.

Verizon has placed a lot of emphasis on building the highest-*quality* service in the business as measured by network coverage and download speeds. It has also been an *innovator*, rolling out the most technologically advanced 4G LTE network ahead of rivals. In addition, Verizon has successfully emphasized *customer responsiveness*. According to surveys by J.D. Power, the company has the best customer care function in the industry. The high quality of its service, coupled with excellent customer responsiveness, has enabled Verizon to drive down its churn rate, which in turn has lowered the company's costs, making it more *efficient*. As you will see in this chapter, efficiency, customer responsiveness, quality, and innovation are the building blocks of competitive advantage.

This chapter focuses on internal analysis, which is concerned with identifying the strengths and weaknesses of the company. Internal analysis, coupled with an analysis of the company's external environment, gives managers the information they need to choose the strategy and business model that will enable their company to attain a sustained competitive advantage. Internal analysis is a three-step process. First, managers must understand the process by which companies create value for customers and profit for the company. Managers must also understand the role of resources, capabilities, and distinctive competencies in this process. Second, they need to understand the importance of superior efficiency, innovation, quality, and customer responsiveness when creating value and generating high profitability. Third, they must be able to analyze the sources of their company's competitive advantage to identify what drives the profitability of their enterprise, and where opportunities for improvement might lie. In other words, they must be able to identify how the strengths of the enterprise boost its profitability and how any weaknesses result in lower profitability.

Three more critical issues in internal analysis are addressed in this chapter. First: What factors influence the durability of competitive advantage? Second: Why do successful companies sometimes lose their competitive advantage? Third: How can companies avoid competitive failure and sustain their competitive advantage over time?

After reading this chapter, you will understand the nature of competitive advantage and why managers need to perform internal analysis (just as they must conduct industry analysis) to achieve superior performance and profitability.

THE ROOTS OF COMPETITIVE ADVANTAGE

A company has a *competitive advantage* over its rivals when its profitability is greater than the average profitability of all companies in its industry. It has a *sustained competitive advantage* when it is able to maintain above-average profitability over a number of years (as Wal-Mart has done in the retail industry and Verizon has done in wireless service). The primary objective of strategy is to achieve a sustained competitive advantage, which in turn will result in superior profitability and profit growth. What are the sources of competitive advantage, and what is the link between strategy, competitive advantage, and profitability?

Distinctive Competencies

Competitive advantage is based upon distinctive competencies. **Distinctive competencies** are firm-specific strengths that allow a company to differentiate its products from those offered by rivals, and/or achieve substantially lower costs than its rivals. Verizon, for example, has a distinctive competence in customer care, which creates value for customers, helps to lower churn rates, and ultimately translates into higher costs (see the Opening case). Similarly, it can be argued that Toyota, which historically has been the stand-out performer in the automobile industry, has distinctive competencies in the development and operation of manufacturing processes (although the company has struggled somewhat since 2008). Toyota pioneered an entire range of manufacturing techniques, such as just-in-time inventory systems, self-managing teams, and reduced setup times for complex equipment. These competencies, collectively known as the "Toyota lean production system," helped the company attain superior efficiency and product quality as the basis of its competitive advantage in the global automobile industry.[1] Distinctive competencies arise from two complementary sources: resources and capabilities.[2]

Resources **Resources** refer to the assets of a company. A company's resources can be divided into two types: tangible and intangible resources. **Tangible resources** are physical entities, such as land, buildings, manufacturing plants, equipment, inventory, and money. In the case of Verizon, its ubiquitous high-speed wireless network is a tangible resource. **Intangible resources** are nonphysical entities that are created by managers and other employees, such as brand names, the reputation of the company, the knowledge that employees have gained through experience, and the intellectual property of the company, including patents, copyrights, and trademarks.

Resources are particularly *valuable* when they enable a company to create strong demand for its products, and/or to lower its costs. Toyota's valuable *tangible resources* include the equipment associated with its lean production system, much of which has been engineered specifically by Toyota for exclusive use in its factories. These valuable tangible resources allow Toyota to lower its costs, relative to competitors. Similarly, Microsoft has a number of valuable *intangible resources*, including its brand name and the software code that comprises its Windows operating system. These valuable resources have historically allowed Microsoft to sell more of its products, relative to competitors.

Valuable resources are more likely to lead to a sustainable competitive advantage if they are *rare*, in the sense that competitors do not possess them, and difficult for rivals to imitate; that is, if there are *barriers to imitation* (we will discuss the source of barriers to imitation in more detail later in this chapter). For example, the software code underlying Windows is *rare* because only Microsoft has full access to it. The code is also difficult to imitate. A rival cannot simply copy the software code underlying Windows and sell a repackaged version of Windows because copyright law protects the code, and reproducing it is illegal.

Capabilities **Capabilities** refer to a company's resource-coordinating skills and productive use. These skills reside in an organization's rules, routines, and procedures, that is, the style or manner through which it makes decisions and manages its internal processes to achieve organizational objectives.[3] More generally, a company's capabilities are the product of its organizational structure, processes, control systems, and hiring strategy. They specify how and where decisions are made within a company, the kind of behaviors the company rewards, and the company's cultural norms and values. (We will discuss how organizational

distinctive competencies
Firm-specific strengths that allow a company to differentiate its products and/or achieve substantially lower costs to achieve a competitive advantage.

resources
Assets of a company.

tangible resources
Physical entities, such as land, buildings, equipment, inventory, and money.

intangible resources
Nonphysical entities such as brand names, company reputation, experiential knowledge, and intellectual property, including patents, copyrights, and trademarks.

capabilities *intangible*
A company's skills at coordinating its resources and putting them to productive use.

Tangible / intangible

structure and control systems help a company obtain capabilities in Chapters 12 and 13.) Capabilities are intangible. They reside not in individuals, but in the way individuals interact, cooperate, and make decisions within the context of an organization.[4]

Like resources, capabilities are particularly valuable if they enable a company to create strong demand for its products, and/or to lower its costs. The competitive advantage of Southwest Airlines is based largely upon its capability to select, motivate, and manage its workforce in such a way that leads to high employee productivity and lower costs. As with resources, valuable capabilities are also more likely to lead to a sustainable competitive advantage if they are both *rare* and protected from copying by *barriers to imitation*.

Resources, Capabilities, and Competencies The distinction between resources and capabilities is critical to understanding what generates a distinctive competency. A company may have firm-specific and valuable resources, but unless it also has the capability to use those resources effectively, it may not be able to create a distinctive competency. Additionally, it is important to recognize that a company may not need firm-specific and valuable resources to establish a distinctive competency so long as it has capabilities that no other competitor possesses. For example, the steel mini-mill operator Nucor is widely acknowledged to be the most cost-efficient steel maker in the United States. Its distinctive competency in low-cost steel making does not come from any firm-specific and valuable resources. Nucor has the same resources (plant, equipment, skilled employees, knowhow) as many other mini-mill operators. What distinguishes Nucor is its unique capability to manage its resources in a highly productive way. Specifically, Nucor's structure, control systems, and culture promote efficiency at all levels within the company.

In sum, for a company to possess a distinctive competency, it must—at a minimum—have either (1) a firm-specific and valuable resource, and the capabilities (skills) necessary to take advantage of that resource, or (2) a firm-specific capability to manage resources (as exemplified by Nucor). A company's distinctive competency is strongest when it possesses both firm-specific and valuable resources and firm-specific capabilities to manage those resources.

The Role of Strategy Figure 3.1 illustrates the relationship of a company's strategies, distinctive competencies, and competitive advantage. Distinctive competencies shape the strategies that the company pursues, which lead to competitive advantage and superior profitability. However, it is also very important to realize that the strategies a company adopts can build new resources and capabilities or strengthen the existing resources and capabilities of the company, thereby enhancing the distinctive competencies of the enterprise. Thus, the relationship between distinctive competencies and strategies is not a linear one; rather, it is a reciprocal one in which distinctive competencies shape strategies, and strategies help to build and create distinctive competencies.[5]

The history of the Walt Disney Company illustrates the way this process works. In the early 1980s, Disney suffered a string of poor financial years that culminated in a 1984 management shakeup when Michael Eisner was appointed CEO. Four years later, Disney's sales had increased from $1.66 billion to $3.75 billion, its net profits from $98 million to $570 million, and its stock market valuation from $1.8 billion to $10.3 billion. What brought about this transformation was the company's deliberate attempt to use its resources and capabilities more aggressively: Disney's enormous film library, its brand name, and its filmmaking skills, particularly in animation. Under Eisner, many old Disney classics were re-released, first in movie theaters and then on video, earning the company millions in the process. Then Eisner reintroduced the product that had originally made Disney famous:

Figure 3.1 Strategy, Resources, Capabilities, and Competencies

[handwritten annotations: "competitive advantage", "Leading to superior of profitability", "① Value of customer"]

the full-length animated feature. Putting together its brand name and in-house animation capabilities, Disney produced a stream of major box office hits, including *The Little Mermaid, Beauty and the Beast, Aladdin, Pocahontas,* and *The Lion King.* Disney also started a cable television channel, the Disney Channel, to use this library and capitalize on the company's brand name. In other words, Disney's existing resources and capabilities shaped its strategies.

Through his choice of strategies, Eisner also developed new competencies in different parts of the business. In the filmmaking arm of Disney, for example, Eisner created a new low-cost film division under the Touchstone label, and the company had a string of low-budget box-office hits. It entered into a long-term agreement with the computer animation company Pixar to develop a competency in computer-generated animated films. This strategic collaboration produced several hits, including *Toy Story* and *Monsters, Inc.* (in 2004 Disney acquired Pixar). In sum, Disney's transformation was based not only on strategies that took advantage of the company's existing resources and capabilities, but also on strategies that built new resources and capabilities, such as those that underlie the company's competency in computer-generated animated films.

Competitive Advantage, Value Creation, and Profitability

Competitive advantage leads to superior profitability. At the most basic level, a company's profitability depends on three factors: (1) the value customers place on the company's products, (2) the price that a company charges for its products, and (3) the costs of creating those products. The value customers place on a product reflects the *utility* they get from a product, or the happiness or satisfaction gained from consuming or owning the product. Value must be distinguished from price. Value is something that customers receive from a product. It is a function of the attributes of the product, such as its performance, design, quality, and point-of-sale and after-sale service. For example, most customers would place a much higher value on a top-end Lexus car from Toyota than on a low-end basic economy car from Kia, precisely because they perceive Lexus to have better performance and

superior design, quality, and service. A company that strengthens the value of its products in the eyes of customers has more pricing options: it can raise prices to reflect that value or hold prices lower to induce more customers to purchase its products, thereby expanding unit sales volume.

Regardless of the pricing option a company may choose, that price is typically less than the value placed upon the good or service by the customer. This is because the customer captures some of that utility in the form of what economists call a *consumer surplus*.[6] The customer is able to do this because it is normally impossible to segment the market to such a degree that the company can charge each customer a price that reflects that individual's unique assessment of the value of a product—what economists refer to as a customer's reservation price. In addition, because the company is competing against rivals for the customer's business, it frequently has to charge a lower price than it could were it a monopoly supplier. For these reasons, the point-of-sale price tends to be less than the value placed on the product by many customers. Nevertheless, remember the basic principle here: the more value that consumers get from a company's products or services, the more pricing options it has.

These concepts are illustrated in Figure 3.2: V is the *average* value per unit of a product to a customer, P is the average price per unit that the company decides to charge for that product, and C is the average unit cost of producing that product (including actual production costs and the cost of capital investments in production systems). The company's average profit per unit is equal to $P - C$, and the consumer surplus is equal to $V - P$. In other words, $V - P$ is a measure of the value the consumer captures, and $P - C$ is a measure of the value the company captures. The company makes a profit so long as P is more than C, and its profitability will be greater the lower C is relative to P. Bear in mind that the difference between V and P is in part determined by the intensity of competitive pressure in the marketplace; the lower the competitive pressure's intensity, the higher the price that can be charged relative to V, but the difference between V and P is also determined by the company's pricing choice.[7] As we shall see, a company may choose to keep prices low relative to volume because lower prices enable the company to sell more products, attain scale economies, and boost its profit margin by lowering C relative to P.

Also, note that the value created by a company is measured by the difference between the value or utility a consumer gets from the product (V) and the costs of production (C),

Figure 3.2 Value Creation per Unit

$V - P$

$P - C$

V

P

C C ——— Includes **cost** of capital per unit

V = **Value** (Utility) to Consumer
P = **Price**
C = **Cost** of production

$V - P$ = Consumer surplus
$P - C$ = **Profit** margin
$V - C$ = **Value** created

© Cengage Learning

that is, $V - C$. A company creates value by converting factors of production that cost C into a product from which customers receive a value of V. A company can create more value for its customers by lowering C or making the product more attractive through superior design, performance, quality, service, and other factors. When customers assign a greater value to the product (V increases), they are willing to pay a higher price (P increases). This discussion suggests that a company has a competitive advantage and high profitability when it creates more value for its customers than rivals.[8]

The company's pricing options are captured in Figure 3.3. Suppose a company's current pricing option is the one pictured in the middle column of Figure 3.3. Imagine that the company decides to pursue strategies to increase the utility of its product offering from V to V^* in order to boost its profitability. Increasing value initially raises production costs because the company must spend money in order to increase product performance, quality, service, and other factors. Now there are two different pricing options that the company can pursue. Option 1 is to raise prices to reflect the higher value: the company raises prices more than its costs increase, and profit per unit ($P - C$) increases. Option 2 involves a very different set of choices: the company lowers prices in order to expand unit volume. Generally, customers recognize that they are getting a great bargain because the price is now much lower than the value (the consumer surplus has increased), so they rush out to buy more (demand has increased). As unit volume expands due to increased demand, the company is able to realize scale economies and reduce its average unit costs. Although creating the extra value initially costs more, and although margins are initially compressed by aggressive pricing, ultimately profit margins widen because the average per-unit cost of production falls as volume increases and scale economies are attained.

Managers must understand the dynamic relationships among value, pricing, demand, and costs in order to make decisions that will maximize competitive advantage and profitability. Option 2 in Figure 3.3, for example, may not be a viable strategy if demand did

Figure 3.3 **Value Creation and Pricing Options**

Option 2: Lower prices to generate demand

Initial State

Option 1: Raise prices to reflect higher value

© Cengage Learning

not increase rapidly with lower prices, or if few economies of scale will result by increasing volume. Managers must understand how value creation and pricing decisions affect demand, as well as how unit costs change with increases in volume. In other words, they must have a good grasp of the demand for the company's product and its cost structure at different levels of output if they are to make decisions that maximize profitability.

Consider the automobile industry. According to a 2008 study by Oliver Wyman, Toyota made $922 in profit on every vehicle it manufactured in North America in 2007. General Motors (GM), in contrast, lost $729 on every vehicle it made.[9] What accounted for the difference? First, Toyota had the best reputation for quality in the industry. According to annual surveys issued by J.D. Power and Associates, Toyota consistently topped the list in terms of quality, whereas GM cars were—at best—in the middle of the pack. Higher quality equaled a higher value and allowed Toyota to charge 5 to 10% higher prices than General Motors for equivalent cars. Second, Toyota had a lower cost per vehicle than General Motors, in part because of its superior labor productivity. For example, in Toyota's North American plants, it took an average of 30.37 employee hours to build one car, compared to 32.29 at GM plants in North America. The 1.94-hour productivity advantage meant lower total labor costs for Toyota, and hence a lower overall cost structure. Therefore, as summarized in Figure 3.4, Toyota's advantage over GM came from greater value (V), which allowed the company to charge a higher price (P) for its cars, and from a lower cost structure (C), which taken together implies greater profitability per vehicle ($P - C$).

Toyota's pricing decisions are guided by its managers' understanding of the relationships between utility, prices, demand, and costs. Given its ability to build more utility into its products, Toyota could have charged even higher prices than those illustrated in Figure 3.4, but that might have led to lower sales volume, fewer scale economies, higher unit costs, and lower profit margins. Toyota's managers sought to find the pricing option that enabled the company to maximize its profits given their assessment of demand for its products and its cost function. Thus, to create superior value, a company does not need to tout the lowest cost structure in an industry, nor create the product with the highest value in the eyes of customers. All that is necessary is that the gap between perceived value (V) and costs of production (C) is greater than the gap attained by competitors.

Note that Toyota has differentiated itself from General Motors by its superior quality, which allows it to charge higher prices, and its superior productivity translates into a lower cost structure. Thus, its competitive advantage over General Motors is the result of

| Figure 3.4 | Comparing Toyota and General Motors |

strategies that have led to distinctive competencies, resulting in greater differentiation and a lower cost structure.

Indeed, at the heart of any company's business model is the combination of congruent strategies aimed at creating distinctive competencies that (1) differentiate its products in some way so that its consumers derive more value from them, which gives the company more pricing options, and (2) result in a lower cost structure, which also gives it a broader range of pricing choices.[10] Achieving superior profitability and a sustained competitive advantage requires the right choices regarding utility through differentiation and pricing (given the demand conditions in the company's market), and the company's cost structure at different levels of output. This issue is addressed in detail in the following chapters.

THE VALUE CHAIN

All of the functions of a company—such as production, marketing, product development, service, information systems, materials management, and human resources—have a role in lowering the cost structure and increasing the perceived value of products through differentiation. As the first step in examining this concept, consider the value chain, which is illustrated in Figure 3.5.[11] The term **value chain** refers to the idea that a company is a chain of activities that transforms inputs into outputs that customers value. The transformation process involves both primary activities and support activities that add value to the product.

value chain

The idea that a company is a chain of activities that transforms inputs into outputs that customers value.

Primary Activities

Primary activities include the design, creation, and delivery of the product, the product's marketing, and its support and after-sales service. In the value chain illustrated in Figure 3.5, the primary activities are broken down into four functions: research and development, production, marketing and sales, and customer service.

primary activities

Activities related to the design, creation, and delivery of the product, its marketing, and its support and after-sales service.

Figure 3.5 The Value Chain

© Cengage Learning

 Research and Development Research and development (R&D) refers to the design of products and production processes. Although we think of R&D as being associated with the design of physical products and production processes in manufacturing enterprises, many service companies also undertake R&D. For example, banks compete with each other by developing new financial products and new ways of delivering those products to customers. Online banking and smart debit cards are two examples of the fruits of new-product development in the banking industry. Earlier examples of innovation in the banking industry included ATM machines, credit cards, and debit cards.

By creating superior product design, R&D can increase the functionality of products, making them more attractive to customers, and thereby adding value. Alternatively, the work of R&D may result in more efficient production processes, thereby lowering production costs. Either way, the R&D function can help to lower costs or raise the utility of a product and permit a company to charge higher prices. At Intel, for example, R&D creates value by developing ever more powerful microprocessors and helping to pioneer ever-more-efficient manufacturing processes (in conjunction with equipment suppliers).

It is important to emphasize that R&D is not just about enhancing the features and functions of a product, it is also about the elegance of a product's design, which can create an impression of superior value in the minds of consumers. For example, part of Apple's success with the iPhone has been based upon the elegance and appeal of the iPhone design, which has turned a piece of electronic equipment into a fashion accessory. For another example of how design elegance can create value, see Strategy in Action 3.1, which discusses value creation at the fashion house Burberry.

Production Production refers to the creation process of a good or service. For physical products, this generally means manufacturing. For services such as banking or retail operations, "production" typically takes place while the service is delivered to the customer, as when a bank makes a loan to a customer. By performing its activities efficiently, the production function of a company helps to lower its cost structure. For example, the efficient production operations of Honda and Toyota help those automobile companies achieve higher profitability relative to competitors such as General Motors. The production function can also perform its activities in a way that is consistent with high product quality, which leads to differentiation (and higher value) and lower costs.

Marketing and Sales There are several ways in which the marketing and sales functions of a company can help to create value. Through brand positioning and advertising, the marketing function can increase the value that customers perceive to be contained in a company's product (and thus the utility they attribute to the product). Insofar as these help to create a favorable impression of the company's product in the minds of customers, they increase utility. For example, the French company Perrier persuaded U.S. customers that slightly carbonated bottled water was worth $1.50 per bottle rather than a price closer to the $0.50 that it cost to collect, bottle, and distribute the water. Perrier's marketing function increased the perception of value that customers ascribed to the product. Similarly, by helping to re-brand the company and its product offering, the marketing department at Burberry helped to create value (see Strategy in Action 3.1). Marketing and sales can also create value by discovering customer needs and communicating them back to the R&D function of the company, which can then design products that better match those needs.

Customer Service The role of the service function of an enterprise is to provide after-sales service and support. This function can create superior utility by solving customer

3.1 STRATEGY IN ACTION

Value Creation at Burberry

© iStockPhoto.com/Tom Nulens

When Rose Marie Bravo, the highly regarded president of Saks Fifth Avenue, announced in 1997 that she was leaving to become CEO of ailing British fashion house Burberry, people thought she was crazy. Burberry, best known as a designer of raincoats with a trademark tartan linings, had been described as an outdated, stuffy business with a fashion cachet of almost zero. When Bravo stepped down in 2006, she was heralded in Britain and the United States as one of the world's best managers. In her tenure at Burberry, she had engineered a remarkable turnaround, leading a transformation of Burberry into what one commentator called an "achingly hip" high-end fashion brand whose famous tartan bedecks everything from raincoats and bikinis to handbags and luggage in a riot of color from pink to blue to purple. In less than a decade, Burberry had become one of the most valuable luxury fashion brands in the world.

When asked how she achieved the transformation, Bravo explains that there was hidden value in the brand, which was unleashed by constant creativity and innovation. Bravo hired world-class designers to redesign Burberry's tired fashion line and bought in Christopher Bailey, one of the very best, to lead the design team. The marketing department worked closely with advertisers to develop hip ads that would appeal to a younger, well-heeled audience. The ads featured supermodel Kate Moss promoting the line, and Burberry hired a top fashion photographer to shoot Moss in Burberry. Burberry exercised tight control over distribution, pulling its products from stores whose image was not consistent with the Burberry brand, and expanding its own chain of Burberry stores.

Bravo also noted that "creativity doesn't just come from designers……ideas can come from the sales floor, the marketing department, even from accountants, believe it or not. People at whatever level they are working have a point of view and have something to say that is worth listening to." Bravo emphasized the importance of teamwork: "One of the things I think people overlook is the quality of the team. It isn't one person, and it isn't two people. It is a whole group of people—a team that works cohesively toward a goal—that makes something happen or not." She notes that her job is to build the team and then motivate the team, "keeping them on track, making sure that they are following the vision."

Sources: Quotes from S. Beatty, "Bass Talk: Plotting Plaid's Future," *Wall Street Journal*, September 9, 2004, p. B1. Also see C. M. Moore and G. Birtwistle, "The Burberry Business Model," *International Journal of Retail and Distribution Management* 32 (2004): 412–422; and M. Dickson, "Bravo's Legacy in Transforming Burberry," *Financial Times*, October 6, 2005, p. 22.

problems and supporting customers after they have purchased the product. For example, Caterpillar, the U.S.-based manufacturer of heavy-earthmoving equipment, can ship spare parts to any location in the world within 24 hours, thereby minimizing the amount of downtime its customers have to face if their Caterpillar equipment malfunctions. This is an extremely valuable support capability in an industry where downtime is very expensive. The extent of customer support has helped to increase the utility that customers associate with Caterpillar products, and therefore the price that Caterpillar can charge for its products.

Support Activities

The **support activities** of the value chain provide inputs that allow the primary activities to take place. These activities are broken down into four functions: materials management (or logistics), human resources, information systems, and company infrastructure (see Figure 3.5).

support activities

Activities of the value chain that provide inputs that allow the primary activities to take place.

Materials Management (Logistics) The materials-management (or logistics) function controls the transmission of physical materials through the value chain, from procurement through production and into distribution. The efficiency with which this is carried out can significantly lower cost, thereby creating more profit. Dell Inc. has a very efficient materials-management process. By tightly controlling the flow of component parts from its suppliers to its assembly plants, and into the hands of consumers, Dell has dramatically reduced its inventory holding costs. Lower inventories equate to lower costs, and hence greater profitability. Another company that has benefited from very efficient materials management, the Spanish fashion company Zara, is discussed in Strategy in Action 3.2.

Human Resources There are numerous ways in which the human resource function can help an enterprise to create more value. This function ensures that the company

3.2 STRATEGY IN ACTION

© iStockPhoto.com/Tom Nulens

Competitive Advantage at Zara

The fashion retailer Zara is one of Spain's fastest-growing and most successful companies, with sales of some $10 billion and a network of 2,800 stores in 64 countries. Zara's competitive advantage centers around one thing: speed. Whereas it takes most fashion houses 6 to 9 months to go from design to having merchandise delivered to a store, Zara can complete the entire process in just 5 weeks. This rapid response time enables Zara to quickly respond to changing fashion trends.

Zara achieves this by breaking many of the rules of operation in the fashion business. Whereas most fashion houses outsource production, Zara has its own factories and keeps approximately half of its production in-house. Zara also has its own designers and own stores. Its designers are in constant contact with the stores, to track what is selling on a real-time basis through information systems, and talk to store managers once a week to get their subjective impressions of what is "hot." This information supplements data gathered from other sources, such as fashion shows.

Drawing on this information, Zara's designers create approximately 40,000 new designs a year from which 10,000 are selected for production. Zara then purchases basic textiles from global suppliers, but performs capital-intensive production activities in its own factories. These factories use computer-controlled machinery to cut pieces for garments. Zara does not produce in large volumes to attain economies of scale; instead it produces in small lots. Labor-intensive activities, such as sewing, are performed by subcontractors located close to Zara's factories. Zara makes a practice of retaining more production capacity than necessary, so that if a new fashion trend emerges, it can quickly respond by designing garments and ramping-up production.

Once a garment has been made, it is delivered to one of Zara's own warehouses, and then shipped to its own stores once a week. Zara deliberately underproduces products, supplying small batches of products in hot demand before quickly shifting to the next fashion trend. Often its merchandise sells out quickly. The empty shelves in Zara stores create a scarcity value—which helps to generate demand. Customers quickly snap up products they like because they know these styles may soon be out of stock, and never produced again.

As a result of this strategy, which is supported by competencies in design, information systems, and logistics management, Zara carries fewer inventories than competitors (Zara's inventory equals about 10% of sales, compared to 15% at rival stores such as The Gap and Benetton). This means fewer price reductions to move products that haven't sold, and higher profit margins.

Sources: "Shining Examples," *The Economist: A Survey of Logistics*, June 17, 2006, pp. 4–6; K. Capell et al., "Fashion Conquistador," *Business Week*, September 4, 2006, pp. 38–39; and K. Ferdows et al., "Rapid Fire Fulfillment," *Harvard Business Review* 82 (November 2004): 101–107.

has the right combination of skilled people to perform its value creation activities effectively. It is also the job of the human resource function to ensure that people are adequately trained, motivated, and compensated to perform their value creation tasks. If the human resources are functioning well, employee productivity rises (which lowers costs) and customer service improves (which raises utility), thereby enabling the company to create more value.

Information Systems Information systems are, primarily, the electronic systems for managing inventory, tracking sales, pricing products, selling products, dealing with customer service inquiries, and so on. Information systems, when coupled with the communications features of the Internet, are holding out the promise of being able to improve the efficiency and effectiveness with which a company manages its other value creation activities. Again, Dell uses Web-based information systems to efficiently manage its global logistics network and increase inventory turnover. World-class information systems are also an aspect of Zara's competitive advantage (see Strategy in Action 3.2).

Company Infrastructure Company infrastructure is the companywide context within which all the other value creation activities take place: the organizational structure, control systems, and company culture. Because top management can exert considerable influence upon shaping these aspects of a company, top management should also be viewed as part of the infrastructure of a company. Indeed, through strong leadership, top management can shape the infrastructure of a company and, through that, the performance of all other value creation activities that take place within it. A good example of this process is given in Strategy in Action 3.1, which looks at how Rose Marie Bravo helped to engineer a turnaround at Burberry.

THE BUILDING BLOCKS OF COMPETITIVE ADVANTAGE

Four factors help a company to build and sustain competitive advantage: superior efficiency, quality, innovation, and customer responsiveness. Each of these factors is the product of a company's distinctive competencies. Indeed, in a very real sense they are "generic" distinctive competencies. These generic competencies allow a company to (1) differentiate its product offering, and hence offer more value to its customers, and (2) lower its cost structure (see Figure 3.6). These factors can be considered generic distinctive competencies because any company, regardless of its industry or the products or services it produces, can pursue these competencies. Although each one is discussed sequentially in the following discussion, all are highly interrelated, and the important ways these competencies affect each other should be noted. For example, superior quality can lead to superior efficiency, and innovation can enhance efficiency, quality, and responsiveness to customers.

Efficiency

In one sense, a business is simply a device for transforming inputs into outputs. Inputs are basic factors of production such as labor, land, capital, management, and technological knowhow. Outputs are the goods and services that the business produces. The simplest

Figure 3.6 Building Blocks of Competitive Advantage

© Cengage Learning

measure of efficiency is the quantity of inputs that it takes to produce a given output, that is, efficiency = outputs/inputs. The more efficient a company is, the fewer inputs required to produce a particular output, and the lower its costs will be.

One common measure of efficiency is employee productivity. **Employee productivity** refers to the output produced per employee. For example, if it takes General Motors 30 hours of employee time to assemble a car, and it takes Ford 25 hours, we can say that Ford has higher employee productivity than GM, and is more efficient. As long as other factors are equal, such as wage rates, we can assume from this information that Ford will have a lower cost structure than GM. Thus, employee productivity helps a company attain a competitive advantage through a lower cost structure.

employee productivity

The output produced per employee.

Quality as Excellence and Reliability

A product can be thought of as a bundle of attributes.[12] The attributes of many physical products include their form, features, performance, durability, reliability, style, and design.[13] A product is said to have *superior quality* when customers perceive that its attributes provide them with higher utility than the attributes of products sold by rivals. For example, a Rolex watch has attributes—such as design, styling, performance, and reliability—that customers perceive as being superior to the same attributes in many other watches. Thus, we can refer to a Rolex as a high-quality product: Rolex has differentiated its watches by these attributes.

When customers evaluate the quality of a product, they commonly measure it against two kinds of attributes: those related to *quality as excellence* and those related to *quality as reliability*. From a quality-as-excellence perspective, the important attributes are things such as a product's design and styling, its aesthetic appeal, its features and functions, the level of service associated with the delivery of the product, and so on. For example,

Figure 3.7	A Quality Map for Wireless Service

customers can purchase a pair of imitation leather boots for $20 from Wal-Mart, or they can buy a handmade pair of butter-soft leather boots from Nordstrom for $500. The boots from Nordstrom will have far superior styling, feel more comfortable, and look much better than those from Wal-Mart. The value consumers will get from the Nordstrom boots will in all probability be much greater than the value derived from the Wal-Mart boots, but of course, they will have to pay far more for them. That is the point: when excellence is built into a product offering, consumers must pay more to own or consume it.

With regard to quality as reliability, a product can be said to be reliable when it consistently performs the function it was designed for, performs it well, and rarely, if ever, breaks down. As with excellence, reliability increases the value (utility) a consumer gets from a product, and thus the price the company can charge for that product and/or demand for the product.

The position of a product against two dimensions, reliability and other attributes, can be plotted on a figure similar to Figure 3.7. For example, as we saw in the Opening Case, Verizon has the most reliable network in the wireless service industry as measured by factors such as coverage, number of dropped calls, dead zones, and so on. Verizon also has the best ratings when it comes to excellence, as measured by download speeds, customer care, and the like. According to J.D. Power surveys, T-Mobile has the worst position in the industry as measured by reliability and excellence.

The concept of quality applies whether we are talking about Toyota automobiles, clothes designed and sold by Zara, Verizon's wireless service, the customer service department of Citibank, or the ability of airlines to arrive on time. Quality is just as relevant to services as it is to goods.[14] The impact of high product quality on competitive advantage is twofold.[15] First, providing high-quality products increases the value (utility) those products provide to customers, which gives the company the option of charging a higher price for the products. In the automobile industry, for example, Toyota has historically been able to charge a higher price for its cars because of the higher quality of its products.

Second, greater efficiency and lower unit costs associated with reliable products of high quality impact competitive advantage. When products are reliable, less employee time is wasted making defective products, or providing substandard services, and less time has to be spent fixing mistakes—which means higher employee productivity and lower unit costs. Thus, high product quality not only enables a company to differentiate its product from that of rivals, but, if the product is reliable, it also lowers costs.

The importance of reliability in building competitive advantage has increased dramatically over the past 20 years. The emphasis many companies place on reliability is so crucial to achieving high product reliability that it can no longer be viewed as just one way of gaining a competitive advantage. In many industries, it has become an absolute imperative for a company's survival.

Innovation

product innovation

Development of products that are new to the world or have superior attributes to existing products.

process innovation

Development of a new process for producing products and delivering them to customers.

Innovation refers to the act of creating new products or processes. There are two main types of innovation: product innovation and process innovation. **Product innovation** is the development of products that are new to the world or have superior attributes to existing products. Examples are Intel's invention of the microprocessor in the early 1970s, Cisco's development of the router for routing data over the Internet in the mid-1980s, and Apple's development of the iPod, iPhone, and iPad in the 2000s. **Process innovation** is the development of a new process for producing products and delivering them to customers. Examples include Toyota, which developed a range of new techniques collectively known as the "Toyota lean production system" for making automobiles: just-in-time inventory systems, self-managing teams, and reduced setup times for complex equipment.

Product innovation creates value by creating new products, or enhanced versions of existing products, that customers perceive as having more value, thus increasing the company's pricing options. Process innovation often allows a company to create more value by lowering production costs. Toyota's lean production system, for example, helped to boost employee productivity, thus giving Toyota a cost-based competitive advantage.[16] Similarly, Staples dramatically lowered the cost of selling office supplies by applying the supermarket business model to retail office supplies. Staples passed on some of this cost savings to customers in the form of lower prices, which enabled the company to increase its market share rapidly.

In the long run, innovation of products and processes is perhaps the most important building block of competitive advantage.[17] Competition can be viewed as a process driven by innovations. Although not all innovations succeed, those that do can be a major source of competitive advantage because, by definition, they give a company something unique—something its competitors lack (at least until they imitate the innovation). Uniqueness can allow a company to differentiate itself from its rivals and charge a premium price for its product, or, in the case of many process innovations, reduce its unit costs far below those of competitors.

Customer Responsiveness

To achieve superior responsiveness to customers, a company must be able to do a better job than competitors of identifying and satisfying its customers' needs. Customers will then attribute more value to its products, creating a competitive advantage based on differentiation. Improving the quality of a company's product offering is consistent with achieving

responsiveness, as is developing new products with features that existing products lack. In other words, achieving superior quality and innovation is integral to achieving superior responsiveness to customers.

Another factor that stands out in any discussion of responsiveness to customers is the need to customize goods and services to the unique demands of individual customers or customer groups. For example, the proliferation of soft drinks and beers can be viewed partly as a response to this trend.

An aspect of responsiveness to customers that has drawn increasing attention is **customer response time**: the time that it takes for a good to be delivered or a service to be performed.[18] For a manufacturer of machinery, response time is the time it takes to fill customer orders. For a bank, it is the time it takes to process a loan, or that a customer must stand in line to wait for a free teller. For a supermarket, it is the time that customers must stand in checkout lines. For a fashion retailer, it is the time required to take a new product from design inception to placement in a retail store (see Strategy in Action 3.2 for a discussion of how the Spanish fashion retailer Zara minimizes this). Customer survey after customer survey has shown slow response time to be a major source of customer dissatisfaction.[19]

Other sources of enhanced responsiveness to customers are superior design, superior service, and superior after-sales service and support. All of these factors enhance responsiveness to customers and allow a company to differentiate itself from its less responsive competitors. In turn, differentiation enables a company to build brand loyalty and charge a premium price for its products. Consider how much more people are prepared to pay for next-day delivery of Express Mail, compared to delivery in 3 to 4 days. In 2012, a two-page letter sent by overnight Express Mail within the United States cost about $10, compared to $0.48 for regular mail. Thus, the price premium for express delivery (reduced response time) was $9.52, or a premium of 1983% over the regular price.

customer response time
Time that it takes for a good to be delivered or a service to be performed.

BUSINESS MODELS, THE VALUE CHAIN, AND GENERIC DISTINCTIVE COMPETENCIES

As noted in Chapter 1, a business model is a manager's conception, or gestalt, of how the various strategies that a firm pursues fit together into a congruent whole, enabling the firm to achieve a competitive advantage. More precisely, a business model represents the way in which managers configure the value chain of the firm through their choice of strategy. It includes the investments they make to support that configuration, so that they can build the distinctive competencies necessary to attain the efficiency, quality, innovation, and customer responsiveness required to support the firm's low-cost or differentiated position, thereby achieving a competitive advantage and generating superior profitability (see Figure 3.8).

For example, the primary strategic goal of Wal-Mart is to be the lowest-cost operator offering a wide display of general merchandise in the retail industry. Wal-Mart's business model involves offering general merchandise in a self-service supermarket type of setting. Wal-Mart's strategies flesh out this business model and help the company to attain its strategic goal. To reduce costs, Wal-Mart limits investments in the fittings and fixtures of its stores. One of the keys to generating sales and lowering costs in this setting

Figure 3.8

Competitive Advantage and the Value Creation Cycle

is rapid inventory turnover, which is achieved through strategic investments in logistics and information systems. Wal-Mart makes major investments in process innovation to improve the effectiveness of its information and logistics systems, which enables the company to respond to customer demands for low-priced goods, and to do so in a very efficient manner.

Wal-Mart's business model is very different from those of retailers such as Nordstrom. Nordstrom's business model is to offer high quality, and high-priced apparel, in a full-service and sophisticated setting. This implies differences in the way the value chain is configured. Nordstrom devotes far more attention to in-store customer service than Wal-Mart does, which implies significant investments in its salespeople. Moreover, Nordstrom invests far more in the furnishings and fittings for its stores compared to Wal-Mart, whose stores have a basic warehouse feel to them. Nordstrom recaptures the costs of this investment by charging higher prices for higher-quality merchandise. Although Wal-Mart and Nordstrom both sell apparel (Wal-Mart is in fact the biggest seller of apparel in the United States), their business models imply very different positions in the marketplace, and very different configurations of value chain activities and investments.

ANALYZING COMPETITIVE ADVANTAGE AND PROFITABILITY

If a company's managers are to perform a good internal analysis, they must be able to analyze the financial performance of their company, identifying how its strategies contribute (or not) to profitability. To identify strengths and weaknesses effectively, they must be able to compare, or benchmark, the performance of their company against competitors, as well

as against the historic performance of the company itself. This will help them determine whether they are more or less profitable than competitors and whether the performance of the company has been improving or deteriorating through time; whether their company strategies are maximizing the value being created; whether their cost structure is out of alignment compared to competitors; and whether they are using the resources of the company to the greatest effect.

As we noted in Chapter 1, the key measure of a company's financial performance is its profitability, which captures the return that a company is generating on its investments. Although several different measures of profitability exist, such as return on assets and return on equity, many authorities on the measurement of profitability argue that return on invested capital (ROIC) is the best measure because "it focuses on the true operating performance of the company."[20] (However, return on assets is very similar in formulation to return on invested capital.)

ROIC is defined as net profit over invested capital, or ROIC = net profit/invested capital. Net profit is calculated by subtracting the total costs of operating the company from its total revenues (total revenues − total costs). *Net profit* is what is left over after the government takes its share in taxes. *Invested capital* is the amount that is invested in the operations of a company: property, plant, equipment, inventories, and other assets. Invested capital comes from two main sources: interest-bearing debt and shareholders' equity. Interest-bearing debt is money the company borrows from banks and those who purchase its bonds. Shareholders' equity is the money raised from selling shares to the public, plus earnings that the company has retained in prior years (and that are available to fund current investments). ROIC measures the effectiveness with which a company is using the capital funds that it has available for investment. As such, it is recognized to be an excellent measure of the value a company is creating.[21]

A company's ROIC can be algebraically divided into two major components: return on sales and capital turnover.[22] Specifically:

$$ROIC = \text{net profits/invested capital}$$
$$= \text{net profits/revenues} \times \text{revenues/invested capital}$$

where net profits/revenues is the return on sales, and revenues/invested capital is capital turnover. Return on sales measures how effectively the company converts revenues into profits. Capital turnover measures how effectively the company employs its invested capital to generate revenues. These two ratios can be further divided into some basic accounting ratios, as shown in Figure 3.9 (these ratios are defined in Table 3.1).[23]

Figure 3.9 notes that a company's managers can increase ROIC by pursuing strategies that increase the company's return on sales. To increase the company's return on sales, they can pursue strategies that reduce the cost of goods sold (COGS) for a given level of sales revenues (COGS/sales); reduce the level of spending on sales-force, marketing, general, and administrative expenses (SG&A) for a given level of sales revenues (SG&A/sales); and reduce R&D spending for a given level of sales revenues (R&D/sales). Alternatively, they can increase return on sales by pursuing strategies that increase sales revenues more than they increase the costs of the business, as measured by COGS, SG&A, and R&D expenses. That is, they can increase the return on sales by pursuing strategies that lower costs or increase value through differentiation, and thus allow the company to increase its prices more than its costs.

Figure 3.9 also tells us that a company's managers can boost the profitability of their company by obtaining greater sales revenues from their invested capital, thereby increasing capital turnover. They do this by pursuing strategies that reduce the amount of working capital, such as the amount of capital invested in inventories, needed to generate a given

Figure 3.9 Drivers of Profitability (ROIC)

© Cengage Learning

Table 3.1 Definitions of Basic Accounting Terms

Term	Definition	Source
Cost of Goods Sold (COGS)	Total costs of producing products	Income statement
Sales, General, and Administrative Expenses (SG&A)	Costs associated with selling products and administering the company	Income statement
R&D Expenses (R&D)	Research and development expenditure	Income statement
Working Capital	The amount of money the company has to "work" with in the short term: Current assets − current liabilities	Balance sheet
Property, Plant, and Equipment (PPE)	The value of investments in the property, plant, and equipment that the company uses to manufacture and sell its products; also known as *fixed capital*	Balance sheet
Return on Sales (ROS)	Net profit expressed as a percentage of sales; measures how effectively the company converts revenues into profits	Ratio
Capital Turnover	Revenues divided by invested capital; measures how effectively the company uses its capital to generate revenues	Ratio
Return on Invested Capital (ROIC)	Net profit divided by invested capital	Ratio
Net Profit	Total revenues minus total costs before tax	Income statement
Invested Capital	Interest-bearing debt plus shareholders' equity	Balance sheet

level of sales (working capital/sales) and then pursuing strategies that reduce the amount of fixed capital that they have to invest in plant, property, and equipment (PPE) to generate a given level of sales (PPE/sales). That is, they pursue strategies that reduce the amount of capital that they need to generate every dollar of sales, and therefore their cost of capital. Recall that cost of capital is part of the cost structure of a company (see Figure 3.2), so strategies designed to increase capital turnover also lower the cost structure.

To see how these basic drivers of profitability help us to understand what is going on in a company and to identify its strengths and weaknesses, let us compare the financial performance of Wal-Mart against one of its more effective competitors, Target. This is done in the following Running Case.

FOCUS ON: Wal-Mart

Wal-Mart and Target

© iStockPhoto.com/caracterdesign

For the financial year ending January 2012, Wal-Mart earned a ROIC of 13.61%, and Target earned a respectable 10.01%. Wal-Mart's superior profitability can be understood in terms of the impact of its strategies on the various ratios identified in Figure 3.9. These are summarized in Figure 3.10.

Figure 3.10 Comparing Wal-Mart and Target, 2012

© Cengage Learning

(continues)

FOCUS ON: Wal-Mart

(continued)

© iStockPhoto.com/caracterdesign

First, note that Wal-Mart has a *lower* return on sales than Target. The main reason for this is that Wal-Mart's cost of goods sold (COGS) as a percentage of sales is higher than Target's (75% against 69.1%). For a retailer, the COGS reflects the price that Wal-Mart pays to its suppliers for merchandise. The lower COGS/sales ratio implies that Wal-Mart does not mark up prices much as Target—its profit margin on each item sold is lower. Consistent with its long-time strategic goal, Wal-Mart passes on the low prices it gets from suppliers to customers. Wal-Mart's higher COGS/sales ratio reflects its strategy of being the lowest-price retailer.

On the other hand, you will notice that Wal-Mart spends less on sales, general, and administrative (SG&A) expenses as a percentage of sales than Target (19.1% against 22.24%). There are three reasons for this. First, you will recall that Wal-Mart's early strategy was to focus on small towns that could only support one discounter. In small towns, the company does not have to advertise heavily because it is not competing against other discounters. Second, Wal-Mart has become such a powerful brand that the company does not need to advertise as heavily as its competitors, even when its stores are located close to them in suburban areas. Third, because Wal-Mart sticks to its low-price philosophy, and because the company manages its inventory so well, it does not usually have an overstocking problem. Thus, the company does not need to hold periodic sales—and nor does it have to bear the costs of promoting those sales (e.g., sending out advertisements and coupons in local newspapers). By reducing spending of sales promotions, these factors reduce Wal-Mart's SG&A/sales ratio.

In addition, Wal-Mart operates with a flat organization structure that has very few layers of management between the head office and store managers (the company has no regional headquarters). This reduces administrative expenses (which are a component of SG&A) and hence the SG&A/sales ratio. Wal-Mart can operate with such flat structure because its information systems allow the company's top managers to monitor and control individual stores directly, rather than rely upon intervening layers of subordinates to do that for them.

It is when we turn to consider the capital turnover side of the ROIC equation, however, that financial impact of Wal-Mart's competitive advantage in information systems and logistics becomes apparent. Wal-Mart generates $3.87 for every dollar of capital invested in the business, whereas Target generates $2.39 for every dollar of capital invested. Wal-Mart is much more efficient in its use of capital than Target. Why?

One reason is that Wal-Mart has a lower working capital/sales ratio than Target. In fact, Wal-Mart has a *negative* ratio (−1.64%), whereas Target has a positive ratio (3.10%). The negative working capital ratio implies that Wal-Mart does not need any capital to finance its day-to-day operations—in fact, Wal-Mart is using its suppliers' capital to finance its day-to-day operations! This is very unusual, but Wal-Mart is able to do this for two reasons. First, Wal-Mart is so powerful that it can demand and get very favorable payment terms from its suppliers. It does not have to pay for merchandise for 60 days after it is delivered. Second, Wal-Mart turns over its inventory so rapidly—around 8 times a year—that it typically sells merchandise *before* it has to pay its suppliers. Thus, suppliers finance Wal-Mart's inventory and the company's short-term capital needs! Wal-Mart's high inventory turnover is the result of strategic investments in information systems and logistics. It is these value chain activities more than any other that explain Wal-Mart's competitive advantage.

Finally, note that Wal-Mart has a significantly lower PPE/sales ratio than Target: 20.72% versus 41.72%. There are several explanations for this. First, many of Wal-Mart's stores are still located in small towns where land is cheap, whereas most of Target's stores are located in more expensive suburban locations. Thus, on average, Wal-Mart needs to spend less on a store than Target. Again, strategy has a clear impact on financial performance! Second, because Wal-Mart turns its inventory over so rapidly, it does not need to devote as much space in stores to storing

(continues)

FOCUS ON: Wal-Mart

(continued)

© iStockPhoto.com/caracterdesign

inventory. This means that more floor space can be devoted to selling merchandise. Other things being equal, this will result in a higher PPE/sales ratio. By the same token, efficient inventory management means that it needs less space at a distribution center to support a store, which again reduces total capital spending on property, plant, and equipment. Third, the higher PPE/sales ratio may also reflect the fact that Wal-Mart's brand is so powerful, and its commitment to low pricing so strong, that store traffic is higher than at comparable discounters such as Target. The stores are simply busier. Hence, the PPE/sales ratio is higher.

In sum, Wal-Mart's high profitability is a function of its strategy, and the distinctive competencies that strategic investments have built over the years, particularly in the area of information systems and logistics. As in the Wal-Mart example, the methodology described in this section can be a very useful tool for analyzing why and how well a company is achieving and sustaining a competitive advantage. It highlights a company's strengths and weaknesses, showing where there is room for improvement and where a company is excelling. As such, it can drive strategy formulation. Moreover, the same methodology can be used to analyze the performance of competitors, and gain a greater understanding of their strengths and weakness, which can in turn inform strategy.

Source: Calculated by the author from 2010 company 10K statements.

THE DURABILITY OF COMPETITIVE ADVANTAGE

The next question we must address is how long a competitive advantage will last once it has been created. In other words: What is the durability of competitive advantage given that other companies are also seeking to develop distinctive competencies that will give them a competitive advantage? The answer depends on three factors: barriers to imitation, the capability of competitors, and the general dynamism of the industry environment.

Barriers to Imitation

A company with a competitive advantage will earn higher-than-average profits. These profits send a signal to rivals that the company has valuable, distinctive competencies allowing it to create superior value. Naturally, its competitors will try to identify and imitate that competency, and insofar as they are successful, ultimately their increased success may whittle away the company's superior profits.[24]

How quickly rivals will imitate a company's distinctive competencies is an important issue, because the speed of imitation has a bearing on the durability of a company's competitive advantage. Other factors being equal, the more rapidly competitors imitate a company's distinctive competencies, the less durable its competitive advantage will be, and the more important it is that the company endeavor to improve its competencies to stay one step ahead of imitators. It is important to stress at the outset that a competitor can imitate almost any distinctive competency. The critical issue is time: the longer it takes competitors

to imitate a distinctive competency, the greater the opportunity the company has to build a strong market position and reputation with customers—which are then more difficult for competitors to attack. Moreover, the longer it takes to achieve an imitation, the greater the opportunity for the imitated company to improve on its competency or build other competencies, thereby remaining one step ahead of the competition.

barriers to imitation
Factors that make it difficult for a competitor to copy a company's distinctive competencies.

Barriers to imitation are a primary determinant of the speed of imitation. Barriers to imitation are factors that make it difficult for a competitor to copy a company's distinctive competencies; the greater the barriers to imitation, the more sustainable a company's competitive advantage.[25] Barriers to imitation differ depending on whether a competitor is trying to imitate resources or capabilities.

Imitating Resources In general, the easiest distinctive competencies for prospective rivals to imitate tend to be those based on possession of firm-specific and valuable tangible resources, such as buildings, manufacturing plants, and equipment. Such resources are visible to competitors and can often be purchased on the open market. For example, if a company's competitive advantage is based on sole possession of efficient-scale manufacturing facilities, competitors may move fairly quickly to establish similar facilities. Although Ford gained a competitive advantage over General Motors in the 1920s by first adopting assembly-line manufacturing technology to produce automobiles, General Motors quickly imitated that innovation, competing away Ford's distinctive competency in the process. A similar process is occurring in the auto industry today as rival automakers try to imitate Toyota's famous production system.

Intangible resources can be more difficult to imitate. This is particularly true of brand names, which are important because they symbolize a company's reputation. In the heavy-earthmoving equipment industry, for example, the Caterpillar brand name is synonymous with high quality and superior after-sales service and support. Similarly, the St. Michael's brand name used by Marks & Spencer, Britain's largest clothing retailer, symbolizes high-quality but reasonably priced clothing. Customers often display a preference for the products of such companies because the brand name is an important guarantee of high quality. Although competitors might like to imitate well-established brand names, the law prohibits them from doing so.

Marketing and technological knowhow are also important intangible resources and can be relatively easy to imitate. The movement of skilled marketing personnel between companies may facilitate the general dissemination of marketing knowhow. More generally, successful marketing strategies are relatively easy to imitate because they are so visible to competitors. Thus, Coca-Cola quickly imitated PepsiCo's Diet Pepsi brand with the introduction of its own brand, Diet Coke.

With regard to technological knowhow, the patent system in theory should make technological knowhow relatively immune to imitation. Patents give the inventor of a new product a 20-year exclusive production agreement. However, this is not always the case. In electrical and computer engineering, for example, it is often possible to invent and circumnavigate the patent process—that is, produce a product that is functionally equivalent but does not rely on the patented technology. One study found that 60% of patented innovations were successfully invented in around 4 years.[26] This suggests that, in general, distinctive competencies based on technological knowhow can be relatively short-lived.

Imitating Capabilities Imitating a company's capabilities tends to be more difficult than imitating its tangible and intangible resources, chiefly because capabilities are based on the way in which decisions are made and processes are managed deep within a company. It is hard for outsiders to discern them.

The invisible nature of capabilities would not be enough to halt imitation; competitors could still gain insights into how a company operates by hiring people away from that company. However, a company's capabilities rarely reside in a single individual. Rather, they are the product of how numerous individuals interact within a unique organizational setting.[27] It is possible that no one individual within a company may be familiar with the totality of a company's internal operating routines and procedures. In such cases, hiring people away from a successful company in order to imitate its key capabilities may not be helpful.

Capability of Competitors

According to work by Pankaj Ghemawat, a major determinant of the capability of competitors to rapidly imitate a company's competitive advantage is the nature of the competitors' prior strategic commitments.[28] By *strategic commitment*, Ghemawat means a company's commitment to a particular way of doing business—that is, to developing a particular set of resources and capabilities. Ghemawat states that once a company has made a strategic commitment, it will have difficulty responding to new competition if doing so requires a break with this commitment. Therefore, when competitors have long-established commitments to a particular way of doing business, they may be slow to imitate an innovating company's competitive advantage. The innovator's competitive advantage may be relatively durable as a result.

The U.S. automobile industry again offers an example. From 1945 to 1975, General Motors, Ford, and Chrysler dominated this stable oligopoly, and all three companies directed their operations to the production of large cars, which American customers demanded at the time. When the market shifted from large cars to small, fuel-efficient vehicles during the late 1970s, U.S. companies lacked the resources and capabilities required to produce these cars. Their prior commitments had built the wrong kind of skills for this new environment. As a result, foreign producers, particularly the Japanese, stepped into the market breach by providing compact, fuel-efficient, high-quality low-cost cars. U.S. auto manufacturers failed to react quickly to the distinctive competency of Japanese auto companies, giving them time to build a strong market position and brand loyalty, which subsequently proved difficult to attack.

Another determinant of the ability of competitors to respond to a company's competitive advantage is the absorptive capacity of competitors.[29] **Absorptive capacity** refers to the ability of an enterprise to identify, value, assimilate, and use new knowledge. For example, in the 1960s, 1970s, and 1980s Toyota developed a competitive advantage based on its innovation of lean production systems. Competitors such as General Motors were slow to imitate this innovation, primarily because they lacked the necessary absorptive capacity. In those days General Motors was such a bureaucratic and inward-looking organization that it was very difficult for the company to identify, value, assimilate, and use the knowledge underscoring lean production systems. Long after General Motors had identified and understood the importance of lean production systems, it was still struggling to assimilate and use that new knowledge. Put differently, internal forces of inertia can make it difficult for established competitors to respond to rivals whose competitive advantage is based on new products or internal processes—that is, on innovation.

Together, factors such as existing strategic commitments and low absorptive capacity limit the ability of established competitors to imitate the competitive advantage of a rival, particularly when that competitive advantage is based on innovative products or processes. This is why value often migrates away from established competitors and toward new enterprises that are operating with new business models when innovations reshape the rules of industry competition.

absorptive capacity
The ability of an enterprise to identify, value, assimilate, and use new knowledge.

Industry Dynamism

A dynamic industry environment is one that changes rapidly. We examined some of the factors that determine the dynamism and intensity of competition in an industry in Chapter 2 when we discussed the external environment. The most dynamic industries tend to be those with a very high rate of product innovation—for instance, the customer electronics industry, the computer industry, and the telecommunications industry. In dynamic industries, the rapid rate of innovation means that product life cycles are shortening and that competitive advantage can be fleeting. A company that has a competitive advantage today may find its market position outflanked tomorrow by a rival's innovation.

In the personal computer industry, the rapid increase in computing power during the past three decades has contributed to a high degree of innovation and a turbulent environment. Reflecting the persistence of computer innovation, Apple had an industry-wide competitive advantage due to its innovation in the late 1970s and early 1980s. In 1981, IBM seized the advantage by introducing its first personal computer. By the mid-1980s, IBM had lost its competitive advantage to high-power "clone" manufacturers, such as Compaq, that had beaten IBM in the race to introduce a computer based on Intel's 386 chip. In the 1990s, Compaq subsequently lost its competitive advantage to Dell, which pioneered new low-cost ways of delivering computers to customers using the Internet as a direct-selling device. In recent years, Apple has again seized the initiative with its innovative product designs and successful differentiation strategy.

Summary

The durability of a company's competitive advantage depends upon the height of barriers to imitation, the capability of competitors to imitate its innovation, and the general level of dynamism in the industry environment. When barriers to imitation are low, capable competitors abound, and innovations are rapidly being developed within a dynamic environment, then competitive advantage is likely to be transitory. But even within such industries, companies can build a more enduring competitive advantage—if they are able to make investments that build barriers to imitation.

AVOIDING FAILURE AND SUSTAINING COMPETITIVE ADVANTAGE

How can a company avoid failure and escape the traps that have snared so many once-successful companies? How can managers build a sustainable competitive advantage? Much of the remainder of this book addresses these questions. Here, we outline a number of key points that set the scene for the coming discussion.

Why Companies Fail

When a company loses its competitive advantage, its profitability falls. The company does not necessarily fail; it may just have average or below-average profitability and can remain in this mode for a considerable time, although its resource and capital base is shrinking. Failure implies something more drastic. A failing company is one whose profitability is substantially

lower than the average profitability of its competitors; it has lost the ability to attract and generate resources and its profit margins and invested capital are rapidly shrinking.

Why does a company lose its competitive advantage and fail? This question is particularly pertinent because some of the most successful companies of the last half-century have seen their competitive position deteriorate at one time or another. IBM, General Motors, American Express, and Sears (among many others), which all were astute examples of managerial excellence, have gone through periods of poor financial performance, during which any competitive advantage was distinctly lacking. We explore three related reasons for failure: inertia, prior strategic commitments, and the Icarus paradox.

Inertia The inertia argument states that companies find it difficult to change their strategies and structures in order to adapt to changing competitive conditions.[30] IBM is a classic example of this problem. For 30 years, it was viewed as the world's most successful computer company. Then, in only a few years, its success turned into a disaster: it lost $5 billion in 1992, and laid off more than 100,000 employees. The underlying cause of IBM's troubles was a dramatic decline in the cost of computing power as a result of innovations in microprocessors. With the advent of powerful low-cost microprocessors, the locus of the computer market shifted from mainframes to small, low-priced personal computers, leaving IBM's huge mainframe operations with a diminished market. Although IBM had a significant presence in the personal computer market, it had failed to shift the focus of its efforts away from mainframes and toward personal computers. This failure meant deep trouble for one of the most successful companies of the 20th century. (IBM has now executed a very successful turnaround, repositioning itself as a provider of information technology infrastructure and solutions.)

One reason companies find it so difficult to adapt to new environmental conditions is the role of capabilities in causing inertia. Organizational capabilities—the way a company makes decisions and manages its processes—can be a source of competitive advantage, but they are often difficult to change. IBM always emphasized close coordination among operating units and favored decision-making processes that stressed consensus among interdependent operating units as a prerequisite for decisions to go forward.[31] This capability was a source of advantage for IBM during the 1970s, when coordination among its worldwide operating units was necessary to develop, manufacture, and sell complex mainframes. But the slow-moving bureaucracy that it had spawned was a source of failure in the 1990s, when organizations needed to readily adapt to rapid environmental change.

Capabilities are difficult to change because distribution of power and influence is embedded within the established decision-making and management processes of an organization. Those who play key roles in a decision-making process clearly have more power. It follows that changing the established capabilities of an organization means changing its existing distribution of power and influence. Most often, those whose power and influence would diminish resist such change; proposals for change trigger turf battles. Power struggles and the hierarchical resistance associated with trying to alter the way in which an organization makes decisions and manages its process—that is, trying to change its capabilities—bring on inertia. This is not to say that companies cannot change. However, those who feel threatened by change often resist it; change in most cases is induced by a crisis. By then, the company may already be failing, as exemplified by IBM.

Prior Strategic Commitments A company's prior strategic commitments not only limit its ability to imitate rivals but may also cause competitive disadvantage.[32] IBM, for instance, had major investments in the mainframe computer business, so when the market

shifted, it was stuck with significant resources specialized to that particular business: its manufacturing facilities largely produced mainframes, and its research organization and sales force were similarly specialized. Because these resources were not well suited to the newly emerging personal computer business, IBM's difficulties in the early 1990s were in a sense inevitable. Its prior strategic commitments locked it into a business that was shrinking. Shedding these resources inevitably caused hardship for all organization stakeholders.

The Icarus Paradox Danny Miller has postulated that the roots of competitive failure can be found in what he termed the "Icarus paradox."[33] Icarus is a figure in Greek mythology who used a pair of wings, made for him by his father, to escape from an island where he was being held prisoner. He flew so well that he climbed higher and higher, ever closer to the sun, until the heat of the sun melted the wax that held his wings together, and he plunged to his death in the Aegean Sea. The paradox is that his greatest asset, his ability to fly, caused his demise. Miller argues that the same paradox applies to many once-successful companies. According to Miller, many companies become so dazzled by their early success that they believe more of the same type of effort is the way to future success. As a result, they can become so specialized and myopic that they lose sight of market realities and the fundamental requirements for achieving a competitive advantage. Sooner or later, this leads to failure. For example, Miller argues that Texas Instruments and Digital Equipment Corporation (DEC) achieved early success through engineering excellence. But thereafter, they became so obsessed with engineering details that they lost sight of market realities. (The story of DEC's demise is summarized in Strategy in Action 3.3.)

Steps to Avoid Failure

Given that so many pitfalls await companies, the question arises as to how strategic managers can use internal analysis to find and escape them. We now look at several steps that managers can take to avoid failure.

Focus on the Building Blocks of Competitive Advantage Maintaining a competitive advantage requires a company to continue focusing on all four generic building blocks of competitive advantage—efficiency, quality, innovation, and responsiveness to customers—and to develop distinctive competencies that contribute to superior performance in these areas. Miller's Icarus paradox promotes the message that many successful companies become unbalanced in their pursuit of distinctive competencies. DEC, for example, focused on engineering quality at the expense of almost everything else, including, most importantly, responsiveness to customers.

Institute Continuous Improvement and Learning Change is constant and inevitable. Today's source of competitive advantage may soon be rapidly imitated by capable competitors or made obsolete by the innovations of a rival. In a dynamic, fast-paced environment, the only way that a company can maintain a competitive advantage over time is to continually improve its efficiency, quality, innovation, and responsiveness to customers. The way to do this is to recognize the importance of learning within the organization.[34] The most successful companies are not those that stand still, resting on their laurels. Companies that are always seeking ways to improve their operations and constantly upgrade the value of their distinctive competencies or create new competencies are the most successful. General Electric and Toyota, for example, have reputations as learning organizations; they are continually analyzing the processes that underlie their efficiency, quality, innovation,

3.3 STRATEGY IN ACTION

The Road to Ruin at DEC

© iStockPhoto.com/Tom Nulens

Digital Equipment Corporation (DEC) was one of the premier computer companies of the 1970s and 1980s. DEC's original success was founded on the minicomputer, a cheaper, more flexible version of its mainframe cousins that Ken Olson and his brilliant team of engineers invented in the 1960s. They then improved on their original minicomputers until they could not be beat for quality and reliability. In the 1970s, their VAX series of minicomputers was widely regarded as the most reliable series of computers ever produced, and DEC was rewarded by high profit rates and rapid growth. By 1990, it was number 27 on the *Fortune* 500 list of the largest corporations in America.

Buoyed by its success, DEC turned into an engineering monoculture: its engineers became idols; marketing and accounting staff, however, were barely tolerated. Component specs and design standards were all that senior managers understood. Technological fine-tuning became such an obsession that the customer's needs for smaller, more economical, user-friendly computers were ignored. DEC's personal computers, for example, bombed because they were out of touch with the needs of customers. The company failed to respond to the threat to its core market, presented by the rise of computer workstations and client–server architecture. Ken Olson was known for dismissing such new products. He once said, "We always say that customers are right, but they are not always right." Perhaps. But DEC, blinded by its early success, failed to remain responsive to its customers and to changing market conditions. In another famous statement, when asked about personal computers in the early 1980s, Olson said: "I can see of no reason why anybody would ever want a computer on their desk."

By the early 1990s, DEC was in deep trouble. Olson was forced out in July 1992, and the company lost billions of dollars between 1992 and 1995. It returned to profitability in 1996, primarily because its turnaround strategy, aimed at reorienting the company to serve the areas that Olson had dismissed, was a success. In 1998, Compaq purchased DEC (which Hewlett Packard later purchased) and DEC disappeared from the business landscape as an independent entity.

Sources: D. Miller, *The Icarus Paradox* (New York: HarperBusiness, 1990); P. D. Llosa, "We Must Know What We Are Doing," *Fortune*, November 14, 1994, p. 68.

and responsiveness to customers. Learning from prior mistakes and seeking out ways to improve processes over time is the primary objective. This approach has enabled Toyota, for instance, to continually upgrade its employee productivity and product quality, and stay one step ahead of imitators.

Track Best Industrial Practice and Use Benchmarking Identifying and adopting best industrial practice is one of the best ways to develop distinctive competencies that contribute to superior efficiency, quality, innovation, and responsiveness to customers. Only in this way will a company be capable of building and maintaining the resources and capabilities that underpin excellence in efficiency, quality, innovation, and responsiveness to customers. (We discuss what constitutes best industrial practice in some depth in Chapter 4.) It requires tracking the practice of other companies, and perhaps the best way to do so is through benchmarking: measuring the company against the products, practices, and services of some of its most efficient global competitors.

Overcome Inertia Overcoming the internal forces that are a barrier to change within an organization is one of the key requirements for maintaining a competitive advantage.

Identifying barriers to change is an important first step. Once barriers are identified, implementing change to overcome these barriers requires good leadership, the judicious use of power, and appropriate subsequent changes in organizational structure and control systems.

The Role of Luck Some scholars have argued that luck plays a critical role in determining competitive success and failure.[35] In its most extreme version, the luck argument devalues the importance of strategy altogether. Instead, it states that in the face of uncertainty, some companies just happen to choose the correct strategy.

Although luck may be the reason for a company's success in particular cases, it is an unconvincing explanation for the persistent success of a company. Recall our argument that the generic building blocks of competitive advantage are superior efficiency, quality, innovation, and responsiveness to customers. In addition, keep in mind that competition is a process in which companies are continually trying to outdo each other in their ability to achieve high efficiency, superior quality, outstanding innovation, and rapid responsiveness to customers. It is possible to imagine a company getting lucky and coming into possession of resources that allow it to achieve excellence within one or more of these dimensions. It is difficult, however, to imagine how sustained excellence within any of these four dimensions could be produced by anything other than conscious effort—that is, by strategy. Luck may indeed play a role in success, and managers must always exploit a lucky break. However, to argue that success is entirely a matter of luck is to strain credibility. As the prominent banker of the early 20th century, J. P. Morgan, once said, "The harder I work, the luckier I seem to get." Managers who strive to formulate and implement strategies that lead to a competitive advantage are more likely to be lucky.

SUMMARY OF CHAPTER

1. Distinctive competencies are the firm-specific strengths of a company. Valuable distinctive competencies enable a company to earn a profit rate that is above the industry average.

2. The distinctive competencies of an organization arise from its resources (its financial, physical, human, technological, and organizational assets) and capabilities (its skills at coordinating resources and putting them to productive use).

3. In order to achieve a competitive advantage, a company needs to pursue strategies that build on its existing resources and capabilities and formulate strategies that build additional resources and capabilities (develop new competencies).

4. The source of a competitive advantage is superior value creation.

5. To create superior value (utility) a company must lower its costs or differentiate its product so that it creates more value and can charge a higher price, or do both simultaneously.

6. Managers must understand how value creation and pricing decisions affect demand and how costs change with increases in volume. They must have a good grasp of the demand conditions in the company's market, and the cost structure of the company at different levels of output, if they are to make decisions that maximize the profitability of their enterprise.

7. The four building blocks of competitive advantage are efficiency, quality, innovation, and responsiveness to customers. These are generic distinctive competencies. Superior efficiency enables a company to lower its costs, superior quality allows it to charge a higher price and lower its costs, and superior customer service lets it charge a higher price. Superior innovation can lead to higher prices, particularly in

the case of product innovations, or lower unit costs, as in the case of process innovations.

8. If a company's managers are to perform a good internal analysis, they need to be able to analyze the financial performance of their company, identifying how the strategies of the company relate to its profitability, as measured by the return on invested capital.

9. The durability of a company's competitive advantage depends on the height of barriers to imitation, the capability of competitors, and environmental dynamism.

10. Failing companies typically earn low or negative profits. Three factors seem to contribute to failure: organizational inertia in the face of environmental change, the nature of a company's prior strategic commitments, and the Icarus paradox.

11. Avoiding failure requires a constant focus on the basic building blocks of competitive advantage: continuous improvement, identification and adoption of best industrial practice, and victory over inertia.

DISCUSSION QUESTIONS

1. What are the primary implications of the material discussed in this chapter for strategy formulation?

2. When is a company's competitive advantage most likely to endure over time?

3. It is possible for a company to be the lowest-cost producer in its industry and simultaneously have an output that is the most valued by customers. Discuss this statement.

4. Why is it important to understand the drivers of profitability, as measured by the return on invested capital?

5. Which is more important in explaining the success and failure of companies: strategizing or luck?

PRACTICING STRATEGIC MANAGEMENT

© iStockPhoto.com/Urilux

Small-Group Exercise: Analyzing Competitive Advantage

Break up into groups of three to five people. Drawing on the concepts introduced in this chapter, analyze the competitive position of your business school in the market for business education. Then answer the following questions:

1. Does your business school have a competitive advantage?
2. If so, upon what is this advantage based, and is this advantage sustainable?
3. If your school does not have a competitive advantage in the market for business education, identify the inhibiting factors that are holding it back.
4. How might the Internet change the way in which business education is delivered?
5. Does the Internet pose a threat to the competitive position of your school in the market for business education, or is it an opportunity for your school to enhance its competitive position?

STRATEGY SIGN ON

© iStockPhoto.com/Ninoslav Dotlic

Article File 3

Find a company that has sustained its competitive advantage for more than 10 years. Identify the source or sources of this competitive advantage, and explain why it has lasted so long.

Strategic Management Project: Module 3

This module deals with the competitive position of your company. With the information you have available, perform the following tasks and answer the listed questions:

1. Identify whether your company has a competitive advantage or disadvantage in its primary industry. (Its primary industry is the one in which it has the most sales.)
2. Evaluate your company against the four generic building blocks of competitive advantage: efficiency, quality, innovation, and responsiveness to customers. How does this exercise help you understand the performance of your company relative to its competitors?
3. What are the distinctive competencies of your company?
4. What roles have prior strategies played in shaping the distinctive competencies of your company? What has been the role of luck?
5. Do the strategies your company is currently pursuing build on its distinctive competencies? Are they an attempt to build new competencies?
6. What are the barriers to imitating the distinctive competencies of your company?
7. Is there any evidence that your company finds it difficult to adapt to changing industry conditions? If so, why do you think this is the case?

ETHICAL DILEMMA

© iStockPhoto.com/P_Wei

Your friend manages a retailer that has a history of superior profitability. She believes that one of the principal sources of competitive advantage for her enterprise are low labor costs. The low labor costs are due to her hiring of minimum-wage workers, the decision not to give them any benefits (such as health benefits), and her consistent opposition to unionization at the company (the workforce is not unionized). Although she acknowledges that this approach does lead to high employee turnover, she argues that the jobs are low skilled, and that it is easy to replace someone who leaves. Is your friend's approach to doing business ethical? Are there ways of achieving low labor costs that do not rely upon the hiring of minimum-wage workers? Would you counsel your friend to use an alternative approach?

CLOSING CASE

Competitive Advantage at Starbucks

The growth of Starbucks is the stuff of business legend. In the 1980s, when the company had only a handful of stores, the company's director of marketing, Howard Schultz, returned from a trip to Italy enchanted with the Italian coffeehouse experience. Schultz, who later purchased the company and became CEO, persuaded the owners to experiment with the coffeehouse format, and the Starbucks experience was born. The strategy was to sell the company's own premium roasted coffee and freshly brewed espresso-style coffee beverages, along with a variety of pastries, coffee accessories, and other products, in a tastefully designed coffeehouse setting. The idea was to transform the act of buying and drinking coffee into a social experience. The stores were to be "third places," where people could meet and talk or relax and read. The company focused on providing superior customer service. Reasoning that motivated employees provide the best customer service, Starbucks' executives devoted much attention to employee hiring and training programs, and progressive compensation policies that gave full-time and part-time employees stock-option grants and medical benefits.

This formula was the bedrock of Starbucks' competitive advantage. Starbucks went from obscurity to one of the best-known brands in the United States within a decade. Between 1995 and 2005, Starbucks added U.S. stores at an annual rate of 27%, reaching almost 12,000 total locations. It also expanded aggressively internationally. Schultz himself stepped down from the CEO role in 2000, although he remained chairman.

By 2008, however, the company was hitting serious headwinds. Competitors from small boutique coffee houses to chains like Tully's and Pete's Coffee, and even McDonald's, were beginning to erode Starbucks' competitive advantage. Although the company was still adding stores at a break-neck pace, same-store sales started to fall. Profitability, measured by return on invested capital (ROIC), slumped from around 21% to just 8.6% in 2008. The stock price tumbled.

At this point, Howard Schultz fired the CEO and again reclaimed the position. His strategy was to return Starbucks to its roots. He wanted the company to reemphasize the creation of value through great customer experiences, and he wanted the company to do that as efficiently as possible. He first closed all Starbucks' stores for a day, and retrained baristas in the art of making coffee. A number of other changes followed. The company redesigned many of its stores to give them a contemporary feel. It stopped selling breakfast sandwiches because Schultz thought that the smell detracted from the premium coffeehouse experience. Instead of grinding enough coffee for an entire day, he told employees to grind more coffee each time a new pot was brewed to create the aroma of freshly brewed coffee. He gave store managers more freedom to decide on specific aspects of their stores, such as the type of artwork displayed. Starbucks also dramatically expanded its fair-trade policy, purchasing its coffee beans from growers adhering to environmentally friendly policies, and it promoted this to customers.

To reduce costs, Schultz announced the closure of 600 underperforming U.S. stores. Starbucks used the threat of possible closure to renegotiate many store leases at lower rates. It cut back on the number of suppliers of pastries and negotiated volume discounts. A lean thinking team was created, and it was tasked with the job of improving employee productivity; baristas needed to become more efficient. The team found that by making simple changes, such as placing commonly ordered syrup flavors closer to where drinks are made, they could shave several seconds off the time it took to make a drink, and give employees more time to interact with customers. Faster customer service meant higher customer satisfaction.

The results have been impressive. What was once nearly dismissed as a stale brand has been reinvigorated. Between 2008 and 2012, Starbucks' revenues expanded from $10.4 billion to $13.3 billion against the background of a weak economy, and ROIC surged from 8.6% to an impressive 26.13%.

Sources: J. Jargon, "Latest Starbucks Buzzword: Lean Japanese Techniques," *Wall Street Journal*, August 4, 2009, p. A1; J. Adamy, "Starbucks Moves to Cut Costs, Retain Customers," *Wall Street Journal*, December 5, 2008, p. B3; "Coffee Wars," *The Economist*, December 1, 2008, pp. 57–59; and R. Lowenstein, "What Latte Lost Its Luster," *Wall Street Journal*, March 29, 2011, p. A17.

CASE DISCUSSION QUESTIONS

1. What is the value that Starbucks creates for its customers? How does the company create this value?
2. How important have innovation, efficiency, quality, and customer responsiveness been to Starbucks' competitive position?
3. Does Starbucks have any distinctive competencies? If so, how do they affect the business?
4. Why do you think the performance of Starbucks started to decline after 2005? What was Schultz trying to do with the changes he made after 2008?

KEY TERMS

Distinctive competencies 83
Resources 83
Tangible resources 83
Intangible resources 83
Capabilities 83
Value chain 89
Primary activities 89
Support activities 91
Employee productivity 94
Product innovation 96
Process innovation 96
Customer response time 97
Barriers to imitation 104
Absorptive capacity 105
Total quality management xx

NOTES

[1]M. Cusumano, *The Japanese Automobile Industry* (Cambridge, Mass.: Harvard University Press, 1989); S. Spear and H. K. Bowen, "Decoding the DNA of the Toyota Production System," *Harvard Business Review* (September–October 1999): 96–108.

[2]The material in this section relies on the resource-based view of the company. For summaries of this perspective, see J. B. Barney, "Company Resources and Sustained Competitive Advantage," *Journal of Management* 17 (1991): 99–120; J. T. Mahoney and J. R. Pandian, "The Resource-Based View Within the Conversation of Strategic Management," *Strategic Management Journal* 13 (1992): 63–380; R. Amit and P. J. H. Schoemaker, "Strategic Assets and Organizational Rent," *Strategic Management Journal* 14 (1993): 33–46; M. A. Peteraf, "The Cornerstones of Competitive Advantage: A Resource-Based View," *Strategic Management Journal* 14 (1993): 179–191; B. Wernerfelt, "A Resource Based View of the Company," *Strategic Management Journal* 15 (1994): 171–180; and K. M. Eisenhardt and J. A. Martin, "Dynamic Capabilities: What Are They?" *Strategic Management Journal* 21 (2000): 1105–1121.

[4]For a discussion of organizational capabilities, see R. R. Nelson and S. Winter, *An Evolutionary Theory of Economic Change* (Cambridge, Mass.: Belknap Press, 1982).

[5]W. Chan Kim and R. Mauborgne, "Value Innovation: The Strategic Logic of High Growth," *Harvard Business Review,* January–February 1997, pp. 102–115.

[6]The concept of consumer surplus is an important one in economics. For a more detailed exposition, see D. Besanko, D. Dranove, and M. Shanley, *Economics of Strategy* (New York: Wiley, 1996).

[7]However, $P = U$ only in the special case when the company has a perfect monopoly and it can charge each customer a unique price that reflects the utility of the product to that

customer (i.e., where perfect price discrimination is possible). More generally, except in the limiting case of perfect price discrimination, even a monopolist will see most customers capture some of the utility of a product in the form of a consumer surplus.

[8]This point is central to the work of Michael Porter. See M. E. Porter, *Competitive Advantage* (New York: Free Press, 1985). See also P. Ghemawat, *Commitment: The Dynamic of Strategy* (New York: Free Press, 1991), chap. 4.

[9]Oliver Wyman, "The Harbor Report," 2008, www.oliverwyman.com/ow/automotive.htm.

[10]Porter, *Competitive Advantage.*

[11]Ibid.

[12]This approach goes back to the pioneering work by K. Lancaster: *Consumer Demand, a New Approach* (New York: 1971).

[13]D. Garvin, "Competing on the Eight Dimensions of Quality," *Harvard Business Review,* November–December 1987, pp. 101–119; P. Kotler, *Marketing Management* (Millennium ed.) (Upper Saddle River, N.J.: Prentice Hall, 2000).

[14]C. K. Prahalad and M. S. Krishnan, "The New Meaning of Quality in the Information Age," *Harvard Business Review,* September–October 1999, pp. 109–118.

[15]See D. Garvin, "What Does Product Quality Really Mean,?" *Sloan Management Review* 26 (Fall 1984): 25–44; P. B. Crosby, *Quality Is Free* (New York: Mentor, 1980); and A. Gabor, *The Man Who Discovered Quality* (New York: Times Books, 1990).

[16]M. Cusumano, *The Japanese Automobile Industry* (Cambridge, Mass.: Harvard University Press, 1989); and S. Spear and H. K. Bowen, "Decoding the DNA of the Toyota Production System," *Harvard Business Review,* September–October 1999, pp. 96–108.

[17]Kim and Mauborgne, "Value Innovation."

[18]G. Stalk and T. M. Hout, *Competing Against Time* (New York: Free Press, 1990).

[19]Ibid.

[20]Tom Copeland, Tim Koller, and Jack Murrin, *Valuation: Measuring and Managing the Value of Companies* (New York: Wiley, 1996). See also S. F. Jablonsky and N. P. Barsky, *The Manager's Guide to Financial Statement Analysis* (New York: Wiley, 2001).

[21]Copeland, Koller, and Murrin, *Valuation.*

[22]This is done as follows. Signifying net profit by π, invested capital by K, and revenues by R, then ROIC $= \pi/K$. If we multiply through by revenues, R, this becomes $R \times (K) = (\pi \times R)/(K \times R)$, which can be rearranged as $\pi/R \times R/K$, where π/R is the return on sales and R/K is capital turnover.

[23]Note that Figure 3.9 is a simplification and ignores some other important items that enter the calculation, such as depreciation/sales (a determinant of ROS) and other assets/sales (a determinant of capital turnover).

[24]This is the nature of the competitive process. For more detail, see C. W. L. Hill and D. Deeds, "The Importance of Industry Structure for the Determination of Company Profitability: A Neo-Austrian Perspective," *Journal of Management Studies* 33 (1996): 429–451.

[25]As with resources and capabilities, so the concept of barriers to imitation is also grounded in the resource-based view of the company. For details, see R. Reed and R. J. DeFillippi, "Causal Ambiguity, Barriers to Imitation, and Sustainable Competitive Advantage," *Academy of Management Review* 15 (1990): 88–102.

[26]E. Mansfield, "How Economists See R&D," *Harvard Business Review,* November–December 1981, pp. 98–106.

[27]S. L. Berman, J. Down, and C. W. L. Hill, "Tacit Knowledge as a Source of Competitive Advantage in the National Basketball Association," *Academy of Management Journal* 45:1 (2002): 13–33.

[28]P. Ghemawat, *Commitment: The Dynamic of Strategy* (New York: Free Press, 1991).

[29]W. M. Cohen and D. A. Levinthal, "Absorptive Capacity: A New Perspective on Learning and Innovation," *Administrative Science Quarterly* 35 (1990): 128–152.

[30]M. T. Hannah and J. Freeman, "Structural Inertia and Organizational Change," *American Sociological Review* 49 (1984): 149–164.

[31]See "IBM Corporation," Harvard Business School Case #180-034.

[32]Ghemawat, *Commitment.*

[33]D. Miller, *The Icarus Paradox* (New York: HarperBusiness, 1990).

[34]P. M. Senge, *The Fifth Discipline: The Art and Practice of the Learning Organization* (New York: Doubleday, 1990).

[35]The classic statement of this position was made by A. A. Alchain, "Uncertainty, Evolution, and Economic Theory," *Journal of Political Economy* 84 (1950): 488–500.

4

Building Competitive Advantage Through Functional-Level Strategies

LEARNING OBJECTIVES

After reading this chapter you should be able to:

4-1 Explain how an enterprise can use functional-level strategies to increase its efficiency

4-2 Explain how an enterprise can use functional-level strategies to increase its quality

4-3 Explain how an enterprise can use functional-level strategies to increase its innovation

4-4 Explain how an enterprise can use functional-level strategies to increase its customer responsiveness

Amazon.Com

When Jeff Bezos started Amazon.com back in 1995, the online retailer focused just on selling books. Music and videos were soon added to the mix. Today, you can purchase a wide range of media and general-merchandise products from Amazon, which is now the world's largest online retailer, with over $60 billion in annual sales. According to Bezos, Amazon's success is based on three main factors: a relentless focus on delivering value to customers, operating efficiencies, and a willingness to innovate.

Amazon offers customers a much wider selection of merchandise than they can find in a physical store, and does so at a low price. Online shopping and purchasing is made easy with a user-friendly interface, product recommendations, customer wish lists, and a one-click purchasing option for repeat customers. The percentage of traffic that Amazon gets from search engines such as Google has been falling for several years, whereas other online retailers are becoming more dependent on third-party search engines. This indicates that Amazon is increasingly becoming the starting point for online purchases. As a result, its active customer base in now approaching 200 million.

To deliver products to customers quickly and accurately, Amazon has been investing heavily in a network of distribution centers. In the United States alone there are now over 40 such centers. Sophisticated software analyzes customer purchasing patterns and tells the company what to order, where to store it in the distribution network, what to charge for it, and when to mark it down to shift it. The goal is to reduce inventory holding costs while always having product in stock. The increasingly dense network of distribution centers enables Amazon to reduce the time it takes to deliver products to

consumers and to cut down on delivery costs. As Amazon becomes larger, it can support a denser distribution network, which it turn enables it to fulfill customer orders more rapidly, and at a lower cost, thereby solidifying its competitive advantage over smaller rivals.

To make its distribution centers work more efficiently, Amazon is embracing automation. Until recently, most of the picking and packing of products at Amazon distribution centers was done by hand, with employees walking as much as 20 miles a shift to pick merchandise off shelves and bring it to packing stations. Although walking 20 miles a day may be good for the physical health of employees, it represents a lot of wasted time and hurts productivity. In 2012 Amazon purchased Kiva, a leading manufacturer of robots that service warehouses. Kiva has announced that for the next 2 to 3 years, it will not take any external orders, and instead focus on automating Amazon's distribution centers. Kiva's robots pick products from shelves and deliver them to packing stations. This reduces the number of employees needed per distribution center by 30 to 40%, and boosts productivity accordingly.

On the innovation front, Amazon has been a leader in pushing the digitalization of media. Its invention of the Kindle digital reader, and the ability of customers to use that reader either on a dedicated Kindle device or on a general-purpose device such as an iPad, turbo charged the digital distribution of books, a market segment where Amazon is the clear leader. Digitalization of books is disrupting the established book retailing industry and strengthening Amazon's advantage in this segment. To store digital media, from books to films and music, and to enable rapid customer download, Amazon has built huge server farms. Its early investment in "cloud-based" infrastructure has turned Amazon into a leader in this field. It is now leveraging its expertise and infrastructure to build another business. Known as Amazon Web Services (AWS), Amazon will host websites, data, and associated software for other companies. In 2012 this new business generated $2.1 billion in revenues, making Amazon one of the early leaders in the emerging field of cloud computing. By 2015, analysts predict that AWS will be a $15 billion business. Jeff Bezos is on record as stating that he believes AWS will ultimately match Amazon's online retail business in sales volume.

Sources: "Amazon to Add 18 New Distribution Centers," *Supply Chain Digest*, August 7, 2012; Adam Lashinsky, "Jeff Bezos: The Ultimate Disrupter," *Fortune*, December 3, 2012, pp. 34–41; S. Banker, "The New Amazon Distribution Model," *Logistics Viewpoints*, August 6, 2012; and G. A. Fowler, "Holiday Hiring Call: People Vs Robots," *Wall Street Journal*, December 10, 2010, p. B1.

OVERVIEW

In this chapter, we take a close look at **functional-level strategies**: those aimed at improving the effectiveness of a company's operations and its ability to attain superior efficiency, quality, innovation, and customer responsiveness.

It is important to keep in mind the relationships between functional strategies, distinctive competencies, differentiation, low cost, value creation, and profitability (see Figure 4.1). Distinctive competencies shape the functional-level strategies that a company can pursue. Managers, through their choices related to functional-level strategies, can build resources

functional-level strategies
Strategy aimed at improving the effectiveness of a company's operations and its ability to attain superior efficiency, quality, innovation, and customer responsiveness.

Figure 4.1

The Roots of Competitive Advantage

and capabilities that enhance a company's distinctive competencies. Also, note that a company's ability to attain superior efficiency, quality, innovation, and customer responsiveness will determine if its product offering is differentiated from that of rivals, and if it has a low-cost structure. Recall that companies that increase the value (utility) consumers get from their products through differentiation, while simultaneously lowering their cost structure, create more value than their rivals—and this leads to a competitive advantage, superior profitability, and profit growth.

The Opening Case illustrates some of these relationships. Amazon has always focused on customer responsiveness. Its wide product selection, low prices, rapid order fulfillment, user-friendly interface, product recommendations, customer wish lists, and one-click purchasing option are all aspects of this. Taken together, these factors *differentiate* Amazon from its rivals in online and physical retailing. Over time, Amazon has also become increasingly efficient and effective at managing inventory and running its growing network of distribution centers. By opening more distribution centers and increasing the density of its distribution network, Amazon is able to deliver products to customers more rapidly (boosting customer satisfaction) and to do so at a lower cost. The current strategy of automating much of the work at its distribution centers promises to further boost employee productivity. All of this helps Amazon to achieve a *low-cost* position. The company is also innovative, developing new products (the Kindle reader, digital downloads of books) and services (Amazon Web Services) that are helping it to solidify its competitive advantage.

Much of this chapter is devoted to looking at the basic strategies that can be adopted at the functional level to improve competitive position, as the Amazon.com example illustrates. By the end of this chapter, you will understand how functional-level strategies can be used to build a sustainable competitive advantage.

ACHIEVING SUPERIOR EFFICIENCY

A company is a device for transforming inputs (labor, land, capital, management, and technological knowhow) into outputs (the goods and services produced). The simplest measure of efficiency is the quantity of inputs that it takes to produce a given output; that is, efficiency = outputs/inputs. The more efficient a company, the fewer the inputs required to produce a given output, and therefore the lower its cost structure. Put another way, an efficient company has higher productivity, and therefore lower costs, than its rivals. Here we review the steps that companies can take at the functional level to increase their efficiency and thereby lower cost structure.

Efficiency and Economies of Scale

Economies of scale are unit cost reductions associated with a large scale of output. You will recall from the last chapter that it is very important for managers to understand how the cost structure of their enterprise varies with output because this understanding should help to drive strategy. For example, if unit costs fall significantly as output is expanded—that is, if there are significant economies of scale—a company may benefit by keeping prices down and increasing volume.

One source of economies of scale is the ability to spread fixed costs over a large production volume. **Fixed costs** are costs that must be incurred to produce a product regardless of the level of output; examples are the costs of purchasing machinery, setting up machinery for individual production runs, building facilities, advertising, and research and development (R&D). For example, Microsoft spent approximately $5 billion to develop the latest version of its Windows operating system, Windows 8. It can realize substantial scale economies by distributing the fixed costs associated with developing the new operating system over the enormous unit sales volume it expects for this system (over 90% of the world's 1.6 billion personal computers [PCs] use the Windows operating system). These scale economies are significant because of the trivial incremental (or marginal) cost of producing additional copies of Windows 8. For example, once the master copy has been produced, original equipment manufacturers (OEMs) can install additional copies of Windows 8 on new PCs for a marginal cost of zero to Microsoft. The key to Microsoft's efficiency and profitability (and that of other companies with high fixed costs and trivial incremental or marginal costs) is to increase sales rapidly enough that fixed costs can be spread out over a large unit volume and substantial scale economies can be realized.

Another source of scale economies is the ability of companies producing in large volumes to achieve a greater division of labor and specialization. Specialization is said to have a favorable impact on productivity, primarily because it enables employees to become very skilled at performing a particular task. The classic example of such economies is Ford's Model T car. The Model T Ford was introduced in 1923, and was the world's first mass-produced car. Until 1923, Ford had made cars using an expensive hand-built craft production method. Introducing mass-production techniques allowed the company to achieve greater division of labor (it split assembly into small, repeatable tasks) and specialization, which boosted employee productivity. Ford was also able to distribute the fixed costs of developing a car and setting up production machinery over a large volume of output. As a result of these economies, the cost of manufacturing a car at Ford fell from $3,000 to less than $900 (in 1958 dollars).

The concept of scale economies is depicted in Figure 4.2, which illustrates that as a company increases its output, unit costs decrease. This process comes to an end at an

economies of scale
Reductions in unit costs attributed to a larger output.

fixed costs
Costs that must be incurred to produce a product regardless of the level of output.

Figure 4.2

Economies and Diseconomies of Scale

Economies of scale

Diseconomies of scale

Unit costs

$

0

Output

Q1

© Cengage Learning

diseconomies of scale

Unit cost increases associated with a large scale of output.

output of Q1, where all scale economies are exhausted. Indeed, at outputs of greater than Q1, the company may encounter **diseconomies of scale**, which are the unit cost increases associated with a large scale of output. Diseconomies of scale occur primarily because of the increased bureaucracy associated with large-scale enterprises and the managerial inefficiencies that can result.[1] Larger enterprises have a tendency to develop extensive managerial hierarchies in which dysfunctional political behavior is commonplace. Information about operating matters can accidentally and deliberately be distorted by the number of managerial layers through which the information must travel to reach top decision makers. The result is poor decision making. Therefore, past a specific point—such as Q1 in Figure 4.2—inefficiencies result from such developments, and outweigh any additional gains from economies of scale. As output expands, unit costs begin to rise.

Managers must know the extent of economies of scale, and where diseconomies of scale begin to occur. At Nucor Steel, for example, the realization that diseconomies of scale exist has led to the company's decision to build plants that only employ 300 individuals or less. The belief is that it is more efficient to build two plants, each employing 300 people, than one plant employing 600 people. Although the larger plant may theoretically make it possible to reap greater scale economies, Nucor's management believes that larger plants would suffer from the diseconomies of scale associated with larger organizational units.

Efficiency and Learning Effects

learning effects

Cost savings that come from learning by doing.

Learning effects are cost savings that come from learning by doing. Labor, for example, learns by repetition how to best carry out a task. Therefore, labor productivity increases over time, and unit costs decrease as individuals learn the most efficient way to perform a particular task. Equally important, management in new manufacturing facilities typically learns over time how best to run the new operation. Hence, production costs decline because of increasing labor productivity and management efficiency.

Figure 4.3 The Impact of Learning and Scale Economies on Unit Costs

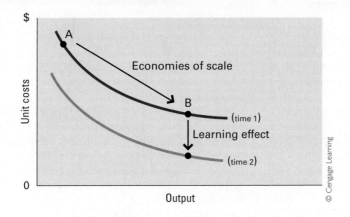

Japanese companies such as Toyota are noted for making learning a central part of their operating philosophy.

Learning effects tend to be more significant when a technologically complex task is repeated because there is more to learn. Thus, learning effects will be more significant in an assembly process that has 1,000 complex steps than in a process with 100 simple steps. Although learning effects are normally associated with the manufacturing process, there is plenty of evidence that they are just as important in service industries. One famous study of learning in the health-care industry discovered that more experienced medical providers posted significantly lower mortality rates for a number of common surgical procedures, suggesting that learning effects are at work in surgery.[2] The authors of this study used the evidence to argue in favor of establishing regional referral centers for the provision of highly specialized medical care. These centers would perform many specific surgical procedures (such as heart surgery), replacing local facilities with lower volumes and presumably higher mortality rates. Another recent study found strong evidence of learning effects in a financial institution. This study looked at a newly established document-processing unit with 100 staff members and found that, over time, documents were processed much more rapidly as the staff learned the process. Overall, the study concluded that unit costs decreased every time the cumulative number of documents processed doubled.[3] Strategy in Action 4.1 looks at the determinants of differences in learning effects across a sample of hospitals performing cardiac surgery.

In terms of the unit cost curve of a company, economies of scale imply a movement along the curve (say, from A to B in Figure 4.3). The realization of learning effects implies a downward shift of the entire curve (B to C in Figure 4.3) as both labor and management become more efficient over time at performing their tasks at every level of output. In accounting terms, learning effects in a production setting will reduce the cost of goods sold as a percentage of revenues, enabling the company to earn a higher return on sales and return on invested capital.

No matter how complex the task is, however, learning effects typically diminish in importance after a period of time. Indeed, it has been suggested that they are most important during the start-up period of a new process, and become trivial after 2 or 3 years.[4] When changes occur to a company's production system—as a result of the use of new information technology, for example—the learning process must begin again.

4.1 STRATEGY IN ACTION

Learning Effects in Cardiac Surgery

© iStockPhoto.com/Tom Nulens

A study carried out by researchers at the Harvard Business School tried to estimate the importance of learning effects in the case of a specific new technology for minimally invasive heart surgery that was approved by federal regulators. The researchers looked at 16 hospitals and obtained data on the operations for 660 patients. They examined how the time required to undertake the procedure varied with cumulative experience. Across the 16 hospitals, they found that average time decreased from 280 minutes for the first procedure with the new technology to 220 minutes once a hospital had performed 50 procedures (note that not all of the hospitals performed 50 procedures, and the estimates represent an extrapolation based on the data).

Next, the study observed differences across hospitals; here they found evidence of very large differences in learning effects. One hospital, in particular, stood out. This hospital, which they called "Hospital M," reduced its net procedure time from 500 minutes on case 1 to 132 minutes by case 50. Hospital M's 88-minute procedure time advantage over the average hospital at case 50 meant a cost savings of approximately $2,250 per case, which allowed surgeons at the hospital to complete one more revenue-generating procedure per day.

The researchers tried to find out why Hospital M was so superior. They noted that all hospitals had similar state-of-the-art operating rooms, all used the same set of devices approved by the Food and Drug Administration (FDA), all adopting surgeons completed the same training courses, and all surgeons came from highly respected training hospitals. Follow-up interviews, however, suggested that Hospital M differed in how it implemented the new procedure. The adopting surgeon handpicked the team that would perform the surgery. Members of the team had significant prior experience working together, which was a key criterion for member selection, and the team trained together to perform the new surgery. Before undertaking a single procedure, the entire team met with the operating room nurses and anesthesiologists to discuss the procedure. In addition, the adopting surgeon mandated that the surgical team and surgical procedure was stable in the early cases. The initial team completed 15 procedures before any new members were added or substituted, and completed 20 cases before the procedures were modified. The adopting surgeon also insisted that the team meet prior to each of the first 10 cases and after the first 20 cases to debrief.

The picture that emerges is one of a core team that was selected and managed to maximize the gains from learning. Unlike other hospitals where team members and procedures were less consistent, and where there was not the same attention to briefing, debriefing, and learning, surgeons at Hospital M learned much faster, and ultimately achieved higher productivity than their peers in other institutions. Clearly, differences in the implementation of the new procedure were very significant.

Source: G. P. Pisano, R. M. J. Bohmer, and A. C. Edmondson, "Organizational Differences in Rates of Learning: Evidence from the Adoption of Minimally Invasive Cardiac Surgery," *Management Science* 47 (2001): 752–768.

Efficiency and the Experience Curve

experience curve

The systematic lowering of the cost structure, and consequent unit cost reductions, that have been observed to occur over the life of a product.

The **experience curve** refers to the systematic lowering of the cost structure, and consequent unit cost reductions, that have been observed to occur over the life of a product.[5] According to the experience-curve concept, per-unit production costs for a product typically decline by some characteristic amount each time accumulated output of the product is doubled (accumulated output is the total output of a product since its introduction). This relationship was first observed in the aircraft industry, where it was found that each time the accumulated output of airframes doubled, unit costs declined to 80% of their previous level.[6] As such, the 4th airframe typically cost only 80% of the 2nd airframe to produce, the 8th airframe only 80% of the 4th,

Figure 4.4

The Experience Curve

the 16th only 80% of the 8th, and so on. The outcome of this process is a relationship between unit manufacturing costs and accumulated output similar to the illustration in Figure 4.4. Economies of scale and learning effects underlie the experience-curve phenomenon. Put simply, as a company increases the accumulated volume of its output over time, it is able to realize both economies of scale (as volume increases) and learning effects. Consequently, unit costs and cost structure fall with increases in accumulated output.

The strategic significance of the experience curve is clear: increasing a company's product volume and market share will lower its cost structure relative to its rivals. In Figure 4.4, Company B has a cost advantage over Company A because of its lower cost structure, and because it is farther down the experience curve. This concept is very important in industries that mass-produce a standardized output, for example, the manufacture of semiconductor chips. A company that wishes to become more efficient and lower its cost structure must try to move down the experience curve as quickly as possible. This means constructing efficient scale manufacturing facilities (even before it has generated demand for the product), and aggressively pursuing cost reductions from learning effects. It might also need to adopt an aggressive marketing strategy, cutting prices drastically and stressing heavy sales promotions and extensive advertising, in order to build up demand and accumulated volume as quickly as possible. A company is likely to have a significant cost advantage over its competitors because of its superior efficiency once it is down the experience curve. For example, it has been argued that Intel uses such tactics to ride down the experience curve and gain a competitive advantage over its rivals in the market for microprocessors.[7]

It is worth emphasizing that this concept is just as important outside of manufacturing. For example, as it invests in its distribution network, online retailer Amazon is trying to both realize economies of scale (spreading the fixed costs of its distribution centers over a large sales volume) and improve the efficiency of its inventory management and order-fulfillment process at distribution centers (a learning effect). Together these two sources of cost savings should enable Amazon to ride down the experience curve ahead of its rivals, thereby gaining a low-cost position that enables it to make greater profits at lower prices than its rivals (see the Opening Case for details).

Managers should not become complacent about efficiency-based cost advantages derived from experience effects. First, because neither learning effects nor economies of scale are sustained forever, the experience curve is likely to bottom out at some point; it must do so by definition. When this occurs, further unit cost reductions from learning effects and economies of scale will be difficult to attain. Over time, other companies can lower their cost structures and match the cost leader. Once this happens, many low-cost companies can have cost parity with each other. In such circumstances, a sustainable competitive advantage must rely on strategic factors other than the minimization of production costs by using existing technologies—factors such as better responsiveness to customers, product quality, or innovation.

Second, cost advantages gained from experience effects can be made obsolete by the development of new technologies. For example, the large "big box" bookstores Borders and Barnes & Noble may have had cost advantages that were derived from economies of scale and learning. However, these cost advantages were reduced when Amazon utilized Web technology to start its online bookstore in 1994. By selling online, Amazon was able to offer a larger selection at a lower cost than its established rivals that had physical storefronts. When Amazon introduced its Kindle digital book reader in 2007, and started to sell books in digital form, it changed the basis of competition once more, effectively nullifying the experience-based advantage enjoyed by Borders and Barnes & Noble. By 2012, Borders was bankrupt, and Barnes & Noble was in financial trouble and closing stores. Amazon, in the meantime, has gone from strength to strength.

Efficiency, Flexible Production Systems, and Mass Customization

Central to the concept of economies of scale is the idea that a lower cost structure, through the mass production of a standardized output, is the best way to achieve high efficiency. The tradeoff implicit in this idea is between unit costs and product variety. Producing greater product variety from a factory implies shorter production runs, which implies an inability to realize economies of scale, and thus higher costs. That is, a wide product variety makes it difficult for a company to increase its production efficiency and reduce its unit costs. According to this logic, the way to increase efficiency and achieve a lower cost structure is to limit product variety and produce a standardized product in large volumes (see Figure 4.5a).

This view of production efficiency has been challenged by the rise of flexible production technologies. The term **flexible production technology** covers a range of technologies designed to reduce setup times for complex equipment, increase the use of individual machines through better scheduling, and improve quality control at all stages of the manufacturing process.[8] Flexible production technologies allow the company to produce a wider variety of end products at a unit cost that at one time could be achieved only through the mass production of a standardized output (see Figure 4.5b). Research suggests that the adoption of flexible production technologies may increase efficiency and lower unit costs relative to what can be achieved by the mass production of a standardized output, while at the same time enabling the company to customize its product offering to a much greater extent than was once thought possible. The term **mass customization** has been coined to describe the company's ability to use flexible manufacturing technology to reconcile two goals that were once thought to be incompatible: low cost and differentiation through product customization.[9]

Dell Computer is pursuing a mass-customization strategy when it allows its customers to build their own machines online. Dell keeps costs and prices under control by allowing customers to make choices within a limited menu of options (e.g., different amounts of memory, hard drive size, video card, microprocessor, etc). The result is to create more value for customers than is possible for rivals that sell a limited range of PC models through retail

flexible production technology
A range of technologies designed to reduce setup times for complex equipment, increase the use of individual machines through better scheduling, and improve quality control at all stages of the manufacturing process.

mass customization
The use of flexible manufacturing technology to reconcile two goals that were once thought to be incompatible: low cost, and differentiation through product customization.

Figure 4.5	Tradeoff Between Costs and Product Variety

(a) Traditional Manufacturing

$ / Unit costs

Total unit costs

Variety-related unit costs

Volume-related unit costs

Production volume and Product variety
Low → High

(b) Flexible Manufacturing

$ / Unit costs

Total unit costs

Volume-related unit costs

Variety-related unit costs

Production volume and Product variety
Low → High

© Cengage Learning

outlets. Similarly, Mars offers a service that enables customers to design their own "personalized" M&Ms over the Web. Called My M&Ms, customers can pick different colors and have messages or pictures printed on their M&Ms. Another example of mass customization is the Internet radio service Pandora, which is discussed in Strategy in Action 4.2.

The effects of installing flexible production technology on a company's cost structure can be dramatic. Over the last decade, the Ford Motor Company has been introducing flexible production technologies into its automotive plants around the world. These technologies have enabled Ford to produce multiple models from the same line and to switch production from one model to another much more quickly than in the past. Ford took $2 billion out of its cost structure between 2006 and 2010 through flexible manufacturing, and is striving to take out more.[10]

Marketing and Efficiency

The marketing strategy that a company adopts can have a major impact on efficiency and cost structure. **Marketing strategy** refers to the position that a company takes with regard to market segmentation, pricing, promotion, advertising, product design, and distribution. Some of the steps leading to greater efficiency are fairly obvious. For example, moving down the experience curve to achieve a lower cost structure can be facilitated by aggressive pricing, promotions, and advertising—all of which are the task of the marketing function. Other aspects of marketing strategy have a less obvious—but no less important impact—on efficiency. One important aspect is the relationship of customer defection rates, cost structure, and unit costs.[11]

Customer defection (or "churn rates") are the percentage of a company's customers who defect every year to competitors. Defection rates are determined by customer loyalty, which in turn is a function of the ability of a company to satisfy its customers. Because

marketing strategy
The position that a company takes with regard to pricing, promotion, advertising, product design, and distribution.

customer defection
Rate percentage of a company's customers who defect every year to competitors.

4.2 STRATEGY IN ACTION

Pandora: Mass Customizing Internet Radio

© iStockPhoto.com/Tom Nulens

M4OS Photos/Alamy

Pandora Media streams music to PCs and mobile devices. Customers start by typing in the kind of music that they want to listen to. With a database of over 100,000 artists, there is a good chance that Pandora has something for you, however obscure your tastes. Customers can then rate the music that Pandora plays for them (thumbs up or down). Pandora takes this feedback and refines the music it streams to a customer. The company also uses sophisticated predictive statistical analysis (what do other customers who also like this song listen to?) and product analysis (what Pandora calls its Music Genome, which analyzes songs and identifies similar songs) to further customize the experience for the individual listener. The Music Genome has the added benefit of introducing listeners to new songs they might like based on an analysis of their listening habits. The result is a radio station that is uniquely tuned into each individual's unique listening preferences. This is mass customization at its most pure.

Started in 2000, by late 2012 Pandora's annualized revenue run rate was close to 500 million. There were 175 million registered users and 63 million active users, giving Pandora a 75% share of the online radio market in the United States. Pandora's revenue comes primarily from advertising, although premium subscribers can pay $36 a year and get commercial-free music.

Despite its rapid growth—a testament to the value of mass customization—Pandora does have its problems. Pandora pays more than half of its revenue in royalties to music publishers. By comparison, satellite radio company Sirius-XM pays out only 7.5% of its revenue in the form of royalties, and cable companies that stream music pay only 15%. The different royalty rates are due to somewhat arcane regulations under which three judges who serve on the Copyright Royalty Board, an arm of the Library of Congress, set royalty fees for radio broadcasters. This method of setting royalty rates has worked against Pandora, although the company is lobbying hard to have the law changed. Pandora is also facing growing competition from Spotify and Rdio, two customizable music-streaming services that have sold equity stakes to recording labels in exchange for access to their music libraries. There are also reports that Apple will soon be offering its own customizable music-streaming service. Whatever happens to Pandora in the long run, however, it would seem that the mass customization of Internet radio is here to stay.

Soures: A. Fixmer, "Pandora Is Boxed in by High Royalty Fees," *Bloomberg Businessweek*, December 24, 2012; E. Smith and J. Letzing, "At Pandora Each Sales Drives up Losses," *Wall Street Journal*, December 6, 2012; and E. Savitz, "Pandora Swoons on Weak Outlook," *Forbes.com*, December 5, 2012.

acquiring a new customer often entails one-time fixed costs, there is a direct relationship between defection rates and costs. For example, when a wireless service company signs up a new subscriber, it has to bear the administrative costs of opening up a new account and the cost of a subsidy that it pays to the manufacturer of the handset the new subscriber decides to use. There are also the costs of advertising and promotions designed to attract new subscribers. The longer a company retains a customer, the greater the volume of customer-generated unit sales that can be set against these fixed costs, and the lower the average unit cost of each sale. Thus, lowering customer defection rates allows a company to achieve a lower cost structure.

Figure 4.6	The Relationship Between Customer Loyalty and Profit per Customer

© Cengage Learning

One consequence of the defection–cost relationship depicted is illustrated in Figure 4.6. Because of the relatively high fixed costs of acquiring new customers, serving customers who stay with the company only for a short time before switching to competitors often leads to a loss on the investment made to acquire those customers. The longer a customer stays with the company, the more the fixed costs of acquiring that customer can be distributed over repeat purchases, boosting the profit per customer. Thus, there is a positive relationship between the length of time that a customer stays with a company and profit per customer. If a company can reduce customer defection rates, it can make a much better return on its investment in acquiring customers, and thereby boost its profitability.

For an example, consider the credit card business.[12] Most credit card companies spend an average of $50 per customer for recruitment and new account setup. These costs are derived from the advertising required to attract new customers, the credit checks required for each customer, and the mechanics of setting up an account and issuing a card. These one-time fixed costs can be recouped only if a customer stays with the company for at least 2 years. Moreover, when customers stay a second year, they tend to increase their use of the credit card, which raises the volume of revenues generated by each customer over time. As a result, although the credit card business loses $50 per customer in year 1, it makes a profit of $44 in year 3 and $55 in year 6.

Another economic benefit of long-time customer loyalty is the free advertising that customers provide for a company. Loyal customers can dramatically increase the volume of business through referrals. A striking example is Britain's largest retailer, the clothing and food company Marks & Spencer, whose success is built on a well-earned reputation for providing its customers with high-quality goods at reasonable prices. The company has generated such customer loyalty that it does not need to advertise in Britain, a major source of cost savings.

The key message, then, is that reducing customer defection rates and building customer loyalty can be major sources of a lower cost structure. One study has estimated that a 5% reduction in customer defection rates leads to the following increases in profits per customer over average customer life: 75% in the credit card business, 50% in the insurance brokerage industry, 45% in the industrial laundry business, and 35% in the computer software industry.[13]

A central component of developing a strategy to reduce defection rates is to identify customers who have defected, find out why they defected, and act on that information so that other customers do not defect for similar reasons in the future. To take these measures, the marketing function must have information systems capable of tracking customer defections.

MATERIALS MANAGEMENT, JUST-IN-TIME SYSTEMS, AND EFFICIENCY

The contribution of materials management (logistics) to boosting the efficiency of a company can be just as dramatic as the contribution of production and marketing. Materials management encompasses the activities necessary to get inputs and components to a production facility (including the costs of purchasing inputs), through the production process, and out through a distribution system to the end-user.[14] Because there are so many sources of cost in this process, the potential for reducing costs through more efficient materials-management strategies is enormous. For a typical manufacturing company, materials and transportation costs account for 50 to 70% of its revenues, so even a small reduction in these costs can have a substantial impact on profitability. According to one estimate, for a company with revenues of $1 million, a return on invested capital of 5%, and materials-management costs that amount to 50% of sales revenues (including purchasing costs), increasing total profits by $15,000 would require either a 30% increase in sales revenues or a 3% reduction in materials costs.[15] In a typical competitive market, reducing materials costs by 3% is usually much easier than increasing sales revenues by 30%.

just-in-time (JIT) inventory system

System of economizing on inventory holding costs by scheduling components to arrive just in time to enter the production process or as stock is depleted.

Improving the efficiency of the materials-management function typically requires the adoption of a just-in-time (JIT) inventory system, which is designed to economize on inventory holding costs by scheduling components to arrive at a manufacturing plant just in time to enter the production process, or to have goods arrive at a retail store only when stock is almost depleted. The major cost saving comes from increasing inventory turnover, which reduces inventory holding costs, such as warehousing and storage costs, and the company's need for working capital. For example, through efficient logistics, Wal-Mart can replenish the stock in its stores at least twice a week; many stores receive daily deliveries if they are needed. The typical competitor replenishes its stock every 2 weeks, so it must carry a much higher inventory, which requires more working capital per dollar of sales. Compared to its competitors, Wal-Mart can maintain the same service levels with a lower investment in inventory, a major source of its lower cost structure. Thus, faster inventory turnover has helped Wal-Mart achieve an efficiency-based competitive advantage in the retailing industry.[16]

More generally, in terms of the profitability model developed in Chapter 3, JIT inventory systems reduce the need for working capital (because there is less inventory to finance) and the need for fixed capital to finance storage space (because there is less to store), which reduces capital needs, increases capital turnover, and, by extension, boosts the return on invested capital.

The drawback of JIT systems is that they leave a company without a buffer stock of inventory. Although buffer stocks are expensive to store, they can help a company prepare for shortages on inputs brought about by disruption among suppliers (for instance, a labor dispute at a key supplier), and can help a company respond quickly to increases in demand. However, there are ways around these limitations. For example, to reduce the risks linked

to dependence on just one supplier for an important input, a company might decide to source inputs from multiple suppliers.

Recently, the efficient management of materials and inventory has been recast in terms of **supply chain management**: the task of managing the flow of inputs and components from suppliers into the company's production processes to minimize inventory holding and maximize inventory turnover. Dell, whose goal is to streamline its supply chain to such an extent that it "replaces inventory with information," is exemplary in terms of supply chain management.

R&D Strategy and Efficiency

The role of superior research and development (R&D) in helping a company achieve a greater efficiency and a lower cost structure is twofold. First, the R&D function can boost efficiency by designing products that are easy to manufacture. By cutting down on the number of parts that make up a product, R&D can dramatically decrease the required assembly time, which results in higher employee productivity, lower costs, and higher profitability. For example, after Texas Instruments redesigned an infrared sighting mechanism that it supplies to the Pentagon, it found that it had reduced the number of parts from 47 to 12, the number of assembly steps from 56 to 13, the time spent fabricating metal from 757 minutes per unit to 219 minutes per unit, and unit assembly time from 129 minutes to 20 minutes. The result was a substantial decline in production costs. Design for manufacturing requires close coordination between the production and R&D functions of the company. Cross-functional teams that contain production and R&D personnel who work jointly can best achieve this.

Pioneering process innovations is the second way in which the R&D function can help a company achieve a lower cost structure. A process innovation is a new, unique way that production processes can operate to improve their efficiency. Process innovations have often been a major source of competitive advantage. Toyota's competitive advantage is based partly on the company's invention of new flexible manufacturing processes that dramatically reduce setup times. This process innovation enabled Toyota to obtain efficiency gains associated with flexible manufacturing systems years ahead of its competitors.

Human Resource Strategy and Efficiency

Employee productivity is one of the key determinants of an enterprise's efficiency, cost structure, and profitability.[17] Productive manufacturing employees can lower the cost of goods sold as a percentage of revenues, a productive sales force can increase sales revenues for a given level of expenses, and productive employees in the company's R&D function can boost the percentage of revenues generated from new products for a given level of R&D expenses. Thus, productive employees lower the costs of generating revenues, increase the return on sales, and, by extension, boost the company's return on invested capital. The challenge for a company's human resource function is to devise ways to increase employee productivity. Among its choices are using certain hiring strategies, training employees, organizing the workforce into self-managing teams, and linking pay to performance.

Hiring Strategy Many companies that are well known for their productive employees devote considerable attention to hiring. Southwest Airlines hires people who have a positive attitude and who work well in teams because it believes that people who have a positive attitude will work hard and interact well with customers, therefore helping

supply chain management
The task of managing the flow of inputs and components from suppliers into the company's production processes to minimize inventory holding and maximize inventory turnover.

to create customer loyalty. Nucor hires people who are self-reliant and goal-oriented, because its employees, who work in self-managing teams, require these skills to perform well. As these examples suggest, it is important to be sure that the hiring strategy of the company is consistent with its own internal organization, culture, and strategic priorities. The people a company hires should have attributes that match the strategic objectives of the company.

Employee Training Employees are a major input into the production process. Those who are highly skilled can perform tasks faster and more accurately, and are more likely to learn the complex tasks associated with many modern production methods than individuals with lesser skills. Training upgrades employee skill levels, bringing the company productivity-related efficiency gains from learning and experimentation.[18]

self-managing teams
Teams where members coordinate their own activities and make their own hiring, training, work, and reward decisions.

Self-Managing Teams The use of **self-managing teams**, whose members coordinate their own activities and make their own hiring, training, work, and reward decisions, has been spreading rapidly. The typical team comprises 5 to 15 employees who produce an entire product or undertake an entire task. Team members learn all team tasks and rotate from job to job. Because a more flexible workforce is one result, team members can fill in for absent coworkers and take over managerial duties such as scheduling work and vacation, ordering materials, and hiring new members. The greater responsibility thrust on team members and the empowerment it implies are seen as motivators. (*Empowerment* is the process of giving lower-level employees decision-making power.) People often respond well to being given greater autonomy and responsibility. Performance bonuses linked to team production and quality targets work as an additional motivator.

The effect of introducing self-managing teams is reportedly an increase in productivity of 30% or more and a substantial increase in product quality. Further cost savings arise from eliminating supervisors and creating a flatter organizational hierarchy, which also lowers the cost structure of the company. In manufacturing companies, perhaps the most potent way to lower the cost structure is to combine self-managing teams with flexible manufacturing cells. For example, after the introduction of flexible manufacturing technology and work practices based on self-managing teams, a General Electric (GE) plant in Salisbury, North Carolina, increased productivity by 250% compared with GE plants that produced the same products 4 years earlier.[19]

Still, teams are no panacea; in manufacturing companies, self-managing teams may fail to live up to their potential unless they are integrated with flexible manufacturing technology. Also, teams place a lot of management responsibilities upon team members, and helping team members to cope with these responsibilities often requires substantial training—a fact that many companies often forget in their rush to drive down costs. Haste can result in teams that don't work out as well as planned.[20]

Pay for Performance It is hardly surprising that linking pay to performance can help increase employee productivity, but the issue is not quite so simple as just introducing incentive pay systems. It is also important to define what kind of job performance is to be rewarded and how. Some of the most efficient companies in the world, mindful that cooperation among employees is necessary to realize productivity gains, link pay to group or team (rather than individual) performance. Nucor Steel divides its workforce into teams of about 30, with bonus pay, which can amount to 30% of base pay, linked to the ability of the team to meet productivity and quality goals. This link creates a strong incentive for individuals to cooperate with each other in pursuit of team goals; that is, it facilitates teamwork.

FOCUS ON: Wal-Mart

Human Resource Strategy and Productivity at Wal-Mart

© iStockPhoto.com/caracterdesign

Wal-Mart has one of the most productive workforces of any retailer. The roots of Wal-Mart's high productivity go back to the company's early days and the business philosophy of the company's founder, Sam Walton. Walton started off his career as a management trainee at J.C. Penney. There he noticed that all employees were called associates, and moreover, that treating them with respect seemed to reap dividends in the form of high employee productivity.

When he founded Wal-Mart, Walton decided to call all employees "associates" to symbolize their importance to the company. He reinforced this by emphasizing that at Wal-Mart, "Our people make the difference." Unlike many managers who have stated this mantra, Walton believed it and put it into action. He believed that if you treat people well, they will return the favor by working hard, and that if you empower them, then ordinary people can work together to achieve extraordinary things. These beliefs formed the basis for a decentralized organization that operated with an open-door policy and open books. This allowed associates to see just how their stores and the company were doing.

Consistent with the open-door policy, Walton continually emphasized that management needed to listen to associates and their ideas. As he noted: "The folks on the front lines—the ones who actually talk to the customer—are the only ones who really know what's going on out there. You'd better find out what they know. This really is what total quality is all about. To push responsibility down in your organization, and to force good ideas to bubble up within it, you must listen to what your Associates are trying to tell you."

For all of his belief in empowerment, however, Walton was notoriously tight on pay. Walton opposed unionization, fearing that it would lead to higher pay and restrictive work rules that would sap productivity. The culture of Wal-Mart also encouraged people to work hard. One of Walton's favorite homilies was the "sundown rule," which stated that one should never leave until tomorrow what can be done today. The sundown rule was enforced by senior managers, including Walton, who would drop in unannounced at a store, peppering store managers and employees with questions, but at the same time praising them for a job well done and celebrating the "heroes" who took the sundown rule to heart, and did today what could have been done tomorrow.

The key to getting extraordinary effort out of employees, while paying them meager salaries, was to reward them with profit-sharing plans and stock-ownership schemes. Long before it became fashionable in American business, Walton was placing a chunk of Wal-Mart's profits into a profit-sharing plan for associates, and the company put matching funds into employee stock-ownership programs. The idea was simple: reward associates by giving them a stake in the company, and they will work hard for low pay, because they know they will make it up in profit sharing and stock price appreciation.

For years this formula worked extraordinarily well, but there are now signs that Wal-Mart's very success is creating problems. In 2012 the company had a staggering 2.2 million associates, making it the largest private employer in the world. As the company has grown, it has become increasingly difficult to hire the kinds of people that Wal-Mart has traditionally relied on—those willing to work long hours for low pay based on the promise of advancement and reward through profit sharing and stock ownership. The company has come under attack for paying its associates low wages and pressuring them to work long hours without overtime pay. Labor unions have made a concerted but so far unsuccessful attempt to unionize stores, and the company itself is the target of lawsuits from employees alleging sexual discrimination. Wal-Mart claims that the negative publicity is based on faulty data, and perhaps that is right, but if the company has indeed become too big to put Walton's principles into practice, the glory days may be over.

Sources: Sam Walton, *Made in America* (New York: Bantam, 1992), S. Maich, "Wal-Mart's Mid-Life Crisis," *Maclean's*, August 23, 2004, p. 45; "The People Make It All Happen," *Discount Store News*, October 1999, pp 103–106; and www.walmartstores.com.

Information Systems and Efficiency

With the rapid spread of computer use, the explosive growth of the Internet and corporate intranets (internal corporate computer networks based on Internet standards), and the spread of high-bandwidth fiber-optics and digital wireless technology, the information systems function has moved to center stage in the quest for operating efficiencies and a lower cost structure.[21] The impact of information systems on productivity is wide ranging and potentially affects all other activities of a company. For example, Cisco Systems was able to realize significant cost savings by moving its ordering and customer service functions online. The company found it could operate with just 300 service agents handling all of its customer accounts, compared to the 900 it would need if sales were not handled online. The difference represented an annual savings of $20 million a year. Moreover, without automated customer service functions, Cisco calculated that it would need at least 1,000 additional service engineers, which would cost around $75 million.[22]

Like Cisco, many companies are using Web-based information systems to reduce the costs of coordination between the company and its customers and the company and its suppliers. By using Web-based programs to automate customer and supplier interactions, they can substantially reduce the number of people required to manage these interfaces, thereby reducing costs. This trend extends beyond high-tech companies. Banks and financial service companies are finding that they can substantially reduce costs by moving customer accounts and support functions online. Such a move reduces the need for customer service representatives, bank tellers, stockbrokers, insurance agents, and others. For example, it costs an average of about $1.07 to execute a transaction at a bank, such as shifting money from one account to another; executing the same transaction over the Internet costs $0.01.[23]

Similarly, the theory behind Internet-based retailers such as Amazon.com is that replacing physical stores and their supporting personnel with an online virtual store and automated ordering and checkout processes allows a company to take significant costs out of the retailing system. Cost savings can also be realized by using Web-based information systems to automate many internal company activities, from managing expense reimbursements to benefits planning and hiring processes, thereby reducing the need for internal support personnel.

Infrastructure and Efficiency

A company's infrastructure—that is, its structure, culture, style of strategic leadership, and control system—determines the context within which all other value creation activities take place. It follows that improving infrastructure can help a company increase efficiency and lower its cost structure. Above all, an appropriate infrastructure can help foster a companywide commitment to efficiency, and promote cooperation among different functions in pursuit of efficiency goals. These issues are addressed at length in Chapters 12 and 13.

For now, it is important to note that strategic leadership is especially important in building a companywide commitment to efficiency. The leadership task is to articulate a vision that recognizes the need for all functions of a company to focus on improving efficiency. It is not enough to improve the efficiency of production, or of marketing, or of R&D in a piecemeal fashion. Achieving superior efficiency requires a companywide commitment to this goal that must be articulated by general and functional managers. A further leadership task is to facilitate the cross-functional cooperation needed to achieve superior efficiency.

For example, designing products that are easy to manufacture requires that production and R&D personnel communicate; integrating JIT systems with production scheduling requires close communication between materials management and production; and designing self-managing teams to perform production tasks requires close cooperation between human resources and production.

Summary

Table 4.1 summarizes the primary roles of various functions in achieving superior efficiency. Keep in mind that achieving superior efficiency is not something that can be tackled on a function-by-function basis. It requires an organization-wide commitment and an ability to ensure close cooperation among functions. Top management, by exercising leadership and influencing the infrastructure, plays a significant role in this process.

Table 4.1	Primary Roles of Value Creation Functions in Achieving Superior Efficiency
Value Creation Function	**Primary Roles**
Infrastructure (leadership)	1. Provide company-wide commitment to efficiency
	2. Facilitate cooperation among functions
Production	1. Where appropriate, pursue economies of scale and learning economics
	2. Implement flexible manufacturing systems
Marketing	1. Where appropriate, adopt aggressive marketing to ride down the experience curve
	2. Limit customer defection rates by building brand loyalty
Materials management	1. Implement JIT systems
	2. Implement supply-chain coordination
R&D	1. Design products for ease of manufacture
	2. Seek process innovations
Information systems	1. Use information systems to automate processes
	2. Use information systems to reduce costs of coordination
Human resources	1. Institute training programs to build skills
	2. Implement self-managing teams
	3. Implement pay for performance

© Cengage Learning

ACHIEVING SUPERIOR QUALITY

In Chapter 3, we noted that quality can be thought of in terms of two dimensions: *quality as reliability* and *quality as excellence*. High-quality products are reliable, do well the job for which they were designed, and are perceived by consumers to have superior attributes. We also noted that superior quality provides a company with two advantages. First, a strong reputation for quality allows a company to differentiate its products from those offered by rivals, thereby creating more value in the eyes of customers, and giving the company the option of charging a premium price for its products. Second, eliminating defects or errors from the production process reduces waste, increases efficiency, lowers the cost structure of the company, and increases its profitability. For example, reducing the number of defects in a company's manufacturing process will lower the cost of goods sold as a percentage of revenues, thereby raising the company's return on sales and return on invested capital. In this section, we look in more depth at what managers can do to enhance the reliability and other attributes of the company's product offering.

Attaining Superior Reliability

total quality management
increasing product reliability so that it consistently performs as it was designed to and rarely breaks down.

The principal tool that most managers now use to increase the reliability of their product offering is the Six Sigma quality improvement methodology. The Six Sigma methodology is a direct descendant of the **total quality management** (TQM) philosophy that was widely adopted, first by Japanese companies and then by American companies, during the 1980s and early 1990s.[24] The TQM concept was developed by a number of American management consultants, including W. Edwards Deming, Joseph Juran, and A. V. Feigenbaum.[25]

Originally, these consultants won few converts in the United States. However, managers in Japan embraced their ideas enthusiastically, and even named their premier annual prize for manufacturing excellence after Deming. The philosophy underlying TQM, as articulated by Deming, is based on the following five-step chain reaction:

1. Improved quality means that costs decrease because of less rework, fewer mistakes, fewer delays, and better use of time and materials.
2. As a result, productivity improves.
3. Better quality leads to higher market share and allows the company to raise prices.
4. Higher prices increase the company's profitability and allow it to stay in business.
5. Thus, the company creates more jobs.[26]

Deming identified a number of steps that should be part of any quality improvement program:

1. Management should embrace the philosophy that mistakes, defects, and poor-quality materials are not acceptable and should be eliminated.
2. Quality of supervision should be improved by allowing more time for supervisors to work with employees, and giving employees appropriate skills for the job.
3. Management should create an environment in which employees will not fear reporting problems or recommending improvements.
4. Work standards should not only be defined as numbers or quotas, but should also include some notion of quality to promote the production of defect-free output.
5. Management is responsible for training employees in new skills to keep pace with changes in the workplace.
6. Achieving better quality requires the commitment of everyone in the company.

Western businesses were blind to the importance of the TQM concept until Japan rose to the top rank of economic powers in the 1980s. Since that time, quality improvement programs have spread rapidly throughout Western industry. Strategy in Action 4.3 describes one of the most successful implementations of a quality improvement process, General Electric's Six Sigma program.

4.3 STRATEGY IN ACTION

General Electric's Six Sigma Quality Improvement Process

© iStockPhoto.com/Tom Nulens

Six Sigma, a quality and efficiency program adopted by many major corporations, including Motorola, General Electric, and AlliedSignal, aims to reduce defects, boost productivity, eliminate waste, and cut costs throughout a company. "Sigma" comes from the Greek letter that statisticians use to represent a standard deviation from a mean: the higher the number of sigmas, the smaller the number of errors. At Six Sigma, a production process would be 99.99966% accurate, creating just 3.4 defects per million units. Although it is almost impossible for a company to achieve such perfection, several companies strive toward that goal.

General Electric (GE) is perhaps the most well-known adopter of the Six Sigma program. Under the direction of long-serving CEO Jack Welch, GE spent nearly $1 billion to convert all of its divisions to the Six Sigma method.

One of the first products designed using Six Sigma processes was a $1.25 million diagnostic computer tomography (CT) scanner, the LightSpeed VCT, which produces rapid three-dimensional images of the human body. The new scanner captured multiple images simultaneously, requiring only 20 seconds to do full-body scans that once took 3 minutes—important because patients must remain perfectly still during the scan. GE spent $50 million to run 250 separate Six Sigma analyses designed to improve the reliability and lower the manufacturing cost of the new scanner. Its efforts were rewarded when LightSpeed VCT's first customers soon noticed that it ran without downtime between patients—a testament to the reliability of the machine.

Achieving that reliability took immense work. GE's engineers deconstructed the scanner into its basic components and tried to improve the reliability of each component through a detailed step-by-step analysis. For example, the most important part of CT scanners is the vacuum tubes that focus x-ray waves. The tubes that GE used in previous scanners, which cost $60,000 each, suffered from low reliability. Hospitals and clinics wanted the tubes to operate for 12 hours a day for at least 6 months, but typically they lasted only half that long. Moreover, GE was scrapping some $20 million in tubes each year because they failed preshipping performance tests, and disturbing numbers of faulty tubes were slipping past inspection, only to be determined as dysfunctional upon arrival.

To try to solve the reliability problem, the Six Sigma team took the tubes apart. They knew that one problem was a petroleum-based oil used in the tubes to prevent short circuits by isolating the anode (which has a positive charge) from the negatively charged cathode. The oil often deteriorated after a few months, leading to short circuits, but the team did not know why. By using statistical "what-if" scenarios on all parts of the tube, the researchers learned that the lead-based paint on the inside of the tube was contaminating the oil. Acting on this information, the team developed a paint that would preserve the tube and protect the oil.

By pursuing this and other improvements, the Six Sigma team was able to extend the average life of a vacuum tube in the CT scanner from 3 months to over 1 year. Although the improvements increased the cost of the tube from $60,000 to $85,000, the increased cost was outweighed by the reduction in replacement costs, making it an attractive proposition for customers.

Sources: C. H. Deutsch, "Six-Sigma Enlightenment," *New York Times,* December 7, 1998, p. 1; J. J. Barshay, "The Six-Sigma Story," *Star Tribune,* June 14, 1999, p. 1; D. D. Bak, "Rethinking Industrial Drives," *Electrical/Electronics Technology,* November 30, 1998, p. 58.

Implementing Reliability Improvement Methodologies

Among companies that have successfully adopted quality improvement methodologies, certain imperatives stand out. These are discussed in the following sections in the order in which they are usually tackled in companies implementing quality improvement programs. What needs to be stressed first, however, is that improvement in product reliability is a cross-functional process. Its implementation requires close cooperation among all functions in the pursuit of the common goal of improving quality; it is a process that works across functions. The roles played by the different functions in implementing reliability improvement methodologies are summarized in Table 4.2.

First, it is important that senior managers agree to a quality improvement program and communicate its importance to the organization. Second, if a quality improvement program is to be successful, individuals must be identified to lead the program. Under the Six Sigma methodology, exceptional employees are identified and put through a "black belt" training course on the Six Sigma methodology. The black belts are taken out of their normal job roles,

Table 4.2	Roles Played by Different Functions in Implementing Reliability Improvement Methodologies
Infrastructure (leadership)	1. Provide leadership and commitment to quality
	2. Find ways to measure quality
	3. Set goals and create incentives
	4. Solicit input from employees
	5. Encourage cooperation among functions
Production	1. Shorten production runs
	2. Trace defects back to the source
Marketing	1. Focus on the customer
	2. Provide customers' feedback on quality
Materials management	1. Rationalize suppliers
	2. Help suppliers implement quality-improvement methodologies
	3. Trace defects back to suppliers
R&D	1. Design products that are easy to manufacture
Information systems	1. Use information systems to monitor defect rates
Human resources	1. Institute quality-improvement training programs
	2. Identify and train "black belts"
	3. Organize employees into quality teams

© Cengage Learning

and assigned to work solely on Six Sigma projects for the next 2 years. In effect, the black belts become internal consultants *and* project leaders. Because they are dedicated to Six Sigma programs, the black belts are not distracted from the task at hand by day-to-day operating responsibilities. To make a black belt assignment attractive, many companies now endorse the program as an advancement in a career path. Successful black belts might not return to their prior job after 2 years, but could instead be promoted and given more responsibility.

Third, quality improvement methodologies preach the need to identify defects that arise from processes, trace them to their source, find out what caused the defects, and make corrections so that they do not recur. Production and materials management are primarily responsible for this task. To uncover defects, quality improvement methodologies rely upon the use of statistical procedures to pinpoint variations in the quality of goods or services. Once variations have been identified, they must be traced to their respective sources and eliminated.

One technique that helps greatly in tracing defects to the source is reducing lot sizes for manufactured products. With short production runs, defects show up immediately. Consequently, they can quickly be sourced, and the problem can be addressed. Reducing lot sizes also means that when defective products are produced, there will not be a large number produced, thus decreasing waste. Flexible manufacturing techniques can be used to reduce lot sizes without raising costs. JIT inventory systems also play a part. Under a JIT system, defective parts enter the manufacturing process immediately; they are not warehoused for several months before use. Hence, defective inputs can be quickly spotted. The problem can then be traced to the supply source and corrected before more defective parts are produced. Under a more traditional system, the practice of warehousing parts for months before they are used may mean that suppliers produce large numbers of defects before entering the production process.

Fourth, another key to any quality improvement program is to create a metric that can be used to measure quality. In manufacturing companies, quality can be measured by criteria such as defects per million parts. In service companies, suitable metrics can be devised with a little creativity. For example, one of the metrics Florida Power & Light uses to measure quality is meter-reading errors per month.

Fifth, once a metric has been devised, the next step is to set a challenging quality goal and create incentives for reaching it. Under Six Sigma programs, the goal is 3.4 defects per million units. One way of creating incentives to attain such a goal is to link rewards, such as bonus pay and promotional opportunities, to the goal.

Sixth, shop-floor employees can be a major source of ideas for improving product quality, so these employees must participate and must be incorporated into a quality improvement program.

Seventh, a major source of poor-quality finished goods is poor-quality component parts. To decrease product defects, a company must work with its suppliers to improve the quality of the parts they supply.

Eighth, the more assembly steps a product requires, the more opportunities there are for mistakes. Thus, designing products with fewer parts is often a major component of any quality improvement program.

Finally, implementing quality improvement methodologies requires organization-wide commitment and substantial cooperation among functions. R&D must cooperate with production to design products that are easy to manufacture; marketing must cooperate with production and R&D so that customer problems identified by marketing can be acted on; and human resource management must cooperate with all the other functions of the company in order to devise suitable quality-training programs.

Improving Quality as Excellence

As we stated in Chapter 3, a product is comprised of different attributes, and reliability is just one attribute, albeit an important one. Products can also be *differentiated* by attributes that collectively define product excellence. These attributes include the form, features, performance, durability, and styling of a product. In addition, a company can create quality as excellence by emphasizing attributes of the service associated with the product, such as ordering ease, prompt delivery, easy installation, the availability of customer training and consulting, and maintenance services. Dell Inc., for example, differentiates itself on ease of ordering (via the Web), prompt delivery, easy installation, and the ready availability of customer support and maintenance services. Differentiation can also be based on the attributes of the people in the company with whom customers interact when making a product purchase, such as their competence, courtesy, credibility, responsiveness, and communication. Singapore Airlines enjoys an excellent reputation for quality service, largely because passengers perceive their flight attendants as competent, courteous, and responsive to their needs. Thus, we can talk about the product attributes, service attributes, and personnel attributes associated with a company's product offering (see Table 4.3).

For a product to be regarded as high in the excellence dimension, a company's product offering must be seen as superior to that of rivals. Achieving a perception of high quality on any of these attributes requires specific actions by managers. First, it is important for managers to collect marketing intelligence indicating which of these attributes are most important to customers. For example, consumers of personal computers (PCs) may place a low weight on durability because they expect their PCs to be made obsolete by technological advances within 3 years, but they may place a high weight on features and performance. Similarly, ease of ordering and timely delivery may be very important attributes for customers of online booksellers (as they indeed are for customers of Amazon.com), whereas customer training and consulting may be very important attributes for customers who purchase complex business-to-business software to manage their relationships with suppliers.

Second, once the company has identified the attributes that are important to customers, it needs to design its products (and the associated services) in such a way that those attributes are embodied in the product. It also needs to make sure that personnel in the company

Table 4.3	Attributes Associated with a Product Offering	
Product Attributes	**Service Attributes**	**Associated Personnel Attributes**
Form	Ordering ease	Competence
Features	Delivery	Courtesy
Performance	Installation	Credibility
Durability	Customer training	Reliability
Reliability	Customer consulting	Responsiveness
Style	Maintenance and repair	Communication

© Cengage Learning

are appropriately trained so that the correct attributes are emphasized during design creation. This requires close coordination between marketing and product development (the topic of the next section) and the involvement of the human resource management function in employee selection and training.

Third, the company must decide which of the significant attributes to promote and how best to position them in the minds of consumers, that is, how to tailor the marketing message so that it creates a consistent image in the minds of customers.[27] At this point, it is important to recognize that although a product might be differentiated on the basis of six attributes, covering all of those attributes in the company's communication messages may lead to an unfocused message. Many marketing experts advocate promoting only one or two central attributes to customers. For example, Volvo consistently emphasizes the safety and durability of its vehicles in all marketing messages, creating the perception in the minds of consumers (backed by product design) that Volvo cars are safe and durable. Volvo cars are also very reliable and have high performance, but the company does not emphasize these attributes in its marketing messages. In contrast, Porsche emphasizes performance and styling in all of its marketing messages; thus, a Porsche is positioned differently in the minds of consumers than Volvo. Both are regarded as high-quality products because both have superior attributes, but the attributes that each of the two companies have chosen to emphasize are very different; they are differentiated from the average car in different ways.

Finally, it must be recognized that competition is not stationary, but instead continually produces improvement in product attributes, and often the development of new-product attributes. This is obvious in fast-moving high-tech industries where product features that were considered leading edge just a few years ago are now obsolete—but the same process is also at work in more stable industries. For example, the rapid diffusion of microwave ovens during the 1980s required food companies to build new attributes into their frozen food products: they had to maintain their texture and consistency while being cooked in the microwave; a product could not be considered high quality unless it could do that. This speaks to the importance of having a strong R&D function in the company that can work with marketing and manufacturing to continually upgrade the quality of the attributes that are designed into the company's product offerings. Exactly how to achieve this is covered in the next section.

ACHIEVING SUPERIOR INNOVATION

In many ways, innovation is the most important source of competitive advantage. This is because innovation can result in new products that better satisfy customer needs, can improve the quality (attributes) of existing products, or can reduce the costs of making products that customers want. The ability to develop innovative new products or processes gives a company a major competitive advantage that allows it to: (1) *differentiate* its products and charge a premium price, and/or (2) *lower its cost structure* below that of its rivals. Competitors, however, attempt to imitate successful innovations and often succeed. Therefore, maintaining a competitive advantage requires a continuing commitment to innovation.

Successful new-product launches are major drivers of superior profitability. Robert Cooper reviewed more than 200 new-product introductions and found that of those classified as successes, some 50% achieve a return on investment in excess of 33%, half have a payback period of 2 years or less, and half achieve a market share in excess of 35%.[28] Many companies have established a track record for successful innovation. Among them are Apple, whose successes include the iPod, iPhone, and iPad; Pfizer, a drug company

that during the 1990s and early 2000s produced eight new blockbuster drugs; 3M, which has applied its core competency in tapes and adhesives to developing a wide range of new products; Intel, which has consistently managed to lead in the development of innovative new microprocessors to run personal computers; and Cisco Systems, whose innovations in communications equipment helped to pave the way for the rapid growth of the Internet.

The High Failure Rate of Innovation

Although promoting innovation can be a source of competitive advantage, the failure rate of innovative new products is high. Research evidence suggests that only 10 to 20% of major R&D projects give rise to commercial products.[29] Well-publicized product failures include Apple's Newton, an early handheld computer that flopped in the market place; Sony's Betamax format in the videocassette recorder segment; Sega's Dreamcast video-game console; and Windows Mobile, an early smartphone operating system created by Microsoft that was made obsolete in the eyes of consumers by the arrival of Apple's iPhone. Although many reasons have been advanced to explain why so many new products fail to generate an economic return, five explanations for failure repeatedly appear.[30]

First, many new products fail because the demand for innovations is inherently uncertain. It is impossible to know prior to market introduction whether the new product has tapped an unmet customer need, and if there sufficient market demand to justify manufacturing the product. Although good market research can reduce the uncertainty about likely future demand for a new technology, that uncertainty cannot be fully eradicated; a certain failure rate is to be expected.

Second, new products often fail because the technology is poorly commercialized. This occurs when there is definite customer demand for a new product, but the product is not well adapted to customer needs because of factors such as poor design and poor quality. For instance, the failure of Microsoft to establish an enduring dominant position in the market for smartphones, despite the fact that phones using the Windows Mobile operating system were introduced in 2003, which was 4 years before Apple's iPhone hit the market, can be traced to its poor design. Windows Mobile phones had a physical keyboard, and a small and cluttered screen that was difficult to navigate, which made them unattractive to many consumers. In contrast, the iPhone's large touchscreen and associated keyboard was very appealing to many consumers, who rushed out to buy it in droves.

positioning strategy
The specific set of options a company adopts for a product based upon four main dimensions of marketing: price, distribution, promotion and advertising, and product features.

Third, new products may fail because of poor positioning strategy. **Positioning strategy** is the specific set of options a company adopts for a product based upon four main dimensions of marketing: price, distribution, promotion and advertising, and product features. Apart from poor design, another reason for the failure of Windows Mobile phones was poor positioning strategy. They were targeted at business users, whereas Apple developed a mass market by targeting the iPhone at retail consumers.

Fourth, many new-product introductions fail because companies often make the mistake of marketing a technology for which there is not enough demand. A company can become blinded by the wizardry of a new technology and fail to determine whether there is sufficient customer demand for the product. A classic example concerns the Segway two-wheeled personal transporter. Despite the fact that its gyroscopic controls were highly sophisticated, and that the product introduction was accompanied by massive media hype, sales fell well below expectations when it transpired that most consumers had no need for such a device.

Finally, companies fail when products are slowly marketed. The more time that elapses between initial development and final marketing—the slower the "cycle time"—the more

likely it is that a competitor will beat the company to market and gain a first-mover advantage.[31] In the car industry, General Motors long suffered from being a slow innovator. Its typical product development cycle used to be about 5 years, compared with 2 to 3 years at Honda, Toyota, and Mazda, and 3 to 4 years at Ford. Because GM's offerings were based on 5-year-old technology and design concepts, they are already out of date when they reached the market.

Reducing Innovation Failures

One of the most important things that managers can do to reduce the high failure rate associated with innovation is to make sure that there is tight integration between R&D, production, and marketing.[32] Tight cross-functional integration can help a company ensure that:

1. Product development projects are driven by customer needs.
2. New products are designed for ease of manufacture.
3. Development costs are not allowed to spiral out of control.
4. The time it takes to develop a product and bring it to market is minimized.
5. Close integration between R&D and marketing is achieved to ensure that product development projects are driven by the needs of customers.

A company's customers can be a primary source of new-product ideas. The identification of customer needs, and particularly unmet needs, can set the context within which successful product innovation takes place. As the point of contact with customers, the marketing function can provide valuable information. Moreover, integrating R&D and marketing is crucial if a new product is to be properly commercialized—otherwise, a company runs the risk of developing products for which there is little or no demand.

Integration between R&D and production can help a company to ensure that products are designed with manufacturing requirements in mind. Design for manufacturing lowers manufacturing costs and leaves less room for mistakes; thus it can lower costs and increase product quality. Integrating R&D and production can help lower development costs and speed products to market. If a new product is not designed with manufacturing capabilities in mind, it may prove too difficult to build with existing manufacturing technology. In that case, the product will need to be redesigned, and both overall development costs and time to market may increase significantly. Making design changes during product planning can increase overall development costs by 50% and add 25% to the time it takes to bring the product to market.[33]

One of the best ways to achieve cross-functional integration is to establish cross-functional product development teams composed of representatives from R&D, marketing, and production. The objective of a team should be to oversee a product development project from initial concept development to market introduction. Specific attributes appear to be important in order for a product development team to function effectively and meet all its development milestones.[34]

First, a project manager who has high status within the organization and the power and authority required to secure the financial and human resources that the team needs to succeed should lead the team and be dedicated primarily, if not entirely, to the project. The leader should believe in the project (be a champion for the project) and be skilled at integrating the perspectives of different functions and helping personnel from different functions work together for a common goal. The leader should also be able to act as an advocate of the team to senior management.

Second, the team should be composed of at least one member from each key function or position. Individual team members should have a number of attributes, including an

ability to contribute functional expertise, high standing within their function, a willingness to share responsibility for team results, and an ability to put functional advocacy aside. It is generally preferable if core team members are 100% dedicated to the project for its duration. This ensures that their focus is upon the project, not upon their ongoing individual work.

Third, the team members should be physically co-located to create a sense of camaraderie and facilitate communication. Fourth, the team should have a clear plan and clear goals, particularly with regard to critical development milestones and development budgets. The team should have incentives to attain those goals; for example, pay bonuses when major development milestones are attained. Fifth, each team needs to develop its own processes for communication, as well as conflict resolution. For example, one product development team at Quantum Corporation, a California-based manufacturer of disk drives for personal

4.4 STRATEGY IN ACTION

© iStockPhoto.com/Tom Nulens

Corning—learning from Innovation Failures

In 1998, Corning, then the world's largest supplier of fiber-optic cable, decided to diversify and develop and manufacture DNA microarrays (DNA chips). DNA chips are used to analyze the function of genes, and are an important research tool in the development processes for pharmaceutical drugs. Corning tried to develop a DNA chip that could print all 28,000 human genes onto a set of slides. By 2000, Corning had invested over $100 million in the project and its first chips were on the market, but the project was a failure and in 2001 it was pulled.

What went wrong? Corning was late to market—a critical mistake. Affymetrix, which had been in the business since the early 1990s, dominated the market. By 2000, Affymetrix's DNA chips were the dominant design—researchers were familiar with them, they performed well, and few people were willing to switch to chips from unproven competitors. Corning was late because it adhered to its long-established innovation processes, which were not entirely appropriate in the biological sciences. In particular, Corning's own in-house experts in the physical sciences insisted on sticking to rigorous quality standards that customers and life scientists felt were higher than necessary. These quality standards proved to be very difficult to achieve, and as a result, the product launch was delayed, giving Affymetrix time to consolidate its hold on the market.

Additionally, Corning failed to allow potential customers to review prototypes of its chips, and consequently, it missed incorporating some crucial features that customers wanted.

After reviewing this failure, Corning decided that in the future, it needed to bring customers into the development process earlier. The company also needed to hire additional outside experts if it planned to diversify into an area where it lacked competencies—and to allow those experts extensive input in the development process.

The project was not a total failure, however, for through it Corning discovered a vibrant and growing market—the market for drug discovery. By combining what it had learned about drug discovery with another failed business, photonics, which manipulates data using light waves, Corning created a new product called "Epic." Epic is a revolutionary technology for drug testing that uses light waves instead of fluorescent dyes (the standard industry practice). Epic promises to accelerate the process of testing potential drugs and save pharmaceutical companies valuable R&D money. Unlike in its DNA microarray project, Corning had 18 pharmaceutical companies test Epic before development was finalized. Corning used this feedback to refine Epic. The product is now an important product offering for the company.

Sources: V. Govindarajan and C. Trimble, "How Forgetting Leads to Innovation," *Chief Executive*, March 2006, pp. 46–50; and J. McGregor, "How Failure Breeds Success," *Business Week*, July 10, 2006, pp. 42–52.

computers, mandated that all major decisions would be made and conflicts resolved during meetings that were held every Monday afternoon. This simple rule helped the team to meet its development goals.[35]

Finally, there is sufficient evidence that developing competencies in innovation requires managers to proactively learn from their experience with product development, and to incorporate the lessons from past successes and failures into future new-product development processes.[36] This is easier said than done. To learn, managers need to undertake an objective assessment process after a product development project has been completed, identifying key success factors and the root causes of failures, and allocating resources toward repairing failures. Leaders also must admit their own failures if they are to encourage other team members to responsibly identify what they did wrong. Strategy in Action 4.4 looks at how Corning learned from a prior mistake to develop a potentially promising new product.

The primary role that the various functions play in achieving superior innovation is summarized in Table 4.4. The table makes two matters clear. First, top management must bear primary responsibility for overseeing the entire development process. This entails both managing the development process and facilitating cooperation among the functions. Second, the effectiveness of R&D in developing new products and processes depends upon its ability to cooperate with marketing and production.

Table 4.4 Functional Roles for Achieving Superior Innovation

Value Creation Function	Primary Roles
Infrastructure (leadership)	1. Manage overall project (i.e., manage the development function) 2. Facilitate cross-functional cooperation
Production	1. Cooperate with R&D on designing products that are easy to manufacture 2. Work with R&D to develop process innovations
Marketing	1. Provide market information to R&D 2. Work with R&D to develop new products
Materials management	No primary responsibility
R&D	1. Develop new products and processes 2. Cooperate with other functions, particularly marketing and manufacturing, in the development process
Information systems	1. Use information systems to coordinate cross-functional and cross-company product development work
Human resources	1. Hire talented scientists and engineers

© Cengage Learning

ACHIEVING SUPERIOR RESPONSIVENESS TO CUSTOMERS

To achieve superior responsiveness to customers, a company must give customers what they want, when they want it, and at a price they are willing to pay—so long as the company's long-term profitability is not compromised in the process. Customer responsiveness is an important differentiating attribute that can help to build brand loyalty. Strong product differentiation and brand loyalty give a company more pricing options; it can charge a premium price for its products, or keep prices low to sell more goods and services to customers. Whether prices are at a premium or kept low, the company that is the most responsive to its customers' needs will have the competitive advantage.

Achieving superior responsiveness to customers means giving customers value for money, and steps taken to improve the efficiency of a company's production process and the quality of its products should be consistent with this aim. In addition, giving customers what they want may require the development of new products with new features. In other words, achieving superior efficiency, quality, and innovation are all part of achieving superior responsiveness to customers. There are two other prerequisites for attaining this goal. First, a company must develop a competency in listening to its customers, focusing on its customers, and in investigating and identifying their needs. Second, it must constantly seek better ways to satisfy those needs.

Focusing on the Customer

A company cannot be responsive to its customers' needs unless it knows what those needs are. Thus, the first step to building superior responsiveness to customers is to motivate the entire company to focus on the customer. The means to this end are: demonstrating leadership, shaping employee attitudes, and using mechanisms for making sure that the needs of the customer are well known within the company.

Demonstrating Leadership Customer focus must begin at the top of the organization. A commitment to superior responsiveness to customers brings attitudinal changes throughout a company that can only be built through strong leadership. A mission statement that puts customers first is one way to send a clear message to employees about the desired focus. Another avenue is top management's own actions. For example, Tom Monaghan, the founder of Domino's Pizza, stayed close to the customer by eating Domino's pizza regularly, visiting as many stores as possible every week, running some deliveries himself, and insisting that other top managers do the same.[37]

Shaping Employee Attitudes Leadership alone is not enough to attain a superior customer focus. All employees must see the customer as the focus of their activity, and be trained to focus on the customer—whether their function is marketing, manufacturing, R&D, or accounting. The objective should be to make employees think of themselves as customers—to put themselves in customers' shoes. From that perspective, employees become better able to identify ways to improve the quality of a customer's experience with the company.

To reinforce this mindset, incentive systems within the company should reward employees for satisfying customers. For example, senior managers at the Four Seasons hotel chain, who pride themselves on customer focus, like to tell the story of Roy Dyment, a doorman in Toronto who neglected to load a departing guest's briefcase into his taxi. The

doorman called the guest, a lawyer, in Washington, D.C., and found that he desperately needed the briefcase for a morning meeting. Dyment hopped on a plane to Washington and returned it—without first securing approval from his boss. Far from punishing Dyment for making a mistake and for not checking with management before going to Washington, the Four Seasons responded by naming Dyment Employee of the Year.[38] This action sent a powerful message to Four Seasons employees, stressing the importance of satisfying customer needs.

Knowning Customer Needs "Know thy customer" is one of the keys to achieving superior responsiveness to customers. Knowing the customer not only requires that employees think like customers themselves; it also demands that they listen to what customers have to say. This involves bringing in customers' opinions by soliciting feedback from customers on the company's goods and services, and by building information systems that communicate the feedback to the relevant people.

For an example, consider direct-selling clothing retailer Lands' End. Through its catalog, the Internet, and customer service telephone operators, Lands' End actively solicits comments from its customers about the quality of its clothing and the kind of merchandise they want it to supply. Indeed, it was customers' insistence that initially prompted the company to move into the clothing segment. Lands' End formerly supplied equipment for sailboats through mail-order catalogs. However, it received so many requests from customers to include outdoor clothing in its offering that it responded by expanding the catalog to fill this need. Soon clothing became its main business, and Lands' End ceased selling the sailboat equipment. Today, the company continues to pay close attention to customer requests. Every month, data on customer requests and comments is reported to managers. This feedback helps the company to fine-tune the merchandise it sells; new lines of merchandise are frequently introduced in response to customer requests.

Satisfying Customer Needs

Once customer focus is an integral part of the company, the next requirement is to satisfy the customer needs that have been identified. As already noted, efficiency, quality, and innovation are crucial competencies that help a company satisfy customer needs. Beyond that, companies can provide a higher level of satisfaction if they differentiate their products by (1) customizing them, where possible, to the requirements of individual customers, and (2) reducing the time it takes to respond to or satisfy customer needs.

Customization Customization means varying the features of a good or service to tailor it to the unique needs or tastes of groups of customers, or—in the extreme case—individual customers. Although extensive customization can raise costs, the development of flexible manufacturing technologies has made it possible to customize products to a greater extent than was feasible 10 to 15 years ago, without experiencing a prohibitive rise in cost structure (particularly when flexible manufacturing technologies are linked with Web-based information systems). For example, online retailers such as Amazon.com have used Web-based technologies to develop a homepage customized for each individual user. When a customer accesses Amazon.com, he or she is offered a list of recommended books and music to purchase based on an analysis of prior buying history—a powerful competency that gives Amazon.com a competitive advantage.

The trend toward customization has fragmented many markets, particularly customer markets, into ever-smaller niches. An example of this fragmentation occurred in Japan

in the early 1980s when Honda dominated the motorcycle market there. Second-place Yamaha had decided to surpass Honda's lead. It announced the opening of a new factory that, when operating at full capacity, would make Yamaha the world's largest manufacturer of motorcycles. Honda responded by proliferating its product line, and increasing its rate of new-product introduction. At the start of what became known as the "motorcycle wars," Honda had 60 motorcycles in its product line. Over the next 18 months thereafter, it rapidly increased its range to 113 models, customizing them to ever-smaller niches. Honda was able to accomplish this without bearing a prohibitive cost penalty due to its competency in flexible manufacturing. The flood of Honda's customized models pushed Yamaha out of much of the market, effectively stalling its bid to overtake Honda.[39]

Response Time To gain a competitive advantage, a company must often respond to customer demands very quickly, whether the transaction is a furniture manufacturer's delivery of a product once it has been ordered, a bank's processing of a loan application, an automobile manufacturer's delivery of a spare part for a car that broke down, or the wait in a supermarket checkout line. We live in a fast-paced society, where time is a valuable commodity. Companies that can satisfy customer demands for rapid response build brand loyalty, differentiate their products, and can charge higher prices for products.

Increased speed often lets a company choose a premium pricing option, as the mail delivery industry illustrates. The air express niche of the mail delivery industry is based on the notion that customers are often willing to pay substantially more for overnight express mail than for regular mail. Another example of the value of rapid response is Caterpillar, the manufacturer of heavy-earthmoving equipment, which can deliver a spare part to any location in the world within 24 hours. Downtime for heavy-construction equipment is very costly, so Caterpillar's ability to respond quickly in the event of equipment malfunction is

Table 4.5	Primary Roles of Different Functions in Achieving Superior Responsiveness to Customers
Value Creation Function	**Primary Roles**
Infrastructure (leadership)	• Through leadership by example, build a company-wide commitment to responsiveness to customers
Production	• Achieve customization through implementation of flexible manufacturing • Achieve rapid response through flexible manufacturing
Marketing	• Know the customer • Communicate customer feedback to appropriate functions
Materials management	• Develop logistics systems capable of responding quickly to unanticipated customer demands (JIT)
R&D	• Bring customers into the product development process
Information systems	• Use Web-based information systems to increase responsiveness to customers
Human resources	• Develop training programs that get employees to think like customers themselves

© Cengage Learning

of prime importance to its customers. As a result, many customers have remained loyal to Caterpillar despite the aggressive low-price competition from Komatsu of Japan.

In general, reducing response time requires: (1) a marketing function that can quickly communicate customer requests to production, (2) production and materials-management functions that can quickly adjust production schedules in response to unanticipated customer demands, and (3) information systems that can help production and marketing in this process.

Table 4.5 summarizes the steps different functions must take if a company is to achieve superior responsiveness to customers. Although marketing plays a critical role in helping a company attain this goal (primarily because it represents the point of contact with the customer), Table 4.5 shows that the other functions also have major roles. Achieving superior responsiveness to customers requires top management to lead in building a customer orientation within the company.

SUMMARY OF CHAPTER

1. A company can increase efficiency through a number of steps: exploiting economies of scale and learning effects; adopting flexible manufacturing technologies; reducing customer defection rates; implementing just-in-time systems; getting the R&D function to design products that are easy to manufacture; upgrading the skills of employees through training; introducing self-managing teams; linking pay to performance; building a companywide commitment to efficiency through strong leadership; and designing structures that facilitate cooperation among different functions in pursuit of efficiency goals.

2. Superior quality can help a company lower its costs, differentiate its product, and charge a premium price.

3. Achieving superior quality demands an organization-wide commitment to quality, and a clear focus on the customer. It also requires metrics to measure quality goals and incentives that emphasize quality; input from employees regarding ways in which quality can be improved; a methodology for tracing defects to their source and correcting the problems that produce them; a rationalization of the company's supply base; cooperation with the suppliers that remain to implement total quality management programs; products that are designed for ease of manufacturing; and substantial cooperation among functions.

4. The failure rate of new-product introductions is high because of factors such as uncertainty, poor commercialization, poor positioning strategy, slow cycle time, and technological myopia.

5. To achieve superior innovation, a company must build skills in basic and applied research; design good processes for managing development projects; and achieve close integration between the different functions of the company, primarily through the adoption of cross-functional product development teams and partly parallel development processes.

6. To achieve superior responsiveness to customers often requires that the company achieve superior efficiency, quality, and innovation.

7. To achieve superior responsiveness to customers, a company must give customers what they want, when they want it. It must ensure a strong customer focus, which can be attained by emphasizing customer focus through leadership; training employees to think like customers; bringing customers into the company through superior market research; customizing products to the unique needs of individual customers or customer groups; and responding quickly to customer demands.

DISCUSSION QUESTIONS

1. How are the four generic building blocks of competitive advantage related to each other?
2. What role can top management play in helping a company achieve superior efficiency, quality, innovation, and responsiveness to customers?
3. Over time, will the adoption of Six Sigma quality improvement processes give a company a competitive advantage, or will it be required only to achieve parity with competitors?
4. From what perspective might innovation be called "the single most important building block" of competitive advantage?

PRACTICING STRATEGIC MANAGEMENT

© iStockPhoto.com/Urilux

Small-Group Exercise: Identifying Excellence

Break up into groups of three to five people, and appoint one group member as a spokesperson who will communicate your findings to the class.

You are the management team of a start-up company that will produce hard drives for the personal computer (PC) industry. You will sell your product to manufacturers of PCs (original equipment manufacturers [OEMs]). The disk drive market is characterized by rapid technological change, product life cycles of only 6 to 9 months, intense price competition, high fixed costs for manufacturing equipment, and substantial manufacturing economies of scale. Your customers, the OEMs, issue very demanding technological specifications that your product must comply with. They also pressure you to deliver your product on time so that it fits in within their company's product introduction schedule.

1. In this industry, what functional competencies are the most important for you to build?
2. How will you design your internal processes to ensure that those competencies are built within the company?

STRATEGY SIGN ON

© iStockPhoto.com/Ninoslav Dotlic

Article File 4

Choose a company that is widely regarded as excellent. Identify the source of its excellence, and relate it to the material discussed in this chapter. Pay particular attention to the role played by the various functions in building excellence.

(continues)

STRATEGY SIGN ON

(continued)

© iStockPhoto.com/Ninoslav Dotlic

Strategic Management Project: Module 4

This module deals with the ability of your company to achieve superior efficiency, quality, innovation, and responsiveness to customers. With the information you have at your disposal, perform the following tasks and answer the listed questions:

1. Is your company pursuing any of the efficiency-enhancing practices discussed in this chapter?
2. Is your company pursuing any of the quality-enhancing practices discussed in this chapter?
3. Is your company pursuing any of the practices designed to enhance innovation discussed in this chapter?
4. Is your company pursuing any of the practices designed to increase responsiveness to customers discussed in this chapter?
5. Evaluate the competitive position of your company with regard to your answers to questions 1–4. Explain what, if anything, the company must do to improve its competitive position.

ETHICAL DILEMMA

© iStockPhoto.com/P_Wei

Is it ethical for Wal-Mart to pay its employees minimum wage and to oppose unionization, given that the organization also works its people very hard?

Are Wal-Mart's employment and compensation practices for lower-level employees ethical?

CLOSING CASE

Lean Production at Virginia Mason

In the early 2000s, Seattle's Virginia Mason Hospital was not performing as well as it should have been. Financial returns were low, patient satisfaction was subpar, too many errors were occurring during patient treatment, and staff morale was suffering. Gary Kaplan, the CEO, was wondering what to do about this when he experienced a chance encounter with Ian Black, the director of lean thinking at Boeing. Black told Kaplan that Boeing had been implementing aspects of Toyota's famous lean production system in its aircraft assembly

operations, and Boeing was seeing positive results. Kaplan soon became convinced that the same system that had helped Toyota build more reliable cars at a lower cost could also be applied to health care to improve patient outcomes at a lower cost.

In 2002, Kaplan and a team of executives began annual trips to Japan to study the Toyota production system. They learned that "lean" meant doing without things that were not needed; it meant removing unnecessary steps in a process so that tasks were performed more efficiently. It meant eliminating waste and elements that didn't add value. Toyota's system applied to health care meant improving patient outcomes through more rapid treatment the elimination of errors in the treatment process.

Kaplan and his team returned from Japan believing in the value of lean production. They quickly set about applying what they had learned to Virginia Mason. Teams were created to look at individual processes in what Virginia Mason called "rapid process improvement workshops." The teams, which included doctors as well as other employees, were freed from their normal duties for 5 days. They learned the methods of lean production, analyzed systems and processes, tested proposed changes, and were empowered to implement the chosen change the following week.

The gains appeared quickly, reflecting the fact that there was a lot of inefficiency in the hospital. One of the first changes involved the delay between a doctor's referral to a specialist and the patient's first consultation with that specialist. By examining the process, it was found that secretaries, whose job it was to arrange these referrals, were not needed. Instead, the doctor would send a text message to the consultant the instant he or she decided that a specialist was required. The specialist then needed to respond within 10 minutes, even if only to confirm the receipt of the message. Delays in referral-to-treatment time dropped by 68% as a consequence of this simple change, which improved patient satisfaction.

On another occasion, a team in the radiation oncology department mapped out the activities that the department performed when processing a patient with the intention of eliminating time wasted in performing those activities. By removing unnecessary workflow activities, patient time spent in the department fell from 45 minutes to just 15 minutes. A similar exercise at Virginia Mason's back clinic cut treatment time from an average of 66 days to just 12.

By 2012, Virginia Mason was claiming that lean production had transformed the hospital into a more efficient, customer-responsive organization where medical errors during treatment had been significantly reduced. Among other gains, lean processes reduced annual inventory costs by more than $1 million, reduced the time it took to report lab tests to a patient by more than 85%, freed up the equivalent of 77 full-time employee positions through more efficient processes, and reduced staff walking distance by 60 miles a day, giving both doctors and nurses more time to spend with patients. These, and many other similar changes, lowered costs, increased the organization's customer responsiveness, improved patient outcomes, and increased the financial performance of the hospital.

Sources: C. Black, "To Build a Better Hospital, Virginia Mason Takes Lessons from Toyota Plants," *Seattle PI*, March 14, 2008; P. Neurath, "Toyota Gives Virginia Mason Docs a Lesson in Lean," *Puget Sound Business Journal*, September 14, 2003; and K. Boyer and R. Verma, *Operations and Supply Chain Management for the 21stCentury* (New York: Cengage, 2009).

CASE DISCUSSION QUESTIONS

1. What do you think were the *underlying* reasons for the performance problems that Virginia Mason Hospital was encountering in the early 2000s?

2. Which of the four building blocks of competitive advantage did lean production techniques help improve at Virginia Mason?

3. What do you think was the key to the apparently successful implementation of lean production techniques at Virginia Mason?

4. Lean production was developed at a manufacturing firm, Toyota, yet it is being applied in this case at a hospital. What does that tell you about the nature of the lean production philosophy for performance improvement?

KEY TERMS

Functional-level strategies 117
Economies of scale 119
Fixed costs 119
Diseconomies of scale 120

Learning effects 120
Experience curve 122
Flexible production technology 124
Mass customization 124
Marketing strategy 125

Customer defection rate 125
Just-in-time inventory system 128
Supply chain management 129

Self-managing teams 130
Positioning strategy 140

NOTES

[1]G. J. Miller, *Managerial Dilemmas: The Political Economy of Hierarchy* (Cambridge: Cambridge University Press, 1992).

[2]H. Luft, J. Bunker, and A. Enthoven, "Should Operations Be Regionalized?" *New England Journal of Medicine* 301 (1979): 1364–1369.

[3]S. Chambers and R. Johnston, "Experience Curves in Services," *International Journal of Operations and Production Management* 20 (2000): 842–860.

[4]G. Hall and S. Howell, "The Experience Curve from an Economist's Perspective," *Strategic Management Journal* 6 (1985): 197–212; M. Lieberman, "The Learning Curve and Pricing in the Chemical Processing Industries," *RAND Journal of Economics* 15 (1984): 213–228; and R. A. Thornton and P. Thompson, "Learning from Experience and Learning from Others," *American Economic Review* 91 (2001): 1350–1369.

[5]Boston Consulting Group, *Perspectives on Experience* (Boston: Boston Consulting Group, 1972); Hall and Howell, "The Experience Curve," pp. 197–212; and W. B. Hirschmann, "Profit from the Learning Curve," *Harvard Business Review* (January–February 1964): 125–139.

[6]A. A. Alchian, "Reliability of Progress Curves in Airframe Production," *Econometrica* 31 (1963): 679–693.

[7]M. Borrus, L. A. Tyson, and J. Zysman, "Creating Advantage: How Government Policies Create Trade in the Semi-Conductor Industry," in P. R. Krugman (ed.), *Strategic Trade Policy and the New International Economics* (Cambridge, Mass.: MIT Press, 1986); and S. Ghoshal and C. A. Bartlett, "Matsushita Electrical Industrial (MEI) in 1987," Harvard Business School Case #388-144 (1988).

[8]See P. Nemetz and L. Fry, "Flexible Manufacturing Organizations: Implications for Strategy Formulation," *Academy of Management Review* 13 (1988): 627–638; N. Greenwood, *Implementing Flexible Manufacturing Systems* (New York: Halstead Press, 1986); J. P. Womack, D. T. Jones, and D. Roos, *The Machine That Changed the World* (New York: Rawson Associates, 1990); and R. Parthasarthy and S. P. Seith, "The Impact of Flexible Automation on Business Strategy and Organizational Structure," *Academy of Management Review* 17 (1992): 86–111.

[9]B. J. Pine, *Mass Customization: The New Frontier in Business Competition* (Boston: Harvard Business School Press, 1993); S. Kotha, "Mass Customization: Implementing the Emerging Paradigm for Competitive Advantage," *Strategic Management Journal* 16 (1995): 21–42; and J. H. Gilmore and B. J. Pine II, "The Four Faces of Mass Customization," *Harvard Business Review* (January–February 1997): 91–101.

[10]P. Waurzyniak, "Ford's Flexible Push," *Manufacturing Engineering*, September 1, 2003, pp. 47–50.

[11]F. F. Reichheld and W. E. Sasser, "Zero Defections: Quality Comes to Service," *Harvard Business Review,* September–October 1990, pp. 105–111.

[12]The example comes from ibid.

[13]Ibid.

[14]R. Narasimhan and J. R. Carter, "Organization, Communication and Coordination of International Sourcing," *International Marketing Review* 7 (1990): 6–20.

[15]H. F. Busch, "Integrated Materials Management," *IJDP & MM* 18 (1990): 28–39.

[16]G. Stalk and T. M. Hout, *Competing Against Time* (New York: Free Press, 1990).

[17]See Peter Bamberger and Ilan Meshoulam, *Human Resource Strategy: Formulation, Implementation, and Impact* (Thousand Oaks, Calif.: Sage, 2000); and P. M. Wright and S. Snell, "Towards a Unifying Framework for Exploring Fit and Flexibility in Human Resource Management," *Academy of Management Review* 23 (October 1998): 756–772.

[18]A. Sorge and M. Warner, "Manpower Training, Manufacturing Organization, and Work Place Relations in Great Britain and West Germany," *British Journal of Industrial Relations* 18 (1980): 318–333; and R. Jaikumar, "Postindustrial Manufacturing," *Harvard Business Review,* November–December 1986, pp. 72–83.

[19]J. Hoerr, "The Payoff from Teamwork," *Business Week,* July 10, 1989, pp. 56–62.

[20]"The Trouble with Teams," *Economist,* January 14, 1995, p. 61.

[21]T. C. Powell and A. Dent-Micallef, "Information Technology as Competitive Advantage: The Role of Human, Business, and Technology Resource," *Strategic Management Journal* 18 (1997): 375–405; and B. Gates, *Business @ the Speed of Thought* (New York: Warner Books, 1999).

[22]"Cisco@speed," *Economist,* June 26, 1999, p. 12; S. Tully, "How Cisco Mastered the Net," *Fortune,* August 17, 1997, pp. 207–210; and C. Kano, "The Real King of the Internet," *Fortune,* September 7, 1998, pp. 82–93.

[23]Gates, *Business @ the Speed of Thought.*

[24]See the articles published in the special issue of the *Academy of Management Review on Total Quality Management* 19:3 (1994). The following article provides a good overview of many of the issues involved from an academic perspective: J. W. Dean and D. E. Bowen, "Man-

agement Theory and Total Quality," *Academy of Management Review* 19 (1994): 392–418. See also T. C. Powell, "Total Quality Management as Competitive Advantage," *Strategic Management Journal* 16 (1995): 15–37.

[25]For general background information, see "How to Build Quality," *Economist,* September 23, 1989, pp. 91–92; A. Gabor, *The Man Who Discovered Quality* (New York: Penguin, 1990); and P. B. Crosby, *Quality Is Free* (New York: Mentor, 1980).

[26]W. E. Deming, "Improvement of Quality and Productivity Through Action by Management," *National Productivity Review* 1 (Winter 1981–1982): 12–22.

[27]A. Ries and J. Trout, *Positioning: The Battle for Your Mind* (New York: Warner Books, 1982).

[28]R. G. Cooper, *Product Leadership* (Reading, Mass.: Perseus Books, 1999).

[29]See Cooper, *Product Leadership*; A. L. Page "PDMA's New Product Development Practices Survey: Performance and Best Practices," presentation at PDMA 15th Annual International Conference, Boston, MA, October 16, 1991; and E. Mansfield, "How Economists See R&D," *Harvard Business Review,* November–December 1981, pp. 98–106.

[30]S. L. Brown and K. M. Eisenhardt, "Product Development: Past Research, Present Findings, and Future Directions," *Academy of Management Review* 20 (1995): 343–378; M. B. Lieberman and D. B. Montgomery, "First Mover Advantages," *Strategic Management Journal* 9 (Special Issue, Summer 1988): 41–58; D. J. Teece, "Profiting from Technological Innovation: Implications for Integration, Collaboration, Licensing and Public Policy," *Research Policy* 15 (1987): 285–305; G. J. Tellis and P. N. Golder, "First to Market, First to Fail?" *Sloan*

Management Review, Winter 1996, pp. 65–75; and G. A. Stevens and J. Burley, "Piloting the Rocket of Radical Innovation," *Research Technology Management* 46 (2003): 16–26.

[31]G. Stalk and T. M. Hout, *Competing Against Time* (New York: Free Press, 1990).

[32]K. B. Clark and S. C. Wheelwright, *Managing New Product and Process Development* (New York: Free Press, 1993); and M. A. Schilling and C. W. L. Hill, "Managing the New Product Development Process," *Academy of Management Executive* 12:3 (August 1998): 67–81.

[33]O. Port, "Moving Past the Assembly Line," *Business Week* (Special Issue, Reinventing America, 1992): 177–180.

[34]K. B. Clark and T. Fujimoto, "The Power of Product Integrity," *Harvard Business Review,* November–December 1990, pp. 107–118; Clark and Wheelwright, *Managing New Product and Process Development;* Brown and Eisenhardt, "Product Development"; and Stalk and Hout, *Competing Against Time.*

[35]C. Christensen, "Quantum Corporation—Business and Product Teams," Harvard Business School Case, #9-692-023.

[36]H. Petroski, *Success Through Failure: The Paradox of Design* (Princeton, NJ: Princeton University Press, 2006). See also A. C. Edmondson, "Learning from Mistakes Is Easier Said Than Done," *Journal of Applied Behavioral Science* 40 (2004): 66–91.

[37]S. Caminiti, "A Mail Order Romance: Lands' End Courts Unseen Customers," *Fortune,* March 13, 1989, pp. 43–44.

[38]Sellers, "Getting Customers to Love You."

[39]Stalk and Hout, *Competing Against Time.*

Business-Level Strategy

LEARNING OBJECTIVES

After reading this chapter, you should be able to:

5-1 Explain the difference between low-cost and differentiation strategies.

5-2 Articulate how the attainment of a differentiated or low-cost position can give a company a competitive advantage.

5-3 Explain how a company executes its business-level strategy through function-level strategies and organizational arrangements.

5-4 Describe what is meant by the term "value innovation."

5-5 Discuss the concept of blue ocean strategy, and explain how innovation in business-level strategy can change the competitive game in an industry, giving the innovator a sustained competitive advantage.

OPENING CASE

nick barounis/Alamy

Nordstrom

Nordstrom is one of American's most successful fashion retailers. John Nordstrom, a Swedish immigrant, established the company in 1901 with a single shoe store in Seattle. Right from the start, Nordstrom's approach to business was to provide exceptional customer service, selection, quality, and value. This approach is still the hallmark of Nordstrom today.

The modern Nordstrom is a fashion specialty chain with some 240 stores in 31 states. Nordstrom generated almost $12 billion of sales in 2012 and makes consistently higher-than-average returns on invested capital. Its return on invested capital (ROIC) has exceeded 30% since 2006, and was 36% in 2012, a remarkable performance for a retailer. Wal-Mart, in contrast, earns an ROIC in the 12% to 14% range.

Nordstrom is a niche company. It focuses on a relatively affluent customer base that is looking for affordable luxury. The stores themselves are located in upscale areas, and have expensive fittings and fixtures that convey an impression of luxury. The stores are inviting and easy to browse in. Touches such as live music being played on a grand piano help create an appealing atmosphere. The merchandise is high quality and fashionable. What really differentiates the company from many of its rivals, however, is Nordstrom's legendary excellence in customer service.

Nordstrom's salespeople are typically well groomed and dressed, polite and helpful, and known for their attention to detail. They are selected for their ability to interact with customers in a positive way. During the interview process for new employees, one of the most important questions asked of candidates is their definition of good customer service. Thank-you cards, home deliveries, personal appointments, and access to personal shoppers are the norm at Nordstrom. There is a no-questions-asked returns policy, with no receipt required. Nordstrom's philosophy is that the customer is always right. The company's salespeople are also well compensated, with good benefits and commissions on sales that range from 6.75% to 10% depending on the department. Top salespeople at Nordstrom have the ability to earn over $100,000 a year, mostly in commissions.

The customer service ethos is central to the culture and organization of Nordstrom. The organization chart is an inverted pyramid, with salespeople on the top, and the CEO at the bottom. According to the CEO, Blake Nordstrom, this is because "I work for them. My job is to make them as successful as possible." Management constantly tells stories emphasizing the primacy of customer service at Nordstrom in order to reinforce the culture. One story relates that when a customer in Fairbanks, Alaska, wanted to return two tires (which Nordstrom does not sell), bought a while ago from another store on the same site, a sales clerk looked up their price and gave him his money back!

Despite its emphasis on quality and luxury, Nordstrom has not taken its eye off operating efficiency. Sales per square foot are $400 despite the large open-plan nature of the stores, and inventory turns exceed 5 times per year, up from 3.5 times a decade ago. Both of these figures are good for a high-end department store. Management is constantly looking for ways to improve efficiency and customer service. Today it is putting mobile checkout devices into the hands of 5,000 salespeople, eliminating the need to wait in line at a checkout stand.

Sources: A. Martinez, "Tale of Lost Diamond Adds Glitter to Nordstrom's Customer Service," *Seattle Times*, May 11, 2011; C. Conte, "Nordstrom Built on Customer Service," *Jacksonville Business Journal*, September 7, 2012; W. S. Goffe, "How Working as a Stock Girl at Nordstrom Prepared Me for Being a Lawyer," *Forbes*, December 3, 2012; and P. Swinand, "Nordstrom Inc," *Morningstar*, February 22, 2013.

OVERVIEW

business-level strategy
The business's overall competitive theme, the way it positions itself in the marketplace to gain a competitive advantage, and the different positioning strategies that can be used in different industry settings

In this chapter we look at the formulation of **business-level strategy**. As you may recall from Chapter 1, business-level strategy refers to the overarching competitive theme of a company in a given market. At its most basic, business-level strategy is about *who* a company decides to serve (which customer segments), what customer *needs* and *desires* the company is trying to satisfy, and *how* the company decides to satisfy those needs and desires.[1] If this sounds familiar, it is because we have already discussed this in Chapter 1 when we considered how companies construct a mission statement.

The high-end retailer Nordstrom provides us with an illustration of how this works. As discussed in the Opening Case, Nordstrom *focuses* on serving mid- to upper-income consumers who *desire* fashionable high-quality merchandise. Nordstrom attempts to satisfy the desires of this customer segment not only through merchandising, but also through excellence in customer service. To the extent it has been successful, Nordstrom has *differentiated* itself from rivals in that segment of the retail space. In essence, Nordstrom is pursuing a business-level strategy of *focused differentiation* that is built on a *distinctive competence*

in customer service. Nordstrom has been so successful at pursuing this strategy that it has been consistently profitable, measured by ROIC, while also continuing to grow both its sales revenues and its net operating profit. In other words, through successful execution of its chosen business-level strategy, Nordstrom has built a sustainable competitive advantage.

In this chapter we will look at how managers decide what business-level strategy to pursue, and how they go about executing that strategy in order to attain a sustainable competitive advantage. We start by looking at two basic ways that companies chose how to compete in a market—by *lowering costs* and by *differentiating* their good or service from that offered by rivals so that they create more value. Next we consider the issue of *customer choice* and *market segmentation*, and discuss the choices that managers must make when it comes to their company's segmentation strategy. Then we then put this together and discuss the various business-level strategies that an enterprise can adopt, and what must be done to successfully implement those strategies. The chapter closes with a discussion of how managers can think about formulating an innovative business-level strategy that gives their company a unique and defendable position in the marketplace.

LOW COST AND DIFFERENTIATION

Strategy is about the search for competitive advantage. As we saw in Chapter 3, at the most fundamental level, a company has a competitive advantage if it can lower costs relative to rivals and/or if it can differentiate its product offering from those of rivals, thereby creating more value. We will look at lowering costs first, and then at differentiation.[2]

Lowering Costs

Imagine that all enterprises in an industry offer products that are very similar in all respects except for price, and that each company is small relative to total market demand so that they are unable to influence the prevailing price. This is the situation that exists in many commodity markets, such as the market for oil, or wheat, or aluminum, or steel. In the world oil market, for example, prices are set by the interaction of supply and demand. Even the world's largest private oil producer, Exxon Mobile, only produces around 3.5% of world output and cannot influence the prevailing price.

In commodity markets, competitive advantage goes to the company that has the lowest costs. Low costs will enable a company to make a profit at price points where its rivals are losing money. Low costs can also allow a company to undercut rivals on price, gain market share, and maintain or even increase profitability. Being the low-cost player in an industry can be a very advantageous position.

Although lowering costs below those of rivals is a particularly powerful strategy in a pure commodity industry, it can also have great utility in other settings. General merchandise retailing, for example, is not a classic commodity business. Nevertheless, Wal-Mart has built a very strong competitive position in United States market by being the low-cost player. Because its costs are so low, Wal-Mart can cut prices, grow its market share, and still make profits at price points where its competitors are losing money. The same is true in the airline industry, where Southwest Airlines has established a low-cost position. Southwest's operating efficiencies have enabled it to make money in an industry that has been hit by repeated bouts of price warfare, and where many of its rivals have been forced into bankruptcy. Strategy in Action 5.1 describes some of actions Southwest has taken to achieve this low-cost position.

5.1 STRATEGY IN ACTION

Low Costs at Southwest Airlines

© iStockPhoto.com/Tom Nulens

Southwest Airlines has long been one of the standout performers in the U.S. airline industry. It is famous for its low fares, generally some 30% below those of its major rivals, which are balanced by an even lower cost structure, which has enabled it to record superior profitability even in bad years such as 2008–2009 when the industry faced slumping demand.

A major source of Southwest's low-cost structure seems to be its very high employee productivity. One way airlines measure employee productivity is by the ratio of employees to passengers carried. According to figures from company 10K statements, in 2012 Southwest had an employee-to-passenger ratio of 1 to 1,999, one of the best in the industry. By comparison, the ratio at one of the better major airlines, Delta, was in the range of 1 to 1,500. These figures suggest that holding size constant, Southwest runs its operation with fewer people than competitors. How does it do this?

First, Southwest's managers devote enormous attention to whom they hire. On average, Southwest hires only 3% of those interviewed in a year. When hiring, it places a big emphasis on teamwork and a positive attitude. Southwest's managers rationalize that skills can be taught, but a positive attitude and a willingness to pitch in cannot. Southwest also creates incentives for its employees to work hard. All employees are covered by a profit-sharing plan, and at least 25% of an employee's share of the profit-sharing plan has to be invested in Southwest Airlines stock. This gives rise to a simple

formula: the harder employees work, the more profitable Southwest becomes, and the richer the employees get. The results are clear. At other airlines, one would never see a pilot helping to check passengers onto the plane. At Southwest, pilots and flight attendants have been known to help clean the aircraft and check in passengers at the gate. They do this to turn around an aircraft as quickly as possible and get it into the air again—because they all know that an aircraft doesn't make money when it is sitting on the ground.

Southwest also reduces its costs by striving to keep its operations as simple as possible. By operating only one type of plane, the Boeing 737, it reduces training costs, maintenance costs, and inventory costs while increasing efficiency in crew and flight scheduling. The operation is nearly ticketless, which reduces cost and back-office accounting functions. There is no seat assignment, which again reduces costs. There are no meals or movies in flight, and the airline will not transfer baggage to other airlines, reducing the need for baggage handlers. Another major difference between Southwest and most other airlines is that Southwest flies point to point rather than operating from congested airport hubs. As a result, its costs are lower because there is no need for dozens of gates and thousands of employees needed to handle banks of flights that come in and then disperse within a 2-hour window, leaving the hub empty until the next flights a few hours later.

Sources: M. Brelis, "Simple Strategy Makes Southwest a Model for Success," *Boston Globe*, November 5, 2000, p. F1; M. Trottman, "At Southwest, New CEO Sits in the Hot seat," *Wall Street Journal*, July 19, 2004, p. B1; J. Helyar, "Southwest Finds Trouble in the Air," *Fortune*, August 9, 2004, p. 38; J. Reingold, "Southwest's Herb Kelleher: Still Crazy After All These Years," *Fortune*, January 14, 2013; and Southwest Airlines 10K 2012.

Differentiation Now let's look at the differentiation side of the equation. Differentiation implies distinguishing yourself from rivals by offering something that they find hard to match. As we saw in the Opening Case, Nordstrom has differentiated itself from its rivals through excellence in customer service. There are many ways that a company can differentiate itself from rivals. A product can be differentiated by superior reliability (it breaks down less often, or not at all), better design, superior functions and features, better point-of-sale service, better after sales service and support, better branding, and so on. A Rolex watch is differentiated from a Timex watch by superior design, materials, and reliability; a Toyota car is differentiated from a General Motors car by superior reliability (historically

new Toyota cars have had fewer defects than new GM cars); Apple differentiates its iPhone from rival offerings through superior product design, ease of use, excellent customer service at its Apple stores, and easy synchronization with other Apple products, such as its computers, tablets, iTunes, and iCloud.

Differentiation gives a company two advantages. First, it can allow the company to charge a premium price for its good or service, should it chose to do so. Second, it can help the company to grow overall demand and capture market share from its rivals. In the case of the iPhone, Apple has been able to reap both of these benefits through its successful differentiation strategy. Apple charges more for its iPhone than people pay for rival smartphone offerings, and the differential appeal of Apple products has led to strong demand growth.

It is important to note that differentiation often (but not always) raises the cost structure of the firm. It costs Nordstrom a lot to create a comfortable and luxurious shopping experience. Nordstrom's stores are sited at expensive locations, and use top-of-the-line fittings and fixtures. The goods Nordstrom sells are also expensive, and turn over far less often than the cheap clothes sold at a Wal-Mart store. This too, will drive up Nordstrom's costs. Then there is the expense associated with hiring, training, and compensating the best salespeople in the industry. None of this is cheap, and as a consequence, it is inevitable that Nordstrom will have a much higher costs structure than lower-end retail establishments.

On the other hand, there are situations where successful differentiation, because it increases primary demand so much, can actually lower costs. Apple's iPhone is a case in point. Apple uses very expensive materials in the iPhone—Gorilla glass for the screen, brushed aluminum for the case. It could have used cheap plastic, but then the product would not have looked as good and would have scratched easily. Although these decisions about materials originally raised the unit costs of the iPhone, the fact is that Apple has sold so many iPhones that it now enjoys economies of scale in purchasing and can effectively bargain down the price it pays for expensive materials. The result for Apple—successful differentiation of the iPhone—not only helped the company to charge a premium price, it has also gown demand to the point where it can lower costs through the attainment of scale economies, thereby widening profit margins. This is why Apple captured 75% of all profits in the global smartphone business in 2012.

More generally, the Apple example points to an essential truth here: successful differentiation gives managers options. One option that managers have is to raise the price to reflect the differentiated nature of the product offering and cover any incremental increase in costs (see Figure 5.1). This is an option that many pursue and it can by itself enhance profitability so long as prices increase by more than costs. For example, the Four Seasons chain has very luxurious hotels. It certainly costs a lot to provide that luxury, but Four Seasons also charges very high prices for its rooms, and the firm is profitable as a result. Nordstrom also pursues such a strategy.

However, as the Apple example suggests, increased profitability and profit growth can also come from the increased demand associated with successful differentiation, which enables the firm to use its assets more efficiently and thereby realize *lower costs* from scale economies. This leads to another option: the successful differentiator can also hold prices constant, or only increase prices slightly, sell more, and boost profitability through the attainment of scale economies (see Figure 5.1).[3]

For another example, consider Starbucks. The company has successfully differentiated its product offering from that of rivals such as Tully's by the excellent quality of its coffee-based drinks; by the quick, efficient, and friendly service that its baristas offer customers; by the comfortable atmosphere created by the design of its stores; and by its strong brand image. This differentiation increases the volume of traffic in each Starbucks store, thereby

Figure 5.1 | Options for Exploiting Differentiation

Source: Charles W.L. Hill © Copyright 2013.

increasing the productivity of employees in the store (they are always busy), and the productivity of the capital invested in the store itself. The result: each store realizes scale economies from greater volume, which lowers the average unit costs at each store. Spread that across the 12,000 stores that Starbucks operates, and you have potentially huge cost savings that translate into higher profitability. Add this to the enhanced demand that comes from successful differentiation, which in the case of Starbucks not only enables the firm to sell more from each store, but also to open more stores, and profit growth will also accelerate.

The Differentiation–Low Cost Tradeoff The thrust of our discussion so far is that a low-cost position and a differentiated position are two very different ways of gaining a competitive advantage. The enterprise that is striving for the lowest costs does everything it can to be productive and drive down its cost structure, whereas the enterprise striving for differentiation necessarily has to bear higher costs to achieve that differentiation. Put simply, one cannot be Wal-Mart and Nordstrom, Porsche and Kia, Rolex and Timex. Managers must make a choice between these two basic ways of attaining a competitive advantage.

However, presenting the choice between differentiation and low costs in these terms is something of a simplification. As we have already noted, the successful differentiator might be able to subsequently reduce costs if differentiation leads to significant demand growth and the attainment of scale economies. But in actuality, the relationship between low cost and differentiation is subtler than this. In reality, strategy is not so much about making discrete choices as it is about deciding what the right balance is between differentiation and low costs.

To understand the issues here, look at Figure 5.2. The convex curve in Figure 5.2 illustrates what is known as an *efficiency frontier* (also known in economics as a production possibility frontier).[4] The efficiency frontier shows all of the different positions that a company can adopt with regard to differentiation and low cost, *assuming* that its internal functions and organizational arrangements are configured efficiently to support a particular position (note that the horizontal axis in Figure 5.2 is reverse scaled—moving along the axis to the right implies lower costs). The efficiency frontier has a convex shape because of diminishing returns. Diminishing returns imply that when an enterprise already has significant differentiation built into its product offering, increasing differentiation by a relatively small amount requires significant additional costs. The converse also holds: when a company already has a low-cost structure, it has to give up a lot of differentiation in its product offering to get additional cost reductions.

The efficiency frontier shown in Figure 5.2 is for the U.S. retail apparel business (Wal-Mart sells more than apparel, but that need not concern us here). As you will see, Nordstrom and Wal-Mart are both shown to be on the frontier, implying that both organizations have configured their internal functions and organizations efficiently. However, they have adopted very different positions; Nordstrom has high differentiation and high costs, whereas Wal-Mart has low costs and low differentiation. These are not the only viable positions in the industry, however. We have also shown The Gap to be on the frontier. The Gap offers higher-quality apparel merchandise than Wal-Mart, sold in a more appealing store format, but its offering is nowhere near as differentiated as that of Nordstrom; it is positioned between Wal-Mart and Nordstrom. This mid-level position, offering moderate differentiation at a higher cost than Wal-Mart, makes perfect sense because there are enough consumers demanding this kind of offering. They don't want to look as if they purchased their clothes at Wal-Mart, but they do want fashionable causal clothes that are more affordable than those available at Nordstrom.

| Figure 5.2 | The Differentiation–Low Cost Tradeoff |

Source: Charles W.L. Hill © Copyright 2013.

The essential point here is that *there are often multiple positions on the differentiation–low cost continuum that are viable in the sense that they have enough demand to support an offering.* The task for managers is to identify a position in the industry that is viable and then configure the functions and organizational arrangements of the enterprise so that they are run as efficiently and effectively as possible, and enable the firm to reach the frontier. Not all companies are able to do this. Only those that can get to the frontier have a competitive advantage. Getting to the frontier requires excellence in strategy implementation. As has been suggested already in this chapter, business-level strategy is implemented through function and organization. Therefore: *to successfully implement a business-level strategy and get to the efficiency frontier, a company must be pursuing the right functional-level strategies, and it must be appropriately organized. Business-level strategy, functional-level strategy, and organizational arrangement must all be aligned with each other.*

It should be noted that not all positions on an industry's efficiency frontier are equally as attractive. For some positions, there may not be sufficient demand to support a product offering. For other positions, there may be too many competitors going after the same basic position—the competitive space might be too crowded—and the resulting competition might drive prices down below levels that are acceptable.

In Figure 5.2, K-Mart is shown to be inside the frontier. K-Mart is trying to position itself in the same basic space as Wal-Mart, but its internal operations are not efficient (the company was operating under bankruptcy protection in the early 2000s, although it is now out of bankruptcy). Also shown in Figure 5.2 is the Seattle-based clothing retailer Eddie Bauer, which is owned by Spiegel. Like K-Mart, Eddie Bauer is not an efficiently run operation relative to its rivals. Its parent company has operated under bankruptcy protection three times in the last 20 years.

Value Innovation: Greater Differention at a Lower Cost The efficiency frontier is not static; it is continually being pushed outwards by the efforts of managers to improve their firm's performance through innovation. For example, in the mid-1990s Dell pushed out the efficiency frontier in the personal computer (PC) industry (see Figure 5.3). Dell pioneered online selling of PCs, and allowed customer to build their own machines online, effectively creating value through customization. In other words, the strategy of selling online allowed Dell to *differentiate* itself from its rivals that sold their machines through retail outlets. At the same time, Dell was able to use order information submitted over the Web to efficiently coordinate and manage the global supply chain, driving down production costs in the process. The net result was that Dell was able to offer more value (through superior *differentiation*) at a *lower cost* than its rivals. Through its process innovations it had redefined the frontier of what was possible in the industry.

value innovation

When innovations push out the efficiency frontier in an industry, allowing for greater value to be offered through superior differentiation at a lower cost than was previously thought possible.

We use the term **value innovation** to describe what happens when innovation pushes out the efficiency frontier in an industry, allowing for greater value to be offered through superior differentiation at a lower cost than was previously thought possible.[5] When a company is able to pioneer process innovations that lead to value innovation, it effectively changes the game in an industry and may be able to outperform its rivals for a long period of time. This is what happened to Dell. After harnessing the power of the Internet to sell PCs online, and coordinate the global supply chain, Dell outperformed its rivals in the industry for over a decade while they scrambled to catch up with the industry leader.

Toyota is another company that benefitted from value innovation. As we have discussed in Chapters 3 and 4, Toyota pioneered lean production systems that improved the quality of automobiles, while simultaneously lowering costs. Toyota *redefined what was possible in the automobile industry*, effectively pushing out the efficiency frontier and enabling the company to better differentiate its product offering at a cost level that its rivals couldn't match. The result was a competitive advantage that persisted for over two decades.

Value Innovation in the PC Industry

Source: Charles W.L. Hill © Copyright 2013

WHO ARE OUR CUSTOMERS? MARKET SEGMENTATION

As noted in the introduction to this chapter, business-level strategy begins with the customer. It starts with deciding *who* the company is going to serve, what *needs* or *desires* it is trying to satisfy, and *how* it is going to satisfy those needs and desires. Answering these questions is not straightforward, because the customers in a market are not homogenous. They often differ in fundamental ways. Some are wealthy, some are not; some are old, some are young; some are women, some are men; some are influenced by popular culture, some never watch TV; some live in cities, some in the suburbs; some care deeply about status symbols, others do not; some place a high value on luxury, some on value for money; some exercise every day, others have never seen the inside of a gym; some speak English most of the time, for others, Spanish is their first language; and so on.

One of the most fundamental questions that any company faces is whether to recognize such differences in customers, and if it does, how to tailor its approach depending on which customer segment or segments it decides to serve. The first step toward answering these questions is to segment the market according to differences in customer demographics, needs, and desires.

Market segmentation refers to the process of subdividing a market into clearly identifiable groups of customers with similar needs, desires, and demand characteristics.

market segmentation
The way a company decides to group customers based on important differences in their needs to gain a competitive advantage.

Customers within these segments are relatively homogenous, whereas they differ in important ways from customers in other segments of the market. For example, Nike segments the athletic shoe market according to sport (running, basketball, football, soccer, and training) and gender (men's shoes and women's shoes). It does this because it believes that people participating in different sports need different things from an athletic shoe (a shoe designed for running is not suitable for playing basketball) and that men and women also desire different things from a shoe in terms of styling and construction (most men don't want to wear pink shoes). Similarly, in the market for colas, Coca-Cola segments the market by needs—regular Coke for the average consumer, and diet cola for those concerned about their weight. The diet cola segment is further subdivided by gender, with *Diet Coke* targeted at women, and *Coke Zero* targeted at men.

Three Approaches to Market Segmentation There are three basic approaches to market segmentation that companies adopt. One is to choose not to tailor different offerings to different segments, and instead produce and sell a standardized product that is targeted at the *average* customer in that market. This was the approach adopted by Coca-Cola until the early 1980s before the introduction of Diet Coke and different flavored cola drinks such as Cherry Cola. In those days Coke was *the* drink for everyone. Coke was differentiated from the offerings of rivals, and particularly Pepsi Cola, by lifestyle advertising that positioned Coke as the iconic American drink, the "real thing." Some network broadcast news programs also choose to adopt this approach today. The coverage offered by ABC News, for example, is tailored toward the average American viewer. The giant retailer Wal-Mart also targets the average customer in the market, although unlike Coca-Cola, Wal-Mart's goal is to drive down costs so that it can charge everyday low prices, give its customers value for money, and still make a profit.

A second approach is to recognize differences between segments and create different product offerings for the different segments. This is the approach that Coca-Cola has adopted since the 1980s. In 1982 it introduced Diet Coke, targeting that drink at the weight and health conscious. In 2007 it introduced Coke Zero, also a diet cola, but this time targeted at men. Coca Cola did this because company research found that men tended to associate Diet Coke with women. Since 2007, Diet Coke has been repositioned as more of a women's diet drink. Similarly, in the automobile industry, Toyota has brands that address the entire market—Scion for budget-constrained young entry-level buyers, Toyota for the middle market, and the Lexus for the luxury end of the market. In each of these segments Toyota pursues a differentiation strategy; it tries to differentiate itself from rivals in the segment by the excellent reliability and high quality of its offerings.

A third approach is to target only a limited number of market segments, or just one, and to become the very best at serving that particular segment. In the automobile market, for example, Porsche focuses exclusively on the very top end of the market, targeting wealthy middle-aged male consumers who have a passion for the speed, power, and engineering excellence associated with its range of sports cars. Porsche is clearly pursuing a differentiation strategy with regard to this segment, although it emphasizes a different type of differentiation than Toyota. Alternatively, Kia of South Korea has positioned itself as low-cost player in the industry, selling vehicles that are aimed at value-conscious buyers in the middle- and lower-income brackets. In the network broadcasting news business, Fox News and MSNBC have also adopted a focused approach. Fox tailors its content toward those on the right of the political spectrum, whereas MSNBC is orientated towards the left.

When managers decide to ignore different segments, and produce a standardized product for the average consumer, we say that they are pursuing a **standardization strategy**.

standardization strategy
When a company decides to ignore different segments, and produce a standardized product for the average consumer.

When they decide to serve many segments, or even the entire market, producing different offerings for different segments, we say that they are pursuing a **segmentation strategy**. When they decide to serve a limited number of segments, or just one segment, we say that they are pursuing a **focus strategy**. Today Wal-Mart is pursuing a standardization strategy, Toyota a segmentation strategy, and Nordstrom a focus strategy.

Market Segmentation, Costs and Revenues It is important to understand that these different approaches to market segmentation have different implications for costs and revenues. Consider first the comparison between a standardization strategy and a segmentation strategy.

A standardization strategy is typically associated with lower costs than a segmentation strategy. A standardization strategy involves the company producing one basic offering, and trying to attain economies of scale by achieving a high volume of sales. Wal-Mart, for example, pursues a standardization strategy and achieves enormous economies of scale in purchasing, driving down its cost of goods sold.

In contrast, a segmentation strategy requires that the company customize its product offering to different segments, producing multiple offerings, one for each segment. Customization can drive up costs for two reasons; first, the company may sell less of each offering, making it harder to achieve economies of scale, and second, products targeted at segments at the higher-income end of the market may require more functions and features, which can raise the costs of production and delivery.

On the other hand, it is important not to lose sight of the fact that advances in production technology, and particularly lean production techniques, have allowed for *mass customization*—that is, the production of more product variety without a large cost penalty (see Chapter 4 for details). In addition, by designing products that share common components, some manufacturing companies are able to achieve substantial economies of scale in component production, while still producing a variety of end products aimed at different segments. This is an approach adopted by large automobile companies, which try to utilize common components and platforms across a wide range of models. To the extent that mass customization and component sharing is possible, the cost penalty borne by a company pursuing a segmentation strategy may be limited.

Although a standardization strategy may have lower costs that a segmentation strategy, a segmentation strategy does have one big advantage: it allows the company to capture incremental revenues by customizing its offerings to the needs of different groups of consumers, and thus selling more in total. A company pursuing a standardization strategy where the product is aimed at the average consumer may lose sales from customers who desire more functions and features, and are prepared to pay more for that. Similarly, it may lose sales from customers who cannot afford to purchase the average product, but might enter the market if a more basic offering was available.

This reality was first recognized in the automobile industry back in the 1920s. The early leader in the automobile industry was Ford with its Model T offering. Henry Ford famously said that consumers could have it "any color as long as it's black." Ford was in essence pursuing a standardization strategy. However, in the 1920s Ford rapidly lost market share to General Motors, a company that pursued a segmentation strategy and offered a range of products aimed at different customer groups.

As for a focus strategy, here the impact on costs and revenues is subtler. Companies that focus on the higher-income or higher-value end of the market will tend to have a higher cost structure for two reasons. First, they will have to add features and functions to their product to appeal to higher-income consumers, and this will raises costs. For

segmentation strategy
When a company decides to serve many segments, or even the entire market, producing different offerings for different segments.

focus strategy
When a company decides to serve a limited number of segments, or just one segment.

example, Nordstrom locates its stores in areas where real estate is expensive, its stores have costly fittings and fixtures and a wide open store plan with lots of room to walk around, and the merchandise is expensive and does not turn over as fast as the basic clothes and shoes sold at somewhere like Wal-Mart. Second, the relatively limited nature of demand associated with serving just a segment of the market may make it harder to attain economies of scale. Offsetting this, however, is that the customization and exclusivity associated with a strategy of focusing on the high-income end of the market may enable such a firm to charge significantly higher prices than those enterprises pursuing standardization and segmentation strategies.

For companies focusing on the lower-income end of the market, or a segment that desires value for money, a different calculus comes into play. First, such companies tend to produce a more basic offering that is relatively inexpensive to produce and deliver. This may help them to drive down their cost structures. The retailer Costco, for example, focuses on consumers who are looking for "value for money", and are less concerned about brands than they are about price. Costco sells a limited range of merchandise in large warehouse-type stores. A Costco store has about 3,750 stock-keeping units (SKUs) compared to 142,000 SKUs at the average Wal-Mart superstore. Products are stored on pallets stacked on utilitarian metal shelves. It offers consumers the opportunity to make bulk purchases of basic goods, such as breakfast cereal, dog food, and paper towels, at lower prices than found elsewhere. It turns over its inventory rapidly, typically selling it before it has to pay its suppliers and thereby reducing its working capital needs. Thus, by tailoring its business to the needs of a segment, Costco is able to undercut the cost structure and pricing of a retail gain such as Wal-Mart, even though it lacks Wal-Mart's enormous economies of scale in purchasing. The drawback, of course, is that Costco offers nowhere near the range of goods that you might get at a Wal-Mart superstore, so for customers looking for one stop-shopping at a low price, Wal-Mart is always going to be the store of choice.

BUSINESS-LEVEL STRATEGY CHOICES

generic business-level strategy

A strategy that gives a company a specific form of competitive position and advantage vis-à-vis its rivals that results in above-average profitability.

broad low-cost strategy

When a company lowers costs so that it can lower prices and still make a profit.

broad differentiation strategy

When a company differentiates its product in some way, such as by recognizing different segments or offering different products to each segment.

We now have enough information to be able to identify the basic business-level strategy choices that companies make. These basic choices are sometimes called **generic business-level strategy**. The various choices are illustrated in Figure 5.4.

Companies that pursue a standardized or segmentation strategy both target a broad market. However, those pursuing a segmentation strategy recognize different segments, and tailor their offering accordingly, whereas those pursuing a standardization strategy just focus on serving the average consumer. Companies that target the broad market can either concentrate on lowering their costs so that they can lower prices and still make a profit, in which case we say they are pursuing a **broad low-cost strategy**, or they can try to differentiate their product in some way, in which case they are pursuing a **broad differentiation strategy**. Companies that decide to recognize different segments, and offer different product to each segment, are by default pursuing a broad differentiation strategy. It is possible, however, to pursue a differentiation strategy while not recognizing different segments, as Coca-Cola did prior to the 1980s. Today, Wal-Mart is pursuing a broad low-cost strategy, whereas Toyota and Coca-Cola are both pursuing a broad differentiation strategy.

Companies that target a few segments, or more typically, just one, are pursuing a focus or niche strategy. These companies can either try to be the low-cost player in that niche,

Figure 5.4	Generic Business-Level Strategies

as Costco has done, in which case we say that they pursuing a **focus low-cost strategy**, or they can try to customizing their offering to the needs of that particular segment through the addition of features and functions, as Nordstrom has done, in which case we say that they are pursuing a **focus differentiation strategy**.

It is important to understand that there is often no one best way of competing in an industry. Different strategies may be equally viable. Wal-Mart, Costco, and Nordstrom are all in the retail industry, all three compete in different ways, and all three have done very well financially. The important thing for managers is to know what their business-level strategy is, to have a clear logic for pursuing that strategy, to have an offering that matches their strategy, and to align the functional activities and organization arrangements of the company with that strategy so that the strategy is well executed.

Michael Porter, who was the originator of the concept of generic business-level strategies, has argued that companies must make a clear choice between the different options outline in Figure 5.4.[6] If they don't, Porter argues, they may become "*stuck in the middle*" and experience poor relative performance. Central to Porter's thesis is the assertion that it is not possible to be both a differentiated company, and a low-cost enterprise. According to Porter, differentiation by its very nature raises costs and makes it impossible to attain the low-cost position in an industry. By the same token, to achieve a low-cost position, companies necessarily have to limit spending on product differentiation.

At the limit, there is certainly considerable value in this perspective. As noted, one cannot be Nordstrom and Wal-Mart, Timex and Rolex, Porsche and Kia. Low cost and differentiation are very different ways of competing—they require different functional strategies and different organizational arrangements, so trying to do both at the same time may not work. On the other hand, there are some important caveats to this argument.

First, as we have already seen in this chapter when we discussed value innovation, through improvements in process and product, a company can push out the efficiency frontier in its industry, redefining what is possible, and deliver more differentiation at a lower cost than its rivals. In such circumstances, a company might find itself in the fortunate position of being both the differentiated player in its industry and having a low-cost position. Ultimately its rivals might catch up, in which case it may well have to make a choice between emphasizing low cost and differentiation, but as we have seen

focus low-cost strategy

When a company targets a certain segment or niche, and tries to be the low-cost player in that niche.

focus differentiation strategy

When a company targets a certain segment or niche, and customizes its offering to the needs of that particular segment through the addition of features and functions.

from the case histories of Dell and Toyota, value innovators can gain a sustain competitive advantage that lasts for years, if not decades (another example of value innovation is given in Strategy in Action 5.2, which looks at the history of Microsoft Office).

Second, it is important for the differentiated company to recognize that it cannot take its eye off the efficiency ball. Similarly, the low-cost company cannot ignore product differentiation. The task facing a company pursuing a differentiation strategy is to be as efficient as possible given its choice of strategy. The differentiated company should not cut costs so far that it harms its ability to differentiate its offering from that of rivals. At the same time, it cannot let costs get out of control. Nordstrom, for example, is very efficient given its choice of strategic position. It is not a low-cost company by any means, but given its choice of how to compete it operates as efficiently as possible. Similarly, the low-cost company cannot totally ignore key differentiators in its industry. Wal-Mart does not provide anywhere near the level of customer service that is found at Nordstrom, but nor can Wal-Mart ignore customer service. Even though Wal-Mart has a self-service business model, there are still people in the store who are available to help customers with questions if that is required. The task for low-cost companies such as Wal-Mart is to be "good enough" with regard to key differentiators. For another example of how this plays out, see Strategy in Action 5.2, which looks at how Google and Microsoft compete in the market for office productivity software.

BUSINESS-LEVEL STRATEGY, INDUSTRY AND COMPETITIVE ADVANTAGE

Properly executed, a well-chosen and well-crafted business-level strategy can give a company a competitive advantage over actual and potential rivals. More precisely, it can put the company in an advantageous position relative to each of the competitive forces that we discussed in Chapter 2—specifically, the threat of entrants, the power of buyers and suppliers, the threat posed by substitute goods or services, and the intensity of rivalry between companies in the industry.

Consider first the low-cost company; by definition, the low-cost enterprise can make profits at price points that its rivals cannot profitably match. This makes it very hard for rivals to enter its market. In other words, the low-cost company can build an entry barrier into its market. It can, in effect, erect an economic moat around its business that keeps higher-cost rivals out. This is what Amazon has done in the online retail business. Through economies of scale and other operating efficiencies, Amazon has attained a very-low-cost structure that effectively constitutes a high entry barrier into this business. Rivals with less volume and fewer economies of scale than Amazon cannot match Amazon on price without losing money—not a very appealing proposition.

A low-cost position and the ability to charge low prices and still make profits also give a company protection against substitute goods or services. Low costs can help a company to absorb cost increases that may be passed on downstream by powerful suppliers. Low costs can also enable the company to respond to demands for deep price discounts from powerful buyers and still make money. The low-cost company is often best positioned to survive price rivalry in its industry. Indeed, a low-cost company may deliberately initiate a price war in order to grow volume and drive its weaker rivals out of the industry. This is what Dell did during its glory days in the early 2000s when it repeatedly cut prices for PCs in order to drive up sales volume and force marginal competitors out of the business. Pursuing such a strategy enabled Dell to become the largest computer company in the world by the mid-2000s.

5.2 STRATEGY IN ACTION

Microsoft Office versus Google Apps

© iStockPhoto.com/Tom Nulens

Microsoft has long been the dominant player in the market for office productivity software with its Office suite of programs that includes a word processor, spreadsheet, presentation software, and e-mail client. Microsoft's rise to dominance in this market was actually the result of an important innovation—in 1989 Microsoft was the first company to bundle word processing, spreadsheet, and presentation programs together into a single offering that was interoperable. At the time, the market leader in word processing software was Word Perfect, in spreadsheet software it was Lotus, and in presentation software it was Harvard Graphics. Microsoft was number 2 in each of these markets. However, by offering a bundle, and pricing the bundle below the price of each program purchased on its own, Microsoft was able to grab share from its competitors, none of which had a full suite of offerings. In effect, Microsoft Office offered consumers more value (interoperability), at a lower price, than could be had from rivals.

As demand for Office expanded, Microsoft was able to spread the fixed costs of product development over a much larger volume than its rivals, and unit costs fell, giving Microsoft the double advantage of a differentiated product offering and a low-cost position. The results included the creation of a monopoly position in office productivity software and two decades of extraordinary high returns for Microsoft in this market.

Things started to shift in 2006 when Google introduced Google Apps, an online suite of office productivity software that was aimed squarely at Microsoft's profitable Office franchise. Unlike Office at the time, Google Apps was an online service. The basic programs reside on the cloud, and documents were saved on the cloud. At first Google lacked a full suite of programs, and traction was slow, but since 2010 adoption of Google Apps has started to accelerate. Today Google Apps has the same basic programs as Office—a word processer, spreadsheet, presentation software, and an e-mail client—but nowhere near the same number of features. Google's approach is not to match Office on features, but to *be good enough* for the majority of users. This helps to reduce development costs. Google also distributes Google Apps exclusively over the Internet, which is a very-low-cost distribution model, whereas Office still has a significant presence in the physical retail channel, raising costs.

In other words, Google is pursuing a low-cost strategy with regard to Google Apps. Consistent with this, Google Apps is also priced significantly below Office. Google charges $50 a year for each person using its product. In contrast, Microsoft Office costs $400 per computer for business users (although significant discounts are often negotiated). Initially Google Apps was targeted at small businesses and start-ups, but more recently, Google seems to be gaining some traction in the enterprise space, which is Microsoft's core market for Office. In 2012, Google scored an impressive string of wins, including the Swiss drug company Hoffman La Roche, where over 80,000 employees use the package, and the U.S. Interior Department, where 90,000 use it. In total, Google Apps earned around $1 billion in revenue in 2012 and estimates suggest that the company has more than 30 million paying subscribers. This still makes it a small offering relative to Microsoft Office, which is installed on over 1 billion computers worldwide. Microsoft Office generated $24 billion in revenue in 2012 and it remains Microsoft's most profitable business. However, Microsoft cannot ignore Google Apps.

Indeed, Microsoft is not standing still. In 2012, Microsoft rolled out its own cloud-based Office offering, Office 365. Office 365 starts at a list price of $72 a year per person, and can cost as much as $240 a person annually in versions that offer many more features and software development capabilities. According to a Microsoft spokesperson, demand for Office 365 has been strong. Microsoft argues that Google cannot match the "quality enterprise experience in areas like privacy, data handling and security" that Microsoft offers. Microsoft's message is clear—it still believes that Office is the superior product offering, differentiated by features, functions, privacy, data handing, and security. Whether Office 365 will keep Google Apps in check, however, remains to be seen.

Sources: Author interviews at Microsoft and Google; Quentin Hardy, "Google Apps Moving onto Microsoft's Business Turf," *New York Times*, December 26, 2012; and A. R. Hickey, "Google Apps: A $1 Billion Business?" *CRN*, February 3, 2012.

Now consider the differentiated company. The successful differentiator is also protected against each of the competitive forces we discussed in Chapter 2. The brand loyalty associated with differentiation can constitute an important entry barrier, protecting the company's market from potential competitors. The brand loyalty enjoyed by Apple in the smartphone business, for example, has set a very high hurdle for any new entrant to match, and effectively acts as a deterrent to entry. Because the successful differentiator sells on non-price factors, such as design or customer service, it is also less exposed to pricing pressure from powerful buyers. Indeed, the converse may be the case—the successful differentiator may be able to implement price increases without encountering much, if any, resistance from buyers. The differentiated company can also fairly easy absorb price increases from powerful suppliers and pass those on downstream in the form of higher prices for its offerings, without suffering much, if any, loss in market share. The brand loyalty enjoyed by the differentiated company also gives it protection from substitute goods and service.

The differentiated company is protected from intense price rivalry within its industry by its brand loyalty, and by the fact that non-price factors are important to its customer set. At the same time, the differentiated company often does have to invest significant effort and resources in non-price rivalry, such as brand building through marketing campaigns or expensive product development efforts, but to the extent that it is successful, it can reap the benefits of these investments in the form of stable or higher prices.

Having said this, it is important to note that focused companies often have an advantage over their broad market rivals in the segment or niche that they compete in. For example, although Wal-Mart and Costco are both low-cost companies, Costco has a cost advantage over Wal-Mart in the segment that it serves. This primarily comes from the fact that Costco carries far fewer SKUs, and those it does are sold in bulk. However, if Costco tried to match Wal-Mart and serve the broader market, the need to carry a wider product selection (Wal-Mart has over 140,000 SKUs) means that its cost advantage would be lost.

The same can be true for a differentiated company. By focusing on a niche, and customizing the offering to that segment, a differentiated company can often outsell differentiated rivals that target a broader market. Thus Porsche can outsell broad market companies like Toyota or General Motors in the high-end sports car niche of the market, in part because the company does not sell outside of its core niche. Thus Porsche creates an image of exclusivity that appeals to its customer base. Were Porsche to start moving down-market, it would lose this exclusive appeal and become just another broad market differentiator.

IMPLEMENTING BUSINESS-LEVEL STRATEGY

As we have already suggested in this chapter, for a company's business-level strategy to translate into a competitive advantage, it must be well implemented. This means that actions taken at the functional level should support the business-level strategy, as should the organizational arrangements of the enterprise. There must, in other words, be *alignment* or *fit* between business-level strategy, functional strategy, and organization (see Figure 5.5). We have already discussed functional strategy in Chapter 4; detailed discussion of organizational arrangements is postponed until Chapter 12. Notwithstanding this, here we do make some basic observations about the functional strategies and organizational arrangements required to implement the business-level strategies of low cost and differentiation.

Strategy is Implemented through Function and Organization

Source: Charles W.L. Hill © Copyright 2013.

Lowering Costs through Functional Strategy and Organization How do companies achieve a low-cost position? They do this primarily through pursuing those functional-level strategies that result in *superior efficiency* and *superior product reliability*, which we discussed in detail in Chapter 4 when we looked at functional-level strategy and the building blocks of competitive advantage. As you will recall from Chapter 4, the following are clearly important:

- Achieving economies of scale and learning effects.
- Adopting lean production and flexible manufacturing technologies.
- Implementing quality improvement methodologies to ensure that the goods or services the company produces are reliable, so that time, materials, and effort are not wasted producing and delivering poor-quality products that have to be scrapped, reworked, or produced again from scratch
- Streamlining processes to take out unnecessary steps
- Using information systems to automate business process
- Implementing just-in-time inventory control systems
- Designing products so that they can be produced and delivered at as low a cost as possible
- Taking steps to increase customer retention and reduce customer churn

In addition, to lower costs the firm must be *organized* in such a way that the structure, control systems, incentive systems, and culture of the company all emphasize and reward employee behaviors and actions that are consistent with, or lead to, higher productivity and greater efficiency. As will be explained in detail in Chapter 12, the kinds of organizational arrangements that are favored in such circumstances include a flat organizational structure with very few levels in the management hierarchy, clear lines of accountability and control, measurement and control systems that focus on productivity and cost containment, incentive systems that encourage employees to work in as productive a manner as possible and empower employees to suggest and pursue initiatives that are consistent with productivity improvements, and a frugal culture that emphasizes the need to control costs. Companies that operate with these kinds of organizational arrangements include Amazon and Wal-Mart.

Differentiation through Functional-Level Strategy and Organization As with low costs, to successfully differentiate itself a company must pursue the right actions at the functional level, and it must organize itself appropriately. Pursuing functional-level strategies that enable the company to achieve *superior quality* in terms of both reliability and excellence are important, as is an emphasis upon *innovation* in the product offering, and high levels of *customer responsiveness*. You will recall from Chapters 3 and 4 that superior quality, innovation, and customer responsiveness are three of the four building blocks of competitive advantage, the other being *efficiency*. Do remember that the differentiated firm cannot ignore efficiency; by virtue of its strategic choice, the differentiated company is likely to have a higher cost structure than the low-cost player in its industry. Specific functional strategies designed to improve differentiation include the following:

- Customization of the product offering and marketing mix to different market segments
- Designing product offerings that have high perceived quality in terms of their functions, features, and performance, in addition to being reliable
- A well-developed customer care function for quickly handling and responding to customer inquiries and problems
- Marketing efforts focused on brand building and perceived differentiation from rivals
- Hiring and employee development strategies designed to ensure that employees act in a manner that is consistent with the image that the company is trying to project to the world

As we saw in the opening case, Nordstrom's successful differentiation is due to its excellent customer service, which is an element of customer responsiveness. Nordstrom also pays close attention to employee recruitment and training to ensure that salespeople at Nordstrom behave in a manner that is consistent with Nordstrom's customer service values when interacting with customers. Similarly, Apple has an excellent customer care function, as demonstrated by its in-store "genius bars" where well-trained employees are available to help customers with inquiries and problems, and give tutorials to help them get the best value out of their purchases. Apple has also been very successful at building a brand that differentiates it from rivals such as Microsoft (for example, the long-running TV advertisements featuring "Mac," a very hip guy, and "PC," the short, overweight man in a shabby gray suit).

As for organizing, creating the right structure, controls, incentives, and culture can all help a company to differentiate itself from rivals. In a differentiated enterprise, one key issue is to make sure that marketing, product design, customer service, and customer care functions all play a key role. Again consider Apple; following the return of Steve Jobs to the company in 1997, he reorganized to give the industrial design group the lead on all new product development efforts. Under this arrangement, industrial design, headed by Johnny Ive, reported directly to Jobs, and engineering reported to industrial design for purposes of product development. This meant that the designers, rather than engineers, specified the look and feel of a new product, and engineers then had to design according to the parameters imposed by the design group. This is in contrast to almost all other companies in the computer and smartphone business, where engineering typically takes the lead on product development. Jobs felt that this organizational arrangement was necessary to ensure that Apple produced beautiful products that not only worked well, but also looked and felt elegant. Because Apple under Jobs was differentiating by design, design was given a pivotal position in the organization.[7]

Making sure that control systems, incentive systems, and culture are aligned with the strategic thrust is also extremely important for differentiated companies. Thus leaders at

Nordstrom constantly emphasize the importance of customer service in order to build a company-wide culture that internalizes this key value. Actions consistent with this include an inverted organizations chart that shows the CEO working for salespeople, and the salespeople working for customers, as well as the repetition of stories that celebrate employees who have gone beyond the call of duty to serve customers. We will return to and expand upon these themes in Chapter 12.

COMPETING DIFFERENTLY: SEARCHING FOR A BLUE OCEAN

We have already suggested in this chapter that sometimes companies can fundamentally shift the game in their industry by figuring out ways to offer more value through differentiation at a lower cost than their rivals. We referred to this as *value innovation*, a term that was first coined by Chan Kim and Renee Mauborgne.[8] Kim and Mauborgne developed their ideas further in the best-selling book *Blue Ocean Strategy*.[9] Their basic proposition is that many successful companies have built their competitive advantage by redefining their product offering through value innovation and, in essence, creating a new market space. They describe the process of thinking through value innovation as searching for the blue ocean—which they characterize as a wide open market space where a company can chart its own course.

One of their examples of a company that found its own blue ocean is Southwest Airlines (see Strategy in Action 5.1 for more details about Southwest Airlines). From its conception, Southwest competed differently than other companies in the U.S. airline industry. Most important, Southwest saw its main competitors not as other airlines, but people who would typically drive or take a bus to travel. For Southwest, the focus was to reduce travel time for its customer set, and to do so in a way that was cheap, reliable, and convenient, so that they would prefer to fly rather than drive.

The very first route that Southwest operated was between Houston and Dallas. To reduce total travel time, it decided to fly into the small downtown airports in both cities, Hobby in Houston and Love Field in Dallas, rather than the large inter-continental airports outside located an hour drive outside of both cities. The goal was to reduce total travel time by eliminating the need to dive to reach a big airport outside the city before even beginning the journey. Southwest then put as many flights a day on the route as possible to make it convenient, and did everything possible to drive down operating costs so that it could charge low prices and still make a profit.

As the company grew and opened more routes, it followed the same basic strategy. Southwest always flew point to point, never routing passengers through hubs. Changing planes in a hub adds to total travel time and can hurt reliability, measured by on-time departures and arrivals, if connections are slow coming into or leaving a hub due to adverse events, such as bad weather delaying arrivals or departures somewhere in an airline's network. Southwest also cut out in-flight meals, only offers coach-class seating, does not have lounges in airports for business-class passengers, and has standardized on one type of aircraft, the Boeing 737, which helps to raise reliability. As we saw in Strategy in Action 5.1, Southwest has also taken a number of steps to boost employee productivity. The net result is that Southwest delivers more value *to its customer set*, and does so at a lower cost than its rivals, enabling it to price lower than them and still make a profit. Southwest is a value innovator.

Kim and Mauborgne use the concept of a *strategy canvas* to map out how value innovators differ from their rivals. A strategy canvas for Southwest is shown in Figure 5.6. This shows that Southwest charges a low price and does not provide meals or lounges in airports, or business-class seating, or connections through hubs (it flies point to point), but does provide a friendly, quick, convenient, and reliable low-cost service, *which is exactly what its customer set values*.

The whole point of the Southwest example, and other business case histories Kim and Mauborgne review, is to illustrate how many successful enterprises compete differently than their less successful rivals: they carve out a unique market space for themselves through value innovation. When thinking about how a company might redefine its market and craft a new business-level strategy, Kim and Mauborgne suggest that managers ask themselves the following questions:

1. **Eliminate**: Which factors that rivals take for granted in our industry can be eliminated, thereby reducing costs?
2. **Reduce**: Which factors should be reduced well below the standard in our industry, thereby lowering costs?
3. **Raise**: Which factors should be raised above the standard in our industry, thereby increasing value?
4. **Create**: What factors can we create that rivals do not offer, thereby increasing value?

Figure 5.6 A Strategy Canvas for Southwest Airlines

Southwest, for example, *eliminated* lounges, business seating, and meals in flight—it *reduced* in-flight refreshment to way below industry standards; but by flying point to point it *raised* speed (reducing travel time) and convenience and reliability. Southwest also *created* more value by flying between smaller downtown airports whenever possible, something that other airlines did not typically do.

This is a useful framework, and it directs managerial attention to the need to think differently than rivals in order to create an offering and strategic position that are unique. If such efforts are successful, they can help a company to build a sustainable advantage.

One of the great advantages of successful value innovation is that it can catch rivals off guard and make it difficult for them to catch up. For example, when Dell Computer started to sell direct over the Internet, it was very difficult for rivals to respond because they had already invested in a different way of doing business—selling though a physical retail channel. Dell's rivals could not easily adopt the Dell model without alienating their channel, which would have resulted in lost sales. The prior strategic investment of Dell's rivals in distribution channels, which at the time they were made seemed reasonable, became a source of inertia that limited their ability to respond in a timely manner to Dell's innovations. The same has been true in the airline industry, where the prior strategic investments of traditional airlines have made it very difficult for them to respond to the threat posed by Southwest.

In sum, value innovation, because it shifts the basis of competition, can result in a sustained competitive advantage for the innovating company due to the relative inertia of rivals and their inability to respond in a timely manner without breaking prior strategic commitments.

SUMMARY OF CHAPTER

1. Business-level strategy refers to the overarching competitive theme of a company in a given market.

2. At the most basic level, a company has a competitive advantage if it can lower costs relative to rivals and/or differentiate its product offering from those of rivals.

3. A low-cost position enables a company to make money at price points where its rivals are losing money.

4. A differentiated company can charge a higher price for its offering, and/or it can use superior value to generate growth in demand.

5. There are often multiple positions along the differentiation–low cost continuum that are viable in a market.

6. Value innovation occurs when a company develops new products, or processes, or strategies that enable it to offer more value through differentiation at a lower cost than its rivals.

7. Formulating business-level strategy starts with deciding *who* the company is going to serve, what *needs* or *desires* it is trying to satisfy, and *how* it is going to satisfy those needs and desires.

8. Market segmentation is the process of subdividing a market into clearly identifiable groups of customers that have similar needs, desires, and demand characteristics.

9. A company's approach to market segmentation is an important aspect of its business-level strategy.

10. There are four generic business-level strategies: broad low cost, broad differentiation, focus low cost, and focus differentiation.

11. Business-level strategy is executed through actions taken at the functional level, and through organizational arrangements.

12. Many successful companies have built their competitive advantage by redefining their

product offering through value innovation and creating a new market space. The process of thinking through value innovation has been described as searching for a "blue ocean"—a wide open market space where a company can chart its own course.

DISCUSSION QUESTIONS

1. What are the main differences between a low-cost strategy and a differentiation strategy?
2. Why is market segmentation such an important step in the process of formulating a business-level strategy?
3. How can a business-level strategy of (a) low cost and (b) differentiation offer some protection against competitive forces in a company's industry?
4. What is required to transform a business-level strategy from an idea into reality?
5. What do we mean by the term *value innovation*? Can you identify a company not discussed in the text that has established a strong competitive position through value innovation?

KEY TERMS

Business-level
 strategy 154
Value innovation 160
Market
 segmentation 161

Standardization
 strategy 162
Segmentation
 strategy 163
Focus strategy 163

Generic business-level
 strategy 164
Broad low-cost
 strategy 164
Broad differentiation
 strategy 164

Focus low-cost
 strategy 165
Focus differentiation
 strategy 165

PRACTICING STRATEGIC MANAGEMENT

© iStockPhoto.com/Urilux

Small-Group Exercise

Break up into groups of three to five each. Appoint one group member as a spokesperson who will communicate the group's findings to the class when called on to do so by the instructor. Discuss the following scenario: Identify a company that you are familiar with that seems to have gained a competitive advantage by being a value innovator within its industry. Explain how this company has (a) created more value that rivals in its industry, and (b) simultaneously been able to drive down its cost structure. How secure do you think this company's competitive advantage is? Explain your reasoning.

STRATEGY SIGN ON

© iStockPhoto.com/Ninoslav Dotlic

Article File 5

Find examples of companies that are pursuing each of the generic business-level strategies identified in Figure 5.4. How successful has each of these companies been at pursuing its chosen strategy?

Strategic Management Project: Developing Your Portfolio 5

This module deals with the business-level strategy pursued by your company:

1. Which market segments is your company serving?
2. What business-level strategy is your company pursuing?
3. How is your company executing its business-level strategy through actions at the functional level, and through organizational arrangements? How well is it doing? Are there things it could do differently?
4. Take a blue ocean approach to the business of your company, and ask if it could and/or should change its business-level strategy by eliminating, reducing, raising, or creating factors related to its product offering.

ETHICAL DILEMMA

© iStockPhoto.com/P_Wei

Costco is pursuing a low-cost strategy. As result of its pressures on suppliers to reduce prices, many of them have outsourced manufacturing to low-wage countries such as China. This may have contributed to the "hollowing out" of the manufacturing base in the United States. Are Costco's actions ethical?

CLOSING CASE

Lululemon

Back in 1998, self-described snowboarder and surfer dude Chip Wilson took his first commercial yoga class. The Vancouver native loved the exercises, but he hated doing them in the cotton clothing that was standard yoga wear at the time. For Wilson, who had worked in the sportswear business and had a passion for technical athletic fabrics, wearing cotton clothes to do sweaty, stretchy power yoga exercises seemed totally inappropriate. And so the idea for Lululemon was born.

Wilson's vision was to create high-quality and stylishly designed clothing for yoga and related sports activities using the very best technical fabrics. He built up a design team, but outsourced manufacturing to low-cost producers, primarily in South East Asia. Rather than selling clothing through existing retailers, Wilson elected to open his own stores. The idea was to staff the stores with employees who were themselves passionate about exercise, and could act as ambassadors for healthy living through yoga and other sports such as running and cycling.

The first store opened in Vancouver, Canada, in 2000. It quickly became a runaway success, and other stores soon followed. In 2007 the company went public, using the capital raised to accelerate its expansion plans. By 2013, Lululemon had over 210 stores, mostly in North America, sales in excess of $1.4 billion, and a market capitalization of $8 to 9 billion. Sales per square foot were estimated to be around $1,800—more than four times that of luxury department store Nordstrom, making Lululemon one of the top retailers in the world on this metric. Along the way, Chip Wilson stepped up into the chairman role. Wilson hired Christine Day to be the CEO in 2008, while he continued to focus on branding. Day had spent 20 years at Starbucks overseeing retail operations in North America, and then around the world.

As it has evolved, Lululemon's strategy focuses on a number of key issues. Getting the product right is undoubtedly a central part of the company's strategy. The company's yoga-inspired athletic clothes are well designed, stylish, comfortable, and use the very best technical fabrics. An equally important part of the strategy is to only stock a limited supply of an item. New colors and seasonal items, for example, get 3- to 12-week life cycles, which keeps the product offerings feeling fresh. The goal is to sell gear at full price, and to condition customers to buy when they see it, rather than wait, because if they do, it may soon be "out of stock." The company only allows product returns if the clothes have not been worn and still have the price tags attached. "We are not Nordstrom," says Day, referring to that retailer's policy of taking products back, no questions asked.

The scarcity strategy has worked; Lululemon never holds sales, and its clothing sells for a premium price. For example, its yoga pants are priced from $78 to $128 a pair, whereas low-priced competitors like Gap Inc.'s Athleta sell yoga pants on their websites for $25 to $50.

Lululemon continues to hire employees who are passionate about fitness. Part of the hiring process involves taking prospective employees to a yoga or spin class. Some 70% of store managers are internal hires; most started on the sales floor and grew up in the culture. Store managers are given $300 to repaint their stores (any color) twice a year. The look and interior design of each store are completely up to its manager. Each store is also given $2,700 a year for employees to contribute to a charity or local event of their own choosing. One store manager in D.C. used the funds to create, with regional community leaders, a global yoga event in 2010. The result, Salutation Nation, is now an annual event in which over 70 Lululemon stores host a free, all-level yoga practice at the same time.

Employees are trained to eavesdrop on customers, who are called "guests." Clothes-folding tables are placed on the sales floor near the fitting rooms rather than in a back room so that employees can overhear complaints. Nearby, a large chalkboard lets customers write suggestions or complaints that are sent back to headquarters. This feedback is then incorporated into the product design process.

CEO Christine Day is not a fan of using "big data" to analyze customer purchases. She believes that software-generated data can give a company a false sense of security about the customer. Instead, Day personally spends hours each week in Lululemon stores observing how customers shop, listening to their complaints, and then using their feedback to tweak product development efforts. On one visit to a store in Whistler, British Columbia, Day noticed that women trying on a knit sweater found the sleeves too tight. After asking store associates if they had heard similar complaints, she canceled all future orders.

Despite the company's focus on providing quality, it has not all been plain sailing for Lululemon. In 2010, Wilson caused a stir when he had the company's tote bags emblazoned with the phrase "Who is John Galt," the opening line from Ayn Rand's 1957 novel, *Atlas Shrugged*. *Atlas Shrugged* has become a libertarian bible, and the underlying message that

Lululemon supported Rand's brand of unregulated capitalism did not sit too well with many of the stores' customers. After negative feedback, the bags were quickly pulled from stores. Wilson himself stepped down from any day-to-day involvement in the company in January 2012, although he remains chairman.

In early 2013, Lululemon found itself dealing with another controversy when it decided to recall some black yoga pants that were apparently too sheer, and effectively "see through" when stretched due to the lack of "rear-end coverage." In addition to the negative fallout from the product itself, some customers report being mistreated by employees who demanded that customers put the pants on and bend over to determine whether the clothing was see-through enough to warrant a refund! Despite this misstep, however, most observers in the media and financial community believe that the company will deal with this issue, and be able to continue its growth trajectory going forward.

Sources: Dana Mattoili, "Lululemon's Secret Sauce," *Wall Street Journal*, March 22, 2012; C. Leahey, "Lululemon CEO: How to Build Trust Inside Your Company," *CNN Money*, March 16, 2012; Tiffany Hsu "Panysgate to Hurt Lululemon Profit: Customer Told to Bend Over," *latimes.com*, March 21, 2013; and C. O'Commor, "Billionaire Founder Chip Wilson out at Yoga Giant Lululemon," *Forbes*, January 9, 2012.

CASE DISCUSSION QUESTIONS

1. How would you describe Lululemon's market segmentation strategy? Who do you think are Lululemon's typical customers?
2. What generic business-level strategy is Lululemon pursuing? Does this strategy give it an advantage over its rivals in the athletic clothing business? If so, how?
3. In order to successfully implement its business-level strategy, what does Lululemon need to do at the functional level? Has the company done these things?
4. How might the marketing and product missteps cited in the case impact upon Lululemon's ability to successfully execute its business-level strategy? What should Lululemon do to make sure that it does not make similar mistakes going forward?

NOTES

[1] Derek F. Abell, *Defining the Business: The Starting Point of Strategic Planning* (Englewood Cliffs NJ: Prentice-Hall, 1980).

[2] M. E. Porter, *Competitive Advantage* (New York: Free Press, 1985); and M. E. Porter, *Competitive Strategy* (New York, Free Press, 1980)

[3] C. W. L. Hill, "Differentiation Versus Low Cost or Differentiation and Low Cost: A Contingency Framework," *Academy of Management Review* 13 (1988): 401–412.

[4] M. E. Porter, "What Is Strategy?" *Harvard Business Review,* On-point Enhanced Edition Article, February 1, 2000.

[5] W.C. Kim and R. Mauborgne, "Value Innovation: The Strategic Logic of High Growth," *Harvard Business Review*, January–February 1997.

[6] Porter, *Competitive Advantage*; and, *Competitive Strategy*.

[7] The story was told to the author, Charles Hill, by an executive at Apple.

[8] Kim and Mauborgne, "Value Innovation: The Strategic Logic of High Growth."

[9] W.C. Kim and R. Mauborgne, Blue Ocean Strategy (Boston, Mass: Harvard Business School Press, 2005).

6

Business-Level Strategy and the Industry Environment

LEARNING OBJECTIVES

After reading this chapter, you should be able to:

6-1 Identify the strategies managers can develop to increase profitability in fragmented industries

6-2 Discuss the special problems that exist in embryonic and growth industries and how companies can develop strategies to effectively compete

6-3 Understand competitive dynamics in mature industries and discuss the strategies managers can develop to increase profitability even when competition is intense

6-4 Outline the different strategies that companies in declining industries can use to support their business models and profitability

OPENING CASE

How to Make Money in Newspaper Advertising

The U.S. newspaper business is a declining industry. Since 1990 newspaper circulation has been in a steady fall, with the drop accelerating in recent years. According to the Newspaper Association of America, in 1990 62.3 million newspapers were sold every day. By 2011 this figure had dropped to 44.4 million. The fall in advertising revenue has been even steeper, with revenues peaking in 2000 at $48.7 billion, and falling to just $20.7 billion in 2011. The reasons for the declines in circulation and advertising revenue are not hard to find; digitalization has disrupted the industry, news consumption has moved to the Web, and advertising has followed suit.

Declining demand for printed newspapers has left established players in the industry reeling. Gannett Co., which publishes *USA Today* and a host of local newspapers, has seen its revenues slip to $5.3 billion in 2012, down from $6.77 billion in 2008. The venerable *New York Times* has watched revenues fall from $2.9 billion to $1.99 billion over the same period. The industry has responded by downsizing newsrooms, shutting down unprofitable newspaper properties, including numerous local newspapers, and expanding Web-based news properties as rapidly as possible. It has proved to be anything

178

but easy. Whereas consumers were once happy to subscribe to their daily print newspaper, they seem to loathe paying for anything on the Web, particularly given the large amount of "free" content that they can access.

Against this background, one local newspaper company is swimming against the tide, and making money at it. The company, Community Impact Newspaper, produces 13 hyper- local editions that are delivered free each month to 855,000 homes in the Austin, Houston, and Dallas areas. The paper was the brainchild of John Garrett, who used to work as an advertising director for the *Austin Business Journal*. Back in 2005, Garrett noticed that the large-circulation local newspapers in Texas did not cover news that was relevant to smaller neighborhoods— such as the construction of a local toll road, or the impact of a new corporate campus for Exxon Mobil. Nor could news about these projects be gleaned from the Web. Yet Garrett believed that local people were still hungry for news about local projects and events that might impact them. So he started the paper, launching the inaugural issue in September 2005, and financing it with $40,000 borrowed from low-interest credit cards.

Today the paper has a staff of 30 journalists, about 35% of the total workforce.

The reporting is pretty straight stuff—there is no investigative reporting—although Impact will do in-depth stories on controversial local issues, but it is careful not to take sides. "That would just lose us business," says Garrett. About half of each edition is devoted to local advertisements, and this is where Impact makes its money. For their part, the advertisers seem happy with the paper. "We've tried everything, from Google Ads to Groupon, but this is the most effective," says Richard Hunter, who spends a few hundred dollars each month to advertise his Houston restaurant, Catfish Station. Another advertiser, Rob Sides, who owns a toy store, Toy Time, places 80% of his advertising dollars with Impact's local edition in order to reach 90,000 homes in the area.

An analysis by *Forbes* estimated that each 40-page issue of Impact brings in about $2.50 in ad revenue per printed copy. About 50 cents of that goes to mailing and distribution costs, 80 cents to payroll, and another 80 cents to printing and overhead, leaving roughly 40 cents per copy for Garrett and his wife, who own the entire company. If this analysis is right, Impact is making very good money for its owners in an industry where most players are struggling just to survive.

Sources: C. Helman, "Breaking: A Local Newspaper Chain That's Actually Making Good Money," *Forbes*, January 21, 2013; News Paper Association of America, "Trends and Numbers," www.naa.org/Trends-and-Numbers/Research.aspx; and J. Agnese, "Publishing and Advertising," S&P netAdvantage, April 12, 2012, http://eresources.library.nd.edu/databases/netadvantage.

OVERVIEW

In Chapter 2 we saw industries go through a life cycle. Some industries are young and dynamic, with rapidly growing demand. Others are mature and relatively stable, whereas still other industries, like the newspaper industry profiled in the opening case, are in decline.

In this chapter we look at the different strategies that companies can pursue to strengthen their competitive position in each of these different stages of the industry life cycle. What we will see is that each stage in the evolution of its industry raises some interesting challenges for a business. Managers must adopt the appropriate strategies to deal with these challenges.

For example, as explained in the Opening Case, the print newspaper business is a declining industry. Due to digital substitution, print circulation and advertising revenues from print have been falling for years. Most incumbents in the industry have responded

by downsizing their print operations, while trying to grow their online presence. However, paradoxically, there is often still good money to be made in a declining industry if managers can figure out the right strategy. A niche strategy of focusing on market segments where demand remains strong is one of the classic ways of making money in a declining industry. This is exactly the strategy pursued by Community Impact Newspaper, the small hyperlocal print newspaper chain profiled in the Opening Case.

Before we look at the different stages of an industry life cycle, however, we first consider strategy in a fragmented industry. We do this because fragmented industries can offer unique opportunities for enterprises to pursue strategies that result in the consolidation of those industries, often creating significant wealth for the consolidating enterprise and its owners.

STRATEGY IN A FRAGMENTED INDUSTRY

fragmented industry
An industry composed of a large number of small- and medium-sized companies.

A **fragmented industry** is one composed of a large number of small- and medium-sized companies. Examples of fragmented industries include the dry-cleaning, hair salon, restaurant, health club, massage, and legal services industries. There are several reasons that an industry may consist of many small companies rather than a few large ones.[1]

Reasons for Fragmentation

First, a lack of scale economies may mean that there are few, if any, cost advantages to large size. There are no obvious scale economies in landscaping and massage services, for example, which helps explain why these industries remain highly fragmented. In some industries customer needs are so specialized that only a small amount of a product is required; hence, there is no scope for a large mass-production operation to satisfy the market. Custom-made jewelry or catering is an example of this. In some industries there may even be diseconomies of scale. In the restaurant business, for example, customers often prefer the unique food and style of a popular local restaurant, rather than the standardized offerings of some national chain. This diseconomy of scale places a limit on the ability of large restaurant chains to dominate the market.

Second, brand loyalty in the industry may primarily be local. It may be difficult to build a brand through differentiation that transcends a particular location or region. Many homebuyers, for example, prefer dealing with local real estate agents, whom they perceive as having better local knowledge than national chains. Similarly, there are no large chains in the massage services industry because differentiation and brand loyalty are primarily driven by differences in the skill sets of individual massage therapists.

Third, the lack of scale economies and national brand loyalty implies low entry barriers. When this is the case, a steady stream of new entrants may keep the industry fragmented. The massage services industry exemplifies this situation. Due to the absence of scale requirements, the costs of opening a massage services business are minor and can be shouldered by a single entrepreneur. The same is true of landscaping services, which helps to keep that industry fragmented.

In industries that have these characteristics, focus strategies tend to work best. Companies may specialize by customer group, customer need, or geographic region. Many small

specialty companies may operate in local or regional markets. All kinds of specialized or custom-made products—furniture, clothing, hats, boots, houses, and so forth—fall into this category, as do all small service operations that cater to personalized customer needs, including dry-cleaning services, landscaping services, hair salons, and massage services.

Consolidating a Fragmented Industry Through Value Innovation

Business history is full of examples of entrepreneurial organizations that have pursued strategies to create meaningful scale economies and national brands where none previously existed. In the process they have consolidated industries that were once fragmented, reaping enormous gains for themselves and their shareholders in the process.

For example, until the 1980s the office supplies business was a highly fragmented industry composed of many small "mom-and-pop" enterprises that served local markets. The typical office supplies enterprise in those days had a limited selection of products, low inventory turnover, limited operating hours, and a focus on providing personal service to local businesses. Customer service included having a small sales force, which visited businesses and took orders, along with several trucks that delivered merchandise to larger customers. Then along came Staples, started by executives who had cut their teeth in the grocery business; they opened a big-box store with a wide product selection, long operating hours, and a self-service business model. They implemented computer information systems to track product sales and make sure that inventory was replenished just before it was out of stock, which drove up inventory turnover. Staples focused on selling to small businesses, and offered them something that established enterprises had not—value from a wide product selection that was always in stock, and long operating hours, all at a low price. True, Staples did not initially offer the same level of personal service that established office supplies enterprises did, but the managers of Staples made a bet that small business customers were more interested in a wide product selection, long opening hours, and low prices—and they were right! Put differently, the managers at Staples had a different view of what was important to their customer set than established enterprises. Today Staples, Office Depot, and Office Max dominate the office supplies business, and most of their small rivals have gone out of businesses.

You may recognize in the Staples story a theme that we discussed in the last chapter: Staples is a *value innovator*.[2] The company's founders figured out a way to offer more value to their customer set, and to do so at a lower cost. Nor have they been alone in doing this. In the retail sector, for example, Wal-Mart and Target did a similar thing in general merchandise, Lowes and Home Depot pulled off the same trick in building materials and home improvement, and Barnes and Noble did this in book retailing. In the restaurant sector, MacDonald's, Taco Bell, Kentucky Fried Chicken, and, more recently, Starbucks have all done a similar thing. In each case, these enterprises succeeded in consolidating once-fragmented industries.

The lesson is clear; fragmented industries are wide open market spaces—blue oceans—just waiting for entrepreneurs to transform them through the pursuit of value innovation. A key to understanding this process is to recognize that in each case, the value innovator defines value differently than established companies, and finds a way to offer that value that lowers costs through the creation of scale economies. In fast food, for example, McDonald's offers reliable, quick, and convenient fast food, and does so at

a low cost. The low cost comes from two sources—first the standardization of processes within each store, which boosts labor productivity, and second, the attainment of scale economies on the input side due to McDonald's considerable purchasing power (which has gotten bigger and bigger over time as McDonald's grew). McDonald's, then, was also a value innovator in its day, and through its choice of strategy the company helped to drive consolidation in the fast-food segment of the restaurant industry.

Chaining and Franchising

In many fragmented industries that have been consolidated through value innovation, the transforming company often starts with a single location, or just a few locations. This was true for Staples, which started with a single store in Boston, and Starbucks, which had just three stores when Howard Shultz took over and started to transform the business. The key is to get the strategy right at the first few locations, and then expand as rapidly as possible to build a national brand and realize scale economies before rivals move into the market. If this is done right, the value innovator can build formidable barriers to new entry by establishing strong brand loyalty and enjoying the scale economies that come from large size (often, these scale economies are associated with purchasing power).

There are two strategies that enterprises use to *replicate* their offering once they get it right. One is chaining and the other is franchising.[3]

chaining

A strategy designed to obtain the advantages of cost leadership by establishing a network of linked merchandising outlets interconnected by information technology that functions as one large company.

Chaining involves opening additional locations that adhere to the same basic formulae, *and that the company owns*. Thus, Staples pursued a chaining strategy when it quickly opened additional stores after perfecting its formula at its original Boston location. Today Staples has over 2,000 stores worldwide. Starbucks too has pursued a chaining strategy, offering the same basic formula in every store that it opens. Its store count now exceeds 18,000 in some 60 countries. Wal-Mart, Barnes & Noble, and Home depot have also all pursued a chaining strategy.

By expanding through chaining, a value innovator can quickly build a national brand. This may be of significant value in a mobile society, such as the United States, where people move and travel frequently, and when in a new town or city they look for familiar offerings. At the same time, by rapidly opening locations, and by knitting those locations together through good information systems, the value innovator can start to realize many of the cost advantages that come from large size. Wal-Mart, for example, tightly controls the flow of inventory through its stores, which allows for rapid inventory turnover (a major source of cost savings). In addition, as Wal-Mart grew, it was able to exercise more and more buying power, driving down the price for the goods that it then resold in its stores (for more details on the Wal-Mart story, see the Running Case in this chapter).

franchising

A strategy in which the franchisor grants to its franchisees the right to use the franchisor's name, reputation, and business model in return for a franchise fee and often a percentage of the profits.

Franchising is similar in many respects to chaining, except that in the case of franchising the founding company—the franchisor—licenses the right to open and operate a new location to another enterprise—franchisee—in return for a fee. Typically, franchisees must adhere to some strict rules that require them to adopt the same basic business model and operate in a certain way. Thus, a McDonald's franchisee has to have the same basic look, feel, offerings, pricing, and business processes as other restaurants in the system, and has to report standardized financial information to McDonald's on a regular basis.

There are some advantages to using a franchising strategy. First, normally the franchisee puts up some or all of the capital to establish his or her operation. This helps to finance the growth of the system, and can result in more rapid expansion. Second, because franchisees are the owners of their operations, and because they often put up capital, they have a

strong incentive to make sure that their operations are run as efficiently and effectively as possible, which is good for the franchisor.

Third, because the franchisees are themselves entrepreneurs, who own their own businesses, they have an incentive to improve the efficiency and effectiveness of their operations by developing new offerings and/or processes. Typically, the franchisor will give them some latitude to do this, so long as they do not deviate too far from the basic business model. Ideas developed in this way may then be transferred to other locations in the system, improving the performance of the entire system. For example, McDonald's has recently been changing the design and menu of its restaurants in the United States based on ideas first pioneered by a franchisee in France.

The drawbacks of a franchising strategy are threefold. First, there may not be the same tight control that can be achieved through a chaining strategy, as, by definition, with a franchising strategy some authority is being delegated to the franchisee. Howard Shultz of Starbucks, for example, decided to expand via a chaining strategy rather than a franchising strategy because he felt that franchising would not give Starbucks the necessary control over customer service in each store. Second, in a franchising system the franchisee captures some of the economic profit from a successful operation, whereas in a chaining strategy it all goes back to the company. Third, because franchisees are small relative to the founding enterprise, they may face a higher cost of capital, which raises system costs and lowers profitability. Given these various pros and cons, the choice between chaining and franchising depends on managers evaluating which is the best strategy given the circumstances facing the founding enterprise.

Horizontal Mergers

Another way of consolidating a fragmented industry is to merge with or acquire competitors, combining them together into a single larger enterprise that is able to realize scale economies and build a more compelling national brand. For example, in the aerospace and defense contracting business there are many small niche producers that make the components that find their way into large products, such as Boeing jets or military aircraft. Esterline, a company based in Bellevue, Washington, has been pursuing horizontal mergers and acquisitions, trying to consolidate this tier of suppliers. Esterline started off as a small supplier itself. Over the last decade it has acquired another 30 or so niche companies, building a larger enterprise that now has sales of almost $2 billion. Esterline's belief is that as a larger enterprise offering a full portfolio of defense and avionic products, it can gain an edge over smaller rivals when selling to companies like Boeing and Lockheed, while its larger size enables it to realize scale economies and lowers its cost of capital.

We will consider the benefits, costs, and risk associated with a strategy of horizontal mergers and acquisitions in Chapters 9 and 10 when we look at corporate-level strategy. For now, it is worth noting that although mergers and acquisitions can help a company to consolidate a fragmented industry, the road to success when pursuing this strategy is littered with failures. Some acquiring companies pay too much for the companies they purchase. Others find out after the acquisition that they have bought a "lemon" that is nowhere as efficient as they thought prior to the acquisition. Still others discover that the gains envisaged for an acquisition are difficult to realize due to a clash between the culture of the acquiring and acquired enterprises. We discuss all of these issues, and how to guard against them, in Chapters 9 and 10.

FOCUS ON: Wal-Mart

Value Innovation at Wal-Mart: Consolidating a Fragmented Market

© iStockPhoto.com/caracterdesign

When Sam Walton opened the first Wal-Mart store in 1967 there were no large-scale general merchandise retailers. The industry was very fragmented. The general merchandise retailers that did exist in its original target markets—small southern towns—were "mom-and-pop stores." These stores offered a limited selection of merchandise in a full-service setting, with store employees helping customers to find the right products for their needs. Open hours were limited (10 a.m. to 6 p.m. being fairly standard), and the stores were often closed 1 or 2 days a week. The storeowners had to pay high prices for the goods they sold, so prices were high too. Inventory turnover was typically low, and infrequent restocking implied that a desired item could be out of stock for a while before the inventory was replenished. If customers wanted an item that was not typically stocked by the store, they would have to place a special order, and wait days or weeks before the item was delivered, or they would have to drive to the nearest city, which could be a 3-hour trip.

Sam Walton's vision was simple: Provide a wide selection of merchandise, stay open seven days a week, and have long operating hours. Buy in bulk to drive down the costs of goods sold, and then pass those cost savings on to customers in the form of lower prices. Reduce costs further by switching from a full-service format to a self-service format. Use good information systems to track what is sold in a store, and make sure that desired products are never out of stock. Gain further efficiencies by *chaining*, opening additional stores in a cluster around a common distribution center. Buy goods in still larger volumes, negotiating deep volume discounts with suppliers. Ship the goods to distribution centers, and then out from the centers to the stores so that inventory arrives just in time, thereby increasing inventory turnover and reducing working capital needs.

It was a brilliant vision. Execution required the development of processes that did not exist at the time, including state-of-the-art information systems to track store sales and inventory turnover, and a logistics system to optimize the flow of inventory from distribution centers to stores. Over the years, as Wal-Mart grew and built these systems, it was able to offer its customer set *more value* on the attributes that mattered to them—wide product selection, always-in-stock inventory, and the convenience of extended opening hours. At the same time, Wal-Mart dispensed with the value that did not matter to its customer set—full service—replacing that with self-service. Due to its increasingly low cost structure, it was able to offer all this at prices significantly below those of its smaller rivals, effectively driving them out of business. Through such value innovation, Wal-Mart was able to consolidate what was once a fragmented market, building a powerful national brand wrapped around the concept of everyday low prices and wide product selection.

STRATEGIES IN EMBRYONIC AND GROWTH INDUSTRIES

As Chapter 2 discusses, an embryonic industry is one that is just beginning to develop, and a growth industry is one in which first-time demand is rapidly expanding as many new customers enter the market. Choosing the strategies needed to succeed in such industries poses special challenges because new groups of customers with different kinds of needs start to enter the market. Managers must be aware of the way competitive forces in embryonic and growth industries change over time because they frequently need to build and develop new kinds of competencies, and refine their business strategy, in order to effectively compete in the future.

Most embryonic industries emerge when a technological innovation creates a new product opportunity. For example, in 1975, the personal computer (PC) industry was born after Intel developed the microprocessor technology that allowed companies to build the world's first PCs; this spawned the growth of the PC software industry that took off after Microsoft developed an operating system for IBM.[4]

Customer demand for the products of an embryonic industry is initially limited for a variety of reasons. Reasons for slow growth in market demand include: (1) the limited performance and poor quality of the first products; (2) customer unfamiliarity with what the new product can do for them; (3) poorly developed distribution channels to get the product to customers; (4) a lack of complementary products that might increase the value of the product for customers; and (5) high production costs because of small volumes of production.

Customer demand for the first cars, for example, was limited by their poor performance (they were no faster than a horse, far noisier, and frequently broke down), a lack of important complementary products (such as a network of paved roads and gas stations), and high production costs that made these cars an expensive luxury (before Ford invented the assembly line, cars were built by hand in a craft-based production setting). Similarly, demand for the first PCs was limited because buyers had to know how to program computers to use them: There were no software programs to purchase that could run on the original PCs. Because of such problems, early demand for the products of embryonic industries typically comes from a small set of technologically savvy customers willing and able to tolerate, and even enjoy, the imperfections in their new purchase.

An industry moves from the embryonic stage to the growth stage when a mass market starts to develop for its product (a **mass market** is one in which large numbers of customers enter the market). Mass markets start to emerge when three things happen: (1) ongoing technological progress makes a product easier to use, and increases its value for the average customer; (2) complementary products are developed that also increase its value; and (3) companies in the industry work to find ways to reduce the costs of producing the new products so they can lower their prices and stimulate high demand.[5] For example, the mass market for cars emerged and the demand for cars surged when: (1) technological progress increased the performance of cars; (2) a network of paved roads and gas stations was established; and (3) Henry Ford began to mass-produce cars using an assembly-line process, something that dramatically reduced production costs and enabled him to decrease car prices and build consumer demand. Similarly, the mass market for PCs emerged when technological advances made computers easier to use, a supply of complementary software (such as spreadsheets and word processing programs) was developed, and companies in the industry (such as Dell) began to use mass production to build PCs at a low cost.

mass market
One in which large numbers of customers enter the market.

The Changing Nature of Market Demand

Managers who understand how the demand for a product is affected by the changing needs of customers can focus on developing new strategies that will protect and strengthen their competitive position, such as building competencies to lower production costs or speed product development. In most product markets, the changing needs of customers lead to the S-shaped growth curve in Figure 6.1. This illustrates how different groups of customers with different needs enter the market over time. The curve is S-shaped because as the stage of market development moves from embryonic to mature, customer demand first accelerates then decelerates as the market approaches the saturation point—where most customers have already purchased the product for the first time, and demand is increasingly limited to replacement demand. This curve has major implications for a company's differentiation, cost, and pricing decisions.

The first group of customers to enter the market is referred to as *innovators*. Innovators are "technocrats" or "gadget geeks"; people who are delighted to be the first to purchase and

Figure 6.1 Market Development and Customer Groups

experiment with a product based on a new technology—even if it is imperfect and expensive. Frequently, innovators have technical talents and interests and that makes them want to "own" and develop the technology because it is so new. In the PC market, the first customers were software engineers and computer hobbyists who wanted to write computer code at home.[6]

Early adopters are the second group of customers to enter the market; they understand that the technology may have important future applications and are willing to experiment with it to see if they can pioneer new uses for the technology. Early adopters are often people who envision how the technology may be used in the future, and they try to be the first to profit from its use. Jeff Bezos, the founder of Amazon.com, was an early adopter of Web technology. In 1994, before anyone else, he saw that the Web could be used in innovative ways to sell books.

Both innovators and early adopters enter the market while the industry is in its embryonic stage. The next group of customers, the *early majority*, forms the leading wave or edge of the mass market. Their entry into the market signifies the beginning of the growth stage. Customers in the early majority are practical and generally understand the value of new technology. They weigh the benefits of adopting new products against the costs, and wait to enter the market until they are confident they will benefit. When the early majority decides to enter the market, a large number of new buyers may be expected. This is what happened in the PC market after IBM's introduction of the PC in 1981. For the early majority, IBM's entry into the market signaled that the benefits of adopting the new PC technology would be worth the cost to purchase and time spent to learn how to use a PC. The growth of the PC market was further strengthened by the development of applications that added value to the PC, such as new spreadsheet and word processing programs. These applications transformed the PC from a hobbyist's toy into a business productivity tool. The same process started to unfold in the smartphone market after Apple introduced its iPhone in 2007. The early majority entered the market at that point because these customers saw the value that a smartphone could have, and they were comfortable adopting new technology.

| Figure 6.2 | Market Share of Different Customer Segments |

When the mass market reaches a critical mass, with about 30% of the potential market penetrated, the next group of customers enters the market. This group is characterized as the *late majority*, the customers who purchase a new technology or product only when it is obvious the technology has great utility and is here to stay. A typical late majority customer group is a somewhat "older" and more behaviorally conservative set of customers. They are familiar with technology that was around when they were younger, but are often unfamiliar with the advantages of new technology. The late majority can be a bit nervous about buying new technology, but they will do so once they see large numbers of people adopting it and getting value out of it. The late majority did not start to enter the PC market until the mid-1990s. In the smartphone business, the late majority started to enter the market in 2012 when it became clear that smartphones had great utility and would be here to stay. Although members of the late majority are hesitant to adopt new technology, they do so when they see that people around them are doing so in large numbers, and they will be left out if they do not do the same. Many older people, for example, started to purchase PCs for the first time when they saw people around them engaging in email exchanges and browsing the Web, and it became clear that these technologies were here to stay and had value for them.

Laggards, the last group of customers to enter the market, are people who are inherently conservative and unappreciative of the uses of new technology. Laggards frequently refuse to adopt new products even when the benefits are obvious, or unless they are forced to do so by circumstances—for example, due to work-related reasons. People who use typewriters rather than computers to write letters and books are an example of laggards. Given the fast rate of adoption of smartphones in the United States, it will not be long before the only people not in the smartphone market are the laggards. These people with either continue to use basic wireless phones, or may not even have a wireless phone, continuing to rely instead on increasingly outdated traditional wire-line phones.

In Figure 6.2, the bell-shaped curve represents the total market, and the divisions in the curve show the average percentage of buyers who fall into each of these customer

groups. Note that early adopters are a very small percentage of the market; hence, the figure illustrates a vital competitive dynamic—the highest market demand and industry profits arise when the early and late majority groups enter the market. Additionally, research has found that although early pioneering companies succeed in attracting innovators and early adopters, many of these companies often *fail* to attract a significant share of early and late majority customers, and ultimately go out of business.[7]

Strategic Implications: Crossing the Chasm

Why are pioneering companies often unable to create a business model that allows them to be successful over time and remain as market leaders? *Innovators and early adopters have very different customer needs from the early majority*. In an influential book, Geoffrey Moore argues that because of the differences in customer needs between these groups, the business-level strategies required for companies to succeed in the emerging mass market are quite different from those required to succeed in the embryonic market.[8] Pioneering companies that do not change the strategies they use to pursue their business model will therefore lose their competitive advantage to those companies that implement new strategies aimed at best serving the needs of the early and late majority. New strategies are often required to strengthen a company's business model as a market develops over time for the following reasons:

- Innovators and early adopters are technologically sophisticated customers willing to tolerate the limitations of the product. The early majority, however, values ease of use and reliability. Companies competing in an embryonic market typically pay more attention to increasing the performance of a product than to its ease of use and reliability. Those competing in a mass market need to make sure that the product is reliable and easy to use. Thus, the product development strategies required for success are different as a market develops over time.
- Innovators and early adopters are typically reached through specialized distribution channels, and products are often sold by word of mouth. Reaching the early majority requires mass-market distribution channels and mass-media advertising campaigns that require a different set of marketing and sales strategies.
- Because innovators and the early majority are relatively few in number and are not particularly price sensitive, companies serving them typically pursue a focus model, produce small quantities of a product, and price high. To serve the rapidly growing mass-market, large-scale mass production may be critical to ensure that a high-quality product can be reliably produced at a low price point.

In sum, the business models and strategies required to compete in an embryonic market populated by early adopters and innovators are very different from those required to compete in a high-growth mass market populated by the early majority. As a consequence, the transition between the embryonic market and the mass market is not a smooth, seamless one. Rather, it represents a *competitive chasm* or gulf that companies must cross. According to Moore, many companies do not or cannot develop the right business model; they fall into the chasm and go out of business. Thus, although embryonic markets are typically populated by a large number of small companies, once the mass market begins to develop, the number of companies sharply decreases.[9] For a detailed example of how this unfolds, see Strategy in Action 6.1, which explains how Microsoft and Research in Motion fell into the chasm in the smartphone market, whereas Apple leaped across it with its iPhone, a product designed for the early majority.

6.1 STRATEGY IN ACTION

Crossing the Chasm in the Smartphone Market

© iStockPhoto.com/Tom Nulens

The first smartphones started to appear in the early 2000s. The early market leaders included Research in Motion (RIM), with its Blackberry line of smartphones, and Microsoft, whose Windows Mobile operating system powered a number of early smartphone offerings made by companies such as Motorola. These phones were sold to business users, and marketed as a business productivity tool. They had small screens, and a physical keyboard that was crammed onto a relatively small form factor. Although they had an ability to send and receive e-mails, browse the Web, and so on, there was no independent applications market, and consequently, the utility of the phones was very limited. Nor were they always easy to use. System administrators were often required to set up basic features such as corporate e-mail access. They were certainly not consumer-friendly devices. The customers at this time were primarily innovators and early adopters.

The market changed dramatically after the introduction of the Apple iPhone in 2007 (see Figure 6.3). First, this phone was aimed not at power business users, but at a broader consumer market. Second, the phone was easy to use, with a large touch-activated screen and a virtual keyboard that vanished when not in use. Third,

the phone was stylishly designed, with an elegance that appealed to many consumers. Fourth, Apple made it very easy for independent developers to write applications that could run on the phone, and they set up an App store that made it easy for developers to market their apps. Very quickly new applications started to appear that added value to the phone. These included mapping applications, news feeds, stock information, and a wide array of games, several of which soon became big hits. Clearly, the iPhone was a device aimed squarely not at business users, but at consumers. The ease of use and utility of the iPhone quickly drew the early majority into the market, and sales surged. Meanwhile, sales of Blackberry devices and Windows Mobile phones started to spiral downward.

Both Microsoft and Blackberry were ultimately forced to abandon their existing phone platforms and strategies, and reorient themselves. Both developed touch-activated screens, similar to those on the iPhone, started app stores, and targeted consumers. However, it may have been too late for them. By early 2013 both former market leaders had market share numbers in the single digits, whereas Apple controlled 45% of the market. Smartphones that used Google's

Figure 6.3 The Chasm in the Smartphone Business

Apple iPhone and Android

Early windows phones
Blackberry phones

THE CHASM

Early adopters
businesses

Early majority
consumers

© Cengage Learning

(continues)

6.1 STRATEGY IN ACTION

(continued)

© iStockPhoto.com/Tom Nulens

Android operating system took up the remaining market share. Introduced some 12 months after the iPhone, Android phones shared many of the same features as the iPhone. Google also supported an app store, and devices makers using the Android operating system, such as Samsung, marketed their phones to consumers who now very clearly constituted the early and late majority of the market.

The implication is clear: to cross the chasm successfully, managers must correctly identify the customer needs of the first wave of early majority users—the leading edge of the mass market. Then they must adjust their business models by developing new strategies to redesign products and create distribution channels and marketing campaigns to satisfy the needs of the early majority. They must have a suitable product available at a reasonable price to sell to the early majority when they begin to enter the market in large numbers. At the same time, the industry pioneers must abandon their outdated, focused business models directed at the needs of innovators and early adopters. Focusing on the outdated model will lead managers to ignore the needs of the early majority—and the need to develop the strategies necessary to pursue a differentiation or cost-leadership business model in order to remain a dominant industry competitor.

Strategic Implications of Differences in Market Growth Rates

Managers must understand a final important issue in embryonic and growth industries: different markets develop at different rates. The speed at which a market develops can be measured by its growth rate, that is, the rate at which customers in that market purchase the industry's product. A number of factors explain the variation in market growth rates for different products, and thus the speed with which a particular market develops. It is important for managers to understand the source of these differences because their choice of strategy can accelerate or retard the rate at which a market grows.[10]

The first factor that accelerates customer demand is a new product's *relative advantage*, that is, the degree to which a new product is perceived as better at satisfying customer needs than the product it supersedes. For example, the early growth in demand for cell phones was partly driven by their economic benefits. Studies showed that because business customers could always be reached by cell phone, they made better use of their time—for example, by not showing up at a meeting that had been cancelled at the last minute—and saved 2 hours per week in time that would otherwise have been wasted. For busy executives, the early adopters, the productivity benefits of owning a cell phone outweighed the costs. Cell phones also rapidly diffused for social reasons, in particular, because they conferred glamour or prestige upon their users (something that also drives demand for the most advanced kinds of smartphones today).

A second factor of considerable importance is *complexity*. Products that are viewed by consumers as being complex and difficult to master will diffuse more slowly than products that are easy to master. The early PCs diffused quite slowly because many people saw the archaic command lines needed operate a PC as being very complex and intimidating. PCs did not become a mass-market device until graphical user interfaces with onscreen icons became

widespread, enabling users to open programs and perform functions by pointing and clicking with a mouse. In contrast, the first cell phones were simple to use and quickly adopted.

Another factor driving growth in demand is *compatibility*, the degree to which a new product is perceived as being consistent with the current needs or existing values of potential adopters. Demand for cell phones grew rapidly because their operation was compatible with the prior experience of potential adopters who used traditional landline phones. A fourth factor is *trialability*, the degree to which potential customers can experiment with a new product during a hands-on trial basis. Many people first used cell phones when borrowing them from colleagues to make calls, and positive experiences helped accelerate growth rates. In contrast, early PCs were more difficult to experiment with because they were rare and expensive and because some training was needed in how to use them. These complications led to slower growth rates for PCs. A final factor is *observability*, the degree to which the results of using and enjoying a new product can be seen and appreciated by other people. Originally, the iPhone and Android phones diffused rapidly because it became obvious how their owners could put them to so many different uses.

Thus managers must be sure to devise strategies that help to educate customers about the value of their new products if they are to grow demand over time. In addition, they need to design their products so that they overcome some of the barriers to adoption by making them less complex and intimidating, and easy to use, and by showcasing their relative advantage over prior technology. This is exactly what Apple did with the iPhone, which helps explain the rapid diffusion of smartphones after Apple introduced its first iPhone in 2007.

When a market is rapidly growing, and the popularity of a new product increases or spreads in a way that is analogous to a *viral model of infection*, a related strategic issue arises. Lead adopters (the first customers who buy a product) in a market become "infected" or enthused with the product, as exemplified by iPhone users. Subsequently, lead adopters infect other people by telling others about the advantages of products. After observing the benefits of the product, these people also adopt and use the product. Companies promoting new products can take advantage of viral diffusion by identifying and aggressively courting opinion leaders in a particular market—the customers whose views command respect. For example, when the manufacturers of new high-tech medical equipment, such as magnetic resonance imaging (MRI) scanners, start to sell a new product, they try to get well-known doctors at major research and teaching hospitals to use the product first. Companies may give these opinion leaders (the doctors) free machines for their research purposes, and work closely with the doctors to further develop the technology. Once these opinion leaders commit to the product and give it their stamp of approval, other doctors at additional hospitals often follow.

In sum, understanding competitive dynamics in embryonic and growth industries is an important strategic issue. The ways in which different kinds of customer groups emerge and the ways in which customer needs change are important determinants of the strategies that need to be pursued to make a business model successful over time. Similarly, understanding the factors that affect a market's growth rate allows managers to tailor their business model to a changing industry environment. (More about competition in high-tech industries is discussed in the next chapter.)

STRATEGY IN MATURE INDUSTRIES

A mature industry is commonly dominated by a small number of large companies. Although a mature industry may also contain many medium-sized companies and a host of small, specialized companies, the large companies often determine the nature of competition in the industry because they can influence the six competitive forces. Indeed, these

large companies hold their leading positions because they have developed the most successful business models and strategies in an industry.

By the end of the shakeout stage, companies have learned how important it is to analyze each other's business model and strategies. They also know that if they change their strategies, their actions are likely to stimulate a competitive response from industry rivals. For example, a differentiator that starts to lower its prices because it has adopted a more cost-efficient technology not only threatens other differentiators, but may also threaten cost leaders that see their competitive advantage being eroded. Hence, by the mature stage of the life cycle, companies have learned the meaning of competitive interdependence.

As a result, in mature industries, business-level strategy revolves around understanding how established companies *collectively* attempt to moderate the intensity of industry competition in order to preserve both company and industry profitability. Interdependent companies can help protect their competitive advantage and profitability by adopting strategies and tactics, first, to deter entry into an industry, and second, to reduce the level of rivalry within an industry.

Strategies to Deter Entry

In mature industries successful enterprises have normally gained substantial economies of scale and established strong brand loyalty. As we saw in Chapter 2, the economies of scale and brand loyalty enjoyed by incumbents in an industry constitute strong barriers to new entry. However, there may be cases in which scale and brand, although significant, are not sufficient to deter entry. In such circumstances there are other strategies that companies can pursue to make new entry less likely. These strategies include product proliferation, limit pricing, and strategic commitments.[11]

Product Proliferation One way in which companies try to enter a mature industry is by looking for market segments or niches that are poorly served by incumbent enterprises. The entry strategy involves entering these segments, gaining experience, scale and brand in that segment, and then progressively moving upmarket. This is how Japanese automobile companies first entered the U.S. market in the late 1970s and early 1980s. They targeted segments at the bottom end of the market for small inexpensive cars that were fuel-efficient. These segments were not well served by large American manufacturers such as Ford and GM. Once companies like Toyota and Honda had gained a strong position in these segments, they started to move upmarket with larger offerings, and ultimately entering the pick-up truck and SUV segments, which historically had been the most profitable parts of the automobile industry for American companies.

product proliferation strategy

The strategy of "filling the niches," or catering to the needs of customers in all market segments to deter entry by competitors.

A **product proliferation strategy** involves incumbent companies attempting to forestall entry by making sure that *every* niche or segment in the marketplace is well served. Had U.S. automobile companies pursued product proliferation in the 1970s and early 1980s, and produced a line of smaller, fuel-efficient cars, it may have been more difficult for Japanese automobile companies to enter the U.S. market. Another example concerns breakfast cereal companies, which are famous for pursuing a product proliferation strategy. Typically they produce many different types of cereal, so that they can cater to all likely consumer needs. The net result is that the three big breakfast cereal companies—General Mills, Post, and Kellogg—have been able to occupy all of the valuable real estate in the industry, which is shelf space in supermarkets, filling it up with a multiplicity of offerings and leaving very little room for new entrants. Moreover, when new entry does occur—as happened when smaller companies entered the market selling granola and organic cereals—the big three

Figure 6.4	Limit Pricing

have moved rapidly to offer their own versions of these products, effectively foreclosing entry. A product proliferation strategy therefore, because it gives new entrants very little opportunity to find an unoccupied niche in an industry, can effectively deter entry.

Limit Price A limit price strategy may be used to deter entry when incumbent companies in an industry enjoy economies of scale, but the resulting cost advantages are *not* enough to keep potential rivals out of the industry. A **limit price strategy** involves charging a price that is lower than that required to maximize profits in the short run, but is above the cost structure of potential entrants.

For illustration, consider Figure 6.4; this shows that incumbent companies have a unit cost structure that is lower than that of potential entrants. However, if incumbents charge the price that the market will bear (Figure 6.4a), this will be above the unit cost structure of new entrants (Figure 6.4b), allowing them to enter and still make a profit under the pricing umbrella set by incumbents. In this situation, the best option for incumbents might be to charge a price that is still above their own cost structure, but just below the cost structure of any potential new entrants (Figure 6.4c). Now there is no incentive for potential entrants to enter the market, because at the lower "limit" price they cannot make a profit. Thus, because it deters entry, the limit price might be thought of as the long-run profit-maximizing price.

Strategic Commitments Incumbent companies can deter entry by engaging in strategic commitments that send a signal to any potential new entrants that entry will be difficult. **Strategic commitments** are investments that signal an incumbent's long-term commitment to a market, or a segment of that market.[12] As an entry-deterring strategy, strategic commitments involve raising the perceived costs of entering a market, thereby reducing the likelihood of entry. To the extent that such actions are successful, strategic commitments can help to protect an industry and lead to greater long-run profits for those already in the industry.

limit price strategy
Charging a price that is lower than that required to maximize profits in the short run, but is above the cost structure of potential entrants.

strategic commitments
Investments that signal an incumbent's long-term commitment to a market, or a segment of that market.

One example of a strategic commitment occurs when incumbent companies invest in excess productive capacity. The idea is to signal to potential entrants that if they do enter, the incumbents have the ability to expand output and drive down prices, making the market less profitable for new entrants. It has been argued, for example, that chemical companies may overinvest in productive capacity as a way of signaling their commitment to a particular market, and indicating that new entrants will find it difficult to compete.[13]

Other strategic commitments that might act as an entry deterrent include making significant investments in basic research, product development, or advertising beyond those necessary to maintain a company's competitive advantage over its existing rivals.[14] In all cases, for such actions to deter entry, potential rivals must be aware of what incumbents are doing, and the investments themselves must be sufficient to deter entry.

Incumbents might also be able to deter entry if they have a history of responding aggressively to new entry through price cutting, accelerating product development efforts, increased advertising expenditures, or some combination of these. For example, in the 1990s when a competitor announced a new software product, Microsoft would often attempt to make entry difficult by quickly announcing that it had a similar software product of its own under development that would work well with Windows (the implication being that consumers should wait for the Microsoft product). The term "vaporware" was often used to describe such aggressive product preannouncements. Many observers believe that the practice did succeed on occasion in forestalling entry.[15]

A history of such actions sends a strong signal to potential rivals that market entry will not be easy, and that the incumbents will respond vigorously to any encroachment on their turf. When established companies have succeeded in signaling this to potential rivals through past actions, we say that they have established a *credible commitment* to respond to new entry.

One thing to note here is that when making strategic commitments, a company must be careful not to fall foul of antitrust law. For example, it is illegal to engage in predatory pricing, or pricing a good or service below the cost of production with the expressed intent of driving a rival out of business and monopolizing a market. In the late 1990s Microsoft fell afoul of antitrust laws when it told PC manufacturers that they had to display Internet Explorer on the PC desktop if they wanted to license the company's Windows operating system. Because Windows was the only viable operating system for PCs at the time, this was basically viewed as strong-arming PC makers. The intent was to give Internet Explorer an edge over rival browsers, and particularly one produced by Netscape. The U.S. Justice Department ruled Microsoft's actions as predatory behavior. Microsoft was forced to pay fines and change its practices.

Strategies to Manage Rivalry

Beyond seeking to deter entry, companies also wish to develop strategies to manage their competitive interdependence and decrease price rivalry. Unrestricted competition over prices reduces both company and industry profitability. Several strategies are available to companies to manage industry rivalry. The most important are price signaling, price leadership, non-price competition, and capacity control.

Price Signaling A company's ability to choose the price option that leads to superior performance is a function of several factors, including the strength of demand for a product and the intensity of competition between rivals. Price signaling is a method by which

Although price leadership can stabilize industry relationships by preventing head-to-head competition and raising the level of profitability within an industry, it has its dangers. It helps companies with high cost structures, allowing them to survive without needing to implement strategies to become more efficient. In the long term, such behavior makes them vulnerable to new entrants that have lower costs because they have developed new low-cost production techniques. This is what happened in the U.S. car industry. After decades of tacit price fixing, and GM as the price leader, U.S. carmakers were subjected to growing low-cost overseas competition that was threatening their survival. In 2009, the U.S. government decided to bail out Chrysler and GM by loaning them billions of dollars after the financial crisis, while forcing them to enter, and then emerge from, bankruptcy. This dramatically lowered the cost structures of these companies, and has made them more competitive today. (This also applies to Ford, which obtained similar benefits while managing to avoid bankruptcy.)

Non-price Competition A third very important aspect of product and market strategy in mature industries is the use of **non-price competition** to manage rivalry within an industry. The use of strategies to try to prevent costly price cutting and price wars does not preclude competition by product differentiation. In many industries, product-differentiation strategies are the principal tools companies use to deter potential entrants and manage rivalry within their industries.

Product differentiation allows industry rivals to compete for market share by offering products with different or superior features, such as smaller, more powerful, or more sophisticated computer chips, as AMD, Intel, and NVIDIA compete to offer, or by applying different marketing techniques, as Procter & Gamble, Colgate, and Unilever do. In Figure 6.5, product and market segment dimensions are used to identify four non-price-competitive strategies based on product differentiation: market penetration, product development, market development, and product proliferation. (Note that this model applies to new market segments, *not* new markets.)

Market Penetration When a company concentrates on expanding market share in its existing product markets, it is engaging in a strategy of **market penetration**. Market penetration involves heavy advertising to promote and build product differentiation. For example, Intel has actively pursued penetration with its aggressive marketing campaign of "Intel Inside."

non-price competition

The use of product differentiation strategies to deter potential entrants and manage rivalry within an industry.

Figure 6.5	Four Nonprice Competitive Strategies

		Products	
		Existing	New
Marketing Segments	Existing	Market penetration	Product development
	New	Market development	Product proliferation

© Cengage Learning

companies attempt to control rivalry among competitors to allow the *industry* to choose the most favorable pricing option. **price signaling** is the process by which companies increase or decrease product prices to convey their intentions to other companies and influence the way other companies price their products. Companies use price signaling to improve industry profitability.

Companies may use price signaling to announce that they will vigorously respond to hostile competitive moves that threaten them. For example, they may signal that if one company starts to aggressively cut prices, they will respond in kind. A *tit-for-tat strategy* is a well-known price signaling maneuver in which a company does exactly what its rivals do: if its rivals cut prices, the company follows; if its rivals raise prices, the company follows. By consistently pursuing this strategy over time, a company sends a clear signal to its rivals that it will mirror any pricing moves they make; sooner or later, rivals will learn that the company will always pursue a tit-for-tat strategy. Because rivals know that the company will match any price reductions and cutting prices will only reduce profits, price cutting becomes less common in the industry. Moreover, a tit-for-tat strategy also signals to rivals that price increases will be imitated, growing the probability that rivals will initiate price increases to raise profits. Thus, a tit-for-tat strategy can be a useful way of shaping pricing behavior in an industry.[16]

The airline industry is a good example of the power of price signaling when prices typically rise and fall depending upon the current state of customer demand. If one carrier signals the intention to lower prices, a price war frequently ensues as other carriers copy one another's signals. If one carrier feels demand is strong, it tests the waters by signaling an intention to increase prices, and price signaling becomes a strategy to obtain uniform price increases. Nonrefundable tickets or charges for a second bag, another strategy adopted to allow airlines to charge higher prices, also originated as a market signal by one company that was quickly copied by all other companies in the industry (it is estimated that extra bag charges have so far allowed airlines to raise over $1 billion in revenues). Carriers have recognized that they can stabilize their revenues and earn interest on customers' money if they collectively act to force customers to assume the risk of buying airline tickets in advance. In essence, price signaling allows companies to give one another information that enables them to understand each other's competitive product or market strategy and make coordinated, price-competitive moves.

Price Leadership When one company assumes the responsibility for setting the pricing option that maximizes industry profitability, that company assumes the position as price leader—a second tactic used to reduce price rivalry between companies in a mature industry. Formal price leadership, or when companies jointly set prices, is illegal under antitrust laws; therefore, the process of **price leadership** is often very subtle. In the car industry, for example, prices are set by imitation. The price set by the weakest company—that is, the company with the highest cost structure—is often used as the basis for competitors' pricing. Thus, in the past, U.S. carmakers set their prices and Japanese carmakers then set their prices in response to the U.S. prices. The Japanese are happy to do this because they have lower costs than U.S. carmakers, and still make higher profits without having to compete on price. Pricing is determined by market segment. The prices of different auto models in a particular range indicate the customer segments that the companies are targeting, and the price range the companies believe the market segment can tolerate. Each manufacturer prices a model in the segment with reference to the prices charged by its competitors, not by reference to competitors' costs. Price leadership also allows differentiators to charge a premium price.

price signaling
The process by which companies increase or decrease product prices to convey their intentions to other companies and influence the price of an industry's products.

price leadership
When one company assumes the responsibility for determining the pricing strategy that maximizes industry profitability.

In a mature industry, advertising aims to influence customers' brand choice and create a brand-name reputation for the company and its products. In this way, a company can increase its market share by attracting its rival's customers. Because brand-name products often command premium prices, building market share in this situation is very profitable.

In some mature industries—for example, soap and detergent, disposable diapers, and brewing—a market-penetration strategy becomes a long-term strategy. In these industries, all companies engage in intensive advertising and battle for market share. Each company fears that if it does not advertise, it will lose market share to rivals who do. Consequently, in the soap and detergent industry, Procter & Gamble spends more than 20% of sales revenues on advertising, with the aim of maintaining, and perhaps building, market share. These huge advertising outlays constitute a barrier to entry for prospective competitors.

Product Development **Product development** is the creation of new or improved products to replace existing ones. The wet-shaving industry depends on product replacement to create successive waves of customer demand, which then create new sources of revenue for companies in the industry. Gillette, for example, periodically unveils a new and improved razor, such as its vibrating razor (that competes with Schick's four-bladed razor), to try to boost its market share. Similarly, in the car industry, each major car company replaces its models every 3 to 5 years to encourage customers to trade in old models and purchase new ones.

Product development is crucial for maintaining product differentiation and building market share. For instance, the laundry detergent Tide has gone through more than 50 changes in formulation during the past 40 years to improve its performance. The product is always advertised as Tide, but it is a different product each year. Refining and improving products is a crucial strategy companies use to fine-tune and improve their business models in a mature industry, but this kind of competition can be as vicious as a price war because it is very expensive and can dramatically increase a company's cost structure. This happened in the computer chip industry, where intense competition to make the fastest or most powerful chip and become the market leader has dramatically increased the cost structure of Intel, AMD, and NVIDIA and sharply reduced their profitability.

Market Development **Market development** finds new market segments for a company's products. A company pursuing this strategy wants to capitalize on the brand name it has developed in one market segment by locating new market segments in which to compete—just as Mattel and Nike do by entering many different segments of the toy and shoe markets, respectively. In this way, a company can leverage the product differentiation advantages of its brand name. The Japanese auto manufacturers provide an interesting example of the use of market development. When each manufacturer entered the market, it offered a car model aimed at the economy segment of the auto market, such as the Toyota Corolla and the Honda Accord. Then, these companies upgraded each model over time; now each company is directed at a more expensive market segment. The Honda Accord is a leading contender in the mid-sized car segment, and the Toyota Corolla fills the small-car segment. By redefining their product offerings, Japanese manufacturers have profitably developed their market segments and successfully attacked their U.S. rivals, wresting market share from these companies. Although the Japanese used to compete primarily as cost leaders, market development has allowed them to become differentiators as well. In fact, as we noted in the previous chapter, Toyota has used market development to become a broad differentiator. Over time, Toyota has used market development to create a vehicle for almost every segment of the car market, a tactic discussed in Strategy in Action 6.2.

product development
The creation of new or improved products to replace existing products.

market development
When a company searches for new market segments for a company's existing products to increase sales.

6.2 STRATEGY IN ACTION

Toyota Uses Market Development to Become the Global Leader

© iStockPhoto.com/Tom Nulens

The car industry has always been one of the most competitive in the world because of the huge revenues and profits that are at stake. Given the difficult economic conditions in the late-2000s, it is hardly surprising that rivalry has increased as global carmakers struggle to develop new car models that better satisfy the needs of particular groups of buyers. One company at the competitive forefront is Toyota.

Toyota produced its first car 40 years ago, the ugly, boxy vehicle that was, however, cheap. As the quality of its car became apparent, sales increased. Toyota, which was then a focused cost leader, reinvested its profits into improving the styling of its vehicles, and into efforts to continually reduce production costs. Over time, Toyota has taken advantage of its low-cost structure to make an ever-increasing range of reasonably priced vehicles tailored to different segments of the car market. The company's ability to begin with the initial design stage and move to the production stage in 2 to 3 years allowed it to make new models available faster than its competitors, and capitalize on the development of new market segments.

Toyota has been a leader in positioning its entire range of vehicles to take advantage of new, emerging market segments. In the SUV segment, for example, its first offering was the expensive Toyota Land Cruiser, even then priced at over $35,000. Realizing the need for SUVs in lower price ranges, it next introduced the 4Runner, priced at $20,000 and designed for the average SUV customer; the RAV4, a small SUV in the low $20,000 range, followed; then came the Sequoia, a bigger, more powerful version of the 4Runner in the upper $20,000 range. Finally, taking the technology from its Lexus division, it introduced the luxury Highlander SUV in the low $30,000 range. Today it offers six SUV models, each offering a particular combination of price, size, performance, styling, and luxury to appeal to a particular customer group within the SUV segment of the car market. In a similar way, Toyota positions its sedans to appeal to the needs of different sets of customers. For example, the Camry is targeted at the middle of the market to customers who can afford to pay about $25,000 and want a balance of luxury, performance, safety, and reliability.

Toyota's broad differentiation business model is geared toward making a range of vehicles that optimizes the amount of value it can create for different groups of customers. At the same time, the number of models it makes is constrained by the need to keep costs under strict control so it can make car-pricing options that will generate maximum revenues and profits. Because competition in each car market segment is now intense, all global carmakers need to balance the advantages of showcasing more cars to attract customers against the increasing costs that result when the number of different car models they make expands to suit the needs of different customers.

Product Proliferation We have already seen how product proliferation can be used to deter entry into an industry. The same strategy can be used to manage rivalry within an industry. As noted earlier, product proliferation generally means that large companies in an industry have a product in each market segment (or niche) If a new niche develops, such as SUVs, designer sunglasses, or shoe-selling websites, the leader gets a first-mover advantage—but soon thereafter, all the other companies catch up. Once again, competition is stabilized, and rivalry within the industry is reduced. Product proliferation thus allows the development of stable industry competition based on product differentiation, not price—that is, non-price competition based on the development of new products. The competitive battle is over a product's perceived uniqueness, quality, features, and performance, not over its price. Strategy in Action 6.3 looks at Nike's history of non-price competition, and how that has helped the company to differentiate itself from rivals.

6.3 STRATEGY IN ACTION

Non-Price Competition at Nike

© iStockPhoto.com/Tom Nulens

The way in which Nike has used non-price-competitive strategies to strengthen its differentiation strategy is highly instructive. Bill Bowerman, a former University of Oregon track coach, and Phil Knight, an entrepreneur in search of a profitable business opportunity, founded Nike, now headquartered in Beaverton, Oregon. Bowerman's dream was to create a new type of sneaker tread that would enhance a runner's traction and speed, and after studying the waffle iron in his home, he came up with the idea for Nike's "waffle tread." Bowerman and Knight made this shoe, and began by selling it out of car trunks at track meets. Nike has since grown into a company that sells almost 45% of the shoes sold in the global $50 billion athletic footwear and apparel industries each year, and made more than $2 billion in profit in 2012.

Nike's amazing success came from its business model, which was always based on differentiation; its strategy was to innovate state-of-the-art athletic shoes and then to publicize the qualities of its shoes through dramatic "guerrilla" marketing. Nike's marketing is designed to persuade customers that its shoes are not only superior, but also a high-fashion statement and a necessary part of a lifestyle based on sporting or athletic interests. Nike's strategy to emphasize the uniqueness of its product obviously paid off, as its market share soared. However, the company received a shock in 1998, when its sales suddenly began to fall; it was

becoming more and more difficult to design new shoes that its existing customers perceived to be significantly better and worth their premium price—in other words, its strategy of market penetration and product development was no longer paying off. Phil Knight recruited a team of talented top managers from leading consumer products companies to help him change Nike's strategy in some fundamental ways.

In the past, Nike shunned sports like golf, soccer, rollerblading, and so on, and focused most of its efforts on making shoes for the track and basketball market segments. However, when its sales started to fall, it realized that using marketing to increase sales in a particular market segment (market penetration) could only grow sales and profits so much. Nike decided to take its existing design and marketing competencies and began to craft new lines of shoes for new market segments. In other words, it began to pursue market development and product proliferation as well as the other non-price strategies.

For example, it revamped its aerobics shoes, launched a line of soccer shoes, and perfected the company's design over time; by the mid-2000s, it took over as the market leader from its archrival Adidas. Nike's strategies significantly strengthened its differentiation business model, which is why its market share and profitability have continued to increase, and also why Nike is the envy of competitors.

Capacity Control Although non-price competition helps mature industries avoid the cut-throat price cutting that reduces company and industry levels of profitability, price competition does periodically occur when excess capacity exists in an industry. Excess capacity arises when companies collectively produce too much output; to dispose of it, they cut prices. When one company cuts prices, other companies quickly do the same because they fear that the price cutter will be able to sell its entire inventory, while they will be left with unwanted goods. The result is a developing price war.

Excess capacity may be caused by a shortfall in demand, as when a recession lowers the demand for cars and causes car companies to give customers price incentives to purchase new cars. In this situation, companies can do nothing but wait for better times. By and large, however, excess capacity results from companies within an industry simultaneously responding to favorable conditions; they all invest in new plants to be able to take advantage of the predicted upsurge in demand. Paradoxically, each individual company's effort

to outperform the others means that, collectively, companies create industry overcapacity, which hurts all companies. Although demand is rising, the consequence of each company's decision to increase capacity is a surge in industry capacity, which drives down prices. To prevent the accumulation of costly excess capacity, companies must devise strategies that let them control—or at least benefit from—capacity expansion programs. Before we examine these strategies, however, we need to consider in greater detail the factors that cause excess capacity.[17]

Factors Causing Excess Capacity The problem of excess capacity often derives from technological developments. Sometimes new low-cost technology can create an issue because all companies invest in it simultaneously to prevent being left behind. Excess capacity occurs because the new technology can produce more than the old. In addition, new technology is often introduced in large increments, which generates overcapacity. For instance, an airline that needs more seats on a route must add another plane, thereby adding hundreds of seats even if only 50 are needed. To take another example, a new chemical process may efficiently operate at the rate of only 1,000 gallons per day, whereas the previous process was efficient at 500 gallons per day. If all companies within an industry change technologies, industry capacity may double, and enormous problems can potentially result.

Overcapacity may also be caused by competitive factors within an industry. Entry into an industry is one such a factor. The recent economic recession caused global overcapacity and the price of steel plunged; with global recovery the price has increased. Sometimes the age of a company's physical assets is the source of the problem. For example, in the hotel industry, given the rapidity with which the quality of hotel room furnishings decline, customers are always attracted to new hotels. When new hotel chains are built alongside the old chains, excess capacity can result. Often, companies are simply making simultaneous competitive moves based on industry trends—but these moves lead to head-to-head competition. Most fast-food chains, for instance, establish new outlets whenever demographic data show population increases. However, companies seem to forget that all other chains use the same data—they are not anticipating their rivals' actions. Thus, a certain locality that has few fast-food outlets may suddenly have several new outlets being built at the same time. Whether all the outlets can survive depends upon the growth rate of customer demand, but most often the least popular outlets close down.

Choosing a Capacity-Control Strategy Given the various ways in which capacity can expand, companies clearly need to find some means of controlling it. If companies are always plagued by price cutting and price wars, they will be unable to recoup the investments in their generic strategies. Low profitability within an industry caused by overcapacity forces not only the weakest companies but also sometimes the major players to exit the industry. In general, companies have two strategic choices: (1) each company individually must try to preempt its rivals and seize the initiative, or (2) the companies must collectively find indirect means of coordinating with each other so that they are all aware of the mutual effects of their actions.

To *preempt* rivals, a company must forecast a large increase in demand in the product market and then move rapidly to establish large-scale operations that will be able to satisfy the predicted demand. By achieving a first-mover advantage, the company may deter other firms from entering the market because the preemptor will usually be able to move down the experience curve, reduce its costs, and therefore reduce its prices as well—and threaten a price war if necessary.

This strategy, however, is extremely risky, for it involves investing resources before the extent and profitability of the future market are clear. A preemptive strategy is also

risky if it does not deter competitors, and they decide to enter the market. If competitors can develop a stronger generic strategy, or have more resources, such as Google or Microsoft, they can make the preemptor suffer. Thus, for the strategy to succeed, the preemptor must generally be a credible company with enough resources to withstand a possible advertising/price war.

To *coordinate* with rivals as a capacity-control strategy, caution must be exercised because collusion on the timing of new investments is illegal under antitrust law. However, tacit coordination is practiced in many industries as companies attempt to understand and forecast one another's competitive moves. Generally, companies use market signaling to secure coordination. They make announcements about their future investment decisions in trade journals and newspapers. In addition, they share information about their production levels and their forecasts of demand within an industry to bring supply and demand into equilibrium. Thus, a coordination strategy reduces the risks associated with investment in the industry. This is very common in the chemical refining and oil businesses, where new capacity investments frequently cost hundreds of millions of dollars.

STRATEGIES IN DECLINING INDUSTRIES

Sooner or later, many industries enter into a decline stage, in which the size of the total market begins to shrink. Examples are the railroad industry, the tobacco industry, the steel industry, and the newspaper business (see the Opening Case). Industries start declining for a number of reasons, including technological change, social trends, and demographic shifts. The railroad and steel industries began to decline when technological changes brought viable substitutes for their products. The advent of the internal combustion engine drove the railroad industry into decline, and the steel industry fell into decline with the rise of plastics and composite materials. Similarly, as noted in the Opening Case, the newspaper industry is in decline because of the rise of news sites on the Web. As for the tobacco industry, changing social attitudes toward smoking, which come from growing concerns about the health effects of smoking, have caused the decline.

The Severity of Decline

When the size of the total market is shrinking, competition tends to intensify in a declining industry, and profit rates tend to fall. The intensity of competition in a declining industry depends on four critical factors, which are indicated in Figure 6.6. First, the intensity of competition is greater in industries in which decline is rapid, as opposed to industries such as tobacco, in which decline is slow and gradual.

Second, the intensity of competition is greater in declining industries in which exit barriers are high. Recall from Chapter 2 that high exit barriers keep companies locked into an industry, even when demand is falling. The result is the emergence of excess productive capacity, and hence an increased probability of fierce price competition.

Third, and related to the previous point, the intensity of competition is greater in declining industries in which fixed costs are high (as in the steel industry). The reason is that the need to cover fixed costs, such as the costs of maintaining productive capacity, can make companies try to use any excess capacity they have by slashing prices, which can trigger a price war.

Finally, the intensity of competition is greater in declining industries in which the product is perceived as a commodity (as it is in the steel industry) in contrast to industries in

Figure 6.6 Factors that Determine the Intensity of Competition in Declining Industries

© Cengage Learning

leadership strategy
When a company develops strategies to become the dominant player in a declining industry.

niche strategy
When a company focuses on pockets of demand that are declining more slowly than the industry as a whole to maintain profitability.

harvest strategy
When a company reduces to a minimum the assets it employs in a business to reduce its cost structure and extract or "milk" maximum profits from its investment.

divestment strategy
When a company decides to exit an industry by selling off its business assets to another company.

which differentiation gives rise to significant brand loyalty, as was true (until very recently) of the declining tobacco industry.

Not all segments of an industry typically decline at the same rate. In some segments, demand may remain reasonably strong despite decline elsewhere. The steel industry illustrates this situation. Although bulk steel products, such as sheet steel, have suffered a general decline, demand has actually risen for specialty steels, such as those used in high-speed machine tools. Vacuum tubes provide another example. Although demand for the tubes collapsed when transistors replaced them as a key component in many electronics products, vacuum tubes still had some limited applications in radar equipment for years afterward. Consequently, demand in this vacuum tube segment remained strong despite the general decline in the demand for vacuum tubes. The point, then, is that there may be pockets of demand in an industry in which demand is declining more slowly than in the industry as a whole—or where demand is not declining at all. Price competition may be far less intense among the companies serving pockets of demand than within the industry as a whole.

Choosing a Strategy

There are four main strategies that companies can adopt to deal with decline: (1) a **leadership strategy**, by which a company seeks to become the dominant player in a declining industry; (2) a **niche strategy**, which focuses on pockets of demand that are declining more slowly than the industry as a whole; (3) a **harvest strategy**, which optimizes cash flow; and (4) a **divestment strategy**, by which a company sells the business to others.[18] Figure 6.7 provides a simple framework for guiding strategic choice. Note that the intensity of competition in the declining industry is measured on the vertical axis, and a company's strengths relative to remaining pockets of demand are measured on the horizontal axis.

Leadership Strategy A leadership strategy aims at growing in a declining industry by picking up the market share of companies that are leaving the industry. A leadership

| Figure 6.7 | Strategy Selection in a Declining Industry |

© Cengage Learning

strategy makes most sense when (1) the company has distinctive strengths that allow it to capture market share in a declining industry and (2) the speed of decline and the intensity of competition in the declining industry are moderate. Philip Morris used this strategy in the tobacco industry. Through strong marketing, Philip Morris increased its market share in a declining industry and earned enormous profits in the process.

The tactical steps companies might use to achieve a leadership position include using aggressive pricing and marketing to build market share, acquiring established competitors to consolidate the industry, and raising the stakes for other competitors, for example, by making new investments in productive capacity. Competitive tactics such as these signal to other competitors that the company is willing and able to stay and compete in the declining industry. These signals may persuade other companies to exit the industry, which would further enhance the competitive position of the industry leader.

Niche Strategy A niche strategy focuses on pockets of demand in the industry in which demand is stable, or declining less rapidly than the industry as a whole. This strategy makes sense when the company has some unique strengths relative to those niches in which demand remains relatively strong. As an example, consider Naval, a company that manufactures whaling harpoons (and small guns to fire them) and makes adequate profits. This might be considered rather odd because the world community has outlawed whaling. However, Naval survived the terminal decline of the harpoon industry by focusing on the one group of people who are still allowed to hunt whales, although only in very limited numbers: North American Inuits. Inuits are permitted to hunt bowhead whales, provided that

they do so only for food and not for commercial purposes. Naval is the sole supplier of small harpoon whaling guns to Inuit communities, and its monopoly position allows the company to earn a healthy return in this small market. Community Impact Newspapers, which was profiled in the Opening Case, is another example of a company that has made money in a declining industry by focusing in a niche where demand is relatively strong—in this case hyper-local newspapers.

Harvest Strategy As we noted earlier, a harvest strategy is the best choice when a company wishes to exit a declining industry and optimize cash flow in the process. This strategy makes the most sense when the company foresees a steep decline and intense future competition, or when it lacks strengths relative to remaining pockets of demand in the industry. A harvest strategy requires the company to halt all new investments in capital equipment, advertising, research and development (R&D), and so forth. The inevitable result is that the company will lose market share, but because it is no longer investing in the business, initially its positive cash flow will increase. Essentially, the company is accepting cash flow in exchange for market share. Ultimately, cash flow will start to decline, and when that occurs, it makes sense for the company to liquidate the business. Although this strategy can be very appealing in theory, it can be somewhat difficult to put into practice. Employee morale in a business that is declining may suffer. Furthermore, if customers realize what the company is doing, they may rapidly defect. Then, market share may decline much faster than the company expects.

Divestment Strategy A divestment strategy rests on the idea that a company can recover most of its investment in an underperforming business by selling it early, before the industry has entered into a steep decline. This strategy is appropriate when the company has few strengths relative to whatever pockets of demand are likely to remain in the industry and when the competition in the declining industry is likely to be intense. The best option may be to sell to a company that is pursuing a leadership strategy in the industry. The drawback of the divestment strategy is that its success depends upon the ability of the company to spot industry decline before it becomes detrimental, and to sell while the company's assets are still valued by others.

ETHICAL DILEMMA

© iStockPhoto.com/P_Wei

A team of marketing managers for a major differentiated consumer products company has been instructed by top managers to develop new strategies to increase the profitability of the company's products. One idea is to lower the cost of ingredients, which will reduce product quality; another is to reduce the content of the products while maintaining the size of the packaging; a third is to slightly change an existing product and then offer it as a "new" premium brand that can be sold at a higher price.

Do you think it is ethical to pursue these strategies and present them to management? In what ways could these strategies backfire and cause the company harm?

SUMMARY OF CHAPTER

1. In fragmented industries composed of a large number of small- and medium-sized companies, the principal forms of competitive strategy are chaining, franchising, and horizontal merger.

2. In embryonic and growth industries, strategy is partly determined by market demand. Innovators and early adopters have different needs than the early and the late majority, and a company must have the right strategies in place to cross the chasms and survive. Similarly, managers must understand the factors that affect a market's growth rate so that they can tailor their business model to a changing industry environment.

3. Mature industries are composed of a few large companies whose actions are so highly interdependent that the success of one company's strategy depends upon the responses of its rivals.

4. The principal strategies used by companies in mature industries to deter entry are product proliferation, price cutting, and maintaining excess capacity.

5. The principal strategies used by companies in mature industries to manage rivalry are price signaling, price leadership, non-price competition, and capacity control.

6. In declining industries, in which market demand has leveled off or is decreasing, companies must tailor their price and non-price strategies to the new competitive environment. Companies also need to manage industry capacity to prevent the emergence of capacity expansion problems.

7. There are four main strategies a company can pursue when demand is falling: leadership, niche, harvest, and divestment. The strategic choice is determined by the severity of industry decline and the company's strengths relative to the remaining pockets of demand.

DISCUSSION QUESTIONS

1. Why are industries fragmented? What are the primary ways in which companies can turn a fragmented industry into a consolidated industry?

2. What are the key problems in maintaining a competitive advantage in embryonic and growth industry environments? What are the dangers associated with being the leader in an industry?

3. What investment strategies should be made by: (a) differentiators in a strong competitive position, and (b) differentiators in a weak competitive position, while managing a company's growth through the life cycle?

4. Discuss how companies can use: (a) product differentiation, and (b) capacity control to manage rivalry and increase an industry's profitability.

5. What kinds of strategies might: (a) a small pizza place operating in a crowded college market, and (b) a detergent manufacturer seeking to unveil new products in an established market use to strengthen their business models?

PRACTICING STRATEGIC MANAGEMENT

© iStockPhoto.com/Urilux

Small-Group Exercises: Creating a Nationwide Health Club

Break into groups of three to five people and discuss the following scenario. Appoint one group member as a spokesperson who will communicate your findings to the class. You are the founders of a health club. The health club industry is quite fragmented, with many small players, and just a few larger players such as LA Fitness, 24 Hour Fitness, and Gold's Gym. Your backers want you to devise a strategy for growing your business, quickly establishing a nationwide chain of health clubs.

1. Is there scope for value innovation in this industry? What might a value innovation strategy look like?
2. Describe how your chosen strategy would enable you to create a national brand and/or attain scale economies.
3. What would your growth strategy be: chaining or franchising? Be sure to justify your answer.

STRATEGY SIGN ON

© iStockPhoto.com/Ninoslav Dotlic

Article File 6

Choose a company (or group of companies) in a particular industry environment and explain how it has adopted a competitive strategy to protect or enhance its business-level strategy.

Strategic Management Project: Developing Your Portfolio 6

This part of the project considers how conditions in the industry environment affect the success of your company's business model and strategies. With the information you have available, perform the tasks and answer the questions listed:

1. In what kind of industry environment (e.g., embryonic, mature, etc.) does your company operate? Use the information from Strategic Management Project: Module 2 to answer this question.
2. Discuss how your company has attempted to develop strategies to protect and strengthen its business model. For example, if your company is operating in an embryonic industry, how has it attempted to increase its competitive advantage over time? If it operates in a mature industry, discuss how it has tried to manage industry competition.
3. What new strategies would you advise your company to pursue to increase its competitive advantage? For example, how should your company attempt to differentiate its products in the future, or lower its cost structure?
4. On the basis of this analysis, do you think your company will be able to maintain its competitive advantage in the future? Why or why not?

CLOSING CASE

Consolidating Dry Cleaning

No large companies dominate the U.S. dry-cleaning industry. The industry has some 30,000 individual businesses employing around 165,000 people. Most establishments are very small. The top 50 enterprises in the industry are estimated to account for no more than 40% of industry revenues. According to the Dry-cleaning & Laundry Institute, the median annual sales for a commercial dry cleaner are less than $250,000. The industry is a favored starting point for many immigrants, who are attracted by the low capital requirements. More than 80% of industry revenues can be attributed to individual retail customers, with hospitals, hotels, and restaurants accounting for much of the balance. The larger companies in the industry tend to focus on serving larger establishments, such as hospitals and hotels.

Total industry revenues are estimated to be around $9 billion. Between 2007 and 2012 demand shrunk at 2.5% per annum. A weak economy with persistently high unemployment, the rise of "business casual" dress norms in many companies, and the development of new clothing materials that do not need dry cleaning or pressing are all cited as reasons for the weak demand conditions.

Demand for dry-cleaning services is very local. All dry cleaners within a 10-minute drive of each other are often viewed as direct competitors. Convenience seems to be one of the major factors leading a consumer to pick one dry cleaner over another. Dry cleaning has been described as a classic low-interest category—there is very little about dry cleaning that excites consumers.

The industry has defied efforts to consolidate it. The largest national dry-cleaning chain in the United States is Martinizing. Started more than 60 years ago, in 2012 Martinizing had some 160 franchisees that operate more than 456 stores. However, as recently as 2001 its franchisees operated almost 800 stores, so the company seems to have been shrinking steadily over the last decade.

In the late 1990s the founders of Staples, the office supplies superstore, entered the dry-cleaning industry, establishing a Boston-based chain known as Zoots. Backed with up to $40 million in capital, they had visions of transforming the dry-cleaning industry (as they had done with office supplies), consolidating a fragmented industry and creating enormous economic value for themselves in the process. They created of cluster of 7 to 10 stores around a central cleaning hub. Each store had a drive through window, self-service lockers for leaving and picking up clothes, and one or two full-time staff members on hand to help customers. The hub had about 40 employees engaged in cleaning processes. Zoots promised to get dry cleaning done right, reliably, and conveniently, and to do this at a reasonable price. Unfortunately, Zoots found that the service-intensive nature of dry cleaning and the very high variability of clothing made it all but impossible to standardize processes. Costs were significantly higher than anticipated, quality was not as good as management hoped, employee turnover was high, and demand came in below forecasts. Today Zoots has less than 40 stores and remains concentrated in the Boston area. The founders are no longer involved in the business and, clearly, it did not come close to transforming the industry.

Sources: IBIS World, "Dry Cleaners in the US: Market Research Report," October 2012; Myra M. Hart and Sharon Peyus, "Zoots: The Cleaner Cleaner," *Harvard Business School*, September 20, 2000; and Fulcrum Inquiry, "Valuation Guide: Dry Cleaners," www .fulcrum.com/drycleaning_appraisal.htm.

CASE DISCUSSION QUESTIONS

1. Why do you think that the dry-cleaning industry has a fragmented structure?

2. The larger enterprises in the industry seem to serve large customers with standardized

needs, such as hotels and hospitals. Why do you think this is the case?

3. Why do you think that Zoots was unable to consolidate the dry-cleaning industry, despite adequate capital and the managerial talent that created Staples?

4. If you were to try to consolidate the dry-cleaning industry, what strategy would you pursue and why?

KEY TERMS

Fragmented industry 180
Chaining 182
Franchising 182
Mass market 185
Product proliferation
 strategy 192
Limit price strategy 193
Strategic
 commitments 193
Price signaling 195
Price leadership 195
Non-price
 competition 196
Product
 development 197
Market development 197
Leadership strategy 202
Niche strategy 202
Harvest strategy 202
Divestment strategy 202

NOTES

[1] M. E. Porter, *Competitive Strategy: Techniques for Analyzing Industries and Competitors* (New York: Free Press, 1980), pp. 191–200.

[2] W. C. Kim and R. Mauborgne, "Value Innovation: The Strategic Logic of High Growth," *Harvard Business Review*, January–February 1997.

[3] S. A. Shane, "Hybrid Organizational Arrangements and Their Implications for Firm Growth and Survival: A Study of New Franchisors," *Academy of Management Journal* 1 (1996): 216–234.

[4] Microsoft is often accused of not being an innovator, but the fact is that Gates and Allen wrote the first commercial software program for the first commercially available personal computer. Microsoft was the first mover in its industry. See P. Freiberger and M. Swaine, *Fire in the Valley* (New York: McGraw-Hill, 2000).

[5] J. M. Utterback, *Mastering the Dynamics of Innovation* (Boston: Harvard Business School Press, 1994).

[6] See Freiberger and Swaine, *Fire in the Valley*.

[7] Utterback, *Mastering the Dynamics of Innovation*.

[8] G. A. Moore, *Crossing the Chasm* (New York: HarperCollins, 1991).

[9] Utterback, *Mastering the Dynamics of Innovation*.

[10] E. Rogers, *Diffusion of Innovations* (New York: Free Press, 1995).

[11] R. J. Gilbert, "Mobility Barriers and the Value of Incumbency," in R. Schmalensee and R. D. Willig (eds.), *Handbook of Industrial Organization* (Elsevier Science Publishers, 1989).

[12] P. Ghemawat, *Commitment: The Dynamic of Strategy* (Harvard Business School Press, 1991).

[13] M. B. Lieberman, "Excess Capacity as a Barrier to Entry: An Empirical Appraisal," *Journal of Industrial Economics* 35 (1987): 607–627.

[14] R. Lukach, P. M. Kort, and J. Plasmans, "Optimal R&D Investment Strategies Under the Threat of New Technology Entry," *International Journal of Industrial Organization* 25 (February 2007): 103–119.

[15] W. B. Arthur, "Increasing Returns and the New World of Business," *Harvard Business Review*, July 1996.

[16] R. Axelrod, *The Evolution of Cooperation* (New York: Basic Books, 1984).

[17] The next section draws heavily on Marvin B. Lieberman, "Strategies for Capacity Expansion," *Sloan Management Review* 8 (1987): 19–27; Porter, *Competitive Strategy*, 324–338.

[18] K. R. Harrigan, "Strategy Formulation in Declining Industries," *Academy of Management Review* 5 (1980): 599–604.

7

Strategy and Technology

LEARNING OBJECTIVES

After reading this chapter you should be able to:

7-1 Understand the tendency toward standardization in many high-technology markets

7-2 Describe the strategies that firms can use to establish their technology as the standard in a market

7-3 Explain the cost structure of many high-technology firms, and articulate the strategic implications of this structure

7-4 Explain the nature of technological paradigm shifts and their implications for enterprise strategy

OPENING CASE

A Battle Emerging in Mobile Payments

In 2012, 75% of the world population was using mobile phones, and 80% of those mobile users accessed the mobile Web. Mobile payment systems offered the potential of enabling all of these users to perform financial transactions on their phones, similar to how they would perform those transactions using personal computers. However, in 2012, there was no dominant mobile payment system, and a battle among competing mobile payment mechanisms and standards was unfolding.

In the United States, several large players, including Google and a joint venture called ISIS between AT&T, T-Mobile, and Verizon Wireless, were developing systems based on Near Field Communication (NFC) chips that were increasingly being incorporated into smartphones. NFC chips enable communication between a mobile device and a point-of-sale system just by having the devices in close proximity. The systems being developed by Google and ISIS would transfer the customer's information wirelessly, and then use merchant banks and credit card systems such as Visa or MasterCard to complete the transaction. These systems were thus very much like existing ways of using credit cards, but enabled completion of the purchase without contact.

Other competitors, such as Square (with Square Wallet) and PayPal, did not require a smartphone with an NFC chip, but instead used a downloadable application and the Web to transmit a customer's information. Square had gained early fame by offering small, free, credit card readers that could be plugged into the audio jack of a smartphone. These readers enabled vendors that would normally only take cash (street vendors, babysitters, etc.) to accept major

credit cards. By mid-2012, merchants were processing over $6 billion a year using Square readers, making the company one of the fastest growing tech start-ups in Silicon Valley. In terms of installed base, however, PayPal had the clear advantage, with over 100 million active registered accounts. With PayPal, customers could complete purchases simply by entering their phone numbers and a pin number, or use a PayPal-issued magnetic stripe cards linked to their PayPal accounts. Users could opt to link their PayPal accounts to their credit cards, or directly to their bank accounts. This meant that of the systems described so far, only the PayPal system offered the possibility of excluding the major credit card companies (and their billions of dollars in transaction fees) from mobile transactions.

In other parts of the world, intriguing alternatives for mobile banking were gaining traction even faster. In India and Africa, for example, there are enormous populations of "unbanked" or "underbanked" people (individuals who do not have bank accounts or make limited use of banking services). In these regions, the proportion of people with mobile phones vastly exceeds the proportion of people with credit cards. The opportunity, then, of giving such people access to fast and inexpensive funds transfer is enormous. The leading system in India is the Inter-bank Mobile Payment Service developed by National Payments Corporation of India (NPCI). NPCI leveraged its ATM network (connecting more than 60 large banks in India) to create a person-to-person mobile banking system that works on mobile phones. The system uses a unique identifier for each individual that links directly to his or her bank account. In parts of Africa, where the proportion of people who are unbanked is even larger, a system called M-Pesa ("M" for *mobile* and "pesa," which is kiswahili for *money*) enables any individual with a passport or national ID card to deposit money into his or her phone account, and transfer money to other users using Short Message Service (SMS). By mid-2012, the M-Pesa system had almost 15 million active users.

By early 2013, it was clear that mobile payments represented a game-changing opportunity that could accelerate e-commerce, smartphone adoption, and the global reach of financial services. However, lack of compatibility between many of the mobile payment systems and uncertainty over what type of mobile payment system would become dominant still posed significant obstacles to consumer and merchant adoption.

Sources: "Mobile Phone Access Reaches Three Quarters of Planet's Population," *The World Bank*, July 17, 2012; J. Kent, "Dominant Mobile Payment Approaches and Leading Mobile Payment Solution Providers: A Review," *Journal of Payments Strategy & Systems* 6:4 (2012): 315–324; V. Govindarajan and M. Balakrishnan, "Developing Countries Are Revolutionizing Mobile Banking," *Harvard Business Review Blog Network*, April 30, 2012; and M. Helft, "The Death of Cash," *Fortune* 166:2 (2012): 118–128.

OVERVIEW

The high-stakes battle that is brewing in mobile payments is typical of the nature of competition in high-technology industries (see the Opening Case). In industries where standards and compatibility are important strategic levers, a technology that gains an initial advantage can sometimes rise to achieve a nearly insurmountable position. Such industries can thus become "winner-take-all" markets. Being successful in such industries can require very different strategies than in more traditional industries. Firms may aggressively subsidize adoption of their preferred technology (including sometimes giving away products for free) in order to win the standards battle.

In this chapter, we will take a close look at the nature of competition and strategy in high-technology industries. Technology refers to the body of scientific knowledge used in the production of goods or services. High-technology (high-tech) industries are those in which the underlying scientific knowledge that companies in the industry use is rapidly advancing, and, by implication, so are the attributes of the products and services that result from its application. The computer industry is often thought of as the quintessential example of a high-technology industry. Other industries often considered high-tech are: telecommunications, where new technologies based on wireless and the Internet have proliferated in recent years; consumer electronics, where the digital technology underlying products from high-definition DVD players to videogame terminals and digital cameras is advancing rapidly; pharmaceuticals, where new technologies based on cell biology, recombinant DNA, and genomics are revolutionizing the process of drug discovery; power generation, where new technologies based on fuel cells and cogeneration may change the economics of the industry; and aerospace, where the combination of new composite materials, electronics, and more efficient jet engines is giving birth to a new era of super-efficient commercial jet aircraft such as Boeing's 787.

This chapter focuses on high-technology industries for a number of reasons. First, technology is accounting for an ever-larger share of economic activity. Estimates suggest that in the last decade, nearly 25% of growth in domestic product was accounted for by information technology industries.[1] This figure actually underestimates the true impact of technology on the economy, because it ignores the other high-technology areas we just mentioned. Moreover, as technology advances, many low-technology industries are becoming more high-tech. For example, the development of biotechnology and genetic engineering transformed the production of seed corn, long considered a low-technology business, into a high-technology business. Retailing was once considered a low technology business, but the shift to online retailing, led by companies like Amazon.com, has changed this. In addition, high-technology products are making their way into a wide range of businesses; today most automobiles contain more computing power than the multimillion-dollar mainframe computers used in the *Apollo* space program, and the competitive advantage of physical stores, such as Wal-Mart, is based on their use of information technology. The circle of high-technology industries is both large and expanding, and technology is revolutionizing aspects of the product or production system even in industries not typically considered high-tech.

Although high-tech industries may produce very different products, when developing a business model and strategies that will lead to a competitive advantage and superior profitability and profit growth, they often face a similar situation. For example, "winner-take-all" format wars are common in many high-technology industries, such as the consumer electronics and computer industries. In mobile payments, for example, it is possible that a new payment system will emerge that could displace Visa, MasterCard, and American Express as the dominant firms for managing payment transactions worldwide—this could result in a tremendous windfall for the firm(s) controlling the new standard (and a tremendous loss for Visa, MasterCard, and American Express). Firms are thus carefully forging alliances and backing standards they believe will best position them to capture the billions of dollars in transactions fees that are at stake (see the Opening Case). This chapter examines the competitive features found in many high-tech industries and the kinds of strategies that companies must adopt to build business models that will allow them to achieve superior profitability and profit growth.

By the time you have completed this chapter, you will have an understanding of the nature of competition in high-tech industries, and the strategies that companies can pursue to succeed in those industries.

TECHNICAL STANDARDS AND FORMAT WARS

Especially in high-tech industries, ownership of **technical standards**—a set of technical specifications that producers adhere to when making the product, or a component of it— can be an important source of competitive advantage.[2] Indeed, in many cases the source of product differentiation is based on the technical standard. Often, only one standard will dominate a market, so many battles in high-tech industries involve companies that are competing to set the standard. For example, for the last three decades, Microsoft has controlled the market as the dominant operating system for personal computers, sometimes exceeding a 90% market share, and with roughly an 85% share by the end of 2012. Notably, however, Microsoft held a very small share (roughly 3% in 2013) of the tablet and smartphone operating system market, suggesting the possibility of turbulent times ahead for the firm (see Strategy in Action 7.1).

technical standards
A set of technical specifications that producers adhere to when making the product, or a component of it.

7.1 STRATEGY IN ACTION

"Segment Zero"—A Serious Threat to Microsoft?

© iStockPhoto.com/Tom Nulens

From 1980 to 2012, Microsoft was entrenched as the dominant personal computer operating system, giving it enormous influence over many aspects of the computer hardware and software industries. Although competing operating systems had been introduced during that time (e.g., Unix, Geoworks, NeXTSTEP, Linux, and the Mac OS), Microsoft's share of the personal computer operating system market held stable at roughly 85% throughout most of that period. In 2013, however, Microsoft's dominance in computer operating systems was under greater threat than it had ever been. A high-stakes race for dominance over the next generation of computing was well under way, and Microsoft was not even in the front pack.

"Segment Zero"
As Andy Grove, former CEO of Intel, noted in 1998, in many industries—including microprocessors, software, motorcycles, and electric vehicles—technologies improve faster than customer demands of those technologies increase. Firms often add features (speed,

power, etc.) to products faster than customers' capacity to absorb them. Why would firms provide higher performance than that required by the bulk of their customers? The answer appears to lie in the market segmentation and pricing objectives of a technology's providers. As competition in an industry drives prices and margins lower, firms often try to shift sales into progressively higher tiers of the market. In these tiers, high-performance and feature-rich products can command higher margins. Although customers may also expect to have better-performing products over time, their ability to fully utilize such performance improvements is slowed by the need to learn how to use new features and adapt their work and lifestyles. Thus, both the trajectory of technology improvement and the trajectory of customer demands are upward sloping, but the trajectory for technology improvement is steeper.

In Figure 7.1 the technology trajectory begins at a point where it provides performance close to that demanded by the mass market, but over time it increases faster than the expectations of the mass market

(continues)

7.1 STRATEGY IN ACTION

(continued)

© iStockPhoto.com/Tom Nulens

| Figure 7.1 | Trajectories of Technology Improvement and Customer Requirements |

© Cengage Learning

as the firm targets the high-end market. As the price of the technology rises, the mass market may feel it is overpaying for technological features it does not value. In Figure 7.1 the low-end market is not being served; it either pays far more for technology that it does not need, or it goes without. It is this market that Andy Grove, former CEO of Intel, refers to as segment zero.

For Intel, segment zero was the market for low-end personal computers (those less than $1,000). Although segment zero may seem unattractive in terms of margins, if it is neglected, it can become the breeding ground for companies that provide lower-end versions of the technology. As Grove notes, "The overlooked, under-served, and seemingly unprofitable end of the market can provide fertile ground for massive competitive change."

As the firms serving low-end markets with simpler technologies ride up their own trajectories (which are also steeper than the slope of the trajectories of cus-tomer expectations), they can eventually reach a per-formance level that meets the demands of the mass market, while offering a much lower price than the

Gmargittai/Dreamstime.com

premium technology (see Figure 7.2). At this point, the firms offering the premium technology may suddenly find they are losing the bulk of their sales revenue to industry contenders that do not look so low-end any-more. For example, by 1998, the combination of rising microprocessor power and decreasing prices enabled personal computers priced under $1,000 to capture 20% of the market.

7.1 STRATEGY IN ACTION

(continued)

© iStockPhoto.com/Tom Nulens

| Figure 7.2 | Low-End Technology's Trajectory Intersects Mass-Market Trajectory |

© Cengage Learning

The Threat to Microsoft

So where was the "segment zero" that could threaten Microsoft? Look in your pocket. In 2013, Apple's iPhone operating system (iOS) and Google's Android collectively controlled over 90% of the worldwide market for smartphones, followed by Research in Motion's Blackberry. Gartner estimates put Microsoft's share at 3%. The iOS and Android interfaces offered a double whammy of beautiful aesthetics and remarkable ease of use. The applications business model used for the phones was also extremely attractive to both developers and customers, and quickly resulted in enormous libraries of applications that ranged from the ridiculous to the indispensable.

From a traditional economics perspective, the phone operating system market should not be that attractive to Microsoft—people do not spend as much on the applications, and the carriers have too much bargaining power, among other reasons. However, those smartphone operating systems soon became tablet operating systems, and tablets were rapidly becoming fully functional computers. Suddenly, all of that mindshare that Apple and Google had achieved in smartphone operating systems was transforming into mindshare in personal computer operating systems. Despite years of masterminding the computing industry, Microsoft's dominant position was at risk of evaporating. The outcome was still uncertain—in 2013 Microsoft had an impressive arsenal of capital, talent, and relationships in its armory, but for the first time, it was fighting the battle from a disadvantaged position.

Sources: Adapted from M. A. Schilling, "'Segment Zero': A Serious Threat to Microsoft?", Conceptual note, New York University, 2013; A. S. Grove, "Managing Segment Zero," *Leader to Leader*, 11 (1999); and L. Dignan, "Android, Apple iOS Flip Consumer, Corporate Market Share. *Between the Lines*", February 13 (2013).

format wars

Battles to control the source of differentiation, and thus the value that such differentiation can create for the customer.

Battles to set and control technical standards in a market are referred to as **format wars**—essentially, battles to control the source of differentiation, and thus the value that such differentiation can create for the customer. Because differentiated products often command premium prices and are often expensive to develop, the competitive stakes are enormous. The profitability and survival of a company may depend on the outcome of the battle.

Examples of Standards

A familiar example of a standard is the layout of a computer keyboard. No matter what keyboard you purchase, the letters are all arranged in the same pattern.[3] The reason is quite obvious. Imagine if each computer maker changed the ways the keys were laid out—if some started with QWERTY on the top row of letters (which is indeed the format used and is known as the QWERTY format), some with YUHGFD, and some with ACFRDS. If you learned to type on one layout, it would be irritating and time consuming to have to relearn on a YUHGFD layout. The standard format (QWERTY) it makes it easy for people to move from computer to computer because the input medium, the keyboard, is set in a standard way.

Another example of a technical standard can be seen in the dimensions of containers used to ship goods on trucks, railcars, and ships: all have the same basic dimensions—the same height, length, and width—and all make use of the same locking mechanisms to hold them onto a surface or to bolt against each other. Having a standard ensures that containers can easily be moved from one mode of transportation to another—from trucks, to railcars, to ships, and back to railcars. If containers lacked standard dimensions and locking mechanisms, it would suddenly become much more difficult to ship containers around the world. Shippers would need to make sure that they had the right kind of container to go on the ships and trucks and railcars scheduled to carry a particular container around the world—a very complicated process.

Consider, finally, the personal computer (PC). Most share a common set of features: an Intel or Intel-compatible microprocessor, random access memory (RAM), a Microsoft operating system, an internal hard drive, a DVD drive, a keyboard, a monitor, a mouse, a modem, and so on. We call this set of features the dominant design for personal computers (a **dominant design** refers to a common set of features or design characteristics). Embedded in this design are several technical standards (see Figure 7.3). For example, there is the Wintel technical standard based on an Intel microprocessor and a Microsoft operating system. Microsoft and Intel "own" that standard, which is central to the personal computer. Developers of software applications, component parts, and peripherals such as printers adhere to this standard when developing their own products because this guarantees that their products will work well with a personal computer based on the Wintel standard. Another technical standard for connecting peripherals to the PC is the Universal Serial Bus (or USB), established by an industry-standards-setting board. No one owns it; the standard is in the public domain. A third technical standard is for communication between a PC and the Internet via a modem. Known as TCP/IP, this standard was also set by an industry association and is in the public domain. Thus, as with many other products, the PC is actually based on several technical standards. It is also important to note that when a company owns a standard, as Microsoft and Intel do with the Wintel standard, it may be a source of competitive advantage and high profitability.

dominant design

Common set of features or design characteristics.

Figure 7.3 | Technical Standards for Personal Computers

© Cengage Learning

Benefits of Standards

Standards emerge because there are economic benefits associated with them. First, a technical standard helps to guarantee compatibility between products and their complements. For example, containers are used with railcars, trucks, and ships, and PCs are used with software applications. Compatibility has the tangible economic benefit of reducing the costs associated with making sure that products work well with each other.

Second, having a standard can help to reduce confusion in the minds of consumers. A few years ago, several consumer electronics companies were vying with each other to produce and market the first generation of DVD players, and they were championing different variants of the basic DVD technology—different standards—that were incompatible with each other; a DVD disc designed to run on a DVD player made by Toshiba would not run on a player made by Sony, and vice versa. The companies feared that selling these incompatible versions of the same technology would produce confusion in the minds of consumers, who would not know which version to purchase and might decide to wait and see which technology would dominate the marketplace. With lack of demand, the technology might fail to gain traction in the marketplace and would not be successful. To avoid this possibility, the developers of DVD equipment established a standard-setting body for the industry, the DVD Forum, which established a common technical standard for DVD players and disks that all companies adhered to. The result was that when DVDs were introduced, there was a common standard and no confusion in consumers' minds. This helped to boost demand for DVD players, making this one of the fastest-selling technologies of the late-1990s and early-2000s.

Third, the emergence of a standard can help to reduce production costs. Once a standard emerges, products that are based on the standard design can be mass produced, enabling

the manufacturers to realize substantial economies of scale while lowering their cost structures. The fact that there is a central standard for PCs (the Wintel standard) means that the component parts for a PC can be mass produced. A manufacturer of internal hard drives, for example, can mass produce drives for Wintel PCs, and so can realize substantial scale economies. If there were several competing and incompatible standards, each of which required a unique type of hard drive, production runs for hard drives would be shorter, unit costs would be higher, and the cost of PCs would increase.

Fourth, the emergence of standards can help to reduce the risks associated with supplying complementary products, and thus increase the supply for those complements. Consider the risks associated with writing software applications to run on personal computers. This is a risky proposition, requiring the investment of considerable sums of money for developing the software before a single unit is sold. Imagine what would occur if there were 10 different operating systems in use for PCs, each with only 10% of the market, rather than the current situation, where over 90% of the world's PCs adhere to the Wintel standard. Software developers would be faced with the need to write 10 different versions of the same software application, each for a much smaller market segment. This would change the economics of software development, increase its risks, and reduce potential profitability. Moreover, because of their higher cost structure and fewer economies of scale, the price of software programs would increase.

Thus, although many people complain about the consequences of Microsoft's near monopoly of PC operating systems, that monopoly does have at least one good effect: it substantially reduces the risks facing the makers of complementary products and the costs of those products. In fact, standards lead to both low-cost and differentiation advantages for individual companies and can help raise the level of industry profitability.

Establishment of Standards

Standards emerge in an industry in three primary ways. First, when the benefits of establishing a standard are recognized, companies in an industry might lobby the government to mandate an industry standard. In the United States, for example, the Federal Communications Commission (FCC), after detailed discussions with broadcasters and consumer electronics companies, mandated a single technical standard for digital television broadcasts (DTV) and required analog television broadcasts to be terminated in 2009. The FCC took this step because it believed that without government action to set the standard, the DTV rollout would be very slow. With a standard set by the government, consumer electronics companies can have greater confidence that a market will emerge, and this should encourage them to develop DTV products.

Second, technical standards are often set by cooperation among businesses, without government help, and often through the medium of an industry association, as the example of the DVD forum illustrates. Companies cooperate in this way when they decide that competition to create a standard might be harmful because of the uncertainty that it would create in the minds of consumers or the risk it would pose to manufacturers and distributors.

public domain
Government- or association-set standards of knowledge or technology that any company can freely incorporate into its product.

When the government or an industry association sets standards, these standards fall into the **public domain**, meaning that any company can freely incorporate the knowledge and technology upon which the standard is based into its products. For example, no one owns the QWERTY format, and therefore no one company can profit from it directly. Similarly, the language that underlies the presentation of text and graphics on the Web, hypertext markup language (HTML), is in the public domain; it is free for all to use. The same is true for TCP/IP, the communications standard used for transmitting data on the Internet.

Often, however, the industry standard is selected competitively by the purchasing patterns of customers in the marketplace—that is, by market demand. In this case, the strategy and business model a company has developed for promoting its technological standard are of critical importance because ownership of an industry standard that is protected from imitation by patents and copyrights is a valuable asset—a source of sustained competitive advantage and superior profitability. Microsoft and Intel, for example, both owe their competitive advantage to their ownership of a specific technological standard or format. As noted earlier, format wars occur when two or more companies compete against each other to get their designs adopted as the industry standard. Format wars are common in high-tech industries where standards are important. The Wintel standard became the dominant standard for PCs only after Microsoft and Intel won format wars against Apple's proprietary system, and later against IBM's OS/2 operating system. The Opening Case describes how a number of firms are engaged in a format war in mobile payments. There is also an ongoing format war within the smartphone business, as Apple, Google, Research in Motion, and Microsoft all battle to get their respective operating systems and phones adopted as the industry standard, as described in Strategy in Action 7.1.

Network Effects, Positive Feedback, and Lockout

There has been a growing realization that when standards are set by competition between companies promoting different formats, network effects are a primary determinant of how standards are established.[4] **Network effects** arise in industries where the size of the "network" of complementary products is a primary determinant of demand for an industry's product. For example, the demand for automobiles early in the 20th century was an increasing function of the network of paved roads and gas stations. Similarly, the demand for telephones is an increasing function of the multitude of other numbers that can be called with that phone; that is, of the size of the telephone network (the telephone network is the complementary product). When the first telephone service was introduced in New York City, only 100 numbers could be called. The network was very small because of the limited number of wires and telephone switches, which made the telephone a relatively useless piece of equipment. But, as an increasing number of people got telephones, and as the network of wires and switches expanded, the telephone connection gained value. This led to an upsurge in demand for telephone lines, which further increased the value of owning a telephone, setting up a positive feedback loop.

> **network effects**
>
> The network of complementary products as a primary determinant of the demand for an industry's product.

To understand why network effects are important in the establishment of standards, consider the classic example of a format war: the battle between Sony and Matsushita to establish their respective technologies for videocassette recorders (VCRs) as the standard in the marketplace. Sony was first to market with its Betamax technology, followed by JVC with its VHS technology. Both companies sold VCR recorder-players, and movie studios issued films prerecorded on VCR tapes for rental to consumers. Initially, all tapes were issued in Betamax format to play on Sony's machine. Sony did not license its Betamax technology, preferring to make all of the player-recorders itself. Because Japan's Ministry of International Trade and Industry (MITI) appeared poised to select Sony's Betamax as a standard for Japan, JVC decided to liberally license its format, and turned to Matsushita (now called Panasonic) to ask for its support. Matsushita was the largest Japanese electronics manufacturer at that time. JVC and Matsushita realized that to make the VHS format players valuable to consumers, they would need to encourage movie studios to issue movies for rental on VHS tapes. The only way to do that, they reasoned, was to increase the installed base of VHS players as rapidly as possible. They believed that the greater the

Figure 7.4 Positive Feedback in the Market for VCRs

© Cengage Learning

installed base of VHS players, the greater the incentive for movie studios to issue films on VHS-format tapes for rental. As more prerecorded VHS tapes were made available for rental, the VHS player became more valuable to consumers, and therefore the demand for VHS players increased (see Figure 7.4). JVC and Matsushita wanted to exploit a positive feedback loop.

To do this, JVC and Matsushita chose a licensing strategy under which any consumer electronics company was allowed to manufacture VHS-format players under license. This strategy worked. A large number of companies signed on to manufacture VHS players, and soon far more VHS players were available for purchase in stores than Betamax players. As sales of VHS players started to grow, movie studios issued more films for rental in VHS format, and this stoked demand. Before long, it was clear to anyone who entered a video rental store that there were more VHS tapes available for rent, and fewer Betamax tapes available. This served to reinforce the positive feedback loop, and ultimately Sony's Betamax technology was shut out of the market. The pivotal difference between the two companies was strategy: JVC and Matsushita chose a licensing strategy, and Sony did not. As a result, JVC's VHS technology became the de facto standard for VCRs, whereas Sony's Betamax technology was locked out.

The general principle that emerges from this example is that when two or more companies are competing with each other to get technology adopted as a standard in an industry, and when network effects and positive feedback loops are important, *the company that wins the format war will be the one whose strategy best exploits positive feedback loops.* This is a very important strategic principle in many high-technology industries, particularly computer hardware, software, telecommunications, and consumer electronics. Microsoft is where it is today because it exploited a positive feedback loop. Dolby presents us with another example of a company that exploited a positive feedback loop. When Ray Dolby invented a technology for reducing the background hiss in professional tape recording, he adopted a licensing model that charged a very modest fee. He knew his technology was valuable, but he also understood that charging a high fee would encourage manufacturers to develop their own noise-reduction technology. He also decided to license the technology

for use on prerecorded tapes for free, collecting licensing fees on the players only. This set up a powerful positive feedback loop: Growing sales of prerecorded tapes encoded with Dolby technology created a demand for tape players that contained Dolby technology, and as the installed base of tape players with Dolby technology grew, the proportion of prerecorded tapes that were encoded with Dolby technology surged—further boosting demand for players incorporating Dolby technology. By the mid-1970s, virtually all prerecorded tapes were encoded with Dolby noise-reduction technology.

As the market settles on a standard, an important implication of the positive feedback process occurs: companies promoting alternative standards can become locked out of the market when consumers are unwilling to bear the switching costs required to abandon the established standard and adopt the new standard. In this context, switching costs are the costs that consumers must bear to switch from a product based on one technological standard to a product based on another technological standard.

For illustration, imagine that a company developed an operating system for personal computers that was both faster and more stable than the current standard in the marketplace, Microsoft Windows. Would this company be able to gain significant market share from Microsoft? Only with great difficulty. Consumers choose personal computers not for their operating system, but for the applications that run on the operating system. A new operating system would initially have a very small installed base, so few developers would be willing to take the risks in writing word processing programs, spreadsheets, games, and other applications for that operating system. Because there would be very few applications available, consumers who did make the switch would have to bear the switching costs associated with giving up some of their applications—something that they might be unwilling to do. Moreover, even if applications were available for the new operating system, consumers would have to bear the costs of purchasing those applications, another source of switching costs. In addition, they would have to bear the costs associated with learning to use the new operating system, yet another source of switching costs. Thus, many consumers would be unwilling to switch even if the new operating system performed better than Windows, and the company promoting the new operating system would be locked out of the market.

However, consumers will bear switching costs if the benefits of adopting the new technology outweigh the costs of switching. For example, in the late 1980s and early 1990s, millions of people switched from analog record players to digital CD players despite that switching costs were significant: consumers had to purchase the new player technology, and many people purchased duplicate copies of their favorite musical recordings. Nevertheless, people made the switch because, for many, the perceived benefit—the incredibly better sound quality associated with CDs—outweighed the costs of switching.

As this switching process continued, a positive feedback loop started to develop, and the installed base of CD players grew, leading to an increase in the number of musical recordings issued on CDs, as opposed to, or in addition to, vinyl records. The installed base of CD players got so big that mainstream music companies began to issue recordings only in CD format. Once this occurred, even those who did not want to switch to the new technology were required to if they wished to purchase new music recordings. The music industry standard had shifted: new technology had locked in as the standard, and the old technology was locked out.

Extrapolating from this example, it can be argued that despite its dominance, the Wintel standard for personal computers could one day be superseded if a competitor finds a way of providing sufficient benefits that enough consumers are willing to bear the switching costs associated with moving to a new operating system. Indeed, there are signs that Apple is

starting to chip away at the dominance of the Wintel standard, primarily by using elegant design and ease of use as tools to get people to bear the costs of switching from Wintel computers to Apple machines.

STRATEGIES FOR WINNING A FORMAT WAR

From the perspective of a company pioneering a new technological standard in a marketplace where network effects and positive feedback loops operate, the key question becomes: "What strategy should we pursue to establish our format as the dominant one?"

The various strategies that companies should adopt in order to win format wars are centered upon *finding ways to make network effects work in their favor and against their competitors*. Winning a format war requires a company to build the installed base for its standard as rapidly as possible, thereby leveraging the positive feedback loop, inducing consumers to bear switching costs, and ultimately locking the market into its technology. It requires the company to jump-start and then accelerate demand for its technological standard or format such that it becomes established as quickly as possible as the industry standard, thereby locking out competing formats. There are a number of key strategies and tactics that can be adopted to try to achieve this.[5]

Ensure a Supply of Complements

It is important for the company to make sure that, in addition to the product itself, there is an adequate supply of complements. For example, no one will purchase the Sony PlayStation 3 unless there is an adequate supply of games to run on that machine. Companies typically take two steps to ensure an adequate supply of complements.

First, they may diversify into the production of complements and seed the market with sufficient supply to help jump-start demand for their format. Before Sony produced the original PlayStation in the early 1990s, for example, it established its own in-house unit to produce videogames for the PlayStation. When it launched the PlayStation, Sony also simultaneously issued 16 games to run on the machine, giving consumers a reason to purchase the format. Second, companies may create incentives or make it easy for independent companies to produce complements. Sony also licensed the right to produce games to a number of independent game developers, charged the developers a lower royalty rate than they had to pay to competitors (such as Nintendo and Sega), and provided them with software tools that made it easier for them to develop the games (note that Apple is now doing the same thing with its smartphones). Thus, the launch of the Sony PlayStation was accompanied by the simultaneous launch of approximately 30 games, which quickly helped to stimulate demand for the machine.

Leverage Killer Applications

killer applications

Applications or uses of a new technology or product that are so compelling that customers adopt them in droves, killing the competing formats.

Killer applications are applications or uses of a new technology or product that are so compelling that they persuade customers to adopt the new format or technology in droves, thereby "killing" demand for competing formats. Killer applications often help to jump-start demand for the new standard. For example, the killer applications that induced consumers to sign up for online services such as AOL in the 1990s were e-mail, chat rooms, and the ability to browse the Web.

Ideally, the company promoting a technological standard will also want to develop its own killer applications—that is, develop the appropriate complementary products. However, it may also be able to leverage the applications that others develop. For example, the early sales of the IBM PC following its 1981 introduction were primarily driven by IBM's decision to license two important software programs for the PC: VisiCalc (a spreadsheet program) and EasyWriter (a word processing program), both developed by independent companies. IBM saw that they were driving rapid adoption of rival personal computers, such as the Apple II, so it quickly licensed software, produced versions that would run on the IBM PC, and sold these programs as complements to the IBM PC, a strategy that was very successful.

Aggressive Pricing and Marketing

A common tactic to jump-start demand is to adopt a **razor and blade strategy**: pricing the product (razor) low in order to stimulate demand and increase the installed base, and then trying to make high profits on the sale of complements (razor blades), which are priced relatively high. This strategy owes its name to Gillette, the company that pioneered this strategy to sell its razors and razor blades. Many other companies have followed this strategy—for example, Hewlett-Packard typically sells its printers at cost but makes significant profits on the subsequent sales of its replacement cartridges. In this case, the printer is the "razor," and it is priced low to stimulate demand and induce consumers to switch from their existing printer, while the cartridges are the "blades," which are priced high to make profits. The inkjet printer represents a proprietary technological format because only HP cartridges can be used with HP printers; cartridges designed for competing inkjet printers, such as those sold by Canon, will not work in HP printers. A similar strategy is used in the videogame industry: manufacturers price videogame consoles at cost to induce consumers to adopt their technology, while they make profits on the royalties received from the sales of games that run on the game system.

razor and blade strategy Pricing the product low in order to stimulate demand, and pricing complements high.

Aggressive marketing is also a key factor in jump-starting demand to get an early lead in an installed base. Substantial upfront marketing and point-of-sales promotion techniques are often used to try to attract potential early adopters who will bear the switching costs associated with adopting the format. If these efforts are successful, they can be the start of a positive feedback loop. Again, the Sony PlayStation provides a good example. Sony co-linked the introduction of the PlayStation with nationwide television advertising aimed at its primary demographic (18- to 34-year-olds) and in-store displays that allowed potential buyers to play games on the machine before making a purchase.

Cooperate with Competitors

Companies have been close to simultaneously introducing competing and incompatible technological standards a number of times. A good example is the compact disc. Initially four companies—Sony, Philips, JVC, and Telefunken—were developing CD players using different variations of the underlying laser technology. If this situation had persisted, they might have introduced incompatible technologies into the marketplace; a CD made for a Philips CD player would not play on a Sony CD player. Understanding that the nearly simultaneous introduction of such incompatible technologies can create significant confusion among consumers, and often lead them to delay their purchases, Sony and Philips decided to join forces and cooperate on developing the technology. Sony contributed its error correction technology, and Philips contributed its laser technology. The result of this cooperation was that momentum among other players in the industry shifted toward the

Sony–Philips alliances; JVC and Telefunken were left with little support. Most important, recording labels announced that they would support the Sony–Philips format but not the Telefunken or JVC format. Telefunken and JVC subsequently decided to abandon their efforts to develop CD technology. The cooperation between Sony and Philips was important because it reduced confusion in the industry and allowed a single format to rise to the fore, which accelerated adoption of the technology. The cooperation was a win-win situation for both Philips and Sony, which eliminated the competitors and enabled them to share in the success of the format.

License the Format

Licensing the format to other enterprises so that those others can produce products based on the format is another strategy often adopted. The company that pioneered the format gains from the licensing fees that return to it, as well as from the enlarged supply of the product, which can stimulate demand and help accelerate market adoption. This was the strategy that JVC and Matsushita adopted with its VHS format for the VCR. As discussed previously, in addition to producing VCRs at Matsushita's factory in Osaka, JVC let a number of other companies produce VHS format players under license, and so VHS players were more widely available. (Sony decided not to license its competing Betamax format and produced all Betamax format players itself.)

The correct strategy to pursue in a particular scenario requires that the company consider all of these different strategies and tactics and pursue those that seem most appropriate given the competitive circumstances prevailing in the industry and the likely strategy of rivals. Although there is no single best combination of strategies and tactics, the company must keep the goal of rapidly increasing the installed base of products based on its standard at the front of its mind. By helping to jump-start demand for its format, a company can induce consumers to bear the switching costs associated with adopting its technology and leverage any positive feedback process that might exist. It is also important not to pursue strategies that have the opposite effect. For example, pricing high to capture profits from early adopters, who tend not to be as price sensitive as later adopters, can have the unfortunate effect of slowing demand growth and allowing a more aggressive competitor to pick up share and establish its format as the industry standard.

COSTS IN HIGH-TECHNOLOGY INDUSTRIES

In many high-tech industries, the fixed costs of developing the product are very high, but the costs of producing one extra unit of the product are very low. This is most obvious in the case of software. For example, it reportedly cost Microsoft $5 billion to develop Windows Vista, but the cost of producing one more copy of Windows Vista is virtually zero. Once the Windows Vista program was complete, Microsoft duplicated its master disks and sent the copies to PC manufacturers, such as Dell Computer, which then installed a copy of Windows Vista onto every PC sold. Microsoft's cost was, effectively, zero, and yet the company receives a significant licensing fee for each copy of Windows Vista installed on a PC.[6] For Microsoft, the marginal cost of making one more copy of Windows Vista is close to zero, although the fixed costs of developing the product were around $5 billion.

Many other high-technology products have similar cost economics: very high fixed costs and very low marginal costs. Most software products share these features, although if the software is sold through stores, the costs of packaging and distribution will raise the marginal costs, and if it is sold by a sales force direct to end-users, this too will raise the marginal costs. Many consumer electronics products have the same basic economics. The fixed costs of developing a DVD player or a videogame console can be very expensive, but the costs of producing an incremental unit are very low. Similarly, the fixed costs of developing a new drug can run to over $800 million, but the marginal cost of producing each additional pill is at most a few cents.

Comparative Cost Economics

To grasp why this cost structure is strategically important, a company must understand that, in many industries, marginal costs rise as a company tries to expand output (economists call this the *law of diminishing returns*). To produce more of a good, a company must hire more labor and invest in more plant and machinery. At the margin, the additional resources used are not as productive, so this leads to increasing marginal costs. However, the law of diminishing returns often does not apply in many high-tech settings, such as the production of software, or sending bits of data through a digital telecommunications network.

Consider two companies, α and β (see Figure 7.5). Company α is a conventional producer and faces diminishing returns, so as it tries to expand output, its marginal

Figure 7.5 Cost Structures in High-Technology Industries

costs rise. Company β is a high-tech producer, and its marginal costs do not rise at all as output is increased. Note that in Figure 7.5, company β's marginal cost curve is drawn as a straight line near to the horizontal axis, implying that marginal costs are close to zero and do not vary with output, whereas company α's marginal costs rise as output is expanded, illustrating diminishing returns. Company β's flat and low marginal cost curve means that its average cost curve will continuously fall over all ranges of output as it spreads its fixed costs out over greater volume. In contrast, the rising marginal costs encountered by company α mean that its average cost curve is the U-shaped curve familiar from basic economics texts. For simplicity, assume that both companies sell their product at the same price, Pm, and both sell exactly the same quantity of output, $0 - Q_1$. You will see from Figure 7.5 that at an output of Q_1, company β has much lower average costs than company α and as a consequence is making far more profit (profit is the shaded area in Figure 7.5).

Strategic Significance

If a company can shift from a cost structure where it encounters increasing marginal costs to one where fixed costs may be high but marginal costs are much lower, its profitability may increase. In the consumer electronics industry, such a shift has been playing out for two decades. Musical recordings were once based on analog technology where marginal costs rose as output expanded due to diminishing returns (as in the case of company α in Figure 7.5). In the 1980s and 1990s, digital systems such as CD players replaced analog systems. Digital systems are software based, and this implies much lower marginal costs of producing one more copy of a recording. As a result, music companies were able to lower prices, expand demand, and see their profitability increase (their production system has more in common with company β in Figure 7.5).

This process, however, was still unfolding. The latest technology for copying musical recordings is based on distribution over the Internet (e.g., by downloading songs onto an iPod). Here, the marginal costs of making one more copy of a recording are lower still. In fact, they are close to zero, and do not increase with output. The only problem is that the low costs of copying and distributing music recordings lead to widespread illegal fire sharing, which ultimately leads to a very large decline in overall revenues in recorded music. According to the International Federation of the Phonographic Industry, worldwide revenues for CDs, vinyl, cassettes and digital downloads dropped from $36.9 billion in 2000 to $15.9 billion in 2010. We discuss copyright issues in more detail shortly when we consider intellectual property rights. The same shift is now beginning to affect other industries. Some companies are building their strategies around trying to exploit and profit from this shift. For an example, Strategy in Action 7.2 looks at SonoSite.

When a high-tech company faces high fixed costs and low marginal costs, its strategy should emphasize the low-cost structure option: deliberately drive down prices in order to increase volume. Look again at Figure 7.5 and you will see that the high-tech company's average costs fall rapidly as output expands. This implies that prices can be reduced to stimulate demand, and so long as prices fall less rapidly than average costs, per unit profit margins will expand as prices fall. This is a consequence of the firm's low marginal costs that do not rise with output. This strategy of pricing low to drive volume and reap wider profit margins is central to the business model of some very successful high-technology companies, including Microsoft.

7.2 STRATEGY IN ACTION

Lowering the Cost of Ultrasound Equipment Through Digitalization

© iStockPhoto.com/Tom Nulens

The ultrasound unit has been an important piece of diagnostic equipment in hospitals for some time. Ultrasound units use the physics of sound to produce images of soft tissues in the human body. Ultrasounds can produce detailed three-dimensional color images of organs and, by using contrast agents, track the flow of fluids through an organ. A cardiologist, for example, can use an ultrasound in combination with contrast agents injected into the bloodstream to track the flow of blood through a beating heart. In addition to the visual diagnosis, ultrasound also produces an array of quantitative diagnostic information of great value to physicians.

Modern ultrasound units are sophisticated instruments that cost about $250,000 to $300,000 each for a top-line model. They are fairly bulky instruments, weighing approximately 300 pounds, and are wheeled around hospitals on carts.

A few years ago, a group of researchers at ATL, one of the leading ultrasound companies, proposed an idea for reducing the size and cost of a basic machine. They theorized that it might be possible to replace up to 80% of the solid circuits in an ultrasound unit with software, and in the process significantly shrink the size and reduce the weight of machines, thereby producing portable ultrasound units. Moreover, by digitalizing much of the ultrasound (replacing hardware with software), they could considerably decrease the marginal costs of making additional units, and would thus be able to make a better profit at much lower price points.

The researchers reasoned that a portable and inexpensive ultrasound unit would find market opportunities in totally new niches. For example, a small, inexpensive ultrasound unit could be placed in an ambulance or carried into battle by an army medic, or purchased by family physicians for use in their offices. Although they realized that it would be some time, perhaps decades, before such small, inexpensive machines could attain the image quality and diagnostic sophistication of top-of-the-line machines, they saw the opportunity in terms of creating market niches that previously could not be served by ultrasound companies because of the high costs and bulk of the product.

The researchers later became part of a project team within ATL, and thereafter became an entirely new company, SonoSite. In late-1999, SonoSite introduced its first portable product, which weighed just 6 pounds and cost about $25,000. SonoSite targeted niches that full-sized ultrasound products could not reach: ambulatory care and foreign markets that could not afford the more expensive equipment. In 2010, the company sold over $275 million of product. In 2011, Fujifilm Holdings bought SonoSite for $995 million to expand its range of medical imaging products and help it overtake the dominant portable ultrasound equipment producer, General Electric.

Source: Interviews by Charles W. L. Hill.

CAPTURING FIRST-MOVER ADVANTAGES

In high-technology industries, companies often compete by striving to be the first to develop revolutionary new products, that is, to be a **first mover**. By definition, the first mover that creates a revolutionary product is in a monopoly position. If the new product satisfies unmet consumer needs and demand is high, the first mover can capture significant revenues and profits. Such revenues and profits signal to potential rivals that imitating the first mover makes money. Figure 7.6 implies that in the absence of strong barriers to imitation, imitators will rush into the market created by the first mover, competing away the first mover's monopoly profits and leaving all participants in the market with a much lower level of returns.

first mover

A firm that pioneers a particular product category or feature by being first to offer it to market.

Figure 7.6 | The Impact of Imitation on Profits of a First Mover

Despite imitation, some first movers have the ability to capitalize on and reap substantial first-mover advantages—the advantages of pioneering new technologies and products that lead to an enduring competitive advantage. Intel introduced the world's first microprocessor in 1971, and, today, still dominates the microprocessor segment of the semiconductor industry. Xerox introduced the world's first photocopier and for a long time enjoyed a leading position in the industry. Cisco introduced the first Internet protocol network router in 1986, and still leads the market for that equipment today. Microsoft introduced the world's first software application for a personal computer in 1979, Microsoft BASIC, and it remains a dominant force in PC software.

Some first movers can reap substantial advantages from their pioneering activities that lead to an enduring competitive advantage. They can, in other words, limit or slow the rate of imitation.

But there are plenty of counterexamples suggesting that first-mover advantages might not be easy to capture and, in fact, that there might be **first-mover disadvantages**—the competitive disadvantages associated with being first. For example, Apple was the first company to introduce a handheld computer, the Apple Newton, but the product failed; a second mover, Palm, succeeded where Apple had failed (although Apple has recently had major success as a first mover with the first true tablet computer, the iPad). In the market for commercial jet aircraft, DeHavilland was first to market with the Comet, but it was the second mover, Boeing, with its 707 jetliner, that went on to dominate the market.

Clearly, being a first mover does not by itself guarantee success. As we shall see, the difference between innovating companies that capture first-mover advantages and those that fall victim to first-mover disadvantages in part incites the strategy that the first mover pursues. Before considering the strategy issue, however, we need to take a closer look at the nature of first-mover advantages and disadvantages.[7]

first-mover
disadvantages

Competitive
disadvantages associated
with being first.

First-Mover Advantages

There are five primary sources of first-mover advantages.[8] First, the first mover has an opportunity to exploit network effects and positive feedback loops, locking consumers into its technology. In the VCR industry, Sony could have exploited network effects by licensing its technology, but instead the company ceded its first-mover advantage to the second mover, Matsushita.

Second, the first mover may be able to establish significant brand loyalty, which is expensive for later entrants to break down. Indeed, if the company is successful in this endeavor, its name may become closely associated with the entire class of products, including those produced by rivals. People still talk of "Xeroxing" when making a photocopy, or "FedExing" when they will be sending a package by overnight mail.

Third, the first mover may be able to increase sales volume ahead of rivals and thus reap cost advantages associated with the realization of scale economies and learning effects (see Chapter 4). Once the first mover has these cost advantages, it can respond to new entrants by cutting prices in order to retain its market share and still earn significant profits.

Fourth, the first mover may be able to create switching costs for its customers that subsequently make it difficult for rivals to enter the market and take customers away from the first mover. Wireless service providers, for example, will give new customers a "free" wireless phone, but customers must sign a contract agreeing to pay for the phone if they terminate the service contract within a specified time period, such as 1 or 2 years. Because the real cost of a wireless phone may run from $100 to $200, this represents a significant switching cost that later entrants must overcome.

Finally, the first mover may be able to accumulate valuable knowledge related to customer needs, distribution channels, product technology, process technology, and so on. Knowledge so accumulated can give it an advantage that later entrants might find difficult or expensive to match. Sharp, for example, was the first mover in the commercial manufacture of active matrix liquid crystal displays used in laptop computers. The process for manufacturing these displays is very difficult, with a high rejection rate for flawed displays. Sharp has accumulated such an advantage with regard to production processes that it has been very difficult for later entrants to match it on product quality, and therefore on costs.

First-Mover Disadvantages

Balanced against these first-mover advantages are a number of disadvantages.[9] First, the first mover has to bear significant pioneering costs that later entrants do not. The first mover must pioneer the technology, develop distribution channels, and educate customers about the nature of the product. All of this can be expensive and time consuming. Later entrants, by way of contrast, might be able to free-ride on the first mover's investments in pioneering the market and customer education. That is, they do not have to bear the pioneering costs of the first mover.

Related to this, first movers are more prone to make mistakes because there are so many uncertainties in a new market. Later entrants may learn from the mistakes made by first movers, improve on the product or the way in which it is sold, and come to market with a superior offering that captures significant market share from the first mover. For example, one of the reasons that the Apple Newton failed was that the handwriting software in the handheld computer failed to recognize human handwriting. The second mover

in this market, Palm, learned from Apple's error. When it introduced the PalmPilot, it used software that recognized letters written in a particular way, Graffiti, and then persuaded customers to learn this method of inputting data into the handheld computer.

Third, first movers run the risk of building the wrong resources and capabilities because they are focusing on a customer set that is not going to be characteristic of the mass market. This is the "crossing the chasm" problem that we discussed in the previous chapter. You will recall that the customers in the early market—those we categorized as innovators and early adopters—have different characteristics from the first wave of the mass market, the early majority. The first mover runs the risk of directing its resources and capabilities to the needs of innovators and early adopters, and not being able to switch when the early majority enters the market. As a result, first movers run a greater risk of plunging into the chasm that separates the early market from the mass market.

Finally, the first mover may invest in inferior or obsolete technology. This can happen when its product innovation is based on underlying technology that is rapidly advancing. By basing its product on an early version of the technology, it may become locked into something that rapidly becomes obsolete. In contrast, later entrants may be able to leapfrog the first mover and introduce products that are based on later versions of the underlying technology. This happened in France during the 1980s when, at the urging of the government, France Telecom introduced the world's first consumer online service, Minitel. France Telecom distributed crude terminals to consumers for free, which connected to the phone line and could be used to browse phone directories. Other simple services were soon added, and before long the French could shop, bank, make travel arrangements, and check weather and news "online"—years before the Web was invented. The problem was that by the standards of the Web, Minitel was very crude and inflexible, and France Telecom, as the first mover, suffered. The French were very slow to adopt personal computers and the Internet primarily because Minitel had such a presence. As late as 1998, only 1/5 of French households had a computer, compared with 2/5 in the United States, and only 2% of households were connected to the Internet, compared to over 30% in the United States. As the result of a government decision, France Telecom, and the entire nation of France, was slow to adopt a revolutionary new online medium—the Web—because they were the first to invest in a more primitive version of the technology.[10]

Strategies for Exploiting First-Mover Advantages

First movers must strategize and determine how to exploit their lead and capitalize on first-mover advantages to build a sustainable long-term competitive advantage while simultaneously reducing the risks associated with first-mover disadvantages. There are three basic strategies available: (1) develop and market the innovation; (2) develop and market the innovation jointly with other companies through a strategic alliance or joint venture; and (3) license the innovation to others and allow them to develop the market.

The optimal choice of strategy depends on the answers to three questions:

1. Does the innovating company have the complementary assets to exploit its innovation and capture first-mover advantages?
2. How difficult is it for imitators to copy the company's innovation? In other words, what is the height of barriers to imitation?
3. Are there capable competitors that could rapidly imitate the innovation?

Complementary Assets Complementary assets are the assets required to exploit a new innovation and gain a competitive advantage.[11] Among the most important complementary assets are competitive manufacturing facilities capable of handling rapid growth in

customer demand while maintaining high product quality. State-of-the-art manufacturing facilities enable the first mover to quickly move down the experience curve without encountering production bottlenecks or problems with the quality of the product. The inability to satisfy demand because of these problems, however, creates the opportunity for imitators to enter the marketplace. For example, in 1998, Immunex was the first company to introduce a revolutionary new biological treatment for rheumatoid arthritis. Sales for this product, Enbrel, very rapidly increased, reaching $750 million in 2001. However, Immunex had not invested in sufficient manufacturing capacity. In mid-2000, it announced that it lacked the capacity to satisfy demand and that bringing additional capacity on line would take at least 2 years. This manufacturing bottleneck gave the second mover in the market, Johnson & Johnson, the opportunity to rapidly expand demand for its product, which by early 2002 was outselling Enbrel. Immunex's first-mover advantage had been partly eroded because it lacked an important complementary asset, the manufacturing capability required to satisfy demand.

Complementary assets also include marketing knowhow, an adequate sales force, access to distribution systems, and an after-sales service and support network. All of these assets can help an innovator build brand loyalty and more rapidly achieve market penetration.[12] In turn, the resulting increases in volume facilitate more rapid movement down the experience curve and the attainment of a sustainable cost-based advantage due to scale economies and learning effects. EMI, the first mover in the market for computerized tomography (CT) scanners, ultimately lost out to established medical equipment companies, such as GE Medical Systems, because it lacked the marketing knowhow, sales force, and distribution systems required to effectively compete in the world's largest market for medical equipment, the United States.

Developing complementary assets can be very expensive, and companies often need large infusions of capital for this purpose. That is why first movers often lose out to late movers that are large, successful companies in other industries with the resources to quickly develop a presence in the new industry. Microsoft and 3M exemplify companies that have moved quickly to capitalize on the opportunities when other companies open up new product markets, such as compact discs or floppy disks. For example, although Netscape pioneered the market for Internet browsers with the Netscape Navigator, Microsoft's Internet Explorer ultimately dominated that market.

Height of Barriers to Imitation Recall from Chapter 3 that barriers to imitation are factors that prevent rivals from imitating a company's distinctive competencies and innovations. Although any innovation can be copied, the higher the barriers are, the longer it takes for rivals to imitate the innovation, and the more time the first mover has to build an enduring competitive advantage.

Barriers to imitation give an innovator time to establish a competitive advantage and build more enduring barriers to entry in the newly created market. Patents, for example, are among the most widely used barriers to imitation. By protecting its photocopier technology with a thicket of patents, Xerox was able to delay any significant imitation of its product for 17 years. However, patents are often easy to "invent around." For example, one study found that this happened to 60% of patented innovations within 4 years.[13] If patent protection is weak, a company might try to slow imitation by developing new products and processes in secret. The most famous example of this approach is Coca-Cola, which has kept the formula for Coke a secret for generations. But Coca-Cola's success in this regard is an exception. A study of 100 companies has estimated that rivals learn about a company's decision to develop a major new product or process and its related proprietary information within about 12–18 months of the original development decision.[14]

Capable Competitors Capable competitors are companies that can move quickly to imitate the pioneering company. Competitors' capability to imitate a pioneer's innovation depends primarily on two factors: (1) research and development (R&D) skills; and (2) access to complementary assets. In general, the greater the number of capable competitors with access to the R&D skills and complementary assets needed to imitate an innovation, the more rapid imitation is likely to be.

In this context, R&D skills refer to the ability of rivals to reverse-engineer an innovation in order to find out how it works and quickly develop a comparable product. As an example, consider the CT scanner. GE bought one of the first CT scanners produced by EMI, and its technical experts reverse-engineered the machine. Despite the product's technological complexity, GE developed its own version, which allowed it to quickly imitate EMI and replace EMI as the major supplier of CT scanners.

Complementary assets, or the access that rivals have to marketing, sales knowhow, and manufacturing capabilities, is one of the key determinants of the rate of imitation. If would-be imitators lack critical complementary assets, not only will they have to imitate the innovation, but they may also need to imitate the innovator's complementary assets. This is expensive, as AT&T discovered when it tried to enter the personal computer business in 1984. AT&T lacked the marketing assets (sales force and distribution systems) necessary to support personal computer products. The lack of these assets and the time it takes to build the assets partly explains why: 4 years after it entered the market, AT&T had lost $2.5 billion and still had not emerged as a viable contender. It subsequently exited this business.

Three Innovation Strategies The way in which these three factors—complementary assets, height of barriers to imitation, and the capability of competitors—influence the choice of innovation strategy is summarized in Table 7.1. The competitive strategy of developing and marketing the innovation alone makes most sense when: (1) the innovator has the complementary assets necessary to develop the innovation, (2) the barriers to imitating a new innovation are high, and (3) the number of capable competitors is limited. Complementary assets allow rapid development and promotion of the innovation. High barriers to imitation give the innovator time to establish a competitive advantage and build enduring barriers to entry through brand loyalty or experience-based cost advantages. The fewer capable competitors there are, the less likely it is that any one of them will succeed in circumventing barriers to imitation and quickly imitating the innovation.

The competitive strategy of developing and marketing the innovation jointly with other companies through a strategic alliance or joint venture makes most sense when:

Table 7.1	Strategies for Profiting from Innovation		
Strategy	**Does the Innovator Have the Required Complementary Assets?**	**Likely Height of Barriers to Imitation**	**Number of Capable Competitors**
Going it alone	Yes	High	Very few
Entering into an alliance	No	High	Moderate number
Licensing the innovation	No	Low	Many

© Cengage Learning

(1) the innovator lacks complementary assets, (2) barriers to imitation are high, and (3) there are several capable competitors. In such circumstances, it makes sense to enter into an alliance with a company that already has the complementary assets—in other words, with a capable competitor. Theoretically, such an alliance should prove to be mutually beneficial, and each partner can share in high profits that neither could earn on its own. Moreover, such a strategy has the benefit of co-opting a potential rival. For example, had EMI teamed with a capable competitor to develop the market for CT scanners, such as GE Medical Systems, instead of going it alone, the company might have been able to build a more enduring competitive advantage, and also have co-opted a potentially powerful rival into its camp.

The third strategy, licensing, makes most sense when: (1) the innovating company lacks the complementary assets, (2) barriers to imitation are low, and (3) there are many capable competitors. The combination of low barriers to imitation and many capable competitors makes rapid imitation almost certain. The innovator's lack of complementary assets further suggests that an imitator will soon capture the innovator's competitive advantage. Given these factors, because rapid diffusion of the innovator's technology through imitation is inevitable, the innovator can at least share in some of the benefits of this diffusion by licensing out its technology.[15]Moreover, by setting a relatively modest licensing fee, the innovator may be able to reduce the incentive that potential rivals have to develop their own competing, and possibly superior, technology. As described previously, this seems to have been the strategy Dolby adopted to get its technology established as the standard for noise reduction in the music and film businesses.

TECHNOLOGICAL PARADIGM SHIFTS

Technological paradigm shifts occur when new technologies revolutionize the structure of the industry, dramatically alter the nature of competition, and require companies to adopt new strategies in order to survive. A good example of a paradigm shift is the evolution of photography from chemical to digital printing processes. For over half a century, the large incumbent enterprises in the photographic industry such as Kodak and Fujifilm have generated most of their revenues from selling and processing film using traditional silver halide technology. The rise of digital photography has been a huge disruptive threat to their business models. Digital cameras do not use film, the mainstay of Kodak's and Fuji's business. In addition, these cameras are more like specialized computers than conventional cameras, and are therefore based on scientific knowledge in which Kodak and Fuji have little expertise. Although both Kodak and Fuji have heavily invested in the development of digital cameras, they are facing intense competition from companies such as Sony, Canon, and Hewlett-Packard, which have developed their own digital cameras; from software developers such as Adobe and Microsoft, which make software for manipulating digital images; and from printer companies such as Hewlett-Packard and Canon, which are making the printers that consumers can use to print high-quality pictures from home. As digital substitution gathers speed in the photography industry, it is not clear that the traditional incumbents will be able to survive this shift; the new competitors might rise to dominance in the new market.

Kodak and Fuji are hardly the first large incumbents to be felled by a technological paradigm shift in their industry. In the early 1980s, the computer industry was revolutionized by the arrival of personal computer technology, which gave rise to client–server networks that replaced traditional mainframe and minicomputers for many business uses. Many incumbent companies in the mainframe era, such as Wang, Control Data, and DEC, ultimately did

technological paradigm shift
Shifts in new technologies that revolutionize the structure of the industry, dramatically alter the nature of competition, and require companies to adopt new strategies in order to survive.

not survive, and even IBM went through a decade of wrenching changes and large losses before it reinvented itself as a provider of e-business solutions. Instead, new entrants such as Microsoft, Intel, Dell, and Compaq rose to dominate this new computer industry.

Today, many believe that the advent of cloud computing is ushering in a paradigm shift in the computer industry. Microsoft, the dominant incumbent in the PC software business, is very vulnerable to this shift. If the center of computing does move to the cloud, with most data and applications stored there, and if all one needs to access data and run applications is a Web browser, then the value of a PC operating system such as Windows is significantly reduced. Microsoft understands this as well as anyone, which is why the company is pushing aggressively into the cloud computing market with Windows Azure.

Examples such as these raise four questions:

1. When do paradigm shifts occur, and how do they unfold?
2. Why do so many incumbents go into decline following a paradigm shift?
3. What strategies can incumbents adopt to increase the probability that they will survive a paradigm shift and emerge on the other side of the market abyss created by the arrival of new technology as a profitable enterprise?
4. What strategies can new entrants into a market adopt to profit from a paradigm shift?

We shall answer each of these questions in the remainder of this chapter.

Paradigm Shifts and the Decline of Established Companies

Paradigm shifts appear to be more likely to occur in an industry when one, or both, of the following conditions are in place.[16] First, the established technology in the industry is mature and approaching or at its "natural limit," and second, a new "disruptive technology" has entered the marketplace and is taking root in niches that are poorly served by incumbent companies using the established technology.

The Natural Limits to Technology Richard Foster has formalized the relationship between the performance of a technology and time in terms of what he calls the technology S-curve (see Figure 7.7).[17] This curve shows the relationship over time of cumulative

Figure 7.7 The Technology S-Curve

investments in R&D and the performance (or functionality) of a given technology. Early in its evolution, R&D investments in a new technology tend to yield rapid improvements in performance as basic engineering problems are solved. After a time, diminishing returns to cumulative R&D begin to set in, the rate of improvement in performance slows, and the technology starts to approach its natural limit, where further advances are not possible. For example, one can argue that there was more improvement in the first 50 years of the commercial aerospace business following the pioneering flight by the Wright Brothers than there has been in the second 50 years. Indeed, the venerable Boeing 747 is based on a 1960s design. In commercial aerospace, therefore, we are now in the region of diminishing returns and may be approaching the natural limit to improvements in the technology of commercial aerospace.

Similarly, it can be argued that we are approaching the natural limit to technology in the performance of silicon-based semiconductor chips. Over the past two decades, the performance of semiconductor chips has been increased dramatically; companies can now manufacture a larger amount of transistors in one single, small silicon chip. This process has helped to increase the power of computers, lower their cost, and shrink their size. But we are starting to approach limits to the ability to shrink the width of lines on a chip and therefore pack ever more transistors onto a single chip. The limit is imposed by the natural laws of physics. Light waves are used to help etch lines onto a chip, and one cannot etch a line that is smaller than the wavelength of light being used. Semiconductor companies are already using light beams with very small wavelengths, such as extreme ultraviolet, to etch lines onto a chip, but there are limits to how far this technology can be pushed, and many believe that we will reach those limits within the decade. Does this mean that our ability to make smaller, faster, cheaper computers is coming to an end? Probably not. It is more likely that we will find another technology to replace silicon-based computing and enable us to continue building smaller, faster, cheaper computers. In fact, several exotic competing technologies are already being developed that may replace silicon-based computing. These include self-organizing molecular computers, three-dimensional microprocessor technology, quantum computing technology, and using DNA to perform computations.[18]

What does all of this have to do with paradigm shifts? According to Foster, when a technology approaches its natural limit, research attention turns to possible alternative technologies, and sooner or later one of those alternatives might be commercialized and replace the established technology. That is, the probability that a paradigm shift will occur increases. Thus, sometime in the next decade or two, another paradigm shift might shake up the foundations of the computer industry as exotic computing technology replaces silicon-based computing. If history is any guide, if and when this happens, many of the incumbents in today's computer industry will go into decline, and new enterprises will rise to dominance.

Foster pushes this point a little further, noting that, initially, the contenders for the replacement technology are not as effective as the established technology in producing the attributes and features that consumers demand in a product. For example, in the early years of the 20th century, automobiles were just beginning to be produced. They were valued for their ability to move people from place to place, but so was the horse and cart (the established technology). When automobiles originally appeared, the horse and cart was still quite a bit better than the automobile (see Figure 7.8). After all, the first cars were slow, noisy, and prone to breakdown. Moreover, they needed a network of paved roads and gas stations to be really useful, and that network didn't yet exist. For most applications, the horse and cart was still the preferred mode of transportation—including the fact that it was cheaper.

Figure 7.8 Established and Successor Technologies

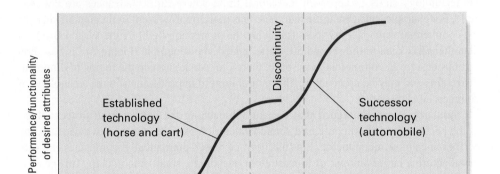

However, this comparison ignored the fact that in the early 20th century, automobile technology was at the very start of its S-curve and was about to experience dramatic improvements in performance as major engineering problems were solved (and those paved roads and gas stations were built). In contrast, after 3,000 years of continuous improvement and refinement, the horse and cart was almost definitely at the end of its technological S-curve. The result was that the rapidly improving automobile soon replaced the horse and cart as the preferred mode of transportation. At time T_1 in Figure 7.8, the horse and cart was still superior to the automobile. By time T_2, the automobile had surpassed the horse and cart.

Foster notes that because the successor technology is initially less efficient than the established technology, established companies and their customers often make the mistake of dismissing it, only to be surprised by its rapid performance improvement. A final point here is that often there is not one potential successor technology but a swarm of potential successor technologies, only one of which might ultimately rise to the fore (see Figure 7.9). When this is the case, established companies are put at a disadvantage. Even if they recognize that a paradigm shift is imminent, companies may not have the resources to invest in all the potential replacement technologies. If they invest in the wrong one, something that is easy to do given the uncertainty that surrounds the entire process, they may be locked out of subsequent development.

Disruptive Technology Clayton Christensen has built on Foster's insights and his own research to develop a theory of disruptive technology that has become very influential in high-technology circles.[19] Christensen uses the term *disruptive technology* to refer to a new technology that gets its start away from the mainstream of a market and then, as its functionality improves over time, invades the main market. Such technologies are disruptive because they revolutionize industry structure and competition, often causing the decline of established companies. They cause a technological paradigm shift.

Christensen's greatest insight is that established companies are often aware of the new technology but do not invest in it because they listen to their customers, and their customers do not want it. Of course, this arises because the new technology is early in its development,

Figure 7.9 Swarm of Successor Technologies

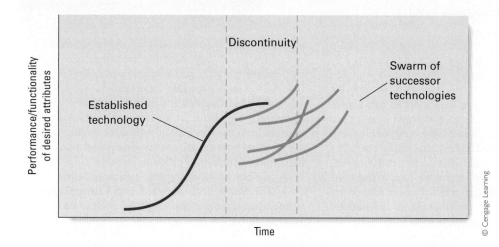

© Cengage Learning

and only at the beginning of the S-curve for that technology. Once the performance of the new technology improves, customers will want it, but by this time it is new entrants (as opposed to established companies), that have accumulated the required knowledge to bring the new technology into the mass market. Christensen supports his view by several detailed historical case studies, one of which is summarized in Strategy in Action 7.3.

In addition to listening too closely to their customers, Christensen also identifies a number of other factors that make it very difficult for established companies to adopt a new disruptive technology. He notes that many established companies decline to invest in new disruptive technologies because initially they serve such small market niches that it seems unlikely there would be an impact on the company's revenues and profits. As the new technology starts to improve in functionality and invade the main market, their investment can often be hindered by the difficult implementation of a new business model required to exploit the new technology.

Both of these points can be illustrated by reference to one more example: the rise of online discount stockbrokers during the 1990s, such as Ameritrade and E*TRADE, which made use of a new technology—the Internet—to allow individual investors to trade stocks for a very low commission fee, whereas full-service stockbrokers, such as Merrill Lynch, which required that orders be placed through a stockbroker who earned a commission for performing the transaction, did not.

Christensen also notes that a new network of suppliers and distributors typically grows alongside the new entrants. Not only do established companies initially ignore disruptive technology, so do their suppliers and distributors. This creates an opportunity for new suppliers and distributors to enter the market to serve the new entrants. As the new entrants grow, so does the associated network. Ultimately, Christensen suggests, the new entrants and their network may replace not only established enterprises, but also the entire network of suppliers and distributors associated with established companies. Taken to its logical extreme, this view suggests that disruptive technologies may result in the demise of the entire network of enterprises associated with established companies in an industry.

The established companies in an industry that is being rocked by a technological paradigm shift often must cope with internal inertia forces that limit their ability to adapt,

7.3 STRATEGY IN ACTION

Disruptive Technology in Mechanical Excavators

© iStockPhoto.com/Tom Nulens

Excavators are used to dig out foundations for large buildings, trenches to lay large pipes for sewers and related components, and foundations and trenches for residential construction and farm work. Prior to the 1940s, the dominant technology used to manipulate the bucket on a mechanical excavator was based on a system of cables and pulleys. Although these mechanical systems could lift large buckets of earth, the excavators themselves were quite large, cumbersome, and expensive. Thus, they were rarely used to dig small trenches for house foundations, irrigation ditches for farmers, and projects of similar scale. In most cases, these small trenches were dug by hand.

In the 1940s, a new technology made its appearance: hydraulics. In theory, hydraulic systems had certain advantages over the established cable and pulley systems. Most important, their energy efficiency was higher: for a given bucket size, a smaller engine would be required using a hydraulic system. However, the initial hydraulic systems also had drawbacks. The seals on hydraulic cylinders were prone to leak under high pressure, effectively limiting the size of bucket that could be lifted. Notwithstanding this drawback, when hydraulics first appeared, many of the incumbent firms in the mechanical excavation industry took the technology seriously enough to ask their primary customers whether they would be interested in hydraulic products. Because the primary customers of incumbents needed excavators with large buckets to dig out the foundations for buildings and large trenches, their reply was negative. For this customer set, the hydraulic systems of the 1940s were neither reliable nor powerful enough. Consequently, after consulting with their customers, these established companies in the industry made the strategic decision not to invest in hydraulics. Instead, they continued to produce excavation equipment based on the dominant cable and pulley technology.

A number of new entrants, which included J. I. Case, John Deere, J. C. Bamford, and Caterpillar, pioneered hydraulic excavation equipment. Because of the limits on bucket size imposed by the seal problem, these companies initially focused on a poorly served niche in the market that could make use of small buckets: residential contractors and farmers. Over time, these new entrants were able to solve the engineering problems associated with weak hydraulic seals, and as they did this, they manufactured excavators with larger buckets. Ultimately, they invaded the market niches served by the old-line companies: general contractors that dug the foundations for large buildings, sewers, and large-scale projects. At this point, Case, Deere, Caterpillar, and similar companies rose to dominance in the industry, whereas the majority of established companies from the prior era lost share. Of the 30 or so manufacturers of cable-actuated equipment in the United States in the late-1930s, only four survived to the 1950s.

Source: Adapted from Christensen, *The Innovator's Dilemma*

but the new entrants do not, and thereby have an advantage. New entrants do not have to deal with an established, conservative customer set, and an obsolete business model. Instead, they can focus on optimizing the new technology, improving its performance, and riding the wave of disruptive technology into new market segments until they invade the main market and challenge the established companies. By then, they may be well equipped to surpass the established companies.

Strategic Implications for Established Companies

Although Christensen has uncovered an important tendency, it is by no means written in stone that all established companies are doomed to fail when faced with disruptive technologies, as we have seen with IBM and Merrill Lynch. Established companies must meet the challenges created by the emergence of disruptive technologies.[20]

First, having access to the knowledge about how disruptive technologies can revolutionize markets is a valuable strategic asset. Many of the established companies that Christensen examined failed because they took a myopic view of the new technology and asked their customers the wrong question. Instead of asking: "Are you interested in this new technology?" they should have recognized that the new technology was likely to improve rapidly over time and instead have asked: "Would you be interested in this new technology if it improves its functionality over time?" If established enterprises had done this, they may have made very different strategic decisions.

Second, it is clearly important for established enterprises to invest in newly emerging technologies that may ultimately become disruptive technologies. Companies have to hedge their bets about new technology. As we have noted, at any time, there may be a swarm of emerging technologies, any one of which might ultimately become a disruptive technology. Large, established companies that are generating significant cash flows can, and often should, establish and fund central R&D operations to invest in and develop such technologies. In addition, they may wish to acquire newly emerging companies that are pioneering potentially disruptive technologies, or enter into alliances with others to jointly develop the technology. The strategy of acquiring companies that are developing potentially disruptive technology is one that Cisco Systems, a dominant provider of Internet network equipment, is famous for pursuing. At the heart of this strategy must be a recognition on behalf of the incumbent enterprise that it is better for the company to develop disruptive technology and then cannibalize its established sales base than to have the sales base taken away by new entrants.

However, Christensen makes a very important point: even when established companies undertake R&D investments in potentially disruptive technologies, they often fail to commercialize those technologies because of internal forces that suppress change. For example, managers who are currently generating the most cash in one part of the business may claim that they need the greatest R&D investment to maintain their market position, and may lobby top management to delay investment in a new technology. This can be a powerful argument when, early in the S-curve, the long-term prospects of a new technology are very unclear. The consequence, however, may be that the company fails to build competence in the new technology, and will suffer accordingly.

In addition, Christensen argues that the commercialization of new disruptive technology often requires a radically different value chain with a completely different cost structure—a new business model. For example, it may require a different manufacturing system, a different distribution system, and different pricing options, and may involve very different gross margins and operating margins. Christensen argues that it is almost impossible for two distinct business models to coexist within the same organization. When companies try to implement both models, the already established model will almost inevitably suffocate the model associated with the disruptive technology.

The solution to this problem is to separate out the disruptive technology and create an autonomous operating division solely for this new technology. For example, during the early 1980s, HP built a very successful laser jet printer business. Then ink jet technology was invented. Some employees at HP believed that ink jet printers would cannibalize sales of laser jet printers, and consequently argued that HP should not produce ink jet printers. Fortunately for HP, senior management saw ink jet technology for what it was: a potential disruptive technology. Instead of choosing not to invest in ink jet technology, HP allocated significant R&D funds toward its commercialization. Furthermore, when the technology was ready for market introduction, HP established an autonomous ink jet division at a different geographical location, including manufacturing, marketing, and distribution departments. HP senior managers accepted that the ink jet division might take sales away from

the laser jet division and decided that it was better for an HP division to cannibalize the sales of another HP division, than allow those sales to be cannibalized by another company. Happily for HP, ink jets cannibalize sales of laser jets only on the margin, and both laser jet and ink jet printers have profitable market niches. This felicitous outcome, however, does not detract from the message of this example: if a company is developing a potentially disruptive technology, the chances for success will be enhanced if it is placed in a stand-alone product division and given its own mandate.

Strategic Implications for New Entrants

Christensen's work also holds implications for new entrants. The new entrants, or attackers, have several advantages over established enterprises. Pressures to continue the existing out-of-date business model do not hamstring new entrants, which do not need to worry about product cannibalization issues. They do not need to worry about their established customer base, or about relationships with established suppliers and distributors. Instead, they can focus all their energies on the opportunities offered by the new disruptive technology, move along the S-curve of technology improvement, and rapidly grow with the market for that technology. This does not mean that the new entrants do not have problems to solve. They may be constrained by a lack of capital or must manage the organizational problems associated with rapid growth; most important, they may need to find a way to take their technology from a small out-of-the-way niche into the mass market.

Perhaps one of the most important issues facing new entrants is choosing whether to partner with an established company, or go it alone in an attempt to develop and profit from a new disruptive technology. Although a new entrant may enjoy all of the advantages of the attacker, it may lack the resources required to fully exploit them. In such a case, the company might want to consider forming a strategic alliance with a larger, established company to gain access to those resources. The main issues here are the same as those discussed earlier when examining the three strategies that a company can pursue to capture first-mover advantages: go it alone, enter into a strategic alliance, or license its technology.

7.1 ETHICAL DILEMMA

© iStockPhoto.com/P_Wei

Your company is in a race with two other enterprises to develop a new technological standard for streaming high-definition video over the Internet. The three technologies are incompatible with each other, and switching costs are presumed to be high. You know that your technology is significantly inferior to the technology being developed by your rivals, but you strongly suspect that you will be the first to the market. Moreover, you know that by bundling your product with one that your company already sells (which is very popular among computer users), you should be able to ensure wide early adoption. You have even considered initially pricing the product at zero in order to ensure rapid take up, thereby shutting out the superior technology that your rivals are developing. You are able to do this because you make so much money from your other products. Once the market has locked into your offering, the strategy will be to raise the price on your technology.

One of your colleagues has suggested that it is not ethical for your company to use its financial muscle and bundling strategies to lock out a superior technology in this manner. Why do you think he makes this argument?

Do you agree with him? Why?

Can you think of a real-world situation that is similar to this case?

SUMMARY OF CHAPTER

1. Technical standards are important in many high-tech industries: they guarantee compatibility, reduce confusion in the minds of customers, allow for mass production and lower costs, and reduce the risks associated with supplying complementary products.
2. Network effects and positive feedback loops often determine which standard will dominate a market.
3. Owning a standard can be a source of sustained competitive advantage.
4. Establishing a proprietary standard as the industry standard may require the company to win a format war against a competing and incompatible standard. Strategies for doing this include producing complementary products, leveraging killer applications, using aggressive pricing and marketing, licensing the technology, and cooperating with competitors.
5. Many high-tech products are characterized by high fixed costs of development but very low or zero marginal costs of producing one extra unit of output. These cost economics create a presumption in favor of strategies that emphasize aggressive pricing to increase volume and drive down average total costs.
6. It is very important for a first mover to develop a strategy to capitalize on first-mover advantages. A company can choose from three strategies: develop and market the technology itself, do so jointly with another company, or license the technology to existing companies. The choice depends on the complementary assets required to capture a first-mover advantage, the height of barriers to imitation, and the capability of competitors.
7. Technological paradigm shifts occur when new technologies come along that revolutionize the structure of the industry, dramatically alter the nature of competition, and require companies to adopt new strategies in order to succeed.
8. Technological paradigm shifts are more likely to occur when progress in improving the established technology is slowing because of diminishing returns and when a new disruptive technology is taking root in a market niche.
9. Established companies can deal with paradigm shifts by investing in technology or setting up a stand-alone division to exploit the technology.

DISCUSSION QUESTIONS

1. What is different about high-tech industries? Were all industries once high tech?
2. Why are standards so important in high-tech industries? What are the competitive implications of this?
3. You work for a small company that has the leading position in an embryonic market. Your boss believes that the company's future is ensured because it has a 60% share of the market, the lowest cost structure in the industry, and the most reliable and highest-valued product. Write a memo to your boss outlining why the assumptions posed might be incorrect.
4. You are working for a small company that has developed an operating system for PCs that is faster and more stable than Microsoft's Windows operating system. What strategies might the company pursue to unseat Windows and establish its own operating system as the dominant technical standard in the industry?
5. You are a manager for a major music record label. Last year, music sales declined by 10%, primarily because of very high piracy rates for CDs. Your boss has asked you to develop a strategy for reducing piracy rates. What would you suggest that the company do?
6. Reread the opening case on the emerging standards battles in mobile payments. Which mobile payment system do you think will become dominant?

PRACTICING STRATEGIC MANAGEMENT

© iStockPhoto.com/Urilux

Small-Group Exercises: Digital Books

Break up into groups of three to five people, and discuss the following scenario. Appoint one group member as a spokesperson who will communicate your findings to the class.

You are a group of managers and software engineers at a small start-up that has developed software that enables customers to easily download and view digital books on a variety of digital devices, including PCs, iPods, and e-book readers. The same software also allows customers to share digital books using peer-to-peer technology (the same technology that allows people to share music files on the Web), and to "burn" digital books onto DVDs.

1. How do you think the market for this software is likely to develop? What factors might inhibit adoption of this software?
2. Can you think of a strategy that your company might pursue in combination with book publishers that will enable your company to increase revenues and the film companies to reduce piracy rates?

STRATEGY SIGN-ON

© iStockPhoto.com/Ninoslav Dotlic

Article File 7

Find an example of an industry that has undergone a technological paradigm shift in recent years. What happened to the established companies as that paradigm shift unfolded?

Strategic Management Project: Developing Your Portfolio 7

This module requires you to analyze the industry environment in which your company is based and determine if it is vulnerable to a technological paradigm shift. With the information you have at your disposal, answer the following questions:

1. What is the dominant product technology used in the industry in which your company is based?
2. Are technical standards important in your industry? If so, what are they?
3. What are the attributes of the majority of customers purchasing the product of your company (e.g., early adopters, early majority, late majority)? What does this tell you about the strategic issues that the company is likely to face in the future?
4. Did the dominant technology in your industry diffuse rapidly or slowly? What drove the speed of diffusion?

STRATEGY SIGN ON *(continued)*

© iStockPhoto.com/Ninoslav Dotlic

5. Where is the dominant technology in your industry on its S-curve? Are alternative competing technologies being developed that might give rise to a paradigm shift in your industry?
6. Are intellectual property rights important to your company? If so, what strategies is it adopting to protect those rights? Is it doing enough?

CLOSING CASE

The Rise of Cloud Computing

There is a paradigm shift beginning in the world of computing. Over the next decade, increasing numbers of businesses will stop purchasing their own computer servers and mainframes, and instead move their applications and data to "the cloud." The cloud is a metaphor for large data centers or "server farms"—collections of hundreds of thousands of co-located and interlinked computer servers. Corporations will be able to "host" their data and applications on cloud computing providers' servers. To run an application hosted on the cloud, all a person will need is a computing device with a Web browser and an Internet connection.

There are significant cost advantages associated with shifting data and applications to the cloud. Business will no longer need to invest in information technology hardware that rapidly becomes obsolete. Cloud providers will instead be responsible for maintenance costs of servers and hardware. Moreover, businesses will no longer need to purchase many software applications. Instead, businesses will utilize a pay-as-you-go pricing model for any applications that they use, which also holds out the promise of reducing costs. (Some studies have concluded that 70% of software purchased by corporations is either underutilized or not used at all.) The Brookings Institute estimates that companies could reduce their information technology costs by as much as 50% by moving to the cloud.

Early adopters of cloud computing services have included InterContinental Hotel Group (IHG), which has 650,000 rooms in 4,400 hotels around the world. Rather than upgrade its own information technology hardware, IHG has decided to move its central reservation system onto server farms owned by Amazon.com, the online retail store that is also emerging as an early leader in the cloud computing market. Similarly, Netflix has decided to utilize Amazon's cloud services for distributing its movies digitally, rather than investing in its own server farms. Another early user of cloud services is Starbucks, which has moved its entire corporate e-mail system off its servers and onto Microsoft's cloud computing system.

Amazon and Microsoft are two of the early leaders in the embryonic cloud computing market. The other significant player is Google. All three companies had to build large server farms to run parts of their own businesses (online retail in the case of Amazon, and Web-searching capabilities in the case of Google and Microsoft). When these corporations soon realized that they could rent out capacity on these server farms to other businesses, the concept of cloud computing was born. Other companies that have announced their intentions to enter the cloud computing market as providers of hosting services include IBM and Hewlett-Packard.

Right now the cloud is small—IDC indicates that worldwide, cloud services accounted for $40 billion in 2012 (just over 1% of the 3.6 trillion spent worldwide on information technology in 2012), and expects that number to grow to 100 billion by 2016. However, cloud services also threatened to redistribute who earned those revenues in information technology, attracting the attention of companies such as Microsoft and Google.

Microsoft has developed an operating system, known as Windows Azure, which is designed to run software applications very efficiently on server farms, allocating workloads and balancing capacity across hundreds of thousands of servers. Microsoft is rewriting many of its own applications, such as Office and SQL server, to run on Azure. The belief is that this will help the company retain existing clients as they transition their data and applications from their own servers onto the cloud. Microsoft has also developed tools to help clients write their own custom applications for the cloud; it has recognized that the shift to the cloud threatens its existing Windows monopoly, and that its best strategy is to try to become the dominant company on the cloud.

Microsoft's rivals were not idly standing by. Google, for example, has developed a cloud-based operating system, Google App Engine, which allows clients to efficiently run their custom software applications on the cloud, and also offers the Chrome OS for individuals to use on dedicated Chrome tablets. Amazon, too, has its own cloud-based operating system, known as Elastic Compute Cloud, or "EC2." Other companies, including IBM and VM Ware, are developing similar software. Software applications that are written for one cloud-based operating system will not run on another cloud operating system without a complete rewrite—meaning that there will be significant switching costs involved in moving an application from one cloud provider to another. This strongly suggests that we are witnessing the beginnings of a format war in cloud computing, much like the format war during the early 1990s between Microsoft, IBM, and Apple to dominate the desktop computer—a war that Microsoft won with its Windows operating system. If business history is any guide, at most only two or three formats will survive, with most other formats falling by the wayside.

Sources: R. Harms and M. Yamartino, "The Economics of the Cloud," *Microsoft White Paper,* November 2011; A. Vance, "The Cloud: Battle of the Tech Titans," *Bloomberg Businessweek,* March 3, 2011; and K. D. Schwartz, "Cloud Computing Can Generate Massive Savings for Agencies," *Federal Computer Week,* January 2011.

CASE DISCUSSION QUESTIONS

1. What are the advantages and disadvantages of using cloud services for individuals and businesses?
2. How does the adoption of cloud services affect the revenues for computer and software makers? Which companies will "win" and "lose" if individuals and businesses continue to shift to using cloud services?
3. What forces would create pressure for a dominant cloud-based operating system to emerge?
4. What individual advantages do you think Microsoft, Amazon, and Google have in promoting their cloud-based operating systems?

KEY TERMS

Technical standards 215
Format wars 218
Dominant design 218
Public domain 220
Network effects 221
Killer applications 224
Razor and blade
 strategy 225
First mover 229
First-mover
 disadvantages 230
Technological paradigm
 shift 235

NOTES

[1]Data from Bureau of Economic Analysis, 2013, www.bea.gov.

[2]J. M. Utterback, *Mastering the Dynamics of Innovation* (Boston: Harvard Business School Press, 1994); C. Shapiro and H. R. Varian, *Information Rules: A Strategic Guide to the Network Economy* (Boston: Harvard Business School Press, 1999).

[3]The layout is not universal, although it is widespread. The French, for example, use a different layout.

[4]For details, see Charles W. L. Hill, "Establishing a Standard: Competitive Strategy and Technology Standards in Winner Take All Industries," *Academy of Management Executive* 11 (1997): 7–25; Shapiro and Varian, *Information Rules;* B. Arthur, "Increasing Returns and the New World of Business," *Harvard Business Review,* July–August 1996, 100–109; G. Gowrisankaran and J. Stavins, "Network Externalities and Technology Adoption: Lessons from Electronic Payments," *Rand Journal of Economics* 35 (2004): 260–277; V. Shankar and B. L. Bayus, "Network Effects and Competition: An Empirical Analysis of the Home Video Game Industry," *Strategic Management Journal* 24 (2003): 375–394; and R. Casadesus-Masanell and P. Ghemawat, "Dynamic Mixed Duopoly: A Model Motivated by Linux vs Windows," *Management Science*, 52 (2006): 1072–1085.

[5]See Shapiro and Varian, *Information Rules;* Hill, "Establishing a Standard"; and M. A. Schilling, "Technological Lockout: An Integrative Model of the Economic and Strategic Factors Driving Technology Success and Failure," *Academy of Management Review* 23:2 (1998): 267–285.

[6]Microsoft does not disclose the per unit licensing fee that it receives from original equipment manufacturers, although media reports speculate it is around $50 a copy.

[7]Much of this section is based on Charles W. L. Hill, Michael Heeley, and Jane Sakson, "Strategies for Profiting from Innovation," in *Advances in Global High Technology Management* 3 (Greenwich, CT: JAI Press, 1993), pp. 79–95.

[8]M. Lieberman and D. Montgomery, "First Mover Advantages," *Strategic Management Journal* 9 (Special Issue, Summer 1988): 41–58.

[9]W. Boulding and M. Christen, "Sustainable Pioneering Advantage? Profit Implications of Market Entry Order?" *Marketing Science* 22 (2003): 371–386; C. Markides and P. Geroski, "Teaching Elephants to Dance and Other Silly Ideas," *Business Strategy Review* 13 (2003): 49–61.

[10]J. Borzo, "Aging Gracefully," *Wall Street Journal,* October 15, 2001, p. R22.

[11]The importance of complementary assets was first noted by D. J. Teece. See D. J. Teece, "Profiting from Technological Innovation," in D. J. Teece (ed.), *The Competitive Challenge* (New York: Harper & Row, 1986), pp. 26–54.

[12]M. J. Chen and D. C. Hambrick, "Speed, Stealth, and Selective Attack: How Small Firms Differ from Large Firms in Competitive Behavior," *Academy of Management Journal* 38 (1995): 453–482.

[13]E. Mansfield, M. Schwartz, and S. Wagner, "Imitation Costs and Patents: An Empirical Study," *Economic Journal* 91 (1981): 907–918.

[14]E. Mansfield, "How Rapidly Does New Industrial Technology Leak Out?" *Journal of Industrial Economics* 34 (1985): 217–223.

[15]This argument has been made in the game theory literature. See R. Caves, H. Cookell, and P. J. Killing, "The Imperfect Market for Technology Licenses," *Oxford Bulletin of Economics and Statistics* 45 (1983): 249–267; N. T. Gallini, "Deterrence by Market Sharing: A Strategic Incentive for Licensing," *American Economic Review* 74 (1984): 931–941; and C. Shapiro, "Patent Licensing and R&D Rivalry," *American Economic Review* 75 (1985): 25–30.

[16]M. Christensen, *The Innovator's Dilemma* (Boston: Harvard Business School Press, 1997); and R. N. Foster, *Innovation: The Attacker's Advantage* (New York: Summit Books, 1986).

[17]Foster, *Innovation.*

[18]Ray Kurzweil, *The Age of the Spiritual Machines* (New York: Penguin Books, 1999).

[19]See Christensen, *The Innovator's Dilemma;* and C. M. Christensen and M. Overdorf, "Meeting the Challenge of Disruptive Change," *Harvard Business Review,* March–April 2000, pp. 66–77.

[20]Charles W. L. Hill and Frank T. Rothaermel, "The Performance of Incumbent Firms in the Face of Radical Technological Innovation," *Academy of Management Review* 28 (2003): 257–274; and F. T. Rothaermel and Charles W. L. Hill, "Technological Discontinuities and Complementary Assets: A Longitudinal Study of Industry and Firm Performance," *Organization Science* 16:1(2005): 52–70.

8

Strategy in the Global Environment

LEARNING OBJECTIVES

After this chapter, you should be able to:

8-1 Understand the process of globalization and how it impacts a company's strategy

8-2 Discuss the motives for expanding internationally

8-3 Review the different strategies that companies use to compete in the global market place

8-4 Explain the pros and cons of different modes for entering foreign markets

OPENING CASE

Ford's Global Strategy

© iStockPhoto.com/GYI NSEA

When Ford CEO Alan Mulally arrived at the company in 2006 after a long career at Boeing, he was shocked to learn that the company produced one Ford Focus for Europe, and a totally different one for the United States. "Can you imagine having one Boeing 737 for Europe and one 737 for the United States?" he said at the time. Due to this product strategy, Ford was unable to buy common parts for the vehicles, could not share development costs, and couldn't use its European Focus plants to make cars for the United States, or vice versa. In a business where economies of scale are important, the result was high costs. Nor were these problems limited to the Ford Focus—the strategy of designing and building different cars for different regions was the standard approach at Ford.

Ford's long-standing strategy of regional models was based upon the assumption that consumers in different regions had different tastes and preferences, which required considerable local customization. Americans, it was argued, loved their trucks and SUVs, whereas Europeans preferred smaller, fuel-efficient cars. Notwithstanding such differences, Mulally still could not understand why small car models like

the Focus or the Escape SUV, which were sold in different regions, were not built on the same platform and did not share common parts. In truth, the strategy probably had more to do with the autonomy of different regions within Ford's organization, a fact that was deeply embedded in Ford's history as one of the oldest multinational corporations.

When the global financial crisis rocked the world's automobile industry in 2008–2009, and precipitated the steepest drop in sales since the Great Depression, Mulally decided that Ford had to change its long-standing practices in order to get its costs under control. Moreover, he felt that there was no way that Ford would be able to compete effectively in the large developing markets of China and India unless Ford leveraged its global scale to produce low-cost cars. The result was Mulally's "One Ford" strategy, which aims to create a handful of car platforms that Ford can use everywhere in the world.

Under this strategy, new models—such as the 2013 Fiesta, Focus, and Escape—share a common design, are built on a common platform, use the same parts, and will be built in identical factories around the world. Ultimately, Ford hopes to have only five platforms to deliver sales of more than 6 million vehicles by 2016. In 2006 Ford had 15 platforms that accounted for sales of 6.6 million vehicles. By pursuing this strategy, Ford can share the costs of design and tooling, and it can attain much greater scale economies in the production of component parts. Ford has stated that it will take about one-third out of the $1 billion cost of developing a new car model and should significantly reduce its $50 billion annual budget for component parts. Moreover, because the different factories producing these cars are identical in all respects, useful knowledge acquired through experience in one factory can quickly be transferred to other factories, resulting in system-wide cost savings.

What Ford hopes is that this strategy will bring down costs sufficiently to enable Ford to make greater profit margins in developed markets, and be able to make good margins at lower price points in hypercompetitive developing nations, such as China, now the world's largest car market, where Ford currently trails its global rivals such as General Motors and Volkswagen. Indeed, the strategy is central to Mulally's goal for growing Ford's sales from 5.5 million in 2010 to 8 million by mid-decade.

Sources: M. Ramsey, "Ford SUV Marks New World Car Strategy," *Wall Street Journal*, November 16, 2011; B. Vlasic, "Ford Strategy Will Call for Stepping up Expansion, Especially in Asia," *New York Times*, June 7, 2011; and "Global Manufacturing Strategy Gives Ford Competitive Advantage," Ford Motor Company, http://media.ford.com/article_display.cfm?article_id=13633.

OVERVIEW

This chapter begins with a discussion of ongoing changes in the global competitive environment and discusses models managers can use for analyzing competition in different national markets. Next, the chapter discusses the various ways in which international expansion can increase a company's profitability and profit growth. We then discuss the advantages and disadvantages of the different strategies companies can pursue to gain a competitive advantage in the global marketplace. This is followed by a discussion of two related strategic issues: (1) how managers decide which foreign markets to enter, when to enter them, and on what scale; and (2) what kind of vehicle or method a company should use to expand globally and enter a foreign country.

Ford Motor Company's One Ford strategy, profiled in the Opening Case, gives a preview of some issues explored in this chapter. Historically Ford pursued a *localization* strategy,

selling cars in the different regions that were designed and produced locally (i.e., one design for Europe, another for North America). Although this strategy did have the virtue of ensuring that the offering was tailored to the tastes and preferences of consumers in different regions, it also involved considerable duplication and high costs. By the late 2000s, Alan Mulally, Ford's CEO, decided that the company could no longer afford the high costs associated with this approach, and he pushed the company to adopt his One Ford strategy. Under this *global standardization strategy,* Ford aims to design and sell the same models worldwide. The idea is to reap substantial cost reduction from sharing design costs, building on common plat-forms, sharing component parts across models, and building cars in identical factories around the world to share tooling costs. To the extent that Ford can do this, the company should be able to lower prices and still make good profits, which should help it not only to hold on to share in developed markets, but also to gain share in rapidly growing emerging markets such as India and China. Although there is a risk that the lack of local customization will lead to some loss of sales at the margin, Mulally clearly feels that the benefits in terms of lower costs and more competitive pricing clearly outweigh this risk. Only time will tell if he is correct.

As we shall see later in this chapter, many other companies have made a similar shift in the last two decades, moving from what can be characterized as a *localization strategy*, where local country managers have considerable autonomy over manufacturing and marketing, to a *global strategy*, where the corporate center exercises more control over manufacturing, marketing, and product development decisions. The tendency to make such a shift in many international businesses is a response to the globalization of markets. We shall discuss this process later in the chapter.

By the time you have completed this chapter, you will have a good understanding of the various strategic issues that companies face when they decide to expand their operations abroad to achieve competitive advantage and superior profitability.

THE GLOBAL AND NATIONAL ENVIRONMENTS

Fifty years ago, most national markets were isolated from one another by significant barri-ers to international trade and investment. In those days, managers could focus on analyzing only those national markets in which their company competed. They did not need to pay much attention to entry by global competitors, for there were few and entry was difficult. Nor did they need to pay much attention to entering foreign markets, because that was often prohibitively expensive. All of this has now changed. Barriers to international trade and investment have tumbled, huge global markets for goods and services have been created, and companies from different nations are entering each other's home markets on an unprec-edented scale, increasing the intensity of competition. Rivalry can no longer be understood merely in terms of what happens within the boundaries of a nation; managers now need to consider how globalization is impacting the environment in which their company competes and what strategies their company should adopt to exploit the unfolding opportunities and counter competitive threats. In this section we look at the changes ushered in by falling barriers to international trade and investment, and we discuss a model for analyzing the competitive situation in different nations.

The Globalization of Production and Markets

The past half-century has seen a dramatic lowering of barriers to international trade and investment. For example, the average tariff rate on manufactured goods traded between

advanced nations has fallen from around 40% to under 4%. Similarly, in nation after nation, regulations prohibiting foreign companies from entering domestic markets and establishing production facilities, or acquiring domestic companies, have been removed. As a result of these developments, there has been a surge in both the volume of international trade and the value of foreign direct investment. The volume of world merchandise trade has been growing faster than the world economy since the 1950s. Between 1970 and 2011, the volume of world merchandise trade increased 30-fold, compared to a 10-fold increase in the size of the world economy. Even in the economically troubled years of 2005–2011, world merchandise trade grew at 3.7% per annum, versus a 2.3% per annum growth in the size of the world economy.[1] As for foreign direct investment, between 1992 and 2011, the total flow of foreign direct investment from all countries increased over 500%, while world trade by value grew by some 150% and world output by around 40%.[2] These trends have led to the globalization of production and the globalization of markets.[3]

The globalization of production has been increasing as companies take advantage of lower barriers to international trade and investment to disperse important parts of their production processes around the globe. Doing so enables them to take advantage of national differences in the cost and quality of factors of production such as labor, energy, land, and capital, which allows companies to lower their cost structures and boost profits. For example, foreign companies build nearly 65% by value of the Boeing Company's 787 commercial jet aircraft. Three Japanese companies build 35% of the 787, and another 20% is allocated to companies located in Italy, Singapore, and the UK.[4] Part of Boeing's rationale for outsourcing so much production to foreign suppliers is that these suppliers are the best in the world at performing their particular activity. Therefore, the result of having foreign suppliers build specific parts is a better final product and higher profitability for Boeing.

As for the globalization of markets, it has been argued that the world's economic system is moving from one in which national markets are distinct entities, isolated from each other by trade barriers and barriers of distance, time, and culture, toward a system in which national markets are merging into one huge global marketplace. Increasingly, customers around the world demand and use the same basic product offerings. Consequently, in many industries, it is no longer meaningful to talk about the German market, the U.S. market, or the Chinese market; there is only the global market. The global acceptance of Coca-Cola, Citigroup credit cards, Starbucks, McDonald's hamburgers, Samsung and Apple smartphones, IKEA furniture, and Microsoft's Windows operating system are examples of this trend.[5]

The trend toward the globalization of production and markets has several important implications for competition within an industry. First, industry boundaries do not stop at national borders. Because many industries are becoming global in scope, competitors and potential future competitors exist not only in a company's home market, but also in other national markets. Managers who analyze only their home market can be caught unprepared by the entry of efficient foreign competitors. The globalization of markets and production implies that companies around the globe are finding their home markets under attack from foreign competitors. For example, in Japan, American financial institutions such as J.P. Morgan have been making inroads against Japanese financial service institutions. In the United States, South Korea's Samsun has been battling Apple for a share of the smartphone market. In the European Union, the once-dominant Dutch company Philips has seen its market share in the customer electronics industry taken by Japan's Panasonic and Sony, and Samsung of South Korea.

Second, the shift from national to global markets has intensified competitive rivalry in many industries. National markets that once were consolidated oligopolies, dominated by three or four companies and subjected to relatively little foreign competition, have been transformed into segments of fragmented global industries in which a large number of companies

battle each other for market share in many countries. This rivalry has threatened to drive down profitability and has made it more critical for companies to maximize their efficiency, quality, customer responsiveness, and innovative ability. The painful restructuring and downsizing that has been occurring at companies such as Kodak is as much a response to the increased intensity of global competition as it is to anything else. However, not all global industries are fragmented. Many remain consolidated oligopolies, except that now they are consolidated global (rather than national) oligopolies. In the videogame industry, for example, three companies are battling for global dominance: Microsoft from the United States and Nintendo and Sony from Japan. In the market for smartphones, Nokia of Finland is in a global battle with Apple of the United States, Samsung and LG from South Korea, and HTC from China.

Finally, although globalization has increased both the threat of entry and the intensity of rivalry within many formerly protected national markets, it has also created enormous opportunities for companies based in those markets. The steady decline in barriers to cross-border trade and investment has opened up many once-protected national markets to companies based outside these nations. Thus, for example, Western European, Japanese, and U.S. companies have accelerated their investments in the nations of Eastern Europe, Latin America, and Southeast Asia as they try to take advantage of growth opportunities in those areas.

National Competitive Advantage

Despite the globalization of production and markets, many of the most successful companies in certain industries are still clustered in a small number of countries. For example, many of the world's most successful biotechnology and computer companies are based in the United States, and many of the most successful consumer electronics companies are based in Japan, Taiwan, and South Korea. Germany is the base for many successful chemical and engineering companies. These facts suggest that the nation-state within which a company is based may have an important bearing on the competitive position of that company in the global marketplace.

In a study of national competitive advantage, Michael Porter identified four attributes of a national or country-specific environment that have an important impact on the global competitiveness of companies located within that nation:[6]

- *Factor endowments*: A nation's position in factors of production such as skilled labor or the infrastructure necessary to compete in a given industry
- *Local demand conditions*: The nature of home demand for the industry's product or service
- *Related and supporting industries*: The presence or absence in a nation of supplier industries and related industries that are internationally competitive
- *Firm strategy, structure, and rivalry*: The conditions in the nation governing how companies are created, organized, and managed, and the nature of domestic rivalry

Porter speaks of these four attributes as constituting the "diamond," arguing that companies from a given nation are most likely to succeed in industries or strategic groups in which the four attributes are favorable (see Figure 8.1). He also argues that the diamond's attributes form a mutually reinforcing system in which the effect of one attribute is dependent on the state of others.

Factor Endowments Factor endowments—the cost and quality of factors of production—are a prime determinant of the competitive advantage that certain countries might have in certain industries. Factors of production include basic factors, such as land, labor, capital, and raw materials, and advanced factors, such as technological knowhow, managerial

Figure 8.1 | National Competitive Advantage

Source: Adapted from M. E. Porter, "The Competitive Advantage of Nations," *Harvard Business Review*, March–April 1990, p. 77.

sophistication, and physical infrastructure (roads, railways, and ports). The competitive advantage that the United States enjoys in biotechnology might be explained by the presence of certain advanced factors of production—for example, technological knowhow—in combination with some basic factors, which might be a pool of relatively low-cost venture capital that can be used to fund risky start-ups in industries such as biotechnology.

Local Demand Conditions Home demand plays an important role in providing the impetus for "upgrading" competitive advantage. Companies are typically most sensitive to the needs of their closest customers. Thus, the characteristics of home demand are particularly important in shaping the attributes of domestically made products and creating pressures for innovation and quality. A nation's companies gain competitive advantage if their domestic customers are sophisticated and demanding, and pressure local companies to meet high standards of product quality and produce innovative products. Japan's sophisticated and knowledgeable buyers of cameras helped stimulate the Japanese camera industry to improve product quality and introduce innovative models. A similar example can be found in the cellular phone equipment industry, where sophisticated and demanding local customers in Scandinavia helped push Nokia of Finland and Ericsson of Sweden to invest in cellular phone technology long before demand for cellular phones increased in other developed nations. As a result, Nokia and Ericsson, together with Motorola, became significant players in the global cellular telephone equipment industry.

Competitiveness of Related and Supporting Industries The third broad attribute of national advantage in an industry is the presence of internationally competitive suppliers or related industries. The benefits of investments in advanced factors of production by related and supporting industries can spill over into an industry, thereby helping it achieve a strong competitive position internationally. Swedish strength in fabricated steel products (such as ball bearings and cutting tools) has drawn on strengths in Sweden's specialty steel industry. Switzerland's success in pharmaceuticals is closely related to its previous international success in the technologically related dye industry. One consequence of this process is that successful industries within a country tend to be grouped into clusters of related industries. Indeed, this is one of the most pervasive findings of Porter's study. One such cluster is the German textile and apparel sector, which includes high-quality cotton, wool, synthetic fibers, sewing machine needles, and a wide range of textile machinery.

Intensity of Rivalry The fourth broad attribute of national competitive advantage in Porter's model is the intensity of rivalry of firms within a nation. Porter makes two important points here. First, different nations are characterized by different management ideologies, which either help them or do not help them to build national competitive advantage. For example, Porter noted the predominance of engineers in top management at German and Japanese firms. He attributed this to these firms' emphasis on improving manufacturing processes and product design. In contrast, Porter noted a predominance of people with finance backgrounds leading many U.S. firms. He linked this to U.S. firms' lack of attention to improving manufacturing processes and product design. He argued that the dominance of finance led to an overemphasis on maximizing short-term financial returns. According to Porter, one consequence of these different management ideologies was a relative loss of U.S. competitiveness in those engineering-based industries where manufacturing processes and product design issues are all-important (such as the automobile industry).

Porter's second point is that there is a strong association between vigorous domestic rivalry and the creation and persistence of competitive advantage in an industry. Rivalry compels companies to look for ways to improve efficiency, which makes them better international competitors. Domestic rivalry creates pressures to innovate, improve quality, reduce costs, and invest in upgrading advanced factors. All this helps to create world-class competitors.

Using the Framework The framework just described can help managers to identify from where their most significant global competitors are likely to originate. For example, there is a cluster of computer service and software companies in Bangalore, India, that includes two of the fastest-growing information technology companies in the world, Infosys and Wipro. These companies have emerged as aggressive competitors in the global market. Both companies have recently opened up offices in the European Union and United States so they can better compete against Western rivals such as IBM and Hewlett Packard, and both are gaining share in the global marketplace.

The framework can also be used to help managers decide where they might want to locate certain productive activities. Seeking to take advantage of U.S. expertise in biotechnology, many foreign companies have set up research facilities in San Diego, Boston, and Seattle, where U.S. biotechnology companies tend to be clustered. Similarly, in an attempt to take advantage of Japanese success in consumer electronics, many U.S. electronics companies have set up research and production facilities in Japan, often in conjunction with Japanese partners.

Finally, the framework can help a company assess how tough it might be to enter certain national markets. If a nation has a competitive advantage in certain industries, it might be challenging for foreigners to enter those industries. For example, the highly competitive retailing industry in the United States has proved to be a very difficult industry for foreign companies to enter. Successful foreign retailers such as Britain's Tesco and Sweden's IKEA have found it tough going into the United States because the U.S. retailing industry is the most competitive in the world.

INCREASING PROFITABILITY AND PROFIT GROWTH THROUGH GLOBAL EXPANSION

Here we look at a number of ways in which global expansion can enable companies to increase and rapidly grow profitability. At the most basic level, global expansion increases the size of the market in which a company is competing, thereby boosting profit growth. Moreover, as we shall see, global expansion offers opportunities for reducing the cost structure of the enterprise or adding value through differentiation, thereby potentially boosting profitability.

Expanding the Market: Leveraging Products

A company can increase its growth rate by taking goods or services developed at home and selling them internationally; almost all multinationals started out doing this. Procter & Gamble, (P&G) for example, developed most of its best-selling products at home and then sold them around the world. Similarly, from its earliest days, Microsoft has always focused on selling its software around the world. Automobile companies such as Ford, Volkswagen, and Toyota also grew by developing products at home and then selling them in international markets. The returns from such a strategy are likely to be greater if indigenous competitors in the nations a company enters lack comparable products. Thus, Toyota has grown its profits by entering the large automobile markets of North America and Europe and by offering products that are differentiated from those offered by local rivals (Ford and GM) by superior quality and reliability.

It is important to note that the success of many **multinational companies** is based not just on the goods or services that they sell in foreign nations, but also upon the distinctive competencies (unique skills) that underlie the production and marketing of those goods or services. Thus Toyota's success is based on its distinctive competency in manufacturing automobiles. International expansion can be seen as a way for Toyota to generate greater returns from this competency. Similarly, P&G global success was based on more than its portfolio of consumer products; it was also based on the company's skills in mass-marketing consumer goods. P&G grew rapidly in international markets between 1950 and 1990 because it was one of the most skilled mass-marketing enterprises in the world and could "out-market" indigenous competitors in the nations it entered. Global expansion was, therefore, a way of generating higher returns from its competency in marketing.

Furthermore, one could say that because distinctive competencies are the most valuable aspects of a company's business model, the successful global expansion of manufacturing companies such as Toyota and P&G was based on the ability to transfer aspects of the business model and apply it to foreign markets.

The same can be said of companies engaged in the service sectors of an economy, such as financial institutions, retailers, restaurant chains, and hotels. Expanding the market

multinational company
A company that does business in two or more national markets.

for their services often means replicating their business model in foreign nations (albeit with some changes to account for local differences, which we will discuss in more detail shortly). Starbucks, for example, has expanded globally by taking the basic business model it developed in the United States and using that as a blueprint for establishing international operations. As detailed in the Running Case, Wal-Mart has done the same thing, establishing stores in 27 other nations since 1992 following the blueprint it developed in the United States.

FOCUS ON: Wal-Mart

Wal-Mart's Global Expansion

© iStockPhoto.com/caracterdesign

In the early 1990s, managers at Wal-Mart realized that the company's opportunities for growth in the United States were becoming more limited. By 1995 the company would be active in all 50 states. Management calculated that by the early 2000s, domestic growth opportunities would be constrained due to market saturation. So the company decided to expand globally. The critics scoffed. Wal-Mart, they said, was too American a company. Although its business model was well suited to the United States, it would not work in other countries where infrastructure was different, consumer tastes and preferences varied, and where established retailers already dominated.

Unperturbed, in 1991 Wal-Mart started to expand internationally with the opening of its first stores in Mexico. The Mexican operation was established as a joint venture with Cifera, the largest local retailer. Initially, Wal-Mart made a number of missteps that seemed to prove the critics right. Wal-Mart had problems replicating its efficient distribution system in Mexico. Poor infrastructure, crowded roads, and a lack of leverage with local suppliers, many of which could not or would not deliver directly to Wal-Mart's stores or distribution centers, resulted in stocking problems and raised costs and prices. Initially, prices at Wal-Mart in Mexico were some 20% above prices for comparable products in the company's U.S. stores, which limited Wal-Mart's ability to gain market share. There were also problems with merchandise selection. Many of the stores in Mexico carried items that were popular in the United States. These included ice skates, riding lawn mowers, leaf blowers, and fishing tackle. Not surprisingly, these items did not sell well in Mexico, so managers would slash prices to move inventory, only to find that the company's automated information systems would immediately order more inventory to replenish the depleted stock.

By the mid-1990s, however, Wal-Mart had learned from its early mistakes and adapted its operations in Mexico to match the local environment. A partnership with a Mexican trucking company dramatically improved the distribution system, and more careful stocking practices meant that the Mexican stores sold merchandise that appealed more to local tastes and preferences. As Wal-Mart's presence grew, many of Wal-Mart's suppliers built factories close by its Mexican distribution centers so that they could better serve the company, which helped to further drive down inventory and logistics costs. In 1998, Wal-Mart acquired a controlling interest in Cifera. Today, Mexico is a leading light in Wal-Mart's international operations, where the company is more than twice the size of its nearest rival.

The Mexican experienced proved to Wal-Mart that it could compete outside of the United States. It has subsequently expanded into 27 other countries. In Canada, Britain, Germany, and Japan, Wal-Mart entered by acquiring existing retailers and then transferring its information systems, logistics, and management expertise. In Puerto Rico, Brazil, Argentina, and China, Wal-Mart established its own stores (although it added to its Chinese operations with a major acquisition in 2007). As a result of these moves, by 2013 the company had over 6,000 stores outside the United States, included 800,000 foreign employees on the payroll, and generated international revenues of more than $125 billion.

In addition to greater growth, expanding internationally has bought Wal-Mart two other major benefits. First, Wal-Mart has also been able to reap significant economies of scale from its global buying power. Many of Wal-Mart's key suppliers have long been international companies; for example, GE (appliances), Unilever (food products), and P&G (personal care products) are all major Wal-Mart suppliers that have long had their own global operations. By building international reach, Wal-Mart has been able to use its enhanced size to demand deeper discounts from the local operations

(continues)

FOCUS ON: Wal-Mart

(continued)

© iStockPhoto.com/caracterdesign

of its global suppliers, increasing the company's ability to lower prices to consumers, gain market share, and ultimately earn greater profits. Second, Wal-Mart has found that it is benefiting from the flow of ideas across the countries in which it now competes. For example, Wal-Mart's Argentina team worked with Wal-Mart's Mexican management to replicate a Wal-Mart store format developed first in Mexico, and to adopt the best practices in human resources and real estate that had been developed in Mexico. Other ideas, such as wine departments in its stores in Argentina, have now been integrated into layouts worldwide.

Moreover, Wal-Mart realized that if it didn't expand internationally, other global retailers would beat it to the punch. In fact, Wal-Mart does face significant global competition from Carrefour of France, Ahold of Holland, and Tesco from the United Kingdom. Carrefour, the world's second-largest retailer, is perhaps the most global of the lot. The pioneer of the hypermarket concept now operates in 26 countries and generates more than 50% of its sales outside France. Compared to this, Wal-Mart is a laggard with just 28% of its sales in 2012 generated from international operations. However, there is still room for significant global expansion—the global retailing market remains very fragmented.

For all of its success, Wal-Mart has hit some significant speed bumps in its drive for global expansion. In 2006 the company pulled out of two markets, South Korea—where it failed to decode the shopping habits of local customers—and Germany, where it could not beat incumbent discount stores on price. It is also struggling in Japan, where the company does not seem to have grasped the market's cultural nuances. One example is Wal-Mart's decision to sell lower-priced gift fruits at Japanese holidays, which failed because customers felt spending less would insult the recipient! It is interesting to note that the markets where Wal-Mart has struggled were all developed markets that it entered through acquisitions, where it faced long-established and efficient local competitors, and where shopping habits were very different than in the United States. In contrast, many of those markets where it has done better have been developing nations that lacked strong local competitors, and where Wal-Mart has built operations from the ground up (e.g., Mexico, Brazil, and, increasingly, China).

Source: A. Lillo, "Wal-Mart Says Global Going Good," *Home Textiles Today*, September 15, 2003, pp. 12–13; A. de Rocha and L. A. Dib, "The Entry of Wal-Mart into Brazil," *International Journal of Retail and Distribution Management* 30 (2002): 61–73; "Wal-Mart: Mexico's Biggest Retailer," *Chain Store Age*, June 2001, pp. 52–54; M. Flagg, "In Asia, Going to the Grocery Increasingly Means Heading for a European Retail Chain," *Wall Street Journal*, April 24, 2001, p. A21; "A Long Way from Bentonville," *The Economist*, September 20, 2006, pp. 38–39; "How Wal-Mart Should Right Itself," *Wall Street Journal*, April 20, 2007, pp. C1, C5; and Wal-Mart website, www.walmart.com.

Realizing Cost Economies from Global Volume

In addition to growing profits more rapidly, a company can realize cost savings from economies of scale, thereby boosting profitability, by expanding its sales volume through international expansion. Such scale economies come from several sources. First, by spreading the fixed costs associated with developing a product and setting up production facilities over its global sales volume, a company can lower its average unit cost. Thus, Microsoft can garner significant scale economies by spreading the $5 to $10 billion it cost to develop Windows 8 over global demand.

Second, by serving a global market, a company can potentially utilize its production facilities more intensively, which leads to higher productivity, lower costs, and greater profitability. For example, if Intel sold microprocessors only in the United States, it might only be able to keep its factories open for 1 shift, 5 days a week. But by serving a global

market from the same factories, it might be able to utilize those assets for 2 shifts, 7 days a week. In other words, the capital invested in those factories is used more intensively if Intel sells to a global—as opposed to a national—market, which translates into higher capital productivity and a higher return on invested capital.

Third, as global sales increase the size of the enterprise, its bargaining power with suppliers increases, which may allow it to bargain down the cost of key inputs and boost profitability that way. For example, Wal-Mart has been able to use its enormous sales volume as a lever to bargain down the price it pays to suppliers for merchandise sold through its stores (see the Running Case).

In addition to the cost savings that come from economies of scale, companies that sell to a global rather than a local marketplace may be able to realize further cost savings from learning effects. We first discussed learning effects in Chapter 4, where we noted that employee productivity increases with cumulative increases in output over time. (For example, it costs considerably less to build the 100th aircraft from a Boeing assembly line than the 10th because employees learn how to perform their tasks more efficiently over time.) By selling to a global market, a company may be able to increase its sales volume more rapidly, and thus the cumulative output from its plants, which in turn should result in accelerated learning, higher employee productivity, and a cost advantage over competitors that are growing more slowly because they lack international markets.

Realizing Location Economies

Earlier in this chapter we discussed how countries differ from each other along a number of dimensions, including differences in the cost and quality of factors of production. These differences imply that some locations are more suited than others for producing certain goods and services.[7] **Location economies** are the economic benefits that arise from performing a value creation activity in the optimal location for that activity, wherever in the world that might be (transportation costs and trade barriers permitting). Thus, if the best designers for a product live in France, a firm should base its design operations in France. If the most productive labor force for assembly operations is in Mexico, assembly operations should be based in Mexico. If the best marketers are in the United States, the marketing strategy should be formulated in the United States—and so on. Apple, for example, designs the iPhone and develops the associated software in California, but undertakes final assembly in China, precisely because the company believes that these are the best locations in the world for carrying out these different value creation activities (Please see the opening case for Chapter 9).

Locating a value creation activity in the optimal location for that activity can have one of two effects: (1) it can lower the costs of value creation, helping the company achieve a low-cost position; or (2) it can enable a company to differentiate its product offering, which gives it the option of charging a premium price or keeping prices low and using differentiation as a means of increasing sales volume. Thus, efforts to realize location economies are consistent with the business-level strategies of low cost and differentiation.

In theory, a company that realizes location economies by dispersing each of its value creation activities to the optimal location for that activity should have a competitive advantage over a company that bases all of its value creation activities at a single location. It should be able to better differentiate its product offering and lower its cost structure more than its single-location competitor. In a world where competitive pressures are increasing, such a strategy may well become an imperative for survival.

Introducing transportation costs and trade barriers can complicate the process of realizing location economies. New Zealand might have a comparative advantage for low-cost

location economies

The economic benefits that arise from performing a value creation activity in an optimal location.

car assembly operations, but high transportation costs make it an uneconomical location from which to serve global markets. Factoring transportation costs and trade barriers into the cost equation helps explain why some U.S. companies have shifted their production from Asia to Mexico. Mexico has three distinct advantages over many Asian countries as a location for value creation activities: low labor costs; Mexico's proximity to the large U.S. market, which reduces transportation costs; and the North American Free Trade Agreement (NAFTA), which has removed many trade barriers between Mexico, the United States, and Canada, increasing Mexico's attractiveness as a production site for the North American market. Thus, although the relative costs of value creation are important, transportation costs and trade barriers also must be considered in location decisions.

Leveraging the Skills of Global Subsidiaries

Initially, many multinational companies develop the valuable competencies and skills that underpin their business model in their home nation and then expand internationally, primarily by selling products and services based on those competencies. However, for more mature multinational enterprises that have already established a network of subsidiary operations in foreign markets, the development of valuable skills can just as well occur in foreign subsidiaries.[8] Skills can be created anywhere within a multinational's global network of operations, wherever people have the opportunity and incentive to try new ways of doing things. The creation of skills that help to lower the costs of production, or to enhance perceived value and support higher product pricing, is not the monopoly of the corporate center.

Leveraging the skills created within subsidiaries and applying them to other operations within the firm's global network may create value. For example, McDonald's is increasingly finding that its foreign franchisees are a source of valuable new ideas. Faced with slow growth in France, its local franchisees have begun to experiment with the menu, as well as the layout and theme of restaurants. Gone are the ubiquitous Golden Arches; gone too are many of the utilitarian chairs and tables and other plastic features of the fast-food giant. Many McDonald's restaurants in France now have hardwood floors, exposed brick walls, and even armchairs. Half of the 930 or so outlets in France have been upgraded to a level that would make them unrecognizable to an American. The menu, too, has been changed to include premier sandwiches, such as chicken on focaccia bread, priced some 30% higher than the average hamburger. In France, this strategy seems to be working. Following these changes, increases in same-store sales rose from 1% annually to 3.4%. Impressed with the impact, McDonald's executives are now considering adopting similar changes at other McDonald's restaurants in markets where same-store sales growth is sluggish, including the United States.[9]

For the managers of a multinational enterprise, this phenomenon creates important new challenges. First, managers must have the humility to recognize that valuable skills can arise anywhere within the firm's global network, not just at the corporate center. Second, they must establish an incentive system that encourages local employees to acquire new competencies. This is not as easy as it sounds. Creating new competencies involves a degree of risk. Not all new skills add value. For every valuable idea created by a McDonald's subsidiary in a foreign country, there may be several failures. The management of the multinational must install incentives that encourage employees to take necessary risks, and the company must reward people for successes and not sanction them unnecessarily for taking risks that did not pan out. Third, managers must have a process for identifying when valuable new skills have been created in a subsidiary, and, finally, they need to act as facilitators, helping to transfer valuable skills within the firm.

COST PRESSURES AND PRESSURES FOR LOCAL RESPONSIVENESS

Companies that compete in the global marketplace typically face two types of competitive pressures: *pressures for cost reductions and pressures to be locally responsive* (see Figure 8.2).[10] These competitive pressures place conflicting demands on a company. Responding to pressures for cost reductions requires that a company attempt to minimize its unit costs. To attain this goal, it may have to base its productive activities at the most favorable low-cost location, wherever in the world that might be. It may also need to offer a standardized product to the global marketplace in order to realize the cost savings that come from economies of scale and learning effects. On the other hand, responding to pressures to be locally responsive requires that a company differentiate its product offering and marketing strategy from country to country in an effort to accommodate the diverse demands arising from national differences in consumer tastes and preferences, business practices, distribution channels, competitive conditions, and government policies. Because differentiation across countries can involve significant duplication and a lack of product standardization, it may raise costs.

Whereas some companies, such as Company A in Figure 8.2, face high pressures for cost reductions and low pressures for local responsiveness, and others, such as Company B, face low pressures for cost reductions and high pressures for local responsiveness, many companies are in the position of Company C. They face high pressures for both cost reductions and local responsiveness. Dealing with these conflicting and contradictory pressures is a difficult strategic challenge, primarily because local responsiveness tends to raise costs.

| Figure 8.2 | Pressures for Cost Reductions and Local Responsiveness |

Pressures for Cost Reductions

In competitive global markets, international businesses often face pressures for cost reductions. To respond to these pressures, a firm must try to lower the costs of value creation. A manufacturer, for example, might mass-produce a standardized product at an optimal location in the world to realize economies of scale and location economies. Alternatively, it might outsource certain functions to low-cost foreign suppliers in an attempt to reduce costs. Thus, many computer companies have outsourced their telephone-based customer service functions to India, where qualified technicians who speak English can be hired for a lower wage rate than in the United States. In the same vein, a retailer like Wal-Mart might push its suppliers (which are manufacturers) to also lower their prices. (In fact, the pressure that Wal-Mart has placed on its suppliers to reduce prices has been cited as a major cause of the trend among North American manufacturers to shift production to China.)[11] A service business, such as a bank, might move some back-office functions, such as information processing, to developing nations where wage rates are lower.

Cost reduction pressures can be particularly intense in industries producing commodity-type products where meaningful differentiation on non-price factors is difficult, and price is the main competitive weapon. This tends to be the case for products that serve universal needs. Universal needs exist when the tastes and preferences of consumers in different nations are similar if not identical, such as for bulk chemicals, petroleum, steel, sugar, and similar products. Pressures for cost reductions also exist for many industrial and consumer products—for example, hand-held calculators, semiconductor chips, personal computers, and liquid crystal display screens. Pressures for cost reductions are also intense in industries where major competitors are based in low-cost locations, where there is persistent excess capacity, and where consumers are powerful and face low switching costs. Many commentators have argued that the liberalization of the world trade and investment environment in recent decades, by facilitating greater international competition, has generally increased cost pressures.[12]

Pressures for Local Responsiveness

Pressures for local responsiveness arise from differences in consumer tastes and preferences, infrastructure and traditional practices, distribution channels, and host government demands. Responding to pressures to be locally responsive requires that a company differentiate its products and marketing strategy from country to country to accommodate these factors, all of which tend to raise a company's cost structure.

Differences in Customer Tastes and Preferences Strong pressures for local responsiveness emerge when customer tastes and preferences differ significantly between countries, as they may for historic or cultural reasons. In such cases, a multinational company's products and marketing message must be customized to appeal to the tastes and preferences of local customers. The company is then typically pressured to delegate production and marketing responsibilities and functions to a company's overseas subsidiaries.

For example, the automobile industry in the 1980s and early 1990s moved toward the creation of "world cars." The idea was that global companies such as General Motors, Ford, and Toyota would be able to sell the same basic vehicle globally, sourcing it from centralized production locations. If successful, the strategy would have enabled automobile companies to reap significant gains from global scale economies. However, this strategy frequently ran aground upon the hard rocks of consumer reality. Consumers in different automobile markets have historically had different tastes and preferences, and these require different types of vehicles. North American consumers show a strong demand for pickup

trucks. This is particularly true in the South and West where many families have a pickup truck as a second or third car. But in European countries, pickup trucks are seen purely as utility vehicles and are purchased primarily by firms rather than individuals. As a consequence, the product mix and marketing message need to be tailored to take into account the different nature of demand in North America and Europe.

Some commentators have argued that customer demands for local customization are on the decline worldwide.[13] According to this argument, modern communications and transport technologies have created the conditions for a convergence of the tastes and preferences of customers from different nations. The result is the emergence of enormous global markets for standardized consumer products. The worldwide acceptance of McDonald's hamburgers, Coca-Cola, GAP clothes, the Apple iPhone, and Sony television sets, all of which are sold globally as standardized products, is often cited as evidence of the increasing homogeneity of the global marketplace.

However, this argument may not hold in many consumer goods markets. Significant differences in consumer tastes and preferences still exist across nations and cultures. Managers in international businesses do not yet have the luxury of being able to ignore these differences, and they may not for a long time to come. For an example of a company that has discovered how important pressures for local responsiveness can still be, read the accompanying Strategy in Action 8.1 on MTV Networks.

8.1 STRATEGY IN ACTION

Local Responsiveness at MTV Networks

© iStockPhoto.com/Tom Nulens

MTV Networks has become a symbol of globalization. Established in 1981, the U.S.-based TV network has been expanding outside of its North American base since 1987 when it opened MTV Europe. Today MTV Networks figures that every second of every day over 2 million people are watching MTV around the world, the majority outside the United States. Despite its international success, MTV's global expansion got off to a weak start. In the 1980s, when the main programming fare was still music videos, it piped a single feed across Europe almost entirely composed of American programming with English-speaking veejays. Naively, the network's U.S. managers thought Europeans would flock to the American programming. But although viewers in Europe shared a common interest in a handful of global superstars, their tastes turned out to be surprisingly local. After losing share to local competitors, which focused more on local tastes, MTV changed it strategy in the 1990s. It broke its service into "feeds" aimed at national or regional markets. Although MTV Networks exercises creative control over these different feeds, and although all the channels have the same familiar frenetic look and feel of MTV in the United States, a significant share of the programming and content is now local.

Today an increasing share of programming is local in conception. Although many programming ideas still originate in the United States, with staples such as "The Real World" having equivalents in different countries, an increasing share of programming is local in conception. In Italy, "MTV Kitchen" combines cooking with a music countdown. "Erotica" airs in Brazil and features a panel of youngsters discussing sex. The Indian channel produces 21 homegrown shows hosted by local veejays who speak "Hinglish," a city-bred version of Hindi and English. Many feeds still feature music videos by locally popular performers. This localization push reaped big benefits for MTV, allowing the network to capture viewers back from local imitators.

Sources: M. Gunther, "MTV's Passage to India," *Fortune*, August 9, 2004, pp. 117–122; B. Pulley and A. Tanzer, "Sumner's Gemstone," *Forbes*, February 21, 2000, pp. 107–11; K. Hoffman, "Youth TV's Old Hand Prepares for the Digital Challenge," *Financial Times*, February 18, 2000, p. 8; presentation by Sumner M. Redstone, chairman and CEO, Viacom Inc., delivered to Salomon Smith Barney 11th Annual Global Entertainment Media, Telecommunications Conference, Scottsdale, AZ, January 8, 2001, archived at www.viacom .com; and Viacom 10K Statement, 2005.

Differences in Infrastructure and Traditional Practices Pressures for local responsiveness also arise from differences in infrastructure or traditional practices among countries, creating a need to customize products accordingly. To meet this need, companies may have to delegate manufacturing and production functions to foreign subsidiaries. For example, in North America, consumer electrical systems are based on 110 volts, whereas in some European countries 240-volt systems are standard. Thus, domestic electrical appliances must be customized to take this difference in infrastructure into account. Traditional social practices also often vary across nations. In Britain, people drive on the left-hand side of the road, creating a demand for right-hand-drive cars, whereas in France and the rest of Europe, people drive on the right-hand side of the road (and therefore want left-hand-drive cars).

Although many of the country differences in infrastructure are rooted in history, some are quite recent. In the wireless telecommunications industry, different technical standards are found in different parts of the world. A technical standard known as GSM is common in Europe, and an alternative standard, CDMA, is more common in the United States and parts of Asia. The significance of these different standards is that equipment designed for GSM will not work on a CDMA network, and vice versa. Thus, companies that manufacture wireless handsets and infrastructure such as switches need to customize their product offerings according to the technical standard prevailing in a given country.

Differences in Distribution Channels A company's marketing strategies may have to be responsive to differences in distribution channels among countries, which may necessitate delegating marketing functions to national subsidiaries. In the pharmaceutical industry, for example, the British and Japanese distribution system is radically different from the U.S. system. British and Japanese doctors will not accept or respond favorably to a U.S.-style high-pressure sales force. Thus, pharmaceutical companies must adopt different marketing practices in Britain and Japan compared with the United States—soft sell versus hard sell.

Similarly, Poland, Brazil, and Russia all have similar per capita income on the basis of purchasing power parity, but there are big differences in distribution systems across the three countries. In Brazil, supermarkets account for 36% of food retailing, in Poland for 18%, and in Russia for less than 1%.[14] These differences in channels require that companies adapt their own distribution and sales strategies.

Host Government Demands Finally, economic and political demands imposed by host country governments may require local responsiveness. For example, pharmaceutical companies are subject to local clinical testing, registration procedures, and pricing restrictions, all of which make it necessary that the manufacturing and marketing of a drug should meet local requirements. Moreover, because governments and government agencies control a significant portion of the health-care budget in most countries, they are in a powerful position to demand a high level of local responsiveness. More generally, threats of protectionism, economic nationalism, and local content rules (which require that a certain percentage of a product should be manufactured locally) can dictate that international businesses manufacture locally.

CHOOSING A GLOBAL STRATEGY

Pressures for local responsiveness imply that it may not be possible for a firm to realize the full benefits from economies of scale and location economies. It may not be possible to serve the global marketplace from a single low-cost location, producing a globally standardized product, and marketing it worldwide to achieve economies of scale. In practice, the need to customize the product offering to local conditions may work against the implementation of such a strategy.

Figure 8.3 Four Basic Strategies

For example, automobile firms have found that Japanese, American, and European consumers demand different kinds of cars, and this necessitates producing products that are customized for local markets. In response, firms such as Honda, Ford, and Toyota are pursuing a strategy of establishing top-to-bottom design and production facilities in each of these regions so that they can better serve local demands. Although such customization brings benefits, it also limits the ability of a firm to realize significant scale economies and location economies.

In addition, pressures for local responsiveness imply that it may not be possible to leverage skills and products associated with a firm's distinctive competencies wholesale from one nation to another. Concessions often have to be made to local conditions. Despite being depicted as "poster child" for the proliferation of standardized global products, even McDonald's has found that it has to customize its product offerings (its menu) in order to account for national differences in tastes and preferences.

Given the need to balance the cost and differentiation (value) sides of a company's business model, how do differences in the strength of pressures for cost reductions versus those for local responsiveness affect the choice of a company's strategy? Companies typically choose among four main strategic postures when competing internationally: a global standardization strategy, a localization strategy, a transnational strategy, and an international strategy.[15] The appropriateness of each strategy varies with the extent of pressures for cost reductions and local responsiveness. Figure 8.3 illustrates the conditions under which each of these strategies is most appropriate.

global standardization strategy

A business model based on pursuing a low-cost strategy on a global scale.

Global Standardization Strategy

Companies that pursue a **global standardization strategy** focus on increasing profitability by reaping the cost reductions that come from economies of scale and location

economies; that is, their business model is based on pursuing a low-cost strategy on a global scale. The production, marketing, and research and development (R&D) activities of companies pursuing a global strategy are concentrated in a few favorable locations. These companies try not to customize their product offerings and marketing strategy to local conditions because customization, which involves shorter production runs and the duplication of functions, can raise costs. Instead, they prefer to market a standardized product worldwide so that they can reap the maximum benefits from economies of scale. They also tend to use their cost advantage to support aggressive pricing in world markets. Dell is a good example of a company that pursues such a strategy.

This strategy makes most sense when there are strong pressures for cost reductions and demand for local responsiveness is minimal. Increasingly, these conditions prevail in many industrial goods industries, whose products often serve universal needs. In the semiconductor industry, for example, global standards have emerged, creating enormous demands for standardized global products. Accordingly, companies such as Intel, Texas Instruments, and Motorola all pursue a global strategy.

These conditions are not always found in many consumer goods markets, where demands for local responsiveness remain high. However, even some consumer goods companies are moving toward a global standardization strategy in an attempt to drive down their costs. P&G, which is featured in the Strategy in Action 8.2 feature, is one example of such a company.

Localization Strategy

A **localization strategy** focuses on increasing profitability by customizing the company's goods or services so that the goods provide a favorable match to tastes and preferences in different national markets. Localization is most appropriate when there are substantial differences across nations with regard to consumer tastes and preferences, and where cost pressures are not too intense. By customizing the product offering to local demands, the company increases the value of that product in the local market. On the downside, because it involves some duplication of functions and smaller production runs, customization limits the ability of the company to capture the cost reductions associated with mass-producing a standardized product for global consumption. The strategy may make sense, however, if the added value associated with local customization supports higher pricing, which would enable the company to recoup its higher costs, or if it leads to substantially greater local demand, enabling the company to reduce costs through the attainment of scale economies in the local market.

MTV is a good example of a company that has had to pursue a localization strategy. If MTV localized its programming to match the demands of viewers in different nations, it would have lost market share to local competitors, its advertising revenues would have fallen, and its profitability would have declined. Thus, even though it raised costs, localization became a strategic imperative at MTV.

At the same time, it is important to realize that companies like MTV still have to closely monitor costs. Companies pursuing a localization strategy still need to be efficient and, whenever possible, capture some scale economies from their global reach. As noted earlier, many automobile companies have found that they have to customize some of their product offerings to local market demands—for example, by producing large pickup trucks for U.S. consumers and small fuel-efficient cars for European and Japanese consumers. At the same time, these companies try to get some scale economies from their global volume by using common vehicle platforms and components across many different models and by manufacturing those platforms and components at efficiently scaled factories that are

localization strategy
A strategy focused on increasing profitability by customizing the company's goods or services so that the goods provide a favorable match to tastes and preferences in different national markets.

optimally located. By designing their products in this way, these companies have been able to localize their product offerings, yet simultaneously capture some scale economies.

Transnational Strategy

We have argued that a global standardization strategy makes most sense when cost pressures are intense and demands for local responsiveness limited. Conversely, a localization strategy makes most sense when demands for local responsiveness are high but cost pressures are moderate or low. What happens, however, when the company simultaneously faces both strong cost pressures and strong pressures for local responsiveness? How can managers balance out such competing and inconsistent demands? According to some researchers, pursuing what has been called a transnational strategy is the answer.

Two of these researchers, Christopher Bartlett and Sumantra Ghoshal, argue that in today's global environment, competitive conditions are so intense that, to survive, companies must do all they can to respond to pressures for both cost reductions and local responsiveness. They must try to realize location economies and economies of scale from global volume, transfer distinctive competencies and skills within the company, and simultaneously pay attention to pressures for local responsiveness.[15]

Moreover, Bartlett and Ghoshal note that, in the modern multinational enterprise, distinctive competencies and skills do not reside just in the home country but can develop in any of the company's worldwide operations. Thus, they maintain that the flow of skills and product offerings should not be all one way, from home company to foreign subsidiary. Rather, the flow should also be from foreign subsidiary to home country and from foreign subsidiary to foreign subsidiary. Transnational companies, in other words, must also focus on leveraging subsidiary skills.

transnational strategy

A business model that simultaneously achieves low costs, differentiates the product offering across geographic markets, and fosters a flow of skills between different subsidiaries in the company's global network of operations.

In essence, companies that pursue a **transnational strategy** are trying to develop a business model that simultaneously achieves low costs, differentiates the product offering across geographic markets, and fosters a flow of skills between different subsidiaries in the company's global network of operations. As attractive as this may sound, the strategy is not an easy one to pursue because it places conflicting demands on the company. Differentiating the product to respond to local demands in different geographic markets raises costs, which runs counter to the goal of reducing costs. Companies such as 3M and ABB (a Swiss-based multinational engineering conglomerate) have tried to embrace a transnational strategy and have found it difficult to implement in practice.

Indeed, how best to implement a transnational strategy is one of the most complex questions that large global companies are grappling with today. It may be that few, if any, companies have perfected this strategic posture. But some clues to the right approach can be derived from a number of companies. Consider, for example, the case of Caterpillar. The need to compete with low-cost competitors such as Komatsu of Japan forced Caterpillar to look for greater cost economies. However, variations in construction practices and government regulations across countries meant that Caterpillar also had to be responsive to local demands. Therefore, Caterpillar confronted significant pressures for cost reductions and for local responsiveness.

To deal with cost pressures, Caterpillar redesigned its products to use many identical components and invested in a few large-scale component-manufacturing facilities, sited at favorable locations, to fill global demand and realize scale economies. At the same time, the company augments the centralized manufacturing of components with assembly plants in each of its major global markets. At these plants, Caterpillar adds local product features, tailoring the finished product to local needs. Thus, Caterpillar

is able to realize many of the benefits of global manufacturing while reacting to pressures for local responsiveness by differentiating its product among national markets.[16] Caterpillar started to pursue this strategy in the 1980s. By the 2000s it had succeeded in doubling output per employee, significantly reducing its overall cost structure in the process. Meanwhile, Komatsu and Hitachi, which are still wedded to a Japan-centric global strategy, have seen their cost advantages evaporate and have been steadily losing market share to Caterpillar.

However, building an organization capable of supporting a transnational strategy is a complex and challenging task. Indeed, some would say it is too complex, because the strategy implementation problems of creating a viable organizational structure and set of control systems to manage this strategy are immense. We shall return to this issue in Chapter 13.

International Strategy

Sometimes it is possible to identify multinational companies that find themselves in the fortunate position of being confronted with low cost pressures and low pressures for local responsiveness. Typically these enterprises are selling a product that serves universal needs, but because they do not face significant competitors, they are not confronted with pressures to reduce their cost structure. Xerox found itself in this position in the 1960s after its invention and commercialization of the photocopier. Strong patents protected the technology comprising the photocopier, so for several years Xerox did not face competitors—it had a monopoly. Because the product was highly valued in most developed nations, Xerox was able to sell the same basic product all over the world, and charge a relatively high price for it. At the same time, because it did not face direct competitors, the company did not have to deal with strong pressures to minimize its costs.

Historically, companies like Xerox have followed a similar developmental pattern as they build their international operations. They tend to centralize product development functions such as R&D at home. However, companies also tend to establish manufacturing and marketing functions in each major country or geographic region in which they do business. Although they may undertake some local customization of product offering and marketing strategy, this tends to be rather limited in scope. Ultimately, in most international companies, the head office retains tight control over marketing and product strategy.

Other companies that have pursued this strategy include P&G, which had historically always developed innovative new products in Cincinnati and thereafter transferred them wholesale to local markets. Microsoft is another company that has followed a similar strategy. The bulk of Microsoft's product development work takes place in Redmond, Washington, where the company is headquartered. Although some localization work is undertaken elsewhere, this is limited to producing foreign-language versions of popular Microsoft programs such as Office.

Changes in Strategy over Time

The Achilles heel of the international strategy is that, over time, competitors inevitably emerge, and if managers do not take proactive steps to reduce their cost structure, their company may be rapidly outflanked by efficient global competitors. This is exactly what happened to Xerox. Japanese companies such as Canon ultimately invented their way

Figure 8.4 Changes over Time

© Cengage Learning

around Xerox's patents, produced their own photocopying equipment in very efficient manufacturing plants, priced the machines below Xerox's products, and rapidly took global market share from Xerox. Xerox's demise was not due to the emergence of competitors, for ultimately that was bound to occur, but rather to its failure to proactively reduce its cost structure in advance of the emergence of efficient global competitors. The message in this story is that an international strategy may not be viable in the long term, and to survive, companies that are able to pursue it need to shift toward a global standardization strategy, or perhaps a transnational strategy, ahead of competitors (see Figure 8.4).

The same can be said about a localization strategy. Localization may give a company a competitive edge, but if it is simultaneously facing aggressive competitors, the company will also need to reduce its cost structure—and the only way to do that may be to adopt a transnational strategy. Thus, as competition intensifies, international and localization strategies tend to become less viable, and managers need to orientate their companies toward either a global standardization strategy or a transnational strategy. Strategy in Action 8.2 describes how this process occurred at Coca-Cola.

8.2 STRATEGY IN ACTION

The Evolving Strategy of Coca-Cola

© iStockPhoto.com/Tom Nulens

Coca-Cola, the iconic American soda maker, has long been among the most international of enterprises. The company made its first move outside the United States in 1902, when it entered Cuba. By 1929, Coke was marketed in 76 countries. In World War II, Coke struck a deal to supply the U.S. military with Coca-Cola, wherever soldiers might be stationed. During this era, the company built 63 bottling plants around the world. Its global push continued after the war, fueled in part by the belief that the U.S. market would eventually reach maturity, and by the perception that huge growth opportunities were overseas. By 2012 Coca Cola was operating in more than 200 countries and over 80% of Coke's case volume was in international markets.

Through until the early 1980s, Coke's strategy could best be characterized as one of considerable localization. Local operations were granted a high degree of independence to oversee operations as managers saw fit. This changed in the 1980s and 1990s under the leadership of Roberto Goizueta, a talented Cuban immigrant who became the CEO of Coke in 1981. Goizueta placed renewed emphasis on Coke's flagship brands, which were extended with the introduction of Diet Coke, Cherry Coke, and similar flavors. His prime belief was that the main difference between the United States and international markets was the lower level of penetration overseas, where consumption per capita of colas was only 10 to 15% of the U.S. figure. Goizueta pushed Coke to become a global company, centralizing a great deal of management and marketing activities at the corporate headquarters in Atlanta, focusing on core brands, and taking equity stakes in foreign bottlers so that the company could exert more strategic control over them. This one-size-fits-all strategy was built around standardization and the realization of economies of scale by, for example, using the same advertising message worldwide.

Goizueta's global strategy was adopted by his successor, Douglas Ivester, but by the late 1990s the drive toward a one-size-fits-all strategy was running out of steam, as smaller, more nimble local competitors that were marketing local beverages began to halt the Coke growth engine. When Coke began failing to hit its financial targets for the first time in a generation,

Ivester resigned in 2000 and was replaced by Douglas Daft. Daft instituted a 180-degree shift in strategy. Daft's belief was that Coke needed to put more power back in the hands of local country managers. He thought that strategy, product development, and marketing should be tailored to local needs. He laid off 6,000 employees, many of them in Atlanta, and granted country managers much greater autonomy. Moreover, in a striking move for a marketing company, he announced that the company would stop using global advertisements, and he placed advertising budgets and control over creative content back in the hands of country managers.

Ivester's move was, in part, influenced by the experience of Coke in Japan, the company's second most profitable market, where the best-selling Coca-Cola product is not a carbonated beverage, but a canned cold coffee drink, Georgia Coffee, that is sold in vending machines. The Japanese experience seemed to signal that products should be customized to local tastes and preferences, and that Coke would do well to decentralize more decision-making authority to local managers.

However, the shift toward localization didn't produce the growth that had been expected, and by 2002, the trend was moving back toward more central coordination, with Atlanta exercising *oversight* over marketing and product development in different nations outside the United States. But this time, it was not the one-size-fits-all ethos of the Goizueta era. Under the leadership of Neville Isdell, who became CEO in March 2004, senior managers at the corporate head office now reviewed and helped to guide local marketing and product development. However, Isdell adopted the belief that strategy (including pricing, product offerings, and marketing message) should be varied from market to market to match local conditions. Isdell's position, in other words, represented a midpoint between the strategy of Goizueta and the strategy of Daft. Moreover, Isdell has stressed the importance of leveraging good ideas across nations, for example, such as Georgia Coffee. Having seen the success of this beverage in Japan, in 2007, Coke entered into a strategic alliance with Illycaffè, one of Italy's premier coffee makers, to build a global franchise for canned or bottled cold coffee beverages. Similarly,

(continues)

8.2 STRATEGY IN ACTION

(continued)

© iStockPhoto.com/Tom Nulens

in 2003, the Coke subsidiary in China developed a low-cost non-carbonated orange-based drink that has rapidly become one of the best-selling drinks in that nation. Seeing the potential of the drink, Coke rolled it out in other Asian countries such as Thailand, where it has been a huge hit.

Sources: "Orange Gold," *The Economist*, March 3, 2007, p. 68; P. Bettis, "Coke Aims to Give Pepsi a Routing in Cold Coffee War," *Financial Times*, October 17, 2007, p. 16; P. Ghemawat, *Redefining Global Strategy* (Boston, Mass: Harvard Business School Press, 2007); D. Foust, "Queen of Pop," *Business Week*, August 7, 2006, pp. 44–47; and W. J. Holstein, "How Coca-Cola Manages 90 Emerging Markets," *Strategy+Business*, November 7, 2011, www.strategy-business.com/article/00093?pg=0.

THE CHOICE OF ENTRY MODE

Any firm contemplating entering a different national market must determine the best mode or vehicle for such entry. There are five primary choices of entry mode: exporting, licensing, franchising, entering into a joint venture with a host country company, and setting up a wholly owned subsidiary in the host country. Each mode has its advantages and disadvantages, and managers must weigh these carefully when deciding which mode to use.[17]

Exporting

Most manufacturing companies begin their global expansion as exporters and only later switch to one of the other modes for serving a foreign market. Exporting has two distinct advantages: it avoids the costs of establishing manufacturing operations in the host country, which are often substantial, and it may be consistent with scale economies and location economies. By manufacturing the product in a centralized location and then exporting it to other national markets, the company may be able to realize substantial scale economies from its global sales volume. That is how Sony came to dominate the global television market, how many Japanese auto companies originally made inroads into the U.S. auto market, and how Samsung gained share in the market for computer memory chips.

There are a number of drawbacks to exporting. First, exporting from the company's home base may not be appropriate if there are lower-cost locations for manufacturing the product abroad (that is, if the company can achieve location economies by moving production elsewhere). Thus, particularly in the case of a company pursuing a global standardization or transnational strategy, it may pay to manufacture in a location where conditions are most favorable from a value creation perspective and then export from that location to the rest of the globe. This is not so much an argument against exporting, but rather an argument against exporting from the company's home country. For example, many U.S. electronics companies have moved some of their manufacturing to Asia because low-cost but highly skilled labor is available there. They export from Asia to the rest of the globe, including the United States (this is what Apple does with the iPhone, see the opening case for Chapter 9.

Another drawback is that high transport costs can make exporting uneconomical, particularly in the case of bulk products. One way of alleviating this problem is to manufacture

bulk products on a regional basis, thereby realizing some economies from large-scale production while limiting transport costs. Many multinational chemical companies manufacture their products on a regional basis, serving several countries in a region from one facility.

Tariff barriers, too, can make exporting uneconomical, and a government's threat to impose tariff barriers can make the strategy very risky. Indeed, the implicit threat from the U.S. Congress to impose tariffs on Japanese cars imported into the United States led directly to the decision by many Japanese auto companies to set up manufacturing plants in the United States.

Finally, a common practice among companies that are just beginning to export also poses risks. A company may delegate marketing activities in each country in which it does business to a local agent, but there is no guarantee that the agent will act in the company's best interest. Often, foreign agents also carry the products of competing companies and thus have divided loyalties. Consequently, agents may not perform as well as the company would if it managed marketing itself. One way to solve this problem is to set up a wholly owned subsidiary in the host country to handle local marketing. In this way, the company can reap the cost advantages that arise from manufacturing the product in a single location and exercise tight control over marketing strategy in the host country.

Licensing

International licensing is an arrangement whereby a foreign licensee purchases the rights to produce a company's product in the licensee's country for a negotiated fee (normally, royalty payments on the number of units sold). The licensee then provides most of the capital necessary to open the overseas operation.[18] The advantage of licensing is that the company does not have to bear the development costs and risks associated with opening up a foreign market. Licensing therefore can be a very attractive option for companies that lack the capital to develop operations overseas. It can also be an attractive option for companies that are unwilling to commit substantial financial resources to an unfamiliar or politically volatile foreign market where political risks are particularly high.

Licensing has three serious drawbacks, however. First, it does not give a company the tight control over manufacturing, marketing, and strategic functions in foreign countries that it needs to have in order to realize scale economies and location economies—as companies pursuing both global standardization and transnational strategies try to do. Typically, each licensee sets up its manufacturing operations. Hence, the company stands little chance of realizing scale economies and location economies by manufacturing its product in a centralized location. When these economies are likely to be important, licensing may not be the best way of expanding overseas.

Second, competing in a global marketplace may make it necessary for a company to coordinate strategic moves across countries so that the profits earned in one country can be used to support competitive attacks in another. Licensing, by its very nature, severely limits a company's ability to coordinate strategy in this way. A licensee is unlikely to let a multinational company take its profits (beyond those due in the form of royalty payments) and use them to support an entirely different licensee operating in another country.

Third, there is risk associated with licensing technological knowhow to foreign companies. For many multinational companies, technological knowhow forms the basis of their competitive advantage, and they would want to maintain control over how this competitive advantage is put to use. By licensing its technology, a company can quickly lose control over it. RCA, for instance, once licensed its color television technology to a number of Japanese companies. The Japanese companies quickly assimilated RCA's technology and

then used it to enter the U.S. market. Now the Japanese have a bigger share of the U.S. market than the RCA brand does.

There are ways of reducing this risk. One way is by entering into a cross-licensing agreement with a foreign firm. Under a cross-licensing agreement, a firm might license some valuable intangible property to a foreign partner and, in addition to a royalty payment, also request that the foreign partner license some of its valuable knowhow to the firm. Such agreements are reckoned to reduce the risks associated with licensing technological knowhow, as the licensee realizes that if it violates the spirit of a licensing contract (by using the knowledge obtained to compete directly with the licensor), the licensor can do the same to it. Put differently, cross-licensing agreements enable firms to hold each other hostage, thereby reducing the probability that they will behave opportunistically toward each other.[19] Such cross-licensing agreements are increasingly common in high-technology industries. For example, the U.S. biotechnology firm Amgen licensed one of its key drugs, Neupogen, to Kirin, the Japanese pharmaceutical company. The license gives Kirin the right to sell Neupogen in Japan. In return, Amgen receives a royalty payment, and through a licensing agreement it gains the right to sell certain Kirin products in the United States.

Franchising

In many respects, franchising is similar to licensing, although franchising tends to involve longer-term commitments than licensing. Franchising is basically a specialized form of licensing in which the franchiser not only sells intangible property to the franchisee (normally a trademark), but also insists that the franchisee agree to abide by strict rules governing how it does business. The franchiser will often assist the franchisee to run the business on an ongoing basis. As with licensing, the franchiser typically receives a royalty payment, which amounts to a percentage of the franchisee revenues.

Whereas licensing is a strategy pursued primarily by manufacturing companies, franchising, which resembles it in some respects, is a strategy employed chiefly by service companies. McDonald's provides a good example of a firm that has grown by using a franchising strategy. McDonald's has set down strict rules as to how franchisees should operate a restaurant. These rules extend to control the menu, cooking methods, staffing policies, and restaurant design and location. McDonald's also organizes the supply chain for its franchisees and provides management training and financial assistance.[20]

The advantages of franchising are similar to those of licensing. Specifically, the franchiser does not need to bear the development costs and risks associated with opening up a foreign market on its own, for the franchisee typically assumes those costs and risks. Thus, using a franchising strategy, a service company can build up a global presence quickly and at a low cost.

The disadvantages of franchising are less pronounced than in licensing. Because service companies often use franchising, there is no reason to consider the need for coordination of manufacturing to achieve experience curve and location economies. But, franchising may inhibit the firm's ability to take profits out of one country to support competitive attacks in another. A more significant disadvantage of franchising is quality control. The foundation of franchising arrangements is that the firm's brand name conveys a message to consumers about the quality of the firm's product. Thus, a business traveler checking in at a Four Seasons hotel in Hong Kong can reasonably expect the same quality of room, food, and service that would be received in New York, Hawaii, or Ontario, Canada. The Four Seasons name is supposed to guarantee consistent product quality. This presents a problem in that foreign franchisees may not be as concerned about quality as they are supposed to be, and

the result of poor quality can extend beyond lost sales in a particular foreign market to a decline in the firm's worldwide reputation. For example, if the business traveler has a bad experience at the Four Seasons in Hong Kong, the traveler may never go to another Four Seasons hotel and may urge colleagues to do likewise. The geographical distance of the firm from its foreign franchisees can make poor quality difficult to detect. In addition, the numbers of franchisees—in the case of McDonald's, tens of thousands—can make quality control difficult. Due to these factors, quality problems may persist.

To reduce this problem, a company can set up a subsidiary in each country or region in which it is expanding. The subsidiary, which might be wholly owned by the company or a joint venture with a foreign company, then assumes the rights and obligations to establish franchisees throughout that particular country or region. The combination of proximity and the limited number of independent franchisees that need to be monitored reduces the quality control problem. Besides, because the subsidiary is at least partly owned by the company, the company can place its own managers in the subsidiary to ensure the kind of quality monitoring it wants. This organizational arrangement has proved very popular in practice; it has been used by McDonald's, KFC, and Hilton Worldwide to expand international operations, to name just three examples.

Joint Ventures

Establishing a joint venture with a foreign company has long been a favored mode for entering a new market. One of the most famous long-term joint ventures is the Fuji–Xerox joint venture to produce photocopiers for the Japanese market. The most typical form of joint venture is a 50/50 joint venture, in which each party takes a 50% ownership stake, and a team of managers from both parent companies shares operating control. Some companies have sought joint ventures in which they have a majority shareholding (for example, a 51% to 49% ownership split), which permits tighter control by the dominant partner.[21]

Joint ventures have a number of advantages. First, a company may feel that it can benefit from a local partner's knowledge of a host country's competitive conditions, culture, language, political systems, and business systems. Second, when the development costs and risks of opening up a foreign market are high, a company might gain by sharing these costs and risks with a local partner. Third, in some countries, political considerations make joint ventures the only feasible entry mode. Historically, for example, many U.S. companies found it much easier to obtain permission to set up operations in Japan if they joined with a Japanese partner than if they tried to enter on their own. This is why Xerox originally teamed up with Fuji to sell photocopiers in Japan.

Despite these advantages, there are major disadvantages with joint ventures. First, as with licensing, a firm that enters into a joint venture risks giving control of its technology to its partner. Thus, a proposed joint venture in 2002 between Boeing and Mitsubishi Heavy Industries to build a new wide-body jet (the 787), raised fears that Boeing might unwittingly give away its commercial airline technology to the Japanese. However, joint-venture agreements can be constructed to minimize this risk. One option is to hold majority ownership in the venture. This allows the dominant partner to exercise greater control over its technology—but it can be difficult to find a foreign partner who is willing to settle for minority ownership. Another option is to "wall off" from a partner technology that is central to the core competence of the firm, while sharing other technology.

A second disadvantage is that a joint venture does not give a firm the tight control over subsidiaries that it might need to realize experience curve or location economies. Nor does it give a firm the tight control over a foreign subsidiary that it might need for engaging in coordinated global attacks against its rivals. Consider the entry of Texas Instruments (TI)

into the Japanese semiconductor market. When TI established semiconductor facilities in Japan, it did so for the dual purpose of checking Japanese manufacturers' market share and limiting the cash they had available for invading TI's global market. In other words, TI was engaging in global strategic coordination. To implement this strategy, TI's subsidiary in Japan had to be prepared to take instructions from corporate headquarters regarding competitive strategy. The strategy also required the Japanese subsidiary to run at a loss if necessary. Few if any potential joint-venture partners would have been willing to accept such conditions, as it would have necessitated a willingness to accept a negative return on investment. Indeed, many joint ventures establish a degree of autonomy that would make such direct control over strategic decisions all but impossible to establish.[22] Thus, to implement this strategy, TI set up a wholly owned subsidiary in Japan.

Wholly Owned Subsidiaries

A wholly owned subsidiary is one in which the parent company owns 100% of the subsidiary's stock. To establish a wholly owned subsidiary in a foreign market, a company can either set up a completely new operation in that country or acquire an established host country company and use it to promote its products in the host market.

Setting up a wholly owned subsidiary offers three advantages. First, when a company's competitive advantage is based on its control of a technological competency, a wholly owned subsidiary will normally be the preferred entry mode, because it reduces the company's risk of losing this control. Consequently, many high-tech companies prefer wholly owned subsidiaries to joint ventures or licensing arrangements. Wholly owned subsidiaries tend to be the favored entry mode in the semiconductor, computer, electronics, and pharmaceutical industries.

Second, a wholly owned subsidiary gives a company the kind of tight control over operations in different countries that it needs if it is going to engage in global strategic coordination—taking profits from one country to support competitive attacks in another.

Third, a wholly owned subsidiary may be the best choice if a company wants to realize location economies and the scale economies that flow from producing a standardized output from a single or limited number of manufacturing plants. When pressures on costs are intense, it may pay a company to configure its value chain in such a way that value added at each stage is maximized. Thus, a national subsidiary may specialize in manufacturing only part of the product line or certain components of the end product, exchanging parts and products with other subsidiaries in the company's global system. Establishing such a global production system requires a high degree of control over the operations of national affiliates. Different national operations must be prepared to accept centrally determined decisions as to how they should produce, how much they should produce, and how their output should be priced for transfer between operations. A wholly owned subsidiary would have to comply with these mandates, whereas licensees or joint-venture partners would most likely shun such a subservient role.

On the other hand, establishing a wholly owned subsidiary is generally the most costly method of serving a foreign market. The parent company must bear all the costs and risks of setting up overseas operations—in contrast to joint ventures, where the costs and risks are shared, or licensing, where the licensee bears most of the costs and risks. But the risks of learning to do business in a new culture diminish if the company acquires an established host country enterprise. Acquisitions, however, raise a whole set of additional problems, such as trying to marry divergent corporate cultures, and these problems may more than offset the benefits. (The problems associated with acquisitions are discussed in Chapter 10.)

Choosing an Entry Strategy

The advantages and disadvantages of the various entry modes are summarized in Table 8.1. Inevitably, there are tradeoffs in choosing one entry mode over another. For example, when considering entry into an unfamiliar country with a track record of nationalizing foreign-owned enterprises, a company might favor a joint venture with a local enterprise. Its rationale might be that the local partner will help it establish operations in an unfamiliar environment and speak out against nationalization should the possibility arise. But if the company's distinctive competency is based on proprietary technology, entering into a joint venture might mean risking loss of control over that technology to the joint venture partner, which would make this strategy unattractive. Despite such hazards, some generalizations can be offered about the optimal choice of entry mode.

Table 8.1	The Advantages and Disadvantages of Different Entry Modes	
Entry Mode	**Advantages**	**Disadvantages**
Exporting	• Ability to realize location- and scale-based economies	• High transport costs • Trade barriers • Problems with local marketing agents
Licensing	• Low development costs and risks	• Inability to realize location- and scale-based economies • Inability to engage in global strategic coordination • Lack of control over technology
Franchising	• Low development costs and risks	• Inability to engage in global strategic coordination • Lack of control over quality
Joint Ventures	• Access to local partner's knowledge • Shared development costs and risks • Political dependency	• Inability to engage in global strategic coordination • Inability to realize location- and scale-based economies • Lack of control over technology
Wholly Owned Subsidiaries	• Protection of technology • Ability to engage in global strategic coordination • Ability to realize location- and scale-based economies	• High costs and risks

Distinctive Competencies and Entry Mode When companies expand internationally to earn greater returns from their differentiated product offerings, entering markets where indigenous competitors lack comparable products, the companies are pursuing an international strategy. The optimal entry mode for such companies depends to some degree upon the nature of their distinctive competency. In particular, we need to distinguish between companies with a distinctive competency in technological knowhow and those with a distinctive competency in management knowhow.

If a company's competitive advantage—its distinctive competency—derives from its control of proprietary technological knowhow, licensing and joint-venture arrangements should be avoided if possible to minimize the risk of losing control of that technology. Thus, if a high-tech company is considering setting up operations in a foreign country in order to profit from a distinctive competency in technological knowhow, it should probably do so through a wholly owned subsidiary.

However, this should not be viewed as a hard-and-fast rule. For instance, a licensing or joint-venture arrangement might be structured in such a way as to reduce the risks that licensees or joint-venture partners will expropriate a company's technological knowhow. (We consider this kind of arrangement in more detail later in the chapter when we discuss the issue of structuring strategic alliances.) Or consider a situation where a company believes its technological advantage will be short lived, and expects rapid imitation of its core technology by competitors. In this situation, the company might want to license its technology as quickly as possible to foreign companies in order to gain global acceptance of its technology before imitation occurs.[23] Such a strategy has some advantages. By licensing its technology to competitors, the company may deter them from developing their own, possibly superior, technology. It also may be able to establish its technology as the dominant design in the industry, ensuring a steady stream of royalty payments. Such situations aside, however, the attractions of licensing are probably outweighed by the risks of losing control of technology, and therefore licensing should be avoided.

The competitive advantage of many service companies, such as McDonald's or Hilton Worldwide, is based on management knowhow. For such companies, the risk of losing control of their management skills to franchisees or joint-venture partners is not that great. The reason is that the valuable asset of such companies is their brand name, and brand names are generally well protected by international laws pertaining to trademarks. Given this fact, many of the issues that arise in the case of technological knowhow do not arise in the case of management knowhow. As a result, many service companies favor a combination of franchising and subsidiaries to control franchisees within a particular country or region. The subsidiary may be wholly owned or a joint venture. In most cases, however, service companies have found that entering into a joint venture with a local partner in order to set up a controlling subsidiary in a country or region works best because a joint venture is often politically more acceptable and brings a degree of local knowledge to the subsidiary.

Pressures for Cost Reduction and Entry Mode The greater the pressures for cost reductions, the more likely that a company will want to pursue some combination of exporting and wholly owned subsidiaries. By manufacturing in the locations where factor conditions are optimal and then exporting to the rest of the world, a company may be able to realize substantial location economies and substantial scale economies. The company might then want to export the finished product to marketing subsidiaries based in various countries. Typically, these subsidiaries would be wholly owned and have the responsibility for overseeing distribution in a particular country. Setting up wholly owned marketing subsidiaries

is preferable to a joint venture arrangement or using a foreign marketing agent because it gives the company the tight control over marketing that might be required to coordinate a globally dispersed value chain. In addition, tight control over a local operation enables the company to use the profits generated in one market to improve its competitive position in another market. Hence companies pursuing global or transnational strategies prefer to establish wholly owned subsidiaries.

GLOBAL STRATEGIC ALLIANCES

Global strategic alliances are cooperative agreements between companies from different countries that are actual or potential competitors. Strategic alliances range from formal joint ventures, in which two or more companies have an equity stake, to short-term contractual agreements, in which two companies may agree to cooperate on a particular problem (such as developing a new product).

global strategic alliances Cooperative agreements between companies from different countries that are actual or potential competitors.

Advantages of Strategic Alliances

Companies enter into strategic alliances with competitors to achieve a number of strategic objectives.[24] First, strategic alliances may facilitate entry into a foreign market. For example, many firms feel that if they are to successfully enter the Chinese market, they need a local partner who understands business conditions, and who has good connections. Thus, Warner Brothers entered into a joint venture with two Chinese partners to produce and distribute films in China. As a foreign film company, Warner found that if it wanted to produce films on its own for the Chinese market, it had to go through a complex approval process for every film. It also had to farm out distribution to a local company, which made doing business in China very difficult. Due to the participation of Chinese firms, however, the joint-venture films will require a streamlined approval process, and the venture will be able to distribute any films it produces. Moreover, the joint venture will be able to produce films for Chinese TV, something that foreign firms are not allowed to do.[25]

Second, strategic alliances allow firms to share the fixed costs (and associated risks) of developing new products or processes. An alliance between Boeing and a number of Japanese companies to build Boeing's latest commercial jetliner, the 787, was motivated by Boeing's desire to share the estimated $8 billion investment required to develop the aircraft.

Third, an alliance is a way to bring together complementary skills and assets that neither company could easily develop on its own.[26] In 2011, for example, Microsoft and Nokia established an alliance aimed at developing and marketing smartphones that used Microsoft's Windows 8 operating system. Microsoft contributed its software engineering skills, particularly with regard to the development of a version of its Windows operating system for smartphones, and Nokia contributed its design, engineering, and marketing knowhow. The first phones resulting from this collaboration reached the market in late 2012.

Fourth, it can make sense to form an alliance that will help firms establish technological standards for the industry that will benefit the firm. This was also a goal of the alliance between Microsoft and Nokia. The idea is to try to establish Windows 8 as the de facto operating system for smartphones in the face of strong competition from Apple, with its iPhone, and Google, whose Android operating system was the most widely used smartphone operating system in the world in 2012.

Disadvantages of Strategic Alliances

The advantages we have discussed can be very significant. Despite this, some commentators have criticized strategic alliances on the grounds that they give competitors a low-cost route to new technology and markets.[27] For example, a few years ago some commentators argued that many strategic alliances between U.S. and Japanese firms were part of an implicit Japanese strategy to keep high-paying, high-value-added jobs in Japan while gaining the project engineering and production process skills that underlie the competitive success of many U.S. companies.[28] They argued that Japanese success in the machine tool and semiconductor industries was built on U.S. technology acquired through strategic alliances. And they argued that U.S. managers were aiding the Japanese by entering alliances that channel new inventions to Japan and provide a U.S. sales and distribution network for the resulting products. Although such deals may generate short-term profits, so the argument goes, in the long term, the result is to "hollow out" U.S. firms, leaving them with no competitive advantage in the global marketplace.

These critics have a point; alliances have risks. Unless a firm is careful, it can give away more than it receives. But there are so many examples of apparently successful alliances between firms—including alliances between U.S. and Japanese firms—that this position appears extreme. It is difficult to see how the Microsoft–Toshiba alliance, the Boeing–Mitsubishi alliance for the 787, or the Fuji–Xerox alliance fit the critics' thesis. In these cases, both partners seem to have gained from the alliance. Why do some alliances benefit both firms while others benefit one firm and hurt the other? The next section provides an answer to this question.

Making Strategic Alliances Work

The failure rate for international strategic alliances is quite high. For example, one study of 49 international strategic alliances found that two-thirds run into serious managerial and financial troubles within 2 years of their formation, and that although many of these problems are ultimately solved, 33% are rated as failures by the parties involved.[29] The success of an alliance seems to be a function of three main factors: partner selection, alliance structure, and the manner in which the alliance is managed.

Partner Selection One of the keys to making a strategic alliance work is to select the right kind of partner. A good partner has three principal characteristics. First, a good partner helps the company achieve strategic goals such as achieving market access, sharing the costs and risks of new-product development, or gaining access to critical core competencies. In other words, the partner must have capabilities that the company lacks and that it values. Second, a good partner shares the firm's vision for the purpose of the alliance. If two companies approach an alliance with radically different agendas, the chances are great that the relationship will not be harmonious and the partnership will end.

Third, a good partner is unlikely to try to exploit the alliance opportunistically for its own ends—that is, to expropriate the company's technological knowhow while giving away little in return. In this respect, firms with reputations for fair play probably make the best partners. For example, IBM is involved in so many strategic alliances that it would not pay the company to trample over individual alliance partners.[30] This would tarnish IBM's reputation of being a good ally and would make it more difficult for IBM to attract alliance partners. Because IBM attaches great importance to its alliances, it is unlikely to engage in the kind of opportunistic behavior that critics highlight. Similarly, their reputations make

it less likely (but by no means impossible) that such Japanese firms as Sony, Toshiba, and Fuji, which have histories of alliances with non-Japanese firms, would opportunistically exploit an alliance partner.

To select a partner with these three characteristics, a company needs to conduct some comprehensive research on potential alliance candidates. To increase the probability of selecting a good partner, the company should collect as much pertinent, publicly available information about potential allies as possible; collect data from informed third parties, including companies that have had alliances with the potential partners, investment bankers who have had dealings with them, and some of their former employees; and get to know potential partners as well as possible before committing to an alliance. This last step should include face-to-face meetings between senior managers (and perhaps middle-level managers) to ensure that the chemistry is right.

Alliance Structure Having selected a partner, the alliance should be structured so that the company's risk of giving too much away to the partner is reduced to an acceptable level. First, alliances can be designed to make it difficult (if not impossible) to transfer technology not meant to be transferred. Specifically, the design, development, manufacture, and service of a product manufactured by an alliance can be structured to "wall off" sensitive technologies to prevent their leakage to the other participant. In the alliance between General Electric and Snecma to build commercial aircraft engines, for example, GE reduced the risk of "excess transfer" by walling off certain steps of the production process. The modularization effectively cut off the transfer of what GE regarded as key competitive technology while permitting Snecma access to final assembly. Similarly, in the alliance between Boeing and the Japanese to build the 787, Boeing walled off research, design, and marketing functions considered central to its competitive position, while allowing the Japanese to share in production technology. Boeing also walled off new technologies not required for 787 production.[31]

Second, contractual safeguards can be written into an alliance agreement to guard against the risk of **opportunism** by a partner. For example, TRW has three strategic alliances with large Japanese auto component suppliers to produce seat belts, engine valves, and steering gears for sale to Japanese-owned auto assembly plants in the United States. TRW has clauses in each of its alliance contracts that bar the Japanese firms from competing with TRW to supply U.S.-owned auto companies with component parts. By doing this, TRW protects itself against the possibility that the Japanese companies are entering into the alliances merely as a means of gaining access to the North American market to compete with TRW in its home market.

Third, both parties in an alliance can agree in advance to exchange skills and technologies that the other covets, thereby ensuring a chance for equitable gain. Cross-licensing agreements are one way to achieve this goal.

Fourth, the risk of opportunism by an alliance partner can be reduced if the firm extracts a significant credible commitment from its partner in advance. The long-term alliance between Xerox and Fuji to build photocopiers for the Asian market perhaps best illustrates this. Rather than enter into an informal agreement or a licensing arrangement (which Fujifilm initially wanted), Xerox insisted that Fuji invest in a 50/50 joint venture to serve Japan and East Asia. This venture constituted such a significant investment in people, equipment, and facilities that Fujifilm was committed from the outset to making the alliance work in order to earn a return on its investment. By agreeing to the joint venture, Fuji essentially made a credible commitment to the alliance. Given this, Xerox felt secure in transferring its photocopier technology to Fuji.

opportunism
Seeking one's own self-interest, often through the use of guile.

Managing the Alliance Once a partner has been selected and an appropriate alliance structure agreed on, the task facing the company is to maximize the benefits from the alliance. One important ingredient of success appears to be sensitivity to cultural differences. Many differences in management style are attributable to cultural differences, and managers need to make allowances for these when dealing with their partners. Beyond this, maximizing the benefits from an alliance seems to involve building trust between partners and learning from partners.[32]

Managing an alliance successfully requires building interpersonal relationships between the firms' managers, or what is sometimes referred to as *relational capital*.[33] This is one lesson that can be drawn from a strategic alliance between Ford and Mazda. Ford and Mazda set up a framework of meetings within which their managers not only discuss matters pertaining to the alliance, but also have time to get to know one another better. The belief is that the resulting friendships help build trust and facilitate harmonious relations between the two firms. Personal relationships also foster an informal management network between the firms. This network can then be used to help solve problems arising in more formal contexts (such as in joint committee meetings between personnel from the two firms).

Academics have argued that a major determinant of how much acquiring knowledge a company gains from an alliance is its ability to learn from its alliance partner.[34] For example, in a study of 15 strategic alliances between major multinationals, Gary Hamel, Yves Doz, and C. K. Prahalad focused on a number of alliances between Japanese companies and Western (European or American) partners.[35] In every case in which a Japanese company emerged from an alliance stronger than its Western partner, the Japanese company had made a greater effort to learn. Few Western companies studied seemed to want to learn from their Japanese partners. They tended to regard the alliance purely as a cost-sharing or risk-sharing device, rather than as an opportunity to learn how a potential competitor does business.

For an example of an alliance in which there was a clear learning asymmetry, consider the agreement between General Motors and Toyota Motor Corp. to build the Chevrolet Nova. This alliance was structured as a formal joint venture, New United Motor Manufacturing, in which both parties had a 50% equity stake. The venture owned an auto plant in Fremont, California. According to one of the Japanese managers, Toyota achieved most of its objectives from the alliance: "We learned about U.S. supply and transportation. And we got the confidence to manage U.S. workers." All that knowledge was then quickly transferred to Georgetown, Kentucky, where Toyota opened a plant of its own. By contrast, although General Motors (GM) got a new product, the Chevrolet Nova, some GM managers complained that their new knowledge was never put to good use inside GM. They say that they should have been kept together as a team to educate GM's engineers and workers about the Japanese system. Instead, they were dispersed to different GM subsidiaries.[36]

When entering an alliance, a company must take some measures to ensure that it learns from its alliance partner and then puts that knowledge to good use within its own organization. One suggested approach is to educate all operating employees about the partner's strengths and weaknesses and make clear to them how acquiring particular skills will bolster their company's competitive position. For such learning to be of value, the knowledge acquired from an alliance must be diffused throughout the organization—which did not happen at GM. To spread this knowledge, the managers involved in an alliance should be used as a resource in familiarizing others within the company about the skills of an alliance partner.

SUMMARY OF CHAPTER

1. For some companies, international expansion represents a way of earning greater returns by transferring the skills and product offerings derived from their distinctive competencies to markets where indigenous competitors lack those skills. As barriers to international trade have fallen, industries have expanded beyond national boundaries and industry competition and opportunities have increased.

2. Because of national differences, it pays for a company to base each value creation activity it performs at the location where factor conditions are most conducive to the performance of that activity. This strategy is known as focusing on the attainment of location economies.

3. By building sales volume more rapidly, international expansion can help a company gain a cost advantage through the realization of scale economies and learning effects.

4. The best strategy for a company to pursue may depend on the kind of pressures it must cope with: pressures for cost reductions or for local responsiveness. Pressures for cost reductions are greatest in industries producing commodity-type products, where price is the main competitive weapon. Pressures for local responsiveness arise from differences in consumer tastes and preferences, as well as from national infrastructure and traditional practices, distribution channels, and host government demands.

5. Companies pursuing an international strategy transfer the skills and products derived from distinctive competencies to foreign markets, while undertaking some limited local customization.

6. Companies pursuing a localization strategy customize their product offerings, marketing strategies, and business strategies to national conditions.

7. Companies pursuing a global standardization strategy focus on reaping the cost reductions that come from scale economies and location economies.

8. Many industries are now so competitive that companies must adopt a transnational strategy. This involves a simultaneous focus upon reducing costs, transferring skills and products, and being locally responsive. Implementing such a strategy may not be easy.

9. There are five different ways of entering a foreign market: exporting, licensing, franchising, entering into a joint venture, and setting up a wholly owned subsidiary. The optimal choice among entry modes depends on the company's strategy.

10. Strategic alliances are cooperative agreements between actual or potential competitors. The advantages of alliances are that they facilitate entry into foreign markets, enable partners to share the fixed costs and risks associated with new products and processes, facilitate the transfer of complementary skills between companies, and help companies establish technical standards.

11. The drawbacks of a strategic alliance are that the company risks giving away technological knowhow and market access to its alliance partner while getting very little in return.

12. The disadvantages associated with alliances can be reduced if the company selects partners carefully, paying close attention to reputation, and structures the alliance in order to avoid unintended transfers of knowhow.

DISCUSSION QUESTIONS

1. Plot the position of the following companies on Figure 8.3: Microsoft, Google, Coca-Cola, Dow Chemicals, Pfizer, and McDonald's. In each case, justify your answer.

2. Are the following global standardization industries, or industries where localization is more important: bulk chemicals, pharmaceuticals, branded food products, moviemaking, television manufacture, personal computers, airline travel, fashion retailing?

3. Discuss how the need for control over foreign operations varies with the strategy and distinctive competencies of a company. What are the implications of this relationship for the choice of entry mode?

4. Licensing proprietary technology to foreign competitors is the best way to give up a company's competitive advantage. Discuss.

5. What kind of companies stand to gain the most from entering into strategic alliances with potential competitors? Why?

PRACTICING STRATEGIC MANAGEMENT

© iStockPhoto.com/Urilux

Small-Group Exercise: Developing a Global Strategy

Break into groups of three to five people, and discuss the following scenario. Appoint one group member as a spokesperson who will communicate your findings to the class. You work for a company in the soft drink industry that has developed a line of carbonated fruit-based drinks. You have already established a significant presence in your home market, and now you are planning the global strategy development of the company in the soft drink industry. You need to decide the following:

1. What overall strategy to pursue: a global standardization strategy, a localization strategy, an international strategy, or a transnational strategy
2. Which markets to enter first
3. What entry strategy to pursue (e.g., franchising, joint venture, wholly owned subsidiary)
4. What information do you need to make this kind of decision? Considering what you do know, what strategy would you recommend?

STRATEGY SIGN-ON

© iStockPhoto.com/Ninoslav Dotlic

Article File 8

Find an example of a multinational company that in recent years has switched its strategy from a localization, international, or global standardization strategy to a transnational strategy. Identify why the company made the switch and any problems that the company may be encountering while it tries to change its strategic orientation.

Strategic Management Project: Module 8

This module requires you to identify how your company might profit from global expansion, the strategy that your company should pursue globally, and the entry mode that it might favor. With the information you have at your disposal, answer the questions regarding the following two situations:

Your company is already doing business in other countries.

1. Is your company creating value or lowering the costs of value creation by realizing location economies, transferring distinctive competencies abroad, or realizing cost economies from the economies of scale? If not, does it have the potential to do so?

(continues)

STRATEGY SIGN ON

© iStockPhoto.com/Ninoslav Dotlic

(continued)

2. How responsive is your company to differences among nations? Does it vary its product and marketing message from country to country? Should it?
3. What are the cost pressures and pressures for local responsiveness in the industry in which your company is based?
4. What strategy is your company pursuing to compete globally? In your opinion, is this the correct strategy, given cost pressures and pressures for local responsiveness?
5. What major foreign market does your company serve, and what mode has it used to enter this market? Why is your company active in these markets and not others? What are the advantages and disadvantages of using this mode? Might another mode be preferable?

Your company is not yet doing business in other countries.

1. What potential does your company have to add value to its products or lower the costs of value creation by expanding internationally?
2. On the international level, what are the cost pressures and pressures for local responsiveness in the industry in which your company is based? What implications do these pressures have for the strategy that your company might pursue if it chose to expand globally?
3. What foreign market might your company enter, and what entry mode should it use to enter this market? Justify your answer.

ETHICAL DILEMMA

© iStockPhoto.com/P_Wei

Your company has established a manufacturing subsidiary in southern China. Labor costs at this factory are much lower than in your home market. Employees also work 10 hours a day, 6 days a week, with mandatory overtime often pushing that to 12 hours a day. They are paid the local minimum wage. The factory also does not adhere to the same standards for environmental protection and employee safety as those mandated in your home nation. On a visit to the factory you notice these things, and ask the expatriate manager who heads up the operation if he should be doing something to improve working conditions and environmental protection. He replies that his view is that "when in Rome, do as the Romans do." He argues that the situation at the factory is normal for China, and he is complying at with all local regulations and laws. Moreover, he notes that the company established this subsidiary to have a low-cost manufacturing base. Improving working conditions and environmental standards beyond those mandated by local laws would not be consistent with this goal.

Is the position taken by the expatriate manager the correct one? Is it ethical? What are the potential negative consequences, if any, of continuing to operate in this manner? What benefits might there be to the company of taking steps to raise working conditions and environmental protection beyond those mandated by local regulations?

CLOSING CASE

Avon Products

For six years after Andrea Jung became CEO in 1999 of Avon Products, the beauty products company famous for its direct sales model, revenues grew in excess of 10% a year. Profits tripled, making Jung a Wall Street favorite. Then in 2005, the success story started to turn ugly. Avon, which derives as much as 70% of its revenues from international markets, mostly in developing nations, suddenly began losing sales across the globe. A ban on direct sales had hurt its business in China (the Chinese government had accused companies that used a direct sales model of engaging in pyramid schemes and of creating "cults"). To compound matters, economic weakness in Eastern Europe, Russia, and Mexico, all drivers of Avon's success, stalled growth there. The dramatic turn of events took investors by surprise. In May 2005 Jung had told investors that Avon would exceed Wall Street's targets for the year. By September she was rapidly backpedaling, and the stock fell 45%.

With her job on the line, Jung began to reevaluate Avon's global strategy. Until this point, the company had expanded primarily by replicating its U.S. strategy and organization in other countries. When it entered a nation, it gave country managers considerable autonomy. All used the Avon brand name and adopted the direct sales model that has been the company's hallmark. The result was an army of 5 million Avon representatives around the world, all independent contractors, who sold the company's skin care and makeup products. However, many country managers also set up their own local manufacturing operations and supply chains, were responsible for local marketing, and developed their own new products. In Jung's words, "they were the king or queen of every decision." The result was a lack of consistency in marketing strategy from nation to nation, extensive duplication of manufacturing operations and supply chains, and a profusion of new products, many of which were not profitable. In Mexico, for example, the roster of products for sale had ballooned to 13,000. The company had 15 layers

of management, making accountability and communication problematic. There was also a distinct lack of data-driven analysis of new-product opportunities, with country managers often making decisions based on their intuition or gut feeling.

Jung's turnaround strategy involved several elements. To help transform Avon, she hired seasoned managers from well-known global consumer products companies such as P&G and Unilever. She flattened the organization to improve communication, performance visibility, and accountability, reducing the number of management layers to just eight and laying off 30% of managers. Manufacturing was consolidated in a number of regional centers, and supply chains were rationalized, eliminating duplication and reducing costs by more than $1 billion a year. Rigorous return-on-investment criteria were introduced to evaluate product profitability. As a consequence, 25% of Avon's products were discontinued. New-product decisions were centralized at Avon's headquarters. Jung also invested in centralized product development. The goal was to develop and introduce blockbuster new products that could be positioned as global brands. And Jung pushed the company to emphasize its value proposition in every national market, which could be characterized as high quality at a low price.

By 2007 this strategy was starting to yield dividends. The company's performance improved and growth resumed. It didn't hurt that Jung, a Chinese-American who speaks Mandarin, was instrumental in persuading Chinese authorities to rescind the ban on direct sales, allowing Avon to recruit 400,000 new representatives in China. Then in 2008 and 2009, the global financial crisis hit. Jung's reaction: This was an opportunity for Avon to expand its business. In 2009, Avon ran ads around the world aimed at recruiting sales representatives. In the ads, female sales representatives talked about working for Avon. "I can't get laid off, I can't get fired," is what one said. Phones started to ring of the hook, and Avon was quickly able

to expand its global sales force. She also instituted an aggressive pricing strategy, and packaging was redesigned for a more elegant look at no additional cost. The idea was to emphasize the "value for money" the Avon products represented. Media stars were used in ads to help market the company's products, and Avon pushed its representatives to use online social networking sites as a medium for representatives to market themselves.

The result of all this was initially good: In the difficult years of 2008 and 2009, Avon gained global market share and its financial performance improved. However, the company started to stumble again in 2010 and 2011. The reasons were complex. In many of Avon's important emerging markets the company found itself increasingly on the defensive against rivals such as P&G that were building a strong retail presence there. Meanwhile, sales in developed markets sputtered

in the face of persistently slow economic growth. To complicate matters, there were reports of numerous operational mistakes—problems with implementing information systems, for example—that were costly for the company. Avon also came under fire for a possible violation of the Foreign Corrupt Practices Act when it was revealed that some executives in China had been paying bribes to local government officials. Under pressure from investors, in December 2011 Andrea Jung relinquished her CEO role, although she will stay on as Chairman until at least 2014.

Sources: A. Chang, "Avon's Ultimate Makeover Artist," *Market-Watch,* December 3, 2009; N. Byrnes, "Avon: More Than Cosmetic Change," *Businessweek,* March 3, 2007, pp. 62–63; J. Hodson, "Avon 4Q Profit Jumps on Higher Overseas Sales," *Wall Street Journal* (online), February 4, 2010; and M. Boyle, "Avon Surges After Saying That Andrea Jung Will Step Down as CEO," Bloomberg Business Week, December 15, 2011.

CASE DISCUSSION QUESTIONS

1. What strategy was Avon pursuing until the mid-2000s? What were the advantages of this strategy? What were the disadvantages?
2. What changes did Andrea Jung make in Avon's strategy after 2005? What were the benefits of these changes? Can you see any drawbacks?
3. In terms of the framework introduced in this chapter, what strategy was Avon pursuing by the late 2000s?
4. Do you think that Avon's problems in 2010 and 2011 were a result of the changes in its strategy, or were there other reasons for this?

KEY TERMS

Multinational company 256
Location economies 259

Global standardization strategy 265
Localization strategy 266

Transnational strategy 267
Global strategic alliances 278

Opportunism 280

NOTES

[1]World Trade Organization (WTO), *International Trade Statistics 2012* (Geneva: WHO, 2012).

[2]Ibid.; and United Nations, *World Investment Report, 2012* (New York and Geneva: United Nations, 2012).

[3]P. Dicken, *Global Shift* (New York: Guilford Press, 1992).

[4]D. Pritchard, "Are Federal Tax Laws and State Subsidies for Boeing 7E7 Selling America Short?" *Aviation Week,* April 12, 2004, pp. 74–75.

[5]T. Levitt, "The Globalization of Markets," *Harvard Business Review,* May–June 1983, pp. 92–102.

[6]M. E. Porter, *The Competitive Advantage of Nations* (New York: Free Press, 1990). See also R. Grant, "Porter's Competitive Advantage of Nations: An Assessment," *Strategic Management Journal* 7 (1991): 535–548.

[7]Porter, *Competitive Advantage of Nations*.

[8]See J. Birkinshaw and N. Hood, "Multinational Subsidiary Evolution: Capability and Charter Change in Foreign Owned Subsidiary Companies," *Academy of Management Review* 23 (October 1998), pp. 773–795; A. K. Gupta and V. J. Govindarajan, "Knowledge Flows Within Multinational Corporations," *Strategic Management Journal* 21 (2000), pp. 473–496; V. J. Govindarajan and A. K. Gupta, *The Quest for Global Dominance* (San Francisco: Jossey-Bass, 2001); T. S. Frost, J. M. Birkinshaw, and P. C. Ensign, "Centers of Excellence in Multinational Corporations," *Strategic Management Journal* 23 (2002), pp. 997–1018; and U. Andersson, M. Forsgren, and U. Holm, "The Strategic Impact of External Networks,"

Strategic Management Journal 23 (2002), pp. 979–996.

[9]S. Leung, "Armchairs, TVs and Espresso: Is It McDonald's?" *Wall Street Journal,* August 30, 2002, pp. A1, A6.

[10]C. K. Prahalad and Yves L. Doz, *The Multinational Mission: Balancing Local Demands and Global Vision* (New York: Free Press, 1987). See also J. Birkinshaw, A. Morrison, and J. Hulland, "Structural and Competitive Determinants of a Global Integration Strategy," *Strategic Management Journal* 16 (1995): 637–655.

[11]J. E. Garten, "Walmart Gives Globalization a Bad Name," *Business Week*, March 8, 2004, p. 24.

[12]Prahalad and Doz, *Multinational Mission*. Prahalad andDoz actually talk about local responsivenessrather than local customization.

[13]Levitt, "Globalization of Markets."

[14]W.W. Lewis. *The Power of Productivity* (Chicago, University of Chicago Press, 2004).

[15]Bartlett and Ghoshal, *Managing Across Borders*.

[16]Ibid.

[17]T. Hout, M. E. Porter, and E. Rudden, "How Global Companies Win Out," *Harvard Business Review,* September–October 1982, pp. 98–108.

[18]This section draws on numerous studies, including: C. W. L. Hill, P. Hwang, and W. C. Kim, "An Eclectic Theory of the Choice of International Entry Mode," *Strategic Management Journal* 11 (1990), pp. 117–28; C. W. L. Hill and W. C. Kim, "Searching for a Dynamic Theory of the Multinational Enterprise:

A Transaction Cost Model," *Strategic Management Journal* 9 (Special Issue on Strategy Content, 1988), pp. 93–104; E. Anderson and H. Gatignon, "Modes of Foreign Entry: A Transaction Cost Analysis and Propositions," *Journal of International Business Studies* 17 (1986), pp. 1–26; F. R. Root, *Entry Strategies for International Markets* (Lexington, MA: D. C. Heath, 1980); A. Madhok, "Cost, Value and Foreign Market Entry: The Transaction and the Firm," *Strategic Management Journal* 18 (1997), pp. 39–61; K. D. Brouthers and L. B. Brouthers, "Acquisition or Greenfield Start-Up?" *Strategic Management Journal* 21:1 (2000): 89–97; X. Martin and R. Salmon, "Knowledge Transfer Capacity and Its Implications for the Theory of the Multinational Enterprise," *Journal of International Business Studies,* July 2003, p. 356; and A. Verbeke, "The Evolutionary View of the MNE and the Future of Internalization Theory," *Journal of International Business Studies,* November 2003, pp. 498–515.

[19]F. J. Contractor, "The Role of Licensing in International Strategy," *Columbia Journal of World Business*, Winter 1982, pp. 73–83.

[20]Andrew E. Serwer, "McDonald's Conquers the World," *Fortune,* October 17, 1994, pp. 103–116.

[21]For an excellent review of the basic theoretical literature of joint ventures, see B. Kogut, "Joint Ventures: Theoretical and Empirical Perspectives," *Strategic Management Journal* 9 (1988), pp. 319–32. More recent studies include T. Chi, "Option to Acquire or Divest a Joint Venture," *Strategic Management Journal* 21:6

(2000): 665–688; H. Merchant and D. Schendel, "How Do International Joint Ventures Create Shareholder Value?" *Strategic Management Journal* 21:7 (2000): 723–37; H. K. Steensma and M. A. Lyles, "Explaining IJV Survival in a Transitional Economy Through Social Exchange and Knowledge Based Perspectives," *Strategic Management Journal* 21:8 (2000): 831–851; and J. F. Hennart and M. Zeng, "Cross Cultural Differences and Joint Venture Longevity," *Journal of International Business Studies,* December 2002, pp. 699–717.

[22]J. A. Robins, S. Tallman, and K. Fladmoe-Lindquist, "Autonomy and Dependence of International Cooperative Ventures," *Strategic Management Journal,* October 2002, pp. 881–902.

[23]C. W. L. Hill, "Strategies for Exploiting Technological Innovations," *Organization Science* 3 (1992): 428–441.

[24]See K. Ohmae, "The Global Logic of Strategic Alliances," *Harvard Business Review*, March–April 1989, pp. 143–154; G. Hamel, Y. L. Doz, and C. K. Prahalad, "Collaborate with Your Competitors and Win!" *Harvard Business Review,* January–February 1989, pp. 133–139; W. Burgers, C. W. L. Hill, and W. C. Kim, "Alliances in the Global Auto Industry," *Strategic Management Journal* 14 (1993): 419–432; and P. Kale, H. Singh, and H. Perlmutter, "Learning and Protection of Proprietary Assets in Strategic Alliances: Building Relational Capital," *Strategic Management Journal* 21 (2000): 217–237.

[25]L. T. Chang, "China Eases Foreign Film Rules," *Wall Street Journal,* October 15, 2004, p. B2.

[26]B. L. Simonin, "Transfer of Marketing Knowhow in International Strategic Alliances," *Journal of International Business Studies,* 1999, pp. 463–91, and J. W. Spencer, "Firms' Knowledge Sharing Strategies in the Global Innovation System," *Strategic Management Journal* 24 (2003): 217–233.

[27]Kale et al., "Learning and Protection of Proprietary Assets."

[28]R. B. Reich and E. D. Mankin, "Joint Ventures with Japan Give Away Our Future," *Harvard Business Review,* March–April 1986, pp. 78–90.

[29]J. Bleeke and D. Ernst, "The Way to Win in Cross-Border Alliances," *Harvard Business Review,* November–December 1991, pp. 127–135.

[30]E. Booker and C. Krol, "IBM Finds Strength in Alliances," *B to B,* February 10, 2003, pp. 3, 27.

[31]W. Roehl and J. F. Truitt, "Stormy Open Marriages Are Better," *Columbia Journal of World Business*, Summer 1987, pp. 87–95.

[32]See T. Khanna, R. Gulati, and N. Nohria, "The Dynamics of Learning Alliances: Competition, Cooperation, and Relative Scope," *Strategic Management Journal* 19 (1998): 193–210; Kale et al., "Learning and Protection of Proprietary Assets."

[33]Kale, Singh, and Perlmutter, "Learning and Protection of Proprietary Assets."

[34]Hamel et al., "Collaborate with Competitors"; Khanna et al., "The Dynamics of Learning Alliances"; and E. W. K. Tang, "Acquiring Knowledge by Foreign Partners from International Joint Ventures in a Transition Economy: Learning by Doing and Learning Myopia," *Strategic Management Journal* 23 (2002): 835–854.

[35]Hamel et al., "Collaborate with Competitors."

[36]B. Wysocki, "Cross Border Alliances Become Favorite Way to Crack New Markets," *Wall Street Journal,* March 4, 1990, p. A1.

Corporate-Level Strategy: Horizontal Integration, Vertical Integration, and Strategic Outsourcing

LEARNING OBJECTIVES

After reading this chapter, you should be able to:

9-1 Discuss how corporate-level strategy can be used to strengthen a company's business model and business-level strategies

9-2 Define *horizontal integration* and discuss the primary advantages and disadvantages associated with this corporate-level strategy

9-3 Explain the difference between a company's internal value chain and the industry value chain

9-4 Describe why, and under what conditions, cooperative relationships such as strategic alliances and outsourcing may become a substitute for vertical integration

OPENING CASE

Outsourcing and Vertical Integration at Apple

At a dinner for Silicon Valley's luminaries in February of 2011, U.S. President Barack Obama asked Steve Jobs of Apple, "What would it take to make iPhones in the United States?" Steve Jobs replied, "Those jobs aren't coming back." Apple's management had concluded that overseas factories provided superior scale, flexibility, diligence, and access to industrial skills—"Made in the U.S.A." just did not make sense for Apple anymore.

As an example of the superior responsiveness of Chinese factories to Apple's needs, an executive described a recent event when Apple wanted to revamp its iPhone manufacturing just weeks before it was scheduled for delivery to stores. At the last minute, Apple had redesigned the screen, and new screens arrived at the Chinese factory at midnight. Fortunately, the 8,000 workers slept in dormitories at the factory—they

were woken, given a cookie and a cup of tea, and were at work fitting glass screens into their beveled frames within 30 minutes. Soon the plant was producing 10,000 iPhones per day. The executive commented, "The speed and flexibility is breathtaking. . . There's no American plant that can match that."

"Foxconn City," a complex where the iPhone is assembled, has 230,000 employees, many of whom work 6 days a week and up to 12 hours a day. It is owned by Foxconn Technology, which has dozens of factories in Asia, Eastern Europe, Mexico, and Brazil. It is estimated that Foxconn assembles 40% of the world's consumer electronics, and boasts a customer list that includes Amazon, Dell, Hewlett-Packard, Motorola, Nintendo, Nokia, Samsung, and Sony, in addition to Apple. Foxconn can hire thousands of engineers overnight and put them up in dorms—something no American firm could do. Nearly 8,700 industrial engineers were needed to oversee the 200,000 assembly-line workers

required to manufacture iPhones. Apple's analysts estimated that it could take 9 months to find that many qualified engineers in the United States. It only took 15 days in China. Moreover, China's advantage was not only in assembly; it offered advantages across the entire supply chain. As noted by an Apple executive, "The entire supply chain is in China now. You need a thousand rubber gaskets? That's the factory next door. You need a million screws? That factory is a block away. You need that screw made a little bit different? It will take three hours." Of Apple's 64,000 employees, nearly one-third are outside of the United States. In response to criticisms about failing to support employment in its home country, Apple executives responded, "We sell iPhones in over a hundred countries. . . . Our only obligation is making the best product possible."

Although Apple epitomizes the opportunities for strategic outsourcing, Apple is also—paradoxically perhaps—more vertically integrated than most computer or smartphone firms. Apple's decision to produce its own hardware and software—and tie them tightly together and sell them its own retail stores—was widely known and hotly debated. However, the vertical integration did not end there. Apple also spends billions of dollars buying production equipment that is used to outfit new and existing Asian factories that will be run by others (an example of *quasi vertical integration*), and then requires those factories to commit to producing for Apple exclusively. By providing the upfront investment, Apple removes most of the risk for its suppliers in investing

in superior technology or scale. For decades, the computer and mobile phone industries have been characterized by commoditization and rapid cost reduction—suppliers had to work hard to reduce costs to win competitive bids, and standardized production facilities trumped specialized facilities as they enabled the suppliers to smooth out the volatility in scale by working with multiple buyers. This meant that most suppliers to the computer and phone industry could produce cost-efficient hardware, but not "insanely great" hardware. Apple's strategy of paying upfront for both the technology and capacity enabled it to induce its suppliers to make specialized investments in technologies that were well beyond the industry standard, and to hold excess capacity that would enable rapid scaling. The net result is that Apple ends up with superior flexibility and technological sophistication that its competitors cannot match.

Seeming to acknowledge the advantages of Apple's strategy of controlling device design and production, Microsoft announced on June 18, 2012, that it too would design and produce its own tablet, the Surface. It also launched its own chain of dedicated Microsoft retail stores that looked remarkably similar to Apple stores. The success of this strategy is far from assured, however. Although Microsoft can imitate some of the individual integration strategies of Apple, it lacks both the tightly woven ecosystem that Apple has developed around those strategies, and its decades of experience in implementing them.

Sources: C. Duhigg and K. Bradsher, "How the U.S. Lost Out on iPhone Work", *New York Times*, January 21, 2012, p. 1; and C. Guglielmo, "Apple's Secret Plan for Its Cash Stash," *Forbes*, May 7, 2012, pp. 116–120.

OVERVIEW

The overriding goal of managers is to maximize the value of a company for its shareholders. The opening case about Apple's outsourcing and vertical integration moves shows how a firm's decisions about what activities to get into—and get out of—influence its profitability. In Apple's case, strategic outsourcing helps it to be more cost efficient, faster to market, and more flexible in scale, and its vertical integration moves give it a technological advantage that is difficult for its competitors to match.

In general, corporate-level strategy involves choices strategic managers must make: (1) deciding in which businesses and industries a company should compete; (2) selecting which value creation activities it should perform in those businesses; and (3) determining how it should enter, consolidate, or exit businesses or industries to maximize long-term profitability. When formulating corporate-level strategy, managers must adopt a long-term perspective and consider how changes taking place in an industry and in its products, technology, customers, and competitors will affect their company's current business model and its future strategies. They then decide how to implement specific corporate-level strategies that redefine their company's business model to allow it to increase its competitive advantage in a changing industry environment by taking advantage of opportunities and countering threats. Thus, the principal goal of corporate-level strategy is to enable a company to sustain or promote its competitive advantage and profitability in its present business—*and in any new businesses or industries that it chooses to enter.*

This chapter is the first of two that describe the role of corporate-level strategy in re-positioning and redefining a company's business model. We discuss three corporate-level strategies—horizontal integration, vertical integration, and strategic outsourcing—that are primarily directed toward improving a company's competitive advantage and profitability in its current business or industry. Diversification, which entails entry into new kinds of businesses or industries, is examined in the next chapter, along with guidelines for choosing the most profitable way to enter new businesses or industries, or to exit others. By the end of this chapter and the next, you will understand how the different levels of strategy contribute to the creation of a successful and profitable business or multibusiness model. You will also be able to distinguish between the types of corporate strategies managers use to maximize long-term company profitability.

CORPORATE-LEVEL STRATEGY AND THE MULTIBUSINESS MODEL

The choice of corporate-level strategies is the final part of the strategy-formulation process. Corporate-level strategies drive a company's business model over time and determine which types of business- and functional-level strategies managers will choose to maximize long-term profitability. The relationship between business-level strategy and functional-level strategy was discussed in Chapter 5. Strategic managers develop a business model and strategies that use their company's distinctive competencies to strive for a cost-leadership position and/or to differentiate its products. Chapter 8 described how global strategy is also an extension of these basic principles.

In this chapter and the next, we repeatedly emphasize that to increase profitability, a corporate-level strategy should enable a company or one or more of its business divisions or units *to perform value-chain functional activities (1) at a lower cost and/or (2) in a way that results in increased differentiation.* Only when it selects the appropriate corporate-level strategies can a company choose the pricing option (lowest, average, or premium price) that will allow it to maximize profitability. In addition, corporate-level strategy will increase profitability if it helps a company reduce industry rivalry by reducing the threat of damaging price competition. In sum, a company's corporate-level strategies should be chosen to promote the success of its business-level strategies, which allows it to achieve a sustainable competitive advantage, leading to higher profitability.

Many companies choose to expand their business activities beyond one market or industry and enter others. When a company decides to expand into new industries, it must construct its business model at two levels. First, it must develop a business model and strategies for each business unit or division in every industry in which it competes. Second, it must also develop a higher-level *multibusiness model* that justifies its entry into different businesses and industries. This multibusiness model should explain how and why entering a new industry will allow the company to use its existing functional competencies and business strategies to increase its overall profitability. This model should also explain any other ways in which a company's involvement in more than one business or industry can increase its profitability. IBM, for example, might argue that its entry into online computer consulting, data storage, and cloud computing enables it to offer its customers a lineup of computer services, which allows it to better compete with HP, Oracle, or Amazon.com. Apple might argue that its entry into digital music and entertainment has given it a commanding lead over rivals such as Sony or Microsoft (which ended sales of its Zune music player in October 2011).

This chapter first focuses on the advantages of staying inside one industry by pursuing horizontal integration. It then looks at why companies use vertical integration and expand into new industries. In the next chapter, we examine two principal corporate strategies companies use to enter new industries to increase their profitability, related and unrelated diversification, and several other strategies companies may use to enter and compete in new industries.

HORIZONTAL INTEGRATION: SINGLE-INDUSTRY CORPORATE STRATEGY

Managers use corporate-level strategy to identify which industries their company should compete in to maximize its long-term profitability. For many companies, profitable growth and expansion often entail finding ways to successfully compete within a single market or industry over time. In other words, a company confines its value creation activities to just one business or industry. Examples of such single-business companies include McDonald's, with its focus on the global fast-food business, and Walmart, with its focus on global discount retailing.

Staying within one industry allows a company to focus all of its managerial, financial, technological, and functional resources and capabilities on competing successfully in one area. This is important in fast-growing and changing industries in which demands on a company's resources and capabilities are likely to be substantial, but where the long-term profits from establishing a competitive advantage are also likely to be substantial.

A second advantage of staying within a single industry is that a company "sticks to the knitting," meaning that it stays focused on what it knows and does best. A company does not make the mistake of entering new industries in which its existing resources and capabilities create little value and/or where a whole new set of competitive industry forces—new competitors, suppliers, and customers—present unanticipated threats. Coca-Cola, like many other companies, has committed this strategic error in the past. Coca-Cola once decided to expand into the movie business and acquired Columbia Pictures; it also acquired a large California winemaker. It soon found it lacked the competencies to successfully compete in these new industries and had not foreseen the strong competitive forces that existed in these industries from movie companies such as Paramount and winemakers such

as Gallo. Coca-Cola concluded that entry into these new industries had reduced rather than created value and lowered its profitability; it divested or sold off these new businesses at a significant loss.

Even when a company stays in one industry, sustaining a successful business model over time can be difficult because of changing conditions in the environment, such as advances in technology that allow new competitors into the market, or because of changing customer needs. Two decades ago, the strategic issue facing telecommunications providers was how to shape their landline phone services to best meet customer needs in local and long-distance telephone service. When a new kind of product—wireless telephone service—emerged and quickly gained in popularity, landline providers like Verizon and AT&T had to quickly change their business models, lower the price of landline service, merge with wireless companies, and offer broadband services to ensure their survival.

Even within one industry, it is very easy for strategic managers to fail to see the "forest" (changing nature of the industry that results in new product/market opportunities) for the "trees" (focusing only on how to position current products). A focus on corporate-level strategy can help managers anticipate future trends and then change their business models to position their companies to compete successfully in a changing environment. Strategic managers must not become so committed to improving their company's *existing* product lines that they fail to recognize *new* product opportunities and threats. Apple has been so successful because it did recognize the increasing number of product opportunities offered by digital entertainment. The task for corporate-level managers is to analyze how new emerging technologies will impact their business models, how and why these technologies might change customer needs and customer groups in the future, and what kinds of new distinctive competencies will be needed to respond to these changes.

One corporate-level strategy that has been widely used to help managers strengthen their company's business model is horizontal integration, a strategy discussed in the chapter-closing case on the airline industry. **Horizontal integration** is the process of acquiring or merging with industry competitors to achieve the competitive advantages that arise from a large size and scope of operations. An **acquisition** occurs when one company uses its capital resources, such as stock, debt, or cash, to purchase another company, and a **merger** is an agreement between equals to pool their operations and create a new entity.

Mergers and acquisitions are common in most industries. In the aerospace industry, Boeing merged with McDonnell Douglas to create the world's largest aerospace company; in the pharmaceutical industry, Pfizer acquired Warner-Lambert to become the largest pharmaceutical firm; and global airlines are increasingly merging their operations (as the chapter-closing case suggests) in order to rationalize the number of flights offered between destinations and increase their market power. The pace of mergers and acquisitions has been rising as companies try to gain a competitive advantage over their rivals. The reason for this is that horizontal integration often significantly improves the competitive advantage and profitability of companies whose managers choose to stay within one industry and focus on managing its competitive position to keep the company at the value creation frontier.

Benefits of Horizontal Integration

In pursuing horizontal integration, managers decide to invest their company's capital resources to purchase the assets of industry competitors to increase the profitability of its single-business model. Profitability increases when horizontal integration (1) lowers the cost structure, (2) increases product differentiation, (3) leverages a competitive advantage

Horizontal integration

The process of acquiring or merging with industry competitors to achieve the competitive advantages that arise from a large size and scope of operations.

Acquisition

When a company uses its capital resources to purchase another company.

Merger

An agreement between two companies to pool their resources and operations and join together to better compete in a business or industry.

more broadly, (4) reduces rivalry within the industry, and (5) increases bargaining power over suppliers and buyers.

Lower Cost Structure Horizontal integration can lower a company's cost structure because it creates increasing *economies of scale*. Suppose five major competitors exist, each of which operates a manufacturing plant in some region of the United States, but none of the plants operate at full capacity. If one competitor buys another and closes that plant, it can operate its own plant at full capacity and reduce its manufacturing costs. Achieving economies of scale is very important in industries that have a high-fixed-cost structure. In such industries, large-scale production allows companies to spread their fixed costs over a large volume, and in this way drive down average unit costs. In the telecommunications industry, for example, the fixed costs of building advanced 4G and LTE broadband networks that offer tremendous increases in speed are enormous, and to make such an investment profitable, a large volume of customers is required. Thus, companies such as AT&T and Verizon purchased other telecommunications companies to acquire their customers, increase their customer base, increase utilization rates, and reduce the cost of servicing each customer. In 2011, AT&T planned to acquire T-Mobile, but abandoned the deal in response to antitrust concerns raised by the U.S. Department of Justice and the Federal Communications Commission. Similar considerations were involved in the hundreds of acquisitions that have taken place in the pharmaceutical industry in the last decade because of the need to realize scale economies in research and development (R&D) and sales and marketing. The fixed costs of building a nationwide pharmaceutical sales force are enormous, and pharmaceutical companies such as Pfizer and Merck must possess a wide portfolio of drugs to sell to effectively make use of their sales forces.

A company can also lower its cost structure when horizontal integration allows it to *reduce the duplication of resources* between two companies, such as by eliminating the need for two sets of corporate head offices, two separate sales teams, and so forth. Notably, however, these cost savings are often overestimated. If two companies are operating a function such as a call center, for example, and both are above the minimum efficient scale for operating such a center, there may be few economies from consolidating call center operations: if each center was already optimally utilized, the consolidated call center may require just as many service people, computers, phone lines, and real estate as the two call centers previously required. Similarly, when banks were consolidating during the late 1990s, one of the justifications was that the banks could save by consolidating their information technology (IT) resources. Ultimately, however, most of the merged banks realized that their potential savings were meager at best, and the costs of attempting to harmonize their information systems were high, so most of the merged banks continued to run the separate legacy systems the banks had prior to merging.

Increased Product Differentiation Horizontal integration may also increase profitability when it increases product differentiation, for example, by increasing the flow of innovative new products that a company's sales force can sell to customers at premium prices. Desperate for new drugs to fill its pipeline, for example, Eli Lilly paid $6.5 billion to ImClone Systems to acquire its new cancer-preventing drugs in order to outbid rival Bristol-Myers Squibb. Google, anxious to provide its users with online coupons, offered to pay $6 billion for Groupon to fill this niche in its online advertising business in order to increase its differentiation advantage—and reduce industry rivalry.

Horizontal integration may also increase differentiation when it allows a company to combine the product lines of merged companies so that it can offer customers a wider range of products that can be bundled together. **Product bundling** involves offering customers

Product bundling
Offering customers the opportunity to purchase a range of products at a single combined price; this increases the value of a company's product line because customers often obtain a price discount when purchasing a set of products at one time, and customers become used to dealing with only one company and its representatives.

FOCUS ON: WAL-MART

Walmart's Expansion into Other Retail Formats

© iStockPhoto.com/caracterdesign

In 2013, Walmart was the largest firm in the world, with sales of $469.2 billion, more than 10,000 stores worldwide, and employing 2.2 million people. However, as the U.S. discount retail market was mature (where Walmart earned 70% of its revenues), it looked for other opportunities to apply its exceptional retailing power and expertise. In the United States it had expanded into Supercenters (that sold groceries in addition to general merchandise) and even-lower-priced warehouse store formats (Sam's Club), both of which were doing well. These stores could directly leverage Walmart's bargaining power over suppliers (for many producers of general merchandise, Walmart accounted for more than 70% of their sales, giving it unrivaled power to negotiate prices and delivery terms), and benefitted from its exceptionally efficient system for transporting, managing, and tracking inventory. Walmart had invested relatively early in advanced information technology: it adopted radio frequency identification (RFID) tagging well ahead of its competitors, and satellites tracked inventory in real time. Walmart knew where each item of inventory was at all times and when it had sold, enabling it to simultaneously minimize its inventory holding costs while optimizing the inventory mix in each store. As a result, it had higher sales per square foot and inventory turnover than either Target or Kmart. It handled inventory through a massive hub-and-spoke distribution system that included more than 140 distribution centers that each served approximately 150 stores

within a 150 miles radius. As Supercenters and Sam's Clubs were also approaching saturation, however, growth had become harder and harder to sustain. Walmart began to pursue other types of expansion opportunities. It expanded into smaller-format neighborhood stores, international stores (many of which were existing chains that were acquired), and was considering getting into organic foods and trendy fashions. While expansion into contiguous geographic regions (e.g., Canada and Mexico) had gone well, its success at overseas expansions was spottier. Walmart's forays into Germany and South Korea, for example, resulted in large losses, and Walmart ultimately exited the markets. Walmart's entry into Japan was also not as successful as hoped, resulting in many years of losses and never gaining a large share of the market. The challenge was that many of these markets already had tough competitors by the time Walmart entered—they weren't the sleepy underserved markets that had initially helped it to grow in the United States. Furthermore, Walmart's IT and logistics advantages could not easily be leveraged into overseas markets—they would require massive upfront investments to replicate, and it would be hard to break even on those investments without having massive scale in those markets. Which of Walmart's advantages could be leveraged overseas and to which markets? Was Walmart better off trying to diversify its product offerings within North America? Or should it perhaps reconsider its growth objectives altogether?

Sources: www.walmart.com.

Cross-selling

When a company takes advantage of or "leverages" its established relationship with customers by way of acquiring additional product lines or categories that it can sell to customers. In this way, a company increases differentiation because it can provide a "total solution" and satisfy all of a customer's specific needs.

the opportunity to purchase a range of products at a single combined price. This increases the value of a company's product line because customers often obtain a price discount when purchasing a set of products at one time, and customers become used to dealing with only one company and its representatives. A company may obtain a competitive advantage from increased product differentiation.

Another way to increase product differentiation is through **cross-selling**, which is when a company takes advantage of or "leverages" its established relationship with customers by way of acquiring additional product lines or categories that it can sell to customers. In this way, a company increases differentiation because it can provide a "total solution" and satisfy all of a customer's specific needs. Cross-selling and becoming a total solution provider is an important rationale for horizontal integration in the computer sector, where IT companies attempt to increase the value of their offerings by satisfying all of the hardware and

9.1 STRATEGY IN ACTION

Larry Ellison Wants Oracle to Become the Biggest and the Best

© iStockPhoto.com/Tom Nulens

Oracle Corporation, based in Redwood Shores, California, is the world's largest maker of database software and the third-largest global software company after Microsoft and IBM. This commanding position is not enough for Oracle, however, which has set its sights on becoming the global leader in the corporate applications software market. In this market, Germany's SAP, with 45% of the market, is the acknowledged leader, and Oracle, with 25%, is a distant second. Corporate applications are a fast-growing and highly profitable market, however, and Oracle has been snapping up leading companies in this segment. Its goal is to quickly build the distinctive competencies it needs to expand the range of products that it can offer to its existing customers and attract new customers to compete with SAP.

Beginning in the mid-2000s Oracle's CEO Larry Ellison has spent over $29 billion to acquire more than 20 leading suppliers of corporate software and hardware, including 2 of the top 5 companies: PeopleSoft, a leading human resource management (HRM) software supplier it bought for $10 billion, and Siebel Systems, a leader in customer relationship management (CRM) software, that it purchased for $5.8 billion.

Oracle expects several competitive advantages to result from its use of acquisitions to pursue the corporate strategy of horizontal integration. First, it is now able to bundle the best software applications of these acquired companies—with Oracle's own first-class set of corporate and database software programs—to create a new integrated software suite that will allow companies to manage all their functional activities, such as accounting, marketing, sales, HRM, CRM, and supply-chain management. Second, through these acquisitions, Oracle obtained access to thousands of new customers—especially the medium and small companies that use the software of the companies it acquired. All of these companies have become potential customers for Oracle's other database and corporate software offerings, and therefore its market share has steadily increased during the 2010s. Third, Oracle's acquisitions have consolidated the corporate software industry. By taking over some of its largest rivals, Oracle has become the second-largest supplier of corporate software and is better positioned to compete with leader SAP. As a result, its stock price has soared in the 2010s—at a much faster rate than that of archrival SAP.

Sources: www.oracle.com and www.sap.com.

service needs of corporate customers. Providing a total solution saves customers' time and money because they do not have to work with several suppliers, and a single sales team can ensure that all the components of a customer's IT seamlessly work together. When horizontal integration increases the differentiated appeal and value of the company's products, the total solution provider gains market share. This was the business model Oracle pursued when it acquired many IT software companies, as discussed in Strategy in Action 9.1.

Leveraging a Competitive Advantage More Broadly For firms that have resources or capabilities that could be valuably deployed across multiple market segments or geographies, horizontal integration may offer opportunities to become more profitable. In the retail industry, for example, Walmart's enormous bargaining power with suppliers and its exceptional efficiency in inventory logistics enabled it to have a competitive advantage in other discount retail store formats, such as its chain of Sam's Clubs (an even-lower-priced warehouse segment). It also expanded the range of products it offers customers when it entered the supermarket business and established a nationwide chain of Walmart supercenters that sell groceries as well as all the clothing, toys, and electronics sold in regular

Walmart stores. It has also replicated its business model globally, although not always with as much success as it had in the United States because many of its efficiencies in logistics (such as its hub-and-spoke distribution system and inventory tracked by satellite) employ fixed assets that are geographically limited (see the Focus on Walmart box for more on this).

Reduced Industry Rivalry Horizontal integration can help to reduce industry rivalry in two ways. First, acquiring or merging with a competitor helps to *eliminate excess capacity* in an industry, which, as we discuss in Chapter 6, often triggers price wars. By taking excess capacity out of an industry, horizontal integration creates a more benign environment in which prices might stabilize—or even increase.

Second, by reducing the number of competitors in an industry, horizontal integration often makes it easier to implement *tacit price coordination* between rivals, that is, coordination reached without communication. (Explicit communication to fix prices is illegal in most countries.) In general, the larger the number of competitors in an industry, the more difficult it is to establish informal pricing agreements—such as price leadership by the dominant company—which increases the possibility that a price war will erupt. By increasing industry concentration and creating an oligopoly, horizontal integration can make it easier to establish tacit coordination among rivals.

Both of these motives also seem to have been behind Oracle's many software acquisitions. There was significant excess capacity in the corporate software industry, and major competitors were offering customers discounted prices that had led to a price war and falling profit margins. Oracle hoped to be able to eliminate excess industry capacity that would reduce price competition. By 2009, it was clear that the major corporate software competitors were focusing on finding ways to better differentiate their product suites to prevent a price war and continuing to make major acquisitions to help their companies build competitive advantage.

Increased Bargaining Power Finally, some companies use horizontal integration because it allows them to obtain bargaining power over suppliers or buyers and increase their profitability at the expense of suppliers or buyers. By consolidating the industry through horizontal integration, a company becomes a much larger buyer of suppliers' products and uses this as leverage to bargain down the price it pays for its inputs, thereby lowering its cost structure. Walmart, for example, is well known for pursuing this strategy. Similarly, by acquiring its competitors, a company gains control over a greater percentage of an industry's product or output. Other things being equal, the company then has more power to raise prices and profits because customers have less choice of suppliers and are more dependent on the company for their products—something both Oracle and SAP are striving for to protect their customer base. When a company has greater ability to raise prices to buyers or bargain down the price paid for inputs, it has obtained increased market power.

Problems with Horizontal Integration

Although horizontal integration can strengthen a company's business model in several ways, there are problems, limitations, and dangers associated with pursuing this corporate-level strategy. *Implementing* a horizontal integration strategy is not an easy task for managers. As we discuss in Chapter 10, there are several reasons why mergers and acquisitions may fail to result in higher profitability: problems associated with merging very different company cultures, high management turnover in the acquired company when the acquisition is a hostile

one, and a tendency of managers to overestimate the potential benefits from a merger or acquisition and underestimate the problems involved in merging their operations.

When a company uses horizontal integration to become a dominant industry competitor, in an attempt to keep using the strategy to continue to grow business, the company comes into conflict with the Federal Trade Commission (FTC), the government agency responsible for enforcing antitrust laws. Antitrust authorities are concerned about the potential for abuse of market power; more competition is generally better for consumers than less competition. The FTC is concerned when a few companies within one industry try to make acquisitions that will allow them to raise consumer prices above the level that would exist in a more competitive situation, and thus abuse their market power. The FTC also wishes to prevent dominant companies from using their market power to crush potential competitors, for example, by cutting prices when a new competitor enters the industry and forcing the competitor out of business, then raising prices after the threatening company has been eliminated.

JASON REED/Reuters/Corbis

Because of these concerns, any merger or acquisition the FTC perceives as creating too much consolidation, and the *potential* for future abuse of market power, may, for antitrust reasons, be blocked. The proposed merger between the two dominant satellite radio companies Sirius and XM was blocked for months until it became clear that customers had many other ways to obtain high-quality radio programming, for example, through their computers and cell phones, so substantial competition would still exist in the industry. In 2011, AT&T's attempt to acquire T-Mobile faced similar hurdles, although as the chapter-closing case discusses, airlines have been permitted to merge in order to reduce their cost structures.

VERTICAL INTEGRATION: ENTERING NEW INDUSTRIES TO STRENGTHEN THE "CORE" BUSINESS MODEL

Many companies that use horizontal integration to strengthen their business model and improve their competitive position also use the corporate-level strategy of vertical integration for the same purpose. When pursuing vertical integration, however, a company is entering new industries to support the business model of its "core" industry, that is, the industry which is the primary source of its competitive advantage and profitability. At this point, therefore, a company must formulate a multibusiness model that explains how entry into a new industry using vertical integration will enhance its long-term profitability. The model that justifies the pursuit of vertical integration is based on a company entering industries that *add value* to its core products because this increases product differentiation and/or lowers its cost structure, thus increasing its profitability.

A company pursuing a strategy of **vertical integration** expands its operations either backward into an industry that produces inputs for the company's products (*backward*

Vertical integration
When a company expands its operations either backward into an industry that produces inputs for the company's products (*backward vertical integration*) or forward into an industry that uses, distributes, or sells the company's products (*forward vertical integration*).

Figure 9.1

Stages in the Raw-Materials-to-Customer Value-Added Chain

Raw materials → Component parts manufacturing → Final assembly → Retail → Customer

Backward vertical integration into upstream industries

Forward vertical integration into downstream industries

© Cengage Learning

vertical integration) or forward into an industry that uses, distributes, or sells the company's products (*forward vertical integration*). To enter an industry, it may establish its own operations and build the value chain needed to compete effectively in that industry, or it may acquire a company that is already in the industry. A steel company that supplies its iron ore needs from company-owned iron ore mines illustrates backward integration. A maker of personal computers (PCs) that sells its laptops through company-owned retail outlets illustrates forward integration. For example, Apple entered the retail industry in 2001 when it decided to establish a chain of Apple stores to sell, promote, and service its products. IBM is a highly vertically integrated company; it integrated backward into the chip and memory disk industry to produce the components that work inside its mainframes and servers, and integrated forward into the computer software and consulting services industries.

Figure 9.1 illustrates four *main* stages in a typical raw-materials-to-customer value-added chain. For a company based in the final assembly stage, backward integration means moving into component parts manufacturing and raw materials production. Forward integration means moving into distribution and sales (retail). At each stage in the chain, *value is added* to the product, meaning that a company at one stage takes the product produced in the previous stage and transforms it in some way so that it is worth more to a company at the next stage in the chain and, ultimately, to the customer. It is important to note that each stage of the value-added chain is a separate industry or industries in which many different companies are competing. Moreover, within each industry, every company has a value chain composed of the value creation activities we discussed in Chapter 3: R&D, production, marketing, customer service, and so on. In other words, we can think of a value chain that runs *across* industries, and embedded within that are the value chains of companies *within* each industry.

As an example of the value-added concept, consider how companies in each industry involved in the production of a PC contribute to the final product (Figure 9.2). The first stage in the chain includes raw materials companies that make specialty ceramics, chemicals, and metal, such as Kyocera of Japan, which manufactures the ceramic substrate for semiconductors. Companies at the first stage in the chain sell their products to the makers of PC component products, such as Intel and AMD, which transform the ceramics, chemicals, and metals they purchase into PC components such as microprocessors, disk drives, and memory chips. In the process, companies *add value* to the raw materials they purchase. At the third stage, the manufactured components are then sold to PC makers such as Apple, Dell, and HP, and these companies decide which of the components to purchase and assemble to *add value* to the final PCs (that they make or outsource to a contract manufacturer). At stage four, the finished PCs are then either sold directly to the final customer over the Internet, or sold to

| Figure 9.2 | The Raw-Materials-to-Customer Value-Added Chain in the PC Industry |

© Cengage Learning

retailers such as Best Buy and Staples, which distribute and sell them to the final customer. Companies that distribute and sell PCs also *add value* to the product because they make the product accessible to customers and provide customer service and support.

Thus, companies in different industries add value at each stage in the raw-materials-to-customer chain. Viewed in this way, vertical integration presents companies with a choice about within which industries in the raw-materials-to-customer chain to operate and compete. This choice is determined by how much establishing operations at a stage in the value chain will increase product differentiation or lower costs—and therefore increase profitability—as we discuss in the following section.

Increasing Profitability Through Vertical Integration

As noted earlier, a company pursues vertical integration to strengthen the business model of its original or core business and to improve its competitive position.[1] Vertical integration increases product differentiation, lowers costs, or reduces industry competition when it (1) facilitates investments in efficiency-enhancing specialized assets, (2) protects product quality, and (3) results in improved scheduling.

Facilitating Investments in Specialized Assets A specialized asset is one that is designed to perform a specific task and whose value is significantly reduced in its next-best use.[2] The asset may be a piece of equipment that has a firm-specific use or the knowhow or skills that a company or employees have acquired through training and experience. Companies invest in specialized assets because these assets allow them to lower their cost structure or to better differentiate their products, which facilitates premium pricing. A company might invest in specialized equipment to lower manufacturing costs, as Toyota does, for example, or it might invest in an advanced technology that allows it to develop better-quality products than its rivals, as Apple does. Thus, specialized assets can help a company achieve a competitive advantage at the business level.

Just as a company invests in specialized assets in its own industry to build competitive advantage, it is often necessary that suppliers invest in specialized assets to produce the inputs that a specific company needs. By investing in these assets, a supplier can make higher-quality inputs that provide its customers with a differentiation advantage, or inputs at a lower cost so it can charge its customers a lower price to keep their business. However,

it is often difficult to persuade companies in adjacent stages of the raw-materials-to-customer value-added chain to make investments in specialized assets. Often, to realize the benefits associated with such investments, a company must vertically integrate and enter into adjacent industries and invest its own resources. Why does this happen?

Imagine that Ford has developed a unique energy-saving electrical engine system that will dramatically increase fuel efficiency and differentiate Ford's cars from those of its rivals, giving it a major competitive advantage. Ford must decide whether to make the system in-house (vertical integration) or contract with a supplier such as a specialist outsourcing manufacturer to make the new engine system. Manufacturing these new systems requires a substantial investment in specialized equipment that can be used only for this purpose. In other words, because of its unique design, the equipment cannot be used to manufacture any other type of electrical engine for Ford or any other carmaker. Thus this is an investment in specialized assets.

Consider this situation from the perspective of the outside supplier deciding whether or not to make this investment. The supplier might reason that once it has made the investment, it will become dependent on Ford for business because *Ford is the only possible customer for the electrical engine made by this specialized equipment*. The supplier realizes that this puts Ford in a strong bargaining position and that Ford might use its buying power to demand lower prices for the engines. Given the risks involved, the supplier declines to make the investment in specialized equipment.

Now consider Ford's position. Ford might reason that if it outsources production of these systems to an outside supplier, it might become too dependent on that supplier for a vital input. Because specialized equipment is required to produce the engine systems, Ford cannot switch its order to other suppliers. Ford realizes that this increases the bargaining power of the supplier, which might use its bargaining power to demand higher prices.

The situation of *mutual dependence* that would be created by the investment in specialized assets makes Ford hesitant to allow outside suppliers to make the product and makes suppliers hesitant to undertake such a risky investment. The problem is a lack of trust—neither Ford nor the supplier can trust the other to operate fairly in this situation. The lack of trust arises from the risk of **holdup**—that is, being taken advantage of by a trading partner *after* the investment in specialized assets has been made.[3] Because of this risk, Ford reasons that the only cost-effective way to get the new engine systems is for it to make the investment in specialized assets and manufacture the engine in-house.

To generalize from this example, if achieving a competitive advantage requires one company to make investments in specialized assets so it can trade with another, *the risk of holdup* may serve as a deterrent, and the investment may not take place. Consequently, the potential for higher profitability from specialization will be lost. To prevent such loss, companies vertically integrate into adjacent stages in the value chain. Historically, the problems surrounding specific assets have driven automobile companies to vertically integrate backward into the production of component parts, steel companies to vertically integrate backward into the production of iron, computer companies to vertically integrate backward into chip production, and aluminum companies to vertically integrate backward into bauxite mining. Often such firms practice **tapered integration**, whereby the firm makes some of the input and buys some of the input. Purchasing part or most of its needs for a given input from suppliers enables the firm to tap the advantages of the market (e.g., being able to choose from more suppliers that are competing to improve quality or lower the cost of the product). At the same time, meeting some of its needs for the input through internal production improves the firm's bargaining power by reducing its likelihood of holdup by a supplier. A firm that is engaged in production of an input is also better able to evaluate the cost and quality of

Holdup

When a company is taken advantage of by another company it does business with after it has made an investment in expensive specialized assets to better meet the needs of the other company.

Tapered integration

When a firm uses a mix of vertical integration and market transactions for a given input. For example, a firm might operate limited semiconductor manufacturing itself, while also buying semiconductor chips on the market. Doing so helps to prevent supplier holdup (because the firm can credibly commit to not buying from external suppliers) and increases its ability to judge the quality and cost of purchased supplies.

9.2 STRATEGY IN ACTION

Specialized Assets and Vertical Integration in the Aluminum Industry

© iStockPhoto.com/Tom Nulens

The metal content and chemical composition of bauxite ore, used to produce aluminum, vary from deposit to deposit, so each type of ore requires a specialized refinery—that is, the refinery must be designed for a particular type of ore. Running one type of bauxite through a refinery designed for another type reportedly increases production costs from 20% to 100%. Thus, the value of an investment in a specialized aluminum refinery and the cost of the output produced by that refinery depend on receiving the right kind of bauxite ore.

Imagine that an aluminum company must decide whether to invest in an aluminum refinery designed to refine a certain type of ore. Also assume that the ore is extracted by a company that owns a single bauxite mine. Using a different type of ore would raise production costs by 50%. Therefore, the value of the aluminum company's investment is dependent on the price it must pay the bauxite company for this material. Recognizing this, once the aluminum company has made the investment in a new refinery, what is to stop the bauxite company from raising prices? Nothing. Once it has made

the investment, the aluminum company is locked into its relationship with its bauxite supplier. The bauxite supplier can increase prices because it knows that as long as the increase in the total production costs of the aluminum company is less than 50%, the aluminum company will continue to buy its ore. Thus, once the aluminum company has made the investment, the bauxite supplier can *hold up* the aluminum company.

How can the aluminum company reduce the risk of holdup? The answer is by purchasing the bauxite supplier. If the aluminum company can purchase the bauxite supplier's mine, it no longer needs to fear that bauxite prices will be increased after the investment in an aluminum refinery has been made. In other words, vertical integration eliminates the risk of holdup, making the specialized investment worthwhile. In practice, it has been argued that these kinds of considerations have driven aluminum companies to pursue vertical integration to such a degree that, according to one study, more than 90% of the total volume of bauxite is transferred within vertically integrated aluminum companies.

Sources: J .F. Hennart, "Upstream Vertical Integration in the Aluminum and Tin Industries," *Journal of Economic Behavior and Organization* 9 (1988): 281–299; and www.alcoa.com.

external suppliers of that input.[4] The way specific asset issues have led to vertical integration in the global aluminum industry is discussed in Strategy in Action 9.2.

Enhancing Product Quality By entering industries at other stages of the value-added chain, a company can often enhance the quality of the products in its core business and strengthen its differentiation advantage. For example, the ability to control the reliability and performance of complex components such as engine and transmission systems may increase a company's competitive advantage in the luxury sedan market and enable it to charge a premium price. Conditions in the banana industry also illustrate the importance of vertical integration in maintaining product quality. Historically, a problem facing food companies that import bananas has been the variable quality of delivered bananas, which often arrive on the shelves of U.S. supermarkets too ripe or not ripe enough. To correct this problem, major U.S. food companies such as Del Monte have integrated backward and now own banana plantations, putting them in control over the banana supply. As a result, they can distribute and sell bananas of a standard quality at the optimal time to better satisfy customers. Knowing they can rely on the quality of these brands, customers are also willing

to pay more for them. Thus, by vertically integrating backward into plantation ownership, banana companies have built customer confidence, which has, in turn, enabled them to charge a premium price for their product.

The same considerations can promote forward vertical integration. Ownership of retail outlets may be necessary if the required standards of after-sales service for complex products are to be maintained. For example, in the 1920s, Kodak owned the retail outlets that distributed its photographic equipment because the company felt that few existing retail outlets had the skills necessary to sell and service its complex equipment. By the 1930s, new retailers had emerged that could provide satisfactory distribution and service for Kodak products, so it left the retail industry.

McDonald's has also used vertical integration to protect product quality and increase efficiency. By the 1990s, McDonald's faced a problem: after decades of rapid growth, the fast-food market was beginning to show signs of market saturation. McDonald's responded to the slowdown by rapidly expanding abroad. In 1980, 28% of the chain's new restaurant openings were abroad; in 1990 it was 60%, and by 2000, 70%. In 2011, more than 12,000 restaurants in 110 countries existed outside the United States.[5] Replication of its value creation skills was the key to successful global expansion and spurred the growth of McDonald's in the countries and world regions in which it operates. McDonald's U.S. success was built on a formula of close relations with suppliers, nationwide marketing might, and tight control over store-level operating procedures.

The biggest global problem McDonald's has faced is replicating its U.S. supply chain in other countries; its domestic suppliers are fiercely loyal to the company because their fortunes are closely linked to its success. McDonald's maintains very rigorous specifications for all the raw ingredients it uses—the key to its consistency and quality control. Outside of the United States, however, McDonald's has found suppliers far less willing to make the investments required to meet its specifications. In Great Britain, for example, McDonald's had problems getting local bakeries to produce the hamburger bun. After experiencing quality problems with two local bakeries, McDonald's had to vertically integrate backward and build its own bakeries to supply its British stores. When McDonald's decided to operate in Russia, it found that local suppliers lacked the capability to produce ingredients of the quality it demanded. It was then forced to vertically integrate through the local food industry on a heroic scale, importing potato seeds and bull semen and indirectly managing dairy farms, cattle ranches, and vegetable plots. It also needed to construct the world's largest food-processing plant at a huge cost. In South America, McDonald's also purchased huge ranches in Argentina, upon which it could raise its own cattle. In short, vertical integration has allowed McDonald's to protect product quality and reduce its global cost structure.[6]

Improved Scheduling Sometimes important strategic advantages can be obtained when vertical integration makes it quicker, easier, and more cost-effective to plan, coordinate, and schedule the transfer of a product, such as raw materials or component parts, between adjacent stages of the value-added chain.[7] Such advantages can be crucial when a company wants to realize the benefits of just-in-time (JIT) inventory systems. For example, in the 1920s, Ford profited from the tight coordination and scheduling that backward vertical integration made possible. Ford integrated backward into steel foundries, iron ore shipping, and iron ore production—it owned mines in Upper Michigan! Deliveries at Ford were coordinated to such an extent that iron ore unloaded at Ford's steel foundries on the Great Lakes was turned into engine blocks within 24 hours, which lowered Ford's cost structure.

Problems with Vertical Integration

Vertical integration can often be used to strengthen a company's business model and increase profitability. However, the opposite can occur when vertical integration results in (1) an increasing cost structure, (2) disadvantages that arise when technology is changing fast, and (3) disadvantages that arise when demand is unpredictable. Sometimes these disadvantages are so great that vertical integration, rather than increasing profitability, may actually reduce it—in which case a company engages in **vertical disintegration** and exits industries adjacent to its core industry in the industry value chain. For example, Ford, which was highly vertically integrated, sold all its companies involved in mining iron ore and making steel when more efficient and specialized steel producers emerged that were able to supply lower-priced steel.

Vertical disintegration
When a company decides to exit industries either forward or backward in the industry value chain to its core industry to increase profitability.

Increasing Cost Structure Although vertical integration is often undertaken to lower a company's cost structure, it can raise costs if, over time, a company makes mistakes, such as continuing to purchase inputs from company-owned suppliers when low-cost independent suppliers that can supply the same inputs exist. For decades, for example, GM's company-owned suppliers made more than 60% of the component parts for its vehicles; this figure was far higher than that for any other major carmaker, which is why GM became such a high-cost carmaker. In the 2000s, it vertically disintegrated by selling off many of its largest component operations, such as Delhi, its electrical components supplier. Thus, vertical integration can be a major disadvantage when company-owned suppliers develop a higher cost structure than those of independent suppliers. Why would a company-owned supplier develop such a high cost structure?

In this example, company-owned or "in-house" suppliers know that they can always sell their components to the car-making divisions of their company—they have a "captive customer." Because company-owned suppliers do not have to compete with independent, outside suppliers for orders, they have much less *incentive* to look for new ways to reduce operating costs or increase component quality. Indeed, in-house suppliers simply pass on cost increases to the car-making divisions in the form of higher **transfer prices**, the prices one division of a company charges other divisions for its products. Unlike independent suppliers, which constantly need to increase their efficiency to protect their competitive advantage, in-house suppliers face no such competition, and the resulting rising cost structure reduces a company's profitability.

Transfer pricing
The price that one division of a company charges another division for its products, which are the inputs the other division requires to manufacture its own products.

The term *bureaucratic costs* refers to the costs of solving the transaction difficulties that arise from managerial inefficiencies and the need to manage the handoffs or exchanges between business units to promote increased differentiation, or to lower a company's cost structure. Bureaucratic costs become a significant component of a company's cost structure because considerable managerial time and effort must be spent to reduce or eliminate managerial inefficiencies, such as those that result when company-owned suppliers lose their incentive to increase efficiency or innovation.

Technological Change When technology is changing fast, vertical integration may lock a company into an old, inefficient technology and prevent it from changing to a new one that would strengthen its business model.[8] Consider Sony, which had integrated backward to become the leading manufacturer of the now outdated cathode ray tubes (CRTs) used in TVs and computer monitors. Because Sony was locked into the outdated CRT technology, it was slow to recognize that the future was flatscreen liquid crystal display (LCD) screens and did not exit the CRT business. Sony's resistance to change in technology forced it to

enter into a strategic alliance with Samsung to supply the LCD screens that are used in its BRAVIA TVs. As a result, Sony lost its competitive advantage and experienced a major loss in TV market share. Thus, vertical integration can pose a serious disadvantage when it prevents a company from adopting new technology, or changing its suppliers or distribution systems to match the requirements of changing technology.

Demand Unpredictability Suppose the demand for a company's core product, such as cars or washing machines, is predictable, and a company knows how many units it needs to make each month or year. Under these conditions, vertical integration allows a company to schedule and coordinate efficiently the flow of products along the industry value-added chain and may result in major cost savings. However, suppose the demand for cars or washing machines wildly fluctuates and is unpredictable. If demand for cars suddenly plummets, the carmaker may find itself burdened with warehouses full of component parts it no longer needs, which is a major drain on profitability—something that has hurt major carmakers during the recent recession. Thus, vertical integration can be risky when demand is unpredictable because it is hard to manage the volume or flow of products along the value-added chain.

For example, a PC maker might vertically integrate backward to acquire a supplier of memory chips so that it can make exactly the number of chips it needs each month. However, if demand for PCs falls because of the popularity of mobile computing devices, the PC maker finds itself locked into a business that is now inefficient because it is not producing at full capacity, and therefore its cost structure starts to rise. In general, high-speed environmental change (e.g., technological change, changing customer demands, and major shifts in institutional norms or competitive dynamics) provides a disincentive for integration, as the firm's asset investments are at greater risk of rapid obsolescence.[9] It is clear that strategic managers must carefully assess the advantages and disadvantages of expanding the boundaries of their company by entering adjacent industries, either backward (upstream) or forward (downstream), in the industry value-added chain. Moreover, although the decision to enter a new industry to make crucial component parts may have been profitable in the past, it may make no economic sense today because so many low-cost global component parts suppliers exist that compete for the company's business. The risks and returns on investing in vertical integration must be continually evaluated, and companies should be as willing to vertically disintegrate, as vertically integrate, to strengthen their core business model.

ALTERNATIVES TO VERTICAL INTEGRATION: COOPERATIVE RELATIONSHIPS

Is it possible to obtain the differentiation and cost-savings advantages associated with vertical integration without having to bear the problems and costs associated with this strategy? In other words, is there another corporate-level strategy that managers can use to obtain the advantages of vertical integration while allowing other companies to perform upstream and downstream activities? Today, companies have found that they can realize many of the benefits associated with vertical integration by entering into *long-term cooperative relationships* with companies in industries along the value-added chain, also known as

quasi integration. Such moves could include, for example, sharing the expenses of investment in production assets or inventory, or making long-term supply or purchase guarantees. Apple's decision to invest in production equipment for its suppliers (in the opening case) is a prime example.

Short-Term Contracts and Competitive Bidding

Many companies use short-term contracts that last for a year or less to establish the price and conditions under which they will purchase raw materials or components from suppliers or sell their final products to distributors or retailers. A classic example is the carmaker that uses a *competitive bidding strategy*, in which independent component suppliers compete to be chosen to supply a particular component, such as brakes, made to agreed-upon specifications, at the lowest price. For example, GM typically solicits bids from global suppliers to produce a particular component and awards a 1-year contract to the supplier that submits the lowest bid. At the end of the year, the contract is once again put out for competitive bid, and once again the lowest-cost supplier is most likely to win the bid.

The advantage of this strategy for GM is that suppliers are forced to compete over price, which drives down the cost of its car components. However, GM has no long-term commitment to outside suppliers—and it drives a hard bargain. For this reason, suppliers are unwilling to make the expensive long-term investments in specialized assets that are required to produce higher-quality or better-designed component parts over time. In addition, suppliers will be reluctant to agree upon the tight scheduling that makes it possible to use a JIT inventory system because this may help GM lower its costs but will increase a supplier's costs and reduce its profitability.

As a result, short-term contracting does not result in the specialized investments that are required to realize differentiation and cost advantages *because it signals a company's lack of long-term commitment to its suppliers*. Of course, this is not a problem when there is minimal need for cooperation, and specialized assets are not required to improve scheduling, enhance product quality, or reduce costs. In this case, competitive bidding may be optimal. However, when there is a need for cooperation, something that is becoming increasingly significant today, the use of short-term contracts and competitive bidding can be a serious drawback.

Strategic Alliances and Long-Term Contracting

Unlike short-term contracts, **strategic alliances** between buyers and suppliers are long-term, cooperative relationships; both companies agree to make specialized investments and work jointly to find ways to lower costs or increase product quality so that they both gain from their relationship. A strategic alliance becomes a *substitute* for vertical integration because it creates a relatively stable long-term partnership that allows both companies to obtain the same kinds of benefits that result from vertical integration. However, it also avoids the problems (bureaucratic costs) that arise from managerial inefficiencies that result when a company owns its own suppliers, such as those that arise because of a lack of incentives, or when a company becomes locked into an old technology even when technology is rapidly changing.

Consider the cooperative relationships that often were established decades ago, which many Japanese carmakers have with their component suppliers (the *keiretsu* system). Japanese carmakers and suppliers cooperate to find ways to maximize the "value added" they

Quasi integration

The use of long-term relationships, or investment into *some* of the activities normally performed by suppliers or buyers, in place of full ownership of operations that are backward or forward in the supply chain.

Strategic alliances

Long-term agreements between two or more companies to jointly develop new products or processes that benefit all companies that are a part of the agreement.

can obtain from being a part of adjacent stages of the value chain. For example, they do this by jointly implementing JIT inventory systems, or sharing future component-parts designs to improve quality and lower assembly costs. As part of this process, suppliers make substantial investments in specialized assets to better serve the needs of a particular carmaker, and the cost savings that result are shared. Thus, Japanese carmakers have been able to capture many of the benefits of vertical integration without having to enter the component industry.

Similarly, component suppliers also benefit because their business and profitability grow as the companies they supply grow, and they can invest their profits in investing in ever more specialized assets.[10] An interesting example of this is the computer chip outsourcing giant Taiwan Semiconductor Manufacturing Company (TSMC) that makes the chips for many companies, such as NVIDIA, Acer, and AMD. The cost of investing in the machinery necessary to build a state-of-the-art chip factory can exceed $10 billion. TSMC is able to make this huge (risky) investment because it has developed cooperative long-term relationships with its computer chip partners. All parties recognize that they will benefit from this outsourcing arrangement, which does not preclude some hard bargaining between TSMC and the chip companies, because all parties want to maximize their profits and reduce their risks. An interesting example of how strategic alliances can go wrong and lead to major problems occurred in 2011, as discussed in Strategy in Action 9.3.

9.3 STRATEGY IN ACTION

© iStockPhoto.com/Tom Nulens

Apple, Samsung, and Nokia Battle in the Smartphone Market

For several years, Apple had formed a strategic alliance with Samsung to make the proprietary chips it uses in its iPhones and iPads, which are based on the designs of British chip company ARM Holdings, the company that dominates the smartphone chip industry. Samsung used its low-cost skills in chip-making to make Apple's new chips—despite that Samsung was one of Apple's competitors, as it also makes its own smartphones. In 2010, Samsung introduced its new generation of Galaxy smartphones and tablet computers that do not use the same chip as Apple's, but perform similar functions, look similar to Apple's products, and have proven to be very popular with customers globally.

In 2011, Apple decided that its alliance with Samsung had allowed that company to imitate the designs of its smartphones and tablet computers and it sued Samsung, arguing that it had infringed on Apple's patents and specialized knowledge. The alliance between the two companies quickly dissolved as

Samsung countersued Apple, arguing that Apple had infringed upon Samsung's own patented designs, and analysts expect Apple to turn to another company to make its chips in the future. At the same time, Nokia, which has spent $60 billion on R&D to develop new smartphone technology in the last decade, was suing Apple! Nokia claimed that Apple had violated its patents and this had allowed it to innovate the iPhone so quickly. Apple countersued Nokia, arguing that Nokia had violated its patents, in particular the touchscreen technology for which it is now so well known. In June 2011, however, Apple agreed to settle with Nokia and to pay Nokia billions of dollars for the right to license its patents and use its technology. Then, also in June 2011, Apple was awarded a patent that protected its touchscreen technology, and it looked like a new round of lawsuits would begin between these smartphone companies to dominate this highly profitable and growing market.

Sources: www.samsung.com, www.nokia.com, and www.apple.com.

Building Long-Term Cooperative Relationships

How does a company create a long-term strategic alliance with another company when the fear of holdup exists, and the possibility of being cheated arises if one company makes a specialized investment with another company? How do companies such as GM or Nissan manage to develop such profitable, enduring relationships with their suppliers?

There are several strategies companies can adopt to promote the success of a long-term cooperative relationship and lessen the chance that one company will renege on its agreement and cheat the other. One strategy is for the company that makes the specialized investment to demand a *hostage* from its partner. Another is to establish a *credible commitment* from both companies that will result in a trusting, long-term relationship.[11]

Hostage Taking **Hostage taking** is essentially a means of guaranteeing that each partner will keep its side of the bargain. The cooperative relationship between Boeing and Northrop Grumman illustrates this type of situation. Northrop is a major subcontractor for Boeing's commercial airline division, providing many components for its aircraft. To serve Boeing's special needs, Northrop has had to make substantial investments in specialized assets, and, in theory, because of this investment, Northrop has become dependent on Boeing—which can threaten to change orders to other suppliers as a way of driving down Northrop's prices. In practice, Boeing is highly unlikely to make a change of suppliers because it is, in turn, a major supplier to Northrop's defense division and provides many parts for its Stealth aircraft; it also has made major investments in specialized assets to serve Northrop's needs. Thus, the companies are *mutually dependent*; each company holds a hostage—the specialized investment the other has made. Thus, Boeing is unlikely to renege on any pricing agreements with Northrop because it knows that Northrop would respond the same way.

Credible Commitments A **credible commitment** is a believable promise or pledge to support the development of a long-term relationship between companies. Consider the way GE and IBM developed such a commitment. GE is one of the major suppliers of advanced semiconductor chips to IBM, and many of the chips are customized to IBM's requirements. To meet IBM's specific needs, GE has had to make substantial investments in specialized assets that have little other value. As a consequence, GE is dependent on IBM and faces a risk that IBM will take advantage of this dependence to demand lower prices. In theory, IBM could back up its demand by threatening to switch its business to another supplier. However, GE reduced this risk by having IBM enter into a contractual agreement that committed IBM to purchase chips from GE for a 10-year period. In addition, IBM agreed to share the costs of the specialized assets needed to develop the customized chips, thereby reducing the risks associated with GE's investment. Thus, by publicly committing itself to a long-term contract and putting some money into the chip development process, IBM made a *credible commitment* that it would continue to purchase chips from GE. When a company violates a credible commitment with its partners, the results can be dramatic, as discussed in Strategy in Action 9.4.

Maintaining Market Discipline Just as a company pursuing vertical integration faces the problem that its company-owned suppliers might become inefficient, a company that forms a strategic alliance with an independent component supplier runs the risk that its alliance partner might become inefficient over time, resulting in higher component costs or lower quality. This also happens because the outside supplier knows it does not need to compete

Hostage taking
A means of exchanging valuable resources to guarantee that each partner to an agreement will keep its side of the bargain.

Credible commitment
A believable promise or pledge to support the development of a long-term relationship between companies.

9.4 STRATEGY IN ACTION

Ebay's Changing Commitment to Its Sellers

© iStockPhoto.com/Tom Nulens

Since its founding in 1995, eBay has always cultivated good relationships with the millions of sellers that advertise their goods for sale on its website. Over time, however, to increase its revenues and profits, eBay has steadily increased the fees it charges sellers to list their products on its sites, to insert photographs, to use its PayPal online payment service, and for other additional services. Although this has caused some grumbling among sellers because it reduced their profit margins, eBay increasingly engages in extensive advertising to attract millions more buyers to its website, so sellers can receive better prices and also increase their total profits. As a result, they remained largely satisfied with eBay's fee structure.

These policies changed when a new CEO, John Donohue, took the place of eBay's long-time CEO, Meg Whitman, who had built the company into a dot.com giant. By 2008, eBay's profits had not increased rapidly enough to keep its investors happy, and its stock price plunged. To increase performance, one of Donohue's first moves was to announce a major overhaul of eBay's fee structure and feedback policy. The new fee structure would reduce upfront seller listing costs, but increase back-end commissions on completed sales and payments. For smaller sellers that already had thin profit margins, these fee hikes were painful. In addition, in the future, eBay announced it would block sellers from leaving negative feedback about buyers—feedback such as buyers didn't pay for the goods they purchased, or buyers took too long to pay for goods. The feedback system that eBay had originally developed had been a major source of its success; it allowed buyers to be certain they were dealing with reputable sellers—and vice versa. All sellers and buyers have feedback scores that provide them with a reputation as good—or bad—individuals to do business with, and these scores helped reduce the risks involved in online transactions. Donohue claimed this change was implemented in order to improve the buyer's experience because many buyers

had complained that if they left negative feedback for a seller, the seller would then leave negative feedback for the buyer!

Together, however, throughout 2009, these changes resulted in conflict between eBay and its millions of sellers, who perceived they were being harmed by these changes. Their bad feelings resulted in a revolt. Blogs and forums all over the Internet were filled with messages claiming that eBay had abandoned its smaller sellers, and was pushing them out of business in favor of high-volume "powersellers" who contributed more to eBay's profits. Donohue and eBay received millions of hostile e-mails, and sellers threatened they would do business elsewhere, such as on Amazon.com and Yahoo!, two companies that were both trying to break into eBay's market. Sellers also organized a 1-week boycott of eBay during which they would list no items with the company to express their dismay and hostility! Many sellers did shut down their eBay online storefronts and moved to Amazon.com, which claimed in 2011 that its network of sites had overtaken eBay in monthly unique viewers or "hits" for the first time. The bottom line was that the level of commitment between eBay and its sellers had fallen dramatically; the bitter feelings produced by the changes eBay had made were likely to result in increasing problems that would hurt its future performance.

Realizing that his changes had backfired, Donohue reversed course and eliminated several of eBay's fee increases and revamped its feedback system; sellers and buyers can now respond to one another's comments in a fairer way. These changes did improve hostility and smooth over the bad feelings between sellers and eBay, but the old "community relationship" it had enjoyed with sellers in its early years largely disappeared. As this example suggests, finding ways to maintain cooperative relationships—such as by testing the waters in advance and asking sellers for their reactions to fee and feedback changes—could have avoided many of the problems that arose.

Source: www.ebay.com.

with other suppliers for the company's business. Consequently, a company seeking to form a mutually beneficial, long-term strategic alliance needs to possess some kind of power that it can use to discipline its partner—should the need arise.

A company holds two strong cards over its supplier partner. First, all contracts, including long-term contracts, are periodically renegotiated, usually every 3 to 5 years, so the supplier knows that if it fails to live up to its commitments, its partner may refuse to renew the contract. Second, many companies that form long-term relationships with suppliers use **parallel sourcing policies**—that is, they enter into long-term contracts with at least *two* suppliers for the *same* component (this is Toyota's policy, for example).[12] This arrangement protects a company against a supplier that adopts an uncooperative attitude because the supplier knows that if it fails to comply with the agreement, the company can switch *all* its business to its other supplier partner. When both the company and its suppliers recognize that the parallel sourcing policy allows a supplier to be replaced at short notice, most suppliers behave because the policy brings market discipline into their relationship.

Parallel sourcing policy
A policy in which a company enters into long-term contracts with at least two suppliers for the same component to prevent any problems of opportunism.

The growing importance of JIT inventory systems as a way to reduce costs and enhance quality and differentiation is increasing the pressure on companies to form strategic alliances in a wide range of industries. The number of strategic alliances formed each year, especially global strategic alliances, is increasing, and the popularity of vertical integration is falling because so many low-cost global suppliers exist in countries like Malaysia, Korea, and China.

STRATEGIC OUTSOURCING

Vertical integration and strategic alliances are alternative ways of managing the value chain *across industries* to strengthen a company's core business model. However, just as low-cost suppliers of component parts exist, so today many *specialized companies* exist that can perform one of a company's *own value-chain activities* in a way that contributes to a company's differentiation advantage or that lowers its cost structure. For example, as noted in the opening case, Apple found that using Foxconn factories in China to assemble its iPhones enabled it to not only benefit by lower costs, but to also much more rapidly incorporate design changes and scale up production.

Strategic outsourcing is the decision to allow one or more of a company's value-chain activities or functions to be performed by independent specialist companies that focus all their skills and knowledge on just one kind of activity. The activity to be outsourced may encompass an entire function, such as the manufacturing function, or it may be just one kind of activity that a function performs. For example, many companies outsource the management of their pension systems while keeping other human resource management (HRM) activities within the company. When a company chooses to outsource a value-chain activity, it is choosing to focus on a *fewer* number of value creation activities to strengthen its business model.

Strategic outsourcing
The decision to allow one or more of a company's value-chain activities to be performed by independent, specialist companies that focus all their skills and knowledge on just one kind of activity to increase performance.

There has been a clear move among many companies to outsource activities that managers regard as being "noncore" or "nonstrategic," meaning they are not a source of a company's distinctive competencies and competitive advantage.[13] The vast majority of companies outsource manufacturing or some other value-chain activity to domestic or overseas companies today; some estimates are that over 60% of all global product manufacturing is outsourced to manufacturing specialists because of pressures to reduce costs. Some well-known companies that outsource include Nike, which does not make its athletic shoes; Gap Inc., which does not make its jeans and clothing; and Microsoft, which does not

9.5 STRATEGY IN ACTION

Apple Tries to Protect Its New Products and the Workers Who Make Them

© iStockPhoto.com/Tom Nulens

Apple's PCs and mobile computing devices are assembled by huge specialist outsourcing companies abroad, especially Foxconn, a subsidiary of Taiwan's giant outsourcer, Hon Hai Precision Industry, which is controlled by its secretive multibillionaire CEO, Terry Gou. Foxconn operates several huge factories in mainland China that each employ hundreds of thousands of workers.

Apple has long been known for its concern for secrecy; it strives to keep the details of its new or improved products, such as its updated iPhone 4S launched in October 2011, hidden while under development. Steve Jobs, who also passed away in October 2011, was always concerned with protecting Apple's secrets. His concern for security led Apple to sue a college student who published a website featuring details of Apple's future products; it has also brought legal action against many bloggers who reveal details about its new products. Even in its own U.S. product engineering units Apple has strict rules that prevent engineers from discussing the projects they are working on with engineers from other units to prevent information flows between engineering units and so protect product secrecy.

Apple has also developed uncompromising rules that govern how its outsourcers should protect product secrecy. To keep Apple's business, outsourcers like Foxconn go to extreme lengths to follow Apple's rules and follow stringent security guidelines in their manufacturing plants to keep the details of Apple's new products secret. For example, Apple dictates that the final product should not be assembled until as late as possible to meet its launch date; so, while workers learn how to assemble components, they have no idea what collection of components will go into the final product. Also, Foxconn strictly controls its factories to make it easier to enforce such rules. For example, Foxconn's massive plant in Longhua, China, employs over 350,000 workers who are discouraged from leaving the factory; it offers them a full array of low-cost services such as canteens, dormitories, and recreational facilities. If employees leave the plant, they are searched; metal detectors are used to ensure they do not take components with them, and they are also scanned when they return. Truck drivers who deliver components to the factory are also scanned, as well as anyone else who enters the factory. Apple's contracts include a confidentiality clause with stiff penalties in the event of a security breach, and

Apple's inspectors perform surprise factory visits to ensure outsourcers follow its rules.

Although Apple insists its outsourcers create elaborate "secrecy" walls around their assembly plants, these same walls make it much more difficult to enforce the extensive and well-publicized rules Apple has developed regarding the fair and equitable treatment of employees who work in these gigantic "sweatshops." For example, in 2006, after reports claimed Foxconn was not following Apple's rules regarding employee treatment, Apple audited its factories and found many violations that were never publicly disclosed. Apple has been criticized for allowing its products to be made at plants with poor employment practices—despite the fact that it claims to enforce many rules governing how employees should be treated. In 2010, Apple announced that new audits had revealed that child labor had been used in Foxconn's and other Chinese factories that made its iPods and other electronic devices: "In each of the three facilities, we required a review of all employment records for the year as well as a complete analysis of the hiring process to clarify how under-age people had been able to gain employment." Also, Apple admitted that sweatshop-like conditions existed inside these factories and at least 55 of the 102 factories had ignored rules that employees should work no more than 60 hours per week. Apple said another of its outsourcers had repeatedly falsified its records to conceal child labor practices and long employee hours; it terminated all contracts with that company: "When we investigated, we uncovered records and conducted worker interviews that revealed excessive working hours and 7 days of continuous work."

Apple's ethical position came under increased scrutiny in 2010 when it was widely publicized that at Foxconn's biggest factory in Shenzhen, which assembles Apple's iPhone, 11 workers had committed suicide by jumping off buildings within a period of 12 months. Once again Apple sent inspectors, including its chief operating officer (COO), to investigate, and within months Foxconn's Terry Gou announced that it would almost double workers' wages and improve working conditions to improve employee morale. These circumstances beg the questions: Which rules does Apple spend the most time and effort to develop and enforce? Which rules does it regard as being most important—the rules that protect the secrecy of its products, or the rules that protect the rights of the workers who make those products?

Source: www.apple.com.

make its Xbox consoles. These products are made under contract at low-cost, global locations by contract manufacturers that specialize in low-cost assembly—and many problems can arise as a result, as Strategy in Action 9.5 discusses.

Although manufacturing is the most common form of strategic outsourcing, as we noted earlier, many other kinds of noncore activities are also outsourced. Microsoft has long outsourced its entire customer technical support operation to an independent company, as does Dell. Both companies have extensive customer support operations in India staffed by skilled operatives who are paid a fraction of what their U.S. counterparts earn. BP outsourced almost all of its human resource function to Exult, a San Antonio company, in a 5-year deal worth $600 million; a few years later Exult won a 10-year, $1.1 billion contract to handle HRM activities for all Bank of America's 150,000 employees. Similarly, American Express outsourced its entire IT function to IBM in a 7-year deal worth $4 billion. In 2006, IBM announced it was outsourcing its purchasing function to an Indian company to save $2 billion a year, and it has steadily increased its use of outsourcing ever since. For example, in 2009, IBM announced it would lay off 5,000 IT employees in the United States and move their jobs to India.[14]

Companies engage in strategic outsourcing to strengthen their business models and increase their profitability. The process of strategic outsourcing typically begins with strategic managers identifying the value-chain activities that form the basis of a company's competitive advantage; these are obviously kept within the company to protect them from competitors. Managers then systematically review the noncore functions to assess whether independent companies that specialize in those activities can perform them more effectively and efficiently. Because these companies specialize in particular activities, they can perform them in ways that lower costs or improve differentiation. If managers decide there are differentiation or cost advantages, these activities are outsourced to those specialists.

This is illustrated in Figure 9.3, which shows the primary value-chain activities and boundaries of a company before and after it has pursued strategic outsourcing. In this

Figure 9.3 Strategic Outsourcing of Primary Value Creation Functions

© Cengage Learning

example, the company decided to outsource its production and customer service functions to specialist companies, leaving only R&D and marketing and sales within the company. Once outsourcing has been executed, the relationships between the company and its specialists are then often structured as long-term contractual relationships, with rich information sharing between the company and the specialist organization to which it has contracted the activity. The term **virtual corporation** has been coined to describe companies that have pursued extensive strategic outsourcing.[15]

Virtual corporation
When companies pursued extensive strategic outsourcing to the extent that they only perform the central value creation functions that lead to competitive advantage.

Benefits of Outsourcing

Strategic outsourcing has several advantages. It can help a company to (1) lower its cost structure, (2) increase product differentiation,[16] and (3) focus on the distinctive competencies that are vital to its long-term competitive advantage and profitability.

Lower Cost Structure Outsourcing will reduce costs when the price that must be paid to a specialist company to perform a particular value-chain activity is less than what it would cost the company to internally perform that activity in-house. Specialists are often able to perform an activity at a lower cost than the company, because they are able to realize scale economies or other efficiencies not available to the company. For example, performing HRM activities, such as managing benefit and pay systems, requires a significant investment in sophisticated HRM IT; purchasing these IT systems represents a considerable fixed cost for one company. But, by aggregating the HRM IT needs of many individual companies, companies that specialize in HRM, such as Exult and Paychex, can obtain huge economies of scale in IT that any single company could not hope to achieve. Some of these cost savings are then passed to the client companies in the form of lower prices, which reduces their cost structure. A similar dynamic is at work in the contract manufacturing business. Once again, manufacturing specialists like Foxconn, Flextronics, and Jabil Circuit make large capital investments to build efficient-scale manufacturing facilities, but then are able to spread those capital costs over a huge volume of output, and drive down unit costs so that they can make a specific product—an Apple iPod or Motorola XOOM, for example—at a lower cost than the company.

Specialists are also likely to obtain the cost savings associated with learning effects much more rapidly than a company that performs an activity just for itself (see Chapter 4 for a review of learning effects). For example, because a company like Flextronics is manufacturing similar products for several different companies, it is able to build up *cumulative* volume more rapidly, and it learns how to manage and operate the manufacturing process more efficiently than any of its clients could. This drives down the specialists' cost structure and also allows them to charge client companies a lower price for a product than if they made that product in-house.

Specialists are also often able to perform activities at lower costs than a specific company because of lower wage rates in those locations. For example, many of the workers at the Foxconn factory that assembles iPhones in China earn less than $17 a day; moving production of iPhones to the United States would, according to estimates, raise the cost of an iPhone by $65.[17] Similarly, Nike also outsources the manufacture of its running shoes to companies based in China because of much lower wage rates. Even though wages have doubled in China since 2010, a Chinese-based specialist can assemble shoes (a very labor-intensive activity) at a much lower cost than could be done in the United States. Although Nike could establish its own operations in China to manufacture running shoes, it would require a major capital investment and limit its ability to switch production to an

even lower-cost location later, for example, Vietnam—and many companies are moving to Vietnam because wage rates are lower there. So, for Nike and most other consumer goods companies, outsourcing manufacturing activities lowers costs and gives the companies the flexibility to switch to a more favorable location if labor costs change is the most efficient way to handle production.

Enhanced Differentiation A company may also be able to differentiate its final products better by outsourcing certain noncore activities to specialists. For this to occur, the *quality* of the activity performed by specialists must be greater than if that same activity was performed by the company. On the reliability dimension of quality, for example, a specialist may be able to achieve a lower error rate in performing an activity, precisely because it focuses solely on that activity and has developed a strong distinctive competency in it. Again, this is one advantage claimed for contract manufacturers. Companies like Flextronics have adopted Six Sigma methodologies (see Chapter 4) and driven down the defect rate associated with manufacturing a product. This means they can provide more reliable products to their clients, which can now differentiate their products on the basis of their superior quality.

A company can also improve product differentiation by outsourcing to specialists when they stand out on the excellence dimension of quality. For example, the excellence of Dell's U.S. customer service is a differentiating factor, and Dell outsources its PC repair and maintenance function to specialist companies. A customer who has a problem with a product purchased from Dell can get excellent help over the phone, and if there is a defective part in the computer, a maintenance person will be dispatched to replace the part within a few days. The excellence of this service differentiates Dell and helps to guarantee repeat purchases, which is why HP has worked hard to match Dell's level of service quality. In a similar way, carmakers often outsource specific kinds of vehicle component design activities, such as microchips or headlights, to specialists that have earned a reputation for design excellence in this particular activity.

Focus on the Core Business A final advantage of strategic outsourcing is that it allows managers to focus their energies and their company's resources on performing those core activities that have the most potential to create value and competitive advantage. In other words, companies can enhance their core competencies and are able to push out the value frontier and create more value for their customers. For example, Cisco Systems remains the dominant competitor in the Internet router industry because it has focused on building its competencies in product design, marketing and sales, and supply-chain management. Companies that focus on the core activities essential for competitive advantage in their industry are better able to drive down the costs of performing those activities, and better differentiate their final products.

Risks of Outsourcing

Although outsourcing noncore activities has many benefits, there are also risks associated with it, risks such as holdup and the possible loss of important information when an activity is outsourced. Managers must assess these risks before they decide to outsource a particular activity, although, as we discuss the following section, these risks can be reduced when the appropriate steps are taken.

Holdup In the context of outsourcing, holdup refers to the risk that a company will become too dependent upon the specialist provider of an outsourced activity and that the

specialist will use this fact to raise prices beyond some previously agreed-upon rate. As with strategic alliances, the risk of holdup can be reduced by outsourcing to several suppliers and pursuing a parallel sourcing policy, as Toyota and Cisco do. Moreover, when an activity can be performed well by any one of several different providers, the threat that a contract will not be renewed in the future is normally sufficient to keep the chosen provider from exercising bargaining power over the company. For example, although IBM enters into long-term contracts to provide IT services to a wide range of companies, it would be unadvisable to attempt to raise prices after the contract has been signed because it knows full well that such an action would reduce its chance of getting the contract renewed in the future. Moreover, because IBM has many strong competitors in the IT services business, such as Accenture, Capgemini, and HP, it has a very strong incentive to deliver significant value to its clients.

Increased Competition As firms employ contract manufacturers for production, they help to build an industry-wide resource that lowers the barriers to entry in that industry. In industries that have efficient and high-quality contract manufacturers, large firms may find that their size no longer affords them protection against competitive pressure; their high investments in fixed assets can become a constraint rather than a source of advantage.[18] Furthermore, firms that use contract manufacturing pay, in essence, for the contract manufacturer to progress down its own learning curve. Over time, the contract manufacturer's capabilities improve, putting it at an even greater manufacturing advantage over the firm. Contract manufacturers in many industries increase the scope of their activities over time, adding a wider range of services (e.g., component purchasing, redesign-for-manufacturability, testing, packaging, and after-sales service) and may eventually produce their own end products in competition with their customers. Contracts to manufacture goods for U.S. and European electronics manufacturers, for example, helped to build the electronics manufacturing giants that exist today in Japan and Korea.

Loss of Information and Forfeited Learning Opportunities A company that is not careful can lose important competitive information when it outsources an activity. For example, many computer hardware and software companies have outsourced their customer technical support function to specialists. Although this makes good sense from a cost and differentiation perspective, it may also mean that a critical point of contact with the customer, and a source of important feedback, is lost. Customer complaints can be useful pieces of information and valuable inputs into future product design, but if those complaints are not clearly communicated to the company by the specialists performing the technical support activity, the company can lose the information. Similarly, a firm that manufactures its own products also gains knowledge about how to improve their design in order to lower the costs of manufacturing or produce more reliable products. Thus, a firm that forfeits the development of manufacturing knowledge could unintentionally forfeit opportunities for improving its capabilities in product design. The firm risks becoming "hollow."[19] These are not arguments against outsourcing. Rather, they are arguments for ensuring that there is appropriate communication between the outsourcing specialist and the company. At Dell, for example, a great deal of attention is paid to making sure that the specialist responsible for providing technical support and onsite maintenance collects and communicates all relevant data regarding product failures and other problems to Dell, so that Dell can design better products.

Ethical Dilemma

Google pursued a strategy of horizontal integration and has bought hundreds of small software companies to become the dominant online advertising company and a major software provider for PCs and mobile computing devices. Google has been accused of using its monopoly power to overcome or undermine its rivals, such as Yahoo! and perhaps Groupon, and in 2011, it was under investigation by the FTC. Google's managers have responded that online advertising costs have actually fallen because its search engine technology allows it to better target customers. in addition, it has given many products away for free such as its Chrome Web browser and Android software, and dramatically improved other online offerings.

If you were on a committee charged with deciding whether Google has behaved in an unethical manner, what kind of criteria would you use to determine the outcome?

SUMMARY OF CHAPTER

1. A corporate strategy should enable a company, or one or more of its business units, to perform one or more of the value creation functions at a lower cost or in a way that allows for differentiation and a premium price.

2. The corporate-level strategy of horizontal integration is pursued to increase the profitability of a company's business model by (a) reducing costs, (b) increasing the value of the company's products through differentiation, (c) replicating the business model, (d) managing rivalry within the industry to reduce the risk of price warfare, and (e) increasing bargaining power over suppliers and buyers.

3. There are two drawbacks associated with horizontal integration: (a) the numerous pitfalls associated with making mergers and acquisitions and (b) the fact that the strategy can bring a company into direct conflict with antitrust authorities.

4. The corporate-level strategy of vertical integration is pursued to increase the profitability of a company's "core" business model in its original industry. Vertical integration can enable a company to achieve a competitive advantage by helping build barriers to entry, facilitating investments in specialized assets, protecting product quality, and helping to improve scheduling between adjacent stages in the value chain.

5. The disadvantages of vertical integration include (i) increasing bureaucratic costs if a company-owned or in-house supplier becomes lazy or inefficient, (ii) potential loss of focus on those resources and capabilities that create the most value for the firm, and (iii), reduced flexibility to adapt to a fast-changing environment. Entering into a long-term contract can enable a company to realize many of the benefits associated with vertical integration without having to bear the same level of bureaucratic costs. However, to avoid the risks associated with becoming too dependent upon its partner, it needs to seek a credible commitment from its partner or establish a mutual hostage-taking situation.

6. The strategic outsourcing of noncore value creation activities may allow a company to lower its costs, better differentiate its products, and make better use of scarce resources, while also enabling it to respond rapidly to changing market conditions. However, strategic outsourcing may have a detrimental effect if the company outsources important value creation activities or becomes too dependent upon the key suppliers of those activities.

DISCUSSION QUESTIONS

1. Under what conditions might horizontal integration be inconsistent with the goal of maximizing profitability?
2. What is the difference between a company's internal value chain and the industry value chain? What is the relationship between vertical integration and the industry value chain?
3. Why was it profitable for GM and Ford to integrate backward into component-parts manufacturing in the past, and why are both companies now buying more of their parts from outside suppliers?
4. What value creation activities should a company outsource to independent suppliers? What are the risks involved in outsourcing these activities?
5. What steps would you recommend that a company take to build mutually beneficial long-term cooperative relationships with its suppliers?

PRACTICING STRATEGIC MANAGEMENT

© iStockPhoto.com/Urilux

Small-Group Exercise: Comparing Vertical Integration Strategies

Break up into small groups of three to five people, and discuss the following scenario. Appoint one group member as a spokesperson who will communicate your findings to the class. Read the following description of the activities of Seagate Technologies and Quantum Corporation, both of which manufacture computer disk drives. On the basis of this description, outline the pros and cons of a vertical integration strategy. Which strategy do you think makes most sense in the context of the computer disk drive industry?

Quantum Corporation and Seagate Technologies are major producers of disk drives for PCs and workstations. The disk drive industry is characterized by sharp fluctuations in the level of demand, intense price competition, rapid technological change, and product life cycles of only 12 to 18 months. Quantum and Seagate have pursued very different vertical integration strategies to meet this challenge.

Seagate is a vertically integrated manufacturer of disk drives, both designing and manufacturing the bulk of its own disk drives. On the other hand, Quantum specializes in design; it outsources most of its manufacturing to a number of independent suppliers, including, most important, Matsushita Kotobuki Electronics (MKE) of Japan. Quantum makes only its newest and most expensive products in-house. Once a new drive is perfected and ready for large-scale manufacturing, Quantum turns over manufacturing to MKE. MKE and Quantum have cemented their partnership over 8 years. At each stage in designing a new product, Quantum's engineers send the newest drawings to a production team at MKE. MKE examines the drawings and proposes changes that make new disk drives easier to manufacture. When the product is ready for manufacture, 8 to 10 Quantum engineers travel to MKE's plant in Japan for at least 1 month to work on production ramp-up.

STRATEGY SIGN-ON

© iStockPhoto.com/Ninoslav Dotlic

Article File 9

Find an example of a company whose horizontal or vertical integration strategy appears to have dissipated rather than created value. Identify why this has been the case and what the company should do to rectify the situation.

Strategic Management Project: Module 9

This module requires you to assess the horizontal and vertical integration strategy being pursued by your company. With the information you have at your disposal, answer the questions and perform the tasks listed:

1. Has your company ever pursued a horizontal integration strategy? What was the strategic reason for pursuing this strategy?
2. How vertically integrated is your company? In what stages of the industry value chain does it operate?
3. Assess the potential for your company to increase profitability through vertical integration. In reaching your assessment, also consider the bureaucratic costs of managing vertical integration.
4. On the basis of your assessment in question 3, do you think your company should (a) outsource some operations that are currently performed in-house or (b) bring some operations in-house that are currently outsourced? Justify your recommendations.
5. Is your company involved in any long-term cooperative relationships with suppliers or buyers? If so, how are these relationships structured? Do you think that these relationships add value to the company? Why or why not?
6. Is there any potential for your company to enter into (additional) long-term cooperative relationships with suppliers or buyers? If so, how might these relationships be structured?

CLOSING CASE

The Rapid Consolidation of the U.S. Airline Industry

In July 2008, American Airlines (AA) was the largest air carrier in the world, and it competed against five other established U.S. airlines as well as newer airlines such as Southwest and JetBlue. Then, oil prices, which are approximately 35% of an airline's total operating costs, were rising, and the recent financial recession occurred that led to a significant decrease in the number of business travelers (who are the most lucrative source of revenue for an airline). These circumstances led to billions of dollars in losses for most major U.S. airlines, including American and JetBlue. Southwest, however, was the exception because it has always pursued a cost-leadership strategy and so had been able to withstand falling ticket prices and rising costs better than the older, more established airlines.

With many major airlines facing bankruptcy, the Justice Department began to look more favorably upon requests by airlines to merge their operations, expand their route structures, and reduce their cost structures. The downside for passengers of merger and horizontal

integration, of course, is that if there are fewer airlines, the remaining carriers are able to reduce the number of flights they offer and services they provide—and the result is that ticket prices increase. For example, industry consolidation makes it easier for carriers to announce changes such as charging for a second checked bag or the right to be seated first, all of which provide airlines with additional sources of revenue.

Nevertheless, in 2009 the Justice Department allowed Delta and Northwest Airlines to merge, resulting in the new Delta becoming the largest U.S. airline. Then in 2010, the merger between United and Continental Airlines was also approved, and by 2011, the newly merged United-Continental Airlines was competing with Delta to become the largest U.S. carrier. American Airlines, by that time, was now number three after its proposal to merge with British Airways (and become the largest global airline) was not approved for antitrust reasons—despite that the global airline industry was also rapidly consolidating.

By 2011, the largest U.S. airlines had achieved most of their goals of reducing costs; they had slashed the number of flights they offered, mothballed hundreds of older planes, laid off thousands of employees, and instituted new surcharges for fuel, baggage, and even for carrying pets onboard. In 2012, Delta and US Airways posted modest profits (Delta earned a net profit margin of 2.4% and a return on assets of 2%; US Airways earned a net profit margin of 4.6% and

a return on assets of 6.8%). United-Continental and American Airlines, however, were still posting losses.

While its rivals had lost many billions over the decade beginning in 2000, Southwest celebrated an unbroken string of consecutive annual profits. By 2011, Southwest served most major U.S. cities, and its managers also saw an opportunity to expand market share and simultaneously keep its cost structure low by acquiring one of its low-cost rivals, Air Tran Holdings, owner of AirTran Airways. AirTran offered low-cost passenger transportation to almost 70 cities, mainly in the United States and the Caribbean. Like Southwest Airlines, it operated an all-Boeing fleet, facilitating its integration with Southwest's operations (Southwest's use of only Boeing 737s was said to be a major source of efficiencies, for example, by reducing parts inventory requirements and increasing pilot flexibility). The revenues of the combined companies reached $17.1 billion in 2012, roughly half the size of the world's largest airlines.

Many analysts, watching Southwest's ever-changing online fares, noted that it, too, was raising fares in response to the moves of other airlines. Although it had staunchly refused to impose baggage fees (in order to not erode its low-cost image), it began to create fees for such services as bringing pets into the cabin and for the travel of unaccompanied minors.

Sources: Hoovers.com; "Southwest Airlines – Details and Fleet History – Planespotters.net Just Aviation," Planespotters.net; and "AirTran Airways – Details and Fleet History – Planespotters.net Just Aviation," Planespotters.net.

CASE DISCUSSION QUESTIONS

1. How does consolidation improve airlines' revenues? How might it improve their costs?
2. Are there any disadvantages to the airlines of consolidating?

3. Why do you think Southwest Airlines is (on average) the most profitable of the U.S. airlines? Should it attempt to integrate with other airlines? Why or why not?

KEY TERMS

Horizontal integration 290	Vertical integration 295	Quasi integration 303	Parallel sourcing
Acquisition 290	Holdup 298	Strategic alliances 303	policy 307
Merger 290	Tapered integration 298	Hostage taking 305	Strategic outsourcing 307
Product bundling 291	Vertical disintegration 301	Credible commitment 305	Virtual corporation 310
Cross-selling 292	Transfer pricing 301		

NOTES

[1] This is the essence of Chandler's argument. See A. D. Chandler, *Strategy and Structure* (Cambridge: MIT Press, 1962). The same argument is also made by J. Pfeffer and G. R. Salancik, *The External Control of Organizations* (New York: Harper & Row, 1978). See also K. R. Harrigan, *Strategic Flexibility* (Lexington: Lexington Books, 1985); K. R. Harrigan, "Vertical Integration and Corporate Strategy," *Academy of Management Journal* 28 (1985): 397–425; and F. M. Scherer, *Industrial Market Structure and Economic Performance* (Chicago: Rand McNally, 1981).

[2] O. E. Williamson, *The Economic Institutions of Capitalism* (New York: Free Press, 1985). For a more recent empirical work that uses this framework, see L. Poppo and T. Zenger, "Testing Alternative Theories of the Firm: Transaction Cost, Knowledge Based, and Measurement Explanations for Make or Buy Decisions in Information Services," *Strategic Management Journal* 19 (1998): 853–878.

[3] Williamson, *Economic Institutions of Capitalism.*

[4] J. M. deFigueiredo and B. S. Silverman, "Firm Survival and Industry Evolution in Vertically Related Populations," *Management Science* 58 (2012):1632–1650.

[5] www.mcdonalds.com.

[6] Ibid.

[7] A. D. Chandler, *The Visible Hand* (Cambridge: Harvard University Press, 1977).

[8] Harrigan, *Strategic Flexibility*, pp. 67–87. See also A. Afuah, "Dynamic Boundaries of the Firm: Are Firms Better Off Being Vertically Integrated in the Face of a Technological Change?" *Academy of Management Journal* 44 (2001): 1121–1228.

[9] K. M. Gilley, J. E. McGee, and A. A. Rasheed, "Perceived Environmental Dynamism and Managerial Risk Aversion as Antecedents of Manufacturing Outsourcing: The Moderating Effects of Firm Maturity," *Journal of Small Business Management*, 42 (2004): 117–134; and M. A. Schilling and H. K. Steensma, "The Use of Modular Organizational Forms: An Industry-Level Analysis," *Academy of Management Journal*, 44(2001): 1149–1169.

[10] X. Martin, W. Mitchell, and A. Swaminathan, "Recreating and Extending Japanese Automobile Buyer-Supplier Links in North America," *Strategic Management Journal* 16 (1995): 589–619; and C. W. L. Hill, "National Institutional Structures, Transaction Cost Economizing, and Competitive Advantage," *Organization Science* 6 (1995): 119–131.

[11] Williamson, *Economic Institutions of Capitalism*. See also J. H. Dyer, "Effective Inter-Firm Collaboration: How Firms Minimize Transaction Costs and Maximize Transaction Value," *Strategic Management Journal* 18 (1997): 535–556.

[12] Richardson, "Parallel Sourcing."

[13] W. H. Davidow and M. S. Malone, *The Virtual Corporation* (New York: Harper & Row, 1992).

[14] J. Krane, "American Express Hires IBM for $4 Billion," *Columbian*, February 26, 2002, p. E2; www.ibm.com.

[15] Davidow and Malone, *The Virtual Corporation.*

[16] Ibid.; H. W. Chesbrough and D. J. Teece, "When Is Virtual Virtuous? Organizing for Innovation," *Harvard Business Review*, January–February 1996, pp. 65–74; J. B. Quinn, "Strategic Outsourcing: Leveraging Knowledge Capabilities," *Sloan Management Review*, Summer 1999, pp. 9–21.

[17] C. Duhigg and K. Bradsher, "How the U.S. Lost Out on iPhone Work," *New York Times*, January 21, 2012, p. 1.

[18] Schilling and Steensma, "The Use of Modular Organizational Forms."

[19] R. Venkatesan, "Strategic Sourcing: To Make or Not to Make. *Harvard Business Review*, November–December 1992, pp. 98–107.

10

Corporate-Level Strategy: Related and Unrelated Diversification

LEARNING OBJECTIVES

After reading this chapter, you should be able to:

10-1 Differentiate between multibusiness models based on related and unrelated diversification

10-2 Explain the five primary ways in which diversification can increase company profitability

10-3 Discuss the conditions that lead managers to pursue related diversification versus unrelated diversification and explain why some companies pursue both strategies

10-4 Describe the three methods companies use to enter new industries—internal new venturing, acquisitions, and joint ventures—and discuss the advantages and disadvantages associated with each of these methods

OPENING CASE

Helen Sessions/Alamy

Citigroup: The Opportunities and Risks of Diversification

In 2013, Citigroup was a $90.1 billion diversified financial services firm known around the world. However, its history had not always been smooth. From the late 1990s through 2010, the company's diversification moves, and its role in the mortgage crisis, combined to bring the company to its knees, making many fear that the venerable bank—one of the oldest and largest in the United States—would not survive.

Citigroup traces its history all the way back to 1812, when it was formed by a group of merchants in response to the abolishment of the First Bank of the United States (the First Bank's charter had been permitted to lapse due to Thomas Jefferson's arguments about the dangers of centralized control of the economy). The merchants, led by Alexander Hamilton, created the City Bank of New York in 1812, which they hoped would be large enough to replicate the scale advantages that had been offered by the First Bank. The bank played some key roles in the rise of the United States as a global power, including lending money to support the purchasing of armaments for the War of 1812, financing the Union war effort in the mid-1800s, and later pioneering foreign-exchange trading, which helped to bring the United States to the world stage in the early 1900s. By 1929, it was the largest commercial bank in the world.

The bank's capital resources and its trusted brand name enabled it to successfully diversify into a range of consumer banking services. The highly innovative company was, for example,

the first to introduce savings accounts with compound interest, unsecured personal loans, checking accounts, and 24-hour ATMs, among other things. However, its business remained almost entirely within traditional retail banking services. That would soon change with the rise of a new concept: the "financial supermarket."

During the 1990s, there was much buzz in the financial industry about the value of having a wider range of financial services within the same bank. Why have your savings account in New Jersey, your stock broker in California, and your insurance agent in Maryland, when you could have everything under one roof? Merging such services under one roof would enable numerous "cross-selling" opportunities: Each company's customer bases could be more fully leveraged by promoting other financial products to them. Furthermore, cost savings might be realized by consolidating operations such as information technology, customer service and billing, and so forth. In 1998, Sanford "Sandy" Weill, who had already begun creating his own financial supermarket that included Travelers insurance, Aetna, Primerica, Salomon Brothers, and Smith Barney Holdings, convinced Citicorp chairman and CEO John Reed that the two companies should merge. Travelers Group purchased all of Citicorp's shares for $70 billion, and issued 2.5 new Citigroup shares for each Citicorp Share. Existing shareholders of each company thus owned approximately half of the new firm. The merger created a $140 billion firm with assets of $700 billion. Renamed Citigroup, it was now the largest financial services organization in the world.

Unfortunately, at almost exactly the same time, the Internet rendered the bricks-and-mortar financial supermarket obsolete: the best deals were to be found at the financial supermarket on the Web. To make matters worse, rather than cross-selling, the different divisions of Citi and Travelers began battling each other to protect their turf. Savings in consolidating back-office operations also turned out to be meager and costly to realize. Harmonizing each company's information technology systems, for example, was going to be so expensive that ultimately the legacy systems were just left intact. Additionally,

though the merged company shed more than 10,000 employees, it was harder to part with other executive—instead, the company kept so many pairs of executives with "co" titles (including co-CEOs Weill and Reed) that some people compared Citi to Noah's Ark. According to Meredith Whitney, a banking analyst who was an early critic of Citi's megabank model, Citi had become "a gobbledygook of companies that were never integrated. . . The businesses didn't communicate with each other. There were dozens of technology systems and dozens of financial ledgers."

To boost earnings, Citi began investing in subprime loans, whose risk was camouflaged by bundling them into mortgage-backed securities known as collateralized debt obligations (CDOs). Trouble began brewing before even Citi knew the scale of risk it had undertaken. Loose lending policies had resulted in a large number of poor-quality mortgages, the vast majority of which had adjustable-rate mortgages (i.e., the initial rate was very low, but would increase over time). This combined with a steep decline in housing prices that made it next to impossible for homebuyers to refinance their mortgages as their interest rates climbed—their homes were now worth less than what they owed. Delinquencies and foreclosures soared, meaning that banks holding those mortgages had assets whose value was rapidly declining. A lawsuit by Citi's shareholders in 2006 accused the company of using a "CDO-related quasi-Ponzi scheme" to falsely give the appearance that it had a healthy asset base and conceal the true risks the company was facing, but even Citi's CEO at the time, Charles O. Prince III, did not know how much the company had invested in mortgage-related assets. Prince found out at a September 2007 meeting that the company had $43 billion in mortgage-related assets, but was assured by Thomas Maheras (who oversaw trading at the bank) that everything was fine. Soon the company was posting billions in losses and its stock price fell to the lowest it had been in a decade (see the accompanying graphs). To Lynn Turner, a former chief accountant with the Securities and Exchange Commission, Citi's crisis was no

surprise. He pointed out that Citi was too large, did not have the right controls, and lacked sufficient accountability for individuals undertaking risks on the company's behalf, making such problems inevitable. The amalgamation of businesses had created conflicts of interest, and Citi's managers lacked the ability to accurately gauge the risk of the exotic financial instruments that were proliferating. As the true scope of the problem was revealed, Citi found itself in very dire circumstances. The losses from writing down its mortgage assets threatened to destroy the entire company, bringing down even its profitable lines of business.

While the U.S. government kept the bank from failing with a $45 billion bailout (for fear that Citi's failure would cause an even greater economic collapse—giving rise to the phrase "too big to fail"), Citigroup began reducing its workforce, and selling off everything it could, dismantling its financial supermarket. Over the next 2 years it slashed over 80,000 jobs and sold Smith Barney, Phibro (its commodities-trading unit), Diner's Club (a credit card), its Japanese brokerage operations, Primerica, and more. Furthermore, to raise capital it sold 5% of its equity to the Abu Dhabi Investment authority for $7.5 billion, and then raised another $12 billion by selling shares to a group of investors that included Prince Alwaleed Bin Talal of Saudi Arabia in 2008. It also restructured itself into two operating units: Citicorp for retail and institutional client business, and Citi Holdings for its brokerage and asset management. This reorganization would help to isolate Citi's banking operations from the riskier assets it wished to sell.

In 2010, Citigroup finally returned to profitability. It repaid its U.S. government loans, and its managers and the investment community breathed a sigh of relief, optimistic that the worst was over. In 2012, Citi posted $71 billion in revenues and $7.5 billion in net income (Citi's consumer and institutional businesses earned $14.1 billion in profits, but were offset by $6.6 billion in losses from Citi Holdings). Today, roughly 50% of its revenues come from its consumer businesses (retail banking, credit cards, mortgages, and commercial banking for small-to-medium businesses), 50% comes from its Institutional Clients group (which provides investment and banking services for corporations, governments, institutions and ultra-high-net-worth individuals), and Citi Holdings posts zero to negative revenues.

Citigroup's Revenues and Net Income (in $US millions), 2003–2012

■ Revenue ■ Net Income

Source: Hoovers.com

OPENING CASE

The saga of Citi seriously undermined the investment community's faith in the financial supermarket model, although in the wake of the mortgage crisis it was difficult to assess how much had been gained and lost through the diversification of the firm. One thing that was clear, however, was that having a very large and complex organization had made it more difficult to provide sufficient, and effective oversight within the firm. This, in turn, allowed problems to grow very large before being detected. Citi's managers knew they would have to think much more carefully about their business choices in the future, and about how to manage the interdependencies between those businesses.

Sources: R. Wile, "Dramatic Highlights from Citi's 200-Year History," *Business Insider,* April 4, 2012, www.businessinsider.com/presenting-a-history-of-citi-2012-4?op=1); "About Citi—Citibank, N.A.," www.citigroup.com; M. Martin, "Citicorp and Travelers Plan to Merge in Record $70 Billion Deal," *New York Times,* April 7, 1998, p. 1; A. Kessler, "The End of Citi's Financial Supermarket,"*Wall Street Journal,* January 16, 2009, p. A11; "Fall Guy," *The Economist,* November 5, 1998; E. Dash and J. Creswell, "Citigroup Saw No Red Flags Even as It Made Bolder Bets," *New York Times,* November 22, 2008, p. 14; P. Hurtado and D. Griffin, "Citigroup Settles Investors' CDO Suit for $590 Million," Bloomberg.com, August 29, 2012; and D. Ellis, "Citi Plunges 26%–Lowest in 15 Years," CNNMoney.com, November 20, 2008.

Citigroup's Stock Price, 2004–2013

Source: NASDAQ.com

OVERVIEW

The chapter-opening case illustrates how diversification can create, and destroy, value. Citibank's reputation, brand name, expertise, and capital had enabled it to profitably expand both its product and geographic scope. However, overestimates of synergies led the firm to diversify into activities that strayed from its key strengths in consumer retail banking. Furthermore, as it became increasingly diversified, it became difficult for managers to provide adequate oversight within the organization. Problems, including conflicts of interest and underestimates of the risk of its assets, grew without being detected. By the time management knew there was trouble within the firm, the company was in desperate circumstances, and may not have survived had it not been bailed out by the U.S. government.

In this chapter, we continue to discuss both the challenges and opportunities created by corporate-level strategies of related and unrelated diversification. A diversification strategy is based upon a company's decision to enter one or more new industries to take advantage of its existing distinctive competencies and business model. We examine the different kinds of multibusiness models upon which related and unrelated diversification are based. Then, we discuss three different ways companies can implement a diversification strategy: internal new ventures, acquisitions, and joint ventures. By the end of this chapter, you will understand the advantages and disadvantages associated with strategic managers' decisions to diversify and enter new markets and industries.

INCREASING PROFITABILITY THROUGH DIVERSIFICATION

diversification

The process of entering new industries, distinct from a company's core or original industry, to make new kinds of products for customers in new markets.

diversified company

A company that makes and sells products in two or more different or distinct industries.

Diversification is the process of entering new industries, distinct from a company's core or original industry, to make new kinds of products that can be sold profitably to customers in these new industries. A multibusiness model based on diversification aims to find ways to use a company's existing strategies and distinctive competencies to make products that are highly valued by customers in the new industries it enters. A **diversified company** is one that makes and sells products in two or more different or distinct industries (industries *not* in adjacent stages of an industry value chain as in vertical integration). As in the case of the corporate strategies discussed in Chapter 9, a diversification strategy should enable a company or its individual business units to perform one or more of the value-chain functions: (1) at a lower cost, (2) in a way that allows for differentiation and gives the company pricing options, or (3) in a way that helps the company to manage industry rivalry better—*in order to increase profitability*.

The managers of most companies often consider diversification when they are generating *free cash flow*. that is, cash in excess of that required to fund new investments in the company's current business and meet existing debt commitments.[1] In other words, free cash flow is cash beyond that needed to make profitable new investments in its existing business. When a company's successful business model is generating free cash flow and profits, managers must decide whether to return that cash to shareholders in the form of higher dividend payouts or to invest it in diversification. In theory, any free cash flow belongs to the company's owners—its shareholders. So, for diversification to be value creating, a company's return on investing free cash flow to pursue diversification opportunities, that is, its future ROIC, *must* exceed the value shareholders would reap by returning the cash to them. When a firm does not pay out its free cash flow to its

shareholders, the shareholders bear an opportunity cost equal to their next best use of those funds (i.e., another investment that pays a similar return at a similar risk, an investment that pays a higher return at a higher risk, or an investment that pays a lower return but at a lower risk). Thus, a diversification strategy must pass the "better off" test: the firm must be more valuable than it was before the diversification, and that value must not be fully capitalized by the cost of the diversification move (i.e., the cost of entry into the new industry must be taken into account when assessing the value created by the diversification move). Thus managers might defer paying dividends now to invest in diversification, but they should do so only when this is expected to create even greater cash flow (and thus higher dividends) in the future.

There are five primary ways in which pursuing a multibusiness model based on diversification can increase company profitability. Diversification can increase profitability when strategic managers (1) transfer competencies between business units in different industries, (2) leverage competencies to create business units in new industries, (3) share resources between business units to realize synergies or economies of scope, (4) use product bundling, and (5) utilize *general* organizational competencies that increase the performance of *all* a company's business units.

Transferring Competencies Across Businesses

Transferring competencies involves taking a distinctive competency developed by a business unit in one industry and implanting it in a business unit operating in another industry. The second business unit is often one a company has acquired. Companies that base their diversification strategy on transferring competencies aim to use one or more of their existing distinctive competencies in a value-chain activity—for example, in manufacturing, marketing, materials management, or research and development (R&D)—to significantly strengthen the business model of the acquired business unit or company. For example, over time, Philip Morris developed distinctive competencies in product development, consumer marketing, and brand positioning that had made it a leader in the tobacco industry. Sensing a profitable opportunity, it acquired Miller Brewing, which at the time was a relatively small player in the brewing industry. Then, to create valuable new products in the brewing industry, Philip Morris transferred some of its best marketing experts to Miller, where they applied the skills acquired at Philip Morris to turn around Miller's lackluster brewing business (see Figure 10.1). The result was the creation of Miller Light, the first "light" beer, and a marketing campaign that helped to push Miller from number 6 to number 2 in market share in the brewing industry.

Companies that base their diversification strategy on transferring competencies tend to acquire new businesses *related* to their existing business activities because of commonalities between one or more of their value-chain functions. A **commonality** is some kind of skill or attribute that, when it is shared or used by two or more business units, allows both businesses to operate more effectively and efficiently and create more value for customers.

For example, Miller Brewing was related to Philip Morris's tobacco business because it was possible to create important marketing commonalities; both beer and tobacco are mass-market consumer goods in which brand positioning, advertising, and product development skills are crucial to create successful new products. In general, such competency transfers increase profitability when they either (1) lower the cost structure of one or more of a diversified company's business units or (2) enable one or more of its business units to better differentiate their products, both of which give business unit pricing options to lower a product's price to increase market share or to charge a premium price.

transferring competencies

The process of taking a distinctive competency developed by a business unit in one industry and implanting it in a business unit operating in another industry.

commonality

Some kind of skill or competency that when shared by two or more business units allows them to operate more effectively and create more value for customers.

Figure 10.1 Transfer of Competencies at Philip Morris

For competency transfers to increase profitability, the competencies transferred must involve value-chain activities that become an important source of a specific business unit's competitive advantage in the future. In other words, the distinctive competency being transferred must have real strategic value. However, all too often companies assume that *any* commonality between their value chains is sufficient for creating value. When they attempt to transfer competencies, they find the anticipated benefits are not forthcoming because the different business units did not share some important attribute in common. For example, Coca-Cola acquired Minute Maid, the fruit juice maker, to take advantage of commonalities in global distribution and marketing, and this acquisition has proved to be highly successful. On the other hand, Coca-Cola once acquired the movie studio Columbia Pictures because it believed it could use its marketing prowess to produce blockbuster movies. This acquisition was a disaster that cost Coca-Cola billions in losses, and Columbia was eventually sold to Sony, which was then able to base many of its successful PlayStation games on the hit movies the studio produced.

Leveraging Competencies to Create a New Business

leveraging competencies
The process of taking a distinctive competency developed by a business unit in one industry and using it to create a new business unit in a different industry.

Firms can also **leverage their competencies** by using them to develop a new business in a different industry. For example, Apple leveraged its competencies in personal computer (PC) hardware and software to enter the smartphone industry. Once again, the multibusiness model is based on the premise that the set of distinctive competencies that are the source of a company's competitive advantage in one industry might be applied to create a differentiation or cost-based competitive advantage for a new business unit or division in a different industry. For example, Canon used its distinctive competencies in precision mechanics, fine optics, and electronic imaging to produce laser jet printers, which, for Canon, was a new business in a new industry. Its competencies enabled it to produce high-quality

(differentiated) laser printers that could be manufactured at a low cost, which created its competitive advantage, and made Canon a leader in the printer industry.

Many companies have based their diversification strategy on leveraging their competencies to create new business units in different industries. Microsoft leveraged its longtime experience and relationships in the computer industry, skills in software development, and its expertise in managing industries characterized by network externalities to create new business units in industries such as videogames (with its Xbox videogame consoles and game), online portals and search engines (e.g., MSN and Bing), and tablet computers (with the introduction of the Surface).

Sharing Resources and Capabilities

A third way in which two or more business units that operate in different industries can increase a diversified company's profitability is when the shared resources and capabilities results in economies of scope, or synergies.[2] **Economies of scope** arise when one or more of a diversified company's business units are able to realize cost-saving or differentiation synergies because they can more effectively pool, share, and utilize expensive resources or capabilities, such as skilled people, equipment, manufacturing facilities, distribution channels, advertising campaigns, and R&D laboratories. If business units in different industries can share a common resource or function, they can collectively lower their cost structure; the idea behind synergies is that $2 + 2 = 5$, not 4, in terms of value created.[3] For example, the costs of GE's consumer products advertising, sales, and service activities reduce costs *across* product lines because they are spread over a wide range of products such as light bulbs, appliances, air conditioners, and furnaces. There are two major sources of these cost reductions.

First, when companies can share resources or capabilities across business units, it lowers their cost structure compared to a company that operates in only one industry and bears the full costs of developing resources and capabilities. For example, P&G makes disposable diapers, toilet paper, and paper towels, which are all paper-based products that customers value for their ability to absorb fluids without disintegrating. Because these products need the same attribute—absorbency—P&G can share the R&D costs associated with developing and making even more advanced absorbent paper-based products across the three distinct businesses (only two are shown in Figure 10.2). Similarly, because all of these products are sold to retailers, P&G can use the same sales force to sell all its products (see Figure 10.2). In contrast, P&G competitors that make only one or two of these products cannot share these costs across industries, so their cost structures are higher. As a result, P&G has lower costs; it can use its marketing function to better differentiate its products, and it achieves a higher ROIC than companies that operate only in one or a few industries—which are unable to obtain economies of scope from the ability to share resources and obtain synergies across business units.

Similarly, Nike, which began strictly as a maker of running shoes, realized that its brand image, and its relationships with athletes and sports events, could be profitably leveraged into other types of athletic footwear, athletic apparel, and accessories such as sunglasses and headphones. Those products were more differentiated because of the Nike brand name and had better exposure because Nike was able to place them in suitable endorsement spots via its relationships with athletes and events, and Nike is able to amortize the cost of its brand-building activities across a wider range of products, thus achieving economies of scope.

Once again, diversification to obtain economies of scope is possible only when there are *significant* commonalities between one or more of the value-chain functions in a company's different business units or divisions that result in synergies that increase profitability.

economies of scope

The synergies that arise when one or more of a diversified company's business units are able to lower costs or increase differentiation because they can more effectively pool, share, and utilize expensive resources or capabilities.

Figure 10.2 Sharing Resources at Proctor & Gamble

© Cengage Learning

In addition, managers must be aware that the costs of coordination necessary to achieve synergies or economies of scope within a company may sometimes be *higher* than the value that can be created by such a strategy.[4] As noted in the opening case, although Citibank had anticipated major cost savings from consolidating operations across its acquisitions, and revenue-increasing opportunities from cross-selling, some of those synergies turned out to be smaller or more difficult to reap than anticipated. In retrospect, the coordination costs that Citi bore (in the form of massive losses due to inadequate oversight over its investment activities) probably vastly exceeded the synergies it gained. Consequently, diversification based on obtaining economies of scope should be pursued only when the sharing of competencies will result in *significant* synergies that will achieve a competitive advantage for one or more of a company's new or existing business units.

Using Product Bundling

In the search for new ways to differentiate products, more and more companies are entering into industries that provide customers with new products that are connected or related to their existing products. This allows a company to expand the range of products it produces in order to be able to satisfy customers' needs for a complete package of related products. This is currently happening in telecommunications, in which customers are increasingly seeking package prices for wired phone service, wireless phone service, high-speed access to the Internet, voice over Internet protocol (VOIP) phone service, television programming, online gaming, video-on-demand, or any combination of these services. To meet this need, large phone companies such as AT&T and Verizon have been acquiring other companies that provide one or more of these services, and cable companies such as Comcast have acquired or formed strategic alliances with companies that can offer their customers a package of these services. In 2010, for example, Comcast acquired GE's NBC division to gain control of its library of content programming. The goal, once again, is to bundle products to offer customers lower prices and/or a superior set of services.

Just as manufacturing companies strive to reduce the number of their component suppliers to reduce costs and increase quality, final customers want to obtain the convenience and reduced price of a bundle of related products—such as from Google or Microsoft's cloud-based commercial, business-oriented online applications. Another example of product bundling comes from the medical equipment industry in which companies that, in the past, made one kind of product, such as operating theater equipment, ultrasound devices, magnetic imaging or X-ray equipment, have now merged with or been acquired by other companies to allow a larger diversified company to provide hospitals with a complete range of medical equipment. This industry consolidation has also been driven by hospitals and health maintenance organizations (HMOs) that wish to obtain the convenience and lower prices that often follow from forming a long-term contract with a single supplier.

It is important to note here that product bundling often does not require joint ownership. In many instances, bundling can be achieved through market contracts. For example, McDonald's does not need to manufacture toys in order to bundle them into Happy Meals—it can buy them through a supply contract. Disney does need to own airline services to offer a package deal on a vacation—an alliance contract will serve just as well. For product bundling to serve as a justification for diversification, there must be a strong need for coordination between the producers of the different products that cannot be overcome through market contracts.

Utilizing General Organizational Competencies

General organizational competencies transcend individual functions or business units and are found at the top or corporate level of a multibusiness company. Typically, **general organizational competencies** are the result of the skills of a company's top managers and functional experts. When these general competencies are present—and many times they are not—they help each business unit within a company perform at a higher level than it could if it operated as a separate or independent company—this increases the profitability of the *entire* corporation.[5] Three kinds of general organizational competencies help a company increase its performance and profitability: (1) entrepreneurial capabilities, (2) organizational design capabilities, and (3) strategic capabilities.

general organizational competencies
Competencies that result from the skills of a company's top managers that help every business unit within a company perform at a higher level than it could if it operated as a separate or independent company.

Entrepreneurial Capabilities A company that generates significant excess cash flow can take advantage of it only if its managers are able to identify new opportunities and act on them to create a stream of new and improved products, in its current industry and in new industries. Some companies seem to have a greater capability to stimulate their managers to act in entrepreneurial ways than others, for example, Apple, 3M, Google, and Samsung.[6]

These companies are able to promote entrepreneurship because they have an organizational culture that stimulates managers to act entrepreneurially. As a result, they are able to create profitable new business units more quickly than other companies; this allows them to take advantage of profitable opportunities for diversification. We discuss one of the strategies required to generate profitable new businesses later in this chapter: internal new venturing. For now, it is important to note that to promote entrepreneurship, a company must (1) encourage managers to take risks, (2) give managers the time and resources to pursue novel ideas, (3) not punish managers when a new idea fails, and (4) make sure that the company's free cash flow is not wasted in pursuing too many risky new ventures that have a low probability of generating a profitable return on investment. Strategic managers

face a significant challenge in achieving all four of these objectives. On the one hand, a company must encourage risk taking, and on the other hand, it must limit the number of risky ventures in which it engages.

Companies that possess strong entrepreneurial capabilities achieve this balancing act. For example, 3M's goal of generating 40% of its revenues from products introduced within the past 4 years focuses managers' attention on the need to develop new products and enter new businesses. 3M's long-standing commitment to help its customers solve problems also ensures that ideas for new businesses are customer focused. The company's celebration of employees who have created successful new businesses helps to reinforce the norm of entrepreneurship and risk taking. Similarly, there is a norm that failure should not be punished but viewed as a learning experience.

organizational design skills

The ability of the managers of a company to create a structure, culture, and control systems that motivate and coordinate employees to perform at a high level.

Capabilities in Organizational Design Organizational design skills are a result of managers' ability to create a structure, culture, and control systems that motivate and coordinate employees to perform at a high level. Organizational design is a major factor that influences a company's entrepreneurial capabilities; it is also an important determinant of a company's ability to create the functional competencies that give it a competitive advantage. The way strategic managers make organizational design decisions, such as how much autonomy to give to managers lower in the hierarchy, what kinds of norms and values should be developed to create an entrepreneurial culture, and even how to design its headquarters buildings to encourage the free flow of ideas, is an important determinant of a diversified company's ability to profit from its multibusiness model. Effective organizational structure and controls create incentives that encourage business-unit (divisional) managers to maximize the efficiency and effectiveness of their units. Moreover, good organizational design helps prevent strategic managers from missing out on profitable new opportunities, as happens when employees become so concerned with protecting their company's competitive position in *existing* industries that they lose sight of new or improved ways to do business and gain profitable opportunities to enter new industries.

The last two chapters of this book look at organizational design in depth. To profit from pursuing the corporate-level strategy of diversification, a company must be able to continuously manage and change its structure and culture to motivate and coordinate its employees to work at a high level and develop the resources and capabilities upon which its competitive advantage depends. The ever-present need to align a company's structure with its strategy is a complex, never-ending task, and only top managers with superior organizational design skills can do it.

Superior Strategic Management Capabilities For diversification to increase profitability, a company's top managers must have superior capabilities in strategic management. They must possess the intangible, hard-to-define governance skills that are required to manage different business units in a way that enables these units to perform better than they would if they were independent companies.[7] These governance skills are a rare and valuable capability. However, certain CEOs and top managers seem to have them; they have developed the aptitude of managing multiple businesses simultaneously and encouraging the top managers of those business units to devise strategies and achieve superior performance. Examples of CEOs famous for their superior strategic management capabilities include Jeffrey Immelt at GE, Steve Jobs at Apple, and Larry Ellison at Oracle.

An especially important governance skill in a diversified company is the ability to diagnose the underlying source of the problems of a poorly performing business unit, and then to understand how to proceed to solve those problems. This might involve recommending new strategies to the existing top managers of the unit or knowing when to replace them with a new management team that is better able to fix the problems. Top managers who have such governance skills tend to be very good at probing business unit managers for information and helping them to think through strategic problems, as the example of United Technologies Corporation (UTC) discussed in Strategy in Action 10.1 suggests.

Related to strategic management skills is the ability of the top managers of a diversified company to identify inefficient and poorly managed companies in other industries and then to acquire and restructure them to improve their performance—and thus the profitability of

10.1 STRATEGY IN ACTION

United Technologies Has an "ACE" in Its Pocket

© iStockPhoto.com/Tom Nulens

United Technologies Corporation (UTC), based in Hartford, Connecticut, is a *conglomerate*, a company that owns a wide variety of other companies that operate separately in many different businesses and industries. UTC has businesses in two main groups, aerospace and building systems. Its aerospace group includes Sikorsky aircraft, Pratt & Whitney Engines, and UTC Aerospace systems, which was formed through the merger of Hamilton Sundstrand and Goodrich. Its building systems group includes Otis elevators and escalators; Carrier and Noresco heating and air-conditioning solutions; building automation businesses that include AutomatedLogic, Onity, Lenel, and UTEC; and fire detection and security businesses that include Chubb, Kidde, Edwards, Fenwal, Marioff, Supra, and Interlogix. Today, investors frown upon companies like UTC that own and operate companies in widely different industries. There is a growing perception that managers can better manage a company's business model when the company operates as an independent or stand-alone entity. How can UTC justify holding all these companies together in a conglomerate? Why would this lead to a greater increase in total profitability than if they operated as independent companies? In the last decade, the boards of directors and CEOs of many conglomerates, such as Tyco and Textron, have realized that by holding diverse companies together they were reducing, not increasing, the profitability of their companies. As a result, many conglomerates have been broken up and their individual companies spun off to allow them to operate as separate, independent entities.

UTC's CEO George David claims that he has created a unique and sophisticated multibusiness model that adds value across UTC's diverse businesses. David joined Otis Elevator as an assistant to its CEO in 1975, but within 1 year, UTC acquired Otis. The 1970s was a decade when a "bigger is better" mindset ruled corporate America, and mergers and acquisitions of all kinds were seen as the best way to grow profits. UTC sent David to manage its South American operations and later gave him responsibility for its Japanese operations. Otis had formed an alliance with Matsushita to develop an elevator for the Japanese market, and the resulting "Elevonic 401," after being installed widely in Japanese buildings, proved to be a disaster. It broke down much more often than elevators made by other Japanese companies, and customers were concerned about the reliability and safety of this model.

Matsushita was extremely embarrassed about the elevator's failure and assigned one of its leading total quality management (TQM) experts, Yuzuru Ito, to head a team of Otis engineers to find out why it performed so poorly. Under Ito's direction, all the employees—managers, designers, and production workers—who had produced the elevator analyzed why the elevators were malfunctioning. This intensive study led to a total redesign of the elevator, and when the new and improved elevator was launched worldwide, it met with great success. Otis's share of the global elevator market dramatically increased, and David was named president of UTC in 1992. He was given the responsibility to cut costs across the entire corporation, including its

10.1 STRATEGY IN ACTION

(continued)

© iStockPhoto.com/Tom Nulens

important Pratt & Whitney division, and his success in reducing UTC's cost structure and increasing its ROIC led to his appointment as CEO in 1994.

Now responsible for all of UTC's diverse companies, David decided that the best way to increase UTC's profitability, which had been declining, was to find ways to improve efficiency and quality in *all* its constituent companies. He convinced Ito to move to Hartford and take responsibility for championing the kinds of improvements that had by now transformed the Otis division. Ito began to develop UTC's TQM system, also known as "Achieving Competitive Excellence," or ACE.

ACE is a set of tasks and procedures that are used by employees from the shop floor to top managers to analyze all aspects of the way a product is made. The goal is to find ways to improve *quality and reliability*, to *lower the costs* of making a product, and, especially, to find ways to make the next generation of a particular product perform better—in other words, to encourage *technological innovation*. David makes every employee in every function and at every level personally responsible for achieving the incremental, step-by-step gains that result in state-of-the-art innovative and efficient products that allow a company to dominate its industry.

David calls these techniques "process disciplines," and he has used them to increase the performance of all UTC companies. Through these techniques, he has created the extra value for UTC that justifies it owning and operating such a diverse set of businesses. David's success can be seen in the performance that his company

has achieved in the decade since he took control: he has quadrupled UTC's earnings per share, and its sales and profits have soared. UTC has been in the top three performers of the companies that make up the Dow Jones industrial average for most of the 2000s, and the company has consistently outperformed GE, another huge conglomerate, in its return to investors.

David and his managers believe that the gains that can be achieved from UTC's process disciplines are never-ending because its own R&D—in which it invests more than $2.5 billion a year—is constantly producing product innovations that can help all its businesses. Recognizing that its skills in creating process improvements are specific to manufacturing companies, UTC's strategy is to only acquire companies that make products that can benefit from the use of its ACE program—hence its Chubb acquisition. At the same time, David invests only in companies that have the potential to remain leading companies in their industries and can therefore charge above-average prices. His acquisitions strengthen the competencies of UTC's existing businesses. For example, he acquired a company called Sundstrand, a leading aerospace and industrial systems company, and combined it with UTC's Hamilton Aerospace Division to create Hamilton Sundstrand, which is now a major supplier to Boeing and makes products that command premium prices. In October 2011, UTC acquired Goodrich, a major supplier of airline components, for over $22 billion to strengthen its aircraft division.

Source: http://utc.com.

turnaround strategy

When managers of a diversified company identify inefficient and poorly managed companies in other industries and then acquire and restructure them to improve their performance—and thus the profitability of the total corporation.

the total corporation. This is known as a **turnaround strategy**.[8] There are several ways to improve the performance of the acquired company. First, the top managers of the acquired company are replaced with a more aggressive top-management team. Second, the new top-management team sells off expensive assets, such as underperforming divisions, executive jets, and elaborate corporate headquarters; it also terminates managers and employees to reduce the cost structure. Third, the new management team works to devise new strategies to improve the performance of the operations of the acquired business and improve its efficiency, quality, innovativeness, and customer responsiveness.

Fourth, to motivate the new top-management team and the other employees of the acquired company to work toward such goals, a company-wide pay-for-performance

bonus system linked to profitability is introduced to reward employees at all levels for their hard work. Fifth, the acquiring company often establishes "stretch" goals for employees at all levels; these are challenging, hard-to-obtain goals that force employees at all levels to work to increase the company's efficiency and effectiveness. Finally, the members of the new top-management team clearly understand that if they fail to increase their division's performance and meet these stretch goals within some agreed-upon amount of time, they will be replaced. In sum, the system of rewards and sanctions that corporate managers of the acquiring company establish provide the new top managers of the acquired unit with strong incentive to develop strategies to improve their unit's operating performance.

TWO TYPES OF DIVERSIFICATION

The last section discussed five principal ways in which companies can use diversification to transfer and implant their business models and strategies into other industries and so increase their long-term profitability. The two corporate strategies of *related diversification* and *unrelated diversification* can be distinguished by how they attempt to realize these five profit-enhancing benefits of diversification.[9]

Related Diversification

Related diversification is a corporate-level strategy that is based on the goal of establishing a business unit (division) in a new industry that is *related* to a company's existing business units by some form of commonality or linkage between the value-chain functions of the existing and new business units. As you might expect, the goal of this strategy is to obtain the benefits from transferring competencies, leveraging competencies, sharing resources, and bundling products, as just discussed.

The multibusiness model of related diversification is based on taking advantage of strong technological, manufacturing, marketing, and sales commonalities between new and existing business units that can be successfully "tweaked" or modified to increase the competitive advantage of one or more business units. Figure 10.3 illustrates the commonalities or linkages possible among the different functions of three different business units or divisions. The greater the number of linkages that can be formed among business units, the greater the potential to realize the profit-enhancing benefits of the five reasons to diversify discussed previously.

One more advantage of related diversification is that it can also allow a company to use any general organizational competency it possesses to increase the overall performance of *all* its different industry divisions. For example, strategic managers may strive to create a structure and culture that encourages entrepreneurship across divisions, as Google, Apple, and 3M have done; beyond these general competences, these companies all have a set of distinctive competences that can be shared among their different business units and that they continuously strive to improve.

Unrelated Diversification

Unrelated diversification is a corporate-level strategy whereby firms own unrelated businesses and attempt to increase their value through an internal capital market, the use of general organizational competencies, or both. Companies pursuing this strategy are

related diversification
A corporate-level strategy that is based on the goal of establishing a business unit in a new industry that is related to a company's existing business units by some form of commonality or linkage between their value-chain functions.

unrelated diversification
A corporate-level strategy based on a multibusiness model that uses general organizational competencies to increase the performance of all the company's business units.

Figure 10.3

Commonalities Between the Value Chains of Three Business Units

Business Units

Value-Chain Functions

© Cengage Learning

internal capital market

A corporate-level strategy whereby the firm's headquarters assesses the performance of business units and allocates money across them. Cash generated by units that are profitable but have poor investment opportunities within their business is used to cross-subsidize businesses that need cash and have strong promise for long-run profitability.

often called *conglomerates,* business organizations that operate in many diverse industries. An **internal capital market** refers to a situation whereby a corporate headquarters assesses the performance of business units and allocates money across them. Cash generated by units that are profitable but have poor investment opportunities within their business is used to cross-subsidize businesses that need cash and have strong promise for long-run profitability. A large and diverse firm may both have free cash generated from its internal businesses and/or have access to cheaper cash on the external capital market than an individual business unit might have. For example, GE's large capital reserves and excellent credit rating enable it to provide funding to advanced technology businesses within its corporate umbrella (e.g., solar power stations, subsea oil production equipment, avionics, photonics) that would otherwise pay a high price (either in interest payments or equity shares) for funding due to their inherent uncertainty.

The benefits of an internal capital market are limited, however, by the efficiency of the external capital market (banks, stockholders, venture capitalists, angel investors, etc.). If the external capital market were perfectly efficient, managers could not create additional value by cross-subsidizing businesses with internal cash. An internal capital market is, in essence, an arbitrage strategy where managers make money by making better investment decisions within the firm than the external capital market would. Often this is because managers have superior information than the external capital market. The amount of value that can be created through an internal capital market is thus directly proportional to the inefficiency of the external capital market. In the United States, where capital markets have become fairly efficient due to (i) reporting requirements mandated by the Securities and Exchange Commission (SEC), (ii) large numbers of research analysts, (iii) an extremely large and active investment community, (iv) strong communication systems, and (v) strong contract law, it is not common to see firms create significant value through an internal capital market. As a result, few large conglomerates have survived, and many of those that do survive trade at a discount (i.e., their stock is worth less than the stock of more specialized firms operating in the same industries). On the other hand, in a market with a

less efficient capital market, conglomerates may create significant value. Tata Group, for example, is an extremely large and diverse business holding group in India. It was founded during the 1800s and took on many projects that its founders felt were crucial to India's development (developing rail system, hotels, power production, etc.) The lack of a well-developed investment community and poor contract law to protect investors and bankers meant that funds were often not available to entrepreneurs in India, or were available only at a very high cost. Tata Group was thus able to use cross-subsidization to fund projects much more cheaply than independent businesses could. Furthermore, the reputation of the company served as a strong guarantee that the company would fulfill its promises (which was particularly important in the absence of strong contract law), and its long and deep relationships with the government gave it an advantage in securing licenses and permits.

Companies pursuing a strategy of unrelated diversification have *no* intention of transferring or leveraging competencies between business units or sharing resources other than cash and general organizational competencies. If the strategic managers of conglomerates have the special skills needed to manage many companies in diverse industries, the strategy can result in superior performance and profitability; often they do not have these skills, as is discussed later in the chapter. Some companies, such as UTC, discussed in Strategy in Action 10.1, have top managers who do possess these special skills.

THE LIMITS AND DISADVANTAGES OF DIVERSIFICATION

Many companies, such as 3M, Samsung, UTC, and Cisco, have achieved the benefits of pursuing either or both of the two diversification strategies just discussed, and they have managed to sustain their profitability over time. On the other hand, companies such as GM, Tyco, Textron, and Philips that pursued diversification failed miserably and became unprofitable. There are three principal reasons why a business model based on diversification may lead to a loss of competitive advantage: (1) changes in the industry or inside a company that occur over time, (2) diversification pursued for the wrong reasons, and (3) excessive diversification that results in increasing bureaucratic costs.

Changes in the Industry or Company

Diversification is a complex strategy. To pursue diversification, top managers must have the ability to recognize profitable opportunities to enter new industries and to implement the strategies necessary to make diversification profitable. Over time, a company's top-management team often changes; sometimes its most able executives join other companies and become their CEOs, and sometimes successful CEOs decide to retire or step down. When the managers who possess the hard-to-define skills leave, they often take their visions with them. A company's new leaders may lack the competency or commitment necessary to pursue diversification successfully over time; thus, the cost structure of the diversified company increases and eliminates any gains the strategy may have produced.

In addition, the environment often changes rapidly and unpredictably over time. When new technology blurs industry boundaries, it can destroy the source of a company's competitive advantage; for example, by 2011, it was clear that Apple's iPhone and iPad had become a direct competitor with Nintendo's and Sony's mobile gaming consoles. When such a major technological change occurs in a company's core business, the benefits it has previously

achieved from transferring or leveraging distinctive competencies disappear. The company is then saddled with a collection of businesses that have all become poor performers in their respective industries because they are not based on the new technology—something that has happened to Sony. Thus, a major problem with diversification is that the future success of a business is hard to predict when this strategy is used. For a company to profit from it over time, managers must be as willing to divest business units as they are to acquire them. Research suggests managers do not behave in this way, however.

Diversification for the Wrong Reasons

As we have discussed, when managers decide to pursue diversification, they must have a clear vision of how their entry into new industries will allow them to create new products that provide more value for customers and increase their company's profitability. Over time, however, a diversification strategy may result in falling profitability for reasons noted earlier, but managers often refuse to recognize that their strategy is failing. Although they know they should divest unprofitable businesses, managers "make up" reasons why they should keep their collection of businesses together.

In the past, for example, one widely used (and false) justification for diversification was that the strategy would allow a company to obtain the benefits of risk pooling. The idea behind risk pooling is that a company can reduce the risk of its revenues and profits rising and falling sharply (something that sharply lowers its stock price) if it acquires and operates companies in several industries that have different business cycles. The business cycle is the tendency for the revenues and profits of companies in an industry to rise and fall over time because of "predictable" changes in customer demand. For example, even in a recession, people still need to eat—the profits earned by supermarket chains will be relatively stable; sales at Safeway, Kroger, and also at "dollar stores" actually rise as shoppers attempt to get more value for their dollars. At the same time, a recession can cause the demand for cars and luxury goods to plunge. Many CEOs argue that diversifying into industries that have different business cycles would allow the sales and revenues of some of their divisions to rise, while sales and revenues in other divisions would fall. A more stable stream of revenue and profits is the net result over time. An example of risk pooling occurred when U.S. Steel diversified into the oil and gas industry in an attempt to offset the adverse effects of cyclical downturns in the steel industry.

This argument ignores two important facts. First, stockholders can eliminate the risk inherent in holding an individual stock by diversifying their *own* portfolios, and they can do so at a much lower cost than a company can. Thus, attempts to pool risks through diversification represent an unproductive use of resources; instead, profits should be returned to shareholders in the form of increased dividends. Second, research suggests that corporate diversification is not an effective way to pool risks because the business cycles of different industries are *inherently difficult to predict,* so it is likely that a diversified company will find that an economic downturn affects *all* its industries simultaneously. If this happens, the company's profitability plunges.[10]

When a company's core business is in trouble, another mistaken justification for diversification is that entry into new industries will rescue the core business and lead to long-term growth and profitability. An example of a company that made this mistake is Kodak. In the 1980s, increased competition from low-cost Japanese competitors, such as Fuji, combined with the beginnings of the digital revolution, soon led its revenues and profits to plateau and then fall. Its managers should have done all they could to reduce its cost structure; instead they took its huge free cash flow and spent tens of billions of dollars to enter new industries, such as health care, biotechnology, and computer hardware, in a desperate and mistaken attempt to find ways to increase profitability.

This was a disaster because every industry Kodak entered was populated by strong companies such as 3M, Canon, and Xerox. Also, Kodak's corporate managers lacked any general competencies to give their new business units a competitive advantage. Moreover, the more industries Kodak entered, the greater the range of threats the company encountered, and the more time managers had to spend dealing with these threats. As a result, they could spend much less time improving the performance of their core film business that continued to decline.

In reality, Kodak's diversification was just for growth itself, but *growth does not create value for stockholders*; growth is just the by-product, not the objective, of a diversification strategy. However, in desperation, companies diversify for reasons of growth alone rather than to gain any well-thought-out strategic advantage.[11] In fact, many studies suggest that too much diversification may reduce rather than improve company profitability.[12] That is, the diversification strategies many companies pursue may *reduce* value instead of creating it.[13]

The Bureaucratic Costs of Diversification

A major reason why diversification often fails to boost profitability is that very often the *bureaucratic costs* of diversification exceed the benefits created by the strategy (that is, the increased profit that results when a company makes and sells a wider range of differentiated products and/or lowers its cost structure). As we mention in the previous chapter, bureaucratic costs are the costs associated with solving the transaction difficulties that arise between a company's business units and between business units and corporate headquarters, as the company attempts to obtain the benefits from transferring, sharing, and leveraging competencies. They also include the costs associated with using general organizational competencies to solve managerial and functional inefficiencies. The level of bureaucratic costs in a diversified organization is a function of two factors: (1) the number of business units in a company's portfolio and (2) the degree to which coordination is required between these different business units to realize the advantages of diversification.

bureaucratic costs
The costs associated with solving the transaction difficulties between business units and corporate headquarters as a company obtains the benefits from transferring, sharing, and leveraging competencies.

Number of Businesses The greater the number of business units in a company's portfolio, the more difficult it is for corporate managers to remain informed about the complexities of each business. Managers simply do not have the time to assess the business model of each unit. This problem occurred at GE in the 1970s when its growth-hungry CEO Reg Jones acquired many new businesses, as he commented:

> I tried to review each plan [of each business unit] in great detail. This effort took untold hours and placed a tremendous burden on the corporate executive office. After a while I began to realize that no matter how hard we would work, we could not achieve the necessary in-depth understanding of the 40-odd business unit plans.[14]

The inability of top managers in extensively diversified companies to maintain control over their multibusiness model over time often leads managers to base important resource allocation decisions only on the most superficial analysis of each business unit's competitive position. For example, a promising business unit may be starved of investment funds, while other business units receive far more cash than they can profitably reinvest in their operations. Furthermore, because they are distant from the day-to-day operations of the business units, corporate managers may find that business unit managers try to hide information on poor performance to save their own jobs. For example, business unit managers might blame poor performance on difficult competitive conditions, even when it is the result of their inability to craft a successful business model. As such organizational problems increase, top

managers must spend an enormous amount of time and effort to solve these problems. This increases bureaucratic costs and cancels out the profit-enhancing advantages of pursuing diversification, such as those obtained from sharing or leveraging competencies.

Coordination Among Businesses The amount of coordination required to realize value from a diversification strategy based on transferring, sharing, or leveraging competencies is a major source of bureaucratic costs. The bureaucratic mechanisms needed to oversee and manage the coordination and handoffs between units, such as cross-business-unit teams and management committees, are a major source of these costs. A second source of bureaucratic costs arises because of the enormous amount of managerial time and effort required to accurately measure the performance and unique profit contribution of a business unit that is transferring or sharing resources with another. Consider a company that has two business units, one making household products (such as liquid soap and laundry detergent) and another making packaged food products. The products of both units are sold through supermarkets. To lower the cost structure, the parent company decides to pool the marketing and sales functions of each business unit, using an organizational structure similar to that illustrated in Figure 10.4. The company is organized into three divisions: a household products division, a food products division, and a marketing division.

Although such an arrangement may significantly lower operating costs, it can also give rise to substantial control problems, and hence bureaucratic costs. For example, if the performance of the household products business begins to slip, identifying who is to be held accountable— managers in the household products division or managers in the marketing division—may prove difficult. Indeed, each may blame the other for poor performance. Although these kinds of problems can be resolved if corporate management performs an in-depth audit of both divisions, the bureaucratic costs (managers' time and effort) involved in doing so may once again cancel out any value achieved from diversification. The need to reduce bureaucratic costs is evident from the experience of Pfizer discussed in Strategy in Action 10.2.

| Figure 10.4 | Coordination Among Related Business Units |

© Cengage Learning

10.2 STRATEGY IN ACTION

How Bureaucratic Costs Rose Then Fell at Pfizer

© iStockPhoto.com/Tom Nulens

Pfizer is the largest global pharmaceuticals company, with sales of almost $50 billion in 2011. Its research scientists have innovated some of the most successful and profitable drugs in the world, such as the first cholesterol reducer, Lipitor. In the 2000s, however, Pfizer encountered major problems in its attempt to innovate new blockbuster drugs while its current blockbuster drugs, such as Lipitor, lost their patent protection. Whereas Lipitor once earned a $13 billion in profits per year, its sales were now fast declining. Pfizer desperately needed to find ways to make its product development pipeline work—and one manager, Martin Mackay, believed he knew how to do it.

When Pfizer's R&D chief retired, Mackay, his deputy, made it clear to CEO Jeffrey Kindler that he wanted the job. Kindler made it equally clear he thought the company could use some new talent and fresh ideas to solve its problems. Mackay realized he had to quickly devise a convincing plan to change the way Pfizer's scientists worked to develop new drugs, gain Kindler's support, and get the top job. Mackay created a detailed plan for changing the way Pfizer's thousands of researchers made decisions, ensuring that the company's resources and its talent and funds would be best put to use. After Kindler reviewed the plan, he was so impressed he promoted Mackay to the top R&D position. What was Mackay's plan?

As Pfizer had grown over time as a result of mergers with two other large pharmaceutical companies, Warner Lambert and Pharmacia, Mackay noted how decision-making problems and conflict between the managers of Pfizer's different drug divisions had increased. As it grew, Pfizer's organizational structure had become taller and taller, and the size of its headquarters staff grew. With more managers and levels in the company's hierarchy there was a greater need for committees to integrate across activities.

However, in these meetings, different groups of managers fought to promote the development of the drugs they had the most interest in, and managers increasingly came into conflict with one another in order to ensure they got the resources needed to develop these drugs. In short, Mackay felt that too many managers and committees resulted in too much conflict between those who

were actively lobbying the managers and the CEO to promote the interests of their own product groups—and the company's performance was suffering as a result. In addition, although Pfizer's success depended upon innovation, this growing conflict had resulted in a bureaucratic culture that reduced the quality of decision making, creating more difficulty when identifying promising new drugs—and increasing bureaucratic costs.

Mackay's bold plan to reduce conflict and bureaucratic costs involved slashing the number of management layers between top managers and scientists from 14 to 7, which resulted in the layoff of thousands of Pfizer's managers. He also abolished the product development committees whose wrangling he believed was slowing down the process of transforming innovative ideas into blockbuster drugs. After streamlining the hierarchy, he focused on reducing the number of bureaucratic rules scientists had to follow, many of which were unnecessary and had promoted conflict. He and his team eliminated every kind of written report that was slowing the innovation process. For example, scientists had been in the habit of submitting quarterly and monthly reports to top managers explaining each drug's progress; Mackay told them to choose which report they wanted to keep, and the other would be eliminated.

As you can imagine, Mackay's efforts caused enormous upheaval in the company as managers fought to keep their positions, and scientists fought to protect the drugs they had in development. However, Mackay was resolute and pushed his agenda through with the support of the CEO, who defended his efforts to create a new R&D product development process that empowered Pfizer's scientists and promoted innovation and entrepreneurship. Pfizer's scientists reported that they felt "liberated" by the new work flow; the level of conflict decreased, and new drugs were manufactured more quickly. By 2011, Pfizer had secured the approval of the Food and Drug Administration (FDA) for a major new antibacterial drug, and Mackay announced that several potential new blockbuster drugs under development were on track. Finding ways to control and reduce bureaucratic costs is a vital element of managing corporate-level strategy.

Source: www.pfizer.com.

In sum, although diversification can be a highly profitable strategy to pursue, it is also the most complex and difficult strategy to manage because it is based on a complex multibusiness model. Even when a company has pursued this strategy successfully in the past, changing conditions both in the industry environment and inside a company may quickly reduce the profit-creating advantages of pursuing this strategy. For example, such changes may result in one or more business units losing their competitive advantage, as happened to Sony. Or, changes may cause the bureaucratic costs associated with pursuing diversification to rise sharply and cancel out its advantages. Thus, the existence of bureaucratic costs places a limit on the amount of diversification that a company can profitably pursue. It makes sense for a company to diversify only when the profit-enhancing advantages of this strategy *exceed* the bureaucratic costs of managing the increasing number of business units required when a company expands and enters new industries.

CHOOSING A STRATEGY

Related Versus Unrelated Diversification

Because related diversification involves more sharing of competencies, one might think it can boost profitability in more ways than unrelated diversification, and is therefore the better diversification strategy. However, some companies can create as much or more value from pursuing unrelated diversification, so this strategy must also have some substantial benefits. An unrelated company does *not* need to achieve coordination between business units; it has to cope only with the bureaucratic costs that arise from the number of businesses in its portfolio. In contrast, a related company must achieve coordination *among* business units if it is to realize the gains that come from utilizing its distinctive competencies. Consequently, it has to cope with the bureaucratic costs that arise *both* from the number of business units in its portfolio *and* from coordination among business units. Although it is true that related diversified companies can create value and profit in more ways than unrelated companies, they also have to bear higher bureaucratic costs to do so. These higher costs may cancel out the higher benefits, making the strategy no more profitable than one of unrelated diversification.

How, then, does a company choose between these strategies? The choice depends upon a comparison of the benefits of each strategy against the bureaucratic costs of pursuing it. It pays a company to pursue related diversification when (1) the company's competencies can be applied across a greater number of industries and (2) the company has superior strategic capabilities that allow it to keep bureaucratic costs under close control—perhaps by encouraging entrepreneurship or by developing a value-creating organizational culture.

Using the same logic, it pays a company to pursue unrelated diversification when (1) each business unit's functional competencies have few useful applications across industries, but the company's top managers are skilled at raising the profitability of poorly run businesses and (2) the company's managers use their superior strategic management competencies to improve the competitive advantage of their business units and keep bureaucratic costs under control. Some well-managed companies, such as UTC, discussed in Strategy in Action 10.1, have managers who can successfully pursue unrelated diversification and reap its rewards.

The Web of Corporate-Level Strategy

Finally, it is important to note that although some companies may choose to pursue a strategy of related or unrelated diversification, there is nothing that stops them from pursuing

both strategies at the same time. The purpose of corporate-level strategy is to increase long-term profitability. A company should pursue any and all strategies as long as strategic managers have weighed the advantages and disadvantages of those strategies and arrived at a multibusiness model that justifies them. Figure 10.5 illustrates how Sony developed a web of corporate strategies to compete in many industries—a program that proved a mistake and actually *reduced* its differentiation advantage and increased its cost structure in the 2000s.

First, Sony's core business is its electronic consumer products business, and in the past, it has been well known for its innovative products that have made it a leading global brand. To protect the quality of its electronic products, Sony decided to manufacture a high percentage of the component parts for its televisions, DVD players, and other units and pursued a strategy of backward vertical integration. Sony also engaged in forward vertical integration: for example, it acquired Columbia Pictures and MGM to enter the movie or "entertainment software" industry, and it opened a chain of Sony stores in shopping malls (to compete with Apple). Sony also shared and leveraged its distinctive competencies by developing its own business units to operate in the computer and smartphone industries, a strategy of related diversification. Finally, when it decided to enter the home videogame industry and develop its PlayStation to compete with Nintendo, it was pursuing a strategy of unrelated diversification. In the 2000s, this division contributed more to Sony's profits than its core electronics business, but the company has not been doing well, as Strategy in Action 10.3 suggests.

| Figure 10.5 | Sony's Web of Corporate-Level Strategy |

© Cengage Learning

As this discussion suggests, Sony's profitability has fallen dramatically because its multibusiness model led the company to diversify into too many industries, in each of which the focus was upon innovating high-quality products—as a result, its cost structure increased so much it swallowed up all the profits its businesses were generating. Sony's strategy of individual-business-unit autonomy also resulted in each unit pursuing its own goals at the expense of the company's multibusiness model—which escalated bureaucratic costs and drained its profitability. In particular, because its different divisions did not share their knowledge and expertise, this incongruence allowed competitors such as Samsung to supersede Sony, especially with smartphones and flatscreen LCD TV products.

10.3 STRATEGY IN ACTION

Sony's "Gaijin" CEO Is Changing the Company's Strategies

© iStockPhoto.com/Tom Nulens

Sony was renowned in the 1990s for using its engineering prowess to develop blockbuster new products such as the Walkman, Trinitron TV, and PlayStation. Its engineers churned out an average of four new product ideas every day, something attributed to its culture, called the "Sony Way," which emphasized communication, cooperation, and harmony among its company-wide product engineering teams. Sony's engineers were empowered to pursue their own ideas, and the leaders of its different divisions and hundreds of product teams were allowed to pursue their own innovations—no matter what the cost. Although this approach to leadership worked so long as Sony could churn out blockbuster products, it did not work in the 2000s as agile global competitors from Taiwan, Korea, and the United States innovated new technologies and products that began to beat Sony at its own game.

Companies such as LG, Samsung, and Apple innovated new technologies—including advanced liquid crystal display (LCD) flatscreens, flash memory, touchscreen commands, mobile digital music and video, global positioning system (GPS) devices, and 3D displays—that made many of Sony's technologies (such as its Trinitron TV and Walkman) obsolete. For example, products such as Apple's iPod and iPhone and Nintendo's Wii game console better met customer needs than Sony's out-of-date and expensive products. Why did Sony lose its leading competitive position?

One reason was that Sony's corporate-level strategies no longer worked in its favor; the leaders of its different product divisions had developed business-level strategies to pursue their own divisions' goals and not those of the whole company. Also, Sony's top managers had been slow to recognize the speed at which

technology was changing, and as each division's performance fell, competition between corporate and divisional managers increased. The result was slower decision making and increased operating costs as each division competed to obtain the funding necessary to develop successful new products.

By 2005, Sony was in big trouble, and at this crucial point in their company's history, Sony's top managers turned to a *gaijin*, or non-Japanese, executive to lead their company. Their choice was Welshman Sir Howard Stringer, who, as the head of Sony's U.S. operations, had been instrumental in cutting costs and increasing profits. Stringer was closely involved in all U.S. top-management decisions, but, nevertheless, he still gave his top executives the authority to develop successful strategies to implement these decisions.

When he became Sony's CEO in 2005, Stringer faced the immediate problem of reducing operating costs that were *double* those of its competitors because divisional managers had seized control of Sony's top-level decision-making authority. Stringer recognized how the extensive power struggles among Sony's different product-division managers were hurting the company. So, he made it clear they needed to work quickly to reduce costs and cooperate, sharing resources and competencies to speed product development across divisions.

By 2008, it was clear that many of Sony's most important divisional leaders were still pursuing their own goals, so Stringer replaced all the divisional leaders who resisted his orders. Then, he downsized Sony's bloated corporate headquarters staff and replaced the top functional managers who had pursued strategies

10.3 STRATEGY IN ACTION

(continued)

© iStockPhoto.com/Tom Nulens

favoring their interests. He promoted younger managers to develop new strategies for its divisions and functions—managers who would obey his orders and focus on creating commonalities between the company's different businesses.

But, Sony's performance continued to decline, and in 2009, Stringer announced that he would assume more control over the divisions' business-level strategies, taking charge of the core electronics division, and continuing to reorganize and streamline Sony's divisions to increase differentiation and reduce costs. He also told managers to prioritize new products and invest only in those with the greatest chance of success in order to reduce out-of-control R&D costs. By 2010, Sony's financial results suggested that Stringer's initiatives were finally paying off; his strategies to reduce costs had stemmed Sony's huge losses and its new digital products were selling better.

In January 2011, Stringer announced that Sony's performance had increased so much that it would be profitable in the second half of 2011. Then, within months, hackers invaded Sony's PlayStation website and stole the private information of millions of its users. Sony was forced to shut down the website for weeks and compensate users, which eventually cost it hundreds of millions of dollars. In addition, it also became clear that customers were not buying Sony's expensive new 3D flatscreen TVs and that its revenues from other consumer products would be lower than expected because of intense competition from companies like Samsung. Stringer reported that he expected Sony to make a record loss in 2011, and that his turnaround efforts had been foiled, as the company desperately strived to meet challenges from Apple and Samsung. In 2012, Sony replaced Stringer with Kazuo Hirai, who had been head of Sony Computer Entertainment. Hirai implemented a company-wide initiative named "One Sony," and a focus on three core areas: digital imaging, games, and mobile. Hirai implemented a cost-cutting program that targeted the cost of components, logistics, and operations. He shifted many of the engineering resources out of Japan and into Malaysia, which further cut costs. He sold Sony's chemical business, and he also dissolved Sony's joint venture with Samsung so that the company could purchase LCD panels on the open market to get better pricing. At the end of 2012, Sony finally posted a profit, after 4 straight years of losses.

Sources: B. Gruley, "Kazuo Hirai on Where He's Taking Sony," *Bloomberg Businessweek*, August 9, 2012, www.businessweek.com/printer/articles/66252-kazuo-hirai-on-where-hes-taking-sony); and www.sony.com, 2011 press releases.

ENTERING NEW INDUSTRIES: INTERNAL NEW VENTURES

We have discussed the sources of value managers seek through corporate-level strategies of related and unrelated diversification (and the challenges and risks these strategies also impose). Now we turn to the three main methods managers employ to enter new industries: internal new ventures, acquisitions, and joint ventures. In this section, we consider the pros and cons of using internal new ventures. In the following sections, we look at acquisitions and joint ventures.

The Attractions of Internal New Venturing

Internal new venturing is typically used to implement corporate-level strategies when a company possesses one or more distinctive competencies in its core business model that

internal new venturing

The process of transferring resources to and creating a new business unit or division in a new industry to innovate new kinds of products.

can be leveraged or recombined to enter a new industry. **Internal new venturing** is the process of transferring resources to and creating a new business unit or division in a new industry. Internal venturing is used most by companies that have a business model based upon using their technology or design skills to innovate new kinds of products and enter related markets or industries. Thus, technology-based companies that pursue related diversification, like DuPont, which has created new markets with products such as cellophane, nylon, Freon, and Teflon, are most likely to use internal new venturing. 3M has a near-legendary knack for creating new or improved products from internally generated ideas, and then establishing new business units to create the business model that enables it to dominate a new market. Similarly, HP entered into the computer and printer industries by using internal new venturing.

A company may also use internal venturing to enter a newly emerging or embryonic industry—one in which no company has yet developed the competencies or business model to give it a dominant position in that industry. This was Monsanto's situation in 1979 when it contemplated entering the biotechnology field to produce herbicides and pest-resistant crop seeds. The biotechnology field was young at that time, and there were no incumbent companies focused on applying biotechnology to agricultural products. Accordingly, Monsanto internally ventured a new division to develop the required competencies necessary to enter and establish a strong competitive position in this newly emerging industry.

Pitfalls of New Ventures

Despite the popularity of internal new venturing, there is a high risk of failure. Research suggests that somewhere between 33% and 60% of all new products that reach the marketplace do not generate an adequate economic return[15] and that most of these products were the result of internal new ventures. Three reasons are often put forward to explain the relatively high failure rate of internal new ventures: (1) market entry on too small a scale, (2) poor commercialization of the new-venture product, and (3) poor corporate management of the new-venture division.[16]

Scale of Entry Research suggests that large-scale entry into a new industry is often a critical precondition for the success of a new venture. In the short run, this means that a substantial capital investment must be made to support large-scale entry; thus, there is a risk of major losses if the new venture fails. But, in the long run, which can be as long as 5 to 12 years (depending on the industry), such a large investment results in far greater returns than if a company chooses to enter on a small scale to limit its investment and reduce potential losses.[17] Large-scale entrants can more rapidly realize scale economies, build brand loyalty, and gain access to distribution channels in the new industry, all of which increase the probability of a new venture's success. In contrast, small-scale entrants may find themselves handicapped by high costs due to a lack of scale economies, and a lack of market presence limits the entrant's ability to build brand loyalty and gain access to distribution channels. These scale effects are particularly significant when a company is entering an *established* industry in which incumbent companies possess scale economies, brand loyalty, and access to distribution channels. In that case, the new entrant must make a major investment to succeed.

Figure 10.6 plots the relationship between scale of entry and profitability over time for successful small-scale and large-scale ventures. The figure shows that successful small-scale entry is associated with lower initial losses, but in the long term, large-scale entry generates greater returns. However, because of the high costs and risks associated with large-scale entry, many companies make the mistake of choosing a small-scale entry strategy, which often means they fail to build the market share necessary for long-term success.

Figure 10.6	Scale of Entry and Profitability

Commercialization Many internal new ventures are driven by the opportunity to use a new or advanced technology to make better products for customers and outperform competitors. But, to be commercially successful, the products under development must be tailored to meet the needs of customers. Many internal new ventures fail when a company ignores the needs of customers in a market. Its managers become so focused on the technological possibilities of a new product that customer requirements are forgotten.[18] Thus, a new venture may fail because it is marketing a product based on a technology for which there is no demand, or the company fails to correctly position or differentiate the product in the market at attract customers.

For example, consider the desktop PC marketed by NeXT, the company that was started by the founder of Apple, Steve Jobs. The NeXT system failed to gain market share because the PC incorporated an array of expensive technologies that consumers simply did not want, such as optical disk drives and hi-fidelity sound. The optical disk drives, in particular, turned off customers because it was difficult to move work from PCs with floppy drives to NeXT machines with optical drives. In other words, NeXT failed because its founder was so dazzled by leading-edge technology that he ignored customer needs. However, Jobs redeemed himself and was named "CEO of the Decade" by *Fortune* magazine in 2010, after he successfully commercialized Apple's iPod, which dominates the MP3 player market. Also, the iPhone set the standard in the smartphone market, and the iPad quickly dominated the tablet computer market following its introduction in 2010.

Poor Implementation Managing the new-venture process, and controlling the new-venture division, creates many difficult managerial and organizational problems.[19] For example, one common mistake some companies make to try to increase their chances of introducing successful products is to establish *too many* different internal new-venture divisions at the same time. Managers attempt to spread the risks of failure by having many divisions, but this places enormous demands upon a company's cash flow. Sometimes, companies are forced to reduce the funding each division receives to keep the entire company profitable,

and this can result in the most promising ventures being starved of the cash they need to succeed.[20] Another common mistake is when corporate managers fail to do the extensive advanced planning necessary to ensure that the new venture's business model is sound and contains all the elements that will be needed later if it is to succeed. Sometimes corporate managers leave this process to the scientists and engineers championing the new technology. Focused on the new technology, managers may innovate new products that have little strategic or commercial value. Corporate managers and scientists must work together to clarify how and why a new venture will lead to a product that has a competitive advantage and jointly establish strategic objectives and a timetable to manage the venture until the product reaches the market.

The failure to anticipate the time and costs involved in the new-venture process constitutes a further mistake. Many companies have unrealistic expectations regarding the time frame and expect profits to flow in quickly. Research suggests that some companies operate with a philosophy of killing new businesses if they do not turn a profit by the end of the third year, which is unrealistic given that it can take 5 years or more before a new venture generates substantial profits.

Guidelines for Successful Internal New Venturing

To avoid these pitfalls, a company should adopt a well-thought-out, structured approach to manage internal new venturing. New venturing is based on R&D. It begins with the *exploratory research* necessary to advance basic science and technology (the "R" in R&D) and *development research* to identify, develop, and perfect the commercial applications of a new technology (the "D" in R&D). Companies with strong track records of success at internal new venturing excel at both kinds of R&D; they help to advance basic science and discover important commercial applications for it.[21] To advance basic science, it is important for companies to have strong links with universities, where much of the scientific knowledge that underlies new technologies is discovered. It is also important to make sure that research funds are being controlled by scientists who understand the importance of both "R" and "D" research. If the "D" is lacking, a company will probably generate few successful commercial ventures no matter how well it does basic research. Companies can take a number of steps to ensure that good science ends up with good, commercially viable products.

First, many companies must place the funding for research into the hands of business unit managers who have the skill or knowhow to narrow down and then select the best set of research projects—those that have the best chance of a significant commercial payoff. Second, to make effective use of its R&D competency, a company's top managers must work with its R&D scientists to continually develop and improve the business model and strategies that guide their efforts and make sure *all* its scientists and engineers understand what they have to do to make it succeed.[22]

Third, a company must also foster close links between R&D and marketing to increase the probability that a new product will be a commercial success in the future. When marketing works to identify the most important customer requirements for a new product and then communicates these requirements to scientists, it ensures that research projects meet the needs of their intended customers. Fourth, a company should also foster close links between R&D and manufacturing to ensure that it has the ability to make a proposed new product in a cost-effective way. Many companies successfully integrate the activities of the different functions by creating cross-functional project teams to oversee the development of new products from their inception to market introduction. This approach can significantly reduce the time it takes to bring a new product to market. For example, while R&D

is working on design, manufacturing is setting up facilities, and marketing is developing a campaign to show customers how much the new product will benefit them.

Finally, because large-scale entry often leads to greater long-term profits, a company can promote the success of internal new venturing by "thinking big." A company should construct efficient-scale manufacturing facilities and give marketing a large budget to develop a future product campaign that will build market presence and brand loyalty quickly, and well in advance of that product's introduction. And, corporate managers should not panic when customers are slow to adopt the new product; they need to accept the fact there will be initial losses and recognize that as long as market share is expanding, the product will eventually succeed.

ENTERING NEW INDUSTRIES: ACQUISITIONS

In Chapter 9, we explained that *acquisitions* are the main vehicle that companies use to implement a horizontal integration strategy. Acquisitions are also a principal way companies enter new industries to pursue vertical integration and diversification, so it is necessary to understand both the benefits and risks associated with using acquisitions to implement a corporate-level strategy.

The Attraction of Acquisitions

In general, acquisitions are used to pursue vertical integration or diversification when a company lacks the distinctive competencies necessary to compete in a new industry, so it uses its financial resources to purchase an established company that has those competencies. A company is particularly likely to use acquisitions when it needs to move fast to establish a presence in an industry, commonly an embryonic or growth industry. Entering a new industry through internal venturing is a relatively slow process; acquisition is a much quicker way for a company to establish a significant market presence. A company can purchase a leading company with a strong competitive position in months, rather than waiting years to build a market leadership position by engaging in internal venturing. Thus, when speed is particularly important, acquisition is the favored entry mode. Intel, for example, used acquisitions to build its communications chip business because it sensed that the market was developing very quickly, and that it would take too long to develop the required competencies.

In addition, acquisitions are often perceived as being less risky than internal new ventures because they involve less commercial uncertainty. Because of the risks of failure associated with internal new venturing, it is difficult to predict its future success and profitability. By contrast, when a company makes an acquisition, it acquires a company with an already established reputation, and it knows the magnitude of the company's market share and profitability.

Finally, acquisitions are an attractive way to enter an industry that is protected by high barriers to entry. Recall from Chapter 2 that barriers to entry arise from factors such as product differentiation, which leads to brand loyalty and high market share that leads to economies of scale. When entry barriers are high, it may be very difficult for a company to enter an industry through internal new venturing because it will have to construct large-scale manufacturing facilities and invest in a massive advertising campaign to establish brand loyalty—difficult goals that require huge capital expenditures. In contrast, if a company acquires another company already established in the industry, possibly the market

leader, it can circumvent most entry barriers because that company has already achieved economies of scale and obtained brand loyalty. In general, the higher the barriers to entry, the more likely it is that acquisitions will be the method used to enter the industry.

Acquisition Pitfalls

For these reasons, acquisitions have long been the most common method that companies use to pursue diversification. However, as we mentioned earlier, research suggests that many acquisitions fail to increase the profitability of the acquiring company and may result in losses. For example, a study of 700 large acquisitions found that although 30% of these resulted in higher profits, 31% led to losses and the remainder had little impact.[23] Research suggests that many acquisitions fail to realize their anticipated benefits.[24] One study of the post-acquisition performance of acquired companies found that the profitability and market share of an acquired company often declines afterward, suggesting that many acquisitions destroy rather than create value.[25]

Acquisitions may fail to raise the performance of the acquiring companies for four reasons: (1) companies frequently experience management problems when they attempt to integrate a different company's organizational structure and culture into their own; (2) companies often overestimate the potential economic benefits from an acquisition; (3) acquisitions tend to be so expensive that they do not increase future profitability; and (4) companies are often negligent in screening their acquisition targets and fail to recognize important problems with their business models.

Integrating the Acquired Company Once an acquisition has been made, the acquiring company has to integrate the acquired company and combine it with its own organizational structure and culture. Integration involves the adoption of common management and financial control systems, the joining together of operations from the acquired and the acquiring company, the establishment of bureaucratic mechanisms to share information and personnel, and the need to create a common culture. Experience has shown that many problems can occur as companies attempt to integrate their activities.

After an acquisition, many acquired companies experience high management turnover because their employees do not like the acquiring company's way of operating—its structure and culture.[26] Research suggests that the loss of management talent and expertise, and the damage from constant tension between the businesses, can materially harm the performance of the acquired unit.[27] Moreover, companies often must take on an enormous amount of debt to fund an acquisition, and they are frequently unable to pay it once these management problems (and sometimes the weaknesses) of the acquired company's business model become clear.

Overestimating Economic Benefits Even when companies find it easy to integrate their activities, they often overestimate by how much combining the different businesses can increase future profitability. Managers often overestimate the competitive advantages that will derive from the acquisition and so pay more for the acquired company than it is worth. One reason is that top managers typically overestimate their own personal general competencies to create valuable new products from an acquisition. Why? The very fact that they have risen to the top of a company gives managers an exaggerated sense of their own capabilities, and a self-importance that distorts their strategic decision making.[28] Coca-Cola's acquisition of a number of medium-sized winemaking companies illustrates this. Reasoning that a beverage is a beverage, Coca-Cola's then-CEO decided he would be able

to mobilize his company's talented marketing managers to develop the strategies needed to dominate the U.S. wine industry. After purchasing three wine companies and enduring 7 years of marginal profits because of failed marketing campaigns, he subsequently decided that wine and soft drinks are very different products; in particular, they have different kinds of appeal, pricing systems, and distribution networks. Coca-Cola eventually sold the wine operations to Joseph E. Seagram and took a substantial loss.[29]

The Expense of Acquisitions Perhaps the most important reason for the failure of acquisitions is that acquiring a company with stock that is publicly traded tends to be very expensive—and the expense of the acquisition can more than wipe out the value of the stream of future profits that are expected from the acquisition. One reason is that the top managers of a company that is "targeted" for acquisition are likely to resist any takeover attempt unless the acquiring company agrees to pay a substantial premium above its current market value. These premiums are often 30 to 50% above the usual value of a company's stock. Similarly, the stockholders of the target company are unlikely to sell their stock unless they are paid major premiums over market value prior to a takeover bid. To pay such high premiums, the acquiring company must be certain it can use its acquisition to generate the stream of future profits that justifies the high price of the target company. This is frequently a difficult thing to do given how fast the industry environment can change and the other problems discussed earlier, such as integrating the acquired company. This is a major reason why acquisitions are frequently unprofitable for the acquiring company.

The reason why the acquiring company must pay such a high premium is that the stock price of the acquisition target increases enormously during the acquisition process as investors speculate on the final price the acquiring company will pay to capture it. In the case of a contested bidding contest, where two or more companies simultaneously bid to acquire the target company, its stock price may surge. Also, when many acquisitions are occurring in one particular industry, investors speculate that the value of the remaining industry companies that have *not* been acquired has increased, and that a bid for these companies will be made at some future point. This also drives up their stock price and increases the cost of making acquisitions. This happened in the telecommunications sector when, to make sure they could meet the needs of customers who were demanding leading-edge equipment, many large companies went on acquisition "binges." Nortel and Alcatel-Lucent engaged in a race to purchase smaller, innovative companies that were developing new telecommunications equipment. The result was that the stock prices for these companies were bid up by investors, and they were purchased at a hugely inflated price. When the telecommunications boom turned to bust, the acquiring companies found that they had vastly overpaid for their acquisitions and had to take enormous accounting write-downs; Nortel was forced to declare bankruptcy and sold off all its assets, and the value of Alcatel-Lucent's stock plunged almost 90%, although by 2011, there were signs of possible recovery.

Inadequate Pre-acquisition Screening As the problems of these companies suggest, top managers often do a poor job of pre-acquisition screening, that is, evaluating how much a potential acquisition may increase future profitability. Researchers have discovered that one important reason for the failure of an acquisition is that managers make the decision to acquire other companies without thoroughly analyzing potential benefits and costs.[30] In many cases, after an acquisition has been completed, many acquiring companies discover that instead of buying a well-managed business with a strong business model, they have purchased a troubled organization. Obviously, the managers of the

target company may manipulate company information or the balance sheet to make their financial condition look much better than it is. The acquiring company must remain aware and complete extensive research. In 2009, IBM was in negotiations to purchase chip-maker Sun Microsystems. After spending one week examining its books, IBM reduced its offer price by 10% when its negotiators found its customer base was not as solid as they had expected. Sun Microsystems was eventually sold to Oracle in 2010, and so far the acquisition has not proven a success, as Sun Microsystems's server sales fell in both 2011 and 2012.[31]

Guidelines for Successful Acquisition

To avoid these pitfalls and make successful acquisitions, companies need to follow an approach to targeting and evaluating potential acquisitions that is based on four main steps: (1) target identification and pre-acquisition screening, (2) bidding strategy, (3) integration, and (4) learning from experience.[32]

Identification and Screening Thorough pre-acquisition screening increases a company's knowledge about a potential takeover target and lessens the risk of purchasing a problem company—one with a weak business model. It also leads to a more realistic assessment of the problems involved in executing a particular acquisition so that a company can plan how to integrate the new business and blend organizational structures and cultures. The screening process should begin with a detailed assessment of the strategic rationale for making the acquisition, an identification of the kind of company that would make an ideal acquisition candidate, and an extensive analysis of the strengths and weaknesses of the prospective company's business model compared to other possible acquisition targets.

Indeed, an acquiring company should select a set of top potential acquisition targets and evaluate each company using a set of criteria that focus on revealing (1) its financial position, (2) its distinctive competencies and competitive advantage, (3) changing industry boundaries, (4) its management capabilities, and (5) its corporate culture. Such an evaluation helps the acquiring company perform a detailed strength, weakness, opportunities, and threats (SWOT) analysis that identifies the best target, for example, by measuring the potential economies of scale and scope that can be achieved between the acquiring company and each target company. This analysis also helps reveal the potential integration problems that might exist when it is necessary to integrate the corporate cultures of the acquiring and acquired companies. For example, managers at Microsoft and SAP, the world's leading provider of enterprise resource planning (ERP) software, met to discuss a possible acquisition by Microsoft. Both companies decided that despite the strong strategic rationale for a merger—together they could dominate the software computing market, satisfying the need of large global companies—they would have challenges to overcome. The difficulties of creating an organizational structure that could successfully integrate their hundreds of thousands of employees throughout the world, and blend two very different cultures, were insurmountable.

Once a company has reduced the list of potential acquisition candidates to the most favored one or two, it needs to contact expert third parties, such as investment bankers like Goldman Sachs and Merrill Lynch. These companies' business models are based on providing valuable insights about the attractiveness of a potential acquisition, and assessing current industry competitive conditions, and handling the many other issues surrounding an acquisition, such as how to select the optimal bidding strategy for acquiring the target company's stock and keep the purchase price as low as possible.

Bidding Strategy The objective of the bidding strategy is to reduce the price that a company must pay for the target company. The most effective way a company can acquire another is to make a friendly takeover bid, which means the two companies decide upon an amicable way to merge the two companies, satisfying the needs of each company's stockholders and top managers. A friendly takeover prevents speculators from bidding up stock prices. By contrast, in a hostile bidding environment, such as between Oracle and PeopleSoft, and Microsoft and Yahoo!, the price of the target company often gets bid up by speculators who expect that the offer price will be raised by the acquirer or by another company that might have a higher counteroffer.

Another essential element of a good bidding strategy is timing. For example, Hanson PLC, one of the most successful companies to pursue unrelated diversification, searched for sound companies suffering from short-term problems because of the business cycle or because performance was being seriously impacted by one underperforming division. Such companies are often undervalued by the stock market, so they can be acquired without paying a high stock premium. With good timing, a company can make a bargain purchase.

Integration Despite good screening and bidding, an acquisition will fail unless the acquiring company possesses the essential organizational design skills needed to integrate the acquired company into its operations, and quickly develop a viable multibusiness model. Integration should center upon the source of the potential strategic advantages of the acquisition, for instance, opportunities to share marketing, manufacturing, R&D, financial, or management resources. Integration should also involve steps to eliminate any duplication of facilities or functions. In addition, any unwanted business units of the acquired company should be divested.

Learning from Experience Research suggests companies that acquire many companies over time become expert in this process, and can generate significant value from their experience of the acquisition process.[33] Their past experience enables them to develop a "playbook," a clever plan that they can follow to execute an acquisition most efficiently and effectively. One successful company, Tyco International, never made hostile acquisitions; it audited the accounts of the target companies in detail, acquired companies to help it achieve a critical mass in an industry, moved quickly to realize cost savings after an acquisition, promoted managers one or two layers down to lead the newly acquired entity, and introduced profit-based incentive pay systems in the acquired unit.[34] Over time, however, Tyco tended to become too large and diversified, leading both investors and management to suspect Tyco was not generating as much value as it could. In 2007, Tyco's health-care and electronics divisions were spun off. Then in 2012, plans Tyco was split again into three parts that would each have their own stock: Tyco Fire and Security, ADT (which provided residential and small business security installation), and Flow Control (which sold water and fluid valves and controls).[35]

ENTERING NEW INDUSTRIES: JOINT VENTURES

Joint ventures, where two or more companies agree to pool their resources to create new business, are most commonly used to enter an embryonic or growth industry. Suppose a company is contemplating creating a new-venture division in an embryonic industry; such a move involves substantial risks and costs because the company must make the huge investment necessary to develop the set of value-chain activities required to make and sell

products in the new industry. On the other hand, an acquisition can be a dangerous proposition because there is rarely an established leading company in an emerging industry; even if there is it will be extremely expensive to purchase.

In this situation, a joint venture frequently becomes the most appropriate method to enter a new industry because it allows a company to share the risks and costs associated with establishing a business unit in the new industry with another company. This is especially true when the companies share *complementary* skills or distinctive competencies because this increases the probability of a joint venture's success. Consider the 50/50 equity joint venture formed between UTC and Dow Chemical to build plastic-based composite parts for the aerospace industry. UTC was already involved in the aerospace industry (it builds Sikorsky helicopters), and Dow Chemical had skills in the development and manufacture of plastic-based composites. The alliance called for UTC to contribute its advanced aerospace skills and Dow to contribute its skills in developing and manufacturing plastic-based composites. Through the joint venture, both companies became involved in new product markets. They were able to realize the benefits associated with related diversification without having to merge their activities into one company or bear the costs and risks of developing new products on their own. Thus, both companies enjoyed the profit-enhancing advantages of entering new markets without having to bear the increased bureaucratic costs.

Although joint ventures usually benefit both partner companies, under some conditions they may result in problems. First, although a joint venture allows companies to share the risks and costs of developing a new business, it also requires that they share in the profits if it succeeds. So, if one partner's skills are more important than the other partner's skills, the partner with more valuable skills will have to "give away" profits to the other party because of the 50/50 agreement. This can create conflict and sour the working relationship as time passes. Second, the joint-venture partners may have different business models or time horizons, and problems can arise if they start to come into conflict about how to run the joint venture; these kinds of problems can disintegrate a business and result in failure. Third, a company that enters into a joint venture runs the risk of giving away important company-specific knowledge to its partner, which might then use the new knowledge to compete with its other partner in the future. For example, having gained access to Dow's expertise in plastic-based composites, UTC might have dissolved the alliance and produced these materials on its own. As the previous chapter discussed, this risk can be minimized if Dow gets a *credible commitment* from UTC, which is what Dow did. UTC had to make an expensive asset-specific investment to make the products the joint venture was formed to create.

Restructuring

Many companies expand into new industries to increase profitability. Sometimes, however, companies need to exit industries to increase their profitability and split their existing businesses into separate, independent companies. **Restructuring** is the process of reorganizing and divesting business units and exiting industries to refocus upon a company's core business and rebuild its distinctive competencies.[36] Why are so many companies restructuring and how do they do it?

Why Restructure?

One main reason that diversified companies have restructured in recent years is that the stock market has valued their stock at a *diversification discount*, meaning that the stock

restructuring
The process of reorganizing and divesting business units and exiting industries to refocus upon a company's core business and rebuild its distinctive competencies

of highly diversified companies is valued lower, relative to their earnings, than the stock of less-diversified companies.[37] Investors see highly diversified companies as less attractive investments for four reasons. First, as we discussed earlier, investors often feel these companies no longer have multibusiness models that justify their participation in many different industries. Second, the complexity of the financial statements of highly diversified enterprises disguises the performance of individual business units; thus, investors cannot identify if their multibusiness models are succeeding. The result is that investors perceive the company as being riskier than companies that operate in one industry, whose competitive advantage and financial statements are more easily understood. Given this situation, restructuring can be seen as an attempt to boost the returns to shareholders by splitting up a multibusiness company into separate and independent parts.

The third reason for the diversification discount is that many investors have learned from experience that managers often have a tendency to pursue too much diversification or do it for the wrong reasons: their attempts to diversify *reduce* profitability.[38] For example, some CEOs pursue growth for its own sake; they are empire builders who expand the scope of their companies to the point where fast-increasing bureaucratic costs become greater than the additional value that their diversification strategy creates. Restructuring thus becomes a response to declining financial performance brought about by over-diversification.

A final factor leading to restructuring is that innovations in strategic management have diminished the advantages of vertical integration or diversification. For example, a few decades ago, there was little understanding of how long-term cooperative relationships or strategic alliances between a company and its suppliers could be a viable alternative to vertical integration. Most companies considered only two alternatives for managing the supply chain: vertical integration or competitive bidding. As we discuss in Chapter 9, in many situations, long-term cooperative relationships can create the most value, especially because they avoid the need to incur bureaucratic costs or dispense with market discipline. As this strategic innovation has spread throughout global business, the relative advantages of vertical integration have declined.

ETHICAL DILEMMA

© iStockPhoto.com/P_Wei

Recently, many top managers have been convicted of illegally altering their company's financial statements or providing false information to hide the poor performance of their company from stockholders—or simply for personal gain. You have been charged with the task of creating a control system for your company to ensure managers behave ethically and legally when reporting the performance of their business. To help develop the control system, you identify the five main ways managers use diversification to increase profitability—transferring and leveraging competences, sharing resources, product bundling, and the use of general managerial competencies.

How might these five methods be associated with unethical behavior? Can you determine rules or procedures that could prevent managers from behaving in an unethical way?

SUMMARY OF CHAPTER

1. Strategic managers often pursue diversification when their companies are generating free cash flow, that is, financial resources they do not need to maintain a competitive advantage in the company's core industry that can be used to fund profitable new business ventures.

2. A diversified company can create value by (a) transferring competencies among existing businesses, (b) leveraging competencies to create new businesses, (c) sharing resources to realize economies of scope, (d) using product bundling, (e) taking advantage of general organizational competencies that enhance the performance of all business units within a diversified company, and (f) operating an internal capital market. The bureaucratic costs of diversification rise as a function of the number of independent business units within a company and the extent to which managers must coordinate the transfer of resources between those business units.

3. Diversification motivated by a desire to pool risks or achieve greater growth often results in falling profitability.

4. There are three methods companies use to enter new industries: internal new venturing, acquisition, and joint ventures.

5. Internal new venturing is used to enter a new industry when a company has a set of valuable competencies in its existing businesses that can be leveraged or recombined to enter a new business or industry.

6. Many internal ventures fail because of entry on too small a scale, poor commercialization, and poor corporate management of the internal venture process. Guarding against failure involves a carefully planned approach toward project selection and management, integration of R&D and marketing to improve the chance new products will be commercially successful, and entry on a scale large enough to result in competitive advantage.

7. Acquisitions are often the best way to enter a new industry when a company lacks the competencies required to compete in a new industry, and it can purchase a company that does have those competencies at a reasonable price. Acquisitions are also the method chosen to enter new industries when there are high barriers to entry and a company is unwilling to accept the time frame, development costs, and risks associated with pursuing internal new venturing.

8. Acquisitions are unprofitable when strategic managers (a) underestimate the problems associated with integrating an acquired company, (b) overestimate the profit that can be created from an acquisition, (c) pay too much for the acquired company, and (d) perform inadequate pre-acquisition screening to ensure the acquired company will increase the profitability of the whole company. Guarding against acquisition failure requires careful pre-acquisition screening, a carefully selected bidding strategy, effective organizational design to successfully integrate the operations of the acquired company into the whole company, and managers who develop a general managerial competency by learning from their experience of past acquisitions.

9. Joint ventures are used to enter a new industry when (a) the risks and costs associated with setting up a new business unit are more than a company is willing to assume on its own and (b) a company can increase the probability that its entry into a new industry will result in a successful new business by teaming up with another company that has skills and assets that complement its own.

10. Restructuring is often required to correct the problems that result from (a) a business model that no longer creates competitive advantage, (b) the inability of investors to assess the competitive advantage of a highly diversified company from its financial statements, (c) excessive diversification because top managers desire to pursue empire building that results in growth without profitability, and (d) innovations in strategic management such as strategic alliances and outsourcing that reduce the advantages of vertical integration and diversification.

DISCUSSION QUESTIONS

1. When is a company likely to choose (a) related diversification and (b) unrelated diversification?
2. What factors make it most likely that (a) acquisitions or (b) internal new venturing will be the preferred method to enter a new industry?
3. Imagine that IBM has decided to diversify into the telecommunications business to provide online cloud computing data services and broadband access for businesses and individuals. What method would you recommend that IBM pursue to enter this industry? Why?
4. Under which conditions are joint ventures a useful way to enter new industries?
5. Identify Honeywell's (www.honeywell.com) portfolio of businesses that can be found by exploring its website. In how many different industries is Honeywell involved? Would you describe Honeywell as a related or an unrelated diversification company? Has Honeywell's diversification strategy increased profitability over time?

KEY TERMS

Diversification 322
Diversified company 322
Transferring competencies 323
Commonality 323

Leveraging competencies 324
Economies of scope 325
General organizational competencies 327
Organizational design skills 329

Turnaround strategy 330
Related diversification 331
Unrelated diversification 331

Internal capital market 332
Bureaucratic costs 335
Internal new venturing 342
Restructuring 350

PRACTICING STRATEGIC MANAGEMENT

© iStockPhoto.com/Urilux

Small-Group Exercises

Small-Group Exercise: Visiting General Electric

Break up into groups of three to five students, and explore GE's website (www.ge.com) to answer the following questions. Then appoint one member of the group as spokesperson who will communicate the group's findings to the class.

1. Review GE's portfolio of major businesses. Upon what multibusiness model is this portfolio of businesses based? How profitable has that model been in past?
2. Has GE's multibusiness model been changing? Has its CEO, Jeffrey Immelt, announced any new strategic initiatives?
3. What kinds of changes would you make to its multibusiness model to boost its profitability?

STRATEGY SIGN ON

© iStockPhoto.com/Ninoslav Dotlic

Article File 10

Find an example of a diversified company that made an acquisition that apparently failed to create any value. Identify and critically evaluate the rationale that top management used to justify the acquisition when it was made. Explain why the acquisition subsequently failed.

Strategic Management Project: Module 10

This module requires you to assess your company's use of acquisitions, internal new ventures, and joint ventures as ways to enter a new business or restructure its portfolio of businesses.

A. Your Company Has Entered a New Industry During the Past Decade

1. Pick one new industry that your company has entered during the past 10 years.
2. Identify the rationale for entering this industry.
3. Identify the strategy used to enter this industry.
4. Evaluate the rationale for using this particular entry strategy. Do you think that this was the best entry strategy to use? Why or why not?
5. Do you think that the addition of this business unit to the company increased or reduced profitability? Why?

B. Your Company Has Restructured Its Corporate Portfolio During the Past Decade

1. Identify the rationale for pursuing a restructuring strategy.
2. Pick one industry from which your company has exited during the past 10 years.
3. Identify the strategy used to exit from this particular industry. Do you think that this was the best exit strategy to use? Why or why not?
4. In general, do you think that exiting from this industry has been in the company's best interest?

CLOSING CASE

VF Corp. Acquires Timberland to Realize the Benefits from Related Diversification

In June 2011, U.S.-based VF Corp., the global apparel and clothing maker, announced that it would acquire Timberland, the U.S.-based global footwear maker, for $2 billion, which was a 40% premium on Timberland's stock price. VF is the maker of such established clothing brands as Lee and Wrangler Jeans, Nautica, lucy, 7 For All Mankind, Vans, Kipling, and outdoor apparel brands such as The North Face, JanSport, and Eagle Creek.

Timberland is well known for its tough waterproof leather footwear, such as its best-selling hiking boots and its classic boat shoes; it also licenses the right to make clothing and accessories under its brand name. Obviously, Timberland's stockholders were thrilled that they had made a 40% profit overnight on their investment; but why would a clothing maker purchase a footwear company that primarily competes in a different industry?

The reason, according to VF's CEO Eric Wiseman, is that the Timberland deal would be a "transformative" acquisition that would add footwear to VF's fastest-growing division, the outdoor and action sports business, which had achieved a 14% gain in revenues in 2010 and contributed $3.2 billion of VF's total revenues of $7.7 billion. By combining the products of the clothing and footwear division, Wiseman claimed that VF could almost double Timberland's profitability by increasing its global sales by at least 15%. At the same time, the addition of the Timberland brand would increase the sales of VF's outdoor brands such as The North Face by 10%. The result would be a major increase in VF's revenues and profitability—an argument its investors agreed with because whereas the stock price of a company that acquires another company normally declines after the announcement, VF's stock price soared by 10%!

Why would this merger of two very different companies result in so much more value being created? The first reason is that it would allow the company to offer an extended range of outdoor products—clothing, shoes, backpacks, and accessories—which could all be packaged together, distributed to retailers, and marketed and sold to customers. The result would be substantial cost savings because purchasing, distribution, and marketing costs would now be shared between the different brands or product lines in VF's expanded portfolio. In addition, VF would be able to increasingly differentiate its outdoor products by, for example, linking its brand The North Face with the Timberland brand, so customers purchasing outdoor clothing would be more likely to purchase Timberland hiking boots and related accessories such as backpacks offered by VF's other outdoor brands.

In addition, although Timberland is a well-known popular brand in the United States, it generates more than 50% of its revenues from global sales (especially in high-growth markets such as China), and it has a niche presence in many countries such as the United Kingdom and Japan. In 2011 VF was only generating 30% of its revenues from global sales; by taking advantage of the commonalities between its outdoor brands, VF argued that purchasing Timberland would increase its sales in overseas markets and also increase the brand recognition and sales of its other primary brands such as Wrangler Jeans and Nautica. For example, hikers could wear VF's Wrangler or Lee Jeans, as well as The North Face clothing, at the same time they put on their Timberland hiking boots. In short, Timberland's global brand cachet and the synergies between the two companies' outdoor lifestyle products would result in major new value creation. Thus, the acquisition would allow VF to increase the global differentiated appeal of all its brands, resulting in lower costs. VF would be able to negotiate better deals with specialist outsourcing companies abroad, and economies of scale would result from reduced global shipping and distribution costs.

In a conference call to analysts, Wiseman said that: "Timberland has been our Number 1 acquisition priority. It knits together two powerful companies into a new global player in the outdoor and action sports space."

After the acquisition, the combined companies had more than 1,225 VF-operated retail stores, of which most were single-brand shops. VF also operated 80 U.S. outlet stores that sold a wide range of excess VF products. VF also sold to specialty stores, department stores, national chains, and mass merchants such as Walmart (Walmart accounted for 8% of VF's total sales in 2012—primarily due to its purchases of jeanswear). The Timberland acquisition increased the range of products VF could distribute and sell through its many distribution channels, resulting in synergies and cost savings. VF's organizational structure leveraged the advantage of centralized purchasing, distribution, and IT to reduce costs across the organization.

Timberland's 2010 sales (prior to the acquisition) had been $1.4 billion, and its net income had been $96 million—a net profit margin of just under 7%. VF's sales in 2010 had been $7.7 billion with net income of $571 million, for a net profit margin of 7.4%. After the acquisition, VF Corporation posted revenues of $9.4 billion and $10.9 billion while also showing an increase in net profit margin to 9.4% and 10.0% in 2011 and 2012, respectively. Although it is difficult to know how much of these gains could be directly attributable to the Timberland acquisition, VF's strategy of related diversification appeared to be paying off!

Sources: www.vfc.com and www.timberland.com.

CASE DISCUSSION QUESTIONS

1. What kinds of resources can likely be shared across different brands between an apparel maker and a footwear maker? What kinds of resources are unlikely to be shared?
2. How much does being a larger, more diversified apparel and footwear company increase VF's market power over its suppliers or customers? How could we assess how much this is worth?
3. If VF had increased its sales only by the amount of Timberland's sales and had not reaped an increase in profitability, would you consider the acquisition successful?
4. How might you compare VF's increase in profits to the premium it paid for Timberland?

NOTES

[1]This resource-based view of diversification can be traced to Edith Penrose's seminal book *The Theory of the Growth of the Firm* (Oxford: Oxford University Press, 1959).

[2]D. J. Teece, "Economies of Scope and the Scope of the Enterprise," *Journal of Economic Behavior and Organization* 3 (1980): 223–247. For more recent empirical work on this topic, see C. H. St. John and J. S. Harrison, "Manufacturing Based Relatedness, Synergy and Coordination," *Strategic Management Journal* 20 (1999): 129–145.

[3]Teece, "Economies of Scope." For more recent empirical work on this topic, see St. John and Harrison, "Manufacturing Based Relatedness, Synergy and Coordination."

[4]For a detailed discussion, see C. W. L. Hill and R. E. Hoskisson, "Strategy and Structure in the Multiproduct Firm," *Academy of Management Review* 12 (1987): 331–341.

[5]See, for example, G. R. Jones and C. W. L. Hill, "A Transaction Cost Analysis of Strategy Structure Choice," *Strategic Management Journal* 2 (1988): 159–172; and O. E. Williamson, *Markets and Hierarchies, Analysis and Antitrust Implications* (New York: Free Press, 1975), pp. 132–175.

[6]R. Buderi, *Engines of Tomorrow* (New York: Simon & Schuster, 2000).

[7]See, for example, Jones and Hill, "A Transaction Cost Analysis"; and Williamson, *Markets and Hierarchies.*

[8]C. A. Trahms, H. A. Ndofor, and D. G. Sirmon, "Organizational Decline and Turnaound: A Review and Agenda for Future Research," *Journal of Management,* 39 (2013): 1277–1307.

[9]The distinction goes back to R. P. Rumelt, *Strategy, Structure and Economic Performance* (Cambridge: Harvard Business School Press, 1974).

[10]For evidence, see C. W. L. Hill, "Conglomerate Performance over the Economic Cycle," *Journal of Industrial Economics* 32 (1983): 197–212; and D. T. C. Mueller, "The Effects of Conglomerate Mergers," *Journal of Banking and Finance* 1 (1977): 315–347.

[11]For reviews of the evidence, see V. Ramanujam and P. Varadarajan, "Research on Corporate Diversification: A Synthesis," *Strategic Management Journal* 10 (1989): 523–551; G. Dess, J. F. Hennart, C. W. L. Hill, and A. Gupta, "Research Issues in Strategic Management," *Journal of Management* 21 (1995): 357–392; and D. C. Hyland and J. D. Diltz, "Why Companies Diversify: An Empirical Examination," *Financial Management* 31 (Spring 2002): 51–81.

[12]M. E. Porter, "From Competitive Advantage to Corporate Strategy," *Harvard Business Review,* May–June 1987, pp. 43–59.

[13]For reviews of the evidence, see Ramanujam and Varadarajan, "Research on Corporate Diversification"; Dess et al., "Research Issues in Strategic Management"; and Hyland and Diltz, "Why Companies Diversify."

[14]C. R. Christensen et al., *Business Policy Text and Cases* (Homewood: Irwin, 1987), p. 778.

[15]See Booz, Allen, and Hamilton, *New Products Management for the 1980s* (New York: Booz, Allen and Hamilton, 1982); A. L. Page, "PDMA's New Product Development Practices Survey: Performance and Best Practices" (presented at the PDMA 15th Annual International Conference, Boston, October 16, 1991); and E. Mansfield, "How Economists See R&D," *Harvard Business Review*, November–December 1981, pp. 98–106.

[16]See R. Biggadike, "The Risky Business of Diversification," *Harvard Business Review*, May–June 1979, pp. 103–111; R. A. Burgelman, "A Process Model of Internal Corporate Venturing in the Diversified Major Firm," *Administrative Science Quarterly* 28 (1983): 223–244; and Z. Block and I. C. MacMillan, *Corporate Venturing* (Boston: Harvard Business School Press, 1993).

[17]Biggadike, "The Risky Business of Diversification"; Block and Macmillan, *Corporate Venturing*.

[18]Buderi, *Engines of Tomorrow*.

[19]I. C. MacMillan and R. George, "Corporate Venturing: Challenges for Senior Managers," *Journal of Business Strategy* 5 (1985): 34–43.

[20]See R. A. Burgelman, M. M. Maidique, and S. C. Wheelwright, *Strategic Management of Technology and Innovation* (Chicago: Irwin, 1996), 493–507. See also Buderi, *Engines of Tomorrow*.

[21]Buderi, *Engines of Tomorrow*.

[22]See Block and Macmillan, *Corporate Venturing*; Burgelman et al., *Strategic Management of Technology and Innovation*; and Buderi, *Engines of Tomorrow*.

[23]For evidence on acquisitions and performance, see R. E. Caves, "Mergers, Takeovers, and Economic Efficiency," *International Journal of Industrial Organization* 7 (1989): 151–174; M. C. Jensen and R. S. Ruback, "The Market for Corporate Control: The Scientific Evidence," *Journal of Financial Economics* 11 (1983): 5–50; R. Roll, "Empirical Evidence on Takeover Activity and Shareholder Wealth," in J. C. Coffee, L. Lowenstein, and S. Rose (eds.), *Knights, Raiders and Targets* (Oxford: Oxford University Press, 1989), pp. 112–127; A. Schleifer and R. W. Vishny, "Takeovers in the 60s and 80s: Evidence and Implications," *Strategic Management Journal* 12 (Special Issue, Winter 1991), pp. 51–60; T. H. Brush, "Predicted Changes in Operational Synergy and Post Acquisition Performance of Acquired Businesses," *Strategic Management Journal* 17 (1996): 1–24; and T. Loughran and A. M. Vijh, "Do Long Term Shareholders Benefit from Corporate Acquisitions?" *Journal of Finance* 5 (1997): 1765–1787.

[24]Ibid.

[25]D. J. Ravenscraft and F. M. Scherer, *Mergers, Sell-offs, and Economic Efficiency* (Washington: Brookings Institution, 1987).

[26]See J. P. Walsh, "Top Management Turnover Following Mergers and Acquisitions," *Strategic Management Journal* 9 (1988): 173–183.

[27]See A. A. Cannella and D. C. Hambrick, "Executive Departure and Acquisition Performance," *Strategic Management Journal* 14 (1993): 137–152.

[28]R. Roll, "The Hubris Hypothesis of Corporate Takeovers," *Journal of Business* 59 (1986): 197–216.

[29]"Coca-Cola: A Sobering Lesson from Its Journey into Wine," *Business Week*, June 3, 1985, pp. 96–98.

[30]P. Haspeslagh and D. Jemison, *Managing Acquisitions* (New York: Free Press, 1991).

[31]A. Ricadela, "Oracle Unveils Faster Servers to Combat Hardware Slump," Bloomberg.com, March 27, 2013.

[32]For views on this issue, see L. L. Fray, D. H. Gaylin, and J. W. Down, "Successful Acquisition Planning," *Journal of Business Strategy* 5 (1984): 46–55; C. W. L. Hill, "Profile of a Conglomerate Takeover: BTR and Thomas Tilling," *Journal of General Management* 10 (1984): 34–50; D. R. Willensky, "Making It Happen: How to Execute an Acquisition," *Business Horizons*, March–April 1985, pp. 38–45; Haspeslagh and Jemison, *Managing Acquisitions*; and P. L. Anslinger and T. E. Copeland, "Growth Through Acquisition: A Fresh Look," *Harvard Business Review*, January–February 1996, pp. 126–135.

[33]M. L. A. Hayward, "When Do Firms Learn from Their Acquisition Experience? Evidence from 1990–1995," *Strategic Management Journal* 23 (2002): 21–39; K. G. Ahuja, "Technological Acquisitions and the Innovation Performance of Acquiring Firms: A Longitudinal Study," *Strategic Management Journal* 23 (2001): 197–220; and H. G. Barkema and F. Vermeulen, "International Expansion Through Startup or Acquisition," *Academy of Management Journal* 41 (1998): 7–26.

[34]Hayward, "When Do Firms Learn from Their Acquisition Experience?"

[35]N. Zieminski, "Tyco Shareholders Approve Three-Way Break-Up," Reuters, September 17, 2012.

[36]For a review of the evidence and some contrary empirical evidence, see D. E. Hatfield, J. P. Liebskind, and T. C. Opler, "The Effects of Corporate Restructuring on Aggregate Industry Specialization," *Strategic Management Journal* 17 (1996): 55–72.

[37]A. Lamont and C. Polk, "The Diversification Discount: Cash Flows Versus Returns," *Journal of Finance* 56 (October 2001): 1693–1721; and R. Raju, H. Servaes, and L. Zingales, "The Cost of Diversity: The Diversification Discount and Inefficient Investment," *Journal of Finance* 55 (2000): 35–80.

[38]For example, see Schleifer and Vishny, "Takeovers in the '60s and '80s."

© iStockPhoto.com/Chepko Danil

Corporate Performance, Governance, and Business Ethics

11

OPENING CASE

Imaginechina/Corbis

HP's Disastrous Acquisition of Autonomy

In 2011, HP was churning on many fronts simultaneously. It had decided to abandon its tablet computer, and was struggling with a decision about whether to exit its $40 billion-a-year personal computer (PC) business altogether. It also had a new CEO, Leo Apotheker (formerly the head of German software company SAP AG) who was intent on making a high-impact acquisition that would transform the firm from being primarily a hardware manufacturer into a fast-growing software firm. The firm also had a new chairman of the board, Ray Lane, who was also a software specialist as well as former president of Oracle.

Leo Apotheker had proposed buying two mid-sized software companies, but both deals fell through—the first was nixed by the board's finance committee, and the second fell apart during negotiations over price. In frustration, Apotheker told Lane, "I'm running out of software companies."

Then in the summer of 2011, Apotheker proposed looking at Autonomy, a British firm that makes software that enables firms to search for relevant information in text files, video files, and other corporate

LEARNING OBJECTIVES

After reading this chapter you should be able to:

11-1 Understand the relationship between stakeholder management and corporate performance

11-2 Explain why maximizing returns to stockholders is often viewed as the preeminent goal in many corporations

11-3 Describe the various governance mechanisms that are used to align the interests of stockholders and managers

11-4 Explain why these governance mechanisms do not always work as intended

11-5 Identify the main ethical issues that arise in business and the causes of unethical behavior

11-6 Identify what managers can do to improve the ethical climate of their organization, and to make sure that business decisions do not violate good ethical principles

359

documents. Lane was enthusiastic about the idea. When Apotheker brought the proposal to the board members in July of 2011, half of them were already busy analyzing the decision to jettison the PC business, so only half of the board evaluated the acquisition proposal. The board ended up approving a price for Autonomy that was about a 50% premium over its market value, and its market value was already high at about 15 times its operating profit. HP announced the acquisition on August 18, 2011, on the same day that it announced it would abandon its tablet computer and was considering exiting the PC industry. The price of the acquisition was $11.1 billion—12.6 times Autonomy's 2010 revenue. Notably, Oracle had already considered acquiring Autonomy and decided that even if the numbers Autonomy was presenting were taken at face value, it was not worth buying even at a $6 billion price tag. HP's stock fell by 20% the next day.

In the days following the announcement, HP's stock continued to tumble, and backlash from shareholders and others in the investment community was scathing. Ray Lane asked HP's advisers if the company could back out of the deal and was told that, according to U.K. takeover rules, backing out was only possible if HP could show that Autonomy engaged in financial impropriety. HP began frantically examining the financials of Autonomy, hoping for a way to get out of the deal. In the midst of harsh disapproval from HP's largest stockholders and other senior executives within the firm, HP fired Leo Apotheker on September 22, 2012, less than a month after the acquisition's announcement, and only 11 months into his job as CEO.

By May of 2012 it was clear that Autonomy was not going to hit its revenue targets, and Michael Lynch, Autonomy's founder (who had been asked to stay on and run the company) was fired. In late November 2012, HP wrote down 8.8 billion of the acquisition, essentially admitting that the company was worth 79% less than it had paid for it. Then the finger pointing began in earnest. HP attributed more than $5 billion of the write-down to a "willful

effort on behalf of certain former Autonomy employees to inflate the underlying financial metrics of the company in order to mislead investors and potential buyers. . . .These misrepresentations and lack of disclosure severely impacted management's ability to fairly value Autonomy at the time of the deal."

Michael Lynch denied the charges, insisting he knew of no wrongdoing at Autonomy, arguing that auditors from Deloitte had approved its financial statements, and pointing out that the firm followed British accounting guidelines, which differ in some ways from American rules. Lynch also accused HP of mismanaging the acquisition, saying "Can HP really state that no part of the $5 billion write-down was, or should be, attributed to HP's operational and financial mismanagement of Autonomy since acquisition?... Why did HP senior management apparently wait six months to inform its shareholders of the possibility of a material event related to Autonomy?"

Many shareholders and analysts also pointed their fingers at HP by saying that the deal was shockingly overpriced. Bernstein analyst Toni Sacconaghi wrote, "We see the decision to purchase Autonomy as value-destroying," and Richard Kugele, an analyst at Needham & Company, wrote, "HP may have eroded what remained of Wall Street's confidence in the company" with the "seemingly overly expensive acquisition of Autonomy for over $10B." Apotheker responded by saying, "We have a pretty rigorous process inside HP that we follow for all our acquisitions, which is a D.C.F.-based model.... Just take it from us. We did that analysis at great length, in great detail, and we feel that we paid a very fair price for Autonomy." However, when Ray Lane was questioned, he seemed unfamiliar with any cash flow analysis done for the acquisition. He noted instead that he believed the price was fair because Autonomy was unique and critical to HP's strategic vision.

According to an article in *Fortune*, Catherine A. Lesjak, the chief financial officer at HP, had spoken out against the deal before it transpired, arguing that it was not in the best interests of

the shareholders and that HP could not afford it. Furthermore, outside auditors for Autonomy apparently informed HP (during a call in the days leading up to the announcement) that an executive at Autonomy had raised allegations of improper accounting at the firm, but a review had deemed the allegations baseless and they were never passed on to HP's board or CEO.

In the third quarter of 2012, HP lost $6.9 billion, largely because of the Autonomy mess. Its stock was trading at $13—almost 60% less than it had been worth when the Autonomy deal was announced. By April 4, 2013, Ray Lane stepped down as chairman of the board (although he continued on as a board member).

Did Autonomy intentionally inflate its financial metrics? Did Apotheker and Lane's eagerness for a "transformative acquisition" cause them to be sloppy in their valuation of Autonomy? Or was the value of Autonomy lost due to the more mundane cause of integration failure? Financial forensic investigators are still at work trying to answer these questions, but irrespective of the underlying causes, Toni Sacconaghi notes that Autonomy "will arguably go down as the worst, most value-destroying deal in the history of corporate America."

Sources: J. Bandler, "HP Should Have Listened to Its CFO," *Fortune*, November 20, 2012; J. B. Stewart, "From HP, a Blunder That Seems to Beat All," *New York Times*, November 30, 2012; M. G. De La Merced, "Autonomy's Ex-Chief Calls on HP to Defend Its Claims," *New York Times Dealbook*, November 27, 2012; and B. Worthen and J. Scheck, "Inside H-P's Missed Chance to Avoid a Disastrous Deal," *Wall Street Journal*, January 21, 2013, pp. A1–A16.

OVERVIEW

The story of HP's acquisition of Autonomy told in the Opening Case highlights some of the issues that we will discuss in this chapter. HP entered into an acquisition that seems to have been driven more by enthusiasm than by diligence or concern for its shareholders. Many shareholders and analysts appear to believe that HP recklessly overpaid for the firm, resulting in many billions of dollars being lost. HP, in turn, blamed Autonomy, stating that the company had not fairly represented its financials and had willfully misled HP. Autonomy's founder denied HP's charges, and blamed HP for mismanaging the acquisition. The acquisition appears to have come at a time when the company was at risk of making a poor decision: it had a new CEO who was looking to make an impression with a large, transformative acquisition; it had a new chairman of the board who understood software more than hardware; and it was in the middle of decisions to drastically reduce its hardware lines, including its tablet computer and potentially the rest of its PC business. Although it is likely that no one will be found legally to blame for the debacle, it seems apparent that at least one party to the transaction (and maybe all of the parties) may have behaved unethically.

We open this chapter with a close look at the governance mechanisms that shareholders implement to ensure that managers are acting in the company's interest and are pursuing strategies that maximize shareholder value. We also discuss how managers need to pay attention to other stakeholders as well, such as employees, suppliers, and customers. Balancing the needs of different stakeholder groups is in the long-term interests of the company's owners, its shareholders. Good governance mechanisms recognize this truth. In addition, we will spend some time reviewing the ethical implications of strategic decisions, and we will discuss how managers can make sure that their strategic decisions are founded upon strong ethical principles.

STAKEHOLDERS AND CORPORATE PERFORMANCE

stakeholders

Individuals or groups with an interest, claim, or stake in the company—in what it does and in how well it performs.

internal stakeholders

Stockholders and employees, including executive officers, other managers, and board members.

external stakeholders

All other individuals and groups that have some claim on the company.

A company's **stakeholders** are individuals or groups with an interest, claim, or stake in the company, in what it does, and in how well it performs.[1] They include stockholders, creditors, employees, customers, the communities in which the company does business, and the general public. Stakeholders can be divided into two groups: internal stakeholders and external stakeholders (see Figure 11.1). **Internal stakeholders** are stockholders and employees, including executive officers, other managers, and board members. **External stakeholders** are all other individuals and groups that have some claim on the company. Typically, this group comprises customers, suppliers, creditors (including banks and bondholders), governments, unions, local communities, and the general public.

All stakeholders are in an exchange relationship with their company. Each of the stakeholder groups listed in Figure 11.1 supplies the organization with important resources (or contributions), and in exchange, each expects its interests to be satisfied (by inducements).[2] Stockholders provide the enterprise with risk capital and in exchange expect management to attempt to maximize the return on their investment. Creditors, and particularly bondholders, also provide the company with capital in the form of debt, and they expect to be repaid on time, with interest. Employees provide labor and skills and in exchange expect commensurate income, job satisfaction, job security, and good working conditions. Customers provide a company with its revenues, and in exchange want high-quality, reliable products that represent value for money. Suppliers provide a company with inputs and in exchange seek revenues and dependable buyers. Governments provide a company with rules and regulations that govern business practice and maintain fair competition. In exchange they want companies that adhere to these rules. Unions help to provide a company with productive employees, and in exchange they want benefits for their members in proportion to their contributions to the company. Local communities provide companies with local infrastructure, and in exchange want companies that are responsible citizens. The general public provides companies with national infrastructure, and in exchange seeks some assurance that the quality of life will be improved as a result of the company's existence.

A company must take these claims into account when formulating its strategies, or else stakeholders may withdraw their support. For example, stockholders may sell their shares, bondholders may demand higher interest payments on new bonds, employees may leave

Figure 11.1	Stakeholders and the Enterprise

their jobs, and customers may buy elsewhere. Suppliers may seek more dependable buyers, and unions may engage in disruptive labor disputes. Government may take civil or criminal action against the company and its top officers, imposing fines and, in some cases, jail terms. Communities may oppose the company's attempts to locate its facilities in their area, and the general public may form pressure groups, demanding action against companies that impair the quality of life. Any of these reactions can have a damaging impact on an enterprise.

Stakeholder Impact Analysis

A company cannot always satisfy the claims of all stakeholders. The goals of different groups may conflict, and, in practice, few organizations have the resources to manage all stakeholders.[3] For example, union claims for higher wages can conflict with consumer demands for reasonable prices and stockholder demands for acceptable returns. Often the company must make choices. To do so, it must identify the most important stakeholders and give highest priority to pursuing strategies that satisfy their needs. Stakeholder impact analysis can provide such identification. Typically, stakeholder impact analysis follows these steps:

1. Identify stakeholders.
2. Identify stakeholders' interests and concerns.
3. As a result, identify what claims stakeholders are likely to make on the organization.
4. Identify the stakeholders who are most important from the organization's perspective.
5. Identify the resulting strategic challenges.[4]

Such an analysis enables a company to identify the stakeholders most critical to its survival and to make sure that the satisfaction of their needs is paramount. Most companies that have gone through this process quickly come to the conclusion that three stakeholder groups must be satisfied above all others if a company is to survive and prosper: customers, employees, and stockholders.

The Unique Role of Stockholders

A company's stockholders are usually put in a different class from other stakeholder groups, and for good reason. Stockholders are the legal owners and the providers of **risk capital**, a major source of the capital resources that allow a company to operate its business. The capital that stockholders provide to a company is seen as risk capital because there is no guarantee that stockholders will ever recoup their investments and/or earn a decent return.

Recent history demonstrates all too clearly the nature of risk capital. For example, many investors who bought shares in Washington Mutual, the large Seattle-based bank and home loan lender, believed that they were making a low-risk investment. The company had been around for decades and paid a solid dividend, which it increased every year. It had a large branch network and billions in deposits. However, during the 2000s, Washington Mutual was also making increasingly risky mortgage loans, reportedly giving mortgages to people without ever properly verifying if they had the funds to pay back those loans on time. By 2008, many of the borrowers were beginning to default on their loans, and Washington Mutual had to take multibillion-dollar write-downs on the value of its loan portfolio, effectively destroying its once-strong balance sheet. The losses were so large that people with deposits at the bank started to worry about its stability, and they withdrew nearly $16 billion in November 2008 from accounts at Washington Mutual. The stock price collapsed from around $40 at the start of 2008 to under $2 a share, and with the bank teetering on the brink of collapse, the federal government intervened, seized the bank's

risk capital
Capital that cannot be recovered if a company fails and goes bankrupt.

assets, and engineered a sale to JP Morgan. What did Washington Mutual's shareholders get? Absolutely nothing! They were wiped out.

Over the past decade, maximizing returns to stockholders has taken on significant importance as an increasing number of employees have become stockholders in the companies for which they work through employee stock ownership plans (ESOPs). At Walmart, for example, all employees who have served for more than 1 year are eligible for the company's ESOP. Under an ESOP, employees are given the opportunity to purchase stock in the company, sometimes at a discount or less than the market value of the stock. The company may also contribute a certain portion of the purchase price to the ESOP. By making employees stockholders, ESOPs tend to increase the already strong emphasis on maximizing returns to stockholders, for they now help to satisfy two key stakeholder groups: stockholders and employees.

Profitability, Profit Growth, and Stakeholder Claims

Because of the unique position assigned to stockholders, managers normally seek to pursue strategies that maximize the returns that stockholders receive from holding shares in the company. As we noted in Chapter 1, stockholders receive a return on their investment in a company's stock in two ways: from dividend payments and from capital appreciation in the market value of a share (that is, by increases in stock market prices). The best way for managers to generate the funds for future dividend payments and keep the stock price appreciating is to pursue strategies that maximize the company's long-term profitability (as measured by the return on invested capital or ROIC) and grow the profits of the company over time.[5]

As we saw in Chapter 3, ROIC is an excellent measure of the profitability of a company. It tells managers how efficiently they are using the capital resources of the company (including the risk capital provided by stockholders) to generate profits. A company that is generating a positive ROIC is covering all of its ongoing expenses and has money left over, which is then added to shareholders' equity, thereby increasing the value of a company and thus the value of a share of stock in the company. The value of each share will increase further if a company can grow its profits over time, because then the profit that is attributable to every share (that is, the company's earnings per share) will also grow. As we have seen in this book, to grow profits, companies must be doing one or more of the following: (a) participating in a market that is growing, (b) taking market share from competitors, (c) consolidating the industry through horizontal integration, and (d) developing new markets through international expansion, vertical integration, or diversification.

Although managers should strive for profit growth if they are trying to maximize shareholder value, the relationship between profitability and profit growth is a complex one because attaining future profit growth may require investments that reduce the current rate of profitability. The task of managers is to find the right balance between profitability and profit growth.[6] Too much emphasis on current profitability at the expense of future profitability and profit growth can make an enterprise less attractive to shareholders. Too much emphasis on profit growth can reduce the profitability of the enterprise and have the same effect. In an uncertain world where the future is unknowable, finding the right balance between profitability and profit growth is as much art as it is science, but it is something that managers must try to do.

In addition to maximizing returns to stockholders, boosting a company's profitability and profit growth rate is also consistent with satisfying the claims of several other key stakeholder groups. When a company is profitable and its profits are continuing to grow, it can pay higher salaries to productive employees and can also afford benefits such as health insurance coverage, all of which help to satisfy employees. In addition, companies with a high level

of profitability and profit growth have no problem meeting their debt commitments, which provides creditors, including bondholders, with a measure of security. More profitable companies are also better able to undertake philanthropic investments, which can help to satisfy some of the claims that local communities and the general public place on a company. Pursuing strategies that maximize the long-term profitability and profit growth of the company is therefore generally consistent with satisfying the claims of various stakeholder groups.

Stakeholder management requires consideration of how the firm's practices affect the cooperation of stakeholders in the short-term, the benefits of building trust and a knowledge-sharing culture with stakeholders in the long run, and the firm's profitability and growth that will enable it to serve stakeholder interests in the future.[7] The company that overpays its employees in the current period, for example, may have very happy employees for a short while, but such action will raise the company's cost structure and limit its ability to attain a competitive advantage in the marketplace, thereby depressing its long-term profitability and hurting its ability to award future pay increases. As far as employees are concerned, the way many companies deal with this situation is to make future pay raises contingent upon improvements in labor productivity. If labor productivity increases, labor costs as a percentage of revenues will fall, profitability will rise, and the company can afford to pay its employees more and offer greater benefits.

Of course, not all stakeholder groups want the company to maximize its long-run profitability and profit growth. Suppliers are more comfortable about selling goods and services to profitable companies because they can be assured that the company will have the funds to pay for those products. Similarly, customers may be more willing to purchase from profitable companies because they can be assured that those companies will be around in the long term to provide after-sales services and support. But neither suppliers nor customers want the company to maximize its profitability at their expense. Rather, they would like to capture some of these profits from the company in the form of higher prices for their goods and services (in the case of suppliers), or lower prices for the products they purchase from the company (in the case of customers). Thus, the company is in a bargaining relationship with some of its stakeholders, a phenomenon we discussed in Chapter 2.

Moreover, despite the argument that maximizing long-term profitability and profit growth is the best way to satisfy the claims of several key stakeholder groups, it should be noted that a company must do so within the limits set by the law and in a manner consistent with societal expectations. The unfettered pursuit of profit can lead to behaviors that are outlawed by government regulations, opposed by important public constituencies, or simply unethical. Governments have enacted a wide range of regulations to govern business behavior, including antitrust laws, environmental laws, and laws pertaining to health and safety in the workplace. It is incumbent on managers to make sure that the company is in compliance with these laws when pursuing strategies.

Unfortunately, there is plenty of evidence that managers can be tempted to cross the line between the legal and illegal in their pursuit of greater profitability and profit growth. For example, in mid-2003 the U.S. Air Force stripped Boeing of $1 billion in contracts to launch satellites when it was discovered that Boeing had obtained thousands of pages of proprietary information from rival Lockheed Martin. Boeing had used that information to prepare its winning bid for the satellite contract. This was followed by the revelation that Boeing's CFO, Mike Sears, had offered a government official, Darleen Druyun, a lucrative job at Boeing while Druyun was still involved in evaluating whether Boeing should be awarded a $17 billion contract to build tankers for the Air Force. Boeing won the contract against strong competition from Airbus, and Boeing hired Druyun. It was clear that the job offer may have had an impact on the Air Force decision. Boeing fired Druyun and the CFO, and shortly thereafter, Boeing CEO Phil Condit resigned in a tacit acknowledgment

that he bore responsibility for the ethics violations that had occurred at Boeing during his tenure as leader.[8] In another case, the chief executive of Archer Daniels Midland, one of the world's largest producers of agricultural products, was sent to jail after the Federal Bureau of Investigation (FBI) determined that the company had systematically tried to fix the price for lysine by colluding with other manufacturers in the global marketplace. In another example of price fixing, the 76-year-old chairman of Sotheby's auction house was sentenced to a jail term and the former CEO to house arrest for fixing prices with rival auction house Christie's over a 6-year period (see Strategy in Action 11.1).

Examples such as these beg the question of why managers would engage in such risky behavior. A body of academic work collectively known as agency theory provides an explanation for why managers might engage in behavior that is either illegal or, at the very least, not in the interest of the company's shareholders.

11.1 STRATEGY IN ACTION

© iStockPhoto.com/Tom Nulens

Price Fixing at Sotheby's and Christie's

Sotheby's and Christie's are the two largest fine-art auction houses in the world. In the mid-1990s, the two companies controlled 90% of the fine-art auction market, which at the time was worth approximately $4 billion per year. Traditionally, auction houses make their profit by the commission they charge on auction sales. In good times, these commissions can be as high as 10% on some items, but in the early 1990s, the auction business was in a slump, with the supply of art for auction shriveling. With Sotheby's and Christie's desperate for works of art, sellers played the two houses against each other, driving commissions down to 2%, or sometimes lower.

To try to control this situation, Sotheby's CEO, Dede Brooks, met with Christie's CEO Christopher Davidge in a series of clandestine meetings held in car parking lots that began in 1993. Brooks claimed that she was acting on behalf of her boss, Alfred Taubman, the chairman and controlling shareholder of Sotheby's. According to Brooks, Taubman had agreed with the chairman of Christie's, Anthony Tennant, to work together in the weak auction market and limit price competition. In their meetings, Brooks and Davidge agreed to a fixed and nonnegotiable commission structure. Based on a sliding scale, the commission structure would range from 10% on a $100,000 item to 2% on a $5 million item. In effect, Brooks and Davidge were agreeing to eliminate price competition between them, thereby guaranteeing both auction houses higher profits. The price-fixing agreement started in 1993 and continued unabated for 6 years until federal investigators uncovered the arrangement and brought charges against Sotheby's and Christie's.

With the deal out in the open, lawyers filed several class-action lawsuits on behalf of the sellers that Sotheby's and Christie's had defrauded. Ultimately, at least 100,000 sellers signed on to the class-action lawsuits, which the auction houses settled with a $512 million payment. The auction houses also pleaded guilty to price fixing and paid $45 million in fines to U.S. antitrust authorities. As for the key players, the chairman of Christie's, as a British subject, was able to avoid prosecution in the United States (price fixing is not an offense for which someone can be extradited). Christie's CEO, Davidge, struck a deal with prosecutors, and in return for amnesty turned incriminating documents in to the authorities. Brooks also cooperated with federal prosecutors and avoided jail (in April 2002 she was sentenced to 3 years of probation, 6 months of home detention, 1,000 hours of community service, and a $350,000 fine). Taubman, ultimately isolated by all his former coconspirators, was sentenced to 1 year in jail and fined $7.5 million.

Sources: S. Tully, "A House Divided," *Fortune,* December 18, 2000, pp. 264–275; J. Chaffin, "Sotheby's Ex CEO Spared Jail Sentence," *Financial Times,* April 30, 2002, p. 10; and T. Thorncroft, "A Courtroom Battle of the Vanities," *Financial Times,* November 3, 2001, p. 3.

AGENCY THEORY

Agency theory looks at the problems that can arise in a business relationship when one person delegates decision-making authority to another. It offers a way of understanding why managers do not always act in the best interests of stakeholders and why they might sometimes behave unethically, and, perhaps, also illegally.[9] Although agency theory was originally formulated to capture the relationship between management and stockholders, the basic principles have also been extended to cover the relationship with other key stakeholders, such as employees, as well as relationships between different layers of management within a corporation.[10] Although the focus of attention in this section is on the relationship between senior management and stockholders, some of the same language can be applied to the relationship between other stakeholders and top managers and between top management and lower levels of management.

Principal–Agent Relationships

The basic propositions of agency theory are relatively straightforward. First, an agency relationship is held to arise whenever one party delegates decision-making authority or control over resources to another. The principal is the person delegating authority, and the agent is the person to whom authority is delegated. The relationship between stockholders and senior managers is the classic example of an agency relationship. Stockholders, who are the principals, provide the company with risk capital but delegate control over that capital to senior managers, and particularly to the CEO, who, as their agent, is expected to use that capital in a manner that is consistent with the best interests of stockholders. As we have seen, this means using that capital to maximize the company's long-term profitability and profit growth rate.

The agency relationship continues down the hierarchy within the company. For example, in the large, complex, multibusiness company, top managers cannot possibly make all the important decisions; therefore, they delegate some decision-making authority and control over capital resources to business unit (divisional) managers. Thus, just as senior managers—such as the CEO—are the agents of stockholders, business unit managers are the agents of the CEO (and in this context, the CEO is the principal). The CEO entrusts business unit managers to use the resources over which they have control in the most effective manner in order to maximize the performance of their units. This helps the CEO ensure that he or she maximizes the performance of the entire company, thereby discharging agency obligation to stockholders. More generally, whenever managers delegate authority to managers below them in the hierarchy and give them the right to control resources, an agency relation is established.

The Agency Problem

Although agency relationships often work well, problems may arise if agents and principals have different goals and if agents take actions that are not in the best interests of their principals. Agents may be able to do this because there is an **information asymmetry** between the principal and the agent: agents almost always have more information about the resources they are managing than the principal does. Unscrupulous agents can take advantage of any information asymmetry to mislead principals and maximize their own interests at the expense of principals.

information asymmetry
A situation where an agent has more information about resources he or she is managing than the principal has.

In the case of stockholders, the information asymmetry arises because they delegate decision-making authority to the CEO, their agent, who, by virtue of his or her position inside the company, is likely to know far more than stockholders do about the company's operations. Indeed, there may be certain information about the company that the CEO is unwilling to share with stockholders because that information would also help competitors. In such a case, withholding some information from stockholders may be in the best interest of all. More generally, the CEO, involved in the day-to-day running of the company, is bound to have an information advantage over stockholders, just as the CEO's subordinates may have an information advantage over the CEO with regard to the resources under their control.

The information asymmetry between principals and agents is not necessarily a bad thing, but it can make it difficult for principals to measure how well an agent is performing and thus hold the agent accountable for how well he or she is using the entrusted resources. There is a certain amount of performance ambiguity inherent in the relationship between a principal and agent: principals cannot know for sure if the agent is acting in his or her best interests. They cannot know for sure if the agent is using the resources to which he or she has been entrusted as effectively and efficiently as possible. This ambiguity is amplified by the fact that agents must engage in behavior that has outcomes for different time horizons. For example, investing in research and development may lower profits today but help to ensure the firm is profitable in the future. Principals who reward only immediate performance outcomes could induce myopic ("short-sighted") behavior on the part of the agent. To an extent, principals must trust the agent to do the right thing.

Of course, this trust is not blind: principals do put mechanisms in place with the purpose of monitoring agents, evaluating their performance, and, if necessary, taking corrective action. As we shall see shortly, the board of directors is one such mechanism, for, in part, the board exists to monitor and evaluate senior managers on behalf of stockholders. In Germany, the codetermination law (*Mitbestimmungsgesetz*) requires that firms with over 2,000 employees have boards of directors that represent the interests of employees—just under half of a firm's supervisory board members must represent workers. Other mechanisms serve a similar purpose. In the United States, publicly owned companies must regularly file detailed financial statements with the Securities and Exchange Commission (SEC) that are in accordance with generally agreed-upon accounting principles (GAAP). This requirement exists to give stockholders consistent and detailed information about how well management is using the capital with which it has been entrusted. Similarly, internal control systems within a company are there to help the CEO ensure that subordinates are using the resources with which they have been entrusted as efficiently and effectively as possible.

Despite the existence of governance mechanisms and comprehensive measurement and control systems, a degree of information asymmetry will always remain between principals and agents, and there is always an element of trust involved in the relationship. Unfortunately, not all agents are worthy of this trust. A minority will deliberately mislead principals for personal gain, sometimes behaving unethically or breaking laws in the process. The interests of principals and agents are not always the same; they diverge, and some agents may take advantage of information asymmetries to maximize their own interests at the expense of principals and to engage in behaviors that the principals would never condone.

For example, some authors have argued that, like many other people, senior managers are motivated by desires for status, power, job security, and income.[11] By virtue of their position within the company, certain managers, such as the CEO, can use their authority and control over corporate funds to satisfy these desires at the cost of returns to stockholders. CEOs might use their positions to invest corporate funds in various perks that enhance their status—executive jets, lavish offices, and expense-paid trips to exotic locations—rather

than investing those funds in ways that increase stockholder returns. Economists have termed such behavior **on-the-job consumption**.[12]

Aside from engaging in on-the-job consumption, CEOs, along with other senior managers, might satisfy their desires for greater income by using their influence or control over the board of directors to persuade the compensation committee of the board to grant pay increases. Critics of U.S. industry claim that extraordinary pay has now become an endemic problem and that senior managers are enriching themselves at the expense of stockholders and other employees. They point out that CEO pay has been increasing far more rapidly than the pay of average workers, primarily because of very liberal stock option grants that enable a CEO to earn huge pay bonuses in a rising stock market, even if the company underperforms the market and competitors.[13] In 1980, the average CEO in *Business Week's* survey of CEOs of the largest 500 American companies earned 42 times what the average blue-collar worker earned. By 1990, this figure had increased to 85 times. In 2012, the AFL-CIO's Executive PayWatch database reported that American CEOs made 354 times the pay of average workers.[14]

What rankles critics is the size of some CEO pay packages and their apparent lack of relationship to company performance.[15] In 2010, a study by Graef Crystal evaluated the relationship between CEO pay and performance and concluded that there virtually is none. For example, if CEOs were paid according to shareholder return, the CEO of CBS Corporation, Leslie Moonves, who earned an impressive $43.2 million in 2009, should have gotten a $28 million paycut, according to Crystal.[16] Critics feel that the size of pay awards to many CEOs is disproportionate to their achievement, representing a clear example of the agency problem. However, in response to shareholder pressure, in recent years more companies have begun adopting compensation practices that more closely tie CEO pay to performance. For example, at Air Products & Chemicals, when the earnings per share fell short of its 9% growth target in 2012, its CEO John McGlade paid the price in the form of a 65% cut in his annual bonus. His stock grants and stock options decreased as well, reducing his total direct compensation 19%, to 9.1 million.[17] A further concern is that in trying to satisfy a desire for status, security, power, and income, a CEO might engage in empire building—buying many new businesses in an attempt to increase the size of the company through diversification.[18] Although such growth may depress the company's long-term profitability and thus stockholder returns, it increases the size of the empire under the CEO's control and, by extension, the CEO's status, power, security, and income (there is a strong relationship between company size and CEO pay). Instead of trying to maximize stockholder returns by seeking the right balance between profitability and profit growth, some senior managers may trade long-term profitability for greater company growth via new business purchases. For example, in the mid-1970s, Compagnie Générale des Eaux was primarily a water utility and waste-management company, operating "near monopolies" in local municipalities in France and generating strong (and stable) cash flows for its shareholders. However, a series of audacious debt-funded acquisitions in the 1980s and 1990s, first by CEO Guy DeJouany and later by his successor Jean-Marie Messier, rapidly transformed the company into one of the world's largest media and telecom empires, renamed "Vivendi." Then in the 2000s, as the tech, media, and telecom bubble began to burst, the Vivendi empire came crashing down under the weight of its debt burden. Jean-Marie Messier was investigated by both French and U.S. courts, and was accused of misleading shareholders, misappropriating funds, and worsening the company's precarious position. He was fined, and forced to resign.[19]

Figure 11.2 graphs long-term profitability against the rate of growth in company revenues. A company that does not grow is likely missing out on some profitable opportunities.[20]

on-the-job consumption
A term used by economists to describe the behavior of senior management's use of company funds to acquire perks (such as lavish offices, jets, etc.) that will enhance their status, instead of investing it to increase stockholder returns.

Figure 11.2 The Tradeoff Between Profitability and Revenue Growth Rates

A moderate revenue growth rate of *G** allows a company to maximize long-term profitability, generating a return of π^*. Thus, a growth rate of *G1* in Figure 11.2 is not consistent with maximizing profitability ($\pi1 < \pi^*$). By the same token, however, attaining growth in excess of *G2* requires diversification into areas that the company knows little about. Consequently, it can be achieved only by sacrificing profitability; that is, past *G**, the investment required to finance further growth does not produce an adequate return, and the company's profitability declines. Yet *G2* may be the growth rate favored by an empire-building CEO, for it will increase his or her power, status, and income. At this growth rate, profitability is equal only to $\pi2$. Because $\pi^* > \pi2$, a company growing at this rate is clearly not maximizing its long-run profitability or the wealth of its stockholders.

The magnitude of agency problems was emphasized in the early 2000s when a series of scandals swept through the corporate world, many of which could be attributed to self-interest-seeking senior executives and a failure of corporate governance mechanisms to hold the largess of those executives in check. In 2003, an investigation revealed that the CEO of Hollinger, Conrad Black, had used "tunneling" to divert over $400 million in company funds to his family and friends (see the Strategy in Action 11.2 for more details on Hollinger and Black). Between 2001 and 2004, accounting scandals also unfolded at a number of major corporations, including Enron, WorldCom, Tyco, Computer Associates, HealthSouth, Adelphia Communications, Dynegy, Royal Dutch Shell, and Parmalat, a major Italian food company. At Enron, $27 billion in debt was hidden from shareholders, employees, and regulators in special partnerships that were removed from the balance sheet. At Parmalat, managers apparently "invented" $8 to $12 billion in assets to shore up the company's balance sheet—assets that never existed. In the case of Royal Dutch Shell,

11.2 STRATEGY IN ACTION

Self-Dealing at Hollinger International Inc.

© iStockPhoto.com/Tom Nulens

From 1999 to 2003, Conrad Black, CEO, and F. David Radler, chief operating officer (COO), of Hollinger International Inc. illegally diverted cash and assets to themselves, family members, and other corporate insiders. Hollinger International was a global publishing empire that owned newspapers around the world, such as the *Chicago Sun-Times*, the *Daily Telegraph* (in London), the *National Post* (in Toronto), and the *Jerusalem Post* (in Israel), among others. According to Stephen Cutler, the director of the SEC's Division of Enforcement, "Black and Radler abused their control of a public company and treated it as their personal piggy bank. Instead of carrying out their responsibilities to protect the interest of public shareholders, the defendants cheated and defrauded these shareholders through a series of deceptive schemes and misstatements." In a practice known as "tunneling," Black and Radler engaged in a series of self-dealing transactions, such as selling some of Hollinger's newspapers at below-market prices to companies privately held by Black and Radler themselves—sometimes for a price as low as one dollar! They also directly channeled money out of the firm under the guise of "non-competition payments." The managers also fraudulently used corporate perks, such as using a company jet to fly to the South Pacific for a vacation, and using corporate funds to live in a swanky New York apartment on Park Avenue and throw a lavish $62,000 birthday party for Black's wife. Black's ill-gotten gains are thought to total more than $400 million, and fallout from the scandal resulted in a loss of $2 billion in shareholder value. Although Black was originally sentenced to 6½ years in jail, he ultimately only served 42 months.

Sources: S. Taub, "SEC Charges Hollinger, Two Executives," *CFO*, November 16, 2004; U.S. Department of Justice, "Former Hollinger Chairman Conrad Black and Three Other Executives Indicted in U.S.–Canada Corporate Fraud Schemes," indictment released November 17, 2005; "Ex-Media Mogul Black Convicted of Fraud," *Associated Press*, July 13, 2007; and A. Stern, "Ex-Media Mogul Conrad Black Sent Back to Prison," *Reuters*, June 24, 2011.

senior managers knowingly inflated the value of the company's oil reserves by 1/5, which amounted to 4 billion barrels of oil that never existed, making the company appear much more valuable than it actually was. At the other companies, earnings were systematically overstated, often by hundreds of millions of dollars, or even billions of dollars in the case of Tyco and WorldCom, which understated its expenses by $3 billion in 2001. In all of these cases, the prime motivation seems to have been an effort to present a more favorable view of corporate affairs to shareholders than was actually the case, thereby securing senior executives significantly higher pay packets.[21]

It is important to remember that the agency problem is not confined to the relationship between senior managers and stockholders. It can also bedevil the relationship between the CEO and subordinates and between them and their subordinates. Subordinates might use control over information to distort the true performance of their unit in order to enhance their pay, increase their job security, or make sure their unit gets more than its fair share of company resources.

Confronted with agency problems, the challenge for principals is to (1) shape the behavior of agents so that they act in accordance with the goals set by principals, (2) reduce the information asymmetry between agents and principals, and (3) develop mechanisms for removing agents who do not act in accordance with the goals of principals and mislead them. Principals try to deal with these challenges through a series of governance mechanisms.

GOVERNANCE MECHANISMS

Governance mechanisms are mechanisms that principals put in place to align incentives between principals and agents and to monitor and control agents. The purpose of governance mechanisms is to reduce the scope and frequency of the agency problem: to help ensure that agents act in a manner that is consistent with the best interests of their principals. In this section, the primary focus is on the governance mechanisms that exist to align the interests of senior managers (as agents) with their principals, stockholders. It should not be forgotten, however, that governance mechanisms also exist to align the interests of business-unit managers with those of their superiors, and likewise down the hierarchy within the organization.

Here we look at four main types of governance mechanisms for aligning stockholder and management interests: the board of directors, stock-based compensation, financial statements, and the takeover constraint. The section closes with a discussion of governance mechanisms within a company to align the interest of senior and lower-level managers.

The Board of Directors

The board of directors is the centerpiece of the corporate governance system. Board members are directly elected by stockholders, and under corporate law, they represent the stockholders' interests in the company. Hence, the board can be held legally accountable for the company's actions. Its position at the apex of decision making within the company allows it to monitor corporate strategy decisions and ensure that they are consistent with stockholder interests. If the board believes that corporate strategies are not in the best interest of stockholders, it can apply sanctions, such as voting against management nominations to the board of directors or submitting its own nominees. In addition, the board has the legal authority to hire, fire, and compensate corporate employees, including, most important, the CEO.[22] The board is also responsible for making sure that audited financial statements of the company present a true picture of its financial situation. Thus, the board exists to reduce the information asymmetry between stockholders and managers and to monitor and control management actions on behalf of stockholders.

The typical board of directors is composed of a mix of inside and outside directors. **Inside directors** are senior employees of the company, such as the CEO. They are required on the board because they have valuable information about the company's activities. Without such information, the board cannot adequately perform its monitoring function. But because insiders are full-time employees of the company, their interests tend to be aligned with those of management. Hence, outside directors are needed to bring objectivity to the monitoring and evaluation processes. **Outside directors** are not full-time employees of the company. Many of them are full-time professional directors who hold positions on the boards of several companies. The need to maintain a reputation as competent outside directors gives them an incentive to perform their tasks as objectively and effectively as possible.[23]

There is little doubt that many boards perform their assigned functions admirably. For example, when the board of Sotheby's discovered that the company had been engaged in price fixing with Christie's, board members moved quickly to oust both the CEO and the chairman of the company (see Strategy in Action 11.1). But not all boards perform as well as they should. The board of now-bankrupt energy company Enron approved the company's audited financial statements, which were later discovered to be grossly misleading.

Critics of the existing governance system charge that inside directors often dominate the outsiders on the board. Insiders can use their position within the management hierarchy to exercise control over what kind of company-specific information the board receives. Consequently, they

inside directors
Senior employees of the company, such as the CEO.

outside directors
Directors who are not full-time employees of the company, needed to provide objectivity to the monitoring and evaluation of processes.

can present information in a way that puts them in a favorable light. In addition, because insiders have intimate knowledge of the company's operations and because superior knowledge and control over information are sources of power, they may be better positioned than outsiders to influence boardroom decision making. The board may become the captive of insiders and merely rubber-stamp management decisions instead of guarding stockholder interests.

Some observers contend that many boards are dominated by the company CEO, particularly when the CEO is also the chairman of the board.[24] To support this view, they point out that both inside and outside directors are often the personal nominees of the CEO. The typical inside director is subordinate to the CEO in the company's hierarchy and therefore unlikely to criticize the boss. Because outside directors are frequently the CEO's nominees as well, they can hardly be expected to evaluate the CEO objectively. Thus, the loyalty of the board may be biased toward the CEO, not the stockholders. Moreover, a CEO who is also chairman of the board may be able to control the agenda of board discussions in such a manner as to deflect any criticisms of his or her leadership. Notably, although shareholders ostensibly vote on board members, board members are not legally required to resign if they do not receive a majority of the vote. The Council of Institutional Investors (which represents pension funds, endowments, and other large investors) published a list of "zombie directors" in 2012—directors who were retained on boards despite being rejected by shareholders. The list includes a wide range of companies, from Boston Beer Company to Loral Space and Communications to Cablevision. In fact, Cablevision was listed as having three directors who lost their shareholder votes twice between 2010 and 2012 yet remained on the board.[25]

In the aftermath of a wave of corporate scandals that hit the corporate world in the early 2000s, there are clear signs that many corporate boards are moving away from merely rubber-stamping top-management decisions and are beginning to play a much more active role in corporate governance. In part, they have been prompted by new legislation, such as the 2002 Sarbanes-Oxley Act in the United States, which tightened rules regulating corporate reporting and corporate governance. A growing trend on the part of the courts to hold directors liable for corporate misstatements has also been important. Powerful institutional investors such as pension funds have also been more aggressive in exerting their power, often pushing for more outside representation on the board of directors and for a separation between the roles of chairman and CEO—with the chairman role going to an outsider. Partly as a result, 43% of firms on the Standard & Poor's 500 index split the chairman and CEO jobs as of November 2012—up from 25% 10 years earlier.[26] Separating the role of chairman and CEO limits the ability of corporate insiders, and particularly of the CEO, to exercise control over the board. Regardless, it must be recognized that boards of directors do not work as well as they should in theory, and other mechanisms are needed to align the interests of stockholders and managers.

Stock-Based Compensation

According to agency theory, one of the best ways to reduce the scope of the agency problem is for principals to establish incentives for agents to behave in the company's best interest through pay-for-performance systems. In the case of stockholders and top managers, stockholders can encourage top managers to pursue strategies that maximize a company's long-term profitability and profit growth, and thus the gains from holding its stock, by linking the pay of those managers to the performance of the stock price.

Giving managers **stock options**— the right to purchase the company's shares at a predetermined (strike) price at some point in the future, usually within 10 years of the grant date—has been the most common pay-for-performance system. Typically, the strike price is the price at which the stock was trading when the option was originally granted. Ideally, stock options will

stock options
The right to purchase company stock at a predetermined price at some point in the future, usually within 10 years of the grant date.

motivate managers to adopt strategies that increase the share price of the company, for in doing so managers will also increase the value of their own stock options. Granting managers stock if they attain predetermined performance targets is another stock-based pay-for-performance system.

Several academic studies suggest that stock-based compensation schemes for executives, such as stock options and stock grants, can align management and stockholder interests. For instance, one study found that managers were more likely to consider the effects of their acquisition decisions on stockholder returns if they were significant shareholders.[27] According to another study, managers who were significant stockholders were less likely to pursue strategies that would maximize the size of the company rather than its profitability.[28] More generally, it is difficult to argue with the proposition that the chance to get rich from exercising stock options is the primary reason for the 14-hour days and 6-day workweeks that many employees of fast-growing companies experience.

However, the practice of granting stock options has become increasingly controversial. Many top managers often earn huge bonuses from exercising stock options that were granted several years prior. Critics claim that these options are often too generous, but do not deny that they motivate managers to improve company performance. A particular cause for concern is that stock options are often granted at such low strike prices that the CEO can hardly fail to make a significant amount of money by exercising them, even if the company underperforms in the stock market by a significant margin. A serious example of the agency problem emerged in 2005 and 2006 when the SEC started to investigate a number of companies that had granted stock options to senior executives and apparently "backdated" the stock to a time when the price was lower, enabling executives to earn more money than if those options had simply been dated on the day they were granted.[29] By late 2006, the SEC was investigating nearly 130 companies for possible fraud related to stock-option dating. Major corporations such as Apple, Jabil Circuit, United Healthcare, and Home Depot were included in the list.[30]

Other critics of stock options, including the famous investor Warren Buffett, complain that huge stock-option grants increase the outstanding number of shares in a company and therefore dilute the equity of stockholders; accordingly, they should be shown in company accounts as an expense against profits. Under accounting regulations that were enforced until 2005, stock options, unlike wages and salaries, were not expensed. However, this has since changed, and as a result, many companies are beginning to reduce their use of options. Microsoft, for example, which had long given generous stock-option grants to high-performing employees, replaced stock options with stock grants in 2005. Requiring senior management to hold large numbers of shares in the company is also not without its downside: Managers holding a large portion of their personal wealth in the company they are managing are likely to be underdiversified. This can lead to excessively risk-averse behavior, or overdiversification of the firm.

Financial Statements and Auditors

Publicly traded companies in the United States are required to file quarterly and annual reports with the SEC that are prepared according to GAAP. The purpose of this requirement is to give consistent, detailed, and accurate information about how efficiently and effectively the agents of stockholders—the managers—are running the company. To make sure that managers do not misrepresent this financial information, the SEC also requires that the accounts be audited by an independent and accredited accounting firm. Similar regulations exist in most other developed nations. If the system works as intended, stockholders can have a lot of faith that the information contained in financial statements accurately reflects the state of affairs at a company. Among other things, such information can enable a stockholder to calculate the profitability (ROIC) of a company in which he or she invests and to compare its ROIC against that of competitors.

Unfortunately, this system has not always worked as intended in the United States. Despite that the vast majority of companies do file accurate information in their financial statements, and although most auditors review that information accurately, there is substantial evidence that a minority of companies have abused the system, aided in part by the compliance of auditors. This was clearly an issue at bankrupt energy trader Enron, where the CFO and others misrepresented the true financial state of the company to investors by creating off-balance-sheet partnerships that hid the true state of Enron's indebtedness from public view. Enron's auditor, Arthur Andersen, was complicit with this deception and in direct violation of its fiduciary duty. Arthur Anderson also had lucrative consulting contracts with Enron that it did not want to jeopardize by questioning the accuracy of the company's financial statements. The losers in this mutual deception were shareholders, who relied only upon inaccurate information to make their investment decisions.

There have been numerous examples in recent years of managers' gaming of financial statements to present a distorted picture of their company's finances to investors (see the accusations made by HP about Autonomy in the chapter-opening case, for example). The typical motive has been to inflate the earnings or revenues of a company, thereby generating investor enthusiasm and propelling the stock price higher, which gives managers an opportunity to cash in stock-option grants for huge personal gain, obviously at the expense of stockholders, who have been mislead by the reports.

The gaming of financial statements by companies such as Enron raises serious questions about the accuracy of the information contained in audited financial statements. In response, the United States passed the Sarbanes-Oxley Act in 2002, representing the biggest overhaul of accounting rules and corporate governance procedures since the 1930s. Among other things, Sarbanes-Oxley set up a new oversight board for accounting firms, required CEOs and CFOs to endorse their company's financial statements, and barred companies from hiring the same accounting firm for auditing and consulting services.

The Takeover Constraint

Given the imperfections in corporate governance mechanisms, it is clear that the agency problem may still exist at some companies. However, stockholders still have some residual power—they can always sell their shares. If stockholders sell in large numbers, the price of the company's shares will decline. If the share price falls far enough, the company might be worth less on the stock market than the actual value of its assets. At this point, the company may become an attractive acquisition target and runs the risk of being purchased by another enterprise, against the wishes of the target company's management.

The risk of being acquired by another company is known as the **takeover constraint**—it limits the extent to which managers can pursue strategies and take actions that put their own interests above those of stockholders. If they ignore stockholder interests and the company is acquired, senior managers typically lose their independence, and likely their jobs as well. Therefore, the threat of takeover can constrain management action and limit the worst excesses of the agency problem.

takeover constraint
The risk of being acquired by another company.

During the 1980s and early 1990s, the threat of takeover was often enforced by corporate raiders: individuals or corporations that purchase large blocks of shares in companies that appear to be pursuing strategies inconsistent with maximizing stockholder wealth. Corporate raiders argue that if these underperforming companies pursued different strategies, they could create more wealth for stockholders. Raiders purchase stock in a company either to take over the business and run it more efficiently or to precipitate a change in the top management, replacing the existing team with one more likely to maximize stockholder returns. Raiders are motivated not by altruism but by gain. If they succeed in

their takeover bid, they can institute strategies that create value for stockholders, including themselves. Even if a takeover bid fails, raiders can still earn millions, for their stockholdings will typically be bought out by the defending company for a hefty premium. Called **greenmail**, this source of gain has stirred much controversy and debate about its benefits. Whereas some claim that the threat posed by raiders has had a salutary effect on enterprise performance by pushing corporate management to run their companies better, others claim there is little evidence of this.[31]

Although the incidence of hostile takeover bids has fallen off significantly since the early 1990s, this should not imply that the takeover constraint has ceased to operate. Unique circumstances existed in the early 2000s that made it more difficult to execute hostile takeovers. The boom years of the 1990s left many corporations with excessive debt (corporate America entered the new century with record levels of debt on its balance sheets), limiting the ability to finance acquisitions, particularly hostile acquisitions, which are often particularly expensive. In addition, the market valuations of many companies became maligned with underlying fundamentals during the stock market bubble of the 1990s, and after a substantial fall in certain segments of the stock market, such as the technology sector, present valuations are still high relative to historic norms—making the hostile acquisition of even poorly run and unprofitable companies expensive. However, takeovers tend to occur in cycles, and it seems likely that once excesses are worked out of the stock market and off corporate balance sheets, the takeover constraint will begin to reassert itself again. It should be remembered that the takeover constraint is the governance mechanism of last resort and is often invoked only when other governance mechanisms have failed.

Governance Mechanisms Inside a Company

Thus far, this chapter has focused on the governance mechanisms designed to reduce the agency problem that potentially exists between stockholders and managers. Agency relationships also exist within a company, and the agency problem can arise between levels of management. In this section, we explore how the agency problem can be reduced within a company by using two complementary governance mechanisms to align the incentives and behavior of employees with those of upper-level management: strategic control systems and incentive systems.

Strategic Control Systems Strategic control systems are the primary governance mechanisms established within a company to reduce the scope of the agency problem between levels of management. These systems are the formal target-setting, measurement, and feedback systems that allow managers to evaluate whether a company is executing the strategies necessary to maximize its long-term profitability and, in particular, whether the company is achieving superior efficiency, quality, innovation, and customer responsiveness. They are discussed in more detail in subsequent chapters.

The purpose of strategic control systems is to (1) establish standards and targets against which performance can be measured, (2) create systems for measuring and monitoring performance on a regular basis, (3) compare actual performance against the established targets, and (4) evaluate results and take corrective action if necessary. In governance terms, their purpose is to ensure that lower-level managers, as the agents of top managers, are acting in a way that is consistent with top managers' goals, which should be to maximize the wealth of stockholders, subject to legal and ethical constraints.

One increasingly influential model that guides managers through the process of creating the right kind of strategic control systems to enhance organizational performance is the balanced scorecard model.[32] According to the balanced scorecard model, managers

have traditionally emphasized financial measures of performance such as ROIC to gauge and evaluate organizational performance. Financial information is extremely important, but it is not enough alone. If managers are to obtain a true picture of organizational performance, financial information must be supplemented with performance measures that indicate how well an organization has been achieving the four building blocks of competitive advantage: efficiency, quality, innovation, and responsiveness to customers. This is because financial results simply inform strategic managers about the results of decisions they have already taken; the other measures balance this picture of performance by informing managers about how accurately the organization has in place the building blocks that drive future performance.[33]

One version of the way the balanced scorecard operates is presented in Figure 11.3. Based on an organization's mission and goals, strategic managers develop a set of criteria for assessing performance according to multiple perspectives, such as:

- *The financial perspective:* for example, the return on capital, cash flow, and revenue growth
- *The customer perspective:* for example, satisfaction, product reliability, on-time delivery, and level of service

Figure 11.3 A Balanced Scorecard Approach

© Cengage Learning

- *The internal perspective:* for example, efficiency, timeliness, and employee satisfaction
- *Innovation and learning:* for example, the number of new products introduced, the percentage of revenues generated from new products in a defined period, the time taken to develop the next generation of new products versus the competition, and the productivity of research and development (R&D)—how much R&D spending is required to produce a successful product

As Kaplan and Norton, the developers of this approach, suggest, "Think of the balanced scorecard as the dials and indicators in an airplane cockpit. For the complex task of navigating and flying an airplane, pilots need detailed information about many aspects of the flight. They need information on fuel, air speed, altitude, learning, destination, and other indicators that summarize the current and predicted environment. Reliance on one instrument can be fatal. Similarly, the complexity of managing an organization today requires that managers be able to view performance in several areas simultaneously."[34]

Based on an evaluation of the complete set of measures in the balanced scorecard, strategic managers are in a good position to reevaluate the company's mission and goals and take corrective action to rectify problems, limit the agency problem, or exploit new opportunities by changing the organization's strategy and structure—which is the purpose of strategic control.

Employee Incentives Control systems alone may not be sufficient to align incentives between stockholders, senior management, and the rest of the organization. To help do this, positive incentive systems are often put into place to motivate employees to work toward goals that are central to maximizing long-term profitability. As already noted, ESOPs are one form of positive incentive, as are stock-option grants. In the 1990s, ESOPs and stock-ownership grants were pushed down deep within many organizations, meaning that employees at many levels of the firm were eligible for the plans. The logic behind such systems is straightforward: recognizing that the stock price, and therefore their own wealth, is dependent upon the profitability of the company, employees will work toward maximizing profitability.

In addition to stock-based compensation systems, employee compensation can also be tied to goals that are linked to the attainment of superior efficiency, quality, innovation, and customer responsiveness. For example, the bonus pay of a manufacturing employee might depend upon attaining quality and productivity targets, which, if reached, will lower the costs of the company, increase customer satisfaction, and boost profitability. Similarly, a salesperson's bonus pay might be dependent upon surpassing sales targets, and an R&D employee's bonus pay may be contingent upon the success of the new products he or she had worked on developing.

ETHICS AND STRATEGY

The term **ethics** refers to accepted principles of right or wrong that govern the conduct of a person, the members of a profession, or the actions of an organization. **Business ethics** are the accepted principles of right or wrong governing the conduct of businesspeople. Ethical decisions are in accordance with those accepted principles, whereas unethical decisions violate accepted principles. This is not as straightforward as it sounds. Managers may be confronted with **ethical dilemmas**, which are situations where there is no agreement over exactly what the accepted principles of right and wrong are, or where none of the available alternatives seems ethically acceptable.

In our society, many accepted principles of right and wrong are not only universally recognized but also codified into law. In the business arena, there are laws governing product

ethics
Accepted principles of right or wrong that govern the conduct of a person, the members of a profession, or the actions of an organization.

business ethics
Accepted principles of right or wrong governing the conduct of businesspeople.

ethical dilemmas
Situations where there is no agreement over exactly what the accepted principles of right and wrong are, or where none of the available alternatives seems ethically acceptable.

liability (tort laws), contracts and breaches of contract (contract law), the protection of intellectual property (intellectual property law), competitive behavior (antitrust law), and the selling of securities (securities law). Not only is it unethical to break these laws, it is illegal.

In this book we argue that the preeminent goal of managers in a business should be to pursue strategies that maximize the long-term profitability and profit growth of the enterprise, thereby boosting returns to stockholders. Strategies, of course, must be consistent with the laws that govern business behavior: managers must act legally while seeking to maximize the long-term profitability of the enterprise. Unfortunately, as we have already seen in this chapter, managers do break laws. Moreover, managers may take advantage of ambiguities and gray areas in the law, of which there are many in our common law system, to pursue actions that are at best legally suspect and, in any event, clearly unethical. It is important to realize, however, that behaving ethically surpasses staying within the bounds of the law. In the chapter-closing case, we discuss how Goldman Sachs sold bonds to investors that were deliberately structured to increase the risk of failure, and did so without informing clients. Although the legality of this action is unclear (Goldman did pay a fine, but it admitted to no wrongdoing), it pushes the boundaries of ethical behavior.

For another example, see Strategy in Action 11.3, which discusses Nike's use of "sweatshop labor" in developing nations to make sneakers for consumers in the developed world. Although Nike was not breaking any laws by using poorly paid laborers who worked long hours for low wages in poor working conditions, and neither were its subcontractors, many considered it unethical to use subcontractors that by Western standards clearly exploited their workforce. In this section, we take a closer look at the ethical issues that managers may confront when developing strategy, and at the steps managers can take to ensure that strategic decisions are not only legal, but also ethical.

11.3 STRATEGY IN ACTION

Nike—the Sweatshop Debate

© iStockPhoto.com/Tom Nulens

Nike is in many ways the quintessential global corporation. Established in 1972 by former University of Oregon track star Phil Knight, Nike is today one of the leading marketers of athletic shoes and apparel in the world, with sales in 140 countries. Nike does not do any manufacturing; rather, it designs and markets its products and contracts for their manufacture from a global network of 600 factories owned by subcontractors scattered around the globe, which together employ nearly 550,000 people. This huge corporation has made founder Phil Knight one of the richest people in the United States. Nike's marketing phrase "Just Do It!" has become as recognizable in popular culture as its "swoosh" logo, or the faces of its celebrity sponsors, such as Tiger Woods.

For years the company was dogged by repeated and persistent accusations that its products are made in "sweatshops" where workers, many of them children, slave away in hazardous conditions for wages below subsistence level. Nike's wealth, its detractors claim, has been built upon the backs of the world's poor. Many critics paint the Nike symbol as a sign of the evils of globalization: a rich Western corporation exploiting the world's poor to provide expensive shoes and apparel to the pampered consumers of the developed world. Nike's "Niketown" stores have become standard targets for anti-globalization protestors. Several nongovernmental organizations, such as San Francisco–based Global Exchange, a human rights organization dedicated to promoting environmental, political, and social justice around the world, targeted Nike for repeated criticism and protests. News organizations such as CBS's *48 Hours*, hosted by Dan Rather, ran exposés on working conditions in foreign factories that supply Nike. Students on the campuses of several

(continues)

11.3 STRATEGY IN ACTION

(continued)

© iStockPhoto.com/Tom Nulens

major U.S. universities, with which Nike entertains lucrative sponsorship deals, have protested against those deals, citing Nike's use of sweatshop labor.

Typical of the allegations were those detailed in the CBS news program *48 Hours* in 1996. The report painted a picture of young women at a Vietnamese subcontractor who worked 6 days per week, in poor working conditions with toxic materials, for only $0.20 per hour. The report also stated that a living wage in Vietnam was at least $3 per day, an income that could not be achieved without working substantial overtime. Nike was not breaking any laws, and nor were its subcontractors, but this report and others like it raised questions about the ethics of using "sweatshop labor" to make what were essentially fashion accessories. These actions may have been legal and may have helped the company to increase its profitability, but was it ethical to use subcontractors that, by Western standards, clearly exploited their workforce? Nike's critics thought not, and the company found itself at the focus of a wave of demonstrations and consumer boycotts.

Adding fuel to the fire, in November 1997, Global Exchange obtained and leaked a confidential report by Ernst & Young of an audit that Nike had commissioned of a Vietnam factory owned by a Nike subcontractor. The factory had 9,200 workers and made 400,000 pairs of shoes per month. The Ernst & Young report painted a dismal picture of thousands of young women, most under age 25, laboring 10½ hours per day, 6 days a week, in excessive heat and noise and foul air, for slightly more than $10 a week. The report also found that workers with skin or breathing problems had not been transferred to departments free of chemicals. More than half the workers who dealt with dangerous chemicals did not wear protective masks or gloves. The report stated that, in parts of the plant, workers were exposed to carcinogens that exceeded local legal standards by 177 times and that 77% of the employees suffered from respiratory problems.

These exposés surrounding Nike's use of subcontractors forced the company to reexamine its policies. Realizing that its subcontracting policies were perceived as unethical, Nike's managers took a number of steps. They established a code of conduct for Nike subcontractors and set up a system whereby independent auditors would annually monitor all subcontractors. Nike's code of conduct required that all employees at footwear factories be at least 18 years old and that exposure to potentially toxic materials would not exceed the permissible exposure limits established by the U.S. Occupational Safety and Health Administration for workers in the United States. In short, Nike concluded that behaving ethically required going beyond the requirements of the law. It required the establishment and enforcement of rules that adhere to accepted moral principles of right and wrong.

Sources: "Boycott Nike," CBS News *48 Hours*, October 17, 1996; D. Jones, "Critics Tie Sweatshop Sneakers to 'Air Jordan,'" *USA Today*, June 6, 1996, p. 1B; "Global Exchange Special Report: Nike Just Don't Do It," www.globalexchange.org/education/publications/newsltr6.97p2.html#nike; S. Greenhouse, "Nike Shoeplant in Vietnam Is Called Unsafe for Workers," *New York Times*, November 8, 1997; and V. Dobnik, "Chinese Workers Abused Making Nikes, Reeboks," *Seattle Times*, September 21, 1997, p. A4.

Ethical Issues in Strategy

The ethical issues that strategic managers confront cover many topics, but most are due to a potential conflict between the goals of the enterprise, or the goals of individual managers, and the fundamental rights of important stakeholders, including stockholders, customers, employees, suppliers, competitors, communities, and the general public. Stakeholders have basic rights that should be respected, and it is unethical to violate those rights.

Stockholders have the right to timely and accurate information about their investments (in accounting statements), and it is unethical to violate that right. Customers have the right to be fully informed about the products and services they purchase, including the right to

information about how those products might cause them harm, and it is unethical to restrict their access to such information. Employees have the right to safe working conditions, fair compensation for the work they perform, and just treatment by managers. Suppliers have the right to expect contracts to be respected, and the company should not take advantage of a power disparity between it and a supplier to opportunistically rewrite a contract. Competitors have the right to expect that the firm will abide by the rules of competition and not violate the basic principles of antitrust laws. Communities and the general public, including their political representatives in government, have the right to expect that a firm will not violate the basic expectations that society places on enterprises—for example, by dumping toxic pollutants into the environment, or overcharging for work performed on government contracts.

Those who take the stakeholder view of business ethics often argue that it is in the enlightened self-interest of managers to behave in an ethical manner that recognizes and respects the fundamental rights of stakeholders, because doing so will ensure the support of stakeholders and, ultimately, benefit the firm and its managers. Others go beyond this instrumental approach to ethics and argue that, in many cases, acting ethically is simply the right thing to do. They argue that businesses need to recognize their *noblesse oblige*, a French term that refers to honorable and benevolent behavior that is considered the responsibility of people of high (noble) birth, and give something back to the society that made their success possible. In a business setting, it is understood that benevolent behavior is the moral responsibility of successful enterprises.

Unethical behavior often arises in a corporate setting when managers decide to put the attainment of their own personal goals, or the goals of the enterprise, above the fundamental rights of one or more stakeholder groups (in other words, unethical behavior may arise from agency problems). The most common examples of such behavior involve self-dealing, information manipulation, anticompetitive behavior, opportunistic exploitation of other players in the value chain in which the firm is embedded (including suppliers, complement providers, and distributors), the maintenance of substandard working conditions, environmental degradation, and corruption.

Self-dealing occurs when managers find a way to feather their own nests with corporate monies, as we have already discussed in several examples in this chapter (such as Conrad Black at Hollinger). **Information manipulation** occurs when managers use their control over corporate data to distort or hide information in order to enhance their own financial situation or the competitive position of the firm, such as HP accused Autonomy of in the chapter-opening case. As we have seen, many accounting scandals have involved the deliberate manipulation of financial information. Information manipulation can also occur with nonfinancial data. An example of this is when managers at the tobacco companies suppressed internal research that linked smoking to health problems, violating the rights of consumers to accurate information about the dangers of smoking. When this evidence came to light, lawyers filed class-action suits against the tobacco companies, claiming that they had intentionally caused harm to smokers: they had broken tort law by promoting a product that they knew was seriously harmful to consumers. In 1999, the tobacco companies settled a lawsuit brought by the states that sought to recover health-care costs associated with tobacco-related illnesses; the total payout to the states was $260 billion.

Anticompetitive behavior covers a range of actions aimed at harming actual or potential competitors, most often by using monopoly power, and thereby enhancing the long-run prospects of the firm. For example, in the 1990s, the Justice Department claimed that Microsoft used its monopoly in operating systems to force PC makers to bundle Microsoft's Web browser, Internet Explorer, with the Windows operating system, and to display the Internet Explorer logo prominently on the computer desktop. Microsoft

self-dealing
Managers using company funds for their own personal consumption, as done by Enron, for example, in previous years.

information manipulation
When managers use their control over corporate data to distort or hide information in order to enhance their own financial situation or the competitive position of the firm.

anticompetitive behavior
A range of actions aimed at harming actual or potential competitors, most often by using monopoly power, and thereby enhancing the long-run prospects of the firm.

reportedly told PC makers that it would not supply them with Windows unless they did this. Because the PC makers needed Windows to sell their machines, this was a powerful threat. The alleged aim of the action, which exemplifies "tie-in sales"—which are illegal under antitrust laws—was to drive a competing browser maker, Netscape, out of business. The courts ruled that Microsoft was indeed abusing its monopoly power in this case, and under a 2001 consent decree, the company was forced to cease this practice.

Legality aside, the actions Microsoft managers allegedly engaged in are unethical on at least three counts; first, by violating the rights of end-users by unfairly limiting their choice; second, by violating the rights of downstream participants in the industry value chain, in this case PC makers, by forcing them to incorporate a particular product in their design; and third, by violating the rights of competitors to free and fair competition.

opportunistic exploitation

Unethical behavior sometimes used by managers to unilaterally rewrite the terms of a contract with suppliers, buyers, or complement providers in a way that is more favorable to the firm.

Opportunistic exploitation of other players in the value chain in which the firm is embedded is another example of unethical behavior. Exploitation of this kind typically occurs when the managers of a firm seek to unilaterally rewrite the terms of a contract with suppliers, buyers, or complement providers in a way that is more favorable to the firm, often using their power to force a revision to the contract. For example, in the late 1990s, Boeing entered into a $2 billion contract with Titanium Metals Corporation to purchase certain amounts of titanium annually for 10 years. In 2000, after Titanium Metals had already spent $100 million to expand its production capacity to fulfill the contract, Boeing demanded that the contract be renegotiated, asking for lower prices and an end to minimum purchase agreements. As a major purchaser of titanium, managers at Boeing probably thought they had the power to push this contract revision through, and Titanium's investment meant that it would be unlikely that the company walk away from the deal. Titanium promptly sued Boeing for breach of contract. The dispute was settled out of court, and under a revised agreement, Boeing agreed to pay monetary damages to Titanium Metals (reported to be in the $60 million range) and entered into an amended contract to purchase titanium.[35] This action was arguably unethical because it violated the supplier's rights to have buyers do business in a fair and open way, regardless of any legality.

substandard working conditions

Arise when managers underinvest in working conditions, or pay employees below-market rates, in order to reduce their production costs.

Substandard working conditions arise when managers underinvest in working conditions, or pay employees below-market rates, in order to reduce their production costs. The most extreme examples of such behavior occur when a firm establishes operations in countries that lack the workplace regulations found in developed nations such as the United States. The example of Nike, mentioned earlier, falls into this category. In another example, The Ohio Art Company ran into an ethical storm when newspaper reports alleged that it had moved production of its popular Etch A Sketch toy from Ohio to a supplier in Shenzhen Province where employees—mostly teenagers—work long hours for $0.24 per hour, below the legal minimum wage of $0.33 per hour. Moreover, production reportedly started at 7:30 a.m. and continued until 10 p.m., with breaks only for lunch and dinner; Saturdays and Sundays were treated as normal workdays, meaning that employees worked 12 hours per day, 7 days per week, or 84 hours per week—well above the standard 40-hour week authorities set in Shenzhen. Working conditions such as these clearly violate employees' rights in China, as specified by local regulations (which are poorly enforced). Is it ethical for the The Ohio Art Company to use such a supplier? Many would say it is not.[36]

environmental degradation

Occurs when a company's actions directly or indirectly result in pollution or other forms of environmental harm.

Environmental degradation occurs when a company's actions directly or indirectly result in pollution or other forms of environmental harm. Environmental degradation can violate the rights of local communities and the general public for things such as clean air and water, land that is free from pollution by toxic chemicals, and properly managed forests.

Finally, **corruption** can arise in a business context when managers pay bribes to gain access to lucrative business contracts. For example, it was alleged that Halliburton was part of a consortium that paid nearly $180 million in bribes to win a lucrative contract to build a natural gas plant in Nigeria.[37] Similarly, between 2006 and 2009, Siemens was found guilty of paying hundreds of millions of dollars in bribes to secure sales contracts; the company was ultimately forced to pay hefty fines, and one of the Chinese executives who accepted $5.1 million in bribes was sentenced to death by Chinese courts.[38] Corruption is clearly unethical because it violates many rights, including the right of competitors to a level playing field when bidding for contracts, and, when government officials are involved, the right of citizens to expect that government officials will act in the best interest of the local community (or nation) and not in response to corrupt payments.

corruption
Can arise in a business context when managers pay bribes to gain access to lucrative business contracts.

The Roots of Unethical Behavior

Why do some managers behave unethically? What motivates managers to engage in actions that violate accepted principals of right and wrong, trample on the rights of one or more stakeholder groups, or simply break the law? Although there is no simple answer to this question, a few generalizations can be made.[39] First, it is important to recognize that business ethics are not divorced from **personal ethics**, which are the generally accepted principles of right and wrong governing the conduct of individuals. As individuals we are taught that it is wrong to lie and cheat and that it is right to behave with integrity and honor and to stand up for what we believe to be right and true. The personal ethical code that guides behavior comes from a number of sources, including parents, schools, religion, and the media. A personal ethical code will exert a profound influence on the way individuals behave as businesspeople. An individual with a strong sense of personal ethics is less likely to behave in an unethical manner in a business setting; in particular, he or she is less likely to engage in self-dealing and more likely to behave with integrity.

personal ethics
Generally accepted principles of right and wrong governing the conduct of individuals.

Second, many studies of unethical behavior in a business setting have come to the conclusion that businesspeople sometimes do not realize that they are behaving unethically, primarily because they simply fail to ask the relevant question: Is this decision or action ethical? Instead, they apply straightforward business calculus to what they perceive to be a business decision, forgetting that the decision may also have an important ethical dimension.[40] The fault here is within the processes that do not incorporate ethical considerations into business decision making. This may have been the case at Nike when managers originally made subcontracting decisions (see the Strategy in Action 11.3). Those decisions were probably made on the basis of good economic logic. Subcontractors were probably chosen on the basis of business variables such as cost, delivery, and product quality, and key managers simply failed to ask: "How does this subcontractor treat its workforce?" If managers pondered this question at all, they probably reasoned that it was the subcontractor's concern, not the company's.

Unfortunately, the climate in some businesses does not encourage people to think through the ethical consequences of business decisions. This brings us to the third cause of unethical behavior in businesses: an organizational culture that de-emphasizes business ethics and considers all decisions to be purely economic ones. Individuals may believe their decisions within the workplace are not subject to the same ethical principles that govern their personal lives, or that their decisions within the firm do not really "belong" to them, but rather that they are merely acting as agents of the firm. A related fourth cause of unethical behavior may be pressure from top management to meet performance goals that are unrealistic and can only be attained by cutting corners or acting in an unethical manner. Thus the pressure to perform induces individuals to behave in ways they otherwise would not.

An organizational culture can "legitimize" behavior that society would judge as unethical, particularly when this is mixed with a focus upon unrealistic performance goals, such as maximizing short-term economic performance regardless of the costs. In such circumstances, there is a greater-than-average probability that managers will violate their own personal ethics and engage in behavior that is unethical. By the same token, an organization's culture can do just the opposite and reinforce the need for ethical behavior. Recreational Equipment Inc. (REI), for example, has a strong culture around valuing environmental sustainability, respect for individuals, and trustworthiness. The firm backs up this belief system with such policies as producing an annual environmental stewardship report and providing health-care benefits for all workers (including part-time employees), a retirement plan that does not require individual contributions, and grants for employees to contribute to their communities or to buy gear to pursue personal outdoor challenges. The company ranked 17th on *Fortune*'s 2013 100 "Best Companies to Work For" and has been on that list every year since 1998.

This brings us to a fifth root cause of unethical behavior: *unethical leadership*. Leaders help to establish the culture of an organization, and they set the example that others follow. Other employees in a business often take their cues from business leaders, and if those leaders do not behave in an ethical manner, employees may not either. It is not what leaders say that matters, but what they do. A good example is Ken Lay, the former CEO of the failed energy company Enron. While constantly referring to Enron's code of ethics in public statements, Lay simultaneously engaged in behavior that was ethically suspect. Among other things, he failed to discipline subordinates who had inflated earnings by engaging in corrupt energy trading schemes. Such behavior sent a very clear message to Enron's employees—unethical behavior would be tolerated if it could boost earnings.

Behaving Ethically

What is the best way for managers to ensure that ethical considerations are taken into account? In many cases, there is no easy answer to this question, for many of the most vexing ethical problems involve very real dilemmas and suggest no obvious right course of action. Nevertheless, managers can and should do at least seven things to ensure that basic ethical principles are adhered to and that ethical issues are routinely considered when making business decisions. They can (1) favor hiring and promoting people with a well-grounded sense of personal ethics, (2) build an organizational culture that places a high value on ethical behavior, (3) make sure that leaders within the business not only articulate the rhetoric of ethical behavior but also act in a manner that is consistent with that rhetoric, (4) put decision-making processes in place that require people to consider the ethical dimension of business decisions, (5) use ethics officers, (6) put strong governance processes in place, and (7) act with moral courage.

Hiring and Promotion It seems obvious that businesses should strive to hire people who have a strong sense of personal ethics and would not engage in unethical or illegal behavior. Similarly, you would rightly expect a business to not promote people, and perhaps fire people, whose behavior does not match generally accepted ethical standards. But doing this is actually very difficult. How do you know if someone has a poor sense of personal ethics? In this society, if someone lacks personal ethics, he or she may hide this fact to retain people's trust.

Is there anything that businesses can do to ensure they do not hire people who have poor personal ethics, particularly given that people have an incentive to hide this from public view (indeed, unethical people may well lie about their nature)? Businesses can give potential employees psychological tests to try to discern their ethical predisposition, and they can check with prior employees regarding someone's reputation, such as by asking for

letters of reference and talking to people who have worked with the prospective employee. The latter approach is certainly not uncommon and does influence the hiring process. Promoting people who have displayed poor ethics should not occur in a company where the organization's culture values ethical behavior and where leaders act accordingly.

Organization Culture and Leadership To foster ethical behavior, businesses must build an organization culture that places a high value on ethical behavior. Three actions are particularly important. First, businesses must explicitly articulate values that place a strong emphasis on ethical behavior. Many companies now do this by drafting a **code of ethics**, a formal statement of the ethical priorities to which a business adheres—in fact, both the New York Stock Exchange and Nasdaq listing services require listed companies to have a code of ethics that identifies areas of ethical risk, provides guidance for recognizing and dealing with ethical issues, provides mechanisms for reporting unethical conduct, and notes procedures to ensure prompt action against violations.[41] Firms also sometimes incorporate ethical statements into documents that articulate the values or mission of the business. For example, the food and consumer products giant Unilever's code of ethics includes the following points: "We will not use any form of forced, compulsory or child labor" and "No employee may offer, give or receive any gift or payment which is, or may be construed as being, a bribe. Any demand for, or offer of, a bribe must be rejected immediately and reported to management."[42] Unilever's principles send a very clear message to managers and employees within the organization. Data from the National Business Ethics Survey, administered by the Ethics Resource Center, a U.S. nonprofit, has found that firms with strong and well-implemented ethics programs have significantly fewer cases of ethical misconduct.[42]

> **code of ethics**
> Formal statement of the ethical priorities to which a business adheres.

Having articulated values in a code of ethics or some other document, it is important that leaders in the business give life and meaning to those words by repeatedly emphasizing their importance and then acting on them. This means using every relevant opportunity to stress the importance of business ethics and making sure that key business decisions not only make good economic sense but also are ethical. Many companies have gone a step further and hired independent firms to audit them and make sure that they are behaving in a manner consistent with their ethical codes. Nike, for example, has in recent years hired independent auditors to make sure that its subcontractors are adhering to Nike's code of conduct.

Finally, building an organization culture that places a high value on ethical behavior requires incentive and reward systems, including promotional systems that reward people who engage in ethical behavior and sanction those who do not.

Decision-Making Processes In addition to establishing the right kind of ethical culture in an organization, businesspeople must be able to think through the ethical implications of decisions in a systematic way. To do this, they need a moral compass, and beliefs about what determines individual rights and justice. Some experts on ethics have proposed a straightforward practical guide, or ethical algorithm, to determine whether a decision is ethical. A decision is acceptable on ethical grounds if a businessperson can answer "yes" to each of these questions:

1. Does my decision fall within the accepted values or standards that typically apply in the organizational environment (as articulated in a code of ethics or some other corporate statement)?
2. Am I willing to see the decision communicated to all stakeholders affected by it—for example, by having it reported in newspapers or on television?
3. Would the people with whom I have a significant personal relationship, such as family members, friends, or even managers in other businesses, approve of the decision?

FOCUS ON: Wal-Mart

Walmart's Statement of Ethics

© iStockPhoto.com/caracterdesign

Walmart has a 35-page "Statement of Ethics" (available in 14 languages) that covers a wide range of issues spanning from harassment and nondiscrimination to fair competition, insider trading, corruption, and money laundering. The statement is organized around the following guiding principles:

- Always act with integrity.
- Lead with integrity, and expect others to work with integrity.
- Follow the law at all times.
- Be honest and fair.
- Reveal and report all information truthfully, without manipulation or misrepresentation.
- Work, actions, and relationships outside of your position with the company should be free of any conflicts of interest.
- Respect and encourage diversity, and never discriminate against anyone.
- Ask your manager or the Global Ethics Office for help if you have questions about this Statement of Ethics, or if you face an ethical problem.
- Promptly report suspected violations of the Statement of Ethics.
- Cooperate with and maintain the private nature of any investigation of a possible ethics violation.

- When involved in an ethics investigation, you should reveal and report all information truthfully. You should present all the facts you are aware of without personal opinion, bias, or judgment.

The statement details what Walmart employees cannot do, and provides helpful examples with Q&A sections such as "Q: A supplier I work with has offered me two tickets to the World Cup if I pay face value for them. Can I buy the tickets?

A: You should decline the offer. Although you may be paying face value for the tickets, it may not necessarily reflect the market value of the item. Some areas allow you to resell tickets, and you might be able to make a profit if you sold them. Also, there could be a gift of prestige in receiving the ability to attend a coveted event, such as the World Cup."

Walmart has a Global Ethics Office that is responsible for developing Walmart's ethics policies, promoting an ethical culture, and providing an anonymous reporting system for misconduct. Walmart also has ethics committees organized by region that employees can contact, and global ethics helplines that employees can call when they have questions.

Source: Data retrieved from http://ethics.walmartstores.com/statementofethics on April 26, 2013.

Ethics Officers To make sure that a business behaves in an ethical manner, a number of firms now have ethics officers. These individuals are responsible for making sure that all employees are trained to be ethically aware, that ethical considerations enter the business decision-making process, and that employees adhere to the company's code of ethics. Ethics officers may also be responsible for auditing decisions to ensure that they are consistent with this code. In many businesses, ethics officers act as an internal ombudsperson with responsibility for handling confidential inquiries from employees, investigating complaints from employees or others, reporting findings, and making recommendations for change.

United Technologies, a large aerospace company with worldwide revenues of about $60 billion, has had a formal code of ethics since 1990. There are now some 450 "business practice officers" (this is the company's name for ethics officers) within United Technologies who are responsible for making sure that employees adhere to the code. United Technologies also established an ombudsperson program in 1986 that allows employees to inquire anonymously about ethics issues.[43]

Strong Corporate Governance Strong corporate governance procedures are needed to ensure that managers adhere to ethical norms, in particular, that senior managers do not engage in self-dealing or information manipulation. Strong corporate governance procedures require an independent board of directors that is willing to hold top managers accountable for self-dealing and is capable of verifying the information managers provide. If companies like Tyco, WorldCom, and Enron had had strong boards of directors, it is unlikely that these companies would have experienced accounting scandals, or that top managers would have been able to access the funds of these corporations as personal treasuries.

There are five cornerstones of strong governance. The first is a board of directors that is composed of a majority of outside directors who have no management responsibilities in the firm, who are willing and able to hold top managers accountable, and who do not have business ties with important insiders. Outside directors should be individuals of high integrity whose reputation is based on their ability to act independently. The second cornerstone is a board where the positions of CEO and chairman are held by separate individuals and the chairman is an outside director. When the CEO is also chairman of the board of directors, he or she can control the agenda, thereby furthering his or her own personal agenda (which may include self-dealing) or limiting criticism against current corporate policies. The third cornerstone is a compensation committee formed by the board that is composed entirely of outside directors. It is the compensation committee that sets the level of pay for top managers, including stock-option grants and additional benefits. The scope of self-dealing is reduced by making sure that the compensation committee is independent of managers. Fourth, the audit committee of the board, which reviews the financial statements of the firm, should also be composed of outsiders, thereby encouraging vigorous independent questioning of the firm's financial statements. Finally, the board should use outside auditors that are truly independent and do not have a conflict of interest. This was not the case in many recent accounting scandals, where outside auditors were also consultants to the corporation and therefore less likely to ask management hard questions for fear that doing so would jeopardize lucrative consulting contracts.

Moral Courage It is important to recognize that sometimes managers and others need significant moral courage. It is moral courage that enables managers to walk away from a decision that is profitable but unethical, that gives employees the strength to say no to superiors who instruct them to behave unethically, and that gives employees the integrity to go to the media and blow the whistle on persistent unethical behavior in a company. Moral courage does not come easily; there are well-known cases where individuals have lost their jobs because they blew the whistle on unethical corporate behaviors.

Companies can strengthen the moral courage of employees by making a commitment to refuse to seek retribution against employees who exercise moral courage, say no to superiors, or otherwise complain about unethical actions. For example, Unilever's code of ethics includes the following:

> *Any breaches of the Code must be reported in accordance with the procedures specified by the Joint Secretaries. The Board of Unilever will not criticize management for any loss of business resulting from adherence to these principles and other mandatory policies and instructions. The Board of Unilever expects employees to bring to their attention, or to that of senior management, any breach or suspected breach of these principles. Provision has been made for employees to be able to report in confidence and no employee will suffer as a consequence of doing so.*

This statement gives "permission" to employees to exercise moral courage. Companies can also set up ethics hotlines that allow employees to anonymously register a complaint with a corporate ethics officer.

Final Words The steps discussed here can help to ensure that when managers make business decisions, they are fully cognizant of the ethical implications and do not violate basic ethical prescripts. At the same time, not all ethical dilemmas have a clean and obvious solution—that is why they are dilemmas. At the end of the day, there are things that a business should not do, and there are things that a business should do, but there are also actions that present managers with true dilemmas. In these cases a premium is placed upon the ability of managers to make sense out of complex, messy situations and to make balanced decisions that are as just as possible.

11.1 ETHICAL DILEMMA

© iStockPhoto.com/P_Wei

You work for a U.S.-based textile company that is having trouble competing with overseas competitors that have access to low-cost labor. Although you pay your factory workers $14 an hour plus benefits, you know that a similar textile mill in Vietnam is paying its employees around $0.50 an hour, and the mill does not have to comply with the same costly safety and environmental regulations that your company does. After transportation costs have been taken into account, the Vietnamese factory still has a clear cost advantage. Your CEO says that it is time to shut down the mill, lay off employees, and move production to a country in Central America or Southeast Asia where labor and compliance costs are much, much lower. The U.S. mill is the only large employer in this small community. Many of the employees have been working at the mill their entire working lives. The mill is marginally profitable.

What appears to be the right action to take for stockholders? What is the most ethical course of action? Is there a conflict in this situation?

SUMMARY OF CHAPTER

1. Stakeholders are individuals or groups that have an interest, claim, or stake in the company—in what it does and in how well it performs.
2. Stakeholders are in an exchange relationship with the company. They supply the organization with important resources (or contributions) and in exchange expect their interests to be satisfied (by inducements).

3. A company cannot always satisfy the claims of all stakeholders. The goals of different groups may conflict. The company must identify the most important stakeholders and give highest priority to pursuing strategies that satisfy their needs.
4. A company's stockholders are its legal owners and the providers of risk capital, a major source of the capital resources that allow a company

to operate its business. As such, they have a unique role among stakeholder groups.

5. Maximizing long-term profitability and profit growth is the route to maximizing returns to stockholders, and it is also consistent with satisfying the claims of several other key stakeholder groups.

6. When pursuing strategies that maximize profitability, a company has the obligation to do so within the limits set by the law and in a manner consistent with societal expectations.

7. An agency relationship is held to arise whenever one party delegates decision-making authority or control over resources to another.

8. The essence of the agency problem is that the interests of principals and agents are not always the same, and some agents may take advantage of information asymmetries to maximize their own interests at the expense of principals.

9. Numerous governance mechanisms serve to limit the agency problem between stockholders and managers. These include the board of directors, stock-based compensation schemes, financial statements and auditors, and the threat of a takeover.

10. The term *ethics* refers to accepted principles of right or wrong that govern the conduct of a person, the members of a profession, or the actions of an organization. Business ethics are the accepted principles of right or wrong governing the conduct of businesspeople, and an ethical strategy is one that does not violate these accepted principles.

11. Unethical behavior is rooted in poor personal ethics; the inability to recognize that ethical issues are at stake; failure to incorporate ethical issues into strategic and operational decision making; a dysfunctional culture; and failure of leaders to act in an ethical manner.

12. To make sure that ethical issues are considered in business decisions, managers should (a) favor hiring and promoting people with a well-grounded sense of personal ethics, (b) build an organizational culture that places a high value on ethical behavior, (c) ensure that leaders within the business not only articulate the rhetoric of ethical behavior but also act in a manner that is consistent with that rhetoric, (d) put decision-making processes in place that require people to consider the ethical dimension of business decisions, (e) use ethics officers, (f) have strong corporate governance procedures, and (g) be morally courageous and encourage others to be the same.

DISCUSSION QUESTIONS

1. How prevalent has the agency problem been in corporate America during the last decade? During the late 1990s there was a boom in initial public offerings of Internet companies (dot.com companies). The boom was supported by sky-high valuations often assigned to Internet start-ups that had no revenues or earnings. The boom came to an abrupt end in 2001, when the Nasdaq stock market collapsed, losing almost 80% of its value. Who do you think benefited most from this boom: investors (stockholders) in those companies, managers, or investment bankers?

2. Why is maximizing ROIC consistent with maximizing returns to stockholders?

3. How might a company configure its strategy-making processes to reduce the probability that managers will pursue their own self-interest at the expense of stockholders?

4. In a public corporation, should the CEO of the company also be allowed to be the chairman of the board (as allowed for by the current law)? What problems might this give rise to?

5. Under what conditions is it ethically defensible to outsource production to producers in the developing world who have much lower labor costs when such actions involve laying off long-term employees in the firm's home country?

6. Is it ethical for a firm faced with a shortage of labor to employ illegal immigrants to meet its needs?

KEY TERMS

Stakeholders 362
Internal stakeholders 362
External
 stakeholders 362
Risk capital 363
Information
 asymmetry 367
On-the-job
 consumption 369

Inside directors 372
Outside directors 372
Stock options 374
Takeover constraint 375
Greenmail 376
Ethics 378
Business ethics 378
Ethical dilemmas 378
Self-dealing 381

Information
 manipulation 381
Anticompetitive
 behavior 381
Opportunistic
 exploitation 382
Substandard working
 conditions 382

Environmental
 degradation 385
Corruption 386
Personal ethics 386
Code of ethics 388

PRACTICING STRATEGIC MANAGEMENT

© Yuri_aRCuRS/iStock Photo

Small Group Exercises

Small-Group Exercise: Evaluating Stakeholder Claims

Break up into groups of three to five people, and appoint one group member as a spokesperson who will communicate your findings to the class when called on by the instructor. Discuss the following:

1. Identify the key stakeholders of your educational institution. What claims do they place on the institution?
2. Strategically, how is the institution responding to those claims? Do you think the institution is pursuing the correct strategies in view of those claims? What might it do differently, if anything?
3. Prioritize the stakeholders in order of their importance for the survival and health of the institution. Do the claims of different stakeholder groups conflict with each other? If the claims do conflict, whose claim should be tackled first?

STRATEGY SIGN ON

© iStockPhoto.com/Ninoslav Dotlic

Article File 11

Find an example of a company that ran into trouble because it failed to take into account the rights of one of its stakeholder groups when making an important strategic decision.

STRATEGY SIGN ON

(continued)

© iStockPhoto.com/Ninoslav Dotlic

Strategic Management Project: Module 11

This module deals with the relationships your company has with its major stakeholder groups. With the information you have at your disposal, perform the tasks and answer the questions that follow:

1. Identify the main stakeholder groups in your company. What claims do they place on the company? How is the company trying to satisfy those claims?
2. Evaluate the performance of the CEO of your company from the perspective of (a) stockholders, (b) employees, (c) customers, and (d) suppliers. What does this evaluation tell you about the ability of the CEO and the priorities that he or she is committed to?
3. Try to establish whether the governance mechanisms that operate in your company do a good job of aligning the interests of top managers with those of stockholders.
4. Pick a major strategic decision made by your company in recent years, and try to think through the ethical implications of that decision. In the light of your review, do you think that the company acted correctly?

CLOSING CASE

Did Goldman Sachs Commit Fraud?

In the mid-2000s, when housing prices in the United States were surging, hedge fund manager John Paulson approached Goldman Sachs. Paulson believed that housing prices had risen too much. There was, he felt, a speculative bubble in housing. In his view, the bubble had been fueled by cheap money from banks. The banks were enticing people to purchase homes with adjustable-rate mortgages with very low interest rates for the first 1 to 3 years. Many of the borrowers, however, could probably not afford their monthly payments once higher rates would later begin. Paulson thought that homeowners would start to default on their mortgage payments in large numbers. When that happened, the housing market would be flooded with distressed sales and house prices would collapse. Paulson wanted to find a way to make money from this situation.

Goldman Sachs devised an investment vehicle that would allow Paulson to do just this. During the early 2000s, mortgage originators had started to pool thousands of individual mortgages together into bonds known as collateralized debt obligations, or CDOs. They then sold the bonds to institutional investors. The underlying idea was simple: the pool of mortgage payments generated income for the bondholders. As long as people continued to make their mortgage payments, the CDOs would generate good income and their price would be stable. Many of these bonds were given favorable ratings from the two main rating agencies, Moody's and Standard & Poor's, suggesting that they were safe investments. At the time, institutional investors were snapping up CDOs. Paulson, however, took a very different view. He believed that the rating agencies were wrong and

(continued)

that many CDOs were far more risky than investors thought. He believed that when people started to default on their mortgage payments, the price of these CDOs would collapse.

Goldman Sachs decided to offer bonds for sale to institutional investors that were a collection of 90 or so CDOs. These bonds were referred to as *synthetic CDOs*. They asked Paulson to identify the CDOs that he thought were very risky and grouped them together into *synthetic CDOs*. Goldman then sold these very same bonds to institutional investors—many were long-time Goldman Sachs clients. Goldman did not tell investors that Paulson had helped to pick the CDOs that were pooled into the bonds, nor did the company tell investors that the underlying CDOs might be a lot more risky than the rating agencies thought. Paulson then took a short position in these synthetic CDOs. Short selling is a technique whereby the investor will make money if the price of the asset goes down over time. Paulson was effectively betting against the synthetic CDOs, a fact that Goldman knew, while he was actively marketing these bonds to institutions.

Shortly thereafter, Paulson was proved correct. People did start to default on their housing payments, the price of houses did fall, and the value of CDOs and the synthetic CDOs that Goldman had created plunged. Paulson made an estimated $3.7 billion in 2007 alone from this event. Goldman Sachs, too, made over $1 billion by betting against the very same bonds that it had been selling.

The SEC soon started to investigate the transactions. Some at the SEC believed that Goldman had knowingly committed fraud by failing to inform buyers that Paulson had selected the CDOs. The SEC's case was strengthened by internal Goldman e-mails. In one, a senior executive described the synthetic CDOs it was selling as "one shitty deal." In another, a colleague applauded the deal for making "lemonade from some big old lemons."

In April 2010, the SEC formally charged Goldman Sachs with civil fraud, arguing that the company had knowingly mislead investors about the risk and value of the synthetic CDOs, and failed to inform them of John Paulson's involvement in selecting the underlying CDOs. Goldman provided a vigorous defense; it argued that a market maker like Goldman Sachs owes no fiduciary duty to clients and offers no warranties—it is up to clients to make their own assessment of the value of a security. However, faced with a barrage of negative publicity, Goldman opted to settle the case out of court and pay a $550 million fine. In doing so, Goldman admitted no legal wrongdoing, but did say that the company had made a "mistake" in not disclosing Paulson's role, and vowed to raise its standards for the future.

Sources: L. Story and G. Morgenson, "SEC Accuses Goldman of Fraud in Housing Deal," *New York Times*, April 16, 2010; J. Stempel and S. Eder, "Goldman Sachs Charged with Fraud by SEC," *Reuters*, April 16, 2010; and "Sachs and the Shitty," *The Economist*, May 1, 2010.

CASE DISCUSSION QUESTIONS

1. Did Goldman Sachs break the law by not telling investors that Paulson had created the synthetic CDOs and was betting against them? Was it unethical for Goldman Sachs to market the CDOs?

2. Would your answer to the question above change if Goldman had not made billions from selling the CDOs? Would your answer to the question above change if Paulson had been wrong, and the CDOs had increased in value?

3. If opinions vary about the quality or riskiness of an investment, does a firm like Goldman Sachs owe a fiduciary duty to its clients to try to represent all of those opinions?

4. Is it unethical for a company like Goldman to permit its managers to trade on the company's account (i.e., invest on the company's behalf rather than an external client's behalf)? If not, how should compensation policies be designed to prevent conflicts of interest from arising between trades on behalf of the firm and trades on behalf of clients?

NOTES

[1]E. Freeman, *Strategic Management: A Stakeholder Approach* (Boston: Pitman Press, 1984).

[2]C. W. L. Hill and T. M. Jones, "Stakeholder-Agency Theory," *Journal of Management Studies* 29 (1992): 131–154; and J. G. March and H. A. Simon, *Organizations* (New York: Wiley, 1958).

[3]Hill and Jones, "Stakeholder-Agency Theory"; and C. Eesley and M. J. Lenox, "Firm Responses to Secondary Stakeholder Action," *Strategic Management Journal* 27 (2006): 13–24.

[4]I. C. Macmillan and P. E. Jones, *Strategy Formulation: Power and Politics* (St. Paul: West, 1986).

[5]Tom Copeland, Tim Koller, and Jack Murrin, *Valuation: Measuring and Managing the Value of Companies* (New York: Wiley, 1996).

[6]R. S. Kaplan and D. P. Norton, *Strategy Maps* (Boston: Harvard Business School Press, 2004).

[7]J. S. Harrison, D. A. Bosse, and R. A. Phillips, "Managing for Stakeholders, Stakeholder Utility Functions, and Competitive Advantage," *Strategic Management Journal* 31 (2010): 58–74.

[8]A. L. Velocci, D. A. Fulghum, and R. Wall, "Damage Control," *Aviation Week*, December 1, 2003, pp. 26–27.

[9]M. C. Jensen and W. H. Meckling, "Theory of the Firm: Managerial Behavior, Agency Costs and Ownership Structure," *Journal of Financial Economics* 3 (1976): 305–360; and E. F. Fama, "Agency Problems and the Theory of the Firm," *Journal of Political Economy* 88 (1980): 375–390.

[10]Hill and Jones, "Stakeholder-Agency Theory."

[11]For example, see R. Marris, *The Economic Theory of Managerial Capitalism* (London: Macmillan, 1964); and J. K. Galbraith, *The New Industrial State* (Boston: Houghton Mifflin, 1970).

[12]Fama, "Agency Problems and the Theory of the Firm."

[13]A. Rappaport, "New Thinking on How to Link Executive Pay with Performance," *Harvard Business Review,* March–April 1999, pp. 91–105.

[14]AFL-CIO's Executive PayWatch Database, www.aflcio.org/Corporate-Watch/CEO-Pay-and-You.

[15]For academic studies that look at the determinants of CEO pay, see M. C. Jensen and K. J. Murphy, "Performance Pay and Top Management Incentives," *Journal of Political Economy* 98 (1990): 225–264; Charles W. L. Hill and Phillip Phan, "CEO Tenure as a Determinant of CEO Pay," *Academy of Management Journal* 34 (1991): 707–717; H. L. Tosi and L. R. Gomez-Mejia, "CEO Compensation Monitoring and Firm Performance," *Academy of Management Journal* 37 (1994): 1002–1016; and Joseph F. Porac, James B. Wade, and Timothy G. Pollock, "Industry Categories and the Politics of the Comparable Firm in CEO Compensation," *Administrative Science Quarterly* 44 (1999): 112–144.

[16]J. Silver-Greenberg and A. Leondis, "CBS Overpaid Moonvest $28 Million, Says Study of CEO Pay," *Bloomberg News*, May 6, 2010.

[17]"'Pay for Performance' No Longer a Punchline," *Wall Street Journal*, March 20, 2013.

[18]For research on this issue, see Peter J. Lane, A. A. Cannella, and M. H. Lubatkin, "Agency Problems as Antecedents to Unrelated Mergers and Diversification: Amihud and Lev Reconsidered," *Strategic Management Journal* 19 (1998): 555–578.

[19]M. Saltmarsh and E. Pfanner, "French Court Convicts Executives in Vivendi Case," *New York Times*, January 21, 2011.

[20]E. T. Penrose, *The Theory of the Growth of the Firm* (London: Macmillan, 1958).

[21]G. Edmondson and L. Cohn, "How Parmalat Went Sour," *Business Week*, January 12, 2004, pp. 46–50; and "Another Enron? Royal Dutch Shell," *Economist,* March 13, 2004, p. 71.

[22]O. E. Williamson, *The Economic Institutions of Capitalism* (New York: Free Press, 1985).

[23]Fama, "Agency Problems and the Theory of the Firm."

[24]S. Finkelstein and R. D'Aveni, "CEO Duality as a Double Edged Sword," *Academy of Management Journal* 37 (1994): 1079–1108; B. Ram Baliga and R. C. Moyer, "CEO Duality and Firm Performance," *Strategic Management Journal* 17 (1996): 41–53; M. L. Mace, *Directors: Myth and Reality* (Cambridge: Harvard University Press, 1971); and S. C. Vance, *Corporate Leadership: Boards of Directors and Strategy* (New York: McGraw-Hill, 1983).

[25]J. B. Stewart, "When Shareholder Democracy Is a Sham," *New York Times*, April 12, 2013.

[26]"Goldman Union Deal Lets Blankfein Keep Dual Roles," Reuters, April 11, 2013.

[27]W. G. Lewellen, C. Eoderer, and A. Rosenfeld, "Merger Decisions and Executive Stock Ownership in Acquiring Firms," *Journal of Accounting and Economics* 7 (1985): 209–231.

[28]C. W. L. Hill and S. A. Snell, "External Control, Corporate Strategy, and Firm Performance," *Strategic Management Journal* 9 (1988): 577–590.

[29]The phenomenon of back dating stock options was uncovered by academic research, and then picked up by the SEC. See Erik Lie, "On the Timing of CEO Stock Option Awards," *Management Science* 51 (2005): 802–812.

[30]G. Colvin, "A Study in CEO Greed," *Fortune*, June 12, 2006, pp. 53–55.

[31]J. P. Walsh and R. D. Kosnik, "Corporate Raiders and Their Disciplinary Role in the Market for Corporate Control," *Academy of Management Journal* 36 (1993): 671–700.

[32]R. S. Kaplan and D. P. Norton, "The Balanced Scorecard—Measures That Drive Performance," *Harvard Business Review,* January–February 1992, pp. 71–79; and Kaplan and Norton, *Strategy Maps* (Boston: Harvard Business School Press, 2004).

[33]R. S. Kaplan and D. P. Norton, "Using the Balanced Scorecard as a Strategic Management System," *Harvard Business Review,* January–February 1996, pp. 75–85; and Kaplan and Norton, *Strategy Maps*.

[34]Kaplan and Norton, "The Balanced Scorecard," p. 72.

[35]"Timet, Boeing Settle Lawsuit," *Metal Center News* 41 (June 2001): 38–39.

[36]Joseph Kahn, "Ruse in Toyland: Chinese Workers Hidden Woe," *New York Times,* December 7, 2003, pp. A1, A8.

[37]N. King, "Halliburton Tells the Pentagon Workers Took Iraq Deal Kickbacks," *Wall Street Journal,* 2004, p. A1; "Whistleblowers Say Company Routinely Overcharged," *Reuters,* February 12, 2004; and R. Gold and J. R. Wilke, "Data Sought in Halliburton Inquiry," *Wall Street Journal*, 2004, p. A6.

[38]L. Jieqi and Z. Hejuan, "Siemens Bribery Scandal Ends in Death Sentence," *Caixin Online*, June 30, 2011.

[39]Saul W. Gellerman, "Why Good Managers Make Bad Ethical Choices," *Ethics in Practice: Managing the Moral Corporation*, ed. Kenneth R. Andrews (Harvard Business School Press, 1989).

[40]Ibid.

[41]S. Hopkins, "How Effective Are Ethics Codes and Programs?" *Financial Executive*, March 2013.

[42]Can be found on Unilever's website, www.unilever.com/company/ourprinciples/.

[43]www.utc.com/governance/ethics.

Implementing Strategy in Companies That Compete in a Single Industry

© iStockPhoto.com/Chepko Danil

LEARNING OBJECTIVES

After reading this chapter, you should be able to:

12-1 Understand how organizational design requires managers to select the right combination of organizational structure, control, and culture

12-2 Discuss how effective organizational design enables a company to increase product differentiation, reduce its cost structure, and build competitive advantage

12-3 Explain why it is so important that managers keep the organizational hierarchy as flat as possible and what factors determine the way they decide to centralize or decentralize authority

12-4 Explain the many advantages of a functional structure and why and when it becomes necessary to utilize a more complex form of organizational structure

12-5 Differentiate between the more complex forms of organizational structures managers adopt to implement specific kinds of business-level strategies

OPENING CASE

© iStockPhoto.com/JGYI NSEA

Organization at Apple

Apple has a legendary ability to produce a steady stream of innovative new products and product improvements that are differentiated by design elegance and ease of use. Product innovation is in many ways the essence of what the company has always done, and what it strives to continue doing. Innovation at Apple began with the Apple II in 1979. The original Macintosh computer, the first personal computer (PC) to use a graphical user interface, a mouse, and onscreen icons, followed in 1984. After founder and former CEO the late Steve Jobs returned to the company in 1997, the list of notable innovations expanded to include the iPod and iTunes, the Mac Airbook, the iPhone, the Apple App store, and the iPad. Apple's ability to continue to innovate, and to improve its existing product offerings, is in large part a result of its organizational structure, controls, and culture.

Unlike most companies of its size, Apple has a functional structure. The people reporting directly to current CEO Tim Cook include the senior vice presidents of operations, Internet software and services, industrial design, software engineering, hardware engineering, and worldwide marketing, along with the CFO and

company general council. This group meets every Monday morning to review the strategy of the company, its operations, and ongoing product development efforts.

The industrial design group takes the lead on new-product development efforts, dictating the look and feel of a new product, and the materials that must be used. The centrality of industrial design is unusual—in most companies engineers first develop products, with industrial design coming into the picture quite late in the process. The key role played by industrial design at Apple, however, is consistent with the company's mission of designing beautiful products that change the world. The industrial design group works closely with hardware and software engineering to develop features and functions for each new product, with operations to ensure that manufacturing can be rapidly scaled up following a product launch, and with worldwide marketing to plan the product launch strategy.

Thus, product development at Apple is a cross-functional effort that requires intense coordination. This coordination is achieved through a centralized command and control structure, with the top-management group driving collaboration and the industrial design group setting key parameters. During his long tenure as CEO, Steve Jobs was well known for clearly articulating who was responsible for what in the product development process, and for holding people accountable if they failed to meet his high standards. His management style could be unforgiving and harsh—there are numerous stories of people

being fired on the spot for failing to meet his standards—but it did get the job done.

Even though Jobs passed away in 2011, the focus on accountability persists at Apple. Each task is given a "directly responsible individual," or DRI in "Apple-speak." Typically, the DRI's name will appear on an agenda for a meeting, so everyone knows who is responsible. Meetings at Apple have an action list, and next to each action item will be a DRI. By such clear control processes, Apple pushes accountability down deep within the ranks.

A key feature of the culture of Apple is the secrecy surrounding much of what the company does. Not only is information that reaches the outside world tightly controlled, so is the flow of information within the company. Many employees are kept in the dark about new-product development efforts and frequently do not know what people in other parts of the company are working on. Access to buildings where teams are developing new products or features is tightly controlled, with only team members allowed in. Cameras monitor sensitive workspaces to make sure that this is not violated. Disclosing what the company is doing to an outside source, or an unauthorized inside source, is grounds for termination—something that all employees are told when they join the company. The idea is to keep new products under very tight wraps until launch day. Apple wants to control the message surrounding new products. It does not want to give the competition time to respond, or media critics time to bash ideas under development, rather than actual products.

Sources: J. Tyrangiel, "Tim Cook's Freshman Year: The Apple CEO Speaks," *Bloomberg Businessweek*, December 6, 2012; A. Lashinsky, "The Secrets Apple Keeps," *CNNMoney*, January 10, 2012; and B. Stone, "Apple's Obsession with Secrecy Grows Stronger," *New York Times*, June 23, 2009.

OVERVIEW

As the story of Apple suggests, organizational structure and culture can have a direct effect on a company's profits. Apple's functional organization, the tight coordination between functions, the strong power vested in the industrial design function, the tradition of responsibility and accountability at the level of individual tasks, and a culture that keeps

new product ideas under wraps until they hit the market all come together to support the company's goal of producing revolutionary new products that surprise and change the world. In other words, Apple's organizational structure and culture supports the company's strategy of differentiation through product innovation.

This chapter examines how managers can best implement their strategies through their organization's structure and culture to achieve a competitive advantage and superior performance. A well-thought-out strategy becomes profitable only if it can be implemented successfully. In practice, however, implementing strategy through structure and culture is a difficult, challenging, and never-ending task. Managers cannot create an organizing framework for a company's value-chain activities and assume it will keep working efficiently and effectively over time—just as they cannot select strategies and assume that these strategies will still be effective in the future—in a changing competitive environment.

We begin by discussing the primary elements of organizational design and the way these elements work together to create an organizing framework that allows a company to implement its chosen strategy. We also discuss how strategic managers can use structure, control, and culture to pursue functional-level strategies that create and build distinctive competencies. We will also discuss the implementation issues facing managers in a single industry at the industry level. The next chapter examines strategy implementation across industries and countries—that is—corporate and global strategy. By the end of this chapter and the next, you will understand why the fortunes of a company often rest on its managers' ability to design and manage its structure, control systems, and culture to best implement its business model.

IMPLEMENTING STRATEGY THROUGH ORGANIZATIONAL DESIGN

Strategy implementation involves the use of **organizational design**, the process of deciding how a company should create, use, and combine organizational structure, control systems, and culture to pursue a business model successfully. **Organizational structure** assigns employees to specific value creation tasks and roles and specifies how these tasks and roles are to work together in a way that increases efficiency, quality, innovation, and responsiveness to customers—the distinctive competencies that build competitive advantage. The purpose of organizational structure is to *coordinate and integrate* the efforts of employees at all levels—corporate, business, and functional—and across a company's functions and business units so that all levels work together in a way that will allow the company to achieve the specific set of strategies in its business model.

Organizational structure does not, by itself, provide the set of incentives through which people can be *motivated* to make the company work. Hence, there is a need for control systems. The purpose of a **control system** is to provide managers with (1) a set of incentives to motivate employees to work toward increasing efficiency, quality, innovation, and responsiveness to customers and (2) specific feedback on how well an organization and its members are performing and building competitive advantage so that managers can continuously take action to strengthen a company's business model. Structure provides an organization with a skeleton; control gives it the muscles, sinews, nerves, and sensations that allow managers to regulate and govern its activities.

Organizational culture, the third element of organizational design, is the specific collection of values, norms, beliefs, and attitudes that are shared by people and groups in an organization and that control the way they interact with each other and with stakeholders outside

organizational design
The process of deciding how a company should create, use, and combine organizational structure, control systems, and culture to pursue a business model successfully.

organizational structure
The means through which a company assigns employees to specific tasks and roles and specifies how these tasks and roles are to be linked together to increase efficiency, quality, innovation, and responsiveness to customers.

control system
Provides managers with incentives for employees as well as feedback on how the company performs.

organizational culture
The specific collection of values, norms, beliefs, and attitudes that are shared by people and groups in an organization and that control the way they interact with each other and with stakeholders outside the organization.

Figure 12.1 Implementing Strategy through Organizational Design

© Cengage Learning

the organization.[1] Organizational culture is a company's way of doing something: it describes the characteristic ways—"this is the way we do it around here"—in which members of an organization get the job done. Top managers, because they can influence which kinds of beliefs and values develop in an organization, are an important determinant of how organizational members will work toward achieving organizational goals, as we discuss later.[2]

Figure 12.1 sums up what has been discussed in this chapter. Organizational structure, control, and culture are the means by which an organization motivates and coordinates its members to work toward achieving the building blocks of competitive advantage.

Top managers who wish to find out why it takes a long time for people to make decisions in a company, why there is a lack of cooperation between sales and manufacturing, or why product innovations are few and far between, need to understand how the design of a company's structure and control system, and the values and norms in its culture, affect employee motivation and behavior. *Organizational structure, control, and culture shape people's behaviors, values, and attitudes and determine how they will implement an organization's business model and strategies.*[3] On the basis of such an analysis, top managers can devise a plan to reorganize or change their company's structure, control systems, and culture to improve coordination and motivation. Effective organizational design allows a company to obtain a competitive advantage and achieve above-average profitability.

BUILDING BLOCKS OF ORGANIZATIONAL STRUCTURE

After formulating a company's business model and strategies, managers must make designing an organizational structure their next priority. The value creation activities of organizational members are meaningless unless some type of structure is used to assign people to tasks and connect the activities of different people and functions.[4] Managers must make three basic choices:

1. How best to group tasks into functions and to group functions into business units or divisions to create distinctive competencies and pursue a particular strategy.

2. How to allocate authority and responsibility to these functions and divisions.
3. How to increase the level of coordination or integration between functions and divisions as a structure evolves and becomes more complex.

We first discuss basic issues and then revisit them when considering appropriate choices of structure at different levels of strategy.

Grouping Tasks, Functions, and Divisions

Because an organization's tasks are, to a large degree, a function of its strategy, the dominant view is that companies choose a form of structure to match their organizational strategy. Perhaps the first person to address this issue formally was Harvard business historian Alfred D. Chandler.[5] After studying the organizational problems experienced in large U.S. corporations such as DuPont and GM as they grew in the early decades of the 20th century, Chandler reached two conclusions: (1) in principle, organizational structure follows the range and variety of tasks that the organization chooses to pursue and (2) the structures of U.S. companies' change as their strategies change in a predictable way over time.[6] In general, this means that most companies first group people and tasks into functions and then functions into divisions.[7]

As we discussed earlier, a *function* is a collection of people who work together and perform the same types of tasks or hold similar positions in an organization.[8] For example, the salespeople in a car dealership belong to the sales function. Together, car sales, car repair, car parts, and accounting are the set of functions that allow a car dealership to sell and maintain cars.

As organizations grow and produce a wider range of products, the amount and complexity of the *handoffs*—that is, the work exchanges or transfers among people, functions, and subunits—increase. The communications and measurement problems and the managerial inefficiencies surrounding these transfers or handoffs are a major source of *bureaucratic costs*, which we discussed in Chapter 10. Recall that these are the costs associated with monitoring and managing the functional exchanges necessary to add value to a product as it flows along a company's value chain to the final customer.[9] We discuss why bureaucratic costs increase as companies pursue more complex strategies later in the chapter.

For now, it is important to note that managers first group tasks into functions, and second, group functions into a business unit or division, to reduce bureaucratic costs. A *division* is a way of grouping functions to allow an organization to better produce and transfer its goods and services to customers. In developing an organizational structure, managers must decide how to group an organization's activities by function and division in a way that achieves organizational goals effectively.[10]

Top managers can choose from the many kinds of structures to group their activities. The choice is made on the basis of the structure's ability to successfully implement the company's business models and strategies.

Allocating Authority and Responsibility

As organizations grow and produce a wider range of goods and services, the size and number of their functions and divisions increase. The number of handoffs, or transfers, between employees also increases. To economize on bureaucratic costs and effectively coordinate the activities of people, functions, and divisions, managers must develop a clear and unambiguous **hierarchy of authority**, or chain of command, that defines each manager's

hierarchy of authority
The clear and unambiguous chain of command that defines each manager's relative authority from the CEO down through top, middle, to first-line managers.

span of control
The number of subordinates reporting directly to a particular manager.

relative authority beginning with the CEO, continuing through middle managers and first-line managers, and then to the employees who directly make goods or provide services.[11] Every manager, at every level of the hierarchy, supervises one or more subordinates. The term **span of control** refers to the number of subordinates who report directly to a manager. When managers know exactly what their authority and responsibilities are, information distortion problems that promote managerial inefficiencies are kept to a minimum, and handoffs or transfers can be negotiated and monitored to economize on bureaucratic costs. For example, managers are less likely to risk invading another manager's turf and can avoid the costly conflicts that inevitably result from such encroachments.

Tall and Flat Organizations Companies choose the number of hierarchical levels they need on the basis of their strategies and the functional tasks necessary to create distinctive competencies.[12] As an organization grows in size or complexity (measured by the number of its employees, functions, and divisions), its hierarchy of authority typically lengthens, making the organizational structure "taller." A *tall structure* has many levels of authority relative to company size; a *flat structure* has fewer levels relative to company size (see Figure 12.2). As the hierarchy becomes taller, problems that make the organization's structure less flexible and slow managers' response to changes in the competitive environment may result. It is vital that managers understand how these problems arise so they know how to change a company's structure to respond accordingly.

First, communication problems may arise. When an organization has many levels in the hierarchy, it can take a long time for the decisions and orders of top managers to reach other managers in the hierarchy, and it can take a long time for top managers to learn how well

Figure 12.2	Tall and Flat Structures

Tall Structure
(8 levels)

Flat Structure
(3 levels)

© Cengage Learning

the actions based upon their decisions work. Feeling out of touch, top managers may want to verify that lower-level managers are following orders and may require written confirmation from them. Lower-level managers, who know they will be held strictly accountable for their actions, start devoting more time to the process of making decisions to improve their chances of being right. They might even try to avoid responsibility by making top managers decide what actions to take.

A second communication problem that can result is the distortion of commands and orders as they are transmitted up and down the hierarchy, which causes managers at different levels to interpret what is happening in their own unique way. Accidental distortion of orders and messages occurs when different managers interpret messages from their own narrow functional perspectives. Intentional distortion can occur when managers lower in the hierarchy decide to interpret information in a way that increases their own personal advantage.

Tall hierarchies usually indicate that an organization is employing too many expensive managers, creating a third problem. Managerial salaries, benefits, offices, and secretaries are a huge expense for organizations. Large companies such as IBM, Ford, and Google pay their managers billions of dollars per year. In the recent recession, millions of middle and lower managers were laid off as companies strived to survive by reorganizing and simplifying their structures, and downsizing their workforce to reduce their cost structure.

The Minimum Chain of Command To avoid the problems that result when an organization becomes too tall and employs too many managers, top managers need to ascertain whether they are employing the right number of top, middle, and first-line managers, and see whether they can redesign their hierarchies to reduce the number of managers. Top managers might follow a basic organizing principle: the **principle of the minimum chain of command**, which states that a company should choose the hierarchy with the *fewest* levels of authority necessary to use organizational resources efficiently and effectively.

principle of the minimum chain of command
The principle that a company should design its hierarchy with the fewest levels of authority necessary to use organizational resources effectively.

Effective managers constantly scrutinize their hierarchies to see whether the number of levels can be reduced—for example, by eliminating one level and giving the responsibilities of managers at that level to managers above, while empowering employees below. This practice has become increasingly common as companies battle with low-cost overseas competitors and search for ways to reduce costs. Many well-known managers such as Alan Mulally continually strive to empower employees and keep the hierarchy as flat as possible; their message is that employees should feel free to go above and beyond their prescribed roles to find ways to better perform their job tasks.

When companies become too tall, and the chain of command too long, strategic managers tend to lose control over the hierarchy, which means they lose control over their strategies. Disaster often follows because a tall organizational structure decreases, rather than promotes, motivation and coordination between employees and functions, and bureaucratic costs escalate as a result. Strategy in Action 12.1 discusses how this happened at Walt Disney.

Centralization or Decentralization? One important way to reduce the problems associated with too-tall hierarchies and reduce bureaucratic costs is to *decentralize authority*—that is, vest authority in managers at lower levels in the hierarchy as well as at the top. Authority is *centralized* when managers at the upper levels of a company's hierarchy retain the authority to make the most important decisions. When authority is decentralized, it is delegated to divisions, functions, and employees at lower levels in the company. Delegating authority in this fashion reduces bureaucratic costs because it avoids the communication and coordination problems that arise when information is sent up the hierarchy, sometimes to the top of

12.1 STRATEGY IN ACTION

© iStockPhoto.com/Tom Nulens

Bob Iger Flattens Walt Disney

When Bob Iger, who had been COO of Disney under its then-CEO Michael Eisner, took control of the troubled Walt Disney company, he decided to immediately act upon a problem he had observed with the way the company was operating. For several years, Disney had been plagued by slow decision making, and analysts claimed it had made many mistakes in putting its new strategies into action. Disney stores were losing money, its Internet properties were not getting many "hits," and even its theme parks seemed to have lost their luster as few new rides or attractions had been introduced.

Iger believed that one of the main reasons for Disney's declining performance was that it had become too tall and bureaucratic, and its top managers were following financial rules that did not lead to innovative strategies. To turn around the performance of the poorly performing company, one of Iger's first decisions was to dismantle Disney's central strategic planning office.

In this office, several levels of managers were responsible for sifting through all the new ideas and innovations suggested by Disney's different business divisions (such as theme parks, movies, gaming) and then deciding which ideas to present to the CEO. Iger saw the strategic planning office as a bureaucratic bottleneck that actually reduced the number of ideas coming from below. He dissolved the office and reassigned its managers to Disney's different business units.

More new ideas are being generated by the different business units as a result of eliminating this unnecessary layer in Disney's hierarchy. The level of innovation has also increased because managers are more willing to speak out and champion ideas when they know they are working directly with the CEO and a top-management team searching for innovative new ways to improve performance rather than a layer of strategic planning "bureaucrats" only concerned for the bottom line.

Source: www.waltdisney.com.

the organization, and then back down again in order for decisions to be made. There are three advantages to decentralization, as discussed next.

First, when top managers delegate operational decision-making responsibility to middle- and first-level managers, they reduce information overload and are able to spend more time on competitively positioning the company and strengthening its business model. Second, when managers in the bottom layers of the company become responsible for implementing strategies to suit local conditions, their motivation and accountability increase. The result is that decentralization promotes flexibility and reduces bureaucratic costs because lower-level managers are authorized to make on-the-spot decisions; handoffs are not needed. The third advantage is that when lower-level employees are given the right to make important decisions, fewer managers are needed to oversee their activities and tell them what to do—a company can flatten its hierarchy.

If decentralization is so effective, why don't all companies decentralize decision making and avoid the problems of tall hierarchies? The answer is that centralization has its advantages, too. Centralized decision making allows for easier coordination of the organizational activities needed to pursue a company's strategy. Thus, we saw in Opening Case that Apple centralizes its product development efforts to ensure tight coordination between industrial design, hardware and software engineering, operations, and marketing. If managers at all levels can make their own decisions, overall planning becomes extremely difficult, and the company may lose control of its decision making.

Centralization also means that decisions fit an organization's broad objectives. When its branch operations managers were getting out of control, for example, Merrill Lynch

increased centralization by installing more information systems to give corporate managers greater control over branch activities. Similarly, the centralization of product development at Apple makes for a very clearly directed strategy. Furthermore, in times of crisis, centralization of authority permits strong leadership because authority is focused upon one person or group. This focus allows for speedy decision making and a concerted response by the whole organization. When Steve Jobs came back to Apple in 1997, for example, he had to quickly execute a turnaround strategy. The centralization of power and authority under Jobs allowed him to make some very quick decisions and effectively save Apple from bankruptcy.

How to choose the right level of centralization for a particular strategy is discussed later. Strategy in Action 12.2 discusses one company that benefits from centralizing authority and one company that benefits from decentralizing authority.

Integration and Integrating Mechanisms

Much coordination takes place among people, functions, and divisions through the hierarchy of authority. Often, however, as a structure becomes complex, this is not enough, and top managers need to use various **integrating mechanisms** to increase communication and coordination among functions and divisions. The greater the complexity of an organization's structure, the greater is the need for coordination among people, functions, and divisions to make the organizational structure work efficiently.[13] We discuss three kinds of integrating mechanisms that illustrate the kinds of issues involved.[14] Once again, these mechanisms are employed to economize on the information distortion problems that commonly arise when managing the handoffs or transfers among the ideas and activities of different people, functions, and divisions.

integrating mechanisms
Ways to increase communication and coordination among functions and divisions.

Direct Contact Direct contact among managers creates a context within which managers from different functions or divisions can work together to solve mutual problems. However, several issues are associated with establishing this contact. Managers from different functions may have different views about what must be done to achieve organizational goals. But if the managers have equal authority (as functional managers typically do), the only manager who can tell them what to do is the CEO. If functional managers cannot reach agreement, no mechanism exists to resolve the conflict apart from the authority of the boss. In fact, one sign of a poorly performing organizational structure is the number of problems sent up the hierarchy for top managers to solve. The need to solve everyday conflicts and hand off or transfer problems raises bureaucratic costs. To reduce such conflicts and solve transfer problems, top managers use more complex integrating mechanisms to increase coordination among functions and divisions.

Liaison Roles Managers can increase coordination among functions and divisions by establishing liaison roles. When the volume of contacts between two functions increases, one way to improve coordination is to give one manager in each function or division the responsibility for coordinating with the other. These managers may meet daily, weekly, monthly, or as needed to solve handoff issues and transfer problems. The responsibility for coordination is part of the liaison's full-time job, and usually an informal relationship forms between the people involved, greatly easing strains between functions. Furthermore, liaison roles provide a way of transmitting information across an organization, which is important in large organizations where employees may know no one outside their immediate function or division.

12.2 STRATEGY IN ACTION

Centralization and Decentralization at Union Pacific and Yahoo!

© iStockPhoto.com/Tom Nulens

Union Pacific (UP), one of the biggest railroad freight carriers in the United States, faced a crisis when an economic boom in the early 2000s led to a record increase in the amount of freight the railroad had to transport. At the same time, the railroad was experiencing record delays in moving this freight. UP's customers complained bitterly about the problem, and the delivery delays cost the company tens of millions of dollars in penalty payments. Why the problem? UP's top managers decided to centralize authority high in the organization and to standardize operations to reduce operating costs. All scheduling and route planning were handled centrally at headquarters to increase efficiency. The job of regional managers was largely to ensure the smooth flow of freight through their regions.

Recognizing that efficiency had to be balanced by the need to be responsive to customers, UP announced a sweeping reorganization. Regional managers would have the authority to make everyday operational decisions; they could alter scheduling and routing to accommodate customer requests even if it raised costs. UP's goal was to "return to excellent performance by simplifying our processes and becoming easier to deal with." In deciding to decentralize authority, UP was following the lead of its competitors that had already decentralized their operations. Its managers would continue to "decentralize decision making into the field, while fostering improved customer responsiveness, operational excellence, and personal accountability." The result has been continued success for the company; in fact, in 2011 several large companies recognized UP as the top railroad in on-time service performance and customer service.

Yahoo! has been forced by circumstances to pursue a different approach to decentralization. In 2009, after Microsoft failed to take over Yahoo! because of the resistance of Jerry Wang, a company founder, the company's stock price plunged. Wang, who had come under intense criticism for preventing

the merger, resigned as CEO and was replaced by Carol Bartz, a manager with a long history of success in managing online companies. Bartz moved quickly to find ways to reduce Yahoo!'s cost structure and simplify its operations to maintain its strong online brand identity. Intense competition from the growing popularity of online companies such as Google, Facebook, and Twitter also threatened its popularity.

Bartz decided the best way to restructure Yahoo! was to recentralize authority. To gain more control over its different business units and reduce operating costs, she decided to centralize functions that had previously been performed by Yahoo!'s different business units, such as product development and marketing activities. For example, all the company's publishing and advertising functions were centralized and placed under the control of a single executive. Yahoo!'s European, Asian, and emerging markets divisions were centralized, and another top executive took control. Bartz's goal was to find out how she could make the company's resources perform better. While she was centralizing authority, she was also holding many "town hall" meetings to ask Yahoo! employees from all functions, "What would you do if you were me?" Even as she centralized authority to help Yahoo! recover its dominant industry position, she was looking for the input of employees at every level in the hierarchy.

Nevertheless, in 2011, Yahoo! was still in a precarious position. It had signed a search agreement with Microsoft to use the latter's search technology, Bing; Bartz had focused on selling off Yahoo!'s noncore business assets to reduce costs and gain the money for strategic acquisitions. But the company was still in an intense battle with other dot-coms that had more resources, such as Google and Facebook, and in September 2011 Bartz was fired by Yahoo!'s board of directors. In October 2011, both Microsoft and Google were reportedly planning to acquire the troubled company for around $20 billion—obviously Yahoo! is still for sale—at the right price.

Source: www.up.com and www.yahoo.com 2011.

Teams When more than two functions or divisions share many common problems, direct contact and liaison roles may not provide sufficient coordination. In these cases, a more complex integrating mechanism, the **team**, may be appropriate. One manager from each relevant function or division is assigned to a team that meets to solve a specific mutual problem; team members are responsible for reporting back to their subunits on the issues addressed and the solutions recommended. Teams are increasingly being used at all organizational levels.

team

Formation of a group that represents each division or department facing a common problem, with the goal of finding a solution to the problem.

STRATEGIC CONTROL SYSTEMS

Managers choose the organizational strategies and structure they hope will allow the organization to use its resources most effectively to pursue its business model and create value and profit. Then they create **strategic control systems**, tools that allow them to monitor and evaluate whether, in fact, their strategies and structure are working as intended, how they could be improved, and how they should be changed if they are not working.

strategic control systems

The mechanism that allows managers to monitor and evaluate whether their business model is working as intended and how it could be improved.

Strategic control is not only about monitoring how well an organization and its members are currently performing, or about how well the firm is using its existing resources. It is also about how to create the incentives to keep employees motivated and focused on the important problems that may confront an organization in the future so that the employees work together and find solutions that can help an organization perform better over time.[15] To understand the vital importance of strategic control, consider how it helps managers obtain superior efficiency, quality, innovation, and responsiveness to customers—the four basic building blocks of competitive advantage:

1. *Control and efficiency.* To determine how *efficiently* they are using organizational resources, managers must be able to accurately measure how many units of inputs (raw materials, human resources, and so on) are being used to produce a unit of output. They must also be able to measure the number of units of outputs (goods and services) they produce. A control system contains the measures or yardsticks that allow managers to assess how efficiently they are producing goods and services. Moreover, if managers experiment to find a more efficient way to produce goods and services, these measures tell managers how successful they have been. Without a control system in place, managers have no idea how well their organizations are performing nor how to perform better in the future—something that is becoming increasingly important in today's highly competitive environment.[16]

2. *Control and quality.* Today, competition often revolves around increasing the *quality* of goods and services. In the car industry, for example, within each price range, cars compete against one another over features, design, and reliability. Whether a customer buys a Ford 500, a GM Impala, a Chrysler 300, a Toyota Camry, or a Honda Accord depends significantly upon the quality of each company's product. Strategic control is important in determining the quality of goods and services because it gives managers feedback on product quality. If managers consistently measure the number of customers' complaints and the number of new cars returned for repairs, they have a good indication of how much quality they have built into their product.

3. *Control and innovation.* Strategic control can help to raise the level of *innovation* in an organization. Successful innovation takes place when managers create an organizational setting in which employees feel empowered to be creative and in which

authority is decentralized to employees so that they feel free to experiment and take risks, such as at 3M and Google. Deciding upon the appropriate control systems to encourage risk taking is an important management challenge. As discussed later in the chapter, an organization's culture becomes important in this regard.

4. *Control and responsiveness to customers.* Finally, strategic managers can help make their organizations more *responsive to customers* if they develop a control system that allows them to evaluate how well employees with customer contact are performing their jobs. Monitoring employees' behavior can help managers find ways to help increase employees' performance level, perhaps by revealing areas in which skills training can help employees, or by finding new procedures that allow employees to perform their jobs more efficiently. When employees know their behaviors are being monitored, they may have more incentive to be helpful and consistent in the way they act toward customers.

Strategic control systems are the formal target-setting, measurement, and feedback systems that allow strategic managers to evaluate whether a company is achieving superior efficiency, quality, innovation, and customer responsiveness and implementing its strategy successfully. An effective control system should have three characteristics. It should be *flexible* enough to allow managers to respond as necessary to unexpected events; it should provide *accurate information*, thus giving a true picture of organizational performance; and it should supply managers with the information in a *timely manner* because making decisions on the basis of outdated information is a recipe for failure.[17] As Figure 12.3 shows, designing an effective strategic control system requires four steps: establishing standards and targets, creating measuring and monitoring systems, comparing performance against targets, and evaluating results.

Figure 12.3 Steps in Designing an Effective Strategic Control System

Established standards and targets.

Create measuring and monitoring systems.

Compare actual performance against the established targets.

Evaluate result and take action if necessary.

© Cengage Learning

Levels of Strategic Control

Strategic control systems are developed to measure performance at four levels in a company: corporate, divisional, functional, and individual. Managers at all levels must develop the most appropriate set of measures to evaluate corporate-, business-, and functional-level performance. As the balanced scorecard approach discussed in Chapter 11 suggests, these measures should be tied as closely as possibly to the goals of developing distinctive competencies in efficiency, quality, innovativeness, and responsiveness to customers. Care must be taken, however, to ensure that the standards used at each level do not cause problems at the other levels—for example, that a division's attempts to improve its performance do not conflict with corporate performance. Furthermore, controls at each level should provide the basis upon which managers at lower levels design their control systems. Figure 12.4 illustrates these relationships.

Types of Strategic Control Systems

In Chapter 11, the balanced scorecard approach was discussed as a way to ensure that managers complement the use of return on invested capital (ROIC) with other kinds of strategic controls to ensure they are pursuing strategies that maximize long-run profitability. In this chapter, we consider three more types of control systems: *personal control, output control,* and *behavior control.*

Figure 12.4	Levels of Organizational Control

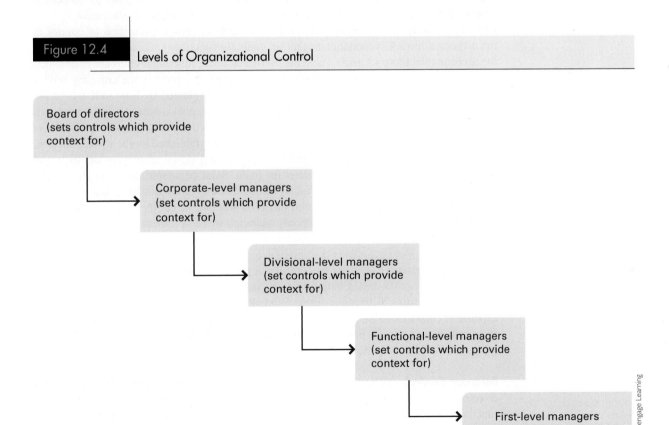

© Cengage Learning

personal control

The way one manager shapes and influences the behavior of another in a face-to-face interaction in the pursuit of a company's goals.

Personal Control **Personal control** is the desire to shape and influence the behavior of a person in a *face-to-face interaction* in the pursuit of a company's goals. The most obvious kind of personal control is direct supervision from a manager farther up in the hierarchy. The personal approach is useful because managers can question subordinates about problems or new issues they are facing to get a better understanding of the situation and to ensure that subordinates are performing their work effectively and that they are not hiding any information that could cause additional problems later. Personal control also can come from a group of peers, such as when people work in teams. Once again, personal control at the group level means that there is more possibility for learning to occur and competencies to develop, as well as greater opportunities to prevent free-riding or shirking.

output control

The control system managers use to establish appropriate performance goals for each division, department, and employee and then measure actual performance relative to these goals.

Output Control **Output control** is a system in which strategic managers estimate or forecast appropriate performance goals for each division, department, and employee, and then measure actual performance relative to these goals. Often a company's reward system is linked to performance on these goals, so output control also provides an incentive structure for motivating employees at all levels in the organization. Goals keep managers informed about how well their strategies are creating a competitive advantage and building the distinctive competencies that lead to future success. Goals exist at all levels in an organization.

Divisional goals state corporate managers' expectations for each division concerning performance on dimensions such as efficiency, quality, innovation, and responsiveness to customers. Generally, corporate managers set challenging divisional goals to encourage divisional managers to create more effective strategies and structures in the future.

Output control at the functional and individual levels is a continuation of control at the divisional level. Divisional managers set goals for functional managers that will allow the division to achieve its goals. As at the divisional level, functional goals are established to encourage the development of generic competencies that provide the company with a competitive advantage, and functional performance is evaluated by how well a function develops a competency. In the sales function, for example, goals related to efficiency (such as cost of sales), quality (such as number of returns), and customer responsiveness (such as the time necessary to respond to customer needs) can be established for the whole function.

Finally, functional managers establish goals that individual employees are expected to achieve to allow the function to meet its goals. Sales personnel, for example, can be given specific goals (related to functional goals) that they are required to achieve. Functions and individuals are then evaluated based on whether or not they are achieving their goals; in sales, compensation is commonly anchored by achievement. The achievement of goals is a sign that the company's strategy is working and meeting the organization's wider objectives.

The inappropriate use of output control can promote conflict among divisions. In general, setting across-the-board output targets, such as ROIC targets for divisions, can lead to destructive results if divisions single-mindedly try to maximize divisional ROIC at the expense of corporate ROIC. Moreover, to reach output targets, divisions may start to distort the numbers and engage in strategic manipulation of the figures to make their divisions look good—which increases bureaucratic costs.[18]

behavior control

Control achieved through the establishment of a comprehensive system of rules and procedures that specify the appropriate behavior of divisions, functions, and people.

Behavior Control **Behavior control** is control achieved through the establishment of a comprehensive system of rules and procedures to direct the actions or behavior of divisions, functions, and individuals.[19] The intent of behavior controls is not to specify the *goals* but to standardize the *way or means* of reaching them. Rules standardize behavior and make

outcomes predictable. If employees follow the rules, then actions are performed and decisions are handled the same way time and time again. The result is predictability and accuracy, the aim of all control systems. The primary kinds of behavior controls are operating budgets, standardization, and rules and procedures.

Once managers at each level have been given a goal to achieve, they establish operating budgets that regulate how managers and workers are to attain those goals. An **operating budget** is a blueprint that outlines how managers intend to use organizational resources to most efficiently achieve organizational goals. Most commonly, managers at one level allocate to managers at a lower level a specific amount of resources to use in the production of goods and services. Once a budget is determined, lower-level managers must decide how they will allocate finances for different organizational activities. Managers are then evaluated on the basis of their ability to stay within the budget and make the best use of it. For example, managers at GE's washing machine division might have a budget of $50 million to develop and sell a new line of washing machines; they must decide how much money to allocate to research and development (R&D), engineering, sales, and so on, to ensure that the division generates the most revenue possible, and hence makes the biggest profit. Most commonly, large companies treat each division as a stand-alone profit center, and corporate managers evaluate each division's performance by its relative contribution to corporate profitability, something discussed in detail in the next chapter.

Standardization refers to the degree to which a company specifies how decisions are to be made so that employees' behavior becomes predictable.[20] In practice, there are three things an organization can standardize: *inputs, conversion activities*, and *outputs.*

When managers standardize, they screen *inputs* according to preestablished criteria, or standards that determine which inputs to allow into the organization. If employees are the input, for example, then one way of standardizing them is to specify which qualities and skills they must possess, and only selecting applicants who possess those qualities. If the inputs are raw materials or component parts, the same considerations apply. The Japanese are renowned for the high quality and precise tolerances they demand from component parts to minimize problems with the product at the manufacturing stage. Just-in-time (JIT) inventory systems also help standardize the flow of inputs.

The aim of standardizing *conversion activities* is to program work activities so that they can be done the same way time and time again; the goal is predictability. Behavior controls, such as rules and procedures, are among the chief means by which companies can standardize throughputs. Fast-food restaurants such as McDonald's and Burger King standardize all aspects of their restaurant operations; the result is consistent fast food.

The goal of standardizing *outputs* is to specify what the performance characteristics of the final product or service should be—the dimensions or tolerances the product should conform to, for example. To ensure that their products are standardized, companies apply quality control and use various criteria to measure this standardization. One criterion might be the number of goods returned from customers, or the number of customer complaints. On production lines, periodic sampling of products can indicate whether they are meeting performance characteristics.

As with other kinds of controls, the use of behavior control is accompanied by potential pitfalls that must be managed if the organization is to avoid strategic problems. Top management must be careful to monitor and evaluate the usefulness of behavior controls over time. Rules constrain people and lead to standardized, predictable behavior. However, rules are always easier to establish than to get rid of, and over time the number of rules an organization uses tends to increase. As new developments lead to additional rules, often the old rules are not discarded, and the company becomes overly bureaucratized. Consequently, the

operating budget
A blueprint that states how managers intend to use organizational resources to most efficiently achieve organizational goals.

standardization
The degree to which a company specifies how decisions are to be made so that employees' behavior becomes measurable and predictable.

organization and the people within it become inflexible and are slow to react to changing or unusual circumstances. Such inflexibility can reduce a company's competitive advantage by lowering the pace of innovation and reducing its responsiveness to customers.

Strategic Reward Systems

Organizations strive to control employees' behavior by linking reward systems to their control systems.[21] Based on a company's strategy (cost leadership or differentiation, for example), strategic managers must decide which behaviors to reward. They then create a control system to measure these behaviors and link the reward structure to them. Determining how to relate rewards to performance is a crucial strategic decision because it determines the incentive structure that affects the way managers and employees behave at all levels in the organization. As Chapter 11 pointed out, top managers can be encouraged to work on behalf of shareholders' interests when rewarded with stock options linked to a company's long-term performance. Companies such as GM require managers to purchase company stock. When managers become shareholders, they are more motivated to pursue long-term rather than short-term goals. Similarly, in designing a pay system for sales-people, the choice is whether to motivate them through salary alone, or salary plus a bonus based on how much they sell. Neiman Marcus, the luxury retailer, pays employees only salary because it wants to encourage high-quality service and discourage a hard-sell approach. Thus, there are no incentives based on quantities sold. On the other hand, the pay system for rewarding car salespeople encourages high-pressure selling; it typically contains a large bonus based on the number and price of cars sold.

ORGANIZATIONAL CULTURE

The third element of successful strategy implementation is managing *organizational culture*, the specific collection of values and norms shared by people and groups in an organization.[22] Organizational values are beliefs and ideas about what kinds of goals the members of an organization should pursue and about the appropriate kinds or standards of behavior organizational members should use to achieve these goals. Microsoft founder Bill Gates is famous for the set of organizational values that he created for Microsoft: entrepreneurship, ownership, creativity, honesty, frankness, and open communication. By stressing entrepreneurship and ownership, he strives to get his employees to feel that Microsoft is not one big bureaucracy but a collection of smaller companies run by the members. Gates emphasizes that lower-level managers should be given autonomy and encouraged to take risks—to act like entrepreneurs, not corporate bureaucrats.[23]

From organizational values develop organizational norms, guidelines, or expectations that prescribe appropriate kinds of behavior by employees in particular situations and control the behavior of organizational members toward one another. Behavioral norms for software programmers at Microsoft include working long hours to ship products, wearing whatever clothing is comfortable (but never a suit and tie), consuming junk food, and communicating with other employees using the company's state-of-the-art communications products such as SharePoint.

Organizational culture functions as a kind of control because strategic managers can influence the kind of values and norms that develop in an organization—values and norms that specify appropriate and inappropriate behaviors, and that shape and influence the way

its members behave.[24] Strategic managers such as Gates deliberately cultivate values that tell their subordinates how they should perform their roles; at 3M and Google innovation and creativity are stressed. These companies establish and support norms that tell employees they should be innovative and entrepreneurial and should experiment even if there is a significant chance of failure.

Other managers might cultivate values that tell employees they should always be conservative and cautious in their dealings with others, consult with their superiors before they make important decisions, and record their actions in writing so they can be held accountable for what happens. Managers of organizations such as chemical and oil companies, financial institutions, and insurance companies—any organization in which great caution is needed—may encourage a conservative, vigilant approach to decision making.[25] In a bank or mutual fund, for example, the risk of losing investors' money makes a cautious approach to investing highly appropriate. Thus, we might expect that managers of different kinds of organizations will deliberately attempt to cultivate and develop the organizational values and norms that are best suited to their strategy and structure.

Organizational socialization is the term used to describe how people learn organizational culture. Through socialization, people internalize and learn the norms and values of the culture so that they become organizational members.[26] Control through culture is so powerful that once these values have been internalized, they become part of the individual's values, and the individual follows organizational values without thinking about them.[27] Often the values and norms of an organization's culture are transmitted to its members through the stories, myths, and language that people in the organization use, as well as by other means.

Culture and Strategic Leadership

Strategic leadership is also provided by an organization's founder and top managers, who help create its organizational culture. The organization's founder is particularly important in determining culture because the founder imprints his or her values and management style on the organization. Walt Disney's conservative influence on the company he established continued well after his death. In the past, managers were afraid to experiment with new forms of entertainment because they were afraid "Walt Disney wouldn't like it." It wasn't until the installation of a new management team under Michael Eisner that the company turned around its fortunes, which allowed it to deal with the realities of the new entertainment industry.

The founder's established leadership style is transmitted to the company's managers; as the company grows, it typically attracts new managers and employees who share the same values. Moreover, members of the organization typically recruit and select only those who share their values. Thus, a company's culture becomes more distinct as its members become more similar. The virtue of these shared values and common culture is that they *increase integration and improve coordination among organizational members.* For example, the common language that typically emerges in an organization when people share the same beliefs and values facilitates cooperation among managers. Similarly, rules and procedures and direct supervision are less important when shared norms and values control behavior and motivate employees. When organizational members buy into cultural norms and values, they feel a bond with the organization and are more committed to finding new ways to help it succeed. The Running Case profiles the way in which Walmart's founder Sam Walton built a strong culture.

FOCUS ON: Wal-Mart

How Sam Walton Shaped Wal-Mart's Culture

© iStockPhoto.com/caracterdesign

Walmart, headquartered in Bentonville, Arkansas, is the largest retailer in the world. In 2012, it sold more than $440 billion worth of products. A large part of Walmart's success is due to the nature of the culture that its founder, the late Sam Walton, established for the company. Walton wanted all his managers and workers to take a hands-on approach to their jobs and be committed to Walmart's primary goal, which he defined as total customer satisfaction. To motivate his employees, Walton created a culture that gave all employees, called "associates," continuous feedback about their performance and the company's performance.

To involve his associates in the business and encourage them to develop work behaviors focused on providing quality customer service, Walton established strong cultural values and norms for his company. One of the norms associates are expected to follow is the "10-foot attitude." This norm encourages associates, in Walton's words, to "promise that whenever you come within 10 feet of a customer, you will look him in the eye, greet him, and ask him if you can help him." The "sundown rule" states that employees should strive to answer customer requests by sundown of the day they are made. The Walmart cheer ("Give me a W, give me an A," and so on) is used in all its stores.

The strong customer-oriented values that Walton has created are exemplified in the stories Walmart members tell one another about associates' concern for customers. They include stories such as the one about Sheila, who risked her own safety when she jumped in front of a car to prevent a little boy from being struck; about Phyllis, who administered cardiopulmonary resuscitation (CPR) to a customer who had suffered a heart attack in her store; and about Annette, who gave up the Power Ranger she had on layaway for her own son to fulfill the birthday wish of a customer's son. The strong Walmart culture helps to control and motivate employees to achieve the stringent output and financial targets the company sets.

A notable way Walmart builds its culture is through its annual stockholders' meeting, its extravagant ceremony celebrating the company's success. Every year, Walmart flies thousands of its highest-performing associates to an annual meeting at its corporate headquarters in Arkansas for entertainment featuring famous singers, rock bands, and comedians. Walmart feels that expensive entertainment is a reward its employees deserve and that the event reinforces the company's high-performance values and culture. The proceedings are also broadcast live to all Walmart stores so that all employees can celebrate the company's achievements together.

Since Sam Walton's death, the public attention's to Walmart, which has more than 2 million employees, has revealed the "hidden side" of its culture. Critics claim that few Walmart employees receive reasonably priced health care or other benefits, and that the company pays employees at little above the minimum wage. They also contend that employees do not question these policies because managers have convinced them into believing that this has to be the case—that the only way Walmart can keep its prices low is by keeping their pay and benefits low. Walmart has been forced to respond to these issues and to public pressure as well as lawsuits. Not only has it paid billions of dollars of fines to satisfy the claims of employees who have been discriminated against, it has also been forced to offer many of its employees increased health benefits—although it is constantly searching for ways to reduce these benefits and make its employees pay a higher share of their costs.

Source: www.walmart.com.

Strategic leadership also affects organizational culture through the way managers design organizational structure—that is, the way they delegate authority and divide task relationships. Thus, the way an organization designs its structure affects the cultural norms and values that develop within the organization. Managers need to be aware of this fact when implementing their strategies. Michael Dell, for example, has always kept his company's structure as flat as possible. He has decentralized authority to lower-level managers and

employees to make them responsible for getting as close to the customer as possible. As a result, he has created a cost-conscious customer service culture at Dell, and employees strive to provide high-quality customer service.

Traits of Strong and Adaptive Corporate Cultures

Few environments are stable for a prolonged period of time. If an organization is to survive, managers must take actions that enable it to adapt to environmental changes. If they do not take such action, they may find themselves faced with declining demand for their products.

Managers can try to create an **adaptive culture**, one that is innovative and that encourages and rewards middle- and lower-level managers for taking initiative.[28] Managers in organizations with adaptive cultures are able to introduce changes in the way the organization operates, including changes in its strategy and structure that allow it to adapt to changes in the external environment. Organizations with adaptive cultures are more likely to survive in a changing environment and should have higher performance than organizations with inert cultures.

Several scholars have tried to uncover the common traits that strong, adaptive corporate cultures share, to find out whether there is a particular set of values that dominates adaptive cultures not present in weak or inert ones. An early but still influential attempt is T. J. Peters and R. H. Waterman's account of the values and norms characteristic of successful organizations and their cultures.[29] They argue that adaptive organizations show three common value sets. First, successful companies have values promoting a *bias for action*. The emphasis is on autonomy and entrepreneurship, and employees are encouraged to take risks—for example, to create new products—despite that there is no assurance that these products will be popular. Managers are closely involved in the day-to-day operations of the company and do not simply make strategic decisions isolated in some ivory tower. Employees have a hands-on, value-driven approach.

The second set of values stems from the *nature of the organization's mission*. The company must continue to do what it does best and develop a business model focused on its mission. A company can easily divert and pursue activities outside its area of expertise because other options seem to promise a quick return. Management should cultivate values so that a company "sticks to its knitting," which means strengthening its business model. A company must also establish close relationships with customers as a way of improving its competitive position. After all, who knows more about a company's performance than those who use its products or services? By emphasizing customer-oriented values, organizations are able to identify customer needs and improve their ability to develop products and services that customers desire. All of these management values are strongly represented in companies such as McDonald's, Walmart, and Toyota, each of which is sure of its mission and continually take steps to maintain it.

The third set of values determines *how to operate the organization*. A company should attempt to establish an organizational design that will motivate employees to perform best. Inherent in this set of values is the belief that productivity is obtained through people and that respect for the individual is the primary means by which a company can create the right atmosphere for productive behavior. An emphasis on entrepreneurship and respect for the employee leads to the establishment of a structure that gives employees the latitude to make decisions and motivates them to succeed. Because a simple structure and a lean staff best fit this situation, the organization should be designed with only the number of managers and hierarchical levels necessary to get the job done. The organization should

adaptive culture
A culture that is innovative and encourages and rewards middle- and lower-level managers for taking the initiative to achieve organizational goals.

also be sufficiently decentralized to permit employees' participation but centralized enough for management to ensure that the company pursues its strategic mission and that cultural values are followed.

In summary, these three primary sets of values are at the center of an organization's culture, and management transmits and maintains these values through strategic leadership. Strategy implementation continues as managers build strategic control systems that help perpetuate a strong adaptive culture, further the development of distinctive competencies, and provide employees with the incentive to build a company's competitive advantage. Finally, organizational structure contributes to the implementation process by providing the framework of tasks and roles that reduces transaction difficulties and allows employees to think and behave in ways that enable a company to achieve superior performance.

BUILDING DISTINCTIVE COMPETENCIES AT THE FUNCTIONAL LEVEL

In this section, we discuss the issue of creating specific kinds of structures, control systems, and cultures to implement a company's business model. The first level of strategy to examine is the functional level because, as Chapters 3 and 4 discussed, a company's business model is implemented through the functional strategies managers adopt to develop the distinctive competencies that allow a company to pursue a particular business model.[30] What is the best kind of structure to use to group people and tasks to build competencies? The answer for most companies is to group them by function and create a functional structure.

Functional Structure: Grouping by Function

In the quest to deliver a final product to the customer, two related value-chain-management problems increase. First, the range of value-chain activities that must be performed expands, and it quickly becomes clear that a company lacks the expertise needed to perform these activities effectively. For example, in a new company, the expertise necessary to effectively perform activities is lacking. It becomes apparent, perhaps, that the services of a professional accountant, a production manager, or a marketing expert are needed to take control of specialized tasks as sales increase. Second, it also becomes clear that a single person cannot successfully perform more than one value-chain activity without becoming overloaded. The new company's founder, for instance, who may have been performing many value-chain activities simultaneously, realizes that he or she can no longer make and sell the product. As most entrepreneurs discover, they must decide how to group new employees to perform the various value-chain activities most efficiently. Most choose the functional structure.

Functional structures group people on the basis of their common expertise and experience or because they use the same resources.[31] For example, engineers are grouped in a function because they perform the same tasks and use the same skills or equipment. Figure 12.5 shows a typical functional structure. Each of the rectangles represents a different functional specialization—R&D, sales and marketing, manufacturing, and so on—and each function concentrates upon its own specialized task.[32]

functional structure
Grouping of employees on the basis of their common expertise and experience or because they use the same resources.

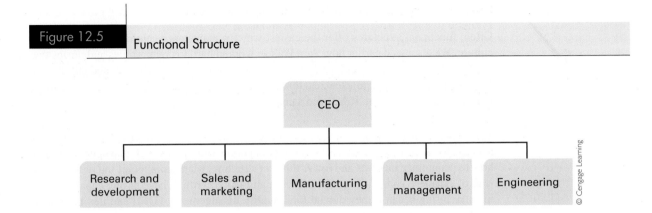

Figure 12.5 Functional Structure

Functional structures have several advantages. First, if people who perform similar tasks are grouped together, they can learn from one another and become more specialized and productive at what they do. This can create capabilities and competencies in each function. Second, they can monitor each other to make sure that all are performing their tasks effectively and not shirking their responsibilities. As a result, the work process becomes more efficient by reducing manufacturing costs and increasing operational flexibility. A third important advantage of functional structures is that they give managers greater control of organizational activities. As already noted, many difficulties arise when the number of levels in the hierarchy increases. If people are grouped into different functions, each with their own managers, then *several different hierarchies are created*, and the company can avoid becoming too tall. There will be one hierarchy in manufacturing, for example, and another in accounting and finance. Managing a business is much easier when different groups specialize in different organizational tasks and are managed separately.

The Role of Strategic Control

An important element of strategic control is to design a system that sets ambitious goals and targets for all managers and employees and then develops performance measures that *stretch and encourage managers and employees* to excel in their quest to raise performance. A functional structure promotes this goal because it increases the ability of managers and employees to monitor and make constant improvements to operating procedures. The structure also encourages organizational learning because managers working closely with subordinates can mentor them and help develop their technical skills.

Grouping by function also makes it easier to apply output control. Measurement criteria can be developed to suit the needs of each function to encourage members to stretch themselves. Each function knows how well it is contributing to overall performance and the part it plays in reducing the cost of goods sold or the gross margin. Managers can look closely to see if they are following the principle of the minimum chain of command and whether or not they need several levels of middle managers. Perhaps, instead of using middle managers, they could practice **management by objectives**, a system in which employees are encouraged to help set their own goals so that managers *manage by exception*, intervening only when they sense something is not going right. Given this increase in control, a functional structure also makes it possible to institute an effective strategic reward system in which pay can be closely linked to performance, and managers can accurately assess the value of each person's contributions.

management by objectives

A system in which employees are encouraged to help set their own goals so that managers *manage by exception*, intervening only when they sense something is not going right.

Developing Culture at the Functional Level

Often, functional structures offer the easiest way for managers to build a strong, cohesive culture. We discussed earlier how Sam Walton worked hard to create values and norms that are shared by Walmart's employees. To understand how structure, control, and culture can help create distinctive competencies, think about how they affect the way these three functions operate: production, R&D, and sales.

Production In production, functional strategy usually centers upon improving efficiency and quality. A company must create an organizational setting in which managers can learn how to economize on costs and lower the cost structure. Many companies today follow the lead of Japanese companies such as Toyota and Honda, which have strong capabilities in manufacturing because they pursue total quality management (TQM) and flexible manufacturing systems (see Chapter 4).

When pursuing TQM, the inputs and involvement of all employees in the decision-making process are necessary to improve production efficiency and quality. Thus, it becomes necessary to decentralize authority to motivate employees to improve the production process. In TQM, work teams are created, and workers are given the responsibility and authority to discover and implement improved work procedures. Managers assume the role of coach and facilitator, and team members jointly take on the supervisory burdens. Work teams are often given the responsibility to control and discipline their own members and also decide who should work in their teams. Frequently, work teams develop strong norms and values, and work-group culture becomes an important means of control; this type of control matches the new decentralized team approach. Quality control circles are created to exchange information and suggestions about problems and work procedures. A bonus system or employee stock-ownership plan is frequently established to motivate workers and to allow them to share in the increased value that TQM often produces.

Nevertheless, to move down the experience curve quickly, most companies still exercise tight control over work activities and create behavior and output controls that standardize the manufacturing process. For example, human inputs are standardized through the recruitment and training of skilled personnel; the work process is programmed, often by computers; and quality control is used to make sure that outputs are being produced correctly. In addition, managers use output controls such as operating budgets to continuously monitor costs and quality. The extensive use of output controls and the continuous measurement of efficiency and quality ensure that the work team's activities meet the goals set for the function by management. Efficiency and quality increase as new and improved work rules and procedures are developed to raise the level of standardization. The aim is to find the match between structure and control and a TQM approach so that manufacturing develops the distinctive competency that leads to superior efficiency and quality.

R&D The functional strategy for an R&D department is to develop distinctive competencies in innovation, quality, and excellence that result in products that fit customers' needs. Consequently, the R&D department's structure, control, and culture should provide the coordination necessary for scientists and engineers to bring high-quality products quickly to market. Moreover, these systems should motivate R&D scientists to develop innovative products.

In practice, R&D departments typically have a flat, decentralized structure that gives their members the freedom and autonomy to experiment and be innovative. Scientists and

engineers are also grouped into teams because their performance can typically be judged only over the long term (it may take several years for a project to be completed). Consequently, extensive supervision by managers and the use of behavior control are a waste of managerial time and effort.[33] Managers avoid the information distortion problems that cause bureaucratic costs by letting teams manage their own transfer and handoff issues rather than using managers and the hierarchy of authority to coordinate work activities. Strategic managers take advantage of scientists' ability to work jointly to solve problems and enhance each other's performance. In small teams, too, the professional values and norms that highly trained employees bring to the situation promote coordination. A culture for innovation frequently emerges to control employees' behavior, as it did at Nokia, Intel, and Microsoft, where the race to be first energizes the R&D teams. To create an innovative culture and speed product development, Intel uses a team structure in its R&D function. Intel has many work teams that operate side by side to develop the next generation of chips. When the company makes mistakes, as it has recently, it can act quickly to join each team's innovations together to make a state-of-the-art chip that meets customer needs, such as multimedia chips. At the same time, to sustain its leading-edge technology, the company creates healthy competition between teams to encourage its scientists and engineers to champion new-product innovations that will allow Intel to control the technology of tomorrow.[34]

To spur teams to work effectively, the reward system should be linked to the performance of the team and company. If scientists, individually or in a team, do not share in the profits a company obtains from its new products, they may have little motivation to contribute wholeheartedly to the team. To prevent the departure of their key employees and encourage high motivation, companies such as Merck, Intel, and Microsoft give their researchers stock options, stock, and other rewards that are tied to their individual performance, their team's performance, and the company's performance.

Sales Salespeople work directly with customers, and when they are dispersed in the field, these employees are especially difficult to monitor. The cost-effective way to monitor their behavior and encourage high responsiveness to customers is usually to develop sophisticated output and behavior controls. Output controls, such as specific sales goals or goals for increasing responsiveness to customers, can be easily established and monitored by sales managers. These controls can then be linked to a bonus reward system to motivate salespeople. Behavioral controls, such as detailed reports that salespeople file describing their interactions with customers, can also be used to standardize behavior and make it easier for supervisors to review performance.[35]

Usually, few managers are needed to monitor salespeople's activities, and a sales director and regional sales managers can oversee large sales forces because outputs and behavior controls are employed. Frequently, however, and especially when salespeople deal with complex products, such as pharmaceutical drugs or even luxury clothing, it becomes important to develop shared employee values and norms about the importance of patient safety or high-quality customer service; managers spend considerable time training and educating employees to create such norms.

Similar considerations apply to the other functions, such as accounting, finance, engineering, and human resource management. Managers must implement functional strategy through the combination of structure, control, and culture to allow each function to create the competencies that lead to superior efficiency, quality, innovation, and responsiveness to customers. Strategic managers must also develop the incentive systems that motivate and align employees' interests with those of their companies.

Functional Structure and Bureaucratic Costs

No matter how complex their strategies become, most companies retain a functional orientation because of its many advantages. Whenever different functions work together, however, bureaucratic costs inevitably arise because of information distortions that lead to the communications and measurement problems discussed in Chapter 10. These problems often arise from the transfers or handoffs across different functions that are necessary to deliver the final product to the customer.[36] The need to economize on the bureaucratic costs of solving such problems leads managers to adopt new organizational arrangements that reduce the scope of information distortions. Usually, companies divide their activities according to more complex plans to match their business models and strategies in discriminating ways. These more complex structures are discussed later in the chapter. First, we review five areas in which information distortions can arise: communications, measurement, customers, location, and strategy.

Communication Problems As separate functional hierarchies evolve, functions can grow more remote from one another, and it becomes increasingly difficult to communicate across functions and coordinate their activities. This communication problem stems from *differences in goal orientations*—the various functions develop distinct outlooks or understandings of the strategic issues facing a company.[37] For example, the pursuit of different competencies can often lead to different time or goal orientations. Some functions, such as manufacturing, have a short time frame and concentrate on achieving short-term goals, such as reducing manufacturing costs. Others, such as R&D, have a long-term point of view; their product development goals may have a time horizon of several years. These factors may cause each function to develop a different view of the strategic issues facing the company. Manufacturing, for example, may see the strategic issue as the need to reduce costs, sales may see it as the need to increase customer responsiveness, and R&D may see it as the need to create new products. These communication and coordination problems among functions increase bureaucratic costs.

Measurement Problems Often a company's product range widens as it develops new competencies and enters new market segments. When this happens, a company may find it difficult to gauge or measure the contribution of a product or a group of products to its overall profitability. Consequently, the company may turn out some unprofitable products without realizing it and may also make poor decisions about resource allocation. This means that the company's measurement systems are not complex enough to serve its needs.

Customer Problems As the range and quality of an organization's goods and services increase, often more and different kinds of customers are attracted to its products. Servicing the needs of more customer groups and tailoring products to suit new kinds of customers will result in increasing the handoff problems among functions. It becomes increasingly difficult to coordinate the activities of value-chain functions across the growing product range. Also, functions such as production, marketing, and sales have little opportunity to differentiate products and increase value for customers by specializing in the needs of particular customer groups. Instead, they are responsible for servicing the complete product range. Thus, the ability to identify and satisfy customer needs may fall short in a functional structure.

Location Problems Being in a particular location or geographical region may also hamper coordination and control. Suppose a growing company in the Northeast begins to

expand and sell its products in many different regional areas. A functional structure will not be able to provide the flexibility needed for managers to respond to the different customer needs or preferences in the various regions.

Strategic Problems The combined effect of all these factors results in long-term strategic considerations that are frequently ignored because managers are preoccupied with solving communication and coordination problems. The result is that a company may lose direction and fail to take advantage of new strategic opportunities—thus bureaucratic costs escalate.

Experiencing one or more of these problems is a sign that bureaucratic costs are increasing. If this is the case, managers must change and adapt their organization's structure, control systems, and culture to economize on bureaucratic costs, build new distinctive competencies, and strengthen the company's business model. These problems indicate that the company has outgrown its structure and that managers need to develop a more complex structure that can meet the needs of their competitive strategy. An alternative, however, is to reduce these problems by adopting the outsourcing option.

The Outsourcing Option

Rather than move to a more complex, expensive structure, companies are increasingly turning to the outsourcing option (discussed in Chapter 9) and solving the organizational design problem by contracting with other companies to perform specific functional tasks. Obviously, it does not make sense to outsource activities in which a company has a distinctive competency, because this would lessen its competitive advantage; but it does make sense to outsource and contract with companies to perform particular value-chain activities in which they specialize and therefore have a competitive advantage.

Thus, one way of avoiding the kinds of communication and measurement problems that arise when a company's product line becomes complex is to reduce the number of functional value-chain activities it performs. This allows a company to focus on those competencies that are at the heart of its competitive advantage and to economize on bureaucratic costs. Today, responsibility for activities such as a company's marketing, pension and health benefits, materials management, and information systems is being increasingly outsourced to companies that specialize in the needs of a company in a particular industry. More outsourcing options, such as using a global network structure, are considered in Chapter 13.

IMPLEMENTING STRATEGY IN A SINGLE INDUSTRY

Building capabilities in organizational design that allow a company to develop a competitive advantage begins at the functional level. However, to pursue its business model successfully, managers must find the right combination of structure, control, and culture that *links and combines* the competencies in a company's value-chain functions so that it enhances its ability to differentiate products or lower the cost structure. Therefore, it is important to coordinate and integrate across functions and business units or divisions. In organizational design, managers must consider two important issues: one concerns the revenue portion of the profit equation and the other concerns the cost portion, as Figure 12.6 illustrates.

Figure 12.6 How Organizational Design Increases Profitability

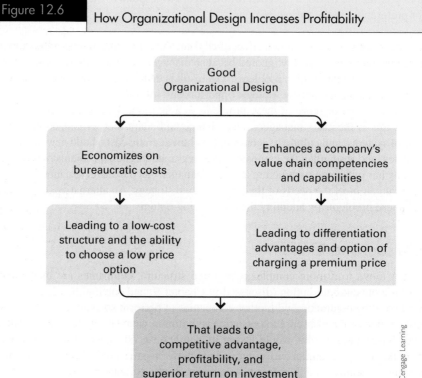

© Cengage Learning

First, effective organizational design improves the way in which people and groups choose the business-level strategies that lead to increasing differentiation, more value for customers, and the opportunity to charge a premium price. For example, capabilities in managing its structure and culture allow a company to more rapidly and effectively combine its distinctive competencies or transfer or leverage competencies across business units to create new and improved, differentiated products.

Second, effective organizational design reduces the bureaucratic costs associated with solving the measurement and communications problems that derive from factors such as transferring a product in progress between functions or a lack of cooperation between marketing and manufacturing or between business units. A poorly designed or inappropriate choice of structure or control system or a slow-moving bureaucratic culture (e.g., a structure that is too centralized, an incentive system that causes functions to compete instead of cooperate, or a culture in which value and norms have little impact on employees) can cause the motivation, communication, measurement, and coordination problems that lead to high bureaucratic costs.

Effective organizational design often means moving to a more complex structure that economizes on bureaucratic costs. A more complex structure will cost more to operate because additional, experienced, and more highly paid managers will be needed; a more expensive information technology (IT) system will be required; there may be a need for extra offices and buildings; and so on. However, these are simply costs of doing business, and a company will happily bear this extra expense provided its new structure leads to

increased revenues from product differentiation and/or new ways to lower its *overall* cost structure by obtaining economies of scale or scope from its expanded operations.

In the following sections, we first examine the implementation and organizational design issues involved in pursuing a cost-leadership or differentiation business model. Then we describe different kinds of organizational structures that allow companies to pursue business models oriented at (1) managing a wide range of products; (2) being responsive to customers; (3) expanding nationally; (4) competing in a fast-changing, high-tech environment; and (5) focusing on a narrow product line.

Implementing Cost Leadership

The aim of a company pursuing cost leadership is to become the lowest-cost producer in the industry, and this involves reducing costs across *all* functions in the organization, including R&D and sales and marketing.[38] If a company is pursuing a cost-leadership strategy, its R&D efforts probably focus on product and process development rather than on the more expensive product innovation, which carries no guarantee of success. In other words, the company stresses competencies that improve product characteristics or lower the cost of making existing products. Similarly, a company tries to decrease the cost of sales and marketing by offering a standard product to a mass market rather than different products aimed at different market segments, which is also more expensive.[39]

To implement cost leadership, a company chooses a combination of structure, control, and culture compatible with lowering its cost structure while preserving its ability to attract customers. In practice, the functional structure is the most suitable provided that care is taken to select integrating mechanisms that will reduce communication and measurement problems. For example, a TQM program can be effectively implemented when a functional structure is overlaid with cross-functional teams because team members can now search for ways to improve operating rules and procedures that lower the cost structure or standardize and raise product quality.[40]

Cost leadership also requires that managers continuously monitor their structures and control systems to find ways to restructure or streamline them so that they operate more effectively. For example, managers need to be alert to ways of using IT to standardize operations and lower costs. To reduce costs further, cost leaders use the cheapest and easiest forms of control available: output controls. For each function, a cost leader adopts output controls that allow it to closely monitor and evaluate functional performance. In the manufacturing function, for example, the company imposes tight controls and stresses meeting budgets based on production, cost, or quality targets.[41] In R&D, the emphasis also falls on the bottom line; to demonstrate their contribution to cost savings, R&D teams focus on improving process technology. Cost leaders are likely to reward employees through generous incentive and bonus plans to encourage high performance. Their culture is often based on values that emphasize the bottom line, such as those of Walmart, McDonald's, and Dell.

Implementing Differentiation

Effective strategy implementation can improve a company's ability to add value and to differentiate its products. To make its product unique in the eyes of the customer, for example, a differentiated company must design its structure, control, and culture around the *particular source* of its competitive advantage.[42] Specifically, differentiators need to design their

structures around the source of their distinctive competencies, the differentiated qualities of their products, and the customer groups they serve. Commonly, in pursuing differentiation, a company starts to produce a wider range of products to serve more market segments, which means it must customize its products for different groups of customers. These factors make it more difficult to standardize activities and usually increase the bureaucratic costs associated with managing the handoffs or transfers between functions. Integration becomes much more of a problem; communications, measurement, location, and strategic problems increasingly arise; and the demands upon functional managers increase.

To respond to these problems, managers develop more sophisticated control systems, increasingly make use of IT, focus on developing cultural norms and values that overcome problems associated with differences in functional orientations, and focus on cross-functional objectives. The control systems used to match the structure should be aligned to a company's distinctive competencies. For successful differentiation, it is important that the various functions do not pull in different directions; indeed, cooperation among the functions is vital for cross-functional integration. However, when functions work together, output controls become much harder to use. In general, it is much more difficult to measure the performance of people in different functions when they are engaged in cooperative efforts. Consequently, a differentiator must rely more upon behavior controls and shared norms and values.

This explains why companies pursuing differentiation often have a markedly different kind of culture from those pursuing cost leadership. Because human resources—scientists, designers, or marketing employees—are often the source of differentiation, these organizations have a culture based on professionalism or collegiality that emphasizes the distinctiveness of the human resources rather than the high pressure of the bottom line.[43] HP, Motorola, and Coca-Cola, all of which emphasize some kind of distinctive competency, exemplify companies with professional cultures.

In practice, the implementation decisions that confront managers who must simultaneously strive for differentiation and a low-cost structure are dealt with together as strategic managers move to implement new, more complex kinds of organizational structure. As a company's business model and strategies evolve, strategic managers usually start to *superimpose* a more complex divisional grouping of activities on its functional structure to better coordinate value-chain activities. This is especially true of companies seeking to become *broad differentiators*—companies that have the ability to simultaneously increase differentiation and lower their cost structures. These companies are the most profitable in their industries, and they have to be especially adept at organizational design—a major source of a differentiation and cost advantage (see Figure 12.6). No matter what the business model, however, more complex structures cost more to operate than a simple functional structure. Managers are willing to bear this extra cost, however, as long as the new structure makes better use of functional competencies, increases revenues, and lowers the overall cost structure.

Product Structure: Implementing a Wide Product Line

The structure that organizations most commonly adopt to solve the control problems that result from producing many different kinds of products for many different market segments is the *product structure*. The intent is to break up a company's growing product line into a number of smaller, more manageable subunits to reduce bureaucratic costs due to communication, measurement, and other problems.

Figure 12.7 Nokia's Product Structure

An organization that chooses a **product structure** first divides its overall product line into product groups or categories (see Figure 12.7, which uses Nokia as an example). Each product group focuses on satisfying the needs of a particular customer group and is managed by its own team of managers. Second, to keep costs as low as possible, value-chain support functions such as basic R&D, marketing, materials, and finance are centralized at the top of the organization, and the different product groups share their services. Each support function, in turn, is divided into product-oriented teams of functional specialists who focus on the needs of one particular product group. This arrangement allows each team to specialize and become expert in managing the needs of its product group. Because all of the R&D teams belong to the same centralized function, however, they can share knowledge and information with each other and build their competence over time.

product structure

A way of grouping employees into separate product groups or units so that each product group can focus on the best ways to increase the effectiveness of the product.

Strategic control systems can now be developed to measure the performance of each product group separately from the others. Thus, the performance of each product group is easy to monitor and evaluate, and corporate managers at the center can move more quickly to intervene if necessary. Also, the strategic reward system can be linked more closely to the performance of each product group, although top managers can still decide to make rewards based on corporate performance an important part of the incentive system. Doing so will encourage the different product groups to share ideas and knowledge and promote the development of a corporate culture, as well as the product group culture that naturally develops inside each product group. A product structure is commonly used by food processors, furniture makers, personal and health products companies, and large electronics companies such as Nokia.

Market Structure: Increasing Responsiveness to Customer Groups

market structure

A way of grouping employees into separate customer groups so that each group can focus on satisfying the needs of a particular customer group in the most effective way.

Suppose the source of competitive advantage in an industry depends upon the ability to meet the needs of distinct and important sets of customers or different customer groups. What is the best way of implementing strategy now? Many companies develop a **market structure** that is conceptually quite similar to the product structure except that the focus is on customer groups instead of product groups.

For a company pursuing a strategy based on increasing responsiveness to customers, it is vital that the nature and needs of each different customer group be identified. Then, employees and functions are grouped by customer or market segment. A different set of managers becomes responsible for developing the products that each group of customers wants and tailoring or customizing products to the needs of each particular customer group. In other words, to promote superior responsiveness to customers, a company will design a structure around its customers, and a market structure is adopted. A typical market structure is shown in Figure 12.8.

A market structure brings customer group managers and employees closer to specific groups of customers. These people can then take their detailed knowledge and feed it back to the support functions, which are kept centralized to reduce costs. For example, information about changes in customer preferences can be quickly fed back to R&D and product design so that a company can protect its competitive advantage by supplying a constant stream of improved products for its installed customer base. This is especially important when a company serves well-identified customer groups such as *Fortune* 500 companies or small businesses.

Geographic Structure: Expanding by Location

geographic structure

A way of grouping employees into different geographic regions to best satisfy the needs of customers within different regions of a state or country.

Suppose a company begins to expand locally, regionally, or nationally through internal expansion or by engaging in horizontal integration and merging with other companies to expand its geographical reach. A company pursuing this competitive approach frequently moves to a **geographic structure** in which geographic regions become the basis for the

Figure 12.8 Market Structure

© Cengage Learning

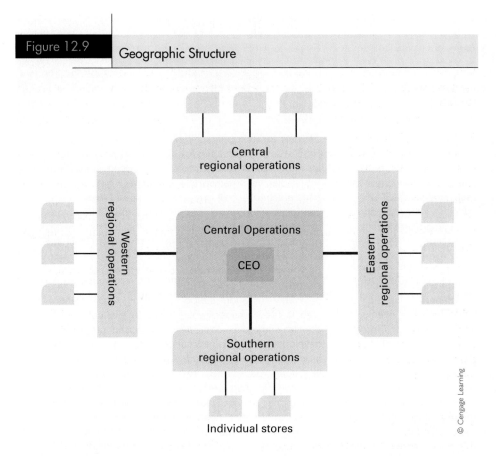

Figure 12.9 Geographic Structure

grouping of organizational activities (see Figure 12.9). A company may divide its manufacturing operations and establish manufacturing plants in different regions of the country, for example. This allows the company to be responsive to the needs of regional customers and reduces transportation costs. Similarly, as a service organization such as a store chain or bank expands beyond one geographic area, it may begin to organize sales and marketing activities on a regional level to better serve the needs of customers in different regions.

A geographic structure provides more coordination and control than a functional structure does because several regional hierarchies are created to take over the work, as in a product structure, where several product group hierarchies are created. A company such as FedEx clearly needs to operate a geographic structure to fulfill its corporate goal: next-day delivery. Large merchandising organizations, such as Neiman Marcus, Dillard's Department Stores, and Walmart, also moved to a geographic structure as they started building stores across the country. With this type of structure, different regional clothing needs (e.g., sunwear in the South, down coats in the Midwest) can be handled as required. At the same time, because the information systems, purchasing, distribution, and marketing functions remain centralized, companies can leverage their skills across all the regions. When using a geographic structure, a company can achieve economies of scale in buying, distributing, and selling and lower its cost structure, while simultaneously being more responsive (differentiated) to customer needs. One organization that moved from a geographic to a market structure to provide better-quality service and reduce costs is discussed in Strategy in Action 12.3.

12.3 STRATEGY IN ACTION

The HISD Moves from a Geographic to a Market Structure

© iStockPhoto.com/Tom Nulens

Like all organizations, state and city government agencies such as school districts may become too tall and bureaucratic over time and, as they grow, develop ineffective and inefficient organizational structures. This happened to the Houston Independent School District (HISD) when the explosive growth of the city during the last decades added over 1 million new students to its schools. As Houston expanded many miles in every direction to become the fourth-largest U.S. city, successive HISD superintendents adopted a geographic structure to coordinate and control all of the teaching functions involved in creating high-performing elementary, middle, and high schools. The HISD eventually created five different geographic regions or regional school districts. And over time, each regional district sought to control more of its own functional activities and became increasingly critical of HISD's central administration. The result was a slowdown in decision making, infighting between districts, an increasingly ineffectual team of district administrators, and falling student academic test scores across the city.

In 2010, a new HISD superintendent was appointed, who, working on the suggestions of HISD's top managers,

decided to reorganize HISD into a market structure. HISD's new organizational structure is now grouped by the needs of its customers—its students—and three "chief officers" oversee all of Houston's high schools, middle schools, and elementary schools, respectively. The focus will now be upon the needs of its three types of students, not on the needs of the former five regional managers. Over 270 positions were eliminated in this restructuring, saving over $8 million per year, and many observers hope to see more cost savings ahead.

Many important support functions were recentralized to HISD's headquarters office to eliminate redundancies and reduce costs, including teacher professional development. Also, a new support function called school improvement was formed, with managers charged to share ideas and information between schools and oversee their performance on many dimensions to improve service and student performance. HISD administrators also hope that eliminating the regional geographic structure will encourage schools to share best practices and cooperate so student education and test scores will improve over time.

Source: By 2011, major cost savings had been achieved, but a huge budget deficit forced the HISD to close 12 middle and elementary schools and relocate students to new facilities in which class sizes would be higher. The result is a streamlined, integrated divisional structure that HISD hopes will increase performance—student scores—in the years ahead, but at a lower cost.

Neiman Marcus developed a geographic structure similar to the one shown in Figure 12.9 to manage its nationwide chain of stores. In each region, it established a team of regional buyers to respond to the needs of customers in each geographic area, for example, the western, central, eastern, and southern regions. The regional buyers then fed their information to the central buyers at corporate headquarters, who coordinated their demands to obtain purchasing economies and ensure that Neiman Marcus's high-quality standards, upon which its differentiation advantage depends, were maintained nationally.

Matrix and Product-Team Structures: Competing in High-Tech Environments

The communication and measurement problems that lead to bureaucratic costs escalate quickly when technology is rapidly changing and industry boundaries are blurring.

Frequently, competitive success depends upon rapid mobilization of a company's skills and resources, and managers face complex strategy implementation issues. A new grouping of people and resources becomes necessary, often one that is based on fostering a company's distinctive competencies in R&D. Managers need to make structure, control, and culture choices around the R&D function. At the same time, they need to ensure that implementation will result in new products that cost-effectively meet customer needs and will not result in products so expensive that customers will not wish to buy them.

matrix structure
A way of grouping employees in two ways simultaneously—by function and by product or project—to maximize the rate at which different kinds of products can be developed.

Matrix Structure To address these problems, many companies choose a matrix structure.[44]

In a **matrix structure**, value-chain activities are grouped in two ways (see Figure 12.10). First, activities are grouped vertically by *function* so that there is a familiar differentiation of tasks into functions such as engineering, sales and marketing, and R&D. In addition, superimposed upon this vertical pattern is a horizontal pattern based on grouping by *product*

Figure 12.10 Matrix Structure

© Cengage Learning

or project, in which people and resources are grouped to meet ongoing product development needs. The resulting network of reporting relationships among projects and functions is designed to make R&D the focus of attention.

Matrix structures are flat and decentralized, and employees inside a matrix have two bosses: a *functional boss*, who is the head of a function, and a *product or project boss*, who is responsible for managing the individual projects. Employees work on a project team with specialists from other functions and report to the project boss on project matters and the functional boss on matters relating to functional issues. All employees who work on a project team are called **two-boss employees** and are responsible for managing coordination and communication among the functions and projects.

Implementing a matrix structure can promote innovation and speeds product development because this type of structure permits intensive cross-functional integration. Integrating mechanisms such as teams help transfer knowledge among functions and are designed around the R&D function. Sales, marketing, and production targets are geared to R&D goals, marketing devises advertising programs that focus upon technological possibilities, and salespeople are evaluated on their understanding of new-product characteristics and their ability to inform potential customers about these new products.

Matrix structures were first developed by companies in high-technology industries such as aerospace and electronics, for example, TRW and Hughes. These companies were developing radically new products in uncertain, competitive environments, and the speed of product development was the crucial consideration. They needed a structure that could respond to this need, but the functional structure was too inflexible to allow the complex role and task interactions necessary to meet new-product development requirements. Moreover, employees in these companies tend to be highly qualified and professional and perform best in autonomous, flexible working conditions. The matrix structure provides such conditions.

This structure requires a minimum of direct hierarchical control by supervisors. Team members control their own behavior, and participation in project teams allows them to monitor other team members and to learn from each other. Furthermore, as the project goes through its different phases, different specialists from various functions are required. For example, at the first stage, the services of R&D specialists may be called for; at the next stage, engineers and marketing specialists may be needed to make cost and marketing projections. As the demand for the type of specialist changes, team members can be moved to other projects that require their services. Thus, the matrix structure can make maximum use of employees' skills as existing projects are completed and new ones come into existence. The freedom given by the matrix not only provides the autonomy to motivate employees but also leaves top management free to concentrate upon strategic issues because they do not have to become involved in operating matters. For all these reasons, the matrix is an excellent tool for creating the flexibility necessary for quick reactions to competitive conditions.

In terms of strategic control and culture, the development of norms and values based on innovation and product excellence is vital if a matrix structure is to work effectively.[45] The constant movement of employees around the matrix means that time and money are spent establishing new team relationships and getting the project running. The two-boss employee's role, as it balances the interests of the project with the function, means that cooperation among employees is problematic, and conflict between different functions and between functions and projects is possible and must be managed. Furthermore, changing product teams, the ambiguity arising from having two bosses, and the greater difficulty of monitoring and evaluating the work of teams increase the problems of coordinating task activities. A strong and cohesive culture with unifying norms and values can mitigate these problems, as can a strategic reward system based on a group- and organizational-level reward system.

two-boss employees
Employees who report both to a project boss and a functional boss.

| Figure 12.11 | Product-Team Structure |

Product teams

Manufacturing units

© Cengage Learning

Product-Team Structure A major structural innovation in recent years is the *product-team structure*. Its advantages are similar to those of a matrix structure, but it is much easier and far less costly to operate because of the way people are organized into permanent cross-functional teams, as Figure 12.11 illustrates. In the **product-team structure**, as in the matrix structure, tasks are divided along product or project lines. However, instead of being assigned only *temporarily* to different projects, as in the matrix structure, functional specialists become part of a *permanent* cross-functional team that focuses on the development of one particular range of products, such as luxury cars or computer workstations. As a result, the problems associated with coordinating cross-functional transfers or hand-offs are much lower than in a matrix structure, in which tasks and reporting relationships change rapidly. Moreover, cross-functional teams are formed at the beginning of the product development process so that any difficulties that arise can be ironed out early, before they lead to major redesign problems. When all functions have direct input from the beginning, design costs and subsequent manufacturing costs can be kept low. Moreover, the use of cross-functional teams speeds innovation and customer responsiveness because, when authority is decentralized, team decisions can be made more quickly.

A product-team structure groups tasks by product, and each product group is managed by a cross-functional product team that has all the support services necessary to bring the product to market. This is why it is different from the product structure, in which support functions remain centralized. The role of the product team is to protect and enhance a company's differentiation advantage and at the same time coordinate with manufacturing to lower costs.

product-team structure
A way of grouping employees by product or project line but employees focus on the development of only one particular type of product.

Focusing on a Narrow Product Line

As Chapter 5 discussed, a focused company concentrates on developing a narrow range of products aimed at one or two market segments, which may be defined by type of customer

or location. As a result, a focuser tends to have a higher cost structure than a cost leader or differentiator, because output levels are lower, making it harder to obtain substantial scale economies. For this reason, a focused company must exercise cost control. On the other hand, some attribute of its product gives the focuser its distinctive competency—possibly its ability to provide customers with high-quality, personalized service. For both reasons, the structure and control system adopted by a focused company has to be inexpensive to operate but flexible enough to allow a distinctive competency to emerge.

A company using a focus strategy normally adopts a functional structure to meet these needs. This structure is appropriate because it is complex enough to manage the activities necessary to make and sell a narrow range of products for one or a few market segments. At the same time, the handoff problems are likely to be relatively easy to solve because a focuser remains small and specialized. Thus, a functional structure can provide all the integration necessary, provided that the focused firm has a strong, adaptive culture, which is vital to the development of some kind of distinctive competency.[46] Additionally, because such a company's competitive advantage is often based on personalized service, the flexibility of this kind of structure allows the company to respond quickly to customers' needs and change its products in response to customers' requests.

RESTRUCTURING AND REENGINEERING

restructuring

The process by which a company streamlines its hierarchy of authority and reduces the number of levels in its hierarchy to a minimum to lower operating costs.

To improve performance, a single business company often employs restructuring and reengineering. **Restructuring** a company involves two steps: (1) streamlining the hierarchy of authority and reducing the number of levels in the hierarchy to a minimum and (2) reducing the number of employees to lower operating costs. Restructuring and downsizing become necessary for many reasons.[47] Sometimes a change in the business environment occurs that could not have been foreseen; perhaps a shift in technology made the company's products obsolete. Sometimes an organization has excess capacity because customers no longer want the goods and services it provides; perhaps the goods and services are outdated or offer poor value for the money. Sometimes organizations downsize because they have grown too tall and inflexible and bureaucratic costs have become much too high. Sometimes they restructure even when they are in a strong position simply to build and improve their competitive advantage and stay ahead of competitors.

All too often, however, companies are forced to downsize and lay off employees because they fail to monitor and control their basic business operations and have not made the incremental changes to their strategies and structures over time that allow them to adjust to changing conditions. Advances in management, such as the development of new models for organizing work activities, or IT advances, offer strategic managers the opportunity to implement their strategies in more effective ways.

reengineering

The process of redesigning business processes to achieve dramatic improvements in performance, such as cost, quality, service, and speed.

A company may operate more effectively using **reengineering**, which involves the "fundamental rethinking and radical redesign of business processes to achieve dramatic improvements in critical, contemporary measures of performance, such as cost, quality, service, and speed."[48] As this definition suggests, strategic managers who use reengineering must completely rethink how they organize their value-chain activities. Instead of focusing on how a company's *functions* operate, strategic managers make business *processes* the focus of attention.

A *business process* is any activity that is vital to delivering goods and services to customers quickly or that promotes high quality or low costs (such as IT, materials management, or product development). It is not the responsibility of any one function but *cuts across functions*. Because reengineering focuses on business processes, not on functions, a company that

reengineers always has to adopt a different approach to organizing its activities. Companies that take up reengineering deliberately ignore the existing arrangement of tasks, roles, and work activities. They start the reengineering process with the customer (not the product or service) and ask: "How can we reorganize the way we do our work—our business processes— to provide the best quality and the lowest-cost goods and services to the customer?"

Frequently, when managers ask this question, they realize that there are more effective ways to organize their value-chain activities. For example, a business process that encompasses members of 10 different functions working sequentially to provide goods and services might be performed by one person or a few people at a fraction of the cost. Often individual jobs become increasingly complex, and people are grouped into cross-functional teams as business processes are reengineered to reduce costs and increase quality.

Hallmark Cards, for example, reengineered its card design process with great success. Before the reengineering effort, artists, writers, and editors worked separately in different functions to produce all kinds of cards. After reengineering, these same artists, writers, and editors were put on cross-functional teams, each of which now works on a specific type of card, such as birthday, Christmas, or Mother's Day. The result is that the production time to bring a new card to market decreased from years to months, and Hallmark's performance increased dramatically.

Reengineering and TQM, discussed in Chapter 4, are highly interrelated and complementary. After reengineering has taken place and value-chain activities have been altered to speed the product to the final customer, TQM takes over, with its focus on how to continue to improve and refine the new process and find better ways of managing task and role relationships. Successful organizations examine both issues simultaneously and continuously attempt to identify new and better processes for meeting the goals of increased efficiency, quality, and customer responsiveness. Thus, companies are always seeking to improve their visions of their desired future.

Another example of reengineering is the change program that took place at IBM Credit, a wholly owned division of IBM that manages the financing and leasing of IBM computers— particularly mainframes—to IBM's customers. Before reengineering took place, a financing request arrived at the division's headquarters in Old Greenwich, Connecticut, and completed a five-step approval process that involved the activities of five different functions. First, the IBM salesperson called the credit department, which logged the request and recorded details about the potential customer. Second, this information was taken to the credit-checking department, where a credit check on the potential customer was done. Third, when the credit check was complete, the request was taken to the contracts department, which wrote the contract. Fourth, from the contracts department, it went to the pricing department, which determined the actual financial details of the loan, such as the interest rate and the term of the loan. Finally, the whole package of information was assembled by the dispatching department and delivered to the sales representative, who presented it to the customer.

This series of cross-functional activities took an average of 7 days to complete, and sales representatives constantly complained that the delay resulted in a low level of customer responsiveness that reduced customer satisfaction. Also, potential customers were tempted to shop around for financing and look at competitors' machines in the process. The delay in closing the deal caused uncertainty for all involved.

The change process began when two senior IBM credit managers reviewed the finance approval process. They found that the time different specialists spent on the different functions processing a loan application was only 90 minutes. The 7-day approval process was caused by the delay in transmitting information and requests between departments. Managers also learned that the activities taking place in each department were not complex; each department had its own computer system containing its own work procedures, but the work done in each department was routine.

Armed with this information, IBM managers realized that the approval process could be reengineered into one overarching process handled by one person with a computer system containing all the necessary information and work procedures to perform the five loan-processing activities. If the application happened to be complex, a team of experts stood ready to help process it, but IBM found that, after the reengineering effort, a typical application could be done in 4 hours rather than the previous 7 days. A sales representative could speak with the customer the same day to close the deal, and all the uncertainty surrounding the transaction was removed.

As reengineering consultants Hammer and Champy note, this dramatic performance increase was instigated by a radical change to the whole process. Change through reengineering requires managers to assess the most basic level and look at each step in the work process to identify a better way to coordinate and integrate the activities necessary to provide customers with goods and services. As this example makes clear, the introduction of new IT is an integral aspect of reengineering. IT also allows a company to restructure its hierarchy because it provides more and better-quality information. IT today is an integral part of the strategy implementation process.

ETHICAL DILEMMA

© iStockPhoto.com/P_Wei

Suppose a poorly performing organization has decided to terminate hundreds of middle managers. Top managers making the termination decisions might choose to keep subordinates whom they like rather than the best performers, or terminate the most highly paid subordinates even if they are top performers. Remembering that organizational structure and culture affect all company stakeholders, which ethical principles about equality, fairness, and justice would you use to redesign the organizational hierarchy? Keep in mind that some employees may feel they have as strong a claim on the organization as some of its stockholders, even claiming to "own" their jobs from contributions to past successes.

Do you think this is an ethical claim? How would it factor into your design?

SUMMARY OF CHAPTER

1. The successful implementation of a company's business model and strategies depends upon organizational design—the process of selecting the right combination of organizational structure, control systems, and culture. Companies must monitor and oversee the organizational design process to achieve superior profitability.

2. Effective organizational design can increase profitability in two ways. First, it economizes on bureaucratic costs and helps a company lower its cost structure. Second, it enhances the ability of a company's value creation functions to achieve superior efficiency, quality, innovativeness, and customer responsiveness and obtain the advantages of differentiation.

3. The main issues in designing organizational structure are how to group tasks, functions, and divisions; how to allocate authority and responsibility (whether to have a tall or flat organization and whether to have a centralized or decentralized

structure); and how to use integrating mechanisms to improve coordination between functions (such as direct contacts, liaison roles, and teams).

4. Strategic control provides the monitoring and incentive systems necessary to make an organizational structure work as intended and extends corporate governance down to all levels inside the company. The main kinds of strategic control systems are personal control, output control, and behavior control. IT is an aid to output and behavior control, and reward systems are linked to every control system.

5. Organizational culture is the set of values, norms, beliefs, and attitudes that help to energize and motivate employees and control their behavior. Culture is a way of doing something, and a company's founder and top managers help determine which kinds of values emerge in an organization.

6. At the functional level, each function requires a different combination of structure and control system to achieve its functional objectives.

7. To successfully implement a company's business model, structure, control, and culture must be combined in ways that increase the relationships among all functions to build distinctive competencies.

8. Cost leadership and differentiation each require a structure and control system that strengthens the business model that is the source of their competitive advantage. Managers must use organizational design in a way that balances pressures to increase differentiation against pressures to lower the cost structure.

9. Other specialized kinds of structures include the product, market, geographic, matrix, and product-team structures. Each has a specialized use and is implemented as a company's strategy warrants.

10. Restructuring and reengineering are two ways of implementing a company's business model more effectively.

DISCUSSION QUESTIONS

1. What is the relationship among organizational structure, control, and culture? Give some examples of when and under what conditions a mismatch among these components might arise.

2. What kind of structure best describes the way your (a) business school and (b) university operate? Why is the structure appropriate? Would another structure fit better?

3. When would a company choose a matrix structure? What are the problems associated with managing this type of structure, and in what circumstances might a product-team structure be preferable?

4. For each of the structures discussed in the chapter, outline the most suitable control systems.

5. What kind of structure, controls, and culture would you be likely to find in (a) a small manufacturing company, (b) a chain store, (c) a high-tech company, and (d) a Big Four accounting firm?

KEY TERMS

Organizational design 397
Organizational structure 397
Control system 397
Organizational culture 397
Hierarchy of authority 399
Span of control 400

Principle of the minimum chain of command 401
Integrating mechanisms 403
Team 405
Strategic control systems 405
Personal control 408
Output control 408

Behavior control 408
Operating budget 409
Standardization 409
Adaptive culture 413
Functional structure 414
Management by objectives 415
Product structure 423
Market structure 424

Geographic structure 424
Matrix structure 427
Two-boss employees 428
Product-team structure 429
Restructuring 430
Reengineering 430

PRACTICING STRATEGIC MANAGEMENT

© iStockPhoto.com/Urilux

Small-Group Exercises

Small-Group Exercise: Deciding on an Organizational Structure

Break up into groups of three to five people and discuss the following scenario. You are a group of managers of a major soft drink company that is going head-to-head with Coca-Cola to increase market share. Your business model is based on increasing your product range to offer a soft drink in every segment of the market to attract customers. Currently you have a functional structure. What you are trying to work out now is how best to implement your business model to launch your new products. Should you move to a more complex kind of product structure, and if so which one? Alternatively, should you establish new-venture divisions and spin off each kind of new soft drink into its own company so that it can focus its resources on its market niche? Thinking strategically, debate the pros and cons of the possible organizational structures and decide which structure you will implement.

STRATEGY SIGN ON

© iStockPhoto.com/Ninoslav Dotlic

Article File 12

Find an example of a company that competes in one industry and has recently changed the way it implements its business model and strategies. What changes did it make? Why did it make these changes? What effect did these changes have on the behavior of people and functions?

Strategic Management Project: Module 12

This module asks you to identify how your company implements its business model and strategy. For this part of your project, you need to obtain information about your company's structure, control systems, and culture. This information may be hard to obtain unless you can interview managers directly. But you can make many inferences about the company's structure from the nature of its activities, and if you write to the company, it may provide you with an organizational chart and other information. Also, published information, such as compensation for top management, is available in the company's annual reports or 10-K reports. If your company is well known, magazines such as *Fortune* and *Businessweek* frequently report on corporate culture or control issues. Nevertheless, you may be forced to make some bold assumptions to complete this part of the project.

1. How large is the company as measured by the number of its employees? How many levels in the hierarchy does it have from the top to the bottom? Based on these two measures and any other information you may have, would you say your company operates with a relatively tall or flat structure? Does your company have a centralized or decentralized approach to decision making?

(continues)

STRATEGY SIGN ON

(continued)

© iStockPhoto.com/Ninoslav Dotlic

2. What changes (if any) would you make to the way the company allocates authority and responsibility?
3. Draw an organizational chart showing the primary way in which your company groups its activities. Based on this chart, decide what kind of structure (functional, product, or divisional) your company is using.
4. Why did your company choose this structure? In what ways is it appropriate for its business model? In what ways is it inappropriate?
5. What kind of integration or integration mechanisms does your company use?
6. What are the primary kinds of control systems your company is using? What kinds of behaviors is the organization trying to (a) shape and (b) motivate through the use of these control systems?
7. What role does the top-management team play in creating the culture of your organization? Can you identify the characteristic norms and values that describe the way people behave in your organization? How does the design of the organization's structure affect its culture?
8. What are the sources of your company's distinctive competencies? Which functions are most important to it? How does your company design its structure, control, and culture to enhance its (a) efficiency, (b) quality, (c) innovativeness, and (d) responsiveness to customers?
9. How does it design its structure and control systems to strengthen its business model? For example, what steps does it take to further cross-functional integration? Does it have a functional, product, or matrix structure?
10. How does your company's culture support its business model? Can you determine any ways in which its top-management team influences its culture?
11. Based on this analysis, would you say your company is coordinating and motivating its people and subunits effectively? Why or why not? What changes (if any) would you make to the way your company's structure operates? What use could it make of restructuring or reengineering?

CLOSING CASE

Alan Mulally Transforms Ford's Structure and Culture

After a loss of more than $13 billion in 2006, William Ford III, who had been Ford Motor's CEO for 5 years, decided he was not the right person to turn around the company's performance. In fact, it became apparent that he was a part of Ford's management problems because he and other top managers at Ford tried to build and protect their own corporate empires, and none would ever admit that mistakes had occurred over the years. As a result, the entire company's performance had suffered; its future was in doubt. Deciding they needed an outsider to change the way the company operated, Ford recruited Alan Mulally from Boeing to become the new CEO.

After arriving at Ford, Mulally attended hundreds of executive meetings with his new managers. At one meeting, he became confused about why one

top-division manager, who obviously did not know the answer to one of Mulally's questions concerning the performance of his car division, rambled on for several minutes trying to disguise his ignorance. Mulally turned to his second-in-command Mark Fields and asked him why the manager had done that. Fields explained that "at Ford you never admit when you don't know something." He also told Mulally that when he arrived as a middle manager at Ford and wanted to ask his boss to lunch to gain information about divisional operations, he was told: "What rank are you at Ford? Don't you know that a subordinate never asks a superior to lunch?"

Mulally discovered that over the years Ford had developed a tall hierarchy composed of managers whose primary goal was to protect their turf and avoid any direct blame for its plunging car sales. When asked why car sales were falling, they did not admit to bad design and poor-quality issues in their divisions; instead they hid in the details. Managers brought thick notebooks and binders to meetings, using the high prices of components and labor costs to explain why their own particular car models were not selling well—or why they had to be sold at a loss. Why, Mulally wondered, did Ford's top executives have this inward-looking, destructive mind-set? How could he change Ford's organizational structure and culture to reduce costs and speed product development to build the kinds of vehicles customers wanted?

First, Mulally decided he needed to change Ford's structure, and that a major reorganization of the company's hierarchy was necessary. He decided to flatten Ford's structure and recentralize control at the top so that all top divisional managers reported to him. But, at the same time, he emphasized teamwork and the development of a cross-divisional approach to manage the enormous value-chain challenges that confronted Ford in its search for ways to reduce its cost structure. He eliminated two levels in the top-management hierarchy and clearly defined each top manager's role in the turnaround process so the company could begin to act as a whole instead of as separate divisions in which managers pursued their own interests.

Mulally also realized, however, that simply changing Ford's structure was not enough to change the way it operated; its other major organizational problem was that the values and norms in Ford's culture that had developed over time hindered cooperation and teamwork. These values and norms promoted secrecy and ambiguity; they emphasized status and rank so managers could protect their information—the best way managers of its different divisions and functions believed to maintain jobs and status was to hoard, rather than share, information. The reason only the boss could ask a subordinate to lunch was to allow superiors to protect their information and positions!

What could Mulally do? He issued a direct order that the managers of every division share with every other Ford division a detailed statement of the costs they incurred to build each of its vehicles. He insisted that each of Ford's divisional presidents should attend a weekly (rather than a monthly) meeting to openly share and discuss the problems all the company's divisions faced. He also told managers they should bring a different subordinate with them to each meeting so every manager in the hierarchy would learn of the problems that had been kept hidden.

Essentially, Mulally's goal was to demolish the dysfunctional values and norms of Ford's culture that focused managers' attention on their own empires at the expense of the entire company. Mulally's goal was to create new values and norms that encouraged employees to admit mistakes, share information about all aspects of model design and costs, and, of course, find ways to speed development and reduce costs. He also wanted to change Ford's culture to allow norms of cooperation to develop both within and across divisions to allow its new structure to work effectively and improve company performance.

By 2011, it was clear that Mulally's attempts to change Ford's structure and culture had succeeded. The company reported a profit in the spring of 2010, for which Mulally received over $17 million in salary and other bonuses, and by 2011 it was reporting record profits as the sales of its vehicles soared. In 2011, Mulally had reached 65, the normal retirement age for Ford's top managers, but in a press conference announcing Ford's record results, William Ford joked that he hoped Mulally would still be in charge of the transformed company in 2025.

Sources: www.ford.com; D. Kiley, "The New Heat on Ford," June 4, 2007, www.businessweek.com; and B. Koenig, "Ford Reorganizes Executives Under New Chief Mulally," December 14, 2006, www .bloomberg.com.

CASE DISCUSSION QUESTIONS

1. How did organizational structure and culture contribute to the poor performance of Ford prior to the arrival of Alan Mulally?
2. One of the first things Mulally did was to flatten the organizational structure at Ford and clearly articulate lines of responsibility. How do you think this contributed to improving Ford's performance?

3. Why was changing the organizational structure not enough to improve Ford's performance?
4. How did Mulally go about changing the culture of Ford? How did this cultural change impact the company's performance?

NOTES

[1]L. Smircich, "Concepts of Culture and Organizational Analysis," *Administrative Science Quarterly* 28 (1983): 339–358.

[2]G. R. Jones and J. M. George, "The Experience and Evolution of Trust: Implications for Cooperation and Teamwork," *Academy of Management Review* 3 (1998): 531–546.

[3]Ibid.

[4]J. R. Galbraith, *Designing Complex Organizations* (Reading: Addison-Wesley, 1973).

[5]A. D. Chandler, *Strategy and Structure* (Cambridge: MIT Press, 1962).

[6]The discussion draws heavily on Chandler, *Strategy and Structure,* and B. R. Scott, *Stages of Corporate Development* (Cambridge: Intercollegiate Clearing House, Harvard Business School, 1971).

[7]R. L. Daft, *Organizational Theory and Design*, 3rd ed. (St. Paul: West, 1986), p. 215.

[8]J. Child, *Organization 9: A Guide for Managers and Administrators* (New York: Harper & Row, 1977), pp. 52–70.

[9]G. R. Jones and J. Butler, "Costs, Revenues, and Business Level Strategy," *Academy of Management Review* 13 (1988): 202–213; and G. R. Jones and C. W. L. Hill, "Transaction Cost Analysis of Strategy-Structure Choice," *Strategic Management Journal* 9 (1988): 159–172.

[10]G. R. Jones, *Organizational Theory, Design, and Change: Text and Cases* (Englewood Cliffs: Pearson, 2011).

[11]Blau, P. M., "A Formal Theory of Differentiation in Organizations," *American Sociological Review* 35 (1970): 684–695.

[12]G. R. Jones, "Organization-Client Transactions and Organizational Governance Structures," *Academy of Management Journal* 30 (1987): 197–218.

[13]P. R. Lawrence and J. Lorsch, *Organization and Environment* (Boston: Division of Research, Harvard Business School, 1967), pp. 50–55.

[14]Galbraith, *Designing Complex Organizations*, Chapter 1; and J. R. Galbraith and R. K. Kazanjian, *Strategy Implementation: Structure System and Process*, 2nd ed. (St. Paul: West, 1986), Chapter 7.

[15]R. Simmons, "Strategic Orientation and Top Management Attention to Control Systems," *Strategic Management Journal* 12 (1991): 49–62.

[16]R. Simmons, "How New Top Managers Use Control Systems as Levers of Strategic Renewal," *Strategic Management Journal* 15 (1994): 169–189.

[17]W. G. Ouchi, "The Transmission of Control Through Organizational Hierarchy," *Academy of Management Journal* 21 (1978):

173–192; and W. H. Newman, *Constructive Control* (Englewood Cliffs: Prentice-Hall, 1975).

[18]E. Flamholtz, "Organizational Control Systems as a Managerial Tool," *California Management Review,* Winter 1979, pp. 50–58.

[19]O. E. Williamson, *Markets and Hierarchies: Analysis and Antitrust Implications* (New York: Free Press, 1975); and W. G. Ouchi, "Markets, Bureaucracies, and Clans," *Administrative Science Quarterly* 25 (1980): 129–141.

[20]H. Mintzberg, *The Structuring of Organizations* (Englewood Cliffs: Prentice-Hall, 1979), pp. 5–9.

[21]E. E. Lawler III, *Motivation in Work Organizations* (Monterey: Brooks/Cole, 1973); and Galbraith and Kazanjian, *Strategy Implementation*, Chapter 6.

[22]Smircich, "Concepts of Culture and Organizational Analysis."

[23]www.microsoft.com, 2011.

[24]Ouchi, "Markets, Bureaucracies, and Clans," 130.

[25]Jones, *Organizational Theory, Design, and Change*.

[26]J. Van Maanen and E. H. Schein, "Towards a Theory of Organizational Socialization," in B. M. Staw (ed.), *Research in Organizational Behavior 1* (Greenwich: JAI Press, 1979), pp. 209–264.

[27]G. R. Jones, "Socialization Tactics, Self-Efficacy, and Newcomers' Adjustments to Organizations," *Academy of Management Journal* 29 (1986): 262–279.

[28]J. P. Kotter and J. L. Heskett, "Corporate Culture and Performance," *Sloan Management Review* 33:3 (1992): 91–92.

[29]T. J. Peters and R. H. Waterman, *In Search of Excellence: Lessons from America's Best-Run Companies* (New York: Harper & Row, 1982).

[30]G. Hamel and C. K. Prahalad, "Strategic Intent," *Harvard Business Review,* May–June 1989, p. 64.

[31]Galbraith and Kazanjian, *Strategy Implementation*; Child, *Organization*; and R. Duncan, "What Is the Right Organization Structure?" *Organizational Dynamics*, Winter 1979, pp. 59–80.

[32]J. Pettet, "Walmart Yesterday and Today," *Discount Merchandiser*, December 1995, pp. 66–67; M. Reid, "Stores of Value," *Economist*, March 4, 1995, ss5–ss7; M. Troy, "The Culture Remains the Constant," *Discount Store News*, June 8, 1998, pp. 95–98; and www.walmart.com.

[33]W. G. Ouchi, "The Relationship Between Organizational Structure and Organizational Control," *Administrative Science Quarterly* 22 (1977): 95–113.

[34]R. Bunderi, "Intel Researchers Aim to Think Big While Staying Close to Development," *Research-Technology Management*, March–April 1998, pp. 3–4.

[35]K. M. Eisenhardt, "Control: Organizational and Economic Approaches," *Management Science* 16 (1985): 134–148.

[36]Williamson, *Markets and Hierarchies*.

[37]P. R. Lawrence and J. W. Lorsch, *Organization and Environment* (Boston: Graduate School of Business Administration, Harvard University, 1967).

[38]M. E. Porter, *Competitive Strategy: Techniques for Analyzing Industries and Competitors* (New York: Free Press, 1980); and D. Miller, "Configurations of Strategy and Structure," *Strategic Management Journal* 7 (1986): 233–249.

[39]D. Miller and P. H. Freisen, *Organizations: A Quantum View* (Englewood Cliffs: Prentice-Hall, 1984).

[40]J. Woodward, *Industrial Organization: Theory and Practice* (London: Oxford University Press, 1965); and Lawrence and Lorsch, *Organization and Environment*.

[41]R. E. White, "Generic Business Strategies, Organizational Context and Performance: An Empirical Investigation," *Strategic Management Journal* 7 (1986): 217–231.

[42]G. Rivlin, "He Naps. He Sings. And He Isn't Michael Dell," *New York Times,* September 11, 2005, p. 31.

[43]Porter, *Competitive Strategy;* and Miller, "Configurations of Strategy and Structure."

[44]S. M. Davis and R. R. Lawrence, *Matrix* (Reading: Addison-Wesley, 1977); and J. R. Galbraith, "Matrix Organization Designs: How to Combine Functional and Project Forms," *Business Horizons* 14 (1971): 29–40.

[45]Duncan, "What Is the Right Organizational Structure?"; and Davis and Lawrence, *Matrix*.

[46]D. Miller, "Configurations of Strategy and Structure," in R. E. Miles and C. C. Snow (eds.), *Organizational Strategy, Structure, and Process* (New York: McGraw-Hill, 1978).

[47]G. D. Bruton, J. K. Keels, and C. L. Shook, "Downsizing the Firm: Answering the Strategic Questions," *Academy of Management Executive*, May 1996, pp. 38–45.

[48]M. Hammer and J. Champy, *Reengineering the Corporation* (New York: HarperCollins, 1993).

Implementing Strategy in Companies That Compete Across Industries and Countries

OPENING CASE

Justin Sullivan/Getty Images

Google Reorganizes

In April of 2011, Larry Page, one of Google's two founders, became CEO of the company. Page had been CEO of Google from its establishment in 1998 through 2001, when Eric Schmidt became the CEO. After 10 years, Schmidt decided to step down and handed the reins back to Page. One of Page's first actions was to reorganize the company into business units.

Under Schmidt, Google was organized into two main entities—an engineering function and a product management group under the leadership of Jonathan Rosenberg. The engineering group was responsible for creating, building, and maintaining Google's products, and the product management group focused on selling Google's offerings, particularly its advertising services. There were, however, two main exceptions to this structure, YouTube and the Android group, both of which were the result of acquisitions, and both of which were left to run their own operations in a largely autonomous manner. Notably, both had been more successful than many of Google's own internally generated new-product ideas.

The great virtue claimed for Google's old organization structure was that it was a flat structure, based around teams, where innovation was encouraged. Indeed, numerous articles were written about the bottom-up new product-development process at Google. Engineers were encouraged to spend 20% of their own time on

LEARNING OBJECTIVES

After reading this chapter, you should be able to:

13-1 Discuss the reasons why companies pursuing different corporate strategies need to implement these strategies using different combinations of organizational structure, control, and culture

13-2 Describe the advantages and disadvantages of a multidivisional structure

13-3 Explain why companies that pursue different kinds of global expansion strategies choose different kinds of global structures and control systems to implement these strategies

13-4 Discuss the strategy-implementation problems associated with the three primary methods used to enter new industries: internal new venturing, joint ventures, and mergers

projects of their own choosing. They were empowered to form teams to flesh out product ideas, and could get funding to take those products to market by going through a formal process that ended with a presentation in front of Page and Google cofounder Sergey Brin. The products that came out of this process included Google News, Google Earth, and Google Apps.

However, by 2011 it was becoming increasingly clear that there were limitations to this structure. There was a lack of accountability for products once they had been developed. The core engineers might move on to other projects. Projects could stay in the beta stage for years, essentially unfinished offerings. No one was really responsible for taking products and making them into stand-alone businesses. Many engineers complained that the process for approving new products had become mired in red tape. It was too slow. A structure that had worked well when Google was still a small start-up was no longer scaling. Furthermore, the structure did not reflect the fact that Google was essentially becoming a multibusi-

ness enterprise, albeit one in which search-based advertising income was still the main driver of the company's revenues. Indeed, that in itself was viewed as an issue, for despite creating many new-product offerings, Google was still dependent upon search-based advertising for the bulk of its income.

Page's solution to this problem was to reorganize Google into seven core product areas or business units: Search, Advertising, YouTube, Mobile (Android), Chrome, Social (Google + and Blogger), and Commerce (Google Apps). A senior vice president who reports directly to Page heads each unit. The heads of each unit have full responsibility (and accountability) for their fates. Getting a new product started no longer requires convincing executives from across the company to get on board. And once a product ships, engineers and managers can't jump to the next thing and leave important products like Gmail in unfinished beta for years. "Now you are accountable not only for delivering something, but for revising and fixing it," said one Google spokesperson.

Sources: Miguel Helft, "The Future According to Google's Larry Page," *CNNMoney*, January 3, 2013; Liz Gannes, "GoogQuake: The Larry Page Reorg Promotes Top Lieutenants to SVP," *All Things Digital*, April 7, 2011; Jessica Guynn, "Google CEO Larry Page Completes Major Reorganization of Internet Search Giant," *Los Angeles Times*, April 7, 2011.

OVERVIEW

As explained in the Opening Case, in 2011 Google reorganized itself to try to improve its performance. Although Google has had stellar financial performance over the years, many of its new business ideas have failed to become big revenue generators. In attempt to solve this problem, CEO Larry Page has essentially created a *multidivisional structure* at Google, with each "division" been given full responsibility to run its own operations, and being held accountable for its own performance. Google is not the first company to wrestle with the problem of how best to manage a company as it grows and starts to generate new-product offerings; there is in fact a long history of companies moving from a functional toward a multidivisional structure as they grow and start to diversify. The organizational structures that are optimal for managing a single business turn out to be inappropriate for managing a more diversified multibusiness enterprise, which Google is in the process of becoming. Indeed, by reorganizing itself, Google may promote more profitable business diversification.

This chapter begins where the last one ends; it examines how to implement strategy when a company decides to enter and compete in new business areas, new industries, or in new countries when it expands globally. The strategy-implementation issue remains the same; however, deciding how to use organizational design and combine organizational structure, control, and culture to strengthen a company's strategy and increase its profitability.

Once a company decides to compete across businesses, industries, and countries, it confronts a new set of problems; some of them are continuations of the organizational problems we discussed in Chapter 12, and some of them are a direct consequence of the decision to enter and compete in overseas markets and new industries. As a result, managers must make a new series of organizational design decisions to successfully implement their company's corporate strategy. By the end of the chapter, you will appreciate the many complex issues that confront global multibusiness companies and understand why effective strategy implementation is an integral part of achieving competitive advantage and superior performance.

CORPORATE STRATEGY AND THE MULTIDIVISIONAL STRUCTURE

As Chapters 10 and 11 discuss, there are many ways in which corporate-level strategies such as vertical integration or diversification can be used to strengthen a company's performance and improve its competitive position. However, important implementation problems also arise when a company enters new industries, often due to the increasing bureaucratic costs associated with managing a collection of business units that operate in different industries. Bureaucratic costs are especially high when a company seeks to gain the differentiation and low-cost advantages of transferring, sharing, or leveraging its distinctive competencies across its business units in different industries. Companies that pursue a strategy of related diversification, for example, face many problems and costs in managing the handoffs or transfers between the value-chain functions of their business units in different industries or around the world to boost profitability. The need to economize on these costs propels managers to search for improved ways to implement corporate-level strategies.

As a company begins to enter new industries and produce different kinds of products, the structures described in Chapter 12, such as the functional and product structures, are not up to the task. These structures cannot provide the level of coordination between managers, functions, and business units necessary to effectively implement corporate-level strategy. As a result, the control problems that give rise to bureaucratic costs, such as those related to measurement, customers, location, or strategy, escalate.

Experiencing these problems is a sign that a company has once again outgrown its structure. Managers need to invest additional resources to develop a different structure—one that allows the company to implement its corporate strategies successfully. The answer for most large, complex companies is to move to a multidivisional structure, design a cross-industry control system, and fashion a global corporate culture to reduce these problems and economize on bureaucratic costs.

A **multidivisional structure** has two organizational design advantages over a functional or product structure that allow a company to grow and diversify while also reducing the coordination and control problems that inevitably arise as it enters and competes in new industries. First, in each industry in which a company operates, managers group all its different business operations in that industry into one division or subunit. Each industry division contains all the value-chain functions it needs to pursue its industry business model

multidivisional structure

A complex organizational design that allows a company to grow and diversify while also reducing coordination and control problems because it uses self-contained divisions and has a separate corporate headquarters staff.

self-contained division

An independent business unit or division that contains all the value-chain functions it needs to pursue its business model successfully.

and is thus called a **self-contained division**. For example, GE competes in eight different industries—and each of its eight main business divisions is self-contained and performs all the value creation functions necessary to give it a competitive advantage.

Second, the office of *corporate headquarters staff* is created to monitor divisional activities and exercise financial control over each division.[1] This office contains the corporate-level managers who oversee the activities of divisional managers. Hence, the organizational hierarchy is taller in a multidivisional structure than in a product or functional structure. An important function of the new level of corporate management is to develop strategic control systems that lower a company's overall cost structure, including finding ways to economize on the costs of controlling the handoffs and transfers between divisions. The extra cost of these corporate managers is more than justified if their actions lower the cost structure of the operating divisions or increase their ability to differentiate their products—both of which boost total company profitability.

corporate headquarters staff

The team of top executives, as well as their support staff, who are responsible for overseeing a company's long-term multibusiness model and providing guidance to increase the value created by the company's self-contained divisions.

In the multidivisional structure, the day-to-day operations of each division are the responsibility of divisional management; that is, divisional managers have *operating responsibility*. The **corporate headquarters staff**, which includes top executives as well as their support staff, is responsible for overseeing the company's long-term growth strategy and providing guidance for increasing the value created by interdivisional projects. These executives have *strategic responsibility*. Such an organizational grouping of self-contained divisions with centralized corporate management results in an organizational structure that provides the extra coordination and control necessary to compete in new industries or world regions successfully.

Figure 13.1 illustrates a typical multidivisional structure found in a large chemical company such as DuPont. Although this company has at least 20 different divisions, only

| Figure 13.1 | Multidivisional Structure |

Typical Chemical Company

Oil division
(functional structure)

Pharmaceuticals division
(product-team structure)

Plastics division
(matrix structure)

© Cengage Learning

three—the oil, pharmaceuticals, and plastics divisions—are represented in this figure. Each division possesses the value-chain functions it needs to pursue its own strategy. Each division is treated by corporate managers as an independent profit center, and measures of profitability such as return on invested capital (ROIC) are used to monitor and evaluate each division's individual performance.[2] The use of this kind of output control makes it easier for corporate managers to identify high-performing and underperforming divisions and to take corrective action as necessary.

Because each division operates independently, the divisional managers in charge of each individual division can choose which organizational structure (e.g., a product, matrix, or market structure), control systems, and culture to adopt to implement its business model and strategies most effectively. Figure 13.1 illustrates how this process works. It shows that managers of the oil division have chosen a functional structure (the one that is the least costly to operate) to pursue a cost-leadership strategy. The pharmaceuticals division has adopted a product-team structure that allows each separate product development team to focus its efforts on the speedy development of new drugs. And, managers of the plastics division have chosen to implement a matrix structure that promotes cooperation between teams and functions and allows for the continuous innovation of improved plastic products that suit the changing needs of customers. These two divisions are pursuing differentiation based on a distinctive competence in innovation.

The CEO famous for employing the multidivisional structure to great advantage was Alfred Sloan, GM's first CEO, who implemented a multidivisional structure in 1921, noting that GM "needs to find a principle for coordination without losing the advantages of decentralization." Sloan placed each of GM's different car brands in a self-contained division so it possessed its own functions—sales, production, engineering, and finance. Each division was treated as a profit center and evaluated on its return on investment. Sloan was clear about the main advantage of decentralization: it made it much easier to evaluate the performance of each division. And, Sloan observed, it: (1) "increases the morale of the organization by placing each operation on its own foundation . . . assuming its own responsibility and contributing its share to the final result"; (2) "develops statistics correctly reflecting . . . the true measure of efficiency"; and (3) "enables the corporation to direct the placing of additional capital where it will result in the greatest benefit to the corporation as a whole."[3]

Sloan recommended that exchanges or handoffs between divisions be set by a *transfer-pricing system* based on the cost of making a product plus some agreed-upon rate of return. He recognized the risks that internal suppliers might become inefficient and raise the cost structure, and he recommended that GM should benchmark competitors to determine the fair price for a component. He established a centralized headquarters management staff to perform these calculations. Corporate management's primary role was to audit divisional performance and plan strategy for the entire organization. Divisional managers were to be responsible for all competitive product-related decisions.

Advantages of a Multidivisional Structure

When managed effectively at both the corporate and the divisional levels, a multidivisional structure offers several strategic advantages. Together, they can raise corporate profitability to a new peak because they allow a company to more effectively implement its corporate-level strategies.

Enhanced Corporate Financial Control The profitability of different business divisions is clearly visible in the multidivisional structure.[4] Because each division is its own **profit center**, financial controls can be applied to each business on the basis of profitability criteria such as ROIC. Corporate managers establish performance goals for each

profit center
When each self-contained division is treated as a separate financial unit and financial controls are used to establish performance goals for each division and measure profitability.

division, monitor their performance on a regular basis, and intervene selectively if a division starts to underperform. They can then use this information to identify the divisions in which investment of the company's financial resources will yield the greatest long-term ROIC. As a result, they can allocate the company's funds among competing divisions in an optimal way—that is, a way that will maximize the profitability of the *whole* company. Essentially, managers at corporate headquarters act as "internal investors" who channel funds to high-performing divisions in which they will produce the most profits.

Enhanced Strategic Control The multidivisional structure makes divisional managers responsible for developing each division's business model and strategies; this allows corporate managers to focus on developing corporate strategy, which is their main responsibility. The structure gives corporate managers the time they need to contemplate wider long-term strategic issues and develop a coordinated response to competitive changes, such as quickly changing industry boundaries. Teams of managers at corporate headquarters can also be created to collect and process crucial information that leads to improved functional performance at the divisional level. These managers also perform long-term strategic and scenario planning to find new ways to increase the performance of the entire company, such as evaluating which of the industries they compete in will likely be the most profitable in the future. Then managers can decide which industries they should expand into and which they should exit.

Profitable Long-Term Growth The division of responsibilities between corporate and divisional managers in the multidivisional structure allows a company to overcome organizational problems, such as communication problems and information overload. Divisional managers work to enhance their divisions' profitability; teams of managers at corporate headquarters devote their time to finding opportunities to expand or diversify existing businesses so that the entire company enjoys profitable growth. Communication problems are also reduced because corporate managers use the same set of standardized accounting and financial output controls to evaluate all divisions. Also, from a behavior control perspective, corporate managers can implement a policy of management by exception, which means that they intervene only when problems arise.

Stronger Pursuit of Internal Efficiency As a single-business company grows, it often becomes difficult for top managers to accurately assess the profit contribution of each functional activity because their activities are so interdependent. This means that it is often difficult for top managers to evaluate how well their company is performing relative to others in its industry—and to identify or pinpoint the specific source of the problem. As a result, inside one company, considerable degrees of **organizational slack**—that is, the unproductive use of functional resources—can go undetected. For example, the head of the finance function might employ a larger staff than is required for efficiency to reduce work pressures inside the department and to bring the manager higher status. In a multidivisional structure, however, corporate managers can compare the performance of one division's cost structure, sales, and the profit it generates against another. The corporate office is therefore in a better position to identify the managerial inefficiencies that result in bureaucratic costs; divisional managers have no excuses for poor performance.

organizational slack
The unproductive use of functional resources by divisional managers that can go undetected unless corporate managers monitor their activities.

Problems in Implementing a Multidivisional Structure

Although research suggests large companies that adopt multidivisional structures outperform those that retain functional structures, multidivisional structures have their disadvantages as well.[5] Good management can eliminate some of these disadvantages, but some

problems are inherent in the structure. Corporate managers must continually pay attention to the way they operate and detect problems.

Establishing the Divisional–Corporate Authority Relationship

The authority relationship between corporate headquarters and the subordinate divisions must be correctly established. The multidivisional structure introduces a new level in the management hierarchy: the corporate level. Corporate managers face the problem of deciding how much authority and control to delegate to divisional managers, and how much authority to retain at corporate headquarters to increase long-term profitability. Sloan encountered this problem when he implemented GM's multidivisional structure.[6] He found that when corporate managers retained too much power and authority, the managers of its business divisions lacked the autonomy required to change its business model to meet rapidly changing competitive conditions; the need to gain approval from corporate managers slowed down decision making. On the other hand, when too much authority is delegated to divisions, managers may start to pursue strategies that benefit their own divisions, but add little to the whole company's profitability. Strategy in Action 13.1 describes the problems CEO Andrea Jung experienced as Avon recentralized control over its functional operations to U.S. corporate managers from overseas divisional managers when under order to overcome this problem.

As this example suggests, the most important issue in managing a multidivisional structure is how much authority should be *centralized* at corporate headquarters and how much should be *decentralized* to the divisions—in different industries or countries. Corporate managers must consider how their company's corporate strategies will be affected by the way they make this decision now and in the future. There is no easy answer because every company is different. In addition, as the environment changes or a company alters its corporate strategy, the optimal balance between centralization and decentralization of authority will also change.

Restrictive Financial Controls Lead to Short-Run Focus Suppose corporate managers place too much emphasis on each division's *individual* profitability, for example, by establishing very high and stringent ROIC targets for each division. Divisional managers may engage in **information distortion**—that is, they may manipulate the facts they supply to corporate managers to hide declining divisional performance, or start to pursue strategies that increase short-term profitability but reduce future profitability. For example, divisional managers may attempt to make the ROIC of their division look better by cutting investments in R&D, product development, or marketing—all of which increase ROIC in the short run. In the long term, however, cutting back on the investments and expenditures necessary to maintain the division's performance, particularly the crucial R&D investments that lead a stream of innovative products, will reduce its long-term profitability. Hence, corporate managers must carefully control their interactions with divisional managers to ensure that both the short- and long-term goals of the business are being met. In sum, a problem can stem from the use of financial controls that are too restrictive; Chapter 11 discusses the "balanced scorecard" approach that helps solve it.

information distortion
The manipulation of facts supplied to corporate managers to hide declining divisional performance.

Competition for Resources The third problem of managing a multidivisional structure is that when the divisions compete among themselves for scarce resources, this rivalry can make it difficult—or sometimes impossible—to obtain the gains from transferring, sharing, or leveraging distinctive competencies across business units. For example, every year the funds available to corporate managers to allocate or distribute to their divisions is fixed, and, usually, the divisions that have obtained the highest ROIC proportionally

13.1 STRATEGY IN ACTION

Organizational Change at Avon

© iStockPhoto.com/Tom Nulens

After a decade of profitable growth, Avon began to experience falling sales in the mid-2000s, both at home and in developing markets abroad. After spending several months visiting the managers of its worldwide divisions, Andrea Jung, Avon's CEO, decided that Avon had lost the balance between centralization and decentralization of authority. Managers abroad had gained so much authority to control operations in their respective countries and world regions that they had made decisions to benefit their own divisions, and these decisions had hurt the performance of the whole company. Specifically, Avon's operating costs were out of control, and it was losing both low-cost and differentiation advantages. Avon's country-level managers from Poland to Mexico ran their own factories, made their own product development decisions, and spearheaded their own advertising campaigns. These decisions were often based on poor marketing knowledge and with little concern for operating costs because the goal was to increase sales as rapidly as possible.

When too much authority is decentralized to managers lower in an organization's hierarchy, these managers often recruit more and more managers to help them build their country "empires." At Avon, the result was an expansion of the global hierarchy—it had risen from 7 levels to 15 levels of managers in a decade as tens of thousands of additional managers were hired around the globe! Because Avon's profits were rising fast, Jung and her top-management team had not paid enough attention to the way Avon's organizational structure was becoming taller and taller—and how this was taking away its competitive advantage.

Once Jung recognized this problem she had to confront the need to lay off thousands of managers and restructure the hierarchy. She embarked on a program to take away the authority of Avon's country-level managers and to transfer authority to regional and corporate headquarters managers to streamline decision making and reduce costs. She cut out seven levels of management and laid off 25% of Avon's global managers in its 114 worldwide markets. Then, using teams of expert managers from corporate headquarters, she embarked on a detailed examination of all Avon's functional activities, country by country, to find out why its costs had risen so quickly, and what could be done to bring them under control. The duplication of marketing efforts in countries around the world was one source of these high costs. In Mexico, one team found that country managers' desire to expand their empires led to the development of a staggering 13,000 different products! Not only had this caused product development costs to soar, it had led to major marketing problems, for how could Avon's Mexican sales reps learn about the differences between 13,000 products—and then find an easy way to tell customers about them?

In Avon's new structure the focus is now upon centralizing all new major product development; Avon develops over 1,000 new products per year, but in the future, the input from different country managers will be used to customize products to country needs, including fragrance, packaging, and so on, and research and development (R&D) will be performed in the United States. Similarly, the future goal is to develop marketing campaigns targeted at the average "global" customer, but that can also be easily customized to any country. Using the appropriate language or changing the nationality of the models used to market the products, for example, could adapt these campaigns. Other initiatives have been to increase the money spent on global marketing and a major push to increase the number of Avon representatives in developing nations in order to attract more customers. By 2011, Avon recruited another 400,000 reps in China alone!

Country-level managers now are responsible for managing this army of Avon reps and for ensuring that marketing dollars are being directed to the right channels for maximum impact. However, they no longer have any authority to engage in major product development or build new manufacturing capacity—or to hire new managers without the agreement of regional- or corporate-level managers. The balance of control has changed at Avon, and Jung and all of her managers are now firmly focused on making operational decisions that lower its costs or increase its differentiation advantage in ways that serve the best interests of the whole company—not just one of the countries in which its cosmetics are sold.

Source: www.avon.com.

receive more of these funds. In turn, because managers have more money to invest in their business, this usually will raise the company's performance the next year, so that strong divisions grow ever stronger. This is what leads to competition for resources and reduces interdivisional coordination; there are many recorded instances in which one divisional manager tells another: "You want our new technology? Well you have to pay us $2 billion to get it." When divisions battle over transfer prices, the potential gains from pursuing a corporate strategy are lost.

Transfer Pricing As just noted, competition among divisions may lead to battles over **transfer pricing**, that is, conflicts over establishing the fair or "competitive" price of a resource or skill developed in one division that is to be transferred and sold to other divisions that require it. As Chapter 9 discusses, a major source of bureaucratic costs is the problems that arise from handoffs or transfers between divisions to obtain the benefits of corporate strategy when pursuing a vertical integration or related diversification strategy. Setting prices for resource transfers between divisions is a major source of these problems, because every supplying division has the incentive to set the highest possible transfer price for its products or resources to maximize its *own* profitability. The "purchasing" divisions realize the supplying divisions' attempts to charge high prices will reduce their profitability; the result is competition between divisions that undermines cooperation and coordination. Such competition can completely destroy the corporate culture and turn a company into a battleground; if unresolved, the benefits of the strategy will not be achieved. Hence, corporate managers must be sensitive to this problem and work hard with the divisions to design incentive and control systems to make the multidivisional structure work. Indeed, managing transfer pricing is one of corporate managers' most important tasks.

Duplication of Functional Resources Because each division has its own set of value-chain functions, functional resources are duplicated across divisions; thus, multidivisional structures are expensive to operate. R&D and marketing are especially costly functional activities; to reduce their cost structure, some companies centralize most of the activities of these two functions at the corporate level, in which they service the needs of all divisions. The expense involved in duplicating functional resources does not result in major problems if the differentiation advantages that result from the use of separate sets of specialist functions are substantial. Corporate managers must decide whether the duplication of functions is financially justified. In addition, they should always be on the lookout for ways to centralize or outsource functional activities to reduce a company's cost structure and increase long-run profitability.

In sum, the advantages of divisional structures must be balanced against the problems of implementing them, but an observant, professional set of corporate (and divisional) managers who are sensitive to the complexities involved can respond to and manage these problems. Indeed, advances in information technology (IT) have made strategy implementation easier, as we will discuss later in this chapter.

Structure, Control, Culture, and Corporate-Level Strategy

Once corporate managers select a multidivisional structure, they must then make choices about what kind of integrating mechanisms and control systems are necessary to make the structure work efficiently. Such choices depend on whether a company chooses to pursue a strategy of unrelated diversification, vertical integration, or related diversification.

As Chapter 9 discusses, many possible differentiation and cost advantages derive from vertical integration. A company can coordinate resource transfers between divisions

transfer pricing
The problem of establishing the fair or "competitive" price of a resource or skill developed in one division that is to be transferred and sold to another division.

operating in adjacent industries to reduce manufacturing costs and improve quality, for example.[7] This might mean locating a rolling mill next to a steel furnace to save on costs to reheat steel ingots, making it easier to control the quality of the final steel product.

The principal benefits from related diversification also derive from transferring, sharing, or leveraging functional competencies across divisions, such as sharing distribution and sales networks to increase differentiation, or lowering the overall cost structure. With both strategies, the benefits to the company result from some *exchange* of distinctive competencies among divisions. To secure these benefits, managers must coordinate the activities of the various divisions, so an organization's structure and control systems must be designed to manage the handoffs or transfers among divisions.

In the case of unrelated diversification, the strategy is based on using general strategic management capabilities, for example, in corporate finance or organizational design. Corporate managers' ability to create a culture that supports entrepreneurial behavior that leads to rapid product development, or to restructure an underperforming company and establish an effective set of financial controls, can result in substantial increases in profitability. With this strategy, however, there are *no* exchanges among divisions; each division operates separately and independently. The only exchanges that need to be coordinated are those between the divisions and corporate headquarters. Structure and control must therefore be designed to allow each division to operate independently, while making it easy for corporate managers to monitor divisional performance and intervene if necessary.

The choice of structure and control mechanisms depends upon the degree to which a company using a multidivisional structure needs to control the handoffs and interactions among divisions. The more *interdependent divisions are*—that is, the more they depend on each other for skills, resources, and competencies—the greater the bureaucratic costs associated with obtaining the potential benefits from a particular corporate-level strategy.[8] Table 13.1 illustrates what forms of structure and control companies should adopt to economize on the bureaucratic costs associated with the three corporate strategies of unrelated diversification, vertical integration, and related diversification.[9] We examine these strategies in detail in the next sections.

Table 13.1	Corporate Strategy, Structure, and Control				
			Type of Control		
Corporate Strategy	**Appropriate Structure**	**Need for Integration**	**Financial Control**	**Behavior Control**	**Organizational Culture**
Unrelated Diversification	Multidivisional	Low (no exchanges between divisions)	Great use (e.g., ROIC)	Some use (e.g., budgets)	Little use
Vertical Integration	Multidivisional	Medium (scheduling resource transfers)	Great use (e.g., ROIC, transfer pricing)	Great use (e.g., standardization, budgets)	Some use (e.g., shared norms and values)
Related Diversification	Multidivisional	High (achieving synergies between divisions by integrating roles)	Little use	Great use (e.g., rules, budgets)	Great use (e.g., norms, values, common language)

Unrelated Diversification Because there are *no exchanges or linkages* among divisions, unrelated diversification is the easiest and cheapest strategy to manage; it is associated with the lowest level of bureaucratic costs. The primary advantage of the structure and control system is that it allows corporate managers to evaluate divisional performance accurately. Thus, companies use multidivisional structures, and each division is evaluated by output controls such as ROIC. A company also uses an IT-based system of financial controls to allow corporate managers to obtain information quickly from the divisions and compare their performance on many dimensions. UTC, Tyco, and Textron are companies well known for their use of sophisticated financial controls to manage their structures and track divisional performance on a daily basis.

Divisions usually have considerable autonomy *unless* they fail to reach their ROIC goals, in which case corporate managers will intervene in the operations of a division to help solve problems. As problems arise, corporate managers step in and take corrective action, such as replacing managers or providing additional funding, depending on the reason for the problem. If they see no possibility of a turnaround, they may decide to divest the division. The multidivisional structure allows the unrelated company to operate its businesses as a portfolio of investments that can be bought and sold as business conditions change. Typically, managers in the various divisions do not know one another; they may not even know what other companies are represented in the corporate portfolio. Hence, the idea of a corporate-wide culture is meaningless.

The use of financial controls to manage a company means that no integration among divisions is necessary. This is why the bureaucratic costs of managing an unrelated company are low. The biggest problem facing corporate managers is to make capital allocations decisions between divisions to maximize the overall profitability of the portfolio and monitor divisional performance to ensure they are meeting ROIC targets.

Alco Standard, once one of the largest U.S. office supply companies, provides an example of how to operate a successful strategy of unrelated diversification. Alco's corporate management believed that authority and control should be completely decentralized to the managers of each of the company's 50 divisions. Each division was then left to make its own manufacturing or purchasing decisions, despite that the potential benefits to be obtained from corporate-wide purchasing or marketing were lost. Corporate managers pursued this nonintervention policy because they judged that the gains from allowing divisional managers to act in an entrepreneurial way exceeded potential cost savings that might result from attempts to coordinate interdivisional activities. Alco believed that a decentralized operating system would allow a big company to act as a small company and avoid the problems that arise when companies become bureaucratic and difficult to change.

Vertical Integration Vertical integration is a more expensive strategy to manage than unrelated diversification because *sequential resource flows* from one division to the next must be coordinated. Once again, the multidivisional structure economizes on the bureaucratic costs associated with achieving such coordination because it provides the centralized control necessary for a vertically integrated company to benefit from resource transfers. Corporate managers are responsible for devising financial output and behavior controls that solve the problems of transferring resources from one division to the next; for example, they solve transfer pricing problems. Also, rules and procedures are created that specify how resource exchanges are made to solve potential handoff problems; complex resource exchanges may lead to conflict among divisions, and corporate managers must try to prevent this.

The way to distribute authority between corporate and divisional managers must be considered carefully in vertically integrated companies. The involvement of corporate

managers in operating issues at the divisional level risks that divisional managers feel they have no autonomy, so their performance suffers. These companies must strike the appropriate balance of centralized control at corporate headquarters and decentralized control at the divisional level if they are to implement this strategy successfully.

Because the interests of their divisions are at stake, divisional managers need to be involved in decisions concerning scheduling and resource transfers. For example, the plastics division in a chemical company has a vital interest in the activities of the oil division because the quality of the products it receives from the oil division determines the quality of its products. Integrating mechanisms must be created between divisions that encourage their managers to freely exchange or transfer information and skills.[10] To facilitate communication among divisions, corporate managers create teams composed of both corporate and divisional managers, called **integrating roles**, whereby an experienced corporate manager assumes the responsibility for managing complex transfers between two or more divisions. The use of integrating roles to coordinate divisions is common in high-tech and chemical companies, for example.

Thus, a strategy of vertical integration is managed through a combination of corporate and divisional controls. As a result, the organizational structure and control systems used to economize upon the bureaucratic costs of managing this strategy are more complex and difficult to implement than those used for unrelated diversification. However, as long as the benefits that derive from vertical integration are realized, the extra expense in implementing this strategy can be justified.

Related Diversification In the case of related diversification, the gains from pursuing this strategy derive from the transfer, sharing, and leveraging of R&D knowledge, industry information, customer bases, and so on, across divisions. Within such companies, the high level of divisional resource sharing and the exchange of functional competencies make it difficult for corporate managers to evaluate the performance of each individual division.[11] Thus, bureaucratic costs are substantial. The multidivisional structure helps to economize on these costs because it provides some of the extra coordination and control that is required. However, if a related company is to obtain the potential benefits from using its competencies efficiently and effectively, it has to adopt more complicated forms of integration and control at the divisional level to make the structure work.

First, output control is difficult to use because divisions share resources, so it is not easy to measure the performance of an individual division. Therefore, a company needs to develop a corporate culture that stresses cooperation among divisions and the corporate team rather than focusing purely on divisional goals. Second, corporate managers must establish sophisticated integrating devices to ensure coordination among divisions. Integrating roles and integrating teams of corporate and divisional managers are essential because these teams provide the forum in which managers can meet, exchange information, and develop a common vision of corporate goals. An organization with a multidivisional structure must have the right mix of incentives and rewards for cooperation if it is to achieve gains from sharing skills and resources among divisions.[12]

With unrelated diversification, divisions operate autonomously, and the company can easily reward managers based upon their division's individual performance. With related diversification, however, rewarding divisions is more difficult because the divisions are engaged in so many shared activities; corporate managers must be alert to the need to achieve equity in the rewards the different divisions receive. The goal is always to design a company's structure and control systems to maximize the benefits from pursuing a particular strategy while economizing on the bureaucratic costs of implementing it.

integrating roles

Managers who work in full-time positions established specifically to improve communication between divisions.

IMPLEMENTING STRATEGY ACROSS COUNTRIES

As companies expand into foreign markets and become multinationals, they face the challenge of how best to organize their activities across different nations and regions. Here we will look at some of the main ways in which multinational companies organize themselves in order to implement their global strategy. Before we review the different organizational types that are used, it is important to remind ourselves of the four different strategies that companies use as they begin to market their products and establish production facilities abroad:

1. A *localization strategy* is oriented toward local responsiveness, and a company decentralizes control to subsidiaries and divisions in each country in which it operates to produce and customize products to local markets.
2. In an *international strategy*, product development is centralized at home and other value creation functions are decentralized to national units.
3. A *global standardization strategy* is oriented toward cost reduction, with all the principal value creation functions centralized at the optimal global location.
4. A *transnational strategy* is focused so that it can achieve local responsiveness and cost reduction. Some functions are centralized; others are decentralized at the global location best suited to achieving these objectives.

international division

A division created by companies that expand abroad and group all of their international activities into one division; often characterizes single businesses and diversified companies that use the multidivisional organizational form.

The International Division

When companies initially expand abroad, they often group all of their international activities into an **international division**. This has tended to be the case for single businesses, and for diversified companies that use the multidivisional organizational form. Regardless of the firm's domestic structure, its international division tends to be organized geographically. Figure 13.2 illustrates this for a firm with a domestic organization based on product divisions.

| Figure 13.2 | An International Division Structure |

© Cengage Learning

Many manufacturing enterprises expanded internationally by exporting the product manufactured at home to foreign subsidiaries to sell. Thus, in the firm illustrated in Figure 13.2, the subsidiaries in countries 1 and 2 would sell the products manufactured by divisions A, B, and C. In time, however, it might prove viable to manufacture the product in each country, and so production facilities would be added on a country-by-country basis. For firms with a functional structure at home, this might mean replicating the functional structure in every country in which the firm does business. For firms with a divisional structure, this might mean replicating the divisional structure in every country in which the firm does business.

This structure has been widely used; according to one study, 60% of all firms that have expanded internationally have initially adopted it. A good example of a company that uses this structure is Walmart, which created an international division in 1993 to manage its global expansion (Walmart's international division is profiled in the Running Case). Despite its popularity, an international division structure can give rise to problems. The dual structure it creates contains inherent potential for conflict and coordination problems between domestic and foreign operations. One problem with the structure is that the heads of foreign subsidiaries are not given as much voice in the organization as the heads of domestic functions (in the case of functional firms) or divisions (in the case of divisional firms). Rather, the head of the international division is presumed to be able to represent the interests of all countries to headquarters. This effectively relegates each country's manager to the second tier of the firm's hierarchy, which is inconsistent with a strategy of trying to expand internationally and build a true multinational organization.

Another problem is the implied lack of coordination between domestic operations and foreign operations, which are isolated from each other in separate parts of the structural hierarchy. This can inhibit the worldwide introduction of new products, the transfer of core competencies between domestic and foreign operations, and the consolidation of global production at key locations so as to realize production efficiencies.

As a result of such problems, many companies that continue to expand internationally abandon this structure and adopt one of the worldwide structures discussed next. The two initial choices are a worldwide product divisional structure, which tends to be adopted by diversified firms that have domestic product divisions, and a worldwide area structure, which tends to be adopted by undiversified firms with domestic structures based on functions.

Worldwide Area Structure

A **worldwide area structure** tends to be favored by companies with a low degree of diversification and a domestic structure based on functions that are pursuing a *localization strategy* (see Figure 13.3). Under this structure, the world is divided into geographic areas. An area may be a country (if the market is large enough) or a group of countries. Each area tends to be a self-contained, largely autonomous entity with its own set of value creation activities (e.g., its own production, marketing, R&D, human resources, and finance functions). Operations authority and strategic decisions relating to each of these activities are typically decentralized to each area, with headquarters retaining authority for the overall strategic direction of the firm and financial control.

This structure facilitates local responsiveness, which is why companies pursuing a *localization strategy* favor it. Because decision-making responsibilities are decentralized, each area can customize product offerings, marketing strategy, and business

worldwide area structure
A structure in which the world is divided into geographic areas; an area may be a country or a group of countries, and each area operates as a self-contained and largely autonomous entity with its own set of value creation activities, with headquarters retaining authority for the overall strategic direction of the firm and financial control; favored by companies with a low degree of diversification and a domestic structure based on functions that are pursuing a localization strategy.

FOCUS ON: Wal-Mart

Wal-Mart's International Division

© iStockPhoto.com/caracterdesign

When Walmart started to expand internationally in the early 1990s, it decided to set up an international division to oversee the process. The international division was based in Bentonville, Arkansas, at the company headquarters. Today the division oversees operations in 27 countries that collectively generate more than $109 billion in sales. In terms of reporting structure, the division is divided into three regions—Europe, Asia, and the Americas—with the CEO of each region reporting to the CEO of the international division, who in turn reports to the CEO of Walmart.

Initially, the senior management of the international division exerted tight centralized control over merchandising strategy and operations in different countries. The reasoning was straightforward; Walmart's managers wanted to make sure that international stores copied the format for stores, merchandising, and operations that had served the company so well in the United States. They believed, naively perhaps, that centralized control over merchandising strategy and operations was the way to make sure this was the case.

By the late 1990s, with the international division approaching $20 billion in sales, Walmart's managers concluded this centralized approach was not serving them well. Country managers had to get permission from their superiors in Bentonville before changing strategy and operations, and this was slowing decision making. Centralization also produced information overload at the headquarters, and led to some poor decisions. Walmart found that managers in Bentonville were not necessarily the best ones to decide on store layout in Mexico, merchandising strategy in Argentina, or compensation policy in the United Kingdom. The need to adapt merchandising strategy and operations to local conditions argued strongly for greater decentralization.

The pivotal event that led to a change in policy at Walmart was the company's 1999 acquisition of Britain's ASDA supermarket chain. The ASDA acquisition added a mature and successful $14 billion operation to Walmart's international division. The company realized that it was not appropriate for managers in Bentonville to be making all-important decisions for ASDA. Accordingly, over the next few months, John Menzer, CEO of the international division, reduced the number of staff located in Bentonville who were devoted to international operations by 50%. Country leaders were given greater responsibility, especially in the area of merchandising and operations. In Menzer's own words, "We were at the point where it was time to break away a little bit.... You can't run the world from one place. The countries have to drive the business.... The change has sent a strong message [to country managers] that they no longer have to wait for approval from Bentonville."

Although Walmart has now decentralized decisions within the international division, it is still struggling to find the right formula for managing global procurement. Ideally, the company would like to centralize procurement in Bentonville so that it could use its enormous purchasing power to bargain down the prices it pays suppliers. As a practical matter, however, this has not been easy to attain given that the product mix in Walmart stores has to be tailored to conditions prevailing in the local market. Currently, significant responsibility for procurement remains at the country and regional level. However, Walmart would like to have a global procurement strategy such that it can negotiate on a global basis with key suppliers and can simultaneously introduce new merchandise into its stores around the world.

As merchandising and operating decisions have been decentralized, the international division has increasingly taken on a new role—that of identifying best practices and transferring them between countries. For example, the division has developed a knowledge management system whereby stores in one country, let's say Argentina, can quickly communicate pictures of items, sales data, and ideas on how to market and promote products to stores in another country, such as Japan. The division is also starting to move personnel between stores in different countries as a way of facilitating the flow of best practices across national borders. Finally, the division is at the cutting edge of moving Walmart away from its U.S.-centric mentality and showing the organization that ideas implemented in foreign operations might also be used to improve the efficiency and effectiveness of Walmart's operations at home.

Sources: M. Troy, "Wal-Mart Braces for International Growth with Personnel Moves," *DSN Retailing Today,* February 9, 2004, pp. 5–7; "Division Heads Let Numbers Do the Talking," *DSN Retailing Today,* June 21, 2004, pp. 26–28; and "The Division That Defines the Future," *DSN Retailing Today,* June 2001, pp. 4–7.

Figure 13.5 A Global-Matrix Structure

The reality of the global matrix structure is that it often does not work as well as the theory predicts. In practice, the matrix often is clumsy and bureaucratic. It can require so many meetings that it is difficult to get any work done. The need to get an area and a product division to reach a decision can slow decision making and produce an inflexible organization unable to respond quickly to market shifts or to innovate. The dual-hierarchy structure can lead to conflict and perpetual power struggles between the areas and the product divisions, catching many managers in the middle. To make matters worse, it can prove difficult to ascertain accountability in this structure. When all critical decisions are the product of negotiation between divisions and areas, one side can always blame the other when things go wrong. As a manager in one global matrix structure, reflecting on a failed product launch, said to the author, "Had we been able to do things our way, instead of having to accommodate those guys from the product division, this would never have happened." (A manager in the product division expressed similar sentiments.) The result of such finger-pointing can be that accountability is compromised, conflict is enhanced, and headquarters loses control over the organization. (See the accompanying Strategy in Action 13.2 for an example of the problems associated with a matrix structure.)

In light of these problems, many companies that pursue a transnational strategy have tried to build "flexible" matrix structures based more on enterprise-wide management knowledge networks, and a shared culture and vision, than on a rigid hierarchical arrangement. Within such companies the informal structure plays a greater role than the formal structure.

FOCUS ON: Wal-Mart

Wal-Mart's International Division

© iStockPhoto.com/caracterdesign

When Walmart started to expand internationally in the early 1990s, it decided to set up an international division to oversee the process. The international division was based in Bentonville, Arkansas, at the company headquarters. Today the division oversees operations in 27 countries that collectively generate more than $109 billion in sales. In terms of reporting structure, the division is divided into three regions—Europe, Asia, and the Americas—with the CEO of each region reporting to the CEO of the international division, who in turn reports to the CEO of Walmart.

Initially, the senior management of the international division exerted tight centralized control over merchandising strategy and operations in different countries. The reasoning was straightforward; Walmart's managers wanted to make sure that international stores copied the format for stores, merchandising, and operations that had served the company so well in the United States. They believed, naively perhaps, that centralized control over merchandising strategy and operations was the way to make sure this was the case.

By the late 1990s, with the international division approaching $20 billion in sales, Walmart's managers concluded this centralized approach was not serving them well. Country managers had to get permission from their superiors in Bentonville before changing strategy and operations, and this was slowing decision making. Centralization also produced information overload at the headquarters, and led to some poor decisions. Walmart found that managers in Bentonville were not necessarily the best ones to decide on store layout in Mexico, merchandising strategy in Argentina, or compensation policy in the United Kingdom. The need to adapt merchandising strategy and operations to local conditions argued strongly for greater decentralization.

The pivotal event that led to a change in policy at Walmart was the company's 1999 acquisition of Britain's ASDA supermarket chain. The ASDA acquisition added a mature and successful $14 billion operation to Walmart's international division. The company realized that it was not appropriate for managers in Bentonville to be making all-important decisions for ASDA. Accordingly, over the next few months, John Menzer, CEO of the international division, reduced the number of staff located in Bentonville who were devoted to international

operations by 50%. Country leaders were given greater responsibility, especially in the area of merchandising and operations. In Menzer's own words, "We were at the point where it was time to break away a little bit.... You can't run the world from one place. The countries have to drive the business.... The change has sent a strong message [to country managers] that they no longer have to wait for approval from Bentonville."

Although Walmart has now decentralized decisions within the international division, it is still struggling to find the right formula for managing global procurement. Ideally, the company would like to centralize procurement in Bentonville so that it could use its enormous purchasing power to bargain down the prices it pays suppliers. As a practical matter, however, this has not been easy to attain given that the product mix in Walmart stores has to be tailored to conditions prevailing in the local market. Currently, significant responsibility for procurement remains at the country and regional level. However, Walmart would like to have a global procurement strategy such that it can negotiate on a global basis with key suppliers and can simultaneously introduce new merchandise into its stores around the world.

As merchandising and operating decisions have been decentralized, the international division has increasingly taken on a new role—that of identifying best practices and transferring them between countries. For example, the division has developed a knowledge management system whereby stores in one country, let's say Argentina, can quickly communicate pictures of items, sales data, and ideas on how to market and promote products to stores in another country, such as Japan. The division is also starting to move personnel between stores in different countries as a way of facilitating the flow of best practices across national borders. Finally, the division is at the cutting edge of moving Walmart away from its U.S.-centric mentality and showing the organization that ideas implemented in foreign operations might also be used to improve the efficiency and effectiveness of Walmart's operations at home.

Sources: M. Troy, "Wal-Mart Braces for International Growth with Personnel Moves," *DSN Retailing Today,* February 9, 2004, pp. 5–7; "Division Heads Let Numbers Do the Talking," *DSN Retailing Today,* June 21, 2004, pp. 26–28; and "The Division That Defines the Future," *DSN Retailing Today,* June 2001, pp. 4–7.

Figure 13.3 A Worldwide Area Structure

© Cengage Learning

strategy to the local conditions. However, this structure encourages fragmentation of the organization into highly autonomous entities. This can make it difficult to transfer distinctive competencies and skills between areas and to realize operating efficiencies. In other words, the structure is consistent with a *localization strategy*, but may make it difficult to realize gains associated with *global standardization*. Companies structured on this basis may encounter significant problems if local responsiveness is less critical than reducing costs or transferring distinctive competencies for establishing a competitive advantage.

Worldwide Product Divisional Structure

worldwide product divisional structure

A structure in which each division is a self-contained, largely autonomous entity with full responsibility for its own value creation activities, with headquarters retaining responsibility for the overall strategic development and financial control of the firm; adopted by firms that are reasonably diversified and originally had domestic structures based on product divisions.

A **worldwide product divisional structure** tends to be adopted by firms that are reasonably diversified and, accordingly, originally had domestic structures based on product divisions. As with the domestic product divisional structure, each division is a self-contained, largely autonomous entity with full responsibility for its own value creation activities. The headquarters retains responsibility for the overall strategic development and financial control of the firm (see Figure 13.4).

Underpinning this organizational form is a belief that the value creation activities of each product division should be coordinated by that division's management, who should be given the responsibility for deciding the geographic location of different activities. Thus, the worldwide product divisional structure is designed to help overcome the coordination problems that arise with the international division and worldwide area structures. This structure provides an organizational context that enhances the consolidation of value creation activities at key locations necessary for realizing location economies and attaining scale economies at the global level (see Chapter 8 for details). It also facilitates the transfer of competencies within a division's worldwide operations and the simultaneous worldwide introduction of new products. As such, the structure is consistent with the implementation of a *global standardization strategy* and an *international strategy*. The main problem with the structure is the limited voice it gives to area or country managers, as they are seen as subservient to product-division managers. The result can be a lack of local responsiveness, which can lead to performance problems.

| Figure 13.4 | A Worldwide Product Division Structure |

© Cengage Learning

Global Matrix Structure

Both the worldwide area structure and the worldwide product divisional structure have strengths and weaknesses. The worldwide area structure facilitates *local responsiveness*, but it can inhibit the realization of location and scale economies and the transfer of core competencies between areas. The worldwide product division structure provides a better framework for pursuing location and scale economies and for transferring skills and competencies within product divisions, but it is weak in local responsiveness. Other things being equal, this suggests that a worldwide area structure is more appropriate if the firm is pursuing a *localization strategy*, whereas a worldwide product divisional structure is more appropriate for firms pursuing *global standardization or international strategies*. However, as we saw in Chapter 8, other things are not equal. As Bartlett and Ghoshal have argued, to survive in some industries, companies must adopt a *transnational strategy*. That is, they must focus simultaneously on realizing location and scale economies, on local responsiveness, and on the internal transfer of competencies and skills across national boundaries (worldwide learning).

Some companies have attempted to cope with the conflicting demands of a transnational strategy by using a matrix structure. In the classic **global matrix structure**, horizontal differentiation proceeds along two dimensions: product division and geographic area (see Figure 13.5). The philosophy is that responsibility for operating decisions pertaining to a particular product should be shared by the product division and the various areas of the firm. Thus, the nature of the product offering, the marketing strategy, and the business strategy to be pursued in area 1 for the products produced by division A are determined by conciliation between division A and area 1 management. It is believed that this dual decision-making responsibility should enable the multinational company to simultaneously achieve its particular objectives. In a classic matrix structure, giving product divisions and geographical areas equal status within the organization reinforces the idea of dual responsibility. Individual managers thus belong to two hierarchies (a divisional hierarchy and an area hierarchy) and have two bosses (a divisional boss and an area boss).

global matrix structure
A structure in which horizontal differentiation proceeds along two dimensions: product division and geographic area.

Figure 13.5 A Global-Matrix Structure

© Cengage Learning

The reality of the global matrix structure is that it often does not work as well as the theory predicts. In practice, the matrix often is clumsy and bureaucratic. It can require so many meetings that it is difficult to get any work done. The need to get an area and a product division to reach a decision can slow decision making and produce an inflexible organization unable to respond quickly to market shifts or to innovate. The dual-hierarchy structure can lead to conflict and perpetual power struggles between the areas and the product divisions, catching many managers in the middle. To make matters worse, it can prove difficult to ascertain accountability in this structure. When all critical decisions are the product of negotiation between divisions and areas, one side can always blame the other when things go wrong. As a manager in one global matrix structure, reflecting on a failed product launch, said to the author, "Had we been able to do things our way, instead of having to accommodate those guys from the product division, this would never have happened." (A manager in the product division expressed similar sentiments.) The result of such finger-pointing can be that accountability is compromised, conflict is enhanced, and headquarters loses control over the organization. (See the accompanying Strategy in Action 13.2 for an example of the problems associated with a matrix structure.)

In light of these problems, many companies that pursue a transnational strategy have tried to build "flexible" matrix structures based more on enterprise-wide management knowledge networks, and a shared culture and vision, than on a rigid hierarchical arrangement. Within such companies the informal structure plays a greater role than the formal structure.

13.2 STRATEGY IN ACTION

© iStockPhoto.com/Tom Nulens

Dow Chemical's Matrix Structure

A handful of major players compete head-to-head around the world in the chemical industry. The barriers to the free flow of chemical products between nations largely disappeared in the 1980s. This, along with the commodity nature of most bulk chemicals, has ushered in a prolonged period of intense price competition. In such an environment, the company that wins the competitive race is the one with the lowest costs. Dow Chemical was long among the cost leaders.

For years, Dow's managers insisted that part of the credit should be placed at the feet of its "matrix" organization. Dow's organizational matrix had three interacting elements: functions (e.g., R&D, manufacturing, marketing), businesses (e.g., ethylene, plastics, pharmaceuticals), and geography (e.g., Spain, Germany, Brazil). Managers' job titles incorporated all three elements—for example, plastics marketing manager for Spain—and most managers reported to at least two bosses. The plastics marketing manager in Spain might report to both the head of the worldwide plastics business and the head of the Spanish operations. The intent of the matrix was to make Dow operations responsive to both local market needs and corporate objectives. Thus, the plastics business might be charged with minimizing Dow's global plastics production costs, and the Spanish operation might be charged with determining how best to sell plastics in the Spanish market.

When Dow introduced this structure, the results were less than promising; multiple reporting channels led to confusion and conflict. The large number of bosses made for an unwieldy bureaucracy. The overlapping responsibilities resulted in turf battles and a lack of accountability. Area managers disagreed with managers overseeing business sectors about which plants should be built and where. In short, the structure didn't work. Instead of abandoning the structure, however, Dow decided to see if it could be made more flexible.

Dow's decision to keep its matrix structure was prompted by its move into the pharmaceuticals industry. The company realized that the pharmaceutical business is very different from the bulk chemicals business. In bulk chemicals, the big returns come from achieving economies of scale in production. This dictates establishing large plants in key locations from which regional or global markets can be served. But in pharmaceuticals, regulatory and marketing requirements for drugs vary so much from country to country that local needs are far more important than reducing manufacturing costs through scale economies. A high degree of local responsiveness is essential. Dow realized its pharmaceutical business would never thrive if it were managed by the same priorities as its mainstream chemical operations.

Accordingly, instead of abandoning its matrix, Dow decided to make it more flexible so it could better accommodate the different businesses, each with its own priorities, within a single management system. A small team of senior executives at headquarters helped set the priorities for each type of business. After priorities were identified for each business sector, one of the three elements of the matrix—function, business, or geographic area—was given primary authority in decision making. Which element took the lead varied according to the type of decision and the market or location in which the company was competing. Such flexibility required that all employees understand what was occurring in the rest of the matrix. Although this may seem confusing, for years Dow claimed this flexible system worked well and credited much of its success to the quality of the decisions it facilitated.

By the mid-1990s, however, Dow had refocused its business on the chemicals industry, divesting itself of its pharmaceutical activities, where the company's performance had been unsatisfactory. Reflecting the change in corporate strategy, in 1995 Dow decided to abandon its matrix structure in favor of a more streamlined structure based on global business divisions. The change was also driven by the realization that the matrix structure was just too complex and costly to manage in the intense competitive environment of the 1990s, particularly given the company's renewed focus on its commodity chemicals, where competitive advantage often went to the low-cost producer. As Dow's then CEO put it in a 1999 interview, "We were an organization that was matrixed and depended on teamwork, but there was no one in charge. When things went well, we didn't know whom to reward; and when things went poorly, we didn't know whom to blame. So we created a global divisional structure, and cut out layers of management. There used to be 11 layers of management between me and the lowest-level employees, now there are five." In short, Dow ultimately found that a matrix structure was unsuited to a company that was competing in very cost-competitive global industries, and it had to abandon its matrix to drive down operating costs.

Sources: "Dow Draws Its Matrix Again, and Again, and Again," *The Economist*, August 5, 1989, pp. 55–56; "Dow Goes for Global Structure," *Chemical Marketing Reporter*, December 11, 1995, pp. 4–5; and R. M. Hodgetts, "Dow Chemical CEO William Stavropoulos on Structure and Decision Making," *Academy of Management Executive*, November 1999, pp. 29–35.

ENTRY MODE AND IMPLEMENTATION

As we discuss in Chapter 10, many organizations today are altering their business models and strategies and entering or leaving industries to find better ways to use their resources and capabilities to create value. This section focuses on the implementation issues that arise when companies use internal new venturing, joint ventures, and/or acquisitions to enter new industries.

Internal New Venturing

Chapter 10 discusses how companies enter new industries by using internal new venturing to transfer and leverage their existing competencies to create the set of value-chain activities necessary to compete effectively in a new industry. How can managers create a setting in which employees are encouraged to think about how to apply their functional competencies in new industries? In particular, how can structure, control, and culture be used to increase the success of the new-venturing process?

intrapreneurs

Managers who pioneer and lead new-venture projects or divisions and act as inside or internal entrepreneurs.

Corporate managers must treat the internal new-venturing process as a form of entrepreneurship and the managers who are to pioneer new ventures as **intrapreneurs**, that is, as inside or internal entrepreneurs. This means that organizational structure, control, and culture must be designed to encourage creativity and give new-venture managers real autonomy to develop and champion new products. At the same time, corporate managers want to make sure that their investment in a new market or industry will be profitable because commonalities exist between the new industry and its core industry, so that the potential benefits of transferring or leveraging competencies will be obtained.[13]

3M is an example of a company that carefully selects the right mix of structure, control, and culture to create a work context that facilitates the new-venturing process and promotes product innovation. 3M's goal is that at least 30% of its growth in sales each year should come from new products developed within the past 5 years. To meet this challenging goal, 3M designed a sophisticated control and incentive system that provides its employees with the freedom and motivation to experiment and take risks.

new-venture division

A separate and independent division established to give its managers the autonomy to develop a new product.

Another approach to internal new venturing is championed by managers who believe that the best way to encourage new-product development is to separate the new-venture unit from the rest of the organization. To provide the new-venture's managers with the autonomy to experiment and take risks, a company establishes a **new-venture division**, that is, a separate and independent division to develop a new product. If a new-venture's managers work within a company's existing structure under the scrutiny of its corporate managers, they will not have the autonomy they need to pursue exciting new-product ideas. In a separate unit in a new location, however, new-venture managers will be able to act as external entrepreneurs as they work to create a new product and develop a business model to bring it to market successfully.

The new-venture unit or division uses controls that reinforce its entrepreneurial spirit. Strict output controls are inappropriate because they may promote short-term thinking and inhibit risk taking. Instead, stock options are often used to create a culture for entrepreneurship. Another issue is how to deal with corporate managers. The upfront R&D costs of new venturing are high, and its success is uncertain. After spending millions of dollars, corporate managers often become concerned about how successful the new-venture division will be. As a result, they might attempt to introduce strict output controls, including restrictive budgets, to make the managers of the new venture more accountable—but which at the same time harm its entrepreneurial culture.[14] Corporate managers may believe it is

important to use output and behavior controls to limit the autonomy of new-venture managers; otherwise, they might make costly mistakes and waste resources on frivolous ideas.

Recently, there have been some indications that 3M's internal approach may be superior to the use of external new-venture divisions. It appears that many new-venture divisions have failed to bring successful new products to market. And even if they do, the new-venture division eventually begins to operate like other divisions and the entire company's cost structure increases because of the duplication of value-chain activities. Another issue is that scientists lack the formal training necessary to develop successful business models. Just as many medical doctors are earning MBAs today to understand the many strategic issues they must confront when they decide to become hospital managers, so scientists need to be able to think strategically. If strategic thinking is lacking in a new-venture division, the result is failure.

Joint Ventures

Joint ventures are a second method used by large, established companies to maintain momentum and grow their profits by entering new markets and industries.[15] A joint venture occurs when two companies agree to pool resources and capabilities and establish a new business unit to develop a new product and a business model that will allow it bring the new product to market successfully. These companies believe that through collaboration—by sharing their technology or marketing skills to develop an improved product, for example—they will be able to create more value and profit in the new industry than if they decide to "go it alone." Both companies transfer competent managers, who have a proven track record of success, to manage the new subunit that they both own. Sometimes they take an equal "50/50" ownership stake, but sometimes one company insists on having a 51% share or more, giving it the ability to buy out the other party at some point in the future should problems emerge. The way a joint venture is organized and controlled becomes an important issue in this context.

Allocating authority and responsibility is the first major implementation issue upon which companies must decide. Both companies need to be able to monitor the progress of the joint venture so that they can learn from its activities and benefit from their investment in it. Some companies insist on 51% ownership stakes because only then do they have the authority and control over the new ventures. Future problems could arise, such as what to do if the new venture performs poorly, or how to proceed if conflict develops between the parent companies over time—because one partner feels "cheated." For example, what will happen in the future is unknown, and frequently one parent company benefits much more from the product innovations the new company develops; if the other company demands "compensation," the companies come into conflict.[16] As was discussed in Chapter 8, a company also risks losing control of its core technology or competence when it enters into a strategic alliance. One parent company might believe this is taking place and feel threatened by the other. A joint venture can also be dangerous not only because one partner might decide to take the new technology and then "go it alone" in the development process, but also because a company's partner might be acquired by a competitor. For example, Compaq shared its proprietary server technology with a company in the computer storage industry to promote joint product development. Then, it watched helplessly as that company was acquired by Sun Microsystems, which consequently obtained Compaq's technology.

The implementation issues are strongly dependent upon whether the purpose of the joint venture is to share and develop technology, jointly distribute and market products and brands, or share access to customers. Sometimes companies can simply realize the joint

benefits from collaboration without having to form a new company. For example, Nestlé and Coca-Cola announced a 10-year joint venture called Beverage Partners Worldwide through which Coca-Cola will distribute and sell Nestlé's Nestea iced tea, Nescafé, and other brands throughout the globe.[17] Similarly, Starbucks' Frappuccino is distributed by Pepsi. In these kinds of joint ventures, both companies can gain from sharing and pooling different competencies so that both realize value that would not otherwise be possible. Issues of ownership and control in these examples are less important.

Once the ownership issue has been settled, one company appoints the CEO, who then becomes responsible for creating a cohesive top-management team out of the managers transferred from the parent companies. The job of the top-management team is to develop a successful business model. These managers then need to choose an organizational structure, such as the functional or product-team structure, that will make the best use of the resources and skills they receive from the parent companies. The need to create an effective organizational design that integrates people and functions is of paramount importance to ensure that the best use is made of limited resources. The need to build a new culture that unites managers who used to work in companies with different cultures is equally as important.

Managing these implementation issues is difficult, expensive, and time consuming, so it is not surprising that when a lot is at stake and the future is uncertain, many companies decide that it would be better to acquire another company and integrate it into their operations. If the risks are lower, however, and it is easier to forecast the future, as in the venture between Coca-Cola and Nestlé, then to reduce bureaucratic costs, a strategic alliance (which does not require the creation of a new subunit) may be capable of managing the transfers of complementary resources and skills between companies.

Mergers and Acquisitions

Mergers and acquisitions are the third method companies use to enter new industries or countries.[18] How to implement structure, control systems, and culture to manage a new acquisition is important because many acquisitions are unsuccessful. One of the primary reasons acquisitions perform poorly is that many companies do not anticipate the difficulties associated with merging or integrating new companies into their existing operations.[19]

At the level of organizational structure, managers of both the acquiring and acquired companies must confront the problem of how to establish new lines of authority and responsibility that will allow them to make the best use of both companies' competencies. The massive merger between HP and Compaq illustrates these issues. Before the merger, the top-management teams of both companies spent thousands of hours analyzing the range of both companies' activities and performing a value-chain analysis to determine how cost and differentiation advantages might be achieved. Based on this analysis, they merged all of the divisions of both companies into four main product groups.

Imagine the problems deciding who would control which group and which operating division, and to whom these divisions would report! To counter fears that infighting would prevent the benefits of the merger from being realized, the CEOs of HP and Compaq were careful to announce in press releases that the process of merging divisions was going smoothly and that battles over responsibilities and control of resources would be resolved. One problem with a mishandled merger is that skilled managers who feel they have been demoted will leave the company, and if many leave, the loss of their skills may prevent the benefits of the merger from being realized. This is why Google, for example, is committed

to giving the software experts in the companies it acquires a major role in its current product development efforts, and why it encourages the development of strong cooperative values while working to maintain its innovative organizational culture.

Once managers have established clear lines of authority, they must decide how to coordinate and streamline the operations of both merged companies to reduce costs and leverage and share competencies. For large companies like HP, the answer is to choose the multidivisional structure, but important control issues still must be resolved. In general, the more similar or related are the acquired companies' products and markets, the easier it is to integrate their operations. If the acquiring company has an efficient control system, for example, it can be adapted to the new company to standardize the way its activities are monitored and measured. Alternatively, managers can work hard to combine the best elements of each company's control systems and cultures or introduce a new IT system to integrate their operations.

If managers make unrelated acquisitions, however, and then attempt to interfere with a company's strategy in an industry they know little about, or apply inappropriate structure and controls to manage the new business, then major strategy-implementation problems can arise. For example, if managers try to integrate unrelated companies with related companies, apply the wrong kinds of controls at the divisional level, or interfere in business-level strategy in the search for some elusive benefits, corporate performance can suffer as bureaucratic costs skyrocket. These mistakes explain why related acquisitions are sometimes more successful than unrelated ones.[20]

Even with examples of related diversification, the business processes of each company are frequently different, and their computer systems may be incompatible. The merged company faces the issue of how to use output and behavior controls to standardize business processes and reduce the cost of handing off and transferring resources. After Nestlé installed SAP's enterprise resource planning (ERP) software, for example, managers discovered that each of Nestlé's 150 different U.S. divisions was buying its own supply of vanilla from the same set of suppliers. However, the divisions were not sharing information about these purchases, and vanilla suppliers, dealing with each Nestlé division separately, tried to charge each division as much as they could![21] Each division paid a different price for the same input, and each division used a different code for its independent purchase. Managers at U.S. headquarters did not have the means to discover this discrepancy until SAP's software provided the information.

Finally, even when acquiring a company in a closely related industry, managers must realize that each company has unique norms, values, and culture. Such idiosyncrasies must be understood to effectively integrate the operations of the merged company. Indeed, such idiosyncrasies are likely to be especially important when companies from different countries merge. Over time, top managers can change the culture and alter the internal workings of the company, but this is a difficult implementation task.

In sum, corporate managers' capabilities in organizational design are vital in ensuring the success of a merger or acquisition. Their ability to integrate and connect divisions to leverage competencies ultimately determines how well the newly merged company will perform.[22] The path to merger and acquisition is fraught with danger, which is why some companies claim that internal new venturing is the safest path and that it is best to grow organically from within. Yet with industry boundaries blurring and new global competitors emerging, companies often do not have the time or resources to go it alone. Choosing how to enter a new industry or country is a complex implementation issue that requires thorough strategic analysis.

ETHICAL DILEMMA

© iStockPhoto.com/P_Wei

Unethical and illegal behavior is prevalent in global business. For example, although bribery is considered "acceptable" in some countries, multinational companies are often found guilty of allowing overseas executives to bribe government officials. Many countries, like the United States, have laws and severe penalties to discourage payouts on bribes. In addition to bribery, many U.S. companies have been accused of perpetuating unethical "sweatshop" conditions abroad and turning a blind eye on contract manufacturers' abusive behavior toward workers.

As a manager, if asked to improve your company's structure to prevent unethical and illegal behavior, what kind of control system could you use? In what ways could you develop a global organizational culture that reduces the likelihood of such behavior? What is the best way to decide upon the balance between centralization and decentralization to reduce these problems?

SUMMARY OF CHAPTER

1. A company uses organizational design to combine structure, control systems, and culture in ways that allow it to successfully implement its corporate strategy.
2. As a company grows and diversifies, it adopts a multidivisional structure. Although this structure costs more to operate than a functional or product structure, it economizes on the bureaucratic costs associated with operating through a functional structure and enables a company to handle its value creation activities more effectively.
3. As companies change their corporate strategies over time, they must change their structures because different strategies are managed in different ways. In particular, the move from unrelated diversification to vertical integration to related diversification increases the bureaucratic costs associated with managing a multibusiness strategy. Each requires a different combination of structure, control, and culture to economize on those costs.
4. Companies that start to expand internationally typically do so through an international division.

More mature multinationals can chose between three main structural forms: a worldwide area structure, a worldwide product division structure, and a global matrix structure. Companies pursuing a localization strategy tend to favor a worldwide area structure, whereas those pursuing other strategies favor a worldwide product division structure. Some companies have experimented with global matrix structures, but with mixed results.

5. To encourage internal new venturing, companies must design internal venturing processes that give new-venture managers the autonomy they need to develop new products. Similarly, when establishing a joint venture with another company, managers need to carefully design the new unit's structure and control systems to maximize its chance of success.

6. The profitability of mergers and acquisitions depends on the structure and control systems that companies adopt to manage them and the way a company integrates them into its existing operating structure.

DISCUSSION QUESTIONS

1. When would a company decide to change from a functional to a multidivisional structure?
2. If a related company begins to purchase unrelated businesses, in what ways should it change its structure or control mechanisms to manage the acquisitions?
3. What prompts a company to change from a global standardization strategy to a transnational strategy, and what new implementation problems arise as it does so?
4. How would you design a structure and control system to encourage entrepreneurship in a large, established corporation?
5. What are the problems associated with implementing a strategy of related diversification through acquisitions?

KEY TERMS

Multidivisional structure 441
Self-contained division 442
Corporate headquarters staff 442
Profit center 443
Organizational slack 444
Information distortion 445
Transfer pricing 447
Integrating roles 450
International division 451
Worldwide area structure 452
Worldwide product divisional structure 454
Global matrix structure 455
Intrapreneurs 458
New-venture division 458

PRACTICING STRATEGIC MANAGEMENT

© iStockPhoto.com/Urilux

Small-Group Exercises

Small-Group Exercise: Deciding on an Organizational Structure

This small-group exercise is a continuation of the small-group exercise in Chapter 12. Break into the same groups that you used in Chapter 12, reread the scenario in that chapter, and recall your group's debate about the appropriate organizational structure for your soft drink company. Because it is your intention to compete with Coca-Cola for market share worldwide, your strategy should also have a global dimension, and you must consider the best structure globally as well as domestically. Debate the pros and cons of the types of global structures and decide which is most appropriate and which will best fit your domestic structure.

STRATEGY SIGN ON

© iStockPhoto.com/Ninoslav Dotlic

Article File 13

Find an example of a company pursuing a diversification strategy that has changed its structure and control systems for better management of its strategy. What were the problems with the way it formerly implemented its strategy? What changes did it make to its structure and control systems? What effects does it expect these changes will have on performance?

Strategic Management Project: Module 13

Take the information that you collected in the strategic management project from Chapter 12 on strategy implementation and link it to the multibusiness model. You should collect information to determine if your company competes across industries or countries. If your company *does* operate across countries or industries, answer the following questions:

1. Does your company use a multidivisional structure? Why or why not? What crucial implementation problems must your company tackle to implement its strategy effectively? For example, what kind of integration mechanisms does it employ?
2. What are your company's corporate-level strategies? How do they affect the way it uses organizational structure, control, and culture?
3. What kind of international strategy does your company pursue? How does it control its global activities? What kind of structure does it use? Why?
4. Can you suggest ways of altering the company's structure or control systems to strengthen its business model? Would these changes increase or decrease bureaucratic costs?
5. Does your company have a particular entry mode that it has used to implement its strategy?
6. In what ways does your company use IT to coordinate its value-chain activities?
7. Assess how well your company has implemented its multibusiness (or business) model.

CLOSING CASE

Organizational Change at Unilever

Unilever is one of the world's oldest multinational corporations, with extensive product offerings in the food, detergent, and personal care businesses. It generates annual revenues in excess of $50 billion and sells a wide range of branded products in virtually every country. Detergents, which account for about 25% of corporate revenues, include well-known names such as Omo, which is sold in more than 50 countries. Personal care products, which account for about 15% of sales, include Calvin Klein Cosmetics, Pepsodent toothpaste brands, Faberge hair care products, and Vaseline skin lotions. Food products account for the remaining 60% of sales and include strong offerings in margarine (where Unilever's market share in most countries exceeds 70%), tea, ice cream, frozen foods, and bakery products.

Historically, Unilever was organized on a decentralized basis. Subsidiary companies in each major national market were responsible for the production, marketing, sales, and distribution of products in that

market. In Western Europe, for example, the company had 17 subsidiaries in the early 1990s, each focused on a different national market. Each was a profit center and each was held accountable for its own performance. This decentralization was viewed as a source of strength. The structure allowed local managers to match product offerings and marketing strategy to local tastes and preferences and to alter sales and distribution strategies to fit the prevailing retail systems. To drive the localization, Unilever recruited local managers to run local organizations; the U.S. subsidiary (Lever Brothers) was run by Americans, the Indian subsidiary by Indians, and so on.

By the mid-1990s, this decentralized structure was increasingly out of step with a rapidly changing competitive environment. Unilever's global competitors, which include the Swiss firm Nestlé and Procter & Gamble from the United States, had been more successful than Unilever on several fronts—building global brands, reducing cost structure by consolidating manufacturing operations at a few choice locations, and executing simultaneous product launches in several national markets. Unilever's decentralized structure worked against efforts to build global or regional brands. It also meant lots of duplication, particularly in manufacturing; a lack of scale economies; and a high-cost structure. Unilever also found that it was falling behind rivals in the race to bring new products to market. In Europe, for example, while Nestlé and Procter & Gamble moved toward pan-European product launches, it could take Unilever 4 to 5 years to "persuade" its 17 European operations to adopt a new product.

Unilever began to change all this in the late 1990s. It introduced a new structure based on regional business groups. Within each business group were a number of divisions, each focusing on a specific category of products. Thus, in the European Business Group, a division focused on detergents, another on ice cream and frozen foods, and so on. These groups and divisions coordinated the activities of national subsidiaries within their regions to drive down operating costs and speed up the process of developing and introducing new products.

For example, Lever Europe was established to consolidate the company's detergent operations. The 17 European companies reported directly to Lever Europe. Using its newfound organizational clout, Lever Europe consolidated the production of detergents in Europe in a few key locations to reduce costs and speed up new-product introduction. Implicit in this new approach was a bargain: the 17 companies relinquished autonomy in their traditional markets in exchange for opportunities to help develop and execute a unified pan-European strategy. The number of European plants manufacturing soap was cut from 10 to 2, and some new products were manufactured at only one site. Product sizing and packaging were harmonized to cut purchasing costs and to accommodate unified pan-European advertising. By taking these steps, Unilever estimated it saved as much as $400 million a year in its European detergent operations.

By the early 2000, however, Unilever found that it was still lagging its competitors, so the company embarked upon another reorganization. This time the goal was to cut the number of brands that Unilever sold from 1,600 to just 400 that could be marketed on a regional or global scale. To support this new focus, the company reduced the number of manufacturing plants from 380 to about 280. The company also established a new organization based on just two global product divisions—a food division and a home and personal care division. Within each division are a number of regional business groups that focus on developing, manufacturing, and marketing either food or personal care products within a given region. For example, Unilever Bestfoods Europe, which is headquartered in Rotterdam, focuses on selling food brands across Western and Eastern Europe, while Unilever Home and Personal Care Europe does the same for home and personal care products. A similar structure can be found in North America, Latin America, and Asia. Thus, Bestfoods North America, headquartered in New Jersey, has a similar charter to Bestfoods Europe, but in keeping with differences in local history, many of the food brands marketed by Unilever in North America are different from those marketed in Europe.

Sources: H. Connon, "Unilever's Got the Nineties Licked," *The Guardian,* May 24, 1998, p. 5; "Unilever: A Networked Organization," *Harvard Business Review,* November–December 1996, p. 138; C. Christensen and J. Zobel, "Unilever's Butter Beater: Innovation for Global Diversity," Harvard Business School Case No. 9-698-017, March 1998; M. Mayer, A. Smith, and R. Whittington, "Restructuring Roulette," *Financial Times,* November 8, 2002, p. 8; and www.unilever.com.

CASE DISCUSSION QUESTIONS

1. Why did Unilever's decentralized structure make sense in the 1960s and 1970s? Why did this structure start to create problems for the company in the 1980s?
2. What was Unilever trying to do when it introduced a new structure based on business groups in the mid-1990s? Why do you think that this structure failed to cure Unilever's ills?

3. In the 2000s, Unilever switched to a structure based on global product divisions. What do you think is the underlying logic for this shift? Does the structure make sense given the nature of competition in the detergents and food business?

NOTES

[1]A. D. Chandler, *Strategy and Structure* (Cambridge: MIT Press, 1962); O. E. Williamson, *Markets and Hierarchies* (New York: Free Press, 1975); and L. Wrigley, "Divisional Autonomy and Diversification" (Ph.D. Diss., Harvard Business School, 1970).

[2]R. P. Rumelt, *Strategy, Structure, and Economic Performance* (Boston: Division of Research, Harvard Business School, 1974); B. R. Scott, *Stages of Corporate Development* (Cambridge: Intercollegiate Clearing House, Harvard Business School, 1971); and Williamson, *Markets and Hierarchies*.

[3]A. P. Sloan, *My Years at General Motors* (Garden City: Doubleday, 1946); A. Taylor III, "Can GM Remodel Itself?" *Fortune*, January 13, 1992, pp. 26–34; W. Hampton and J. Norman, "General Motors: What Went Wrong?" *Business Week*, March 16, 1987, pp. 102–110; and www.gm.com (2002). The

quotations are on pages 46 and 50 in Sloan, *My Years at General Motors*.

[4]The discussion draws on each of the sources cited in endnotes 18–25 and on G. R. Jones and C. W. L. Hill, "Transaction Cost Analysis of Strategy-Structure Choice," *Strategic Management Journal* 9 (1988): 159–172.

[5]H. O. Armour and D. J. Teece, "Organizational Structure and Economic Performance: A Test of the Multidivisional Hypothesis," *Bell Journal of Economics* 9 (1978): 106–122.

[6]Sloan, *My Years at General Motors*.

[7]Jones and Hill, "Transaction Cost Analysis of Strategy-Structure Choice."

[8]Ibid.

[9]R. A. D'Aveni and D. J. Ravenscraft, "Economies of Integration Versus Bureaucracy Costs: Does Vertical Integration Improve Performance?" *Academy of Management Journal* 5 (1994): 1167–1206.

[10]P. R. Lawrence and J. Lorsch, *Organization and Environment* (Boston: Division of Research, Harvard Business School, 1967); J. R. Galbraith, *Designing Complex Organizations* (Reading: Addison-Wesley, 1973); and M. Porter, *Competitive Advantage: Creating and Sustaining Superior Performance* (New York: Free Press, 1985).

[11]P. R. Nayyar, "Performance Effects of Information Asymmetry and Economies of Scope in Diversified Service Firm," *Academy of Management Journal* 36 (1993): 28–57.

[12]L. R. Gomez-Mejia, "Structure and Process of Diversification, Compensation Strategy, and Performance," *Strategic Management Journal* 13 (1992): 381–397.

[13]R. A. Burgelman, "Managing the New Venture Division: Research Findings and the Implications for Strategic Management," *Strategic Management Journal* 6 (1985): 39–54.

[14]Burgelman, "Managing the New Venture Division."

[15]R. A. Burgelman, "Corporate Entrepreneurship and Strategic Management: Insights from a Process Study," *Management Science* 29 (1983): 1349–1364.

[16]G. R. Jones, "Towards a Positive Interpretation of Transaction Cost Theory: The Central Role of Entrepreneurship and Trust," in M. Hitt, R. E. Freeman, and J. S. Harrison (eds.), *Handbook of Strategic Management* (London: Blackwell, 2001), pp. 208–228.

[17]www.nestle.com and www.cocacola.com.

[18]M. S. Salter and W. A. Weinhold, *Diversification Through Acquisition* (New York: Free Press, 1979).

[19]F. T. Paine and D. J. Power, "Merger Strategy: An Examination of Drucker's Five Rules for Successful Acquisitions," *Strategic Management Journal* 5 (1984): 99–110.

[20]H. Singh and C. A. Montgomery, "Corporate Acquisitions and Economic Performance" (unpublished manuscript, 1984).

[21]B. Worthen, "Nestlé's ERP Odyssey," *CIO*, 2002, 1–5.

[22]G. D. Bruton, B. M. Oviatt, and M. A. White, "Performance of Acquisitions of Distressed Firms," *Academy of Management Journal* 4 (1994): 972–989.

Case
Study
Analysis

Analyzing a Case Study and Writing a Case Study Analysis

WHAT IS CASE STUDY ANALYSIS?

Case study analysis is an integral part of a course in strategic management. The purpose of a case study is to provide students with experience of the strategic management problems that actual organizations face. A case study presents an account of what happened to a business or industry over a number of years. It chronicles the events that managers had to deal with, such as changes in the competitive environment, and charts the managers' response, which usually involved changing the business- or corporate-level strategy. The cases in this book cover a wide range of issues and problems that managers have had to confront. Some cases are about finding the right business-level strategy to compete in changing conditions. Some are about companies that grew by acquisition, with little concern for the rationale behind their growth, and how growth by acquisition affected their future profitability. Each case is different because each organization is different. The underlying thread in all cases, however, is the use of strategic management techniques to solve business problems.

Cases prove valuable in a strategic management course for several reasons. First, cases provide you, the student, with experience of organizational problems that you probably have not had the opportunity to experience firsthand. In a relatively short period of time, you will have the chance to appreciate and analyze the problems faced by many different companies and to understand how managers tried to deal with them.

Second, cases illustrate the theory and content of strategic management. The meaning and implications of this information are made clearer when they are applied to case studies. The theory and concepts help reveal what is going on in the companies studied and allow you to evaluate the solutions that specific companies adopted to deal with their problems. Consequently, when you analyze cases, you will be like a detective who, with a set of conceptual tools, probes what happened and what or who was responsible and then marshals the evidence that provides the solution. Top managers enjoy the thrill of testing their problem-solving abilities in the real world. It is important to remember that no one knows what the right answer is. All that managers can do is to make the best guess. In fact, managers say repeatedly that they are happy if they are right only half the time in solving strategic problems. Strategic management is an uncertain game, and using cases to see how theory can be put into practice is one way of improving your skills of diagnostic investigation.

Third, case studies provide you with the opportunity to participate in class and to gain experience in presenting your ideas to others. Instructors may sometimes call on students as a group to identify what is going on in a case, and through classroom discussion the issues in and solutions to the case problem will reveal themselves. In such a situation, you will have to organize your views and conclusions so that you can present them to the class. Your classmates may have analyzed the issues differently from you, and they will want you

to argue your points before they will accept your conclusions, so be prepared for debate. This mode of discussion is an example of the dialectical approach to decision making. This is how decisions are made in the actual business world.

Instructors also may assign an individual, but more commonly a group, to analyze the case before the whole class. The individual or group probably will be responsible for a 30 to 40 minute presentation of the case to the class. That presentation must cover the issues posed, the problems facing the company, and a series of recommendations for resolving the problems. The discussion then will be thrown open to the class, and you will have to defend your ideas. Through such discussions and presentations, you will experience how to convey your ideas effectively to others. Remember that a great deal of managers' time is spent in these kinds of situations: presenting their ideas and engaging in discussion with other managers who have their own views about what is going on. Thus, you will experience in the classroom the actual process of strategic management, and this will serve you well in your future career.

If you work in groups to analyze case studies, you also will learn about the group process involved in working as a team. When people work in groups, it is often difficult to schedule time and allocate responsibility for the case analysis. There are always group members who shirk their responsibilities and group members who are so sure of their own ideas that they try to dominate the group's analysis. Most of the strategic management takes place in groups, however, and it is best if you learn about these problems now.

ANALYZING A CASE STUDY

The purpose of the case study is to let you apply the concepts of strategic management when you analyze the issues facing a specific company. To analyze a case study, therefore, you must examine closely the issues confronting the company. Most often you will need to read the case several times—once to grasp the overall picture of what is happening to the company and then several times more to discover and grasp the specific problems.

Generally, detailed analysis of a case study should include eight areas:

1. The history, development, and growth of the company over time
2. The identification of the company's internal strengths and weaknesses
3. The nature of the external environment surrounding the company
4. A SWOT analysis
5. The kind of corporate-level strategy that the company is pursuing
6. The nature of the company's business-level strategy
7. The company's structure and control systems and how they match its strategy
8. Recommendations

To analyze a case, you need to apply the concepts taught in this course to each of these areas. To help you further, we next offer a summary of the steps you can take to analyze the case material for each of the eight points we just noted:

1. *Analyze the company's history, development, and growth.* A convenient way to investigate how a company's past strategy and structure affect it in the present is to chart the critical incidents in its history—that is, the events that were the most unusual or the most essential for its development into the company it is today. Some

of the events have to do with its founding, its initial products, how it makes new-product market decisions, and how it developed and chose functional competencies to pursue. Its entry into new businesses and shifts in its main lines of business are also important milestones to consider.

2. *Identify the company's internal strengths and weaknesses.* Once the historical profile is completed, you can begin the SWOT analysis. Use all the incidents you have charted to develop an account of the company's strengths and weaknesses as they have emerged historically. Examine each of the value creation functions of the company, and identify the functions in which the company is currently strong and currently weak. Some companies might be weak in marketing; some might be strong in research and development. Make lists of these strengths and weaknesses. The SWOT Checklist (Table 1) gives examples of what might go in these lists.

Table 1 A SWOT Checklist

Potential Internal Strengths	Potential Internal Weaknesses
Many product lines?	Obsolete, narrow product lines?
Broad market coverage?	Rising manufacturing costs?
Manufacturing competence?	Decline in R&D innovations?
Good marketing skills?	Poor marketing plan?
Good materials management systems?	Poor material management systems?
R&D skills and leadership?	Loss of customer good will?
Information system competencies?	Inadequate human resources?
Human resource competencies?	Inadequate information systems?
Brand name reputation?	Loss of brand name capital?
Portfolio management skills?	Growth without direction?
Cost of differentiation advantage?	Bad portfolio management?
New-venture management expertise?	Loss of corporate direction?
Appropriate management style?	Infighting among divisions?
Appropriate organizational structure?	Loss of corporate control?
Appropriate control systems?	Inappropriate organizational
Ability to manage strategic change?	structure and control systems?
Well-developed corporate strategy?	High conflict and politics?
Good financial management?	Poor financial management?
Others?	Others?

Table 1 [*continued*]

Potential Environmental Opportunities	Potential Environment Threats
Expand core business(es)?	Attacks on core business(es)?
Exploit new market segments?	Increases in domestic competition?
Widen product range?	Increase in foreign competition?
Extend cost or differentiation advantage?	Change in consumer tastes?
Diversify into new growth businesses?	Fall in barriers to entry?
Expand into foreign markets?	Rise in new or substitute products?
Apply R&D skills in new areas?	Increase in industry rivalry?
Enter new related businesses?	New forms of industry competition?
Vertically integrate forward?	Potential for takeover?
Vertically integrate backward?	Existence of corporate raiders?
Enlarge corporate portfolio?	Increase in regional competition?
Overcome barriers to entry?	Changes in demographic factors?
Reduce rivalry among competitors?	Changes in economic factors?
Make profitable new acquisitions?	Downturn in economy?
Apply brand name capital in new areas?	Rising labor costs?
Seek fast market growth?	Slower market growth?
Others?	Others?

© Cengage Learning 2013

3. *Analyze the external environment.* To identify environmental opportunities and threats, apply all the concepts on industry and macroenvironments to analyze the environment the company is confronting. Of particular importance at the industry level are the Competitive Forces Model, adapted from Porter's Five Forces Model and the stage of the life-cycle model. Which factors in the macroenvironment will appear salient depends on the specific company being analyzed. Use each factor in turn (for instance, demographic factors) to see whether it is relevant for the company in question.

 Having done this analysis, you will have generated both an analysis of the company's environment and a list of opportunities and threats. The SWOT Checklist table also lists some common environmental opportunities and threats that you may look for, but the list you generate will be specific to your company.

4. *Evaluate the SWOT analysis.* Having identified the company's external opportunities and threats as well as its internal strengths and weaknesses, consider what your findings mean. You need to balance strengths and weaknesses against opportunities and threats. Is the company in an overall strong competitive position? Can it continue to pursue its current business- or corporate-level strategy profitably? What can the company do to turn weaknesses into strengths and threats into opportunities? Can it develop new functional, business, or corporate strategies to accomplish this change? *Never merely generate the SWOT analysis and then put it aside.* Because it provides

a succinct summary of the company's condition, a good SWOT analysis is the key to all the analyses that follow.

5. *Analyze corporate-level strategy.* To analyze corporate-level strategy, you first need to define the company's mission and goals. Sometimes the mission and goals are stated explicitly in the case; at other times, you will have to infer them from available information. The information you need to collect to find out the company's corporate strategy includes such factors as its lines of business and the nature of its subsidiaries and acquisitions. It is important to analyze the relationship among the company's businesses. Do they trade or exchange resources? Are there gains to be achieved from synergy? Alternatively, is the company just running a portfolio of investments? This analysis should enable you to define the corporate strategy that the company is pursuing (for example, related or unrelated diversification, or a combination of both) and to conclude whether the company operates in just one core business. Then, using your SWOT analysis, debate the merits of this strategy. Is it appropriate given the environment the company is in? Could a change in corporate strategy provide the company with new opportunities or transform a weakness into a strength? For example, should the company diversify from its core business into new businesses?

Other issues should be considered as well. How and why has the company's strategy changed over time? What is the claimed rationale for any changes? Often, it is a good idea to analyze the company's businesses or products to assess its situation and identify which divisions contribute the most to or detract from its competitive advantage. It is also useful to explore how the company has built its portfolio over time. Did it acquire new businesses, or did it internally venture its own? All of these factors provide clues about the company and indicate ways of improving its future performance.

6. *Analyze business-level strategy.* Once you know the company's corporate-level strategy and have done the SWOT analysis, the next step is to identify the company's business-level strategy. If the company is a single-business company, its business-level strategy is identical to its corporate-level strategy. If the company is in many businesses, each business will have its own business-level strategy. You will need to identify the company's generic competitive strategy—differentiation, low-cost, or focus—and its investment strategy, given its relative competitive position and the stage of the life cycle. The company also may market different products using different business-level strategies. For example, it may offer a low-cost product range and a line of differentiated products. Be sure to give a full account of a company's business-level strategy to show how it competes.

Identifying the functional strategies that a company pursues to build competitive advantage through superior efficiency, quality, innovation, and customer responsiveness and to achieve its business-level strategy is very important. The SWOT analysis will have provided you with information on the company's functional competencies. You should investigate its production, marketing, or research and development strategy further to gain a picture of where the company is going. For example, pursuing a low-cost or a differentiation strategy successfully requires very different sets of competencies. Has the company developed the right ones? If it has, how can it exploit them further? Can it pursue both a low-cost and a differentiation strategy simultaneously?

The SWOT analysis is especially important at this point if the industry analysis, particularly Porter's model, has revealed threats to the company from the environment. Can the company deal with these threats? How should it change its business-level strategy to counter them? To evaluate the potential of a company's business-level

strategy, you must first perform a thorough SWOT analysis that captures the essence of its problems.

Once you complete this analysis, you will have a full picture of the way the company is operating and be in a position to evaluate the potential of its strategy. Thus, you will be able to make recommendations concerning the pattern of its future actions. However, first you need to consider strategy implementation, or the way the company tries to achieve its strategy.

7. *Analyze structure and control systems*. The aim of this analysis is to identify what structure and control systems the company is using to implement its strategy and to evaluate whether that structure is the appropriate one for the company. Different corporate and business strategies require different structures. You need to determine the *degree of fit between the company's strategy and structure.* For example, does the company have the right level of vertical differentiation (e.g., does it have the appropriate number of levels in the hierarchy or decentralized control?) or horizontal differentiation (does it use a functional structure when it should be using a product structure?)? Similarly, is the company using the right integration or control systems to manage its operations? Are managers being appropriately rewarded? Are the right rewards in place for encouraging cooperation among divisions? These are all issues to consider.

In some cases, there will be little information on these issues, whereas in others there will be a lot. In analyzing each case, you should gear the analysis toward its most salient issues. For example, organizational conflict, power, and politics will be important issues for some companies. Try to analyze why problems in these areas are occurring. Do they occur because of bad strategy formulation or because of bad strategy implementation?

Organizational change is an issue in many cases because the companies are attempting to alter their strategies or structures to solve strategic problems. Thus, as part of the analysis, you might suggest an action plan that the company in question could use to achieve its goals. For example, you might list in a logical sequence the steps the company would need to follow to alter its business-level strategy from differentiation to focus.

8. *Make recommendations*. The quality of your recommendations is a direct result of the thoroughness with which you prepared the case analysis. Recommendations are directed at solving whatever strategic problem the company is facing and increasing its future profitability. Your recommendations should be in line with your analysis; that is, they should follow logically from the previous discussion. For example, your recommendation generally will center on the specific ways of changing functional, business, and corporate strategies and organizational structure and control to improve business performance. The set of recommendations will be specific to each case, and so it is difficult to discuss these recommendations here. Such recommendations might include an increase in spending on specific research and development projects, the divesting of certain businesses, a change from a strategy of unrelated to related diversification, an increase in the level of integration among divisions by using task forces and teams, or a move to a different kind of structure to implement a new business-level strategy. Make sure your recommendations are mutually consistent and written in the form of an action plan. The plan might contain a timetable that sequences the actions for changing the company's strategy and a description of how changes at the corporate level will necessitate changes at the business level and subsequently at the functional level.

After following all these stages, you will have performed a thorough analysis of the case and will be in a position to join in class discussion or present your ideas to the class, depending on the format used by your professor. Remember that you must tailor your analysis to suit the specific issue discussed in your case. In some cases, you might completely omit one of the steps in the analysis because it is not relevant to the situation you are considering. You must be sensitive to the needs of the case and not apply the framework we have discussed in this section blindly. The framework is meant only as a guide, not as an outline.

WRITING A CASE STUDY ANALYSIS

Often, as part of your course requirements, you will need to present a written case analysis. This may be an individual or a group report. Whatever the situation, there are certain guidelines to follow in writing a case analysis that will improve the evaluation your work will receive from your instructor. Before we discuss these guidelines and before you use them, make sure that they do not conflict with any directions your instructor has given you.

The structure of your written report is critical. Generally, if you follow the steps for analysis discussed in the previous section, *you already will have a good structure for your written discussion*. All reports begin with an *introduction* to the case. In it, outline briefly what the company does, how it developed historically, what problems it is experiencing, and how you are going to approach the issues in the case write-up. Do this sequentially by writing, for example, "First, we discuss the environment of Company. . . . Third, we discuss Company X's business-level strategy. . . . Last, we provide recommendations for turning around Company X's business."

In the second part of the case write-up, the *strategic analysis* section, do the SWOT analysis, analyze and discuss the nature and problems of the company's business-level and corporate strategies, and then analyze its structure and control systems. Make sure you use plenty of headings and subheadings to structure your analysis. For example, have separate sections on any important conceptual tool you use. Thus, you might have a section on the Competitive Forces Model as part of your analysis of the environment. You might offer a separate section on portfolio techniques when analyzing a company's corporate strategy. Tailor the sections and subsections to the specific issues of importance in the case.

In the third part of the case write-up, present your *solutions and recommendations*. Be comprehensive, and make sure they are in line with the previous analysis so that the recommendations fit together and move logically from one to the next. The recommendations section is very revealing because your instructor will have a good idea of how much work you put into the case from the quality of your recommendations.

Following this framework will provide a good structure for most written reports, though it must be shaped to fit the individual case being considered. Some cases are about excellent companies experiencing no problems. In such instances, it is hard to write recommendations. Instead, you can focus on analyzing why the company is doing so well, using that analysis to structure the discussion. Following are some minor suggestions that can help make a good analysis even better:

1. Do not repeat in summary form large pieces of factual information from the case. The instructor has read the case and knows what is going on. Rather, use the information in the case to illustrate your statements, defend your arguments, or make salient points. Beyond the brief introduction to the company, you must avoid being *descriptive*; instead, you must be *analytical*.

2. Make sure the sections and subsections of your discussion flow logically and smooth-ly from one to the next. That is, try to build on what has gone before so that the analy-sis of the case study moves toward a climax. This is particularly important for group analysis, because there is a tendency for people in a group to split up the work and say, "I'll do the beginning, you take the middle, and I'll do the end." The result is a choppy, stilted analysis; the parts do not flow from one to the next, and it is obvious to the instructor that no real group work has been done.

3. Avoid grammatical and spelling errors. They make your work look sloppy.

4. In some instances, cases dealing with well-known companies end in 1998 or 1999 because no later information was available when the case was written. If possible, do a search for more information on what has happened to the company in subse-quent years.

 Many libraries now have comprehensive web-based electronic data search facili-ties that offer such sources as *ABI/Inform, The Wall Street Journal Index,* the *F&S Index,* and the *Nexis-Lexis* databases. These enable you to identify any article that has been written in the business press on the company of your choice within the past few years. A number of nonelectronic data sources are also useful. For example, *F&S Predicasts* publishes an annual list of articles relating to major companies that ap-peared in the national and international business press. *S&P Industry Surveys* is a great source for basic industry data, and *Value Line Ratings and Reports* can contain good summaries of a firm's financial position and future prospects. You will also want to collect full financial information on the company. Again, this can be accessed from Web-based electronic databases such as the *Edgar* database, which archives all forms that publicly quoted companies have to file with the Securities and Exchange Com-mission (SEC; e.g., 10-K filings can be accessed from the SEC's *Edgar* database). Most SEC forms for public companies can now be accessed from Internet-based financial sites, such as Yahoo's finance site (http://finance.yahoo.com/).

5. Sometimes instructors hand out questions for each case to help you in your analysis. Use these as a guide for writing the case analysis. They often illuminate the important issues that have to be covered in the discussion.

 If you follow the guidelines in this section, you should be able to write a thorough and effective evaluation.

THE ROLE OF FINANCIAL ANALYSIS IN CASE STUDY ANALYSIS

An important aspect of analyzing a case study and writing a case study analysis is the role and use of financial information. A careful analysis of the company's financial condi-tion immensely improves a case write-up. After all, financial data represent the concrete results of the company's strategy and structure. Although analyzing financial statements can be quite complex, a general idea of a company's financial position can be determined through the use of ratio analysis. Financial performance ratios can be calculated from the balance sheet and income statement. These ratios can be classified into five subgroups: profit ratios, liquidity ratios, activity ratios, leverage ratios, and shareholder-return ratios. These ratios should be compared with the industry average or the company's prior years of performance. It should be noted, however, that deviation from the average is not neces-sarily bad; it simply warrants further investigation. For example, young companies will

have purchased assets at a different price and will likely have a different capital structure than older companies do. In addition to ratio analysis, a company's cash flow position is of critical importance and should be assessed. Cash flow shows how much actual cash a company possesses.

Profit Ratios

Profit ratios measure the efficiency with which the company uses its resources. The more efficient the company, the greater is its profitability. It is useful to compare a company's profitability against that of its major competitors in its industry to determine whether the company is operating more or less efficiently than its rivals. In addition, the change in a company's profit ratios over time tells whether its performance is improving or declining.

A number of different profit ratios can be used, and each of them measures a different aspect of a company's performance. Here, we look at the most commonly used profit ratios.

Return on Invested Capital (ROIC). This ratio measures the profit earned on the capital invested in the company. It is defined as follows:

$$\text{Return on invested capital (ROIC)} = \frac{\text{Net profit}}{\text{Invested capital}}$$

Net profit is calculated by subtracting the total costs of operating the company away from its total revenues (total revenues − total costs). Total costs are the (1) costs of goods sold, (2) sales, general, and administrative expenses, (3) R&D expenses, and (4) other expenses. Net profit can be calculated before or after taxes, although many financial analysts prefer the before-tax figure. Invested capital is the amount that is invested in the operations of a company—that is, in property, plant, equipment, inventories, and other assets. Invested capital comes from two main sources: interest-bearing debt and shareholders' equity. Interest-bearing debt is money the company borrows from banks and from those who purchase its bonds. Shareholders' equity is the money raised from selling shares to the public, *plus* earnings that have been retained by the company in prior years and are available to fund current investments. ROIC measures the effectiveness with which a company is using the capital funds that it has available for investment. As such, it is recognized to be an excellent measure of the value a company is creating.1 Remember that a company's ROIC can be decomposed into its constituent parts.

Return on Total Assets (ROA). This ratio measures the profit earned on the employment of assets. It is defined as follows:

$$\text{Return on total assests} = \frac{\text{Net profit}}{\text{Total assets}}$$

Return on Stockholders' Equity (ROE). This ratio measures the percentage of profit earned on common stockholders' investment in the company. It is defined as follows:

$$\text{Return on stockholders equity} = \frac{\text{Net profit}}{\text{Stockholders equity}}$$

If a company has no debt, this will be the same as ROIC.

Liquidity Ratios

A company's liquidity is a measure of its ability to meet short-term obligations. An asset is deemed liquid if it can be readily converted into cash. Liquid assets are current assets such as cash, marketable securities, accounts receivable, and so on. Two liquidity ratios are commonly used.

Current Ratio. The current ratio measures the extent to which the claims of short-term creditors are covered by assets that can be quickly converted into cash. Most companies should have a ratio of at least 1, because failure to meet these commitments can lead to bankruptcy. The ratio is defined as follows:

$$\text{Current ratio} = \frac{\text{Current assets}}{\text{Current liabilities}}$$

Quick Ratio. The quick ratio measures a company's ability to pay off the claims of short-term creditors without relying on selling its inventories. This is a valuable measure since in practice the sale of inventories is often difficult. It is defined as follows:

$$\text{Quick ratio} = \frac{\text{Current assets} - \text{inventory}}{\text{Current liabilities}}$$

Activity Ratios

Activity ratios indicate how effectively a company is managing its assets. Two ratios are particularly useful.

Inventory Turnover. This measures the number of times inventory is turned over. It is useful in determining whether a firm is carrying excess stock in inventory. It is defined as follows:

$$\text{Inventory turnover} = \frac{\text{Cost of goods sold}}{\text{Inventory}}$$

Cost of goods sold is a better measure of turnover than sales because it is the cost of the inventory items. Inventory is taken at the balance sheet date. Some companies choose to compute an average inventory, beginning inventory, and ending inventory, but for simplicity, use the inventory at the balance sheet date.

Days Sales Outstanding (DSO) or Average Collection Period. This ratio is the average time a company has to wait to receive its cash after making a sale. It measures how effective the company's credit, billing, and collection procedures are. It is defined as follows:

$$\text{DSO} = \frac{\text{Accounts receivable}}{\text{Total sales} / 360}$$

Accounts receivable is divided by average daily sales. The use of 360 is the standard number of days for most financial analysis.

Leverage Ratios

A company is said to be highly leveraged if it uses more debt than equity, including stock and retained earnings. The balance between debt and equity is called the *capital structure*. The optimal capital structure is determined by the individual company. Debt has a lower cost because creditors take less risk; they know they will get their interest and principal. However, debt can be risky to the firm because if enough profit is not made to cover the interest and principal payments, bankruptcy can result. Three leverage ratios are commonly used.

Debt-to-Assets Ratio. The debt-to-assets ratio is the most direct measure of the extent to which borrowed funds have been used to finance a company's investments. It is defined as follows:

$$\text{Debt-to-assets ratio} = \frac{\text{Total debt}}{\text{Total assets}}$$

Total debt is the sum of a company's current liabilities and its long-term debt, and total assets are the sum of fixed assets and current assets.

Debt-to-Equity Ratio. The debt-to-equity ratio indicates the balance between debt and equity in a company's capital structure. This is perhaps the most widely used measure of a company's leverage. It is defined as follows:

$$\text{Debt-to-equity ratio} = \frac{\text{Total debt}}{\text{Total equity}}$$

Times-Covered Ratio. The times-covered ratio measures the extent to which a company's gross profit covers its annual interest payments. If this ratio declines to less than 1, the company is unable to meet its interest costs and is technically insolvent. The ratio is defined as follows:

$$\text{Times-covered ratio} = \frac{\text{Profit before interest and tax}}{\text{Total interest charges}}$$

Shareholder-Return Ratios

Shareholder-return ratios measure the return that shareholders earn from holding stock in the company. Given the goal of maximizing stockholders' wealth, providing shareholders with an adequate rate of return is a primary objective of most companies. As with profit ratios, it can be helpful to compare a company's shareholder returns against those of similar companies as a yardstick for determining how well the company is satisfying the demands of this particularly important group of organizational constituents. Four ratios are commonly used.

Total Shareholder Returns. Total shareholder returns measure the returns earned by time $t + 1$ on an investment in a company's stock made at time t. (Time t is the time at which the initial investment is made.) Total shareholder returns include both dividend

payments and appreciation in the value of the stock (adjusted for stock splits) and are defined as follows:

$$\text{Total shareholder returns} = \frac{\text{Stock price} (t+1) - \text{stock price} (t) + \text{sum of annual dividends per share}}{\text{Stock price} (t)}$$

If a shareholder invests $2 at time t and at time $t + 1$ the share is worth $3, while the sum of annual dividends for the period t to $t + 1$ has amounted to $0.20, total shareholder returns are equal to $(3 - 2 + 0.2)/2 = 0.6$, which is a 60% return on an initial investment of $2 made at time t.

Price-Earnings Ratio. The price-earnings ratio measures the amount investors are willing to pay per dollar of profit. It is defined as follows:

$$\text{Price-earnings ratio} = \frac{\text{Market price per share}}{\text{Earnings per share}}$$

Market-to-Book Value. Market-to-book value measures a company's expected future growth prospects. It is defined as follows:

$$\text{Market-to-book value} = \frac{\text{Market price per share}}{\text{Earnings per share}}$$

Dividend Yield. The dividend yield measures the return to shareholders received in the form of dividends. It is defined as follows:

$$\text{Dividend} = \frac{\text{Dividend per share}}{\text{Market price per share}}$$

Market price per share can be calculated for the first of the year, in which case the dividend yield refers to the return on an investment made at the beginning of the year. Alternatively, the average share price over the year may be used. A company must decide how much of its profits to pay to stockholders and how much to reinvest in the company. Companies with strong growth prospects should have a lower dividend payout ratio than mature companies. The rationale is that shareholders can invest the money elsewhere if the company is not growing. The optimal ratio depends on the individual firm, but the key decider is whether the company can produce better returns than the investor can earn elsewhere.

Cash Flow

Cash flow position is cash received minus cash distributed. The net cash flow can be taken from a company's statement of cash flows. Cash flow is important for what it reveals about a company's financing needs. A strong positive cash flow enables a company to fund future investments without having to borrow money from bankers or investors. This is desirable because the company avoids paying out interest or dividends. A weak or negative cash flow

means that a company has to turn to external sources to fund future investments. Generally, companies in strong-growth industries often find themselves in a poor cash flow position (because their investment needs are substantial), whereas successful companies based in mature industries generally find themselves in a strong cash flow position.

A company's internally generated cash flow is calculated by adding back its depreciation provision to profits after interest, taxes, and dividend payments. If this figure is insufficient to cover proposed new investments, the company has little choice but to borrow funds to make up the shortfall or to curtail investments. If this figure exceeds proposed new investments, the company can use the excess to build up its liquidity (that is, through investments in financial assets) or repay existing loans ahead of schedule.

CONCLUSION

When evaluating a case, it is important to be *systematic*. Analyze the case in a logical fashion, beginning with the identification of operating and financial strengths and weaknesses and environmental opportunities and threats. Move on to assess the value of a company's current strategies only when you are fully conversant with the SWOT analysis of the company. Ask yourself whether the company's current strategies make sense given its SWOT analysis. If they do not, what changes need to be made? What are your recommendations? Above all, link any strategic recommendations you may make to the SWOT analysis. State explicitly how the strategies you identify take advantage of the company's strengths to exploit environmental opportunities, how they rectify the company's weaknesses, and how they counter environmental threats. Also, do not forget to outline what needs to be done to implement your recommendations.

ENDNOTE

1. Tom Copeland, Tim Koller, and Jack Murrin, *Valuation: Measuring and Managing the Value of Companies* (New York: Wiley, 1996).

Glossary

absolute cost advantage A cost advantage that is enjoyed by incumbents in an industry and that new entrants cannot expect to match.

absorptive capacity The ability of an enterprise to identify, value, assimilate, and use new knowledge.

acquisition When a company uses its capital resources to purchase another company.

adaptive culture A culture that is innovative and encourages and rewards middle- and lower-level managers for taking the initiative to achieve organizational goals.

anticompetitive behavior A range of actions aimed at harming actual or potential competitors, most often by using monopoly power, and thereby enhancing the long-run prospects of the firm.

availability error A bias that arises from our predisposition to estimate the probability of an outcome based on how easy the outcome is to imagine.

barriers to imitation Factors that make it difficult for a competitor to copy a company's distinctive competencies.

behavior control Control achieved through the establishment of a comprehensive system of rules and procedures that specify the appropriate behavior of divisions, functions, and people.

brand loyalty Preference of consumers for the products of established companies.

broad differentiation strategy When a company differentiates its product in some way, such as by recognizing different segments or offering different products to each segment.

broad low-cost strategy When a company lowers costs so that it can lower prices and still make a profit.

bureaucratic costs The costs associated with solving the transaction difficulties between business units and corporate headquarters as a company obtains the benefits from transferring, sharing, and leveraging competencies.

business ethics Accepted principles of right or wrong governing the conduct of businesspeople.

business model The conception of how strategies should work together as a whole to enable the company to achieve competitive advantage.

business unit A self-contained division that provides a product or service for a particular market.

business-level strategy The business's overall competitive theme, the way it positions itself in the marketplace to gain a competitive advantage, and the different positioning strategies that can be used in different industry settings.

capabilities A company's skills at coordinating its resources and putting them to productive use.

chaining A strategy designed to obtain the advantages of cost leadership by establishing a network of linked merchandising outlets interconnected by information technology that functions as one large company.

code of ethics Formal statement of the ethical priorities to which a business adheres.

cognitive biases Systematic errors in human decision making that arise from the way people process information.

commonality Some kind of skill or competency that when shared by two or more business units allows them to operate more effectively and create more value for customers.

competitive advantage The achieved advantage over rivals when a company's profitability is greater than the average profitability of firms in its industry.

control system Provides managers with incentives for employees as well as feedback on how the company performs.

corporate headquarters staff The team of top executives, as well as their support staff, who are responsible for overseeing a company's long-term multibusiness model and providing guidance to increase the value created by the company's self-contained divisions.

corruption Can arise in a business context when managers pay bribes to gain access to lucrative business contracts.

credible commitment A believable promise or pledge to support the development of a long-term relationship between companies.

cross-selling When a company takes advantage of or "leverages" its established relationship with customers by way of acquiring additional product lines or categories that it can sell to customers. In this way, a company increases differentiation because it can provide a "total solution" and satisfy all of a customer's specific needs.

customer defection Rate percentage of a company's customers who defect every year to competitors.

customer response time Time that it takes for a good to be delivered or a service to be performed.

devil's advocacy A technique in which one member of a decision-making team identifies all the considerations that might make a proposal unacceptable.

dialectic inquiry The generation of a plan (a thesis) and a counterplan (an antithesis) that reflect plausible but conflicting courses of action.

diseconomies of scale Unit cost increases associated with a large scale of output.

distinctive competencies Firm-specific strengths that allow a company to differentiate its products and/or achieve substantially lower costs to achieve a competitive advantage.

diversification The process of entering new industries, distinct from a company's core or original industry, to make new kinds of products for customers in new markets.

diversified company A company that makes and sells products in two or more different or distinct industries.

divestment strategy When a company decides to exit an industry by selling off its business assets to another company.

dominant design Common set of features or design characteristics.

economies of scale Reductions in unit costs attributed to a larger output.

economies of scope The synergies that arise when one or more of a diversified company's business units are able to lower costs or increase differentiation because they can more effectively pool, share, and utilize expensive resources or capabilities.

employee productivity The output produced per employee.

environmental degradation Occurs when a company's actions directly or indirectly result in pollution or other forms of environmental harm.

escalating commitment A cognitive bias that occurs when decision makers, having already committed significant resources to a project, commit even more resources after receiving feedback that the project is failing.

ethical dilemmas Situations where there is no agreement over exactly what the accepted principles of right and wrong are, or where none of the available alternatives seems ethically acceptable.

ethics Accepted principles of right or wrong that govern the conduct of a person, the members of a profession, or the actions of an organization.

experience curve The systematic lowering of the cost structure, and consequent unit cost reductions, that have been observed to occur over the life of a product.

external stakeholders All other individuals and groups that have some claim on the company.

first mover A firm that pioneers a particular product category or feature by being first to offer it to market.

first-mover disadvantages Competitive disadvantages associated with being first.

fixed costs Costs that must be incurred to produce a product regardless of the level of output.

flexible production technology A range of technologies designed to reduce setup times for complex equipment, increase the use of individual machines through better scheduling, and improve quality control at all stages of the manufacturing process.

focus differentiation strategy When a company targets a certain segment or niche, and customizes its offering to the needs of that particular segment through the addition of features and functions.

focus low-cost strategy When a company targets a certain segment or niche, and tries to be the low-cost player in that niche.

focus strategy When a company decides to serve a limited number of segments, or just one segment.

format wars Battles to control the source of differentiation, and thus the value that such differentiation can create for the customer.

fragmented industry An industry composed of a large number of small- and medium-sized companies.

franchising A strategy in which the franchisor grants to its franchisees the right to use the franchisor's name, reputation, and business model in return for a franchise fee and often a percentage of the profits.

functional managers Managers responsible for supervising a particular function, that is, a task, activity, or operation, such as accounting, marketing, research and development (R&D), information technology, or logistics.

functional structure Grouping of employees on the basis of their common expertise and experience or because they use the same resources.

functional-level strategies Strategy aimed at improving the effectiveness of a company's operations and its ability to attain superior efficiency, quality, innovation, and customer responsiveness.

general managers Managers who bear responsibility for the overall performance of the company or for one of its major self-contained subunits or divisions.

general organizational competencies Competencies that result from the skills of a company's top managers that help every business unit within a company perform at a higher level than it could if it operated as a separate or independent company.

generic business-level strategy A strategy that gives a company a specific form of competitive position and advantage vis-à-vis its rivals that results in above-average profitability.

geographic structure A way of grouping employees into different geographic regions to best satisfy the needs of customers within different regions of a state or country.

global matrix structure A structure in which horizontal differentiation proceeds along two dimensions: product division and geographic area.

global standardization strategy A business model based on pursuing a low-cost strategy on a global scale.

global strategic alliances Cooperative agreements between companies from different countries that are actual or potential competitors.

greenmail A source of gaining wealth by corporate raiders who benefit by pushing companies to either change their corporate strategy to one that will benefit stockholders, or by charging a premium for these stocks when the company wants to buy them back.

harvest strategy When a company reduces to a minimum the assets it employs in a business to reduce its cost structure and extract or "milk" maximum profits from its investment.

hierarchy of authority The clear and unambiguous chain of command that defines each manager's relative authority from the CEO down through top, middle, to first-line managers.

holdup When a company is taken advantage of by another company it does business with after it has made an investment in expensive specialized assets to better meet the needs of the other company.

horizontal integration The process of acquiring or merging with industry competitors to achieve the competitive advantages that arise from a large size and scope of operations.

hostage taking A means of exchanging valuable resources to guarantee that each partner to an agreement will keep its side of the bargain.

illusion of control A cognitive bias rooted in the tendency to overestimate one's ability to control events.

industry A group of companies offering products or services that are close substitutes for each other.

information asymmetry A situation where an agent has more information about resources he or she is managing than the principal has.

information distortion The manipulation of facts supplied to corporate managers to hide declining divisional performance.

information manipulation When managers use their control over corporate data to distort or hide information in order to enhance their own financial situation or the competitive position of the firm.

inside directors Senior employees of the company, such as the CEO.

intangible resources Nonphysical entities such as brand names, company reputation, experiential knowledge, and intellectual property, including patents, copyrights, and trademarks.

integrating mechanisms Ways to increase communication and coordination among functions and divisions.

integrating roles Managers who work in full-time positions established specifically to improve communication between divisions.

internal capital market A corporate-level strategy whereby the firm's headquarters assesses the performance of business units and allocates money across them. Cash generated by units that are profitable but have poor investment opportunities within their business is used to cross-subsidize businesses that need cash and have strong promise for long-run profitability.

internal new venturing The process of transferring resources to and creating a new business unit or division in a new industry to innovate new kinds of products.

internal stakeholders Stockholders and employees, including executive officers, other managers, and board members.

international division A division created by companies that expand abroad and group all of their international activities into one division; often characterizes single businesses and diversified companies that use the multidivisional organizational form.

intrapreneurs Managers who pioneer and lead new-venture projects or divisions and act as inside or internal entrepreneurs.

just-in-time (JIT) inventory system System of economizing on inventory holding costs by scheduling components to arrive just in time to enter the production process or as stock is depleted.

killer applications Applications or uses of a new technology or product that are so compelling that customers adopt them in droves, killing the competing formats.

leadership strategy When a company develops strategies to become the dominant player in a declining industry.

learning effects Cost savings that come from learning by doing.

leveraging competencies The process of taking a distinctive competency developed by a business unit in one industry and using it to create a new business unit in a different industry.

limit price strategy Charging a price that is lower than that required to maximize profits in the short run, but is above the cost structure of potential entrants.

localization strategy A strategy focused on increasing profitability by customizing the company's goods or services so that the goods provide a favorable match to tastes and preferences in different national markets.

location economies The economic benefits that arise from performing a value creation activity in an optimal location.

management by objectives A system in which employees are encouraged to help set their own goals so that managers manage by exception, intervening only when they sense something is not going right.

market development When a company searches for new market segments for a company's existing products to increase sales.

market segmentation The way a company decides to group customers based on important differences in their needs to gain a competitive advantage.

market structure A way of grouping employees into separate customer groups so that each group can focus on satisfying the needs of a particular customer group in the most effective way.

marketing strategy The position that a company takes with regard to pricing, promotion, advertising, product design, and distribution.

mass customization The use of flexible manufacturing technology to reconcile two goals that were once thought to be incompatible: low cost, and differentiation through product customization.

mass market One in which large numbers of customers enter the market.

matrix structure A way of grouping employees in two ways simultaneously—by function and by product or project—to maximize the rate at which different kinds of products can be developed.

merger An agreement between two companies to pool their resources and operations and join together to better compete in a business or industry.

mission The purpose of the company, or a statement of what the company strives to do.

multidivisional company A company that competes in several different businesses and has created a separate self-contained division to manage each.

multidivisional structure A complex organizational design that allows a company to grow and diversify while also reducing coordination and control problems because it uses self-contained divisions and has a separate corporate headquarters staff.

multinational company A company that does business in two or more national markets.

network effects The network of complementary products as a primary determinant of the demand for an industry's product.

new-venture division A separate and independent division established to give its managers the autonomy to develop a new product.

niche strategy When a company focuses on pockets of demand that are declining more slowly than the industry as a whole to maintain profitability.

non-price competition The use of product differentiation strategies to deter potential entrants and manage rivalry within an industry.

on-the-job consumption A term used by economists to describe the behavior of senior management's use of company funds to acquire perks (such as lavish offices, jets, etc.) that will enhance their status, instead of investing it to increase stockholder returns.

operating budget A blueprint that states how managers intend to use organizational resources to most efficiently achieve organizational goals.

opportunism Seeking one's own self-interest, often through the use of guile.

opportunistic exploitation Unethical behavior sometimes used by managers to unilaterally rewrite the terms of a contract with suppliers, buyers, or complement providers in a way that is more favorable to the firm.

opportunities Elements and conditions in a company's environment that allow it to formulate and implement strategies that enable it to become more profitable.

organizational culture The specific collection of values, norms, beliefs, and attitudes that are shared by people and groups in an organization and that control the way they interact with each other and with stakeholders outside the organization.

organizational design skills The ability of the managers of a company to create a structure, culture, and control systems that motivate and coordinate employees to perform at a high level.

organizational design The process of deciding how a company should create, use, and combine organizational structure, control systems, and culture to pursue a business model successfully.

organizational slack The unproductive use of functional resources by divisional managers that can go undetected unless corporate managers monitor their activities.

organizational structure The means through which a company assigns employees to specific tasks and roles and specifies how these tasks and roles are to be linked together to increase efficiency, quality, innovation, and responsiveness to customers.

output control The control system managers use to establish appropriate performance goals for each division, department, and employee and then measure actual performance relative to these goals.

outside directors Directors who are not full-time employees of the company, needed to provide objectivity to the monitoring and evaluation of processes.

outside view Identification of past successful or failed strategic initiatives to determine whether those initiatives will work for project at hand.

parallel sourcing policy A policy in which a company enters into long-term contracts with at least two suppliers for the same component to prevent any problems of opportunism.

personal control The way one manager shapes and influences the behavior of another in a face-to-face interaction in the pursuit of a company's goals.

personal ethics Generally accepted principles of right and wrong governing the conduct of individuals.

positioning strategy The specific set of options a company adopts for a product based upon four main dimensions of marketing: price, distribution, promotion and advertising, and product features.

potential competitors Companies that are currently not competing in the industry but have the potential to do so.

price leadership When one company assumes the responsibility for determining the pricing strategy that maximizes industry profitability.

price signaling The process by which companies increase or decrease product prices to convey their intentions to other companies and influence the price of an industry's products.

primary activities Activities related to the design, creation, and delivery of the product, its marketing, and its support and after-sales service.

principle of the minimum chain of command The principle that a company should design its hierarchy with the fewest levels of authority necessary to use organizational resources effectively.

prior hypothesis bias A cognitive bias that occurs when decision makers who have strong prior beliefs tend to make decisions on the basis of these beliefs, even when presented with evidence that their beliefs are wrong.

process innovation Development of a new process for producing products and delivering them to customers.

product bundling Offering customers the opportunity to purchase a range of products at a single combined price; this increases the value of a company's product line because customers often obtain a price discount when purchasing a set of products at one time, and customers become used to dealing with only one company and its representatives.

product development The creation of new or improved products to replace existing products.

product innovation Development of products that are new to the world or have superior attributes to existing products.

product proliferation strategy The strategy of "filling the niches," or catering to the needs of customers in all market segments to deter entry by competitors.

product structure A way of grouping employees into separate product groups or units so that each product group can focus on the best ways to increase the effectiveness of the product.

product-team structure A way of grouping employees by product or project line but employees focus on the development of only one particular type of product.

profit center When each self-contained division is treated as a separate financial unit and financial controls are used to establish performance goals for each division and measure profitability.

profit growth The increase in net profit over time.

profitability The return a company makes on the capital invested in the enterprise.

public domain Government- or association-set standards of knowledge or technology that any company can freely incorporate into its product.

quasi integration The use of long-term relationships, or investment into some of the activities normally performed by suppliers or buyers, in place of full ownership of operations that are backward or forward in the supply chain.

razor and blade strategy Pricing the product low in order to stimulate demand, and pricing complements high.

reasoning by analogy Use of simple analogies to make sense out of complex problems.

reengineering The process of redesigning business processes to achieve dramatic improvements in performance, such as cost, quality, service, and speed.

related diversification A corporate-level strategy that is based on the goal of establishing a business unit in a new industry that is related to a company's existing business units by some form of commonality or linkage between their value-chain functions.

representativeness A bias rooted in the tendency to generalize from a small sample or even a single vivid anecdote.

resources Assets of a company.

restructuring The process by which a company streamlines its hierarchy of authority and reduces the number of levels in its hierarchy to a minimum to lower operating costs.

restructuring The process of reorganizing and divesting business units and exiting industries to refocus upon a company's core business and rebuild its distinctive competencies.

risk capital Capital that cannot be recovered if a company fails and goes bankrupt.

risk capital Equity capital for which there is no guarantee that stockholders will ever recoup their investment or earn a decent return.

scenario planning Formulating plans that are based upon "what-if" scenarios about the future.

sector A group of closely related industries.

segmentation strategy When a company decides to serve many segments, or even the entire market, producing different offerings for different segments.

self-contained division An independent business unit or division that contains all the value-chain functions it needs to pursue its business model successfully.

self-dealing Managers using company funds for their own personal consumption, as done by Enron, for example, in previous years.

self-managing teams Teams where members coordinate their own activities and make their own hiring, training, work, and reward decisions.

shareholder value Returns that shareholders earn from purchasing shares in a company.

span of control The number of subordinates reporting directly to a particular manager.

stakeholders Individuals or groups with an interest, claim, or stake in the company—in what it does and in how well it performs.

standardization strategy When a company decides to ignore different segments, and produce a standardized product for the average consumer.

standardization The degree to which a company specifies how decisions are to be made so that employees' behavior becomes measurable and predictable.

stock options The right to purchase company stock at a predetermined price at some point in the future, usually within 10 years of the grant date.

strategic alliances Long-term agreements between two or more companies to jointly develop new products or processes that benefit all companies that are a part of the agreement.

strategic commitments Investments that signal an incumbent's long-term commitment to a market, or a segment of that market.

strategic control systems The mechanism that allows managers to monitor and evaluate whether their business model is working as intended and how it could be improved.

strategic leadership Creating competitive advantage through effective management of the strategy-making process.

strategic outsourcing The decision to allow one or more of a company's value-chain activities to be performed by independent, specialist companies that focus all their skills and knowledge on just one kind of activity to increase performance.

strategy A set of related actions that managers take to increase their company's performance.

strategy formulation Selecting strategies based on analysis of an organization's external and internal environment.

strategy implementation Putting strategies into action.

substandard working conditions Arise when managers underinvest in working conditions, or pay employees below-market rates, in order to reduce their production costs.

supply chain management The task of managing the flow of inputs and components from suppliers into the company's production processes to minimize inventory holding and maximize inventory turnover.

support activities Activities of the value chain that provide inputs that allow the primary activities to take place.

sustained competitive advantage A company's strategies enable it to maintain above-average profitability for a number of years.

switching costs Costs that consumers must bear to switch from the products offered by one established company to the products offered by a new entrant.

SWOT analysis The comparison of strengths, weaknesses, opportunities, and threats.

takeover constraint The risk of being acquired by another company.

tangible resources Physical entities, such as land, buildings, equipment, inventory, and money.

tapered integration When a firm uses a mix of vertical integration and market transactions for a given input. For example, a firm might operate limited semiconductor manufacturing itself, while also buying semiconductor chips on the market. Doing so helps to prevent supplier holdup (because the firm can credibly commit to not buying from external suppliers) and increases its ability to judge the quality and cost of purchased supplies.

team Formation of a group that represents each division or department facing a common problem, with the goal of finding a solution to the problem.

technical standards A set of technical specifications that producers adhere to when making the product, or a component of it.

technological paradigm shift Shifts in new technologies that revolutionize the structure of the industry, dramatically alter the nature of competition, and require companies to adopt new strategies in order to survive.

threats Elements in the external environment that could endanger the integrity and profitability of the company's business.

total quality management increasing product reliability so that it consistently performs as it was designed to and rarely breaks down.

transfer pricing The price that one division of a company charges another division for its products, which are the inputs the other division requires to manufacture its own products. The problem of establishing the fair or "competitive" price of a resource or skill developed in one division that is to be transferred and sold to another division.

transferring competencies The process of taking a distinctive competency developed by a business unit in one industry and implanting it in a business unit operating in another industry.

transnational strategy A business model that simultaneously achieves low costs, differentiates the product offering across geographic markets, and fosters a flow of skills between different subsidiaries in the company's global network of operations.

turnaround strategy When managers of a diversified company identify inefficient and poorly managed companies in other industries and then acquire and restructure them to improve their performance—and thus the profitability of the total corporation.

two-boss employees Employees who report both to a project boss and a functional boss.

unrelated diversification A corporate-level strategy based on a multibusiness model that uses general organizational competencies to increase the performance of all the company's business units.

value chain The idea that a company is a chain of activities that transforms inputs into outputs that customers value.

value innovation When innovations push out the efficiency frontier in an industry, allowing for greater value to be offered through superior differentiation at a lower cost than was previously thought possible.

values A statement of how employees should conduct themselves and their business to help achieve the company mission.

vertical disintegration When a company decides to exit industries either forward or backward in the industry value chain to its core industry to increase profitability.

vertical integration When a company expands its operations either backward into an industry that produces inputs for the company's products (backward vertical integration) or forward into an industry that uses, distributes, or sells the company's products (forward vertical integration).

virtual corporation When companies pursued extensive strategic outsourcing to the extent that they only perform the central value creation functions that lead to competitive advantage.

vision The articulation of a company's desired achievements or future state.

worldwide area structure A structure in which the world is divided into geographic areas; an area may be a country or a group of countries, and each area operates as a self-contained and largely autonomous entity with its own set of value creation activities, with headquarters retaining authority for the overall strategic direction of the firm and financial control; favored by companies with a low degree of diversification and a domestic structure based on functions that are pursuing a localization strategy.

worldwide product divisional structure A structure in which each division is a self-contained, largely autonomous entity with full responsibility for its own value creation activities, with headquarters retaining responsibility for the overall strategic development and financial control of the firm; adopted by firms that are reasonably diversified and originally had domestic structures based on product divisions.

Index

A

ABC News, 162
Absolute cost advantages, 49–50
Absorptive capacity, 105
Accounting terms, 100t
ACE (Achieving Competence Excellence) program, 330
Acquisitions, 345–349, 460–461
 benefits of, 345–346
 bidding strategies for, 349
 definition of, 290
 disadvantages of, 346–348
 and economic benefits, 346–347
 and entry barriers, 345–346
 expense of, 347
 guidelines for successful, 348–349
 horizontal integration of, 183, 346, 349
 screening of, 347–348
 turnaround strategy for, 330–331
Adaptive culture, 413
Advertising, 125–127
Affymetrix, 142
Agency theory, of business relationships
 common problems in, 368–371
 and governance mechanisms, 372
 overview of, 367–368
Airbus, 43–44, 60–61
Aircraft industry, 43–44, 60f, 122–123, 235
Airline industry, 76–77, 195, 315–316
Airtran Airways, 316
Alco Standard, 449
Alliances. See Strategic alliances
Aluminum industry, 299
Amazon.com, 116–118, 123, 145, 166, 243–244
AMD (Advanced Micro Design), 56, 196, 197

American Airlines, 315
Amgen, 270
Anticompetitive behavior, 381
Antitrust laws, 194, 195, 295
Apothekar, Leo, 359–361
Apple
 and differentiation, 157, 170
 and dynamism, 106
 and innovation, 139
 and leveraging competencies, 324
 organization at, 395–396, 402–403
 and outsourcing at, 308
 and smartphone industry, 49, 189, 215, 304
 and vertical integration at, 286–287
Archer Daniel Midlands, 366
Arthur Andersen, 375
ASDA, 453
Assets. See Complementary assets; Resources; Specialized assets
ATL, 227
Auditors, 374–375
Authority
 between corporate headquarters and division, 445
 in joint ventures, 459
 in mergers and acquisitions, 460–461
 in multidivisional structure, 449–450
 in organizations, 399–402
Automobile component supply industry, 56
Automobile industry, 88–89, 105, 192, 195–196, 198, 259–260
Autonomous actions, 21–22
Autonomy Corporation, 359–361
Availability error, 28–29
Avon, 282–283
Avon Products, 446

B

Backward integration, 296, 299–300
Balanced scorecard model, 376–378
Bargaining power, 55–57, 294
Barnes & Noble, 124
Bartlett, Christopher, 264, 455
Bartz, Carol, 404
Beer industry, 47, 66, 72
Behavior control, 408–409, 410, 448t, 461
Benchmarking, 109
Betamax technology, 219–220
Bezos, Jeff, 116–117, 186
Bidding strategies
 for acquisitions, 349
 competitive, 303
Black, Conrad, 370, 371
Black, Ian, 149
Blue Ocean Strategy (Kim and Mauborgne), 171
Board of directors, 368, 372–373, 387
Boeing, 43–44, 60–61, 149, 271, 365, 382
Bombardier, 43–44, 60–61
Bookselling industry, 69
Borders Books, 124
Bosses, in matrix structure, 428
Bowerman, Bill, 199
Brand loyalty, 49, 97, 144, 180, 229
Bravo, Rose Marie, 91
Breakfast cereal industry, 53, 192–193
Broad differentiation strategy, 164, 165f, 422
Broad low-cost strategy, 164, 165f
Brooks, Dede, 366
Buffet, Warren, 76
Burberry, 91
Bureaucratic costs
 and delegation of authority, 401–402
 of diversification, 335–338
 and functional structure, 418–419
 handoffs as, 399

 and interdependent divisions, 448
 and unrelated diversification, 449
 and vertical integration, 301
Burgelman, Robert, 21
Business, defining the, 12, 14, 14f
Business ethics. See also Ethics
 definition of, 378
 and ethical behavior, 384–385
 and managers, 379, 384–385
 roots of unethical behavior in, 383–384
 and stakeholders, 380–381
 and strategic management, 381–383
Business-level managers, 10–11
Business-level strategies
 alignment of, with functional-level strategies and organization, 160
 and competitive advantage, 166–168
 definition of, 19, 154
 generic, 164–166, 165f
 implementation of, 168–171
 and organizational culture, 170–171
 types of, 164–166
Business models. See also Multibusiness model
 analysis of, 17, 19
 and competitive advantage, 6–7
 control systems for, 405–410
 and corporate-level strategies, 288–289
 disruptive technologies and, 239
 leadership articulation of, 31
 market development and, 188, 190
 strategies for, 397–410
 value creation and, 97–98
Business units
 and bureaucratic costs, 335–336, 338

Business units (continued)
definition of, 10
self-contained, 441–442
Buyers, bargaining power of,
55–56

C

Canon, 324–325
Capabilities
and competitive
advantage, 118f
of competitors, 105,
232–233
definition of, 83–84
as distinctive
competencies, 84
entrepreneurial, 327–328
imitation of, 104–105
in organizational design, 328,
419–420
sharing of, and cost structure,
325–326
and strategy, 85f
Capacity
control strategies for,
199–201
and demand, 64–66
excess, causes of, 200
and horizontal
integration, 294
Capital resources. See Risk
capital
Capital turnover, 99, 100f,
100t, 101
Cardiac surgery, and learning
effects, 122
Carrefour, 255
Cash flow, 322–323
Caterpillar, 91, 146–147,
264–265
Centralization, of authority,
402, 404, 445
Chaining strategy, 182
Chain of command, 399–401
Champy, James, 432
Chandler, Alfred D., 399
Change, impact of, on
industries, 67–69
Charles Schwab, 23
Chasms, competitive, 188,
189f, 230
Chief executive officers
(CEOs), and board of
directors, 372–373
Christensen, Clayton,
236–239, 240
Christie's, 366
Churchill, Winston, 30

Churn rates. See Customer
defection rates
Cisco Systems, 132, 140
Citigroup, 318–321
Cloud computing industry, 234,
243–244
Coca-Cola, 45–46, 51, 162,
231, 267–268, 289–290,
324, 422, 460
Code of ethics, 385
Cognitive biases, 27–28
Comac (Commercial Aircraft
Corporation of
China), 44
Commercialization, of internal
venturing, 343
Commitment, of leaders, 30–31
Commonality
and related diversification,
331, 332f
in transferring
competencies, 323
Communications
and functional structure, 418
in hierarchies, 400–401
integrating mechanisms for,
403–404
in multidivisional structure,
444, 450
Communities. See Local
communities, as
stakeholders
Community Impact Newspaper,
179, 204
Compact disc industry, 221,
223–224
Company infrastructure. See
Infrastructure
Compaq, 106, 459, 460
Compatibility, of products,
191, 217
Compensation
and CEO performance, 369
and productivity, 130
Competencies
versus capabilities and
resources, 85f
distinctive. see Distinctive
competencies
general organizational,
327–328, 331
leveraging, in
diversification, 325
and outsourcing, 311
transfering, in diversification,
323–324
Competition
in declining markets,
201–202

and globalization of products
and markets, 249
and international strategy,
265–266
in multidivisional structure,
445, 447
non-price, 196, 196f, 199
and outsourcing, 312
Competitive advantage
attributes of national,
250–253
building blocks of,
93–97, 108
and business-level strategy,
166–168
durability of, 103–106
and outsourcing, 312
and overestimation of
acquisitions, 346–347
and profitability, 85–86, 85f,
98–103
roots of, 118f
sources of, 83–85
strategies for achieving, 19
sustained, 6, 83, 106–110,
227–228
and value, 85–86
Competitive analysis, tools for,
47–66
Competitive bidding, 303
Competitive chasms, 188,
189f, 230
Competitive structure, 52,
68–69
Competitors
capabilities of, 105, 232–233
cooperation with, 223–224
identification and assessment
of global, 252–253
resource imitation by, 104
risk of entry by potential,
48–50
rivalry among, 50–55,
194–201, 249–250,
252, 294
strategic alliances with,
232–233, 240
Complementary assets,
230–233
Complementors, 58, 218, 222
Complexity, of products,
190–191
Computer component supply
industry, 46
Computer industry, 233–234.
See also Personal
computer industry
Condit, Phil, 365
Conglomerates, 329, 332–333

Consistency, of leaders, 30
Consolidated industries, 52, 54,
181–182
Consumer electronics
industry, 226
Consumer surplus, 86
Continental Airlines, 316
Contracts
and horizontal
integration, 303
and vertical integration, 307
Control systems
for business models,
405–410
design of, 406f
and differentiation, 170–171
and efficiency, 405
as governance mechanisms,
376–378
and innovation, 405–406
levels of, 407
in mergers and acquisitions,
460–461
and multidivisional structure,
443–444, 447
organizational culture as,
410–414
and performance, 407–410
and product structure, 423
purpose of, 397
and quality, 405
role of strategic, 415–419
types of, 407–410
Conversion activities,
standardization of, 409
Cook, Tim, 395
Cooper, Robert, 139
Cooperation
in long-term business
relationships, 304–305
and standards, 218, 223–224
Coordination
and bureaucratic costs,
336, 338
integrating mechanisms for,
403–404
and international
divisions, 452
in mergers and
acquisitions, 461
of pricing, by rivals, 294
with rivals, 201
and worldwide product divi-
sional structure, 454
Core competencies. See
Competencies
Corning, 142
Corporate headquarters
staff, 442

Corporate-level managers, 10, 442, 445, 458–459
Corporate-level strategies
 for acquisitions, 345–349
 for business model, 288–289
 and diversification, 338–341
 horizontal integration as, 289–295
 and joint ventures, 349–351
 and new ventures, 341–345
 outsourcing as, 307–312
 purpose of, 19, 288–289
 vertical integration as, 295–302
Corporate raiders, 375–376
Corruption, 383
Cost advantages, 49–50
Costco, 164, 168
Cost leadership strategy, 421. *See also* Low-cost position
Cost of goods sold (COGS), 99, 100f, 100t
Cost reduction
 and entry modes, 274–275
 versus local responsiveness, 261
 pressures for, 258, 259
 in transnational strategy, 264
Cost(s)
 of customer switching, 50
 fixed, 54
 and quality, 96
 unit, 49, 217
Cost structure
 advantages in, 49–50
 and differentiation, 157, 158f
 and fixed costs, 54
 and focus strategies, 163–164
 global expansion and, 255–256
 in high-technology industries, 224–227
 and horizontal integration, 291
 and marketing strategies, 164
 and outsourcing, 310
 and shared resources and capabilities, 325–326
 and vertical integration, 301–302
Cott Corporation, 51
Credible commitment, 305
Creditors, as stakeholders, 362
Cross-licensing, 270, 277
Cross-selling, 292
Culture, company. *See* Organizational culture
Currency exchange rates, 70–71

Customer defection rates, 80–81, 125–128
Customer groups
 and demand, 185–188
 and market development, 185, 186f
Customer loyalty, 127, 144
Customer needs
 awareness of, 144–145
 based on taste and preferences, 259–260
 of innovators and early adopters, 188–190
 and market segmentation, 161–162
 and new ventures, 343
 response time to, 96–97, 146–147
 satisfaction of, 145–147, 418
Customer orientation, 14, 44
Customers
 focus on, 144–145
 identification of, 161–164
 as stakeholders, 362
Customer service
 at Nordstrom, 153–155
 and value creation, 90
Customization
 and customer satisfaction, 145–146
 and efficiency, 124

D

Daft, Douglas, 267
David, George, 329–330
Davidge, Christopher, 366
Day, Christine, 176
DEC (Digital Equipment Corporation), 109
Decentralization
 at Alco Standard, 449
 of authority, 401–402, 404, 445
 at GM, 443
Decision-making
 cognitive biases and, 27–28
 and ethical behavior, 385
 techniques for improvement of, 29
 and unethical behavior, 383
Decline stage, of industry development, 66, 201–204, 234–235
Defection rates. *See* Customer defection rates
Deflation rates, 71
Delegation, by leaders, 31, 401–402

Dell, Inc.
 and dynamism, 106
 as innovators, 67
 mass customization at, 124–125
 materials managment at, 92, 93
 value innovation at, 160, 173
Dell, Michael, 30, 412–413
Delta Airlines, 316
Demand. *See also* Market demand
 and capacity, 64–66
 and customer groups, 185–188
 and industry rivalry, 54
 local, and competitive advantage, 251
 and market growth rates, 190–191
 pricing to encourage, 223
 and substitutes and complementors, 58
 value and, 87
 and vertical integration, 302
Deming, W. Edwards, 134
Demographics, 72, 161–162
Deregulation, 72–73
Devil's advocacy, 29
Dialectic inquiry, 29
Differentiation
 achievement of, 170
 advantages of, 156–158
 and competitive advantage, 118f, 168
 format wars and, 216
 and horizontal integration, 291–292
 and location economies, 256
 and low-cost tradeoff, 158–160, 159f, 161f, 166
 marketing strategies for, 164–165
 and market share, 196
 and organizational design, 421–422
 and outsourcing, 311
 quality of excellence and, 138
 and response to customers' needs, 144
 technical standards and, 213
 value creation and, 97
Digital Equipment Corporation (DEC), 109
Digitalization, and margin costs, 227
Digitalization and margin costs, 226

Diminishing returns, law of, 225
Direct contact, as integrating mechanism, 403
Directors, types of, 372–373
Diseconomies of scale, 120
Disney, Walt, 411
Disruptive technology, theory of, 236–240
Distinctive competencies
 in competitive advantage, 118f
 definition of, 83
 at functional level, 414–419
 and functional-level strategies, 117
 and global market entry modes, 273t
 in global markets, 253–254
 resources and capabilities in, 83–84
 strategy and, 84–85
Distribution, in global markets, 261
Diversification
 bureaucratic costs of, 335–336, 338
 and Citigroup, 318–321
 definition of, 322
 and growth, 334–335
 limits and disadvantages of, 333–341
 and profitability, 322–331
 related/unrelated, 447–448, 448t, 449, 450
 and restructuring, 350–351
 risk pooling and, 334
 strategies for, choosing, 338–341
 types of, 331–333
Diversification discount, 350–351
Diversified company, 322
Divestment strategy, 202, 204
Divisional managers, 442
Divisions, 439, 448. *See also* Business units
Dolby, Ray, 220–221
Dominant design, 216, 217f
Donald, Jim, 31
Dow Chemical, 349, 457
Doz, Yves, 278
Drucker, Peter, 12
Druyun, Darleen, 365
Dry-cleaning industry, 207
DuPont, 442–443
DVD technology, 217
Dyment, Roy, 144–145
Dynamism, in industries, 106

E

e*trade, 23
Early adopters, 186, 188
Early majority, 186, 188
eBay, 306
Economic benefits
 and acquisitions, 346–347
 of location, 256
 of scale. *see* Economies of
 scale
 of scope. *see* Economies of
 scope
Economic growth, 69–70
Economies of scale
 definition of, 49
 and efficiency, 119–120
 and first-mover
 advantages, 229
 and global expansion,
 255–256
 and horizontal
 integration, 291
 lack of, in fragmented
 industries, 180
 learning effects and, 123–124
Economies of scope, 325–326
Eddie Bauer, 159f, 160
Efficiency, 119–133
 as competitive advantage
 factor, 93–94
 and control systems, 405
 and economies of scale,
 119–120
 and experience curve,
 122–123
 and human resource strategy,
 129–130
 and information systems, 132
 and infrastructure, 132–133
 and learning effects, 120–121
 and marketing, 125–126
 in materials management,
 128–129
 measurement of, 119
 and multidivisional
 structure, 444
 and production systems,
 124–125
 and quality, 96
 and research and
 development, 129
 and strategic leadership,
 132–133
 and value creation, 133t
Efficiency frontier, 159–160
Eisner, Michael, 84–85, 411
Ellison, Larry, 293
Eloquence, of leaders, 30

Embraer, 43–44, 60–61
Embryonic industries, 63,
 185–188, 190–191
Emergent strategies, 22–23
EMI, 232
Emotional intelligence, of
 leaders, 32
Empathy, in leaders, 32
Employees
 and customer responsiveness,
 144–145
 grouping of, 427–428
 incentive systems for,
 131, 378
 performance of, 130
 productivity of, 94, 129–130
 as stakeholders, 362
 training of, 130
Employee stock ownership
 plans (ESOPs), 131,
 364, 378
Empowerment, 31, 130
Enron, 370, 372, 375
Entrepreneurship, of managers,
 327–328
Entry, into new markets
 by potential competitors,
 48–49, 51
 scale and, 342, 343f
Entry barriers
 and acquisitions, 345–346
 fragmentation and low, 180
 to the global marketplace,
 249–250
 strategies to create, 192–194
Entry modes. *See also*
 Exporting, to global
 markets; Franchising;
 Joint ventures;
 Licensing; Subsidiaries,
 wholly owned
 and cost reduction, 274–275
 into global markets,
 268–275, 273t
 into new industries, 48–49,
 51, 458–461
Environmental degradation, 382
Equilibrium, 68
Escalating commitment, 28
ESOPs. *See* Employee stock
 ownership plans
Established companies, and
 paradigm shifts,
 234–240
Esterline, 183
Ethical dilemmas, definition
 of, 378
Ethics, 378. *See also* Business
 ethics; Personal ethics

Ethics officers, 386–387
Excellence, quality of, 94–95,
 138–139
Exit barriers, industry, 54–55
Expectations. *See*
 Organizational culture
Experience curve,
 122–123, 123f
Exporting, to global markets,
 268–269
External analysis. *See* Cost(s);
 Industries, external
 analysis; Opportunities
External stakeholders, 362

F

Factor endowments, 250–251
Failure
 and innovation, 140–142
 and new ventures, 342–344
 reasons for, 106–108
 steps to avoid, 108–110
 of strategic alliances, 276
Federal Trade Commission
 (FTC), 295
Feedback loops, 13f, 20, 220f,
 221, 229
Feigenbaum, A. V., 134
Financial control, 448t
Financial statements,
 as governance
 mechanisms, 368,
 374–375
First movers. *See also*
 Innovation
 advantages of, 227–228, 229,
 230–233
 definition of, 227
 disadvantages for, 228,
 229–230
Five Forces model, 47–59
 buyers' bargaining power in,
 55–56
 competitive forces in, 48f
 complement providers in,
 58–59
 intensity of rivalry among
 competitors in,
 50–55
 and macroenvironment, 70f
 risk of entry by competitors,
 48–50
 substitute products in, 58
 suppliers' bargaining power
 in, 56–57
Fixed costs, 119
Flat organizational structure,
 400–401

Flexible production technology,
 124, 130
Focus differentiation strategy,
 165–166
Focus low-cost strategy,
 165–166
Focus strategies
 definition of, 163
 in fragmented industries,
 180–181
 with narrow product line,
 429–430
Ford Motor Company, 119,
 125, 163, 246–247, 278,
 435–436
Foreign direct investment, 249
Format wars, 216, 219–220,
 222–224
Forward integration, 296, 300
Foster, Richard, 234–236
Foxconn Technology, 286, 308
Fox News, 162
Fragmented industries, 52,
 180–183
France Telecom, 230
Franchising, 182–183, 270–271
Free cash flow, 322–323
Fuji, 233, 271, 277
Functional-level managers, 9,
 11, 117–118, 403, 407f
Functional-level strategies
 alignment of, with business-
 level strategies and orga-
 nization, 160, 168–169
 definition of, 117, 118f
 focus of, 19
Functional structure, 414–415,
 421, 441
Functions. *See also* Human
 resources; Information
 systems; Infrastructure;
 Marketing; Materials
 management;
 Production; Research
 and development (R&D)
 duplication of, 447
 grouping of, 399, 414–419

G

Gannett Co., 178
The Gap, 159f
Garrett, John, 179
Gates, Bill, 30, 410
GE (General Electric), 10,
 26–27, 36–37, 135,
 232, 305
General managers, 9, 10–11
General Mills, 53

General Motors. *See* GM (General Motors)

General organizational competencies, 327–328, 331

General public, as stakeholders, 362

Generic business-level strategy, 164–166, 165f

Geographic structure, in organizations, 424–426

Ghemawat, Pankaj, 105

Ghoshal, Sumantra, 264, 455

Gillette, 223

Global companies
organizational structures for, 451–457
strategic alliances of, 275
strategies for, 19

Global markets
organizational strategies for, 451
rise of, 71
trend toward, 249

Global matrix structure. *See* Matrix structure

Global standardization strategy, 248, 262–263, 451, 454

GM (General Motors), 88–89, 90, 278, 410, 443, 445

Goals
characteristics of company, 16
and functional structure, 415–416
and output control, 408

Goizueta, Roberto, 267

Goldman Sachs, 391–392

Goleman, Daniel, 32

Google
Apps, 167
business model of, 20
and cloud computing markets, 243–244
ethical dilemma on, 313
mission statements of, 12, 14
in mobile payment industry, 210–211
reorganization at, 439–440
in smartphone industry, 215

Gou, Terry, 308

Governance mechanisms, 372–378
for ethical behavior, 387–388
external, 372–376
internal, 376–378
purpose of, 372

Government regulations. *See* Regulation(s)

Governments, as stakeholders, 362

Greenmail, 376

Grove, Andrew, 21, 58, 213–214

Growth industries, 64, 185–188, 190–191

Guidelines. *See* Organizational culture

H

Hallmark Cards, Inc., 431

Hamel, Gary, 278

Hammer, Michael, 432

Handoffs, 301, 399–400, 443

Harvest strategy, in declining industries, 202, 204

Hennegar, Anne, 23

Hewlett-Packard Company. *See* HP

Hierarchies
of authority, 399
in global matrix structure, 455–456

High-technology industries
cross-licensing in, 270
organizational structure in, 426–429

Hirai, Kazuo, 341

Hiring strategies
and efficiency, 129–130
and ethical behavior, 384

Holdup
definition of, 298
and outsourcing, 311–312
and vertical integration, 299

Hollinger International Inc., 370, 371

Honda Motor Co., 22–24, 90, 145, 197

Horizontal integration
benefits of, 290–294
definition of, 290
implementation of, 295
problems with, 294–295

Hostage-taking, as strategic alliance strategy, 305

Host country governments and local responsiveness, 261

Hostile takeovers, 375–376

Houston Independent School District, 426

HP, 223, 239–240, 359, 422, 460

Human resources
and achievement of innovation, 143t

and customer responsiveness, 146t
efficiency in, 129–130
function of, 92–93
reliability improvement and, 136t

Hydraulic technology and paradigm shifts, 238

I

IBM, 15, 106, 107–108, 223, 276–277, 305

IBM Credit, 431–432

Icarus paradox, 108

Iger, Bob, 402

Illusion of control, 28

Imitation, barriers to, 83, 103–105, 231–233

Immelt, Jeffrey, 10, 36–37

Immunex, 231

Implementation, and internal venturing, 343–344

Incentive systems, 170–171, 378

Industries. *See also specific types of industries*
analysis of, 47–60, 67
boundaries of, 47
changes in, and diversification, 333–334
competitive forces model of, 47–59
competitiveness of related and supporting, 252
competitive structure of, 52
definition of, 45
dynamism in, 106
entry into new markets within, 48–49, 51
exit barriers, 54–55
external analysis, 44–73
fragmentation in, 180
innovation and change in, 67–69
life-cycle stages of, 63–66, 67
macroenvironment forces and, 69–73
rivalry within, 50–55
and sectors, 46
strategic groups within, 60–62

Industry standards, 218–219, 222

Industry structure. *See* Competitive structure

Inertia, 107, 109–110

Infection, viral model of, 191

Inflation rates, 71

Information asymmetry, 367–369

Information distortion, 445

Information gathering, by leaders, 31

Information manipulation, 381

Information systems
and achievement of innovation, 143t
and customer responsiveness, 146t
and efficiency, 132
reliability improvement and, 136t
in value chain, 93

Information technology industries, 212, 243–244

Infosys, 252

Infrastructure. *See also* Control systems; Management; Organizational structure
and efficiency, 132–133
and globalization of products and markets, 261
reliability improvement and, 136t
in value chain, 89

Innovation. *See also* Product innovation; Value innovation
achievement of, 139–143
and control systems, 405–406
and dynamism, 106
and efficiency frontier, 160
and failure, 140–142
impact of, on industries, 67–69
strategies for profiting from, 232–233
types of, 96

Innovators, 185–186, 188

Inputs, standardization of, 409

Inside directors, 372–373

Intangible resources, 83, 104

Integration. *See also* Horizontal integration; Tapered integration; Vertical integration
of acquisitions, 346, 349
forward, 296, 300
and matrix structure, 428
mechanisms for, 403, 447, 450

Integrity, 383

Intel, 140, 196, 197, 214, 417

Intended strategies, 22–23

InterContinental Hotel Group (IHG), 243

Interest rates, 70
Internal analysis. *See*
 Capabilities;
 Competencies;
 Resources
Internal capital market, 332
Internal new venturing,
 341–345, 458
Internal stakeholders, 362
International division structure,
 451–452
International strategy, 451, 454
International trade, 248–249
Intrapreneurs, 458
Inventory systems, just-in-time,
 128–129
Invested capital (IC), 99,
 100f, 100t
iPhone, 189–190, 191, 215
iPhones, 286–287
Isdell, Neville, 267
ISIS, 210–211
Ito, Yuzuru, 329
Iverson, Ken, 30, 31
Ivester, Douglas, 267

J

JetBlue Airlines, 315, 316
Jobs, Steve, 170, 343, 395,
 396, 403
Joint ventures, 232–233,
 240, 271–272, 275,
 349–351, 459
Jones, Reg, 335
Jones, Tim, 21
Jung, Andrea, 282–283, 446
Juran, Joseph, 134
Just-in-time (JIT) inventory
 system, 128–129
JVC, 220, 223–224

K

Kahneman, Daniel, 29
Kaplan, Gary, 149–150
Keiretsu system, 303–304
Kelleher, Herb, 31
Kellogg's, 53
Kennedy, John F., 30
Kia, 162
Killer applications, 222
Kim, Chan, 171–172
Kindler, Jeffrey, 337
King, Martin Luther, Jr., 30
K-Mart, 159f, 160
Knight, Phil, 199
Knowledge management
 and alliances, 278
 of first movers, 229

in foreign markets, 271
 knowhow, 269
Kodak, 233, 334–335
Kraft Foods, 53
Kugele, Richard, 360

L

Laggards, 187
Lands' End, 145
Lane, Ray, 360
Late majority, 187
Law of diminishing returns, 225
Laws. *See* Regulation(s)
Laws, changes in, 72–73
Leadership. *See* Management;
 Strategic leadership
Leadership strategy, in
 declining industries,
 202–203
Learning, importance of,
 108–109
Learning effects, 120–121, 122,
 229, 256, 310
Lesjak, Catherine A., 360
Leverage, and horizontal
 integration, 293–294
Leveraging companies,
 324–325
Liaison roles, among
 managers, 403
Licensing, 224, 232t, 233,
 269–270
Life-cycle stages, of industries,
 63–66, 67
Limit price strategy, 193
Local communities, as
 stakeholders, 362
Localization strategy, 247–248,
 263–264, 267–268,
 451, 452
Local responsiveness, 258,
 259–261, 264
Location, 418–419
Location economies, 256–257
Logistics, 92, 128
Long-term goals, 444
Low-cost position
 achievement of, 169
 and competitive advantage,
 118, 166
 as competitive strategy,
 155–156
 and differentiation tradeoff,
 158–160, 159f, 166
 in global markets, 262–263
 and location, 256
 marketing strategies for,
 164–165, 165f
 and organizational design, 421

Luck, and competitive
 success, 110
Lululemon, 175–177
Lynch, Michael, 360

M

Mackay, Martin, 337
Macroeconomic forces, 69–70
Macroenvironment forces and
 industries, 69–73
Management. *See also*
 Knowledge management
 and achievement of innova-
 tion, 143t
 in agency theory, 367
 and customer responsiveness,
 146t
 and ethical behavior,
 384–385
 on-the-job consumption by,
 368–369
 levels of, 9–11, 9f
 by objectives, 415
 and response to
 customers, 144
 strategic, 9, 328–329,
 381–385
 types of unethical behavior
 by, 381–383
 unethical, 384
Managers. *See also specific
 types of managers,
 e.g. Functional-level
 managers*
 autonomous actions by,
 21–22
 and business ethics, 379,
 384–385
 and diversification, 322–323,
 327–334
 entrepreneurship of,
 327–328
 and functional-level
 strategies, 117–118
 goal of, 287
 integrating roles of, 450
 at international divisions, 452
 liaison roles among, 403
 and stockholders, 364–366
 types of, 9–11
Manufacturing
 as complementary asset,
 230–231
 flexible versus
 traditional, 125f
 and research and develop-
 ment, 344–345
Margin costs, and digitalization,
 226, 227

Market demand. *See also*
 Demand
 accelerants of, 190–191
 and adoption of disruptive
 technologies,
 236–237, 239
 and industry standards, 219
 and types of customers,
 185–188
Market development
 business models and, 188, 190
 and customer groups,
 185–186, 186f
 demand and growth rates in,
 190–191
 function and purpose of, 197
 as non-price competitive
 strategy, 196f
 at Toyota, 198
Marketing
 and achievement of
 innovation, 141–142, 143t
 as complementary asset, 231
 and customer responsiveness,
 146t
 format wars and, 223
 imitation of, by rivals, 104
 and reliability improvement,
 136t
 and research
 and development, 344
 strategies, 125
 and value creation, 90
Market penetration, 186f,
 196–197, 196f
Markets, global. *See* Global
 markets
Market saturation, 186f
Market segmentation
 approaches to, 162
 costs and revenues with,
 163–164
 definition of, 161
 types of strategies for,
 162–166
Market segments, 47
Market share
 and customer groups, 187f
 and product differentiation,
 196
Market structure, in
 organizations, 424,
 427–428
Marks & Spencer, 127
Mars, Inc., 125
Martinizing, 207
Mass customization, 124,
 126, 163
Mass market, 185, 186f,
 187–188

Materials management
and achievement of
innovation, 143t
and customer responsiveness,
146t
and efficiency, 128
and reliability improvement,
136t
in value chain, 92
Matrix structure
definition of, 427–428
at Dow, 457
global, 455–456
Matsushita, 219–220, 224
Mature stage, of industry
development, 65–66,
191–201
Mauborgne, Renee, 171–172
Mazda, 278
McDonald's, 181–182, 257,
270, 300, 421
Medical equipment industry, 327
Menzer, John, 453
Mergers, 183, 290, 460–461
Merrill Lynch, 402–403
Messier, Jean-Marie, 369
Microsoft
and anticompetitive behavior,
381–382
and antitrust laws, 195
and Apple's strategy, 287
and cloud computing,
243–244
culture at, 410
as first mover, 231
international strategy of, 265
and leveraging
competencies, 325
and smartphone industry,
49, 189
smartphone industry and, 275
threat of segment zero and,
213–215
vision of, 15
Microsoft Office, 167
Miller, Danny, 108
Miller Brewing Company,
323–324
Mintzberg, Harold, 22–25
Mission, definition of, 12
Mission statements, 12, 14
Mitsubishi Heavy Industries, 271
Mobile payments industry,
210–211
Mobility barriers, 62
Moore, Ann, 18
Moore, Geoffrey, 188
Moral courage, and ethics,
387–388
Morgan, J. P., 110

Motivation, in leaders, 32
Motorcycle industry, 24–25
Motorola, 422
MSN, 20–21
MSNBC, 162
MTV Networks, 260, 263
Mulally, Alan, 246–247,
435–436
Multibusiness model
establishment of, 288–289
strategies for, 441–450
and vertical integration,
295–296
Multidivisional companies,
definition of, 9
Multidivisional structure,
441–450
advantages of, 443–444
corporate headquarters staff
in, 442
definition of, 441
issues with implementing,
444–445
self-contained divisions in,
441–442
and vertical integration,
449–450
Multinational organization,
253, 265
Mutual dependence, 298, 305

N

NAFTA, 257
National markets, 249
Naval, 203–204
Neiman Marcus, 410, 426
Nelson, Martha, 18
Nestlé, 460, 461, 465
Netflix, 243
Net profit, 99, 100f, 100t
Network effects, 219, 229, 237
Newspaper industry, 178–179
New ventures
and corporate-level strategies,
341–345
and customer needs, 343
divisions for, 458
and failure, 342–344
NeXT system, 343
Niche strategy, 164–165, 202,
203–204. See also
Market segmentation
Nike, 162, 199, 325, 379–380
Nintendo, 59
Nokia, 275, 304, 423f
Non-price competition, 196,
196f, 199
Nonprofit enterprises,
performance in, 8

Nordstrom, 97–98, 153–154,
159f, 170
Norms. See Organizational
culture
Northwest Airlines, 316
Nucor Steel, 15, 31, 84, 120, 130
Nvidia, 196, 197

O

Observability, of products, 191
Office supply industry, 181
Oligopolies, 66, 249–250
Olson, Ken, 109
On-the-job consumption,
368–369
Operating budgets, as behavior
control system, 409
Operating environments, 17
Opportunism, 277
Opportunistic exploitation, 382
Opportunities
definition of, 44
strategic groups and, 61–62
Oracle Corporation, 293
Organizational culture
at Apple, 396
and business-level strategy,
170–171
definition of, 397–398
and ethical behavior, 385
at the functional level, 416
function of, 410–411
and matrix structure, 428
in multidivisional structure,
448t
and risk-taking, 327–328
and strategic leadership,
411–413
traits of strong and adaptive,
413–414
and unethical behavior,
383–384
Organizational design,
168–169, 397, 398,
419–421, 460–461
Organizational design skills, 328
Organizational slack, 444
Organizational socialization, 411
Organizational structure
building blocks of, 398–399
definition of, 397
within divisions, 443
function and elements of, 397
for global companies, 451–457
hierarchical levels in,
400–401
levels of control in, 407f
and strategic leadership,
412–413

types of, 414–419, 424–430,
441–450
Organizations
managers in, 9
mission statements of, 14–16
stakeholders in, 362f
values in, 15–16
vision of, 15
Orientation. See Customer
orientation; Product
orientation
Output
standardization of, 409
unit costs and, 119–120
Output control, 408, 415, 421
in mergers and
acquisitions, 461
in new-venture divisions, 458
with related
diversification, 450
Outside directors, 372–373, 387
Outside view, in decision-
making, 29
Outsourcing, 307–312, 419
at Apple, 286–287
benefits of, 310–311
and profitability, 309–310
risks of, 311–312
and value creation, 307–312
Overcapacity, 200

P

P&G (Proctor & Gamble),
325, 326f
Page, Larry, 439, 440
Palm, 228, 230
Pandora Media, 125, 126
Paradigm shifts, in technology,
233–240, 243
Parallel sourcing policy, 307
Parmalat, 370
Partners, selection of,
276–277
Pascale, Richard, 22
Patents, 104, 231
Paulson, John, 391–392
Pay-for-performance, 130,
372–373
Paypal, 210–211
Pearson, William, 23
PepsiCo, 51
Performance. See also Pay-for-
performance
and CEO compensation, 369
and control systems, 407–410
employee, 130
improvements to, 430–432
improving, 330–331
industry differences in, 7–8

Performance *(continued)*
and innovation, 160
in nonprofit enterprises, 8
reward systems for, 410, 417
and unethical behavior, 383
valuation of, 5–6
Perrier, 90
Personal computer industry.
See also Computer
industry
dominant design in, 216
market demand in, 185–186
technical standards in, 217f
value innovation in, 161f
Personal control, 408
Personal ethics, 383, 384
Peters, T. J., 413
Pfeffer, Jeffery, 32
Pfizer, 139, 337
Pharmaceutical industry,
61–62, 261
Philip Morris, 202, 323–324
Philips, 223–224
Photography industry, 233
Planned strategies
decentralized, 26–27
internal analysis in, 17
reasons for, 25
steps of, 11–12, 13f
unpredictability in, 20–21
Political changes, 72–73
Poltruck, David, 23
Porsche, 139, 162, 168
Porter, Bill, 23
Porter, Michael E., 47, 68, 165,
250, 252. *See also* Five
Forces model
Positioning strategy, for
products, 140
Positive feedback. *See*
Feedback loops
Potential competitors, risk of
entry by, 48–49
Power, use of, in leadership, 32
Prahalad, C. K., 278
Premium pricing, 157
Price fixing, 366
Price leadership, 195–196
Price signaling, 194–195
Price wars, 52, 53, 65, 199, 201
Pricing. *See also* Transfer
pricing
coordination of, by
rivals, 294
to encourage demand, 223
premium, 157
tit-for-tat, 195
and value creation, 86–88
Primary activities, in value
chain, 89–90

Prince, Charles O., III, 319
Principal-agent
relationships, 367
Prior hypothesis bias, 28
Procedures, as behavior control
system, 409
Process innovation, 96, 129, 160
Proctor & Gamble (P&G),
196–197, 253, 265, 465
Product attributes
quality of excellence and,
138–139
table of, 138t
Product bundling, 291–292,
326–327
Product development, 196f,
197, 395–396, 418
Product innovation, 106, 395
Production
and achievement of innova-
tion, 141–142, 143t
cost and quality factors of,
250–251
costs of, and value, 85–88
and customer
responsiveness, 146t
flexibility in, 124–125, 130
and functional-level strate-
gies, 416
globalization of, 249
and reliability
improvement, 136t
and value creation, 90
Productivity
and compensation, 130
employee, 94, 129–130
learning effects and, 120–122
at Wal-Mart, 131
Product orientation, 14
Product proliferation, 192,
196f, 198
Products
positioning strategy for, 140
substitute, 58
Product structure, 422–423, 441
Product substitution, 58
Product-team structure, 429–430
Profitability. *See also* Return on
invested capital (ROIC)
and competitive advantage,
85–86, 98–103, 118f
definition of, 5
and diversification, 322–331
failure of, 106–110
global expansion and, 253,
255, 263
and horizontal integration,
290–291, 293–294
and multidivisional structure,
443–444, 445

and organizational design,
419–421
and outsourcing, 309–310
and revenue growth
rates, 370
and scale of entry into new
markets, 342, 343f
and stakeholders, 364–365
and vertical integration,
297–298, 301–302
Profit centers, 443–444
Profit growth
definition of, 5
as determinant of shareholder
value, 4f
global expansion and,
253–254
rate of, and enterprise valua-
tion, 38–39
and stakeholders, 364–365
and stockholder value, 335
Promotion strategies, and
ethical behavior, 384
Property, plant and equipment
(PPE), 99, 100f, 100t
Public domain, 218
Publishing industry, 18
Punctuated equilibrium, 68

Q

Quality
achievement of, 134–139
attribute of superior, 94–96
and control systems, 405
and cost(s), 96
and pricing in the U.S. auto
industry, 88
and vertical integration, 299
Quality control, and
franchising, 270–271
Quasi integration, 302–303

R

R&D. *See* Research and
development (R&D)
Radler, F. David, 371
Razor and blade strategy,
19, 223
RCA, 269–270
Reasoning by analogy, 28
Reed, John, 319
Reengineering, 430–432
Regulation(s)
government, 50, 72–73
and management of profit
growth and
profitability, 365
self, 32

Regulatory protection, 50
Related diversification,
331, 338
Relational capital, 278
Relative advantage, of
products, 190
Reliability, quality of, 94,
95–96, 134–137
Reorganization
at Google, 439–440
at Unilever, 464–465
Representativeness, 28
Research and development
(R&D)
and achievement of innova-
tion, 141–142, 143t
and customer
responsiveness, 146t
and disruptive
technologies, 239
and efficiency, 129
and functional-level
strategies, 416–417
and new ventures, 344–345
overview of, 90
and reliability
improvement, 136t
Research in Motion
(RIM), 189
Reservation price, 86
Resources
versus capabilities and com-
petencies, 85f
and competitive
advantage, 118f
as distinctive competen-
cies, 84
duplication of functional, 447
imitation of, by
competitors, 104
in multidivisional
structure, 447
reduction of duplicated, 291
sharing of, and cost structure,
325–326
tangible and intangible,
83, 104
value of, 83
and vertical integration,
297–298
Response time, to customers'
needs. *See also* Local
responsiveness
advantages of increased,
146–147
and control systems, 406
and customer satisfaction,
96–97
and employees, 144–145
and functions, 146t

and market structure, 424
and worldwide area structure,
 452, 454
Responsibility, allocation of,
 399–400, 455, 459
Restructuring, 350–351, 430
Retail industry, 61
Return on invested capital
 (ROIC)
 and diversification, 322
 and enterprise valuation,
 38–39
 and profitability, 5,
 99–101, 364
 in selected industries, 8f
Return on sales (ROS), 99,
 100f, 100t
Revenue growth
 and marketing strategies, 163
 rate of, and profitability, 370
Reward systems
 for performance, 410, 417
 and product structure, 423
 and unrelated/related
 diversification, 450
Risk capital, 5, 363
Risk pooling, 334
Rivalry, among competitors,
 50–55
 in the global marketplace,
 249–250
 and horizontal integration, 294
 and national competitive
 advantage, 252
 strategies for managing,
 194–201
ROIC. See Return on invested
 capital
Roll, Richard, 28
Royal Dutch Shell, 25,
 370–371
Rules, as behavior control
 system, 409–410
Rumelt, Richard, 69

S

Sacconaghi, Tony, 360, 361
Sales
 and functional-level strate-
 gies, 417
 and value creation, 90
Sales, general and
 administrative expenses
 (SG&A), 99, 100f, 100t
Samsung, 301–302, 304
Sarbanes-Oaxley Act (2002), 375
Scenario planning, 25–26
Scheduling, and vertical
 integration, 300–301

Schmidt, Eric, 439
Schultz, Howard, 21, 113, 183
Schwab, Charles, 23
Screening, of acquisitions,
 347–348
Sears, Mike, 365
Sectors, 46
Segmentation strategy, 163
Segment zero markets, 213–214
Seip, Tom, 23
Self-awareness, 32
Self-contained divisions,
 441–442
Self-dealing, 381, 387
Self-managing teams, 130
Self-regulation, 32
Semiconductor chip industry,
 235
Serendipity, 22
Services. See Technical support
Shakeout stage, of industry
 development, 64–65
Shareholder value
 definition of, 5
 determinants of, 4f
 and diversification, 322–323
Sharp, 229
Short-run focus, 445
Singapore Airlines, 138
Six Sigma programs
 at General Electric (GE), 135
 implementation of, 136–137
 and reliability
 improvement, 134
Skills. See Capabilities
Skills, leveraging of
 in global subsidiaries, 257
 in transnational strategy, 264
Slack, organizational, 444
Sloan, Alfred, 443, 445
Smartphone industry, 49,
 186–187, 189–190, 215,
 275, 304
Smith Corona, 14
Social changes, 72
Socialization, 411
Social skills, 32
Soft drink industry, 45–46, 51
SonoSite, 227
Sony
 and aggressive
 marketing, 223
 and complements, 222
 and cooperation with
 competitors, 223–224
 corporate-level strategies of,
 339–341
 in format war, 219–220
 and technological change,
 301–302

Sotheby's, 366, 372
Southwest Airlines, 31, 84,
 129, 156, 171–173,
 315, 316
Span of control, 400
Specialization, 119
Specialized assets, 297–298,
 303–304
Square, Inc., 210–211
Stakeholders
 and business ethics, 380–381
 definition of, 362
 impact analysis of, 363
 management of profit growth
 and profitability for,
 364–365
Standardization
 as behavior control
 system, 409
 of products, in global
 markets, 260
Standardization strategy,
 162, 163
Standards. See Industry
 standards; Technical
 standards
Staples, 181, 182
Starbucks, 21, 113, 157,
 182, 243
Steel industry, 67–68
Stockholders
 in agency theory, 367
 as stakeholders, 362,
 363–364
Stock-option grants, 374, 378
Stock options, 373
Strategic alliances
 with competitors,
 232–233, 240
 in corporate-level strategy,
 303–307
 global, 275–278
 management of, 278
 partners in, 276–277
 structures of, 277–278
Strategic commitments, 105,
 107–108, 193–194
Strategic control systems. See
 Control systems
Strategic groups, 60–62
Strategic leadership
 characteristics of, 29–32
 definition of, 4
 and efficiency, 132–133
 and organizational culture,
 411–413
 and organizational structure,
 412–413
Strategic management. See
 Management

Strategic managers. See
 Managers
Strategic outsourcing. See
 Outsourcing
Strategy
 analysis of, 17
 and competitive advantage
 and competencies, 85f
 definition of, 3
 development of, 22–25
 distinctive competencies and,
 84–85
 as an emergent process,
 20–21
 formulation of, 4, 11–19,
 44–73
 implementation of, 4, 13f,
 19–20, 397
Strategy canvas, 172
Stringer, Howard, 340–341
Subsidiaries, wholly
 owned, 272
Substandard working
 conditions, 382
Substitutes, for products, 58
Sun Microsystems, 459
Supermarket industry, 53
Suppliers
 bargaining power of, 56–57
 as stakeholders, 362
Supply chain management, 129,
 305–307
Support activities, in value
 chain, 89f, 91–93
Sustained competitive
 advantage, 6, 83,
 106–110, 227–228
Switching costs, 50, 221, 229
SWOT (strengths, weaknesses,
 opportunities, threats)
 analysis, 17, 19
Synergies. See Economies of
 scope

T

Tacit price coordination, 294
Taiwan Semiconductor
 Manufacturing
 Company (TSMC),
 303–304
Takeover constraint, 375–376
Tall organizational structure,
 400–401
Tangible resources, 83, 104
Tapered integration, 298–299
Target Corporation, drivers
 of profitability for,
 101–103
Tariff barriers, 269

Tasks, grouping of, into functions, 399
Taubman, Alfred, 366
Teams
cross-functional integration of, 141–142
as integrating mechanisms, 405
in matrix structure, 428
in product-team structure, 428
in total quality management, 416
Teams, self-managing, 130
Technical standards
benefits of, 217
definition of, 213
establishment of, 218–222
examples of, 216
Technical support, 90
Technological paradigm shift, 233–240, 243
Technology
changes in, 71–72, 301–302
disruptive, 236–240
experience curve and, 124
first movers and, 230
flexible production, 124–125, 130
imitation of, 104
killer applications in, 222–223
natural limits of, 234–235
paradigm shifts in, 233–240, 243
S-curve, 234–235
successor, 235–236
trajectory of improvements and customer requirements, 214f
Telecommunications industry, 326
Telefunken, 223–224
Telephone industry, 290
Tennant, Anthony, 366
Texas Instruments (TI), 272
Thatcher, Margaret, 30
Threats
definition of, 45
strategic groups and, 61–62
3M, 22, 140, 231, 458, 459
Timberland, 354–355
Time Inc., 17–20
Titanium Metals Corporation, 382
Tit-for-tat pricing strategy, 195
Total quality management (TQM), 134–135, 416, 431

Total solution strategy, 292–293
Toyota
and alliances, 278
differentiation strategy of, 162–163, 164, 165f
lean production system of, 83, 105
market development at, 197, 198
and value creation, 88–89
and value innovation, 160
Toys "R" Us, 67
Trade barriers, 257
Training, of employees, 130
Transfer pricing, 301, 443, 447
Transferring competencies, 323–324
Transnational strategy, 264–265, 451, 455
Transportation costs, 257
Trialability, of products, 191
Trust, in agency theory, 368
TRW, 277
Turnaround strategy, 330
Two-boss employees, 428

U

Ultrasound technology, 227
Unilever, 385, 464–465
Union Pacific (UP), 404
Unit costs
and experience curve, 122–123
and flexible production technology, 124–125
and limit price strategy, 193
output and, 119–120
United Airlines, 316
United Technologies Corporation (UTC), 329–330, 349
Unrelated diversification, 331–332, 338
U.S. Airways, 316

V

Value chain, 89–93, 296, 427
Value creation, 85–93
and competitive advantage, 118f
and efficiency, 133t
and location, 256–257
and outsourcing, 307–312
and pricing, 86–88
and vertical integration, 296–297

Value innovation
and competitive advantage, 171–173
and fragmented industry consolidation, 181–182
overview of, 160
in the personal computer industry, 161f
at Wal-Mart, 184
Values. See also Organizational culture
definition of, 15–16
in mergers and acquisitions, 461
in organizations, 410–414
Ventures. See Joint ventures; New ventures
Verizon, 82, 83
Verizon Wireless, 80–81
Vertical disintegration, 301
Vertical integration, 295–302
alternatives to, 302–307
at Apple, 286–287
and bureaucratic costs, 301
and contracts, 307
and cost structure, 301–302
definition of, 295–296
and demand, 302
and holdup, 299
and McDonald's, 300
and multidivisional structure, 447–448, 448t, 449–450
problems with, 301–302
and product quality, 299
and profitability, 297–298, 301–302
and restructuring, 351
scheduling and, 300–301
and supply chain management, 305–307
and value creation, 296–297
VF Corporation, 354–355
VHS technology, 219–220
Viral model of infection, 191
Virginia Mason Hospital, 149–150
Virtual corporation, 310
Vision
definition of, 15
in leadership, 30
Vivendi, 369
Volvo, 139

W

Wal-Mart
bargaining power of, 57
in breakfast cereal industry, 53

business model of, 7
competitive advantages of, 1–3
cost leadership strategy at, 421
differentiation-low cost tradeoff strategy at, 159f
drivers of profitability for, 101–103
global expansion and, 254–255
human resources and productivity at, 131
as innovators, 67
international divisions at, 452, 453
organizational culture in, 412
productivity at, 131
in soft drink industry, 51
statement of ethics at, 386
value creation and, 97–98
value innovation at, 184
Walt Disney Company, 84–85, 402, 411
Walton, Sam, 2, 9, 30, 131, 412
Wang, Jerry, 404
Warner Brothers, 275
Washington Mutual, 363–364
Waterman, R. H., 413
Weill, Sanford "Sandy", 319
Welch, Jack, 30
Wholly owned subsidiaries, 272
Wilson, Chip, 175–176
Windows Azure, 244
Wipro, 252
Wiseman, Eric, 355
Working capital, 99, 100f, 100t
Worldwide area structure, 452, 454
Worldwide product divisional structure, 454–455
Wrapp, Edward, 32
Wyman, Oliver, 88–89

X

Xerox, 265, 271, 277

Y

Yahoo!, 21, 404
Yamaha, 145

Z

Zara, 92
Zoots, 207